PICASSO AND AMERICAN ART

PICASSO AND AMERICAN ART

MICHAEL FITZGERALD

WITH A CHRONOLOGY BY JULIA MAY BODDEWYN

*The exhibition was organized by Michael FitzGerald, guest curator, in association with
Dana Miller, associate curator, Whitney Museum of American Art*

WHITNEY MUSEUM OF AMERICAN ART, NEW YORK

IN ASSOCIATION WITH YALE UNIVERSITY PRESS, NEW HAVEN AND LONDON

Published on the occasion of the exhibition *Picasso and American Art*, organized by the Whitney Museum of American Art, New York. The exhibition was organized by Michael FitzGerald, guest curator, in association with Dana Miller, associate curator, and with the assistance of Stacey Goergen, curatorial assistant, and Jennie Goldstein, curatorial assistant.

Whitney Museum of American Art, New York
September 28, 2006–January 28, 2007

San Francisco Museum of Modern Art
February 25–May 28, 2007

Walker Art Center, Minneapolis
June 17–September 9, 2007

Designed by Makiko Ushiba Katoh
Set in Berthold Bodoni Old Face by Günter Gerhard Lange
Printed on 157 gsm Japanese matte art
Printed by C+C Offset Printing Co., Ltd. China

This publication was produced by the Publications and New Media Department at the Whitney Museum of American Art, New York: Rachel de W. Wixom, head of publications and new media; Thea Hetzner, associate editor; Jennifer MacNair, associate editor; Makiko Ushiba Katoh, manager, graphic design; Anna Knoell, design assistant; Vickie Leung, production manager; Anita Duquette, manager, rights and reproductions; and Joann Harrah, rights and reproductions assistant; in association with Yale University Press: Patricia Fidler, publisher, art and architecture; John Long, photo editor; and Kate Zanzucchi, senior production editor.

Library of Congress Cataloging-in-Publication Data
FitzGerald, Michael C.
Picasso and American art / Michael FitzGerald ; with a chronology by Julia May Boddewyn.
p. cm.
Published on the occasion of an exhibition organized by the Whitney Museum of American Art, New York and held also at the San Francisco Museum of Modern Art and Walker Art Center, Minneapolis.
Includes bibliographical references and index.
ISBN-13: 978-0-300-11452-2 (hardcover : alk. paper)
ISBN-10: 0-300-11452-4 (hardcover : alk. paper)
ISBN-13: 978-0-87427-154-6 (pbk. : alk. paper)
ISBN-10: 0-87427-154-1 (pbk. : alk. paper)
1. Art, American—20TH century—Exhibitions. 2. Avant-garde (Aesthetics)—United States—History—20TH century—Exhibitions. 3. Picasso, Pablo, 1881–1973–Influence–Exhibitions. I. Boddewyn, Julia May, 1964– II. Whitney Museum of American Art. III. San Francisco Museum of Modern Art. IV. Walker Art Center. V. Title.
N6512.F58 2006
709.73′0747471–DC22
 2006001402

10 9 8 7 6 5 4 3 2 1

Cover illustrations:
(front) **ROY LICHTENSTEIN**, *Girl with Beach Ball III*, 1977 (plate 135)
(back) **PABLO PICASSO**, *Seated Woman with Wrist Watch*, August 17, 1932 (plate 101)

Endpapers: **JACKSON POLLOCK**, *Untitled*, ca. 1939–42 (fig. 83, both sides of drawing)

Frontispiece: **JASPER JOHNS**, *Sketch for Cups 2 Picasso/Cups 4 Picasso*, 1971–72 (plate 148)

Lead Sponsor

The exhibition and catalogue are made possible through a generous grant from the Terra Foundation for American Art.

TERRA
FOUNDATION FOR AMERICAN ART

75th Anniversary Sponsor DEBEVOISE & PLIMPTON LLP

Major support is provided by the Birchrock Foundation, the Horace W. Goldsmith Foundation, and a grant from the National Endowment for the Arts.

Additional support is provided by Linda and Harry Macklowe, Susan R. Malloy, Robert E. Meyerhoff, Mary and Louis S. Myers Foundation, Aaron I. Fleischman, and Irvin and Lois E. Cohen.

This exhibition is supported by an indemnity from the Federal Council on the Arts and the Humanities.

NATIONAL
ENDOWMENT
FOR THE ARTS
Established 1965

CONTENTS

SPONSOR'S STATEMENT

CIT is proud to be the lead sponsor of *Picasso and American Art* at the Whitney Museum of American Art. This is an extraordinary exhibition that examines the fundamental role that Pablo Picasso played in the development of American art over the past century. Many American artists acknowledge Picasso's role as the central figure of the modern art movement and have defined their own artistic achievements through their absorption, critique, or rejection of his style. Through this incredible exhibition, we are given the opportunity to view his influence alongside the work of renowned American artists such as Max Weber, Stuart Davis, Arshile Gorky, John Graham, Willem de Kooning, Jackson Pollock, David Smith, Roy Lichtenstein, Jasper Johns, and many other distinguished international artists.

CIT's support of the Whitney Museum of American Art personifies our longstanding commitment to New York City's cultural institutions and our efforts to serve as responsible corporate citizens. Our philanthropic commitments are fundamental to the relationships we maintain with our employees, customers, and the communities in which we live and work.

We congratulate the Whitney's Board of Directors and its supporters for bringing *Picasso and American Art* to the Whitney Museum of American Art. Michael FitzGerald, guest curator, should be commended on his brilliant essay contained herein and should be applauded for the extraordinary exhibition he has organized in association with Dana Miller, associate curator. We also extend a special thank you to Adam D. Weinberg, Alice Pratt Brown Director, and his entire staff for bringing *Picasso and American Art* to CIT's attention and for their continued dedication and hard work. Congratulations to the San Francisco Museum of Modern Art and the Walker Art Center for collaborating with the Whitney to bring this special exhibition across the country. I hope you enjoy *Picasso and American Art* and encourage your family and friends to visit the Whitney Museum of American Art.

—JEFFREY M. PEEK, CHAIRMAN & CHIEF EXECUTIVE OFFICER

DIRECTOR'S FOREWORD

"'LOOKING' IS & IS NOT 'EATING' & ALSO 'BEING EATEN.'"
Jasper Johns, 1964

The history of art is also the history of influences. Although a painting typically is demarcated, contained and removed from the world by the four sides of its frame, it is anything but an encapsulated object. A painting, like the artist, is part of a larger flow of ideas and culture. Moreover, a painting acts as a sieve, capturing and distilling certain experiences, techniques, emotions, knowledge, and aspirations that flow through it. How are these ideas transmitted? They travel by word of mouth, in bars, artist studios, and public discussions; through publications, via magazines, books, catalogues, and the internet; and perhaps most importantly through the works themselves, as seen in galleries, private collections, museums, and public expositions. Artistic influences are like viruses: they travel, they know no boundaries, they are picked up often unconsciously and transported from place to place, sometimes infecting few and other times leading to epidemics.

For American artists of the twentieth century, no artist loomed larger for a longer period of time than Pablo Picasso, lest we forget a Spanish artist working in France. The great, haughty artist/impresario Alfred Stieglitz, upon learning that Picasso admired his iconic photograph *The Steerage*, sounded like a schoolboy when he wrote in 1914, "It was mighty interesting to hear what Picasso had to say about my photographs. Of course I value his opinion tremendously." And, wanting to obtain an exhibition of Picasso's work for his gallery 291, he wrote, "I am more eager than ever to have him. 291 needs it badly. That is New York needs it." Several decades later, Jackson Pollock, who first saw Picasso's work in 1922 in reproductions in *Dial* magazine, cursed "That fucking Picasso . . . he's done everything."

For more than eight decades, the Whitney Museum of American Art, and its antecedent, the Whitney Studio Club, has held a central and influential role in framing the discussion and consideration of American art. While many have thought, and some still think, that the Whitney's role is to define an American art, from its inception the museum has acknowledged its responsibility to be part of a larger international dialogue, as evidenced by its exhibition program.

In 1923, the Whitney Studio Club mounted an exhibition of "Recent Paintings by Pablo Picasso and Negro Sculptures." At roughly the same time, Juliana Force, the museum's first director, together with artist, critic, and curator Marius de Zayas organized an exhibition of seven American painters to be presented at the Durand Ruel Galleries in Paris. A year later, Charles Sheeler, an artist often considered to be one of the most "American of American artists," curated the exhibition "Pablo Picasso, Marcel

Duchamp, Marius de Zayas and Georges Braque." While one might think that the Whitney was getting its bearings, which no doubt it was, the museum understood that framing the "dialogue" of American art also had to do with influencing and being influenced. Force was undoubtedly a nationalistic champion of American art in the years before World War II, when many questioned whether significant art was being produced in the United States. But she also understood that the museum was a conduit for artistic influence, as she wrote in her foreword to the Whitney exhibition "Painting in France 1939–1946": "We are pleased to aid in the clearing of channels of communication that will bring about the free flow of ideas that are essential to the fullest development of American art."

This project, "Picasso and American Art," traces the transmission of Picasso's ideas and images. The exhibition—ten years in the researching and realization by art historian Michael FitzGerald—does not present works that are Picasso look-alikes. Rather, FitzGerald has tracked down the specific works, exhibitions, and publications seen by American artists. In short, the volume and the exhibition it accompanies are a precise, dare I say almost scientific case study regarding the nature of influence. This study examines perhaps the single most important and visually thrilling instance of influence in American art. While this project focuses on the effect of Picasso's work on nine key American artists (Max Weber, Stuart Davis, Arshile Gorky, John Graham, Willem de Kooning, Jackson Pollock, David Smith, Roy Lichtenstein, and Jasper Johns), it also encompasses the work of more than a dozen other significant artists from Man Ray to Andy Warhol. Given the importance of this subject and the extraordinary care and time that have gone into this effort, I believe that this book is destined to be an essential reference book on twentieth-century American art and a touchstone for further explorations of artistic influence. Moreover, the exhibition itself will be a surprising and unforgettable experience.

How does one thank someone for a decade-long endeavor except to say that the Whitney is honored to have been Michael FitzGerald's partner? This is an exhibition that many a museum would have been delighted to host; we are truly fortunate to be the beneficiary of FitzGerald's dogged scholarship, inventive approach to the exhibition structure, and persistent curatorial pursuit of loans. Dana Miller, Associate Curator, Permanent Collection, has worked closely with FitzGerald on this project for the last five years. Miller's detailed and dedicated involvement on every aspect of this project—the catalogue, exhibition, and tour—has ensured its

excellence and success. My thanks also to Stacey Goergen, curatorial assistant, and Jennie Goldstein, curatorial assistant, for their hard work on the project.

I would like to acknowledge the hard work of the entire Whitney staff. An exhibition of this scale and complexity involves every department of the museum. Many of them are mentioned in the acknowledgments, but we must never take their devotion for granted.

"Picasso and American Art" is indeed one of the most ambitious and long-term undertakings in the Whitney's history; it is also one of the most costly. We are fortunate that a number of corporations, foundations, and individuals have understood the significance of this endeavor. Thanks to their extraordinary generosity many thousands of visitors will be enriched by the exhibition, and scholarship in the area of twentieth-century American art has been considerably advanced. I would like to express my gratitude to CIT as our lead corporate sponsor. Jeffrey Peek, Chairman and CEO, Anita F. Contini, and Stacy Papas were immediately enthusiastic about supporting the exhibition and have worked closely with us to make it known and available to expanded audiences. Elizabeth Glassman, President and CEO, and Marshall Field V, Chairman, of The Terra Foundation for American Art have a deep understanding of this exhibition's importance and accordingly have wholeheartedly endorsed and supported its creation. The Partners of Debevoise & Plimpton LLP, who, like the Whitney Museum, are celebrating their seventy-fifth anniversary, have also given generously to the project. Major support has been provided by The Birchrock Foundation and grants from the Horace W. Goldsmith Foundation and the National Endowment for the Arts. The Whitney Museum is lucky to have such good friends, some of whom have been involved for decades, others more recently. Linda and Harry Macklowe, Susan R. Malloy, Robert E. Meyerhoff, and the Mary and Louis S. Myers Foundation have all been important donors. Aaron I. Fleischman and Irvin and Lois E. Cohen have also provided support, for which we are grateful. In addition, the exhibition is underwritten by an indemnity from the Federal Council on the Arts and Humanities.

Above all, I wish to thank the Whitney Board of Trustees and, in particular, Leonard A. Lauder for his faith in this project from its inception a decade ago. Without his hard work, this exhibition would never have come to fruition.

—ADAM D. WEINBERG, ALICE PRATT BROWN DIRECTOR

LIST OF LENDERS

Ackland Art Museum, The University of North Carolina at
 Chapel Hill
Acquavella Galleries, New York
Art Gallery of Ontario, Toronto
The Art Institute of Chicago
Beinecke Rare Book and Manuscript Library, Yale University,
 New Haven
Louise Bourgeois, courtesy of Cheim & Read, New York
Bridgestone Museum of Art, Ishibashi Foundation, Tokyo
The Eli and Edythe L. Broad Collection
Brooklyn Museum
Donald L. Bryant, Jr., Family Trust
Barbara Bertozzi Castelli
Private collection, courtesy of Cheim & Read, New York
Columbus Museum of Art, Ohio
Curtis Galleries, Minneapolis
Dallas Museum of Art
Barbaralee Diamonstein and Carl Spielvogel
Diocese of the Armenian Church of America (Eastern), on
 deposit at the Modern Art Center, Calouste Gulbenkian
 Foundation, Lisbon
Barney A. Ebsworth
Aaron I. Fleischman
The Gemeentemuseum Den Haag, The Hague, The Netherlands
The Alex Hillman Family Foundation, New York
Hirshhorn Museum and Sculpture Garden, Smithsonian
 Institution, Washington, D.C.
Jasper Johns
Joslyn Art Museum, Omaha
Emily Fisher Landau
Terese and Alvin S. Lane
Frances Lehman Loeb Art Center, Vassar College, Poughkeepsie,
 New York
Martin Z. Margulies
Marks Family Collection
Thomas McCormick Gallery, Chicago
McNay Art Museum, San Antonio
The Menil Collection, Houston
The Metropolitan Museum of Art, New York
Robert and Jane Meyerhoff Modern Art Foundation, Inc.,
 Phoenix, Maryland
Modern Art Museum of Fort Worth
Montclair Art Museum, New Jersey
Musée National d'Art Moderne, Centre Georges Pompidou, Paris

Musée National Picasso, Paris
Museo Nacional Centro de Arte Reina Sofia, Madrid
Museo Thyssen-Bornemisza, Madrid
Museum of Fine Arts, Boston
The Museum of Modern Art, New York
National Gallery of Art, Washington, D.C.
The Newark Museum, New Jersey
Philadelphia Museum of Art
The Phillips Collection, Washington, D.C.
The Picker Art Gallery, Colgate University, Hamilton, New York
James and Linda Ries
Thaddaeus Ropac
The Rose Art Museum, Brandeis University, Waltham,
 Massachusetts
San Francisco Museum of Modern Art
Michael and Fiona Scharf
Mr. and Mrs. Henry C. Schwob
Theodore P. Shen
The Berardo Collection, Sintra Museum of Modern Art, Lisbon
Smithsonian American Art Museum, Washington, D.C.
Solomon R. Guggenheim Museum, New York
Staatliche Museen zu Berlin, Nationalgalerie, Museum Berggruen
Stedelijk Museum, Amsterdam
Private collection, courtesy Allan Stone Gallery, New York
Hope and Howard Stringer
David Teiger
Terra Foundation for American Art, Chicago
Jan T. and Marica Vilcek
Wadsworth Atheneum Museum of Art, Hartford, Connecticut
Walker Art Center, Minneapolis
Joan T. Washburn Gallery, New York, and the Pollock-Krasner
 Foundation, Inc.
Weatherspoon Art Museum, University of North Carolina at
 Greensboro
Frederick R. Weisman Art Foundation, Los Angeles
Frederick R. Weisman Art Museum, University of Minnesota,
 Minneapolis
Whitney Museum of American Art, New York
Yale University Art Gallery, New Haven
Private collections

INTRODUCTION

"YOUNG PAINTERS SHOULD TAKE UP OUR RESEARCHES IN ORDER TO REACT CLEARLY AGAINST US—
THE WHOLE WORLD IS OPEN BEFORE US, EVERYTHING WAITING TO BE DONE, NOT JUST REDONE."

Pablo Picasso, 1935

Pablo Picasso never set foot in America. He never crossed the Atlantic. And few American artists ever met him in France, where he spent most of his adult life. Yet Picasso's rise to the pinnacle of international acclaim was profoundly intertwined with America. In Paris, American collectors were among the first to champion his career; in New York, Chicago, and across the United States, American artists were prime advocates of his art, from its arrival in this country—in 1909, in the baggage of the painter Max Weber—through the missionary campaigns of John Graham and Arshile Gorky in the 1930s, to the decades-long confrontations pursued in more recent years by Roy Lichtenstein and Jasper Johns. Along the way, American artists created some of the greatest art of the twentieth century in response to Picasso's art, and they helped to found and develop institutions that have guided, interpreted, and sometimes embodied modern culture in this country, particularly the Whitney Museum of American Art and the Museum of Modern Art. To a considerable extent, Americans' conceptions of Picasso have defined our ideas of contemporary art, and in the process have built Picasso's worldwide reputation.

This book is an attempt to tell these interwoven stories: the rise of Picasso's reputation in this country, and the responses of American artists to his work. The diversity of this history—the sheer abundance of artists involved—requires that an author choose either to devote modest discussion to a great many individuals (either by subordinating them to sweeping themes or offering synoptic treatments) or to select a small number to study in depth. Aware of potential bias on my part and of disagreements that readers may have with my choices, I have taken the latter course in order to bring the greater attention to the accomplishments of those I have chosen, rather than compile a catalogue of Picasso's influence in this subset of the North American continent.

Having spent most of the last ten years researching this history (and two and a half decades writing about Picasso), I have focused on nine American artists as the primary subjects of this book: Weber, Stuart Davis, Graham, Gorky, Willem de Kooning, David Smith, Jackson Pollock, Lichtenstein, and Johns. These artists span the twentieth century. In my view, they have had the most substantial dialogues with Picasso's art, and they have created art from this address that makes among the most significant contributions to the culture of their time. Many other artists made important contributions to American art after briefer encounters with Picasso's work, and some of these figure in the narrative as well, among them Marsden Hartley, Lee Krasner, Claes Oldenburg, Andy Warhol, and Louise Bourgeois.

In part, this selection is determined by my decision to include only artists who took up Picasso's art before his death, in 1973. This is not intended as a criticism of the many artists who have employed Picasso's work in recent decades, but rather as an acknowledgment of what seems to me a fundamentally different situation. While an artist's work may be extremely influential after his or her death (Paul Cézanne is a prime example), the impossibility of that artist ever producing work that might challenge art derived from his or hers defines a less charged relationship, especially in the case of Picasso, who was both well-known during his lifetime and personally identified with his work. (Cézanne's art, however, was not widely known until the end of his life.) Thus, the work by Americans discussed in this volume ranges in date from around 1910 through 2003, but none of the artists treated at length began their careers in the last thirty years. Another outcome of this decision is the disappointing fact that only a few women are included. While Picasso's reputation for macho swagger has sometimes made him a lightning rod of criticism, the dearth of women artists involved with his art during most of the twentieth century seems primarily determined by the small representation of women artists in the American art world before the early 1970s. In their very different ways, Krasner and Bourgeois define this situation.

Even though Picasso's impact on American art has been widely recognized for a long time, it has primarily been discussed in the course of monographic studies of individual artists. Rather than string together these necessarily circumscribed accounts or impose a theoretical model on nearly a century of diverse art, I have returned to the historical evidence. With the great contribution of Julia May Boddewyn (whose extensive chronology is published in this volume), we have attempted to construct a record of precisely when and where specific works by Picasso entered this country and became available for artists and others to see. With this documentation in hand, I have examined the work, biographies, and correspondence of dozens of American artists, as well as of collectors, curators, critics, and dealers. Although it has been frustrating to find that American art is generally less well documented than European art of the period, our research has produced a much more extensive record of Picasso's presence in this country than has been previously known, and a much fuller history of Americans' responses to his work.

This documentary approach has shaped two unexpected conclusions. First, at least until the 1960s, American artists responded primarily to Picasso's actual paintings, sculptures, and drawings rather than to reproductions in magazines or books.

This concentration on the actual art objects has been extremely helpful in interpreting how artists engaged Picasso's work; and the possibility of making specific comparisons between works by Picasso and by Americans has enriched my presentation of this history. It has also been the organizing principle of the exhibition for which this book serves as the catalogue. Second, the significance of artists actually seeing particular works by Picasso places great importance on the exhibitions presented in galleries and museums. This has led to the rediscovery of influential exhibitions that are now largely forgotten (such as a large exhibition of modern European art at the Brooklyn Museum in 1921 and an exhibition of Picasso's work alongside African art at the Whitney Studio Club galleries in 1923). Besides the opportunities these shows offered artists to see Picasso's work, they demonstrate the crucial role that Picasso's art played in creating our institutions of modern and contemporary art. For a writer, it is reassuring to find that one book had an unparalleled impact on American artists' understanding of Picasso: Alfred H. Barr, Jr.'s *Picasso: Forty Years of His Art*, which was published in 1939 by the Museum of Modern Art as the catalogue of the first comprehensive exhibition of Picasso's work held in this country.

Americans first met Picasso as an outsider. In a pamphlet accompanying his initial exhibition in this country, in 1911, New Yorkers learned of his Spanish heritage; and the author, the artist and critic Marius de Zayas, held out hope to American artists by describing the success that foreign painters were having in Paris. Throughout his life, Picasso would remain a Spanish citizen and, in his view, an alien in a country whose museums barely acknowledged his art, even as he was acclaimed the greatest artist in France. Sometimes informed by this history and sometimes not, Americans became the primary promoters of Picasso's career during much of the century, and American artists chose his work, probably more than that of any other artist, as the test for their achievements. Picasso famously affirmed his right to take what he found useful in other artists' work, and he urged others to plunder his own. This book is an attempt to follow the remarkably varied course of certain American artists' engagement with Picasso's art, to allow each artist and each work to reveal the particular character of each exchange, and to allow these myriad intricate histories to accumulate into one of the fundamental stories of art in the twentieth century.

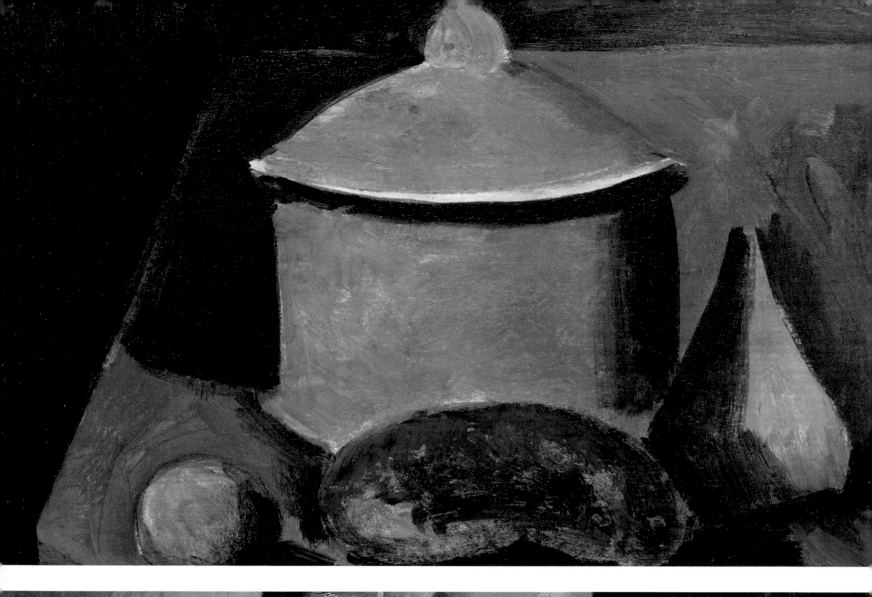

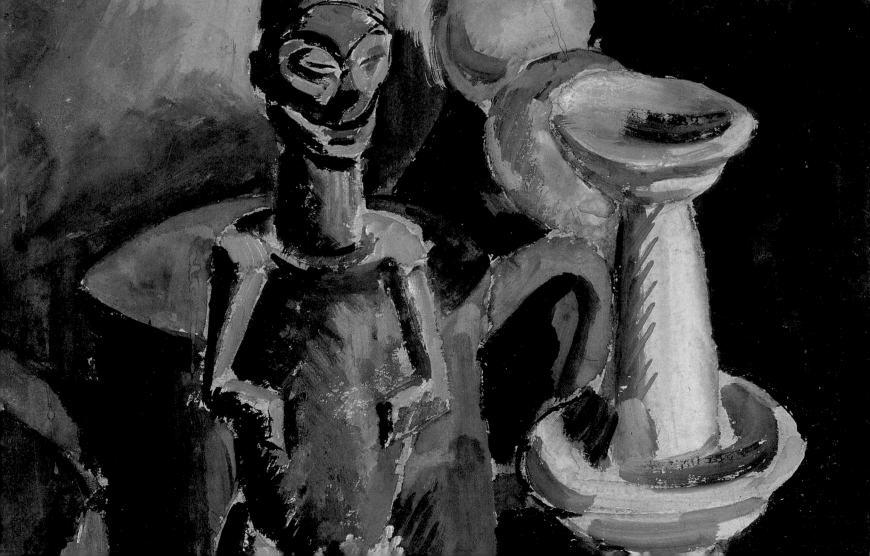

CHAPTER ONE
(1905–1913)

"SUCH MAD PICTURES WOULD NEVER MEAN ANYTHING TO AMERICA"

Bryson Burroughs, 1911

On January 9, 1909, Max Weber brought the European avant-garde to America. He arrived in New York Harbor aboard the steamship *Oceanic*, with a tiny collection of contemporary art salted among the paintings and drawings he had made during the three years and three months he had spent as an art student in Paris. Gathered as lodestones for his future career, these were Weber's treasures, the bits he could stretch to buy on a pauper's budget—yet at the time this odd lot constituted the most important group of contemporary European art in America. When shown to fellow artists and the public during the following few years, Weber's pictures would give New Yorkers some of their first glimpses of what had happened in Paris during the first decade of the twentieth century, and would help to shape the reception of avant-garde art in this country.

Weber's gift extended beyond these pictures. Despite an unpromising start, he returned to New York with a remarkable command of the Paris art world. Born in Russia in 1881, Weber had settled in Brooklyn at the age of ten, then graduated from Pratt Institute and taught drawing in Virginia and Minnesota before escaping to Paris in September 1905.[1] That fall was the season of the "Fauves," but Weber spent a couple of years migrating through academic studios before committing himself to the movement. By the end of 1907, he was sufficiently involved to help organize Henri Matisse's school and to become one of its first students. Weber grew to know many of the most innovative artists and collectors in Paris through an exceptionally well-connected community of American expatriates, primarily the Steins: Gertrude and Leo, the household of siblings at 27 rue de Fleurus, and their brother Michael and his wife, Sarah, who lived nearby. Independent wealth enabled the Steins to remain in Europe and pay little attention to their native land beyond welcoming American artists and intellectuals who appeared at their doors. They were a boon to many young students who arrived in Paris without a command of French, little knowledge of bohemian culture, and no money to waste. Weber took full advantage of their hospitality and became an admired friend. His poverty precluded permanent residence abroad, however, which, as it happens, enriched his fellow Americans, at least those interested in the avant-garde.

Back in New York, Weber threw himself into promotion. His goal was to advance his career—he was an artist, after all—but his work was unintelligible without an appreciation of what Paul Cézanne, Matisse, and Pablo Picasso had accomplished over the previous two decades. And their work was almost unknown in this country. The only substantial American collection of Post-Impressionist art belonged to Henry Osborne Havemeyer and his wife, Louisine, who kept their pictures private. (On Louisine's death, many of these works would be bequeathed to the Metropolitan Museum of Art, New York, but that was not until 1929.)[2] Apparently there were two or three paintings by Matisse in American collections: one in Boston, one in New York, and possibly another in the Baltimore collection of the Cone sisters, who had purchased his work and some drawings by Picasso while visiting their old friends the Steins in Paris.[3] Of necessity, then, but probably also out of desire, Weber became a passionate advocate and educator. He cultivated the few people who could build an audience for avant-garde art, primarily dealers who had shown some interest in modern European painting. Weber's persistence and persuasiveness, combined with his little cache of pictures and his own skills as an artist, won over a crucial few who would build the first stages of an audience for avant-garde art in America.

In fact, Weber was the first in a string of American artists who took on a mission of promoting the reputations of other artists in order to build their own careers. Placing their roots in the traditions of Post-Impressionism and early-twentieth-century European art, these artists became the chief proselytizers for their French and Spanish contemporaries, sometimes to the detriment of their own reputations. This pattern of artists promoting artists distinguishes the American reception of Picasso and others of the European avant-garde. It went far beyond studio shoptalk and bar banter to fill the pages of influential magazines and govern the contents of major and minor exhibitions. The most visible of these men was Alfred Stieglitz, through his Little Galleries of the Photo-Secession at 291 Fifth Avenue, but the group of pioneers also included Edward Steichen, Walter Pach, Arthur B. Davies, and Marius de Zayas. Having largely abandoned his own calling as an artist to serve as a critic and dealer, de Zayas played an exceptionally important role by guiding Picasso's career in America during most of the years before the founding of the Museum of Modern Art, in 1929.

Weber's stash of pictures might seem laughable: a tile painted by Matisse, seven paintings and drawings by the Douanier Rousseau, and a small oil by Picasso, along with a dozen black-and-white reproductions of paintings by Cézanne.[4] Yet their reception demonstrates how little even cosmopolitan New Yorkers knew about the European avant-garde, and how eagerly some sought enlightenment. Even the reproductions of Cézanne's paintings were considered precious: nearly two years after Weber's

PABLO PICASSO, *Still Life*, ca. 1908 (detail of plate 1)

MAX WEBER, *African Sculpture*, 1910 (detail of plate 2)

return, Stieglitz included them in a group show at 291—the first exhibition in the United States to present Cézanne's work.[5] Almost three years later, Weber's paintings and drawings by Rousseau filled out that artist's representation at the Armory Show.

While the presence of the Matisse tile represented a modest homage to Weber's teacher and primary influence at the time, the other works marked directions he would follow in future years. Weber probably gained his appreciation of "primitive" styles from Matisse, but the prominence of Rousseau among his pictures reflects the close friendship that had developed between the elderly outsider and the eager student. Cézanne's prices had already soared beyond Weber's reach, but he believed so strongly in Cézanne as the crucial nineteenth-century artist, and the founder of contemporary art, that he paid the considerable sum of thirty francs for each reproduction.

The lone Picasso in Weber's tiny collection, *Still Life* (ca. 1908; plate 1), is the most surprising choice. As far as we can determine, this was the first of Picasso's paintings to enter the United States (at the time, the Cone Collection contained only Picasso's drawings and prints), and notes preserved in the archives of the Musée Picasso provide a vivid record of Weber's efforts to obtain the work in the fall of 1908.[6] On October 25, he signaled Picasso that he would drop in sometime that week to collect "my little still life" and confirmed that he was "certain I will have the money." Clearly he had already visited Picasso's studio in the Bateau-Lavoir and agreed to purchase a picture; the arrangements were casual. Measuring just over eight by ten inches, the painting is small enough to carry under an arm or slip into a notebook. It is one of at least ten paintings—also including *Wineglasses and Fruit* (1908; fig. 1)—that Picasso made on wooden panels of this size, probably during the weeks preceding Weber's visit.[7] And it matches their sparse selection of common fruit and plain cups, glasses, jars, or bowls arranged to study the objects' simple masses and abutting edges as Picasso entered one of the most austere phases of early Cubism. It is not a major work but just the sort that Picasso might happily have offered to a sympathetic fellow artist, at a price that Weber might be able to afford—since Picasso evidently expected to be paid (no price is recorded).[8] Picasso reciprocated with a note on November 10, writing that he apologized for missing Weber but would welcome a visit the following day.[9] Having collected the painting, Weber left Paris for New York on December 21. Making an intermediate stop in London, he mailed a final card to Picasso (as well as one to Rousseau) with regrets for not having made a parting visit and wishing Picasso "beaucoup beaucoup du succes [*sic*]," along with a recommendation to see the "numerous and superb" Congo pieces in the British Museum. Three months after Weber's arrival in New York, a note from Rousseau passed along Picasso's greetings.[10]

Since Weber had been a student in Matisse's class, his admiration for Picasso and eagerness to own his work might seem unexpected. Indeed, Gertrude Stein later quipped that the purchase "was treason," even though she had played a primary role in sparking Weber's interest in Picasso.[11] Stein was celebrating the controversies she loved to stir, as well as her position at the epicenter of contemporary developments. American artists who visited Paris in the decade before World War I and had the savvy

to locate the Steins were incredibly lucky: the Steins were, quite simply, the most important patrons of contemporary art in France.[12] Certain French collectors, such as André Level, and Germans, such as Wilhelm Uhde, made early commitments to Picasso and his contemporaries, and two Russians, Sergei Shchukin and Ivan Morozov, bought more extensively from Picasso and Matisse. Nonetheless, the Steins rightly claimed to be among the first. And they had the great advantage of living in Paris, where their weekly social gatherings brought their guests together with the leading artists and their major works. Outside an official program, such as the American Academy in Rome or the Académie Française at the Villa Medici, there has probably never been a more accessible way for Americans to penetrate an alien culture. Moreover, the Steins' community lacked the guideposts of academic establishments and would have been nearly inaccessible to visitors without the entrée provided by Leo and Gertrude. For American artists seeking knowledge of contemporary art, the Steins served a full meal every Saturday evening.

As Weber gladly acknowledged, "Being an American, I felt at home with [the Steins] at once . . . we became very good friends and still more friendly when the Matisse class was started."[13] Since plans for the class began to take shape in late

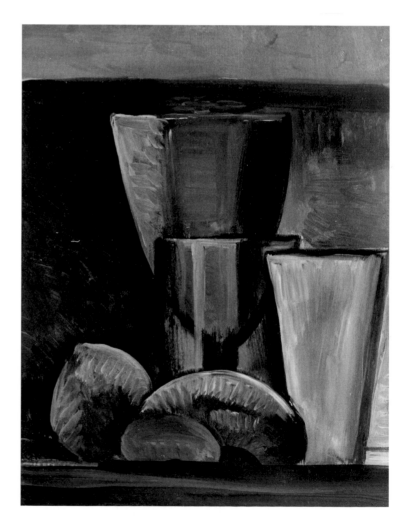

FIG. 1
PABLO PICASSO (1881–1973), *Wineglasses and Fruit*, 1908. Oil on canvas, 10 5/8 x 8 3/8 in. (27 x 21 cm). Museo Thyssen-Bornemisza, Madrid

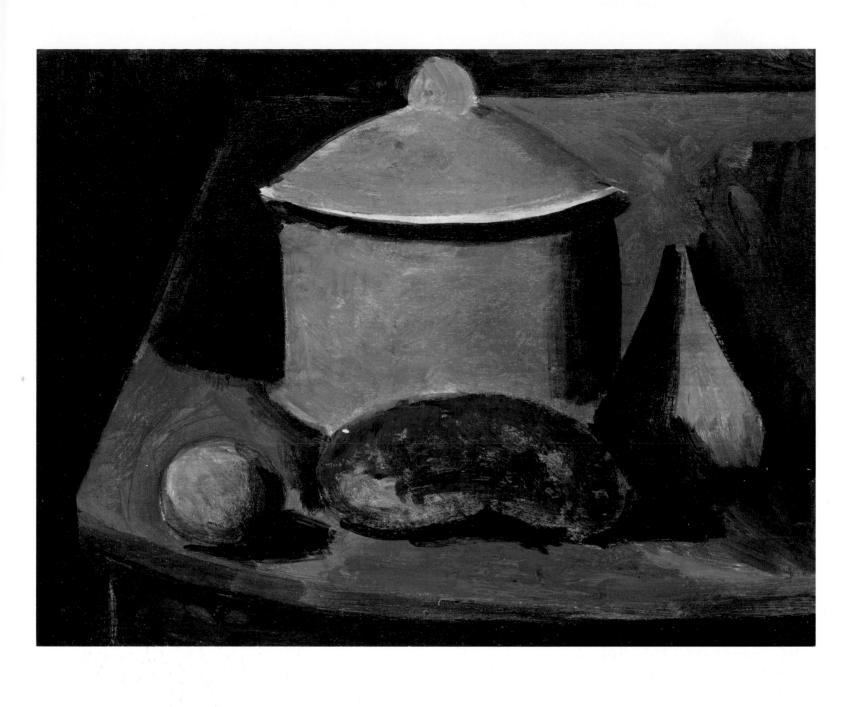

PLATE I
PABLO PICASSO, *Still Life*, ca. 1908. Oil on
panel, 8 x 10 in. (20.3 x 25.4 cm). Private
collection

17

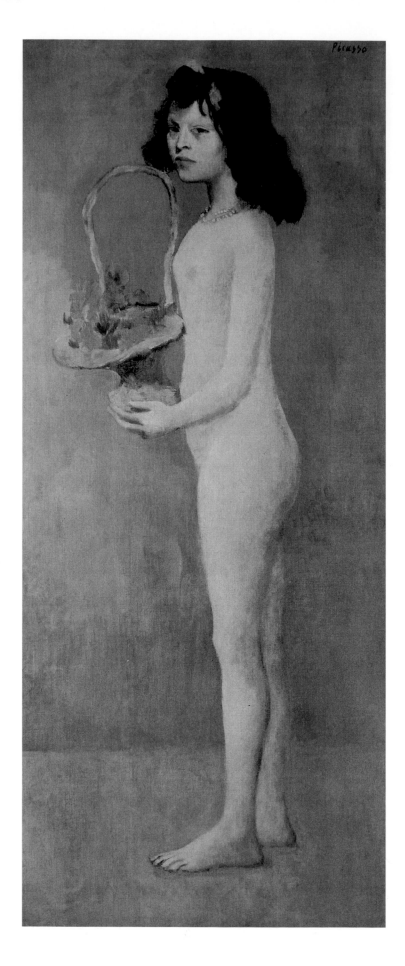

FIG. 2
PABLO PICASSO, *Young Girl with a Basket of Flowers*, 1905. Oil on canvas, 61 x 26 in. (154.9 x 66 cm). Private collection

1907, Weber's intimacy with the Steins spanned the year or so before his return to the United States at the end of 1908. By that point, he had successfully submitted paintings to the Salon des Indépendants of both 1906 and 1907 and to the Salon d'Automne of 1907—annual exhibitions that championed the avant-garde over the artistic establishment. His accomplishments far surpassed those of most Americans, and he could reasonably consider himself more than a student, if still a follower of pathbreaking artists. He left a vivid recollection of the sessions that honed his knowledge of cutting-edge art:

> Leo and Gertrude Stein graciously received art students, students of philosophy and languages at the Sorbonne; writers, young poets, musicians, and scientists who came to study the paintings of Cézanne and those of the other rising artists. For hours they stood around a large table in the center of the room, examining the portfolios full of drawings by Matisse, Picasso, and others, and folios stocked with superb Japanese prints. This salon was a sort of intellectual clearing house of ideas and matters of art, for the young and aspiring artists from all over the world. Lengthy and involved discussions on the most recent developments and trends in art took place, with Leo as moderator and pontiff. Here one felt free to throw artistic atom bombs and many cerebral explosions did take place.[14]

Although Picasso probably lobbed his bombs from across the room (his French was too poor for direct debate, and he preferred cunning jokes to earnest declarations), the proceedings certainly gained gravity from the presence of leading artists and the remarkable pictures carpeting the walls.

During Weber's four years in Paris, the Stein family amassed an unsurpassed collection of contemporary art, one even finer than the holdings of the devoted Russian collector Shchukin, whose voluminous buying took off around 1909 and continued until the beginning of World War I. The Steins began in 1904 with Leo's and Gertrude's purchase of Cézanne's *Portrait of Madame Cézanne* (1880s), a painting that remained the measure for future purchases but also the goad to find young artists whose responses to his achievements were not yet appreciated. At the Salon d'Automne of 1905, they stepped into the fray by buying one of the most controversial paintings in the so-called "cage of Fauves," Matisse's *Woman with a Hat* (1905). And during the following few years they purchased many of Matisse's breakthrough paintings as they appeared at the annual salons—including *Le Bonheur de vivre* (1906), which brought a highly stylized consistency to the apparent chaos of Fauvism, and *Blue Nude (Souvenir of Biskra)* (1907), his most aggressive appropriation of African art. These pictures, along with those purchased by Michael and Sarah Stein, made their homes the primary showcase for Matisse's art outside his studio, at least until he signed a contract with the Galerie Bernheim-Jeune in September 1909.

Gertrude and Leo's commitment to Picasso grew more slowly but proved more enduring. Within a few weeks of buying Matisse's *Woman with a Hat*, they purchased two works by Picasso:

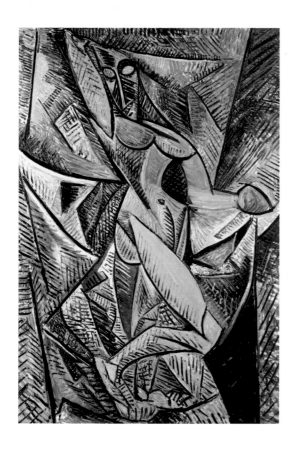

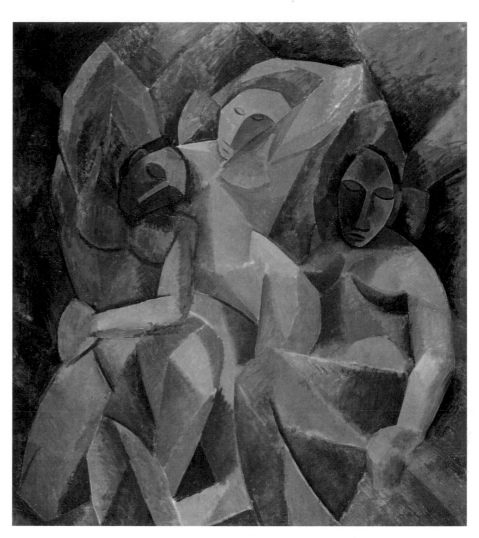

a gouache, *Harlequin's Family with an Ape* (1905), and an oil, *Young Girl with a Basket of Flowers* (1905; fig. 2). These pictures were as new as the Matisse, but did not carry its aura of innovation. Their style is tentative and academic compared to Matisse's challenging mixture of textures and hues, and the Steins bought them from an inconspicuous dealer rather than from one of the most prominent Parisian exhibitions of contemporary art. Still, Leo saw promise. He wrote to a friend that the two pictures "were by a young Spaniard named Picasso whom I consider a genius of very considerable magnitude and one of the most notable draughtsmen living."[15] Picasso soon became a regular at their gatherings (where he may have met Matisse for the first time), and major works of his, including *Boy with a Horse* (1906), began to enter the collection.

Since Picasso was less established than Matisse, and did not submit his work to public exhibitions where it could be reviewed and his reputation built, the Steins took a greater risk in supporting his art. Their continued faith during 1907 and the early years of Cubism, when many of the collectors and dealers who had bought his work withdrew, was crucial to his confidence and his growing relationship with Daniel-Henry Kahnweiler, who had effectively become his dealer by 1910. As Picasso moved into the violent distortions of the *Demoiselles d'Avignon* period, the Steins bought a painting of nearly equal challenge, *Nude with Drapery* (fig. 3), in the fall of 1907—only a

few months after Picasso finished it. Probably in late 1908, they bought two little still lifes that mark the beginnings of Cubism (for one of the two, see fig. 1), works that may have prompted Weber to choose another from the series as his last acquisition before returning to America. In 1909, when Gertrude and Leo purchased the masterpiece of this phase, *Three Women* (1908; fig. 4), they had already ceased to collect Matisse's art.

Picasso's movement into Cubism fascinated Leo (even though he condemned its later phases), but the personal attachment between Gertrude and Picasso may have been as important to their commitment. During his first dinner at the Steins' home, in the fall of 1905, Picasso invited Gertrude to sit for a portrait, and he quickly dashed off images of Leo and of Michael's son, Allen, while he labored over the big picture of Gertrude during the winter of 1905–6. Scores of sittings in Picasso's studio gave Gertrude and Pablo ample time to explore their views of modern art and to develop a profound mutual respect that would endure for decades. Picasso's difficulty in finishing the painting has been widely discussed (he obliterated the face before leaving for a summer trip to Gósol, Spain), but it is less often noted that his

FIG. 3
PABLO PICASSO, *Nude with Drapery*, 1907. Oil on canvas, 59 7/8 x 39 3/4 in. (152.1 x 101 cm). Hermitage, St. Petersburg, Russia

FIG. 4
PABLO PICASSO, *Three Women*, 1908. Oil on canvas, 78 3/4 x 70 1/8 in. (200 x 178 cm). Hermitage, St. Petersburg, Russia

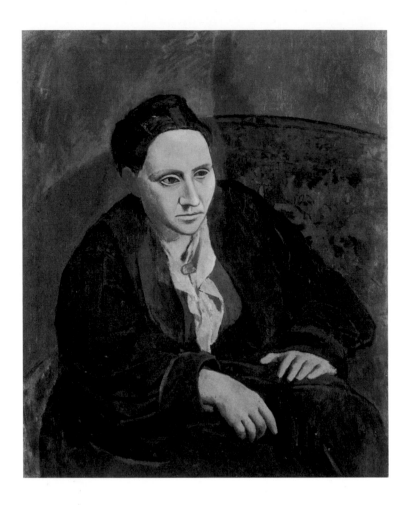

final solution (fig. 5), emphasizing Gertrude's massive bulk and broad facial planes, duplicates the hieratic earthiness of the self-portrait he had just completed (*Self-Portrait with Palette*, fig. 50), making them appear almost twins. If that implied a deep bond, Gertrude immediately affirmed the portrait's power, hanging it in her home above Matisse's *Woman with a Hat*. She later made it the only work she willed to a public collection: the Metropolitan Museum of Art. Although this was the first of the Steins' major Picassos to enter an American collection (many more followed in the 1960s after the death of Gertrude's lover, Alice B. Toklas),[16] their advocacy of Matisse and Picasso defined contemporary European art in the perceptions of Americans, even many who never visited 27 rue de Fleurus.

Had the Steins kept a guest book, it would be filled with the names of prominent American artists, critics, dealers, and collectors who saw their pictures, received Leo's pronouncements, and returned home to spread the word that this was the best of contemporary art.[17] Around 1911, Morgan Russell sketched *Three Women* while it hung in the collection (fig. 6), but he stood temporally in the middle of a long line of visitors who streamed through and sometimes, like Weber, became regulars. In November 1905, the Steins introduced Picasso to Etta Cone, an old friend from Baltimore who immediately bought the first of

FIG. 5
PABLO PICASSO, *Portrait of Gertrude Stein,* 1906. Oil on canvas, 39 3/8 x 32 in. (100 x 81.3 cm). The Metropolitan Museum of Art, New York, Bequest of Gertrude Stein, 1946 (47.106)

many drawings that she and her sister, Claribel, would acquire. In 1912, Albert Barnes toured both Stein collections on his first buying trip to Paris, absorbing knowledge and offering to purchase Picassos off their walls.[18] Like many Americans, Barnes gained entrée through Alfred Maurer, a painter originally from New York whom Gertrude would remember as "an old habitué of the house [who] had been there before there were these pictures, when there were only japanese prints."[19] Maurer remained obsessed with the Cézannes and Matisses in the Steins' home as the community of American artists in Paris joined him there on Saturday evenings, among them Patrick Henry Bruce, Arthur B. Carles, Pach, and Weber. Marsden Hartley dropped by in 1912 and became a fast friend of Gertrude's; in 1921 Man Ray relied on her to help him settle in Paris. Besides nourishing artists and collectors, the Steins took an interest in educating Americans who could not make the trip to Montparnasse. In late 1912, when Pach brought Davies and Walt Kuhn to discuss plans for the Armory Show, the Steins agreed to lend three paintings by Matisse (including *Blue Nude*) and two by Picasso, likely including a magnificent still life of 1908–9, *Fruit Dish* (fig. 7).[20]

Of the visitors, Steichen probably learned the most, advancing his education as an artist, expanding his ties in the art community, and passing on recommendations of what Americans should see. By the time he first encountered the Steins, in 1907, he had already spent two years in Paris (1900–1902), a period in which he had gained the confidence of Auguste Rodin and created acclaimed portraits of the sculptor; but financial need had sent him back to New York and Stieglitz's campaign for photography. In the fall of 1906, Steichen returned to Paris as Stieglitz's collaborator and chief talent scout for the new gallery at 291 Fifth Avenue, where they planned to exhibit the most important art they could find—in any medium. During his many years in Paris, Steichen proved a remarkably adept observer and a graceful conciliator, who was crucial in making the Little Galleries by far the most dynamic program of contemporary art in the United States. Along the way, he also introduced many visiting Americans to the ways of the Paris art world.[21] Rodin remained the most famous artist in Europe, so Steichen's ability to arrange an exhibition of his drawings was a coup (it appeared at 291 in January 1908). Rather than dwelling on historical figures, however, Steichen sought to understand the changes that had occurred in the Paris art world since 1902. His explorations quickly led to Leo and Gertrude and an invitation to join their Saturday gatherings. In no time, he spread the Steins' favorites to Stieglitz, who was in no position to argue and largely adopted these long-distance judgments as the program of European art at 291.

Leo and Gertrude probably paid little attention to the New York scene, although they may have been pleased to know of their influence there. Sarah and Michael, however, had already brought some of Matisse's work to the States, in the hope of expanding his reputation there, and had sold a painting (*Nude in a Wood,* 1906) to George Of, Stieglitz's framer. In Paris, they befriended Steichen and taught him to share their overwhelming respect for Matisse, then encouraged Matisse to accept Steichen's offer of an exhibition at 291. In January 1908, Steichen prepped Stieglitz, "I have another cracker-jack exhibition for you that is going to be as fine

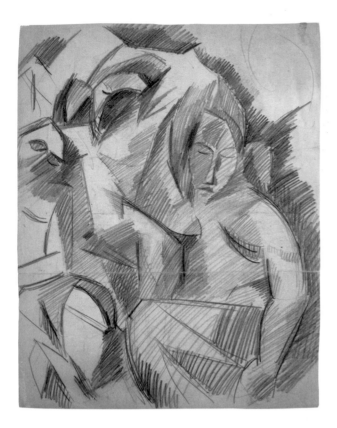

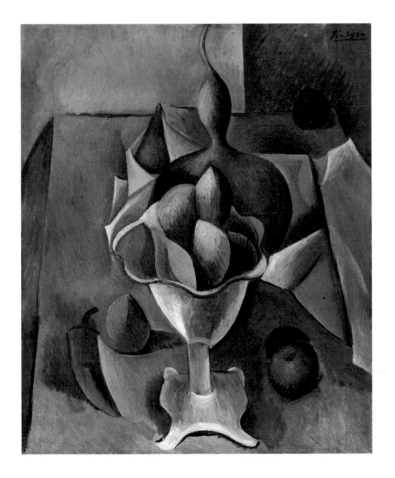

FIG. 6
MORGAN RUSSELL (1886–1953), *Study after Picasso's "Three Women,"* ca. 1911. Graphite on paper, 11 5/8 x 9 1/8 in. (29.5 x 23.2 cm). Montclair Art Museum, N.J., Gift of Mr. and Mrs. Henry Reed 1985.172.39

FIG. 7
PABLO PICASSO, *Fruit Dish*, 1908–9. Oil on canvas, 29 1/4 x 24 in. (74.3 x 61 cm). The Museum of Modern Art, New York, Acquired through the Lillie P. Bliss Bequest

in its way as the Rodins are. Drawings by Henri Matisse the most modern of the moderns. . . . Ask young Of about him." He added a gesture of collegiality, "I don't know if you will remember any of his paintings at Bernheim's," and closed with the admonition that "unless I get a cable from you not to come," he would arrive in early March with the exhibition in hand.[22]

This first presentation of Matisse's art in America, following only three months after Rodin's, brought to 291 the most controversial contemporary artist in Europe only three years after he had gained notoriety in Paris. As soon as Matisse was committed, Steichen began exploring the possibility of exhibiting Picasso's work but found the situation more problematic. Since Steichen asked Gertrude to help in "softening" Picasso, the artist had presumably resisted his overture.[23] Gertrude was probably less eager than Sarah had been with Matisse, leaving Steichen to argue his cause to an artist who placed little faith in exhibitions, particularly so far from the city where he was only beginning to develop a reputation. Besides, Steichen was becoming less certain about Picasso's achievements as the artist's exquisite Rose Period Harlequins turned into gruesome nudes inspired by African art. Leo and Gertrude rarely included Steichen in their inner circle, so he heard little more than Leo's fulsome lectures at the soirées to counter his doubts. Nonetheless, in the summer of 1908, he sent Stieglitz a halfhearted recommendation of Picasso as their next sensation: "As for the red flag I am sure Picasso would fit the bill if I can get them but he is a crazy galloot hates exhibiting etc. However we will try him."[24]

In the end, Picasso's exhibition at 291 lagged behind Matisse's by nearly three years, and might never have taken place had Steichen not extended his accustomed generosity to Weber. By early 1908, Steichen had met most of the aspiring American artists in Paris, and many of them looked to him for guidance. His accomplishments as a photographer over the last decade, his friendships with leading French artists, and his power to organize exhibitions made him a potent figure among these painters and sculptors, who had achieved very little recognition. That February, a group met at his studio to discuss how they might gain attention for their work, which was closer to the trends of avant-garde art in Paris than to emerging New York artists, such as Robert Henri and others, whose images of street life in the city, largely derived from Impressionism, led unsympathetic critics to call them "The Ash Can."[25] The francophiles organized a Society of Younger American Painters in Paris and planned an exhibition for the spring. Besides Steichen, the advisory board included Maurer, D. Putnam Brinley, Donald Shaw Maclaughlin, and Weber, who was by far the most advanced of the group both technically and aesthetically. Yet without sales or charity, he could not remain abroad, and neither patrons nor the Society's exhibition materialized. Optimistically, Steichen counseled Weber that his art would be well received in New York, and advised him to return, see Stieglitz, and join the activities of 291.

Although Weber seems likely to have visited the gallery soon after his arrival in New York, in January 1909, Stieglitz would not recall meeting him until the spring, when he presented himself there unannounced: "a short, stocky, smooth shaven, pallid young man with a large portfolio in his arm appeared at the door.

. . . He informed me that he had come from Paris and that his friend, Mr. Steichen, had told him to look me up."[26] Perhaps Weber had been put off by the tepid exhibitions at the gallery during the early months of the year—photographs by members of the Photo-Secession and drawings by Pamela Colman Smith of scenes inspired by the theater and "visions evoked by music, sketched during the concert or opera," work perfumed by the sentimentality of late-nineteenth-century Symbolism rather than braced by the self-conscious crudity that Weber had learned to love in Paris. Even de Zayas's caricatures, shown in January, cloaked the artist's skepticism in rotund flourishes. When Weber finally came to 291, he found Stieglitz totally unsympathetic: "I told him that if he were Leonardo da Vinci, Rembrandt, Michelangelo and God himself rolled into one, I was much too tired to look at any pictures or think of giving any further exhibitions."[27] As this string of names suggests, Stieglitz's frame of reference in 1909 was far from the cutting edge of contemporary art. Had he taken the time to study the contents of Weber's portfolio, he would have been at a loss to place them in the aesthetic debates of the time. Yet two years later he would exhibit the young American artist's work, which by then had moved far beyond the respectful emulation characterizing Weber's efforts in early 1909 and had stepped forward to engage the revolution touched off by the *Demoiselles d'Avignon* (1907; plate 110).

During those two years, Stieglitz matured from a distant follower of modern trends to the most public advocate of avant-garde art in America. Although he had spent part of the summer of 1907 in Paris, he was then consumed by the world of photography and paid little attention to vanguard painting. Until the summer of 1909, when his family forced him to tour Europe, Stieglitz's knowledge of developments in Paris was secondhand and almost entirely limited to intelligence from Steichen. The Rodin and Matisse shows had created the impression that Stieglitz was in touch with contemporary modernism, but he demonstrated no eagerness to learn firsthand. Back in Paris the following year, however, he accepted Steichen's offer to introduce him to some of the chief figures. Since Matisse was too busy supervising the construction of his new studio in the Parisian suburb of Issy-les-Moulineaux to see them, Rodin was apparently the only prominent European artist Stieglitz met.

Like so many Americans, Stieglitz was initiated at the homes of the Steins. Even though Steichen had told him about them, Stieglitz was unprepared for what he encountered. First visiting Sarah and Michael, he was dazzled by the Matisse works he saw there, saying they were "new and exceptionally wonderful to me."[28] The next day, Steichen presented him to Gertrude and Leo, where Stieglitz saw, presumably for the first time, a varied display of challenging contemporary art. Since Stieglitz made no other studio visits during the trip, he not only relied on the Steins for access to paintings but also heard only their interpretations of the current art. Dismissing Rodin as a mediocre artist, Leo praised Cézanne and Matisse and called Picasso the leading genius of the age. No doubt shocked by the repudiation, Stieglitz made no effort to defend Rodin; he must have been overwhelmed by his ignorance. A man already famous for grandiosity and intellectual intimidation had met his match: "I quickly realized I had never

heard more beautiful English nor anything clearer."[29] Stieglitz immediately offered to publish Leo's pronouncements in his journal *Camera Work*.

No text arrived in the mail, and Stieglitz did not return to Paris until the fall of 1911, after he had closed a two-season run at 291 that featured the second American exhibition of the work of Matisse (February–March 1910) and the first of both Cézanne (March 1911) and Picasso (March–May 1911). Even though Steichen and others were counseling Stieglitz on his program, it is difficult to imagine him presenting this set of exhibitions without that confrontation with Leo. These artists were the Steins' triumvirate, and few other collectors or critics had praised them as forcefully. Yet during 1910 and 1911, the profiles of Matisse and Picasso began to rise in the United States through publications and word of mouth. Furthermore, Stieglitz found that he had a comrade in New York who could further the education he had begun so briefly in Paris. During that visit, Steichen had asked whether Stieglitz had met Weber, and then had replied to Stieglitz's account of the meeting that "Weber was one of the most gifted of young American artists in Paris, a thorough modern, but rather unfortunate as far as temperament."[30] When Weber came to see another exhibition at 291 at the end of 1909, Stieglitz not only greeted him and asked to see his art but praised it, drawing parallels with the work of exactly these three artists. In the following months, Stieglitz entered an intense friendship with Weber and took him into his household. He absorbed Weber's experience of the Steins' circle and shared the dialogue with Cézanne and Picasso that Weber was developing in his art. In the early months of 1911, only one exhibition divided Weber's one-man show in January from those of Cézanne and Picasso.

Stieglitz's decision to exhibit Matisse's work clearly echoed recent events in Paris. The Fauves' success in 1905 had earned them recognition as the first art movement of the century and Matisse the label of *chef d'école*, so his art was the obvious choice. Even more than his early appearances in Paris, the 291 exhibitions of 1908 and 1910 established Matisse in the United States as the leading artist of the avant-garde, simply because none of his contemporaries had so far appeared on this side of the Atlantic. Yet they soon trickled in, and Matisse's prominence greatly diminished. Stieglitz held only one more exhibition of Matisse's work (a 1912 show of sculpture and drawings) and his interest steadily turned toward Picasso. Perhaps Leo Stein's lecture, which Stieglitz would vividly recall decades later, set the program: Matisse might be the greatest of all modern sculptors but Picasso was the leading genius of the time.

In the spring of 1910, these backstage judgments burst on the American public when *Architectural Record* published Gelett Burgess's article "The Wild Men of Paris." Although Burgess was an illustrator and popular poet from Boston rather than an art-world insider, he got in touch with the Steins during a French trip in 1908 and pursued their recommendations into the studios of Matisse, Picasso, André Derain, and Georges Braque. He had the good luck to arrive at the moment when Picasso and Braque were moving beyond the radical disruptions of the *Demoiselles d'Avignon* to the earliest stages of Cubism, and he managed to gather and publish photographs of the *Demoiselles* (the painting's first appear-

ance anywhere outside Picasso's studio), three paintings Picasso made the following year (including *Three Women*), a drawing reflecting Braque's response to these pictures, and a small selection of paintings by other artists, as well as photographs of the principals (Braque in a three-piece suit and Picasso casually seated before two African figurines).

Burgess's text is a whimsical caricature of recent events, yet it captures real dynamics in the art world, particularly Matisse's frustration while he tried to slip his sensational reputation as the leading Fauve, along with Picasso's newly minted recognition as one of the most audacious artists in Paris. After touching on Cézanne, Burgess declared that "it was Matisse who took the first step into the undiscovered land of the ugly." He called him "Maître" but also "poor, patient Matisse," "serious, plaintive, a conscientious experimenter" who was disturbed by the outlandish claims made about his art. "Whereat, little mad-cap Picasso, keen as a whip, spirited as a devil, mad as a hatter, runs around the studio and contrives a huge nude woman composed entirely of triangles, and presents it in triumph. What wonder Matisse shakes his head and does not smile! . . . and wild Braque climbs to his attic and builds an architectural monster which he names Woman, with balanced masses and parts, with openings and columnar legs and cornices."[31]

Despite his manner of high seriousness, Stieglitz clearly respected Burgess and enjoyed his bemused view of the contemporary scene. In the fall of 1911, a year and a half after the article was published, 291 presented a visual counterpart to it: a display of Burgess's watercolor parodies of avant-garde styles. And at least one New York artist—Weber—immediately engaged the black-and-white reproductions in the magazine itself. It was the beginning of a long-distance relationship between American artists and Picasso's art that would span the remaining six decades of Picasso's life and continue into the next century.

Weber set the foundation for that relationship in a small gouache, *African Sculpture* (1910; plate 2). He had acquired the Congolese figure portrayed in it during his stay in France, reflecting an interest in African carving that he shared with Picasso (and with others in the Paris art world). Having spent a year back in New York, Weber turned to the two possessions that linked him with the last work he had seen in Picasso's studio—the figurine and small still-life painting—to forge a new style. The broad planes of Weber's rendering reflect both the rough carving of the sculpture and the simplified forms that Picasso had derived from similar African objects in shaping the style of *Still Life*. In particular, the squat proportions of Weber's unadorned cup and candlestick match the covered jar in Picasso's painting, and both pictures share a centrally massed composition and a subdued palette to create an effect of blunt crudity. By 1910 Weber had stripped his art to the bare essentials of early Cubism, a radical reduction of pictorial means that few other artists on either side of the Atlantic willed so soon after Picasso's and Braque's innovations.

Yet in that year, Weber's art registered another great change: his response to the nudes by Picasso and Braque reproduced in "The Wild Men," whose impact transformed his subject matter and inspired him to create monumental Cubist compositions. Naked women suddenly filled his paintings, some throwing back their arms to reveal their bodies or staring fixedly from the

picture. Although Weber may have seen the *Demoiselles* in Picasso's studio, his art made no definite reference to it until 1910. In *Summer* (1909; fig. 9), he may have recalled the gestures of its nudes, but his source could as easily have been Cézanne's compositions of bathers. For the background, he turned to a jungle setting, apparently in homage to his friend Rousseau.

Reproduced in black and white in *Architectural Record*, the *Demoiselles* appeared as little more than a fractured collage of flamboyant gestures, but the image of Braque's response to it—a three-figure composition titled in the magazine *La Femme* (1908; fig. 8)—gave Weber a detailed model.[32] Braque's sketch is relatively legible because he used distinct pen strokes to define contours and hatch planes. Weber adopted the technique for large paintings (*Two Figures*, 1910, and *Composition with Three Figures*, 1910; plates 3 and 4) that are really tinted drawings. He emulated both Braque's refusal to engage the sexuality of the *Demoiselles* and more compressed grouping of the figures, showing a packed overlay of thick bodies. The knife-edged facets of the women's bodies in both of Weber's paintings also recall the Congolese statue, the poses have Braque's dynamism, and the paintings' large size gives the figures a mammoth stature.

A selection of these works appeared among the more than thirty paintings and drawings by Weber shown at 291 in January 1911. *Summer* led the checklist, with *African Sculpture* (called *Congo Statuette*) near the middle and several compositions of women toward the end. These last were each titled *Figures and Trees*, suggesting an explanation for the greenery in the backgrounds (a holdover from *Summer* and Rousseau). Without question, this was the first exhibition in the country to demonstrate that an American artist was near the cutting edge of the international avant-garde. It could have begun a long history of Stieglitz promoting Weber's art. Instead, their relationship ended abruptly and absolutely on the fourth day of the show.

Both men left self-justifying accounts of the friendship and its demise.[33] According to Weber, "Mr. Stieglitz knew nothing about modern art. What he did know, he learned from the artists. And I think, with great humility and honesty, I have brought him the first information that was authentic."[34] For his part, Stieglitz wrote that "often at 291 when Weber and I were together alone . . . he told me of his experiences in Paris." He acknowledged, "And I frankly say I missed Weber as a man. An intelligent one. A worker. And it took me two years to get over missing him."[35] In retrospect, the relationship was doomed: Weber's strength as a teacher caused a predictable conflict as Stieglitz began to assert his authority as the impresario of 291, and Weber refused to retire. Weber recalled, "I studied and worked on my own earnings in Europe, and when I came back I wasn't going to be 'found' and 'made,' so-called, by one who has no conception of what the struggle was, in life as well as actual effort, that went into years of study. Mr. Stieglitz knew nothing about modern art."[36] Although Weber's pricing of his pictures sparked the explosion, the months of intense friendship followed by three long days fielding questions in the exhibition packed the charge. Circumspect as usual, Steichen summed up: "Weber was a little fighting cock; what he believed in was sacred to him, and he fought Stieglitz tooth and nail. The relationship became intolerable to both."[37]

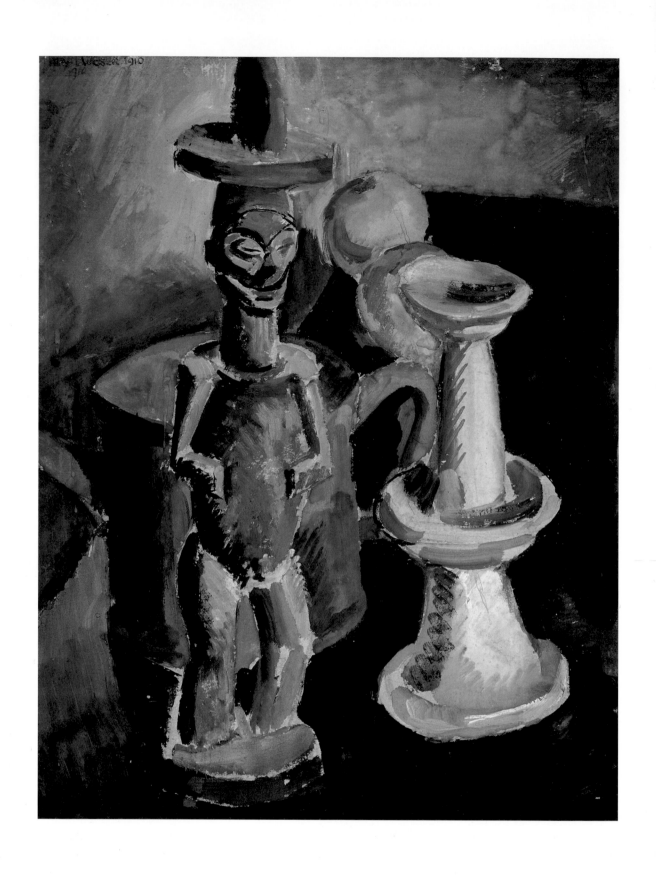

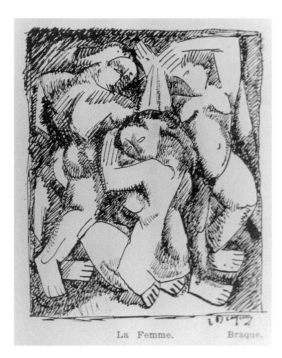

La Femme. Braque.

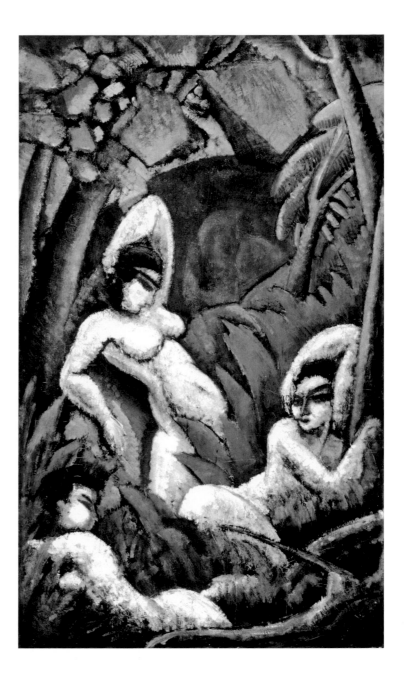

When Weber and Stieglitz parted, each man lost a soul mate and his chief inspiration in recent months. For Weber, Stieglitz had offered the only chance in New York to exhibit his work in the company of European modernists, as well as the promise of a promoter who might convince Americans to respect his contributions to this new art. Nonetheless, he was a mature artist and could pursue his painting without advice from Stieglitz or anyone else. Stieglitz, however, saw it as his mission to act as the New York spokesman for modern art through 291, where he remained rooted. Without expert scouts, he was blind.

During the fall of 1910, Stieglitz wrestled with the question of whether to offer Picasso his first exhibition in America. Since Steichen had suggested the idea three years earlier, Picasso had gained stature in Paris, and his works had begun to appear in exhibitions in England and Germany. Following 291's exhibitions of Rodin, Matisse, and Cézanne, Picasso seemed the logical next step. Yet by late 1910, the "Wild Men" article had already introduced the *Demoiselles* to New York, and Picasso's art had taken a course that many, including Steichen, could not fathom. The change, of course, was called Cubism.

Stieglitz's only exposure to Picasso's work had been during his brief visit to the Steins in the summer of 1909, when Leo had praised the artist extravagantly. Without Weber's advocacy in New York, it is doubtful that Stieglitz would have gone forward with the exhibition. Although Weber, too, was unacquainted with Picasso's recent work, it was almost certainly his appreciation of Cézanne and of Picasso's earlier work that convinced Stieglitz to put aside Steichen's growing skepticism and offer Picasso, and Cubism, their first venue in America. Ironically, Weber walked out of 291 two months before the exhibition opened, at the end of March 1911. The organization of the show fell to Steichen and his friends in Paris.

The divergence between Steichen and Stieglitz is best captured by their differing opinions of a Picasso drawing, *Standing*

Female Nude (1910; plate 5), that would become the most sensational piece in the exhibition. Steichen told Stieglitz that he was too "sensitive to the flesh" to appreciate *Standing Female Nude* and found its lack of color and highly schematic rendering incomprehensible.[38] Alerted to the drawing's extreme style, Stieglitz reacted with fascination when he unpacked it in New York; he bought it for himself, reproduced it in *Camera Work*, and used its structure as a model for his own photographs in future years.

Stieglitz's intense attraction to this drawing, and to the ideas of Cubism, mark his adoption of a new guide as much as his distance from Steichen. A recruit had joined the ranks of 291's outriders, a young man who himself underwent an accelerated education while helping to arrange the exhibition and then vividly explained it to Stieglitz and to the viewing public. Marius de

FIG. 8
GEORGES BRAQUE (1882–1963), *La Femme* (so-called), 1908. Ink on paper, dimensions unknown. Whereabouts unknown

FIG. 9
MAX WEBER, *Summer*, 1909. Oil on canvas, 40 1/4 x 23 7/8 in. (102.2 x 60.6 cm). Smithsonian American Art Museum, Washington, D.C.

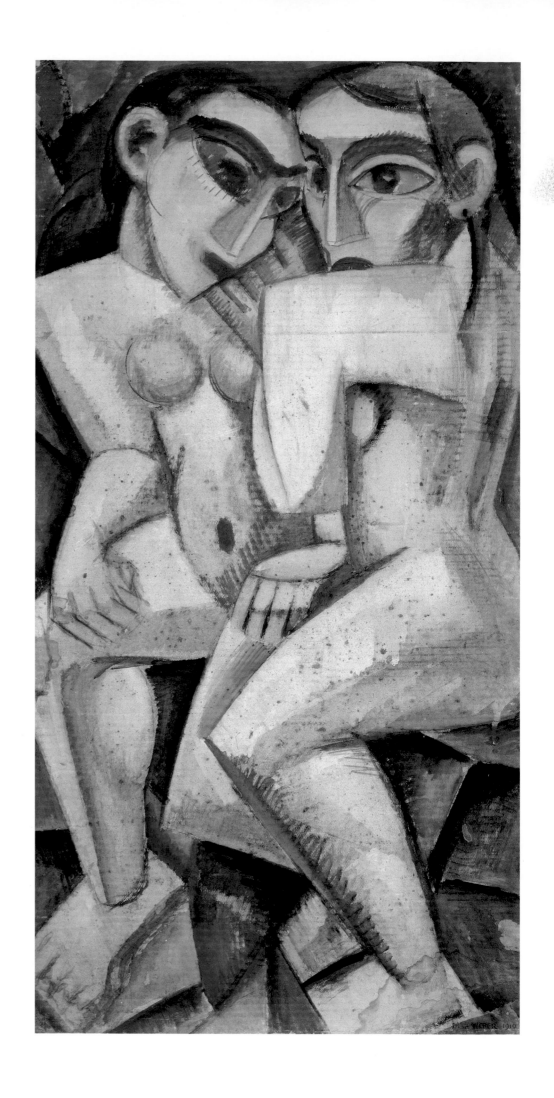

PLATE 3
MAX WEBER, *Two Figures*, 1910. Oil on
board, 47 1/2 x 24 1/2 in. (120.7 x
62.2 cm). Curtis Galleries, Minneapolis

26

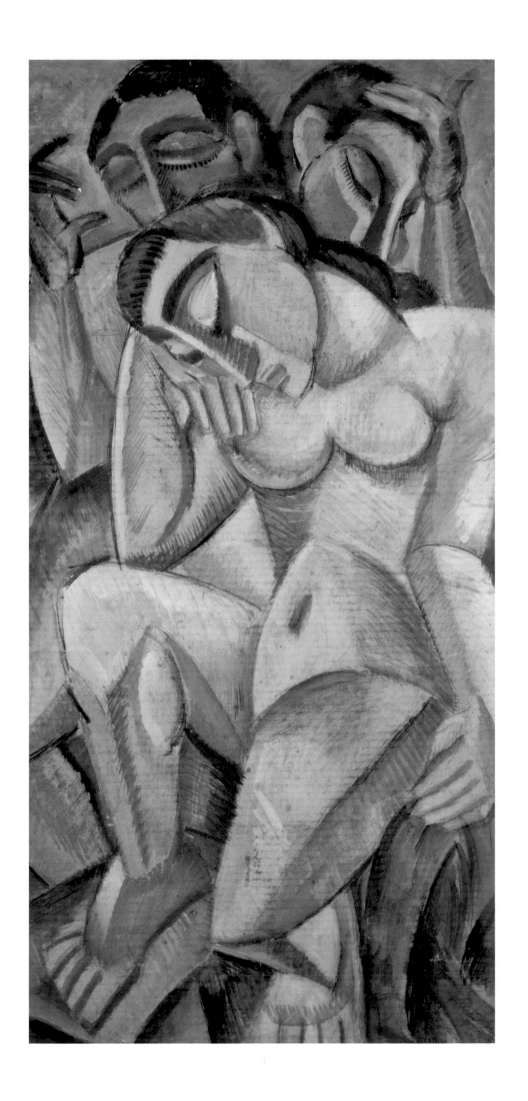

PLATE 4
MAX WEBER, *Composition with Three Figures*, 1910. Watercolor and gouache on brown paper, 47 x 23 in. (119.4 x 58.4 cm). Ackland Art Museum, The University of North Carolina at Chapel Hill, Ackland Fund 60.4.1

27

Zayas had made a career as a cartoonist, first for his father's newspapers in his native Mexico and later in New York after political unrest forced the family to emigrate. The incisive line in his satirical caricatures of public figures had convinced Stieglitz to offer him shows in 1909 and 1910. At 291, de Zayas quickly found that he preferred art to journalism. On October 1, 1910, he left for Paris, where Steichen began to introduce him to the scene.[39]

Arriving at the moment of Cubism's triumph as a cause célèbre, de Zayas reacted with both fascination and disgust. Cubism made its first real appearance before the public in the spring and fall exhibitions that year, in the paintings of Jean Metzinger, Albert Gleizes, Fernand Léger, Robert Delaunay, and a few others. The effect rivaled that of the debut of the Fauves in 1905, except that astute critics and other art-world insiders knew that these artists were following in the wake of the pioneering work that Picasso and Braque had made during the previous three years but had rarely exhibited. Between arriving in Paris on October 13 and writing to Stieglitz on October 28, de Zayas visited the Salon d'Automne four times and remained especially troubled by one painting: "Its title is 'Nu' and it is executed by Mr. Metzinger. I was lucky enough to find a reproduction in a magazine. The theory of this gentleman is that he sees everything geometrically, and to tell the truth, he is absolutely consequent with his theory."[40] In his following review for Camera Work, de Zayas moved beyond studious attention to outright frustration with Metzinger's "Tower of Babel painting, in which all the languages of technique, colors and subjects, were spoken in an incoherent and absurd manner."[41] Perhaps de Zayas can be excused for dismissing Cubism on the basis of the paintings he saw at the Salon; he wrote to Stieglitz that Metzinger was considered "an imitator," and that "the real article is a Spaniard, whose name I don't recall, but [Paul Burty] Haviland knows it, because he is a friend of his brother."[42] Obviously de Zayas had not yet visited the Steins and was barely in the loop of discussions at 291. Yet when he did meet Picasso later that fall, they began a friendship that would endure for decades and would make de Zayas one of the most articulate advocates of both Cubism and Picasso's work on either side of the Atlantic.

Within weeks of writing about the fall Salon, de Zayas accompanied Steichen and Paul Haviland to Picasso's studio on the boulevard de Clichy. De Zayas's native Spanish may well have been his entrée. Though an art-world neophyte, he would have been a welcome addition to the party, since Picasso spoke no English and his French was idiosyncratic. At this and other visits stretching into the first months of 1911, the group worked to select the drawings that would present Picasso to America. De Zayas recorded the first visit in a series of eight caricatures that show Haviland becoming increasingly angular and fragmented as he approaches Picasso's studio, until he stands inside as a fully Cubist sculpture.[43] In fact, Haviland was the only member of the trio who already supported Cubism (he painted in a Cubist style); the real convert was de Zayas. As they sifted through piles of drawings and discussed them, de Zayas moved out of Metzinger's orbit and into Picasso's. Unlike the other Americans, whose views of the avant-garde were largely dictated by the Steins, his relationship with Picasso was direct. Their shared language and cultural traditions formed the basis of a bond that transformed de Zayas into an acolyte of Picasso and the avant-garde, and Picasso reciprocated his trust. If de Zayas entered the selection process as an interpreter, he finished it as the most informed advocate of Picasso's work with roots in New York.

By late January 1911, de Zayas was preparing an essay on Picasso, based on an interview, which he offered Stieglitz as the first in a series about artists appearing in exhibitions at 291. "In this interview my principal object is to make them explain their point of view, and answer questions that I know will be asked when their work would be shown. I think it would save you a lot of trouble and make it easier for the public to understand the work of this man. . . . Tell me what you think of the idea. Steichen thinks it is a good one."[44] When he received the text, Stieglitz not only accepted it for publication in Camera Work but distributed broadsheet copies at the exhibition.[45]

De Zayas's essay, "Pablo Picasso," could not contrast more strongly with Burgess's "Wild Men" article, especially the latter's bemused tone and its emphasis on antic behavior. He offered a testament intended to win the confidence of readers, convince them of Picasso's seriousness as an artist, and then provide a brief but sophisticated explanation of the goals of this very arcane art. It would stand as the finest writing on Picasso in an American publication until 1923, when de Zayas again joined with Picasso to prepare "Picasso Speaks," the artist's wide-ranging commentary on Cubism and his diverse styles of the early 1920s. In many ways, the essay is that of an artist. Reflecting Picasso's beliefs as well as his own, de Zayas began with the statement, "I do not believe in art criticism," and he argued against both the dogma of art academies and the tendency of individuals to impose their personal standards on the imaginations of others. He immediately underscored Picasso's difference by introducing him as Spanish, an emigrant from Málaga—one of "the notable number of Spanish painters living in Paris, who prosper there, gaining enviable fame, and who, at the end will figure among the French glories." While obvious to anyone who had met Picasso, his nationality probably came as a surprise to most Americans, who, if they had heard of him at all, saw him discussed in the context of Parisian art and assumed that he was French. Yet de Zayas's decision to emphasize their shared Hispanic heritage alerted Americans to the fact that leaders of contemporary art in Paris might hail from other countries—perhaps even from the United States.

Before describing Picasso's art, de Zayas gave a testimonial: "I have studied Picasso, both the artist and his work, which is not difficult, for he is a sincere and spontaneous man, who makes no mystery of his ideals nor the method he employs to realize them." This assessment must reflect de Zayas's experience during the preceding weeks and the friendship that had developed between them by the time the exhibition was complete. His acceptance marks a radical change from his response to the Salon; it marks a person who has become a believer. De Zayas next plunged directly into an effort to describe Picasso's process: "He receives a direct impression from external nature, he analyzes, develops, and translates it, and afterwards executes it in his own particular style, with the intention that the picture should be the pictorial equivalent of the emotion produced by nature. In presenting his work he

PLATE 5
PABLO PICASSO, *Standing Female Nude*,
1910. Charcoal on paper, 19 x 12 3/8 in.
(48.3 x 31.4 cm). The Metropolitan
Museum of Art, New York, Alfred Stieglitz
Collection, 1949 (49.70.34)

wants the spectator to look for the emotion or idea generated from the spectacle and not the spectacle itself." One indication of de Zayas's sympathy with Picasso is his avoidance of the term "Cubism," which Picasso and Braque, unlike Metzinger and Gleizes, had dismissed as a distraction from their work. Although he went on to discuss some of Picasso's pictorial devices, particularly the unconventional use of perspective and illumination, he never mentioned a specific drawing or painting. His brief essay offered a challenging distillation, proposing an understanding of art as profoundly cerebral and rooted in the imaginative power of the artist to transform a subject into an image of his own experience. For New Yorkers, this was Picasso.

Stieglitz responded with real enthusiasm by matching these abstract ideas with *Standing Female Nude*. It is far harder to judge how his visitors reacted, or even exactly what they saw. Despite Charles Brock's recent exhaustive effort to document the exhibition, no catalogue or photographic record of it has emerged. We must rely on published reviews and the brief comments of the principals to venture opinions about its contents.[46] We do know that, like the earlier Rodin and Matisse exhibitions at 291, it consisted of works on paper. Being less valuable, more numerous, and easier to ship than paintings, drawings were a practical choice. In this case, too, they were probably a necessity, since Picasso had sold many of his recent paintings to Kahnweiler, who was too busy trying to develop a market for the work in France and Germany to send a significant group to America. For the Matisse exhibition, Stieglitz had added one of that artist's paintings that was already in New York, and he probably would have shown Weber's little oil if the two had remained friends. Instead, Americans had to wait for the Armory Show, two years later, to see a painting by Picasso.

As Brock reconstructed the setting, "The Picasso exhibition opened on 28 March 1911 and consisted of forty-nine watercolors and drawings displayed under sheets of glass mounted directly on the wall. In some cases works were grouped by subject matter and, given the large number of drawings involved and the small confines of the 291 gallery, it can be assumed that they were often double- or even triple-hung. Thirty-four additional drawings were also available on request."[47] De Zayas would recall that most of the drawings were recent: "Picasso brought out all the latest drawings he had, and there were many. I don't remember how many we took, but certainly enough to fill the Little Gallery, and you can be sure they were the best Picasso had done up to that time. The drawings were 'cubistic,' needless to say."[48] But Steichen also attempted to balance this emphasis on the more challenging contemporary work: "I came for a little advice in the end to make the collection a little more clear by its evolution. It shows his early work and his 'latest'—certainly 'abstract'—nothing but angles and line that has got [to be] the wildest thing you ever saw laid out for fair."[49]

Only two of the eighty-three works can be identified with certainty. These were very likely among the newest (Stieglitz's *Standing Female Nude*) and the oldest, *Study of a Nude Woman* (1906), which was purchased by Hamilton Easter Field. Fortuitously, this pair demonstrates the evolution that Steichen sought to present—from the delicate classicism of the 1906 sketch,

in which Picasso was only beginning to deviate from conventional poses and bodily proportions, to the rigorous, nearly disembodied schema of 1910. Brock concluded his account, "The evidence suggests . . . that Picasso's Gósol works from 1906, such as Field's study and the peasant woman that greeted visitors at the entrance to the show [fig. 10], were the earliest drawings displayed, with the balance of the installation featuring rich thematic groupings of works before 1911 that conveyed Picasso's genius for inventively reworking a common theme."[50]

The extensive reviews of the exhibition provide only a general idea of its contents, since none of the critics had any familiarity with either Picasso's work in particular or the stylistic issues of avant-garde art in general. Nonetheless, descriptions of "fearfully and wonderfully colored" figures and "childish wooden images, Alaskan totem-poles" probably refer to Picasso's art of 1907–8, when he was most deeply involved with African art. And a "plate containing a crystal, a fruit which resembles a crystal and the head of a woman which undeniably resembles the fruit" presumably describes his work of the following year or two, when he began to develop Cubism.[51] The full range of his subjects was represented, from figures and still lifes to landscapes, although, not surprisingly, most of the critics focused on his transformations of the human body.

As Stieglitz talked to visitors in the gallery, he made *Standing Female Nude* the center of attention, but critics were dismissive, calling it "The Fire Escape," among other things. If de Zayas correctly characterized the show as primarily recent drawings, many similar works must have adorned the walls—compositions of such radical simplicity that they gave few clues to unsophisticated observers. Picasso's drawings of late 1909 through 1910 are primarily executed in charcoal or pen (not the colorful gouache and watercolor of his preceding ones) and use a very limited array of basically geometric lines to articulate structures that are supplemented with shading. If the drawings were shown without titles, they would have been unintelligible to the audience at 291. Even descriptive ones would have offered little access to Picasso's concerns and little enticement to viewers.

For all its virtues, de Zayas's text was of limited help. He did capture the essence of his conversations with Picasso, and conveyed a general sense of Picasso's continuing exploration of pictorial relationships between representation and abstraction—relationships derived from Cézanne. Yet New Yorkers had only been introduced to Cézanne's work one month earlier. By choosing not to provide the historical background that Steichen had added to the selection of works for the exhibition, and by refraining from discussing a single object, de Zayas counted on his earnest admiration to gain the trust of readers and open their minds to his highly conceptual approach. While a few reviews were tolerant, most were unreceptive. Elizabeth Luther Carey suggested that Picasso had "the genuine pioneer quality from which we may expect discoveries that stir the imagination," but many attacked both Picasso and de Zayas. One critic even parodied de Zayas's method to ridicule the pair: "We stand absolutely with Mr. de Zayas, and say that form produces in our spirit impressions resulting in a totally different coefficient from that produced in Picasso's case, and that his pictures displease us radically and vio-

lently."[52] Yet one week after the opening, Stieglitz wrote to de Zayas, "Exhibition a very great success. We've again made a hit at the psychological moment. In a way this is the most important show we have had. The room looks very alive & swell. . . . This little pamphlet [de Zayas's essay] is doing its works well."[53] Clearly, Stieglitz reveled in the show's popularity and felt that the adverse critical response only validated the art's importance. He extended the run for an additional month so that it ended 291's spring season in May and offered visitors approximately two months to study the dozens of drawings.

By his own account, Stieglitz suggested to Bryson Burroughs, a curator at the Metropolitan Museum of Art, that the institution acquire the entire group of drawings. Burroughs replied that he "saw nothing in Picasso and vouched that such mad pictures would never mean anything to America."[54] The remarkable thing is not that the drawings were widely ridiculed but that this first exhibition of Picasso's art almost certainly had a profound impact on the work of several young artists who would be leaders of American art during the teens and 1920s. Probably because it has been impossible to establish precisely which drawings were shown, the exhibition has received little attention in discussions of the dramatic changes that occurred in the art of Weber, Hartley, and Arthur Dove at around this time. Each of these artists, however, not only significantly departed from his accustomed manner by assimilating basic principles of Cubism but also adopted very similar styles and subjects in what appears to be a nearly communal response to the drawings in the exhibition. The works of this period by Weber, Hartley, and Dove are so consistent as a group, and so different from each artist's previous work, that they seem to hold a mirror to the drawings that hung at 291 and offer indirect testimony about them. There can be little doubt that some American artists immediately engaged the pictures on display and launched in earnest the rich dialogue with Picasso's art that continues to the present.

Stieglitz's two-barreled presentation of Cézanne followed by Picasso transformed American art. One must link the two exhibitions not only because they occurred in sequence but because the selection of Cézanne's watercolors effectively introduced many of the formal devices and pictorial issues of the early Cubist works in the Picasso show. Steichen had sent Stieglitz a group of twenty watercolors chosen primarily from Cézanne's later work of about 1890–1900. The majority were landscapes rendered in touches of color widely dispersed across the sheets. Like many reviews, the *New York Evening World*'s dismissed them as "fragmentary drawings washed in here and there with spots and patches of flat tints."[55] For the attentive observer, however, this apparent simplicity revealed Cézanne's technique of structuring his compositions through clusters of lines and overlapping touches of color. Nonetheless, their austerity was hard to accept. In comparison, Picasso's works of 1908 and 1909 must have been easier to digest, with their large, chunky forms and, in the gouaches, heavily worked surfaces. And it was possible to see that his pared-down drawings of 1910 followed logically from what Cézanne had done ten years earlier. Stieglitz could not have presented a better course in the formal development of twentieth-century art.

Despite his blowup with Stieglitz, Weber must have attended

the exhibition, renewed his acquaintance with Picasso's work, and assessed the changes since his departure from Paris. Predictably, Weber's drawings and paintings of 1911 reflect the fullest understanding of Picasso's work among those of his contemporaries, but they also establish the pattern of response. All of the artists downplayed the figural works, even though these drawings had been the focus of published reviews. At least in Weber's case, he had long known the work of the *Demoiselles* period, had been refreshed by the illustrations in "The Wild Men," and was already developing a series of multifigure compositions.

A few of Weber's watercolors treat Picasso's simple still lifes from 1909–10, works that follow the painting he had purchased. They fragment objects into broad facets—the "crystal" mentioned in reviews, a term that Weber would apply to his own Cubist compositions of later years. From the evidence of his work, though, Weber, like Hartley and Dove, devoted most attention to the landscapes in the exhibition, some of which seem to have been among those that Picasso painted in the summer of 1908.[56] More than any of Picasso's own work from that time, Weber's pictures, a high point of early Cubism, provide the most accessible examples of an integrated pictorial field. He clearly saw the possibility of escaping

the central focus of most figural images and creating evenly articulated, overall compositions. In drawings and at least one painting, he reduced the trunks, branches, and intervening sky to rough-hewed planes that abut to map a surface pattern with shallow depth, as in *Trees* (1911; plate 6). Weber's pictures are more densely patterned than Picasso's of 1908, and he quickly developed a highly reductive approach using crescent-shaped segments to pack the composition without reference to nature. The shallow overlap and stack of these elements in the drawing *Forest Scene* (1911; fig. 11) creates a pictorial dynamic more abstract than Picasso's most generalized studies for *Three Women* of 1908. Though lacking the flexibility and spatial complexity of *Standing Female Nude* owned by Stieglitz, *Forest Scene* marks Weber's break from representation to a geometrically structured field.

If Weber might have been expected to leap ahead, other artists in the Stieglitz circle made even more dramatic changes in the wake of the Picasso exhibition. As in so many later cases, it is impossible to distinguish how much artists learned from Picasso's work directly and how much they acquired through fellow Americans who were also engaging his art. More important than this distinction, however, is the community of interest evident in the work.

Hartley had held his first exhibition at 291 in May 1909, and had been a regular at the gallery during Weber's heyday there. He may have relied on Weber to explain the art he saw, so different from the Impressionist-derived landscapes he was painting at the time. Hartley's sudden development in 1911 is particularly surprising since he missed the Cézanne exhibition and had no substantial knowledge of European avant-garde art. His choice of the landscape genre may have reflected his customary practice, but his new style did not. In the paintings *Landscape No. 32* and *Landscape No. 10* (both 1911; plate 7, fig. 12) Hartley matched Weber's assimilation of Picasso's style. In *Abstraction* (1911; fig. 13) he moved beyond representation and adapted the irregular grid of Picasso's most recent work to create a composition more visually complex and varied than Weber's *Forest Scene*.

One year later, when Hartley arrived in Paris on his first European trip, he sought out the latest developments in Picasso's art. He visited Kahnweiler's gallery, and at Gertrude Stein's he studied her newest purchase, *The Architect's Table* (1912; fig. 14). This painting and its contemporaries signal Picasso's turn away from abstraction with the inclusion of legible words, such as "Vieux Marc" or "Ma Jolie," that refer to his everyday life while linking typographically with the linear structure of the painting. Writing to Stieglitz in July, Hartley judged this departure "not as interesting," although he included a sketch to illustrate the procedure (*Sketch of Picasso Painting*, 1912; fig. 15) and explained, "Just now he is doing things that have running over and across these network designs—names of people and words like jolie or bien and numbers like 75."[57] Surely this drawing and description made the rounds at 291.

If Hartley at first disagreed with Picasso, he soon assimilated the new ideas into his paintings. The title of *Musical Theme No. 2 (Bach Preludes et Fugues)* (1912; plate 8) may have drawn on Braque's recent evocations of music, but the heavy "network" and the words inscribed near the bottom of the canvas correspond to Hartley's simplified sketch. Unlike *Abstraction*, done the previous year, the near-monochrome *Musical Theme No. 2* closely approaches Analytic Cubism, but Hartley continued to emphasize the edges of his planes, thereby avoiding "*passage*"—the merging of planes that Picasso lifted from Cézanne and used to give his Cubist grids a shifting ambiguity. This preference for simplicity of design and distinct linear patterns characterized Hartley's art long before he saw a Picasso and continued to dominate his interpretation of Cubism through the mid-teens. As Jonathan Weinberg has noted, "What is interesting about the sketch [that Hartley sent Stieglitz] is the way in which it dramatically simplifies and flattens the characteristic forms of Picasso's analytic cubism, even as it exaggerates the legibility of the [numbers and words]. Indeed, it seems like an antecedent of *Portrait of a German Officer* [*Painting, No. 5*, 1914–15; fig. 16] and of the War Motif series in general."[58] During 1913–15, Hartley would turn to the work of Delaunay and Wassily Kandinsky and would develop his own distinctive subject matter, but his compositions of richly saturated blocks of color parallel Picasso's shift from Analytic to Synthetic Cubism.

Among the artists of 291, the one most deeply affected by the Picasso exhibition may have been Dove. Certainly Abraham Walkowitz mimicked Picasso's *Standing Female Nude* at some point in the mid-teens, but the chronology of his progress is too uncertain to determine how soon after the exhibition his response occurred, and his misdating of his work only complicates the matter.[59] Dove, however, seems to have taken what he wanted very quickly—so quickly that his interest in Picasso's new style has gone largely unnoted. Dove is often portrayed as isolated from international events, as if his move to a Connecticut chicken farm in 1910 had definitively separated him from contemporary art. Yet in 1908–9 he had spent fifteen months in Europe, where he had socialized with Weber and other Paris-based Americans. He was familiar with trends in French art and painted in a Fauvist style. Soon after returning to New York, in the summer of 1909, Dove had joined the group at 291. In March–April 1910, Stieglitz had included some works by Dove in a "Younger American Painters" exhibition at the gallery, along with paintings and sketches by Maurer, Steichen, Weber, Hartley, John Marin, and others. Throughout his adult life, he spoke of his respect for Picasso, and there is little doubt that he saw both the Cézanne and the Picasso shows in the spring of 1911.[60]

Dove's series of six "Abstractions" from this period are as innovative as some of the works in those exhibitions. They are generally said to have been made in 1910–11, some months before either exhibition took place; yet no documentary evidence is known to support such a chronology. Art historians have focused on the vivid coloring of several in the group and have placed them in the context of the Fauvist paintings that Dove made in 1908–9.[61] Yet three of these six works employ subdued tones of green, brown, and black, colors common in Analytic Cubism. They are also all landscapes, the primary focus of other artists' response to the Picasso show. Organized with irregular grids of heavy lines surrounding broad, flattened passages, some of these works present the looser structure and flowing color of Cézanne's watercolors, while others are much more tightly articulated by the parallel hatching of Picasso's early Cubism. All are stylistically light years from the faint Fauvism of Dove's preceding art.

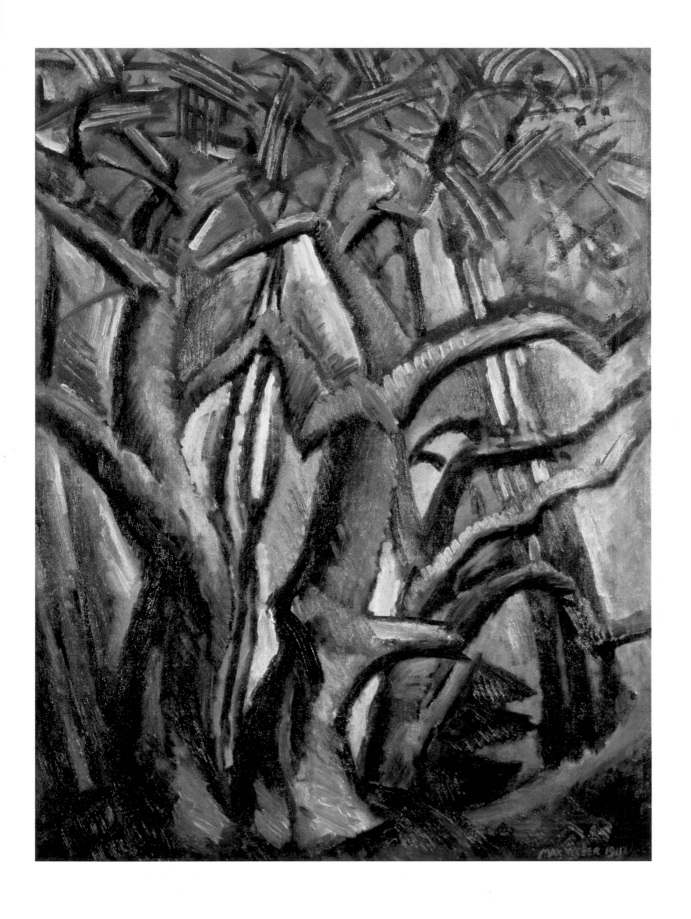

PLATE 6
MAX WEBER, *Trees*, 1911. Oil on canvas,
28 x 22 in. (71.1 x 55.9 cm). Collection of
Michael and Fiona Scharf

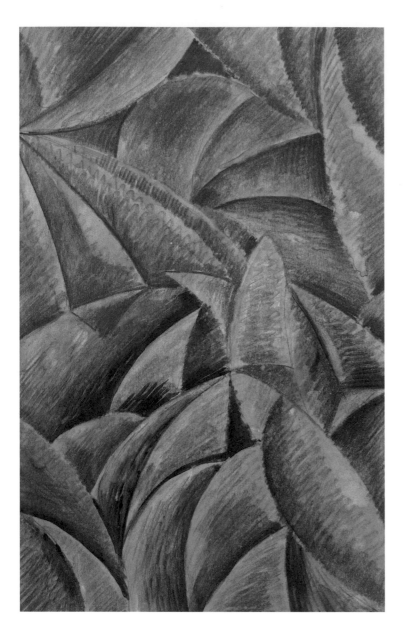

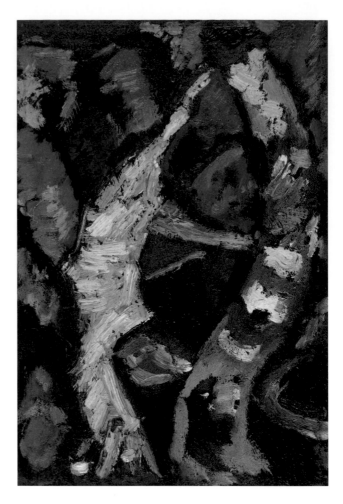

Painted in oil on paper or board, Dove's "Abstractions" are tiny (approximately eight by ten inches)—exactly the format an artist might chose to explore new ideas, particularly when his inspirations are drawings. And the string of studies suggests how quickly Dove absorbed the lessons of Cézanne and Picasso. If the numbering of the panels reflects the sequence of their execution, Dove seems to be closer to Cézanne's watercolors in numbers 1, 2, and 4, closer to Picasso in numbers 3, 5, and 6. The most precisely rendered of the group, *Abstraction #3* (plate 9), fits remarkably well with the pictures that Weber and Hartley made after seeing the Picasso exhibition, although numbers 5 and 6 are quite similar. All use the patterns of tree trunks and branches to generate a network of faceted planes that map the surface and move into shallow depth—in the manner of Picasso's 1908 landscapes.

Weber would later recall a visit to Dove in Connecticut in 1911, when they discussed their wish to "symbolize"—to simplify, or abstract, observations of nature.[62] There is a very good chance that Weber played a role in Dove's introduction to Cubism and his rapid adaptation of it in "Nature Symbolized," his series of 1911–12. *Nature Symbolized No. 1*, also known as *Roofs* (plate 10), employs a reductive geometry of architectural shapes quite similar to Picasso's drawings of Horta from the summer of 1909 and succeeding months. But Dove's imaginative use of curvilinear forms and somber, saturated greens (plate 11) evokes nature through the lens of *Abstraction #3*, and creates a velvety texture very different from the rough planes of Picasso.

The consistency of Hartley's, Dove's, and Weber's initial responses to Cubism is signal. It seems impossible without the experiences shared by Weber and Dove in Paris, and the involvement of all three in the community around 291 during the year in which Weber shaped their understanding of contemporary art. Other Americans, such as Conrad Cramer, also emulated Picasso's example—yet this first phase of Cubism in the United States rapidly dissipated. The artists transformed the style into their own idioms, and the intellectual community that had spawned their interest fragmented.[63] Hartley left for Europe, Dove settled into rural life, and Weber sought new audiences for his work and addressed a rising generation of artists.

No new works by Picasso appeared in the U.S. before the Armory Show of 1913, and the eight in that exhibition neither

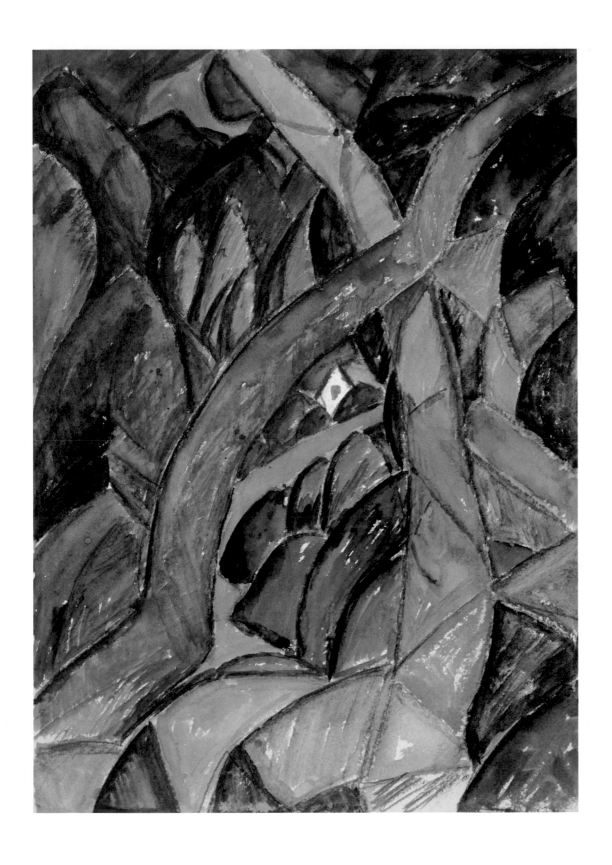

PLATE 7
MARSDEN HARTLEY, *Landscape No. 32*,
1911. Watercolor on paper, 14 1/16 x
10 1/16 in. (35.7 x 25.6 cm). Frederick R.
Weisman Art Museum, University of
Minnesota, Minneapolis, Bequest of
Hudson D. Walker from the Ione and
Hudson D. Walker Collection

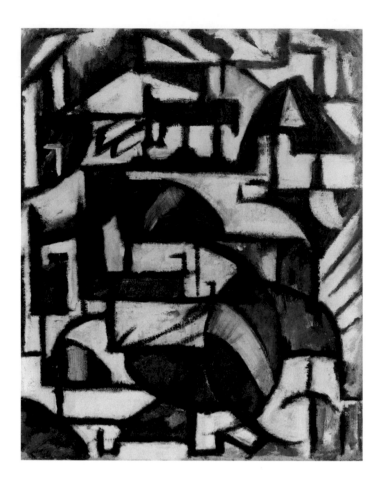

FIG. 13
MARSDEN HARTLEY, *Abstraction,* 1911. Oil
on paper on cardboard, 16 3/8 x 13 1/4 in.
(41.6 x 33.7 cm). Frederick R. Weisman
Art Museum, University of Minnesota,
Minneapolis, Gift of Ione and Hudson D.
Walker 61.3

Woman with Mustard Pot (1910; plate 14) and *Head of a Man* (1912).[66] Since *Woman with Mustard Pot* had just returned from a landmark exhibition at the Grafton Gallery in London, the unidentified painting called *Head of a Man* may well have been the picture bearing the same title that appeared in the London exhibition. If so, it included the addition Hartley had described: letters painted into the highly fragmented field. But for those interested in Picasso's work, the real contribution of these pictures was the fact that they were paintings. Unlike the opaque surfaces of gouache, or the largely linear touch of charcoal or pen in the drawings Stieglitz had shown, these were oils. They fully embody the scumbled and layered transparency of *passage* that is crucial to the spatial complexity of Picasso's Cubism.

Weber quickly absorbed the lesson. He had concluded his obsession with the images reproduced in "The Wild Men" by painting *Figures in a Landscape* (1912; plate 15), a version of the *Demoiselles* that turns the crude aggression of that painting and its inmates into a highly refined exercise in coyness. (Most of Weber's women either close their eyes or avert their glances from the audience.) Shifting his attention to other images in the article, he addressed the simple masses of *Three Women* and Braque's similar sketch, with its planes shaped by parallel pen-strokes, then pushed into the Cubism of 1909–10. Generally called "Crystal Cubism," Weber's paintings of 1911–12 render densely packed groups of contorted figures (à la *Demoiselles*) through near-monochromatic washes and lines built by repeated narrow strokes. More like drawings than paintings, they probably reflect the work he had seen at 291 and mark his changing approach to Cubism during 1913.

By early 1912, Weber had found a new forum for his proselytizing, the Ferrer Center or Modern School, on East 107th Street in Manhattan. Weber wrote the introduction to the Center's April exhibition, which included three of his paintings (one of them a *Crystal Study*) together with nine by a newly emerging talent, Man Ray. Like others before him, Man Ray followed Weber's appreciation of tribal art, Cézanne, and Picasso. His landscapes of 1913, in watercolor and oil, fit the pattern that Weber had established two years earlier and continued to develop in the "Crystal" compositions. Man Ray's *Departure of Summer* (1914; fig. 17) and *Five Figures* (1914; plate 16) are outright homages to Weber and Picasso.[67] *Departure of Summer's* flattened silhouettes of nude figures cavorting in a landscape recalls both Weber's first likely responses to the *Demoiselles,* in pictures such as *Summer,* and his preference for natural settings out of Rousseau. *Five Figures* passes through Weber to address Picasso directly.

Man Ray probably began by looking at *Figures in a Landscape,* Weber's last turn on the *Demoiselles,* but his painting is far starker than Weber's and contains none of its cuteness. He must have examined "The Wild Men," for *Five Figures* borrows elements of the Braque drawing and of two of the Picasso paintings reproduced there. From Braque's sketch, Man Ray lifted the hatched edges that Weber had long used and the reduction of the figures' facial features to linear notations. He modified the sculptural blocks of *Three Women* to lay in broad, thickly brushed planes. But the primary effect of *Five Figures* is of an engagement with the *Demoiselles*: the five women, and their placement with three to the left and a stack of two on the right, recall the massing

reflected his newest ideas nor dominated the public's responses to that massive display of contemporary art. Instead of Picasso's innovations in collage and papier collé, the selection of his work on view gave the impression that his art had changed little since the exhibition at 291, while Cubism had exploded through an enormous variety of practitioners, most controversially Marcel Duchamp. The organizers of the Armory Show, particularly Pach and Davies, were not to blame. They had sought contributions from Picasso and Kahnweiler without much success. Picasso continued to avoid such salons, and Kahnweiler was still focused on promoting the artist in Europe. Nonetheless, he did supply three paintings and a drawing, probably because he did not wish to offend the Steins, who lent two of their Picassos.

The two remaining works were owned by Stieglitz, who, as if to remind Americans that he had first brought Picasso's work to these shores, lent his drawing *Standing Female Nude*.[64] He added another exceptional piece he had just acquired, a bronze cast of *Head of Fernande* (1909; plate 12)—an introduction to Cubist sculpture that percolated in Weber's imagination for several years before he created his own three-dimensional carvings. The Steins' two still lifes almost certainly dated from the earliest phases of Cubism in 1908 or '09.[65] Kahnweiler's contributions consisted of a painting of 1903, a gouache of 1907, and two recent paintings:

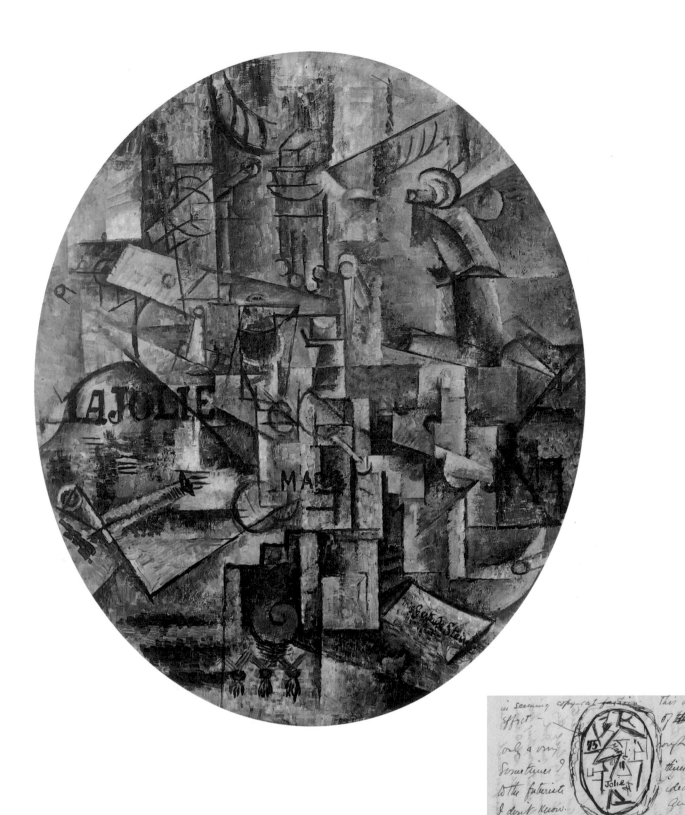

FIG. 14
PABLO PICASSO, *The Architect's Table*, 1912.
Oil on canvas mounted on panel, 28 5/8 x
23 1/2 in. (72.7 x 59.7 cm). The Museum
of Modern Art, New York, The William S.
Paley Collection 697.71

FIG. 15
MARSDEN HARTLEY, *Sketch of Picasso
Painting*, July 12, 1912. Ink on paper in
letter to Alfred Stieglitz. Yale Collection
of American Literature, Beinecke Rare
Book and Manuscript Library, Yale
University, New Haven, Conn.

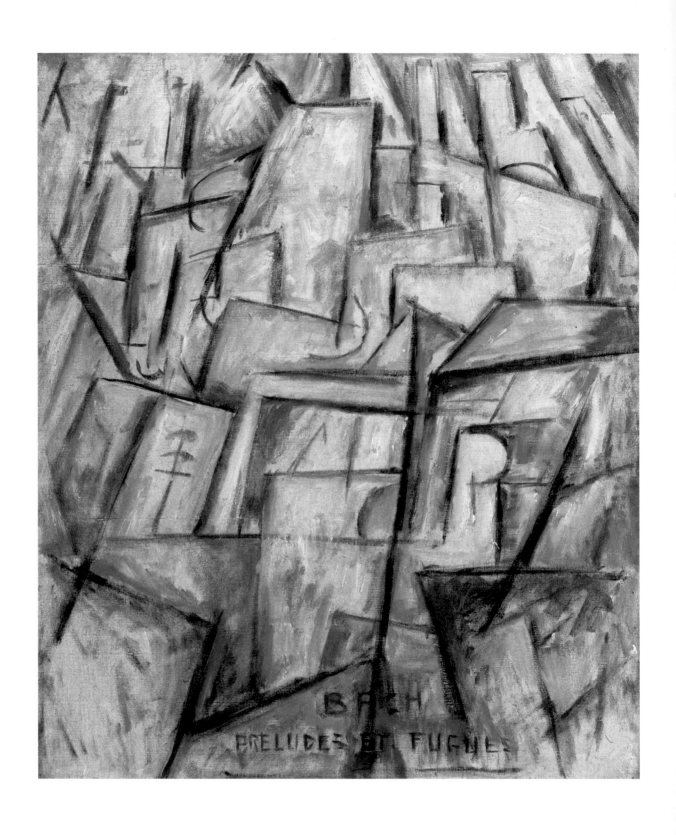

PLATE 8
MARSDEN HARTLEY, *Musical Theme No. 2
(Bach Preludes et Fugues)*, 1912. Oil on
canvas on Masonite, 24 x 20 in. (61 x
50.8 cm). Museo Thyssen-Bornemisza,
Madrid

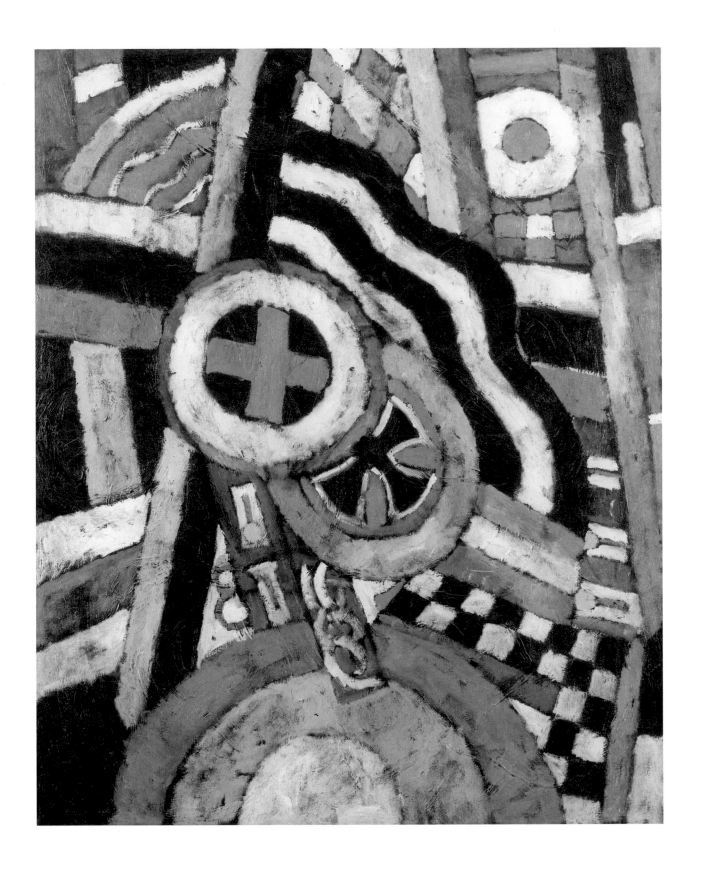

FIG. 16
MARSDEN HARTLEY, *Painting, No. 5,*
1914–15. Oil on canvas, 39 1/2 x 31 3/4 in.
(100.3 x 80.6 cm). Whitney Museum of
American Art, New York, Gift of an
anonymous donor 58.65

PLATE 11
ARTHUR G. DOVE, *Plant Forms*, ca. 1912.
Pastel on canvas, 17 1/4 x 23 7/8 in.
(43.8 x 60.6 cm). Whitney Museum of
American Art, New York, Purchase, with
funds from Mr. and Mrs. Roy R.
Neuberger 51.20

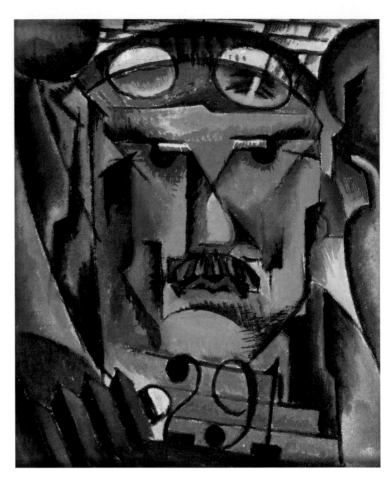

of Picasso's composition, and the face at the upper right sports vertical bands of color that evoke the striated, masklike face of the same figure in the *Demoiselles*. Man Ray ultimately created an image that conveys the monumentality of the *Demoiselles* while avoiding its jarring disparity of styles and aggressive sexuality.

Although Man Ray claimed that the Armory Show was so overwhelming that "I did nothing for six months. It took me that time to digest what I had seen," he had already studied Picasso's exhibition at 291 and had heard Weber's interpretations of it.[68] The first painting he is thought to have made after the Armory Show, *Portrait of Alfred Stieglitz* (1913; plate 13), demonstrates his fine understanding of Analytic Cubism and his appreciation of its history in America. It also showcases his familiarity with Stieglitz, its chief promoter, whose gallery he had frequented since the Cézanne exhibition and who thought enough of the young artist to invite him to lunch from time to time.[69] While the reproduction of a portrait of Fernande Olivier (1909) in the July 1912 issue of *Camera Work* may have provided a foundation for Man Ray,[70] he brushed his painting with a tonal subtlety and variation of hues that reflect the oils in the Armory Show, particularly *Woman*

with Mustard Pot. (Weber too must have studied this painting, responding to it in his *Imaginary Portrait of a Woman* [1913; fig. 18] and *Bather* [1913, plate 17], in which Weber also borrowed from Duchamp's *Nude Descending a Staircase, No. 2*, 1912.) Portraying Stieglitz in close-up, Man Ray lightened the darkly worked face in *Woman with Mustard Pot*, but emulated its counterpoint of sharp lines and loosely edged planes to articulate the figure and surrounding space. Because it outlines Stieglitz's features, including his mustache and the glasses pushed high on his brow, Man Ray's composition is more legible than Picasso's, but it plays on the mustard pot by including the bellows of Stieglitz's camera, and it also contains a radical element: the number "291." Located next to the bellows and inscribed across horizontal ranks that may represent copies of *Camera Work*, the numerals complete a cluster of references to Stieglitz's diverse activities. Man Ray had found a perfect use for Picasso's and Braque's latest innovation.

Man Ray's *Portrait of Alfred Stieglitz* marks the end of the first era of American artists' involvement with Picasso. Although both Stieglitz and the Cubism he had introduced would remain influential, the Armory Show unleashed a tremendous variety of approaches to contemporary art, effectively diminishing the recognition of both Stieglitz and Picasso during the next several years as other artists, aesthetics, and advocates achieved prominence. Man Ray's own Cubist period soon passed, but Picasso continued to shape his conception of what it meant to be a modern artist. By the mid-1920s, the two men were friends, and a decade later they were collaborators—a rare episode of artistic camaraderie for Picasso, and his only real one with an American.[71]

PLATE 12
PABLO PICASSO, *Head of Fernande*, 1909. Bronze, 16 1/4 in. (41.3 cm) high. Private collection

PLATE 13
MAN RAY (1890–1976), *Portrait of Alfred Stieglitz*, 1913. Oil on canvas, 10 1/2 x 8 1/2 in. (26.7 x 21.6 cm). Beinecke Rare Book and Manuscript Library, Yale University, New Haven, Conn.

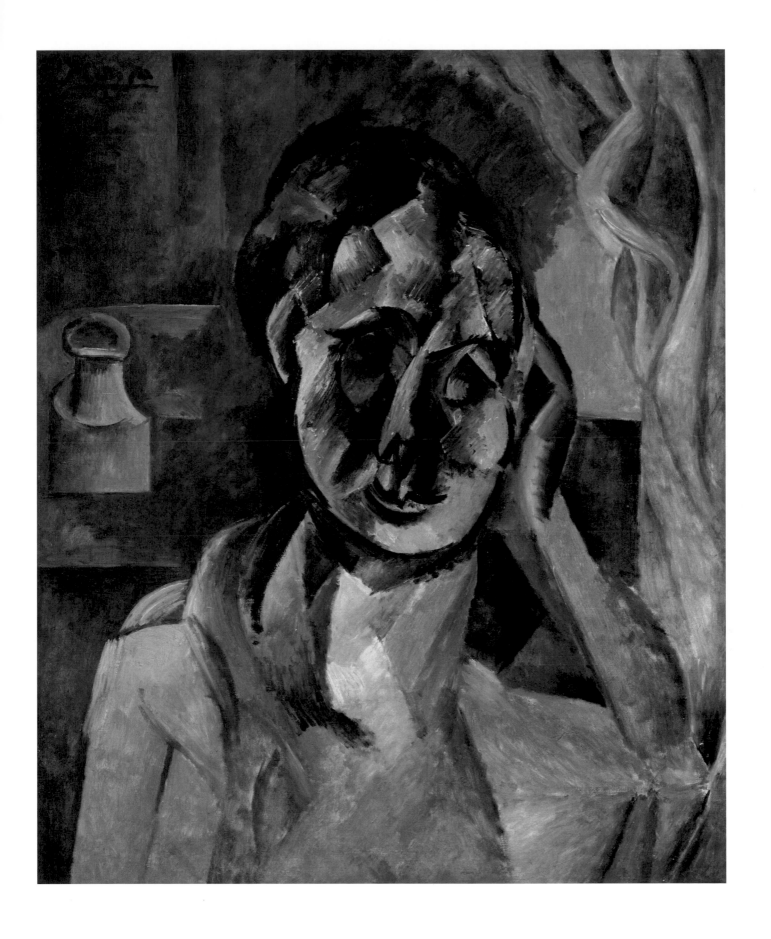

PLATE 14
PABLO PICASSO, *Woman with Mustard Pot*,
1910. Oil on canvas, 28 3/4 x 23 5/8 in.
(73 x 60 cm). Gemeentemuseum Den
Haag, The Hague, The Netherlands

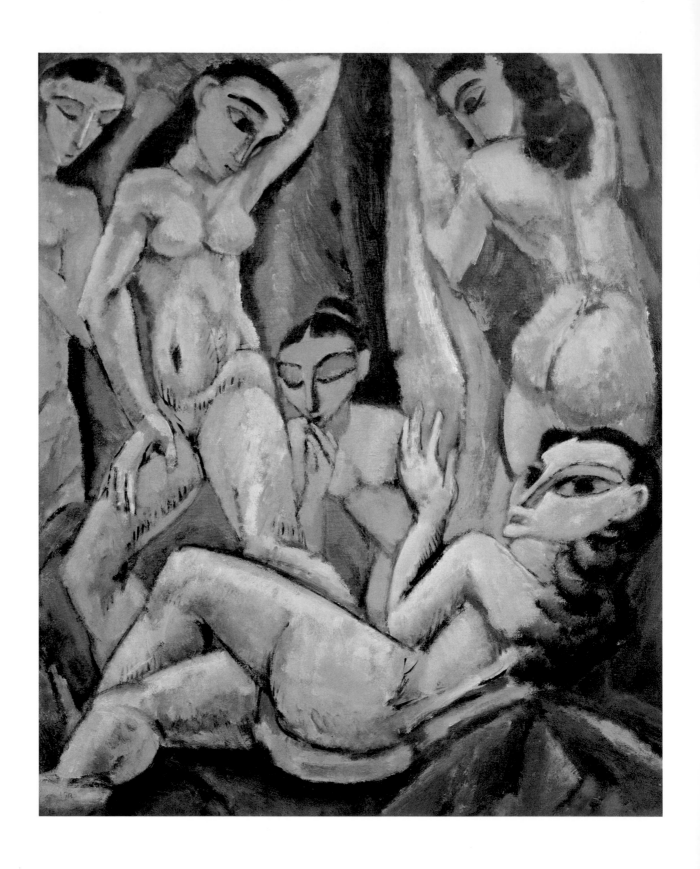

PLATE 15
MAX WEBER, *Figures in a Landscape*, 1912.
Oil on canvas, 28 x 23 in. (71.1 x 58.4 cm).
The Rose Art Museum, Brandeis
University, Waltham, Mass., Gift of Mrs.
Max Weber and her children Maynard and
Joy, Great Neck, N.Y., In memory of Max
Weber

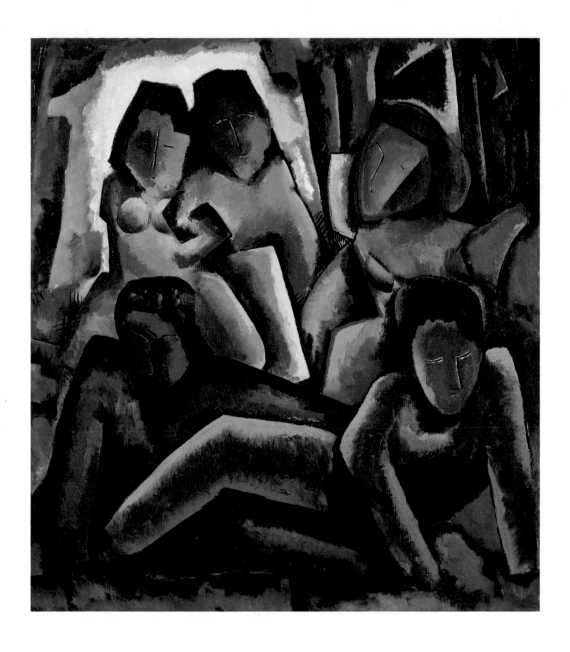

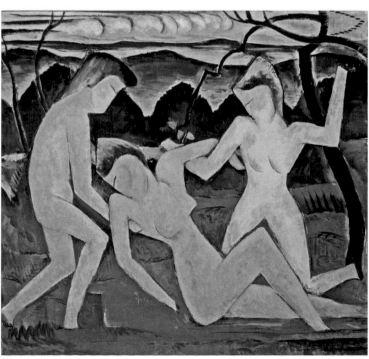

PLATE 16
MAN RAY, *Five Figures*, 1914. Oil on
canvas, 36 x 32 in. (91.4 x 81.3 cm).
Whitney Museum of American Art,
New York, Gift of Katherine Kuh 56.36

FIG. 17
MAN RAY, *Departure of Summer*, 1914.
Oil on canvas, 32 1/2 x 35 1/2 in. (82.5 x
90.2 cm). The Art Institute of Chicago,
through prior gift of the Mary and Leigh
Block Collection 1992.653

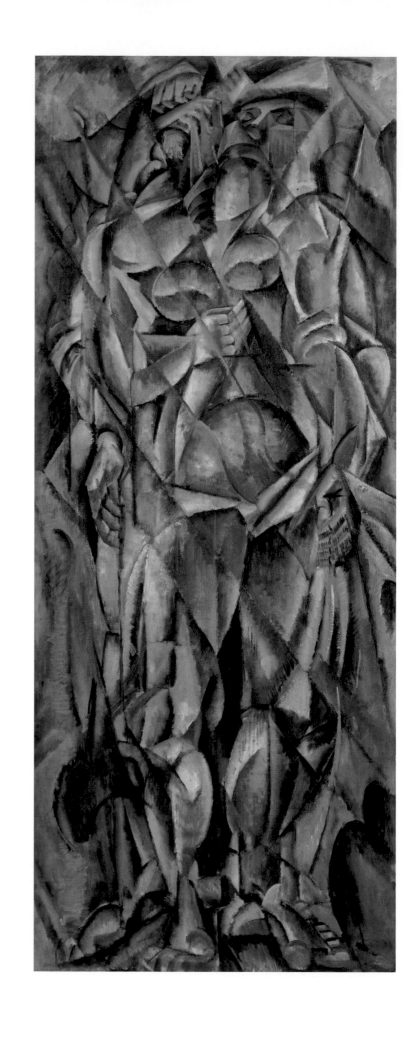

PLATE 17
MAX WEBER, *Bather*, 1913. Oil on canvas,
60 5/8 x 24 3/8 in. (154 x 61.9 cm).
Hirshhorn Museum and Sculpture
Garden, Smithsonian Institution,
Washington, D.C., Gift of Joseph H.
Hirshhorn, 1966

FIG. 18
MAX WEBER, *Imaginary Portrait of a Woman*, 1913. Oil on canvas, 36 x 24 in. (91.4 x 61 cm). Private collection

CHAPTER TWO
(1914–1929)

"HEAVEN SEND NEW YORK A MUSEUM OF MODERN ART,
SO THAT FOLKS MAY SEE WHAT IS GOING ON IN THE WORLD!"

Forbes Watson, 1926

When Marius de Zayas opened the Modern Gallery in New York, on October 7, 1915, he announced a new relationship between Americans and avant-garde art. After the groundbreaking exhibitions at 291, and the wide exposure given to modernism at the Armory Show, de Zayas had decided that a substantial group of Americans was no longer mere gawkers or followers of distant trends but knowledgeable participants in contemporary art. He further bet that this community of artists, collectors, and critics was large enough to sustain a commercial gallery. And he took the position that a business, rather than a largely nonprofit venture such as 291, was the best way to increase the audience for contemporary art and to underwrite the careers of artists in both Europe and America.

World War I slowed the progress of de Zayas's gallery and he lost his taste for commercial exchange, but his optimism was not entirely premature. During the fourteen years, one month, and one day between the opening of the Modern Gallery and the debut exhibition of the Museum of Modern Art, on November 8, 1929, the United States vaulted from the periphery of the contemporary-art world to its center—in terms of collecting, at least, if not yet to that of artmaking. Even so, only a small group nurtured the reputations of modern artists, organized the exhibitions, and bought the pictures that offered Americans the opportunity to see what Picasso and other leading artists were doing. Opposing a trend toward isolation after the war, these advocates believed that Europe led international developments in contemporary art, and they worked to bring the best examples to this country. Increasingly acclaimed as the foremost artist of the twentieth century, Picasso came to be seen as the measure of achievement, even the personification of modern art—a conception that is now a cliché, at the same time that his stature endures. For advocates of the avant-garde, his past work defined the history of recent art, and his newest work often (although not always) shaped perceptions of art's future.

As many modern European works entered the United States in the caches of collectors, their private holdings grew to constitute a substantial array of contemporary art and fueled campaigns to make modern art a public trust. These Americans, unlike their European counterparts, made a truly exceptional promise to reach beyond the intellectuals and wealthy sympathizers who constituted the art communities of both continents and to open their collections to the public. Whether in Stieglitz's elite crusade or in the far more popular outreach of the Armory Show, the American advocacy of the avant-garde included a deep commitment to education, a fundamental belief that art could benefit society and should be shared by all. While European artists had certainly made this claim, European collectors had offered little more than occasional viewings of their holdings, and few museum curators had tried to make their institutions regular showcases for contemporary art. Despite all their well-intentioned rhetoric, European artists, dealers, and collectors rarely ventured outside the galleries, cafés, and *quartiers* of their regular haunts. But the visits of tens of thousands to the Armory Show in its three venues—about 88,000 in New York, 200,000 in Chicago, and 13,000 in Boston[1]—convinced many Americans that modern art could gain a mass audience in the United States, and planted the idea of regular exhibitions of this new work. Within little more than a decade after the Armory Show, that idea had matured into the founding of full-fledged museums of modern art.[2]

Even more than critics and dealers, American artists continued to be the chief brokers of Picasso's reputation. Collectors who admired these artists often grew to accept their praise of Picasso and eventually made the purchases that brought his works here. Whether or not the artists followed his example in their own art, they helped to gather the works that would become the primers of future generations. Even so, in the late teens and most of the 1920s, works by Picasso and other artists of the European avant-garde made only rare appearances in American exhibitions. American artists still had to travel if they were to study this art firsthand. Even as Picasso's work became more widely displayed, relatively few American artists took the immediate opportunity to absorb his innovations deeply and develop complex responses to the objects they saw. The exception was Stuart Davis, who plumbed his rare sightings to create a rich dialogue with his contemporaries across the sea. By the mid-1920s, Davis's devotion to Cubism had drawn him into a confrontation with Picasso's art far surpassing that of any earlier American artist. In the process, he ended nearly two decades of American artists' episodic responses to this work and laid the foundation for the next generation to join the international avant-garde.

With the Modern Gallery, de Zayas emerged from Stieglitz's shadow and took the public role as impresario of the avant-garde that he had played behind the scenes since his first encounter with Picasso. Whether as dealer, writer, or artist, de Zayas more than anyone rooted the avant-garde in America during the late teens, and then, in the early 1920s, inspired and sometimes led the international dialogue that transformed American art during the remainder of the twentieth century.

PABLO PICASSO, *Landscape with Dead and Live Trees,* 1919 (detail of plate 27)

STUART DAVIS, *Early American Landscape,* 1925 (detail of plate 36)

De Zayas's initiation in Paris in 1911 began a three-and-a-half-year apprenticeship of deepening relationships with artists and critics there and in New York. Summarizing the experiences of that opening year, Stieglitz raved about the "most remarkable three weeks spent in Paris. There I had long and most interesting sessions with Picasso, Matisse, Rodin, Gordon Craig, [Ambroise] Vollard, Bernheim [one of the brothers, Josse and Gaston, who ran the Galerie Bernheim-Jeune]. . . . All this I did in the company of de Zayas or Steichen, or both." While praising Steichen, he emphasized that "de Zayas has developed remarkably and is a big fellow."[3] (Since illness had kept de Zayas in bed for much of that year, Stieglitz was clearly referring to his intellectual rather than his physical weight.) Not surprisingly, Stieglitz concluded his series of visits with the feeling that "Matisse is doing beautiful work, but somehow or other it didn't grip me. Possibly he is ahead of me! Picasso appears to me the bigger man. I think his viewpoint is bigger; he may not as yet have fully realized in his work the thing he is after, but I am sure he is the man that will count."[4] De Zayas, similarly, did not champion Matisse, even while he did expand his contacts beyond Picasso to the primary Paris art critic of the teens—Guillaume Apollinaire—and to the younger artists who were taking Cubism in new directions.

Continued illness confined de Zayas to New York in 1912 but did not stop him from benefiting from the events surrounding the Armory Show. Its array of European artists held few surprises for him, nor did its display of paintings by the "Salon Cubists" lessen the scorn he had felt for their work on his first encounter with it, in the fall of 1910. Despite his commitment to Cubism itself, de Zayas never warmed to these artists, even after Albert Gleizes took an extended trip to New York in 1915. He did, however, begin a close and productive friendship with Francis Picabia, one of the few European participants in the show who visited New York during its run. Picabia's brash dismissals of traditional art, and his enthusiasm for the modernity of the city's skyline, won him a large audience. He particularly charmed Stieglitz, who saw in him an opportunity to reassert 291's standing as the leading venue for contemporary art, and offered him an exhibition.

Opening just as the Armory Show closed, the exhibition at 291 consisted of watercolors Picabia had made during his weeks in New York as celebrations of the city: "Did I paint the flatiron Building, or the Woolworth Building, when I painted my impressions of the fabulous skyscrapers of your great city? No. I gave you the rush of upward movement, the feeling of those who attempted to build the Tower of Babel—man's desire to reach the heavens, attain infinity."[5] Although indebted to Marcel Duchamp's work over the previous two years, Picabia's watercolors were in the forefront of contemporary art and were hailed by critics as "Post-Cubist." They gave New Yorkers the first union of truly cutting-edge style with a subject that spoke of America. Yet this distinction held for only a few weeks, since Stieglitz followed Picabia's show with one devoted to de Zayas's recent caricatures of the 291 crowd—drawings that pushed beyond Picabia's more hesitant technique to engage both the radical simplicity of Picasso's most abstract work and the mathematical feints of Duchamp's notorious paintings (fig. 19). With the Armory exhibition packed off to Chicago and Boston, the team

of Picabia and de Zayas proved that some Europeans and Americans had already bridged the aesthetic differences that generally divided the two continents.

Finally, de Zayas returned to Paris in May 1914. Commissioned by *Puck* magazine to make caricatures of contemporary European artists and writers, he kept 291 at the top of his agenda: "After many calls I saw Picasso and Picabia," he wrote to Stieglitz in early June. "I didn't see any of Picasso's latest work his studio being all upset. Picabia's latest work is more simple but still complicated and arbitrary."[6] If this shorthand doesn't convey much about Picabia's art, it may be because de Zayas was so busy accompanying that very sociable artist on his rounds through the art world: "I was introduced to the crowd of the '*Soirées de Paris*.' A rather interesting bunch of artists headed by Apollinaire."[7] Recognizing a similarity to the group around *Camera Work*, de Zayas began to cultivate the great poet, critic, and old friend of Picasso's. He succeeded almost immediately: the July issue of *Les Soirées de Paris*, which Apollinaire edited, carried his caricatures of Picabia, Stieglitz, Vollard, and the poet himself.

Picasso proved more difficult. His personal relations with de Zayas remained cordial, but business did not come easily.

FIG. 19
MARIUS DE ZAYAS (1880–1961), *Alfred Stieglitz*, ca. 1913. Charcoal on paper, 24 1/2 x 18 3/4 in. (62.2 x 47.6 cm). The Metropolitan Museum of Art, New York, Alfred Stieglitz Collection, 1949 (49.70.184)

Always sensitive to exploitation, particularly by dealers, Picasso probably felt some hesitation about working with 291 again: after his show there in 1911, Stieglitz had delayed a couple of months in returning his unsold drawings, making Picasso "very sore at the way he has been treated," de Zayas reported.[8] Besides, three years had passed, and Picasso had signed a contract giving Daniel-Henry Kahnweiler commercial control of his art. As de Zayas wrote to Stieglitz shortly after his arrival in Paris, "I spoke with Picasso about an exhibition at '291.' He is willing but all those matters have to be treated with Kahnweiler."[9] Four days later, he continued, "I saw Kahnweiler and ask[ed] him about the Picasso exhibition. He said he was very sorry not to be able to be of any service to you because he has a contract with [Michael] Brenner who has opened a gallerie in Washington Sq., N.Y. . . . Kahnweiler also is taking a decided attitude of commercialism and pure commercialism."[10] Although World War I would void the agreement before any exhibitions occurred, Kahnweiler had just signed a contract for Brenner and a partner, Robert Coady, to be his exclusive agents in New York. Best known as the art editor of the little magazine *The Soil* (1916–17), Coady had probably met Brenner, a sculptor, in Paris, where they befriended Max Weber around 1908. In the spring of 1914, they opened the Washington Square Gallery at 46 Washington Square South, which survived five years and probably showed a small number of Picasso's works in 1914 and 1915.[11]

Even though Kahnweiler's contract with Coady and Brenner seemed to present an insurmountable barrier in the summer of 1914, Stieglitz urged de Zayas to persevere: "I hope you will be able to make connections with Kahnweiler for a Picasso show. I am more eager than ever to have him. '291' needs it badly. That is New York needs it."[12] This moment of equivocation cuts through Stieglitz's imperial manner and captures both his insecurity in the post-Armory art world of New York and his fundamental reliance on Picasso as the leader of the avant-garde.

Luckily, de Zayas had a solution. Picabia and his wife, Gabrielle Buffet, owned eighteen recent Picassos ("8 of which are of his latest style"), pictures that the couple had been unable to sell at the short-lived gallery they had founded in Paris during the war. They were willing to offer these works to Stieglitz in the hope of raising some cash. De Zayas accordingly wrote to Stieglitz, "You can have an exhibition of Picasso's latest work." He added that the works were "very well selected" and that "Picasso's latest pictures are to me the best and deepest expression of the man, with a remarkable purity that his other work lacks."[13] Stieglitz politely took what he could get: "Of course, I feel that '291' ought to have a Picasso show. And so it is doubly gratifying that the Picabias are in a position to help us out with a fine show of what you say is the right Picasso stuff."[14] More than usual, Stieglitz had to trust the judgment of others.

De Zayas's accounts of his discussions with Picasso must have reassured Stieglitz: On June 11, he wrote, "The day I left Paris [for London] I was with Picasso for quite a long time. We had a very interesting and intimate talk on art and on his latest manner of expression. He open[ed] himself quite frankly."[15] There was also an unexpected revelation: "He confesses that he has absolutely enter[ed] into the field of photography." Picasso had

actually been taking photographs for some years, so this statement may have been prompted by the set of Stieglitz's prints that de Zayas had brought along: "I showed him your photographs. . . . He came to the conclusion that you are the only one who has understood photography and understood and admired the 'steerage' to the point that I felt inclined to give it to him. But my will power prevented me from doing it."[16] Stieglitz replied, "It was mighty interesting to hear what Picasso had to say about my photographs. Of course I value his opinion tremendously."[17] De Zayas's letter surely stimulated Stieglitz's efforts to integrate Cubism and photography during the following year. Sarah Greenough, one of the foremost scholars of Stieglitz's career, has argued that his encounter with Picasso's art transformed his perception of his own most famous image, *The Steerage*, and guided his photography during the mid-teens:

> Stieglitz's art achieved a new level of maturity in early 1915. Now fully understanding the graphic complexity and analytic, gridlike structure of *The Steerage*, 1907, he returned to it and reproduced it in the avant-garde periodical *291*. Although in later years he claimed to have immediately recognized its importance, he did not reproduce *The Steerage* until 1911 or exhibit it until 1913 and seems not to have conceived of it as a picture "of shapes related to each other," expressive of his feelings "about life," as he would later claim, until he reached this fuller understanding of Picasso's art.[18]

In portraits of his daughter Kitty and the artist Charles Demuth, Stieglitz juxtaposed the sitters with Picasso's drawings. His cityscapes (plate 18), however, show his greatest absorption of Cubism:

> As if testing how his new understanding of art and photography would affect his continuing relationship with the city, in the spring of 1915, Stieglitz photographed out of the back windows of 291. . . . Far less iconic and dramatic than his 1910 views of the city, Stieglitz's 1915 photographs record the patterning of lights in office buildings at night or snow on adjacent roof tops and indicate that he, like Picasso, was fascinated with revealing the underlying architectural structure of the city.[19]

Devoid of people, Stieglitz's views capture the interplay of simple geometry and spatial ambiguity that Picasso explored in Cubism, whether the subject was a figure or landscape. Stieglitz assimilated the "compressed space, absence of foreground, stacked and tilted planes," and "gridlike forms" of the Picasso drawing he had acquired in 1911, *Standing Female Nude* (plate 5), and of *Bottle and Wine Glass on a Table* (1912; plate 19), a papier collé that he purchased in 1914,[20] to create stripped-down architectural photographs that inspired the nearly contemporaneous work of Paul Strand and Charles Sheeler and set a new course for American photography.[21]

In that summer of 1914, Stieglitz and de Zayas remained focused on Picasso's work and excitedly discussed an acquisition by their

PLATE 18
ALFRED STIEGLITZ (1864–1946), *From the Back Window, 291*, 1915. Platinum print, 9 7/8 x 7 15/16 in. (25.1 x 20.2 cm). The Metropolitan Museum of Art, New York, Alfred Stieglitz Collection, 1949 (49.55.35)

friend and colleague Agnes Ernst Meyer, the wife of a wealthy banker, Eugene Meyer, Jr. As de Zayas reported, "I saw Mrs. Meyer before she went to London. We went around the galleries and as a result she bought a little Picasso quite characteristic of his latest style."[22] Stieglitz concurred, "That is great."[23] The purchase of this small canvas, *Still Life with a Bunch of Grapes* (1914; plate 20), was a big event. Along with Albert Barnes's contemporaneous acquisitions, it was one of the first paintings by Picasso to enter an American collection since Weber's return from Paris in 1909.

The purchase also marked a passage that could have radically transformed the access of Americans to Picasso's art. Soon after Meyer acquired the painting, in June 1914, Kahnweiler closed his gallery for the summer and left for a vacation in Italy, assuming that rumors of war were greatly exaggerated. When Germany declared war on France that August, Kahnweiler remained optimistic and refused Brenner's offer to transfer the gallery's inventory to New York for safekeeping—a decision that cost him his great trove and denied Americans the opportunity to immerse themselves in the full range of Cubism by Picasso, Braque, Juan Gris, and Léger. How different the course of American art might have been had this mother lode been available in New York at that time, especially since Picasso might have accompanied his work to the United States. Instead, Kahnweiler's German citizenship enabled the French government to declare him an enemy alien and confiscate his property, including the entire inventory of the gallery. His vast stock of pictures remained in storage until it was dispersed in a series of liquidations ordered by the government in the early 1920s. Once sold, these classic Cubist paintings began to appear in the United States, but de Zayas's tour of the galleries with Meyer in 1914 had already brought to New York one of the few examples of Picasso's latest work to escape the confiscation. *Still Life with a Bunch of Grapes* was fresh from the artist's studio. It sported a new style of brightly stippled colors and rough surfaces, built up out of sawdust, that Picasso was using to put meat on the bones of his previous, more schematic works. At ten by ten inches, the painting was only slightly larger than the 1908 still life that Weber owned, and it easily traveled in Meyer's capacious trunks. Once in New York, its vivid style must have fascinated her friends among the avant-garde.

Even before de Zayas wrote to Stieglitz about her purchase, Meyer had announced it to him herself, along with her hope to convince her husband to buy a far more expensive painting by Paul Cézanne. Stieglitz immediately began scheming with de Zayas to exhibit the Cézanne at 291 "by hook or brook. . . . A batch of the fellows can sleep up in the place and act as guard."[24] Meyer's Picasso was not valuable enough to require security, and there is little doubt that Stieglitz and de Zayas intended to include it in the exhibition of the Picabias' group of Picassos that they were planning for the end of the year. Since those eighteen works would not fill the "Little Galleries," Stieglitz added a group of about nine drawings that he was holding as collateral for a loan to the German critic Adolphe Basler.[25] Still, at fewer than thirty works, the assemblage was far smaller than the forty-nine watercolors and drawings in 291's first Picasso exhibition (not counting the portfolio of thirty-four additional drawings available to view on request during that earlier show).

Despite its smaller size, the exhibition, which opened on December 9, matched the first show remarkably well—in fact misleadingly so, creating an impression of continuity in Picasso's work that disguised the real diversity of his activities by the end of 1914. Once again, the absence of a catalogue, checklist, or photographs of the installation makes it difficult to determine precisely what pictures were on view. Nonetheless, Pepe Karmel has sifted the evidence to surmise that while the exhibition contained a fair sampling of early Cubism (1908–9) and a smaller group of nearly abstract works from 1910 to '11, it was "exceptionally rich in pictures manifesting the simpler, more open style of later 1912 and 1913."[26] Although this configuration was fortuitous, in light of the first exhibition it must have seemed quite logical: it allowed viewers to see Picasso moving from the linear frameworks of his 1910 drawings (such as Stieglitz's *Standing Female Nude*) to dressing the skeletons with strips of wallpaper and newsprint. The revelation of the exhibition was certainly its papiers collés, a form that Braque had invented but that Picasso had immediately adopted and that both artists had explored through closely related works in 1912 and '13. None of their works in the Armory Show had displayed this innovation, but the exhibition at 291 in 1914 included several fine pieces, including the one Stieglitz acquired, *Bottle and Wine Glass on a Table*.

FIG. 20
PABLO PICASSO, *Violin and Guitar*, 1913. Oil, pasted cloth, charcoal, and gesso on oval canvas, 35 3/8 x 25 1/4 in. (89.9 x 64.1 cm). Philadelphia Museum of Art, The Louise and Walter C. Arensberg Collection, 1950

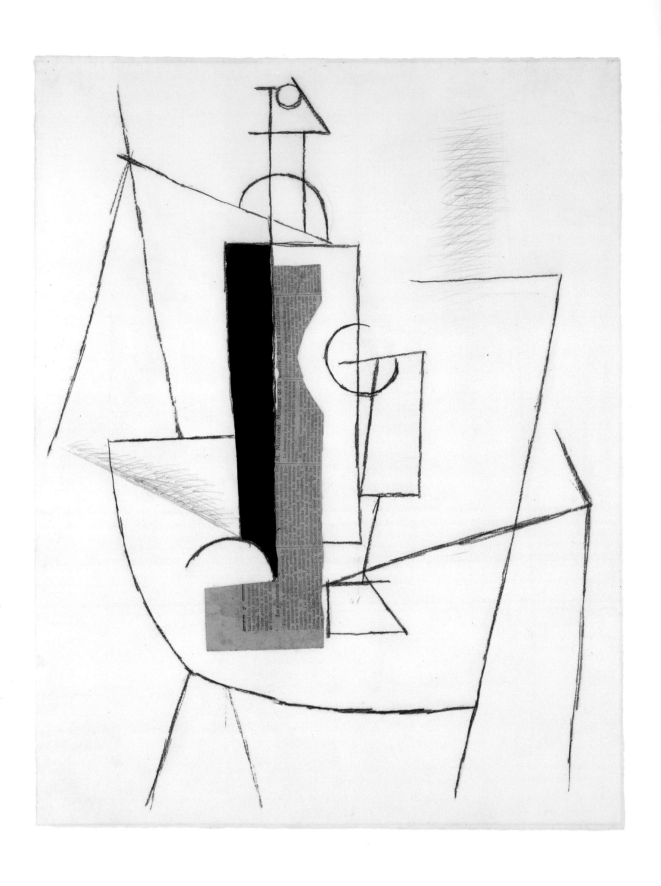

PLATE 19
PABLO PICASSO, *Bottle and Wine Glass on a Table*, 1912. Charcoal, ink, cut and pasted newspaper, and graphite on paper, 24 5/8 x 18 5/8 in. (62.6 x 47.3 cm). The Metropolitan Museum of Art, New York, Alfred Stieglitz Collection, 1949 (49.70.33)

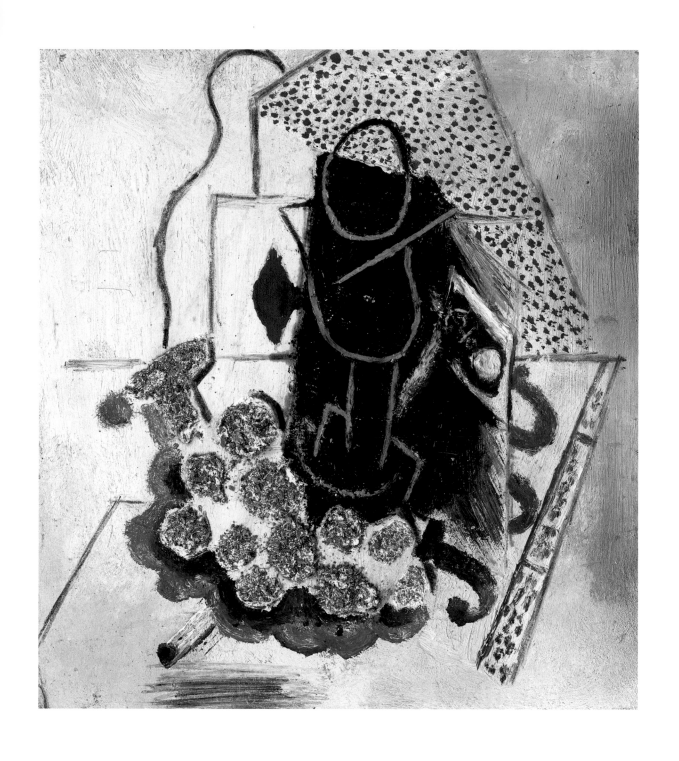

PLATE 20
PABLO PICASSO, *Still Life with a Bunch of Grapes*, 1914. Oil and sawdust on cardboard, 10 1/2 x 9 3/4 in. (27 x 25 cm). Staatliche Museen zu Berlin, Nationalgalerie, Museum Berggruen

Since the pieces owned by the Picabias and Basler happened to be works on paper, the 291 audience received the impression that Picasso was primarily a draftsman—and an austere, cerebral one at that. The only one of his canvases known for certain to have been in the show, *Violin and Guitar* (early 1913; fig. 20), has a structure of broad planes set in a linear framework that makes it a close relative of the drawings. Only its patches of heavily worked textures hint at the changes Picasso would make in the months to come.

This odd exhibition may have delivered one more twist of fate: the announcement of Picasso's new manner of painting through a picture by Braque. Probably at the insistence of the Picabias, who were eager to sell as much as possible, de Zayas cajoled Stieglitz into making the exhibition a two-man affair. As de Zayas wrote, "It is all arranged with Mrs. Picabia to send all the Picassos she has." That settled, he continued, "After a long talk with Picabia we have agreed that in order to make the exhibition complete some paintings of Braque ought to be shown at the same time." He then gave an awkward justification that began with an accurate statement of Braque's importance but soon bowed to Stieglitz's favorite: "These two men really complete one expression, and in order to be entirely just both of them must be shown together. . . . It is true that Braque is a satellite of Picasso." Finally, after a little backtracking, de Zayas cut to the chase: "Braque would never have existed without Picasso but Picasso owes very many things to Braque. I am sure you will not hesitate in exhibiting both together so I have asked Mrs. Picabia to lend us the Braques she has."[27] Stieglitz's response is unknown, but he did hang all the works. At least the Braques (uncertain in number) helped to fill out the display.

Years later, de Zayas would chastise himself in print. "An unpardonable sin committed by both the Photo-Secession and the Modern Gallery," he wrote in the 1940s, "was not to have had a one-man exhibition of the work of Braque. His contribution to modern art was, and is, one of the most valuable." De Zayas's explanation of the omission captured his view at the time, which probably matched that of "the public": "The overpowering personality of the Spaniard overshadows that of the Frenchman in the public's mind."[28] This emphasis on personality goes back to the Steins, who took no real interest in Braque while lionizing Picasso. As a result, Steichen and the others were directed to Picasso, and the New York art world saw nothing of Braque's work until the Armory Show, where three canvases represented his career from Fauvism through Cubism. This skimpy selection could not convey his achievement or dominate the field.

Writing in the 1940s, de Zayas would note, "Strange was the fact that the critics overlooked Braque's part in the exhibition [at 291] concentrating only on Picasso."[29] Since the press had been primed to accept Picasso as the leader, their focus should at this point not surprise us, but it does mean they may have missed a view into the future. If Karmel is correct in proposing that Braque's small painting *Cards and Dice* (1914) was in the exhibition, that work would have shown a new style, incorporating rich hues and confetti-like dots, that both artists had begun to develop in late 1913. Braque ratcheted up the color more slowly than Picasso, but *Cards and Dice* displays the new approach. Picasso's *Still Life with a*

Bunch of Grapes, however, the painting acquired by Meyer, was a full-blown exemplar. Since Meyer was an old friend of Stieglitz's and a sometime backer of 291, it is hard to believe that she would not have agreed to lend her new acquisition, and it is equally hard to believe that Stieglitz and de Zayas would not have requested the loan. The question is particularly relevant because a year later the Modern Gallery showed a group of these paintings to considerable acclaim; yet at least one American artist, Max Weber, had already joined the party, and *Bunch of Grapes* may have been his ticket.

When the Picasso/Braque exhibition closed, in January 1915, it had achieved no more financial success than Stieglitz's first exhibition of Picasso's drawings in 1911. Even so, de Zayas decided to pursue his desire to create a truly commercial gallery devoted to contemporary avant-garde art. With Picabia's encouragement, he convinced the Meyers to underwrite him, but he had no desire to split the 291 community by threatening Stieglitz's prominence. On August 23, 1915, he broached the issue with Stieglitz, who replied three days later with two fundamental concerns. The first was money; the second was Picasso: "Unless we can get Picasso's support I feel the underlying thing we are intending to work for would be nullified." In a second letter that same day, Stieglitz repeated, "And secondarily it will take Picasso's undivided support to give it that standing we all wish to have."[30] Clearly Stieglitz believed not only that Picasso was the most significant contemporary artist but that he already possessed a public reputation that could validate a wider program.

This degree of certainty is remarkable so early in Picasso's career, particularly in the man who was the acknowledged leader of contemporary art in America. Indeed, Stieglitz's opinion forms the bedrock of Picasso's reputation in this country—yet he took this position with very little direct knowledge of the man or his work. De Zayas had no less respect for Picasso, but his extensive conversations with the artist had given him a much less utopian view: "Picasso does not work for an idea. He works for his ideas and for money, in order to be able to keep on having ideas. Picasso is a very practical man, and we could not have his work exclusively unless we would make a contract with him. That we cannot do."[31] Although de Zayas and his friends could not afford to promise Picasso the type of contract Kahnweiler gave his artists (which in 1913 paid Picasso an income of 51,400 French francs—approximately $10,300), there was a lot that de Zayas could do. The closing of Kahnweiler's gallery had canceled his commitments and forced his artists to scramble for sales as the war strangled the European economies; therefore, de Zayas was "sure that we will have all the Picasso paintings that we would need, and that is, after all, the important thing."[32] Besides, de Zayas was deeply interested in other artists besides Picasso.

Opening on October 7, 1915, with an exhibition of paintings by Picabia, Braque, Picasso, and several Americans, as well as of photographs by Stieglitz, the Modern Gallery presented a mix of established and upcoming artists with the goal of earning an honest buck: "Our object in opening a new gallery is to do *business* not only to fight against dishonest commercialism but in order to support ourselves and make others able to support themselves . . . and make them able to continue the evolution of modern art."[33] The selection of Stieglitz's photographs included

The Steerage, and their placement in this company reflected both de Zayas's genuine respect for Stieglitz's art and his understanding of the photographer's intensifying dialogue with Cubism. Judging from reviews, the exhibition was a smorgasbord. In addition to the European works, there were "cube sculptures" by Adolf Wolff and unspecified works by Frank Burty Haviland, Arthur Dove, John Marin, Abraham Walkowitz, and de Zayas.[34] There were also four "Congo votive offerings."[35] None of the newspaper accounts allows identification of the paintings by the Europeans, and de Zayas's correspondence records no arrangements to obtain new works. They probably came from stock, then primarily the unsold pictures owned by the Picabias.

Soon after the opening, de Zayas returned to Paris to gather works for the next two exhibitions—paintings by Vincent van Gogh and Picasso. Unlike the inaugural, these shows were landmarks; they signaled the real beginning of his gallery. Throughout the short life of the Modern Gallery, de Zayas alternated shows of work by historical modernists (which might bring high prices) with shows devoted to contemporary artists. The display of eight paintings by van Gogh was among the first of the Dutch artist's to be presented in the United States. Exhibitions of Picasso's work were becoming common by comparison, but de Zayas's, which opened on December 13, 1915, offered an array of his paintings that would shape Americans' perception of Picasso for decades. Among the eleven paintings on view, nine dated from 1914 or '15 and showcased the major stylistic leap that the last exhibition at 291 had barely touched. Unlike the spare designs and ephemeral materials of the papiers collés, which perpetuated the idea of Picasso as an essentially cerebral artist, these oils achieved the large scale and visual richness of old master painting. They announced that Cubism embraced the full range of colors, textures, and even representation. Picasso's Synthetic Cubism reclaimed the sensual pleasure of traditional painting without forfeiting his formal rigor and his frankness about the artifice of picture-making.

With Kahnweiler's gallery closed and few Europeans buying, Picasso had almost every one of his recent paintings still in his studio, and he had every incentive to encourage American interest. He lent de Zayas some of his finest pictures of the previous eighteen months, as well as two earlier canvases to set the scene. One, listed by de Zayas as *Figure d'homme* (*Figure of a Man*), is unidentified but came from the group of pictures that Picasso had made in Sorgues in the summer of 1912, which marked his first steps away from the transparent, interpenetrating planes of Analytic Cubism toward the opaque, overlapping ones of the Synthetic phase. *Bar-Table with Musical Instruments and Fruit Bowl* (ca. 1913; plate 21) is a pioneering example of the opportunity this different approach offered to saturate surfaces with bright colors.

The full-blown transformation occurred in paintings Kahnweiler never received—those Picasso made in Avignon during the summer of 1914 and the following winter in Paris. The best-known of these is *Fruit Bowl, Wineglass, Bowl of Fruit*, often called *Green Still Life* (plate 28), famous in part because it was one of the first Picassos acquired by the Museum of Modern Art, in 1934. Yet it was already in New York in 1920, in the collection of Dikran Kelekian, and by 1921 it had become a cardinal reference point for American artists. They may have had the opportunity to see it

six years earlier in de Zayas's exhibition, although the records do not make this clear. Whether or not de Zayas obtained that picture, he did show the greatest Avignon painting, *Young Girl*, which is equally green but also filled with an encyclopedia of illusionistic effects, from the feather boa surrounding the girl to her confetti-dotted shawl and the floral wallpaper in the background (plate 24). The result is a riot of patterns and colors that unequivocally announced a new direction in Picasso's art. Meanwhile *Untitled* (*Man with a Moustache, Buttoned Vest, and Pipe, Seated in an Armchair*) (plate 22) demonstrated to de Zayas's audience how Picasso carried this painterly style of simulated collage to a higher level of complexity in 1915 by multiplying the number of fragments and rendering each illusionistic passage in precise detail, whether it be the man's mouth, his waistcoat, or the chair rail and ceiling molding of the room.

One newspaper ran the headline "Paintings by Picasso in New Color Scheme."[36] With de Zayas present to explain the pictures, several critics responded with both pleasure and insight. The *Evening World* observed, "He relies upon unrelated forms out of which to synthesize and to create."[37] The *New York Times*'s critic praised "the fun of trying to make out his absurdly complicated riddles" and suggested "they ought to be accompanied by 'Keep Off the Canvas' signs. You rub them to feel if the piece of something that looks like calico is calico or illusion. You run your finger over the piece of newspaper to see if the ink on it will smudge as it does on your last edition."[38] Given this attention, it is not so surprising that Picasso's smallest and most experimental piece received not only the most press but also a rather tolerant reception. Called *Still Life in a Garden* (now titled *Glass, Pipe, and Playing Card*, 1914; fig. 21), this small, circular relief of painted wood and metal, about thirteen inches in diameter, depicts a glass, pipe, dice, playing card, and table rim on a background of mottled green. The *Times*'s critic praised its "cryptic combination of little pieces of substance and applications of pigment," while others found it "curious" and "so foolish as to be mildly funny."[39] Over the decades, these works would have a decisive impact on Davis, Arshile Gorky, and even Roy Lichtenstein—but the first artist to absorb them seems to have been Weber.

In 1915, Weber painted a series of paintings of New York, including *New York at Night* and *Rush Hour, New York* (fig. 22), that capture the fragmented lights of the city's nighttime scene and the intensity of its daytime activities. Stylistically these works harness the dynamism that Duchamp gave the interpenetrating and dissolving planes of Analytic Cubism in his *Nude Descending a Staircase, No. 2* (1912), exhibited in the Armory Show. Combining the Stieglitz circle's long-standing urbanism with the fascination that New York held for newcomers such as Picabia and Gleizes (who arrived there in September 1915),[40] the paintings convey the flux of the city more abstractly than Picabia's watercolor sketches or Gleizes's focus on specific signage and architectural monuments of Manhattan. Yet the masterpiece of the group, *Chinese Restaurant* (1915; plate 23), is built on a different model. While it contains passages reminiscent of Analytic Cubism, the painting is largely composed of flat, evenly colored or patterned geometric planes—the hallmark of Synthetic Cubism. (Gleizes's contemporaneous version of that style, by contrast, is far more tentative.) So

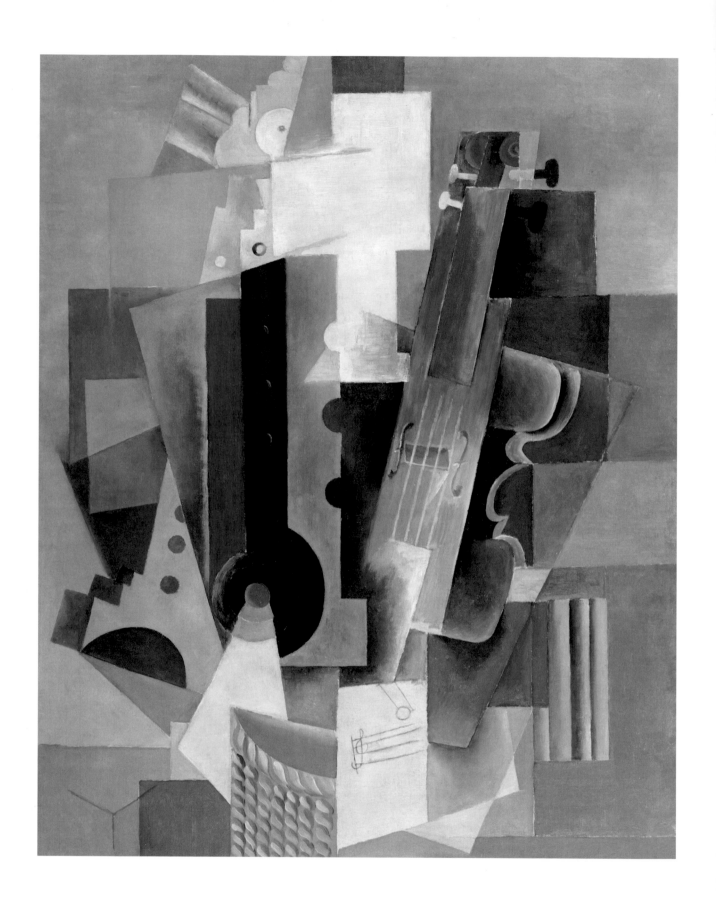

PLATE 21
PABLO PICASSO, *Bar-Table with Musical
Instruments and Fruit Bowl*, ca. 1913. Oil on
canvas, 39 3/8 x 31 7/8 in. (100 x 81 cm).
Private collection

the question arises whether Weber arrived at this new approach alone or whether he somehow had access to the paintings that Picasso and Braque had been making for the previous year. If he accomplished the feat by himself, it was a remarkable innovation for an artist with only a limited knowledge of Cubism's development (though a deep understanding of Cézanne).

The question is particularly challenging because Weber exhibited *Chinese Restaurant* at the Montross Galleries in a one-man exhibition that opened on December 14, 1915—the day after de Zayas opened his Picasso exhibition at the Modern Gallery. De Zayas's correspondence with Picasso states that five small paintings intended for the exhibition did not arrive in time for the vernissage, but the possibility remains that the six large paintings were in the gallery by early December and that Weber might have seen them there. Still, that would have left little time for him to paint (or repaint) a canvas of this size, and to do it so definitively—including bits of collage along with intricately executed patterns. Meyer's little Picasso still life could have given him a clue but not a model for such a complex composition. Another possible source is an exhibition that has nearly escaped the notice of historians: the small show presumably held at Brenner and Coady's Washington Square Gallery sometime in the late winter or early spring of 1915. Having secured four paintings and six drawings from Picasso in early February and brought them to New York, Brenner and Coady surely presented an exhibition, although neither a catalogue nor a review is known to have survived. The description of the four paintings in undated correspondence is too vague for identification, but the group probably included at least one of Picasso's recent paintings and likely would have shown the style he perfected in Avignon.[41] Given Weber's devotion to Picasso and his familiarity with Brenner and Coady, he almost certainly would have known about the exhibition, whether or not it appeared in the press. Moreover, Weber's friend Alvin Coburn suggested in April 1915 that Weber make a "Memory Picture of the essence of China-Town, in honor of the many nights (Happy ones) that we have spent there."[42] Perhaps the Washington Square exhibition was fresh in Coburn's mind.

The documentation is tenuous but the physical rapport among the paintings is not. Since the Picasso and Weber exhibitions ran concurrently in the same building (500 Fifth Avenue, near the intersection with 42nd Street), with the Picassos "on view a few doors below on the avenue," critics easily made a connection.[43] Some simply condemned Weber for a "zeal of imitation,"[44] but Henry McBride, one of the most thoughtful critics of that and later decades, began his review with praise: "The Max Weber exhibition in the Montross Galleries is of the highest importance and one that no one who is interested in the art life of the day can afford to miss.... Max Weber's cause, and the modern cause generally, is partly won, but not wholly. For that reason it is doubly interesting, because alive." McBride explicitly paired Weber and Picasso without rebuke: "But one would imagine the mental and soul courage of Max Weber and Picasso would be admired even by those who consider them mad men." McBride focused not on the two artists' shared vocabulary but on the way each man used it to accomplish different goals. Suggesting that Picasso "is a classicist.... His latest painting is so pure in spirit that the only thing

it can be compared to for purity is with Greek sculpture," he emphasized the difference in subject matter that did distinguish the two artists' work: "But Max Weber, as befits an American, is less ethereal and tumultuous; he is as all accepting as Walt Whitman, and at last we have an artist who is not afraid of this great big city of New York."[45]

Singling out *Chinese Restaurant*, McBride admitted that he might not have guessed its subject yet "I should have taken great joy in its rhythms and placements and startlingly agreeable and novel colors."[46] He quoted a Mr. Bahr, "well known in New York as an authority upon Chinese art," who exclaimed, "You can almost smell the Chinese food."[47] In later years, Weber would give his own description of the painting's subject:

> On entering a Chinese Restaurant from the darkness of the night outside, a maze and blaze of light seemed to split into fragments the interior and its contents, the human and inanimate.... To express this, kaleidoscopic means had to be chosen. The memory of bits of patterns were less obvious than the spirit and festive loveliness and gaiety—almost exotic movement. Therefore, the glow, the charm, the poetry of geometry was stressed.[48]

In all likelihood, Weber did appropriate Picasso's most recent style, yet this rapid, masterly assimilation was a feat in itself. Even long-distance, Weber showed an understanding of Picasso's ideas that surpassed most of his contemporaries.

FIG. 21
PABLO PICASSO, *Glass, Pipe, and Playing Card*, 1914. Painted wooden and metal components on a wooden base painted in oils, 13 3/8 diameter x 3 3/8 in. (34 x 8.5 cm). Musée National Picasso, Paris

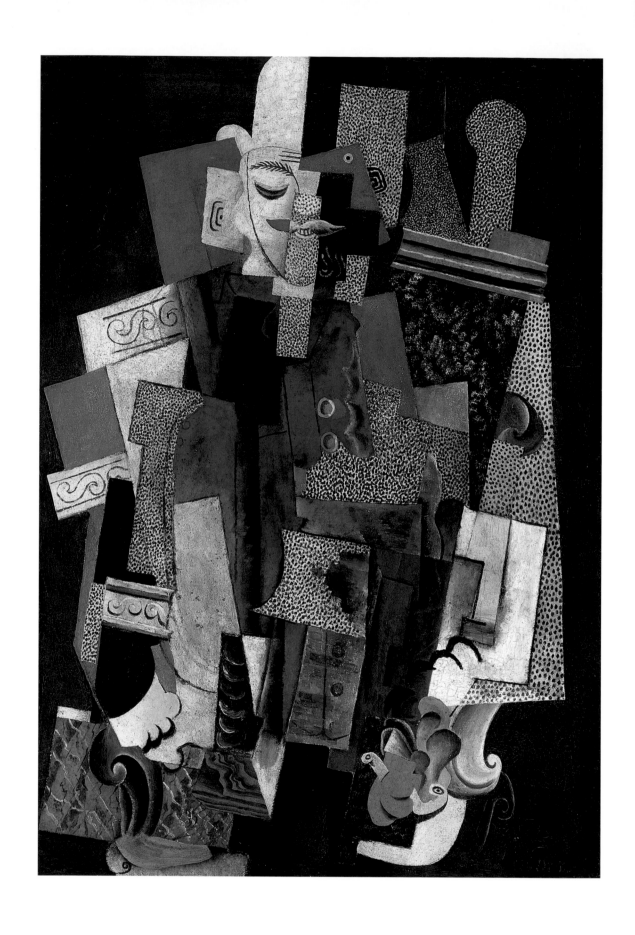

PLATE 22
PABLO PICASSO, *Untitled (Man with a Moustache, Buttoned Vest, and Pipe, Seated in an Armchair)*, 1915. Oil on canvas, 51 1/4 x 35 1/4 in. (130.2 x 89.5 cm). The Art Institute of Chicago, Gift of Mrs. Leigh B. Block in memory of Albert D. Lasker

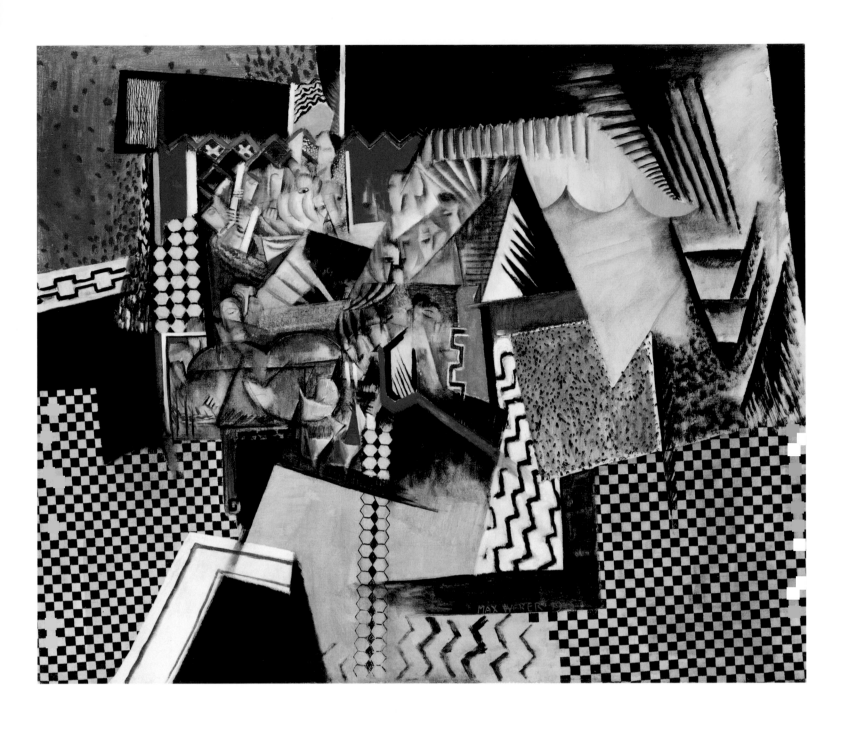

PLATE 23
MAX WEBER, *Chinese Restaurant*, 1915. Oil
on canvas, 40 x 48 in. (101.6 x 121.9 cm).
Whitney Museum of American Art, New
York, Purchase 31.382

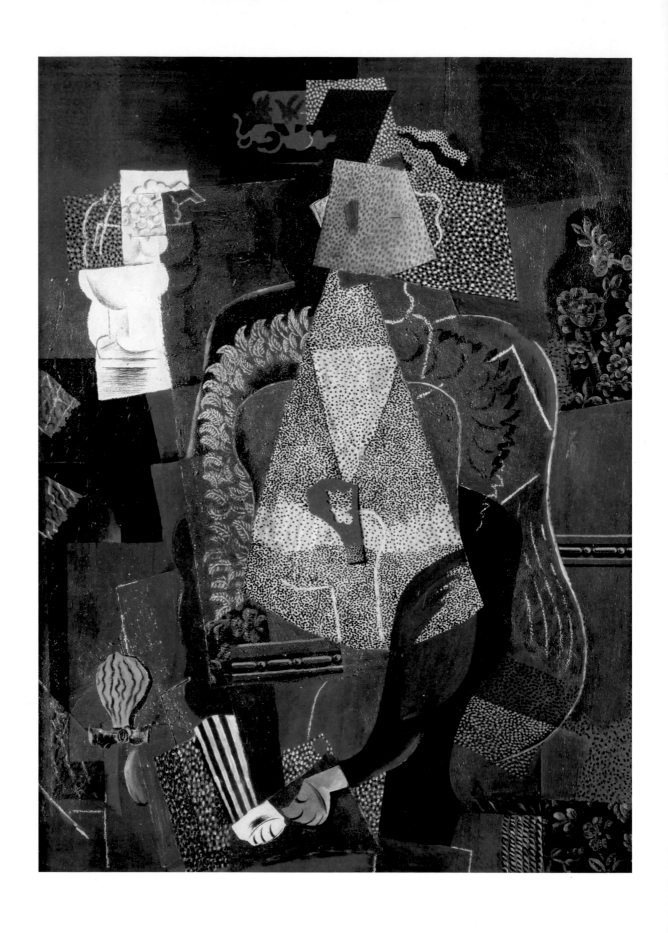

PLATE 24
PABLO PICASSO, *Young Girl*, 1914. Oil on canvas. 51 1/4 x 38 in. (130 x 96.5 cm). Musée National d'Art Moderne, Centre Georges Pompidou, Paris

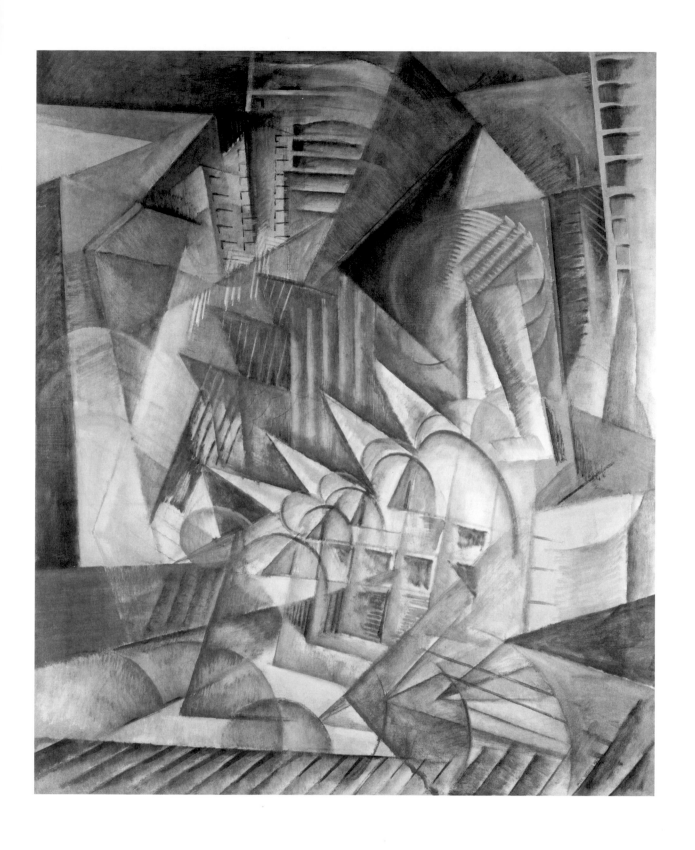

FIG. 22
MAX WEBER, *Rush Hour, New York*, 1915.
Oil on canvas, 36 1/4 x 30 1/4 in. (92 x
76.9 cm). National Gallery of Art,
Washington, D.C., Gift of the Avalon
Foundation 1970.6.1

Using Picasso's flat planes of bright colors, intense patterns, and simulacra of wainscot and frames, Weber structured a space radically opposed to Picasso's shallow, evenly dispersed fields. *Chinese Restaurant* builds a centripetal, Synthetic composition spiraling from an Analytic core. Left of center, a group of figures sit around a table that thrusts into the depth of the picture's illusionistic space, creating the effect of a dark restaurant interior. Although the table sports a strip of collage painted to simulate wood, most of the figures are rendered in the subdued colors and dissolving planes of Analytic Cubism. The diners' heads in particular merge and blend into the depth. A spiral radiates from the zigzag borders of this central group, and rays extend into the surrounding space of checkerboard or stippled planes, evoking tablecloths, red wallpaper, and a tiled floor. *Chinese Restaurant* is a dynamic hybrid, a combination of Cubism's two modes to convey Weber's themes of the bustling restaurant and of the nightlife of New York. It introduces the Synthetic devices that he would explore over the next few years (plate 25) before shifting to another style of Picasso's contemporary art, neoclassicism (plate 26).

By 1916, the regularity of exhibitions devoted to Cubism in New York had prompted some critics to claim that the movement had slipped from cutting edge to mainstream. Whether upstarts like the Carroll or old-timers such as the Daniel, several of the city's galleries presented a wide sampling of Cubism and other avant-garde trends during the middle years of the decade, often reinforced by the presence of artists such as Gleizes and Duchamp, who passed most of the war years in New York and sometimes remained after the armistice. Yet this broad flurry of activity soon collapsed. Picasso's presence in particular dwindled to the point that by the late teens he had come to seem a historical figure.

Between the Modern Gallery's first Picasso exhibition and May 1923, when the first of a string of exhibitions and publications introduced Americans to the radically different art that Picasso had been producing for nearly a decade, only one major show of Picasso's art occurred in America (at the Art Institute of Chicago in March–April 1923), and few others in the late teens or early 1920s displayed the work of Picasso or other leading Europeans. Picasso went underground in America. Despite his stature, only a handful of collectors continued to follow his career and acquire his work. Except for a signal appearance of several paintings and drawings of his at the Brooklyn Museum in 1921, he had become a respected but shadowy presence. Even after the flurry of activity in 1923, two more years passed before events in the winter of 1925–26 revealed that one of the finest groups of his work anywhere in the world had been assembled by an American devoted to the avant-gardes of both continents: John Quinn. This news offered little chance for reflection, however, since the entire group of paintings was immediately snatched away by Paris dealers.

As the magnitude of the loss became apparent, New York critics, collectors, and artists turned the liquidation of this private collection into a campaign for public institutions devoted to modern art—both exhibition halls and permanent museums. Support for these projects had slowly built through the early 1920s but required the jolt of the Quinn loss and later ones to transform talk into action. Beginning with efforts to return some of the pictures that had already crossed the Atlantic, Picasso became the focus of the outcry—the emblem of the efforts to create public collections of modern art in America that resulted in the founding of the Museum of Modern Art and the Whitney Museum of American Art at the end of the decade. Sandwiched between two periods of withdrawal, the mid-1920s witnessed a renewal of internationalism that surpassed the brief adventure of the war years and created a permanent foundation for future generations of artists in America.

At first, World War I had simply overwhelmed the nascent art community. German submarine attacks on ships made artists reluctant to dispatch their works across the Atlantic, and the United States' growing involvement in the war left the public with less time for art. But Picasso himself played a counteracting role: with no dealer during most of the war, he gladly sent work to New York (until the explosives threatened). By the end of the war, however, Picasso had replaced Kahnweiler with a new commercial representative. In the fall of 1918, he joined forces with Paul Rosenberg and Georges Wildenstein, two firmly established dealers in old master and modern art.[49] Their sponsorship rapidly expanded the European market for his art, earning him the financial freedom to buy a townhouse on the chic rue La Boétie and to frequent Parisian society with his new wife, ballerina Olga Khokhlova. Although Picasso welcomed his old friend de Zayas, Rosenberg handled all business—and Rosenberg listened carefully to his American clients' cautions about the unstable economy and art market in the United States. He refrained from organizing an exhibition there until the fall of 1923.

While Picasso and his dealer were cautious, the American art world too was becoming less receptive. Even among devotees of the European avant-garde, the war prompted many Americans to hope that artists in this country might develop independently of their contemporaries across the Atlantic. When Stieglitz renewed his commercial activities in the early 1920s, he proclaimed the need for "America without the damned French flavor!—It has made me sick all these years. No one respects the French [more] than I do. But when the world is to be France I strenuously hate the idea quite as much as if the world were made 'American' or 'Prussian.'"[50] While Stieglitz did believe that Georgia O'Keeffe, Marin, and other American artists had by this time absorbed the lessons he had offered at 291, and no longer required constant exposure to contemporary European art, this was still a remarkable shift from his earlier acclamation of Picasso (assuming the artist's Spanish, not French, citizenship was immaterial to him). Meanwhile, less sympathetic individuals were openly condemning foreign contemporary art, calling a fairly conservative exhibition at the Metropolitan Museum of Art in 1921, for example, "Bolshevistic."[51] (Quinn, a crack attorney, immediately denounced this charge as "Ku Klux" criticism.)[52]

Such attacks on modern art—which recall the accusations made by certain French critics, around the beginning of the war, that Cubism was a German plot—would worsen over the course of the 1920s, foreshadowing the rigid nationalism that would split the American art world by the decade's end. During the war years and most of the 1920s, however, the lines were less clearly drawn, and

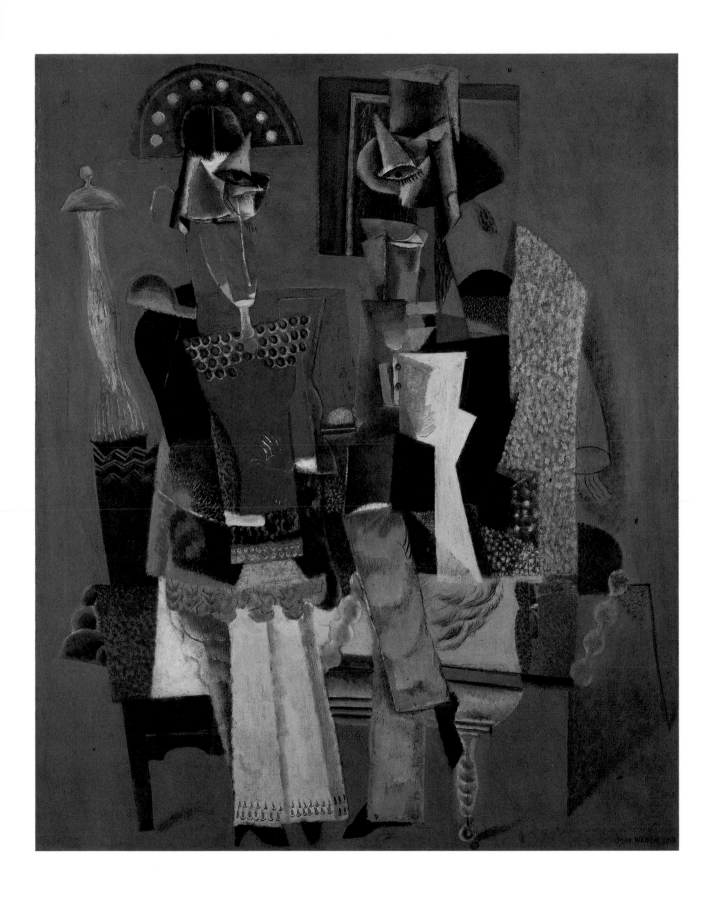

PLATE 25
MAX WEBER, *Conversation*, 1919. Oil on
canvas, 42 x 32 in. (106.7 x 81.3 cm).
McNay Art Museum, San Antonio,
Museum Purchase

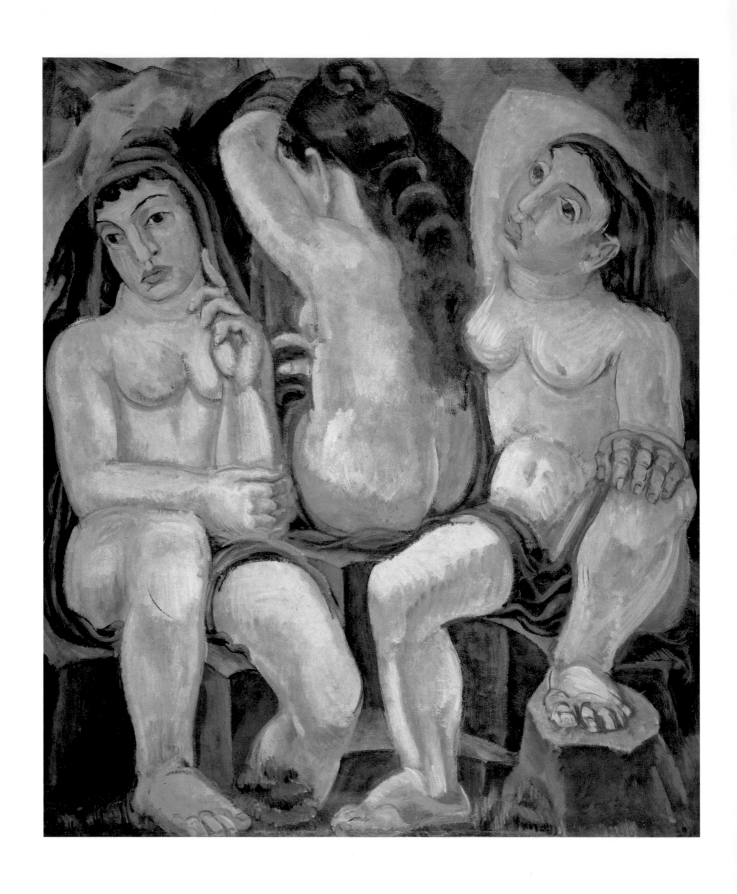

PLATE 26
MAX WEBER, *Three Figures*, 1921. Oil on
canvas, 36 x 30 in. (91.4 x 76.2 cm).
Collection of James and Linda Ries

support for American artists was less often framed by outright rejection of European models. In October 1922, McBride measured the balance that prevailed among supporters of the avant-garde: "The advantage that France had is now not so overwhelming as it was. It still leads—and we are still Francophile enough to admit that—but it would require subtler mathematics than we possess to figure out by what percentage."[53] Nine months earlier he had given a remarkably personal account of how this shift in perception occurred:

Before the war I used to spend as much time in Europe as I could afford and was frequently told by English and French friends "Why we should never take you for an American!" This was meant as a compliment and was accepted as such. My stock reply to this compliment was, "I am not one, I am an exile in America and only begin to live when I get abroad," which went great as you may well believe. However, when the war broke out something happened to me that happened to many others of the hyphenated and I took out spiritual naturalization papers to the land of my birth.

Whatever was to be the final outcome of the war I saw at once in 1914 that the supply of mysterious ether that had hitherto sustained artists in Europe upon a higher plane would be exhausted; that Europe as far as you and I, Stuart, was concerned, was finished. I believe that the dominating country in the world has the chance for the greatest expression in art, and although I was forced to take immediate passage back to this country I realized instantly upon landing that the sceptre of power had beat me to New York. This city had taken on the indescribable air of a world capital—with all the cosmopolitanism and liberty and authority that go with it. It was impossible not to be sorry a little—much, even—for London and Paris, but it was also impossible not to exult and feel pride in what fate had brought us.[54]

Although McBride wrote this for publication in the *New York Herald*, his comments were addressed to Stuart Davis. He was replying to a letter that Davis had sent to the newspaper asserting "a regular vampire of an idea. The knowledge that right now, around us, in New York City, as well as elsewhere, artists are creating worthwhile things."[55] As McBride's use of Davis's given name indicates, the two knew each other well. Both were members of the small community of intellectual cosmopolites, and Davis was then engaged in an intense dialogue with the art of Picasso and of other Europeans that would define his coming achievements as the finest Cubist in America and one of the leading artists of his time. His metaphor aptly captures the sense among many artists that they were ghostly presences haunting the everyday life of Americans. McBride was one of the few critics who brought them recognition.

Davis's appeal to a netherworld, however, applies not only to American artists in the early 1920s but to the collectors who pioneered the acquisition of modern art in the United States during the teens, and who continued through the lean years to gather collections that would make the country the primary repository of art by Picasso and many of his peers. In the process, they provided a valuable measure for American artists, a tool that was sometimes essential to gauge their achievements. When Davis first reached Paris, in 1928, he had already wrung every drop from the Picassos that were available in New York and had largely defined the course of his art.

In the history of American collecting, Albert Barnes holds a spectacularly contradictory place. As the founder of one of the country's first public institutions devoted to modern art, he was a pioneer of public access to this work, yet he was also a misanthrope, particularly when it came to the art world. His attitude toward Picasso was no less fraught: the first U.S. resident to form a substantial collection of that artist's work (see fig. 23), he was also the first in the small group of American collectors to repudiate Cubism. Barnes didn't buy anything from Stieglitz's 1911 exhibition, but the show must have been his introduction to Picasso's work. He took his first buying trip to Paris the following year, and fell under the spell of Leo Stein. The trajectory of his attitude toward Picasso closely follows Stein's—from early devotion to condemnation by the mid-teens. In the summer and fall of 1912, Barnes purchased at least six paintings by Picasso from Vollard and Kahnweiler, ranging from the 1901 *Woman with a Cigarette* (apparently the first of these purchases) to a small canvas of 1908, *Wineglass and Fruit.*[56] His records are incomplete, but he purchased at least three more paintings from Kahnweiler before the summer of 1914, including a more recent picture, *Packet of Cigarettes and Newspaper* (1911–12; fig. 24).[57] In February 1914, he wrote to Stein that his collection included twelve canvases by Picasso.[58] Though secluded in his mansion in Merion, Pennsylvania, this group vastly surpassed in number, quality, and range the relative scraps that others had brought to America.

The collection appears even more impressive in light of the dates of Barnes's purchases: he acquired most of these pictures before the Armory Show of 1913. While that exhibition prompted many to give serious consideration to contemporary art, it had the opposite effect on Barnes, convincing him that showmanship had swamped aesthetics. In January 1916 he published an obituary for Cubism in the magazine *Arts and Decoration*; his article, "Cubism: Requiescat in Pace," began, "Three years ago cubism got considerable attention because of the fresh vivid impressions it brought in the name of art. The parents of sensationalism . . . ensured an unhealthy and short life for its cubic offspring."[59] Barnes's diatribe mentioned Picasso and a few other artists, but only in passing, and cited just one painting, Duchamp's *Nude Descending a Staircase, No. 2* (although the editors reproduced Picasso's 1910 *Portrait of Kahnweiler* and Picabia's 1912 *Dancers*, the former already reproduced in *Camera Work* and the latter shown at the Armory Show). Instead, describing Cubism as "faulty metaphysics," it launched a theoretical attack that prompted the editors of the magazine to ask de Zayas for a reply. In the April 1916 issue, armed with reproductions of African carvings and more recent works by Picasso (*Violin and Guitar*, which had been shown at 291 in 1914–15) and Picabia (*A Little Solitude in the Midst of the Suns*, 1915), de Zayas politely dismissed Barnes's argument, asserting that "the work of art has always preceded aesthetics and aesthetics can never be more than

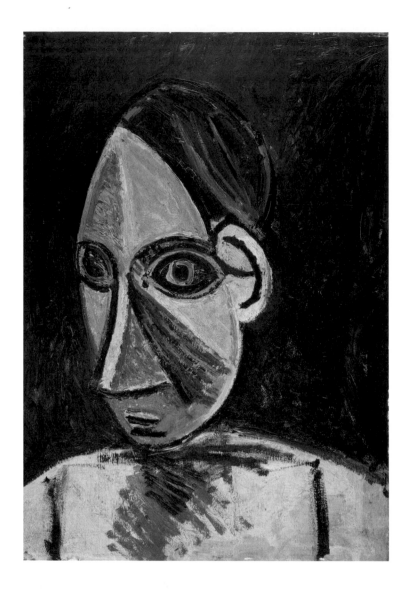

an explanation rather than a theory of art."[60] With the qualification that one is speaking of a *successful* work of art, this simple observation continues to be widely ignored in the twenty-first century. It is certainly true of Picasso's art, as de Zayas had been trying to explain for five years.

Barnes remained aloof from Cubism until he spent time with Picasso in September 1921, when he warmed enough to purchase a few drawings. Presumably Paul Guillaume, Barnes's primary agent in Paris and a friend of Picasso, had arranged the meeting with the hope of brokering sales; three years later, Guillaume finally did sell to Barnes a major early painting, *Two Harlequins* (1905), as the American planned the 1925 opening of his foundation in Merion—a school rather than a museum, but open to the public on limited terms.

Besides Barnes, a few other pioneering residents of the United States began buying modern art before the Armory Show, and most of these collectors kept the faith and became driving forces behind Picasso's reputation in America. The Cone sisters in Baltimore, whose friendship with the Steins had prompted them

FIG. 23
PABLO PICASSO, *Head of a Woman*, 1907.
Oil on canvas, 18 1/8 x 13 in. (46 x 33 cm).
The Barnes Foundation, Merion, Pa. BF421

FIG. 24
PABLO PICASSO, *Packet of Cigarettes and Newspaper*, 1911–12. Oil on panel, 7 3/8 x 10 5/8 in. (18.6 x 26.8 cm). The Barnes Foundation, Merion, Pa. BF200

to buy some of Picasso's drawings in 1905–6, became major buyers after World War I. The first person to attempt a substantial collection of Picasso's work in the United States was Hamilton Easter Field, although he never acquired a single painting. A part of the international Haviland family, whose company produced fine china, Field was an artist and joined his cousins Paul Burty Haviland and Frank Burty Haviland on their rounds in Paris before the war. Along with Steichen, Paul was one of Stieglitz's first bridges to the French avant-garde. He took Field to the evenings at the Steins and introduced him to Picasso. As Field would recall, "In my enthusiasm after his work, I went to him in 1909 and told him that it seemed to me . . . he should get orders to decorate buildings. I could not offer him a house to decorate, but I had a library with no pieces of furniture except the bookshelves and a few low chairs. The decorations are not yet finished."[61] Field wrote this account ten years after he had extended the invitation. Although Picasso seems to have produced some paintings for the project, none arrived at Field's Brooklyn home.[62] Even so, Field remained an ardent supporter of Picasso—he was one of only two recorded buyers from the 1911 exhibition at 291, purchasing *Study of a Nude Woman* (1906), the other sold work being *Standing Female Nude*, bought by Steiglitz himself. He would later become a public force by founding a magazine, *The Arts*, that from its first issue, in December 1920, was the primary journal of the avant-garde in New York, taking up where Stieglitz's *Camera Work* and *291* had stopped.

More than collectors, though, it was artists who had the greatest impact—artists such as Arthur B. Davies, who, as William Innes Homer put it, "is one of the most interesting, original, and underestimated figures in the history of early twentieth-century American art."[63] Davies maintained an avid interest in vanguard art, even while he himself was a painter of fin-de-siècle idylls who cultivated clients for his own work among the society matrons and business leaders of New York. Besides admiring his art, however, these patrons valued his opinions on cultural matters, and he proved an extremely effective bridge between established society and cutting-edge contemporary art during the late teens and 1920s. His taste developed from minor collecting to organizing exhibitions, and he even painted in a Cubist style during the midteens, but his most enduring contribution was posthumous: his role in bringing modern art to America's museums.

The sale of the Davies estate in April 1929 included 249 lots of modern art, of which 19 were works by Picasso. And this was only the last of several sales of his collection.[64] In 1909, Davies bought two pictures from Weber's first exhibition in New York, and he was the only buyer from Stieglitz's exhibition of Cézanne's watercolors in March 1911. Though not an immediate part of Stieglitz's circle, he was on good terms with the group around 291 and a constant visitor to its exhibitions. He certainly saw the Picasso exhibition that followed Cézanne's, and he may have bought his first Picasso drawing from it: one work in his collection, *Woman with a Fan*, came from the same series of drawings (made at Gósol in the summer of 1906) as the sheet that Field purchased from that exhibition. It was probably the first of "a very large additional group of Picasso drawings" that Davies owned but that is now dispersed, with little hope of identification.[65]

If Davies didn't purchase the drawing from Stieglitz, he picked it up the following year in Paris, where he spent two weeks rushing around the city gathering works for the Armory Show. He played a crucial role in winning a large place for the European avant-garde in that exhibition, and turned out to be the only purchaser of a Picasso from the works in the show—a gouache, *Landscape (Two Trees)* (1908), for $243. (Davies may also have bought a Braque from the 1914–15 Picasso/Braque show at 291.)[66] By the time of the Modern Gallery's first Picasso exhibition, he was ready to make a more substantial purchase, acquiring the large, extremely colorful *Bar-Table with Musical Instruments and Fruit Bowl* (plate 21). As de Zayas recorded, "In the three years of [the Modern Gallery's] existence there were only two buyers, Arthur B. Davies, who knew all there was to be known about buying pictures, and John Quinn, who just bought and bought."[67]

One more buyer, Walter Arensberg, arrived on the scene just after the gallery closed, in 1918. Arensberg was a new breed of American collector, drawn into the field by the Armory Show and more focused on the artists who emerged there or later than on Picasso and other founders of twentieth-century art. For Walter and his wife, Louise, social and intellectual exchanges were crucial to their involvement with contemporary art; during the late teens and early 1920s, when Duchamp and other French artists were in New York, the couple oversaw an idiosyncratic mixture of anarchist commune and Parisian salon and gathered works by Picabia, Man Ray, Duchamp, and others.[68] Nonetheless, they bought some choice Picassos as the foundation for their collection. Davies sold them his gouache, *Tree*, and probably in 1918 de Zayas finally found in them a buyer for the painting *Violin and Guitar*, which he had been trying to sell since the December 1914 exhibition at 291. Arensberg was a backer of de Zayas's later commercial venture, the De Zayas Gallery (1919–21), and the two men had a similar commitment to new art, even though de Zayas remained a champion of Picasso.

Quinn, as de Zayas would recall, "just bought and bought." His was the vast and extraordinarily fine collection that caused such controversy in the winter of 1925–26, and he too, like Arensberg, became fascinated with the avant-garde at the Armory Show, which he had supported with advice and funding. Unlike Barnes, whom he rivaled for preeminence among American collectors,

Quinn saw the Armory Show as a great blow on behalf of modern art and did everything he could to increase its notoriety. He purchased thirty-seven works from the exhibition and began to expand his previous focus on Post-Impressionism to include a wide array of contemporary artists. His buying continued at a phenomenal rate until his premature death in 1924.[69]

In July 1915, Quinn purchased a fine Picasso gouache, *Nudes in a Forest* (1908), from 291, and in September 1917 he bought another gouache of 1909 and an important early painting, *Woman Combing Her Hair* (1906), from the Modern Gallery. But in the early years Quinn's real buying took place at a fledgling venture he helped to found, the Carroll Galleries. Like others, Quinn believed that the Armory Show heralded a boom in the U.S. art market, and he immediately laid plans to capitalize on it. After using his legal skills to help convince Congress to drop import duties on contemporary art, he joined a few friends to create the Carroll Galleries, with Harriet C. Bryant as shopkeeper and Walter Pach, another key organizer of the Armory Show, as scout in Europe. Although the outbreak of war delayed plans for the gallery's first exhibition, two shows of French art were held there in the winter of 1914–15. Quinn bought extensively from these shows (presumably at insider prices), and in February 1915 he praised the enterprise to Vollard. Since Quinn had already bought paintings by Cézanne, van Gogh, and Paul Gauguin from Vollard, it is not surprising that the dealer agreed to consign a group of Picasso's works to the Carroll for an exhibition in March. Quinn promptly bought six paintings from that show. Ranging from *The Old Guitarist* (1903; fig. 25) to *Two Nudes* (1906; fig. 54) and *Figure* (1909), this group immediately made him the most important American collector of Picasso's work next to Barnes, and he was only beginning.

Despite his rapid acquisitions, Quinn valued his privacy and the freedom to negotiate that he gained by keeping his purchases confidential. "There has been a great curiosity as to who bought them, but I have given strict orders that my name should not be mentioned. Stieglitz has gone in and tried to find out who bought them. Then Eugene Meyer, who is one of Stieglitz's supporters or backers [Meyer would also back de Zayas's Modern Gallery later that year], has tried to find out. Both have been blocked."[70] A new era of financial sophistication and aesthetic confidence in collecting began with Quinn that blew past Stieglitz and defined the rules of the field for decades. The major quarry was Picasso, and Quinn stalked him beyond the view of most New Yorkers.

After his purchases from the Carroll Galleries, 291, and the Modern Gallery in 1915, and with the exception of a Picasso still life picked up in a New York auction in 1918,[71] Quinn didn't really resume buying modern art until a couple of years after the war. At that point, he largely bypassed the American dealers to go directly to the sources in Paris. Despite de Zayas's claim that Quinn was a big customer at the de Zayas Gallery, he actually bought sparingly there, instead doing a great deal of business with the Rosenberg brothers, Léonce and Paul. Léonce had bought some of Picasso's finest recent paintings during the war and had hoped to become his dealer. Even before the armistice brought peace, though, he proved a poor businessman, and Paul stepped in with his established gallery and deep-pocketed backers. After picking up a 1915

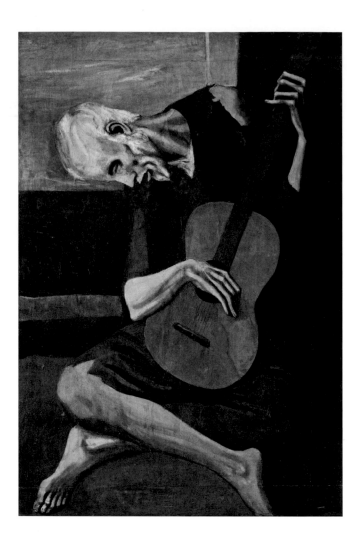

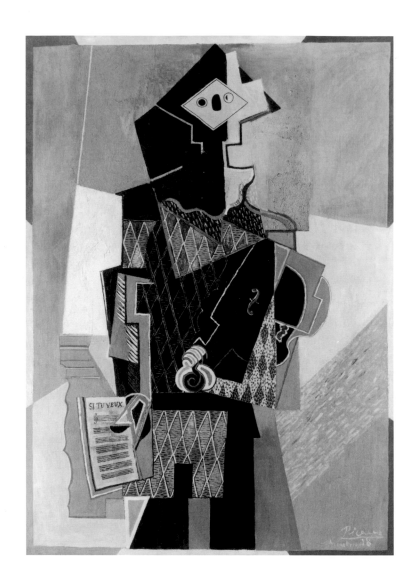

still life (in the series shown by de Zayas at the Modern Gallery in December of that year) from Léonce, Quinn built a relationship with Paul.[72] Either during his regular visits to Paris or through his agent, Henri-Pierre Roché, he became one of the Galerie Paul Rosenberg's biggest clients, beginning with the purchase of two postwar paintings in November 1920—*Harlequin with Violin ("Si Tu Veux")* (1918; fig. 26) and *Girl with a Hoop* (1919).

At approximately the same time, Dikran Kelekian, an Armenian dealer in Near Eastern antiquities, assembled a collection of paintings, shipped it to New York, and orchestrated an exhibition that almost single-handedly revived modern art as a public cause in America. The circumstances of this strange turn of events are not entirely clear, but they include a particularly contemporary combination of marketing genius on Kelekian's part and a dawning awareness among critics, collectors, and museum officials. In Paris, Kelekian had plied the trade in fine *objets* since the early years of the century (Field recalled meeting him during his own "student days").[73] He must have had a seasoned knowledge of the art market and a sure sense of commercial value that extended from his specialty in ancient art to contemporary work.

His interest in the modern was probably sparked by artists who frequented his shop: American painter Walt Kuhn recalled an anecdote of Kelikian meeting both Picasso and Matisse outside it in 1911, and Matisse, at least, could have been drawn to Kelekian's wares by his fascination with Persian miniatures and fabrics during those years.[74] Matisse and Kelekian were certainly acquainted by 1916, and Kelekian was buying Matisse's paintings.[75]

Kelekian's Paris gallery was located on the place Vendôme, and he also maintained shops in Cairo and New York (where his clients included not only Louisine Havemeyer but Lillie Bliss and Abby Aldrich Rockefeller, future cofounders of the Museum of Modern Art).[76] With his business in antiquities thriving, he focused his attention on assembling a substantial collection of Post-Impressionist paintings. His catalogue, published in 1920 with laudatory texts by Roger Fry and other leading critics of the day, listed dozens of paintings by Cézanne, Edgar Degas, Gustave Courbet, and his friend Mary Cassatt. As he filled out the group, Kelekian added works by several twentieth-century artists, including Matisse, André Derain, Maurice Utrillo, and Maurice de Vlaminck, but particularly Picasso. Among the five paintings and several drawings by Picasso, the two major pictures were purchased from Rosenberg in 1920: *Fruit Bowl, Wineglass, Bowl of Fruit (Green Still Life)* (1914; plate 28)—and *Landscape with Dead and Live Trees* (1919; plate 27).[77]

FIG. 25
PABLO PICASSO, *The Old Guitarist*, 1903. Oil on panel, 48 3/8 x 32 1/2 in. (122.9 x 82.6 cm). The Art Institute of Chicago, Helen Birch Bartlett Memorial Collection 1926.253

FIG. 26
PABLO PICASSO, *Harlequin with Violin ("Si Tu Veux")*, 1918. Oil on canvas, 56 x 39 1/2 in. (142.2 x 100.3 cm). The Cleveland Museum of Art, Leonard C. Hanna, Jr., Fund 1975.2

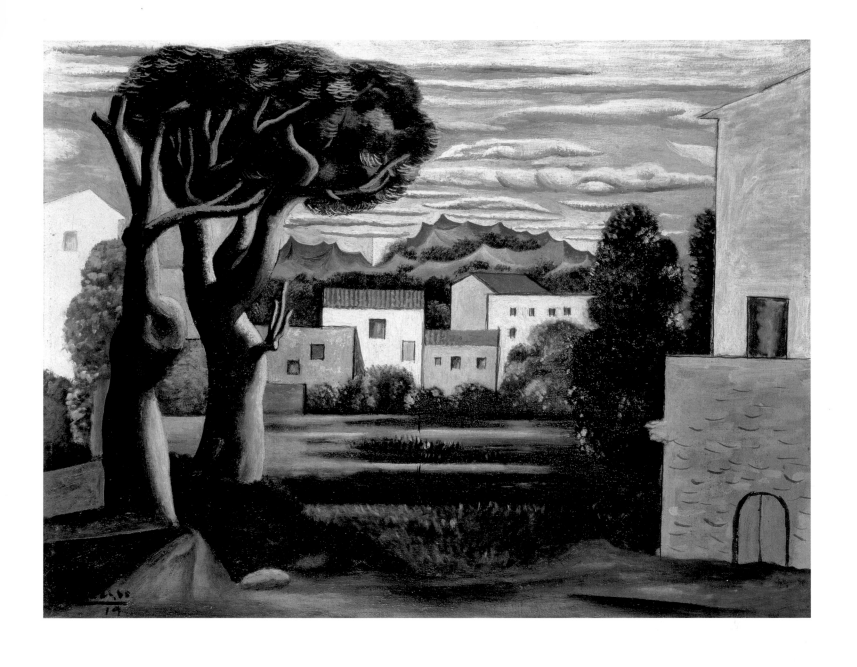

By McBride's account, when Kelekian brought the collection to New York, "It began to be famous instantly upon its arrival and though it was kept hidden according to the best Fifth Avenue traditions—for Mr. Kelekian's first thought was to sell his collection *en bloc* and in America the great millionaires who buy things *en bloc* are not much tempted by the objects that the public had access to—its varied attractions soon became known."[78] Even though Quinn (almost certainly the target)[79] declined to buy, he did join with other cultural leaders to resurrect the issue of public support for modern art, an idea that had stood in the background since the first American exhibitions of this kind of work. Stieglitz and his colleagues had long hoped that American museums would open their collections to contemporary art, as France's Musée du Luxembourg in Paris had accepted, if not welcomed, Impressionist paintings in 1895. Stieglitz had tried to convince Bryson Burroughs, the curator of painting at the Metropolitan Museum of Art, to purchase the entire contents of his 1911 show of Picasso drawings, but Burroughs rejected the idea out of hand, dismissing them as "mad pictures."[80] Still curator at the Metropolitan in January 1921, Burroughs received a letter urging the museum to mount a "special exhibition, illustrative of the best in modern French art." The signatories included Davies, Agnes Meyer, Bliss, Gertrude Vanderbilt Whitney, and Quinn—among the most substantial contributors to the museum. Quinn had floated the idea of a "contemporary art society" in the wake of the Armory Show,[81] and this time he and his friends did not intend to let the matter drop: they specified that the exhibition should open in the spring, and they pledged to secure the pictures.

Burroughs staged the exhibition. While he refused Quinn's appeal to show a Cubist Picasso, he did include three of that artist's earlier pictures and demonstrated his own admiration for Post-Impressionism by selecting many works by Cézanne, Gauguin, and van Gogh. Yet when the exhibition finally opened, in May 1921, it was already old news to any New Yorker willing to visit the Brooklyn Museum, which had scooped the Metropolitan with an exhibition that not only opened two months earlier but included a far more daring selection of contemporary works. More than half the pictures in the Brooklyn exhibition, and all the most challenging ones, came from Kelekian's collection—146 in all.[82]

Kelekian's lavish catalogue of 1920, and his cultivation of European critics such as Roger Fry, may have been preparation for an American campaign. At any rate, he quickly set about generating publicity and visibility in New York. In January 1921—the same month that Quinn and his friends wrote to Burroughs—Kelekian approached William Henry Fox, the director of the Brooklyn Museum. Fox saw an opportunity to distinguish the museum as a venue for recent art and shelved his personal doubts to accept a loan of the pictures.[83] All five of Kelekian's Picassos appeared in the exhibition, including *Landscape with Dead and Live Trees*, which was just over a year old. When Fox brought painter John Singer Sargent and etcher Paul Helleu through the exhibition, Sargent commented, "Well, I am glad this collection is only a *loan*," and Helleu accused Fox of "corrupting the taste of Americans."[84]

The partisans were triumphant. Field reported in the *Brooklyn Daily Eagle*, "The first step has been taken. An important

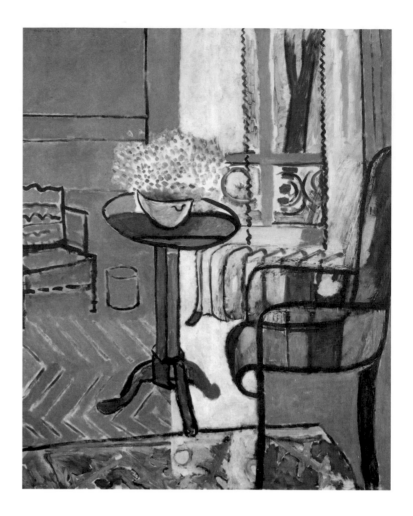

American museum has opened an exhibition of modern French art which is really representative of modern tendencies. . . . The beauty of the show as a whole is due largely to the quality of the paintings by Matisse, by Picasso, and by Cézanne."[85] Even the staff (or the donors) at the Metropolitan judged the Kelekian pictures so important that the museum delayed the opening of its own show one week in order to obtain twenty-five of them, including a Picasso of 1901 and the 1919 *Landscape with Dead and Live Trees*.

That summer, *The Arts* published an account of the Paris art world by Louis Bouché that affirmed Matisse and Picasso, but particularly Picasso, as modern masters. Comparing them to the Dadaists, Bouché wrote, "Matisse and Picasso . . . are placed on higher pedestals, receive greater homage." After praising Matisse's recent work, he turned to Picasso, who,

> on the other hand, is quieter, but finer, more subtle and more lasting. . . . Picasso is the prestidigitator of this "20th century." Is he not, with Braque, the father of "Cubism," the grandfather of "Futurism," and the great grandfather of all later "isms"? . . . Picasso in fact is no longer doubted in Paris, he is a past master.[86]

FIG. 27
HENRI MATISSE (1869–1954), *The Window*, 1916. Oil on canvas, 57 1/2 x 46 in. (146 x 116.8 cm). The Detroit Institute of Arts, City of Detroit Purchase

In November, Forbes Watson, a contributor to *The Arts*, took several of Kelekian's Picassos (including *Landscape with Dead and Live Trees*) to Chicago for exhibition at the Arts Club. The next month, Field published his own profile of Kelekian and his collection in *The Arts*.[87] Actually the piece was a farewell, since the entire group of pictures was scheduled to be auctioned in January 1922 at the American Art Association. In New York little more than a year, they were already the most famous modern pictures in the city and the focus of controversy—over not only aesthetics but art's place in the country's cultural life. To affirm that the collection was a world-class one, Field excerpted the auction catalogue's effusive essays, by Fry, a past director of the Metropolitan, and by Arsène Alexandre, a principal of the French national museums. He went on to begin a campaign that *The Arts*, other critics, and philanthropists would pursue for the rest of the decade, through the founding of the Museum of Modern Art in 1929:

> What has happened to the pioneering spirit of our ancestors? Why have so few of us any of it left? Why is it that, as I think of this sale and of the wonderful opportunity now given us to help to make this country of ours the abiding place of great art, a fear comes over me that France and Germany, impoverished though they are, will outbid us and that the masterpieces of the Kelekian collection will return to Europe?[88]

Assuming that no museum would bid in the Kelekian auction, Field was urging individuals to spend their own funds out of a sense of national mission that had not yet dawned on the continent and would not for decades to come. As the 1920s passed, he and his confreres would increase their demands for an American museum of avant-garde art. The ground of their appeal was nationalism, but the impulse was cosmopolitan—the flip side of the decade's growing spirit of isolationist retrenchment.

The superb promotion did not achieve great commercial success in the auction, and Field's fear that the works would leave the country proved unjustified. All of Kelekian's major Picassos sold to Americans: Quinn bought *Landscape with Dead and Live Trees*, Bliss *Fruit Bowl, Wineglass, Bowl of Fruit*, and Davies a small still life of 1918, while Sheeler acquired a watercolor still life of 1908–9 for Agnes Meyer. Newspapers printed the list of buyers, but Quinn thought that even the reported sales were suspect, because he believed that Kelekian had arranged false bids on many works—that without such security, "the sale would have been a slaughter, an Armenian massacre."[89] However, in the case of *Landscape with Dead and Live Trees*, Quinn complained he had been forced to pay a high price ($2,000) by dealers in league with Kelekian who bid against him to drive up the price. Moreover, the distinguished director of the Detroit Institute of Arts, W. R. Valentiner, bought Matisse's *The Window* (1916; fig. 27) for $2,500—apparently the first of that artist's paintings (and probably the first by any member of the twentieth-century avant-garde) to enter an American public collection.[90]

Did Kelekian engineer the Brooklyn exhibition to promote his collection for its upcoming sale?[91] We may never know, but the affair does seem to be a case of rank commerce being harnessed to altruistic purposes. The exhibitions at the Brooklyn and the Metropolitan museums were the largest displays of modern European art to appear in the United States since the Armory Show, and they shook up an art scene that had become moribund as galleries closed or reduced activities in the late teens, and as the American art world turned inward. (Both the accusation of "Bolshevistic Art" and Quinn's rejoinder of "Ku Klux" criticism were sparked by this exhibition at the Metropolitan.) Given the rarity of these opportunities, artists must have flocked to both museums. Sheeler's activity at the subsequent auction certainly registers his awareness. But the artist who seems to have taken greatest advantage was Davis.[92]

Having first exhibited in an Ashcan School show ("Exhibition of Independent Artists") in April 1910, Davis had developed slowly and fitfully through the teens, sometimes experimenting with cutting-edge styles and sometimes falling back to Post-Impressionist approaches. In 1921–22, however—right around the time of the shows in Brooklyn and at the Metropolitan—he suddenly made a breakthrough to full-blown Cubism. Although he did not travel to Europe until 1928, he absorbed a substantial understanding of avant-garde art from the exhibitions he saw in New York, and he befriended Field, who had shown Davis's work at the Ardsley Studios (a gallery in Field's Brooklyn house) in 1918.[93] During the early 1920s, when Field was starting *The Arts* and reviewing exhibitions for the *Brooklyn Daily Eagle*, both men were members of a promotional group called Modern Artists of America.[94] Field presumably gave Davis access to his own and other collectors' works by European artists, and shared his excitement over the display of Picasso's work in Brooklyn.

Davis's paintings of the next year show an intense dialogue with these pictures, at the same time that his notebook records combative ruminations on Picasso and other European artists.[95] He may have returned to Cubism by painting versions of papiers collés in the spring of 1921, but the epiphany came when he engaged Picasso's *Fruit Bowl, Wineglass, Bowl of Fruit (Green Still Life)*, which was shown not only in the Brooklyn exhibition but in the pre-auction viewing at the American Art Association in January 1922. Davis had ample opportunity to study the painting then, and its presence in his work grew through 1921 and the following year. His debt is most obviously revealed through the multicolored dots scattered across sections of each canvas. *Garden Scene* (1921; plate 30) adapts Picasso's green planes, black edges, and playful combination of flat colors, patterns, and representational fragments to build a loose checkerboard. In *Landscape, Gloucester* (plate 29), painted in the summer of 1922, Davis created a far more radical variation on *Fruit Bowl, Wineglass, Bowl of Fruit* by using blue instead of green for the background and by placing a tightly articulated set of planes in the work's center. Despite the appearance of a boat's mast and prow, along with references to waves and other elements of the Massachusetts port, the composition reads as a largely abstract design of intense color, here flat, there densely stippled. To achieve the central, profoundly flat articulation of rectangular planes, Davis may well have drawn on another work reproduced in the article lauding Picasso in *The Arts*

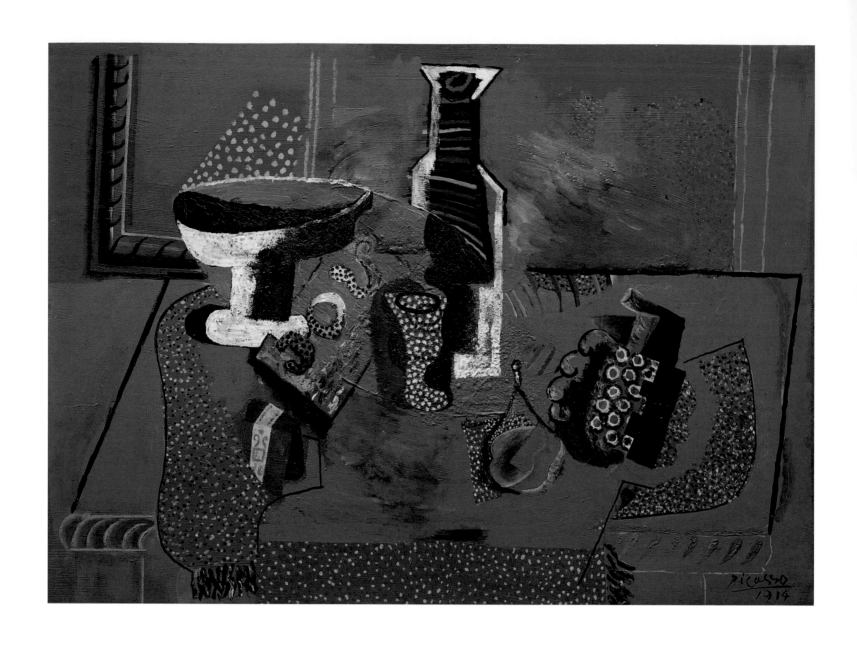

PLATE 29
STUART DAVIS (1892–1964), *Landscape, Gloucester*, 1922. Oil on board, 12 x 16 in. (30.5 x 40.6 cm). Collection of Theodore P. Shen

in the summer of 1921, *Still Life with Compote and Glass* (1914–15; plate 31).[96]

More than thirty years later, Davis would return to *Landscape, Gloucester* as the basis for *Colonial Cubism* (1954; plate 32), one of his finest late works and a magisterial repudiation of its ironic title. In 1921, however, in these landscapes and a series of still lifes that stretched through the next year, he was still beginning to forge his Cubist style. His engagement with the art of Picasso was the most intense among American artists since Weber's of around 1915, and it is remarkable that both artists concentrated on the same set of works: Picasso's still lifes of 1914 and '15. While Weber's involvement with Picasso's ideas soon dissipated and had relatively little effect on other artists, Davis's laid the foundation of his career and introduced a generation of American artists to Cubism.

In a series of four still lifes, Davis rapidly matured from a hesitant imitator of Picasso to a confident practitioner of his own Cubist style. *Three Table Still Life* (1922; plate 33) lacks the tight structure achieved in the much smaller *Landscape, Gloucester*. It awkwardly juggles many of Picasso's elements, particularly bright passages of green, multicolored dots, and tilted tabletops holding fruit bowls and bottles. In *Still Life with "Dial"* (1922; plate 34), however, Davis filled the canvas with a pedestal table and articulated the surrounding space with a series of strongly outlined planes. Unlike Picasso's surfaces, Davis's do not reproduce specific textures but are mottled to suggest both passages of light and depth. Davis also replaced Picasso's reference to *Le Journal* with an image of *The Dial*, a leading American magazine of international art and literature that regularly reproduced his drawings. What better way to claim his place as a "colonial"?

As Davis's stature grew through the 1920s, his dialogue with Picasso continued to spark some of his finest paintings. *Super Table* (1925; plate 35) is a more austere variation on the still lifes of 1922 and on a group of Picasso gouaches that were exhibited at the Whitney Studio Club's galleries in 1923. Another of Kelekian's Picassos may have had a particularly lasting impact on Davis's work as the painting passed through the New York art world: both the Brooklyn and the Metropolitan exhibitions included *Landscape with Dead and Live Trees* of 1919, the work that Quinn so wanted he was prepared to pay an inflated price for it at the Kelekian auction. The most current of Kelekian's Picassos, this rather uncharacteristic painting shows a naturalistically colored, three-dimensionally modeled landscape framed by foreground trees and blank, planar house fronts. The effect of this stagelike composition, with its decorative flats stepping into the distance, is highly stylized. Whether initially or over time, the painting's extreme artifice evidently appealed to Davis, for he revived it in *Early American Landscape* (1925; plate 36), in which tubular trees mark a foreground that drops to a background panel of buildings and vegetation. Even more than Picasso's painting, Davis's seems to be constructed of hinged cards that could fold flat or open to suggest a stage set. Its title is obviously a joke: the fishing-village scene might evoke an American past or many others, and its anti-naturalistic style could update American folk art, but the painting is full-blown Cubism. Davis shows off his international command with a pose of nationalism and achieves a marriage of both traditions.

When Davis finally reached Paris in 1928, he continued to mine this format for his images of the city. *Early American Landscape* and several of his Paris scenes entered the collection of his chief patron, Gertrude Vanderbilt Whitney, who a year later would found the Whitney Museum of American Art. Whitney, working with her colleague Juliana Force, had supported Davis's work since the late teens and presented his most important early exhibition, at the Whitney Studio Club in December 1926. She also paid the expenses of his trip to France, for which she received *Early American Landscape* and two other paintings. This decade-long commitment to Davis when he desperately needed financial support was only the most prominent of Whitney's and Force's stewardship of American artists, some of whom strayed far from the realist art the pair famously defended. Indeed, in the mid-1920s, Whitney and Force embraced the avant-garde and offered a rare venue for European art in New York.

As Davis testified, Whitney did "a lot to help young American artists long before she founded the museum."[97] She began to present exhibitions of contemporary art in her renovated studio on Eighth Street in 1914, the year after the Armory Show, but her project was very different from others following in the wake of that exhibition. Although she was solicited as a sponsor of the Armory Show, her own sculpture was excluded from it, and she expressed no regrets about spending its New York run in Europe.[98] At that point, she had no interest in art more modern than the Beaux-Arts tradition of her sculpture or the Impressionist styles of painters such as J. Alden Weir and the Ashcan School, but she did have a firm belief in American artists. Her first exhibitions at the Whitney Studio Club's galleries—fund-raisers to provide French troops with medical supplies—combined a love of France with support for local artists, evolving by the late teens into miscellanies of work by Americans.

Force had begun working for Whitney in 1907 as an administrative assistant handling charitable events. Without any knowledge of art, she assimilated Whitney's taste and became a determined buffer between her employer and the many artists seeking gifts, purchases, or exhibitions. Whitney quickly gained confidence in Force's ability to navigate the art world and gave her a greater role in directing the program of the Whitney Studio Club's galleries. Both relied on experienced artists, critics, and dealers to alert them to new talent and to help define how their program would support American art. One long-standing adviser, John Sloan, recommended Davis to Whitney and Force around 1917. That same year, Watson, an outspoken young critic, impressed them with his denunciation of their exhibition "Modern Paintings by American and Foreign Artists" as modern only in name. His insistence that American artists were more original than Europeans (he called Davies "the most important man to experiment in the field of cubism") offered Force and Whitney a way to engage with vanguard American art.[99] They quickly drew Watson into their circle.

Except for two years as an ambulance driver during and shortly after World War I, Watson shared a close collaborative relationship with Force and Whitney that lasted more than fourteen years.[100] In his case, military service offered opportunities to visit Paris galleries and museums, and he returned to New York in 1919

with a much higher respect for the European avant-garde. According to Lloyd Goodrich, a future director of the Whitney Museum, Watson, Force, and Whitney "saw eye to eye. And I think probably the initiative in many cases came from him. He would tell them about younger people, tell Mrs. Force that they should be exhibited."[101] Soon the three were tightly bound. When Field suddenly died, in April 1922, Force convinced Whitney to buy *The Arts* and to promote Watson from contributor to editor-in-chief.[102] Meanwhile, Watson and Force became lovers in a fairly open affair that was tolerated by Forbes's wife, Nan, and Juliana's husband, Dr. Willard Force, a dentist. (During most of the 1920s, the Forces and the Watsons lived next door to one another on Eighth Street.) With Whitney's backing, Force and Forbes controlled New York's most prominent venue for contemporary art and its strongest journalistic advocate of modernism.

To invigorate both the Whitney Studio Club and *The Arts*, the trio turned to an old hand: de Zayas. After ten years of promoting the avant-garde in New York, de Zayas had accepted insolvency, closed his gallery in autumn 1921, and moved to Europe. The combination of economic instability and political isolation caused him to write to Stieglitz in August 1922, "Neither the public nor I care a damn about each other."[103] Yet Field had lamented in *The Arts*, "Few things which have recently happened in New York have caused more gloom among art lovers than the closing of the De Zayas Gallery."[104] And Bliss had praised de Zayas to Sheeler, who passed along to him her commendation "that no one in this country has the knowledge and intuition that you have."[105] By the beginning of 1923, Force and Watson were offering de Zayas new opportunities to put his seasoned knowledge to use, throw off his funk, and earn a bit of money. Their two projects combined to create the greatest Picasso events in New York since the exhibition at 291 in 1911.

It is not clear who contacted de Zayas first, but he had an advocate in the Whitney circle. Sheeler had worked as his assistant in his last gallery and had then moved to the Whitney Studio Club, where Force greatly valued the artist's opinions. Sheeler and de Zayas corresponded regularly, not only about winding down the gallery's business but about wide-ranging personal matters. In a letter of February 1923, de Zayas wrote that Watson had suggested he undertake a series of articles about contemporary European artists for *The Arts*. Watson had originally asked de Zayas to oversee essays in which prominent artists would write about their peers, but de Zayas knew that was naïve: "Those fellows do not like to express opinions or even mention others in the business."[106] In the end, he produced an essay, "Picasso Speaks," published in May 1923, that appears to be a paraphrase of his conversations with Picasso.[107] It rapidly became accepted as one of Picasso's most influential statements on art.

An exhibition was also in hand. Penning his letter to Sheeler on shipboard as he returned from the United States to Europe, de Zayas mentioned that he would sail back to New York on March 7—"if Mrs. Picabia has acted intelligently." Just as he had relied on the Picabias to supply most of the Picassos shown at 291 in 1914, she evidently served this time too as an intermediary with Paul Rosenberg.[108] All went smoothly: on March 31, Rosenberg drew up an invoice consigning twelve Picasso paintings and ten gouaches to the Whitney Studio.[109] These, plus one additional painting (probably supplied by Gabrielle Picabia) and a set of prints, constituted the exhibition that opened a month later at the Studio. Besides selecting the pictures, de Zayas put his mark on the show by combining the Picassos with thirteen African masks and cups, arguing his long-standing belief that African art was an essential source for Cubism.

What a transformation from the Ashcan days to see Picasso and African art at the Whitney. But this was only the first of seven exhibitions that Force and Whitney hired de Zayas to organize during the 1923–24 season, all of them devoted to European artists, including Aristide Maillol and the Douanier Rousseau.[110] The June 1923 issue of *The Arts* ran a full-page announcement that the Picasso exhibition "was so successful, artistically, and from the point of view of sales," that the Studio was "assembling six special exhibitions for the season of 1923–24 which will be held under the direction of Marius de Zayas," who "in the art world of today . . . occupies a unique position."[111] In February 1924, Sheeler contributed to the program by organizing a show of work by Picasso, Braque, Duchamp, and de Zayas himself, made possible by loans from Quinn and the Arensbergs.[112] According to the Studio's press, the initiative was successful: an announcement in *The Arts* in June 1924 crowed that "during the season of 1923 to 1924 the attendance at the WHITNEY STUDIO CLUB exhibitions has doubled, the sales have increased, and public interest in general in these exhibitions has greatly advanced."[113] Though temporary, this embrace of European modernism by the chief guardians of American art offered the possibility of reviving the internationalism that Stieglitz and de Zayas had preached in the teens but that had almost disappeared after the war.

A few collectors, particularly the Arensbergs and Quinn, remained constant. But public venues, with exceptions such as the Brooklyn Museum in 1921, were rare indeed. Only Katherine Dreier's Société Anonyme offered the opportunity to see cutting-edge cosmopolitan art in New York during the early 1920s, and it quickly faded from prominence. Founded in 1920 with the collaboration of Duchamp, Dreier's program resembled Whitney's in its single-minded devotion to promoting contemporary artists (in this case European), but it lacked her deep pockets. After a string of seventeen New York exhibitions from April 1920 though June 1921 that drew little support, it sputtered out, resumed a more limited schedule in 1923, then effectively become a private collection in 1924. The early exhibitions included a small number of works by Picasso borrowed from the Arensbergs and Davies, but they primarily focused on the Dada artists whom Duchamp most admired.[114]

Perhaps Dreier's example spurred Force and Whitney to broaden their program, or perhaps all three shared with Field and Watson the belief that American culture did not need protection from Europe and other continents. Certainly their initiatives (along with those of Bliss, Mary Quinn Sullivan, and Abby Aldrich Rockefeller, the founders of the Museum of Modern Art) highlight the crucial leadership of women in creating New York's public institutions of modern art during the 1920s.

Whitney took a strong interest in the Whitney Studio's new venture and wrote to sculptor Jo Davidson, "The Picasso show was a huge success, looked really distinguished + I was really surprised

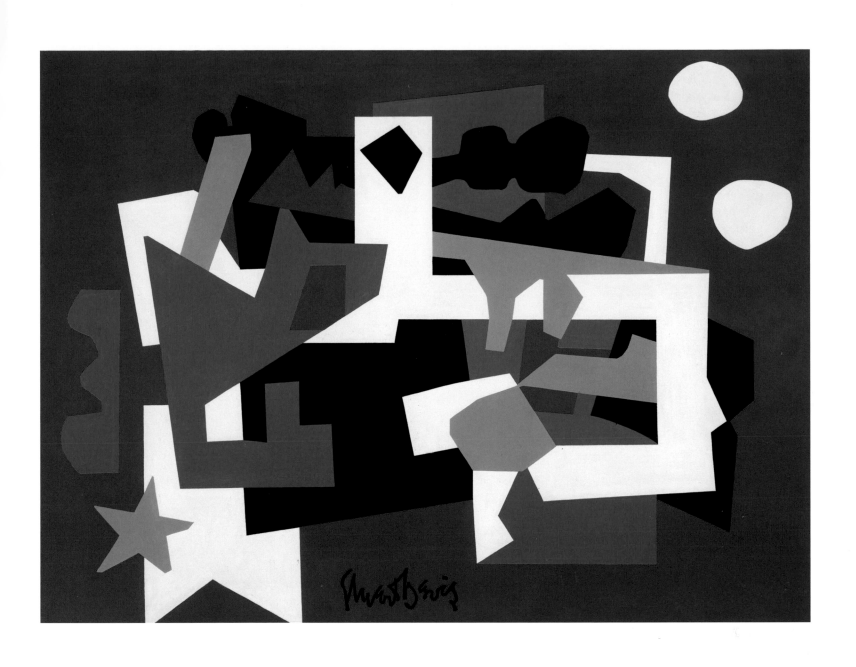

PLATE 32
STUART DAVIS, *Colonial Cubism*, 1954. Oil
on canvas, 45 1/8 x 60 1/4 in. (114.6 x
153 cm). Walker Art Center, Minneapolis,
Gift of the T. B. Walker Foundation, 1955

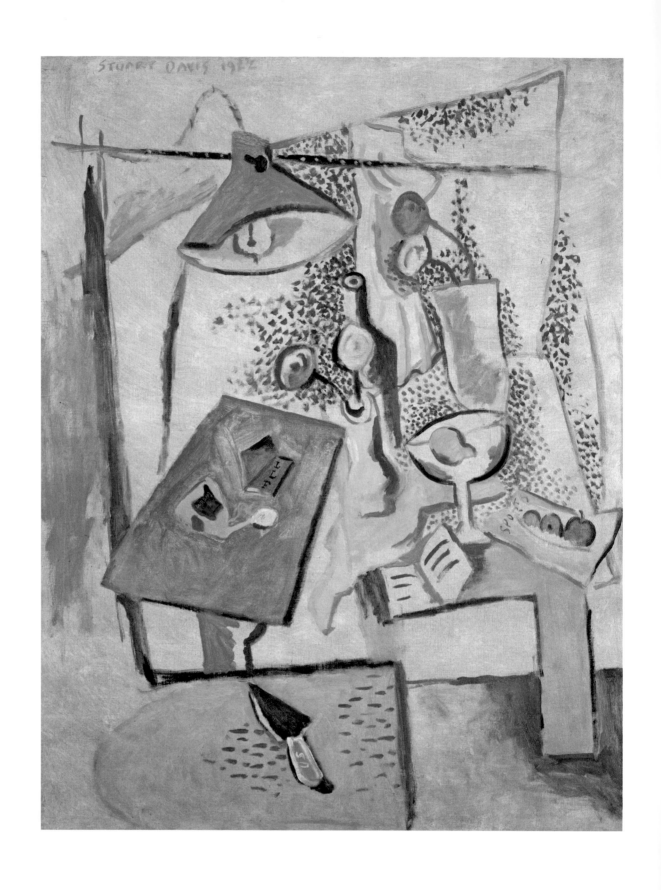

PLATE 33
STUART DAVIS, *Three Table Still Life*, 1922.
Oil on canvas, 42 x 32 in. (106.7 x 81.3 cm).
Private collection

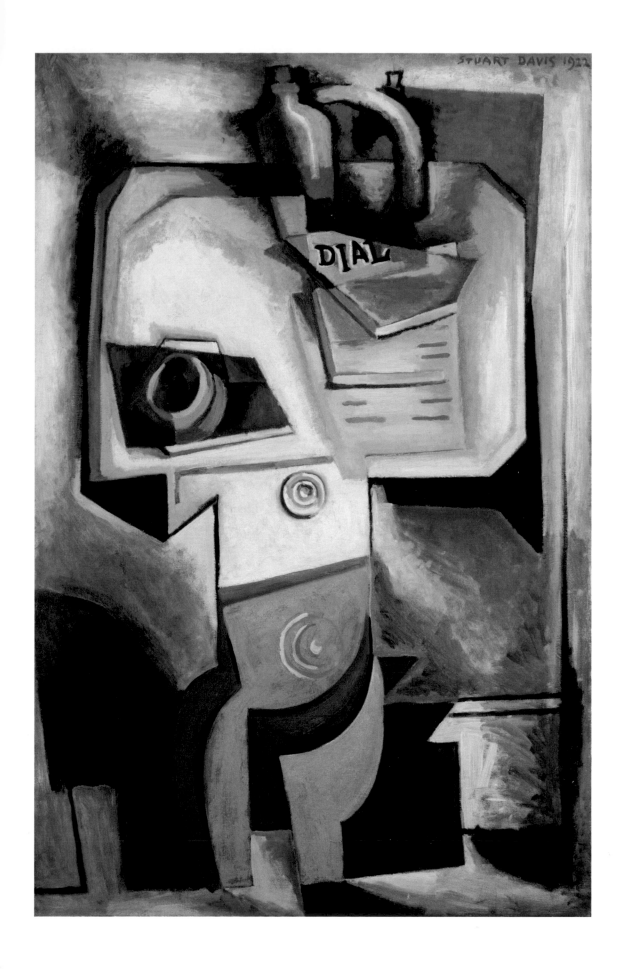

PLATE 34
STUART DAVIS, *Still Life with "Dial,"* 1922.
Oil on canvas, 49 3/4 x 31 7/8 in. (126.4 x
81 cm). Collection of Jan T. and Marica
Vilcek

81

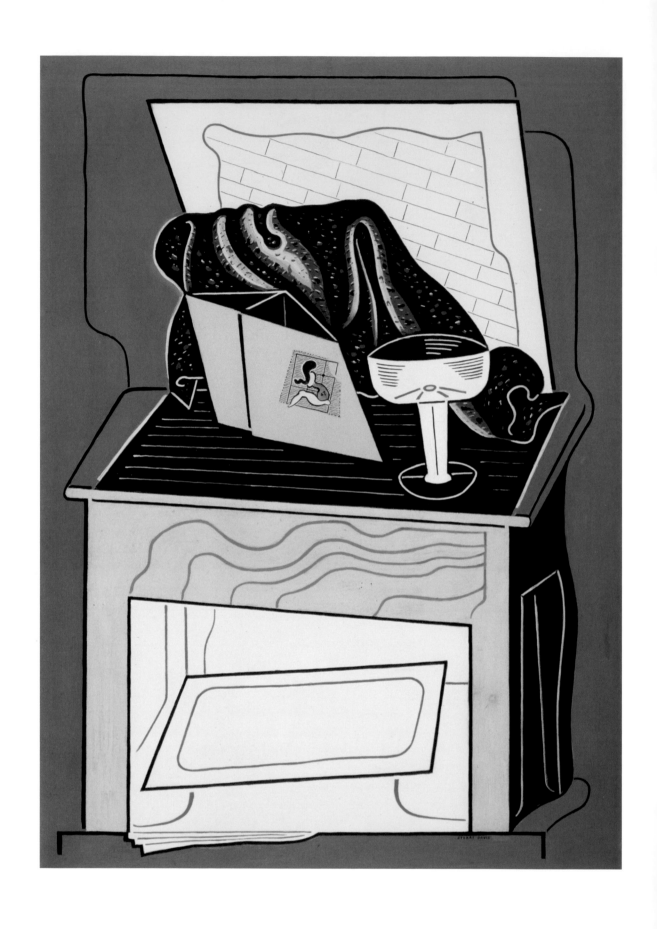

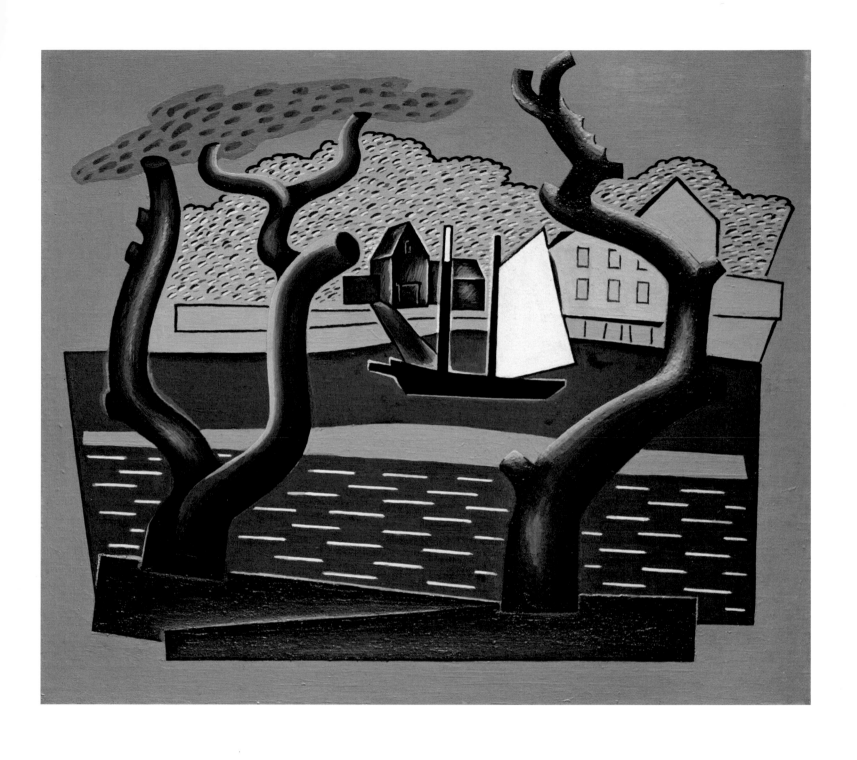

at the interest taken."[115] If Whitney's comment suggests that she still reserved judgment on Picasso's art, Force was convinced, and soon made her commitment obvious by purchasing *Pipe, Glass, and Bottle of Rum* (1914; plate 37), one of the wartime papiers collés—works of such simple design and modest materials that many people still refused to accept them as art.[116] Hanging in Force's personal apartment on top of the Studio, it must have startled the art-world guests who regularly streamed through the rooms. It asserted Force's independence from both the old Whitney program and Watson's once superior experience.

Thanks to the invoice from Paul Rosenberg (fig. 28) and to photographs of the installation taken by Sheeler, the Whitney Studio Club's May 1923 exhibition, "Recent Paintings by Pablo Picasso and Negro Sculpture," is more fully documented than any previous exhibition of Picasso's work in America (figs. 30–35). We know not only what pictures were in the exhibition but where they hung and how they related to the African objects and to the architecture of the rooms. This is lucky, since the review in Whitney's journal, *The Arts*, embraced partisanship to praise the installation as

> certainly one of the most perfectly arranged exhibitions ever held in New York. To the actual list of works of art which make up the display must be added another work

FIG. 28
Invoice from Paul Rosenberg to Whitney Studio, dated "le 31 Mars 1923," photocopy in de Zayas Papers, Whitney Museum Archives, Gift of Francis Naumann

of art—the arrangement. A sense of balanced spaces that would warm the heart of Picasso has been achieved in presenting the work, and what rare notes the masks make in relation to the walls and the pictures attached to them. No such opportunity to study the recent work of Picasso, under conditions so sympathetic, has been offered before.[117]

With only a few of the gouaches and prints double hung, the paintings spread across the walls in spacious, symmetrical groups. The real distinction of the exhibition, however, was de Zayas's deft orchestration of the objects to create continuities within Picasso's art and to imply a dialogue between his paintings and the African masks. For years, de Zayas had believed that Picasso's discovery of African art around 1907 was the "point of departure" for the "complete evolution" of his art.[118] In the Whitney Studio Club's galleries, he juxtaposed paintings and masks to suggest this relationship, and disregarded the chronological sequence of Picasso's work to present unity within the changing forms of Cubism. As captured by one of Sheeler's photographs of the works' installation (fig. 35), de Zayas hung the earliest and finest painting in the exhibition, *Portrait of Wilhelm Uhde* (1910; plate 38), between two of Picasso's most recent still lifes, spanning the chronological range of his works on view there. Next to this triad, he stood a large Guro mask from the Ivory Coast that bears a remarkable resemblance to Uhde's features in the painting (long, thin face, with a high forehead and a small mouth), a juxtaposition that also highlights other similarities between the styles of the two works (large, open planes, angular edges, crisp lines). Without engaging in a scholarly dissertation on "primitivism," de Zayas's little show made his points with elegance.

De Zayas also exercised his taste by restricting the selection of Picasso's works to Cubism. In Paris, the auctions of paintings confiscated from Kahnweiler and other German residents of France during World War I had just concluded, and Paul Rosenberg, among others, had taken advantage of the absurdly low prices to pick up a few masterpieces. *Portrait of Wilhelm Uhde* came from the liquidation of Uhde's own collection. The Picabias' likely contribution, *Female Nude (J'aime Eva)* (1912–13; plate 39), was one of Kahnweiler's gems. Together with *Bowl of Fruit (The Fruit Dish)* (1912; plate 40), the exhibition at the Studio included three excellent works of Analytic Cubism.

Its strength, however, was Cubism since the war, pictures that, but for *Landscape with Dead and Live Trees,* which Quinn had acquired from Kelekian, had not been shown in New York. After *Guitar, Clarinet, and Bottle on a Pedestal Table* (1916; fig. 29), the exhibition skipped to 1918 and presented nine oils and ten gouaches from the following four years. Though lacking any monumental pictures, it displayed Picasso's development from ornamented trompe l'oeil effects at the end of the war (*Paquet de tabac, vase à fleurs, journal, verre, bouteille [Package of Tobacco, Vase of Flowers, Newspaper, Glass, and Bottle]*, 1918; plate 41) to the precise geometry and near abstraction of the early 1920s (*Bouteille et raisins [Bottle and Grapes]*, 1922; plate 42). De Zayas was offering Americans an opportunity to study thirteen years of Cubism, from an early phase of Analytic Cubism to Picasso's latest Synthetic pictures.

In order to benefit the artists, pictures at the Whitney Studio were usually for sale, and this exhibition was no exception. Despite the Studio's public statement in *The Arts,* de Zayas's records show the reality of exhibiting avant-garde art in those years: he sold two oils, three gouaches, and six sets of reproductions (*pochoirs,* i.e., stencil prints) for a total of $1,925.[119] After paying Rosenberg the cost of the pictures, he was left with $652—against expenses of $1,780. No wonder he produced no catalogue. The larger of the two oils that were sold, *Bottle of Port and Glass (Still Life [Oporto])* (1919; plate 43), apparently went to Earl Horter, a Philadelphia collector who assembled a fine collection of Cubism in the 1920s on a small budget.[120] The balance sheet was a little stronger since the single painting not supplied by Rosenberg, *Female Nude (J'aime Eva),* sold to Davies. Quinn remained fixed on the portrait of Uhde; it was a steal at $375 (the price of a much smaller new painting), but Quinn decided to go directly to Rosenberg. He ended up paying nearly fifty percent more for the picture when they closed the deal in the fall.[121]

In some ways the six sets of reproductions are the most interesting sales here. At approximately $50 each, they were not cheap, but these stencil prints (figs. 36–40) offered an extremely good way to obtain fine reproductions of Picasso's recent work at a time when monographic volumes stuffed with color illustrations did not exist. Bliss apparently bought one,[122] and Sheeler's photographs of his home in North Salem, New York, show that by the late 1920s he too owned at least one of the images.[123] Did others go into the studios of artists? The review in *The Arts* appeared while the show was still up, so there was plenty of opportunity for them to know about it. Besides, the Whitney Studio was already established as New York's primary showcase for contemporary art.

Sheeler certainly passed the word about the show to his friends, and Davis would surely not have missed it, both as an artist favored by Force and as a confirmed admirer of Picasso. Finally, anyone who did miss the show at the Studio had another chance to see it when it was rehung as part of the "1923 Spring Salon" at the American Art Galleries in May.[124]

Guitar, Clarinet, and Bottle on a Pedestal Table probably struck Davis as remarkably like his own recently completed *Still Life with "Dial."* Other pieces in the exhibition point forward to his work of the next year or two: the combination of a schematic, flattened space with realistically rendered tobacco paper and other objects in *Package of Tobacco, Vase of Flowers, Newspaper, Glass, and Bottle,* for example, underlies Davis's *Lucky Strike* (1924; plate 44), which more fully transcribes newspaper, pipe, and tobacco while compressing them in a shallow space. But Picasso's more recent work seems to have been of greater interest to Davis. Picasso's Cubist oils and gouaches of the early

FIG. 29
PABLO PICASSO, *Guitar, Clarinet, and Bottle on a Pedestal Table,* 1916. Oil on canvas, 46 x 29 1/2 in. (116.8 x 74.9 cm). Private collection

PLATE 37.
PABLO PICASSO, *Pipe, Glass, and Bottle of Rum*, March 1914. Cut-and-pasted colored paper, printed paper, and painted paper, pencil, and gouache on gessoed board, 15 3/4 x 20 3/4 in. (40 x 52.7 cm). The Museum of Modern Art, New York, Gift of Mr. and Mrs. Daniel Saidenberg

FIG. 30
CHARLES SHEELER (1883–1965), *Installation view of Whitney Studio Club exhibition "Recent Paintings by Pablo Picasso and Negro Sculpture,"* 1923. Gelatin silver print, 7 1/2 x 9 3/8 in. (19.1 x 23.8 cm). Whitney Museum of American Art, New York, Gift of Gertrude Vanderbilt Whitney 93.23.3

FIG. 32
CHARLES SHEELER, *Installation view of Whitney Studio Club exhibition "Recent Paintings by Pablo Picasso and Negro Sculpture,"* 1923. Gelatin silver print, 7 1/16 x 9 5/16 in. (17.9 x 23.7 cm). Whitney Museum of American Art, New York, Gift of Gertrude Vanderbilt Whitney 93.23.2

FIG. 34
CHARLES SHEELER, *Installation view of Whitney Studio Club exhibition "Recent Paintings by Pablo Picasso and Negro Sculpture,"* 1923. Gelatin silver print, 7 1/2 x 9 1/4 in. (19.1 x 23.5 cm). Whitney Museum of American Art, New York, Gift of Gertrude Vanderbilt Whitney 93.23.6

FIG. 31
CHARLES SHEELER, *Installation view of Whitney Studio Club exhibition "Recent Paintings by Pablo Picasso and Negro Sculpture,"* 1923. Gelatin silver print, 7 3/8 x 9 3/16 in. (18.7 x 23.3 cm). Whitney Museum of American Art, New York, Gift of Gertrude Vanderbilt Whitney 93.23.4

FIG. 33
CHARLES SHEELER, *Installation view of Whitney Studio Club exhibition "Recent Paintings by Pablo Picasso and Negro Sculpture,"* 1923. Gelatin silver print, 7 7/16 x 9 3/8 in. (18.9 x 23.8 cm). Whitney Museum of American Art, New York, Gift of Gertrude Vanderbilt Whitney 93.23.1

FIG. 35
CHARLES SHEELER, *Installation view of Whitney Studio Club exhibition "Recent Paintings by Pablo Picasso and Negro Sculpture,"* 1923. Gelatin silver print, 7 7/16 x 9 3/8 in. (18.9 x 23.8 cm). Whitney Museum of American Art, New York, Gift of Gertrude Vanderbilt Whitney 93.23.5

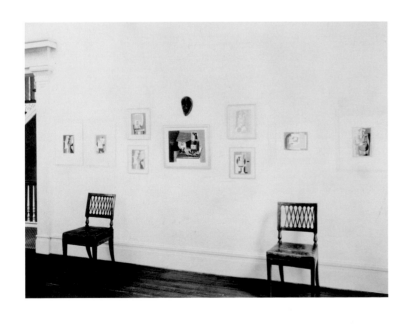

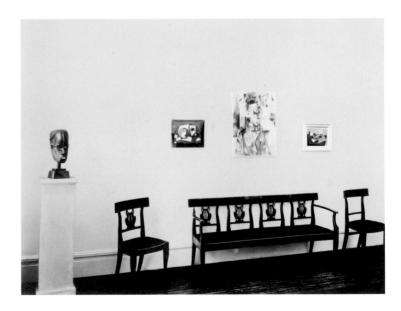

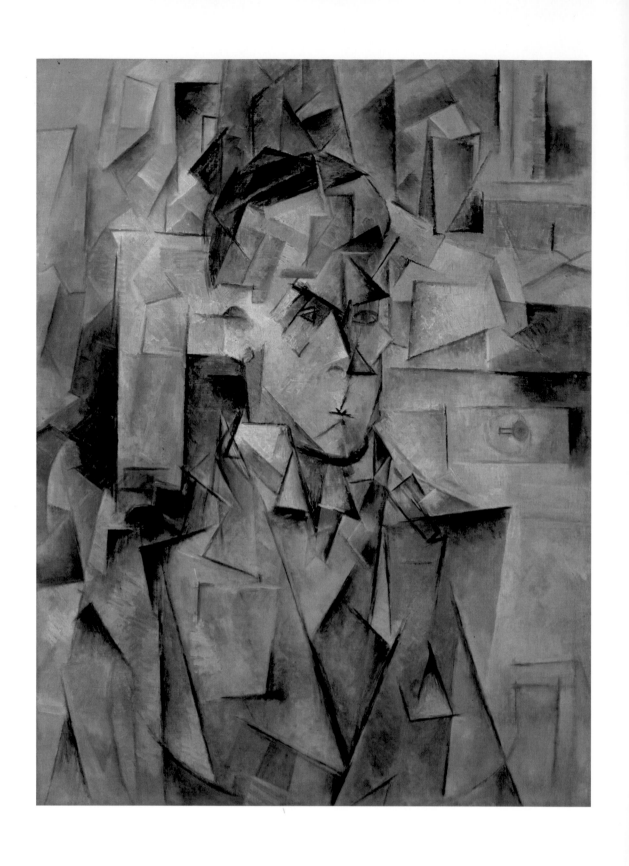

PLATE 38
PABLO PICASSO, *Portrait of Wilhelm Uhde*,
1910. Oil on canvas, 31 7/8 x 23 5/8 in.
(81 x 60 cm). Private collection

1920s are extremely reductive designs, exhibiting the hard edges, flat planes, and bright colors of Davis's work of the mid-1920s such as *Untitled (E.A.T.)* (1922; plate 46).[125] While some of these Picassos are almost devoid of line and suggest puzzlelike constructions, others define planes with sequences of parallel lines (*Bottle and Grapes*), as Davis did in *Apples and Jug* (1923; plate 45) and *Super Table* (1925; plate 35).[126] Since the pochoirs primarily reproduced works of this sort, access to a set would have enabled Davis to study them long after the show closed, and the flat, uniform surface of the prints may have appealed to him even more than the gouaches themselves. His engagement with those works culminated in *Super Table*, a painting modeled on Picasso's gouaches in the exhibition, and one that coincides in time with *Early American Landscape*, Davis's response to Picasso's *Landscape with Dead and Live Trees* in Quinn's collection.

Throughout the late 1920s and early '30s, paintings scored with parallel lines blanketed not only Davis's work but also those of friends of his such as Gorky and John Graham, leaders in the next generation of American artists addressing Picasso's work. Five months after the Whitney Studio exhibition closed, *The Arts* published an article by Andrew Dasburg, an early but minor American Cubist, called "Cubism—Its Rise and Influence." A reproduction of one of the oil paintings from the exhibition, *Bottle and Grapes*, appeared above the title, and one of the gouaches ran inside. The essay began, "The influence of Cubism on American Art is apparent." Citing only Picasso as the inventor of Cubism, Dasburg listed nineteen American artists who had "at some time or other shown an influence of Cubism in their work." Beginning with Sheeler and Man Ray, the list culminated with Weber; Davis was omitted. As a painter whose name was also on the list, Dasburg explained that none of these artists would call themselves Cubists, because the "classification implies a loss of identity." He dismissed that reservation, however, as "the illusion of individuality," and argued that artists had always learned from existing art and that his own generation's relationship to Cubism was no different: "This ambition to achieve the distinctly personal would be admirable were it not accompanied by a self-deception which, admitting nothing, takes from many sources the formal materials for our art."[127] Dasburg's critique touched on a sensitive point for American artists who responded to the avant-garde: far more than nationalism, the issue that dogged them was the claim that they lacked originality—that their work was derivative of Europe. The charge had plagued Weber since his return to the United States, and it would persist through generations as Picasso's reputation grew and his styles multiplied.

The coverage of "Picasso and Negro Sculpture" in *The Arts* expanded the exhibition's impact far beyond the modest group of objects in the Whitney Studio Club's galleries and established views of both Picasso and primitivism that would shape American attitudes for years to come. In March 1923, in anticipation of the show, the same magazine published de Zayas's article "Negro Art," which articulated his ideas about African art and reproduced Sheeler's exquisite photographs of many of the masks and figurines that would appear in the exhibition.[128] The bombshell, though, was "Picasso Speaks," which ran in May, the month of the exhibition.

The May issue was an homage to Picasso and the Paris avant-garde. The cover bore a portrait of Apollinaire that Picasso had drawn during World War I, when bandages still wrapped a head wound that the poet had received in the trenches, transforming the founder of the vanguard journal *Les Soirées de Paris* into a decorated warrior. On the back cover was an advertisement for the Whitney Studio show, announcing its opening on May 3: "First Presentation in America of Twenty Recent Paintings by Pablo Picasso . . . on exhibition and sale." Inside, "Picasso Speaks" consumed sixteen pages of the magazine. Subtitled "A Statement by the Artist," it began with an editor's note that "Picasso gave his interview to THE ARTS in Spanish, and subsequently authenticated the Spanish text" for translation.[129] Although we cannot be certain, it is extremely likely that de Zayas was the interlocutor, and that the text resulted from Watson's commission for articles by European artists.[130] Whatever the history, the text suggests intimate access to Picasso, beginning with the delicately drawn self-portrait that engages the reader at the article's head. From the opening "I," the text reads as if Picasso had welcomed a friend into his studio and spoken frankly about his art, with flashes of humor and moments of irritation that make his comments all the more believable.

Matching de Zayas's first article on the artist, the introduction notes, "Picasso believes that the speech of a painter should be painting, and that art theories are often misleading and of no practical use to an artist." Picasso's conversation dismisses conceptions of Cubism, particularly an analogy to science that casts his art as a form of research or evolution. He explodes such high-flown ideas with clear-eyed practicality about what artists do. Admitting the obvious fact that nature and art are two different things, he says, "I would like to know if anyone has ever seen a natural work of art." He toys with the distinction by claiming that "through art we express our conception of what nature is not." Asserting that Cubism is no different from other art, Picasso dwells on the fundamental artifice of all art: "We all know that art is not truth." But he claims this falsity as art's great virtue: "Art is a lie that make us realize the truth, at least the truth that is given us to understand."

Praising the "joy of discovery" and "the pleasure of the unexpected," Picasso sets no rules. He openly acknowledges the many styles he has employed as simply a reflection of his passing interests rather than philosophies of art: "If an artist varies his mode of expression this only means that he has changed his manner of thinking, and in changing, it might be for the better or might be the worse." He welcomes the freedom offered by eclecticism: "If the subjects I have wanted to express have suggested different ways of expression I have never hesitated to adopt them. . . . Different motives inevitably require different methods of expression."[131] By embracing a diversity of styles and avoiding any substantial discussion of his "different motives" or "manners of thinking," he evades all attempts to define the avant-garde and leaves the field wide open. He concludes by restating the priority of the work of art: "But of what use is it to say what we do when everybody can see it if he wants to?"[132]

The Arts certainly honored Picasso's opinion. Watson, the magazine's editor, printed a dozen full-page reproductions of his work and six smaller ones. This array of images greatly increased

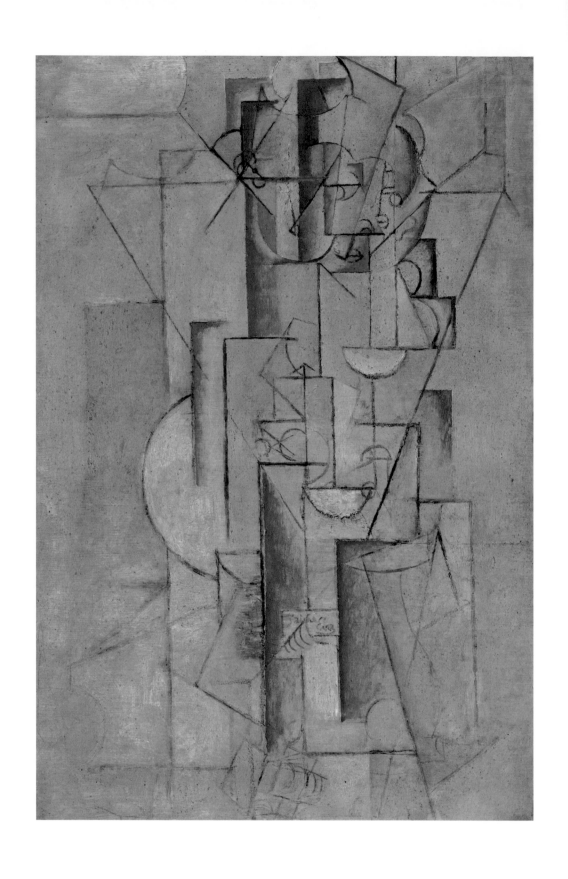

PLATE 39
PABLO PICASSO, *Female Nude (J'aime Eva)*,
1912–13. Oil, sand, and charcoal on
canvas, 29 3/4 x 26 in. (75.6 x 66 cm).
Columbus Museum of Art, Ohio, Gift of
Ferdinand Howald

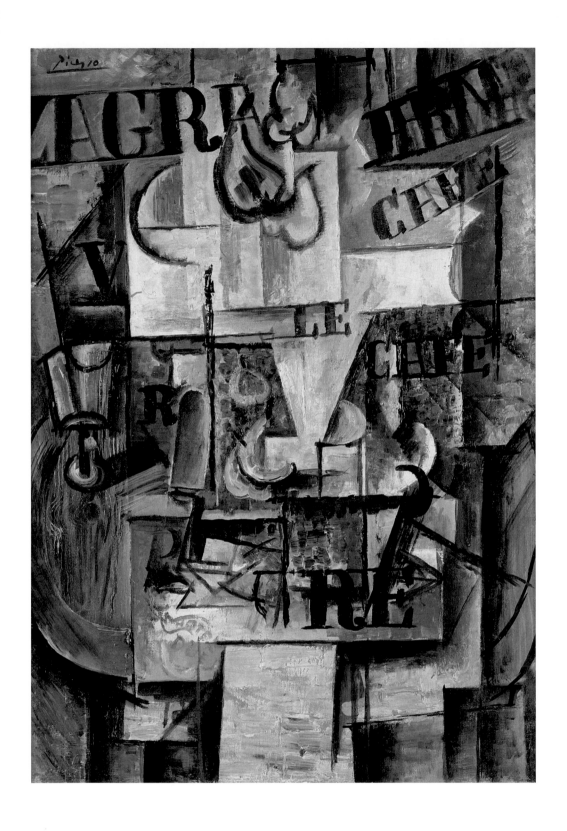

PLATE 40
PABLO PICASSO, *Bowl of Fruit (The Fruit
Dish)*, 1912. Oil on canvas, 21 5⁄8 x 18 1⁄2 in.
(54.9 x 47 cm). Private collection

91

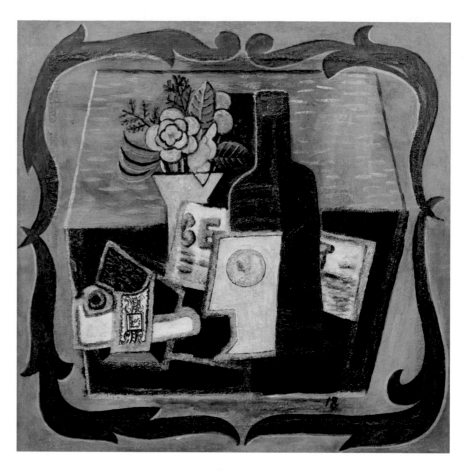

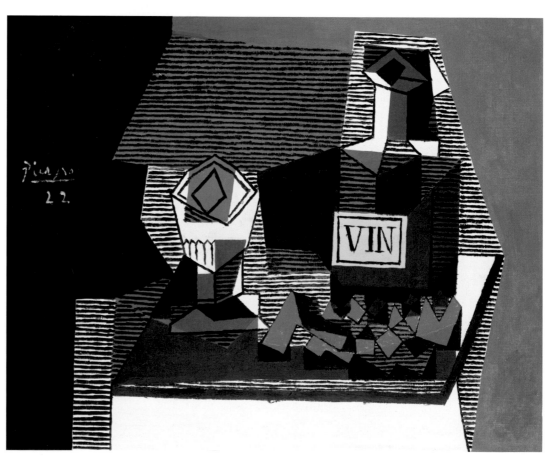

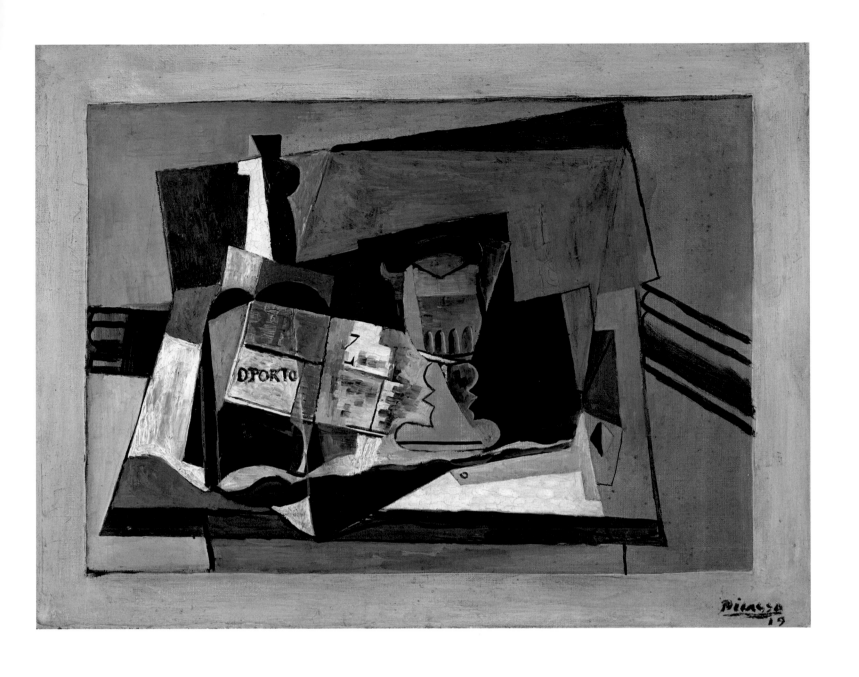

PLATE 43
PABLO PICASSO, *Bottle of Port and Glass
(Still Life [Oporto])*, 1919. Oil on canvas,
18 x 24 in. (45.7 x 61 cm). Dallas
Museum of Art, Museum League
Purchase Fund, The Cecil and Ida Green
Foundation, Edward W. and Evelyn
Potter Rose, The Pollock Foundation,
Mary Noel Lamont, Mr. and Mrs. Thomas
O. Hicks, Howard E. Rachofsky, an
anonymous donor, Mrs. Charlene Marsh
in honor of Tom F. Marsh, Gayle and
Paul Stoffel, Natalie H. (Schatzie) and
George T. Lee, Mr. and Mrs. Jeremy L.
Halbreich, Dr. and Mrs. Bryan Williams,
and Mr. and Mrs. William E. Rose

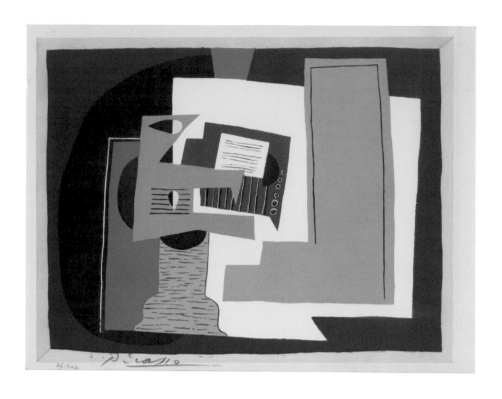

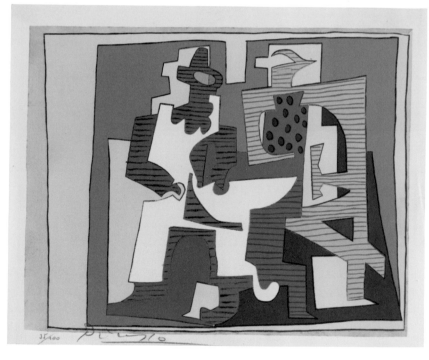

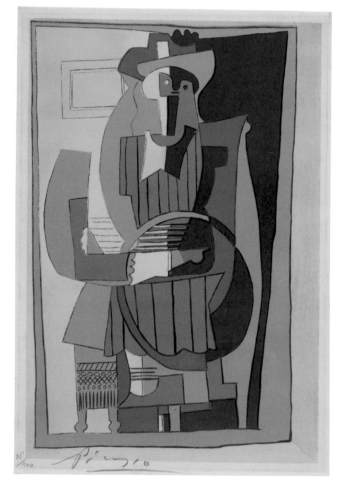

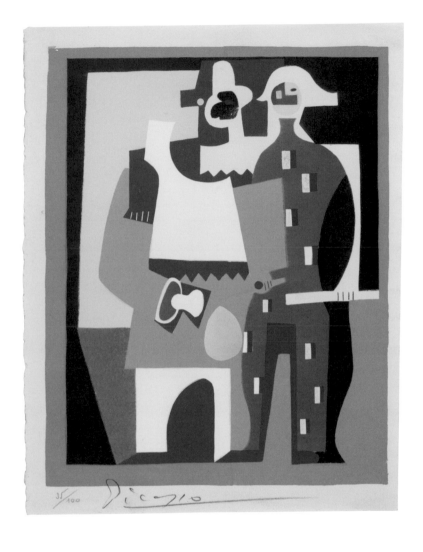

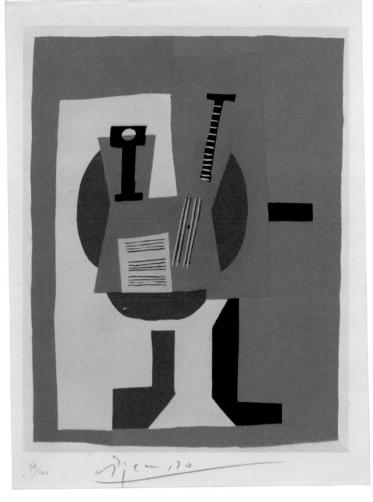

FIG. 39
PABLO PICASSO, *Pierrot and Red Harlequin, Standing*, ca. 1920. Stencil, 10 13/16 x 8 3/8 in. (27.5 x 21.3 cm). The Museum of Modern Art, New York, Lillie P. Bliss Collection, 1934

FIG. 40
PABLO PICASSO, *Still Life*, ca. 1920. Stencil, 10 9/16 x 8 1/8 in. (26.9 x 20.6 cm). The Museum of Modern Art, New York, Lillie P. Bliss Collection, 1934

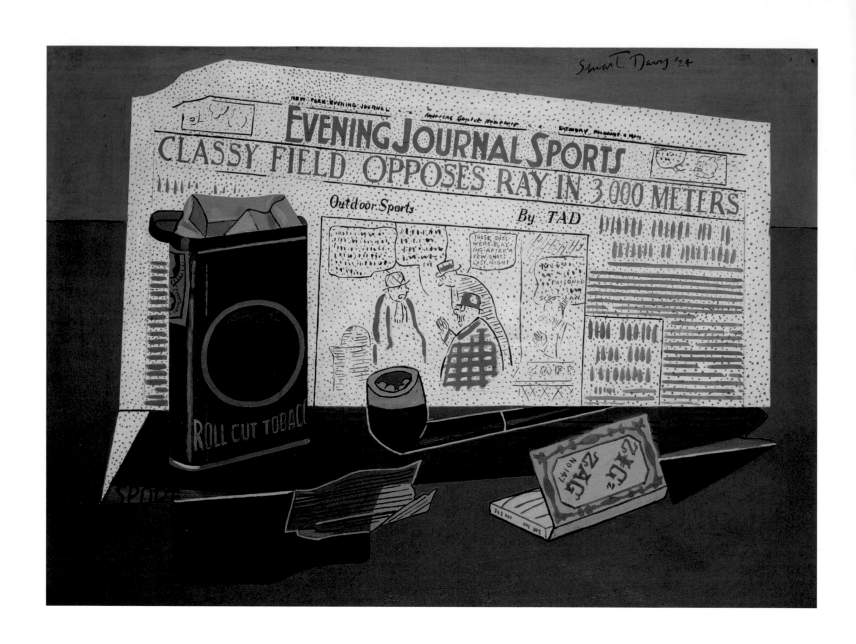

PLATE 44
STUART DAVIS, *Lucky Strike*, 1924. Oil on
board, 18 x 24 in. (45.7 x 61 cm).
Hirshhorn Museum and Sculpture
Garden, Smithsonian Institution,
Washington, D.C., Museum Purchase, 1974

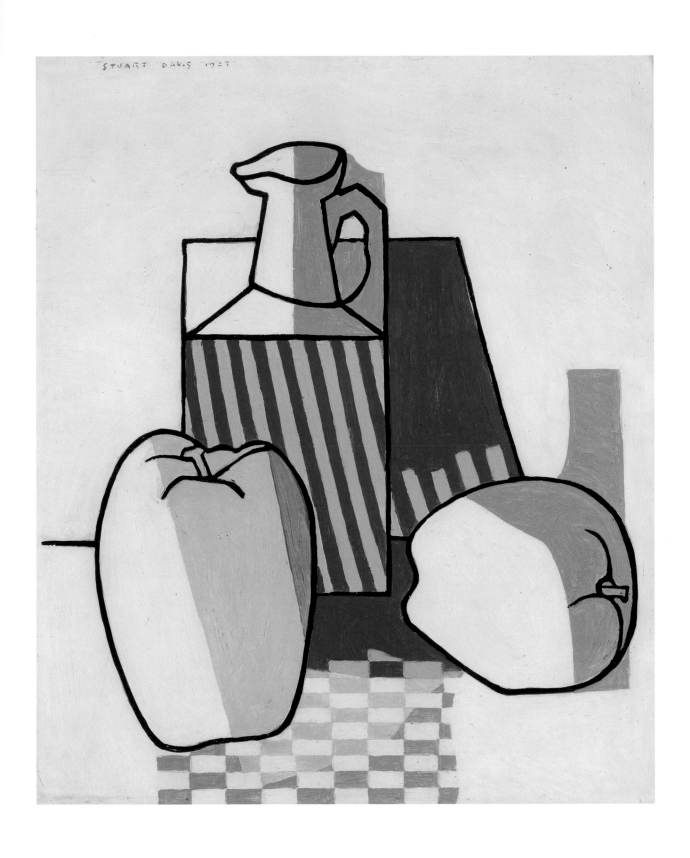

STUART DAVIS 1923

PLATE 45
STUART DAVIS, *Apples and Jug*, 1923. Oil
on board, 21 3/8 x 17 3/4 in. (54.3 x
45.1 cm). Museum of Fine Arts, Boston,
Gift of the William H. Lane Foundation

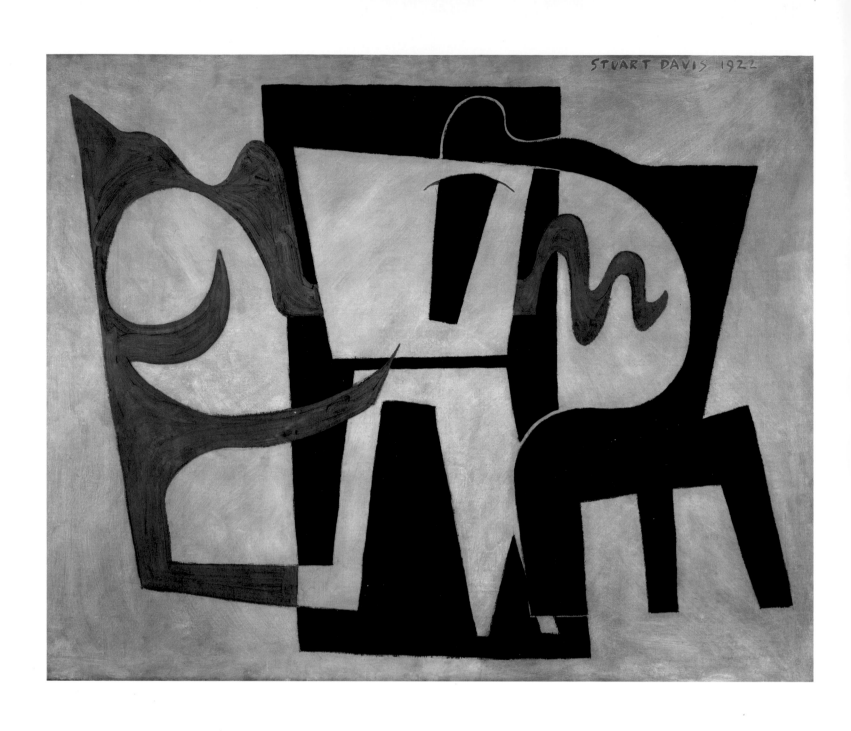

PLATE 46
STUART DAVIS, *Untitled (E.A.T.)*, 1922.
Oil on canvas, 32 x 40 in. (81.3 x
101.6 cm). Curtis Galleries, Minneapolis

98

 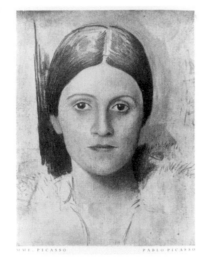 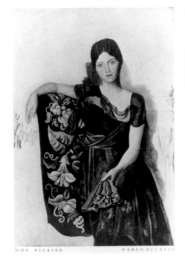

the force of his comments by vividly illustrating the diversity of his current styles, both Cubist and neoclassical. Instead of featuring a Cubist image such as those shown concurrently at the Whitney Studio, the article opened with a highly realistic sketch that Picasso had painted of his wife, Olga Khokhlova, in full close-up (fig. 41). Its nearly academic style and her bourgeois appearance could not have been farther from the abstract rigor of his contemporary Cubism. Running through the text were four double-page spreads that pair a Cubist painting with a neoclassical one—clearly affirming the diversity of Picasso's work and challenging the reader to make sense of the contrast. While two of the Cubist pictures were credited to the Whitney Studio, all the neoclassical ones were provided by Picasso and Paul Rosenberg. They included his portrait of Olga in an armchair (paired with *Man Leaning on a Table*, 1916; fig. 42), a portrait of Rosenberg's wife and daughter (paired with *Harlequin with Violin ["Si Tu Veux"]*), and a concluding pair of portrait drawings of Igor Stravinsky and Erik Satie. Other classicizing drawings and paintings portrayed bathers, robed maidens, bullfights, and fish sellers.

Throughout Picasso's relationship with America—this was its thirteenth year—he had been known as a Cubist, often as the sole inventor of Cubism. Because of that, this presentation of his true diversity must have been startling to those who had not seen his exhibitions in Paris or closely followed art-world news. In fact, Picasso had begun to use neoclassical styles as early as 1914, and a scoop relating the change, reported by Beatrice Hastings (Amedeo Modigliani's longest-running mistress), had been published in the London journal *The New Age* the following January.[133] The news certainly reached some of Picasso's New York audience: when Elizabeth Luther Carey reviewed de Zayas's 1915 Picasso show for the *New York Times*, she wrote with relief, "The Modern Gallery sits silently triumphant in the presence of Picasso's latest, which is not the reactionary salonistic production recently described."[134] And in a letter of December 1915, de Zayas passed on the sentiments to Picasso: "The intelligent public here is pleased to see that the rumor that you have abandoned your art completely to return to totally objective painting is false."[135] Always an advocate of Cubism, de Zayas may have chosen the Whitney Studio pictures to represent what he believed was Picasso's greatest work, or he

may have wished to avoid the confusion and consternation that a full menu might have generated.[136] Whatever the case, *The Arts* showed all the cards in an unmistakable display.

Six months later, Paul Rosenberg presented the first American exhibition of Picasso's neoclassical paintings. Although he had been Picasso's dealer since late 1918 and had facilitated an exhibition of the artist's drawings in Chicago in the spring of 1923,[137] Rosenberg had for the most part heeded Quinn's advice to avoid the country's unsettled economy in the postwar years, instead letting the few serious American collectors find their way to his gallery in Paris. In the fall of 1923, however, he finally organized an American exhibition of Picasso's work, opening it in New York in November and then taking it to Chicago, which he called "the most important artistic center in America," the following month.[138] Knowing that America would be a commercial challenge but believing the time was right to open a campaign to sell Picasso's work there, Rosenberg came himself, arriving by ship in New York and later traveling on by rail. He brought thirteen paintings and three pastels to the New York gallery of his partner Georges Wildenstein. Rooms in which visitors were accustomed to see paintings by old masters or nineteenth-century artists such as Corot or Courbet now displayed Picasso's own homages to tradition and his escape hatch from the academy that Cubism had become in Paris (fig. 43).

The subjects ranged from harlequins and *saltimbanques* to lovers (fig. 44) and women in meditation. The quiescent poses of the figures and each painting's apparently conventional execution masked a range of stylistic feints as complex as any Cubist picture's but far less explicit. Once again, Watson played a central role in the show's reception. Reproducing one of the paintings on the cover of the December issue of *The Arts*, and writing that most of the paintings "will eventually be reproduced in THE ARTS as part of the complete record which this magazine is making of the

FIG. 41
Opening spread of "Picasso Speaks," *The Arts* (May 1923): pp. 314–15, reproducing a sketch of Olga Khokhlova painted by Picasso in 1918 and, on the facing page, a self-portrait

FIG. 42
Another spread of "Picasso Speaks," *The Arts* (May 1923): pp. 320–21, reproducing two paintings by Picasso: *Painting* (now called *Man Leaning on a Table*, 1916) and *Mme. Picasso* (now called *Olga in an Armchair*, 1917)

FIG. 43.
Seven recent neoclassical works by Picasso in the exhibition at Wildenstein Galleries, November 1923. Courtesy of Wildenstein & Co., New York

leading artists of the day," he called the exhibition "unquestionably the most exciting event of the winter thus far."[139]

The show, however, was not a resounding success. While Picasso's Cubism had long received respect (if grudgingly) from the New York audience, these paintings prompted even his partisans to voice doubts about their aesthetic merit. Watson found himself among the dissenters, and his reporting captures the conflict so well that it deserves extensive quotation. Amazingly, he described these paintings as "a phase of the art of Picasso which is less easy to understand than his cubist pictures, and less easy also than those particularly representative paintings of his that have within them the qualities of acid and iron which have given Pablo Picasso his deserved eminence."[140] Clearly, at least some in New York wanted their Picasso straight up and 100 proof. They were diehard avant-gardists.

Except for previous reproductions in *The Arts* and the inclusion of one neoclassical painting in a 1922 exhibition,[141] the style was new to the community, so Watson introduced "a Picasso who is, comparatively speaking, unknown in America. Incidentally none of these pictures has been shown in Paris. They are seen in New York for the first time." Although Rosenberg already planned a show of the pictures in his Paris gallery the following spring, misgivings lingered that Picasso had made them for provincials rather than for the home audience. "They are large canvases exhibiting a degree of virtuosity that is startling, and, in the eyes of some artists, suspicious; as you enter the beautiful gallery where they hang their brilliant color and arbitrary methods strike the eye as with a blow." Watson wrestled with the contrast between their passages of old master-ish modeling and abrupt shifts to flattened or even entirely blank areas, the legacy of Cubism. He counseled repeated viewings and finally concluded that "frank confession compels the statement that on each visit these particular paintings have fallen a notch."

Not wishing to be arbitrary, Watson turned to a group of artists—who really heated things up. "I happened upon a party of artists almost breaking each other's noses in a furious argument on the merits and demerits of their great idol, Pablo Picasso." His

quotation of the conversation, whether or not it is entirely accurate, captures the debate:

"He thought he'd get the American public with all that romantic junk," exclaimed one young barbarian, who a week before considered Picasso a god incapable of error.

"The forms do not work," said another.

"Why, there isn't any form to work, in such sickly things as *The Woman With the Blue Veil* or *The Lovers*," said a third.

Then an able young painter began to talk more coherently and said:

"Picasso didn't necessarily paint these things for the American market. They are the real Picasso. His earliest pictures show that he was born with a rotten romantic streak in him. Picasso never was quite human. That's why he's greater as a cubist. Keep him down to a real intellectual problem which prevents him from cheap illustration like *The Lovers* and the power of the man comes out in pure expression. But once let him illustrate and he reverts to type."

Unfortunately, Watson did not identify the speakers, so we cannot determine if it was perhaps Davis who dismissed the "romantic junk," or Graham who offered the learned disquisition on Picasso's past, but he did report a general consensus: "That Picasso had fallen in the esteem of his most ardent American followers was evident as the talk went on." Although Watson praised some of the paintings in the exhibition, he concluded by offering the magazine as a forum for further discussion of "the revised estimate that his American followers are making of Picasso."[142]

The intensity of these artists' responses is remarkable. Clearly, a committed community of vanguard artists had developed in the United States by the early 1920s, and Picasso was their revered figure. Yet this community had largely grown in isolation, unable to travel to Europe (as many of the first generation of modernists had), and they were nourished by rare publications and exhibitions that offered only a slice of Picasso's current work. While some of their criticisms were well taken, these artists were also reacting to the transformation of his style as European artists had nearly ten years earlier: as if Picasso had sold out the avant-garde. And in the presence of his pictures, his words in "Picasso Speaks" did not carry the day. A new generation of American artists, several of them European by birth, would have to mature before the American art world would tolerate the complexity, contradiction, and playfulness of Picasso's various modes.

During the mid-1920s, a few American collectors stepped forward to buy Picasso's neoclassical works. In 1927, Bliss purchased *Woman in White* (1923; plate 47) from Kraushaar Galleries in New York.[143] By then, the rhetoric had faded, and Bliss may in any case have paid no attention to it, since she only rarely bought Picasso's work. In any case, this painting became a regular feature of the early exhibitions at the Museum of Modern Art and a model for American artists in the 1930s.

In the closing months of 1923, Rosenberg shielded Picasso

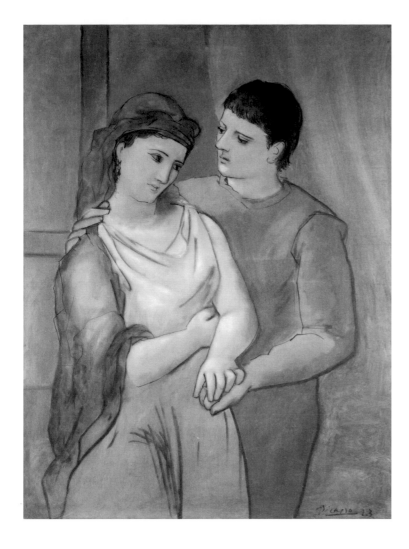

his apartment, Quinn strongly resisted Rosenberg's relentless sales pitches.[145] He died in July 1924.

Upon Quinn's death, his collection went public. The startled response to his pictures by even sophisticated critics and artists proves how secluded he had kept them. Any visitor to the Wildenstein show who had seen the group of neoclassical paintings that Quinn had accumulated in his apartment over the preceding year and more might have disapproved of Picasso's most recent explorations but would not have been surprised by the classicism of the style. But Quinn, who had piled hundreds of pictures against the walls as if the apartment were a warehouse, had invited only close friends to shift through the stacks. Davies and Pach had been among the privileged, along with a few wealthy collectors of modern art, including Bliss and Mary Quinn Sullivan (a cofounder of the Museum of Modern Art but not a relative of John Quinn's).

Quinn had specified in his will that all of his art should be sold, except for Georges Seurat's *Circus*, which he left to the Louvre, and two paintings by Puvis de Chavannes, which he offered to the Metropolitan. During the rest of 1924 and the following year, then, his executors worked with Pach, Davies, and dealer Joseph Brummer to devise a method of liquidating the pictures at reasonable prices. A few months after Quinn's death, his companion, Jeanne Robert Foster, stated the problem in an open letter to *The Transatlantic Review*: "Who are the people who will buy his modern art in this country? A few artists with modest purses will buy a little. Dr. Barnes of Baltimore [*sic*] was a rival buyer. He will not buy much because his pride would be lowered. . . . Miss Bliss . . . Mrs. Havemeyer . . . They are about all, and of the dealers there are only one or two who would buy honestly and risk money in investment in the kind of modern art Mr. Quinn bought. His collection is fifty years ahead of popular taste." She quoted Quinn's own fears: "Mr. Quinn said to me about two weeks before he died: 'If anything happens to me and there was a sale of my paintings, there would be a slaughter. He went on to say . . . that the large Picasso nudes could hardly be given away now." And she pointedly raised the question, "Who will at the present time buy twenty Picassos . . . in this country?"[146] As the American art world learned the extent of Quinn's collection, it simultaneously saw the work slipping through its fingers.

A sale was looming by late 1925. To kick it off, the executors of the Quinn estate scheduled a three-week exhibition from January 7 to 30, 1926, at the Art Center on 56th Street in New York, featuring more than one hundred works. That month, Watson eulogized the collection in *The Arts*, while also seizing the occasion to revive a long-standing goal: just as Field had urged Americans to buy Kelekian's pictures for the nation in 1922, Watson now called for a museum of modern art.[147] By the end of the decade, the campaign that he began in this article would transform the American art world. Asking rhetorically how many of Quinn's pictures would go into American museums, Watson stated flatly that the existing institutions would not buy them, then continued, "These facts . . . have brought up again the question of America's need for a museum of modern art." He and his friends had clearly thought about this matter for some time, as he immediately offered an outline of the museum's program—an outline that would turn out to bear a strong resemblance to the initial

from the American criticism, but he could not hide the near-total lack of sales. Collectors apparently shared the views of most American artists. Quinn was the only American collector who had followed Picasso's development closely and made a substantial commitment to his neoclassical work. During extended trips to Paris in the summers of 1921 and 1922, Quinn had come to know Picasso well, and had visited him on vacation. He had also shifted his purchases from Cubism to some of Picasso's largest and most ambitious appropriations of classical modes. Although he considered buying a version of Picasso's greatest Cubist composition of the 1920s, *Three Musicians* (1921; plate 65), he ultimately purchased six neoclassical pictures—including *Mother and Child* (1921; plate 48), *Two Female Nudes* (1920; plate 51), and *Three Women at the Spring* (1921), a counterpart to *Three Musicians*. Quinn became such a regular visitor and major buyer that he managed to purchase *Three Women* and another picture directly from Picasso, leaving Rosenberg in the cold.[144] But *Portrait of Wilhelm Uhde* was the last work by Picasso that he bought. When Quinn returned to New York in November 1923, he was seriously ill with cancer. Although he finally gave in to Rosenberg's requests to see his collection and invited Rosenberg and Felix Wildenstein to dinner at

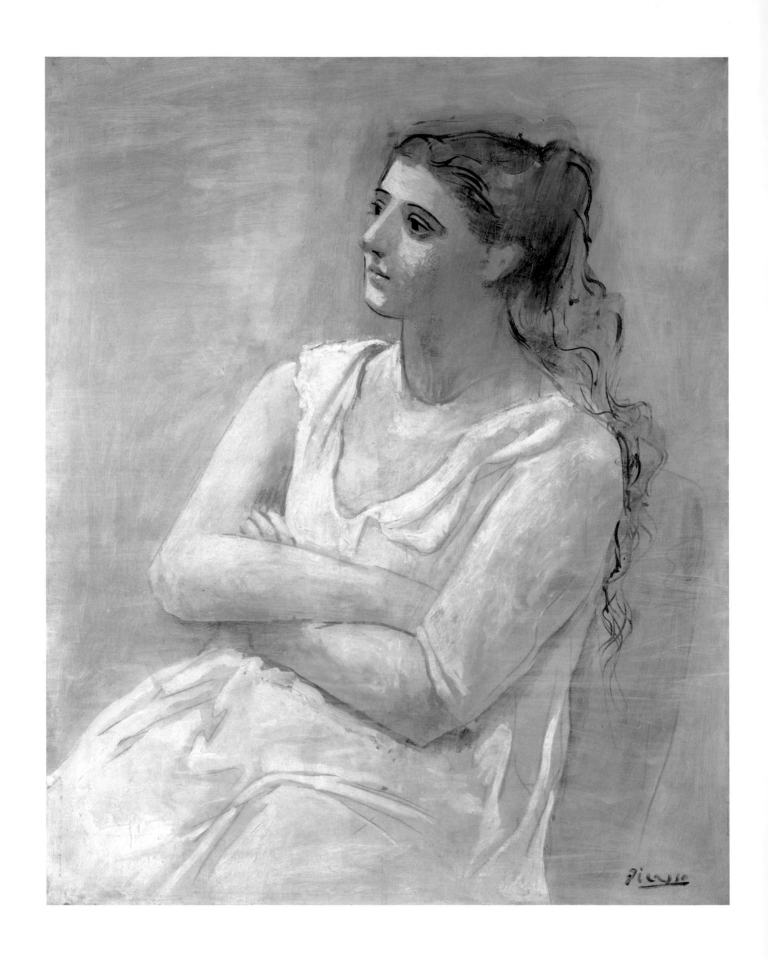

PLATE 47
PABLO PICASSO, *Woman in White*, 1923.
Oil on canvas, 39 x 31 1/2 in. (99.1 x
80 cm). The Metropolitan Museum of Art,
New York, Rogers Fund, 1951, Acquired
from The Museum of Modern Art, Lillie
P. Bliss Collection (53.140.4)

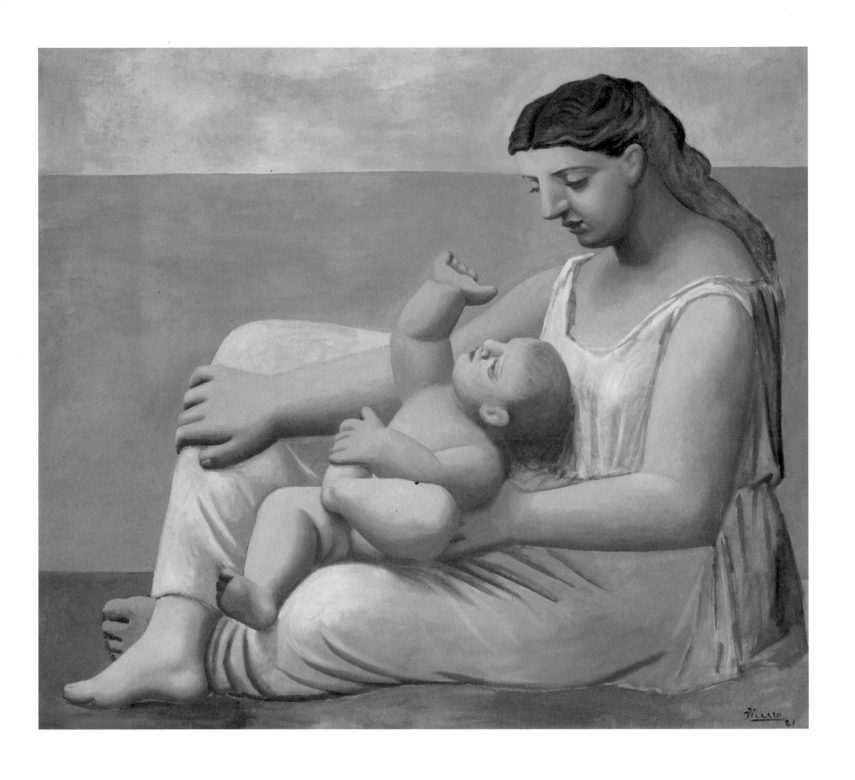

PLATE 48
PABLO PICASSO, *Mother and Child*, 1921.
Oil on canvas, 56 3/8 x 68 in. (142.9 x
172.7 cm). The Art Institute of Chicago,
Restricted gift of Maymar Corporation,
Mrs. Maurice L. Rothschild, Mr. and Mrs.
Chauncey McCormick; Mary and Leigh
Block Fund; Ada Turnbull Hertle
Endowment; through prior gift of Mr. and
Mrs. Edwin E. Hokin 1954.270

program of the future Museum of Modern Art. "The contemplated museum of modern art," Watson wrote, "might act in time to secure such works of art for its own permanent collection, or it might act as a sort of trial museum for the centrally situated museums throughout the country . . . buying modern art as it appeared and allowing its purchases gradually to sift through its portals into the permanent collections of the other museums, as time verified the selections that it would make if managed by a director freed from the interference of lay trustees." Indeed, Watson pressed the need for an independent, professional director: "Whether a proposed museum of modern art could be rescued from politics, whether it would be possible to secure for its director someone daring enough to purchase works of modern artists before their fame had skyrocketed their prices, I cannot say. But no one will deny that either an institution of this kind should be created or some sort of trial annex should be added to our museums."[148]

Holding up Quinn as an example to future trustees, Watson praised him for following the advice of living artists, particularly regarding the work of their contemporaries. Quinn had owned many excellent works by Matisse, Constantin Brancusi, Derain, and others, but Watson singled out his collection of Picassos as an investment in the chief figure of their time. "Mr. Quinn did not like [Picasso's] work very much when he first began to purchase it," Watson wrote, "but he was well advised (the point is made once more) by the artists with whom he associated." His commitment grew until

> among the famous painters who have followed Cézanne, perhaps no artist is more completely represented in the Quinn collection than Picasso. . . . When all of Mr. Quinn's Picassos are shown as a single exhibition many a visitor will find it almost impossible to make up his mind what kind of human being this dazzling eclectic is. . . . Picasso has been a blazing light, shining down upon the battling armies of lesser strugglers in the arts. . . . When you see the man personally, with those omnivorous eyes taking in everything about him he seems to have taken hints from a thousand sources which he developed to his purposes. His sophistication is overwhelming.[149]

Despite his skepticism about Picasso's neoclassical work, Watson was affirming the cult of personality that increasingly surrounded Picasso's art.[150]

Quinn's Picassos were considered so distinctive that at one point Brummer planned a separate exhibition of these approximately forty works, and Watson predicted that "the American student of Picasso will have an opportunity to estimate Picasso's remarkable talent in ways that he has never had before."[151] Once the exhibition at the Art Center opened, nearly two thousand people visited it a day,[152] but they saw only four Picassos: *Sad Mother* (1901), *Woman Dressing Her Hair* (1906), a Cubist still life,[153] and *Mother and Child* (1921; fig. 56). (Of these, only the last offered anything unfamiliar.) As the *New York Times* reported, Paul Rosenberg had bought the entire group of Picassos (sup-

posedly "52 paintings"), as well as some works by Seurat, before the show began. No one could fault him for defending the artist's market, but a great many mourned the loss of this primary group, even as a reported eighty works by other artists were sold from the exhibition.[154] This time, instead of merely lamenting, a few collectors acted—not only to bring the pictures back to America but to give them to the public. It is impossible to determine how much Watson's editorial influenced their decisions, but their purchases and donations marked the first entry of Picasso's paintings into the collections of American museums.[155] In fact, they might be called the first in the world, since only one other museum, the provincial Musée de Grenoble in France, owned one of his paintings—and that had been donated a few years earlier by Picasso himself. The arrival of Picasso's work in American museums was more than a milestone for his reputation. While Matisse was the first through the door (when the Detroit Institute of Arts bought one of his paintings from Kelekian's collection at the auction in 1922), American museums' acceptance of Picasso led their slowly maturing dedication to the twentieth-century avant-garde.[156]

The seeds were not planted in New York. In May 1926, a Chicago collector, Frederic Clay Bartlett, bought *The Old Guitarist* (fig. 25), one of Quinn's Picassos, from French Galleries (a New York venue for Rosenberg's stock) before it could be shipped to Paris. He paid the high sum of $9,500 and immediately donated the painting to the Art Institute of Chicago as part of the Helen Birch Bartlett Collection, a gift he had offered the previous year in honor of his recently deceased wife. The donation also included two paintings by Matisse, *Woman before an Aquarium* (1923) and *Woman on a Rose Divan* (1921).[157]

At approximately the same time, A. Conger Goodyear bought Picasso's *La Toilette* (1906; fig. 45) for the Albright Art Gallery in Buffalo (renamed the Albright-Knox Art Gallery in 1962). As the head of the board, Goodyear apparently acted independently to purchase this Rose Period masterpiece for the modest amount of $5,000. His decision created a scandal among his fellow board members of this museum associated with the Buffalo Fine Arts Academy. They promptly voted him off the board—an action that proved a great boost to his career when it caught the attention of a small group of women who were contemplating founding a museum of modern art in New York City.

Although these masterpieces from Quinn's collection were only two paintings, they marked the first acceptance of Picasso's art in American museums. The following year, Duncan Phillips confirmed the pattern by purchasing *The Blue Room* (1901; fig. 46)—an early painting that did not bear the Quinn provenance—for his newly established public collection in Washington, D.C. With a patina of twenty years or more, Picasso's Blue and Rose Period paintings were becoming desirable for the most adventurous museums. Cubism, however, or even the recent neoclassical pictures, were not.[158] Over the decades, many of Quinn's paintings would flow into the collections of American museums;[159] but at that time, only one collector, Ferdinand Howald, bought any of Picasso's Cubist pictures that had been in Quinn's collection. In April 1926, Howald, a Swiss-born engineer, gave Paul Rosenberg $4,000 for *Still Life with Compote and*

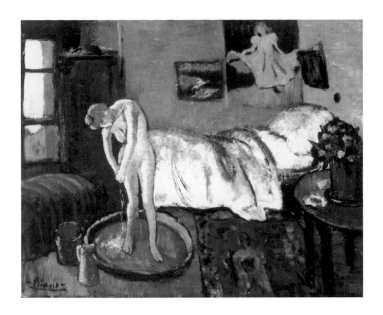

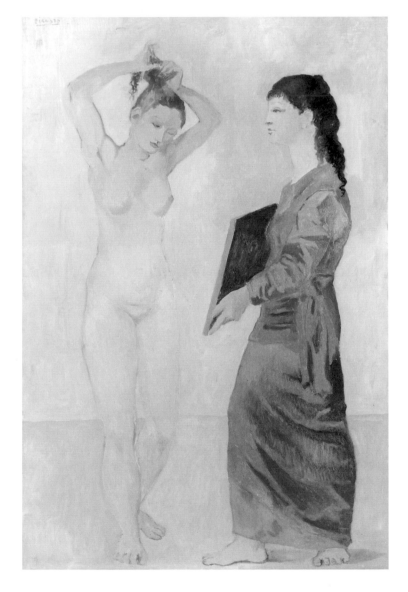

Glass, which had been reproduced five years earlier in *The Arts*.[160] This luxuriously surfaced painting, with its tightly articulated geometric structure, may have appealed to the collector through its relationship to works by Davis; Howald was putting together a collection of the American avant-garde at the time. In 1931, he gave this painting and others to the Columbus Gallery of Art, a museum he largely underwrote in his adopted hometown.

After many of Quinn's pictures were dispersed in 1926, Watson wrote a valedictory preface to a lavish catalogue of the collection, published later that year. With full-page reproductions of seventy-one works (eleven by Picasso), the book became not only a testament to Quinn's achievement but an important source for artists.

At least one of Picasso's drawings escaped Rosenberg's haul. In February 1927, Dreier bought a slight sketch, *Head of a Woman* (1906), from the last auction of Quinn's material in New York.[161] She had attended the sale with Duchamp, who had recently helped her to organize a large and daring exhibition of contemporary art for the Brooklyn Museum. Once again, Brooklyn had proved willing to buck prevailing tastes. Soon after the first exhibition of Quinn's collection, the museum gave Dreier free rein to organize an exhibition rivaling the Armory Show in size and in the comprehensiveness of its international display of current art.[162] When this "International Exhibition of Modern Art" opened, in November 1926, it included more than 300 works by 106 artists from nineteen countries (28 were American) and delivered an amazingly up-to-date presentation of Dada, Surrealism, De Stijl, Constructivism, and the Bauhaus. Despite a goal of including only a small number of works by the early-twentieth-century avant-garde, Dreier tried to meet Picasso in order to obtain works directly from him. Presumably she was seeking his most recent art, but, unfortunately, she failed to see him.[163] In the end, only two of his works appeared in the exhibition: the 1913 still life *Bar-Table with Musical Instruments and Fruit Bowl*, owned by Dreier,[164] and the papier collé *Pipe, Glass, and Bottle of Rum*, "lent through the courtesy of Mrs. Force."[165] Though widely attended and reviewed, the exhibition seems to have had no substantial impact on American artists. Nonetheless, it marked the first appearance of Joan Miró's work in the U.S. and it prompted McBride to conclude his review of the show with the statement that "a modern museum devoted to this 'new thought' is imperatively needed."[166]

Force's willingness to lend her papier collé is another reflection of the broad mission that she and Whitney were charting for the Whitney Studio during the mid- and late 1920s. While it would be easy to isolate Whitney and Dreier as supporting opposite camps of artists and aesthetics, their activities substantially overlapped in these years. During the run of the Brooklyn Museum exhibition, Whitney demonstrated her new appreciation for the European avant-garde by having the family's legal team defend Brancusi, whose work she had earlier dismissed as "chunks of marble."[167] Duchamp had organized a retrospective of Brancusi's sculpture for New York's Brummer Gallery, but U.S. customs officials would not accept the objects as works of art. A Brancusi *Maiastra* belonging to Steichen was recorded under "kitchen utensils and hospital supplies," and the entire exhibition was assessed a $4,000 tariff—whereas works of art traveled free.

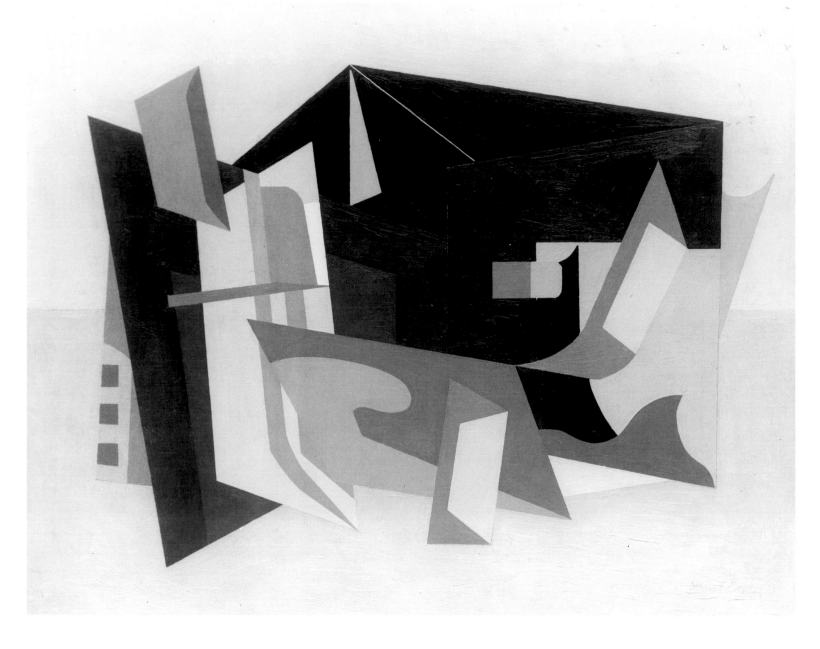

FIG. 47
STUART DAVIS, *Egg Beater No. 1*, 1927. Oil
on canvas, 29 1/8 x 36 in. (73.9 x 91.4 cm).
Whitney Museum of American Art, New
York, Gift of Gertrude Vanderbilt Whitney
31.169

With Quinn's legal skills sorely missed, Whitney offered Steichen
her help. As her attorneys fought through the courts, Watson edi-
torialized in *The Arts* and joined McBride and Duchamp in
protests at the Customs House in downtown Manhattan. Finally, in
November 1928, the court accepted the *Maiastra* as a sculpture.

Force and Whitney singled out Davis for their patronage
during these years. In December 1926, with some of his work
already hanging in the "International Exhibition" in Brooklyn, the
Whitney Studio Club held a major retrospective of his art.
Comprising at least thirty works,[168] the show charted Davis's
career from 1911 to the present. It included four of the still lifes
that had announced his engagement with Picasso's ideas in
1921–22 and set his course over the following years, although

Force selected few of the most recent works. Despite lukewarm
reviews from Watson and McBride in the press, she gave Davis an
allowance of $125 a month for twelve months: "That was what I
lived on for a year."[169] Having watched Davis for nearly ten years,
Force and Whitney chose this moment of internationalism in New
York to bet on him. During his year on stipend, Davis created the
first in his abstract "Egg Beater" series (fig. 47), based on the flat,
brightly colored geometries he had seen in Picasso's gouaches at
the Whitney Studio in 1923, and that he could have been able to
keep on hand in a set of reproductions. By 1927, geometric
abstraction was widespread among European artists, and had been
featured in the "International Exhibition" in Brooklyn the pre-
vious fall, but it was still a rarity in the United States.

Soon after the year on stipend ended, Force and Whitney
gave Davis an exceptional gift. They sent him to Paris, where their
continued support enabled him to remain from May 1928 through
August 1929. There he rented Jan Matulka's studio, wandered the
city, and sought out his heroes among contemporary artists.
Twenty years later, he echoed McBride's sentiments: "I am strictly

a European (French, that is) man myself, altho forced by birth and circumstance to live in the American Art Desert as exile. And then of course the 'Europe' I mentally dwell in no longer exists in actuality."[170] For a short time in the late 1920s, this "exile" must have seemed less fixed. By September 1928, he had exchanged studio visits with Léger: "He showed me all his newest work. Very strong. Next day he came to see my work. He liked the Egg Beaters very much and said they showed a concept of space similar to his latest development."[171] In his first letter home, Davis announced that an American editor, Elliot Paul, "is going to take me to Picasso's studio soon."[172] Since Davis never mentioned a meeting—and surely would have, had it taken place—Paul must have been unable to arrange a rendezvous with the increasingly elusive Picasso.

Nevertheless, Davis's paintings of this period (see plate 49) are steeped in two things: Picasso and the city of Paris. Indeed they are Paris seen through Picasso's eyes, or at least through the lens of the Picassos that Davis had known in New York during the 1920s—particularly the 1919 *Landscape with Dead and Live Trees* that had debuted among Kelekian's pictures at the Brooklyn Museum exhibition of 1921 and had then passed to Quinn. As Lewis Kachur has written, "The Paris pictures above all reveal Davis's consolidation of a stagelike space, often with a centralized architectural focus, a device he used in many later paintings."[173] This was the schema he had lifted from Picasso three years earlier for *Early American Landscape*, and he employed it to capture the intimate scale and theatrical pleasures of Paris—so different from the monumental grind of New York. Upon his return, Davis gave Whitney a triad of his work that perfectly captured his relationship to America and Picasso: *Early American Landscape, Egg Beater No. 1*, and one of the finest of his Parisian scenes, *Place Pasdeloup* (plate 49).

At the end of the 1920s, the New York art world was booming with diverse exhibitions and new venues for contemporary art. There were so many artists and so many galleries that late in the summer of 1928 Whitney and Force decided to close the Whitney Studio Club, which had served as a lifeline for many American artists and sponsored the Studio exhibitions. Renamed "the Whitney Studio Galleries," the program offered less financial support to artists and focused on presenting exhibitions to educate new, free-spending collectors.[174] The major arrival was "The Gallery of Living Art," an experimental institution that took the place of Dreier's Société Anonyme in representing "progressive twentieth century painters" and offered a more evenly matched counterweight to the Whitney Studio.[175] Located on the Washington Square campus of New York University, only a few blocks from the Studio on Eighth Street, the Gallery was the creation of Albert Gallatin, a wealthy blueblood who led a desultory life until middle age, when he became a committed convert to modernism.[176] The dissolution of Quinn's collection and Watson's editorializing for a museum of modern art played large roles in shaping his course, as did the advice of his friend McBride. Having joined the board of N.Y.U. in December 1926 (his great-grandfather had been a cofounder of the institution), Gallatin opened the Gallery of Living Art a year later with a display centered on Picasso.

In July 1927, Gallatin wrote to McBride about his preparations for opening the gallery: "For nearly four months now I have devoted most of my time to studying the Ecole de Paris. I have had three visits of about three hours each, to Picasso, who has shown me an almost endless amount of work."[177] Mentioning that he had bought two of Picasso's Cubist drawings, a painting by Braque, and a watercolor by Léger, Gallatin isolated a phase of Picasso's art that would become the foundation for the Gallery's program: "To date I think his compositions and abstractions of 1912–15 are his most important things. . . . I have bought a very fine painting of this period for my collection." The inaugural exhibition included this picture, *Still Life with Bottle, Playing Cards, and a Wineglass on a Table* (1914; fig. 48), along with four other works by Picasso. With the acquisition of six more during the next two years, the collection earned the praise of James Johnson Sweeney (a future curator of the Museum of Modern Art) as "offering what is probably the fullest representation [of Cubism] publicly visible" in the United States.[178]

There was no need to qualify the compliment. At that moment, no public or private collection rivaled Gallatin's Cubist group. In fact, of any American collector, Gallatin had come closest to rebuilding Quinn's collection, albeit on a narrower plan. But Sweeney's description caught the dual nature of the Gallery of Living Art. It was Gallatin's private collection—he selected and paid for all of its pictures, and in the 1930s would guide its aesthetic toward geometric abstraction. Yet during its fourteen years on Washington Square (until 1942, when the University abruptly decided to withdraw the rooms that housed it, and he moved the entire collection to the Philadelphia Museum of Art), the Gallery functioned as a museum open to the public, one that offered rare opportunities to approach avant-garde art. The inaugural exhibition included thirteen American artists, ranging from Kuhn and Charles Burchfield to Charles Demuth, Marsden Hartley, and Force's assistant Alexander Brook. Gallatin conceived a space that resembled the Whitney Studio Club more than it did any future museum—a series of lounges filled with tables and chairs, where individuals and groups could gather to examine the art at their leisure and engage in conversation, serious or casual. While N.Y.U. students often ridiculed the paintings hanging on the walls, the gallery truly became a cradle of "living art" in the Depression years.

By the late 1920s, America's economic prosperity buoyed increasing enthusiasm for the idea of a museum devoted to modern art, whether American or European. This interest ranged across generations, from the pioneers Whitney, Dreier, and Barnes (whose foundation opened in Merion, Pennsylvania, in 1925) to the newcomer Gallatin and other established collectors who had not yet extended their private passion into a public commitment. It was another editorial by Watson, in June 1927, that inspired Gallatin to pursue his project of the Gallery of Living Art.[179] "The Ideal Autocrat" began by rehearsing Watson's campaign: "The need for a museum of contemporary art has been set forth frequently in THE ARTS. 'Heaven send New York a museum of modern art, so that folks may see what is going on in the world!' This is a sentence from THE ARTS of May, 1926." Drawing on his years of experience working with Force and Whitney, Watson shifted from repeating the call for a museum to laying out an

ambitious mandate for the director of this anticipated institution, who he asserted would have to be forceful, enlightened, and autocratic. To press this view, he surveyed the alternative, decrying how "slowly and timidly" museum committees work, and he criticized the influence of patrons, amateurs, and artists: "Yet, ungracious as it may sound, the capacity to make handsome gifts to a museum does not prove that the generous donor is endowed with the necessary wisdom to give advice helpful to the museum." Arguing for public disclosure of all the museum's internal deliberations and "a director who is fearless and capable of withstanding the pressure brought to bear by private organizations of artists or by other politically inclined groups," he dreamed that "our new museum of modern art can and will be a power in the enrichment of American civilization. Its success will depend upon its good fortune in discovering an ideal autocrat who is immune to favoritism."[180] Here, Watson was not entirely realistic. While Gallatin could serve as both board of trustees and director of his Gallery of Living Art, a truly diverse museum would require numerous patrons and could not escape a far more complex relationship between donors and staff. Watson knew this, but, perhaps testing his own candidacy or promoting Force's, he had advanced to the question of how an ideal museum should function.[181] This may suggest he believed that patrons were already committed to founding institutions.

For all the editorializing, however, it was a death and another auction that tipped the balance. Once again Picasso was at the center. October 1928 saw the passing of Arthur B. Davies. Six months later his collection of at least 450 items, 201 antique and 249 modern, crossed the block at the American Art Association, where Kelekian's had appeared six years earlier. Between these two sales, the American art world had grown to maturity—in fact, it had begun to reach the first stages of worldwide leadership. Davies had become a legend as an organizer of the Armory Show in 1913, and he was a trusted advisor to Quinn and Bliss, among other adventurous collectors. One measure of his eminence was his nomination by Watson to join Quinn in leading the acquisitions committee of the Metropolitan Museum of Art during an attempt (ultimately defeated) to open it to modern art in 1921. Despite the fact that he was an artist and his own work might come under consideration, Davies was considered beyond reproach.

Davies was famous for the wide range of artists he endorsed, but he had a particularly deep and long-standing fascination with Picasso. He probably bought from Stieglitz's first exhibition in 1911 and certainly purchased a gouache from the Armory Show. In 1915 he acquired a major Cubist painting from the Modern Gallery, and he continued to add works during the later teens and 1920s. Among those documented are the small *Abstraction, Biarritz* (1918), which he purchased at Kelekian's sale in 1922, and *Female Nude (J'aime Eva)*, acquired from the Whitney Studio Club's 1923 exhibition. Since Davies did not keep precise records of his collection and regularly disposed of works, it is impossible to determine the exact scope of his acquisitions. In a 1926 auction of works from his collection, he offered thirteen Picassos, and the following year he sold to Dreier *Bar-Table with Musical Instruments and Fruit Bowl* (ca. 1913), the painting he had bought from the Modern Gallery in 1915.

The sale of Davies's estate, in April 1929, received nearly as much attention as Quinn's, but this time Americans did not merely lament its liquidation. Howald acquired *Female Nude (J'aime Eva)* and quickly gave it to the Columbus Gallery of Art. Pach bought the Armory gouache *Landscape (Two Trees)* for Walter Arensberg. And soon after the sale, Phillips bought the small Picasso that had been in Kelekian's collection, *Abstraction, Biarritz*. His Memorial Gallery (which opened in Washington in 1921) was one of the first private museums devoted to modern art. Coming two years after his 1927 purchase of *The Blue Room*, his decision to buy *Abstraction, Biarritz* suggests a leap into Cubism, but Phillips remained skeptical of both Picasso and the style. Rare among Americans, he preferred the liquid passages and smoky tonalities of Braque, whom he thought more "French."[182] The real importance of the sale, however, lay not in the purchase of art. (Davies's pictures didn't rival the quality of Quinn's.) Rather, the event was the final shove that galvanized Davies's friends to found the institution that he and many others in the art world had long sought.

A series of concurrent exhibitions celebrated Davies's career as an artist and revealed how devoted and prominent his patrons had really been. One of these shows was organized by Bliss and Abby Aldrich Rockefeller, and took place in the private gallery of the Rockefeller mansion. The *Herald Tribune* reported, "That it should be organized at all was by itself a testimony to the power which Davies exerted though his art."[183] Although these women certainly admired Davies's art, his opinions were at least as influential. Pach recalled that he and Davies had long urged Bliss to establish a public exhibition hall.[184] In the view of Bliss's niece, Elizabeth Bliss Cobb, Davies was the crucial inspiration for both their collecting and their decision to found the Museum of Modern Art: "These women would never have [founded MoMA] or even maybe made their collections if it hadn't been for Arthur B. Davies. . . . I think that his influence on these women is what brought it all about."[185] In December 1928, Abby Aldrich Rockefeller told Davies's son, "I feel that I owe [your father] a very great deal, because he inspired and encouraged me to acquire modern paintings, and without the confidence which his approval gave me I should never have dared venture into the field of modern art."[186] When Bliss and Rockefeller happened to meet in Haifa during a winter trip to the Middle East, they gave serious thought to founding the museum. Back home, they invited another of Davies's admirers, Mary Quinn Sullivan, to join them in the venture and began to draw up a plan for the institution. With their mentor dead, a candidate for president was essential. Kuhn would claim that he declined Bliss's suggestion that he take the job and instead recommended A. Conger Goodyear.[187]

A month after the auction, Goodyear received an invitation to lunch with Mrs. Rockefeller. Not having met her before but eager to know her and to see her collection, he accepted and found himself seated with Bliss, Sullivan, and his hostess. As Rockefeller summarized the events to Goodyear seven years later,

> I suggested [to Bliss and Sullivan] that we form ourselves into a committee of three and that we find a man to be president of the museum that was to be. We met again and after much thought decided that we would invite you

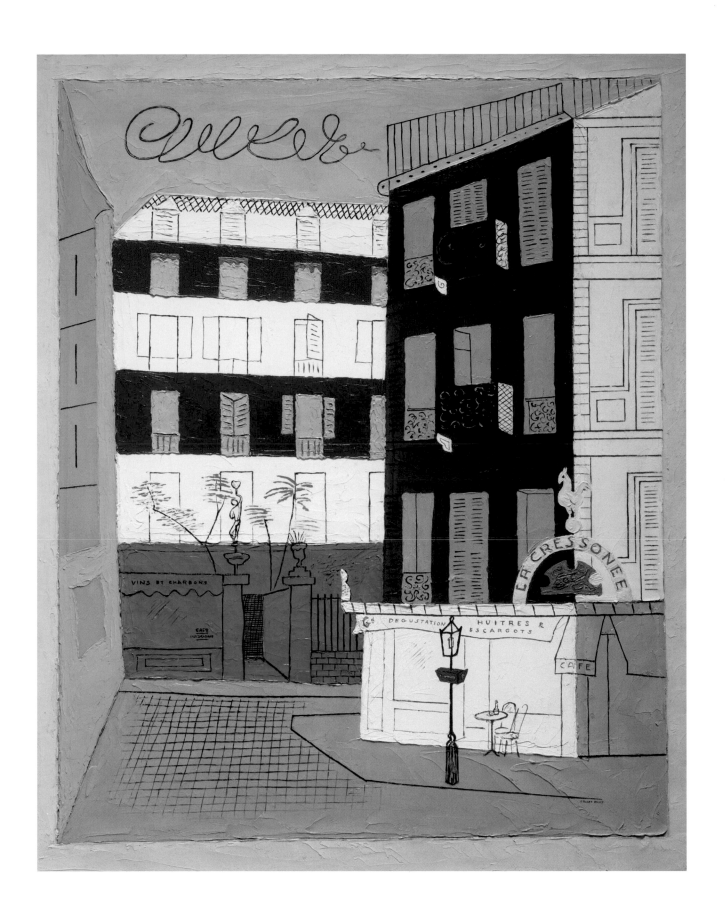

PLATE 49
STUART DAVIS, *Place Pasdeloup*, 1928. Oil
on canvas, 36 1/4 x 28 3/4 in. (92.1 x
73 cm). Whitney Museum of American
Art, New York, Gift of Gertrude
Vanderbilt Whitney 31.170

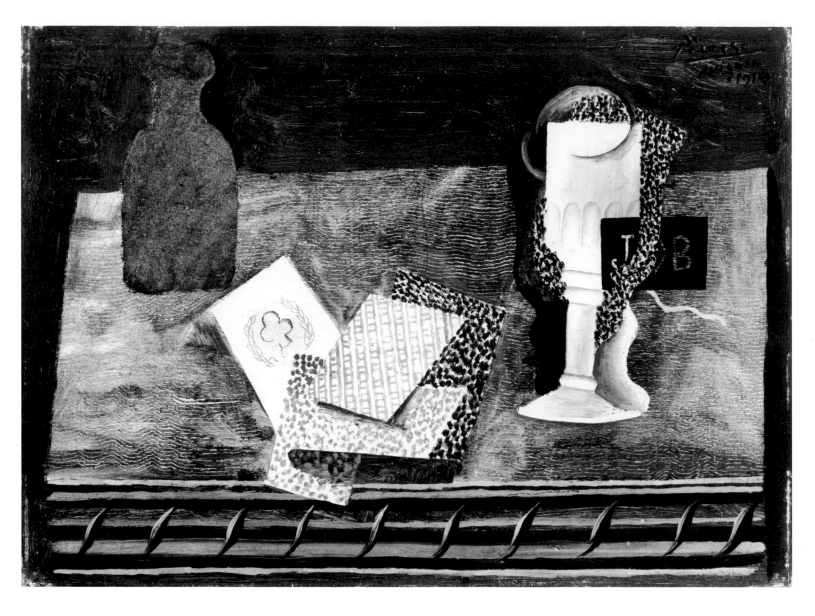

to meet with us and discuss the possibility of your being president. We did this because we had been told of your efforts in the cause of modern art in Buffalo and that you had resigned the presidency of that museum because the trustees would not go along with you in your desire to show the best things in modern art.[188]

Goodyear had brought Dreier's "International Exhibition" to the Albright Gallery, and had acquired several modern works for the collection. The more important recommendation, though, was surely his acquisition of Picasso's *La Toilette* in 1926 and his resulting dismissal from the board, which created an art-world scandal that reached the most rarefied circles of Manhattan society. Whether or not Davies recounted the tale to the women, they chose a candidate with proven resolve (enough to match Watson's "Ideal Autocrat"), and Picasso was the test. From the origin of the Modern, Picasso was the emblem of the institution's commitment to the avant-garde.

As the founders of MoMA addressed potential supporters and Goodyear sought candidates for director through the summer, Whitney, Force, and Watson were advancing in their thinking about the museum of exclusively American art that they had long

contemplated.[189] Rather than create a separate institution, Whitney decided to offer her collection to the Metropolitan, along with sufficient funds to build a wing to house it. With proper guidance, these gifts would have achieved an integration of historical and contemporary, European and North American art (as well as Asian, Latin American, and African) that would have allowed American art to define its place in international culture. But the director of the Metropolitan at that time, Edward Robinson, did not share this comprehensive vision. In October 1929, perhaps sensing his resistance, or holding herself aloof as the great patron she was, Whitney sent Force to make the offer to him. Before Force could mention the endowment for the building, he dismissed the gift of art: "We have a cellar full of those things already."[190] When Force reported his response to Whitney and Forbes Watson (who arrived for the debriefing), Whitney resolved to found her own museum. Later, Watson's wife, Nan, insisted, "Don't you ever forget that it

FIG. 48
PABLO PICASSO, *Still Life with Bottle, Playing Cards, and a Wineglass on a Table*, 1914. Oil on panel, 12 1/2 x 16 7/8 in. (31.8 x 42.9 cm). Philadelphia Museum of Art, A. E. Gallatin Collection, 1952 (1952-61-95)

was Forbes's idea that it should be called the Whitney Museum of *American* Art."[191] And when the museum finally opened, in November 1931, so it was.

With the establishment of these two institutions in 1929, the United States both vaulted to the forefront of the international art world and began to sink into the nationalistic and aesthetic divisions that would rack the New York scene through the 1930s and '40s. The period of dreams and initiatives in the late 1920s gave way to more rigid defenses. The Whitney Museum of American Art was highly determined by its very name, which both gave the Whitney family public standing over other potential patrons and implied that the Whitney Studio's diverse program of recent years no longer held. The Museum of Modern Art was more generically titled, but encountered its own problems with the ambiguity of the word "Modern," and was accused of having veered to the opposite extreme from the Whitney in turning its back on the art of this country.[192]

These hostilities were already appearing throughout the art world as the two museums were founded. In November 1929, a group show at the Whitney Studio Galleries revealed how clearly the lines had been drawn. Reviewing the exhibition in the *New York Sun*, McBride focused on Davis, praising him as "the best delver into the abstract that we have." But he attacked him as indebted to Cubism: "if Picasso and Braque had never lived this artist of ours would have had to think out a method for himself. . . . It sticks in my gorge a trifle to see a swell American painter painting French."[193] Setting aside the facts that Picasso was Spanish and Davis showed no interest in Braque, McBride had dropped his years of advocating European art, and his love of Paris, to erect a barrier between the cultures.

Seeing this position as narrow-minded ignorance, Davis wrote an open letter to *Creative Art* laying out the absurdity of national divisions and accusations of influence. "In speaking of French art as opposed to American the assumption is made that there is an American art. Where is it and how does one recognize it? Has any American artist created a style which was unique in painting, completely divorced from European models? To soften this flock of hard questions I will answer the last,—no." Davis forthrightly stated Picasso's outstanding importance: Picasso "has been the dominant painter of the world for the last twenty years and there are very few young painters of any country who have not been influenced by him." And he took a commonsensical approach to the necessity of influence: "I did not spring into the world fully equipped to paint the kind of pictures I want to paint . . . why one should be penalized for a Picasso influence and not for a Rembrandt or a Renoir influence I can't understand."[194] While Picasso was far from the only European artist to inspire Americans in the following decades, he remained for Davis the fundamental point of reference. In turn, Davis became the mentor to less established figures, such as John Graham and the younger generation of Gorky and Willem de Kooning. Refusing the blinders offered by McBride and many others, these artists built on Davis's example to gather a community whose breadth of artistic reference and achievements blew past the gatekeepers.

CHAPTER THREE
(1930–1939)

"I FEEL PICASSO RUNNING THROUGH MY FINGER TIPS"
Arshile Gorky, mid–1930s

In the early 1930s, Arshile Gorky got his hands on the catalogue of John Quinn's collection, pored over its finely printed full-page reproductions, and made detailed copies of four paintings and one drawing, as well as slighter sketches of two more works. He may even have acquired the book with this goal in mind, since among its largely alphabetical compendium, stretching from Ingres's *Raphael and La Fornarina* (1814) to Cézanne's portraits of his father and wife, Seurat's *Poseuses* (ca. 1887), and Matisse's *Blue Nude (Souvenir of Biskra)* (1907), Gorky settled on a remarkably consistent group: seven in all, the works use classicizing styles to depict monumental figures, and the core are paintings by Picasso— *Harlequin* (1901; figs. 51 and 52), *Two Nudes* (1906; figs. 53 and 54), *Two Female Nudes* (1920; plates 50 and 51), and *Mother and Child* (1921; figs. 55 and 56). Ignoring Cubist pictures in Quinn's collection such as *Portrait of Wilhelm Uhde* (1910; plate 38) and *Harlequin with Violin ("Si Tu Veux")* (1918; fig. 26), he copied works that fell to either side of them chronologically: figurative works of the Blue and Rose periods and later neoclassical ones. The pictures Gorky chose by other artists reinforce his interest in monumental nudes: Jules Pascin's *Nude Study* (ca. 1915), Puvis de Chavanne's *Female Nude* (ca. 1865), and Augustus John's *Nude Study* (ca. 1915).[1]

Clearly, Gorky was fascinated by Picasso's neoclassical paintings, and he turned to the Quinn collection as the best place to find them. Many older artists in the American avant-garde had doubted these works since their first appearance in New York in the mid-1920s, understanding them as a retreat from Picasso's Cubist art of the teens, but Gorky and his community of artists embraced them. Nor did they pair this interest with a rejection of Cubism or other styles, historical or contemporary. During the same years, Gorky explored Analytic Cubism in several drawings, including a likely self-portrait in which he wears a diamond-patterned sweater that resembles the Harlequin costume Picasso frequently rendered (figs. 49 and 58). And he remained attentive to the old masters throughout his life. More than any other generation of Americans, however, Gorky and his peers proclaimed Picasso the undisputed master of contemporary art, and their respect for him stemmed as much from the freedom of style and subject matter he had practiced for more than a decade as from his earlier work. In the 1930s, New York artists such as Gorky's confreres John Graham, Stuart Davis, and Willem de Kooning, and a loose community including Jan Matulka, David Smith, Lee Krasner, and Jackson Pollock, among others, coalesced into an avant-garde of far greater depth and breadth than had previously existed in the United States. And Picasso was the unifying figure—on the one hand, for the range and power of his art,

which awed these young artists, and on the other, for the vociferous attacks on him by American critics who sought to define a national art isolated from European trends. As the decade passed, the artists' open embrace of Picasso made them first his defenders and later his intense competitors while they struggled to establish their own identities as avant-garde artists in America.

Although the prosperity of the late 1920s offered many American artists opportunities to visit Paris, few could maintain international travel during the 1930s. They fell back on gallery exhibitions to remain informed, supplemented by two increasingly important sources: a stream of publications devoted to prominent European artists and the showcase of the Museum of Modern Art. Most valuable among the publications was *Cahiers d'art*, which offered a window on what was happening in Paris by presenting large, high-quality reproductions of art, often photographed before the works left the artists' studios. When *Cahiers* debuted, in 1926, its editor, Christian Zervos, clearly judged Picasso the foremost contemporary artist, and he proved his long-term devotion six years later by producing the first book in a full-scale, multivolume catalogue raisonné that would continue publication until 1978. The Museum of Modern Art opened in November 1929 and held its first major exhibition in 1930; its program began slowly, but by the middle years of the decade exhibitions such as "Cubism and Abstract Art" and "Fantastic Art, Dada and Surrealism," both in 1936, had made it a primary force. Although the museum that organized the first American retrospective of Picasso's work was Hartford's Wadsworth Atheneum, in 1934, the Modern became the primary international arbiter of his reputation when it opened "Picasso: Forty Years of His Art" in the fall of 1939. During the decade of the 1930s, the Modern's founding director, Alfred H. Barr, Jr., largely built the institution's reputation through his support of Picasso, and a group of American artists emerged through dialogues with Picasso's art that were often defined by the pictures shown at the Modern.

Despite these growing opportunities, Gorky had to search to gain access to Picasso's neoclassical works, then more than a decade old. Upon his first arrival in New York, in late 1924, he had only begun to be interested in Cézanne's art and had not yet approached Picasso's, so if he followed the coverage of the Quinn collection at all, he probably paid attention to the array of Post-Impressionist pictures. When Gorky turned to neoclassicism some years later, the catalogue was a crucial resource, since none of these paintings had been purchased by Americans. (The early

PABLO PICASSO, *Femme Assise (Seated Woman)*, 1927 (detail of plate 63)

ARSHILE GORKY, *Blue Figure in Chair*, ca. 1934–35 (detail of plate 64)

classicizing painting *La Toilette* [1906; fig. 45], was in distant Rochester, and few similar pictures had attracted U.S. collectors.) Although it is easy to imagine Gorky being equally interested in the book's reproductions of *Three Women at the Spring* (1921) and *Mother and Child* (1921; plate 48), he focused instead on a double-page spread presenting the other Maternity and *Two Female Nudes*. Both are monumental, two-figure compositions of the early 1920s, but despite their similarities, they mark opposite poles of Picasso's neoclassicism: *Mother and Child* is a compact design rendered in broad brushstrokes and washes, with relatively little detail or layered modeling; *Two Female Nudes* is a highly finished work in which the massively rounded figures nearly fill an approximately square canvas and orchestrate a dialogue of overlapping, touching, and adjacent hands and legs. Not only is each woman densely modeled to emphasize her bulk but the planes of eyes, nose, mouth, and ears are drawn as sharply as carved stone. This painting particularly held Gorky's interest. Both in his copy itself and in the margins of the sheet, he repeatedly studied Picasso's schemas for the volumes of forehead, brow, socket, and lash surrounding the black irises, the geometry of the ear channels, and the clefts and bulges of the lips. He drew and redrew the positions of arms and legs to adjust both their girth and interplay. While Gorky simplified the composition of *Mother and Child* to a pattern of outlines and highlights defining the unity of infant and mother, he transformed the poses of the two seated nudes into a ballet of gestures and analyzed the precise mechanics of expression.

Along with many works made by Gorky and his friends during the late 1920s and '30s, his two paintings titled *The Artist and His Mother* cannot be precisely dated (ca. 1926–36; plate 53 and fig. 57). Like de Kooning, among others, Gorky rarely dated works during these years; whereas Picasso worked with a sense of his place in history, and in the knowledge that buyers awaited, these Americans worked in isolation from the marketplace and without expectations of any public reputation. They often repainted the canvases in their studios and kept few records of the works' stages, leaving historians with both the frustrations and the pleasures of attempting to understand such ambiguous material. Gorky may have begun to plan his composition in the mid-1920s and may have revised the two paintings as late as the early 1940s, but the evidence of his drawings and paintings suggests that he did the lion's share of the work in the early and mid-1930s. Whether or not he turned to the Quinn catalogue while he was conceiving the composition, he must have found its images relevant to the final two paintings: the subject of a mother and her child permeated Picasso's work of the early 1920s (after his son, Paulo, was born in 1921), and the Quinn book reproduced *Mother and Child* as well as the *Maternity* that Gorky copied. Besides the value of these images, his attention to the interplay of gestures in *Two Female Nudes*, and to the dark, chiseled eyes of the figures, seems deeply rooted in the most refined version of *The Artist and His Mother* (plate 53).

The two versions of *The Artist and His Mother* offer far more than the drawings that Gorky based on the Picassos; they are lovingly, laboriously wrought paintings. And reproductions—particularly black-and-white reproductions, like those in the

Quinn catalogue—convey little about the substance of paint, no matter how finely they are printed. Beginning in January 1930, however, a few of Picasso's neoclassical works were regularly on view in New York, initially in the Museum of Modern Art's first major exhibition of European art, "Painting in Paris from American Collections," and then in galleries that drew on private holdings in the city (plate 52).[2] The exhibition included three neoclassical pictures: Lillie Bliss's *Woman in White* (plate 47); *The Lovers*, lent by Mary Hoyt Wiborg (fig. 44); and a *Woman and Child*. All are from 1923, and all are characteristic of Picasso's neoclassicism of the mid-1920s. Where his idiom of the early 1920s had been highly sculptural (as in *Two Female Nudes*), these paintings are executed in a fluid technique that combines virtuoso runs of line with layered glazes and passages of encrusted pigment. *The Lovers* had been among the controversial paintings shown in New York at Wildenstein in 1923, and *Woman in White* may be his most exquisite painting in this series of neoclassical works.

In 1931, New Yorkers had an opportunity to see several more of these paintings when Maud and Chester Dale showed many of their recently acquired pictures at the Museum of French Art, a minor institution that the Dales briefly invigorated in the 1930s. Their collection was particularly apt for Gorky, since it reflected his own selection of Quinn's paintings: the Dales' admiration for Picasso's recent classicizing work led them to assemble a collection that jumped from the Blue and Rose periods to neoclassicism, with little attention to Cubism. This coherent presentation of Picasso's figurative work must have been a great boon to artists seeking to understand his departures from Cubism. In February 1931, the Dales achieved their greatest coup by purchasing *The Family of Saltimbanques* (1905) from a Swiss bank that had acquired it in a foreclosure, and at the end of the decade they bought *The Lovers* from Wiborg.[3] Maud Dale's 1930 monograph on Picasso apparently attracted Gorky, since he copied at least one of the works illustrated, *Woman Reading* (1920)—another neoclassical painting (see fig. 59).[4]

Although Gorky made fairly literal variations on Picasso's classicizing works,[5] his assimilation of their styles shaped many of Gorky's major paintings of the 1930s, including *Self-Portrait with Palette* (1937; plate 82) and the two versions of *The Artist and His Mother*. His episodic execution of both versions of the latter work over many years so intermingled their conceptions that it is impossible to establish a sure sequence. Nonetheless, the version in the National Gallery of Art, Washington, D.C. (fig. 57), is most likely to be the initial rendering, for it corresponds most closely to the source of Gorky's images, a photograph showing the young artist and his mother in 1912. The one in the collection of the Whitney Museum of American Art significantly alters the photograph in many ways, particularly by narrowing Gorky's left arm, turning his right foot to introduce a physical separation between the closely placed figures (a dialogue of proximity and detachment that is similarly explored in his copy of Picasso's *Two Female Nudes*), and sharply defining the volumes of their dark, deep-set eyes (also as in the studies of *Two Female Nudes*).

The surfaces and textures of the pigment play exceptional roles in both works, and here again a general sequence emerges. While both are accumulations of many layers, the National

Gallery's painting consists of roughly blocked areas filled with loose, often parallel strokes of dry pigment. The effect is sketch-like, particularly when compared with the meticulously polished finish of the Whitney's painting and its generally more dense execution. Even the areas of the Whitney picture that maintain a fluid structure (particularly Gorky's coat and his mother's apron) were sanded to remove the ridges of individual brushstrokes. Like the changes of posture, the technique suggests a process of meticulous refinement, passing from the photograph through the National Gallery's painting to the Whitney's. Gorky's broad, loosely layered strokes likely drew on Picasso's neoclassical paintings of the mid-1920s and, equally important, on the paintings of other Americans who were mining Picasso's work.

Graham had intently followed Picasso's career, in all of its variety, since the early 1920s. A Russian émigré who arrived in New York in 1920 and quickly established himself among the artists close to the Whitney Studio (where he began exhibiting in 1925),[6] Graham probably saw the exhibition at Wildenstein Galleries in New York in 1923, but he also made frequent trips to Paris that allowed him far more access to Picasso's recent production than most Americans enjoyed.[7] Graham took full advantage. In 1928 he painted his own version of Picasso's recent Harlequins (*Harlequin in Grey*, plate 54),[8] and in 1929 his variations on Picasso's neoclassical and Cubist work received recognition in Paris through an exhibition at the Galerie Zborowsky (famous for establishing Modigliani's reputation) and a monograph by a leading French critic, Waldemar George.[9] This acclaim in the French capital was unprecedented for a contemporary American artist (even a highly cultivated Russian), and Graham trumpeted his success to his patron Duncan Phillips.[10]

The previous year, Davis had arrived in Paris on Gertrude Vanderbilt Whitney's stipend, and had moved into the apartment of Matulka, another immigrant American who enjoyed the patronage of the Whitney Studio in the mid-1920s. (Even earlier than Graham, Matulka explored the range of Picasso's art in the 1920s [see plates 56 and 57], and later became a crucial friend and teacher of Smith and Dorothy Dehner.) As Davis and Graham spent time together in Paris, their friendship deepened, and back in New York in 1930 they joined with Gorky to create a triumvirate of contemporary American artists close enough that de Kooning would call them "the Three Musketeers."[11] As Davis

increasingly turned to political concerns during the following decade, Graham became the primary arbiter of Picasso's reputation among American artists.

Graham was too involved in the New York art world of the mid-1920s to have missed hearing about Quinn's collection, and he may well have called its rich group of Picasso's neoclassical pictures to Gorky's notice. Among his own paintings, his variations on these massive nudes received the greatest attention both from French critics and from Phillips,[12] and he showed a particular respect for the more lyrical paintings of 1923–24. Graham, like Gorky, was most drawn to Picasso's images of women, which in these years were often depictions of his wife, Olga Khokhlova. Graham's 1930 portrait of his own wife, Elinor Gibson (plate 55), preserves the pristine tonality and detached melancholy of *Woman in White*. Painted in the same year that *Woman in White* and related pictures appeared at the Modern, the portrait demonstrates Graham's share of a common response by himself and Gorky;[13] his dense variations on the washes of these Picassos offer an approach that Gorky seems to have worked into the National Gallery's version of *The Artist and His Mother*. Far more than technique, however, these paintings by Picasso and the two Americans are

FIG. 49
Anonymous photo of Arshile Gorky in his studio at 26 Union Square, signed "Arshile Gorky" and dated 1933

FIG. 50
PABLO PICASSO, *Self-Portrait with Palette*, 1906. Oil on canvas, 36 1/4 x 28 3/4 in. (91.9 x 73.3 cm). Philadelphia Museum of Art, A. E. Gallatin Collection, 1950

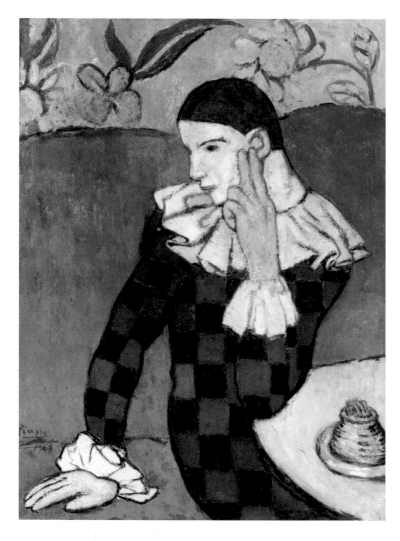

FIG. 51
ARSHILE GORKY (1904–1948), *Diptych: After Jules Pascin's "Nude Study" and Picasso's "Harlequin,"* ca. 1932. Graphite on paper, 12 x 16 in. (30.5 x 40.6 cm). Diocese of the Armenian Church of America (Eastern), on deposit at the Calouste Gulbenkian Foundation, Lisbon, Portugal

FIG. 52
PABLO PICASSO, *Harlequin*, 1901. Oil on canvas, 32 5/8 x 24 1/8 in. (82.9 x 61.3 cm). The Metropolitan Museum of Art, New York, Gift of Mr. and Mrs. John L. Loeb, 1960 (60.87)

FIG. 53
ARSHILE GORKY, *After Picasso's "Two Nudes,"* ca. 1932. Graphite on paper, 12 x 16 in. (30.4 x 40.6 cm). Diocese of the Armenian Church of America (Eastern), on deposit at the Calouste Gulbenkian Foundation, Lisbon, Portugal

FIG. 54
PABLO PICASSO, *Two Nudes*, 1906. Oil on canvas, 59 5/8 x 36 5/8 in. (151.4 x 93 cm). The Museum of Modern Art, New York, Gift of G. David Thompson in honor of Alfred H. Barr, Jr. (621.1959)

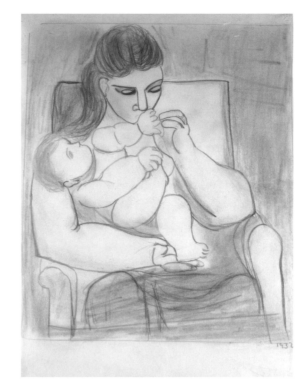

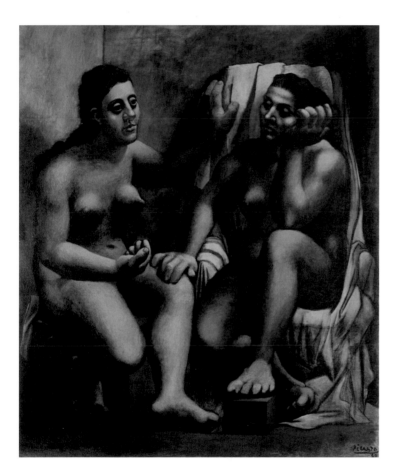

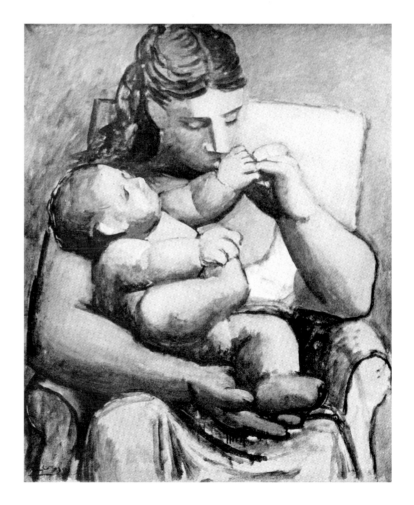

PLATE 50
ARSHILE GORKY, *After Picasso's "Two Female Nudes,"* ca. 1932. Graphite on paper, 12 x 16 in. (30.5 x 40.6 cm). Diocese of the Armenian Church of America (Eastern), on deposit at the Calouste Gulbenkian Foundation, Lisbon, Portugal

PLATE 51
PABLO PICASSO, *Two Female Nudes*, 1920. Oil on canvas, 76 3/4 x 64 1/4 in. (195 x 163 cm). Kunstsammlung Nordrhein-Westfalen, Dusseldorf (Inv.-Nr. 1039)

FIG. 55
ARSHILE GORKY, *After Picasso's "Mother and Child,"* 1932. Graphite on paper, 9 5/8 x 8 1/8 in. (27.5 x 20.6 cm). Diocese of the Armenian Church of America (Eastern), on deposit at the Calouste Gulbenkian Foundation, Lisbon, Portugal

FIG. 56
PABLO PICASSO, *Mother and Child*, 1921. Oil on canvas, 40 1/4 x 32 7/8 in. (102.1 x 83.5 cm). Private collection (location unknown)

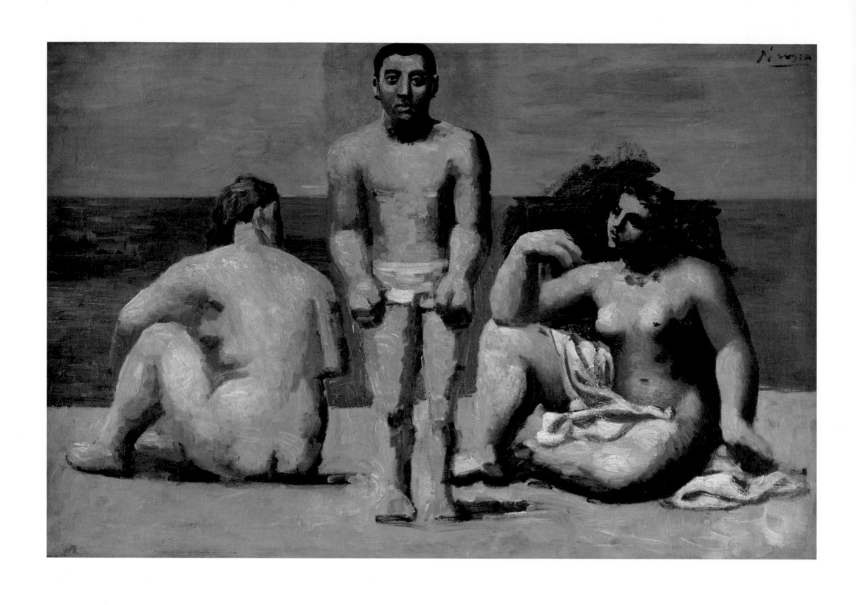

PLATE 52
PABLO PICASSO, *Bathers*, 1920. Oil on
canvas, 21 1/4 x 31 7/8 in. (54 x 81 cm).
Acquavella Galleries, New York

united in their elegiac mood and autobiographical subjects. Gorky transformed a small, battered photograph of himself and his mother, standing in the stilted poses of commercial portrait photography, into a monumental image capturing his reverence for her and the devastating loss he felt at her death through the Turkish decimation of the Armenians during World War I.[14] As he developed his concept, he drew on every aspect of Picasso's neoclassicism—its precise gestures, its definition of eyes and mouth, its substantial volumes, and the hazy atmosphere that detaches the images from naturalism and introduces a mythic distance.

Gorky's portraits plumbed neoclassicism well into the 1930s, but as the Depression wore on, he and his friends turned to another picture recently arrived in New York. In 1929, Albert Gallatin had bought Picasso's 1906 *Self-Portrait with Palette* from the artist and installed it in his Gallery of Living Art on Washington Square (fig. 50). Given the collection's primary emphasis on Cubism, the picture, one of the earliest works on view, was an anomaly there. While linked to Picasso's later neoclassical pictures, it avoids their elegance. This chiseled image of a powerful yet threadbare artist would resonate through Gorky's own self-portrait of 1937 (plate 82) and through de Kooning's images of men from the early 1940s.

From its opening, in 1927, until 1943, the Gallery of Living Art provided a Greenwich Village meeting place for avant-garde artists. Gorky and Graham shared their views of contemporary art here, surrounded primarily by the work of Europeans, particularly Picasso (who for Gallatin was "the big man of our time").[15] Like Graham, Gorky, and de Kooning, many of the American artists whose works were on view at the Gallery were themselves foreign born, and others had spent time in European capitals. The Gallery provided a haven of internationalism in a city and country of increasing provincialism.

Nonetheless, the bond that developed between Davis and Graham in Paris might never have emerged in New York, where Davis was seen as a longstanding devotee of Cubism and an associate of the Whitney Studio Club, while Graham had only begun to earn a reputation as a serious painter rather than a flamboyant poseur on the periphery of the art world. In Paris, however, Davis was a self-conscious Yank adrift in French culture, while Graham's true cosmopolitanism enabled him to attract admiration for his art and win the exhibition at Zborowsky that proclaimed his devotion to the School of Paris. Their differences balancing out, the two could meet in France as relative equals, although it was Graham who absorbed the most from the growing friendship.

Like Gorky, Graham freely embraced the stylistic variety of Picasso's many modes and had already painted a number of Cubist pictures in the mid-1920s besides his many neoclassical ones (see plate 58). Living only a short walk from Davis in Paris, he began a series of pictures that addressed Picasso through the lens of the American artist. In paintings based on views of Paris or of French towns, but particularly in *Palermo* (plate 59), a work he made in Italy in the summer of 1928, he adopted the stagelike composition that Davis had derived from Picasso in 1925, in *Early American Landscape* (plate 36), and had then employed as his primary device for depicting the city. Graham may have seen the original Picasso (*Landscape with Dead and Live Trees*, 1919; plate 27) during a July

visit to Baron Fukushima's collection;[16] if he didn't encounter it there, or find the reproduction of it in the Quinn catalogue, he must have discussed with Davis the underlying principles of the design. Back in New York, he increasingly joined Davis's explorations of Cubism, and he drew Gorky into close collaboration. By December 1931, he had announced to Phillips that "Stuart Davis, Gorky and myself have formed a group and something original, purely american [*sic*] is coming out from under our brushes."[17] Throughout the 1930s, Picasso remained the fundamental reference point for these three artists, but the crossfire among them often obscured the precise links to the master. The principles of Picasso's art were growing American roots.

The union among Graham, Gorky, and Davis, however, grew not only from their joint aesthetic beliefs but from their need to defend themselves against a rising hostility toward contemporary European art, and toward Americans who followed its models. When Henry McBride criticized Davis in late 1929 for "painting French," he singled out the most prominent Cubist in America, but he extended the charge to other artists, including Davis's friends. A few months earlier, he had reviewed Graham's first solo show in New York with the comment that "the Picasso influence continues strongly and disconcertingly." Apparently irritated that Graham had not followed journalists' previous advice, he had lectured the artist that "the criticism has been urged in print several times and no doubt will shortly get his art founded on something more securely his own. He must, in fact, if he is to have a career."[18] Other critics, if less bluntly, had similarly emphasized Graham's dependence on Picasso and his fellow Europeans. Writing for the *New York Times*, Lloyd Goodrich had dismissed the work as "rather crude reminiscences of Picasso, Braque, Gris and Matisse."[19] By December, Graham would complain to Phillips that *The Arts* (where Goodrich was a regular contributor) was ignoring his work and that "the Whitney Club intrigue seems to make my efforts in New York hopeless."[20]

Davis's lengthy and considered response to McBride's "painting French" charge spoke in defense not only of his own work in the Whitney Studio show that McBride was reviewing but of the young artists around him and the beliefs they shared. Their sense of artmaking as an ongoing process enriched by references to other art, both past and present, was profoundly historical; yet the history they addressed was primarily European. This direction conflicted with the increasingly provincial focus of many American art critics, who were given a loophole, an opening to attack, by the artists' willingness to expose the roots of their work rather than claim creative autonomy. The artists' feeling that they were joining modernist traditions, indeed their pleasure at the prospect, enabled their detractors to harness an avant-garde standard—originality—to question their accomplishment by asserting that their immersion in the work of Picasso and his contemporaries constituted a failure of imagination. Meanwhile, artists who adopted an "American" stance, such as Thomas Hart Benton, were praised for their revisions of Renaissance and Baroque prototypes. American avant-garde artists would confront this double-edged definition of originality for most of the next two decades, simultaneously struggling with their own self-doubts, trying to defend themselves from unsympathetic critics, and working to create art that they and their supporters believed would make a significant contribution to modern traditions.

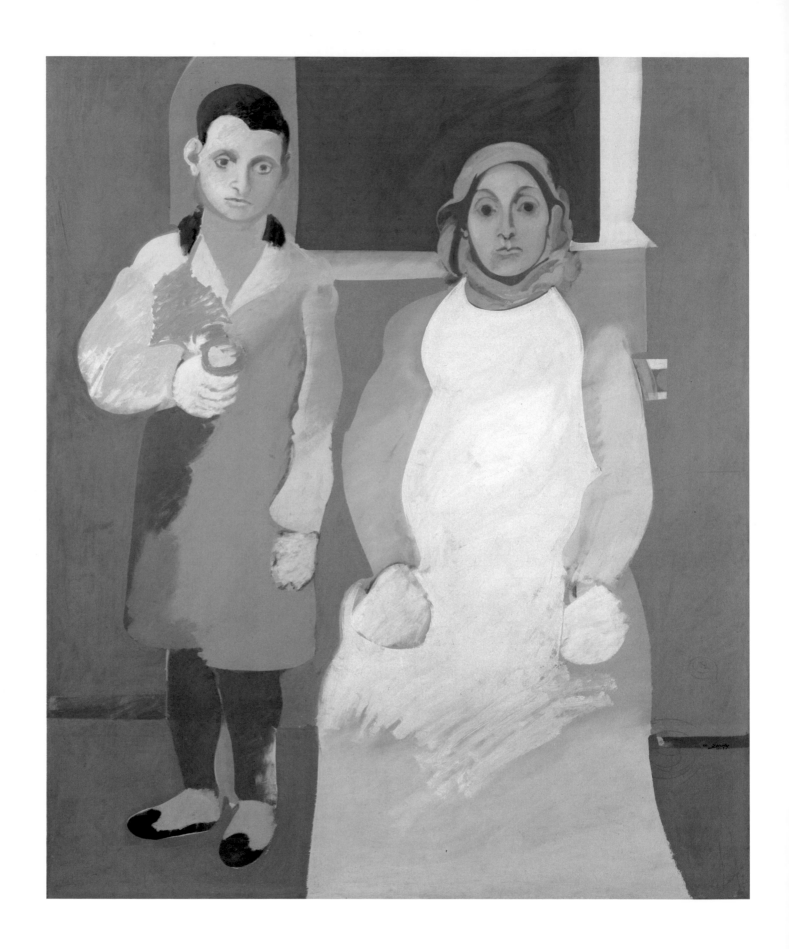

PLATE 53
ARSHILE GORKY, *The Artist and His
Mother*, ca. 1926–36. Oil on canvas, 60 x
50 in. (152.4 x 127 cm). Whitney Museum
of American Art, New York, Gift of Julien
Levy for Maro and Natasha Gorky in
memory of their father 50.17

120

FIG. 57
ARSHILE GORKY, *The Artist and His
Mother*, ca. 1926–36. Oil on canvas, 60 x
50 in. (152.3 x 127 cm). National Gallery
of Art, Washington, D.C., Ailsa Mellon
Bruce Fund

121

FIG. 58
ARSHILE GORKY, *Cubist Portrait*, ca.
1928–31. Graphite on paper, 30 x 22 in.
(76.2 x 55.9 cm). Private collection

FIG. 59
ARSHILE GORKY, *After Picasso's "Woman
Reading,"* 1932. Graphite on paper, 10 3/4 x
8 1/4 in. (27.3 x 20.9 cm). Diocese of the
Armenian Church of America (Eastern),
on deposit at the Calouste Gulbenkian
Foundation, Lisbon, Portugal

Having witnessed the critics' shifting positions toward European art during the 1920s, Davis could step back and try to wake them up with deadpan wit and clarity. For Graham, the situation was more intimidating, especially as it affected his only substantial patron. In February 1930, Graham felt confident enough of Phillips's support to recommend the purchase of work by Davis, but a month later Phillips wrote to say that he was returning an *Abstraction* by Graham ("Frankly our collection is not quite so radical as that, not even my experiment station") and to announce that the country's economic collapse, and the settlement of his mother's estate, would require him to end a regular $200 payment that was Graham's only dependable income. Phillips disapproved of Graham's avoidance of his wife and child, and this played a role in the rejection, but the patron was closing his aesthetic preferences along with his checkbook. Support could continue, he told Graham, if the artist would

put a curb on your impetuous inventions and be satisfied just to paint good pictures based on traditions . . . instead of keeping one eye on Picasso and trying to constantly keep up with him. It wouldn't do you any harm to stay in this country with your Wife and child as I fear when you go to Paris you get too much Bohemia and too much of the contagions and the latest movements which are really a curb on your originality. You are one of the best painters in America and you stand out more over here than you do in Paris where there are so many like you. Think it over.[21]

Graham spent much of the 1930s doing just that. In the coming months and years he would send Phillips a number of long-winded analyses casting Picasso as a figure of the past and justifying Graham's own claims of uniqueness. A rambling effort of May 1931 stressed "the difference between my paintings and Picasso's. . . . Outside of a slight superficial resemblance they are mutually opposed to each other, while Picasso's painting is analytic mine is synthetic." Graham concluded, "One more thing that separates us is that Picasso is still a romantic, sentimentalist (even in his most daring, weird and abstract things) of the soft Victorian era, while I am all of our iron age, am all of steel"[22]—a characterization remarkably like one quoted in Forbes Watson's review of Picasso's exhibition at Wildenstein in 1923. Despite the dismissive rhetoric, Graham did not hide his admiration of Picasso, or his rejection of the notion that artists must repudiate the past. In a follow-up letter to Phillips, he described Picasso as "by far the greatest painter of our generation. Leger, Arp, Mondrian are more up to date, more modern but he is greater than all of them taken together, though he is the last vestige of romanticism. His influence is enormous, and his influence cannot be escaped as he could not escape the influence of his predecessors." In an effort to introduce some perspective and defuse the issue, Graham focused on the most recent historical artist of undisputed importance: "All paintings after Leonardo are chronologically after Leonardo; all paintings after Cézanne are chronologically after and could not be before. Everybody was influenced by Cézanne, including Picasso. Artists who denounce

Cézanne are influenced by Cézanne . . . everybody who came after Cézanne were painting *after Cézanne* to some extent at least." Then he leaped to the current situation: "All painting after Picasso is *after* and can not be before, such is the law of time. We all use the discoveries of the past as we all use brushes and canvas. We use the painters of the past as we use paint, so much per tube, so much per magazine reproduction."[23] Graham's conception of art as a historical process enriched by references to works both past and present matched Davis's in his response to McBride the preceding year, and guided his fellow artists, particularly Gorky and de Kooning, across the decade as they wrestled with both their own desires for self-expression and the art world's view of modernism.

The emphatic "after" of Graham's quip became famous in the art world as he gained stature and became Picasso's strongest advocate in New York. It passed from late-night discussions at the Waldorf (not the grand hotel but an automat where downtown artists gathered during the Depression) to his theoretical text *Systems and Dialectics of Art*, which he finally saw published in 1937. This wide-ranging polemic barely masked an obsessive fascination with Picasso. The following year, Graham explicitly acclaimed Picasso's genius in a widely read article, "Primitive Art and Picasso." Four years later, he organized the most influential early exhibition to pair contemporary American art with works by Picasso and his confreres, "American and French Paintings," at McMillen gallery in New York.

During the 1930s, Graham's artistic productivity diminished, while his activities as a critic and an advisor to collectors became his principal means of earning a living. Not surprisingly, when he resumed painting in the early 1940s his mark was still Picasso, but now he turned from admiring competitor into rabid detractor, circulating a hyperbolically hostile essay, "Case of Mr. Picasso," that embarrassed even friends such as de Kooning and Pollock.[24] During the preceding decade, however, even if Graham was far too erratic and self-aggrandizing to enhance Picasso's reputation among the American public (as Barr would accomplish so discreetly), his influence on artists, critics, and curators had been profound. His intimacy with artists in Paris gave him an authority that matched his natural bravado and made him a powerful advocate of the avant-garde among the American artists who were plumbing and transforming modern tradition.

The condemnations of the early 1930s were not limited to Picasso's "followers." At the moment his reputation appeared secure, critics began to ridicule his own work, leaving his American admirers even more alone in a rising tide of antimodernism. As a young writer for *The Arts*, Goodrich was one of the first to attack, although he later admitted, "I'm ashamed of it, because it was very . . . anti, and didn't show any interest in what he was doing at all, the new developments in Picasso's art."[25] His excuse was Watson, the editor of the magazine, who had turned away from his earlier support of European art to become an ardent nationalist. In February 1930 and again in March 1931, *The Arts* ran dismissive reviews by Goodrich that cast doubt on Picasso's present and past achievements. The first article was a roundup on both a retrospective of Picasso and Derain and the Modern's "Painting in Paris" exhibition. While admitting "the

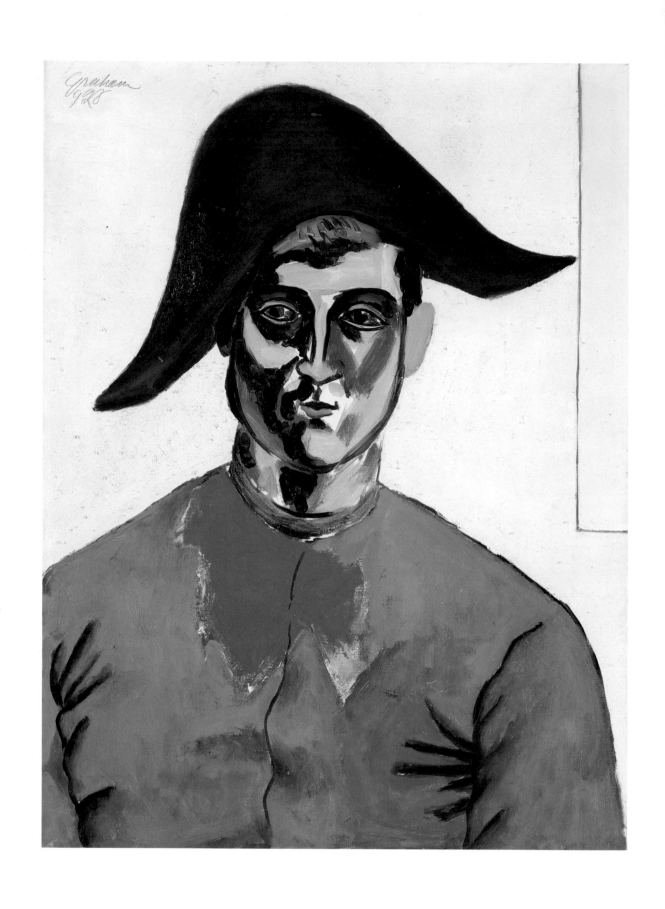

PLATE 54
JOHN D. GRAHAM (1881–1961), *Harlequin in Grey*, 1928. Oil on canvas, 28 5/8 x 21 1/4 in. (72.7 x 54 cm). The Phillips Collection, Washington, D.C.

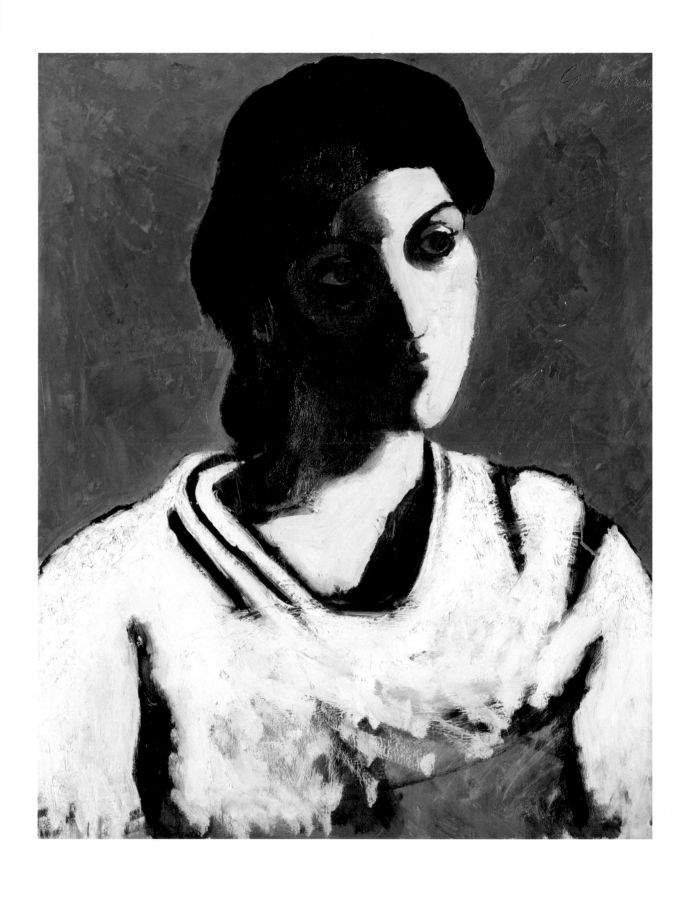

PLATE 55
JOHN D. GRAHAM, *Portrait of Elinor Gibson,*
1930. Oil on canvas, 28 1/8 x 22 in. (71.4 x
55.9 cm). The Phillips Collection,
Washington, D.C.

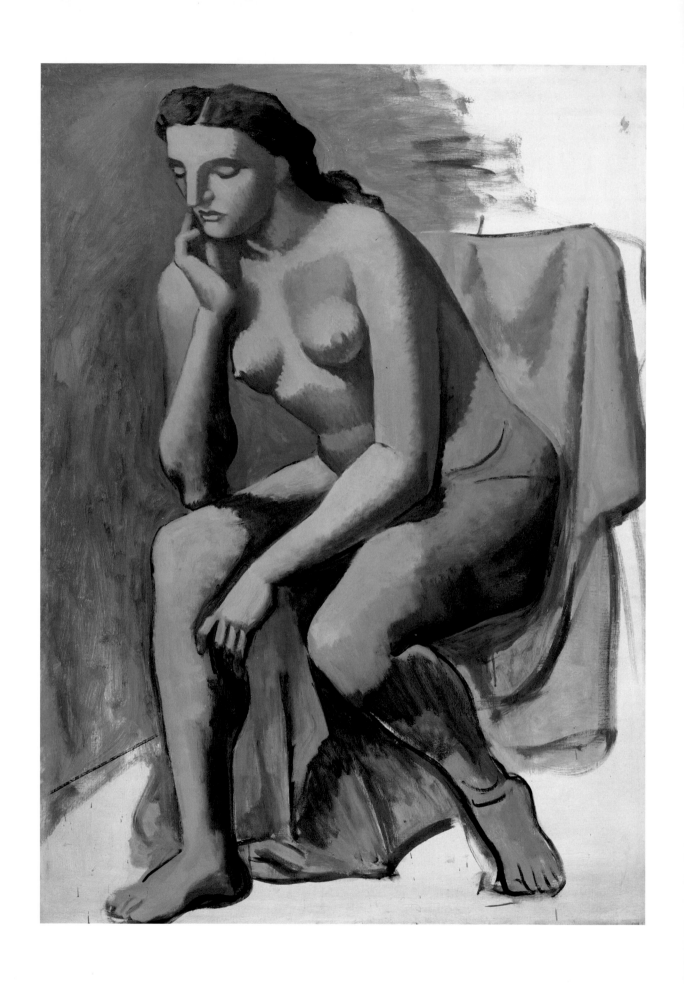

PLATE 56
JAN MATULKA (1890–1972), *Seated Nude with Eyes Closed*, ca. 1921. Oil on canvas, 48 x 34 in. (121.9 x 86.4 cm). Thomas McCormick Gallery, Chicago

devouring curiosity, the demoniac brilliancy, that make Picasso the most ingenious and fertile inventor in painting today, with an influence over contemporary styles probably more widespread than that of any single artist," Goodrich adopted the old line that Picasso's diversity was his downfall. Recalling "the *chic* insipidness of form in his sentimental, pseudo-romantic figures of a few years ago," the critic proposed that his art suffered from "a constant pursuit of stylistic novelties rather than an organic development of central artistic character . . . the profoundest qualities of formal design seem to have remained unrealized by him." With a nasty turn, Goodrich ended with the suggestion that "these purely decorative propensities" were "a reversion to the Oriental tradition which in former ages has entered Europe by way of Spain," making Picasso's art "as much Oriental and African as Latin."[26] In a culture increasingly hostile to the foreign, Picasso was declared more alien than the Europeans.

Goodrich's March 1931 review addressed "Abstractions of Picasso," a survey of recent work at the Valentine Gallery (see fig. 60). Joking that the group might better be called "Extractions by Picasso" because of the bonelike elements in many compositions, Goodrich repeated the charge that "he has never really attacked the central problems of art form" and only made "brilliant *pastiches* and parodies." This time with greater confidence, Goodrich returned to his charge of "Moorish" influence on Picasso's art and belittled him as having

> long been the Playboy of the Western World; and in his inexhaustible, restless search for novelties, he has hit upon a new method of startling us. But I doubt whether so many people will be startled this time. Most of us know our Freud too well and have been psychoanalyzed too often to be frightened by bugagoos in which the stage-setting is so apparent. These nightmares are no more convincing than the plaster goddesses that Picasso was erecting back in 1920 or the plushy Victorian lovers of a few years ago.[27]

For these tough Americans, neoclassicism remained a signal failure.

Goodrich capped his dismissal of Picasso's work in the Valentine exhibition with the observation, "It is significant that these creations do not seem to have caused as much of a stir as Picasso's inventions have done in the past, and that they seemed to interest the populace more than the artists, who looked at them with a rather skeptical eye."[28] Many American artists did pay less attention than they had in the 1920s, and they took little interest in the psychological explorations that underlay this phase of Picasso's art. Yet this exhibition and others across the decade were crucial to the artists who would be recognized as leading American art in later years, particularly Graham and Gorky.

Among the critics of avant-garde art, Thomas Craven was both the most vitriolic and the most influential, first in his dismissal of contemporary European work, then in his acclamation of Benton and other Americans associated with Regionalism.[29] His 1929 article "The Curse of French Culture" made McBride's slaps seem like accolades.[30] In 1934, in his book *Modern Art: The Men, the Monuments, the Meaning*, Craven sought to deliver the final blow to

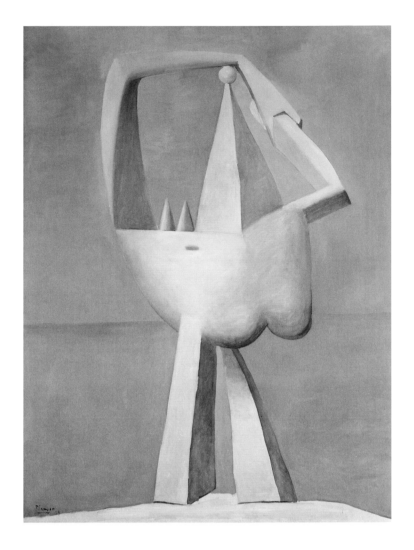

the avant-garde, artist by artist: Picasso was "the king of the international Bohemia in which whim and lazy cultivation of illusion take the place of life."[31] He was "rude and illiterate,"[32] and his art was a fraud "sold to dealers" by "Max Jacob, an apostate Jew."[33] While Craven spewed bigotry and lies with abandon, his ultimate criticism was that Picasso's art "reflects no environment, contains no meanings, carries no significance beyond the borders of the Bohemian world of its birth . . . he is at the service of nothing."[34] In a desperate effort to claim an American contribution that obviously did not exist on aesthetic grounds, Craven defined a highly politicized environment in which art was judged by its social purpose and moral goals. During just this period, ironically, as war began again in Europe in the mid-1930s, Picasso and many of his contemporaries were responding directly to its challenge and creating some of the most powerful political art of the century.

As the 1930s passed, museums began to take control of Picasso's reputation in America. The first retrospective was the one in 1934 at the Wadsworth Atheneum, whose frenetic director, Chick Austin, leaped over Barr's meticulous efforts to organize a Picasso retrospective at the Modern by ceding curatorial control

FIG. 60
PABLO PICASSO, *Nude Standing by the Sea* (*Nu debout au bord de la mer*), 1929. Oil on canvas, 51 1/8 x 38 1/8 in. (129.9 x 96.8 cm). The Metropolitan Museum of Art, New York, Bequest of Florence M. Schoenborn, 1995 (1996.403.4)

PLATE 57
JAN MATULKA, *Arrangement with*
Phonograph, 1929. Oil on canvas, 30 x
40 in. (76.2 x 101.6 cm). Whitney Museum
of American Art, New York, Gift of
Gertrude Vanderbilt Whitney 31.298

PLATE 58
JOHN D. GRAHAM, *Still Life*, 1925. Oil on
canvas, 14 1/8 x 17 in. (35.9 x 43.2 cm).
Private collection

PLATE 59
JOHN D. GRAHAM, *Palermo*, 1928. Oil on
canvas, 15 3/4 x 19 3/4 in. (40 x 50.2 cm).
The Phillips Collection, Washington, D.C.

to Picasso's dealer Paul Rosenberg.[35] Opening on February 6, and running until the beginning of March, the show included seventy-seven paintings and sixty drawings and prints. It covered Picasso's career erratically, emphasizing his Blue and Rose periods and the work since he had joined Rosenberg's gallery in 1918. While the selection neglected Cubism, it did bring to America a few of Picasso's finest recent paintings, including *The Dream* and *Girl before a Mirror* (both 1932; see fig. 61).

Unfortunately, no artists have been identified among the twenty-one thousand visitors to the exhibition during its three-week run, but it seems likely that some took the train up to Hartford—and even if they did not, Rosenberg presented a selection of the work in a group show at the Durand-Ruel Galleries in New York. Although none of the recent paintings appeared, the exhibition did hang nine even newer watercolors and gouaches, works that Picasso had made in 1933 when disputes with his wife, and the birth of his daughter with his lover, Marie-Thérèse Walter, distracted him from large canvases. Rosenberg reported to Picasso that visitors bought seventy-two catalogues a day. McBride even put aside his hectoring of American artists to recall an old cause: "It is too bad that the times are what they are [he was referring to the Depression], for under happier conditions this series of pictures might have been swept en bloc into our modern museum."[36]

Barr was slowly building the Modern's collection, but until the end of the decade his efforts with potential donors brought only a few major acquisitions. During most of these years, the most frequent and varied opportunities to see Picasso's art came in galleries. Some, such as Reinhardt or de Hauke, presented occasional shows that included works by him, but the Valentine Gallery was the primary venue, particularly for Picasso's new work.[37] The business was named after F. Valentine Dudensing, who started it in 1926 with Matisse's son, Pierre, as his partner. Dudensing's father, Frank, had owned a gallery devoted to nineteenth-century French art, but had occasionally showed contemporary work—in fact, he had staged Graham's first exhibition in New York. Dudensing opened the gallery to represent contemporary art from France, and in 1930 he mounted Joan Miró's first solo exhibition in the United States. During the gallery's early years, he showed Picasso in annual group shows, but he made no great commitment to the artist until late 1930, when he severed ties with Pierre Matisse and strengthened his relationship with Rosenberg, who was eager to circulate inventory during the Depression. Dudensing developed a friendship with Rosenberg and Picasso that enabled him to obtain much of the artist's most important work during the 1930s and to be the first to present it in New York. His gallery became the essential place to keep track of Picasso. Beginning in January 1931 with the "Abstractions of Picasso" show that Goodrich would attack in *The Arts*, Dudensing held a string of major exhibitions in 1933, 1936, 1937, 1938, and 1939, several of them spanning Picasso's entire career. The last of these shows had by far the greatest impact: it ganged *Guernica* (1937; plate 86) and dozens of its studies in Dudensing's 57th Street gallery, where they drew large crowds and much publicity.

"Abstractions of Picasso" was a startling beginning to this great run. Unlike *The Arts*, *Artnews* predicted that the exhibition's focus on abstraction would cause a "tremendous awakening in this new field of painting in America."[38] Although a third of the paintings were titled "Abstract Forms" or "Abstraction," they clearly described skeletal heads and monumental figures. Probably chosen by Rosenberg or Dudensing to suggest the works' fantastic imagery, the title did not disguise the malevolence of these creatures, which Picasso had conjured to capture the "convulsive beauty" and psychosexual conflict championed by the Surrealists. In future years, Picasso's Surrealist images would have a tremendous impact on American artists—far greater than the program dictated by the group's leader, André Breton. At this first introduction, however, only Graham seems to have responded to them: his aggressively crude painting *Embrace* (1932; plate 61) presents himself and his wife as crusty blobs locked in intercourse.

Most of the other paintings in the exhibition were still lifes showcasing the development of Synthetic Cubism from 1913 through 1929. These pictures immediately attracted both Graham and Gorky. Graham's *Blue Still Life* (1931; plate 60) adopts objects long familiar from Picasso's work: guitar, bust, and fish. The simplified geometries of the mid-1920s pictures in the exhibition had shown Graham how to achieve the suggestion of abstraction by reducing objects to a network of outlines of varying thicknesses, wrapped in a single color. Graham described similar principles in writing to Phillips a few months later about the relationship of his work to Picasso's: "Of the paintings, I have sent you [including *Blue Still Life*], some of them are based on the idea of incorporating several compositions in one. For instance—compositions of objects; composition of form and design independent of composition of objects; composition of color independent of the two previous. . . . This I say to stress the difference between my paintings and Picasso's."[39] Whether or not Phillips acknowledged the contradiction here between word and deed, he recognized a fine painting, and bought it.

Gorky, who had paid rather cursory attention to Analytic Cubism, responded deeply to the still lifes in "Abstractions of Picasso"—indeed, they marked the real beginning of his involvement

FIG. 61
Photograph of the Picasso exhibition at the Wadsworth Atheneum, Hartford, Conn., 1934, showing at right *Girl before a Mirror* and *The Dream*, Wadsworth Atheneum Archives, Hartford, Conn.

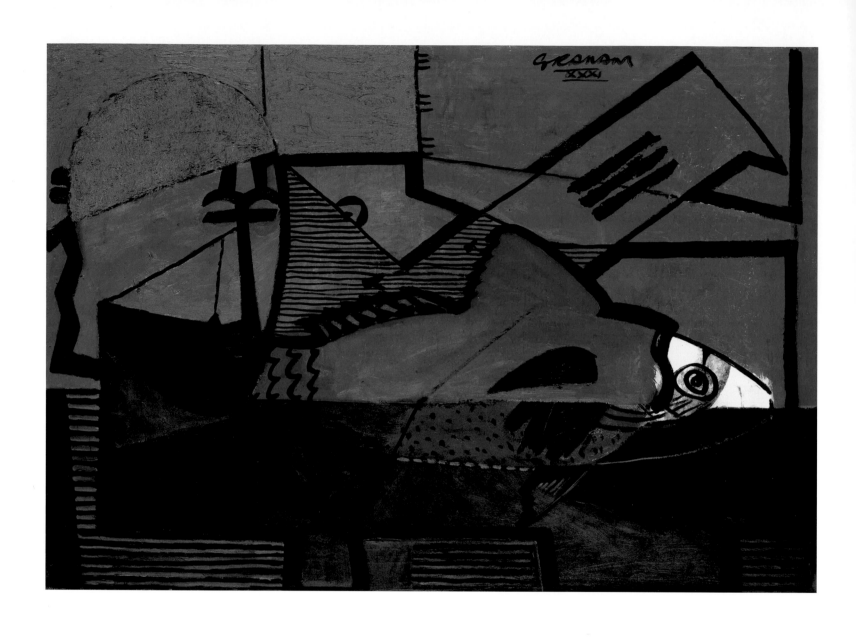

PLATE 60
JOHN D. GRAHAM, *Blue Still Life*, 1931.
Oil on canvas, 25 5/8 x 36 1/8 in. (65.1 x
91.8 cm). The Phillips Collection,
Washington, D.C.

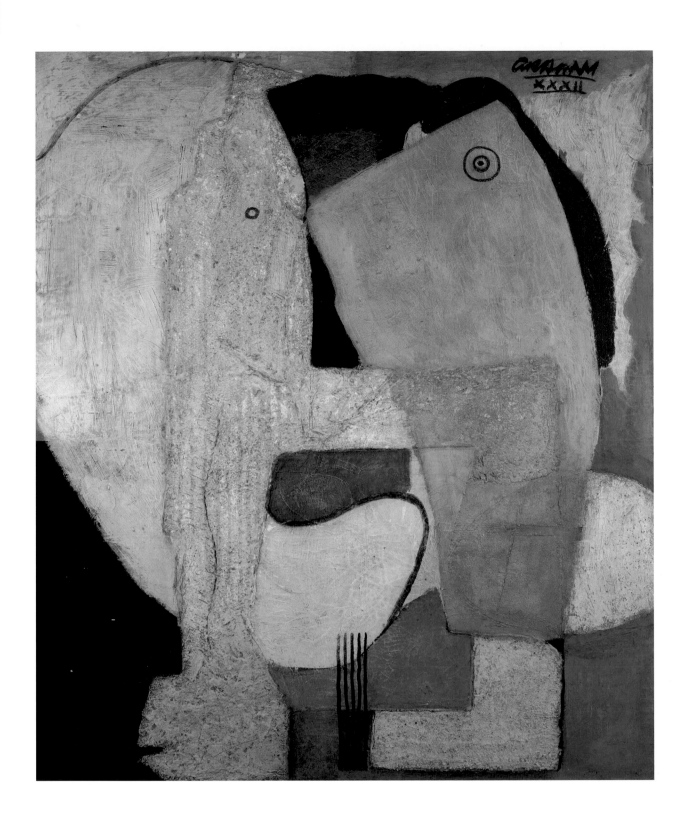

PLATE 61
JOHN D. GRAHAM, *Embrace*, 1932. Oil on
canvas, 36 x 30 in. (91.4 x 76.2 cm). The
Phillips Collection, Washington, D.C.

with Cubism and with the evocative power of ambivalence, eventually his greatest tool. He could not match either Davis's decade-long engagement with Picasso or Graham's sophisticated command of aesthetic theory, but in the end he proved the greater painter. By the mid-1930s, he had mastered the gamut of Picasso's techniques so fully that he could fairly claim "I feel Picasso running through my finger tips"—a double-edged assertion that captures his willingness to assume the other's styles without fearing the loss of his own artistic identity.[40] Even more than Davis and Graham, Gorky nurtured his art through a profound sense of tradition. Modernism sheltered him from an unresponsive American public and enabled him to believe that the works created by him and his friends were not isolated experiments but in the mainstream of a vital international culture. As Meyer Schapiro wrote in the 1950s, "To be a disciple of Picasso in New York in the 1920s and early '30s was an act of originality and, for a young artist in the solitude of his exceptional taste, an enormous task."[41]

In the months following the Dudensing exhibition, Gorky painted a series of still lifes adapting the interplay between simple geometric structures and bright, thickly textured pigments found in Picasso's still lifes of the early and mid-1920s. Nearly ten years earlier, in May 1923, these pictures had been well represented in the exhibition organized by Marius de Zayas for the Whitney Studio Club, but they had otherwise appeared rarely in New York before Dudensing presented his group of six. Reproductions in books and magazines, when available, had misrepresented their blocks of brilliant hues by reducing them to shades of gray.[42] The actual paintings seemed fresh, then; Gallatin and Walter Chrysler each bought one from the show. Gorky made a close variation, *Harmony* (ca. 1931–33; plate 62), in which he matched Graham's appropriation of outlines of varying thickness to impart a sense of abstraction to an arrangement of common objects, even though he did not employ the near monochrome of *Blue Still Life*. At this point, Gorky's paintings, particularly in his edges and arrays of parallel lines (favored by Davis as well), were cruder than Graham's. During the next year or two, however, in paintings such as *Quartet* (fig. 62), he would greatly refine his technique to achieve the virtuosity of Picasso's pictures—gliding from elegant lines to scumbled layers, from thin washes to rough masses of pigment. Meanwhile, Graham was drifting away from painting into efforts as a critic and consultant, while Davis was also reducing his studio time to focus on political organizing for socialist causes.

While Dudensing's opening exhibition of 1931 was influential, his final show of the year proved more important for Gorky. "Since Cézanne" was a title that certainly would have caught his attention, and the array of paintings included one by Picasso that would fuel his art for the next few years: *Femme Assise (Seated Woman)* (1927; plate 63), one of a long series of highly distorted figures that Picasso had begun in 1926. These works would have a profound effect on de Kooning's art in the 1940s, but Gorky preceded him by nearly a decade. One painting in the group, also called *Seated Woman* or more familiarly "Parrot Woman" (1927; fig. 63), was already notorious in America. Purchased by Mary Hoyt Wiborg in the late 1920s, it

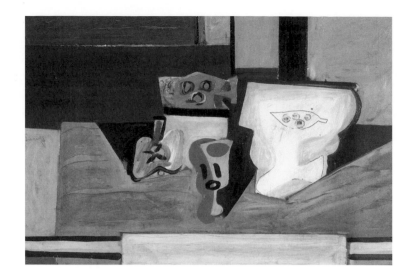

had been shown at the Modern in 1930 in "Painting in Paris," appeared in a show of Picasso's work at the Demotte Gallery in December 1931, and became even more famous after James Thrall Soby purchased it in April 1932, regularly lent it to the Modern, and later donated it to the museum. This *Seated Woman* presents a particularly malevolent image through its fleshy, beaked profile surrounded by shadowy ones, naillike clenched fingers, and dissonant colors of orange, red, and pink. Around 1934–35, in *Head* (fig. 64), Gorky would defuse this figure's threat by eliminating the dark frame and loosening the woman's taut profile into a series of cascading curves that flow into the surrounding composition.

The *Seated Woman* shown at the Valentine Gallery was also a sensation. Writing for *Artnews*, Ralph Flint called the painting "pivotal," although he found it less disturbing than the version in Wiborg's collection:

> It does not pack the terrific punch of the Wiborg vision, so psychically vivid and forbiddingly severe, but it is the same mazy kind of designing in which quick line and contrasting color areas interpenetrate with the inexplicable elasticity of mental imagery. There is something fiery and fierce about this Picasso, like a quivering gaze cast from afar upon a startled camp. With its harplike shapes and stringings, playing through the composition, it might just be called "The Harpy." Just as Miss Wiborg has repeated a goodly *reclamé* for her splendid Picassos, so will the collector acquire undoubted merit if he dare to take on this proud piece of abstract painting. If I were called to advise, I should urge him to do so forthright, let the chips fall where they may.[43]

Whether or not he read this review, Stephen Clark bought the painting from the Valentine Gallery on January 30, 1932, for

FIG. 62
ARSHILE GORKY, *Quartet*, 1932. Oil on canvas, 21 x 30 in. (53.3 x 76.2 cm). Diocese of the Armenian Church of America (Eastern), on deposit at the Calouste Gulbenkian Foundation, Lisbon, Portugal

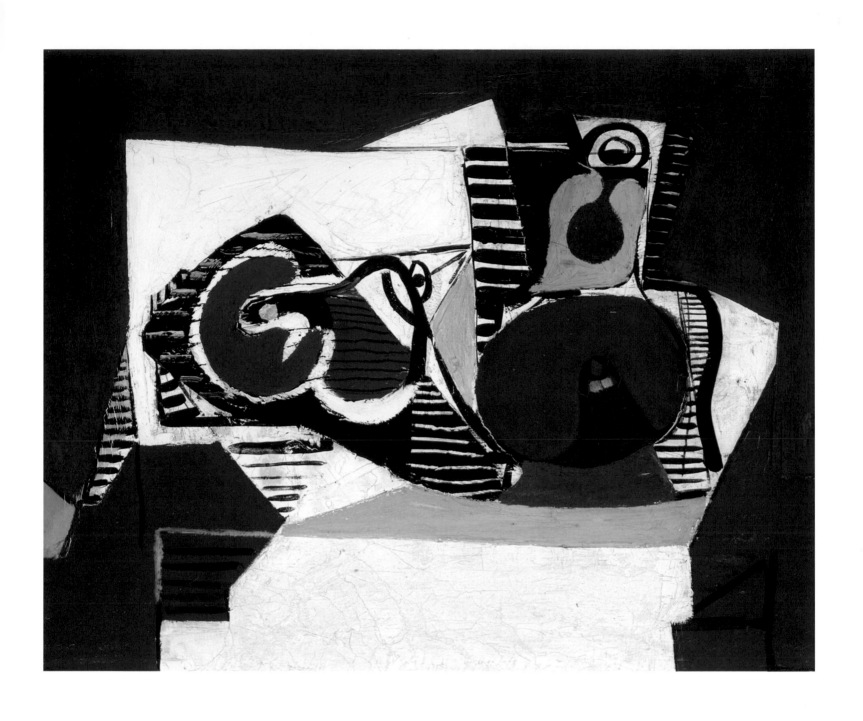

PLATE 62
ARSHILE GORKY, *Harmony*, ca. 1931–33.
Oil on canvas, 22 x 27 in. (55.9 x 68.6 cm).
Diocese of the Armenian Church of
America (Eastern), on deposit at the
Calouste Gulbenkian Foundation, Lisbon,
Portugal

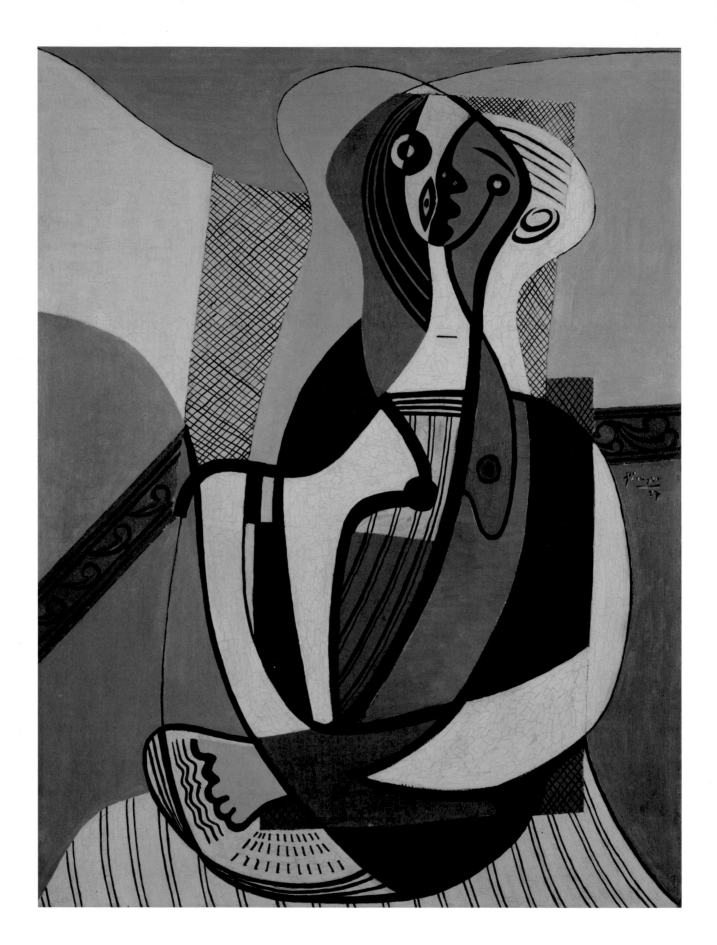

PLATE 63
PABLO PICASSO, *Femme Assise (Seated Woman)*, 1927. Oil on canvas, 51 x 38 in. (130.8 x 97.8 cm). Art Gallery of Ontario, Toronto, Purchase, with assistance from the Women's Committee and anonymous contributions, 1964

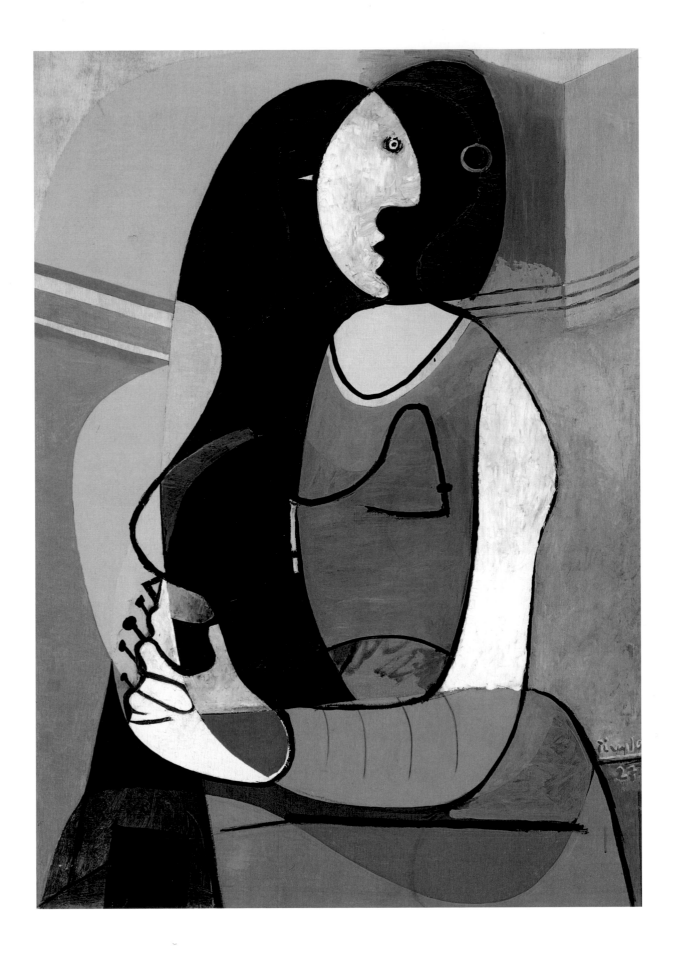

FIG. 63
PABLO PICASSO, *Seated Woman*, 1927.
Oil on wood, 51 1/8 x 38 1/4 in. (129.9 x
97.2 cm). The Museum of Modern Art,
New York, Gift of James Thrall Soby
(516.1961)

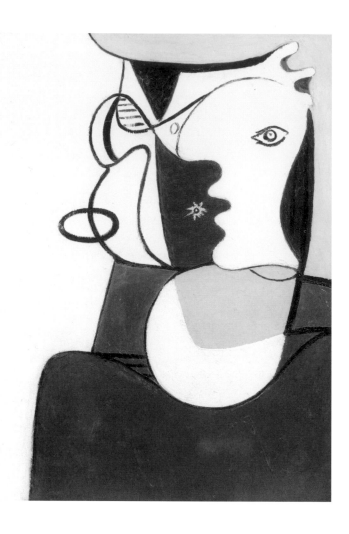

FIG. 64
ARSHILE GORKY, *Head*, ca. 1934–35.
Oil on canvas, 38 1/2 x 30 1/2 in. (97.8 x
77.5 cm). Collection of Carroll Janis

FIG. 65
ARSHILE GORKY, *Untitled (Abstract, Seated
Figure)*, 1932. Lithograph, 11 1/4 x 9 7/8 in.
(28.6 x 25.1). Brooklyn Museum, Dick S.
Ramsay Fund [63.116.5]

FIG. 66
ARSHILE GORKY, *After Picasso's "Seated
Woman"* (*Merkuhi*), 1932. Ink and
graphite on paper, 16 x 12 in. (40.6 x
30.5 cm). Diocese of the Armenian
Church of America (Eastern), on deposit
at the Calouste Gulbenkian Foundation,
Lisbon, Portugal

$15,000; in 1937 he donated it to the Modern, where he was a trustee.[44]

Flint's emphasis on the psychological impact of both pictures clearly placed them in the context of Surrealism, demonstrating that sophisticated American observers were well aware of the movement by that time. (Even Goodrich, earlier in 1931, had accused Picasso of making lame references to Freud.) After all, the movement had officially begun in 1924. Cosmopolitan Americans had seen the Surrealists' activities firsthand, and some American journals had passed on synopses of the movement's theories; among artists, Graham had absorbed many of those ideas on his visits to Paris. Yet the first substantial appearance of Surrealist art in America did not come until the same period as Dudensing's exhibition of *Seated Woman*, the winter of 1931–32. First, that November, the Wadsworth Atheneum opened an exhibition titled "Newer Super-Realism," presenting nine Picassos along with works by Giorgio de Chirico, Salvator Dalí, Max Ernst, André Masson, Miró, Pierre Roy, and Léopold Survage. Then, in January, Julien Levy opened a small version of the same show at his gallery in New York, but included three American artists as well. During the following three years, Miró, Dalí, and Ernst would receive one-man shows at either Levy's gallery or Pierre Matisse's.[45]

Although Picasso never joined the Surrealists, Breton claimed him as theirs, and much of his art of the late 1920s and '30s did explore Surrealist themes. Even with the scattered exhibitions of the official Surrealists in New York, Picasso's work was far more prominent and became the primary embodiment of Surrealist ideas for American artists; these ideas in turn drove many critics' interpretation of his work. Gorky's engagement with the Surrealist Picassos, however, resists the easy interpretations of critics and suggests little of the receptiveness to Surrealism that he would show in the early 1940s.

The dating of Gorky's work is so imprecise that it is unclear whether his preoccupation with *Seated Woman* lasted months or years, but there is no doubt that he focused on it intensively. Whenever in the three-week run of "Since Cézanne" he visited the show, he must have studied the painting closely and surely obtained a copy of the catalogue, which gave the picture a full-page reproduction.[46] His first essay may have been a sketch in ink and pencil that renders a woman's head and torso (fig. 66), with only the slightest attention to a setting—a band of cross-hatched wainscoting, probably derived from the painting. Although the drawing repeats the painting's combination of frontal and profile views, it encloses them in a regular sphere, giving the impression of a more naturalistic head than Picasso's elongated version. Gorky's rendering of the woman's breasts, too, are more naturalistically rounded and shaded, but his interest lay primarily in line rather than volume, particularly drooping and looping patterns that migrate from the woman's shoulders and chest to fill the interior of the figure and spill over its contours. Having laid out the basic design in pencil, Gorky reinforced parts of the sequence with pen and heavily worked the eyes and planes of the face to immerse the figure in a network of curves.

Probably in early 1932, Gorky also made a copy of *Seated Woman* in an untitled lithograph (fig. 65), generally called "Painter and Model," that is both closer to Picasso's picture and

more focused on Gorky's own pursuit of abstraction.[47] It fills out the surrounding space to show the woman seated in an interior, and certain features anchor the design to Picasso's—the closer conformity to Picasso's schema for the woman's head and breasts, for example, among other parts of her body. Yet Gorky did not preserve the grounding in realism that gives Picasso's image a sexual edge. He ignored the demure dress, with its high collar and striped fabric, that Picasso used as a foil for her nakedness, and he reduced Picasso's precise but scrambled rendering of her eyes, mouth, and long hair to a pattern of little more than shapes of solid black or white. Without reference to Picasso's image, one might easily read the print as a study in looping lines that overlap to generate areas colored black or gray, or simply left blank.

Gorky's decision to emphasize geometry over naturalism is confirmed by the surprising design in the upper-left corner of his lithograph, where he placed an even more direct reference to Picasso's work: a copy of one of his papiers collés, *Head* (1913; fig. 67). Rarely reproduced and nearly twenty years old, this collage of cut paper and a few strokes of black chalk was a far more unusual choice for Gorky than a recent painting on view in New York.

FIG. 67
PABLO PICASSO, *Head*, 1913. Papier collé with black chalk on card, 17 1/8 x 13 in. (43.5 x 33 cm). Scottish National Gallery of Modern Art, Edinburgh, purchased with assistance from the Heritage Lottery Fund and the National Art Collections Fund 1995

Moreover, it is one of Picasso's most radical reductions of the human form—an array of largely rectilinear shapes clustered to evoke the volume and planes of a head. Gorky's lithograph juxtaposes the collage to his own equally radical transformation of a woman's head. Initially, then, the print presents a comparison between Picasso's early Cubist innovations and Gorky's contemporary appropriation of those principles—yet the game is really three-sided, since Picasso's *Seated Woman* underlies Gorky's version.

Gorky's reference to the papier collé reveals more than his interest in Cubism: it also suggests his knowledge of Surrealism. For *Head* was owned by Breton, and one of its few publications was as an illustration in his book *Le Surréalisme et le peinture* (1928), an unlikely source for Gorky, except that the first American exhibitions of Surrealism—"Newer Super-Realism" at the Wadsworth Atheneum and the smaller version of it at the Levy gallery—occurred just before and after Valentine's "Since Cézanne" show. Presumably, these events attracted Gorky to Breton's manifesto of painting, where he saw the illustration of *Head* and may have learned of Breton's admonition that "the plastic work of art will either refer to a *purely internal model* or will cease to exist."[48] If so, his view of imaginative freedom was laboriously wrought, far from Breton's affirmation of spontaneity and the unconscious.

In December 1933, Graham wrote to Phillips, "I gave up abstract painting altogether, leaving it to Picasso who can do it best of all."[49] Gorky saw no need to cede the territory. His painting *Blue Figure in Chair* (ca. 1934–35; plate 64) marks the beginning of his most intense engagement with both Picasso's art and issues of abstraction, issues that would shape his mature styles. It is also proof of his devotion to the act of painting—both his own process and Picasso's. *Blue Figure in Chair* almost certainly follows the lithograph "Painter and Model," as well as the few extant drawings in which Gorky transformed shapes and tonal patterns of *Seated Woman*. He probably began with the design of the lithograph, and many aspects of it (particularly the swirling, black-and-white configuration of the head) remain. Yet the painting simplifies Picasso's composition much more than the lithograph had. In the process, the body of pigment itself, laid on in layers of shifting fields and defined by sharply contoured edges, becomes the source of Gorky's art.

Blue Figure in Chair is nearly indecipherable without reference to *Seated Woman*. The comparison shows how closely Gorky followed some elements of the composition, such as the outline of Picasso's double heads and the overlap of their profiles, while jettisoning most of the interior articulation that creates a sense of specificity. In fact, Gorky looked very closely at Picasso's painting (not just the reproduction of it) and focused on its execution in addition to its imagery. Beneath the polished rhythms of Picasso's final composition are the records of its development—layers of color, and edges of shifted planes, that reveal a work far more complex than the surface image alone. Picasso had not so willingly shown his tracks since the early years of Cubism; his openness to exposing his process had grown in parallel with the Surrealists' acclaim for the raw bedrock of the imagination. Even so, he rarely, if ever, left a complex composition in its initial state. More than Davis or Graham, Gorky pounced on the underlying

turmoil of Picasso's paintings. (He passed this fascination on to de Kooning, who made it the center of his art.) Dismissing the woman's twisted anatomy, and most of the other descriptive surfaces in Picasso's picture, Gorky located its drama in a competition of forms, a physical jockeying for place across the surface of the canvas and through its depth, both real and illusory. By dispensing with the details of Picasso's image, Gorky cleared the field so that each shape remained coherent, whether roughly outlined in black or honed to a sharp edge of color. One of the few details Gorky preserved was the commalike pattern of Picasso's wainscot, itself a shape in character with his own. Textured brushwork articulates the interiors of each form and integrates underlying layers of different hues without effacing previous formations.

As if to anchor the center of his composition, Gorky surrounded his spinning and overlapping curvilinear planes with an armature of rectangles. At the upper left, they replace the reference to *Head*, Picasso's papier collé of 1913, although they may appropriate its austere geometry. The lower band of the composition, however, is the most significant, both providing the figure's legs and directly articulating the work's center. These two slats and their interlocking mates bear a striking resemblance to the array of legs in another great Picasso: *Three Musicians* (1921; plate 65), which Gallatin acquired and showed at the Museum of Living Art in the fall of 1936. It is quite possible that Gorky resolved most of the composition in 1932 or '33 and returned to it after seeing *Three Musicians*. But there was an earlier chance: he could have seen the painting at the Modern late in 1934.[50] Whatever the occasion, Gorky's *Blue Figure in Chair* ranges across more than a decade of Picasso's Cubism to create a fundamentally new work.

Not only did Dudensing's "Since Cézanne" catalogue reproduce Picasso's *Seated Woman*, it also announced the availability of *The Studio* (1927–28; plate 66), a masterpiece that would obsess Gorky and his friends for the remainder of the decade. Dudensing first exhibited the picture in the major Picasso exhibition he held in March 1933. He soon sold it to Chrysler, who gave it to the Museum of Modern Art in 1935; only the third Picasso painting to enter the museum's collection, it immediately became a mainstay of the galleries.[51] *The Studio*'s spare vocabulary of primarily rectangular elements, clearly outlined and distributed across the canvas with little illusion of depth, creates an impression of highly disciplined order. Although Davis, Graham, and Gorky may have known the painting from reproductions in the late 1920s, those black-and-white images masked the vivid passages of yellow, red, and green that enliven the actual picture. And Gorky at least was not prepared to absorb its radical austerity until the mid-1930s, when it provided a laboratory for the abstraction that he and his friends were pursuing.

The impact of *The Studio* was intensified by the arrival of its sibling, Picasso's *Painter and Model* (1928; plate 68), at nearly the same time. Having contemplated the picture in Rosenberg's gallery for several years, New York collector Sidney Janis finally came to an agreement with him to buy it in 1933. The next year, Janis lent it to the Wadsworth Atheneum's Picasso retrospective, and the following year to the Modern for an exhibition of his own

PLATE 64
ARSHILE GORKY, *Blue Figure in Chair*,
ca. 1934–35. Oil on canvas, 48 x 38 in.
(121.9 x 96.5 cm). Private collection

PLATE 65
PABLO PICASSO, *Three Musicians*, 1921. Oil
on canvas, 80 1/2 x 74 1/8 in. (204.5 x
188.3 cm). Philadelphia Museum of Art,
A. E. Gallatin Collection, 1952

collection. But for once Gorky had no need of a public venue to see Picasso's work. The combination of economic collapse and the aesthetic dominance of American Regionalism during the 1930s kept most avant-garde artists isolated from all but a few collectors. Gorky and Janis were exceptions: like most who bought modern art, Janis primarily followed Europeans, but he had met Gorky in 1929 and had come to admire both his ability as an artist and his understanding of Picasso's work. He visited exhibitions with Gorky and enjoyed debating pictures with the artist. They may well have discussed *Painter and Model* during his years of hesitation, and there is no doubt that Gorky had ample time to study it in the Janises' apartment, which he visited regularly.[52]

Among Gorky's major paintings, *Organization* (plate 67) is his most layered and most protracted meditation on specific works by Picasso. For once, the dates Gorky inscribed on the canvas, "33–36," are probably accurate—stretching from the first New York exhibition of *The Studio* through its arrival at the Modern and residence near Picasso's *Painter and Model*. Gorky's sketches show an early desire to combine the open, linear architecture of *The Studio* with the more complex patterns of *Painter and Model*, but his response to Picasso's studio paintings turned from design to the challenge of realizing his concept in oil. By 1935, he was satisfied; he had spent approximately two years painting and repainting the canvas to achieve both a resolution of its imagery and the sheer body of pigment that gives tangibility to the painting's largely abstract forms. Yet Gorky almost immediately returned to the painting and again substantially remade it. In the process, he created two additional paintings— *Composition with Head* (plate 69) and *Still Life on Table* (both ca. 1936–37), major works as meticulously wrought as *Organization*— that extended his dialogue with Picasso's paintings into 1937.[53] This trio of paintings is in many ways the counterpart of the two versions of *The Artist and His Mother*, a pairing confirmed by the size of the five canvases, Gorky's largest of the 1930s; *Organization* and both versions of *Artist and His Mother* measure fifty by sixty inches each.

Not only did *Organization* and *The Artist and His Mother* consume Gorky for years but they overlapped in execution, since he probably worked most intensely on *The Artist and His Mother* during the mid-1930s. They confirm both his mastery of two seemingly opposing styles drawn from Picasso—neoclassicism and Surrealist abstraction—and his understanding of these styles' profound interconnections, as he fluently shifted from canvas to canvas and interwove the modes in each composition. The finish of each painting completes this interplay. While equally laborious, each creates a fundamentally different experience: the realism of the two figures in *The Artist and His Mother* is subverted by its ethereal polish, and the geometric structures of *Organization* are made tangible by its heavy crust.

We know that Gorky was satisfied with *Organization* by 1935 because he posed for a celebratory photograph (fig. 68). He and his friend de Kooning stand next to the canvas, giving it pride of place. Nor is this a typical photograph of artists in a studio: Gorky wears a three-piece suit and de Kooning is only slightly more casual, apparently having shed his suit jacket. In the depths of the Depression, neither dressed so formally except on

special occasions. The photograph suggests a public presentation, also a rare event for Gorky and his friends. By 1935, he had had only a single solo exhibition (at Mellon Galleries, Philadelphia, in 1934) and his work had appeared in only nine group shows. The first, and most hopeful, had been the Modern's "Exhibition of Works of 46 Painters and Sculptors under 35 Years of Age," in 1930. Although Barr had chosen three of Gorky's paintings for this show, his interest in Gorky's art had rapidly dwindled.

During the mid-1930s, however, Gorky began to receive serious public attention. In 1935—a year before Barr's famous "Cubism and Abstract Art" exhibition at the Modern—the Whitney Museum organized "Abstract Painting in America." The curators, Hermon More and Karl Free, were primarily concerned with established artists such as Max Weber, Marsden Hartley, and Georgia O'Keeffe, but even so they included four of Gorky's paintings. The topic of American artists' involvement with abstraction not only deviated from the Whitney's usual focus on realist art but demonstrated that Regionalist or "American Scene" painting, though dominant, was not the only significant approach to art in the country. "Abstract Painting in America" presented 134 works, ranging from Weber's *Bather* (1913) through the current day. To increase the exhibition's stature, the Whitney invited Davis to write the catalogue essay and introduced him as "one of the most brilliant exponents of the movement." Davis, of course, was not only the most prominent American artist associated with abstract art but a longtime associate of the Whitney. His essay drew on his experience of the Armory Show of 1913 and the following two decades of American art to establish the heritage of abstract tendencies in the country and to make a strong appeal for its current importance. An early draft contained direct criticism of American Scene painting, but this was dropped, presumably at the curators' request. The final text took the succinct, no-nonsense approach to the often arcane topic of aesthetic theory that Davis had long stated: "Our pictures will be expressions which are parallel to nature and parallel lines never meet."[54]

Perhaps Davis also advised the curators on the contents of the exhibition, but whether or not, their decision to include four paintings by Gorky was startling. Only seven artists equaled or surpassed his representation, and they were long established: Davis, O'Keeffe, Weber (whose nine works outnumbered any other artist's), Charles Demuth, Arthur Dove, Alfred Maurer, and John Marin. Three of Gorky's paintings came to the museum from a dealer, J. B. Neumann, but the last came from Gorky himself: *Organization*, dated in the catalogue 1933–34. Given the limited documentation of the exhibition, it is impossible to be certain whether this painting was the canvas that is now in the National Gallery of Art. Its title is generic, and is attached to another extant painting of these years; but that picture is quite small, and would seem an unlikely one for Gorky to have chosen from the many in his studio. Moreover, the photograph provides substantial evidence that Gorky was extremely happy with the big *Organization* when the exhibition was being arranged. The photograph might even celebrate its acceptance.

Attending a symposium held during the exhibition's run, Gorky was outspoken.[55] With three guests—Walter Pach, Leo Katz, and Morris Davidson—assembled to discuss "The Problem of

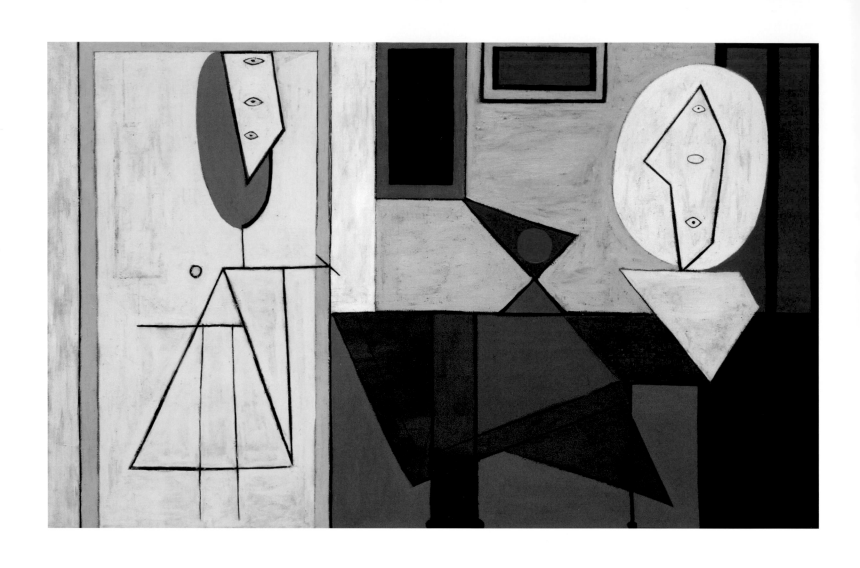

PLATE 66
PABLO PICASSO, *The Studio*, 1927–28. Oil
on canvas, 59 x 91 in. (149.9 x 231.2 cm).
The Museum of Modern Art, New York,
Gift of Walter P. Chrysler, Jr., 1935

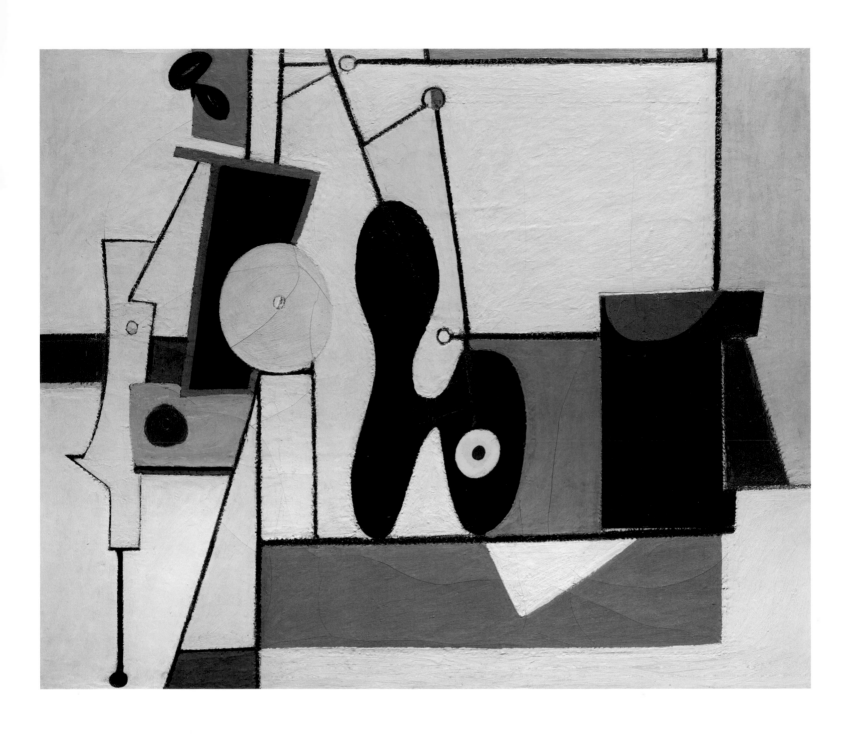

PLATE 67
ARSHILE GORKY, *Organization*, 1933–36.
Oil on canvas, 49 3/4 x 60 in. (126.4 x
152.4 cm). National Gallery of Art,
Washington, D.C., Ailsa Mellon Bruce
Fund 1979.13.3

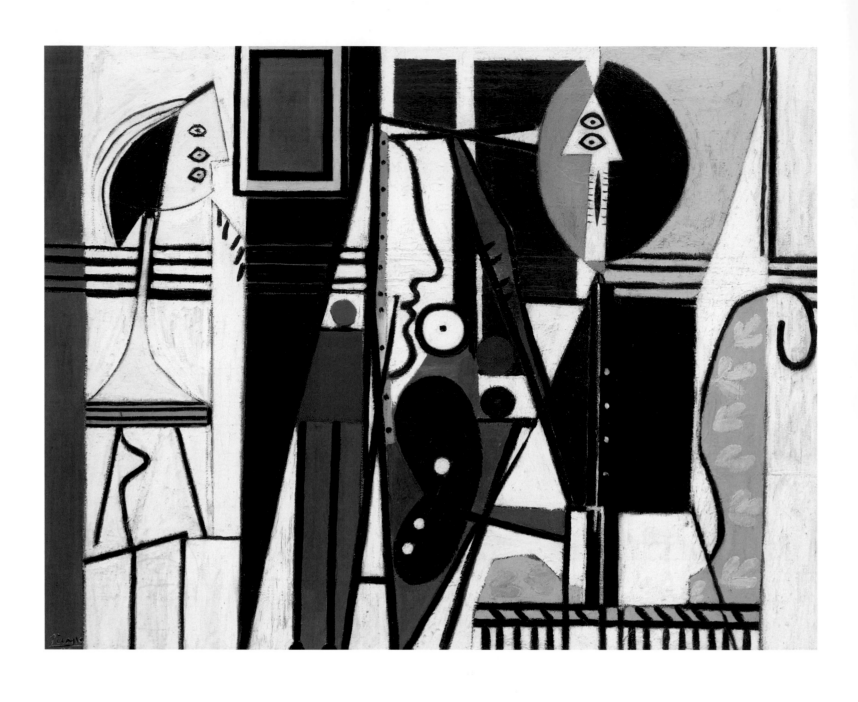

PLATE 68
PABLO PICASSO, *Painter and Model*, 1928.
Oil on canvas, 51 1/8 x 64 1/4 in. (129.9 x
163.2 cm). The Museum of Modern Art,
New York, The Sidney and Harriet Janis
Collection (644.19)

PLATE 69
ARSHILE GORKY, *Composition with Head*,
ca. 1936–37. Oil on canvas, 76 1/2 x
60 1/2 in. (194.3 x 153.7 cm). Collection
of Donald L. Bryant, Jr., Family Trust

146

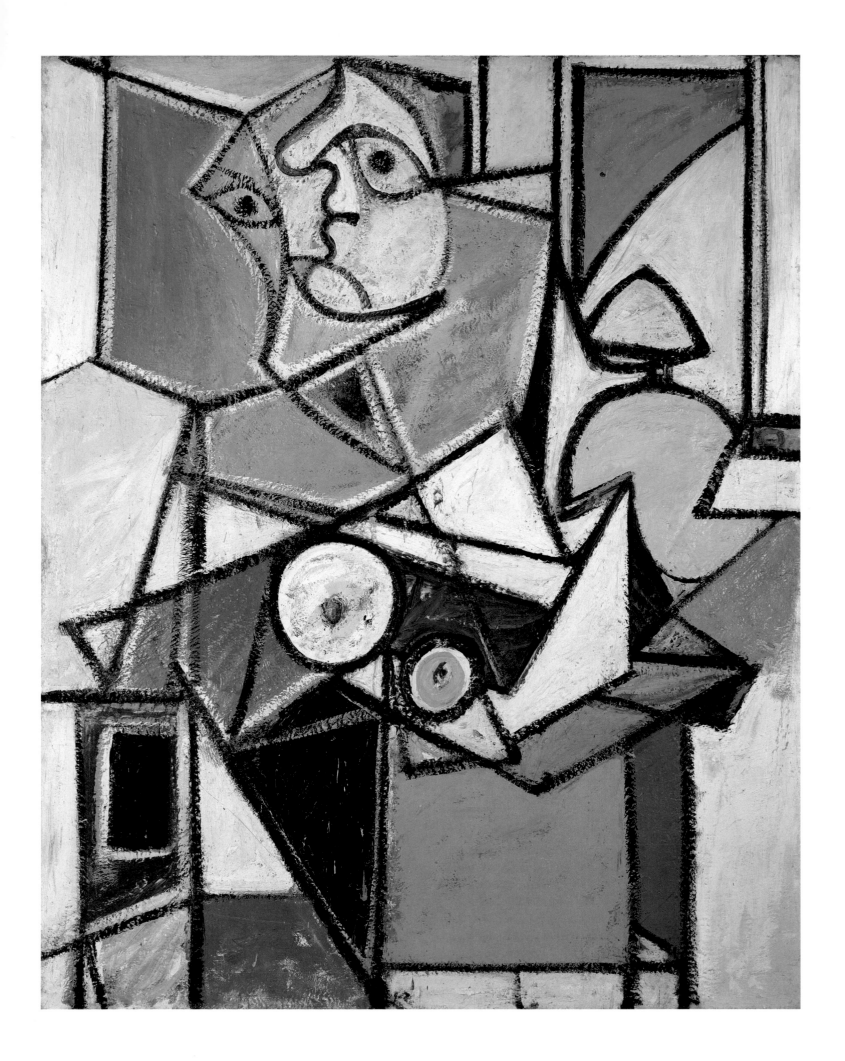

Subject Matter and Abstract Esthetics in Painting," Goodrich, both moderating and representing the museum, stated the conventional view that the greatest subject of art was the human figure. Gorky, one among many artists in the audience, stood up to challenge the speakers, saying, as Goodrich would recall, "You must analyze abstract art the way you analyze a fugue by Bach," then elaborating at length. If Gorky's analogy was neither surprising nor original, his audacity was. His recent achievements as an artist gave him confidence, and he must have felt emboldened by his prominence in the exhibition to speak so forcefully in public. "I didn't understand what he was talking about then," Goodrich would later remember, "so I thought he was being facetious, but of course he was serious. I didn't get what he was saying and I told him to sit down. He was right, and I was wrong. I never should have talked like that to an artist—I've always felt badly about it."[56] Indeed, Goodrich's response turned from dismissal to devotion remarkably fast. The following year, the *Organization* we know appeared in the Whitney's Third Biennial; in 1937 the Whitney bought *Painting* from that year's Annual (the first purchase of Gorky's art by any museum); his work appeared frequently in Whitney Annuals until his death, in 1948; and Goodrich, as the museum's director, spent years overseeing both a memorial retrospective held in 1951 and the first monograph on his work, published in 1957. It is hard to imagine a more ardent conversion. Even Barr relied on Goodrich's evaluations of Gorky's work.[57]

When *Organization* appeared in the Whitney's Third Biennial, in November and December 1936, it looked very different from the painting in the photograph of a year or two earlier. This transformation, a documented second campaign that was probably one of many during the mid-1930s, constitutes a radical reworking of the composition. Effectively it was a new painting, and to the Whitney curators who must have followed its progress, the changes may have justified a second exhibition. In a sense, Gorky's reference to a Bach fugue applies to the *Organization* recorded in the photograph. That first version was a dense array of lines, connecting to frame curvilinear forms and to articulate the field of the canvas. It lies halfway between Picasso's two paintings, *The Studio* and *Painter and Model*, though less figural than either one. The left side of Gorky's picture follows that section of *The Studio*—the stick figure of the painter, down to the oval disk of his head. Most of the composition, however, is more closely linked to *Painter and Model*, most obviously in the bulging black palette at the center of the composition, but also in the closely packed set of short, thick parallel lines that structures both the surface of the painting and an illusion of depth between the painter and his tool.

In comparison, the final version of *Organization* is far more economical and resolved. This direction suggests that Gorky had a second look at *The Studio*, and the timing seems right: after traveling as far as Honolulu (with intermediate stops in San Francisco and Chicago), the picture returned to New York for a summer exhibition at the Museum of Modern Art (June 4–September 24, 1935). This was four months after the closing of the Whitney's "Abstract Painting in America" show and more than a year before the Whitney Biennial of 1936. A photograph (generally dated 1935; fig. 69) shows Gorky at work on the canvas once again. He has already substituted blocks of color for the array of parallel lines

FIG. 68
Anonymous photograph of Arshile Gorky and Willem de Kooning in Gorky's studio standing next to *Organization*, ca. 1935. Courtesy of Xavier Fourcade, Inc.

FIG. 69
WYATT DAVIS (1906–1984), photograph of Arshile Gorky working on *Organization*, ca. 1935. Courtesy Joan Davis

near the center, painted out the lower range, and given the artist at the left a more continuous body and two firm legs. He has also eliminated any consistent reference to illusionistic depth.

As Gorky absorbed *The Studio*'s lessons of simplicity, he adopted elements of the vocabulary of *Painter and Model* to create an object infused with his own sensibility and iconography. Since this conclusion may seem contradictory, it is worth noting that both these paintings of Picasso's are among his most deeply indebted to a contemporary, Piet Mondrian, and that Picasso never hesitated to borrow from past or present art to achieve his goals. As Gorky refined *Organization*, he had the benefit of being able to compare Picasso's two paintings directly, since the Modern's summer exhibition included both. As Gorky followed *The Studio* to a sparser armature, he rejected formal elements that Picasso had used to give the painting clarity and complexity—the pervasive use of black lines to bound every shape in the composition, and the transparency of hues that lends depth to the flat, linear pattern. Gorky's dense pigments not only pile layers on the canvas but nearly obliterate underlying colors and create textures of rough and smooth passages across the picture. In the final painting, design and surface coalesce to create the effect of a shallow relief. *Painter and Model* offers this same kind of massing of pigment, and it also displays the approach to defining shapes that Gorky explored so successfully in *Organization*. Gorky's great contribution was to wed this style with a stripped-down structure that enabled him to highlight his mastery of the painted "edge."

Gorky's attention to the contours of shapes was famous among downtown artists in the mid-1930s. Smith recalled him "working over an area edge probably a hundred times" to achieve the relationships of surface and depth that he sought.[58] *Organization* is the finest example of this technique. Following *Painter and Model*, Gorky dropped the systematic use of black outlines for a more varied pattern of thickened lines and contours defined only by changes of color and brushstroke. Even though each shape is densely and evenly painted as a solid block, Gorky's different treatments of the edges encourage optical effects of spatial shifts across the loosely framed composition. As he modulated his composition, Gorky chose a range of colors distinctly different from Picasso's (or Mondrian's). In *Painter and Model*, Picasso had followed Mondrian's discipline of primaries supplemented with black, white, and gray—except for a sly touch of green to signify fruit (nature outside human activities). Gorky transformed the spots of green into large patches of turquoise, and he supplemented the basic color scheme with brilliant passages of violet and pink.

Most important, Gorky took one of Picasso's playful distortions and made it the central symbol of his painting. Both *The Studio* and *Painter and Model* represent an artist at work in his studio, and both show the artist holding a palette while he works. In *The Studio*, this rectangle (extending above the artist's left arm like a paddle) is only a ghost beneath a layer of intense yellow. In *Painter and Model* (the later composition) the palette is prominent because of its enlarged size, black color, and central placement. It is one of the most legible objects in the painting, and it takes on multiple connotations as both a tool held by the artist and a symbolic form that may be painted on the canvas shown standing in the studio. Whether "real" or invented, its large extended lobes suggest vitality. Gorky immediately connected with this idea. In all his versions of the composition, the palette is even bigger and more central. Its additional, third lobe gives it an impression of standing with head erect. Departing from Picasso's example, Gorky makes this form the only recognizable shape, and the composition's focus. In the early version of *Organization* seen in the photograph, it is tightly framed by the armature of lines, as if a thriving curvilinear force were confined by a rectilinear cage. In the final painting, it stands free. Gorky eliminated a thick line that had framed its tall profile and opened up a white passage to another curvilinear shape, a bright yellow disk, that mirrors the smaller one dotted with red and inscribed on the body of the palette. Together with a small red circle, the three disks form a triad of shapes and colors that extends the rhythm of the palette across the composition and creates a counterpoint to the angular grid. Gorky had liberated from the two Picasso paintings a shape that would remain central to the meanings of his art. Throughout the remainder of his career, he would invoke the palette as a symbol of both his presence and his artistic imagination.[59] In *Organization*, he achieved a remarkable balance between his respect for Picasso and his own art. He defined a vigorous form of abstraction that remained deeply rooted in realism and had a profound impact on American art in the late 1930s.

By the end of 1936, Gorky had assumed a new stature in the art world of New York. The year marked a watershed in his relationship with Davis, who had become increasingly involved with the leftist political activities of the Artists' Union and the American Artists' Congress and had little time for painting. Meanwhile, Gorky remained committed to art. As Davis would recall, "In the nature of the situation, our interests began to diverge and finally ceased to coincide altogether. Our friendship terminated and was never resumed."[60] Davis had been a tremendous supporter during Gorky's early development, but Gorky's growing confidence as an artist and his new support at the Whitney made him far more independent. Indeed, Davis's last contribution to Gorky's career may have been his role in placing Gorky's work in "Abstract Painting in America."

As Davis withdrew from aesthetic debates, Gorky stepped forward. A number of artists in the downtown community were equally focused on the issues of abstraction, and in late 1935 they began to discuss forming a group modeled on the French association Abstraction-Création. Plans for American Abstract Artists (A.A.A.) were taking shape by November 1936. At a meeting in the studio of Harry Holtzman, Gorky presented himself as the leader of the group (which included Rosalind Bengelsdorf, Byron Browne, Holtzman, and Ilya Bolotowsky, among others). When his authority was questioned, he reportedly replied, "Of all the bunch here, I exhibit at the Whitney Museum any time I want and you people still hardly can make it. And so I'm the natural one to open the field."[61] Gorky left the meeting, however, and never joined the organization. Indeed, as time passed, the artists' approaches diverged: the members of A.A.A. increasingly turned

FIG. 70
HANS BURKHARDT (1904–1994), *Artist
and Model*, 1936–37. Oil on canvas, 35 x
40 in. (88.9 x 101.6 cm). Courtesy of Jack
Rutberg Fine Arts, Inc. JRFA #1468

toward forms of geometric abstraction, while Gorky kept his
moorings in realism and explored biomorphic forms.

Gorky was no more suited to leading a group than was
Picasso, but he was beginning to command considerable respect
among a small network of artists. When he walked out of
Holtzman's studio, his friend de Kooning left with him; by the
mid-1930s, Gorky was guiding de Kooning as Davis and Graham
had guided him earlier in the decade. Others too gathered
around him, including Smith. During the early 1930s, Smith had
studied with Matulka and befriended Graham, who had intro-

duced him to Gorky and to Julio González's sculpture of welded
metal. The collaboration of Picasso and González in the late
1920s and early '30s was a revelation to many artists when their
welded figures were reproduced in *Cahiers d'art*.[62] Since only a
few of González's sculptures traveled to the United States before
1939, this was a rare case of the illustrations being the primary,
and nearly exclusive, source of knowledge about this influential
body of work. With Graham's strong encouragement, Smith
spent nearly a year in Europe between October 1935 and July
1936, most of it in Paris. There he famously turned down a
chance to meet Picasso, because he had heard he would have to
address the older artist as *maître*. Whether Smith was taken in by
the joke or simply preferred to keep his distance, he scoured the
Paris exhibitions of Picasso's work and returned to New York
well versed in both his painting and his sculpture.

When the Whitney's curators were visiting studios to organize "Abstract Painting in America," Smith joined Davis, Graham, Gorky, and a few others in a united front: none of them would exhibit in the show, they claimed, unless all of them did. But Davis was of course the crucial figure and the group quickly disintegrated, with only Graham and Gorky joining him on the Whitney's walls.[63] Smith's comment about Gorky's obsessive technique reflects his frequent presence in Gorky's studio, despite stories of their vitriolic arguments. As Dehner, Smith's wife, recalled, "We were friends with him in a way, though it was difficult to penetrate the front he presented to the world."[64] In the mid-1930s, both Smith and de Kooning shared Gorky's obsession with Picasso's two studio paintings, and the three participated in a remarkable artistic exchange that must have swung back and forth among them, sometimes focused on Picasso and sometimes independent of the works of his that had sparked their interest, but now probably obscured from full recovery by vagaries of date and a dearth of records beyond the art itself. Gorky's studio-mate from 1928 to 1937, Hans Burkhardt, also joined the round robin (fig. 70).[65]

In March 1935, while Gorky's *Organization* was hanging at the Whitney in "Abstract Painting in America," Smith made his own response to Picasso's studio pictures in a modestly sized composition, *Untitled* (plate 72), that begins with *The Studio* but pushes beyond it in two opposing directions. On the left, Smith set a triangular design on a solid field, in imitation of that portion of *The Studio*, but he moved more deeply into abstraction by eliminating every reference to the figure of Picasso's artist. He also rendered the section spatially more complex by choosing a variety of hues (blue, green, and white) instead of following Picasso's unifying yellow. These departures matched Gorky's response to the painting, but Smith then filled the right side of his canvas with an aggressively three-dimensional figure. Separated by a notched outline, these two halves of the picture juxtapose Smith's commitments to both painting and sculpture. They propose relationships between those two mediums that guided Smith's work and drew on his knowledge of Picasso's innovations in both forms. Constructed of angular as well as rounded planes, Smith's figure shows the potential of the left side's linear design to articulate volume by rotating and interlocking its parts. The figure's gray coloring and modeling enhance an illusion of three-dimensionality, as does the tabletop or base on which it stands. Viewed left to right, the painting presents not two disparate sections but continuity through the articulation of similar formal elements in two or three dimensions. As Smith knew from illustrations in *Cahiers d'art*, Picasso had explored these alternatives in separate paintings and sculptures during the late 1920s and early '30s without so explicitly joining them in a single composition. Picasso's sculptures of welded metal fragments executed with González (such as *Head of a Woman*, 1930; plate 74) provide the model for Smith's projection, but Picasso, too, had resorted to canvas or paper to render many of the sculptural figures he imagined in those years. Many of these had been seen in the Valentine "Abstractions" show in 1931 and in subsequent exhibitions, and Smith would become deeply absorbed in the use of this vocabu-

lary to articulate sculptural versions of the human form.

During the following fall or winter in Paris, Smith may have turned down the chance to meet Picasso, but he took every opportunity to study his work in exhibitions. Dehner wrote a friend, "Saw the newest Picasso, hot off the easel. Entirely different from any he has done before. Not very abstract in general conception but part abstractly painted—leaves for hands and so on—very heavy paint—quite rough."[66] When Smith returned to New York, his interest in Picasso's studio pictures remained, but he increasingly incorporated aspects of the artist's new work, particularly the curvilinear frameworks and organic metamorphosis of his mid-1930s art. In *Untitled (Billiard Players)* (1936; plate 70), Smith revisited the subject of figures in an interior while shifting the focus away from artistic practice to another form of brinksmanship. The more fragmented pattern of *Painter and Model* and its diverse array of colors seem the likely reference, although Smith rounded the straight lines of its grid and introduced a more dynamic spatial thrust, stretching from the tip of a cue in the right foreground to the naked body of a woman in the left background. This is clearly an unconventional billiards game, less distant from the studio than it might seem.

The following year, Smith both revised the composition for a welded-iron sculpture and created two more sculptures that explore the ideas of his previous paintings in full three-dimensionality and robust materials. *Sculptor and Model* (1937; plate 73) returns not only to the subject of the artist but also to the medium that increasingly claimed Smith's attention. The inspiration for this rendering of a female artist next to a small sculpture on a modeling stand is probably Picasso's *La Statuaire* (1925; fig. 71), a painting that had appeared in several American exhibitions since 1930, particularly at the Valentine Gallery and in the Wadsworth Atheneum's retrospective. In late 1937, Clark would make it a gift to the Museum of Modern Art. Although Smith took its subject (and possibly the material suggestion of its wrought-iron railing), his version drops the painting's haunting neoclassicism for the rough materials and metamorphic analogies that he saw in Picasso's more recent work. The bell-shaped torso of his sculptress, and her extended arms, rhyme with the rounded, open form on the stand—presumably a sculpture combining references to both the human body and the tendrils and leaves of plants. The figure's female gender may be significant in this analogy, although Smith said, "I don't make boy sculptures. They become kind of personages, and sometimes they cry out to me that I should have been better or bigger."[67] Both the thick, rough-edged legs of his sculptor and the small-scale intricacy of her head suggest the potential for far larger works that Smith would pursue during the following decades.

Smith's freestanding figures seem to address the remarkable range of Cubism. *The Hero* (1951–52; plate 75) adapts the style's early simplification of the human form and austere, rectilinear structures to create a monumental presence; *Running Daughter* (1956; fig. 72) translates later Cubism's equally disciplined curvilinear frame to capture the gestures of Smith's daughter in full stride.[68] Even the stainless steel sheets of Smith's 1960s work maintain a dialogue: the great stack of plates in

PLATE 70
DAVID SMITH (1906–1965), *Untitled
(Billiard Players)*, 1936. Oil on canvas,
46 7/8 x 52 in. (119.1 x 132.1 cm). Collection
of Barney A. Ebsworth

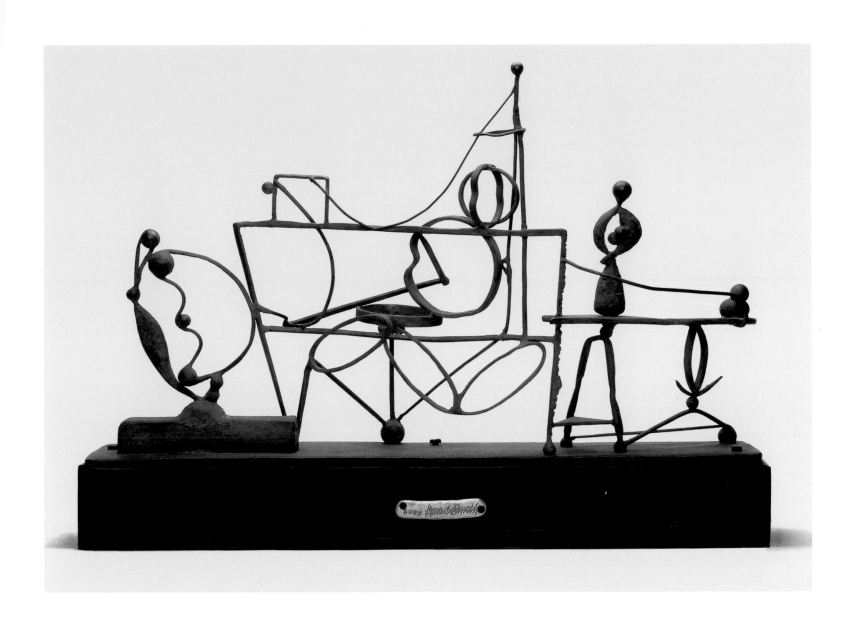

PLATE 71
DAVID SMITH, *Interior*, 1937. Welded steel
with cast iron balls, 15 1/2 x 26 x 6 in.
(39.4 x 66 x 15.2 cm). Weatherspoon Art
Museum, University of North Carolina at
Greensboro, Museum Purchase, with
funds from anonymous donors, 1979

153

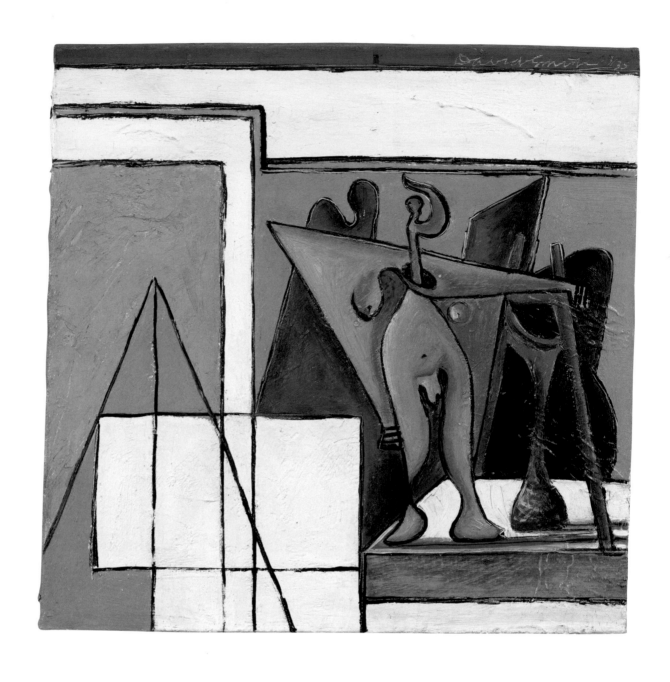

PLATE 72
DAVID SMITH, *Untitled*, March 1935. Oil on
canvas, 17 x 17 in. (43.2 x 43.2 cm).
Collection of Terese and Alvin S. Lane

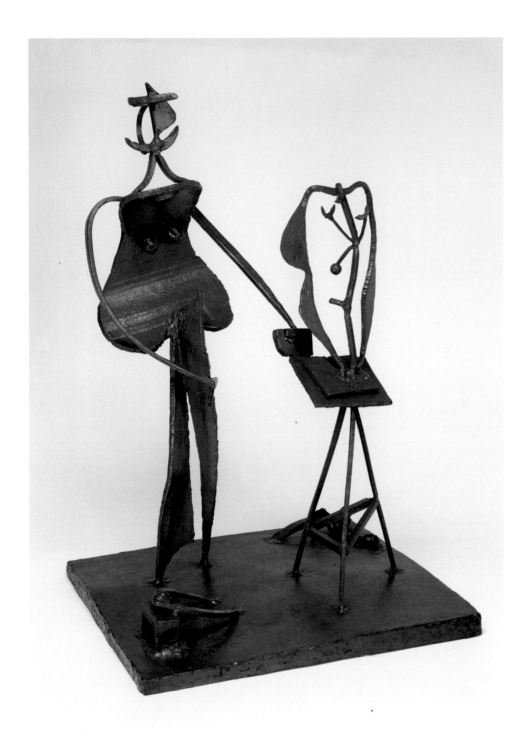

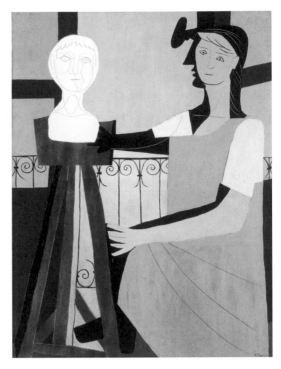

PLATE 73
DAVID SMITH, *Sculptor and Model*, 1937.
Welded iron painted with red oxide,
28 1/2 x 18 7/8 x 16 5/8 in. (72.4 x 47.9 x
42.2 cm). Collection of Aaron I.
Fleischman

FIG. 71
PABLO PICASSO, *La Statuaire*, 1925. Oil on
canvas, 51 5/8 x 38 1/8 in. (131 x 97 cm).
Private collection

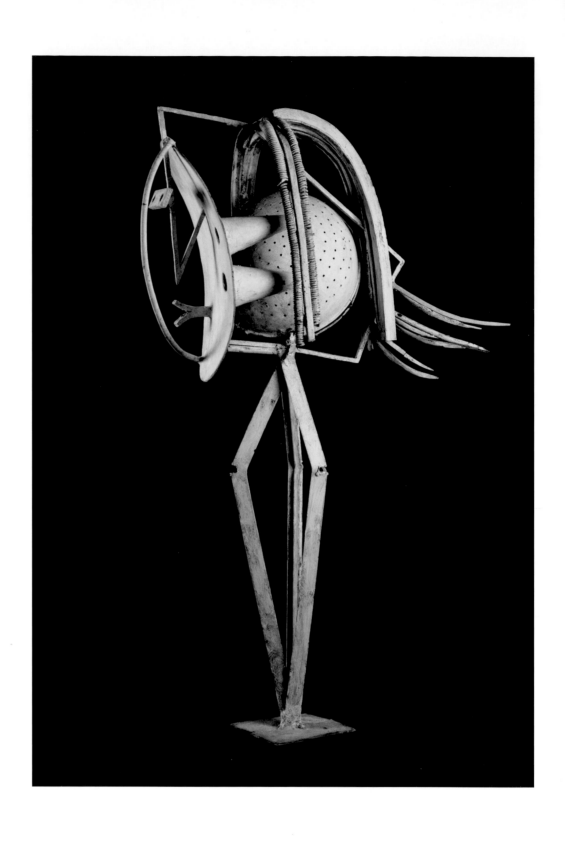

PLATE 74
PABLO PICASSO, *Head of a Woman*, 1930.
Iron, 39 3⁄8 in. (100 cm) high. Musée
National Picasso, Paris

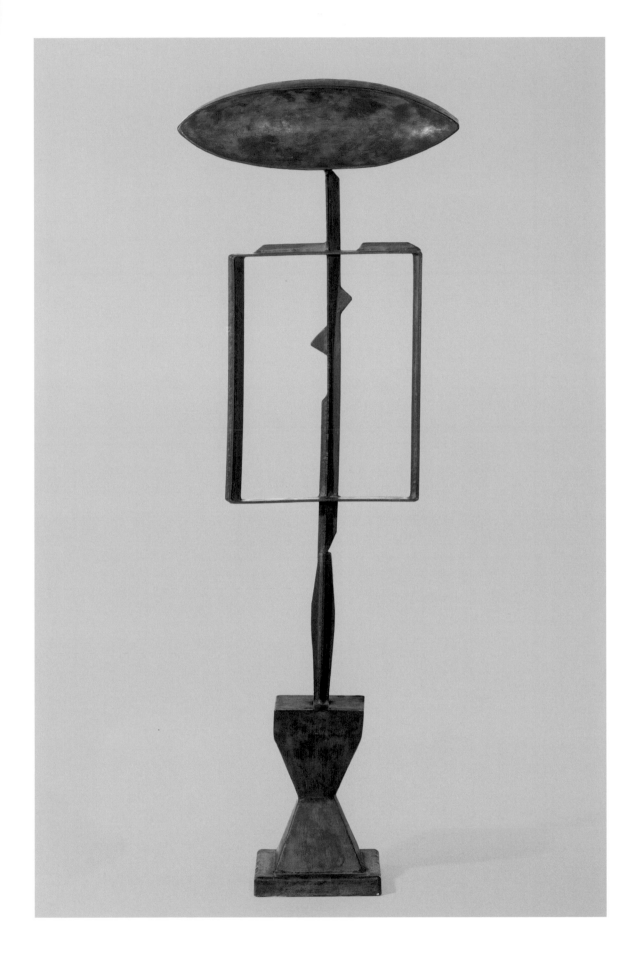

PLATE 75
DAVID SMITH, *The Hero*, 1951–52. Steel,
73 11/16 x 25 1/2 x 11 3/4 in. (187.2 x
64.8 x 29.8 cm). Brooklyn Museum, Dick
S. Ramsay Fund 57.185

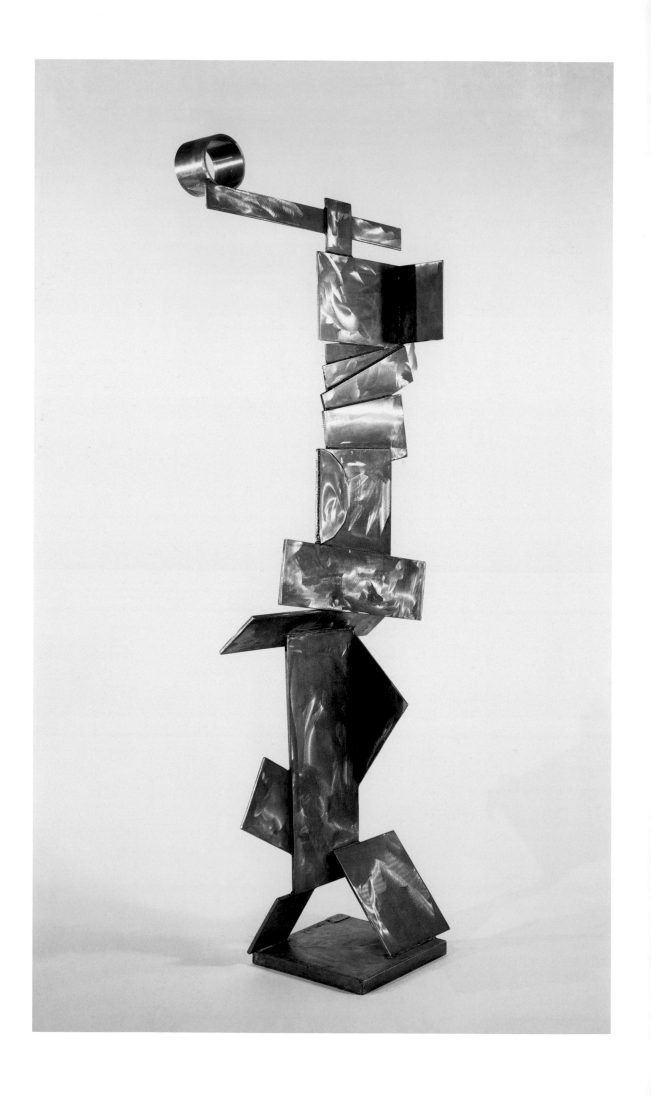

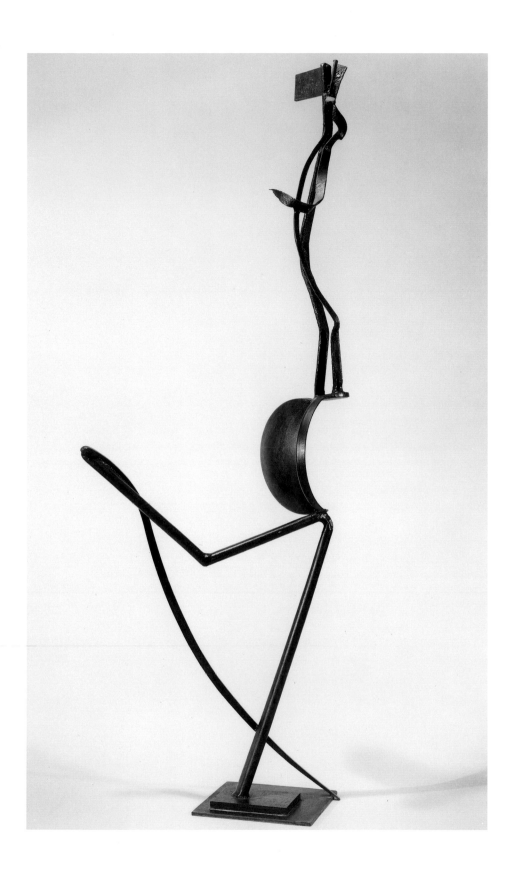

PLATE 76
DAVID SMITH, *Lectern Sentinel*, 1961.
Stainless steel, 101 3/4 x 33 x 20 1/2 in.
(258.5 x 83.8 x 52.1 cm). Whitney
Museum of American Art, New York,
Purchase, with funds from the Friends of
the Whitney Museum of American Art
62.15

FIG. 72
DAVID SMITH, *Running Daughter*, 1956.
Painted steel, 100 3/8 x 34 x 20 in. (255 x
86.4 x 50.8 cm). Whitney Museum of
American Art, New York, 50th Anniversary
Gift of Mr. and Mrs. Oscar Kolin 81.42

Lectern Sentinel (1961; plate 76), rising in patchwork fashion to an off-center circle, harnesses Synthetic Cubism's play with tangibility to create a literal form as imposing as one of Picasso's musicians.

The two-part structure of *Sculptor and Model* contains both the potential for each element to develop independently and the implication of an encompassing environment in which the two sections stand together. *Interior* (1937; plate 71) articulates that implied spatial envelope with great fluency. It is Smith's greatest contribution to the exchange pursued by Gorky and other Americans through Picasso's studio pictures. Framed between two sculptures (the left on the floor, the right on a table), an irregular, rectilinear frame surrounds a central configuration of spiraling lines. The effect, which recalls Gorky's *Organization*, constitutes Smith's transformation of the pervasive grid of *The Studio* into a flexible structure suited to implying rounded masses or volumes and incorporating real three-dimensionality. Extending twenty-six inches across, fifteen high, and six deep, the sculpture occupies space as a shallow relief, resembling the paintings by Gorky and Picasso but also commanding a literal thickness and multiple view-points, which separate it from Gorky's flat, angular composition in particular. Gorky's studies for *Organization*, however, generally dated to about 1935, had exhibited considerable spatial depth, and employed wirelike, curving lines similar to Smith's sculpture; he dropped this approach for the painting, but it would not be sur-prising if Smith, with his numerous visits to Gorky's studio, knew of these earlier plans.[69] Smith's design, however, is more fluid and encompassing than Gorky's sketches. It creates a linear dynamism that suggests Pollock's later work as much as Picasso's past ones. Nonetheless, specific elements such as the iron balls scattered throughout Smith's sculpture fix his place among the Americans absorbed by Picasso's knob-ended lines and broad planes, the parameters of a space verging on the abstract.

"When, about fifteen years ago, I walked into Arshile's studio for the first time, the atmosphere was so beautiful that I got a little dizzy and when I came to, I was bright enough to take the hint immediately. If the bookkeepers think it is necessary continuously to make sure of where things and people come from, well then, I come from 36 Union Square."[70] Writing to the editor of *Artnews* toward the end of 1948, de Kooning probably made an honest mistake when he placed his first visit to Gorky's studio in the mid-1930s rather than around the actual date of several years earlier. His suggestion that the bare fact of acquaintanceship does not capture the flow of ideas carries great weight given the many years that he and Gorky and their friends lived under the shadow of artistic influence. With a bow to Gorky's deep belief in tradition, however, de Kooning readily acknowledged his debt: "I am glad that it is impossible to get away from his powerful influence." Moreover, bookkeeping may pay off in this case at least: de Kooning's chronological slip points to what so impressed him about Gorky. It fixes his recollection to the years when Gorky became the master of his artistic means, and to a time when his immaculate studio was dominated by one painting, *Organization*—the painting before which Gorky and de Kooning posed around 1935.

De Kooning mined Gorky's recent art throughout the late 1930s and early '40s, often choosing works based on Picassos. Even more than Smith, he joined a complex dialogue that stretched from

his immediate friends to Picasso's pictures on view in New York. Gorky served him not simply as an interpreter of Picasso's ideas but as a source in his own right, one both intertwined with Picasso and distinct. In these years when de Kooning was immersing himself in the issues of abstraction, the atmosphere of 36 Union Square informed his art more deeply than exhibitions at the Museum of Modern Art or the Valentine Gallery.

A far more frequent visitor to Gorky's studio than Smith, de Kooning closely followed the transformations of *Organization* as Gorky brought it to completion in 1936. Although he probably knew the works that Smith was making in dialogue with Gorky, de Kooning seems to have waited until the following year to enter the exchange. When he did, he created a cluster of responses and initiatives that would stand as basic principles of his art through the next decade. Many years later, de Kooning would recall that from first sight he "was crazy about" *The Studio*, and the work became the bedrock of his first sustained series, a group of at least a half dozen paintings made in 1937 and the following year or two.[71] Once again undated by the artist and not yet precisely placed by historians, the paintings indicate their exploratory nature through their compositional variety and small size (most are no larger than a standard sheet of stationery). Measuring only four by seven inches, *Untitled* (1937; plate 77) is a deft step beyond both Gorky and Picasso. Focusing the composition on a red version of Gorky's undulating palette, de Kooning followed his friend in suppressing both the spatial depth of Picasso's trans-parent planes and his references to figures and objects. Compared to *Organization*, however, de Kooning's little painting is a gem of austere elegance. Almost entirely lacking the linear framework that crisscrosses Gorky's picture, it is articulated instead through a grid of densely painted planes. Despite its size, its open design and large blocks of color give it the scale of a much larger work. In this sense, it approaches the presence of Picasso's *Studio*.

The rest of the series (plates 78–80), most of them untitled, explores variations on these themes, sometimes resorting to a comprehensive linear grid and sometimes pushing the structure to the periphery, so that colored planes seem to hang from the top of the frame or float in empty space (as in *Father, Mother, Sister, and Brother*, ca. 1937, the largest work in the series). Of the set, a gouache in the collection of the Whitney (plate 80) is closest to *The Studio*: its pervasive grid, and the boxlike frame enclosing a linear structure on the left, reflect the painting, as do several other shapes that de Kooning apparently separated from the uses given to them by Picasso (the central plane of the table, for example, and the adjacent triangle of the fruit bowl). The red curvilinear form at the center seems both a reference to the bust in *The Studio* (though shifted into silhouette) and a tamer version of the oscillating palette, passing to de Kooning from Picasso's *Painter and Model* via Gorky's *Organization*. De Kooning's wide-spread use of a pastel tonality (particularly pale blue or turquoise) identifies his point of reference as Gorky's painting more than Picasso's.

Following Gorky's lead, de Kooning approached Picasso's work less as a model for emulation than as a starting point for fur-ther reduction. Both artists largely suppressed the paintings' rich iconography of artistic practice and moved very close to the pure

TOP
PLATE 77
WILLEM DE KOONING (1904–1997),
Untitled, 1937. Oil on board, 4 x 7 in.
(10.2 x 17.8 cm). Private collection,
courtesy Allan Stone Gallery, New York

CENTER LEFT
PLATE 78
WILLEM DE KOONING, *Untitled*, 1937. Oil
on board, 9 x 13 3/4 in. (22.9 x 35 cm).
Private collection

CENTER RIGHT
PLATE 79
WILLEM DE KOONING, *Untitled*, 1939–40.
Oil on mat board, 8 1/2 x 12 3/4 in.
(21.6 x 32.4 cm). The Picker Art Gallery,
Colgate University, Hamilton, N.Y.

BOTTOM
PLATE 80
WILLEM DE KOONING, *Untitled*, ca. 1937.
Gouache and graphite on paper, 6 3/4 x
13 3/4 in. (17.2 x 34.9 cm). Whitney
Museum of American Art, New York,
Purchase, with funds from Frances and
Sydney Lewis 77.34

abstraction promoted by the A.A.A. Yet neither Gorky nor de Kooning accepted the exclusive position of this group or any other. Both would explore abstraction during the following decade, yet neither approached it as closely as they did in the mid-1930s, and neither stopped making figurative art alongside more abstract works. Gorky's overlapping execution of *The Artist and His Mother* and *Organization* explicitly affirmed his preference for aesthetic diversity. During the same years he painted these abstractions, de Kooning began a series of men.

For Gorky this was nothing new, since he had first engaged Picasso by emulating both his neoclassical and Cubist styles, in an affirmation of Picasso's statement in *The Arts* in 1923 that "different motives inevitably require different methods of expression."[72] This fluidity received a timely update when Picasso criticized pure abstraction in a statement published in *Cahiers d'art* in late 1935. Although Gorky and his friends certainly saw the magazine, they had to rely on Graham or other French readers to translate or paraphrase the lengthy text—but they surely grasped Picasso's fundamental belief that all serious art is based on reality. For him, abstraction was either decorative or not truly abstract: "There is no abstract art. You must always start with something. Afterwards you can remove all traces of reality."[73] Coming from an artist who apparently embraced everything, the statement must have seemed heartfelt. It also described exactly what Gorky and de Kooning were doing, although they began by addressing real things at one remove—that is, through the medium of Picasso's own pictures.

Four years after Picasso's statement appeared in *Cahiers d'art*, a translation appeared in the catalogue of Barr's 1939 exhibition "Picasso: Forty Years of His Art," and had a formidable impact. Gorky, however, seems to have absorbed it soon after its publication in French. Rather than simply attacking abstraction, Picasso made a plea for a profoundly humanistic art. Invoking "Cézanne's anxiety" and the "torment of van Gogh," he described the artist as "a receptacle of emotions," and "the metamorphoses of a picture" as the "materialization of a dream." Most evocatively, he stated, "In my case a picture is a sum of destructions." Having avoided the dogma of Surrealism for more than ten years, Picasso nonetheless evoked its themes to describe his creative process.

In 1936–37, as de Kooning pursued his variations on the crisp structures of *Organization* and *The Studio*, Gorky again turned his attention to Picasso's studio paintings. This time, however, he ignored *The Studio* to address *Painter and Model*. Unlike *Organization*, *Enigmatic Combat* (plate 81) is broadly brushed, and its thick pigments are scumbled and dragged over encrusted surfaces to leave constantly shifting densities and hues that are only partially bounded by heavily layered black lines. Still straddling the border between abstraction and Picasso's reality, Gorky significantly expanded his references to legible forms and illusionistic space to create a heightened tension with the flat field of the painting. The kidney-shaped palette returns as vivid passages of violet and red, now shifted to represent the torso of the artist. Although the canvas depicted in *Painter and Model* does not appear, the classical profile it contains is transferred to the model, a woman's head that in Gorky's painting rests on a tabletop. The various figures in Picasso's picture are reduced to the artist and

model, while the surrounding space is fractured into irregular triangles, derived from the acute angles of the Picasso. The complex patterns of Picasso's studio are transformed into a set of similar sections that enclose the figures and articulate both the surface and the constantly shifting depth of the fictive interior. Together with Gorky's caked and loosely brushed surfaces, the painting resembles a mosaic shimmering in three-dimensional space.

In *Enigmatic Combat*, Gorky returned from the brink of abstraction to a robust style of great formal sophistication and iconographic complexity. He produced a mix of painterly structures and representational imagery that de Kooning would take up in a great series of paintings during the mid-1940s. More immediately, *Enigmatic Combat* brought Gorky back in dialogue with Graham's art and writing. That same year, after years of searching, Graham finally found publishers for *Systems and Dialectics of Art*, first in Paris, then in New York. In April, *Magazine of Art* printed his article on Picasso's recent work, "Primitive Art and Picasso," which he had written the previous year.[74] Reflecting the 1935 statement in *Cahiers d'art*, Graham explicitly characterized Picasso's art in Surrealist terms. Claiming that Picasso "delved into the deepest recesses of the Unconscious," he stated that "the unconscious mind is the creative factor and the source and the storehouse of all knowledge, past and future."[75] His primary point of reference was *Girl before a Mirror* (plate 94), which had first appeared in the United States during the Wadsworth Atheneum's 1934 retrospective and had returned for the Valentine Gallery's 1936 show. The Museum of Modern Art would buy the painting in 1938, making it a centerpiece of their installations. Its impact on American art, however, would not begin in earnest until the Modern's retrospective of the following year. Soon after, Graham would create his own version of *Girl before a Mirror*, in his *Interior* of ca. 1939–40 (plate 97). Pollock, too, would begin an intense dialogue with the picture that would continue into the 1950s.

Even the title *Enigmatic Combat* suggests that Gorky had turned from the primarily formal concerns of *Organization* to an art of conflict and unresolved mystery. His concern with expression would grow as he became more aware of Surrealism and found ways to harness its fascination with memory and the violence of nature to address his own tragic childhood and the history of the Armenian people. During the late 1930s, Gorky was beginning to join the disparate strands of his life and his art.

Since fall 1929, the Gallery of Living Art had displayed Picasso's 1906 *Self-Portrait with Palette* (fig. 50) only a few blocks from Union Square, and Gorky and his friends had made it one of their primary pilgrimage sites. The painting figured in the mix of neoclassical styles that Gorky employed in the mid-1930s, and it was an obvious model when he decided to paint the picture that would stand as his most ambitious self-portrait. Much of the appeal must have been how closely the worlds of Picasso's youth and the contemporary scene in New York seemed to coincide. No matter how celebrated Picasso had become in the 1920s and '30s, his early self-portraits preserved his beginnings as an impoverished immigrant in Paris. In this case, the laborer's collarless shirt and blue pants affirmed his solidarity with workmen, as did his decisions to dispense with brushes in his right hand and to press

PLATE 81
ARSHILE GORKY, *Enigmatic Combat*,
1936–37. Oil on canvas, 35 3/4 x 48 in.
(90.8 x 121.9 cm). San Francisco
Museum of Modern Art, Gift of Jeanne
Reynal

the palette flat against his left side, like a mason's tool. Gorky emulated all of this in his *Self-Portrait with Palette* (1937; plate 82), wearing a T-shirt underneath a jacket and showing his painting arm exposed to the elbow and held at his waist to match Picasso's earthy gesture.[76] Again the brushes are absent, and the palette, nearly transparent, is suppressed.

Despite their similarities, the two paintings convey contrasting self-conceptions. With his massive, close-cropped head and wide chest set toward the viewer, Picasso projects a brute force almost entirely absent from Gorky's more guarded posture and position deeper within the space of the painting. Below a nearly matching hairline, Gorky left his features indistinct, barely defining the line of his jaw and sinking his pupils within his head. Where Picasso's technique in this particular picture is rough, Gorky laboriously built his painting in a manner that combines the sanded smoothness of the Whitney's version of his *Artist and His Mother* with the fluid layering of the National Gallery's version. Distancing his direct gaze behind atmospheric fields of subtle tones and polished surfaces, he made his image far less confrontational than Picasso's, drawing on the inward, contemplative glance of Picasso's eyes rather than on the looming physique that almost overwhelms them. This self-portrait is an image of exquisite sensibility in rags.

Gorky accompanied the painting with four more portraits depicting his step-sister Ahko, a picture that Gorky called "portrait of myself and my imaginary wife," his studiomate Burckhardt, and another artist identified as "Master Bill."[77] These paintings portray an extended community gathered around Gorky (at least psychologically), as opposed to the lost one of his childhood. Among the artists, de Kooning was his closest ally during the later 1930s. And de Kooning followed his dual modes, making both small abstractions and much larger paintings of men that borrowed heavily from the style and pose of Gorky's self-image. Probably the first of these works is recorded only in a photograph, from around 1938, which shows de Kooning standing beside the large canvas (fig. 73).[78] The man's clothes—a suit over a collarless shirt—and the palette he holds in his right hand recall Gorky's variation on Picasso. More significant, his deep black eyes and broadly rendered anatomy adopt Gorky's style of delicately layered passages abutting and overlapping without outlines. Continuing the series into the early 1940s, de Kooning would paint a sequence of men

FIG. 73
RUDOLPH BURCKHARDT (1914–1999), photograph of Willem de Kooning in his studio, ca. 1938. Courtesy Tibor de Nagy Gallery, New York

who may or may not be self-portraits but seem to capture the marginal existence of the art community during the final years of the Depression. *Standing Man* (ca. 1942; plate 83) is one of the last, and announces a new ambition. While the tonality of the picture remains subdued and the man poorly dressed, the painting itself is full of innovations. De Kooning brought together his two modes in a single painting by juxtaposing the man's ovoid head with a drawing of another head loosely pinned to the wall at the upper left and another at the far right. These vaguely rendered, curling sheets both suggest the three-dimensionality of the man's cranium and stand alone as abstractions. Equally important for his later work, de Kooning's rendering of the man's body allows line to float free of form and merges loosely brushed passages of color without reference to representation.

An important sign of change in the art world occurred in May 1939, when *Guernica* and dozens of its studies went on display in New York. It was on a world tour to raise money for the Spanish Republican cause, and it occupied Valentine Dudensing's gallery before traveling to Los Angeles, San Francisco, and Chicago, then returning for the opening of the Modern's retrospective in November. Approximately 100 people paid $5 each to attend the preview at the Valentine Gallery on May 4, and around 2,000 more visited during the exhibition's three-week run.[79] Two symposia were organized to explain the picture, and instead of only critics and politicians, a few artists were invited to speak, Gorky among them. Since his proclamation at the Whitney's symposium on abstract art, Gorky had had few opportunities to show his art outside of Whitney Annuals, yet his reputation had grown to the point that he was handed a forum to interpret Picasso's challenging and controversial mural. Although no transcript exists, a recollection does. Dorothea Tanning, a young artist who would join the Surrealists and marry Ernst, happened to stop by the Valentine Gallery as Gorky spoke.

> There was already a little crowd of nobodies like us sitting on the floor before a large Picasso painting called *Guernica*.
>
> We listened as a gaunt, intense young man with an enormous Nietzschean mustache, sitting opposite us, talked about the picture. It was not his accent, which I couldn't place, that held me, but the controlled emotion in his voice, at once gentle and ignited, that illuminated the painting with a sustained flash of new light. I believe he talked about intentions and fury and tenderness and the suffering of the Spanish people. He would point out a strategic line and follow it into battle as it clashed on the far side of the picture with spiky chaos. He did not, during the entire evening, smile. It was as if he could not. Only afterward was I told the man's name: Arshile Gorky.[80]

During the 1930s, Gorky had followed his steady course to become one of the most respected artists in New York, legendary for his understanding of Picasso. His discussion of *Guernica* (no doubt lengthy) not only dissected the painting's composition and

style but bored into the message of the mural, passionately describing how Picasso had marshaled his pictorial means to speak about the fate of the Spanish people. Of all the artists in New York, Gorky was the most qualified to address this achievement. His childhood experiences had taught him about war and the destruction of homeland. His knowledge of Picasso's art enabled him to realize immediately that Picasso had created a compelling response to contemporary political events, breaking down the barriers between the avant-garde and official art, giving Cubism a public voice at the center of a world crisis, and inspiring Gorky to use his full artistic means to address his own heritage.

PLATE 82
ARSHILE GORKY, *Self-Portrait with
Palette*, 1937. Oil on canvas, 55 1/4 x
23 7/8 in. (140.3 x 60.6 cm). Private
collection

PLATE 83
WILLEM DE KOONING, *Standing Man,*
ca. 1942. Oil on canvas, 41 x 34 in. (104.1 x
86.4 cm). Wadsworth Atheneum Museum
of Art, Hartford, Conn., The Ella Gallup
Sumner and Mary Catlin Sumner
Collection Fund

"THIS IS 1950. THIS IS WHEN IT'S GOING TO HAPPEN"
Willem de Kooning

"You must have heard there was an exhibition of 400 paintings by Picasso (forty years' work). It was so beautiful, and it revealed such genius and such a collection of treasures that I did not pick up a paintbrush for a month. Complete shutdown. I cleaned brushes, palettes, etc. Once the source of such joy disappeared, life became depressing."[1] Written by the twenty-eight-year-old Louise Bourgeois, these words reflect the impact of the Modern's retrospective of 1939 on many artists. Among those on record, Willem de Kooning called it "staggering"[2] and "prodigiously important."[3] The exhibition would travel the country, and its catalogue would serve as a handbook for American artists throughout the 1940s and '50s. Only the exhibition at 291 in 1911 was as influential in the United States, and that had been a guerrilla debut—an attack with a bundle of Picasso's drawings that offered Americans an opening to a burgeoning avant-garde. The retrospective organized by Alfred Barr celebrated an established artist in all his diversity and longevity. Bourgeois frankly articulated the awe that many felt before the variety, quality, and sheer abundance of the works in the exhibition, yet Barr presented more than a blockbuster: he contradicted conventional opinion by tracing coherence through Picasso's shifting phases, and he emphasized the importance of current work. The Picasso of this exhibition seemed a colossus straddling contemporary art, occupying every possible position and branding each with a stylistic marker that precluded appropriation. Robert Goldwater, an eminent art historian and Bourgeois's husband, concluded his review of the exhibition with a declaration that would challenge American artists for the next decade and more: "Another artist cannot begin at the point at which Picasso ends."[4]

Barr had been planning a Picasso exhibition for at least eight years before "Picasso: Forty Years of His Art" opened at the Modern on November 15, 1939.[5] In 1931, he had struggled to organize a retrospective for the following year, but had found his plans derailed by Picasso's decision to cooperate with a competing exhibition organized by a consortium of French dealers for the Galerie Georges Petit in Paris and the Kunsthaus in Zurich. During the next eight years, Barr had worked diligently both to raise Picasso's presence in the Modern's exhibitions, particularly "Cubism and Abstract Art" (with twenty-nine works by the artist) and "Fantastic Art, Dada, Surrealism" (with eight), both in 1936, and to increase the small number of his works in the collection. Lillie Bliss's bequest of *Woman in White* (1923; plate 47) and *Fruit Bowl, Wineglass, Bowl of Fruit (Green Still Life)* (1914; plate 28) in 1934 provided MoMA with its first paintings by Picasso, followed by Walter Chrysler's gift of *The Studio* (1927–28; plate 66) in 1935 and Stephen Clarke's donation of *Femme Assise (Seated Woman)*

(1927; plate 63), *La Statuaire* (1925; fig. 71), and *Guitar and Fruit* (1927) in 1937. In 1938 and 1939, Barr captured his two greatest early acquisitions through purchases: *Girl before a Mirror* (1932; plate 94) and *Les Demoiselles d'Avignon* (1907; plate 110). The former had been a highlight of the Wadsworth Atheneum's Picasso retrospective in 1934. Valentine Dudensing brought it back to the United States three years later to show at his gallery, where it sparked John Graham's fascination and prompted Barr to ask Mrs. Simon Guggenheim to buy it for the Modern. Although the museum announced the acquisition of the *Demoiselles* in 1939, the complex negotiations for its purchase had begun in November 1937, when Jacques Seligmann showed it at his gallery in New York.

The press release recording the acquisition of the *Demoiselles* also declared the museum's plan to present "Picasso: Forty Years of His Art," in conjunction with the Art Institute of Chicago. This joint statement was well calculated. The acquisition of the *Demoiselles*—already considered a masterpiece of twentieth-century art, and acclaimed by the Surrealists, who still dominated avant-garde opinion—confirmed the Modern as the premier collection of Picasso's art at the moment it made the upcoming retrospective public. Having waited so long, Barr was determined to construct an exhibition that would be as comprehensive as possible, without lapsing into the unfocused evenness that can turn large shows into bland parades. Barr sought both to define Picasso's historical contribution by demonstrating the full range of his activities and to trace a unity in his work underlying the power of his recent art.

Among the approximately 350 paintings, drawings, and prints in the exhibition, Barr justly claimed to have assembled "almost all of [Picasso's] eight or ten capital works."[6] Despite Germany's invasion of France in September 1939, and the curtailment of transatlantic travel, he insured success by shipping most of the European loans months before the opening. The inflections Barr gave to Picasso's career through the particular works he chose to present here were subtle but significant. He brought far greater attention to Cubism than had the Atheneum's retrospective, and within Cubism he focused especially on the formative year of 1907, the "Negro" period that culminated in the *Demoiselles*. For Barr, this work was the touchstone of Picasso's art, a judgment that mirrored the views of the Surrealists but that Barr marshaled artworks to manifest in particularly vivid and compelling ways. Rather than emphasizing the historical importance of the *Demoiselles*, he described it as an almost contemporary work, one driven by ideas that were still in play: "The *Demoiselles* is a

PABLO PICASSO, *Guernica*, 1937 (detail of plate 86)

JACKSON POLLOCK, *The Water Bull*, ca. 1946 (detail of plate 109)

transitional picture, a laboratory or, better, a battlefield of trial and experiment; but it is also a work of formidable, dynamic power unsurpassed in European art of its time."[7] And he directly linked it to Picasso's current work. "It is worth noting that Picasso at the present time is particularly interested in the work of this Negro Period. Fortunately, the *Demoiselles d'Avignon*, the *Dancer* (fig. 80), and the *Woman in Yellow*, the three most important works of the period west of Moscow, can be included in the exhibition."[8]

In the exhibition and in the reproductions in the catalogue, Barr elaborated his metaphors for Picasso's creative process with an exceptional decision: the inclusion of studies to show the evolution of two key works, the *Demoiselles* and *Guernica* (1937; plate 86). Perhaps the availability of the *Guernica* sketches prompted this approach, but Barr extended it to frame the *Demoiselles* with three studies tracing the work's shift from a narrative brothel scene to the final, iconic image. With this arrangement, he turned the focus from finished masterpieces to the dynamic and contradictory process of creating them. (For *Guernica* studies, see plates 84, 93.)

Moreover, Barr reprinted in the catalogue two texts by Picasso that underpinned the curator's references to a "laboratory or, better, battlefield of trial and experiment." The first was a long-familiar interview, Marius de Zayas's "Picasso Speaks," which *The Arts* had published in 1923. There, Picasso is quoted as saying, "Many think that cubism is an art of transition, an experiment,"[9] and referring to a commonly held idea that "the principal objective of my work" is a "spirit of research,"[10] only to deliver his famous dismissal: "To search means nothing in painting. To find, is the thing."[11] By the mid-1930s, however, Picasso had talked extensively about the process rather than the final product, and Barr's shift from a scientific metaphor to a military one matched the tone of his descriptions. In the second text Barr reprinted, "Statement by Picasso: 1935," Christian Zervos recorded the artist saying, "A picture used to be a sum of additions. In my case a picture is a sum of destructions. I do a picture—then I destroy it. In the end, though, nothing is lost."[12] Picasso highlighted this idea by stating, "It would be interesting to preserve photographically, not the stages, but the metamorphoses of a picture." As if to clarify his use of the Surrealists' term, he explained, "Possibly one might then discover the path followed by the brain in materializing a dream," and acknowledged, "A picture is not thought out and settled beforehand."[13]

As the catalogue showed, *Guernica* was the exemplar of this method. It had been photographed, by Dora Maar, "in eight progressive stages," all of which Barr reproduced in the catalogue, along with many of the studies, as *Cahiers d'art* had done in 1937.[14] At the Modern, a series of these photographs and the fifty-nine studies enabled audiences to examine not only the development of the mural but the many ancillary and independent engagements that burst from the commission. Besides this remarkable evidence of his tumultuous process, Picasso's text explicitly addressed how he moved from specific objects in the world to the images of his art:

Do you think it concerns me that a particular picture of mine represents two people? Though these two people

once existed for me, they exist no longer. The "vision" of them gave me a preliminary emotion; then little by little their actual presences became blurred; they developed into a fiction and then disappeared altogether, or rather they were transformed into all kinds of problems. They are no longer two people, you see, but forms and colors: forms and colors that have taken on, meanwhile, the *idea* of two people and preserve the vibration of their life.[15]

Paired with the art, this conception of a dynamic process that is as much an end in itself as a means to a final goal would become a fundamental issue for American artists.[16] In the "Statement," this text preceded Picasso's charge to young artists, a challenge to make his art the fodder of creative destruction: "With the exception of a few painters who are opening new horizons to painting, young painters today don't know which way to go. Instead of taking up our researches in order to react clearly against us, they are absorbed with bringing the past back to life—when truly the whole world is open before us, everything waiting to be done, not just redone."[17]

Bourgeois overcame her block by revisiting a particular group of Picasso's work. Eight months before the retrospective opened, she had written in her diary,

Study of *Cahiers d'art*, Picasso's Works 1933–34–35: Picasso paints what is true; true movements, true feelings. . . . All movements painted by Picasso have been *seen* and *felt*; he is never theatrical. The Surrealists are theatrical. New York painting, the painting that wants to be or is fashionable, is theatrical. Theater is the image of life and Picasso sees life or rather *reality*! Keep your integrity. You will only count, for yourself and in your art, to the extent that you keep your integrity.[18]

Growing up in Paris, Bourgeois knew Picasso's work well. She had met Goldwater over the sale of a Picasso, and "in between discussions about Surrealism and the latest trends, we got married."[19] In turning to Picasso's work of the mid-1930s, she singled out the period Picasso called "the worst time in my life"[20]—years in which his marriage to Olga Khokhlova degenerated into fierce confrontations and his longstanding affair with Marie-Thérèse Walter became common knowledge when their child, Maya, was born on September 5, 1935. In *Minotaur Moving* (April 6, 1936; plate 160), a painting that would fascinate Jasper Johns in the 1980s, Picasso spun the situation into a symbolic image of his alter ego, the Minotaur, humbly pulling a cart piled with his belongings, including a mangled horse. Picasso's domestic turmoil based on covert liaison and betrayal may have struck Bourgeois, whose childhood had been defined by her father's clandestine relationship with her governess.[21]

In 1940–41, Bourgeois made two untitled paintings that use Picasso's vocabulary of multiple profiles to structure a scene redolent of her own experience. The first is a small sketch of a silhouetted figure standing between two massive profiles, each facing outward (1940; plate 87). The heads both constrain and protect the diminutive figure, turning their backs and serving as

PLATE 84
PABLO PICASSO, *Mother and Dead Child
(IV)*, May 28, 1937. Graphite, crayon,
gouache, and hair on paper, 9 x 11 5/16 in.
(23 x 29 cm). Museo Nacional Centro de
Arte Reina Sofia, Madrid

PLATE 85
PABLO PICASSO, *Sketch of a Head of
Weeping Woman (II)*, May 24, 1937.
Graphite and gouache on paper, 11 5/16 x
9 in. (29 x 23 cm). Museo Nacional
Centro de Arte Reina Sofia, Madrid

PLATE 86
PABLO PICASSO, *Guernica*, 1937. Oil on
canvas, 138 x 306 in. (349.3 x 776.6 cm).
Museo Nacional Centro de Arte Reina
Sofía, Madrid

174

shields. Like Picasso's, the meanings of Bourgeois's art spiral from autobiography into myth. In this painting, the little figure is probably her son Jean-Louis (born on July 4, 1940). The profiles definitely represent Bourgeois (on the right) and Goldwater (on the left)—the two halves of the shell from which their son would grow.[22] Yet the identifications are not explicit. The central figure could be anyone, and the profiles register most strongly as contrasting types—the faint line and neutral tonality of the woman versus the boldly drawn and colored man.

The large painting (1941; plate 88) applies the motifs to a different domestic situation. Here the silhouette is red, and is clearly that of Bourgeois. Wearing an ankle-length dress trimmed in white, she is a mature woman, with facial features, a necklace, and rounded breasts scratched into the rusty surface. Again, two huge profiles frame the silhouette, but this time they are both female, and they face toward the figure, gripping her head and upper torso between their undulating outlines of nose, mouth, and chin. The features of the right profile are rounded (they are Bourgeois's),[23] and the cheeks are stippled to suggest the foliage of a tree, its trunk the head's neck, rooted in the red soil. The other profile is larger and angular, with a sharply pointed chin and tiny eye. This too is a representation of Bourgeois.[24] Her curving jaw joins the sloping roof of an adjacent house, creating a puzzlelike assemblage of pieces across the composition. Juxtapositions abound—of profiles and full figures, figures and house, and home and nature. Though loosely rendered, the house contains an attic window, which Bourgeois penciled over the painted surface. An arm and a curl of smoke escape through the opening.

The house is Bourgeois's childhood home in Antony, a town south of Paris, and the profiles probably present opposing self-conceptions associated with the troubled domestic life of that household and the girl's feeling of liberation outdoors. While separate from the house, however, the figure of Bourgeois seems stiff, like a wooden doll, and hemmed in by her personas. Despite the hope of her new life with Goldwater, the painting evokes her deep sense of loneliness as an immigrant; she called her early years in New York "l'époque du mal du pays" (the period of homesickness).[25] Yet the conflicts splitting the image reach beyond her personal situation. As Robert Storr has concluded, "The content of her art is not primarily autobiographical but archetypal, an astonishingly rich, nuanced, sometimes alarming, often funny and almost always startling fusion of classical personifications of human passions and terrors, Symbolist variations on them, Freudian reinterpretations of both, and direct or indirect transcription of her own unblinking glimpses into the murkiest waters of the psyche."[26] Bearing down on her life with the same "integrity" she admired in Picasso's self-revelations, Bourgeois achieved equally rich transformations of mundane events into complex, searing dramas.

Bourgeois translated the rigid figures and dense configurations of these paintings into sculpture, and here, too, she may have drawn on Picasso's example. A 1936 issue of Cahiers d'art had run an extensive article on his sculpture, including a double-page spread illustrating a recent group.[27] Crudely carved from wood, they are tall, very thin female figures—more fragile sticks than

bodies. The magazine reproduced seven of these sculptures across the spread, giving the impression of a group of polelike personages. Bourgeois's Quarantania (1941; plate 89) consists of seven pine shafts carved to suggest rudimentary human forms and clustered together on a base. (The title is a reference to a place of quarantine.) While more ambiguous than Picasso's whittled women, these personages share his evocation of tribal carving (a specialty of Goldwater's) and the impression of community orchestrated in Cahiers d'art. Still stemming from Bourgeois's homesickness and her sense that she had abandoned her family, Quarantania takes the compressed pictorial narrative of the untitled paintings to a broader range of meanings and literal presence in the world.[28]

Perhaps Bourgeois so successfully appropriated and transformed Picasso's work because his autobiographical model, and the principle of "truthfulness" she drew from it, liberated her to explore her own different and extraordinary life as a young woman in France and America. For the largely male artists of the New York scene, however, this switch was not possible. Many wrestled with the finality that Goldwater proposed in his review. Increasingly, they put aside the apprenticeships of the 1930s and took up Picasso's challenge to engage his "researches in order to react clearly against" him.

Stuart Davis, Arshile Gorky, and Graham, the long-disbanded "Three Musketeers" of the 1930s, responded to the retrospective in very different ways. Davis, the eldest of the three, remained most detached. Having already defined his distinctive blend of commitments to political action and theories of formal composition, he paid little attention to Picasso's recent work, and would admit to only a middling admiration for Guernica when he spoke at a symposium at the Modern in 1947.[29] When, in the 1950s, he returned to some of the specific compositions he had painted in the 1920s after Picasso's pictures, he revisited that formative period only to demonstrate how much he had set his own course in the following decades. Colonial Cubism (1954; plate 32) is a highly refined, monumental version of Landscape, Gloucester (1922; plate 29), Davis's strongest variation on Picasso's Fruit Bowl, Wineglass, Bowl of Fruit. The Paris Bit (1959; fig. 74) is both a syncopated revision of one of his Paris pictures, Rue Lipp (1928), and a memorial to his recently deceased friend Bob Brown, whose camaraderie during the French sojourn is preserved in the posters and wordplay of both paintings.[30]

Gorky's immersion in Guernica marked the end of his intensive period "with Picasso," as he had closed his time "with Cézanne" a decade before. The retrospective offered little that surprised him; instead he turned to a new source of inspiration, one increasingly present in New York. Although the beginning of World War II nearly prevented Barr's exhibition, it opened a flood of refugees seeking sanctuary in America. Like many artists in New York, Gorky leaped at the chance to know and question European artists who came to the city, rather than just study their works. Indeed, these artists' residence in New York often gave them more prominence there than Picasso, who remained in France. In 1940, Gorky met Roberto Matta y Echaurren, an eloquent artist on the periphery of André Breton's circle who could initiate him into the latest trends in Paris. As Breton, Max Ernst, and other Surrealists arrived in New York over the next two years, Matta brought them

and Gorky together, and Breton's admiration for the Armenian artist's work grew until he formally proclaimed Gorky a Surrealist and introduced a 1945 exhibition of his work with the statement "Arshile Gorky—for me the first painter to whom the secret has been completely revealed!"[31] Under Matta's guidance, Gorky changed his methods of painting from the thickly layered fields of the late 1930s to fluid washes of oil thinned with turpentine, in a technique suggesting automatism.[32] Yet the discipline he had learned from Picasso never disappeared, and by the mid-1940s he began to reclaim the structures and gestures of Picasso's legacy to create his most personal art, paintings and drawings that joined the themes and images of *Guernica* with his own history.

Graham was reborn. Not only did he return to painting, but he gathered around him a younger generation of artists who shared his fascination with Picasso. Among these, de Kooning walked into the retrospective with the longest exposure to Picasso's work. Perhaps because of this background, the exhibition's impact on him was less immediate, although it grew in importance across the decade. In contrast, Jackson Pollock entered with far less knowledge. Although he had encountered

Picasso's work in 1922, at the age of ten, through reproductions in the magazine *The Dial* (sent to him in California by his brother Charles),[33] Pollock spent most of the 1930s under the influence of Thomas Hart Benton, who shared Thomas Craven's disgust with Picasso as the paradigm of contemporary European art. Nonetheless, Phillip Pavia, a friend of Pollock's, recalled encounters between the two of them and Gorky around the Art Students League in the mid-1930s and Pollock's growing respect for Gorky's skills, particularly his mastery of Picasso's styles.[34] In the spring of 1940, Sande Pollock, another brother, in a letter to Charles Pollock, laid out a radical shift of attitude in Jackson's immediate community: "The Benton show last year seemed to have no positive reaction. Except that his latter work (the nudes) were disappointing. The whole idea of a Missouri Venitian [*sic*],

FIG. 74
STUART DAVIS, *The Paris Bit*, 1959. Oil on canvas, 46 x 60 in. (116.8 x 152.4 cm). Whitney Museum of American Art, New York, Purchase, with funds from the Friends of the Whitney Museum of American Art 59.38a–b

PLATE 91
PABLO PICASSO, *Sketch of a Head of a Bull-Man*, May 20, 1937. Graphite and gouache on paper, 9 x 11 5/16 in. (23 x 29 cm). Museo Nacional Centro de Arte Reina Sofia, Madrid

PLATE 92
JACKSON POLLOCK, *Untitled (Orange Head)*,
ca. 1938–41. Oil on canvas, 18 1/4 x 15 1/4 in.
(46.4 x 38.7 cm). Private collection

PLATE 93
PABLO PICASSO, *Head of Weeping Woman
(III)*, May 31, 1937. Graphite, crayon, and
gouache on paper, 9 x 11 5/16 in. (23 x
29 cm). Museo Nacional Centro de Arte
Reina Sofía, Madrid

both the idea and paintings seemed phony. One had a feeling he should rush up and hold the pretty girls on the canvas. The large Picasso show was a fine one. For imagination and creative painting he is hard to equal."[35]

Whether at Dudensing's exhibition or at the Modern's, *Guernica* and its studies enthralled Pollock. These exhibitions mark his first substantial exposure to Picasso's art, and the attachment seems to have been immediate, almost like that of Arthur Dove and Marsden Hartley in 1911. Whatever Pollock knew of Picasso's work from previous exhibitions and publications, only the most recent pictures compelled him, with their violence, ambition, and size. In drawings and at least two small paintings, he addressed specific motifs of *Guernica*.[36] Pollock's *Head* (ca. 1938–41; plate 90) not only adapts Picasso's essential subject of the Minotaur but also employs the blackened backgrounds and thick interior lines of his pencil-and-gouache drawings (see plate 91) to create a dark field from which the bestial figure emerges and subsides. *Untitled (Orange Head)* (ca. 1938–41; plate 92) transforms Picasso's close-up studies of screaming women (see plate 85) into a blur of encrusted oils loaded with orange and intense yellows, blues, and reds—colors that Picasso applied liberally in the studies but banished from the final painting. Rather than duplicating Picasso's precise imagery of popping eyes or thrusting tongue, Pollock achieved his tormented effect through strident colors and swirling pigments. At first, he was drawn to the sketches more than to the mural, or at least he found ways to possess these images more readily. Certainly their small size and focus on a single subject made them easier to digest. Also, their rough execution resembles the Expressionist styles that Pollock had recently derived from José Clemente Orozco and other Mexican muralists. These artists' public murals prepared him for *Guernica* and set an ambition for large-scale painting that would bring him back to Picasso's mural in years to come.

As the works hanging at the Modern increasingly gripped Pollock, he grew closer to Graham, whom he had probably met a few years earlier. He had sent Graham a fan letter after reading Graham's article "Primitive Art and Picasso," but most accounts conclude that they became friends in 1939 or 1940—with Graham serving as mentor, particularly regarding Picasso. Although the Modern's retrospective jolted Graham back to painting, his obsession remained *Girl before a Mirror* (plate 94). Ringed with jagged points like a sunburst, the staring face in *Interior* (1939–40; plate 97) evokes both the rounded head of Picasso's girl and Graham's belief, expressed in "Primitive Art and Picasso," that "Picasso's painting has the same ease of access to the unconscious as have primitive artists—plus a conscious intelligence."[37] Specifically, Graham addressed the "conscious" element in *Girl before a Mirror*: "In his approach to primitivism the great Spaniard uses arbitrary contortions of features in two-dimensional spatial arrangements."[38] Graham pursued this discipline of flatness through teeming, complex grids of geometric patterns derived from the diamond background and striped costume worn by Marie-Thérèse Walter in Picasso's picture. Attracted by the widespread use of gold, red, and green in *Girl before a Mirror*, Graham exceeded Picasso's own dense patterning; *Queen of Hearts* (1941; plate 96) applies the method to decorating a female figure resem-

bling Walter. Graham even signed and dated pictures of this period using Roman numerals in imitation of Picasso's practice during the early 1930s.

Under Graham's tutelage, Pollock shifted his attention from *Guernica* to *Girl before a Mirror*. These two paintings would remain touchstones for Pollock until the end of his life, and for all Graham's rhetoric about primitivism and the unconscious, Pollock found far more convincing ways to plumb the metamorphosing identities of Picasso's image. He also accepted the challenge to make larger and more integrated compositions. Pollock's *Masqued Image* (ca. 1938–41; plate 95) echoes the palette of *Girl before a Mirror*, and adopts the mirrored opposition of two heads near its top in order to multiply these pairings throughout the painting, generating the repertory of masks suggested in the title. They range from the distinct face near the lower left to others that are only outlines or ciphers in a dense, shallow field of circular patterns, suggesting continual transformation of personas. *The Magic Mirror* (1941; plate 98) began with an image even closer to *Girl before a Mirror*, a woman reflected in a glass at the upper right.[39] As Pollock layered the canvas with thickened pigments, he left visible only segments of the objects' outlines, making discontinuous, curvilinear patterns across a field of tawny white. Finally he repainted the woman's head (with a gaping mouth resembling Picasso's women of the late 1920s), the reflected image, and scattered passages of the woman's body. The effect of this transparent reworking, clothed in a crust of white, resembles Gorky's laborious efforts and devotion to Picasso's "white pictures" in works such as *Composition with Head* (ca. 1936–37; plate 69), and may indicate that Pollock looked beyond Graham for ideas about how to deal with Picasso's precedent. *Masqued Image* and *The Magic Mirror* present two original and very different ways of dealing with Picasso's painting, one emphasizing linear pattern and the other a unified field—but both instilling the images with a crude physical presence and symbolic ambiguity that move beyond Picasso's picture.

In the early 1940s, Graham's renewed enthusiasm for Picasso's art turned to competition. In January 1942, at the New York decorating firm of McMillen, he organized "American and French Paintings," an exhibition that showcased the work of American artists alongside the leading Europeans—one of the first such comparisons to be held anywhere.[40] As might be expected, Graham secured a motley representation of the Europeans (clearly he meant "School of Paris," not "French"): one work each by Georges Braque, Pierre Bonnard, Henri Matisse, Georges Rouault, André Derain, Giorgio de Chirico, and Amedeo Modigliani; three by Picasso; and two by André Dunoyer de Segonzac (presumably a personal favorite). The three Picassos were an unidentified portrait of Maar, a picture called *Roses*, and another titled in the checklist *Femme au fauteuil, deux profils* (*Woman in an Armchair [Two Profiles]*, 1927; fig. 75). This last entry probably corresponds to a painting, apparently unique in Picasso's work, that depicts a radically distorted woman seated in an armchair with a classicizing female silhouette floating on either side of the chair like a shadow cast into the room. (The woman's twisted face and gaping mouth may have influenced Pollock's rendering in *The Magic Mirror*; the painting may also have suggested to Pollock the use of a veil of

whites and grays over the figure.) Graham's selection of Americans in the show was equally idiosyncratic: one or two pictures by David Burliuk, Pat Collins, Davis, de Kooning, Lee Krasner, Walt Kuhn, Pollock, H. Leavitt Purdy, Nicholas Vasilieff, Virginia Diaz, and Graham himself. There is no question that the finest work by an American was Pollock's *Birth* (ca. 1941; fig. 76). Closely related to *Masqued Image*, it made a strong case for Americans rising to the challenge of European art.

The show is famous for prompting Krasner to look up Pollock (whom she may have met earlier). Having studied with Hans Hofmann in the late 1930s and become a regular exhibitor with the Abstract American Artists association in the early 1940s, Krasner was among the most sophisticated young artists in New York. As she and Pollock developed strong bonds, she shared her more seasoned knowledge of contemporary art and gave him a sense of modernist history that he lacked. She had already won rare acceptance in the downtown art world as one of the few women artists welcomed by Gorky and Graham in their late-night discussions at automats and cheap restaurants. Now lost, her *Abstraction* (ca. 1941) in the exhibition was part of series she created in the early 1940s and described as "abstract, Picassoid, with heavy black lines, brilliant intense colors, and thick impasto" (see plates 99, 100).[41] These paintings occupy another corner of the multisided interplay between the work of Picasso and a community of Americans who regularly exchanged studio visits and ideas. As in the case of David Smith and de Kooning, Gorky stood at the center of the exchange. His *Composition with Head* set the terms for Krasner's response, and his absence from Graham's show is signal evidence that Graham no longer considered him a protégé.

Four years after "American and French Paintings," Graham was circulating "Case of Mr. Picasso," a typed broadsheet attacking him as "a talented and malicious little man" whose "fame is a great international, money-making intrigue. His art is a hoax."[42] Craven should have taken notes. Graham's repudiation of the artist he had idolized for twenty years would be hilarious were it not so desperately sad. Having again immersed himself in Picasso's art, Graham again found himself only a follower. His envy drove the text. "The victims of Picasso's publicity frequently ask—but who is better? There are many, known and unknown. Of course, those who are conditioned to see art in terms of Picasso's jargon, cannot see anything, they are blind."[43] As Graham had shown by including Pollock in "American and French Paintings," there was truth in his assessment, but Pollock himself was willing to give the competition its due, at least at this stage. In 1944, he told an interviewer, "I accept the fact that the important painting of the last hundred years was done in France." And he identified Picasso and Joan Miró as the "two artists I most admire." "The idea of an isolated American painting, so popular in this country during the thirties, seems absurd to me. . . . An American is an American and his painting would naturally be qualified by that fact, whether he wills it or not. But the basic problems of contemporary painting are independent of any one country."[44] Certainly

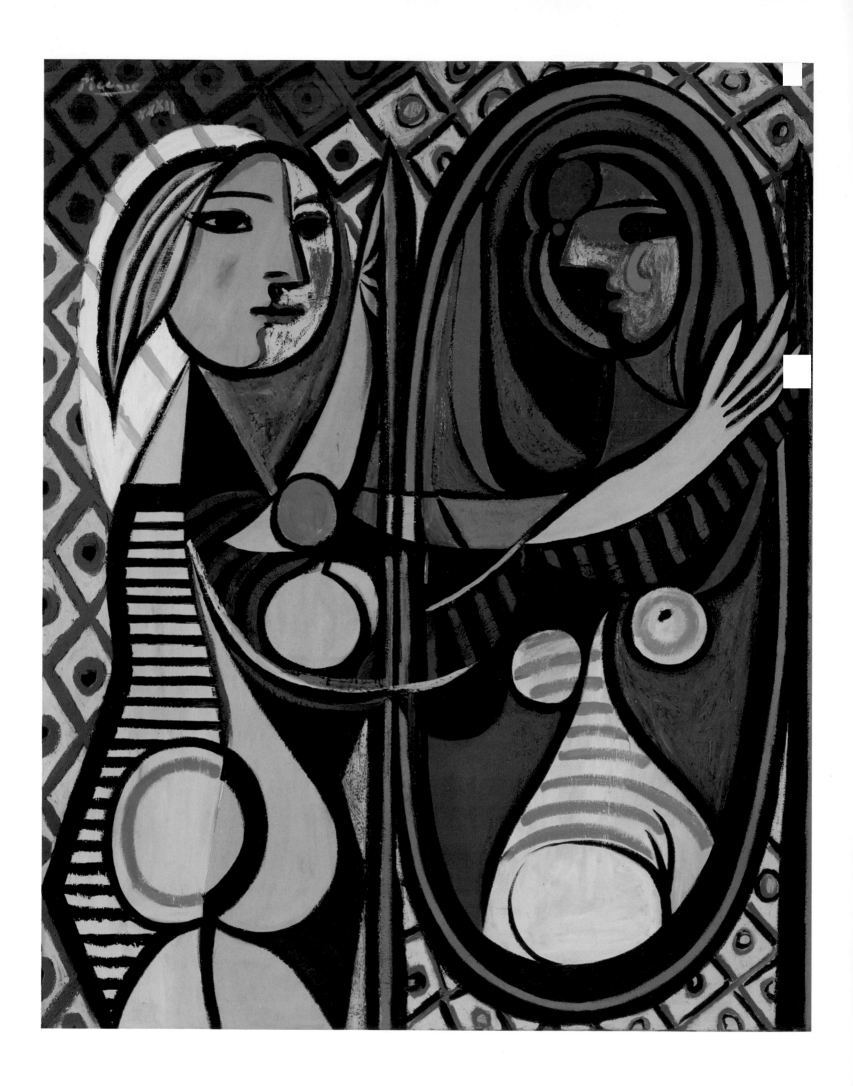

PLATE 94
PABLO PICASSO, *Girl before a Mirror*, 1932.
Oil on canvas, 64 x 51 1/4 in. (162.6 x
103.2 cm). The Museum of Modern Art,
New York, Gift of Mrs. Simon
Guggenheim (2.1938)

PLATE 95
JACKSON POLLOCK, *Masqued Image*,
ca. 1938–41. Oil on canvas, 40 x 24 in.
(101.6 x 61 cm). Modern Art Museum
of Fort Worth, Museum Purchase made
possible by a grant from The Burnett
Foundation

PLATE 96
JOHN D. GRAHAM, *Queen of Hearts*, 1941.
Oil on canvas, 25 x 20 in. (63.5 x 50.8 cm).
Private collection

PLATE 97
JOHN D. GRAHAM, *Interior*, 1939–40. Oil
on canvas, 30 x 20 in. (76.2 x 50.8 cm).
The Rose Art Museum, Brandeis
University, Waltham, Mass., Bequest of
Louis Schapiro, Boston, Mass.

186

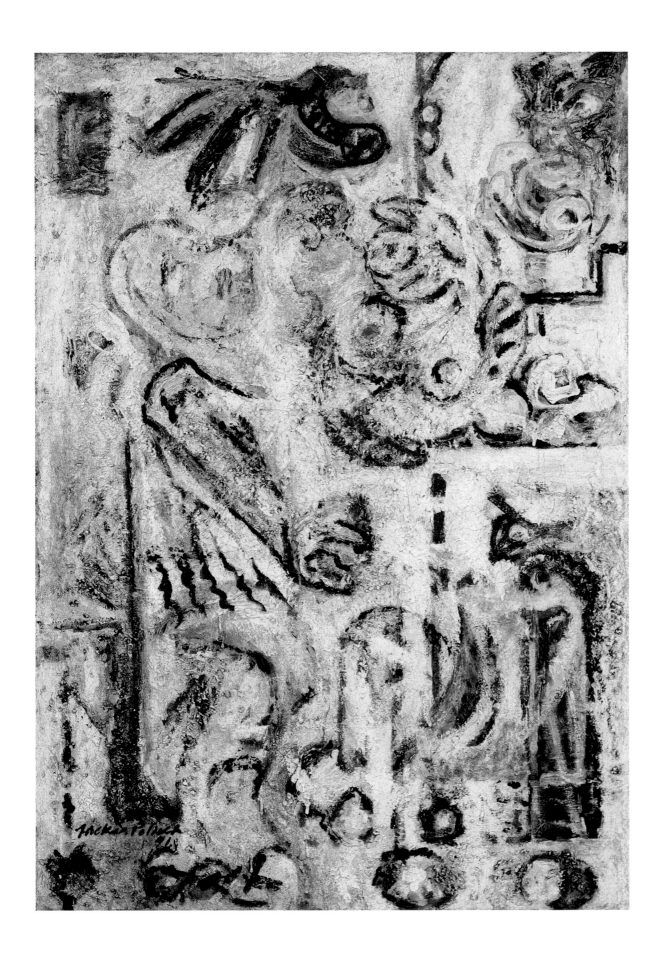

PLATE 98
JACKSON POLLOCK, *The Magic Mirror*,
1941. Oil, granular filler, and glass fragment
on canvas, 46 x 32 in. (116.8 x 81.3 cm).
The Menil Collection, Houston

PLATE 99
LEE KRASNER (1908–1984), *Untitled,* 1940.
Oil on canvas, 30 1/4 x 24 1/4 in. (76.8 x
61.6 cm). Private collection, courtesy of
Cheim & Read, New York

PLATE 100
LEE KRASNER, *Composition*, 1943. Oil on canvas, 30 1/8 x 24 1/4 in. (76.5 x 61.6 cm). Smithsonian American Art Museum, Washington, D.C., Museum Purchase made possible by Mrs. Otto L. Spaeth, David S. Purvis, and anonymous donors and through the Director's Discretionary Fund

Picasso, a Spaniard, would have agreed with that last statement. Pollock's open-mindedness bears a remarkable resemblance to Davis's defense of internationalism in 1929, and marks the end of a fifteen-year period when nationalism had dominated art criticism and many artists' careers in the United States. This change intensified the competition.

Graham's inclusion of de Kooning in his show was not surprising, since the two men had become acquainted in the early 1930s, but it did offer de Kooning a rare opportunity to exhibit, earned him his first review,[45] and, according to one scholar, began "the friendship and subtle rivalry" between de Kooning and Pollock.[46] However, the work Graham chose, a small painting of a man, was both minor and several years old.[47] It did not reflect the very substantial changes in de Kooning's art that had begun in 1939 or 1940, changes probably prompted by two events: his meeting Elaine Fried, in late 1939, and the exhibitions of Picasso's work during that same year. De Kooning's romance with Fried certainly justified phasing out the series of downtrodden men he had pursued through the late 1930s.[48] She was a flesh-and-blood equivalent of Picasso's mistress Walter, and a compelling reason to appropriate the vibrant, imposing paintings that Picasso made of Marie-Thérèse in the early 1930s (such as *Seated Woman with Wrist Watch*, 1932; plate 101). Unquestionably de Kooning's most famous series, the "Women" would extend episodically through the remainder of his career. *Seated Woman* (ca. 1940; plate 102) was apparently the first. The image resembles photographs of Fried from that time, but constitutes far more than a switch of gender. Gone are the muddied tones that pervaded the paintings of men; instead, the picture is built on contrasting blocks of brilliant color—particularly the glowing pink of the woman's flesh and the vivid green and red of the background areas. This underlying graphic clarity and vivacity of hue, as well as the monumentality of the figure, reflect the paintings of Walter that had appeared in Barr's exhibition but had rarely been shown in America during the previous decade.

Compared to the pictures that Pollock made after the 1939 retrospective, *Seated Woman* is a less full-blown appropriation of Picasso. De Kooning had a more thorough training in art than Pollock did, and more years of experience with the avant-garde. His early response was more rooted in his previous work than Pollock's was. De Kooning did not mimic the extreme flatness of Picasso's pictures, which emphasize Walter's swelling profile (fig. 77): the head of *Seated Woman* is modeled in subtle gradations to project the three-dimensionality of de Kooning's earlier men, a manner he soon retired. The real initiative is a different way of suggesting both space and movement: multiple positions of the woman's head and limbs, and a painterly technique that overlaps flat passages of pigment with looser strokes and lines of charcoal to create a sketchlike effect.

From this point forward, a mixed technique, including areas of apparent unfinish, was the driving force of de Kooning's art. In a sense, it represented an unpacking of the heavily layered compositions that he and Gorky had laboriously built in the late 1930s. The process was revealed, and aesthetic decisions, both resolved and pending, took on a greater part of the work's meaning. This change may register de Kooning's attention to the calls for spontaneity that

accompanied Surrealism, yet his art, always calculated in terms of the final result, accorded far better with Picasso's willingness to make chance just one of the many tools in his kit, rather than jettison all the others. Again, Barr's exhibition and catalogue may have been crucial here, in their selection not only of Picasso's work but of Picasso's words "I do a picture—then I destroy it. In the end, though, nothing is lost." Even his description of process is remarkably resonant in terms of de Kooning: "The 'vision' of [two people] gave me a preliminary emotion; then little by little their actual presences became blurred; they developed into a fiction and then disappeared altogether, or rather they were transformed into all kinds of problems. They are no longer two people, you see, but forms and colors: forms and colors that have taken on, meanwhile, the *idea* of two people and preserve the vibration of their life."

Although few of Picasso's figure paintings in the exhibition evinced this process, other works did—not only the *Guernica* sketches but *Guernica* itself. The crudity and improvisatory quality of the sketches are obvious and were widely noted at the time, but for many visitors the painting's eleven-foot height and twenty-five-foot expanse overwhelmed close study and left only the schematic impression that many people still retain. For those who

FIG. 77
PABLO PICASSO, *Head of a Woman, Right Profile (Marie-Therese Walter)*, 1934. Oil and charcoal on canvas, 25 1/2 x 19 1/2 in. (64.8 x 49.5 cm). Collection of Aaron I. Fleischman

examine the painting, however, the surface is a tissue of dripped paint and rough revision.[49] Photographs of its earlier stages preserve the history, but close attention to the finished canvas reveals an image still in flux. Pollock and de Kooning spent long sessions studying the mural, and one artist who saw it on the Chicago leg of its tour recorded his outrage:

> I was appalled! I noticed on *Guernica* that Picasso hadn't even erased some of his chalk marks and charcoal drawing. It was all so crude! I was upset! But by the time the show came down, I was enthralled with Picasso! It explained a lot to me—how one departs from academic training to a more expressive, a broader, approach to art.[50]

Drips and runs of paint cross many of the figures, including the woman who reaches over more than a quarter of the canvas to shine a lamp on the scene, but the animals receive the crudest renderings. Screaming in pain, the horse's open jaws froth with pigment; bare teeth are streaked as if saliva were flowing over them. The bull's head is the roughest part of the picture; because it is overlaid with a thin coat of white, the revisions and many states of the composition are evident here. Several versions of the bull's features are visible: some drawn in black oil underlie others freely sketched in charcoal and still others in upper layers of oil. At times the versions match, but in other cases, particularly in the placement of the eyes, they create conflicts of images and materials that convey both Picasso's dynamic process and the chaotic violence of the bull. Even now, the painting is a startling combination of vast size and public address with intimate, fitful execution. Its spontaneity must have shocked those accustomed to the wall works produced by the artists of the Works Progress Administration.

Directly below the bull is a woman who is spattered with only a few drips of paint but screams, with the same anguish as the horse, over the dead child cradled in her arms. Unlike the stable volumes of Picasso's images of Walter, her form is stretched and twisted to register her grief. This woman may have provided de Kooning with the far more agitated figure he portrayed in *Pink Lady* (ca. 1944; fig. 78); her distended breasts, extended neck, and thrown-back head are remarkably close to de Kooning's image, as are her oblong, nearly bald head and her eyes propelled toward the dome of her skull. These basic similarities, however, capture little of de Kooning's forceful image. Anatomy is only a point of departure for a painting that takes Picasso's display of process much farther. The sketched positions of her head, and the prominent mixture of charcoal and oil, both create an effect of erratic movement and reflect the countless choices de Kooning has made. In his "Case of Mr. Picasso," Graham attacked Picasso for not finishing his pictures: "Why should you accept a sketch for a painting when you would not accept a half-finished suit from a tailor, an understructure instead of a house, a bridge sketched in a fetching way, or an incomplete automobile?"[51] Graham misses the point of merging the understructure with the whole rather than burying it beneath a neat skin, an achievement that de Kooning made his own.

Through the mid- and late 1940s, de Kooning pushed the ideas implicit in Picasso's technique to define one of the first

American styles that met Picasso's challenge to surpass his own command. After all, de Kooning had been trained by Gorky to absorb Picasso's styles, and he had the education and the cultural traditions to understand both Picasso's fascination with diverse approaches and his desire to transform them. In *Picasso: Forty Years of His Art*, Barr reproduced Picasso's *Figure* (1927; plate 103) and emphasized its originality: "The human form has undergone a metamorphosis so radical that foot, head, breast and arm are not readily recognizable. Only a few rather isolated cubist works of 1913–14 anticipate such fantastic anatomy."[52] De Kooning's *Pink Angels* (ca. 1945; plate 104) achieves an even more radical distortion of the body against a similarly bare geometric structure. Yet, to the clarity of Picasso's precisely outlined distortions and dislocations, de Kooning added the record of their being drawn and redrawn as they were painted, creating a new dimension of spatial torque and apparent velocity.

Near the lower-right corner of *Pink Angels*, a small rectangle is visible below a large, rounded shape, the fullest in the painting. This heavily outlined box provides both a counterpoint to the curvilinear, biomorphic passages of pink and the possibility

FIG. 78
WILLEM DE KOONING, *Pink Lady*, ca. 1944. Oil and charcoal on panel, 48 1/4 x 35 1/4 in. (122.6 x 89.5 cm). Courtesy Richard Gray Gallery

PLATE 101
PABLO PICASSO, *Seated Woman with Wrist Watch*, August 17, 1932. Oil on canvas, 51 3/16 x 38 3/16 in. (130 x 97 cm). Collection of Emily Fisher Landau

PLATE 102
WILLEM DE KOONING, *Seated Woman*,
ca. 1940. Oil and charcoal on Masonite,
54 1/16 x 36 in. (137.3 x 91.4 cm).
Philadelphia Museum of Art, The Albert
M. Greenfield and Elizabeth M.
Greenfield Collection, 1974

PLATE 103
PABLO PICASSO, *Figure*, 1927. Oil on ply-
wood, 50 13/16 x 37 7/16 in. (129 x 96 cm).
Musée National Picasso, Paris

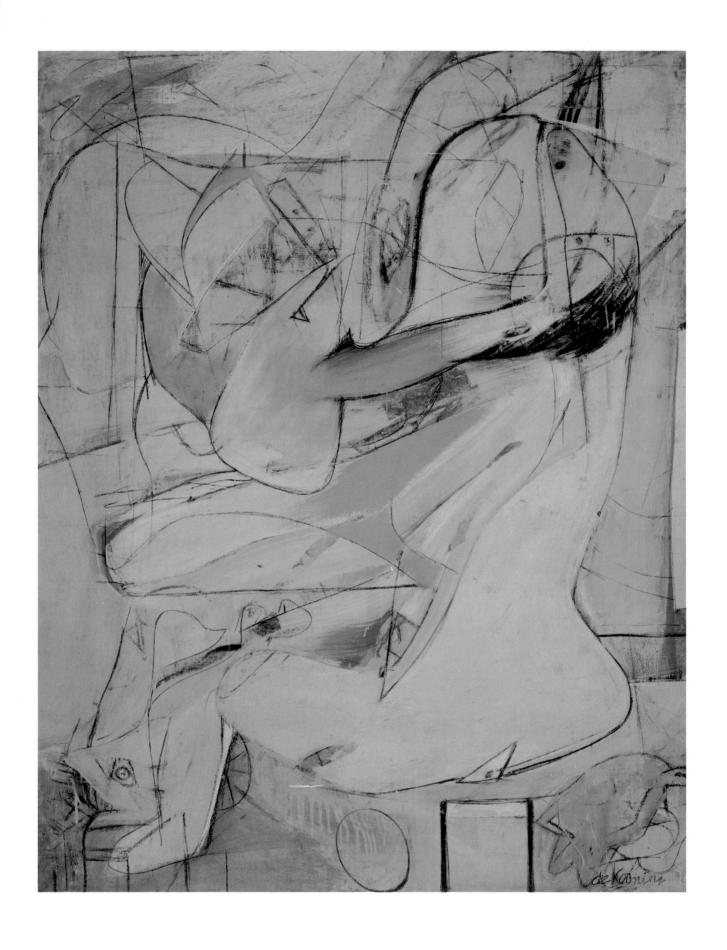

PLATE 104
WILLEM DE KOONING, *Pink Angels*,
ca. 1945. Oil and charcoal on canvas, 52 x
40 in. (132.1 x 101.6 cm). Frederick R.
Weisman Art Foundation, Los Angeles

of a window or door into deeper space. Throughout the 1940s, de Kooning used these rectilinear frames to recall the grid that underlay each composition and, sometimes, to evoke an architectural setting, as he did in *Fire Island* (1946, fig. 79). The schematic structures of these compositions lap back to his small variations on Gorky's *Organization* (1933–36; plate 67) and Picasso's *The Studio* in the late 1930s, but they also respond to the more complex space of *Guernica*, with its stagelike enclosure of the figures.[53] In one small painting of the late 1940s, *Abstraction* (1949–50; plate 105), de Kooning's reference to *Guernica* is explicit. While the upper half of the composition is filled with the billowing and distending forms of de Kooning's contemporary works, though now flecked with blood red, the lower band contains not only a recognizable figure but unmistakable motifs of the mural and its studies: a human skull at the base of a ladder that rises to an open window and roof. Clearly, de Kooning remained fascinated with the mural throughout the decade, but he drew greater inspiration from its style than from its subject matter.

In a 1969 interview, B. H. Friedman asked Krasner whether Pollock might have drawn on *Guernica* for his black-and-white series of the early 1950s. She replied precisely,

> If so, it was an awfully slow burn—say, twenty years. But there's no question that he admired Picasso and at the same time competed with him, wanted to go past him. Even before we lived in East Hampton [where they moved in November 1945], I remember one time I heard something fall and then Jackson yelling, "God damn it, that guy missed nothing!" I went to see what had happened. Jackson was sitting, staring; and on the floor, where he had thrown it, was a book of Picasso's work.[54]

If this account is not enough to demonstrate Pollock's continuing fascination and growing competitiveness with Picasso, an early inventory of Pollock's library includes an intriguing entry by the compiler, James Valliers: "*Picasso*, The cover and frontispiece are missing, so I cannot determin [*sic*] the name of the author. This book contains references up to 1937. The book is a catalogue with over 100 black and white plates."[55] With this number of reproductions and specific chronological range, the volume could only have been Barr's *Forty Years*.[56] Its battered state also suggests a volume that Pollock studied many times, and might even have hurled to the floor on occasion. The book Valliers saw cannot be identified conclusively because it seems to have been lost in a fire (along with many of Pollock's magazines, including some containing articles on Picasso, such as early issues of *The Dial*, *The Arts*, and probably *Cahiers d'art*),[57] but, in any case, Barr's catalogue and its 1946 sequel, *Picasso: Fifty Years of His Art*, were ubiquitous. And if the subject was *Guernica*, artists did not need to open a book: in the fall of 1942, the mural returned to the Modern after touring for most of the previous two and a half years, and it remained on view at the museum until 1981, when it was finally sent to Spain in fulfillment of Picasso's wish to donate the mural when the country was once again a democracy.

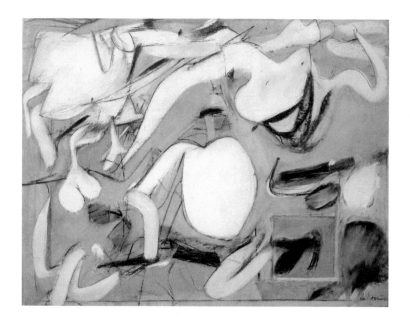

After Graham's exhibition, Pollock pursued a wide variety of styles, some related to Picasso's work, some to Miró's, and others less clearly referential. He often seemed to explore divergent directions impulsively in isolated clusters of work (a method significantly different from that of de Kooning, who tended to amalgamate contrasting styles and techniques in his finished works). Cutting across Pollock's work of the mid-1940s is a series of paintings that readdress *Guernica*. Like his first responses, they began with a concentration on one of the mural's motifs, but this time they eventually engaged the entire composition. Pollock's "Equine Series" of approximately 1944, the counterpart to his early focus on the bull and Minotaur, takes on the tormented horse at the center of *Guernica*. *Untitled (Composition with Sgraffito II)* (ca. 1944; plate 106) flattens the splayed animal into a graphic silhouette of white on black, in part by scratching through the black layers to expose the white canvas. *Untitled (Equine Series I)* (ca. 1944; plate 107) captures the horse's twisting body and gaping mouth, without mimicking the exaggerated anatomical details that Picasso used to convey anguish. Largely reduced to a network of heavy black lines, Pollock's image conveys drama through the physical torque of the animal. Its tonality of blues and yellowish white, instead of the black and white of *Untitled (Composition with Sgraffito II)*, lowers the contrast but also recalls the bluish tints throughout Picasso's painting.

In *The Water Bull* (ca. 1946; plate 109), Pollock grappled with the entire composition. The title, which Krasner recalled was chosen by Pollock,[58] shifts the focus back to his original fascination with the agent of violence. While not nearly as large as Picasso's mural, *The Water Bull* is about seven feet across—large by Pollock's standards at the time. Yet the canvas's proportions are more significant. Its height of thirty inches is much shorter than that of most of his contemporary pictures and creates a strongly horizontal field, one close to the shape of *Guernica*. As a reprise of

FIG. 79
WILLEM DE KOONING, *Fire Island*, 1946.
Oil on paper, 19 1/2 x 27 1/2 in. (49.5 x 69.9 cm). Collection of Martin Z. Margulies

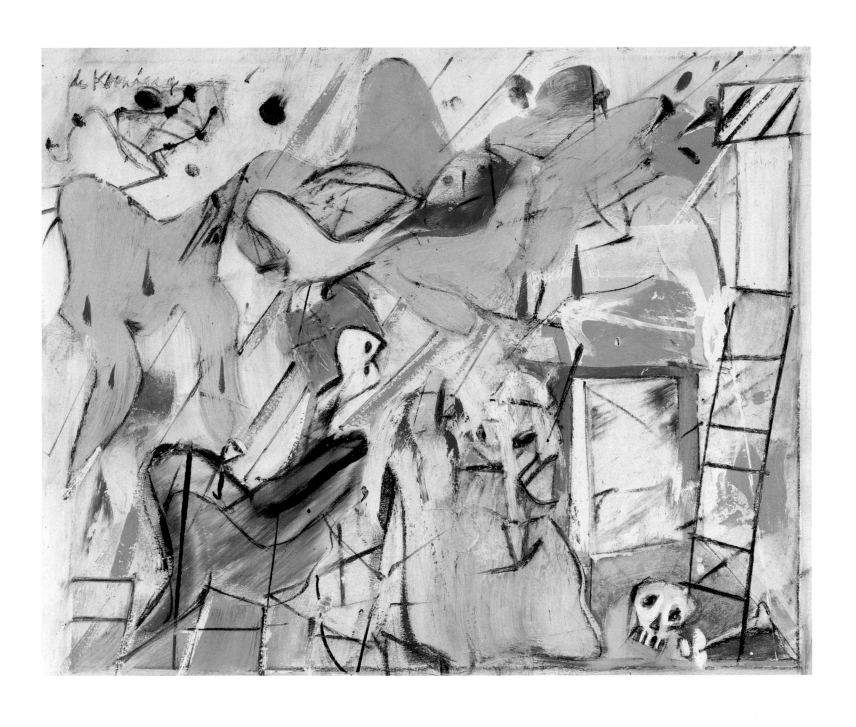

PLATE 105
WILLEM DE KOONING, *Abstraction*,
1949–50. Oil on cardboard, 14 1/2 x
18 1/2 in. (36.8 x 47 cm). Museo Thyssen-
Bornemisza, Madrid

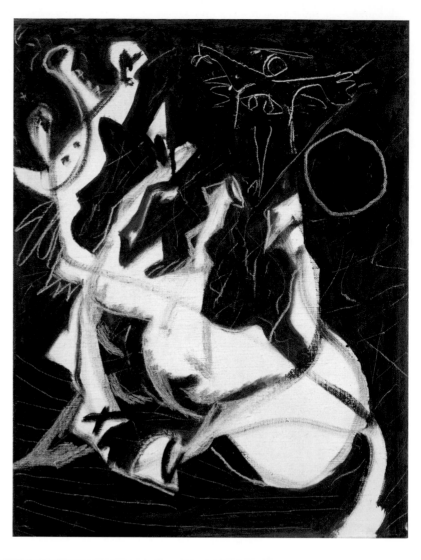

PLATE 106
JACKSON POLLOCK, *Untitled (Composition with Sgraffito II)*, ca. 1944. Oil on canvas, 18 1/4 x 13 7/8 in. (45.7 x 35.2 cm). Courtesy Joan T. Washburn Gallery, New York, and the Pollock-Krasner Foundation, Inc.

PLATE 107
JACKSON POLLOCK, *Untitled (Equine Series I)*, ca. 1944. Oil on canvas, 17 x 30 in. (43.2 x 76.2 cm). Collection of Laurence Graff, Courtesy Joan T. Washburn Gallery, New York, and the Pollock-Krasner Foundation, Inc.

PLATE 108
PABLO PICASSO, *Bullfight*, 1934. Oil and sand on canvas, 13 x 16 1/8 in. (33 x 41 cm). Philadelphia Museum of Art, Gift of Henry P. McIlhenny, 1957

PLATE 109
JACKSON POLLOCK, *The Water Bull,*
ca. 1946. Oil on canvas, 30 1/8 x 84 7/8 in.
(76.5 x 215.6 cm). Stedelijk Museum,
Amsterdam

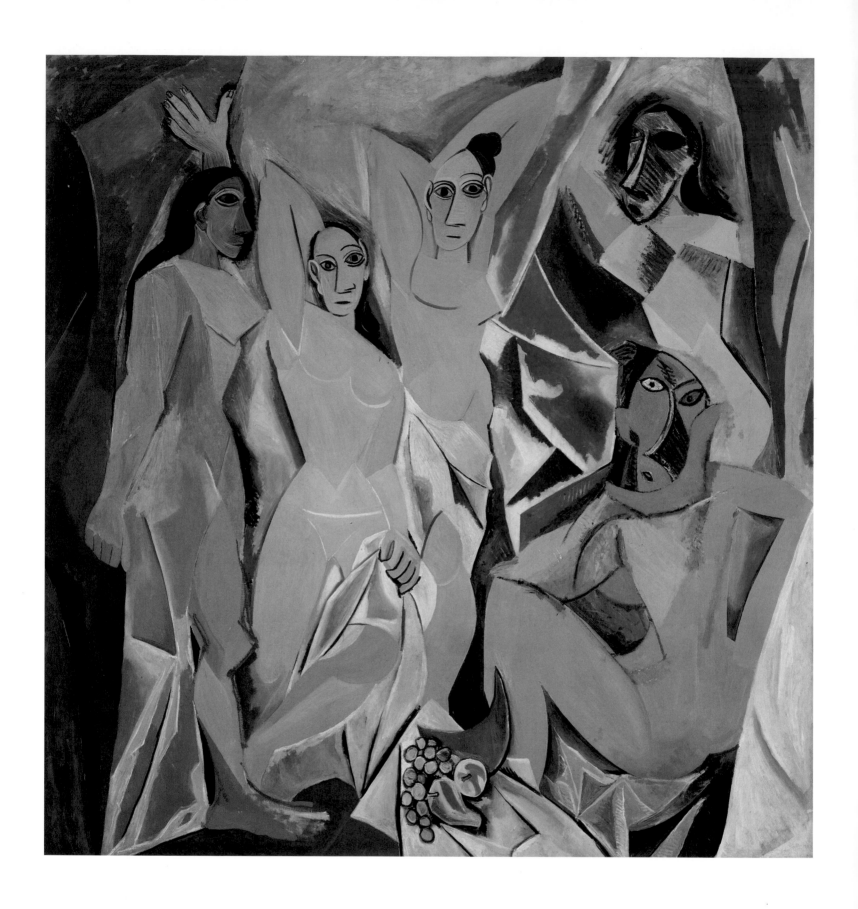

PLATE 110
PABLO PICASSO, *Les Demoiselles d'Avignon*,
1907. Oil on canvas, 96 x 92 in. (243.8 x
233.7 cm). The Museum of Modern Art,
New York, Acquired through the Lillie P.
Bliss Bequest (333.1939)

the mural, however, *The Water Bull* takes tremendous liberties with imagery, execution, and palette. As in *Guernica*, three parts are linked by diagonal lines rising across the composition, and certain of Picasso's figures appear as dynamic schemas. Most clearly, Pollock combined the thrusting head and reaching arm of Picasso's woman extending a lamp, making an arcing triangle that stretches from the upper-right corner of *The Water Bull* to its center. Within, loose scribbles register the fingers and profile of Picasso's woman. Less distinct on the far left, Picasso's slaughtered child, with head, arms, and legs dangling, seems to be the basis for a cipher of a circle enclosing a large eye next to a series of oscillating lines. Although these references to Picasso's figures remain, his two combatants, the bull and the horse, are reduced to illegible fields of clashing colors and broad strokes. Even in later years, Pollock followed this sequence, beginning with loose versions of Picasso's figures and broadening his treatment to create a largely independent painting.

Both the rough handling of *The Water Bull* and its vivid hues seem far from Picasso's, although it does maintain *Guernica*'s tonal balance, ranging from bright white through grays to black, by building from the white undercoat through light yellows and greens to darker reds and deep blues. Yet both this choice of colors and the painting's rough facture may have come from Picasso, and specifically from a painting of a bullfight closely associated with *Guernica*. Barr's retrospective included *Bullfight* (1934; plate 108), a brilliantly colored and coarsely painted picture only slightly less abstract than Pollock's.[59] Moreover, Barr's *Picasso: Fifty Years of His Art*, which appeared the same year Pollock probably painted *The Water Bull*, added a reproduction of the painting, and a caption stating, "In the small canvas . . . the agony of the picador's horse and the ferocity of the bull are almost lost in the whirling linear fury which rises from the spiraling dust to the snapping pennants far above."[60] Mixing vivid oil pigment with granular sand to produce a thick brew, Picasso created a churning image of a bull speared by a picador's lance. Man, horse, and bull are easily lost in the arrays of multihued lines and eddies of paint emanating from the wound. This is the sort of Picasso that Graham came to condemn, but its crude energy is exactly what Pollock sought in his own work.

Without citing either *Bullfight* or *The Water Bull*, Jonathan Weinberg has proposed that Pollock's famous reference to "veiling the image" was informed by Picasso's description of "blurring" as translated in Barr's catalogue.[61] In the 1935 statement that Barr reprinted, Picasso is also quoted proclaiming, "Abstract art is only painting. What about drama?" and "There is no abstract art." He elaborates,

> You must always start with something. Afterward you can remove all traces of reality. There's no danger then, anyway, because the idea of the object will have left an indelible mark. It is what started the artist off, excited his ideas, and stirred his emotions. Ideas and emotions will in the end be prisoners of his work. Whatever they do, they can't escape from the picture.

Picasso ends the passage with the statement, "Whether he likes it

or not, man is the instrument of nature"—a phrase strikingly similar to Pollock's retort "I *am* nature," although separated by a crucial distinction: Pollock's apparent belief (perhaps Jungian in origin) that he could channel nature within himself rather than shape it from without.[62]

Speaking in the year after he painted *Bullfight*, Picasso could easily have been describing his working method in that picture, which is one of his least legible, but his words suggest even-less-representational results and may well have guided Pollock toward his "drip" technique of the late 1940s. In the intervening years, Pollock ranged through many styles, and, among Picasso's, seems to have explored the connection Barr made between Picasso's work of the late 1930s and his "Negro Period" of 1907. Several scholars have suggested that *Gothic* (1944; plate 111) might derive its rhythmic repetition of curves and intensely kneaded space from Picasso's greatest painting of 1908, *Three Women* (fig. 4), or its related works.[63] Yet *Three Women* was sequestered in the Soviet Union and did not join Barr's retrospective; neither did the related works, and the few in this country were not exhibited anywhere near New York.[64] Critic Clement Greenberg may have been closer to the mark when he said that Pollock painted *Gothic* "under the inspiration" of *Les Demoiselles d'Avignon* (plate 110), which was on view at the Museum of Modern Art. He also mentioned that this was the first instance, as far as he knew, of an American artist "discovering" this painting.[65] Actually, Gorky had painted two small variations on the primitive heads in the *Demoiselles* within a few months of its first showing in

FIG. 80
PABLO PICASSO, *Nude with Raised Arms (The Dancer of Avignon)*, 1907. Oil on canvas, 59 x 39 1/4 in. (150 x 100 cm). Private collection

New York, but his paintings had not been exhibited. It is surprising that few Americans engaged this celebrated painting. Perhaps its revolutionary style and violently aggressive subject matter were so well integrated into *Guernica* that responses were directed at the more contemporary mural. Nonetheless, the *Demoiselles* was an essential picture for artists who fully engaged Picasso's art. Pollock told Krasner that the picture had been "terribly important to him."[66] And Kirk Varnedoe, in his essay for the Modern's Pollock retrospective of 1998, proposed that "the *Demoiselles*, too, branded itself in the painter's eye, not just for its mean psychic voltage but for the way its spiky linear energies violated the distinctions between volumes and space and gave the whole scene an irrepressible, discomfiting animation."[67] During the late 1940s and early 1950s, de Kooning would make the painting a major focus of his art.

Picasso spoke of the *Demoiselles* as his "first exorcism painting," a phrase that has evoked a vast range of interpretations, from Picasso's fear of contracting syphilis to his fight for liberation from the ghosts of past artists.[68] His obvious reliance on Cézanne's bathers, however, makes his relation to his revered predecessor one of the prime issues he confronted in the *Demoiselles*'s fractured structure and gruesomely masked prostitutes. Instead of engaging the *Demoiselles* directly, Pollock seems to have turned to a surrogate, another painting by Picasso that presents only the central woman of the *Demoiselles*. Called *Nude with Raised Arms (The Dancer of Avignon)* (1907; fig. 80), the painting appeared in both Barr's exhibition and the catalogue. It depicts a monumental, flattened figure, modeled on Gabonese sculpture, in a pose that both simulates movement and creates a surface rhythm of surrounding angular shapes.[69] Pollock's notes indicate that he intended the painting we know as *Gothic* to be one part of a three-part "mural" called *Black Dancer*.[70] This abandoned triptych would probably have been wider than the *Demoiselles* and nearly as high, but its force would have been generated by the paintings' churning pattern of arcs, dense surface, and luminous colors. In the final painting—called *Gothic* because of its "stained-glass" effect—Picasso's glaring woman seems not so much suppressed as diffused through the composition, her presence registered through thrusting arcs that beat the rhythm of the picture.

Pollock seems to have turned to the *Demoiselles* both for its fearsome human presences and its impact as a "battlefield"—the way its fractured, piecemeal structure and jarring styles carry the figures' intensity through the entire composition. The face near the upper-left corner of *Troubled Queen* (1945; plate 112) adopts the broad, pointed planes of Picasso's "Africanized" masks to convey a similar monumentality and aggression. Like Picasso, Pollock extended angular planes through the surrounding space, making a field of zigzagging facets. Even the reddish-brown and green striations across the upper mask in the *Demoiselles* may be reflected in the short, thick strokes scattered across *Troubled Queen*.[71] The crudely striped, angular facets that Picasso wove through the woman's body and surrounding space to organize a shifting field suggested a point of departure for Pollock, who articulated a far more mobile space structured by whipsawing lines, with broadly brushed passages and one of his first uses of splattered and poured pigment in a major painting.

Galaxy (1946–47; plate 113)—originally titled *The Little King*, and exhibited under that name in a very different form—embeds this fundamental transformation of Pollock's art in its multiple layers. In April 1946, Peggy Guggenheim, Pollock's patron from 1943 through 1947, presented a solo exhibition of his work at her New York gallery, Art of This Century. It included both *Troubled Queen* and *The Little King*. As a contemporary photograph reveals (fig. 81), the two paintings shared a strong resemblance. *The Little King*, too, was centered on a single monumental figure, whose face of triangular planes was grounded in a field of dark interlacings filled with patches of lighter pigments. When the painting appeared as *Galaxy* a year and a half later in the Whitney Museum's "Annual Exhibition of Contemporary American Painting" (Pollock's second consecutive representation in a Whitney Annual), it was radically changed. The wedge-shaped face now anchored a far more fluid field that left visible only vestiges of the earlier composition. Whereas *The Little King* had been painted with a brush, *Galaxy* is defined by poured and splattered pigments, particularly the reflective aluminum paint that creates a luminous screen between the "king" and the filigrees of white and yellow (along with touches of many other colors, including violet and green) that Pollock laid on top. While the silver creates an optical space between the two multicolored layers, its many openings link them in overlapping and adjacent passages of broadly brushed and flowed pigment, building off the original composition. It is hard to imagine a clearer example of art as "a sum of destructions."

Galaxy is the most explicit example we know in which Pollock chose "to veil the image," even though he used this phrase in discussing another painting.[72] As a composite of his last brush style and his first drip technique, *Galaxy* is at the origin of a controversy over how Pollock composed his classic drip paintings of 1947–50: whether he generally began with figurative images and obscured or eliminated them as he added layers to the canvases, or whether he started abstract and remained so to the end of each painting. Because Pollock worked directly on the canvas without reliance on preparatory drawings, it is remarkable that any evidence exists to help resolve the question. What evidence we do have records only a few of the classic paintings, and then only partially. Yet one of the most complete records demonstrates not only that Pollock began with figural images but that they stemmed from his earliest fascination with Picasso's work.

The only chance we have to know how Pollock began is to find extensive, serial photographs of the drip paintings during their initial stages. In the years in which Pollock developed the style, he worked privately in his barn in Springs, outside East Hampton, but after many of his drip paintings were shown in 1948 and 1949 at the Betty Parsons Gallery in New York, his reputation grew, and a young photographer, Hans Namuth, sought him out and asked to photograph him at work.[73] Not only would Namuth's photos capture "the metamorphoses of a picture" that Picasso had cited in the interview reprinted in Barr's catalogue, and that Maar had recorded during the painting of *Guernica*, they would also show Pollock in the process of putting paint to canvas. After a session of taking still images in the summer of 1950, Namuth wanted to film Pollock at work: "To make a film was the next logical step. . . . Pollock's method of painting suggested a moving picture."[74] At the end of the

summer, he returned with his wife's movie camera, "an inexpensive Bell and Howell," which he shot with, using handheld positions and available light, to make a black-and-white film. The five minutes and thirty-four seconds it captures are a sometimes disorienting assortment of partial views, as Pollock moves back and forth around the canvas he is painting and Namuth breaks off and shifts from an overhead position to one near the canvas on the floor. Even though Namuth commented that "the painting [Pollock] created during the black-and-white film was particularly beautiful; no one knows today where it is or what became of it," the film was never officially released and was rarely viewed.

In preparation for the Modern's Pollock retrospective of 1998, Pepe Karmel applied computer technology to a frame-by-frame analysis of the film and its outtakes. His study not only revealed that the painting is *Number 27, 1950* (1950, plate 114) but also pieced together a surprisingly complete record of its early development. While some frames show distinct sections of the painting, the most valuable images are a series of composites consisting of several frames joined through computer enhancement to create images of the entire canvas (fig. 82). These display a full view of the canvas after Pollock had used only a dripped line of black paint to lay down a series of outlined forms. The array is similar to the dispersal of shapes in the underdrawing of *The Water Bull*, still visible below the upper layers of pigment in that work. Moreover, the attenuated and rounded shapes Pollock used to begin *Number 27, 1950* flow back through those in *The Water Bull* to the art of Picasso. Earlier, in drawings such as *Untitled* (ca. 1939–42; fig. 83), Pollock had used a fluctuating line of black ink to fill sheets with figures whose fantastically distorted anatomies mirror the dramatic gestures of those in *Guernica*. Although he was now flowing pigment off the brush, Pollock used a remarkably similar style to begin *Number 27, 1950*, and one of its initial sketches may specifically refer to a bullfight.[75]

Two minutes of film record Pollock laying out the composition. They leave two vivid impressions: his mastery of the drip technique and his methodical building of the composition through discrete figures.[76] Instead of moving back and forth across the nearly nine-foot canvas, Pollock began in one corner and hovered there until he had sketched an image. Then he repeated the activity over an adjacent area, and another, until he had loosely covered the entire canvas. In making each configuration, he showed remarkable control of paint flowing from a hardened brush. Lightly dipping the instrument into a can, Pollock held it a few inches above the canvas and slowly ran paint over the area within reach. Even though the brush never touched the canvas, Pollock was drawing, and he sketched not only outlines but interior details. While he generally kept the brush moving, he made small-scale additions by holding it steady and tilting the loaded end upward, allowing drips of paint to fall as discrete dots rather than flowing lines. Rarely standing to survey the entire canvas, Pollock created a piecemeal initial composition assembled from figures that Karmel correctly identifies as "Picassoid."

Pollock next increased the speed and thrust of his movements, shifting from the small scale of drawing to larger, more forceful gestures of painting. As Karmel explains, "The initial lay-in of the canvas had been done with a brush held horizontal and

moved smoothly along a linear path. Now, crouching low over the canvas, Pollock plunges his brush deeply into the can and discharges the paint with a rapid flick of the wrist. It descends onto the canvas to form an elongated blotch or splat."[77] Still using only black paint, Pollock built a field articulated by these accumulations of pigment. Karmel continues, "This is the point at which the painting is transformed from a collection of independent pictographs into a single allover composition, unified by a consistent rhythm of dark and light, thick and thin, extending across the surface. It also seems to be the point at which the original collection of 'representational' images becomes an 'abstract' composition."[78] Well before Pollock completes the painting, the movie abruptly ends, perhaps because Namuth ran out of film.

In a little more than five minutes of film time and probably not a great deal more in life, Pollock transformed a blank canvas measuring nearly four by nine feet into a painting well on the way to completion. Unlike the composition in the film, however, *Number 27, 1950* shows opulent color—broad skeins of white, yellow, and pink interwoven with metallic runs of gold and aluminum. These substantial additions almost certainly required further sessions to build up layers of distinct colors, rather than the intermingling that results from painting wet on wet. In one dramatic still of the studio, Namuth caught the lower-left corner of the painting after Pollock had begun this process, but there is no additional film or, apparently, still photography that would reveal further changes to it.

Namuth's still photographs show early stages of two other masterpieces Pollock painted in this remarkable year, *Autumn Rhythm* and *One*. Although the evidence on these works is less extensive, it is legible enough to conclude that Pollock also began *Autumn Rhythm* with figurative imagery; *One* may have started this way as well, but seems to have fluctuated between figuration and abstraction as it developed. We will probably never have more substantial documentation of the classic paintings. In the case of *Number 27, 1950*, however, Namuth's frames record a gathering of forms that thread its surging webs through Pollock's decade-long obsession with Picasso. These twisted and stretched figures stem from Picasso's violent distortions in *Guernica* and supply the building blocks of Pollock's foundation, but the relationship rests on more than these elements: as in *The Water Bull*, it extends to the full scope of the mural, its powerful motifs, its intricately interwoven imagery, and the raw force it projects across a broad expanse. In these paintings at least, Pollock seems to have taken up Picasso's researches, extending his techniques to obliterate the limits he imposed and creating a new art of remarkable subtlety that, like Picasso's, embraces complexity and contradiction.

Even at the time, 1950 seemed a watershed. "The Club," a group of downtown artists that embraced members of American Abstract Artists and "the Picasso men" (which included de Kooning and Phillip Pavia, among others),[79] began plans for the year with two huge collages that covered their East 8th Street space's walls and ceiling in lieu of typical Christmas decorations and continued through the main event: New Year's. The party lasted for three days. At some point Pavia stood up and proclaimed, "The first half of the century belonged to Paris. The next half century will be

PLATE 111
JACKSON POLLOCK, *Gothic*, 1944. Oil on canvas, 84 5/8 x 56 in. (215 x 142.2 cm). The Museum of Modern Art, New York, Bequest of Lee Krasner, 1984

PLATE 112
JACKSON POLLOCK, *Troubled Queen*, 1945. Oil and enamel on canvas, 74 1/8 x 43 1/2 in. (188.3 x 110.5 cm). Museum of Fine Arts, Boston, Charles H. Bayley Picture and Painting Fund and Gift of Mrs. Albert J. Beveridge and Juliana Cheney Edwards Collection, by exchange

207

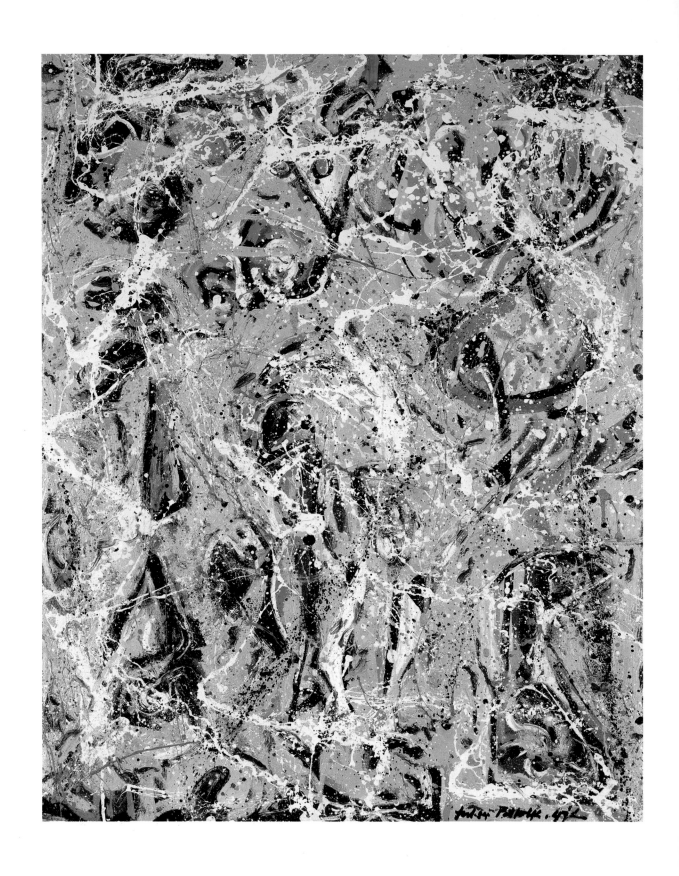

PLATE 113
JACKSON POLLOCK, *Galaxy*, 1947.
Aluminum paint, oil-based commercial
paint, and small gravel on canvas, 44 x
34 in. (111.8 x 86.4 cm). Joslyn Art
Museum, Omaha, Nebr., Gift of Peggy
Guggenheim

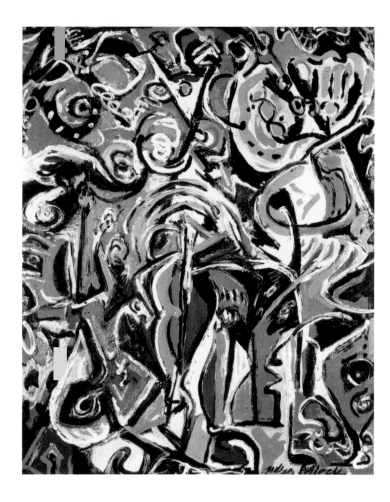

competence though on a very large scale. One of them, however, Jackson Pollock, is a striking exception. He is undeniably an American phenomenon. Working without brushes, he spreads his canvas on the floor and dribbles the contents of paint-tubes onto it from above. The result is an elaborate if meaningless tangle of cordage and smears, abstract and shapeless, but to quote Alfred Barr of the Museum of Modern Art, it is "an energetic adventure of the eyes." Personally, I think it is merely silly.[83]

These remarks might be inconsequential except that Cooper was one of the most important collectors of Picasso's work, as well as his neighbor and regular dinner companion in the South of France.

In 1950, the struggle that American artists had been waging with Picasso mushroomed. Not only did European critics begin to evaluate the Americans' work, but in all likelihood Picasso himself began to hear about and see it as the paintings began to arrive in Paris and other European capitals.[84] While the artists themselves generally remained on their home turf in the early 1950s, the circulation of their work made it possible for European artists to address the Americans' painting, just as, for decades, the Americans had responded to the Europeans'. In a memorable phrase that would intrigue Jasper Johns nearly thirty years later, a critic, or even possibly Picasso himself, reportedly belittled de Kooning's painting as "melted Picasso,"[85] yet the question immediately arose whether Picasso still dominated contemporary art and whether this new American painting might influence his own work. The issue was sufficiently in the air for an Italian journalist, Bruno Alfieri, to write an essay announcing the end of an era.

Alfieri's review reflected only a first encounter with Pollock's art, but it interested Peggy Guggenheim enough to reprint it in the catalogue of an exhibition she organized in Venice as an adjunct to the 1950 Biennale. Presumably Alfieri's last paragraph excused an equivocation earlier in the essay about Pollock's style:

> The exact conclusion is that Jackson Pollock is the modern painter who sits at the extreme apex of the most advanced and unprejudiced avant-garde of modern art. You might say that his position is too advanced, but you may not say that his pictures are ugly, because in that case you would destroy pieces of famous classical paintings and half of all contemporary art. Compared to Pollock, Picasso, poor Pablo Picasso, the little gentleman who, since a few decades, troubles the sleep of his colleagues with the everlasting nightmare of his destructive undertakings, becomes a quiet conformist, a painter of the past.[86]

In July, when Pollock's family paid a rare visit to Springs, he repeatedly asked if anyone read Italian and quoted the line "*E al confronto di Pollock, Picasso, il povero Pablo Picasso...*" to the point where his sister-in-law Alma asked, "Is Picasso more important than your family?"[87] When *Time* published extensive excerpts from Alfieri's article the following November but omitted the conclusion, Pollock sent the magazine a cable rejecting Alfieri's criticism of his style—"NO CHAOS DAMN IT"—while also pointing out what *Time*'s edit had dropped: "THINK YOU LEFT OUT MOST EXCITING

ours." De Kooning confirmed, "This is 1950. This is when it's going to happen."[80]

"It" started early. In January, the Museum of Modern Art acquired Pollock's *Number 1A, 1948*, one of his largest early drip paintings. A few months later, Barr chose paintings by Pollock, de Kooning, and Gorky to represent young American artists at the twenty-fifth Venice Biennale—the first major exhibition in Europe of artists associated with Abstract Expressionism.[81] This introduction won few converts in the press, but it marked a change of tide that would gain momentum during the decade with further exhibitions of work by Pollock, de Kooning, and their contemporaries—first in Paris in 1952, and six years later with "The New American Painting," a large exhibition organized by the Modern for eight European cities.

Previously, the Atlantic divide had made it relatively easy for Continentals to ignore American art. Even when that art appeared in Europe, most critics took the path of dismissing the American paintings at the Biennale as derivative or merely amateurish.[82] One leading critic and connoisseur, Douglas Cooper, tartly concluded,

> The younger painters in this pavilion mostly imitate well-known Europeans, with a singular lack of conviction and

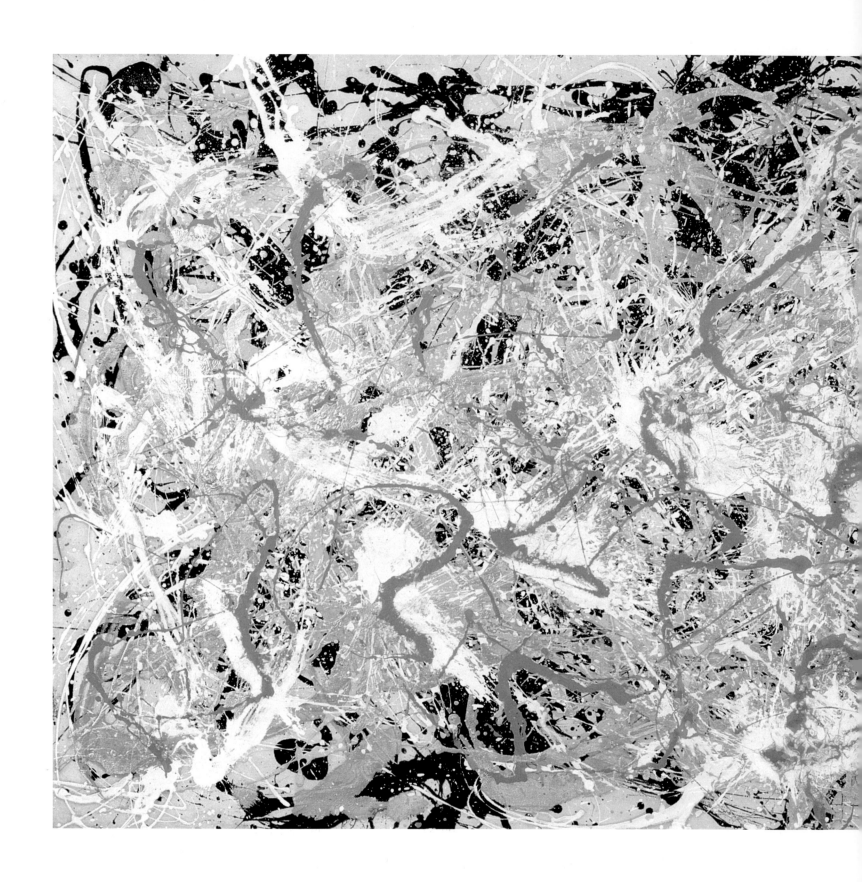

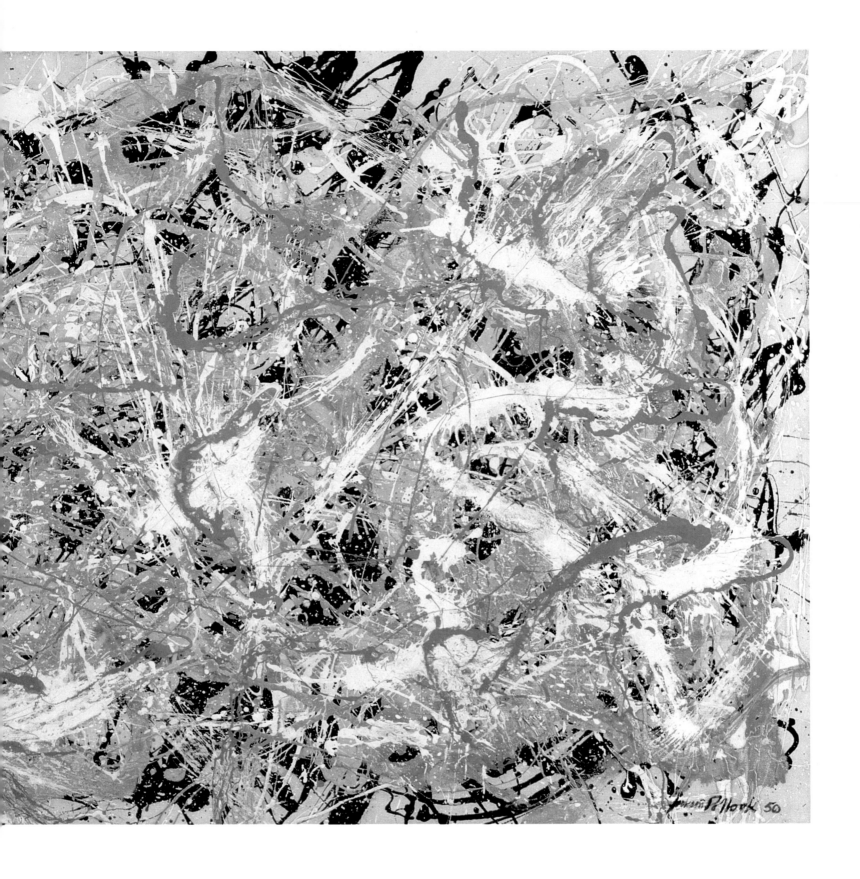

PLATE 114
JACKSON POLLOCK, *Number 27, 1950*,
1950. Oil on canvas, 49 x 106 in.
(124.5 x 269.2 cm). Whitney Museum of
American Art, New York, Purchase 53.12

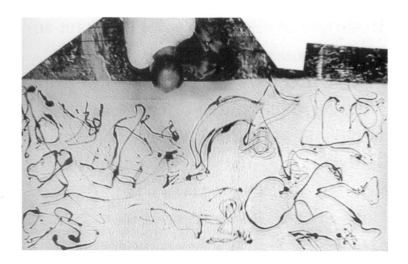

FIG. 82
Jackson Pollock beginning *Number 27,
1950,* 1950. Film frame composite from
Jackson Pollock (1950) by Hans Namuth.
The Museum of Modern Art, New York

FIG. 83
JACKSON POLLOCK, *Untitled,* ca. 1939–42.
India ink on paper (double-sided), 18 x
13 7/8 in. (45.72 x 35.24 cm). Whitney
Museum of American Art, New York,
Purchase, with funds from the Julia B.
Engel Purchase Fund and the Drawing
Committee 85.19a-b

PART OF MR. ALFIERI'S PIECE."[88] Grace Hartigan, a young painter
and friend of Pollock's, would recall him saying he was out to "kill
Picasso."[89] In 1950 she painted a large gestural abstraction called
The King is Dead, a title she explained as a celebration of the
belief that Pollock had succeeded.[90]

What did Picasso think of Pollock's art? Thanks to Françoise
Gilot, a young artist who lived with Picasso from 1946 through
1953, we have an account not only of Picasso's opinion but of
Matisse's as well.[91] During their years together, Picasso and Gilot
regularly visited Matisse at his home in the South of France, and
on one of these occasions (probably around 1950)[92] Matisse
showed them some catalogues sent to him by his son Pierre,
whose New York gallery handled work by leading Europeans
(including Matisse, Miró, and Picasso) and a few Americans. The
catalogues contained reproductions of paintings "by Jackson
Pollock and others of that persuasion." Pierre may have sent the
books because he was considering adding Pollock to his roster,
and Pollock himself would have the same idea, seeking to join the
gallery in the summer of 1951. As one of Pollock's friends recalled,
"Jackson thought he deserved the best, and Matisse was the
best."[93] But Pierre turned down Pollock's initiative, reportedly after
receiving a dismissive shrug from Duchamp.[94]

Gilot's extensive quotations of the conversation about the
New York catalogues are later reconstructions (her book, *Life with
Picasso,* was published in 1964) and contain some phrases ("gesture"
and "action of painting," for example) that suggest the language of
art criticism in the late 1950s. Nonetheless, her documentation of
Picasso's sayings and doings has proven remarkably accurate, and
her rendition probably does capture the gist of the discussion. When
Matisse showed the reproductions to Picasso and Gilot, he readily
admitted that he couldn't judge the work because he believed the
new art had nothing to do with his own. "When a painter hasn't
completely forgotten me I understand him a little bit, even though
he goes beyond me. But when he gets to the point where he no
longer makes any references to what for me is painting, I can no
longer understand him. I can't judge him either. It's completely over
my head." Given Matisse's advanced age (he turned eighty-one in
1950) and seclusion from the art world, his equanimity is unsur-
prising, even though it is possible to see connections between his
work and that of the Americans, particularly in terms of size.

On the cusp of his seventh decade, Picasso evinced no such
serenity. Since he enjoyed sparring with his old friend and rival,
he may have laced his response with a playful contrariness, but his
intensely argued rebuttal is far more than an offhand reply.
Declaring "I don't care whether I'm in a good position to judge
what comes after me. I'm against that sort of stuff," he launched an
attack on the assumptions that he believed underlay the art: "As
far as these new painters are concerned, I think it is a mistake to
let oneself go completely and lose oneself in the gesture. Giving
oneself up entirely to the action of painting—there's something in
that which displeases me enormously." Yet he immediately
clarified, "It's not at all that I hold a rationalist conception of
painting . . . but in any case the unconscious is so strong in us that
it expresses itself in one fashion or another. . . . Whatever we may
do, it expresses itself in spite of us. So why should we deliberately
hand ourselves over to it?"

In his "Statement" of 1935, Picasso had offered, "Whether he likes it or not, man is the instrument of nature. It forces on him its character and appearance."[95] And in his conversation with Matisse, he placed the new American painters' ideas in the context of Surrealism: "During the surrealist period, everyone was doing automatic writing. That was a bit of a joke, at least in part, because when you want to be completely automatic, you never can be. There's always a moment when you 'arrange' things just a little." Picasso believed that the friction between the unconscious and aesthetic choice was a great source of art. The question was balance. He asked Matisse, "Why not admit frankly that one is making use of all that substratum of the unconscious but keep one's hand on it?" And he offered an explanation of how this applied to his art: "My own thought in doing a painting is often a continuous non sequitur, a series of jumps from one mountain peak to another. It's what you might call a somnambulist's thought. That doesn't mean it can't be a kind of directed dream, but it's just as far from pure automatism as it is from rational thought."

Finally Picasso turned to subject matter. "Whatever the source of the emotion that drives me to create, I want to give it a form which has some connection with the visible world, even if it is only to wage war on the world. Otherwise a painting is just an old grab bag for everyone to reach into and pull out what he himself has put in. I want my paintings to be able to defend themselves, to resist the invader, just as though there were razor blades on all surfaces so no one could touch them without cutting his hands." He ended his argument against the Americans, "As I've often said, I don't try to express nature; rather, as the Chinese put it, to work like nature. And I want that internal surge—my creative dynamism—to propose itself to the viewer in the form of traditional painting violated." Maintaining his longstanding principle of separation between art and nature,[96] Picasso described a process of marshaling his means to contrive an illusion of nature's force.

While Pollock's drip paintings certainly violated traditional painting, he countered charges of chaos by emphasizing his "total control" and "denial of the accident" to convey "states of order," "organic intensity," and "energy and motion made visible," along with a few other shorthand phrases.[97] Picasso clearly had not registered Pollock's control—but then, unless the conversation with Matisse took place after the American's first Paris show, in March 1952, Picasso almost certainly wouldn't have seen an actual drip painting, although he may have encountered high-quality reproductions in *Life*.[98] Even so, surprisingly, Picasso had evidently thought seriously about this art. He had identified its origins in Surrealism, and he argued intensely over fine—but crucial—distinctions of control and subject matter.

Neither Pollock nor Picasso was a theoretician, and neither favored words over paint and canvas. In November 1948, Picasso set out to make a painting of an extremely banal subject: the kitchen in his apartment on the rue des Grands-Augustins in Paris, where he had painted *Guernica*. Although he probably knew nothing of Pollock's breakthrough the year before, *The Kitchen* (November 9, 1948; plate 115) proved to be his closest approach to the drip paintings. And when it first appeared in New York—in 1957, the year after Pollock's death—it was taken as a measure of each artist's achievement.

Except for the usual culinary equipment, a few birdcages, and three colorful Spanish plates on the wall, the room, according to Gilot, was "an empty white cube." Picasso proposed "to make a canvas out of that—that is, out of nothing."[99] Returning to the geometry of *The Studio*, he drew a linear pattern on the canvas that is both less continuous and more abstract than the earlier picture.[100] Without the title, its subject would be unrecognizable, and the objects mentioned by Gilot would be indecipherable. Picasso both reduced his representational signs and loosened his pictorial means. Where *The Studio* features a tightly structured space of rectangles and other consistently outlined shapes, *The Kitchen* is defined by open geometries. It uses *The Studio*'s vocabulary of lines terminating in "dots" to construct a maze of shorter segments, irregular shapes, and open spaces. Without footholds in reality, the space is without cardinal orientation, and the painting's lack of color enhances its detachment from everyday things, leaving a dynamic, unified field.

By limiting his palette to black and white and allowing the primed canvas to show in many areas, Picasso created an austere, elemental work that foregrounds his process, making it the focus of the painting's visual incidents. Instead of *The Studio*'s consistent border set within the shape of the stretched canvas, *The Kitchen* uses a series of short segments ending in balls or perpendicular bars to press toward the edge of the canvas at irregular intervals, so that the picture's linear network both honors and avoids the literal limits of the field. Smudges of black only partly obscure Picasso's false starts toward this structure and spread through the maze in concert with bare canvas and roughly textured films of white. Sometimes bounded by the linear structure, sometimes overlapping it, and at other times independent, these passages create an effect of fluctuation that tempers the bold linear design and enhances the composition's spatial ambiguity, an effect magnified by the painting's dimensions of approximately six by eight feet.[101]

If this description borrows terms used to analyze Pollock's drip paintings, Picasso made it clear that his reference was not contemporary but historical. He told Gilot, "When you look at Cézanne's apples, you see that he hasn't really painted apples, as such. What he did was to paint terribly well the weight of space on that circular form. The form itself is only a hollow area with sufficient pressure applied to it by the space surrounding it to make the apple *seem* to appear, even though in reality it doesn't exist. It's the rhythmic thrust of space on the form that counts."[102] This is a classic case of Picasso following his own guidance to take up another artist's researches in order to react against them. Even if he borrowed from geometric abstraction and Surrealism, the two great movements in Europe between the wars, his art remained profoundly rooted in representation and in the inspiration of the "rhythmic thrust" that had led him to Cubism.

Pollock's great *Number 1A, 1948*, painted the same year as *The Kitchen*, is one inch shorter than Picasso's work and six inches longer. Both create encompassing environments that press against their physical boundaries through lines flowing across canvas left bare or toned with little more than black or white paint. Perhaps surprisingly, Pollock's is the more colorful of the two paintings—shot through with reflective silver and skeins of yellow and orange,

among other hues. And while both works achieve a high degree of linear rhythm interwoven with spatial flux, the Pollock is vastly more subtle, complex, and raw. While Picasso's title pulls his composition out of abstraction and enables viewers to surmise a few objects, only Pollock's handprints across the top of the canvas establish human scale and presence. Pollock's dialogue with Picasso's work may have instilled a sense of Cézanne's insights, but he created a radically new relationship between line and space—not simply the interdependence cited by Picasso but an identity attained through the modulating, flowing lines and puddles that almost alone constitute the painted surface.[103] Failing to understand Pollock's ability to control his dripped line, Picasso did not realize that the American artist had achieved a balance between spontaneity and discipline that surpassed his own achievements.

Although Picasso refused to be treated "as an historic monument,"[104] the sense was growing that he was a figure of the past. The paintings of Pollock, de Kooning, and their contemporaries amply justify their fame, but there was another factor in Picasso's eclipse: during the 1940s, he was little more than a ghost in New York. In the six and a half years between January 1940 and May 1946, no new work by Picasso appeared in that city, or anywhere else in the U.S. After "Picasso: Forty Years of His Art" departed for Chicago, the Modern held only one Picasso exhibition in the 1940s, "Masterpieces by Picasso" in 1941, and that was a sliver cut from the preceding retrospective. Galleries also relied on previous work to stock commercial exhibitions. The war made transport impossible; then the Nazi conquest of France severed communication. Barr constantly sought information about artists in Europe, and played a crucial role in bringing many to the United States, but Picasso refused all invitations to leave France, remaining there, primarily in Paris, until the city was liberated, in August 1944. For the first time since his 1911 debut in New York, Picasso was truly a historical figure in America, represented only by work of the preceding decades.

As soon as the Allies freed Paris, Barr opened every possible line of communication to learn about Picasso's wartime art. He published a dossier of these works in the January 1945 issue of the museum's *Bulletin*.[105] Even earlier, in the fall of 1944, he had believed so strongly in the need for Americans to see the latest work of European artists that he had actually exhibited color reproductions of recent paintings by Picasso, Matisse, and Bonnard. (Nearly simultaneously, Peggy Guggenheim's Art of This Century had shown sixteen color reproductions of Picasso's wartime work.)[106] Yet a substantial group of the paintings themselves did not appear until a new dealer, Sam Kootz, presented a much publicized exhibition in January and February of 1947.

Meanwhile the Whitney responded to the spirit of the time by extending its program to an international range of artists. As Allied troops swept across Germany in the spring of 1945, the Museum opened "European Artists in America," an exhibition devoted to those who had come to the U.S. during the previous seven years. Ranging from Breton and Herbert Bayer to Ernst, Marcel Duchamp, Fernand Léger, André Masson, Piet Mondrian, and Ossip Zadkine, the exhibition revived the internationalism of the Whitney Studio during the mid-1920s. The exhibition's curator, Hermon More, took the opportunity to undercut the "Regionalist" aesthetic that many had associated with the Whitney's program during the preceding decade: "From Colonial days it has been the genius of America to absorb foreign influences in art, and from these sources, to develop distinctive national characteristics. The Whitney Museum has never tried to define art in terms of a narrow nationalism, and we feel that this exhibition recognizes the international spirit which has played so important a part in the American art of our day."[107]

Two years later, the museum moved even farther outside its accustomed territory to present "Painting in France, 1939–46," a more ambitious survey organized for the Whitney by a panel of distinguished French curators, including René Huyghe (chief curator of paintings at the Louvre) and Jean Cassou (chief curator of the Musée National d'Art Moderne in Paris).[108] As the Whitney's director, Juliana Force, wrote,

> In stepping out of our accustomed role for the second time our Museum is afforded an opportunity . . . to pay a sincere tribute to the artists of France, who with indomitable courage continued to work in the face of dangers and hardships of the Nazi occupation. . . . It seems fitting that an American museum should be the first to renew relations in art that have been almost severed for six years, and in a small way to return the hospitality accorded American artists in the happier days before the war, when the spirit of liberality and freedom made France an international testing ground for new ideas in art that influenced the western world.[109]

Picasso, Matisse, Bonnard, and other established artists were represented on that occasion by just one painting each (and the Picasso is dated 1939), but the exhibition did include several young artists, such as Edouard Pignon, who would play prominent roles in French art during the following decade.

However welcome the interlude, the Whitney's embrace of this worldly approach faded rapidly. The venture probably stemmed from instability at the Museum of Modern Art as much as from postwar euphoria; in a sense, the Whitney stepped in when MoMA could not fulfill its mandate of internationalism. In October 1943, Barr had been fired as the Modern's director. Refusing to leave the institution, he found research and writing tasks replacing his administrative and curatorial responsibilities. As the trustees searched for a proper successor on those fronts, Barr lost the ability to organize substantial exhibitions, the forum he had perfected to address the central issues of contemporary art. This occurred at the moment when his expertise was especially needed to sort through the profoundly complex period of the war. Yet this terrible period in Barr's life (which improved somewhat when he was given the title of director of collections in March 1947) did enable him to revise and update the catalogue of his Picasso retrospective of 1939, and to publish it in the fall of 1946 as *Picasso: Fifty Years of His Art*.[110]

The major change in the book, of course, was the treatment of the war years. Although Barr did not return to France or personally interview Picasso, he and his agents gathered a mass of information about his work during this period, and were able to

put questions directly to the artist through his secretary, Jaime Sabartés. While Barr offered a thorough overview of the work, he centered his account on Picasso's transformation from an artist (however famous) to an international political figure:

> Picasso, unlike his friends Paul Eluard and another ex-Surrealist poet Louis Aragon, had taken no active part in the underground Resistance movement, yet . . . Picasso's presence in Paris while the Germans were there had gradually taken on an aura of great symbolic importance. His attitude had been passive but it had been implacable and uncompromising and had created a legend which had probably been more effective than if he himself had joined the F.F.I. and gone underground.[111]

Although there is no evidence that Picasso had ever considered these actions, Barr quoted his statement of 1945, to the Paris journal *Les Lettres françaises*, directly intertwining art and politics: "What do you think an artist is? An imbecile who has only his eyes if he is a painter. . . . On the contrary, he's at the same time a political being, constantly alive to heart-rending, fiery or happy events, to which he responds in every way." And Picasso's succinct conclusion: "No, painting is not done to decorate apartments. It is an instrument of war for attack and defense against the enemy."[112]

For Barr, "Picasso's most important postwar composition," and the fulfillment of the artist's words, was *Charnel House* (1945). "The *Charnel-House*," Barr wrote,

> is a very large canvas, one of the largest Picasso has painted since *Guernica*. And like *Guernica* it was obviously inspired by the day's atrocious news. The *Guernica* was a modern Laocoon, a Calvary, a doom picture. . . . In the *Charnel-House* there are no symbols and, perhaps, no

FIG. 84
PABLO PICASSO, *Charnel House* (third unfinished state), 1945. Charcoal on canvas, 78 3/4 x 96 1/2 in. (200 x 245 cm)

prophesy. Its figures are facts—the famished, waxen cadavers of Buchenwald, Dachau and Belsen.[113]

Whereas Barr's description focused on the physical violence that united *Guernica* and *Charnel House*, capturing the arc of the war from initial outrage to exhausted silence, the accompanying illustration told a different story: Barr reproduced the painting in an unfinished state, a work-in-progress that reads as a network of lines more than anatomies—with forms outlined, canceled, and varying in weight from crisp black to shadowy grays (fig. 84).[114] This is the final image in the book, which de Kooning, Pollock, and many other artists would soon acquire.[115]

When Picasso's paintings began to appear in New York after the war, it was Greenberg who delivered the city's equivocal judgment. Although the works did not appear in any quantity until Kootz's show in January 1947, in May 1946 Pierre Matisse offered a small group of wartime pictures by Matisse, Picasso, Bonnard, Rouault, Jean Dubuffet, and André Marchaud. Having opened his review of the show with a deep bow to tradition—"The School of Paris remains still the creative fountainhead of modern art, and its every move is decisive for advanced art everywhere else"—Greenberg did not hesitate to criticize Picasso's painting: "And his still life in the Matisse Gallery show, for all its connection with the School of Paris' recent consumer's preoccupation with food and intimate objects, strives for the same *terribilitá* as his figure pieces. This picture fails as sadly as does all of Picasso's recent work that I have seen in reproduction."[116] Greenberg was not simply responding to the pictures, he was defining a position that he would argue for decades to come:

> He insists on representation in order to answer our time with an art equally explicit as to the violence and terror, but at the same time the inherent logic of his genius and his period still pushes him toward the abstract. In my opinion it is Picasso's temperamental resistance to the abstract that has landed him in the impasse in which he now finds himself. It seems to be a case of split personality, which is rather shockingly reflected in the helpless and almost vulgar way in which he has painted the pitcher in the still life at Matisse's.[117]

Perhaps Greenberg would have felt differently had he realized that the object in *Still Life* (1944) that he was describing was a coffee pot, not a pitcher, but his belief in the inevitability of abstraction overrode close observation.[118] It is ludicrous to think of Picasso "clinging to the representational,"[119] yet Greenberg was doing his best to pry New York artists free of the restrictions he saw in Picasso's work.

The ten paintings shown in Kootz's 1947 exhibition "The First Post-War Showing in America of Recent Paintings by Picasso," and the few additional ones presented in two exhibitions at the gallery during the following year, must only have confirmed Greenberg's doubts.[120] Hype in any case overwhelmed art in these shows; catching Picasso between dealers, Kootz had managed to buy a dozen or so paintings, but they were far from the artist's best. Mainly conventional figures and still lifes, none registered

the violence of the war, or reflected the political commitment that Picasso had announced. Kootz soon closed his venture, and the collector Sidney Janis took over the space for his own new gallery, which in the early 1950s represented Pollock.

Artists, meanwhile, had their own response. By the late 1940s, Picasso had reestablished relations with his old dealer Daniel-Henry Kahnweiler, and Kahnweiler authorized Curt Valentine to represent Picasso's work in the United States. At that time, his recent paintings began to appear more regularly in New York, but even before then the few that did appear were stirring up the city's artists, less for their subject matter than for Picasso's use of Ripolin enamel paint. Joop Sanders recalled a dinner in the mid-1940s, not long after the war had ended and people had begun to see Picasso's latest works, at which "everybody was talking about the Ripolin. There is a seated woman by Picasso, I think in 1942, in which he uses enamel on plywood or Masonite and left drips in. This was discussed at length."[121] Although Picasso had used this shiny commercial paint occasionally for decades, his fluid application of it then may well have struck artists in New York as surprisingly relevant.

Certainly, neither the paint nor the method were anything new to Pollock and de Kooning, or to any of the artists who had studied Picasso's work of the late 1930s—and who had spent the war years developing their own styles without frequent barrages of Picasso's latest pictures. Ironically, this absence may have been a boon. Without Picasso's constant presence, it was far easier for artists to break free of the conviction that he was always ahead. They had the chance to work through their own fascination with particular paintings as the pictures passed into history. In *Troubled Queen*, Pollock freely mixed oil and enamel to create passages of spatters and runs far beyond anything Picasso had allowed; and de Kooning, in paintings such as *Event in a Barn* (1947; plate 116), made drips a hallmark of his style. Based on the paintings at the Kootz Gallery, American artists could reasonably conclude that Picasso had lost his edge.

Of course, 1947 was the year Pollock exhibited his newly revised *Galaxy* at the Whitney Biennial and painted the first of his major canvases in the dripped and splattered technique that he would explore over the next four years. When Greenberg reviewed the drip paintings during their first exhibition, in 1948, he suggested that their style "reminds one of Picasso's and Braque's masterpieces of the 1912–15 phase of cubism. There is something of the same encasement in a style that, so to speak, feels for the painter and relieves him of the anguish and awkwardness of invention, leaving his gift to function almost automatically."[122] Ever since, Pollock's webs have prompted critics and scholars to suggest connections between the shifting fields of Analytic Cubism at its most diffuse and the layered skeins of Pollock's paint. Yet Pollock showed only slight interest in early Cubism.[123] He responded primarily to Picasso's work of the 1930s, which drew on all of that artist's earlier approaches, and to the "African" pieces that formed its strongest precedent. Nonetheless, Greenberg's proposition that Pollock might rely on Picasso's and Braque's style as a point of departure, "leaving his gift to function almost automatically," does strike close to the process that Picasso

described as "blurring" or canceling his imagery—the process of "veiling" that we know Pollock followed in *Number 27, 1950*.

As Krasner later said, "Many of them, many of the most abstract, began with more or less recognizable imagery—heads, parts of the body, fantastic creatures."[124] The final result, however, had little apparent connection to these origins, and abstraction became the focus of the critics attempting to characterize Pollock's new work. Greenberg highlighted a "dissolution of the picture into sheer texture, sheer sensation," and an "all-over" composition "knit together of a multiplicity of identical or similar elements," repeated "from one end of the canvas to the other" and apparently dispensing with "beginning, middle and ending."[125] After de Kooning's exhibition of ten black-and-white paintings at the Egan Gallery in April 1948 (his first solo show), Greenberg asserted that "de Kooning is an outright 'abstract' painter"[126] and proposed a group of artists who were exploring the possibilities of "all over" composition: "These painters weave the work of art into a tight mesh whose principle of formal unity is contained and recapitulated in each thread, so that we find the essence of the whole work in every one of its parts."[127] In an interview with *The New Yorker* two years later, Krasner explained, "Jackson used to give his pictures conventional titles: 'Eyes in the Heat' and 'Blue Unconscious' and so on but now he simply numbers them. Numbers are neutral. They make people look at a picture for what it is—pure painting." Pollock cut to the point: "I decided to stop adding to the confusion. Abstract painting is abstract."[128]

By 1951, abstraction seemed dominant in New York. In January of that year, the Museum of Modern Art acknowledged its currency with the exhibition "Abstract Painting and Sculpture in America," a sprawling assemblage of American art from the Armory Show to the present. In his introduction to the catalogue, the museum's new curator, Andrew Carnduff Ritchie, recalled the Whitney's 1935 "Abstract Painting in America" show and offered a similar grab bag of approaches. Among contemporary artists, Ritchie proposed five categories: pure geometric, architectural and mechanical geometric, naturalistic geometric, expressionist geometric, and expressionist biomorphic. The last included Gorky, de Kooning, and Pollock but also Mark Rothko, William Baziotes, and Isamu Noguchi (to name only the most well-known of eighteen artists). Since the exhibition revealed more inconsistencies and contradictions than coherence, the museum organized a symposium for artists to explain "What Abstract Art Means to Me."[129] Davis reprised his essay for the Whitney's 1935 catalogue, and Alexander Calder weighed in, while Robert Motherwell and de Kooning represented emerging artists.

De Kooning showed no interest in speaking on behalf of a group, or in allowing categories to hamstring what he did in the studio: "The group instinct could be a good idea, but there is always some little dictator who wants to make his instinct the group instinct." Strong words in the aftermath of World War II. Then he exploded the idea of abstraction itself: "There *is* no style of painting now. There are as many naturalists among the abstract painters as there are abstract painters in the so-called subject-matter school."[130] Speaking for himself, he said, "Personally, I don't need a movement." Nonetheless, he insisted on his respect for Cubism:

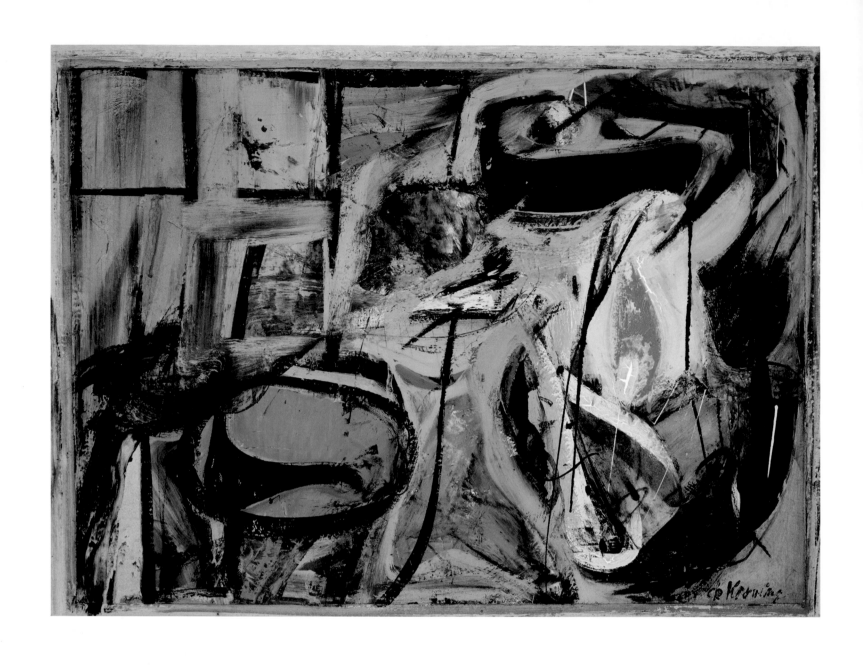

PLATE 116
WILLEM DE KOONING, *Event in a Barn*,
1947. Oil on paper and Masonite, 24 x
36 in. (61 x 91.4 cm). Private collection,
courtesy of Allan Stone Gallery, New York

Of all movements I like Cubism most. It had that wonderful unsure atmosphere of reflection—a poetic frame where something could be possible, where an artist could practice intuition. It didn't want to get rid of what went before. Instead it added something to it. The parts that I can appreciate in other movements came out of Cubism. Cubism *became* a movement, it didn't set out to be one. It has force in it, but it was no "force-movement."[131]

De Kooning's dismissal of theory in favor of intuition, and his eagerness to embrace whatever satisfied his constantly shifting speculations, whether or not they appeared contradictory, are direct descendants of Picasso's avowal that "different motives inevitably require different methods of expression."[132] After all, the myriad ambiguities of Cubism were not ended in 1915; they played through his entire oeuvre. Picasso's profound skepticism of theory is often opposed to Duchamp's conceptualism, although both artists thrived on breaking aesthetic "rules." Apparently de Kooning understood their similarity, for he followed his praise of Cubism with applause for "that one-man movement, Marcel Duchamp—for me a truly modern movement because it implies that each artist can do what he thinks he ought to—a movement for each person and open to everybody."[133] At the moment when de Kooning could easily have claimed leadership of an abstract movement, he publicly repudiated the idea as mere sloganeering, not the substance of art.

Besides de Kooning, only Motherwell, Richard Pousette-Dart, and Pollock were represented in "Abstract Painting and Sculpture in America" by works already owned by the Modern. Like the others, Pollock joined the opening celebrations. He wrote to his friend and patron Alfonso Ossorio, "The Museum of M.A. opened the survey of American abstract painting—with drinks—and supper for about two hundred painters in the pent house—and at least five thousand down stairs in the gallery—couldn't get any idea of the show, will send a catalogue."[134] Despite his statement in August 1950 that "abstract painting is abstract," and his decision to give his paintings numbers rather than titles, Pollock, too, had doubts. On June 7, 1951, he again wrote to Ossorio, "I've had a period of drawing on canvas in black—with some of my early images coming thru—think the non-objectivists will find them disturbing—and the kids who think it simple to splash a Pollock out."[135] At least for Pollock and de Kooning, the Modern's exhibition was more of a funeral for abstraction than an inauguration.

One need only compare de Kooning's tiny untitled oil from about 1937 (plate 80) and *Event in a Barn* from 1947 (plate 116) to see how far he had come in a decade, and how deeply rooted in Picasso his art remained. The fluctuating forms of both paintings are tightly structured by the rectangle of the canvas, and by interior grids that descend from Picasso's studio paintings of the late 1920s, but in *Event in a Barn*, de Kooning's mastery of explicit reworkings (also seen in *Pink Angels* and other works of the mid-1940s) imparts a powerful dynamic to his previously more static biomorphs and unleashes the painterly gesture widely perceived as his signature style. When Motherwell turned to *The Studio* as the basis for *La Résistance* (1945; plate 117), one of the paintings that announced his entry on the New York scene, he proved that Picasso's studio paintings of the late 1920s still compelled young artists.[136]

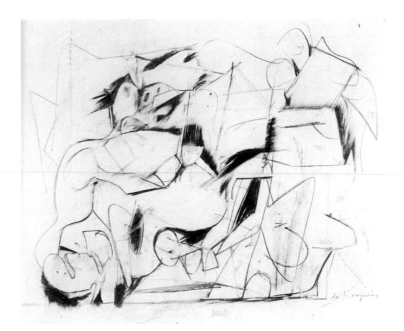

Event in a Barn directly precedes the series of paintings shown in de Kooning's public debut at the Egan gallery, which established him as a leading painter of abstractions. Unlike *Event in a Barn*, with its fluid field and pungent hues, these compositions are densely packed and almost unremittingly black and white. Often discussed as at least partly a response to the tonality of *Guernica*, they may bear a closer relationship to the picture Barr praised as Picasso's finest work of the war years, *Charnel House*, and specifically to its appearance in *Picasso: Fifty Years of His Art*. The illustration of the unfinished canvas in that book presents an outline drawing of the composition, with the piled bodies so lacking in detail that they border on abstract shapes, interspersed with a legible head, hand, or foot. While these precisely incised forms fill the lower half of the composition, the upper portion is largely vacant, just beginning to be supplied with sketches of the table and utensils that will appear in the final painting (although only as outlines).

An untitled de Kooning drawing of 1945 (fig. 85) bears a strong resemblance to the reproduction in Barr's book, both in such details as the gaping head at the lower left and in the composition's compact mass of attenuated oblong forms. These correspondences may be arbitrary, yet they mark de Kooning's shift from more open and dispersed compositions to densely packed fields pressing close to the picture plane. These features appear in many works, from the quite legible oil-on-paper sketches of 1947 to the series of black-and-white abstractions (such as *Painting*, 1948; fig. 86). There, the tonality of the drawing is reversed: the blank, rounded shapes of the drawing become black planes, and the drawing's dark contours and crossing strokes are white lines and smears of paint. Since no color reproductions of *Charnel House* were published in the mid-1940s, its blue-gray tonality appeared in books as nearly black and white. If de Kooning did take *Charnel House* as his point of departure for the works shown at Egan, he captured the solemnity of Picasso's composition

FIG. 85
WILLEM DE KOONING, *Untitled*, 1945. Graphite on paper, 18 x 23 in. (45.7 x 58.4 cm). Private collection

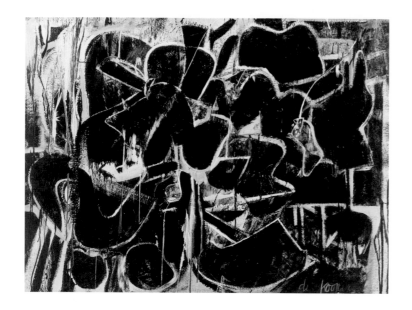

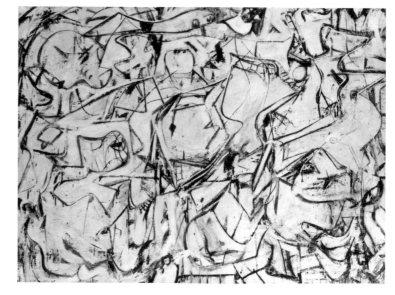

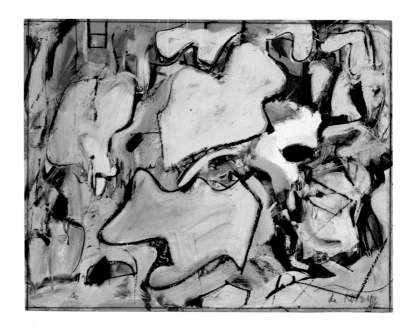

without resort to anecdote—as Greenberg had urged. He also invented a pictorial language that he would elaborate in 1949 and 1950 through increasingly large and complex paintings, *Attic* (fig. 87) and *Excavation*, that would finally match the size of Picasso's picture. Given the possibility that de Kooning took his challenge from *Guernica* and *Charnel House* in the late 1940s, it is not so surprising to spy a ladder behind the jigsaw shapes of a study for *Attic* (fig. 88), or the much more explicit reference in the 1949–50 painting *Abstraction* (plate 105).[137]

The conclusion that de Kooning made the *Demoiselles d'Avignon* an anchor of his art in the late 1940s and early '50s is far less speculative. Despite the painting's early impact on Max Weber and Man Ray, it left relatively little impression on American art, even after the Modern acquired it in 1939 and kept it on nearly permanent exhibition. Even so, it remained a tremendous challenge to artists in the 1940s, particularly Pollock. De Kooning addressed the *Demoiselles* more explicitly than Pollock, creating images that mimic its composition and appropriate both the women's confrontational gazes and the way their aggression seems to radiate through the twisted bodies and fractured space.

In the months following his completion of the black-and-white paintings, de Kooning reclaimed the figure as an unambiguous presence in his aesthetic mix. Without abandoning abstraction, he returned not only to the subject of women but to Picasso's conceptions of them. At the beginning of the 1940s, de Kooning had chosen the portraits of Walter to begin his profound engagement with Picasso. At the end of the decade, he revisited Picasso to measure his achievement and to define the remarkably diverse approach to painting that he would pursue in the 1950s and beyond. For this face-off, de Kooning chose not the sensual portraits of Walter but the far more threatening *Demoiselles*, Picasso's acknowledged masterpiece.

FIG. 86
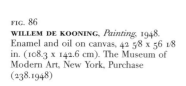
WILLEM DE KOONING, *Painting*, 1948. Enamel and oil on canvas, 42 5/8 x 56 1/8 in. (108.3 x 142.6 cm). The Museum of Modern Art, New York, Purchase (238.1948)

FIG. 87
WILLEM DE KOONING, *Attic*, 1949. Oil, enamel, and newspaper transfer on canvas, 61 7/8 x 81 in. (157.2 x 205.7 cm). The Metropolitan Museum of Art, New York, The Muriel Kallis Steinberg Newman Collection, jointly owned by The Metropolitan Museum of Art and Muriel Kallis Newman, in honor of her son, Glenn David Steinberg, 1982 (1982.16.3)

FIG. 88
WILLEM DE KOONING, *Attic Study*, 1949. Oil, graphite, and enamel on paperboard mounted on Masonite, 18 7/8 x 23 7/8 in. (47.9 x 60.6 cm). The Menil Collection, Houston

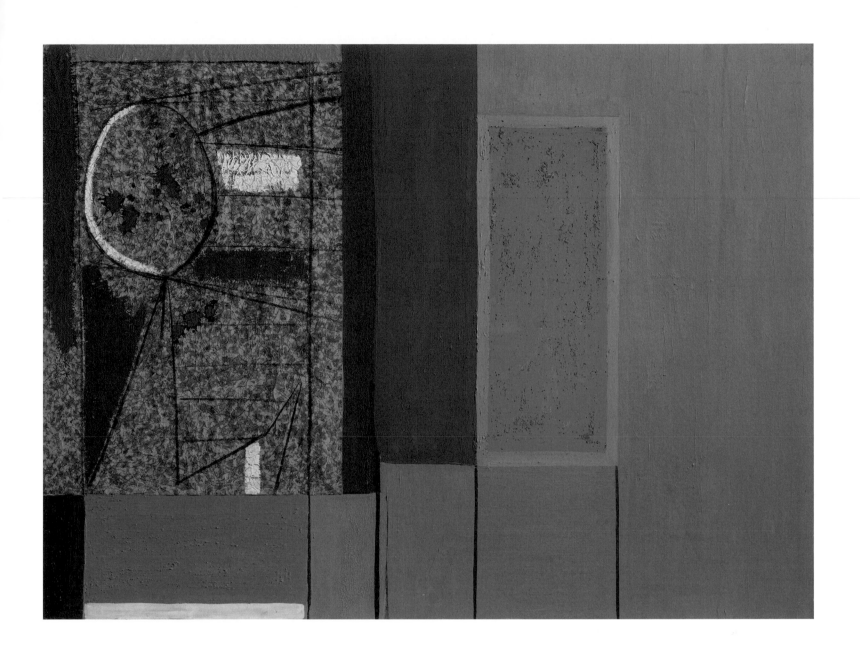

PLATE 117
ROBERT MOTHERWELL (1915–1991),
La Résistance, 1945. Collage with oil on
paperboard, 36 x 47 3/4 in. (91.4 x
121.3 cm). Yale University Art Gallery,
New Haven, Gift of Fred Olsen

He began with a series of paintings on paper. In the largest and most complete, *Untitled (Three Women)* (ca. 1948; plate 118), he obviously recast the *Demoiselles*—indeed, instead of disguising his source, de Kooning flaunted it, raising the stakes of the confrontation. Even his choice of figures is clear: among the five in Picasso's painting, he selected, from left to right, the second, third, and fifth. Showing no desire to copy the African masks that Picasso applied to intensify his characters' animality, de Kooning chose the most convoluted poses and direct stares in Picasso's picture. He arranged his trio across the sheet so that the crouching figure is framed by the standing ones and fills the space between them. The woman at the left, the least finished, throws back her head to exaggerate the instability that Picasso introduced through his figure's one-legged pose. Picasso's squatting woman is the most horrific *demoiselle*, primarily because her head seems to be rotated far beyond human endurance and wears the most distorted mask in the group; de Kooning plopped his version on a table in the foreground (like the one holding Picasso's fruit), and her deeply cleft rump implies the vagina between her spread legs. In place of Picasso's mask, de Kooning reinforced her bestiality with a face of displaced eyes and teeth separated from a lipsticked mouth. He made her the fulcrum of his composition, pivoting from the fugitive figure at the left to the more robust one at the right. Far more than Picasso's composition, de Kooning's integrates the women into the surrounding environment, creating a dynamic flux of shifting bodies and fractured space.

In the long run, de Kooning's version of the woman glaring from the center of Picasso's composition is the most important. She stands at the right of *Untitled (Three Women)*, filling the sheet from top to bottom and spreading her ample torso widely. By far the most monumental figure in the painting, she is also the most static. Instead of reaching behind her head, her arms hang at right angles from her shoulders, and her massive, pyramidal neck rises to an iconic face. De Kooning exaggerated Picasso's simplified schema for this woman, making her eyes even larger and more pointed at the corners but reducing the pupils to vertical slits, like those of a night prowler. He caked her cheeks with red, in a pattern that bounces between Picasso's striated African masks and contemporary fashion. And he dismissed Picasso's rudimentary dashes to give her a gaping mouth approaching the scale of her huge eyes. With her bulging breasts, a cleft pudenda, and open mouth, she looks at the viewer with a stare that packs a sexual voltage beyond that of any of the *demoiselles*; yet she remains detached, standing firmly frontal and locked into her third of the canvas.

Woman I (1950–52; plate 119) began with a pair of lips de Kooning clipped from a cigarette advertisement in a magazine, a source reflecting his fascination with commercial imagery as well as art.[138] Gluing the cutout to a sheet of paper, he allied it with wide-open eyes, full breasts, and clearly marked vulva, all enveloped in a field of broad, colorful strokes and crisp black lines. During de Kooning's arduous two-year process of bringing *Woman I* to a point he accepted as complete, the woman gained a skirt and greater mass. She is an even more powerful descendant of the figure in *Untitled (Three Women)*, yet one who retains her predecessor's contradictory balance between sexual aggression and physical detachment from the viewer. Having begun by reducing the *Demoiselles* to three

figures, de Kooning finally packed it into one, harnessing all of its raw force, intensity, and coldness. He said the choice of a figure "eliminated composition, arrangement, relationships,"[139] but the frontality of his figure, so different from the twisting, seated poses of his earlier women, both instills her with greater dignity and presses her onto the canvas. Whereas Picasso transferred his women's spiky poses to the fractured spaces around them, creating a wall to confront the work's viewers, de Kooning found a different solution: his interweaving of figure and ground both sets image and pigment against each other and reinforces the woman's dominance. By allowing creation through "a sum of destructions" to take its risky course, he transformed the debate over abstraction. *Woman I* is both compellingly real and explicitly abstract, a knife-edged balance between representation and pure painting.

Woman and Bicycle (1952–53; plate 120) is the boisterous younger sister of *Woman I*. Occupying less of the canvas with a less massively proportioned body, the figure equally resembles the standing woman at the right of *Untitled (Three Women)*. Except for the three lobes of face and breasts, she merges fluidly with the field of broad strokes, saturated with greens that suggest a natural complement to the bicycle she holds. This frolicsome, pastoral tone is emphasized by the doubling of her toothy, lipsticked mouth, as if it were a necklace across her bosom. While the composition probably reflects de Kooning's enjoyment of eastern Long Island (where he, following after Pollock, was beginning to spend time), it may not be mere chance that the year he began the painting coincided with the Modern's acquisition of Picasso's *Night Fishing at Antibes* (1939; fig. 89). As Picasso's largest picture since *Guernica*, it received great attention, and it is a mix of coastal scenes, including fishermen spearing a catch and women strolling the quays. The most prominent of these, a woman who bears the physical attributes of a *demoiselle* as she licks a double cone of ice cream, holds a bicycle with her left hand. Such a conjunction of art history and contemporary life suits de Kooning's mixture of artistic styles and subjects, ranging across popular culture and tradition.[140]

Of all the American artists, de Kooning shared the most with Picasso, at least in the studio—not simply because of his European origins but because of his openness to experiment and his profound attachment to the sensuality of materials. (As he said in 1950, "Flesh was the reason why oil paint was invented.")[141] In the early 1950s, when Pollock liked to needle de Kooning for being "nothing but a French painter,"[142] he was probably referring to de Kooning's love of *matière*; he may also have intended to criticize de Kooning for not hiding his roots in the work of a Spanish painter, among other Europeans (including Rubens). Yet the sense of tradition that de Kooning learned from Gorky in the late 1930s, and challenged in the 1940s, grounded his art. This was not a static tradition, but rather one of assimilation and transformation. As Picasso said, it embraced radical change, and this was its greatest strength. Pollock, however, had begun with the narrow, Regionalist doctrine of Benton, and when he broke with Benton, his own intensely channeled creativity did not allow for the sort of fluent eclecticism commanded by de Kooning. Still, Pollock drew inspiration from Picasso no less than de Kooning did—one difference being that where de Kooning saw "destruction" as a strategy, Pollock could see it as a goal.

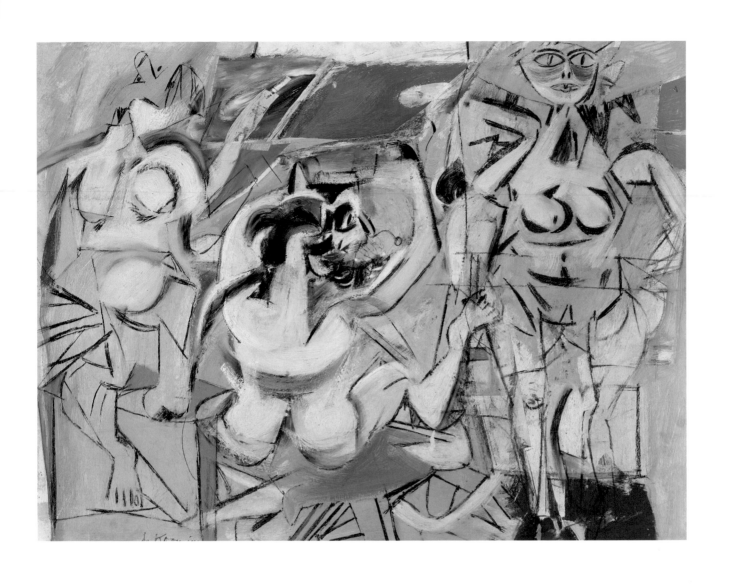

PLATE 118
WILLEM DE KOONING, *Untitled (Three Women)*, ca. 1948. Oil and crayon on thick white paper adhered to board, 20 x 26 3/8 in. (50.8 x 67 cm). Frances Lehman Loeb Art Center, Vassar College, Poughkeepsie, N.Y., Gift of Mrs. Richard Deutsch (Katherine W. Sanford, class of 1940)

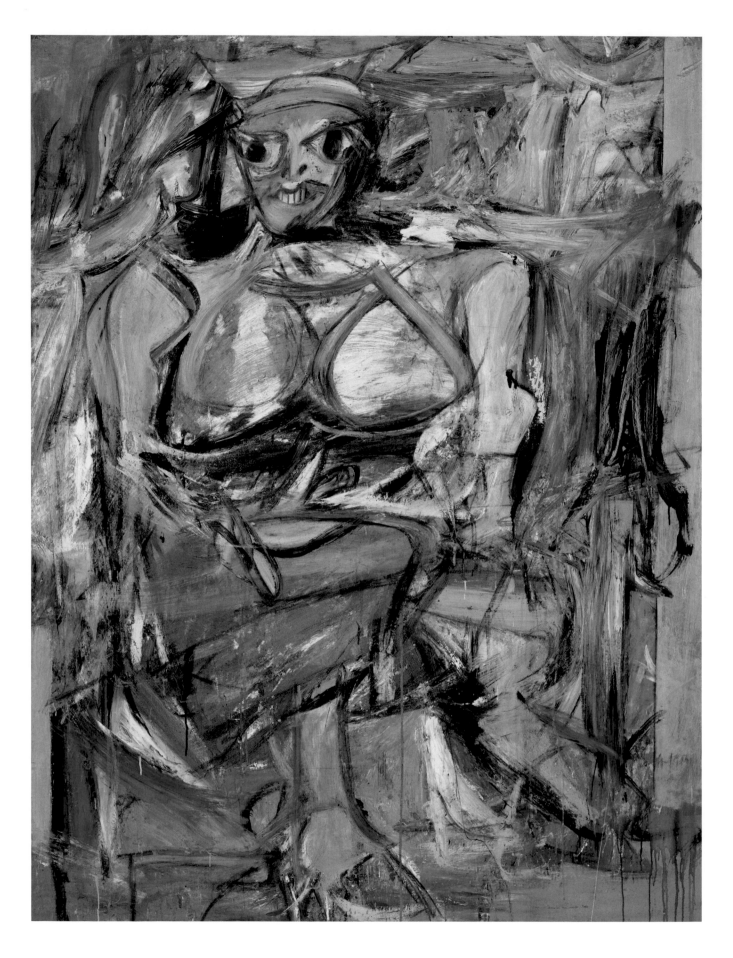

PLATE 119
WILLEM DE KOONING, *Woman I*, 1950–52.
Oil on canvas, 75 7/8 x 58 in. (192.7 x
147.3 cm). The Museum of Modern Art,
New York, Purchase (478.53)

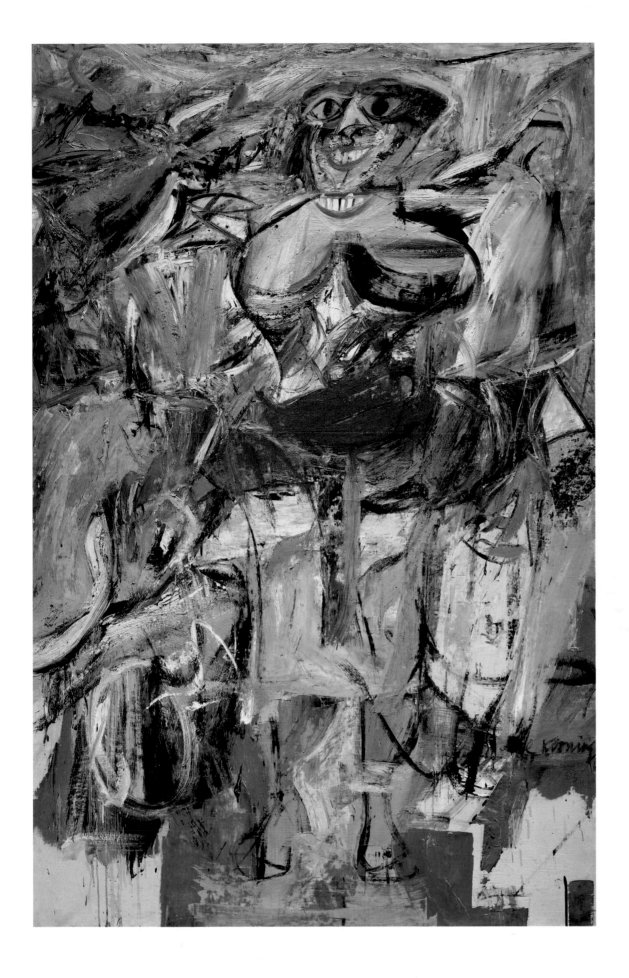

PLATE 120
WILLEM DE KOONING, *Woman and Bicycle*,
1952–53. Oil on canvas, 76 1/2 x 49 in.
(194.3 x 124.5 cm). Whitney Museum of
American Art, New York, Purchase 55.35

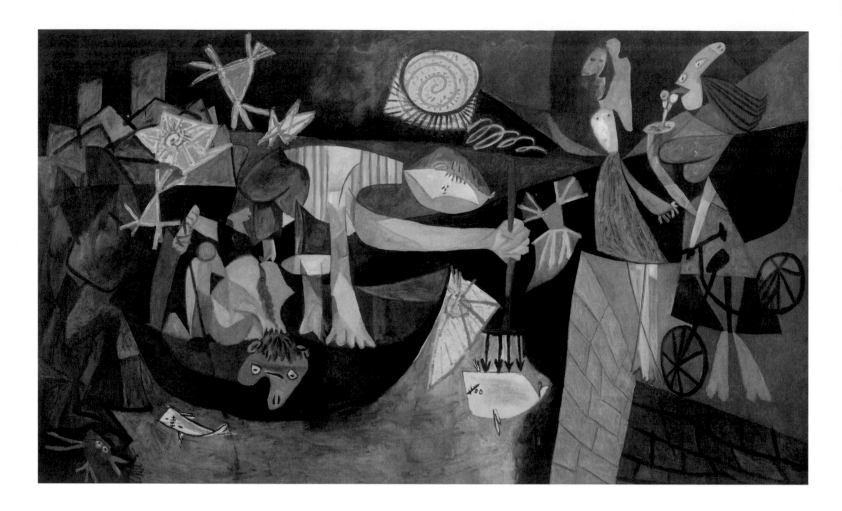

FIG. 89
PABLO PICASSO, *Night Fishing at Antibes*,
1939. Oil on canvas, 6 ft. 9 in. x 11 ft. 4 in.
(205.7 x 345.4 cm). The Museum of
Modern Art, New York, Mrs. Simon
Guggenheim Fund (13.1952)

In November 1950, Pollock showed many of his finest drip
paintings at the Betty Parsons Gallery in New York. All painted
that year, they included *Number 1, 1950, Autumn Rhythm, Lavender
Mist*, and *Number 27, 1950* (later acquired by the Whitney).[143]
Opening five months after the Venice "Biennale" and two before
the Modern's "Abstract Painting and Sculpture in America," the
exhibition demonstrated Pollock's tremendous achievements
during the year and confirmed his standing as the foremost
abstract painter. Yet it left Pollock shattered. Instead of inspiring
him, the sight of Parsons's gallery packed with his new drip paint-
ings left him drained and directionless. His letter to Ossorio about
the Modern's January 1951 opening began, "I really hit an all time
low—with depression and drinking—NYC is brutal. I got out of it
about a week and a half ago."[144]

In the city temporarily during the early months of 1951 and
without a place to paint, Pollock and Krasner made the rounds of the
exhibitions and bars. Among the former, he sent Ossorio news of
two: a show of Dubuffet's recent paintings, at Pierre Matisse's
gallery, and the memorial retrospective of Gorky's art that opened
at the Whitney on January 5, 1951. While he admired the
Dubuffets (Ossorio was a Dubuffet collector), Pollock saved most
of his praise for Gorky, who had committed suicide in July 1948,
after a series of illnesses and injuries: "Gorky's show opened yes-
terday—it's really impressive and wonderful to see an artist's
development in one big show. More than 90 percent of the work
I'd never seen before—he was on the beam the last few years of
his life."[145] The exhibition impressed many artists in New York
who had thought they knew Gorky's career, and it became a mar-
shaling point when the New York *Herald Tribune* published a
thoughtless review dismissing Gorky's art as "a blatant parroting
of someone else's style" and the exhibition as "a high-pressure
post-mortem promotion program." The writer, Emily Genauer, con-
cluded, "I'm beginning to think that the only thing worse than the
idolatry of second-rate artists while they're living is idolatry of
them after they're dead."[146] Pollock and Krasner were among the
first to sign a letter protesting the review as "a piece of savage
presumption and callousness that Gorky's friends resent."
Ultimately, the letter bore sixty-nine signatures, including those of
de Kooning, Parsons, Rothko, Hofmann, Barnett Newman, and
Meyer Schapiro—a veritable roll call of the New York art world,
speaking in defense of Gorky but also closing ranks around the
first artist of their generation to receive a museum retrospective.

As Pollock tormented himself with the question of how to
follow his latest paintings, the sight of Gorky's full career must
have offered both hope for his future and proof of the differences
between the two artists' approaches. Gorky's paintings, particularly
the many late pictures that were new to Pollock, may have helped
him set a new course. The exhibition was heavily weighted to
emphasize the last phase; more than two-thirds of the works dated
from Gorky's final five years, a time when he emerged from his

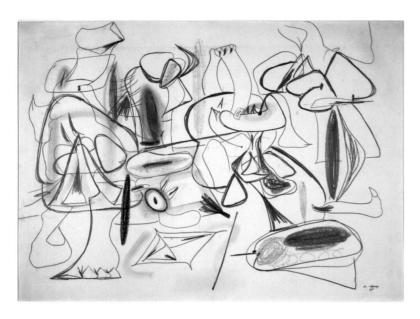

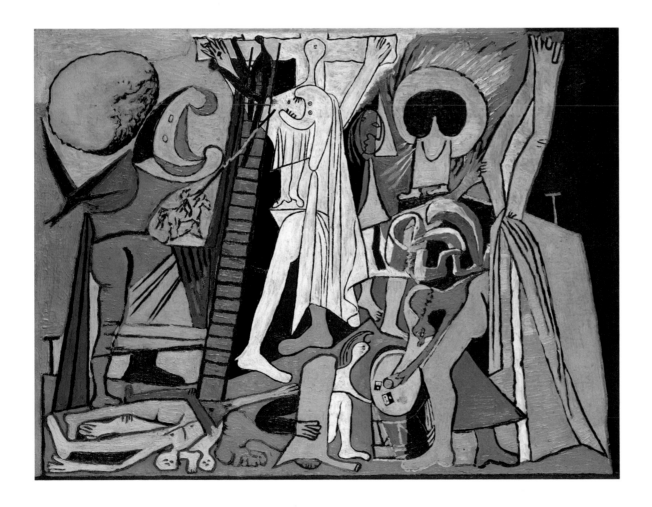

FIG. 90
ARSHILE GORKY, *Study for "They Will Take My Island,"* 1944. Crayon on white wove paper, 22 x 30 in. (55.9 x 76.2 cm). Brooklyn Museum, Dick S. Ramsay Fund 57.16

FIG. 91
ARSHILE GORKY, *They Will Take My Island*, 1944. Oil on canvas, 38 x 48 in. (96.5 x 121.9 cm). Art Gallery of Ontario, Toronto, Purchased with assistance from the Volunteer Committee Fund, 1980 (80/71)

PLATE 121
PABLO PICASSO, *La Crucifixion*, 1930. Oil on panel, 20 1/4 x 26 3/16 in. (51.5 x 66.5 cm). Musée National Picasso, Paris

227

PLATE 122
ARSHILE GORKY, *Nude*, 1946. Oil on canvas, 50 x 38 1/8 in. (127 x 96.8 cm). Hirshhorn Museum and Sculpture Garden, Smithsonian Institution, Washington, D.C., Gift of the Joseph H. Hirshhorn Foundation, 1966

FIG. 92
ARSHILE GORKY, *Charred Beloved II*, 1946.
Oil on canvas, 53 7/8 x 40 in. (137 x
101.6 cm). National Gallery of Canada,
Ottawa, Purchased 1971

involvement with Surrealism and defined his most personal style. Preserving the spontaneous effects of his works of the early 1940s while reclaiming the draftsmanship of his previous period of devotion to Picasso, Gorky used every means to engage the trauma of both his contemporary life and his Armenian heritage. In *They Will Take My Island* (1944; figs. 90, 91), he appropriated a gesture of despair that Picasso had used in *Guernica* and *Crucifixion* (1930; plate 121)—a pair of locked arms thrust upward—to evoke the emotion of the title (probably a reference to his lost homeland) and to articulate the center of a field of filigree lines and stained colors. In *Nude* (1946; plate 122), he used the same gesture to characterize a figure stretched along the diagonal of the canvas. This extremely reductive outline—which is similar to the schema Pollock would use as he began *Number 27, 1950*—maps a body that Gorky fragmented in *Charred Beloved II* (1946; fig. 92) to evoke a fire in January 1946 that destroyed his Connecticut studio and many of the paintings he had made in the previous year.

Looking at these pictures, Pollock may have sensed an alternative for himself, not so much following Gorky's example as returning to his own work of the mid-1940s and his engagement with Picasso. Half joking, Pollock told painter Paul Brach that he made the drip paintings "to get rid of Picasso."[147] When he resumed painting in the summer of 1951, Pollock allowed Picasso a more explicit presence in the paintings that he described to Ossorio: "drawing on canvas in black—with some of my early images coming thru." Until his death, in 1956, Picasso would remain his touchstone.

After the tremendous complexity of the drip paintings, Pollock simplified his art. He reduced his means to a single paint, black enamel, and he poured it on raw canvas with a variety of basic tools, including hardened brushes and turkey basters. Passing through the schematic figures he had used to start the drip pictures, his imagery revisited his major paintings of the early 1940s: among the paintings of 1951, *Number 18, 1951* (plate 123) and *Number 22, 1951* recall the vertical figure of *Gothic*, from 1944, while *Echo: Number 25, 1951* (plate 124) returns to the duality of *Masqued Image*, from about 1938–41. Yet Pollock also seems to have traveled farther back in time, for the closeness of the enamel paintings to the works by Picasso that had served as his sources in those years suggests that he focused not just on his own early work but on the creative nexus of his first important paintings. Wishing to put aside his drip technique, at least temporarily, he reached back to this crossroads to set a new direction for his art. While the thick curves articulating *Gothic* recur in *Number 18, 1951*, the 1951 painting more clearly depicts a single female figure. Standing in the center of the canvas with arms locked behind her head, elbows outthrust and legs splayed, this woman matches the pose of Picasso's *Nude with Raised Arms (The Dancer of Avignon)* (fig. 80). Not unlike de Kooning's *Woman I*, she conveys both dynamism and iconic fixity in a monumental image, swathed in pours of black enamel spinning from her body like strips of cloth.

The Picasso picture of greatest importance for Pollock in 1951 and the remaining years of his career was *Girl before a Mirror*, a painting revered by Graham and the one that had introduced Pollock to the psychological and stylistic complexities of Picasso's art. *Girl before a Mirror* is defined by dualities, not only in the

woman and her reflected image but in her bifurcated visage and the composition's dissonant stylistic patterning. Moreover, the dualities are often contradictory: the woman is two-faced, virginal and whorish, and the architecture of the painting swings from rounded curves to tightly packed rectangles that modulate into circles. Ten years earlier, in *Masqued Image*, Pollock had turned these binaries into a war of paired masks. Now, in *Echo: Number 25, 1951*, he engaged Picasso's conceit. On the left, a woman stands in profile and reaches across the canvas. As the title (which Pollock may not have chosen) implies, the right side of the painting is her reflection. Picasso's transformation of the woman on the left of his canvas into the dark, swirling configuration of her mirror image had stretched representation to the verge of abstraction. With the experience gained from his drip pictures, Pollock pushed it much farther, both in the poured fluency of his figure and in the dense and extremely varied marks of the metamorphosing "echo." As in many other cases of Pollock's responses to Picasso, *Echo: Number 25, 1951* skins off the hard-won elegance of Picasso's style and intensifies the violent conflicts of his themes.

The largest and probably the most important of Pollock's final paintings, *Portrait and a Dream* (1953; plate 125), is also his last significant confrontation with Picasso. But for a single strand of paint running from the poured design at the left to the head at the right, the composition would be a diptych, a juxtaposition of two separate pictures. Like the woman's arm in *Girl before a Mirror*, however, this poured line joins the two parts and establishes the connection stated in the title (which in this case was chosen by Pollock). Eliminating Picasso's busy background and the figure's body, Pollock created a gigantic close-up of psychological inquiry. Though constructed of both frontal and profile views, the head is clearly representational and is fleshed out with intense oranges, reds, and yellows, while the black pouring remains schematic and abstract, despite suggestively anatomical passages. The two halves of the painting imply the aesthetic debates of the previous ten years, and Pollock's uneasy position straddling supposed opposites.

The stylistic differences in *Portrait and a Dream*, however, are largely metaphorical. Like Picasso, Pollock used the work's two pictorial modes to shift from exterior appearance to the imagination, while maintaining a connection between the two with a thin tether. This effort to project the inner workings of the mind is all the more compelling when one realizes that in the right half of the picture Pollock was probably painting a portrait of himself. Not only does the head resemble his appearance in the mid-1950s, but he reportedly told his doctor, "That's a portrait of me, can't you see," and clarified that it showed him when he "was not sober."[148] In his entire career, Pollock made only two confirmed self-portraits,[149] but Picasso was famous for depicting himself across the decades. Pollock's startling decision to create this portrait was both a courageous act of self-revelation and a direct, perhaps desperate assault on Picasso's primary territory.[150] In August 1956, Pollock died at the wheel of a car. That October, Picasso turned seventy-five. The Museum of Modern Art had been planning to honor both artists for some months, Pollock with a mid-career retrospective, Picasso with a show covering his work during more or less the same period, the years since *Guernica*.

Whether or not the museum intended a comparison, the exhibitions would have provided a remarkable opportunity to evaluate the two artists over this crucial twenty-eight-year stretch. Instead, the Pollock exhibition, which opened that December, became a modest memorial of forty-two works and confronted its curator, Sam Hunter, with the excruciating task of summing up Pollock's achievements in the immediate aftermath of his final erratic years. Praising the great contribution of the drip paintings, Hunter offered,

> Pollock himself was the best judge of the size of his painting ambition, and the conflicts, perils, and risks it necessarily entailed. And, because he was so sensitive to his own artistic purpose and fundamentally uncompromising, when the impulse to paint suddenly eluded him, as it did over periods of prolonged inactivity during the last three years of his life, he was desolated by anxiety and by his own self-rebukes. It is idle to speculate whether he would have again resumed painting with some consistency if tragedy had not intervened. . . . Happening as it did, death may have come as a deliverance from the deep mental anguish of a paralyzing spiritual crisis.[151]

As a straw, Hunter affirmed that "one of [Pollock's] significant achievements was to rejuvenate the European sense of art and make it viable again for native sensibility."[152]

When the Picasso show opened, in September 1957, it had ballooned into a full retrospective of more than 300 works. It also returned Barr to the curatorial saddle, if only as "Director of the Exhibition" rather than of the museum. While less systematic than "Picasso: Forty Years of His Art," "Picasso: Seventy-Fifth Anniversary Exhibition" covered the artist's career from teenage sketches from 1899 through a major painting done in June 1956. It also showcased the remarkable acquisitions that Barr had overseen since the end of the war, beginning with *"Ma Jolie"* (1911–12) in 1945 and continuing through *Three Musicians* (1921; plate 65) in 1949, *Harlequin* (1915; fig. 123) in 1950, and both *Three Women at the Spring* (1921) and *Night Fishing at Antibes* (1939; fig. 89) in 1952. During the exhibition's run, the Modern bought one of Picasso's latest paintings, *Studio in a Painted Frame* (1956).

This time Barr wrote no interpretive text, but Greenberg took the opportunity to rate Picasso against his conception of modern art and the recent achievements of Americans. Greenberg's lengthy analysis drew on the principles he had formulated while reviewing the work of Pollock and other contemporary artists in New York during the previous decade, and provided a theoretical basis for his dismissal of Picasso's wartime work in 1946.[153] Suggesting that Picasso might have "succumbed to the myth of himself," Greenberg set the artist straight, calling many of his paintings since 1930 "downright bad" or "truly ridiculous" and his sculpture "lamentable." For Greenberg, Picasso had entered a crisis in the late 1920s because he had shared the Surrealists' taste for the literary and, most important, had failed to honor "the inherent laws" of Cubism, which, "by the late twenties . . . all seemed to be driving toward abstraction." By continuing to draw his subject

matter from nature, Picasso had neglected to pursue the flat surface and "immediate physical qualities of painting." Simply put, "Picasso refused to draw the lessons of his own experience." In Greenberg's opinion, even *Guernica* was a "bulging and buckling" failure. Even so, a few paintings of the 1930s were "realized absolutely," particularly "the little Henry P. McIlhenny *Bullfight* of 1934"—a painting that Pollock may well have responded to in *The Water Bull.*

Given Greenberg's obliviousness to the actual diversity of Cubism, he could find only one recent painting to praise: *The Kitchen,* which he called "the most adventurous as well as the most abstract work of Picasso's that I know. . . . It is certainly the most interesting of the post-1938 paintings in the Museum show, and perhaps the best." Despite this praise, Greenberg found a "slightly disturbing heaviness and deliberateness of line" in the painting, and "the tightness with which the frame grasps the four sides gives it a boxed-in, over-enclosed and over-controlled effect." Unfortunately, Greenberg did not pursue the challenge of specifying this description's implicit comparison with Pollock's work. Instead, he took a cheap shot by suggesting that Picasso might have been inspired by the pictographs of Adolph Gottlieb, which had been shown in Paris in 1947 and which Greenberg claimed Picasso had admired.[154] He was wise to skip an explanation of this connection, since Gottlieb's grids were themselves derived from Picasso's *The Studio,* a painting long in the Modern's collection and a primary source of *The Kitchen* as well. Nonetheless, Greenberg did single out a painting that the Modern would acquire in 1980.

Greenberg's review bristled with aggression toward Picasso and barely masked the desire to take him down and put the artists associated with Abstract Expressionism in his place. Yet Greenberg never made that claim outright. His attack was below the belt, slipping in Gottlieb or quoting a report in *Time* that Picasso "once grabbed an ink-stained blotter, shoved it at a visitor and snapped 'Jackson Pollock!'"[155] As Picasso's discussion with Matisse demonstrates, his views were far more complex. Yet Greenberg's street-fighting cuts show how intensely he still took the competition with Picasso. If anything, his animosity may have increased with Pollock's decline and death.

Without drawing the contrast to Pollock, Barr's catalogue foreword for "Picasso: 75th Anniversary Exhibition" celebrated Picasso for his "sustained invention and vitality."[156] Yet Barr, too, was deeply disappointed with him, not for his supposed betrayal of modernist imperatives but for the political positions he had taken during the 1950s and the way these guided his art. Ten years earlier, in 1946, Barr had made *Fifty Years of His Art* a heartfelt endorsement of Picasso as a man of high principle. Discussing *Charnel House,* he had quoted Picasso's statement that painting is "an instrument of war" against "brutality and darkness," and had ended the book with a short, celebratory sentence: "Twice in the past decade Picasso has magnificently fulfilled his own words."[157] In the following decade, however, Picasso's allegiance to the Communist Party and his participation in Party conferences had made him a dupe of sectarian dogma instead of a cultural ambassador to the world. In 1951, he had painted *Massacre in Korea,* a descendant of *Guernica* as rigid and lifeless as the anti-American propaganda it promoted.

PLATE 123
JACKSON POLLOCK, *Number 18, 1951*, 1951.
Enamel on canvas, 59 1/4 x 55 7/8 in.
(150.5 x 141.9 cm). Whitney Museum of
American Art, New York, Gift of The
American Contemporary Art Foundation
Inc., Leonard A. Lauder, President
2002.258

PLATE 124
JACKSON POLLOCK, *Echo: Number 25, 1951,*
1951. Enamel on unprimed canvas, 91 7/8 x
86 in. (233.4 x 218.4 cm). The Museum of
Modern Art, New York, Acquired through
the Lillie P. Bliss Bequest and the Mr. and
Mrs. David Rockefeller Fund (241.1969)

234

PLATE 125
JACKSON POLLOCK, *Portrait and a Dream*,
1953. Oil on canvas, 58 1/2 x 134 3/4 in.
(148.6 x 342.3 cm). Dallas Museum of Art,
Gift of Mr. and Mrs. Algur H. Meadows
and the Meadows Foundation,
Incorporated

FIG. 93
PABLO PICASSO, *Women of Algiers, after
Delacroix, Version O,* 1955. Oil on canvas,
44 7/8 x 57 1/2 in. (114 x 146 cm). Private
collection

When Stalin died two years later, Picasso had obligingly drawn a
portrait of the dictator for a French newspaper. Publicly, Barr kept
silent about these actions, but he included neither of these works
in the exhibition. When Picasso finally broke with the Party over
the Soviet Union's suppression of revolt in Hungary in 1956, Barr
did tell Roland Penrose, the artist's friend and biographer, "Of
course I am pleased that he signed the open letter to *L'Humanité*
[the newspaper of the French Communist Party], but I can't help
feeling a certain sense of disgust that it should have taken him so
long to declare what has been so painfully obvious to the rest of
the world."[158]

With Picasso's Communist affiliation both an embarrassment
and a possible diplomatic issue in the extreme political climate of

the mid-1950s, Barr focused on aesthetic matters. Unlike Greenberg,
he greatly admired Picasso's sculpture; in 1939, he had lamented,
"The most serious disappointment caused by the war is the absence
of a large and very important group of Picasso's recent sculpture
some of which was being cast especially for the show."[159] In the 1957
exhibition, he offered "the largest showing in America of Picasso's
rather neglected sculpture," and he recalled the wartime situation of
his earlier retrospective to aver, "Had the many major pieces still in
Picasso's possession been available (as was expected), the artist
would, I believe, have been revealed as one of the greatest sculptors
of our time."[160] From among Picasso's recent sculpture, the exhibi-
tion included *Man with a Lamb* (1944), *Pregnant Woman* (1950), and
a cast of the fantastic assemblage *Baboon and Young* (1951).

If Picasso's long, episodic involvement with sculpture was
one high point of the exhibition, the other was a single clutch of
his very recent paintings. From December 1954 through February
1955, Picasso had painted fifteen variations on Delacroix's *Les
Femmes d'Alger* (*Women of Algiers*, 1834 and 1849), and Barr assem-

bled the entire series for the exhibition (see fig. 93). Far from
Greenbergian aesthetics, the paintings address Picasso's complex
sense of history as an artist at the center of what had grown into
a modern tradition. He had engaged these issues at least since
he had folded neoclassical styles into Cubism at the beginning
of World War I, and his statement in 1935 that young artists
should take up his researches in order to react against him
confirmed his belief in historical continuity.[161] Instead of
marking a radical break with the past, as it was so often thought
to do, his art over the course of his career increasingly mani-
fested his profound sense of his place in the history of art, a
constantly shifting construction of old masters and contempo-
raries that accepted no barriers between the avant-garde and the
ancien. When Matisse died in 1954, Picasso said, "He left his
odalisques to me as a legacy."[162] As the Modern's exhibition
opened, he was at work on a series more numerous than the
paintings after Delacroix, this time based on Velazquez's *Las
Meninas,* and he would create other serial variations in the 1960s
(including one after Manet's *Déjeuner sur l'herbe,* in 1959–62).
But his paintings after *Les Femmes d'Alger* marked a public
turning point, shattering the concept of a modernist imperative
that Greenberg in particular preached. By creating independent
variations, rather than stages toward a culminating work (as in
the photographs of *Guernica*'s transformation), they turned the
idea of a masterpiece on its head. And they opened the way to
an even greater eclecticism of style, subject matter, and refer-
ences to the past as well as the present.

Picasso's *Femmes d'Alger* lived in America: the entire series
had been purchased by Victor and Sally Ganz in 1956, and sev-
eral usually hung in their apartment in New York.[163] The Ganzes
had begun to buy Picasso's work in the 1940s, and by the end of
the 1950s had formed the finest private collection of his art in
America. Then, however, they turned to young American artists;
beginning in 1962, they bought work by Robert Rauschenberg,
Roy Lichtenstein, and Claes Oldenburg, and became devoted
collectors and friends of Jasper Johns. Freely mixing works by
Picasso and these artists, the Ganzes' apartment was often filled
with the art community. It offered a McMillen exhibition for a
new generation of Americans.

CHAPTER FIVE
(1958–2003)

"I THINK PICASSO WOULD HAVE THROWN UP IF HE'D SEEN MY VERSIONS. MAYBE NOT, THOUGH. MAYBE HE WOULD HAVE FALLEN IN LOVE WITH THEM AND THEN DESTROYED ALL HIS OTHER WORK"

Roy Lichtenstein, 1988

Roy Lichtenstein's copy of *Picasso: Forty Years of His Art* has lost its binding. Although there is no evidence that he hurled the book to the floor, it has been heavily used: its pages are grimy and frayed; a reproduction of Picasso's "first compositional study for *Guernica*" has been carefully razored out; and square brackets mark sections of the artist's two statements in the book. Given Lichtenstein's association with the cool, apparently anonymous styles of Pop art, it is surprising to find him noting Picasso's desire to record "the metamorphoses of a picture" in order to "discover the path followed by the brain in materializing a dream."[1] Nonetheless, most of Lichtenstein's notations address Picasso's focus on the artifice of art—the limitations of academic training, the distinction between art and nature, the conventions of painting, and his claim that abstract art must stem from an artist's response to nature.[2] Without ignoring the passion of Picasso's words, Lichtenstein's choice of passages highlights the tools of the artist's trade and the process of transforming things into works of art.

The Museum of Modern Art's Picasso exhibition of 1939 opened during the fall of Lichtenstein's senior year at the Franklin School for Boys on West 89th Street in Manhattan. The following fall, he began studying fine art at Ohio State University, where one of his teachers, Hoyt L. Sherman, shared his admiration for the School of Paris—this at a time when the midwestern art scene was still dominated by Regionalism. Today, when Lichtenstein is so well-known as a member of the new generation that broke away from Abstract Expressionism, it is remarkable to think of him encountering Picasso in depth at the same time as Jackson Pollock. (Of course, Pollock had seen reproductions of Picasso's works in the early 1920s and some paintings in the 1930s.) Whether Lichtenstein visited Barr's exhibition is uncertain, but he named *Girl before a Mirror* (1932; plate 94) as the first Picasso he remembered seeing. It was reproduced in *A Treasury of Art Masterpieces*, a book he received as a Christmas present around the time of its publication, in 1939.[3] The editor was the old nationalist Thomas Craven, and Lichtenstein had the impression that the text "said very berating things about" the painting.[4] He also recalled seeing *Guernica* (1937; plate 86) in Ohio during his first year or two of college (it was shown at the Columbus Museum of Art in the fall of 1941).

To the generation of American artists who began their careers after the emergence of the New York School, Abstract Expressionism can seem a great divide, separating them from the art of the earlier twentieth century and forming the bedrock of later developments. More than any artist, Picasso registers the change. During the twenty years before his death, in 1973, he was more frequently discussed for his celebrity than for the art he continued to make until the final weeks of his life. He had already dominated contemporary art for nearly half a century, a feat few artists even approached. But he fought retirement, saying that he did not wish to become "a historic monument," and his final self-portraits are among the most unvarnished depictions of physical and mental decay ever made. Among artists, only Salvador Dalí could rival him in fame, or in the number of sycophants surrounding him, but Dalí's new work was generally ridiculed. Picasso's received the polite praise due a distinguished *maître*, a smothering blanket of compliments that he alternately railed against and wrapped around himself as insulation from the broader world. To the majority of the public, he was most famous for his wealth, his casual lifestyle in the South of France, and his place among international celebrities, with film stars the likes of Gary Cooper paying calls. His willingness to pose for hundreds of photographs at his châteaux or on the beach only fed the frenzy;[5] Andy Warhol certainly took note.[6] One of the rare Americans to summon the courage to break though the entourage and touch Picasso as an artist was Saul Steinberg, who visited him in May 1958 and engaged him in a game of "exquisite corpse" that resulted in four collaborative drawings (see fig. 94).[7] Many Americans, however, did not address the art of Picasso's last years until well after his death—until 1980, when the Museum of Modern Art held a large retrospective, and more particularly 1983, when the Guggenheim Museum devoted an extensive exhibition to the work of his final decade.

Yet Lichtenstein was not the only artist of his generation to receive a shock from his first encounter with Picasso's art and to return to it later as a prime source of his own work.[8] Jasper Johns, recalling his initial sighting around 1949, would say, "I remember the first Picasso I ever saw, the first real Picasso. . . . I could not believe it was a Picasso, I thought it was the ugliest thing I'd ever seen. I'd been used to the light coming through color slides; I didn't realize I would have to revise my notions of what painting is."[9] In retrospect, this statement is richly loaded. It introduces generations of artists who from adolescence had access to a wide array of modern art in reproduction—not the black-and-white reproductions of previous books and magazines but high-quality color plates, and the color slides projected in the proliferating number of college art-history courses. For artists of the first half of the century, reproductions were clearly counterfeit. However useful an illustration might be, it was no substitute for the actual painting. These new reproductions were more confusing, and Johns's immediate

PABLO PICASSO, *Minotaur Moving*, April 6, 1936 (detail of plate 160)

JASPER JOHNS, *Summer*, 1985 (detail of plate 159)

attention to the fundamental differences between image and object registers a new relationship between an original artwork and its reproduction. This awareness resonates through his oeuvre, and his initial sense that Picasso's pictures defined the medium of painting would become a major theme in his art at the end of the twentieth century and the beginning of the twenty-first.

Besides sustained campaigns by Johns and Lichtenstein, substantial forays into Picasso's work were made by a number of other American artists, including Claes Oldenburg. And as Picasso joined the pantheon and then, finally, died, he and his work also became the target of numerous parodies. Red Groom's send-up of a 1951 photograph showing Picasso and Françoise Gilot parading across the beach manages both to poke fun at the grandeur of the picture and to acknowledge Picasso's own jovial hamming for the camera (figs. 95, 96).[10] Once Picasso was dead, exhibitions increased the presence of his art in museums and galleries around the world, but the impossibility of a reply from the grave changed the game, particularly for artists who had not reached maturity during the decades of his dominance.

Lichtenstein painted his first variation after Picasso in 1943 (a version of *Portrait of Gertrude Stein*, 1906; fig. 5), and when he

was stationed in Paris as a G.I., at the end of World War II, he made a pilgrimage to Picasso's home:

> I remember I always wanted to meet Picasso and I found out he had a studio in was it—rue des Grands Augustins or something and went there. . . . I went but I was actually afraid to go in. There was a big gate and there was a paper mill or something on part of it, it was very closed off. I think actually at that time Picasso was not seeing GI's any longer. This was rather late . . . but I went to look at it and kind of thought, you know, wouldn't it be nice if he came out and I'd say hello to him or something, but he never came out and I never went in. . . . what do I have to say to him that would be of any value to him.[11]

Lichtenstein's reference to Picasso seeing G.I.'s recalls the latter's practice of welcoming American soldiers into his studio in the months following the liberation of Paris in August 1944. Whether or not they had an interest in art, many came to meet the most famous artist in the world, and a man who had stood firm against the Nazi Occupation. Picasso gave many interviews, and some soldiers, such as James Lord, turned an encounter with the great man into a friendship.[12] While Lichtenstein returned to Ohio State after his

FIG. 94
PABLO PICASSO AND SAUL STEINBERG
(1914–1999), *Exquisite corpse drawings*,
May 16, 1958. Each 10 1/2 x 8 in. (26.7 x
20.3 cm). Left: colored pencil, Beinecke
Rare Book and Manuscript Library, Yale
University; right: pen, private collection

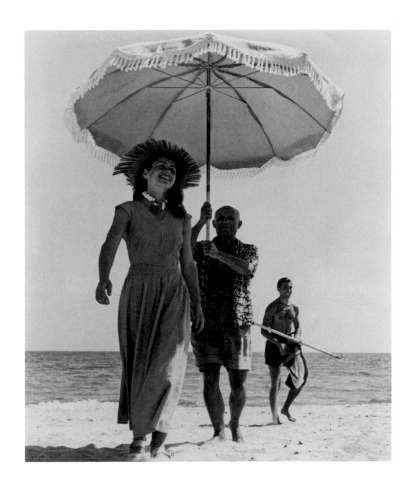

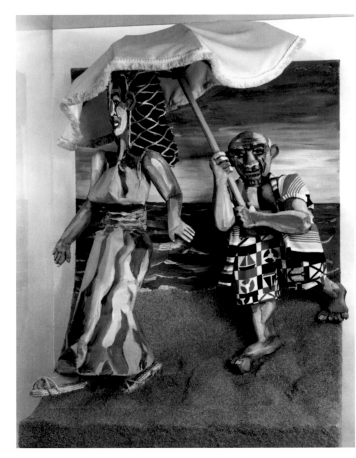

demobilization in January 1946, using the G.I. Bill to fund his studies, many other artists who had served in the military took the Bill as an opportunity to live for a while in Paris. Jack Youngerman arrived in 1947. The next year, Robert Rauschenberg came over, as did Ellsworth Kelly, Al Held, and others. As Youngerman recalled, "In 1948, art was still French in everybody's minds. It was a French province."[13]

Kelly had served in France in 1944 and knew his way around the country and the capital. As with other young artists, his admiration for Picasso played a large role in his decision to return to Paris.[14] Living in a succession of hotels in the Latin Quarter (Picasso's neighborhood), he painted small canvases of women in the style of Picasso's recent portraits of Gilot, compositions that reduce the woman's features to quasi-geometric elements and embed them in surrounding fields of neutral pigment.[15] While some of Picasso's pictures were readily available in galleries, in 1949 Kelly had two exceptional opportunities to see extensive groups of his work: a visit to Alice B. Toklas, the lover and heir of Gertrude Stein, and a major exhibition of Picasso's recent work at the Maison de la Pensée Française.[16]

Among Stein's pictures, Kelly particularly admired a papier collé, *Student with a Pipe* (1913–14),[17] whose newspaper beret may have inspired him to cut *Head with a Beard* (1949) from a single sheet of newsprint. The real discovery, however, came at the exhibition,[18] where Kelly saw *The Kitchen* (1948; plate 115)—the year after Picasso painted it and eight years before its New York appearance at the Museum of Modern Art. Shifting from the human form to architecture, this painting offered Kelly a path out of his tentative emulation of Picasso's formal plays between figure

and ground. The austere linear structure and fluctuating white space of *The Kitchen* isolate a segment of architecture and articulate not the objects within the space but the relationships between them (a dialogue Picasso derived from Cézanne). In a series of works made during the second half of 1949 and continuing into 1950, Kelly explored both Picasso's pictorial means in this painting (black line on white ground) and similar subjects. His *Toilette* (1949), a straightforward view of the "Turkish" model common in the bathrooms of Parisian cafés, preceded his visit to the exhibition and introduced the approach, but in *Tennis Court* (1949; fig. 97) Kelly created a more complex counterpoint between the simple geometric structure of *The Kitchen* and his own, subtly varied rendering, which set him on the course to his mature art.[19]

Lichtenstein's progress was much slower, yet he too engaged Picasso's works seriously in the late 1940s. His library contains a clutch of books on Picasso published in France during that decade.[20] Two of these—a portfolio of reproductions, *Picasso: Seize peintures*, and Paul Éluard's *À Pablo Picasso*—appeared in 1943 and '44, respectively, early enough that he may have picked them up while he was stationed in Paris.[21] Whatever year he acquired the portfolio, its large, tipped-in plates lodged in his memory. When he decided to paint explicit variations on paintings by Picasso in the early 1960s, he chose these reproductions as the basis for the first two of these pictures.[22] He certainly

FIG. 95
ROBERT CAPA (1913–1954). *Picasso, Françoise Gilot and Fin Vilato*, 1951. Photograph

FIG. 96
RED GROOMS (born 1937), *The Picassos by the Sea*, 1974–75. Mixed media, 51 x 36 1/2 x 24 in. (129.5 x 92.7 x 61 cm). Private collection

owned Éluard's *Á Pablo Picasso* in the 1940s, because around 1947 he used the book's blank pages for drawings of figures in a scratchy line that incorporate Picasso's classicizing styles.[23] These drawings suggest a competition, lighthearted in manner but serious in intention, that would continue throughout Lichtenstein's career. One of them, a Picassoid bust, appears on the flyleaf, as if it were the opening image of the book. It is signed "Lichtenstein." Another is sketched above the printed legend "COLLECTION LES GRANDS PEINTRES PAR LEUR AMIS" (Collection of great artists by their friends), and opposite a reproduction of one of Picasso's classical gods of the early 1930s, Lichtenstein drew a loose version of a massive male head.

Once Lichtenstein locked onto Picasso's work during his graduate study at Ohio State, he never relinquished his grip.[24] He would describe his years from 1949 to about 1960 as his "sort of cubist period": "In my early cubist work I was always afraid of looking like Picasso. The more I tried to evade his influence the more self-conscious the paintings got and the more evident was the source."[25] One of his thesis paintings, *The Musician* (1948; plate 126), captures the earnest analysis and goofy pleasure of Lichtenstein's early responses to Picasso. The painting's subject of a man playing a clarinet, and its style of Synthetic Cubism, show that he was looking at Picasso's *Three Musicians* (1921; plate 65, but probably both versions). Besides exhibiting a considerable command of technique,

The Musician cleverly plays the game of Cubist fragmentation and reconstruction to contrive a seemingly nonsensical face for the man. Under his pointed head, a tiny pair of legs (sporting blue pants and black shoes) stands on a white crescent. Perhaps the lyrics of the song he is playing recount the exploits of a stout man who went to the moon, but the shapes are lifted from Picasso's composition, particularly the Philadelphia version. Lichtenstein derived the pants from the masks of Picasso's musicians (particularly that of the central clarinetist) and the "moon" from one half of an adjacent musician's mustache (which Picasso split into black-and-white halves). The diamond pattern below Lichtenstein's assemblage picks up the costume of Picasso's *Harlequin*.[26] What at first appears to be merely a send-up of one of Picasso's masterpieces turns out to be both deeply attentive to his composition and richly amusing. Erudition is hidden behind horseplay.

Looking back during an interview with Richard Brown Baker in 1963, Lichtenstein admitted that his work of the 1950s was art about art, a conjunction of American history painting and Picasso that initially appeared wildly peculiar but addressed his sense of being at the intersection of two formidable currents of contemporary art. He described his pictures as "the ones I did of American paintings by [Frederic] Remington, Charles Wilson Peale and William Ranney. They were of American Scene but they were seen more through Picasso's eyes, I think, than mine." Lichtenstein's method certainly set the model for his later practice, but during the 1950s he was turning these historical pictures into Synthetic Cubist compositions. He was "making them more artistic. . . . And I think I enjoy[ed] this because there I was trying to get away from Picasso."[27] Besides Emmanuel Leutze's *Washington Crossing the Delaware* (1851), Lichtenstein took on advertisements employing pioneer imagery (as in *The Explorer*, ca. 1952)[28] in styles he derived from *Three Musicians* and related pictures. By the late 1950s he had appropriated a more fluid style, mixing Abstract Expressionism and Picasso's contemporary idiom, to update stodgy portraits in ways that predate Picasso's musketeers of the 1960s (see *James Lawrence Esq.*, 1953; plate 127).[29]

As Lichtenstein sought to escape Picasso's orbit, he tried out Abstract Expressionism, but he ended up believing that "even Abstract Expressionism almost as a movement was an effort to get away from Picasso."[30] In 1960, he landed in an environment that would provide a real escape route: Douglass College of Rutgers University, where he joined Oldenburg and Allan Kaprow on the faculty, and was exposed to the idea of Happenings. More than the work that Johns and Rauschenberg had been making for nearly ten years, Happenings transformed Lichtenstein's thinking. "I was more aware of the Happenings of Oldenburg, [Jim] Dine, [Robert] Whitman, and Kaprow . . . I didn't see many Happenings, but they seemed concerned with the American industrial scene. They also brought up in my mind the whole question of the object and merchandising."[31] To clarify, he made a specific comparison between the work of Johns and of Oldenburg: "Although the Happenings were undoubtedly influenced by Johns and Rauschenberg, an Oldenburg Fried Egg is much more glamorized merchandise and relates to my ideas more than Johns's beer cans. I want my images to be as critical, as threatening, and as insistent as possible."[32] Although one might dispute the characterization,

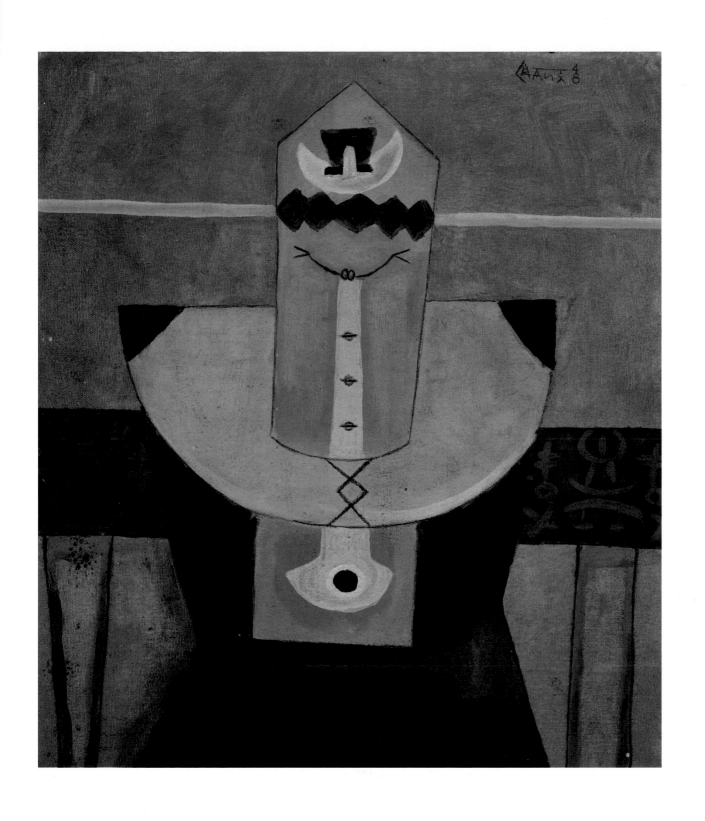

PLATE 126
ROY LICHTENSTEIN (1923–1997), *The Musician*, 1948. Oil and graphite on canvas, 18 x 16 1/4 in. (45.7 x 41.3 cm). Private collection

Lichtenstein's respect for Oldenburg is evident in this 1963 interview.

Oldenburg may not only have played a role in inspiring Lichtenstein to turn to modern commercial imagery but also kept alive his dialogue with Picasso. As Lichtenstein recognized, Oldenburg created work that was critical and threatening in its insistence that art could still engage humanistic themes, and he acknowledged *Guernica* as a prime source. Alongside his sketches for the 1960 installation *The Street*, Oldenburg wrote, "The guernica is the only *metamorphic* mural. My street is such a mural in 3-D. Subject is everyday agony. *Sketches*[:] not as decor.[ative] as guernica."33 Oldenburg saw *Guernica* as a model for his desire to record the desperate state of life in New York City's slums.34 Instead of mimicking the black and white of newsprint, Oldenburg used real things—crumpled newspaper, burlap bags, wire—to create an array of gesturing figures as dramatic as Picasso's but literally tumbling off the walls into a debris-filled room.

While Oldenburg and Lichtenstein shared a belief that Picasso's art remained compelling, Lichtenstein took a fundamentally different approach to the intersection of art and life. "I personally care about society," he said, "but I don't think my art is involved in it." And he maintained his long-standing focus on the formal qualities of an image: "I really don't think that art can be gross and oversimplified and remain art. I mean, it must have subtleties, and it must yield to aesthetic unity, or otherwise it's not art."35 Nonetheless, he clearly did not consider Oldenburg's work "gross," and his search for critical, threatening, and insistent art took him back to Picasso.

Just a year after Lichtenstein made his first Pop pictures, he began a series of paintings based on Picasso's that extended from 1962 to 1964. Although these paintings are only four among the dozens that Lichtenstein made during these years, they are the primary counterweight to his involvement in commercial imagery, and they establish the breadth of his ambitions. On the face of it, his choice of Picasso wasn't fundamentally different from his choice of a comic book. As he said, "A Picasso has become a kind of popular object—one has the feeling there should be a reproduction of Picasso in every home."36 That is exactly what Tom Wesselmann portrayed in *Still Life #30* (1963; plate 128), a three-dimensional relief that places a framed reproduction of a Picasso next to a row of 7-Up bottles standing on top of the refrigerator. This particular Picasso painting, *Seated Woman* (1927; fig. 63), had defined the American public's sense of Picasso's most raw and challenging work since its appearance in the Modern's 1930 exhibition "Painting in Paris from American Collections," and had captivated Arshile Gorky, Willem de Kooning, and their friends during the following two decades. Reduced to a postcard thirty years later, it seems at home in the mass-market clutter of the kitchen. For his part, Lichtenstein affirmed in the same interview of 1963 that "I think Picasso is the best artist of this century," and he elaborated that "it is interesting to do an oversimplified Picasso—to misconstrue the meaning of his shapes and still produce art."37

Lichtenstein's return to Picasso involved far more than simple parody of that artist's celebrity. It was an artistic engagement more intense than his struggle to transform Cubism over the past fifteen years, and one that would continue to the end of his life. His choices were extremely pointed. The first two Picassos he picked, *Femme au chapeau* (known in English as *Woman in Grey*, 1942; plate 129) in 1962 and *Femme dans un fauteuil* (*Woman in an Armchair*, 1941) in 1963, are certainly signature images, but both also appear in *Picasso: Seize peintures*, the portfolio that Lichtenstein had owned for years. These wartime pictures return to Lichtenstein's first serious encounters with Picasso's art: the paintings he knew as contemporary in the 1940s, and the reproductions that had probably sat in his library for nearly twenty years. In selecting them, Lichtenstein went back to the beginning of his fascination with Picasso.

These were perfect paintings on which to test his new style. They are characteristic of Picasso's wartime work—extremely austere compositions with a minimum of objects, simple patterns, and few colors. Among these, Lichtenstein's first choice, *Femme au chapeau*, is not only one of the most reductive but among Picasso's most gruesome evocations of the deprivations of the Occupation. The woman's flattened face and strips of flesh are grotesque in a field of slate gray, accented by a ridiculous hat and pointed collar. The painting bristles with the qualities that first struck Lichtenstein about Picasso's work:

> I remember when I first looked at Picasso's [art] it looked very insensitive—Picasso's—to me. . . . Now they look like art and they look very sensitive but I think that, you know, if you compare Picasso with some of the work that went before Picasso, the first, say, the *Demoiselles d'Avignon* or *Guernica* or something, it looks like shorthand and it looks very crude. After a while you see the subtlety in it and you realize it's a sensitive work but it has sensitivity because of its apparent crudeness.38

How remarkably similar were the first responses of Lichtenstein and Johns to Picasso's work. In part, this consonance may be explained by the fact that both men were probably looking at similar Picassos during the same span of years, yet their attention to the gross texture of Picasso's paintings picked up the baton from de Kooning and Pollock but raced in a radically different direction. The qualities that Lichtenstein saw in Picasso were the ones he hoped to achieve in his own art—"something brash, something more insistent and demanding."39 Yet his method pushed "insensitivity" to the point where it seemed to exclude the personal expression at the core of both Picasso's art and the art of the Abstract Expressionists.

Lichtenstein may have seen *Femme au chapeau* in 1957, at the Modern's "Picasso: 75th Anniversary Exhibition" (where Greenberg encountered *The Kitchen*).40 Whether or not he recognized the painting from the portfolio he owned and took the opportunity to examine its obdurate surface of scaly flesh and washes on a hard board, he almost certainly resorted to the reproduction when he began his version five years later (plate 130). Unlike the kind of postcard he might have picked up at the exhibition, the plates in *Picasso: Seize peintures* are unusually fine, particularly since they were made during the war. Printed on glossy paper, the large reproduction of *Femme au chapeau* records

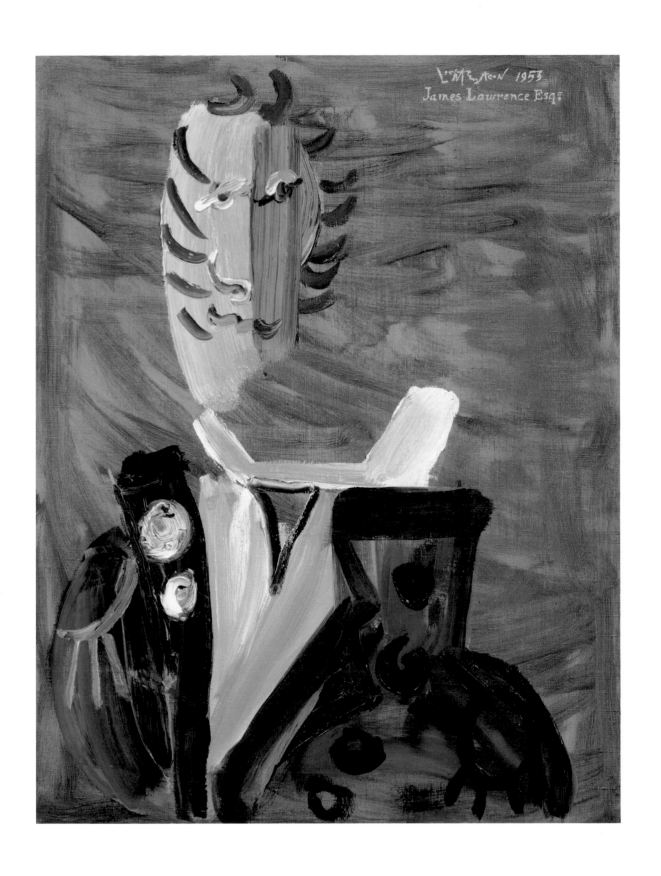

with considerable accuracy the touches of rose and purple in Picasso's gray field and the shifting density of his black outlines.[41] Even the thin drips of pigment across the woman's neck are clearly legible. Despite this resolution, the image is slightly blurred by the dots of the printing process. Because the plates in *Seize peintures* are mounted on thick sheets of paper that can be attached to a wall without tape obscuring the image, they are well suited for copying. The support also states the title of *Femme au chapeau*, and its dimensions. Presumably following this text, Lichtenstein used the French title for his painting, rather than *Woman in Grey*, the title printed in the Modern's catalogue and used by the painting's American owners.[42]

The photographic reproduction in *Seize peintures* served as a halfway point between Picasso's original painting and Lichtenstein's version of it. In a succession of revisions, Lichtenstein subjected his own work to the same process of radical simplification that he was imposing on the source. He mostly focused on his compositional sketch: "I don't draw a picture in order to reproduce it—I do it in order to recompose it."[43] He noted that the process of painting the picture was relatively fast, but "a lot of time is taken up with the drawing part and there's more work in the drawing part probably than is apparent."[44] Making his purpose "entirely aesthetic"—"Relationships and unity are the thing I'm really after," Lichtenstein would say—he tried to perfect his design in drawing.[45] Even so, the process extended into the painting:

> It never works out quite the way I plan it because I always end up erasing half of the painting, redoing it, and redotting it. I work in Magna color because it's soluble in turpentine. This enables me to get the paint off completely whenever I want so there is no record of the changes I made. Then, using paint which is the same color as the canvas, I repaint areas to remove any stain marks from the erasures.[46]

This extreme step of repainting the white ground to make it appear fresh canvas is emblematic of Lichtenstein's discipline. In suppressing all evidence of process, whether in Picasso's paintings or his own, he was throwing out one of the richest sources for art during the previous three decades, one put in play by the Surrealists in the 1920s, embraced by Picasso in his statement of 1935, and transformed by de Kooning and Pollock, among other American artists of their generation. It also presents a challenge to anyone hoping to uncover Lichtenstein's tracks.[47]

A photograph of Lichtenstein's studio taken in late 1963 (fig. 98), when he was completing his fourth variation after Picasso, *Woman with Flowered Hat*, shows that he painted with a reproduction of Picasso's picture next to his easel (and also, in this case, a tiny study he had made for projection onto the canvas). He followed a dual course of refinement, maintaining a dialogue with the Picasso at his side as he polished his own painting. Knowing the quality of the reproduction Lichtenstein presumably used for *Femme au chapeau* makes it possible to determine many of his choices. He completely omitted lines falling from the left fin of the woman's hat, which are embedded in the

background of the painting, as well as all the variations of hues and tones in that field. Instead he applied a consistent overlay of black dots, imitating the Benday-dot method of photographic reproduction, always visible in cheaply printed comic books. Lichtenstein's most obvious changes, and often the only ones noted in the literature on these works, are those of color. At this point, he had already reduced his palette to only four colors besides black and white: "a purplish-blue," a "lemon-yellow," "a green that was between red and blue in value (I don't use it too much because it is an intermediate color)," and "a medium-standard red."[48] His description of these hues demonstrates that his restricted palette was not arbitrary but stocked with careful choices. When he turned to *Femme au chapeau*, he slashed it even further by putting aside half the colors—nor did he make obvious choices in his use of the remaining two. Instead of replacing the flesh-colored strip that Picasso had used for the woman's face and neck with red, he used yellow, and he left one of the adjacent sections white—defusing Picasso's construction of black planes, compressing this pink band, and emphasizing the woman's triangular left eye. By extending the looping left outline of her head, Lichtenstein further enhanced the

FIG. 98
JOHN LOENGARD (born 1934), photograph of Roy Lichtenstein in his studio, 1963 or '64, reproduced in *Life* 56, no. 5 (January 31, 1964): p. 79

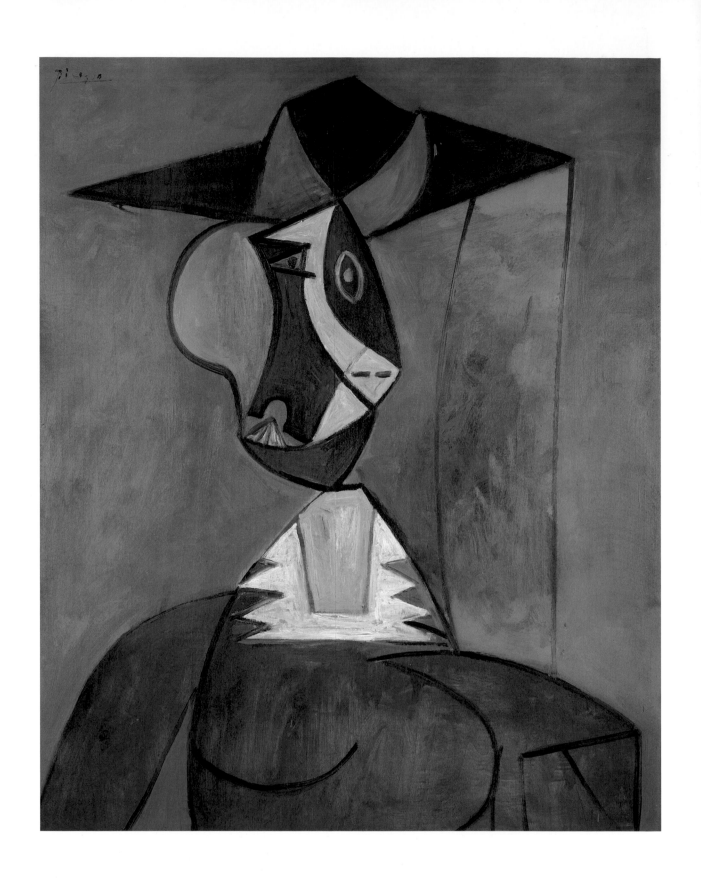

PLATE 129
PABLO PICASSO, *Woman in Grey*, 1942. Oil
on panel, 39 1/4 x 31 7/8 in. (99.7 x
81 cm). The Alex Hillman Family
Foundation, New York

PLATE 130
ROY LICHTENSTEIN, *Femme au Chapeau*,
1962. Oil and Magna on canvas, 68 x 56 in.
(172.7 x 142.2 cm). Collection of Martin Z.
Margulies

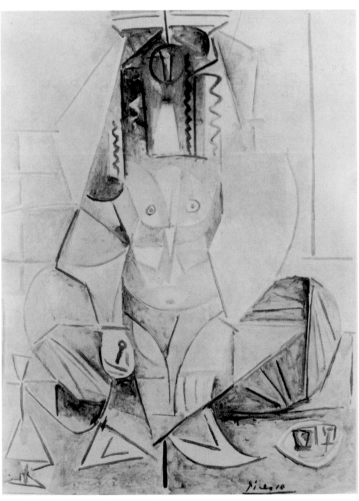

FIG. 99
PABLO PICASSO, *Women of Algiers, after Delacroix, Version K,* February 6, 1955. Oil on canvas, 51 1/8 x 63 3/4 in. (130 x 162 cm). Christie's Images Ltd.

FIG. 100
PABLO PICASSO, *Women of Algiers, after Delacroix, Version L,* 1955. Oil on canvas, 51 1/4 x 38 1/8 in. (130.2 x 96.8 cm). Private collection

effect of openness, as the face settles into the background. Picasso had created a sense of instability by suppressing the tails on the left side of the woman's hat and balancing her head on a one-point perch, as if about to topple; Lichtenstein's composition is entirely anchored by his integration of face and field, and by the thick black struts securing the woman's hat to her black shoulder.

Nearly every segment of Picasso's painting has been altered, but as Lichtenstein said, the changes are subtle. His resort to blue and black for the woman's costume is not as predictable as it might seem: the Picasso might as easily have suggested green (which Lichtenstein would use in his second variation, *Femme dans un fauteuil*, 1963).[49] To mention only a few more changes, Lichtenstein reshaped the dress's mountainous collar and the contours of the woman's right arm. Besides these shifts of outlines, he altered both the modulation and the colors of the interior contours, using white to highlight the bulge of the woman's bosom and articulating her left arm in patterns that invigorate a fairly drab portion of Picasso's painting.

Of course, the greatest change is the nearly immaculate application of color. No matter how many times Lichtenstein may have stripped the Magna with turpentine and repainted the ground, the final painting shows little evidence of alteration. This uniformity extends from the lack of visible brushstrokes to the consistent density of each colored segment—an effect fundamentally different from the smoky atmosphere, and touches ranging from thick crusts to thin washes, that Picasso used to articulate his image (and that the plate in *Seize Peintures* captured well). By increasing the tonal contrast of his painting, Lichtenstein made each of its elements distinct. Moreover, he dramatically increased their size. While the portfolio fairly accurately records the size of Picasso's painting as 100 by 81 centimeters (39 1/4 by 31 7/8 inches), Lichtenstein's is nearly 173 by 142 centimeters (68 by 56 inches)—more than fifty percent larger. Lichtenstein created a crisp, bright, monumental presence that consigned Picasso's to the realm of old masterly nuance. At the same time, he expertly exploited subtlety for his own ends.

After making two paintings based on pictures by Picasso, Lichtenstein raised the ante: he addressed Picasso's most important recent series of works, "Women of Algiers" (1954–55), and he directly engaged the issue of historical reference that underlay his variations on Picasso. As with *Femme au chapeau*, he may have seen the fifteen canvases that constitute this series in "Picasso: 75th Anniversary Exhibition." Begun after the death of Henri Matisse, in November 1954, and completed barely two years before the opening of the retrospective at MoMA, these works announced Picasso's increasing absorption in historical reverie rather than the contemporary scene. His decision to take up Delacroix's *Women of Algiers* allowed him to measure himself against one of the predecessors he most admired, and it opened general questions about the relationship of modern art to history. By referring to Delacroix's two versions of the subject, Picasso undercut the idea of a singular masterpiece that had dominated traditional practice,[50] and he multiplied Delacroix's versions (which were separated by fifteen years) into fifteen paintings, ranging from a fully finished "showpiece" to large canvases, small ones, and sketchlike grisailles.

To a query about "what Picasso thinks of [what] you're doing?" Lichtenstein replied, "I have no idea," but he acknowledged that he painted *Femme d'Alger* (1963; plate 131) "because he did it from Delacroix."[51] Yet Lichtenstein apparently ignored Delacroix's images, instead casting Picasso as the old master, though one still wielding his brush and walking the streets of Paris. Lichtenstein would chuckle over one of his Picasso variations being mistaken for an original during his 1963 show in the French capital (at the Sonnabend Gallery in June), remembering that an unsympathetic dealer had groused, "And they had the nerve to show a Picasso along with that junk."[52] Anyone giving the work more than a superficial glance would have realized that the painting was by Lichtenstein. Unlike his earlier one-to-one confrontations, Lichtenstein's *Femme d'Alger* is a complex amalgam, commenting both on Picasso's dialogue with history and on the issue of series by combining several of Picasso's variations into a single composition. When planning his pictures, Lichtenstein began with line, and he drew his framework from Picasso's version "K" (fig. 99; Picasso's fifteen paintings are known by the letters A through O, based on the order in which they were done between December 13, 1954, and February 14, 1955). In fact he chopped Picasso's picture in half, transferring only the figure at the left. Her round face, parallel zigzags of curls, asymmetrical breasts, and the bracelet on her left wrist are easily recognizable. Yet Lichtenstein also adjusted this image in many ways, simplifying that bracelet and wrist, and covering the woman's backside (which Picasso had twisted around to expose). Meanwhile he took the schema for the woman's facial features, the pattern covering her left knee, and the naillike protrusion on her right hand from Picasso's version "L" (fig. 100)—like Lichtenstein's, a single-figure composition.

Lichtenstein's painting is obviously different from either version K or version L for one reason: it is brightly colored, while both of Picasso's are grisailles. Although Lichtenstein had painted many black-and-white pictures, he clearly chose to make color an important part of the dialogue. Several works in Picasso's Delacroix series are multihued, but only the final one, version "O," could have served Lichtenstein's purpose. It is the most finished painting in the group, and its blocks of deep blue, red, yellow, and green are strikingly close to Lichtenstein's standard palette. (This version also apparently contributed the pattern of floor tiles in the lower-right corner.) Lichtenstein's layout of colors, however, is tied to the tonal structure of the grisailles, and the exceptional irregularity of his dotted sections (both black and colored) gives the picture a painterly quality absent from his earlier variations. For anyone familiar with Picasso's series (and many people had seen them in reproduction or at the Modern), Lichtenstein's painting is a tour de force. Packed with Picasso's compositions and with Lichtenstein's interpretations of their motifs, the painting is still so elegantly balanced that it achieves his goal of apparent simplicity.

The picture may offer a clue to another aspect of Lichtenstein's relationship with Picasso. On January 1, 1964, Victor Ganz purchased two of Lichtenstein's paintings from New York art dealer Leo Castelli. This was a major event, since Ganz had begun buying the work of Johns and Rauschenberg during the preceding few years, and he already had the greatest private collection of

Picasso's works in the United States, including five versions of the "Women of Algiers." Since Ganz was a friend of Castelli's and famous for devoting long thought to his purchases, it is safe to assume he had been considering Lichtenstein's work since the dealer had begun showing it, in early 1962.[53] Ganz may have met Lichtenstein during this period, and it wouldn't be surprising if he had invited the artist to see the Picassos in his collection.[54] If so, Lichtenstein could have studied firsthand the two primary versions he used (K and O). But the more interesting question is what might have happened after he finished the painting. A purchase by Ganz would have placed Lichtenstein's variation in the midst of Picasso's harem and orchestrated a head-to-head competition. Instead, the painting was sold to another collector.[55]

In late 1963, Lichtenstein began using an opaque projector to transfer his sources to canvas, a method that happened to leave a record of his early ideas for the compositions. True to his discipline of drawing, he did not take the easy route of projecting a reproduction. Instead, he drew a version of the composition small enough to fit the bed of his machine, and then he projected this sketch onto his canvas, thereby saving himself the initial step of enlargement that he had previously done freehand. Lichtenstein used this procedure for his fourth variation after Picasso, *Woman with Flowered Hat* (1963; fig. 101), derived from another of Picasso's wartime women. In this case, the owner of Picasso's 1939–40 painting (fig. 103), Morton Neumann, sent a reproduction to Lichtenstein after seeing one of Lichtenstein's works based on Picasso's. This reproduction is the image that hangs to the left of Lichtenstein's canvas in the photograph taken for *Life* when the painting was in progress. Stuck to the wall above the reproduction is the tiny line drawing that Lichtenstein made for projection (fig. 102). The existence of this initial sketch, together with the photograph of the painting underway in the studio and Lichtenstein's contemporary description to Baker, make *Woman with Flowered Hat* the most thoroughly documented of his variations after Picasso (and possibly of all his early paintings). As he told Baker,

> There are some changes in this [Lichtenstein's painting] from the Picasso, obviously complete changes all over, but the more obvious ones: I've changed the face color to the pink dots and the hair color to yellow, since all my girls have yellow hair, almost all of them do. And I was curious to see what it would look like with a more pseudo-realistic color, sort of correcting Picasso as though he had made an error in making the face blue. And one of the purposes of it is to make what looks like an insensitive reproduction of the Picasso, and changing the color of face and hair to ones that would be more conventional would be part of that insensitivity, and there is a general change in the shape of the whole position of the head.[56]

It was to clarify his use of the word "insensitivity" that Lichtenstein gave his description of first thinking Picasso's work "crude" before realizing its "subtlety."

We are particularly lucky to have the initial drawing for Lichtenstein's fourth and final variation during the 1960s, *Still Life after Picasso* (1964; plate 132), because it is by far his most extreme transformation of Picasso's work. Lichtenstein's choice of *Guitar, Glass, and Fruit Bowl* (1924; fig. 104) is a departure from his previous focus on Picasso's women, especially those of the wartime period. It engages the more relaxed years of the mid-1920s and the less fraught theme of the still life. Perhaps Lichtenstein thought its inanimate objects were better suited for what he had in mind, and he may have been attracted by the large blocks of red, blue, and yellow at the left side of the picture, which anticipate his own style. His initial sketch (1964; fig. 105) is fully colored, and plays with the triad by keeping the red and blue but changing the yellow to black.[57] More insistently, he tightened Picasso's composition, rounded many contours, and firmed the sometimes slack lines of a painting that Picasso intended to celebrate the pleasures of life on the Côte d'Azur.

In his painting, Lichtenstein compressed the composition until its central glass is squeezed between the guitar and the fruit bowl. The major difference, though, is in the surface: the painting is executed on Plexiglas, and has its shiny smoothness. *Still Life after Picasso* is one of a group of paintings that Lichtenstein made in 1962–64 (including a slightly earlier still life, *Mustard on White*, 1962) employing this industrial material, often used, according to the artist, for deli signs "like Nedick's."[58] Lichtenstein said that he wanted "the cold, industrial look."[59] To achieve it, he effectively painted on the "back" of the Plexiglas sheet. Then he framed the finished sheet so that its untouched side faced viewers, thereby creating a picture in which the machined surface of smooth plastic replaced his brushstrokes and the textures of paint. Moreover, he used a backing material that allowed him to razor his lines: "The character of the cut lines is quite different from the one of painted lines. It's much more commercial looking and sharper . . . very steely, kind of exactingly cold."[60] Somewhat startled when he saw the painting in progress, Baker asked, "You don't think people are going to have the feeling that these things have been manufactured rather than handpainted?" Lichtenstein replied, "Well, I don't mind that. I think that's what I sort of like, particularly it's good for things like Picassos."[61] Measuring four by five feet, *Still Life after Picasso* is a glorious sign of Lichtenstein's dominance.[62]

During his discussions with Baker, Lichtenstein acknowledged admiring Picasso's sculptures as much as his paintings,[63] and a series that Lichtenstein did in 1965 captures a quality he particularly respected in Picasso's three-dimensional pieces. Cast in ceramic, Lichtenstein's apparently casual stacks of cups, saucers, and spoons (the first in the series, fig. 106, featured just cups) reflect both the domestic objects of Picasso's *Absinthe Glass* (1914; plate 146) and its assault on the moribund tradition of monumental sculpture. In 1973, speaking soon after Picasso's death, Lichtenstein forthrightly stated,

> I think his sculpture is the best sculpture of our time, by far. It has elements of everything that came after it—his understanding of form is so great. It's also not pompous. Until Oldenburg, people tended to think of sculpture as

monuments, and that was a huge error. Picasso's sculpture has incredible strength combined with a lack of pomposity.[64]

The diverse body of sculpture Lichtenstein produced from the mid-1960s through the '90s is similarly graced by humor and lack of pretension.[65]

During the late 1960s, Oldenburg engaged Picasso's sculpture in a dialogue that ranged from cuff links to outdoor monuments, and explicitly addressed the legal and political issues underlying public art. Earlier in the decade, architects representing the city of Chicago had commissioned Picasso to design a large sculpture for the plaza in front of the new Civic Center.[66] The sculpture he delivered in April 1965 depicts a woman's head standing on a deep shelf to suggest her neck and shoulders. Constructed of iron rods and sheet metal, it unites his early Cubist constructions, such as the *Guitar* of 1912,[67] with his projects for monumental sculptures of the late 1920s and early '30s (particularly the *Monument to Guillaume Apollinaire*).[68] None of these projects had been realized, however, and only one Picasso sculpture, a cast of *Man with a Sheep* (1943), stood as a public monument (in the market square of Vallauris, a Mediterranean village near Picasso's home). Accordingly, the Chicago commission not only planted a huge Picasso in a major American city but offered the artist a chance to achieve his long-standing goal of locating his sculpture in a truly public setting. To fulfill the commission, Picasso produced a three-and-a-half-foot maquette (plate 133), with instructions for the fabrication of a fifty-foot (fifteen-meter) version in Cor-Ten steel. After this giant was inaugurated, in August 1967, the city presented him with a check for $100,000, which he refused, calling the sculpture a gift to the people of the city.[69]

Oldenburg's project began with a barber, Maestro Gerhard Nonnemacher, whose shop stood across the street from the Civic Center and who therefore felt free to place a drawing of the sculpture on his appointment card. The city government demurred; having identified the Picasso as a revenue stream, officials filed a claim of copyright on the full-scale monument (though not on the maquette, which Picasso had donated to the Art Institute) and threatened a lawsuit against anyone who used the image without paying a fee. The local press followed the David-and-Goliath story of Nonnemacher's fight against the city with headlines such as "Barber's in Lather over Picasso Fees."[70] Among the regulars at his "swank barbershop"[71] was an attorney named Barnet Hodes, who offered to take Nonnemacher's case and enlisted a friend, collector William Copley, in the cause.

Jousting with city hall continued through the summer of 1968, when Mayor Richard Daley's brutal suppression of protests against the Democratic Party convention then taking place in Chicago galvanized opposition to Daley's control of city government. Having grown up in Chicago, Oldenburg had returned there with reporter's credentials to attend the convention and was beaten during one of the police assaults on Lincoln Park, where many of the protesters camped.[72] He responded by canceling an exhibition he had planned to celebrate the city at Richard Feigen's gallery there and publishing an open letter condemning

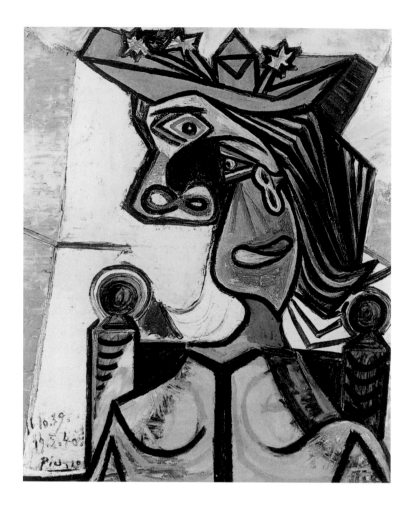

FIG. 101
PABLO PICASSO, *Woman with Flowered Hat*, 1939–40. Oil on canvas, 28 x 23 in. (71.1 x 58.4 cm). Morton G. Neumann Family Collection

FIG. 102
ROY LICHTENSTEIN, *Untitled Study for "Woman with Flowered Hat,"* 1963. Graphite on paper, 6 x 6 in. (15.2 x 15.2 cm). Private collection

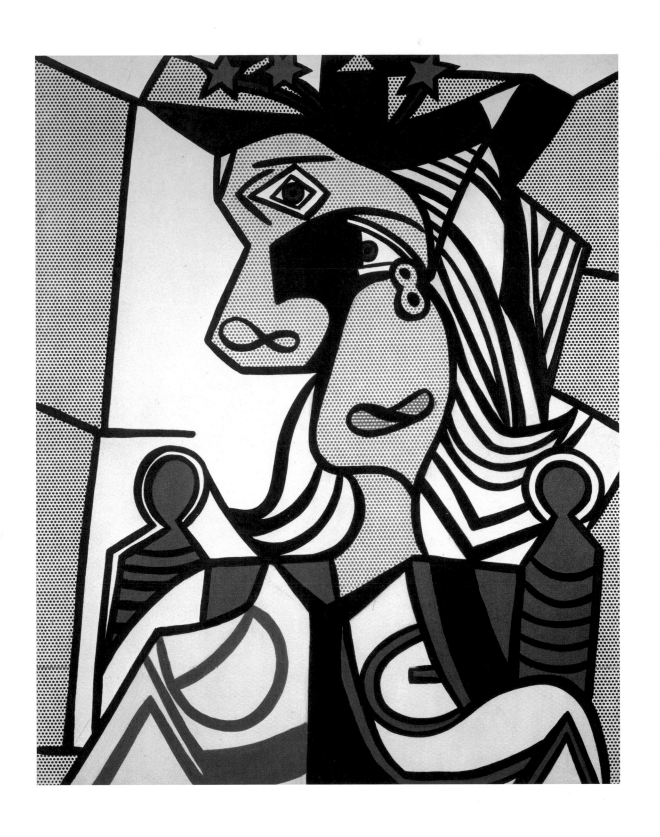

FIG. 103
ROY LICHTENSTEIN, *Woman with Flowered Hat*, 1963. Magna on canvas, 50 x 40 in. (127 x 101.6 cm). Private collection

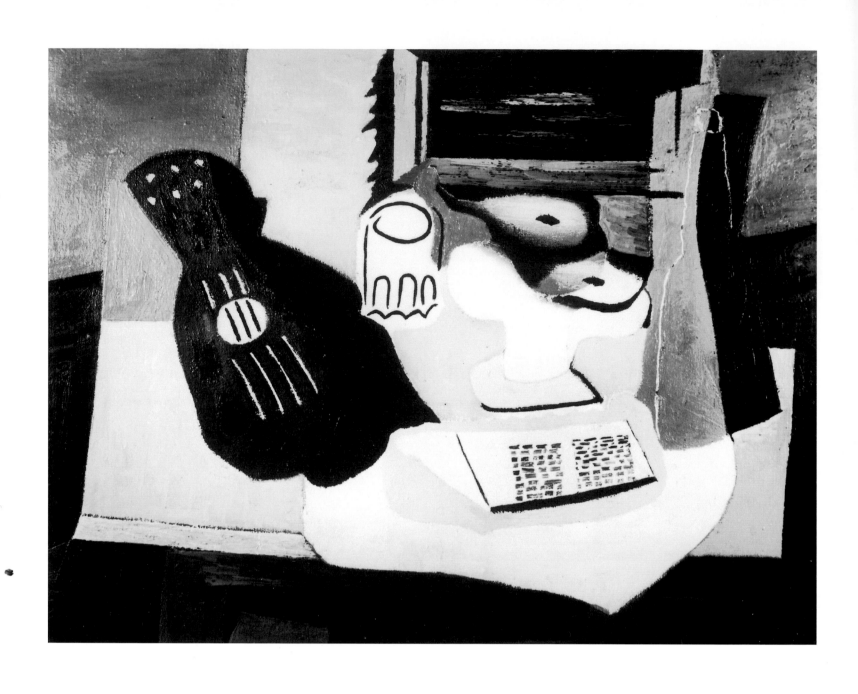

FIG. 104
PABLO PICASSO, *Guitar, Glass, and Fruit Bowl*, 1924. Oil on canvas, 38 1/4 x 51 3/4 in. (97 x 130.5 cm). Kunsthaus Zurich

PLATE 132
ROY LICHTENSTEIN, *Still Life after Picasso*, 1964. Magna on plexiglass, 48 x 60 in. (121.9 x 152.4 cm). Collection of Barbara Bertozzi Castelli

FIG. 105
ROY LICHTENSTEIN, *Drawing for "Still Life
after Picasso,"* 1964. Graphite and colored
pencil on paper, 5 1/8 x 5 7/8 in. (13 x
14.9 cm). Private collection

the events. Instead, Oldenburg contributed a set of "Chicago Fire Plugs" (intended for throwing through windows) to Feigen's "Richard J. Daley" show in October.[73] And he joined the effort to defend Nonnemacher against city hall.

Supported by a formal legal opinion from Hodes that the city's copyright claim was bogus, Copley asked Oldenburg to make a replica of Picasso's sculpture.[74] Happy to challenge Daley, Oldenburg chose to make more than a copy: his *Soft Version of Maquette for a Monument Donated to the City of Chicago by Pablo Picasso* (1969; plate 134) thumbed its nose at the mayor, even as it moved beyond that aspect of it to engage both Picasso and the tradition of public monuments. To support Nonnemacher's case, Oldenburg had to reproduce the Picasso, so he obtained the measurements of the maquette that the city had used for its enlargement and made a precise copy in cardboard.[75] He also bought one of the replicas then on sale with the city's blessing; cut apart and reassembled in a twisting pattern, this souvenir became a study for his reconception of the sculpture, and ultimately joined the objects on exhibit in the *Mouse Museum* (1972). Oldenburg had made drawings for public monuments since 1964 (after the Democratic convention, he proposed a broken nightstick for Lincoln Park, Chicago), but his ideas had remained on paper. Like Picasso's projects of the late 1920s, his efforts to reinvigorate public sculpture had met great resistance. When Picasso created *Absinthe Glass*, he had seemed to dismiss a problematic genre that appeared limited to patriotic statues or saccharine moral tableaux, yet in later years he made such proposals as his 1928 plan to line the Croisette at Cannes with gigantic construc-

tions resembling weathered bones, suggesting the possibility of opening public sculpture to the primeval themes of Surrealism. Even though his monument for Chicago did not realize this possibility, it did explicitly refuse most of the conventional functions of a monument. (Indeed, Daley insisted on calling it "a dog.")[76] Oldenburg respected Picasso's ambition to reinvent monumental sculpture. He said, "Picasso's Chicago sculpture was a special subject for me because it was one of the first sculptures of architectural scale—the scale I would later work in—put up in an American city. And of course I grew up in Chicago."[77]

While Oldenburg's decision to substitute cloth for the rigid metal of Picasso's sculpture may suggest a simple parody, a deflation of the imposing form of the "master," it evolved into an aesthetic dialogue distinct from the political and legal issues that prompted the commission. "What was unusual about the soft Picasso was that I took the original, followed it in a very slavish way, and yet transformed it. I thought that was an accomplishment." Using his cardboard model of Picasso's maquette, Oldenburg cut patterns to be sewn in canvas; the rods connecting the planes of the head in Picasso's sculpture became ropes. Then the cloth was stained "the rust color of the steel in the Picasso when it was relatively new. Unlike the real Picasso, mine doesn't change color; it stays the colors of the postcard you buy at the airport, taken early in the monument's history."[78] As Oldenburg saw the effect of his materials, he became fascinated by the formal dialogue with the original:

> I was fond of my Picasso when I did it. Making his work soft was a nice way to deal with him. . . . Because cloth behaves differently from metal, the sculpture drooped and changed form. It wouldn't stand without a spine, so I made a spiral in back of it to hold it up. The spiral was twistable like a lamp and there was no end to the number of ways you could position it.[79]

The seemingly endless possibilities for positioning the sculpture created what Oldenburg described as "Super-Cubism."[80] "My soft Picasso," he said, "was more cubist than cubism: in a cubist sculpture, you can see an object from perhaps ten different viewpoints; in mine the viewpoints were unlimited."[81] While ridiculing both the pomposity of many monuments and the commercial exploitation of Picasso's Chicago sculpture, Oldenburg nonetheless honored Picasso's contribution to modern sculpture in the process of reinvigorating it.

The year before Oldenburg joined the Civic Center controversy, Picasso's sculptures finally received the exposure that Alfred Barr had long urged. The Museum of Modern Art presented 204 of these works in an exhibition from October 1967 through January 1968 (after an initial showing at the Tate Gallery in the summer of 1967), organized by Picasso's friend and biographer Roland Penrose, and drawn primarily from the artist's personal holdings of the often unique pieces. The final sculpture in the exhibition was Picasso's maquette for Chicago.[82] This was the most important show of Picasso's work held in the United States between the Modern's "75th Anniversary Exhibition" in 1957 and his death in 1973. During his final fifteen years, no complete Picasso retrospec-

tives occurred in this country, nor were there large exhibitions of his contemporary work. The Modern acquired only one recent painting (*Woman in an Armchair*, 1961–62), although it did substantially enhance its collection with two gifts from Picasso: in 1971, his first constructed sculpture, the sheet-metal *Guitar*, and the following year, a six-foot version of *Wire Construction* (1928), a design for a monument to Apollinaire, which the museum enlarged to a thirteen-foot version for its sculpture garden.

Picasso's death, on April 8, 1973, prompted the extensive news coverage to be expected for the most famous and one of the most long-lived artists of the century. Obituaries preceded testimonials and endless efforts to summarize his career. The *New York Times* gathered tributes from Barr, art historian Meyer Schapiro, ministers of the French and Spanish governments, and the directors of the Guggenheim and the National Gallery of Art in Washington, D.C. This enshrinement among cultural officials, so unlike Picasso's preferred company, was turned into a barbed compliment by one of the two artists consulted by the *Times*, Robert Motherwell (the other was the still skeptical Thomas Hart Benton), who offered, "He is the last artist in this century who will dominate the scene, and who will have been a real king during his lifetime. Now it will be a republic. . . . I think any contemporary modern artist feels as though his beloved grandfather had died."[83] Picasso's influence on Motherwell's peers was actually immediate and direct, but if the "grandfather" remark added a generation, and thereby minimized Motherwell's own dependence on his art, this portrayal of him as a figure of the distant past did capture a common view. Only after the settlement of his estate, in the late 1970s, did the American public have the opportunity to see the work he had made in his final years, first as part of the Modern's full retrospective in 1980, and then in an influential exhibition, "Picasso: The Last Years, 1963–73," at the Guggenheim.

Lichtenstein responded immediately to Picasso's death, contributing a print, *Still Life with Picasso* (1973), to a six-volume celebration of the late artist and his work.[84] (Among the sixty-nine artists represented were Dine, Motherwell, and Henry Moore.) His homage juxtaposes a pitcher of brushes and a pile of fruit with his version of a drawing Picasso made of Dora Maar on June 13, 1938[85]–appropriately an image from the body of Picasso's work that Lichtenstein had first encountered. In 1973, Lichtenstein also insinuated his own *Still Life after Picasso* of 1964 into a painting he modeled on Matisse's *Red Studio* (1911), in the Museum of Modern Art. Peeking from behind one of Lichtenstein's comic-book paintings, *Still Life* brings Picasso into what at first seems an exclusive confrontation with Matisse. As Lichtenstein's mining of art history expanded through the 1970s and '80s to include most of the recognized movements, Picasso would remain his chief reference.

In one of the most inquiring of the many posthumous articles offering artists' comments about Picasso, Lichtenstein forthrightly said, "I don't think there is any question that Picasso is the greatest figure of the twentieth century."[86] (Unfortunately, none of the artists who had emerged during the late 1960s and '70s was interviewed; one, Robert Smithson, died a few months after Picasso.) De Kooning rebuffed the interviewer as if he were still engaged in the battles of the 1940s:

I'm not going to answer your questions. There are certain things I like to keep to myself. He's always with me—certain artists are always with me. And surely Picasso is one of them. . . . I'm not going to answer your questions because to me the answers are self-evident.[87]

Lichtenstein's taste for explicit references, and perhaps his more direct nature, enabled him to state his admiration for Picasso frankly. Within his general comments, he pinpointed one painting:

Girl before a Mirror has a special meaning for me. Its strength and color relationships are extraordinary. So many people think of Matisse as a colorist, which of course he was, but they don't understand the interesting color relationships Picasso is capable of. I think his color is extraordinary in many of his works and reaches a level of discord and intensity that has few parallels.[88]

Lichtenstein's restricted choice of hues might suggest a lack of interest in color, yet he was clearly attuned to it, and his palette slowly began to multiply until the 1990s, when it blossomed with a wide variety of gradations. Moreover, his selection of this painting

FIG. 106
ROY LICHTENSTEIN, *Ceramic Sculpture*, 1965. Glazed ceramic, 9 1/2 in. (22.8 cm) high. Private collection

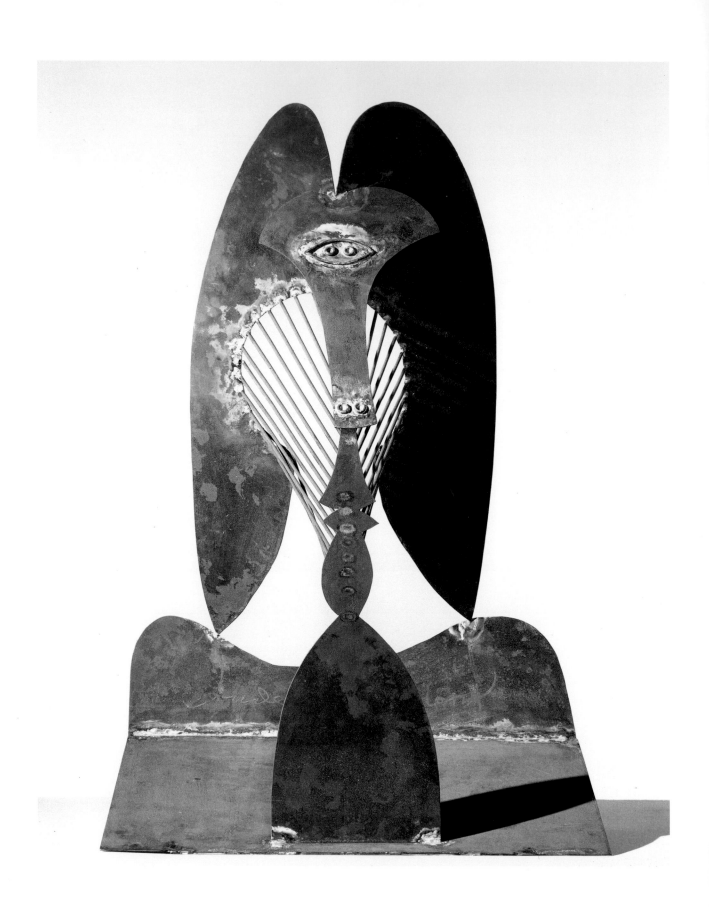

PLATE 133
PABLO PICASSO, *Maquette for Richard J. Daley Center Monument*, 1965. Welded steel (simulated and oxidized), 41 1/4 x 27 1/2 x 19 in. (104.8 x 69.9 x 48.3 cm). The Art Institute of Chicago, Gift of Pablo Picasso

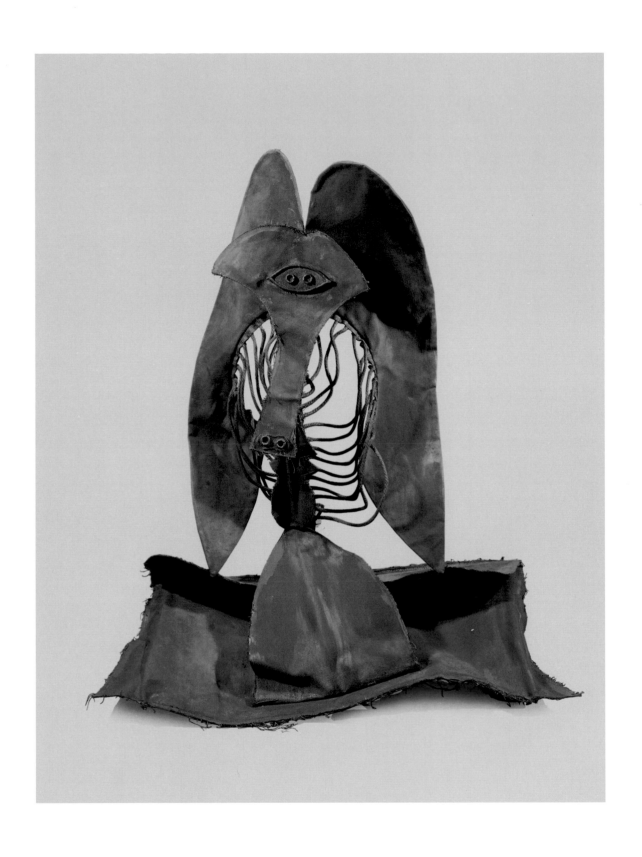

PLATE 134
CLAES OLDENBURG (born 1929), *Soft
Version of Maquette for a Monument
Donated to the City of Chicago by Pablo
Picasso*, 1969. Canvas and rope, painted
with synthetic polymer, dimensions
variable, 38 x 28 3/4 x 21 in. (96.5 x
73 x 53.3 cm) at full height. Musée
National d'Art Moderne, Centre
Georges Pompidou, Paris

highlights the duration of his involvement with Picasso. *Girl before a Mirror* was the first of Picasso's paintings that Lichtenstein recalled seeing, and it became a primary reference for his work during the late 1970s.

During those years, Lichtenstein's art reflected a deep interest in Surrealism and explored the polymorphous forms and unexpected juxtapositions found in the work of Dalí and René Magritte, among others. While this departure surprised those who saw Lichtenstein's work as primarily a mirror of popular culture, it was another manifestation of his equally firm foundation in the mainstream of modern art. Having achieved the stature of a "master," Lichtenstein delved more fully into the past, addressing not only Surrealism but Futurism and Purism. Surrealism was the strongest of these engagements, but it was far from new. Lichtenstein was returning to his fascination with the workings of the imagination that had led him to mark Picasso's statements in *Picasso: Forty Years of His Art* about recording "the metamorphoses of a picture. Possibly one might then discover the path followed by the brain in materializing the dream."

In 1977, Lichtenstein embarked on a series of works that clarifies the remarkable range and inventiveness underlying his seemingly deadpan compositions. No longer confining his focus to a single Picasso, he freely interwove pulp advertising and his own previous art with the Picasso work he most admired, *Girl before a Mirror*. The sequence began with a return to one of his earliest Pop paintings, *Girl with Ball* (1961; fig. 107), which he had based on a crude advertisement for the Mount Airy Lodge in the Poconos. Removing the girl in this panel from the ad copy, Lichtenstein had enlarged her upper half so that her flattened face and long, rubbery arms read as much as a reference to Picassoid distortions as to the sloppy printing of tabloids. In *Girl with Beach Ball II* (1977; fig. 108), Lichtenstein gave free rein to these oddities. Retaining little more than the red-and-white beach ball the girl holds, he created his own cipher by stretching and squeezing her body beyond conventional human anatomy, and he added a cabana frequently seen in Picasso's paintings of bathers cavorting on the beach.[89] This focus on Picasso's paintings of the late 1920s and early '30s may well have been what led him to revisit *Girl before a Mirror*, Picasso's most thematically and pictorially complex exploration of youthful energy and sexuality.

In the third and final version, *Girl with Beach Ball III* (1977; plate 135), Lichtenstein added Picasso's image from *Girl before a Mirror* to his already layered composition and created a work that matches the visual magnificence of Picasso's painting without precisely copying any of its details. While he added the striped costume and one-armed reach of Picasso's girl, his dialogue with the painting centered on the woman's head. Here, the striking similarity between Picasso's rendering of his mistress, Marie-Thérèse Walter, and the comic-book blondes Lichtenstein had long used is evident. But Lichtenstein veered toward an illustrator's version of her features, only to slice and stack them in Picasso's manner. Famously, Picasso had created a "double-headed" figure.[90] Her smoothly stroked lavender profile overlays a thickly impastoed and brightly rouged frontal view, creating the impression of dual personas that is multiplied by the reflection in the mirror. Lichtenstein reversed this order, leaving the frontal view pure white and coloring the profile and lips red. Carrying this process further, he also reversed the direction of the profile's eye and added a third layer to the head. A full mouth floats on top of the double head, either making it a triple head or resurrecting the lips hidden below the profile. In a sense, Lichtenstein found a way to integrate Picasso's third image of the girl, but in doing so he created a structure as tightly designed and visually dynamic as anything in Picasso's painting. Shot with rays of light and scattered with clouds, Lichtenstein's background avoids Picasso's consistent geometry to offer a more open stage for his complex figure.

The tear falling from the girl's right eye is another motif linking Lichtenstein's early comic-book paintings (such as *Hopeless*, 1963) with Picasso, this time his "Weeping Woman" prints of the *Guernica* era. Lichtenstein took this theme as the prime subject for another painting of 1977, *Girl with Tear I* (plate 136). Stacking the tear, eye, and a great fall of blond hair, he imagined a giant freestanding sculpture flanked by tiny figures. This, too, is a variation on a Picasso painting, *Monument: Head of a Woman* (1929).[91] Lichtenstein's paintings of 1977 mark not only one of his most intense periods of involvement with Picasso's work but a fundamental change in the way he addressed Picasso's precedent. No longer focusing on re-creating existing compositions, he borrowed widely from different paintings and other visual sources, and he adopted Picasso's compositional strategies to create his own independent compositions. His paintings of this period approach those that Gorky made in the 1930s when he "was with Picasso," yet Lichtenstein's unmistakable style—flat color, ruled lines, stenciled dots, tightly restricted palette—always maintains his authorship, not to mention his humor and a range of references outside Picasso's work. Over a period of fifteen years, Lichtenstein had passed from dueling with Picasso over specific images to freely folding Picasso's style into his own signature look. In a sense, he had finally solved the problem that he had begun to address in his work during the 1950s.

In July 1978, the Whitney opened "Art about Art," an exhibition that addressed American artists' use of past art. Although a few works dated from the 1940s and '50s, the vast majority had been made after 1960, and the exhibition showcased the wide range of historical sources used by contemporary artists, from Rembrandt and Velázquez to Manet and Matisse. References to Picasso appeared frequently among these artists, with works based on his by George Segal (*Picasso's Chair*, 1973) and Peter Saul (*Luddul Gurnica*, 1973), as well as Oldenburg's *Soft Version* of the Chicago maquette and Wesselmann's *Still Life #30*. With seventeen works reproduced, Lichtenstein was the artist most widely represented in the catalogue, and he also contributed an original design for the book's cover (a canvas peeled back to reveal an eye, from which drips a mouth turned vertically to double as a tear). Moreover, his recently completed *Girl with Beach Ball III* was one of the newest works included in the exhibition.

The show caught the early stages of a phenomenon that would become a primary issue of art in the 1980s. Under the banner of "appropriation," young artists were staking out relationships to the art of the past. Some argued against the concept

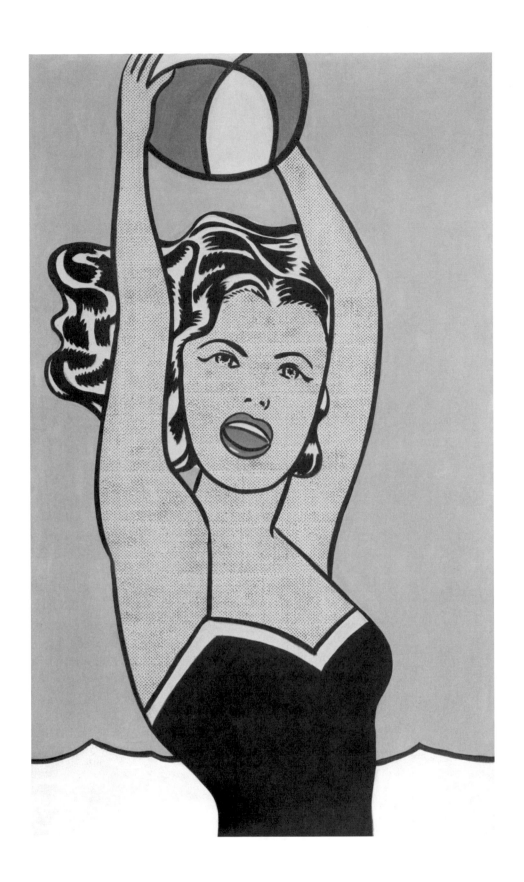

FIG. 107
ROY LICHTENSTEIN, *Girl with Ball*, 1961.
Oil and synthetic polymer paint on
canvas, 60 1/4 x 36 1/4 in. (153 x 92.1 cm).
The Museum of Modern Art, New York,
Gift of Philip Johnson (421.1981)

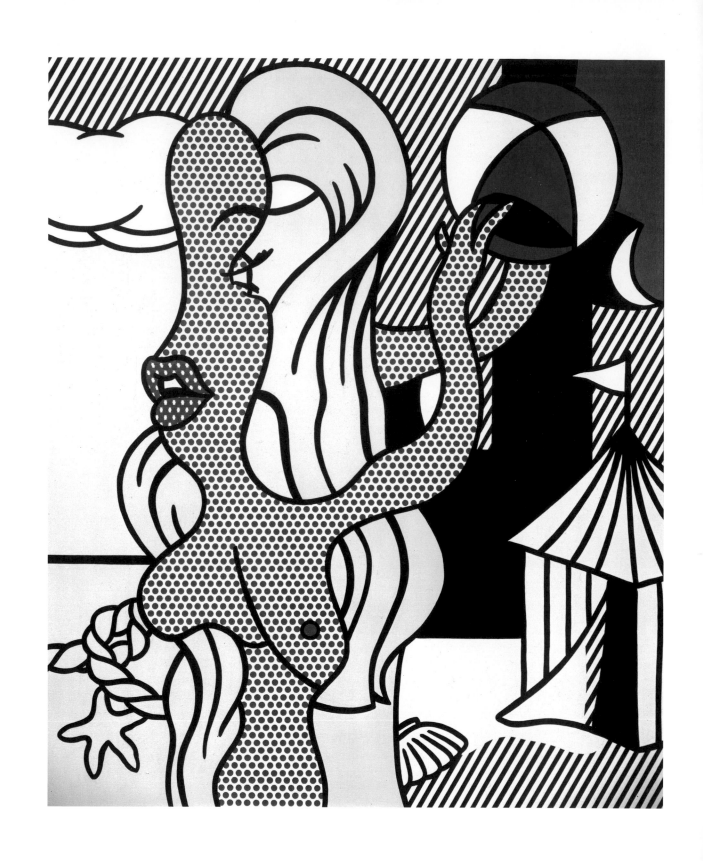

FIG. 108
ROY LICHTENSTEIN, *Girl with Beach Ball
II,* 1977. Oil and Magna on canvas, 60 x
50 in. (152.4 x 127 cm). Private collection

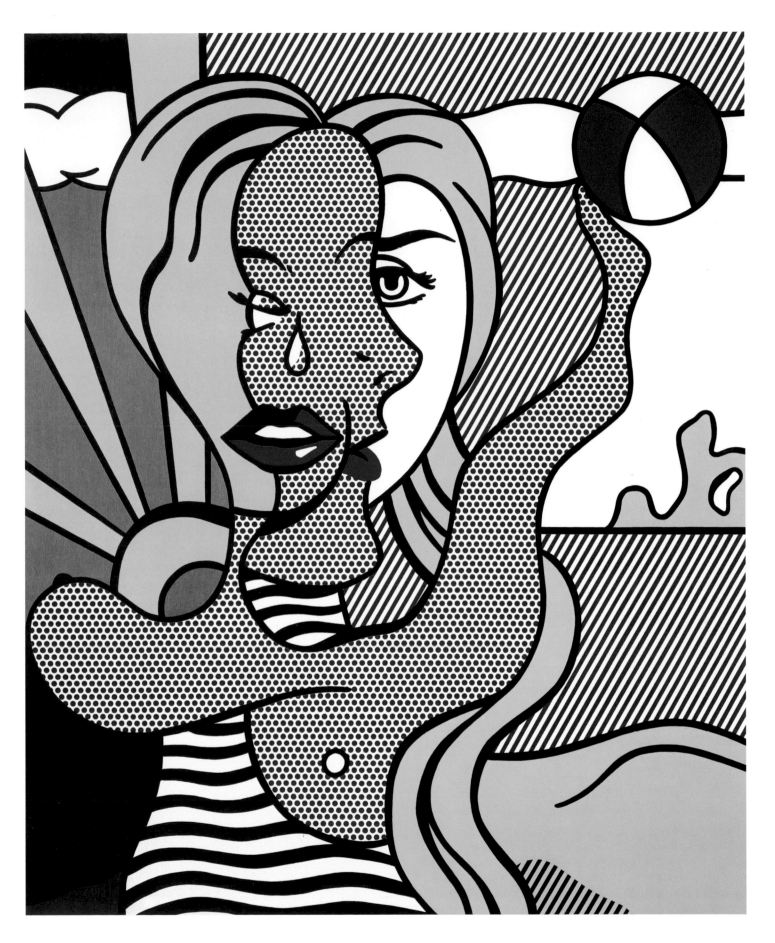

PLATE 135
ROY LICHTENSTEIN, *Girl with Beach Ball III*, 1977. Oil and Magna on canvas, 80 x 66 in. (203.2 x 167.6 cm). Collection of the Robert and Jane Meyerhoff Modern Art Foundation, Inc., Phoenix, Md.

of artistic genius and sought to devalue respect for unique art-works by reproducing them. Others seemed to hope that their copies might capture some of a masterpiece's acclaim. For either of these positions, Picasso certainly offered the biggest challenge. In January 1988, Castelli presented the ultimate effort to borrow Picasso's stature by appropriating his images: Mike Bidlo's exhibition "Picasso's Women 1901–71" consisted of seven dozen of Bidlo's meticulously painted, full-scale copies of Picasso's paintings. Although Bidlo worked hard to reproduce Picasso's execution, his copies never approach the quality of the originals, nor do they attempt the transformation that Lichtenstein had achieved twenty-five years earlier.[92]

During the 1980s, Picasso was not merely the mummy suggested by Bidlo's copies. The settlement of his estate at the end of the 1970s touched off a series of exhibitions that brought to New York the first full retrospective of his art in twenty-three years and a remarkable exhibition of his final work. The Modern's 1980 retrospective included many works from the estate that had never been shown publicly, yet it became known for the extensive publicity surrounding it and for the crowds that filed through the galleries—a perfect battleground for those who ridiculed the acclaim given to individual artists and those who hoped to grab some of it. In any case, the far smaller exhibition held at the Guggenheim Museum in 1983 was the real revelation. "Picasso: The Last Years, 1963–73" presented works that were largely unknown in New York, and the essay by Gert Schiff that accompanied its extensive selection of late drawings and paintings argued passionately for a reconsideration of work that was largely neglected or dismissed: "Today we can see that the apparent carelessness of execution in many of his last paintings contained a pictorial shorthand rich in the most striking expressive values and even the most 'sloppily' painted pictures reveal an unfailing formal control."[93] Schiff even dared to flout the cynicism of much contemporary criticism:

> Picasso was a genius. He was also a man endowed with an ardent soul, with passions and drives stronger and more persistent than those of most ordinary humans. To the last, he poured all his impassioned humanity into his art. Thus, his last works teach us something that cannot be deduced from the more detached works of other giants in their old age.[94]

The works on view did show a sexual desire that some (including Picasso himself) found laughable in an octogenarian, as well as brushwork so liquefied as to challenge the survival of Picasso's legendary control. But the most startling works were a series of drawings, self-portraits in which Picasso seemed to acknowledge his approaching death. The most powerful of these (fig. 109)—it appeared on the cover of the catalogue—shows Picasso's large head set on narrow shoulders, his cranium shrinking, and his alternatively dilated and narrowed pupils uncoordinated. Picasso had described the drawing to his friend and biographer Pierre Daix: "I did a drawing yesterday; and I think maybe I touched on something. It's not like anything I've done before."[95] This confrontation with his own death (as Daix

characterized the drawing) was an incisive tonic to his florid images of geriatic potency.

Picasso's last works attracted the attention of many artists in New York, and fed the revival of painting that had begun to infiltrate the art world in the late 1970s, after more than a decade of marginalization. Young artists such as George Condo and Jean-Michel Basquiat responded to both Picasso's celebrity and his freewheeling use of the brush,[96] and Basquiat's mentor Andy Warhol chose this moment to finally engage the art of the man whose fame and wealth he had revered since the 1960s. In 1985, Warhol bought one of Picasso's late paintings, *Head of a Woman* (1965), and he made a series of at least nineteen paintings after similar works by Picasso.[97] Reflecting the vogue for painting, Warhol put aside his long-standing technique of silk screen to execute all of these pictures with a brush.

Warhol chose the most banal Picassos possible: anonymous heads from 1960, and drawings rather than paintings (see fig. 110). Having photographed the drawings as they appeared in Christian Zervos's catalogue raisonné of Picasso's work, he projected a transparency of each one onto a canvas and sketched the outlines.[98] Since these greatly enlarged black-and-white images retained only the schema of Picasso's actual work, Warhol was free to transform them as he wished. In a group of nine paintings after one drawing, he substituted a variety of colors for Picasso's black ink and then dissected the image into blocks of color and line (plate 137). This serial approach reflected his existing practice with silk-screen, but his reduction of Picasso's already basic image to its essential elements tested the limits of Picasso's style and the point at which the segmented work would cease registering as a Picasso. In one painting, Warhol revealed his method by transferring a quartet of Picasso's images—that is, a page of the Zervos catalogue showing four drawings (fig. 111). This set of similar heads displays the range of stylistic possibilities that Warhol explored in the isolated images and explicitly offers a parallel between Picasso's phenomenal productivity and Warhol's factory output (see plate 138). As Warhol commented, "When Picasso died I read in a magazine that he had made four thousand masterpieces in his lifetime and I thought, 'Gee, I could do that in a day.'"[99] By his own account, he stopped after making around 500 pictures in about a month. No comment on whether they were masterpieces.

Lichtenstein's work of the 1980s only nods to contemporary trends, although the wider attention to painting and its history brought him recognition as one of the artists who had most thoughtfully pursued these subjects. In a 1988 interview, he offered that "appropriation is just a modern word for something that has always happened. But I think we're probably consciously reviewing history by drawing attention to it in a way that refers to the past."[100] In this pursuit, he again acknowledged that Picasso "is the greatest artist of the twentieth century by far," yet he did so with a new confidence underlying his playful tone and self-deprecation. He ended the session with remarks that did not appear in the published version of the interview: "I think [Picasso] would have thrown up [if he'd seen my versions]. Maybe not, though. Maybe he would have fallen in love with them and then destroyed all his other work."[101] Whether

PLATE 136
ROY LICHTENSTEIN, *Girl with Tear I,*
1977. Oil and Magna on canvas, 70 x
50 in. (177.8 x 127 cm). Solomon R.
Guggenheim Museum, New York, Gift
of the artist, by exchange, 1980

FIG. 109
PABLO PICASSO, *Self-Portrait*, 1972. Wax crayon on paper, 25 7/8 x 20 in. (65.7 x 50.5 cm). Private collection, courtesy Fuji Television Gallery, Tokyo

Lichtenstein had second thoughts about his uncharacteristic raunchiness or an editor demurred, the image of Picasso racked by waves of revulsion and adulation surpasses anything conjured by the Abstract Expressionists.

In *Two Paintings with Dado* (1983; plate 139), Lichtenstein stepped back twenty years to excerpt his variation after Picasso's *Woman with Flowered Hat*, pairing the segment with a band of facets that might reproduce the lower border of the Picasso but instead are abstract patterns derived from Cubism. His paintings of the mid-1980s explore the puzzling ways in which art has been structured by critics and historians. *Paintings: Picasso Head* (1984; plate 140) places a drawing of Marie-Thérèse Walter that Picasso made on December 17, 1937,[102] in front of a generalized landscape, and juxtaposes both with a framed picture of loose brushstrokes. Following his established practice, Lichtenstein adapted Picasso's drawing to his own style by simplifying the design and strengthening the remaining lines. His brushstroke painting also combines references, in this case to both Abstract Expressionism and Lichtenstein's own paintings (from both the 1950s and the early 1980s). The composition presents a layering of doubles: the historical styles that shaped Lichtenstein's early career, and his transformation of each in his mature work. Under Lichtenstein's disciplined style, the historical division between Cubism and Abstract Expressionism—and the visual disparities between the two images—reach tentative resolutions and escape the conventional sequence of modern movements.

At the end of the decade, Lichtenstein explicitly employed the contemplative possibilities of duality in a series of "Reflections." While the group ranges across his subjects, from comic books to abstract brushstrokes to modern masters, three of the pictures engage major paintings by Picasso in the collection of the Museum of Modern Art: *The Studio* (1927–28; plate 66), *Painter and Model* (1928; plate 68), and *Interior with a Girl Drawing* (1935; fig. 112)—each of which itself involves a play of mirroring or doubling. Characteristically mixing lighthearted wit with serious rumination, Lichtenstein called each of his pictures a "reflection on" a particular work. His format gives the impression of literal glare across the painting (perhaps caused by the glass increasingly used to protect acclaimed pictures), but it also suggests an image reflected in a mirror and the act of looking implied by this exchange. Since 1969, he had painted images of mirrors (including one replacing his head in a 1978 *Self-Portrait*) bearing abstract patterns of light that leave unresolved the contemplation at the heart of Picasso's *Girl before a Mirror*. Lichtenstein's choice of *Interior with a Girl Drawing* matches his own ambiguous approach to the convention of a revealing reflection, because the framed image at the left side of the painting is probably intended to be a mirror reflecting an indecipherable view of the room beyond the two girls. This disjunction between our views of the mirror and of the girl (who presumably is drawing a self-portrait from a reflected image we cannot see) fragments the interior space and separates us from the scene. Lichtenstein's study for *Reflections on Interior with Girl Drawing* (1990; fig. 113) layers a postcard reproduction of Picasso's painting with strips of paper colored with linear patterns. Leaving legible only the mirror and the girl, the study and final work bring to the surface the pictorial

PLATE 137
ANDY WARHOL (1928–1987), *Head (After Picasso)*, 1985. Synthetic polymer on canvas, 50 x 50 in. (127 x 127 cm). Collection of David Teiger

FIG. 110
PABLO PICASSO, *Head*, 1960. Lavis on paper, 25 5⁄8 x 19 5⁄8 in. (65 x 50 cm). Private collection

FIG. 111
Four drawings by Picasso as reproduced
in Christian Zervos, *Pablo Picasso* (Paris:
Cahiers d'art, 1932–), vol. 19, nos. 389,
394, 396, 393.

discontinuity buried in Picasso's painting and challenge viewers to reestablish their relation to the original by penetrating the glare.

Lichtenstein's two other "Reflections on" Picasso's work (see fig. 114, plates 141, 142) invoke paintings key to the previous sixty years of art: *The Studio* and *Painter and Model*, works that had been primary points of departure for Gorky and de Kooning as they defined their mature styles, and that continued to be widely admired. Although Lichtenstein used postcards to prepare these compositions, he admitted conspiratorially that he had also studied the paintings themselves at the Modern, departing from his usual practice of working from reproductions.[103] Of course, he had known these pictures for nearly five decades, so his decision to revisit them in preparation for making his own works signals a desire for his paintings to reach beyond reproductions to engage the originals themselves. Not only are these Picasso's most influential paintings after *Guernica* and the *Demoiselles d'Avignon*, but their style is astonishingly close to Lichtenstein's. Painted under the strong influence of Piet Mondrian, *The Studio* in particular is composed of fairly regular, thick black lines and blocks of mainly primary colors—a style closely approaching the one that Lichtenstein had derived largely from comic books. Since the early 1960s, this stripped-down manner had defined his personal style and had been his chief weapon against Picasso and other previous artists. Yet in this case, the difference is remark-

ably small, and Lichtenstein's presence registers by degrees—slightly more consistent lines and colors, a few changes of tone, and the addition of diagonally striped sections to Picasso's composition. Saving his characteristic dots for the glare playing across the surface, *Reflections on "The Artist's Studio"* comes far closer to the original than his variations of the early 1960s do. It is a fitting homage to a work Lichtenstein greatly admired, and a clue to the real complexity of his relationships to both modern art and popular design.

In his final years, Lichtenstein delved deeper into the apparent contradictions between high and low, and the ways in which Picasso's diverse modes knit them together. His *Beach Scene with Starfish* (1995; see plate 143) not only revisits his beach girls of previous decades but specifically recasts Picasso's bathers of the late 1920s (see plate 144).[104] Down to the star-patterned balls they toss into the air, the girls romping before cabanas are drawn from Picasso's thrusting playmates. Of course, Lichtenstein employed a different style—his figures exhibit the faces and bodies of comic-book heroines. Moreover, his lines, dots, and flat passages of color have become baroque: no longer limited to four hues (each in a single shade) and black and white, the giant final painting and its several studies are shot with additional hues and multiple shades of each, along with sponged patterns. The bathers' realistic bodies would seem an obvious contradiction of Lichtenstein's source in Picasso's work, except for a nearly contemporary painting, *Nude* (1997; fig. 115), a frontal image of another naked blonde that seems like an outtake from *Beach Scene with Starfish* but is actually another variation after Picasso. Thanks to a Post-It note left in Lichtenstein's copy of David Douglas Duncan's *Picasso's Picassos*, we know his source: Picasso's 1923 painting *Female Nude*.[105] Besides turning the woman's arms outward in a gesture of display and giving her a 1960s flip, Lichtenstein closely followed the composition, even including a rectangular pedestal in the background.[106] No longer a simple creature of comic-book illustration, Lichtenstein's *Nude* descends from Picasso's paintings of neoclassical goddesses and joins the debate over the commercialism of the style that had rocked American art since those paintings' first appearance in New York, in 1923. The conundrum is whether Lichtenstein had dipped into Picasso's diverse bag when he invented the style in the early 1960s or had come in later years to recognize the similarity between the supposedly antithetical modes. Whatever the time line, Lichtenstein must have loved the trick.

Lichtenstein's supple interplay of multiple readings ranges beyond his own art and sources to insinuate sly and sometimes ironic references to at least one of his contemporaries. The juxtaposed fragments in *Two Paintings with Dado* may bridge decades of Lichtenstein's work, and evoke his foundation in Cubism, but they also signal his attention to the recent work of Jasper Johns. In fact, the flat lozenges of Lichtenstein's upper fragment are closer to Johns's "flagstone" panels than to the facets of Picasso's *Woman with Flowered Hat*, or for that matter to Lichtenstein's own geometric "Abstractions" of the 1970s.[107] Apparently, Lichtenstein widened his conversation with Picasso's work to include a playful nod to a peer who might have been mining the same material.[108]

PLATE 138
ANDY WARHOL, *Head (After Picasso)*,
1985. Synthetic polymer on canvas,
50 x 50 in. (127 x 127 cm). Collection
of Thaddaeus Ropac

PLATE 139
ROY LICHTENSTEIN, *Two Paintings with Dado*, 1983. Oil and Magna on canvas, 50 x 42 in. (127 x 106.7 cm). Collection of Hope and Howard Stringer

PLATE 140
ROY LICHTENSTEIN, *Paintings: Picasso
Head*, 1984. Magna and oil on canvas,
64 x 70 in. (162.6 x 177.8 cm). Private
collection

273

FIG. 112
PABLO PICASSO, *Interior with a Girl Drawing*, 1935. Oil on canvas, 51 1/4 x 64 5/8 in. (130.7 x 195 cm). The Museum of Modern Art, New York, Nelson A. Rockefeller Bequest (969.1979)

FIG. 113
ROY LICHTENSTEIN, *Collage for "Reflections on Interior with Girl Drawing,"* 1990. Graphite, colored pencils, and collage on notecard, 7 x 4 3/4 in. (17.8 x 12.2 cm). Private collection

FIG. 114
ROY LICHTENSTEIN, *Reflections on Painter and Model*, 1990. Oil and Magna on canvas, 78 x 96 in. (198.1 x 243.8 cm). Private collection

PLATE 141
ROY LICHTENSTEIN, *Collage for Reflections on "The Artist's Studio,"* 1989. Graphite, colored pencil, and collage on chromogenic color print, 5 x 7 in. (12.7 x 17.8 cm). Private collection

PLATE 142
ROY LICHTENSTEIN, *Collage for Reflections on "Painter and Model,"* 1990. Graphite, colored pencil, and collage on postcard, 4 1/4 x 6 in. (10.8 x 15.2 cm). Private collection

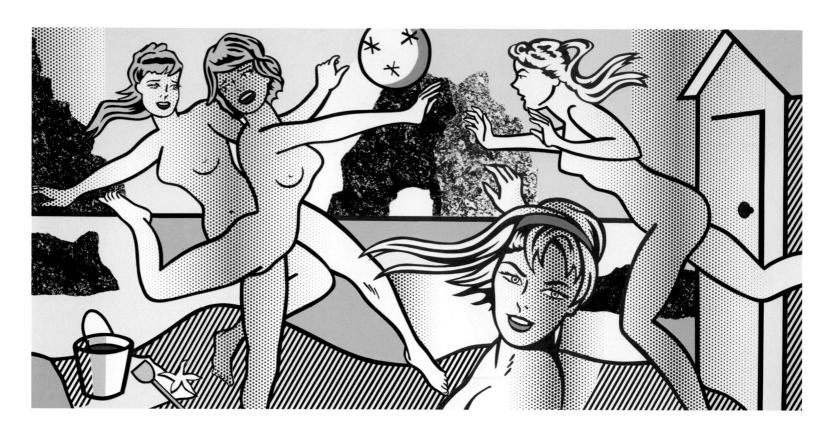

PLATE 143
ROY LICHTENSTEIN, *Collage for Beach
Scene with Starfish*, 1995. Tape, painted
and printed paper on board, 39 3/16 x
79 1/8 in. (99.5 x 201 cm). Private
collection

PLATE 144
PABLO PICASSO, *Bathers with Beach Ball*,
1928. Oil on canvas, 6 1/4 x 8 1/4 in.
(15.9 x 21 cm). Private collection

278

Although Johns has explained that he derived the flagstone pattern from a painted wall he glimpsed while driving through Harlem, Lichtenstein's citation is striking, since Johns in turn began an explicit dialogue with Picasso's work the following year.[109]

Johns's engagement with Picasso's art, which is still under way, is a densely layered conclusion to a century of American artists' involvement with this work. Yet it is also a significant departure from the conceptions that guided previous artists. Since the mid-1980s, Johns has produced dozens of paintings, drawings, and prints out of this exchange, many of them essential contributions to his art of the period. During the first twenty years of his career, however, he directly addressed Picasso only once, and after Picasso's death, in 1973, he allowed another decade and more to pass before beginning the inquiry that since then has grown to such importance in his art.

Although Lichtenstein rose to prominence as one of the Pop artists of the 1960s, his relationship with Picasso traces his conception of modern art back into the 1940s. Johns's age and circumstances constituted a different context, one that placed him at a divide in the history of American artists' responses to Picasso and other pillars of modernism. Born seven years after Lichtenstein, Johns had no substantial experience with real art objects and only limited exposure to reproductions of modern art before 1948, when he left his home in South Carolina for New York. He remained in that city until he was drafted into the military, in May 1951. Whereas Lichtenstein was posted to Paris, and was able to stop by Picasso's residence and to stock up on books about contemporary art, Johns passed most of his two years' service in South Carolina and Japan. He did have the chance to visit a Tokyo exhibition of Japanese artists inspired by Dada and Surrealism, as well as a Cézanne retrospective at the Metropolitan Museum of Art, New York, in 1952.

Both these exhibitions may have been important to Johns as he resumed his efforts to become an artist in New York in the summer of 1953, but by that time the American art world had been transformed by Abstract Expressionism. During his initial sojourn in the city, Johns had been shocked by his first sight of a work by Picasso. Having arrived in New York with a sense of Picasso as a "mythological figure"[110] but only a limited knowledge of his work through reproduction, Johns, we know, remembered his first Picasso as "the ugliest thing I'd ever seen. I'd been used to the light coming through color slides; I didn't realize I would have to revise my notions of what painting was."[111] Since he encountered this picture during regular visits to galleries showing the work of historical and contemporary artists, the impact of the Picasso is signal: clearly Johns accepted Picasso as the premier painter of the time, and based his understanding of painting on Picasso's pictures.[112] Not long afterward, however, he saw Pollock's 1950 exhibition at Betty Parsons's gallery, as well as her Barnett Newman show the following year. Unlike the distant, "mythological" Picasso, these artists offered immediate evidence of the vitality in contemporary American art. Johns described the contrast:

Well you see when I was a student in South Carolina, one knew that there were these Europeans, Picasso, Matisse, etc. One was almost not aware of an American art world, down there. . . . It was only after I came back from the

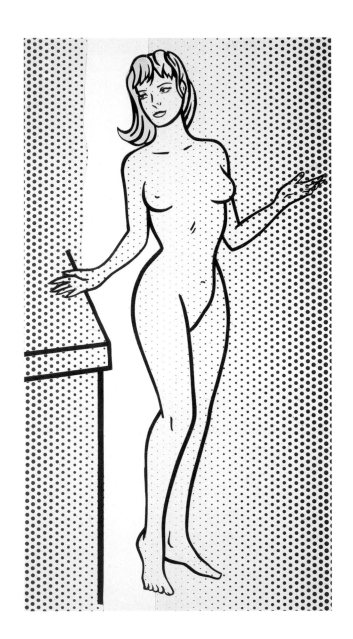

Army that I began to see that there was an art world in America with these people who had backgrounds, experiences, and histories, that they had developed art forms that one had to consider very seriously and to come to terms with it somehow. And within all of this structure, there was an older generation, a younger generation, and opposing schools; it was very complicated. So that European painting at that moment seemed very old and distant as it were. Not something of immediate concern really.[113]

One of the artists Johns encountered as he explored the New York scene, Robert Rauschenberg, recalled a similarly disengaged attitude toward Picasso: "I had taken him for granted as a giant. All he drew from me was respect."[114]

These were years when Picasso's work was not extensively shown in American galleries or museums. By the time of the

Modern's "75th Anniversary Exhibition," in the summer of 1957, Johns had already created his first mature body of work and had agreed to show it at the gallery of Leo Castelli.[115] Though exquisitely executed, Johns's mixed-media reliefs of encaustic over newspapers, canvas, and other objects, as well as their standardized subjects of flags, targets, numbers, and alphabets, seemed the antithesis of the Picasso who was widely respected as a historical figure—a painter above all, and one whose art was profoundly autobiographical. Of course, Barr's exhibition presented a much more diverse, and accurate, summary of Picasso's career, with particular emphasis on his production outside of painting. Barr notably highlighted his achievement as a sculptor, finally representing the range of his activity in that field, but the medium that wove through the entire exhibition was collage. Despite the purchase of *Bottle and Wine Glass on a Table* (1912; plate 19) by Alfred Stieglitz in 1915, and of *Pipe, Glass, and Bottle of Rum* (1914; plate 37) by Juliana Force about a decade later, American collectors had gathered only a small number of Picasso's collages, and only a few of these had found their way into museum collections. Albert Gallatin had bought one around 1930; the Modern acquired a single example in 1937; the Metropolitan Museum of Art received Stieglitz's *Bottle and Wine Glass on a Table* as a gift in the late 1940s; and the year before the "75th Anniversary Exhibition," the Modern finally acquired Force's fine piece. Yet because of the works' fragility, they could rarely be shown. During the 1940s and '50s, American artists had little access to Picasso's and Georges Braque's papiers collés; so when Rauschenberg, Johns, and their contemporaries became interested in collage, they probably turned to more recent artists (particularly those associated with Dada and Surrealism) who had already appropriated collage for the opportunities it offered to challenge assumptions about the relationship of art to other forms of contemporary experience. Picasso's *Absinthe Glass* (1914; plate 146) stands at the origin of two-dimensional collage being projected into three-dimensional objects that literally rival everyday things. Yet, until the Modern acquired one of these sculptures, in 1956, an example had not been regularly on view in New York since 1943, when Gallatin moved his collection to Philadelphia.

Johns's *Painted Bronze* (1960; plate 147) stems from the tradition of Picasso's *Absinthe Glass*, but a close examination shows how distant it is from Picasso's precedent. In *Absinthe Glass*, Kirk Varnedoe wrote, Picasso "played consistently on the *trompe-l'esprit* interchange between simulacra, abstraction, and direct one-to-one identity that marked the relationship between his collages and their tabletop subjects. He gave the surrogate glass the same scale and volumetric presence as its model, and left the foot as solid and functional as on the genuine vessel; then he pushed the uncertainties of the mix to an extreme by inserting an actual strainer beneath the ersatz sugar cube at the top of the composition."[116] Johns's *Painted Bronze* contains all of these formal and conceptual plays but dispenses with what by the 1950s appeared to many artists as self-conscious artiness in Picasso's piece: the yawning gap between the obviously handmade sculpture and a real bar glass. At first glance, Johns's two ale cans eradicate this gap; they register with "the swift, surgical wit" that Marcel Duchamp employed by surpassing Picasso's and Braque's crafted collages of real-world materials with actual "readymade" objects.[117] Yet Johns was not satisfied with such a literal resort to Duchamp's strategy, or with a deadpan realization of de Kooning's reported jibe that Castelli could sell two cans of beer as works of art.[118] Even a casual observer will discern that the conceptual clarity of *Painted Bronze* is a foil for the complex dialogue of making and matching that Johns highlighted with the work's title, and with his description of forming the original plaster: "Parts were done by casting, parts by building up from scratch, parts by molding, breaking, and then restoring. I was deliberately making it difficult to tell how it was made."[119] Then Johns had the plaster version cast in bronze, reworked the cast, and painted it. Both Johns's ale cans and Picasso's absinthe glass, both based on intimate objects made for the hand, ultimately draw their meanings from the evidence of their handmade construction and their difference from their industrial sources. Nonetheless, separated by nearly a half century, they approach each other from opposite ends of this aesthetic divide.

While Lichtenstein's playful response to *Absinthe Glass* in the mid-1960s reflects his long-standing obsession with Picasso, Johns's ale cans demonstrate how distant Picasso could seem from contemporary art. During the 1960s, however, Picasso's work became a vital part of Johns's experience. In 1961, Victor and Sally Ganz purchased a pastel-and-collage image of an American flag that Johns had made in 1957.[120] Their choice of this signature image—related to the work that Johns had shown in his first exhibition, in 1958—would not have been unusual except that for the previous twenty years the Ganzes had collected works by Picasso almost exclusively.[121] They had become legends for both their devotion to that artist and their selection of some of his most challenging work. Their commitment reached back to 1941, the year after Barr's landmark exhibition "Picasso: Forty Years of His Art," when they bought *The Dream* (1932), one of Picasso's most brilliantly colored and luxuriously sensual paintings of his mistress Marie-Thérèse Walter, a few months before the United States entered World War II. Once the war ended, the Ganzes began to collect seriously, buying a major Picasso every year or two through the 1950s, most adventurously the entire fifteen canvases of Picasso's series after Delacroix's *Women of Algiers* (see figs. 93, 99, 100), of which they kept five hung together in a room of their apartment. They closed the decade with a retrospective acquisition, *Bather with Beach Ball* (1932), one of Picasso's most fantastic parodies of a seaside frolic and a counterpoint to the classical poise of *The Dream*.

The Ganzes' purchases continued through the 1960s with prime examples of Picasso's assemblage sculptures (*Baboon and Young*, 1951, and *Figure with Spoon*, 1958, bought in 1960 and 1961 respectively) and more paintings and prints. Two years after acquiring Johns's *Flag*, they bought one of Picasso's recent paintings, *Seated Woman* (1959), yet by this time they had radically changed the pattern of their collecting: after 1962, far more works by contemporary Americans—Rauschenberg, Johns, Frank Stella, and Eva Hesse (along with two by Lichtenstein and one by Oldenburg)—entered the collection than works by Picasso. By 1967, when they purchased their final, and greatest, Picasso painting, *Woman in an Armchair* (1913; plate 145), the Ganzes owned twelve major drawings or paintings by Johns and thirteen

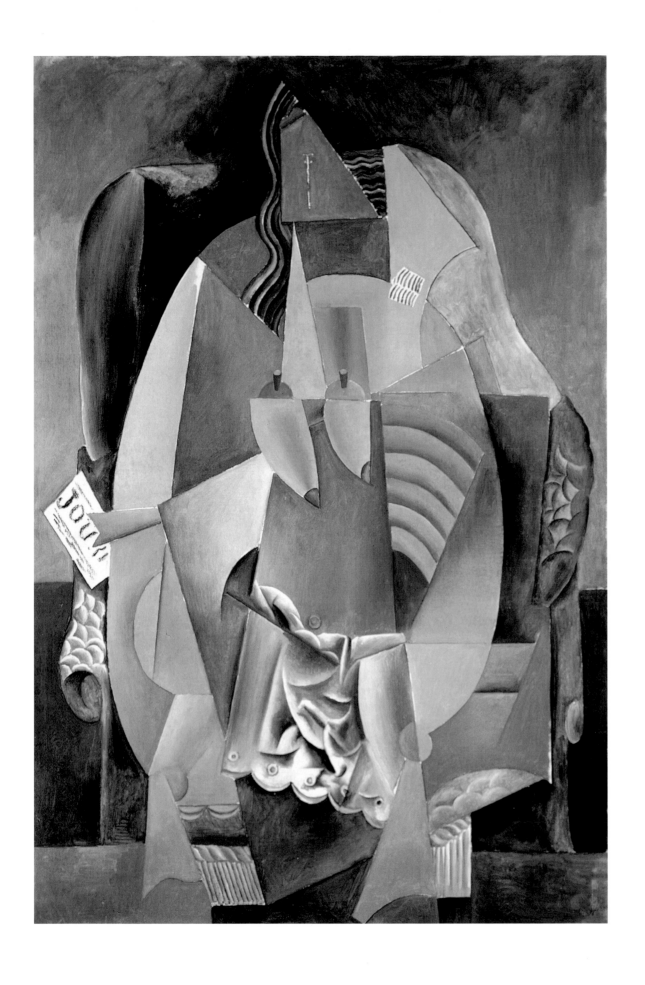

PLATE 145
PABLO PICASSO, *Woman in an Armchair*,
1913. Oil on canvas, 59 x 39 3/16 in.
(149.9 x 99.5 cm). Private collection

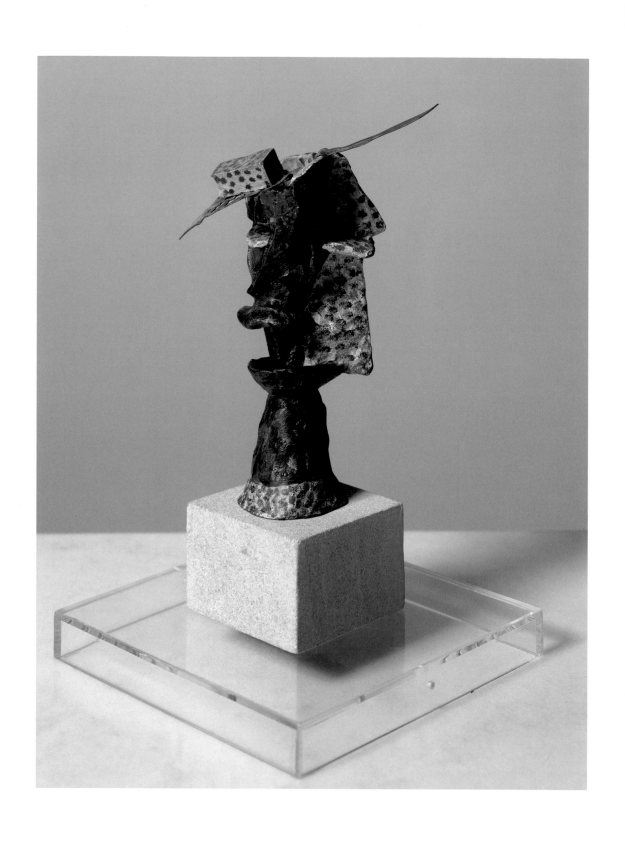

PLATE 146
PABLO PICASSO, *Absinthe Glass*, 1914.
Painted bronze, 8 1/2 x 6 1/2 in. (21.6 x
16.5 cm). Private collection

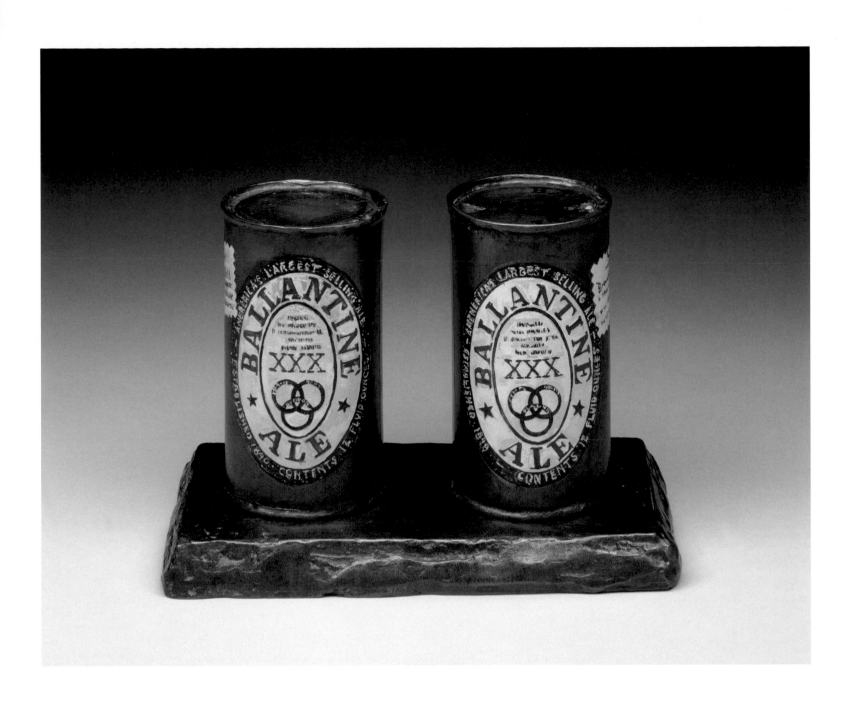

PLATE 147
JASPER JOHNS (born 1930), *Painted Bronze*, 1960 (cast and painted 1964). Painted bronze, edition 2/2, 5 1/2 x 8 x 4 1/2 in. (14 x 20.3 x 11.4 cm). Collection of the artist

FIG. 116
ROBERT RAUSCHENBERG (born 1925),
Odalisk, 1955–58. Combine: oil, water-
color, graphite, crayon, paper, fabric,
photographs, printed reproductions,
miniature blueprint, newspaper, metal,
glass, dried grass, and steel wool, with
pillow, wood post, electric lights, and
Plymouth Rock rooster, on wood struc-
ture mounted on four casters, 6 ft. 11 in. x
2 ft. 1 1/4 in. x 2 ft. 1 1/8 in. (210.8 x 64.1 x
63.8 cm). Museum Ludwig, Cologne

by Rauschenberg (whose work they had begun to collect in 1963), as well as prints by both artists.

In focusing on this small group of young artists, the Ganzes did not abandon Picasso. To the contrary, Picasso was the standard for their choices (rather as Leo and Gertrude Stein had made Cézanne their yardstick in judging the art of the early twentieth century). In an interview after both Victor and Sally had died, Castelli stated, "Victor tried to find people who in one way or another were part of the main current that started with Picasso." And he replied to a question about whether Ganz saw "a particular affinity between Picasso and Johns," "Oh, yes. He thought that most of contemporary art derived in one way or another from Picasso, that Picasso was a sort of father figure for most of the artists of our time."[122] If the Ganzes had collected Pollock or de Kooning along with Picasso, this idea would have seemed obvious, but by leaping over the Abstract Expressionist generation to champion artists who apparently rejected the traditions of painterly self-expression that de Kooning, Pollock, and many of their contemporaries derived from Picasso, the Ganzes proposed an unconventional alignment.

Though never stated for the record, their sense of the interplay between Picasso and the postwar artists is suggested by certain of their choices. Begun the same year Picasso began his variations after Delacroix's *Women of Algiers*, Rauschenberg's *Odalisk* (1955–58; fig. 116) presents a radically different branch of a dialogue with the tradition of the harem beauty. Instead of following Picasso's course of confining the exchange to himself and a great painting of the past (if with the ghost of Matisse looking over his shoulder), Rauschenberg exploded the paradigm by substituting a peepshow box for the canvas, plastering it with images ranging from Titian (the nude female figure at the left of *Concert Champêtre*, of about 1508, in the Louvre) to contemporary pinups, and parodying the voyeuristic sensuality of the subject by placing a stuffed cock on the box's top and plunging the work's base through a pillow near the floor (wryly suggesting the obelisk captured in the punning "combine" title). Clearly, in the Ganzes' eyes, these artists' relationship with Picasso was a matter not so much of responding to particular works as of the broad issues of modernism defined through his career.

The Ganzes' prominence in the American art world brought attention to the artists they chose, and unavoidably prompted comparisons between those artists' work and Picasso's. In reply to a question of whether it was "important for your artists to be collected by someone who had this collection of Picassos," Castelli said, "To be in the Victor Ganz collection was really an honor for them, a distinction that the artist could stand up to that competition."[123] In the apartment, provocative juxtapositions abounded, since works by the young artists hung side by side with some of Picasso's established masterpieces (interspersed with lamps and tables arrayed with family photos). As the years passed and the Ganzes refined their choices of contemporary artists, their home seemed particularly to feature one pairing of young and old.[124] Critic David Sylvester, who was a regular visitor, observed, "As one wandered around the Ganzes' apartment, the collection seemed a lot less varied than it did on paper, seemed very much dominated by two artists, Picasso and Johns, not least because the corridors and staircase were so full of their prints and drawings."[125]

Among the many works in question, unexpected similarities emerged, and were no less resonant for being established by the Ganzes' choices rather than by those of the artists. Having gathered some of Picasso's bleakest paintings of the war years and their aftermath (*Still Life with Blood Sausage*, 1941 [fig. 117], *Reclining Nude*, 1942, *Cock and Knife*, 1947, and *Winter Landscape*, 1950), the Ganzes found powerful complements for these paintings' somber tonalities, rigorous structures, and heavily worked surfaces in Johns's art of the 1960s: the drawings *Watchman* (1966), *Tennyson* (1967), and particularly *Diver* (1963; fig. 119). Their purchase of this last, very large drawing in 1964 sealed their commitment to Johns, and the choice reflected their ability to find continuity where most contemporaries saw divergence. Although Cézanne's paintings of male bathers may have been a basis for the reaching arms in *Diver*, Johns, like Picasso in his resorting to Cézanne's female bathers for the *Demoiselles d'Avignon*, seems to have been less concerned with the specific poses of Cézanne's figures than with the way those figures are woven into the surface and pictorial depth of the paintings.[126] Johns's panels of densely worked charcoal, pastel, and passages of watercolor on paper

FIG. 117
PABLO PICASSO, *Still Life with Blood Sausage*, 1941. Oil on canvas, 36 1/2 x 35 7/8 in. (92.7 x 91.1 cm). Collection of Tony and Gail Ganz, Los Angeles

FIG. 118
JASPER JOHNS, *Weeping Women*, 1975.
Encaustic and collage on canvas (three
panels), 50 x 102 1/4 in. (127 x 260 cm).
Collection of David Geffen, Los Angeles

FIG. 119
JASPER JOHNS, *Diver*, 1963. Charcoal,
pastel, and watercolor on paper mounted
on canvas, two panels, 86 1/2 x 71 3/4 in.
(219.7 x 182.2 cm). The Museum of
Modern Art, New York, Partial gift of Kate
Ganz and Tony Ganz in memory of their
parents, Victor and Sally Ganz, and in
memory of Kirk Varnedoe; Mrs. John Hay
Whitney Bequest Fund; Gift of Edgar
Kaufmann, Jr. (by exchange) and pur-
chase. Acquired by the Trustees of the
Museum of Modern Art in memory of
Kirk Varnedoe (377.2003.a–b)

revive Cézanne's dynamic, oscillating space without mimicking his luminous watercolors and oils. They create a unified field so dark as to nearly repel sight, an effect most powerfully achieved in recent art by Picasso's wartime pictures. At least when it hung in the Ganzes' apartment, *Diver* closed ranks with their dark Picassos, obviating for the moment the Abstract Expressionist work that lay between them and enhancing the impact of both Johns and Picasso as compelling contemporary artists.

An unexpected invitation to contribute to a portfolio honoring Picasso's ninetieth birthday, on October 25, 1971, prompted Johns to make Picasso a subject of his art.[127] Having so far avoided Picasso's shadow, and preferring not to join this particular enterprise, Johns declined, only to find himself absorbed by the challenge of creating an appropriate work. "I said I wouldn't do it. . . . And then, of course, I stayed awake all night thinking: if I were to do it, I would do it this way."[128] His final design doubles a partial silhouette of Picasso's head and places the two profiles almost nose to nose, so that the white space between them reads as the shape of a goblet.[129] Titled *Cups 2 Picasso* or *Cups 4 Picasso*, the final lithographs play on the optical illusion of a "Rubin's figure" to present both a celebratory glass and an image of the honoree in a lighthearted but polyvalent evocation of Picasso and other artists important to Johns.[130] Combining the acclaim appropriate to the occasion with the idea of art as a competition like many others, Johns adapted his title from a nineteenth-century American painting, John Peto's *The Cup We All Race 4* (ca. 1900), which he had parodied in the early 1960s, apparently enjoying both its wordplay and its wry view of success (Peto's prize is a dented tin cup).[131] Johns's use of an artist's silhouette also invokes a specific competitor of Picasso's, or at least another influential contemporary of his: Duchamp.[132] In the early 1960s, Johns had copied Duchamp's *Self-Portrait in Profile* (1958) into his own *According to What* (1964), one of his largest and most explicit homages to Duchamp, the artist he most admired in those years. In 1971, he re-created this detail of the painting in a series of prints, *Fragments—According to What*.

Although *Cup 2 Picasso* and *Cups 4 Picasso* filter the dialogue through a series of other artists, Johns began with a tangible image of Picasso. Having settled on the idea of a repeated silhouette, he cast around for a recent photograph showing a clear profile and chose one that captures considerably more than the rounded outline Picasso had used to represent himself in several paintings of the late 1920s.[133] While not registering the artist's serious physical decline in 1971, it shows the bald head, wrinkled eyes, and loose jowls of an aged man. Laying a transparent sheet over the photograph, Johns traced the profile he needed without obscuring Picasso's other features, and he cut a second, reduced, silhouette that lodges at the right side of the sketch, overlapping thumbnails for the overall design (plate 148). Unlike the broadly inked passages filling the areas behind the profiles in the lithographs, the photograph palpably roots the sketch in the Picasso of recent years. The *Cups* are a playful bow to the master, yet they nonetheless introduce themes of longevity and fame that Johns would address in depth in the 1980s, when he began to take Picasso's work as a primary point of departure.[134]

Johns seems to have made occasional references to Picasso's work over the ensuing ten years, but none so explicit or substantial as either the *Cups* or the extensive citations in later decades.[135] He may have derived the title of *Weeping Women* (1975; fig. 118), for example, from Picasso's "Weeping Woman" prints (1937); the four impressions of a domestic iron in Johns's painting may refer to the jagged fingernails in one of those works, or to the pointed pegged breasts in Picasso's 1913 *Woman in an Armchair*. The visual impact of *Weeping Women*, however, is rooted primarily in the clusters of parallel lines that map its surface, creating "*spaces* that suggest a connection to physical presences," as Johns has said of the "cross-hatch" series.[136] While Johns has noted that he got the idea for these compositions from the decoration of a car he glimpsed on the Long Island Expressway, the motif resembles the sets of short parallel lines that Picasso wove through a painting Johns knew well from his visits to the Ganzes, the final version of *Women of Algiers*.[137] When Johns took up Picasso's work in earnest, he chose images whose spatial ambiguity conveys great emotional resonance.

In the winter of 1984–85, Johns selected three paintings from Duncan's *Picasso's Picassos*, a coffee-table book assembled in 1961 to document Picasso's collection of his own work and to show Duncan's photographs of the artist at home at La Californie, his villa in the South of France. The opening paragraph of Duncan's accompanying commentary conveys the full-throated sycophancy that enveloped Picasso during his last years: "No painter of this century's Midas-touched art world has seen more of his colors and canvas change to gold than Pablo Picasso: no painter of any century rose farther above misery and starvation to enjoy the frontierless freedom of universal acclaim. Today . . . he is almost regally disdainful of all such homage." Claiming that seeing Picasso's personal collection was equivalent to "piercing the sealed vaults guarding Tutankhamon's treasury in the Valley of Kings along the Upper Nile," Duncan cooed that "only he, among all artists, is known to have concealed hundreds of great canvases painted throughout his lifetime just because he cherished them himself, as his own offspring, and planned that they remain forever together."[138] In fact, Picasso's collection of his own paintings was a motley assortment. Until the 1920s, when he became financially independent, he sold nearly everything he could, and in later years he made no concerted effort to buy back favorite works, so what early paintings remained in his possession was largely a matter of chance. Even after he felt free to retain what he liked, Picasso usually preferred to sell his major works. Nor did he keep his holdings secret; many of the paintings were widely published and exhibited (he lent many to Barr's "Picasso: Forty Years" and to other exhibitions). Nonetheless, the 531 paintings in *Picasso's Picassos*, spanning from 1895 to 1960, included dozens that would constitute the collection of the Musée Picasso in Paris, after the settlement of the artist's estate, and a substantial number that were largely unknown, having escaped Zervos's decades-long effort to catalogue Picasso's production, and having been available only to those who saw them in Picasso's home.

When Duncan's book first appeared, Johns's interests lay elsewhere; and when he did pick up the volume, its cachet had been diffused by widely publicized exhibitions presenting many of the paintings that had previously been undocumented, including *Woman in a Straw Hat with Blue Leaves* (1936; plate 149), *Minotaur*

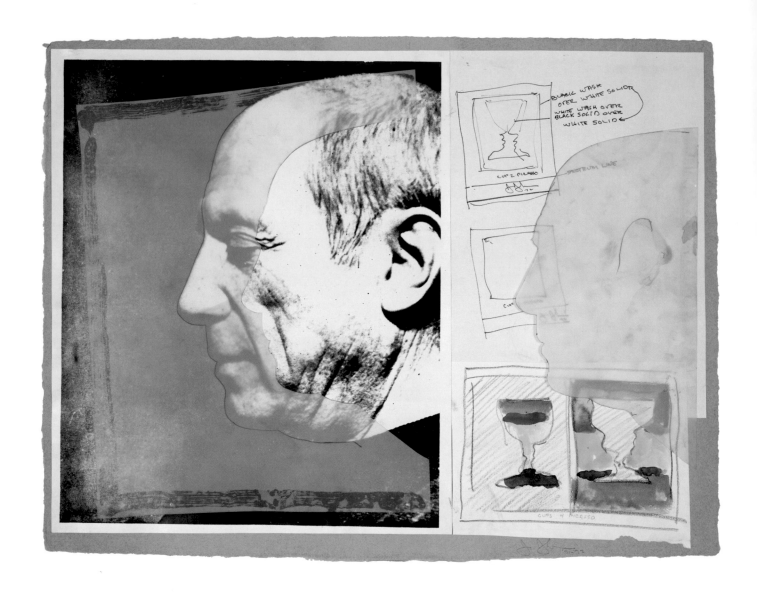

PLATE 148
JASPER JOHNS, *Sketch for Cups 2*
Picasso/Cups 4 Picasso, 1971–72. Collage,
watercolor, graphite and ink on paper,
15 3/8 x 20 1/4 in. (39.1 x 51.4 cm).
Collection of the artist

Moving (1936; plate 160), and *The Shadow* (1953; plate 161), the three paintings that would hold Johns's interest for years. Although *Minotaur Moving* and *The Shadow* would spark Johns's first group of paintings after Picasso and prove his most enduring connection to Picasso's work (at least to date), the design that initiated this long involvement was an untitled drawing after *Woman in a Straw Hat with Blue Leaves* (1984; plate 150). Made in Stony Point, New York, before Johns left to spend the winter in his home on the island of Saint Martin, it is a radical transformation of the original. In later years, Johns would step back to make straightforward copies of Picasso's composition (plate 151), but his first address pushes an idea latent in Picasso's image to its furthest extreme. The painting *Woman in a Straw Hat with Blue Leaves* is a bust-length rendering of a woman set against a nearly uniform, reddish-brown background (all the colors are dulled in Duncan's reproduction). The figure's schematic shoulders and neck serve as little more than a base for her face, which appears suspended from her hat or pressed toward the flattened forms behind. Seemingly swollen to the point of bursting, the face distends into four lobes. Eyes, nose, and mouth are pressed to the bulging edges. With one eye at the peak of a lobe, like a nipple on a breast, and the other thrown against the bridge of the nose, the woman's face bounces between a suggestion of receptive sensuality and frantic flight.

At first, Johns set aside the painting's obvious psychological attributes to explore the formal implication of the face's splayed features. Whereas Picasso had moderated the shock of his distorted face by framing it with a broad pictorial field, Johns discarded that device: by placing the eyes and mouth at the edge of the sheet (and schematic nostrils near the lower-left corner), he removed the distinction between the pictorial object and the sheet of paper on which it is depicted. Within the metaphor of Picasso's work, Johns stretched the face until it wrapped around the edges of the support and the woman's skin became one with the surface of the paper. The thick eyelashes and peaked pink mouth of Johns's version impart a comic-strip sexiness made more ridiculous, and more disturbing, by the small sketch "nailed" to her forehead. Occupying the space of the woman's face in Picasso's painting, this sheet reestablishes the relationships of Picasso's composition while extending Johns's interpretation of it to make the face suggest a section of wall. Meanwhile, the little sketch itself introduces another form of flesh.[139]

Johns had addressed the issues embedded in this first variation on Picasso's work since the 1950s, primarily through an intense scrutiny of representation that he had defined in painting by rendering manufactured, two-dimensional objects so that they became consonant with his canvas, as in his series of paintings of the American flag. At times, too, he had extended and challenged his seemingly impersonal discipline by including impressions of his own features.[140] During the early 1980s, he significantly expanded the range of his practice by adopting an interior wall (often of his studio) as the pictorial ground for representations of his paintings and embracing a greater degree of illusion in depicting both common objects and works of art attached to the wall.[141] The little sketch inserted at the center of the untitled drawing based on *Woman in a Straw Hat with Blue Leaves* is one of these references; it shows a pattern that Johns derived from a

diseased demon at the lower-left corner of the *Temptation of St. Anthony* section of Grünewald's Isenheim altarpiece (ca. 1512–16), and that he used frequently in the 1980s.

In a sense, Johns brought Picasso into his art in the company of an older master, Grünewald, and as a part of the wide-ranging dialogue that he has conducted with past art during the last quarter century. Both Grünewald's writhing, pustule-covered demon and Picasso's ballooning woman are among the most extreme representations of physical transformation ever devised, and potent proof of art's ability to convey profound emotions through absurdly artificial means.[142] Johns, by elaborating on Picasso's design to invent a pictorial structure that could fold these two images into his long-standing concerns, put his art in explicit dialogue with the same kind of succession of previous artists that Picasso had engaged with his variations after Delacroix's *Women of Algiers*. Despite Johns's passion for the work of Cézanne and Duchamp, Picasso seems to have offered him greater access to the history of art, and to the interwoven themes of mortality and sensuality that in Western art since the Renaissance have chiefly been defined in painting.

Johns continued to draw on *Woman in a Straw Hat with Blue Leaves* for a decade. He generally adapted the entire image (plates 152–56), but in the early 1990s he revisited his first sketch in a series of untitled paintings (one of his last to date after this particular Picasso work).[143] Here, he transformed his original, candy-colored version into somber, nearly monochromatic fields, and he extended the conjunction of Picasso and Grünewald beyond art history by substituting for the Grünewald insert a drawing of a face with scrambled features, made by a schizophrenic child.[144] In one particularly layered work that Johns painted over a three-year period (1991–94; plate 156), the Grünewald passage is transposed to the background, where, barely visible in a heavily worked field of deep purple, it merges with the displaced eyes, mouth, and nose of Picasso's painting.

As Johns's variations proliferated, his attachment to the original image may seem so defused among the multiple references to other works of various kinds, and the expanding set of Johns's own concerns, that the distinction of its maker becomes negligible. After all, Picasso had been dead for more than ten years when Johns first addressed *Woman in a Straw Hat with Blue Leaves*. Only his historical reputation could be challenged, and Johns worked from a reproduction rather than the actual painting. This distance from the painting would have mattered more to many of the artists who preceded Johns than it did to him, since what compelled him was more the imaginative leap captured in the general configuration of Picasso's image than its precise execution. Nonetheless, Johns is an artist for whom no form exists apart from the qualities of its making. In this, he resembles Picasso and a succession of modern artists, particularly Cézanne. Moreover, Johns's variations after *Woman in a Straw Hat with Blue Leaves* not only record Picasso's continuing presence but acknowledge that Johns's interest in him extended back at least to the *Cups* of the early 1970s. In an untitled watercolor of 1988 (plate 153), he combined those tongue-in-cheek homages to Picasso with a reversed replica of *Woman in a Straw Hat with Blue Leaves* and a copy of Duchamp's *Bride* (1912).[145] Rendering *The*

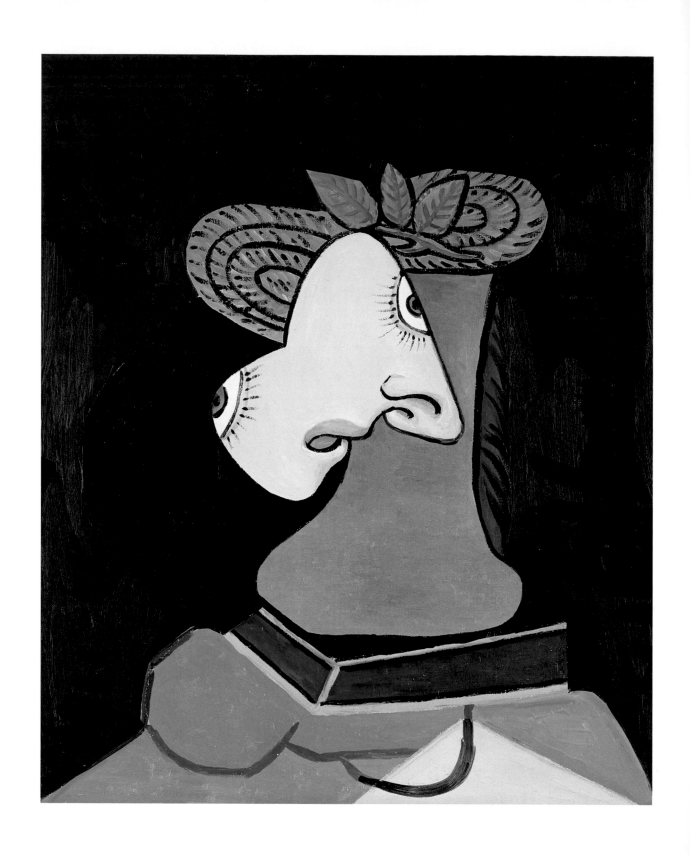

PLATE 149
PABLO PICASSO, *Woman in a Straw Hat
with Blue Leaves*, 1936. Oil on canvas,
23 13/16 x 19 11/16 in. (61 x 50 cm).
Musée National Picasso, Paris

PLATE 150
JASPER JOHNS, *Untitled*, 1984. Pastel and
graphite on paper, 22 1/4 x 16 1/2 in.
(56.5 x 41.9 cm). Collection of the artist

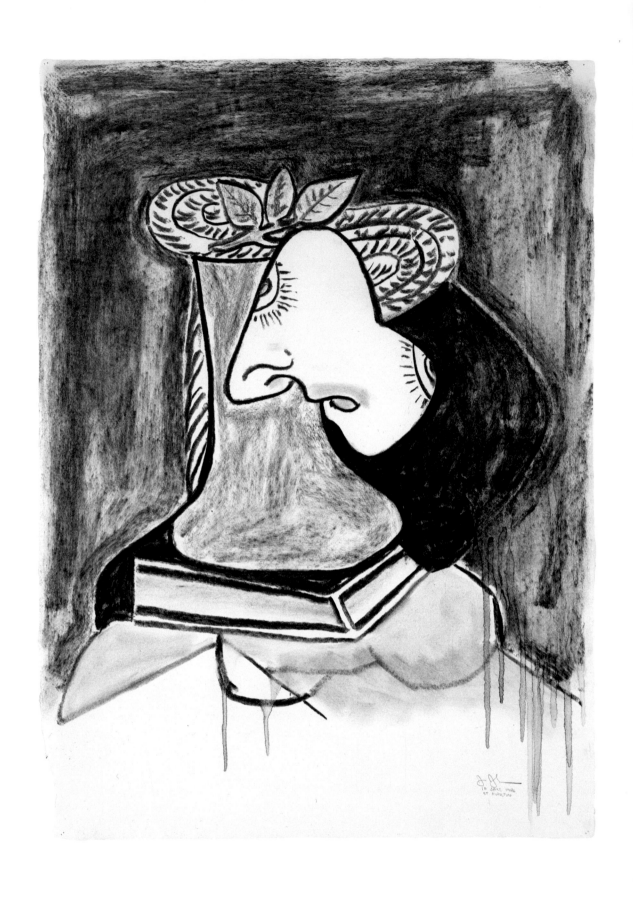

PLATE 151
JASPER JOHNS, *After Picasso*, 1986.
Charcoal on paper, 31 x 22 1/16 in.
(78.7 x 56 cm). Collection of the artist

Bride as a diffuse monochromatic background (rather as he had treated the Grünewald details), he created a fluid field across which the brightly colored *Cups* seems to have floated until bumping into the Picasso painting and spilling a drop of liquid. Opening from a set of floorboards depicted at the left (blunt reminders of reality and flatness), the watercolor concocts a collision of artworks along with the reversal of *Woman in a Straw Hat with Blue Leaves*, and evokes an imaginative space in which a sequence of aligned profiles joins the woman in Picasso's painting with Picasso's own profile in *Cups* (at the right) and the vague shapes of Duchamp's painting (at the left). While the dual profile framing the cup basically follows Picasso's features, its slightly sharper outline has prompted the suggestion that it may include Johns himself in the gathering.[146]

Johns's variations on the composition include a painting in the wax medium of encaustic, *Untitled* (1988; plate 152), which excludes the reference to *Cups* but bores into the central question of Picasso's legacy. Choosing Grünewald's diseased demon for his background, he rotated the figure so that its beaked profile nearly matches the long nose of Picasso's *Woman in a Straw Hat with Blue Leaves*. Here, instead of suspending his *Cups* in ether, he rendered a real object standing by the edge of a bathtub: a vase shaped by the same principle of facing profiles, in this case those of Queen Elizabeth and Prince Philip of England.[147] The visual conundrum of *Untitled*, however, is its modulation of the encaustic, ranging from the precisely edged contours of the vase, through the sketchily blocked section of the Grünewald, to the blurred runs of the Picasso. Since the medium of encaustic has been identified with Johns's art from his first exhibition at the Castelli Gallery, in 1958, one might interpret this gamut of pigmented, once molten wax as a virtuosic display culminating in the near-obliteration of Picasso's work.

If so, it was triggered by a different story, one supposedly situated in the years around 1950, when Johns was finding his place in New York and the work of the Abstract Expressionists was first being shown in Europe. A denizen of that art world, painter and critic Paul Brach, recalled hearing someone say that Picasso had ridiculed the first work by de Kooning he had seen as "melted Picasso." Witnessing Johns's involvement with Picasso's work in the 1980s, Brach passed on the undocumented anecdote to Johns, who was struck by it—probably for several reasons: the edge of competition in Picasso's dismissal of de Kooning, the irony of how well the remark conjures up what Picasso achieved in *Woman in a Straw Hat with Blue Leaves*, and the fact that Johns had been making paintings with melted pigments for decades.[148] Johns's runny version of *Woman in a Straw Hat with Blue Leaves* pushes its suggestion of metamorphosing features to the point of dissolution while blurring its graphic clarity so thoroughly that the image's violent, bulging eroticism seems reduced to pitiful decomposing flesh.

Johns said that he had expected his paintings of this motif to end up seeming amusing, but "even when [a painting] was lighthearted there was something disturbing about it."[149] Drawing on another anecdote, this one related by Jean Cocteau, Johns connected his idea of melting Picasso's art with that of dissolving Picasso himself: "I read a book of Cocteau's in which he writes

that Picasso said he was always amazed, when he took a bath, that he didn't melt like a cube of sugar. That image stuck in my mind, and I decided I wanted to use an image of a melting Picasso. Finally, I put it together with the bath."[150] The reference is to Johns's own bath in his home at Stony Point. The taps at the bottom of *Untitled* establish this location, and suggest that we are viewing Picasso's *Woman in a Straw Hat with Blue Leaves* (doubled, split, and smeared) from the tub. Given these overlapping stories, the identity of artist and artwork is explicit, and two comic turns devolve into emblems of physical decay and the impermanence of artistic legacy, themes all the more poignant when one realizes that Johns was portraying his own bath.

After more than a decade of intense involvement with Picasso's imagery, Johns decided to engage Picasso's process itself, the "hand" that so many American artists before him had sought to emulate or overcome. In a unique essay, he deviated from his standard practice of explicitly reworking his source material to attempt to duplicate as accurately as possible a particular painting by Picasso. Titled *After Picasso* (1998; plate 157) to distinguish it from his untitled variations, the painting re-creates *Reclining Nude*, which dates from 1938, two years after *Woman in a Straw Hat with Blue Leaves*. Johns had never seen the painting itself; to make his work, he used a color reproduction in *Artnews* (fig. 120). He neither contacted the painting's owner (whom the magazine article identified) nor visited a contemporaneous New York exhibition in which it appeared, decisions that produced startling results when he finally encountered Picasso's picture not long after completing his own.[151]

The full-length figure lying on barren soil in *Reclining Nude* is one of a series of contorted female bodies that Picasso painted as the violence of the Spanish Civil War spread into World War II.[152] Her stumpy torso and short legs are exaggerated by the flattening of her breasts and the twist of her buttocks into bulbous tumors on her left leg, in contrast to the elongation of her neck and head. Yet her features remain far more realistic than those of *Woman in a Straw Hat with Blue Leaves*. Johns chose a painting characteristic of Picasso's work during the World War II, the work that was contemporary when he and Lichtenstein had first encountered Picasso's art, and one whose subject and style could certainly be described as "ugly." In his version, Johns excluded the figure's lower torso and legs, but otherwise followed the reproduction, down to details such as the woman's head, which is clipped by the right edge of the illustration in *Artnews*. Small (2 7/8 by 5 1/4 inches) and obviously crude, the magazine reproduction captures little of Picasso's rendering. Where a high-quality illustration would allow at least the lines, colors, and tones of the original (although not the texture and viscosity of the oil) to be transcribed with fair accuracy, this image offers only a schema of the Picasso—far less of the original than the tipped-in plates in Duncan's book.

Clearly Johns set himself a challenge that involved more than manual skill. Because of the reproduction's poor quality, he could only duplicate the painting successfully by achieving such a thorough understanding of Picasso's process that he could complete the many vague passages as Picasso had done—obviously a hopeless task. In a sense, Johns was seeking, as Gorky had, to

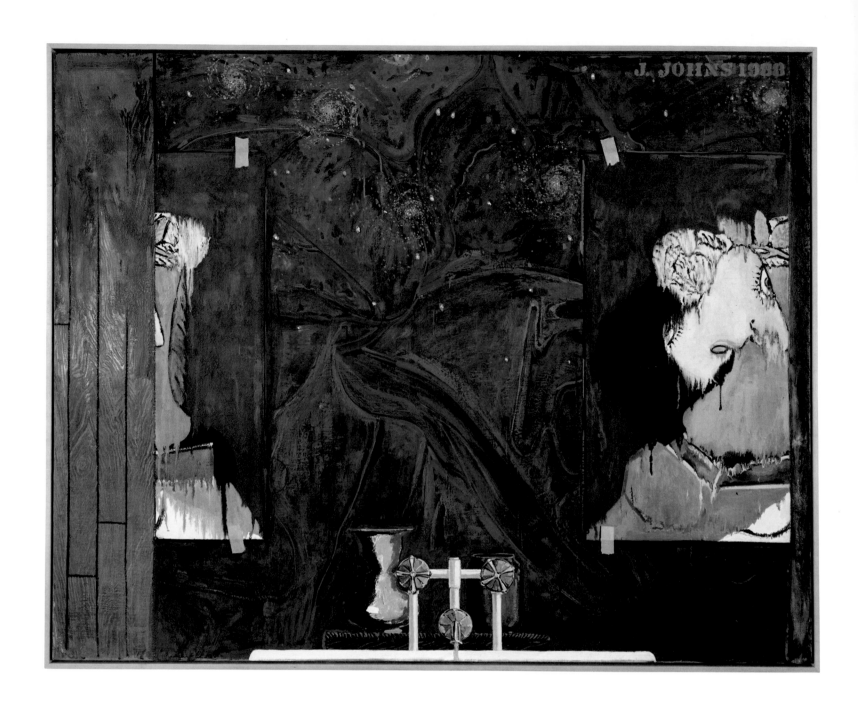

PLATE 152
JASPER JOHNS, *Untitled*, 1988. Encaustic
on canvas, 48 x 60 in. (121.9 x 152.4 cm).
Private collection

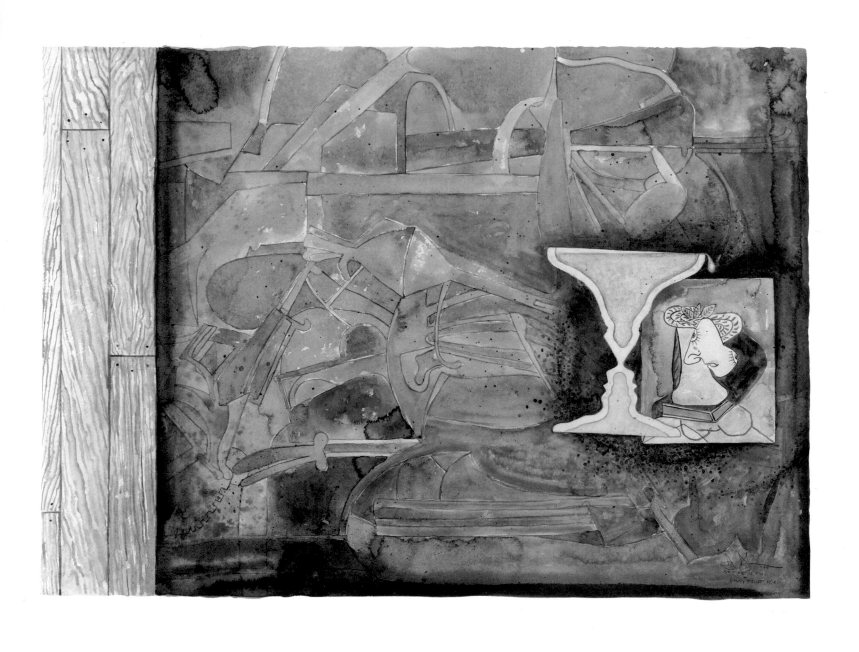

PLATE 153
JASPER JOHNS, *Untitled*, 1988. Watercolor
and graphite on paper, 21 3⁄8 x 29 3⁄4 in.
(54.3 x 75.6 cm). Collection of Barbaralee
Diamonstein and Carl Spielvogel

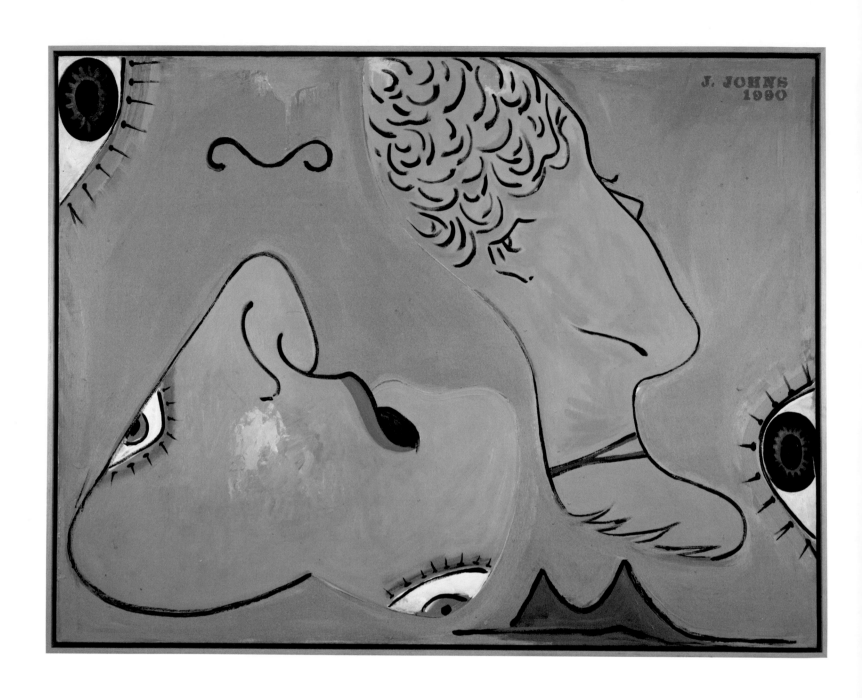

PLATE 154
JASPER JOHNS, *Untitled*, 1990. Oil on
canvas, 31 5⁄8 x 41 in. (80.3 x 104.1 cm).
Collection of the artist

PLATE 155
JASPER JOHNS, *Untitled*, 1990. Oil on canvas, 75 x 50 in. (190.5 x 127 cm). Collection of the artist

PLATE 156
JASPER JOHNS, *Untitled*, 1991–94. Oil on canvas, 60 1/4 x 40 in. (153 x 101.6 cm). Collection of the artist

"feel Picasso running through my fingertips," but with a detachment that few American admirers of Picasso's work had managed over the nine decades since his work had first become known in this country. During those many years, hardly any artists (including Gorky) had made precise copies of particular works by Picasso. Instead, they had maintained a degree of separation by creating variations on specific works to demonstrate not only their understanding of his art but at the same time their independence from it. Johns's position, however, was different. More than forty years into a career that had earned him a stature comparable to Picasso's, Johns could establish a space in which he could attempt to put aside his own artistic identity in order to enter Picasso's, and do so without risk of losing his way. In the twentieth century, at least, this marks a final address of Picasso's working process, a challenge that had occupied American artists from Max Weber, John Graham, and Gorky through Pollock and Lichtenstein.

As Johns prepared his painting, he chose a canvas that turned out to be almost the size of Picasso's (*Artnews* had supplied no dimensions), and he enlarged the image freehand, concentrating primarily on the figure's head and surrounding hands.[153] This cluster of similarly shaped fingertips, eyes, and nostrils is barely visible in the reproduction, but it is by far the most complex portion of Picasso's painting. In the original, it conveys an almost infantile absorption with facial orifices and groping touches. Johns studied the configuration in two pencil drawings (both 1998; figs. 121, 122); his reduction of Picasso's fumbling body parts to an array of similar ovoids reestablishes the structure underlying Picasso's depiction of the naturalistic gestures. In a third drawing (1998; plate 158), he turned to the tonal structure of this section of the painting. Working over the sheet in ink wash, he filled in the black background of the reproduction and intricately hatched the head and hands down to the point at which they joined the figure's wrists. Here, he shifted the hatching to two adjacent areas, thereby leaving the figure's arms as barely articulated blanks and creating a new set of "arms" more tightly gathered around the head. In the painting itself (oil, as in Picasso's), Johns returned to Picasso's rendering of the arms and applied a set of colors that differs substantially from the reproduction. In place of the dark, yellowish-brown cast of the *Artnews* image (similar to the aged varnish of old master paintings), Johns's reconstruction gives the woman's flesh an almost neutral tone, buffered with gray and struck with a few passages of red only slightly more subdued than Picasso's.

When Johns happened upon Picasso's painting at a New York gallery some months after finishing his picture, he found that the illustration in *Artnews* was even less accurate than he had thought: not only did it blur the details of the painting and dull its colors, it showed the work upside down. Besides other, smaller differences, such as the cropping of the top of the woman's head, the space of the picture is completely inverted: where the Picasso places the woman outside on bare ground, the reproduction suggests that she lies on a white bed, her torso somehow floating above the sheets (an effect Johns minimized by excluding most of her body). In a way, this obvious divergence is a gift, because the two paintings are profoundly different. Picasso's smells of the earth, and reaches out to convey the writhing motion of a real body. Johns's is a painting before all else. Making no effort to

contrive an illusion of reality, it focuses instead on the qualities of structure (both linear design and tonal unity) that detach the figure from the world and create a coherent work of art.

A single detail, the woman's gesture of placing her finger in her mouth, makes the point. Picasso painted this finger with a bend at the knuckle, a slight bow to anatomy that ties his painted image to an actual body. This nuance is invisible in the magazine's reproduction and Johns did not include it, but it is only one of many subtle inflections that Picasso used to suggest the presence of flesh and bone, a play for strict verisimilitude that was crucial to his art but is alien to Johns's. If Johns's failure to reimagine *Reclining Nude* was certain from the start (as he well knew), his experiment proved the essential identity of each artist's style and offered a head-to-head comparison of two of the greatest painters of the century.

Johns used the two other images he selected from Duncan's *Picasso's Picassos* in different ways than he did *Woman in a Straw Hat with Blue Leaves* or *Reclining Nude*: rather than directly copy or re-create these two paintings, he chose among the images and structural devices of *Minotaur Moving* and *The Shadow* for primary elements of his own pictures. Although he had assembled his compositions from diverse sources since the start of his career, Johns's treatment of these Picassos brought him closer to mid-century American artists' emulation of specific pictures, particularly since his overall compositions, as well as specific images, are closely tied to Picasso's. Unlike these artists, however, Johns chose Picassos that enriched models he had already established. In *Summer* (1985; plate 159) and the three paintings that followed it—and that together came to be called *The Seasons*—he not only assimilated Picasso's paintings but merged his own long-standing themes with the issues underlying two of Picasso's most intricate responses to turbulent passages in his life.[154]

The template for *Summer* is *Minotaur Moving* (plate 160), which depicts a rather meek version of the legendary creature pulling a cart loaded with belongings (including a painting, a ladder, and, most strangely, a horse giving birth to a foal), all crudely tied together with rope. Duncan's narrative includes the comment that the Minotaur appeared in Picasso's art "when his personal life was in turmoil, when there must have seemed no way out,"[155] and Picasso does seem to have conceived the half-man, half-bull as an alter ego (second only to the Harlequin in his oeuvre). Particularly during the mid-1930s, he used it to reflect on difficult circumstances, for example when his long-standing affair with Marie-Thérèse Walter became public with the birth of their daughter, Maya, on October 5, 1935, and his wife Olga Khokhlova threatened a divorce that would have forced him to sell many of the paintings he owned.[156] Although he and Khokhlova ultimately separated without a divorce, Picasso found it extremely difficult to make art during this period, enduring one of the rare dry spells of his career. The Minotaur plodding along with his few things captures this fall from grace.

When Johns became interested in *Minotaur Moving*, he was in the process of building a house on Saint Martin and was considering a move in New York, so he may have responded to its portrayal of domestic chaos. Nonetheless, his painting avoids Picasso's fairly direct references to his life outside art, while being

PLATE 157
JASPER JOHNS, *After Picasso*, 1998. Oil on
canvas, 34 1/2 x 28 1/2 in. (87.6 x 72.4 cm).
Collection of the artist

Reclining Nude, a 1938 work by Pablo Picasso from the collection of his granddaughter Marina. Krugier has had a long relationship with the artist's family.

more literally personal and exploring a wider set of dislocations. The two-part structure of *Summer* is implicit in the way *Minotaur Moving* divides along the wooden frame of the painting piled on the wagon—on one side the creature, and on the other his cart. Johns enforced this division with an image of the thin trunk of a tree, and pointed it up by setting near the lower edge a configuration of geometric shapes that is mirrored on both sides.[157] This partition enabled him to juxtapose two different situations: an assemblage of gear (at the right) and a shadow cast on a stone wall (at the left). The items at the right clearly follow those hauled by the Minotaur: the ladder and rope are transferred, and a panel seems to function both as a mount for images (such as a reproduction of Leonardo's *Mona Lisa*) and a painting containing an assembly of Johns's motifs as well as pots by George Ohr, an artist he admires. (The painting in *Minotaur Moving* does not resemble a Picasso.) Even the horse may be acknowledged by the presence of a seahorse near the center of Johns's composition, and the yellow stars on a green field at the upper right of his picture are drawn from Picasso's. At first glance, the hand turning in a half circle at the lower right seems to refer only to such earlier Johns works as *Periscope (Hart Crane)* (1963), but it also recalls the cart's spoked wheel and highlights the consonance Johns found between *Minotaur Moving* and his own work over several decades. As Johns said of *Minotaur Moving*, "More than most of his paintings, the catalog of things is very layered."[158]

For the motif of a shadow, Johns turned to another painting inspired by a crisis in Picasso's life: the departure of his lover Françoise Gilot and their two children, Claude and Paloma, in 1953, ending a relationship that had lasted nearly ten years and plunging Picasso into a meditation on isolation and old age. (That year, he turned seventy-two.) In *The Shadow* (plate 161) Picasso painted his own black silhouette falling into a room occupied by a woman reclining on a bed. As Picasso told Duncan, "It was our bedroom."[159] The woman's voluptuous body strongly contrasts with the artist's flaccid silhouette, and the intimacy suggested by the proximity of man and woman is contradicted by the spectral quality of his presence and by Gilot's absence in real life.[160] Whether or not Johns

FIG. 120
PABLO PICASSO, *Reclining Nude*, 1938, as reproduced in *Artnews* 97, no. 4 (April 1998): 82

was fully aware of these circumstances, he adapted the motif to present his own shadow cast onto the wall of his studio in Stony Point, although he partially relieved the somber tonality of his image by depicting a hummingbird in the central tree.[161] The distinct features and looming size of his shadow create a presence both more specific than Picasso's surrogate in the 1953 painting and more ethereal than the laboring Minotaur in the earlier work.

As Johns completed his painting, and finally chose the title *Summer* for it, he shifted its meanings from himself to the arc of a career. Having begun with a pair of works that marked two of Picasso's most dismal moments, and created a composition that seems to dispute Johns's own identity by juxtaposing a phantom of himself with a vivid range of his art (from his "Flags" of the 1950s to his recent work), he stepped back from apparent self-examination to produce three more works, all in 1986, that projected the enterprise into one of art's great historical subjects, a cycle of life.[162] In *Spring*, Johns's shadow is paired with a boy's amid a different group of his work, the turning hand begins its downward swing, and the entire scene is streaked as if rain were falling across it. In *Winter*, the hand's arc is complete, and the painting empties into snowy grayness. Among the three paintings Johns conceived after *Summer*, *Fall* (1986; plate 162) is most closely linked to the initial painting and to Picasso. With Johns's silhouette divided into two, placed one part on each of the composition's outer sides, a well filled with objects opens at the center of the painting, although Johns's consistent palette still maintains a shallow pictorial depth across the canvas. Behind the clocklike disk and its advancing hand, things are extremely jumbled. With the ladder and rope snapped, artworks have tumbled to the ground in a pile, with some objects referring to Johns's art, some to Ohr's pots, and some to other artists. Explicitly introducing a theme of mortality, a skull and crossbones (actually a Swiss sign warning of falling ice) peeks from behind one of Johns's variations on Grünewald. It appears as if taped to a board next to a copy of the Duchamp self-portrait that Johns had represented in *According to What*, and that had lain behind *Cups 2 Picasso*—a line drawing of Duchamp's head in silhouette. The pairing of silhouette and skull suggests a widening and darkening reverie. The dark outline of Duchamp's profile on a light field (the reverse of Picasso's *Shadow*) offers a different face for Johns's own split and vanishing silhouette. Almost lost in the jumble of objects at the bottom of the picture, the double profile of Picasso in the *Cups* appears (and is more clearly rendered in a study for *Fall*; plate 163). Together with the untitled watercolor of 1988 (plate 153), in which Johns included the *Cups* alongside Duchamp's *Bride* and Picasso's *Woman in a Straw Hat with Blue Leaves*, this appearance in *Fall* evinces Johns's wide-ranging responses to Picasso's art during the mid-1980s.

Like many of Johns's images, the iconography of *The Seasons* entered his repertory and became transformed as it tunneled through his later art. In 1990, in an aquatint also called *The Seasons*, he arrayed the four compositions as a cruciform, with the child of *Spring* near the center and the sequence of seasons moving clockwise through each arm of the cross, with *Spring* at the top.[163] While eliminating and rearranging much of the paintings' imagery to accommodate this configuration, he retained the clearly delineated

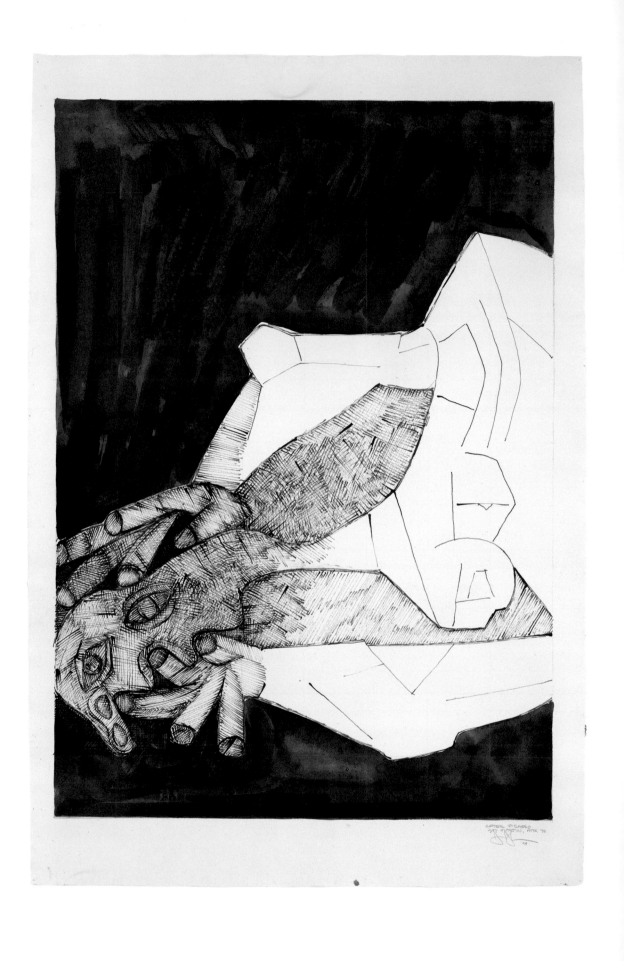

PLATE 158
JASPER JOHNS, *After Picasso*, 1998. Ink
and graphite on paper, 40 x 27 in.
(101.6 x 68.6 cm). Collection of the artist

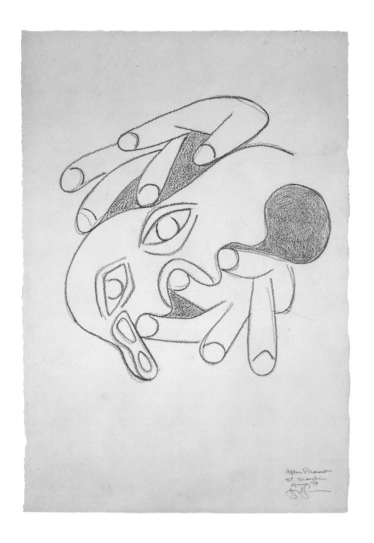

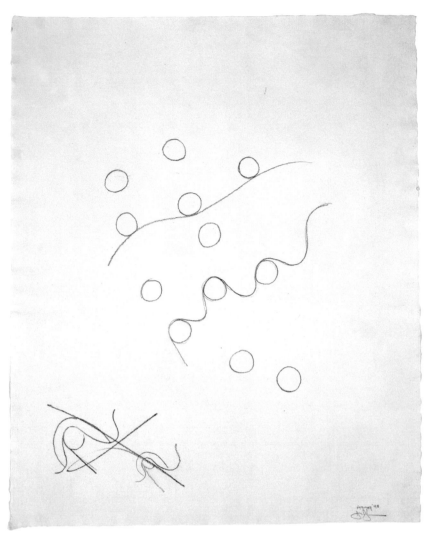

FIG. I2I

JASPER JOHNS, *After Picasso*, 1998.
Graphite on paper, 22 5/8 x 15 7/16 in.
(57.5 x 39.2 cm). Collection of the artist

FIG. I22

JASPER JOHNS, *Study After Picasso*, 1998.
Graphite on paper, 24 1/4 x 19 1/2 in.
(61.6 x 49.5 cm). Collection of the artist

303

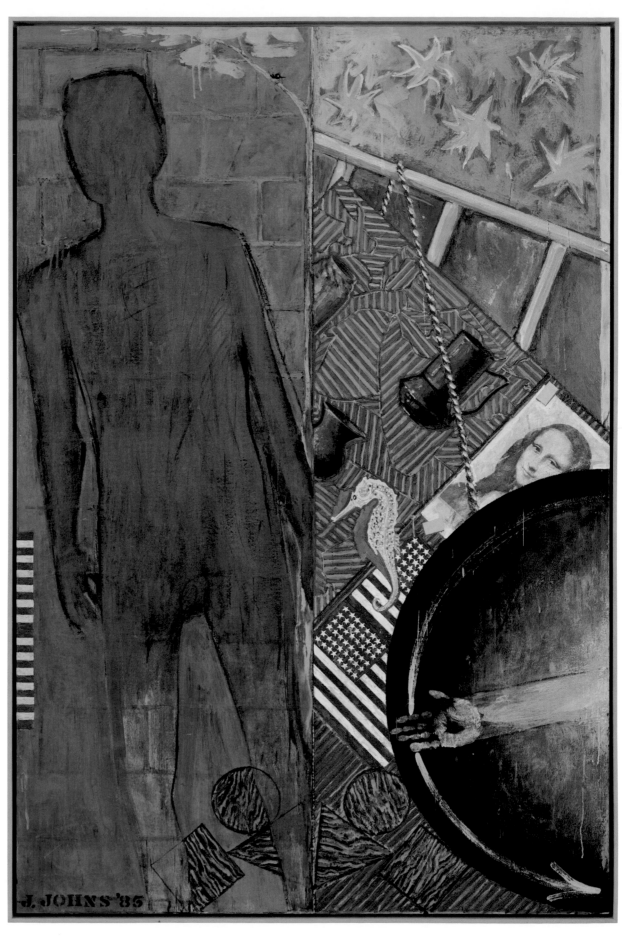

PLATE 159
JASPER JOHNS, *Summer*, 1985. Encaustic
on canvas, 75 x 50 in. (190.5 x 127 cm).
The Museum of Modern Art, New York,
Gift of Philip Johnson, 1998

PLATE 161
PABLO PICASSO, *The Shadow*, 1953. Oil
and charcoal on canvas, 51 x 30 3/16 in.
(129.5 x 76.6 cm). Musée National
Picasso, Paris

PLATE 162
JASPER JOHNS, *Fall*, 1986. Encaustic on canvas, 75 x 50 in. (190.5 x 127 cm). Collection of the artist

PLATE 163
JASPER JOHNS, *Study for "Fall,"* 1986.
Watercolor on paper, 17 3/8 x 21 1/4 in.
(44.1 x 54 cm). Collection of Barbaralee
Diamonstein and Carl Spielvogel

PLATE 164
JASPER JOHNS, *Untitled*, 1992–94.
Encaustic on canvas, 78 1/2 x 118 3/8 in.
(199.4 x 300.7 cm). Collection of Eli and
Edythe L. Broad

PLATE 165
JASPER JOHNS, *Untitled*, 1998. Ink and
graphite on paper glued to backing sheet,
41 x 25 in. (104.1 x 63.5 cm). Collection
of the artist

PLATE 166
JASPER JOHNS, *Untitled*, 1998. Ink on
paper glued to backing sheet, 41 x
25 3/16 in. (104.1 x 64 cm). Collection of
the artist

PLATE 167
JASPER JOHNS, *Pyre*, 2003. Encaustic
on canvas with wood slat and hinge,
66 1/2 x 44 1/8 x 2 1/8 in. (168.9 x 112.1 x
5.4 cm). Private collection

PLATE 168
JASPER JOHNS, *Pyre 2*, 2003. Oil on canvas
with wood slat, string, and hinge, 66 1/4 x
44 x 6 3/4 in. (168.3 x 111.8 x 17.1 cm).
Private collection

profiles of Duchamp and Picasso in *Fall,* and he added another reference to Picasso: the attenuated, almost limp figure of Icarus plummeting from the sky in Picasso's *Fall of Icarus* (1958).[164] For this appearance, Johns reversed the headlong drop of Picasso's figure, rotating it ninety degrees so that it stands upright and placing it in the closing panels, *Fall* and *Winter.* This new version of *The Seasons* returns in one of Johns's largest and most layered paintings of the 1990s, *Untitled* (1992–94; plate 164), a composition that combines Johns's recollection of the floor plan of one of his childhood homes with one of his designs based on *Woman in a Straw Hat with Blue Leaves* and motifs from his earlier art.[165] Overlaid with a wide plunging arrow and smaller circling lines, the cruciform is stripped down to a few images (primarily the child, the ladder, and Icarus) and is rotated forty-five degrees on its axis, as if spinning in the direction of the vectors and outstretched fingers of the tumbling figure. Near the center of the painting, Johns's handprint anchors the kaleidoscopic effect.[166]

In a series of untitled ink-and-graphite drawings from 1998 (plates 165, 166), Johns elaborated on this austere design, edging closer to a subject that seems to have underlaid the configuration from the beginning and to articulate many of his compositions during at least the preceding fifteen years. Free of arrows, the cruciform stands upright from the bottom of the sheet, surrounded by a nuanced field of dark brushstrokes. It resembles a cross, and this impression is reinforced by the five forms that Johns has drawn on it clearly: three silhouettes from *The Seasons* (Johns's from *Fall* and *Winter* and the boy's from *Spring*), a ladder, and the falling Icarus figure. With the boy positioned vertically at the center and the other two silhouettes laid horizontally, the three span the width of the cross, like a crucified figure with arms outspread. Since 1981, when Johns began to use motifs from Grünewald's Isenheim altarpiece, he had chosen details of the side panels rather than the central one depicting Christ on the cross attended by Saint John the Baptist, Mary Magdalen, and two other figures. The 1998 drawings do not follow this central panel of Grünewald's triptych, but they do reflect its subject. The blackened silhouette of the boy at the intersection of the cross's arms invokes a theme of innocent sacrifice, which the adjoining outlines of Johns extend into adulthood. Occupying the top of the cross, the ladder seems to serve its traditional function in medieval iconography of suggesting a means of escape (although here without destination), while the limp Icarus figure is suspended (or frozen in mid-fall) against the cross's lower arm.[167] Another drawing in the series (plate 166) is more explicitly expressionistic. Unlike the close-toned planarity of the preceding drawing, this one offers a strong contrast between the white cross bearing outlined silhouettes of the figures and the dark, fluidly brushed space surrounding them. In the midst of this swirling space, a white disk appears behind the cross, and the falling figure, no longer overlapping the cross, is shown twice, as if tumbling toward the ground.

By the late 1990s, Johns had delved into Picasso's imagery for fifteen years, and during those years he had salted his art with more references to Picasso than to any other artist except perhaps Grünewald. Within the tremendous diversity of Picasso's art, Johns had mined a vein of harsh realism about mortality and human suffering that runs throughout the older artist's oeuvre but surfaces

most strongly in the dark wartime work, which Johns had seen at the Ganzes' apartment, and in the final, brutally frank self-portraits.[168] These themes had never been far from the surface of Johns's own art, and are paramount in works such as *Liar* (1961), *Periscope (Hart Crane),* and *Tantric Detail* (1980). Both Grünewald and Picasso must have reinforced Johns's skepticism about the human condition, but Picasso also presented iconographies that bridged the divide between autobiography and humanistic discourse. Particularly in his variations after older art, he conceived fundamental themes of Western art through his personal history, and his work seems to have guided Johns as the younger artist focused his own art more explicitly on himself and on long-standing historical subjects. Johns seems to take Picasso not as a paradigm of style or fame (as he is to many artists) but rather as a sympathetic interlocutor, both opening paths into history and standing as an exemplar of the artist as a self-conscious medium of his time.[169]

Johns's most recent responses to Picasso's work depart from a painting he has known for many years but has not previously addressed. They join the compositions he had developed during the late 1990s with Picasso's *Harlequin* (1915; fig. 123), a painting in the collection of the Museum of Modern Art that is remarkably well suited to Johns's formal structures and is saturated with themes long explored by both artists. While *Pyre* and *Pyre 2* (both 2003; plates 167, 168) may not mark Johns's final engagement with Picasso's art, they would constitute a fitting and somber farewell.

In *Bridge* (1997) and later works, Johns stripped his painted surfaces of most imagery, instead making them a backdrop for a string that rises in a catenary arc from the lower left of the canvas to a hinged slat that protrudes from the upper right.[170] Spanning the canvas, the string traverses a disparate set of visual references, ranging from celestial bodies to abstract patterns, without touching them or physically uniting the painted field. Among the few images populating the nuanced ground are the cloth that Johns derived in the early 1980s from Picasso's "Weeping Woman"

FIG. 123
PABLO PICASSO, *Harlequin,* 1915. Oil on canvas, 72 1/4 x 41 3/8 in. (183.5 x 105.1 cm). The Museum of Modern Art, New York, Acquired through the Lillie P. Bliss Bequest

prints[171] and a band of abutting diamond shapes along the right edge of the canvas. Particularly when paired in some works with the outline of a dragon (which Johns said he based on a Chinese costume he had seen as a child), the pattern of bright, multicolored diamonds has suggested to several critics the traditional dress of Harlequin, the commedia dell'arte performer portrayed by Cézanne and Picasso, among many other artists.[172] (While Johns accepts the association of the pattern with Harlequin, he denies that he was thinking of Picasso's pictures in particular.)[173] In one work from the series, *Catenary* (1998)—subtitled "I Call to the Grave," a phrase stenciled across the bottom edge of the canvas along with Johns's name and the painting's date—the interplay among the separate zones of the painting and the suspended string suggests an elegiac dissolution. The string rises across a deep gray expanse of encaustic, inflected only by heavily worked brushstrokes until the zone blends with a band of diamonds that Johns has overpainted with grays so that they nearly disappear into the field.

As Johns elaborated the series into the first years of the twenty-first century, he turned to Picasso's *Harlequin*, not one of the well-known pictures of the Blue and Rose Periods but Picasso's major Cubist painting of the subject.[174] As an itinerate artist on the fringe of society, Harlequin charts a legacy of melancholic estrangement, one that Picasso portrayed one hundred years ago in a number of watercolors and oils of circus performers. His largest canvas in the group, *The Family of Saltimbanques* (1905), casts Picasso, his friends (the writers Guillaume Apollinaire, Max Jacob, and André Salmon), and his lover Fernande Olivier as a troupe resting on a desolate plain. Next to Apollinaire's *saltimbanque* and Salmon's clown, Picasso assumes the towering figure of Harlequin, an alter ego he used often in his early work and made explicit in *At the Lapin Agile* (1905), which shows him wearing Harlequin's costume and seated next to a woman at a bar.[175] His *Harlequin* of 1915 intensifies these themes, a shift to be understood in the context of the harrowing events that he and other Europeans experienced during World War I.[176] Picasso folded the chaos and violence of the war into the events of his life: the fatal illness of his then lover Eva Gouel, and the apparent collapse of the art world at the beginning of hostilities.[177] Despite Harlequin's brilliantly colored costume, his body is dismembered, his head being reduced to a gruesome black knob, his mouth to a toothy grin, and his hands to tiny claws as he pitches back and forth against a black background in a dance of death.

Harlequin returns us to the years when Marius de Zayas was beginning to show Picasso's Synthetic Cubist paintings at the Modern Gallery in New York, and when Max Weber was becoming the first of a succession of American artists, particularly Stuart Davis, who based their art on the tightly articulated planes of these pictures. *Harlequin* also presents a reminder of how deeply rooted in modernist traditions Johns's art appears to be. The painting's background of even black, and its array of solidly colored rectangles abutting and overlapping in the shallowest of pictorial spaces, are remarkably similar to the structures Johns has employed since the early 1980s.[178] By comparison, Johns's paintings actually seem to include a greater illusion of depth and light.

Johns's *Pyre* and *Pyre 2* do not directly appropriate these characteristics of Picasso's picture. Although lacking the curving

string of *Bridge* and following works, the structures of the *Pyres* are closely related to these paintings; they too involve a fragile spanning of disparate things. Rendered in a warm, golden-toned encaustic, *Pyre* rearranges the horizontal spread of the "Bridge" series into a vertical stack, with the abstract field standing above a band of Harlequin's diamonds at the bottom of the canvas. As the curve of the costume's belt demonstrates, this Harlequin is clearly based on Picasso's painting of 1915, and Johns has adapted Picasso's radical reduction of Harlequin's torso and legs to an open-ended rectangle covered with diamonds. In *Pyre*, Johns has pressed the legs together until only a thin line divides them, and he has subdued the diamond facets to either yellowish white or tones of blue and black, making a nearly solid zone across the lower canvas. Above this, a narrow band of letters, stenciled in alphabetical order, separates Harlequin from the field covering the remainder of the canvas. Two more elements complete the composition: a small rectangle reproducing in black and white the central intersection of Harlequin, alphabet, and field, and a thin wooden slat, which is hinged directly above the letters at the center of the canvas and extends upward to the top edge of the picture, painted to match the adjoining field but tilting slightly away from its surface.

With its palette reduced to black, white, and gray, and less translucent oil substituted for encaustic, *Pyre 2* is a more somber painting, and in certain ways more integrated. More closely following the schema of Picasso's *Harlequin*, Johns included between the figure's legs a rectangular space that approximates the width of both the parallel band of letters and the perpendicular wooden slat.[179] The separation between figure and field is less distinct, since the upper part of the painting is also divided into zones of black or white and contains both a detail of the lower composition (this time reversed) and a triangle that presumably derives from Harlequin's diamonds. Now lapping across the three vertical zones (at the level of Harlequin's belt), the wooden slat is hinged from the bottom of the canvas and dangles a string toward the ground.

Despite these modifications, the two paintings are not variations but a pair, a set that moves from the tawny hues of Picasso's Cubist figure to his painting's jet-black background, and from its sparse collection of rectilinear elements to an intricate orchestration of jostling parts. Within this formal dialogue, the primary focus seems to be the interplay of cardinal axes. Reinforcing its central figure, Picasso's painting is monumentally vertical, in both its height of six feet and its unusually narrow width. Johns's canvases are less exaggeratedly upright (shorter by half a foot and wider by a few inches) to accommodate the costume draped across their lower range. While this band of diamonds evokes a cascade of associations—extending from the many representations of Harlequin to the flagstones Johns has painted since the 1970s—it does not lose touch with Picasso's macabre, mournful image of 1915. Harlequin lies encased under a layer of language and an abstract field, itself divided by the hinged slat and the repetition of the painting's awkward nexus. Guided by Johns's titles, it is impossible to avoid picturing a body laid on a bonfire. A century after Americans' first encounter with Picasso's art and more than thirty years after Picasso's death, his art remains potent tinder for these two *Pyres* of "fire" and "ash."[180]

NOTES

CHAPTER ONE

1. This account of Max Weber's career draws extensively on the scholarship of Percy North, particularly *Max Weber: The Cubist Decade, 1910–1920* (Atlanta: High Museum of Art, 1991); "Turmoil at 291," *Archives of American Art Journal* 24, no. 1 (1984): 12–20; and "Bringing Cubism to America: Max Weber and Pablo Picasso," *American Art Journal* (Fall 2000): 59–77. North has also generously shared her extensive knowledge of Weber's work and aided our research for this publication and exhibition. Weber's typescript memoir "The Reminiscences of Max Weber" (1958) is preserved in the Oral History Research Office of Columbia University and offers invaluable information about the period.

2. See Frances Weitzenhoffer, *The Havemeyers: Impressionism Comes to America* (New York: Harry N. Abrams, 1986).

3. Our research is especially indebted to the remarkable work that Sarah Greenough and her colleagues presented in *Modern Art and America: Alfred Stieglitz and His New York Galleries* (Washington, D.C.: National Gallery of Art, 2000). On the Cone sisters' collecting, see Brenda Richardson, *Dr. Claribel and Miss Etta: The Cone Collection of the Baltimore Museum of Art* (Baltimore: Baltimore Museum of Art, 1985). Richardson's chronology of the collection states that the Cones bought their first works by Picasso on November 2, 1905 (apparently a drawing and an etching), and the first by Henri Matisse ("two drawings") on January 15, 1906. Later in 1906 they bought other works on paper by Picasso and Matisse, particularly "11 drawings 7 etchings" by Picasso on March 3. They bought another Picasso drawing on January 7, 1908, and then no more of his work until the 1920s, when their collecting greatly increased, and they bought a few of his paintings and sculpture as well as drawings. Their purchases during the period 1905–8 seem to have been relatively minor works, mostly sketches rather than finished drawings. During the 1920s, the Cones acquired many of Matisse's paintings and sculptures, but they may have made their first purchase of one of his paintings in 1906. There is no documentation of the purchase, however, and circumstantial evidence is contradictory; see Richardson, p. 158 (n. 35) and p. 168.

4. See North, "Bringing Cubism to America" (see n. 1 above), p. 61, for documentation of the collection.

5. These reproductions were donated by the artist's daughter, Joy Weber, to the archive of the Museum of Modern Art.

6. Preserved in the archive of the Musée Picasso, Paris, this correspondence is transcribed and translated into English in North, "Bringing Cubism to America" (see n. 1 above), pp. 64, 68.

7. See Pierre Daix and Joan Rosselet, *Picasso: The Cubist Years. A Catalogue Raisonné of the Paintings and Related Works* (Boston: New York Graphic Society, 1979), p. 229.

8. For Picasso's series of paintings on panel (27 x 21 cm), see ibid., p. 227. The table depicted in the painting owned by Weber appears to be shown in a painting dated by Daix to spring–summer 1908 (D.173), and the covered jar in Weber's painting seems to be depicted in D.226 (dated by Daix "spring 1909 (?)"). The still life owned by Weber does not appear in either Daix's catalogue raisonné or the one compiled by Christian Zervos (beginning in the 1920s). Since there is no record of this painting being shown or reproduced until 2000, it is unlikely that either author knew of its existence.

9. In a typescript dated September 7, 1942, Weber wrote, "In November 1908 I visited Picasso. . . . Two or three weeks after that visit, Picasso came to see me in my studio in the rue Belloni." Artist's File, Whitney Museum of American Art, n.p.

10. Rousseau, card to Weber, March 20, 1909, quoted in North, *Max Weber: The Cubist Decade* (see n. 1 above), p. 68.

11. Gertrude Stein, *The Autobiography of Alice B. Toklas*, 1933 (reprint ed. New York: Vintage, 1990), p. 67. Although Stein did not name Weber, her description undoubtedly refers to him: "One of the americans under the plea of poverty was receiving his tuition for nothing and then was found to have purchased for himself a tiny Matisse and a tiny Picasso and a tiny Seurat. This was not only unfair, because many others wanted and could not afford to own a picture by the master and they were paying their tuition, but since he also bought a Picasso, it was treason." There is no evidence that Weber owned a work by Seurat, but Stein could easily have misremembered. She wrote the book in 1932.

12. On the Steins and their circle, see Margaret Potter, Irene Gordon, and Leon Katz, *Four Americans in Paris: The Collection of Gertrude Stein and Her Family* (New York: Museum of Modern Art, 1970), and Gail Stavitsky, *Gertrude Stein: The American Connection* (New York: Sid Deutsch Gallery, 1990).

13. Weber, "Reminiscences" (see n. 1 above), pp. 73–74.

14. Ibid.

15. Leo Stein, letter to Mabel Weeks, November 29, 1905, in the Gertrude Stein Collection, Beinecke Library, Yale University; quoted in Penelope Niven, *Steichen: A Biography* (New York: Clarkson Potter, 1997), p. 228.

16. For an account of the liquidation of the collection in the 1960s, see Russell Lynes, *Good Old Modern: An Intimate Portrait of the Museum of Modern Art* (New York: Atheneum, 1973), p. 307, and David Rockefeller's recollection "The Gertrude Stein Collection," in Kirk Varnedoe, *Masterpieces from the David and Peggy Rockefeller Collection: Manet to Picasso* (New York: Museum of Modern Art, 1994), pp. 96–97.

17. Stavitsky, *Gertrude Stein*, pp. 7–28 (see n. 12 above).

18. Howard Greenfeld, *The Devil and Dr. Barnes: Portrait of an American Art Collector* (New York: Viking, 1987), p. 45.

19. Gertrude Stein, quoted in Stavitsky, *Gertrude Stein* (see n. 12 above), p. 6.

20. Daix cites this painting as having been shown in the Armory Show. See Daix and Rosselet, *Picasso: The Cubist Years* (see n. 7 above), D.211.

21. On Edward Steichen's activities in Paris, see Niven, *Steichen: A Biography* (see n. 15 above), and Steichen, *A Life in Photography* (New York: Doubleday, 1963).

22. Steichen, quoted in Greenough, ed., *Modern Art and America* (see n. 3 above), pp. 83–84.

23. Steichen, quoted in Niven, *Steichen: A Biography* (see n. 15 above), p. 235.

24. Niven, *Steichen: A Biography* (see n. 15 above), 289; Niven dates Steichen's letter to summer 1908.

25. On these developments in New York and the "Ash Can" artists, see Barbara Haskell, *The American Century: Art and Culture 1900–1950* (New York: Whitney Museum of American Art, in association with W.W. Norton, 1999), pp. 91–92.

26. Stieglitz, letter to Edith Halpert, December 20, 1930, transcribed in North, *Max Weber: The Cubist Decade* (see n. 1 above), p. 16.

27. Ibid.

28. Stieglitz, quoted in Dorothy Norman, *Alfred Stieglitz: An American Seer* (New York: Random House, 1973), pp. 97–98.

29. Ibid.

30. Stieglitz's account is quoted in North, *Max Weber: The Cubist Decade* (see n. 1 above), p. 16.

31. Gelett Burgess, "The Wild Men of Paris," *Architectural Record*, May 1910, pp. 401–14.

32. The likelihood of Weber having relied on this reproduction of Braque's drawing was noted long ago by Jack Lane in "The Sources of Max Weber's Cubism," *College Art Journal*, Spring 1976, p. 233.

33. Weber's account is in his "Reminiscences" (see n. 1 above); Stieglitz's is in a letter to Edith Halpert, December 20, 1930, printed in North, "Turmoil at 291" (see n. 1 above), pp. 16–20.

34. Weber, "Reminiscences" (see n. 1 above), p. 103.

35. Quoted in North, *Max Weber: The Cubist Decade* (see n. 1 above), p. 19.

36. Weber, "Reminiscences" (see n. 1 above), p. 103.

37. Steichen, quoted in North, *Max Weber: The Cubist Decade* (see n. 1 above), p. 15; Weber was known for being critical of other artists' work. In his letter to Halpert, Stieglitz wrote, "Many of the insiders threatened to withdraw from 291 if I continued to give Weber the privilege of arrogantly denying the validity of everybody's work but Cézanne's, Henri Rousseau's and his own."

38. Steichen, letter to Stieglitz, 1911, quoted in Niven, *Steichen: A Biography* (see n. 15 above), p. 345.

39. This discussion of Marius de Zayas's involvement relies on his own account and on the invaluable research of Francis M. Naumann. See de Zayas, *How, When, and Why Modern Art Came to New York*, ed. Naumann (Cambridge, Mass.: M.I.T. Press, 1996). Naumann has donated to the library of the Whitney his extensive photocopies of documents in the collection of the de Zayas family (Seville, Spain). These materials are available to scholars at the Whitney.

40. De Zayas, letter to Stieglitz, October 28, 1910, in ibid., p. 157.

41. De Zayas, "The New Art in Paris," *Camera Work*, April–July 1911, pp. 29–34, reprinted in ibid., p. x.

42. De Zayas, letter to Stieglitz, October 28, 1910, in ibid., p. 157.

43. These drawings are reproduced in de Zayas, *How, When, and Why* (see n. 39 above), pp. 135–36.

44. De Zayas, letter to Stieglitz, January 25, 1911, in ibid., pp. 160–61.

45. *Camera Work*, April–July 1911, pp. 65–67.

46. See Charles Brock, "Pablo Picasso: An Intellectual Cocktail," in Greenough, ed., *Modern Art and America* (see n. 3 above), pp. 117–25. My sincerest thanks to Brock for patiently answering my many questions about the exhibition.

47. Ibid., p. 119.

48. De Zayas, *How, When, and Why* (see n. 39 above), p. 21.

49. Steichen, letter to Stieglitz, 1911, Beinecke Library, Yale University, leaf 347.

50. Greenough, ed., *Modern Art and America* (see n. 3 above), pp. 120–21.

51. Quoted in ibid., pp. 121–23.

52. Quoted in ibid., p. 122.

53. Stieglitz, letter to de Zayas, April 4, 1911, in de Zayas, *How, When, and Why* (see n. 39 above), p. 162.

54. See Norman, *Alfred Stieglitz: An American Seer* (see n. 28 above), p. 108. In 1910, Mrs. George Blumenthal (wife of a longstanding President of the Metropolitan Museum of Art in New York) purchased three drawings by Matisse from Stieglitz's second exhibition of Matisse's work and donated them to the Metropolitan; these were probably the first works by Matisse to enter a public collection in the U.S. As Alfred Barr

recounted (based on an account given by Stieglitz to Dorothy Norman): "Briefly, Mrs. Blumenthal asked [Stieglitz] the price of a drawing. Stieglitz informed her they were a hundred francs—twenty dollars—apiece. She picked out three, but Stieglitz, with his quixotic contrariness, refused to let her buy them, thinking she would take them home to hang in her great mansion full of Gothic and Renaissance art. When she explained that she intended to give them to the Metropolitan Museum, Stieglitz was dumb-founded. 'What, the Metropolitan Museum of Art! Why, they'll never accept them.' Mrs. Blumenthal drew herself up proudly. 'The Museum will take what I offer it,' she said. In that case, at least, the Museum did accept and furthermore hung the acquisitions for a while, for Stieglitz saw them there during the following year (Alfred H. Barr, *Matisse: His Art and His Public* [New York: Museum of Modern Art, 1951], p. 115). Apparently, Mrs. Blumenthal took no interest in Picasso's drawings when Stieglitz exhibited them in 1911 (the year in which the Matisse drawings hung in the Metropolitan's galleries), but the episode may have encouraged him to recommend that the Met's curator, Bryson Burroughs, purchase the Picassos at 291 for the museum's collection.

55. John Rewald, *Paul Cézanne: The Watercolors. A Catalogue Raisonné* (Boston: Little, Brown, 1983), p. 146.

56. Although contemporary accounts do not specify that the show included these works, the reviews are far from exhaustive, and the cluster of drawings by Marsden Hartley, Arthur Dove, and Weber is so consistent and unprecedented that a source in Picasso's work is extremely likely.

Among the works by Picasso that may have been included in the exhibition is *Landscape (Two Trees)* (1908; Daix 179), which appeared in the Armory Show in New York in 1913. The artist and collector Arthur B. Davies purchased the gouache from this exhibition, and it was later acquired by the Philadelphia Museum of Art.

57. Hartley, letter to Stieglitz, July 1912, quoted in Jonathan Weinberg, "Marsden Hartley: Writing on Painting," in Elizabeth Mankin Kornhauser, ed., *Marsden Hartley* (Hartford: Wadsworth Atheneum Museum of Art, and New Haven: Yale University Press, 2002), p. 125.

58. Ibid.

59. Walkowitz's untitled drawing in the collection of the Whitney is one of these problematic works. Although Walkowitz inscribed it "1908," it almost certainly dates from the mid-teens. See Michael FitzGerald, *Picassoid*, exh. brochure (New York: Whitney Museum of American Art, 1995), n.p., n. 9.

60. I am greatly indebted to William Agee for his generous advice about the careers of Dove and his contemporaries in America. Agee is preparing a study that will discuss Dove's interest in Picasso.

61. See Anne Lee Morgan, *Arthur Dove: Life and Work. With a Catalogue Raisonné* (Newark: University of Delaware Press, and London: Associated University Presses, 1984), pp. 40–41, for a discussion of the chronology of the series. See also William Inness Homer, "Identifying Arthur Dove's 'The Ten Commandments,'" *American Art Journal* (1980), pp. 21–32. In *Alfred Stieglitz and the American Avant-Garde* (Boston: New York Graphic Society, 1977), p. 113, Homer stated regarding the development of the series, "There is every possibility that Dove gained a knowledge of Picasso's work from his exhibition at 291 in March and April 1911."

62. Weber, quoted in Homer, *Alfred Stieglitz and the American Avant-Garde* (see n. 61 above), p. 114.

63. For a relevant work by Konrad Cramer, see *Improvisation #1* (1912) in the collection of the Whitney.

64. For documentation of works by Picasso shown in the Armory Show, see Milton W. Brown, *The Story of the Armory Show* (New York: Abbeville, 1988), pp. 301–2.

65. Brown, in ibid., has only been able to establish that the two pictures were still lifes painted in oil. The Steins are known to have owned three works that might fit this description: D.203, 206, and 211 (the latter being the largest, and cited by Daix as having been included in the exhibition). See *Picasso: The Cubist Years* (see n. 7 above), pp. 229–30.

66. *Head of Man with Moustache* (1912; D.468) was shown at the Grafton exhibition and may have been the painting included in the Armory Show. See ibid., p. 279.

67. See Francis M. Naumann, *Conversion to Modernism: The Early Work of Man Ray* (New Brunswick: Rutgers University Press, 2003), pp. 96–101.

68. Ibid., p. 44.

69. Ibid., pp. 46–47.

70. *Head of a Woman in a Mantilla* (1909; D.293).

71. Because this collaboration occurred in France and had no substantial effect on contemporary art in America, it falls outside the boundaries of this study. On January 3, 1934, Picasso drew a portrait of Man Ray (Zervos.VIII.165). In 1937, the leading French journal *Cahiers d'art* published Man Ray's article on Picasso's photographs, "Picasso photographe," pp. 168–78. For the context of Picasso's photographic work in the 1920s and '30s, see Anne Baldassari, *Picasso and Photography: The Dark Mirror* (Houston: Museum of Fine Arts, 1997), pp. 189–214.

CHAPTER TWO

1. Milton Brown, *The Story of the Armory Show* (New York: Abbeville, 1988), pp. 118, 214, 217.

2. Two public European museums offered some inspiration for Americans who sought to create museums of modern art in the U.S.: the National Gallery of British Art in London (better known as the Tate Gallery) and the Musée du Luxembourg in Paris. Opened in 1897, the Tate was devoted to modern British art (defined as works by artists born after 1790), and in 1917 it also took charge of the national collection of international modern art; however, the British establishment's very limited acceptance of art by the mainstream of modern artists made the collection relatively insignificant and the program largely irrelevant. The Musée du Luxembourg, created in 1818 by Louis XVIII to display work by living artists, barely acknowledged the Impressionists and succeeding modern artists. The museum's efforts, in 1894, to refuse Gustave Caillebotte's bequest of Impressionist paintings became a marshalling cause for those who believed modern art belonged in public collections, but did not substantially change the policy of the museum; see Anne Distel, *Impressionism: The First Collectors* (New York: Harry. N. Abrams, 1990, pp. 252–63). At the time of the International Exhibition of Modern Decorative Arts in Paris in 1925, however, plans began to take shape for a museum devoted to modern and contemporary art (these developments have received little study, and it is not clear whether there was any relationship between these plans and contemporaneous events in the U.S.). In 1937, a new building intended to house a museum of modern art finally opened in Paris, but World War II delayed the program. No substantial effort to build a collection or exhibition program began until 1947, when, as Alfred Barr noted, "the French Government, after decades of neglect and delay, made a real effort to make up for lost time in purchasing representative groups of paintings by Matisse, Rouault and Braque. For this purpose, Georges Salles, the progressive new Director-General of the museums of France, secured considerable funds and gave his full support to Jean Cassou, the enlightened Curator-in-Chief of the Musée National d'Art Moderne. This new institution, which now superseded the old Musée Luxembourg, was housed in the Palais de New-York, a wing of the huge Palais de Chaillot originally built for the Paris Exposition of 1937"; Barr, *Matisse: His Art and His Public* (New York: Museum of Modern Art, 1951), p. 260. In May 1947, Picasso acquiesced to Cassou's requests for donations by giving ten paintings to the Musée National d'Art Moderne. Aside from a 1901 Picasso portrait of critic and collector Gustave Coquiot (donated to the Luxembourg by Coquiot's widow), there were only two works by Picasso in French public collections (both in the Grenoble museum). For Cassou's negotiations with Picasso, see Françoise Gilot and Carlton Lake, *Life with Picasso* (New York: McGraw-Hill, 1964), pp. 198–203.

3. Alfred Stieglitz, letter to Sadakichi Hartmann, December 22, 1911, quoted in Dorothy Norman, *Alfred Stieglitz: An American Seer* (New York: Aperture Press, 1973), pp. 109–10.

4. Ibid.

5. Francis Picabia, quoted in Sarah Greenough, ed., *Modern Art and America: Alfred Stieglitz and His New York Galleries* (Washington, D.C.: National Gallery of Art, 2001), p. 135.

6. Marius de Zayas, letter to Stieglitz, June 3, 1914, in de Zayas, *How, When, and Why Modern Art Came to New York*, ed. Francis Naumann (Cambridge, Mass.: M.I.T. Press, 1996, p. 172.

7. Ibid.

8. De Zayas, letter to Stieglitz, July 10, 1911, in ibid., p. 164.

9. De Zayas, letter to Stieglitz, May 22, 1914, in ibid., pp. 169–70.

10. De Zayas, letter to Stieglitz, May 26, 1914, in ibid., pp. 170–71.

11. On Robert Coady, see Judith K. Zilczer, "Robert J. Coady, Forgotten Spokesman for Avant-Garde Culture in America," *American Art Review*, November–December 1975, pp. 77–89. Michael Brenner's correspondence with Picasso is preserved in the Archive of the Musée

Picasso, Paris. John Richardson, in *A Life of Picasso* (New York: Random House, 1996), vol. 2, p. 296, has proposed that in 1914–15 Picasso lent Coady and Brenner *Young Woman*, his major painting of 1914, which de Zayas certainly showed at the Modern Gallery in December 1915. This suggestion seems to be based on a misreading of a letter from Picasso to de Zayas of September 14, 1916, in which Picasso wrote, "I have sold the portrait that I had in America, of a woman in front of a chimney seated in an armchair with a feather boa, and for the price I was asking"; see de Zayas, *How, When, and Why* (see n. 6 above), p. 224. In discussing the painting he "had in America," Picasso is almost certainly referring to the exhibition at the Modern Gallery. Moreover, it seems unlikely that Picasso sent Coady and Brenner such an important painting. Without describing them, de Zayas stated that the Washington Square Gallery did exhibit some of Picasso's paintings in 1915 (ibid., p. 71). Presumably this exhibition would have taken place in the late winter or spring of 1915, after Picasso consigned the four paintings to them in February.

12. Stieglitz, letter to de Zayas, June 3, 1914, in de Zayas, *How, When, and Why* (see n. 6 above), p. 172.
13. De Zayas, letter to Stieglitz, May 26, 1914, in ibid., pp. 170–71.
14. Stieglitz, letter to de Zayas, June 9, 1914, in ibid., p. 174.
15. De Zayas, letter to Stieglitz, June 11, 1914, in ibid., p. 177.
16. Ibid.
17. Stieglitz, letter to de Zayas, June 22, 1914, in ibid., p. 178.
18. Sarah Greenough, *Alfred Stieglitz: The Key Set* (Washington, D.C.: National Gallery of Art, 2002), p. xxxi. My thanks to Greenough for discussing with me her analysis of Stieglitz's work.
19. Ibid., pp. xxvi, xxx.
20. See ibid., p. xxvi. Greenough also cites possible sources in *The Mill at Horta* (1909), which was reproduced in *Camera Work* in 1912.
21. Ibid., p. xxxii. Strand's most innovative photos probably date from 1915. On Charles Sheeler's photographs, see Theodore Stebbins et al., *The Photography of Charles Sheeler* (Boston: Bulfinch Press, 2002), pp. 9–13. De Zayas particularly acclaimed the photographs Sheeler took of the house he rented in Bucks County, Pennsylvania, in 1915–17: "It was Charles Sheeler who proved that cubism exists in nature and that photography can record it," he wrote, and he explicitly cited a source in Picasso's Cubism. De Zayas, *How, When, and Why* (see n. 6 above), pp. 34–35. De Zayas held an exhibition of Sheeler's photographs at the Modern Gallery, December 3–15, 1917.
22. De Zayas, letter to Stieglitz, July 9, 1914, in de Zayas, *How, When, and Why* (see n. 6 above), p. 184.
23. Stieglitz, letter to de Zayas, July 7, 1914, in ibid., p. 182. This letter predates de Zayas's, above, because Stieglitz had already heard about the purchase: "Mrs. Meyer wrote to me that she had seen you and that she had bought a Picasso."
24. Ibid.
25. Pepe Karmel, "Francis Picabia, 1915: The Sex of a New Machine," in Sarah Greenough, ed., *Modern Art and America* (see n. 5 above), pp. 185–202.
26. Ibid., p. 191.
27. De Zayas, letter to Stieglitz, June 30, 1914, in de Zayas, *How, When, and Why* (see n. 6 above), p. 180.
28. De Zayas, ibid., p. 41.
29. Ibid.
30. Stieglitz, letters to de Zayas, August 26, 1915, in ibid., pp. 188, 189.
31. De Zayas, letter to Stieglitz, August 27, 1915, in ibid., p. 190.
32. For an account of the effect of World War I on Daniel-Henry Kahnweiler's gallery and some of his artists, see Michael FitzGerald, *Making Modernism: Picasso and the Creation of a Market for Twentieth-Century Art* (New York: Farrar, Straus and Giroux, 1995), pp. 47–79.
33. De Zayas, letter to Stieglitz, August 27, 1915, in *How, When, and Why* (see n. 6 above), p. 191.
34. Ibid., p. 93.
35. "Advanced Modern Exhibit," *New York Press*, October 11, 1915, photocopy of clipping in De Zayas Papers, Whitney Museum of American Art Archive,

gift of Francis Naumann.
36. *New York Press*, December 1915, photocopy of clipping in De Zayas Papers, Whitney Museum of American Art Archive, gift of Francis Naumann.
37. Anonymous, "Picasso's Here, and 'Hark, Hark!' Dogs Do Bark,'" *The Evening World*, December 18, 1915.
38. "Picasso at the Modern Gallery," *New York Times*, January 16, 1916, photocopy of clipping in De Zayas Papers, Whitney Museum of American Art Archive, gift of Francis Naumann. Elizabeth Luther Carey wrote many art reviews for the *Times* in these years; she was probably the author of this piece.
39. "Paintings by Picasso in New Color Scheme," *New York Press*, photocopy in De Zayas Papers, Whitney Museum of American Art Archive, gift of Francis Naumann.
40. Albert Gleizes and his wife, Juliette Roch, arrived in New York in September 1915. Max Weber attended the welcoming dinner, organized by Marcel Duchamp and held a few days after their arrival. See Francis M. Naumann, *New York Dada 1915–23* (New York: Harry N. Abrams, 1994), pp. 96–97. On the broad influence of Cubism on American art in this period, see *Inheriting Cubism: The Impact of Cubism on American Art, 1909–1936* (New York: Hollis Taggart Galleries, 2001).
41. In an undated letter from Brenner to Picasso, the paintings are described as "a painted composition on wood, a painting of a nude on canvas, a painting of a portrait on canvas, a painting of a man's head on canvas," each with a price of 5,000 francs. Archive, Musée Picasso, Paris.
42. Alvin Coburn, letter to Weber, April 6, 1915, quoted in Percy North, *Max Weber: The Cubist Decade 1910–1920* (Atlanta: High Museum of Art, 1991), pp. 36–37.
43. Henry McBride, in *The Sun*, December 19, 1915, reprinted in McBride, *The Flow of Art: Essays and Criticisms of Henry McBride*, ed. Daniel Catton Rich (New Haven: Yale University Press, 1997), p. 94.
44. North, *Max Weber: The Cubist Decade* (see n. 42 above), p. 40.
45. McBride, quoted in ibid.
46. Ibid.
47. Ibid., p. 95.
48. Weber, quoted in Alfred H. Barr, Jr., *Max Weber, Retrospective Exhibition 1907–1930* (New York: Plandome Press, 1930), p. 18.
49. See FitzGerald, *Making Modernism* (see n. 32 above), pp. 80–85.
50. Stieglitz, letter to Paul Rosenfeld, 1923, quoted in Greenough, ed., *Modern Art and America* (see n. 5 above), p. 280.
51. Judith Zilczer, *"The Noble Buyer": John Quinn, Patron of the Avant-Garde* (Washington, D.C.: Hirshhorn Museum and Sculpture Garden, Smithsonian Institution, 1978), p. 55.
52. Ibid.
53. McBride, *The Flow of Art* (see n. 43 above), pp. 164–65.
54. McBride, *New York Herald*, February 5, 1922, restated in "American Art is 'Looking Up,'" *New York Herald*, October 15, 1922; reprinted in McBride, *The Flow of Art* (see n. 43 above), pp. 163–96. Stuart Davis preserved a clipping of the February 5 article in his notebook of 1920–22 (microfilm copy in Archives of American Art). For an account of nationalism that differs substantially from the account in this book, see Wanda M. Corn, *The Great American Thing: Modern Art and National Identity, 1915–1935* (Berkeley: University of California Press, 1999).
55. Ibid.
56. *Wineglass and Fruit* is Daix.204; Zervos IIa.95.
57. My thanks to Sarah E. Noreika of the Barnes Foundation for generously compiling information about Barnes's collection of Picasso's work.
58. Howard Greenfeld, *The Devil and Dr. Barnes: Portrait of an American Collector* (New York: Viking, 1987), p. 46.
59. Albert Barnes, "Cubism: Requiescat in Pace," *Arts and Decoration*, January 1916, p. 121.
60. De Zayas, *How, When and Why* (see n. 6 above), p. 34.
61. Field, quoted in Doreen Bolger, "Hamilton Easter Field and His Contribution to American Modernism," *The American Art Journal* 20, no. 2 (1988): 87.

62. "Appendix: The Library of Hamilton Easter Field," in William Rubin, *Picasso and Braque: Pioneering Cubism* (New York: Museum of Modern Art, 1989), pp. 63–68. Rubin proposes that *Nude* (1910; National Gallery of Art, Washington, D.C.) was the first painting Picasso executed for the project (p. 64).
63. William Inness Homer, *Alfred Stieglitz and the American Avant-Garde* (Boston: New York Graphic Society, 1977), p. 84.
64. See Andrea Kirsh, *Arthur B. Davies: Artist and Collector* (West Nyack, N.Y.: Rockland Center for the Arts, 1977).
65. According to *The Thannhauser Collection of the Guggenheim* (New York: Guggenheim Museum, 2001), p. 292, the drawing was "probably acquired from the artist by Arthur B. Davies, Nov. 1912," but no evidence is presented.
66. See Pepe Karmel, "Picasso and Georges Braque, 1914–15: Skeletons of Thought," in Greenough, ed., *Modern Art and America* (see n. 5 above), p. 192.
67. De Zayas, *How, When, and Why* (see n. 6 above), p. 94.
68. Francis Naumann, "Walter Conrad Arensburg: Poet, Patron, and Participant in the New York Avant-Garde," *Philadelphia Museum of Art Bulletin*, Spring 1980, pp. 1–32.
69. The primary sources on John Quinn are B. L. Reid, *The Man from New York: John Quinn and His Friends* (New York: Oxford University Press, 1968), and Zilczer, "The Noble Buyer" (see n. 51 above).
70. Quinn, quoted in Zilczer, "The Noble Buyer" (see n. 51 above), p. 33.
71. See ibid., p. 130.
72. Ibid., p. 131.
73. I would particularly like to thank Julia May Boddewyn, who contributed to every aspect of this publication, for bringing to my attention Dikran Kelekian's collection and the exhibition of his collection at the Brooklyn Museum in 1921, neither of which was known to me. Boddewyn's research in the archives of the Brooklyn Museum and her analysis of the events contributed greatly to this presentation.
74. Philip Adams, *Walt Kuhn, Painter: His Life and Work* (Columbus: Ohio State University Press, 1978), p. 151. In an exhibition at the Louvre in February–March 1907 of "oriental velvets, carpets and silks . . . the most comprehensive collection ever presented to the Parisian public," one of the largest lenders to the show was Dikran Kelekian, according to Rémy Labrusse, in his essay "'What Remains Belongs to God': Henri Matisse, Alois Riegl and the Arts of Islam" in *Matisse, His Art and His Textiles: The Fabric of Dreams*, exh. cat. (London: Royal Academy of Arts, 2004), p. 51, and n. 41 on p. 60. My thanks to Joachim Pissarro and Rémi Labrusse for their advice regarding Kelekian's relationship with Matisse.
75. See Henri Matisse, letter to Hans Purrmann, June 1, 1916, in Alfred H. Barr, *Matisse: His Art and His Public* (see n. 2 above), pp. 181–82; this letter records a purchase from Kelekian, which Barr reproduces and includes a sketch of *The Window* (1916), which Kelekian purchased directly from Matisse (as cited in the entry for lot 160 of the Kelekian sale, American Art Association, January 30 and 31, 1922). It is possible that the two met even earlier than 1911, according to Rémi Labrusse, who cites Pierre Matisse dating "his father's encounter with Kelekian to between 1907 and 1912," in *Matisse, His Art and His Textiles* (see preceding note), p. 60 (n. 41).
76. Rona Roob, "A Noble Legacy," *Art in America*, November 2003, p. 75.
77. See FitzGerald, *Making Modernism* (see n. 32 above), p. 110.
78. Henry McBride, "Modern Art," *The Dial*, February 1922, p. 223.
79. McBride's description of the "millionaire" could only be Quinn: "The millionaire, I thought, who would buy these things *en bloc* from Mr Kelekian, should have a happy lot. But it appears that our millionaire—I speak of him as one, for though, it is true, we have millionaires all over the place, there is only one in these sad days who continues to spend huge sums upon art—our millionaire, it appears, refuses to be happy. Perhaps he became piqued, when Mr Kelekian, becoming impatient or, from a dealer's point of view, careless, lent some of his choicest

morsels to the museums temporarily." Ibid., pp. 222–23. Given Quinn's support for the exhibition at the Metropolitan Museum of Art, McBride seems to have misunderstood the situation.

80. Stieglitz, letter to Edward Alden Jewell, December 19, 1939, quoted in Norman, *Alfred Stieglitz: An American Seer* (see n. 3 above), p. 108.

81. Zilczer, *"The Noble Buyer"* (see n. 51 above), p. 32.

82. See *Paintings by Modern French Masters Representing the Post-Impressionists and Their Predecessors* (Brooklyn, N.Y.: Brooklyn Museum, 1921).

83. "Unpublished Manuscript of the Memoirs of Dr. William Henry Fox, 1858–1952," Brooklyn Museum Archives, pp. 417–18. At an unspecified date, Fox proposed that the Metropolitan Museum and the Brooklyn Museum split their coverage of art to reflect the division between the Louvre and the Luxembourg. "I felt that in order to impress the Board of Estimate of the city [the Borough of Brooklyn] and retain our full maintenance appropriation, I had to present the museum in a different guise from that of the Metropolitan. To make our collections the authoritative representation of modern art, with a backing of the artists and friends, would carry much more weight with the authorities than an attempt to repeat the successes of the older institution with the earlier art." Ibid., p. 418.

84. Ibid., p. 407.

85. Hamilton Easter Field, "Modern Art Propaganda and Its Effects: French Show at Brooklyn," *Brooklyn Daily Eagle*, March 27, 1921, p. 7.

86. Louis Bouché, "Art Activities in Post War Paris," *The Arts*, June–July 1921, p. 30.

87. Field, "The Kelekian Collection," *The Arts*, December 1921, pp. 132–48.

88. Ibid., p. 140.

89. Quinn, quoted in Reid, *The Man from New York* (see n. 69 above), p. 548.

90. See *Matisse in Nice* (Washington, D.C.: National Gallery of Art, 1986), p. 248.

91. After the exhibition at the Metropolitan closed, in April 1921, Kelekian's pictures were returned to the Brooklyn Museum. From there, they were sent directly to the American Art Association for auction.

92. My thanks to William Agee for sharing his knowledge of Davis's career with me.

93. Patricia Hills, *Stuart Davis* (New York: Harry N. Abrams, 1996), p. 55.

94. Ibid., p. 48.

95. Davis, notebooks 1920–22 (microfilm in Archives of American Art, New York).

96. Bouché, "Art Activities in Post War Paris" (see n. 86 above), p. 30. Although no collection was listed in the article, Quinn purchased this painting in November 1920, at an auction of art belonging to Léonce Rosenberg. The black-and-white reproduction in the magazine emphasizes the distinct planes and shallow articulation of the painting.

97. Davis, quoted in Avis Berman, *Rebels on Eighth Street: Juliana Force and the Whitney Museum of American Art* (New York: Atheneum, 1990), p. 106.

98. Ibid., pp. 102–4.

99. Leonore Clark, *Forbes Watson: Independent Revolutionary* (Kent, Ohio: Kent State University Press, 2001), p. 36.

100. Ibid., p. 39.

101. Ibid., p. 49.

102. Ibid., p. 53.

103. De Zayas, letter to Stieglitz, August 3, 1922, in de Zayas, *How, Why, and When* (see n. 6 above), p. 208.

104. Field, in an untitled editorial in *The Arts*, October 1921, quoted in ibid., p. 132.

105. Sheeler, letter to de Zayas, November 22, 1920, quoted in ibid., p. 132.

106. De Zayas, letter to Sheeler, February 15, 1923, in ibid., p. 228.

107. De Zayas, "Picasso Speaks," *The Arts*, May 1923, pp. 314–29.

108. A letter from de Zayas to Paul Rosenberg, June 13, 1923, includes a handwritten postscript stating, "Mrs. Picabia informs me that the price of the three sets of reproductions sent to the Whitney Studio on May 20 were increased in price from 300 frs to 500 frs." Photocopy in De Zayas Papers, Whitney Museum of American Art Archive, gift of Francis Naumann.

109. The invoice from the Galerie Paul Rosenberg is dated March 31, 1923. Photocopy in De Zayas Papers, Whitney Museum of American Art Archive, gift of Francis Naumann.

110. Berman, *Rebels on Eighth Street* (see n. 97 above), p. 191.

111. *The Arts*, June 1923, p. iv.

112. Berman, *Rebels on Eighth Street* (see n. 97 above), p. 202.

113. *The Arts*, June 1924, inside front cover.

114. Robert Herbert, ed., *The Société Anonyme and the Dreier Bequest at Yale University: A Catalogue Raisonné* (New Haven: Yale University Press, 1984), p. 191.

115. Gertrude Whitney, quoted in Berman, *Rebels on Eighth Street* (see n. 97 above), p. 191.

116. In ibid., pp. 191–92, Berman states that Force owned this piece "by the mid 1920s." It was sold in the second auction of Kahnweiler's stock (November 17–18, 1921) and possibly bought by the Surrealist poet Phillippe Soupault. Exactly when and where Force acquired it is unknown, although it was in her possession by 1926, when she lent it to the exhibition of modern art that Katherine Dreier organized for the Brooklyn Museum. Force also acquired a bronze *Prometheus* by Constantin Brancusi during these years; ibid.

117. "The Exhibitions," *The Arts*, May 1923, p. 364.

118. De Zayas first published these ideas in 1916. See Rubin, "Picasso," in William Rubin, ed., *"Primitivism" in 20th Century Art* (New York: Museum of Modern Art, 1984), 1:260. Although de Zayas had organized an exhibition of African art for 291 in November 1914 and had shown African objects at his own galleries (see de Zayas, *How, When and Why*, pp. 55–66 [see n. 6 above]), the source of the African pieces exhibited at the Whitney Studio in May 1923 is not known; nor has it been possible to identify the precise works shown there. William C. Siegmann, Curator and Chair of Africa and the Pacific Islands at the Brooklyn Museum of Art, has kindly examined Sheeler's photographs to identify the cultures of the objects. My thanks also to Michelle Gilbert for her aid in identifying the works. Following is a list of the Sheeler photographs and the cultures of the African objects (left to right in the photos); figures 30–33 overlap to show one side of the exhibition space, and figures 34 and 35 apparently show the opposite side of the galleries.
93.23.3 (fig. 30)—Dan Mask, Dan Mask, Kuba Cup, Fang Head
93.23.4 (fig. 31)—Fang Head (also visible in 93.23.3), Dan Mask, Kwele? Mask (more clearly visible in 93.23.2)
93.23.2 (fig. 32)—Kwele? (Gabon) or Congo Brazaville Mask, Dan Mask, Dan Mask (both Dan Masks are also visible in 93.23.1)
93.23.1 (fig. 33)—Dan Mask, Dan/Guere Mask, Fang Figure
93.23.6 (fig. 34)—Dan Mask
93.23.5 (fig. 35)—Guro Mask (Ivory Coast)

119. De Zayas, letter to Paul Rosenberg, June 13, 1923, photocopy in De Zayas Papers, Whitney Museum of American Art Archive, gift of Francis Naumann.

120. Innis Howe Shoemaker, *Mad for Modernism: Earl Horter and His Collection* (Philadelphia: Philadelphia Museum of Art, 1999), p. 101.

121. Reid, *The Man from New York* (see n. 69 above), p. 594.

122. These pochoirs are listed in *The Lillie P. Bliss Collection*, the catalogue of Bliss's bequest to the Museum of Modern Art (published by the Museum in 1934), pp. 82–83. No provenance is given. My thanks to Roob for discussing Bliss with me. Roob's research into Bliss's collection indicates that she made the great majority of her purchases in New York.

123. See Stebbins et al., *The Photography of Charles Sheeler* (see n. 21 above), p. 196.

124. See *The Arts*, June 1923, p. 428, where it is reported as currently hanging.

125. Although Davis dated the painting 1922, he may have made it the following year.

126. John R. Lane, in his exhibition catalogue *Stuart Davis: Art and Art Theory* (Brooklyn: Brooklyn Museum, 1978), p. 100, has proposed that a drawing by Picasso, *Musical Instruments and Score before an Open Window* (1919), may have been a source for Davis's *Super Table*, since it was reproduced in the April 1925 issue of *The Arts*. Although this is possible,

the drawing is also part of the series reproduced in the pochoirs, and the relatively small black-and-white reproduction in the magazine would probably have had little impact on Davis had he not seen the pochoirs at the Whitney Studio. At the time of Lane's writing, the contents of the Whitney exhibition were unknown.

127. Andrew Dasburg, "Cubism—Its Rise and Influence," *The Arts*, November 1923, p. 297.

128. De Zayas, "Negro Art," *The Arts*, March 1923, pp. 199–205.

129. "Picasso Speaks," *The Arts*, May 1923, p. 315.

130. De Zayas, *How, When, and Why* (see n. 6 above), p. 243, note 17.

131. "Picasso Speaks" (see n. 129 above), p. 323.

132. Ibid., p. 326.

133. Richardson, *A Life of Picasso* (see n. 11 above), vol. 2, p. 368, and Hélène Seckel, *Max Jacob et Picasso* (Paris: Réunion des Musées Nationaux, 1994), p. 116.

134. [Probably Carey], "Picasso at the Modern Gallery," *New York Times*, January 16, 1916. Photocopy in De Zayas Papers, Whitney Museum of American Art Archive, gift of Francis Naumann.

135. De Zayas, letter to Picasso, December 16, 1915, in de Zayas, *How, When, and Why* (see n. 6 above), p. 226.

136. One review of the exhibition at the Whitney Studio makes a cryptic reference to a "small group of lithographs that are as close as [Picasso] ever approaches the conservative tradition. The figures are in outline"; "Picasso's Recent Work," *The Art News*, May 12, 1923, p. 2. Since no such images (prints or drawings) are visible either in Sheeler's photographs of the installation or in the documentation of the exhibition, it is unclear what these works may have been. The reviewer may have been referring to the pochoirs in the exhibition, or there may have been other, undocumented works present, perhaps in portfolio, although in that case some documentation would be expected. If these additional works were present, they may have been neoclassical in style, but this single review is not sufficient to justify that conclusion.

137. *Original Drawings by Picasso*, Arts Club of Chicago, March 20–April 22, 1923.

138. Paul Rosenberg, letter to Picasso, December 20, 1923. Archive, Musée Picasso, Paris.

139. Watson, "A Note on Picasso," *The Arts*, December 1923, p. 332.

140. Ibid.

141. One of Quinn's paintings by Picasso, *Two Female Nudes* (1920), was included in a show called "Contemporary French Art" at the Sculptor's Gallery, New York, March 24–April 10, 1922. In his review of the exhibition, McBride called it "the most interesting of French art seen this winter" and reported that "the much talked of 'later phases' of Picasso and Matisse are also in evidence. There will be differences of opinion in regard to these works and the discussions will do good. It is a show that should not be missed." *New York Herald*, March 26, 1922, p. 10. Apparently the exhibition was not as widely noted as McBride believed.

142. Watson, "A Note on Picasso" (see n. 139 above), p. 332. No further discussion was published in *The Arts*, but Leo Stein responded to Picasso's neoclassical work in *The New Republic*, April 23, 1924.

143. Although *Woman in White* was not shown in the 1923 exhibition at Wildenstein, it is part of this series of paintings. Also in the late 1920s, Mary Hoyt Wiborg—the sister of Gerald Murphy—bought one of the paintings that had hung at Wildenstein (*The Lovers*, 1923) and two other paintings by Picasso; see Christian Geelhaar, *Picasso: Wegbereiter und Förderer seines Aufstiegs 1899–1939* (Zurich: Palladion, 1993), p. 178. Murphy and his wife, Sara, were close friends of Picasso in the mid-1920s, and Murphy was one of the most interesting painters of the period. Their relationship with Picasso, and Murphy's production of all of his most significant work, however, took place in France (1921–32). Like much of the career of Man Ray, it therefore lies outside the bounds of this book, which is devoted to American artists who remained, at least primarily, in the United States. Nonetheless, the Murphys and other American expatriates in Europe were another important dimension of American artists' relationship with the international avant-garde. For a recent treatment of Murphy's art, see Elizabeth Hutton

Turner, ed., *Americans in Paris (1921–31): Man Ray, Gerald Murphy, Stuart Davis, and Alexander Calder* (Washington, D.C.: Phillips Collection, 1996).

144. FitzGerald, *Making Modernism* (see n. 32 above), p. 122.

145. For Quinn's account of the situation, see ibid., p. 125.

146. Jeanne Robert Foster, letter to the editor of *The Transatlantic Review*, October 18, 1924, reprinted in Zilczer, "The Noble Buyer" (see n. 51 above), pp. 58–59.

147. Watson, untitled editorial, *The Arts*, January 1926, pp. 3–4. An article on Quinn, "A Modernist Collector" (*The Literary Digest*, August 16, 1924, vol. 62, no. 7, p. 29) quoted a recent piece in the *New York Sun* (probably written by McBride, who was the *Sun*'s regular art reviewer) stating that Quinn's "collection ought to find a home somewhere [in America] in its integrity."

148. Watson, untitled editorial, *The Arts* (see no. 147 above), pp. 3–4.

149. Watson, "The John Quinn Collection," *The Arts*, January 1926, pp. 15–16.

150. On Picasso's portrayal in the press, see Eunice Lipton, *Picasso Criticism, 1901–1939: The Making of an Artist-Hero* (New York: Garland, 1976).

151. Ibid., p. 15.

152. See *The Arts*, February 1927, p. 97.

153. Zilczer proposes that the Cubist work was *Still Life: Bottle, Newspaper and Glass* (1914), now in the collection of the Philadelphia Museum of Art; "The Noble Buyer" (see n. 51 above), p. 130.

154. Ibid., p. 68, n. 43.

155. American museums already owned a small number of his prints and drawings. Further research may locate other Picasso paintings that entered the collections of American museums around this time.

156. On the Detroit Institute of Arts' acquisition, see Margit Hanloser-Ingold, "Collecting Matisses of the 1920s in the 1920s," in Jack Cowart, ed., *Henri Matisse: The Early Years in Nice, 1916–1930* (Washington, D.C.: National Gallery of Art, 1986), p. 248. For American museums' early acquisitions of Picasso's work, see Michael FitzGerald, "America's Embrace of Picasso: Permanent Collections and Ephemeral Histories," in Pepe Karmel, ed., *La época de Picasso: Donaciones a los museos americanos* (Santander: Fundación Marcelino Botín, 2004), pp. 245–55.

157. Courtney Graham Donnell, "Frederic Clay and Helen Birch Bartlett: The Collectors," *The Art Institute of Chicago Museum Studies* 12, no. 2 (1986): 85–102.

158. FitzGerald, "America's Embrace of Picasso" (see n. 156 above), pp. 250–52.

159. *Three Women at the Spring* (1921) went to the Museum of Modern Art, New York, in 1952; *Figure* (1909) went to the Albright-Knox Art Gallery, Buffalo, in 1954; *Mother and Child* (1921) to the Art Institute of Chicago in 1954; *Two Nudes* (1906) to the Museum of Modern Art in 1959; *Harlequin with Violin ("Si Tu Veux")* (1918) to the Cleveland Museum of Art in 1975; and *Still Life* (1914) to the Philadelphia Museum of Art in 1967.

160. Ferdinand Howald's catalogue of his collection records the purchase from Paul Rosenberg, the price of the painting, and the purchase date (the frame cost $27). My thanks to Rod Bouc, director of curatorial operations and chief registrar of the Columbus Museum of Art, for supplying this information.

161. Herbert, ed., *The Société Anonyme* (see n. 114 above), p. 532.

162. In early March 1926, Dreier announced plans for the exhibition to Duchamp. Ibid., p. 7.

163. Ibid., p. 530.

164. n.622.

165. Entry for *Pipe, Glass, and Bottle of Rum* in *An International Exhibition of Modern Art Assembled by the Société Anonyme* (Brooklyn: Brooklyn Museum, 1927), no. 213. In 1927, Dreier bought *Bar-table with Musical Instruments and Fruit Bowl* (ca. 1913) from Davies, who had bought it from de Zayas when it was exhibited at the Modern Gallery in 1915. She had already bought two still lifes from Léonce Rosenberg in 1922. See Herbert, ed., *The Société Anonyme* (see n. 114 above), p. 530. The *International Exhibition* traveled in a reduced form to the Anderson Galleries in Manhattan, the Albright Gallery in Buffalo, and the Toronto Art Gallery. See ibid., pp. 7–12.

166. Henry McBride, "Modern Art," *The Dial*, July

1927, p. 87.

167. Berman, *Rebels on Eighth Street* (see n. 97 above), pp. 243–44, 248. Whitney had made the dismissive remark about Brancusi's sculpture in the wake of the Armory Show.

168. Hills states that the exhibition included forty-three of Davis's paintings; *Stuart Davis* (see n. 93 above), p. 73.

169. Berman, *Rebels on Eighth Street* (see n. 97 above), p. 237.

170. Davis, letter to Edith Halpert, 1953, quoted in Lewis Kachur, *Stuart Davis: An American in Paris* (New York: Whitney Museum of American Art at Philip Morris, 1987), p. 10.

171. Davis, letter to his father, September 17, 1928, quoted in ibid., p. 6.

172. Davis, letter to his father, June 20, 1927, quoted in ibid, p. 6.

173. Ibid., p. 10.

174. The Whitney Studio Club closed on September 7, 1928.

175. Albert Gallatin, statement in the catalogue of the opening exhibition of the Gallery of Living Art, quoted in Gail Stavitsky, "The A. E. Gallatin Collection: An Early Adventure in Modern Art," *Philadelphia Museum of Art Bulletin*, Winter/Spring 1994, p. 12.

176. Ibid., p. 8.

177. Gallatin, letter to McBride, July 1927, quoted in ibid., p. 11.

178. James Johnson Sweeney, quoted in ibid., p. 12.

179. Stavitsky, in ibid., p. 8.

180. Watson, "The Ideal Autocrat," *The Arts*, June 1927, p. 281.

181. See Berman, *Rebels on Eighth Street* (see n. 97 above), p. 265.

182. See Kenneth Silver, "Braque, Picasso and Other Cubists," in Erika D. Passantino, ed., *The Eye of Duncan Phillips* (New Haven: Yale University Press, 1999), pp. 234–35. Duncan Phillips bought *Abstraction, Biarritz* from New York dealer F. Valentine Dudensing in 1927.

183. Quoted in Bennard B. Perlman, *The Lives, Loves, and Art of Arthur B. Davies* (Albany: State Universities of New York Press, 1998), p. 367.

184. Walt Kuhn, "The Story of the Armory Show," *Arts Magazine*, June 1984, p. 141.

185. Elizabeth Bliss Cobb, quoted in Perlman, *The Lives, Loves, and Art of Arthur B. Davies* (see n. 183 above), p. 372.

186. Abby Aldrich Rockefeller, letter to Arthur David Davies, December 18, 1928, quoted in Sybil Gordon Kantor, *Alfred H. Barr, Jr. and the Intellectual Origins of the Museum of Modern Art* (Cambridge, Mass.: M.I.T. Press, 2002), p. 191.

187. In approximately 1938, Kuhn wrote, "For years Davies and the writer urged Miss Lillie Bliss, probably one of the truly disinterested collectors of her time, and a staunch supporter of the Armory Show, to establish just that sort of permanent place for contemporary art [the Museum of Modern Art], but she wasn't ready. After the death of Davies I kept up the pleading. Finally, she decided and called me to steer the ship. I felt it was not my place and turned it over to another [A. Conger Goodyear], who now is doing a good job. Kuhn, "The Story of the Armory Show" (see n. 184 above), p. 141. Although Kuhn may exaggerate his role, in a letter of July 9, 1929, to his wife, Vera, he "took credit for the fact that Goodyear was made chairman of this exploratory committee [for the establishment of MoMA]." See Roob, "A Noble Legacy" (see n. 76 above), p. 80.

188. Abby Aldrich Rockefeller, quoted in Russell Lynes, *Good Old Modern: An Intimate Portrait of the Museum of Modern Art* (New York: Atheneum, 1973), p. 10.

189. Berman, in *Rebels on Eighth Street* (see n. 97 above), p. 261, suggests that Whitney, Force, and Watson had been considering plans for a museum since 1926 or 1927, although Force indicated that they had begun around 1923.

190. According to Lloyd Goodrich's account. See ibid., p. 263.

191. Ibid., p. 264.

192. On the position of the Whitney Museum when it first opened, see Berman, *Rebels on Eighth Street* (see n. 97 above), pp. 278–79; on its position in later years,

see chapters 3 and 4 of this book. On its development away from reliance on the financial support of the Whitney family, see Flora Miller Biddle, *The Whitney Women and the Museum They Made* (New York: Arcade, 1999), pp. 139–72. Criticisms of the Modern's presentation of American art began with the second exhibition it presented, "Paintings by Nineteen Living Americans," in November 1929. See Lynes, *Good Old Modern* (see n. 188 above), pp. 66–72.

193. McBride, quoted in Berman, *Rebels on Eighth Street* (see n. 97 above), p. 272.

194. Davis, open letter to *Creative Art* (a magazine edited by McBride), February 1930, quoted in ibid., p. 273.

CHAPTER THREE

1. Among these last three, both Jules Pascin's *Nude Study* and Puvis de Chavanne's *Female Nude* appeared near the group of Picassos clustered toward the center of the book. Arshile Gorky copied the drawing by Augustus John next to Picasso's *Two Female Nudes*, he seems to have sketched it as a variation on the poses in that painting. According to Matthew Spender and Melvin Lader (in conversations with the author), Gorky's copy of the John Quinn collection catalogue is in the library of his daughter, Maro, and her husband, Spender. This copy contains marginal drawings by Gorky. My thanks to Lader for bringing these drawings to my attention and helping to identify their sources.

2. "Painting in Paris from American Collections" opened at the Museum of Modern Art on January 19, 1930, and was scheduled to close on February 16. Because it proved so popular, the exhibition was extended to March 2.

3. See Michael FitzGerald, *Making Modernism: Picasso and the Creation of a Market for Twentieth-Century Art* (New York: Farrar, Straus and Giroux, 1995), pp. 198–99.

4. Gorky's drawing based on *Woman Reading* is in the collection of the Armenian Diocese of America. My thanks to Lader for bringing this to my attention.

5. Gorky's *Seated Woman with Vase* (ca. 1929; Hirshhorn Museum and Sculpture Garden, Washington, D.C.), for example, is closely based on Picasso's neoclassical paintings, particularly *Three Women at the Spring* (1921; Museum of Modern Art), which was reproduced in the catalogue of the Quinn collection.

6. Avis Berman, *Rebels on Eighth Street: Juliana Force and the Whitney Museum of American Art* (New York: Athenaeum, 1990), p. 210.

7. On John Graham, see Eleanor Green, *John Graham: Artist and Avatar* (Washington, D.C.: Phillips Collection, 1987).

8. Picasso's recent *Harlequin* paintings would include *Harlequin* (1923; Centre Georges Pompidou, Paris) and *Seated Harlequin* (1923; Kunstmuseum, Basel), both of which had appeared in the 1923 exhibition at Wildenstein in New York.

9. Waldemar George, *John Graham* (Paris: Les Editions Trinagle, 1929).

10. On December 8, [1929], Graham wrote to Duncan Phillips, "Do you know William Seabrook? he is the man who [wrote] the 'Magic Island' he used to say in Paris that the next decade will see me as the greatest living painter. Several people wrote me expressing their opinion that they think me being the best living painter. Picasso himself came several times to my exhibition." The correspondence between Graham and Phillips is preserved in the Archives of the Phillips Collection, Washington, D.C.

11. Willem de Kooning, quoted in James T. Valliere, "De Kooning on Pollock," *Partisan Review*, Autumn 1967, pp. 603–5.

12. For example, Graham's *Tribute to Isadore Duncan* (1927), in the Phillips Collection.

13. Graham certainly visited the exhibition "Painting in Paris," since on February 3, [1930], he wrote to Phillips, "I have seen the French show at the Modern Art Museum and found the paintings from your collection are outstanding in quality." Archives, Phillips Collection.

14. On Gorky's life, see Hayden Herrera, *Arshile Gorky: His Life and Work* (New York: Farrar, Straus and Giroux, 2003), and Matthew Spender, *From a High Place: A Life of Arshile Gorky* (New York: Knopf, 1999).

15. Albert Gallatin, quoted in Jacques Mauny, "The Gallery of Living Art," *Gallery of Living Art* (New York: New York University, 1930), p. 12.

16. Graham, letter to Phillips, July 19, [1928], Archives, Phillips Collection.

17. Graham, letter to Phillips, December 28, [1931], Archives, Phillips Collection.

18. Henry McBride, "Attractions in the Galleries," *New York Sun*, April 6, 1929, p. 9.

19. Lloyd Goodrich, "A Round of Galleries," *New York Times*, April 7, 1929, sec. X, p. 13.

20. Graham, letter to Phillips, December 3, 1929, Archives, Phillips Collection.

21. Phillips, letter to Graham, March 14, 1930, Archives, Phillips Collection.

22. Graham, letter to Phillips, May 13, 1931, Archives, Phillips Collection.

23. Graham, letter to Phillips, dated only "1931," Archives, Phillips Collection.

24. According to Green, *John Graham* (see n. 7 above), p. 66, Graham mailed out copies of the typescript in April 1946. There is a copy of the typescript in the Archives of the Phillips Collection.

25. Goodrich, quoted in Lenore Clark, *Forbes Watson: Independent Revolutionary* (Kent, Ohio: Kent State University, 2001), p. 212, n. 50.

26. Goodrich, "In the Galleries," *The Arts*, February 1930, p. 412.

27. Goodrich, "Exhibitions: Picasso's Latest," *The Arts*, March 1931, pp. 413–14.

28. Ibid., p. 414.

29. See Henry Adams, *Thomas Hart Benton: An American Original* (New York: Alfred A. Knopf, 1989), p. 214.

30. Thomas Craven, "The Curse of French Culture," *Forum*, July 1, 1929, pp. 57–63.

31. Craven, *Modern Art: The Men, the Monuments, the Meaning* (New York: Simon and Schuster, 1934), p. 192.

32. Ibid., p. 181.

33. Ibid., p. 182.

34. Ibid., pp. 188, 192.

35. See FitzGerald, *Making Modernism* (see n. 3 above), pp. 215–26.

36. Henry McBride, "The Durand-Ruel Galleries Exhibit Best of Picasso, Braque and Matisse," *The Sun*, March 17, 1934, p. 31.

37. On the Valentine Gallery see Julia May Boddewyn, "The Valentine Gallery: Valentine Dudensing and the Temple of European Modernism," M.A. thesis, Hunter College, 1997, and her article "A Valentine to European Modernism," *The Modernism Magazine*, Summer 2001, pp. 43–48.

38. "Abstract Art in America," *Artnews* 29, no. 15 (January 10, 1931): 14.

39. Graham, letter to Phillips, May 13, 1931, Archives, Phillips Collection.

40. Gorky, quoted in Balcombe Greene, "Memories of Arshile Gorky," p. 109. Written in January 1951 for *Magazine of Art*, Greene's article was not published until March 1976, in *Arts Magazine*. There is a manuscript copy in Gorky's Artist File, Archives, Whitney Museum of American Art. See Herrera, *Arshile Gorky* (see n. 14 above), p. 663, note for p. 181.

41. Meyer Schapiro, quoted in Ethel K. Schwabacher, *Arshile Gorky* (New York: Whitney Museum of American Art, 1957), p. 11.

42. Mary Hoyt Wiborg purchased one of these paintings in the late 1920s—*Still Life with Mandolin* (1924; National Gallery of Ireland, Dublin).

43. Ralph Flint, "'Since Cézanne' Exhibit Features Leading Moderns," *Artnews* 30, no. 14 (January 2, 1932): 5, 8.

44. Established by Boddewyn based on her review of the gallery's purchase records (there is a copy of the records in her possession). See also Boddewyn, "The Valentine Gallery" (see n. 37 above). In 1964, the Museum of Modern Art sold the painting to the Art Gallery of Ontario, Canada (then called the Art Gallery of Toronto). My thanks to Michael Parke-Taylor, Associate Curator of European art at the O.A.G., for supplying this information.

45. See Isabelle Dervaux, ed., *Surrealism USA* (New York: National Academy Museum, 2005), pp. 173–74.

46. "Since Cézanne," December 28, 1931–January 16, 1932. Since most of Gorky's library was destroyed in a fire in 1946, its contents remain largely unknown.

47. The lithograph is dated 1931 in the lower-left margin, but like so many of the dates that Gorky applied, this is probably a later dating that places the work too early. Given the relation of the image to Picasso's *Seated Woman*, it is much more likely to have been made during or after the exhibition at Valentine—that is, in 1932.

48. André Breton, *Le Surréalisme et le peinture* (Paris: Nouvelle Revue Française, 1928), p. 4; Picasso's *Head* is illustrated on p. 56. (Eng. trans. New York: Bretano's, 1945, reprint ed. New York: Harper and Row, 1972.)

49. Graham, letter to Phillips, December 23, 1933, Archives, Phillips Collection.

50. *Three Musicians* was shown in "Modern Works of Art: 5th Anniversary Exhibition" at the Museum of Modern Art, November 20, 1934–January 20, 1935.

51. The first two paintings by Picasso to enter MoMA's collection were *Woman in White* and *Fruit Bowl, Wineglass, Bowl of Fruit (Green Still Life)*, both of them given to the Museum by Lillie Bliss.

52. In reply to my query, Sidney Janis's son, Carroll, wrote on April 7, 2005:

My parents began collecting Picasso in Paris [in] the late 1920's and they met Gorky in New York about 1929. Picasso's *Painter and Model* was acquired in 1933 (I was born in 1931 and my brother Conrad in 1928). *Painter and Model* was the largest work at home except for the great Rousseau *The Dream* which was acquired a few years earlier.

My parents and Gorky became great friends spending much time together visiting art exhibitions and attending other events in each other's company. I recall Gorky at our apartment a number of times as well as visiting us in the country on summer vacations. He seemed a very large man with a deeply resonant voice—but always appeared to be gentle and good humored. My father told me years later that Gorky came many times to view *Painter and Model* in our living room, studying it for hours at a time. The work no doubt had a profound effect reflected in many works of the 1930s. . . . Answering your question I don't know if Gorky ever advised on Picasso purchases—perhaps not—but Picasso was discussed often and in great detail. Gorky from all accounts was a passionate viewer as were my parents. . . .

On a personal note our parents were also fans of child art and they encouraged us to draw and paint from an early age. One day when looking at the *Painter and Model* I noticed—from a three-year-old's height—that there was a lot of color submerged under still visible edges of the heavy black line of the artist's easel. I thought this color good. I decided this black and white area needed more color, so I took my color crayons and worked over this area as a child might do.

When I explained to my bemused parents why I had drawn on the painting they delightedly left the little additions on for a long time—at least a year or two. Gorky on one of his visits noticed this and was apparently most taken with the idea that a child felt the Picasso needed more color! My mother later told me that Gorky called this his favorite art world story! When the work was to go out on loan and the time had finally come to remove the crayon marks on *Painter and Model* it was Gorky who did so.

P.S. As to your other question, neither my older brother or I have any recollection that Gorky was ever our baby-sitter, nor do I think he ever would have been.

53. See Jim M. Jordan and Robert Goldwater, *The Paintings of Arshile Gorky: A Critical Catalogue* (New York and London: New York University Press, 1982), p. 304, no. 164.

54. Stuart Davis, *Abstract Painting in America* (New York: Whitney Museum of American Art, 1935), n.p. (second page of introduction). The Whitney also balanced its program by following the exhibition with "American Genre: The Social Scene in Paintings and Prints (1800–1925)." See Berman, *Rebels on Eighth Street* (see n. 6 above), p. 377.

55. The symposium took place on April 10, 1935. For Goodrich's comments see Berman, *Rebels on Eighth Street* (see n. 6 above), p. 375.

56. Ibid., p. 376.

57. Goodrich apparently played a significant role in the Modern's first purchase of a painting by Gorky. The Whitney's 1941 Annual had included one of Gorky's new series, *Garden in Sochi* (1941; Museum of Modern Art). According to Spender, Gorky's biographer and son-in-law, Goodrich recognized the

importance of Gorky's new work and sent word to Barr: "Six months after Goodrich had exhibited the green *Garden in Sochi*, Alfred Barr appeared at Gorky's studio to have a look at it. As he crossed the threshold he said, 'Goodrich tells me you have painted your best painting.'" Spender, *From a High Place* (see n. 14 above), p. 241. In an e-mail to the author, February 3, 2000, Spender wrote, "the story re Barr was told to Mougouch [Gorky's wife] by Gorky, who told it to me." See also FitzGerald, "Arshile Gorky and the Whitney Museum of American Art," Whitney Museum Web site (www.whitney.org/research/gorky), 2000, which excerpts a letter from Barr to Gorky's nephew Karlen Mooradian, dated March 30, 1966, regarding Barr's fluctuating interest in Gorky's work during the 1930s. The letter is in the Alfred H. Barr, Jr., Papers, Museum of Modern Art Archives.

58. David Smith, quoted in Herrera, *Arshile Gorky* (see n. 14 above), p. 278.

59. See FitzGerald, "Arshile Gorky's *The Limit*," *Art Magazine*, March 1980, pp. 110–15.

60. Davis, "Arshile Gorky in the 1930s: A Personal Recollection," *Magazine of Art*, February 1951, p. 58.

61. Gorky, quoted in an interview with his nephew Mooradian, 1973, in Karlen Mooradian, *The Many Worlds of Arshile Gorky* (Chicago: Gilgamesh Press, 1980), p. 110.

62. "Julio González: Sculpture, 1936," *Cahiers d'art* 11, nos. 6–7 (1936): 201–2 (illustrations only).

63. Herrera, *Arshile Gorky* (see n. 14 above), p. 221.

64. Dorothy Dehner, quoted in ibid., p. 174.

65. My thanks to Jack Rutberg for sharing his knowledge of Hans Burkhardt and his extensive archive of Burkhardt's art.

66. Dehner, quoted in Karen Wilkin, *David Smith: The Formative Years* (Edmunton: Edmunton Art Gallery, 1981), p. 9.

67. Smith, in Cleve Gray, ed., *Smith by Smith* (New York: Holt, Rinehart and Winston, 1968), p. 87.

68. Smith based the sculpture on a photograph.

69. For Gorky's preliminary drawings, see *Arshile Gorky: Paintings and Drawings 1929–42* (New York: Gagosian Gallery, 1988), pp. 77, 79, 81.

70. De Kooning, letter to the editor, *Artnews* 47, no. 9 (January 1947): 6.

71. See Sally Yard, "The One Wind and The Studio: Willem de Kooning in the Thirties," *The Picker Art Gallery Journal* 3, no. 3 (1991–92): 7.

72. Picasso, in Marius de Zayas, "Picasso Speaks," *The Arts*, May 1923, p. 323.

73. Picasso, "Conversation avec Picasso," *Cahiers d'art* 10, no. 10 (1935): 173–78.

74. Graham, "Primitive Art and Picasso," *Magazine of Art* 30, no. 4 (April 1937): 236–39, 260.

75. Ibid., pp. 260, 237.

76. Since Gorky was right-handed, he painted his image reflected in a mirror. An additional source for both paintings is Cézanne's *Self-Portrait with Palette* (ca. 1890; Buhrle Foundation, Zurich).

77. Herrera identifies "Master Bill" as "a Swedish house painter to whom [Gorky] gave lessons in exchange for having his studio painted." *Arshile Gorky* (see n. 14 above), p. 299.

78. This painting does not appear to be extant; de Kooning probably overpainted it with another work.

79. Herschel B. Chipp, *Picasso's Guernica: History, Transformations, Meanings* (Berkeley: University of California Press, 1988), p. 161.

80. Dorothea Tanning, *Between Lives: An Artist and Her World* (New York: Norton, 2001), pp. 47–48. Tanning was mistaken in recalling that the exhibition took place at Paul Rosenberg's gallery.

CHAPTER FOUR

1. Louise Bourgeois, *Destruction of the Father/ Reconstruction of the Father: Writings and Interviews 1923–97* (Cambridge, Mass.: M.I.T. Press, 1998), pp. 38–39.

2. Willem de Kooning, in the documentary film *De Kooning on de Kooning*, dir. Charlotte Zwerin, prod. Courtney Sale, New York, 1981.

3. De Kooning, quoted in Sally Yard, interview with de Kooning, August 5, 1979, in Yard, *Willem de Kooning* (New York: Rizzoli, 1997), p. 20.

4. Robert Goldwater, "Picasso: Forty Years of His Art," *Art in America*, January 1940, p. 44.

5. See Michael FitzGerald, *Making Modernism: Picasso and the Creation of a Market for Twentieth-Century Art* (New York: Farrar, Straus and Giroux, 1995), pp. 204–15.

6. Alfred H. Barr, Jr., *Picasso: Forty Years of His Art* (New York: Museum of Modern Art, 1939), p. 6. The second edition of the catalogue includes a list of 16 works (out of 362 on the checklist) that ultimately did not appear in the exhibition owing to travel restrictions.

7. Ibid., p. 60.

8. Ibid., p. 65.

9. Pablo Picasso, in Marius de Zayas, "Picasso Speaks," in ibid., p. 12.

10. Ibid., p. 9.

11. Ibid.

12. Picasso, in Christian Zervos, "Statement by Picasso: 1935," in ibid., pp. 13, 15.

13. Ibid., p. 15.

14. Barr, *Picasso: Forty Years of His Art* (see n. 6 above), p. 175. A special issue of *Cahiers d'art* (nos. 4–5, 1937) was devoted to *Guernica* and reproduced Dora Maar's photographs of the painting in progress.

15. Picasso, in Zervos, "Statement by Picasso: 1935," in Barr, *Picasso: Forty Years of His Art* (see n. 6 above), p. 17.

16. For discussions of the relevance of this text (particularly the phrase "sum of destructions") to Pollock's work, see Jonathan Weinberg, "Pollock and Picasso: The Rivalry and the 'Escape,'" *Arts Magazine* 61, no. 10 (June 1987): 42–48, and Pepe Karmel, "A Sum of Destructions," in Kirk Varnedoe and Karmel, eds., *Jackson Pollock: New Approaches* (New York: Museum of Modern Art, 1999), pp. 71–100.

17. Picasso, in Zervos, "Statement by Picasso: 1935," in Barr, *Picasso: Forty Years of His Art* (see n. 6 above), p. 19.

18. Louise Bourgeois, diary entry, March 6, 1939, in Bourgeois, *Writings and Interviews* (see n. 1 above), p. 40.

19. Bourgeois, letter to Colette Richarme, September 1938, in ibid., pp. 29–31.

20. Picasso, quoted in Pierre Cabanne, *Le Siècle de Picasso* (Paris: Denoel, 1975), vol. 2, p. 226.

21. On Bourgeois's early life, see Josef Helfenstein, *The Early Work of Louise Bourgeois* (Champaign, Ill.: Krannert Art Museum, 2002).

22. An untitled drawing in a private collection (1940; BOUR-0468) explicitly depicts a baby surrounded by two adult profiles. I very much appreciate the generosity of Jerry Gorovoy and Wendy Williams, assistants to Bourgeois, in presenting my questions to her, and their contributions to interpreting the paintings.

23. Gorovoy supplied this identification.

24. Identified by Gorovoy.

25. Bourgeois, quoted in Alain Kirili, "The Passion for Sculpture: A Conversation with Louise Bourgeois," *Arts Magazine*, March 1989, p. 69.

26. Robert Storr, "A Sketch for a Portrait: Louise Bourgeois," in Storr, Paulo Herkenhoff, and Allan Schwartzman, eds., *Louise Bourgeois* (New York: Phaidon, 2003), pp. 33, 36.

27. My thanks to Gorovoy for questioning Bourgeois about this article and conveying to me that she does not believe these sculptures are relevant to her work.

28. "The homesickness was doubled by a sensation of abandonment. *I felt I had abandoned them.*" Bourgeois, quoted in Kirili, "The Passion for Sculpture" (see n. 25 above), p. 70.

29. Stuart Davis's text is published in Diane Kelder, ed., *Stuart Davis* (New York: Praeger, 1971), pp. 176–78.

30. See Lewis Kachur's entry on the painting in "Stuart Davis's Word-Pictures," in *Stuart Davis:*

American Painter (New York: Metropolitan Museum of Art, 1991), p. 300.

31. André Breton, "The Eye Spring: Arshile Gorky," exh. cat. (New York: Julien Levy Gallery, 1945).

32. See Hayden Herrera, *Arshile Gorky: His Life and Work* (New York: Farrar, Straus and Giroux, 2003), p. 383.

33. The lost magazines and clippings are mentioned in Francis Valentine O'Connor, "Jackson Pollock's Library," in O'Connor and Eugene Victor Thaw, eds., *Jackson Pollock: A Catalogue Raisonné of Paintings, Drawings and Other Works* (New Haven and London: Yale University Press, 1978), vol. 4, p. 187.

34. Jeffrey Potter, *To a Violent Grave: An Oral Biography of Jackson Pollock* (New York: Putnam, 1987), pp. 36, 61.

35. According to O'Connor's notations on a copy of this letter in the collection of the Pollock-Krasner House (Springs, New York), the letter probably dates from the spring of 1940. In 1965, Sylvia Pollock confirmed to O'Connor a date of May 1940.

36. Generally dated ca. 1938–41, these works probably date more precisely from May 1939–41. They are likely to reflect Pollock's encounter not with reproductions but with Picasso's actual drawings at the Valentine Gallery and at the Modern.

37. John Graham, "Primitive Art and Picasso," *Magazine of Art* 30, no. 4 (April 1937): 238.

38. Ibid.

39. For a thorough analysis of this painting see Walter Hopps, "*The Magic Mirror* by Jackson Pollock," in Hopps, ed., *The Menil Collection* (New York: Harry N. Abrams, 1987), pp. 254–73.

40. The exhibition ran from January 20 to February 14, 1942. The checklist of twenty-eight works lists them intermixed. In the Armory Show of 1913, American and European art were hung separately; however, at the Brooklyn Museum's "International Exhibition of Modern Art" in 1926, the nationalities were mixed.

41. Quoted in Ellen G. Landau, *Lee Krasner: A Catalogue Raisonné* (New York: Harry N. Abrams, 1995), p. 75, in the entry on *Abstraction*, the painting shown in "American and French Paintings."

42. John Graham, "Case of Mr. Picasso," typescript in the Archive of the Phillips Collection, Washington, D.C., p. 1.

43. Ibid., p. 3.

44. "Jackson Pollock, A Questionnaire," *Arts and Architecture* (February 1944) in Pepe Karmel, ed., *Jackson Pollock: Interviews, Articles, and Reviews* (New York: Museum of Modern Art, 1999), p. 16.

45. Anonymous, "Congenial Company," *Arts Digest*, January 15, 1942, p. 18. The review reproduced de Kooning's *Man*, ca. 1939 (private collection).

46. Yard, *Willem de Kooning* (see n. 3 above), p. 28.

47. *Man* (ca. 1939), illustrated in Paul Cummings, Jörn Merkert, and Claire Stoullig, *Willem de Kooning* (New York: Whitney Museum of American Art, 1983), p. 136, no. 136.

48. See Mark Stevens and Annalyn Swan, *De Kooning: An American Master* (New York: Alfred Knopf, 2004), pp. 188–89.

49. Henry McBride noted the difference between photographic reproductions of the mural and the painting itself: "The great reduction necessary in the photo reproductions destroys the surface variety that the picture has"; "Picasso's Guernica Here," *New York Sun*, May 6, 1939, reprinted in Ellen Oppler, ed., *Picasso's Guernica* (New York: Norton, 1988), pp. 227–28.

50. Dean Meeker, in telephone interview, August 30, 1995, published in Dave and Reba Williams, *Contacting Picasso*, exh. brochure (New York: Spanish Institute, 1995), n.p.

51. Graham, "Case of Mr. Picasso" (see n. 42 above), p. 1.

52. Barr, *Picasso: Forty Years of His Art* (see n. 6 above), p. 135. David Sylvester compared Picasso's *Figure* and de Kooning's *Pink Angels* in "Flesh Was the Reason," in Marla Prather, ed., *William de Kooning: Paintings* (Washington, D.C.: National Gallery of Art, 1994), pp. 18–19.

53. Picasso's original design for the mural depicted an artist's studio, and he retained the lightbulb and tight space of this conception in his final composition. See

Herschel B. Chipp, *Picasso's Guernica: History, Transformations, Meanings* (Berkeley: University of California Press, 1988), pp. 58–69.

54. Lee Krasner, quoted in B. H. Friedman, "An Interview with Lee Krasner Pollock," in Friedman, *Jackson Pollock: Black and White* (New York: Marlborough-Gerson Gallery, 1969), reprinted in Karmel, ed., *Pollock: Interviews, Articles, and Reviews* (see n. 44 above), p. 36.

55. James Valliers, "Inventory of Pollock-Krasner Library," typescript, dated June 10, 1963, copy in the collection of the Pollock-Krasner House.

56. Other than a volume of Zervos's catalogue raisonné, this was the only book on Picasso published during Pollock's lifetime with this many illustrations, and no volume of Zervos has the specified chronological range. Although Barr's catalogue included works through 1939, these final pages could easily have been lost, along with the cover and title of the volume.

57. See O'Connor, "Jackson Pollock's Library" (see n. 33 above), p. 187.

58. See Ellen Landau, *Jackson Pollock* (New York: Harry N. Abrams, 1989), p. 161.

59. Barr, *Picasso: Forty Years of His Art* (see n. 6 above), p. 167. The caption cites the earlier reproduction of this painting in Alfred Barr, *Fantastic Art, Dada, Surrealism* (New York: Museum of Modern Art, 1936), plate 260.

60. Alfred Barr, *Picasso: Fifty Years of His Art* (New York: Museum of Modern Art, 1946), pp. 186–87.

61. Weinberg, "Pollock and Picasso" (see n. 16 above), pp. 44–45. Krasner quoted Pollock's statement to her about "veiling" imagery and discussed its meaning with Friedman, in "An Interview with Lee Krasner Pollock" (see n. 54 above), p. 36.

62. For the circumstances of Pollock's remark, in an encounter with Hans Hofmann, see Landau, *Jackson Pollock* (see n. 58 above), p. 259, n. 2. On the widespread speculation about Pollock's references to Jung's theories, see Elizabeth L. Langhorne, "Jackson Pollock's 'The Moon Woman Cuts the Circle,'" *Arts Magazine*, March 1979, and William Rubin, "Pollock as Jungian Illustrator: The Limits of Psychological Criticism," *Art in America*, November and December 1979, both reprinted in Karmel, ed., *Pollock: Interviews, Articles, and Reviews* (see n. 44 above), pp. 202–62. Landau finds a possible reference to Jungian ideas of a "collective unconscious" in the titles of some of Pollock's early drip paintings; Landau, *Jackson Pollock* (see n. 58 above), p. 175.

63. Varnedoe cites a proposal by E. A. Carmean that *Gothic* relates to *Three Women*, and offers his own views, in Kirk Varnedoe with Pepe Karmel, *Jackson Pollock* (New York: Museum of Modern Art, 1998), p. 81, n. 83. In the fall of 2002, Varnedoe stated to me his belief that *Gothic* is a response to the *Demoiselles*.

64. There are two substantial studies for *Three Women* in the collection of the Boston Museum of Fine Arts and the Baltimore Museum of Art, but they were not included in major exhibitions during the 1940s or '50s.

65. Clement Greenberg's remarks are recorded in a memo written by Judith Cousins for the files of the Museum of Modern Art; see Karmel, "A Sum of Destructions" (see n. 16 above), p. 95, n. 7.

66. Krasner, interviewed by Rubin, quoted in Steven Naifeh and Gregory White Smith, *Jackson Pollock: An American Saga* (Aiken: Woodward/White, 1989), pp. 351, 851.

67. Varnedoe, "Comet: Jackson Pollock's Life and Work," in Varnedoe with Karmel, *Jackson Pollock* (see n. 63 above), pp. 33–34.

68. Picasso's remark about the *Demoiselles* being his "first exorcism painting" was recorded by André Malraux and discussed extensively by Rubin in a special issue of the Museum of Modern Art's *Studies in Modern Art* devoted to the painting (no. 3, 1994). John Richardson and Marilyn McCully have offered a significantly different interpretation in their biography, *A Life of Picasso* (New York: Random House, 1996), vol. 2, pp. 11–45.

69. One measure of American artists' changing relationship with Picasso's work is a comparison of Max Weber's *African Sculpture* (1910) with Pollock's *Gothic*.

70. See the entry for *Gothic* in O'Connor and Thaw, eds., *Jackson Pollock: A Catalogue Raisonné* (see n. 33

71. The masklike face that Picasso used for the figure in the lower right of the *Demoiselles* may have been a reference for the mask that Pollock painted in the upper right of *Masqued Image*.

72. When she quoted Pollock saying this, Krasner was referring to *There Were Seven in Eight* (ca. 1945); see Pepe Karmel, "Pollock at Work: The Films and Photographs of Hans Namuth," in Varnedoe with Karmel, *Jackson Pollock* (see n. 63 above), p. 105.

73. Ibid., p. 89.

74. Hans Namuth, quoted in ibid., p. 91.

75. Karmel interprets this figure as a dog or wolf, but as the drawing he reproduces shows, it is more likely to be a gored horse; ibid., p. 108.

76. My thanks to Helen A. Harrison, director of the Pollock-Krasner House, for allowing me to view Namuth's film.

77. Karmel, "Pollock at Work" (see n. 72 above), pp. 109–10.

78. Ibid., p. 110.

79. Phillip Pavia, as quoted in Stevens and Swan, *De Kooning: An American Master* (see n. 48 above), p. 288.

80. This account is based on an interview with Gus Falk, July 28, 1992, in ibid., p. 292. On the Club, see also Irving Sandler, *A Sweeper-Up after Artists: A Memoir* (New York: Thames & Hudson, 2003), pp. 27–37.

81. The exhibition was divided between a large group of John Marin's work and smaller presentations of six younger artists—three chosen by Barr and three by Alfred Frankfurter (Hyman Blum, Lee Gatch, and Rico Lebrun). A much smaller exhibition of work by William Baziotes, Romare Bearden, Byron Browne, Adolph Gottlieb, Carl Holty, and Robert Motherwell had been held at the Galerie Maeght, Paris, in April 1947, under the title "Introduction à la peinture moderne américaine."

82. My thanks to Amy Schichtel and Roger Sherman of the de Kooning estate office for their assistance in assembling and evaluating these reviews.

83. Douglas Cooper, "Jackson Pollock," *The Listener*, July 6, 1950, reprinted in B. H. Friedman, *Jackson Pollock: Energy Made Visible* (New York: McGraw-Hill, 1972), p. 155.

84. Picasso may have begun to see the new American art a little earlier, for example in the Motherwell exhibition that appeared at Galerie Maeght, Paris, in 1947.

85. New York artist and critic Paul Brach passed on to Jasper Johns an undocumented rumor that Picasso's first reaction to seeing one of de Kooning's paintings was to call it "melted Picasso." My efforts to trace this comment to Picasso or any published source have been unsuccessful. My thanks to Brach for discussing with me (on June 13, 2005) his recollection of this statement and his comment to Johns.

86. Bruno Alfieri, "A Short Statement on the Painting of Jackson Pollock," trans. in Karmel, ed., *Pollock: Interviews, Articles, and Reviews* (see n. 44 above), p. 69.

87. See Deborah Solomon, *Jackson Pollock: A Biography* (New York: Simon and Schuster, 1987), p. 204. Solomon had interviewed Marie Levitt Pollock in July 1983.

88. Pollock, cable to *Time*, published in the December 11, 1950, issue, quoted in Friedman, *Energy Made Visible* (see n. 83 above), p. 160.

89. Grace Hartigan, quoted in Varnedoe, "Comet" (see n. 67 above), p. 59.

90. See Robert Saltonstall Mattison, *Grace Hartigan: A Painter's World* (New York: Hudson Hills, 1990), p. 16.

91. For an account of Picasso's years with Gilot, see Michael FitzGerald, "A Triangle of Ambitions: Art, Politics, and Family during the Postwar Years with Françoise Gilot," in William Rubin, ed., *Picasso and Portraiture* (New York: Museum of Modern Art, 1996), pp. 296–335, and Gilot with Carleton Lake, *My Life with Picasso* (New York: McGraw-Hill, 1964), pp. 268–70. All the quotations of this conversation that follow are from these pages.

92. Pierre Daix, in *Picasso: Life and Art* (New York: Icon, 1993), p. 323, dates the conversation to "around 1950."

93. Naifeh and Smith, in *An American Saga* (see n. 66 above), p. 679, give the source of this account as their interview with John Little.

94. Ibid., pp. 679–80.

95. Picasso, in Zervos, "Statement by Picasso: 1935," in Barr, *Picasso: Forty Years of His Art* (see n. 6 above), p. 16.

96. In his 1923 "Statement," Picasso said "Nature and art, being two different things, cannot be the same," reprinted in ibid., p. 10.

97. Pollock, signed statement, dated 1950 by Francis Valentine O'Connor, in Karmel, ed., *Pollock: Interviews, Articles, and Reviews* (see n. 44 above), p. 24. Pollock probably prepared the statement for the interview with William Wright in which he also said, "It seems to be possible to control the flow of the paint, to a great extent, and I don't use—I don't use the accident—'cause I deny the accident"; in ibid., p. 22.

98. *Life* reproduced *Cathedral* in its issue of October 11, 1948, p. 78. The issue of August 8, 1949, included Dorothy Seiberling's article "Jackson Pollock: Is He the Greatest Living Painter in the United States?" which reproduced several of the drip paintings, pp. 42–45. Picasso grafittied a story about Abstract Expressionism in the November 16, 1959, issue of *Life*; see Anne Baldassari, *Picasso et la photographie* (Paris: Musée Nationaux, 1995), p. 145.

99. Picasso, quoted in Gilot with Lake, *My Life with Picasso* (see n. 91 above), pp. 219–20.

100. Picasso's so-called "dot and line" drawings of 1924 are important precedents for *The Studio*.

101. Canvases of this size were not exceptional for Picasso in these years. His second version of *The Kitchen* (November 1948, now in the Musée Picasso, Paris) is the same size, and began with Gilot copying the basic design of the original composition. The second version is more representational and finished.

102. Picasso, quoted in Gilot with Lake, *My Life with Picasso* (see n. 91 above), p. 219.

103. See Varnedoe, "Comet" (see n. 67 above), pp. 47–56, for a substantial contribution to the understanding of Pollock's technique and a summary of the literature.

104. Daix recounts hearing Picasso make this statement, in *Picasso: Life and Art* (see n. 92 above), p. 285.

105. See Michael FitzGerald, "Reports from the Home Fronts: Some Skirmishes over Picasso's Reputation," in Steven Nash, ed., *Picasso and the War Years 1937–1945* (New York: Thames & Hudson, 1998), pp. 113–21.

106. In a review in *The Art Digest*, Jon Stroup stated that Peggy Guggenheim was showing at her gallery, Art of This Century, "sixteen color reproductions of the paintings Picasso has been occupied with since 1939 while in German-occupied Paris." These were probably the sixteen plates in the portfolio *Seize Peintures 1939–43*, published by Editions du Chêne, Paris, in 1943; see Stroup, "Motherwell, Modern," *The Art Digest* 19, no. 3 (November 1, 1944): 16. In November 1944, the Museum of Modern Art presented an exhibition called "The War Years: Color Reproductions of Works by Picasso, Matisse, Bonnard 1939–43," which probably included some of these same reproductions, although the museum's archives contain no specific information about the show's contents; my thanks to Michelle Elligott, archivist at the Museum of Modern Art. Roy Lichtenstein owned a copy of the *Seize Peintures* portfolio and used images from it for his first two Pop variations after Picasso; see Chapter 5 in the present volume.

107. Hermon More, "Foreword," in *European Artists in America* (New York: Whitney Museum of American Art). The exhibition ran from March 13 to April 11, 1945.

108. The exhibition ran from January 25 to March 2, 1947.

109. Juliana Force, "Foreword," *Painting in France 1939–46* (New York: Whitney Museum of American Art, 1947), p. 3.

110. On this period of Barr's professional life, see Russell Lynes, *Good Old Modern* (New York: Atheneum, 1973), pp. 240–63, and Alice Goldfarb Marquis, *Alfred H. Barr: Missionary for the Modern* (New York: Contemporary Books, 1989), pp. 203–40.

111. Barr, *Picasso: Fifty Years of His Art* (see n. 60 above), p. 245.

112. Picasso, quoted in ibid., pp. 247–48.

113. Barr, in ibid., p. 250.

114. Sidney Janis published a black-and-white reproduction of *Charnel House* in *Picasso: The Recent Years 1936–1946* (New York: Doubleday, 1946), pl. 16. He

sent an inscribed copy of the book to Pollock and Krasner, now in the collection of the Pollock-Krasner House.

115. There was a copy of *Picasso: Fifty Years of His Art* in the Krasner-Pollock library, now in the collection of the Pollock-Krasner House.

116. Greenberg, "Review of an Exhibition of School of Paris Painters," in *Clement Greenberg: The Collected Essays and Criticism*, ed. John O'Brian, vol. 2, *1945–1949* (Chicago: University of Chicago Press, 1986), p. 89. Greenberg states that the show contained a dozen paintings, only one of them by Picasso. The review first appeared in *The Nation*, June 29, 1946.

117. Ibid.

118. This still life is Z.XIII.256.

119. Greenberg used this phrase in his revision of the review for publication in *Art and Culture* (Boston: Beacon, 1961), p. 122.

120. "The First Post-War Showing in America of Recent Paintings by Picasso," January 27–February 15, 1947, and "Paintings of 1947 by Picasso," January 26–February 14, 1948, both at the Samuel M. Kootz Gallery, New York.

121. Joop Sanders, quoted in Stevens and Swan, *An American Master*, p. 245. Stevens's and Swan's interviews with Sander took place between October 31, 1990, and March 13, 1993.

122. Clement Greenberg, "Art," in Karmel, ed., *Pollock: Interviews, Articles, and Reviews* (see n. 44 above), pp. 59–60. The review was originally published in *The Nation*, January 24, 1948, pp. 107–8.

123. Pollock made one painting, *Interior with Figures* (ca. 1938–41), in a style that approximates Analytic Cubism.

124. Krasner, quoted in Friedman, "An Interview with Lee Krasner Pollock" (see n. 54 above), p. 36.

125. Clement Greenberg, "The Crisis of the Easel Picture," *Partisan Review*, April 1948, reprinted in *Greenberg: Collected Essays and Criticism*, ed. O'Brian (see n. 116 above), vol. 2, p. 224. See Karmel, "Pollock at Work" (see n. 72 above), p. 100, for an analysis of these statements.

126. Clement Greenberg, "Review of an Exhibition of Willem de Kooning," *The Nation*, April 24, 1948, reprinted in *Greenberg: Collected Essays and Criticism*, ed. O'Brian (see n. 116 above), vol. 2, p. 228.

127. Greenberg, "The Crisis of the Easel Picture" (see n. 125 above), p. 224.

128. Krasner and Pollock, quoted in Berton Rouéché, "Unframed Space," *The New Yorker*, August 5, 1950, reprinted in Karmel, ed., *Pollock: Interviews, Articles, and Reviews* (see n. 44 above), p. 19.

129. The symposium took place on February 5, 1951; the artists' statements were printed in *The Museum of Modern Art Bulletin* 18, no. 3 (Spring 1951).

130. De Kooning, in ibid., p. 7.

131. Ibid.

132. Picasso, in Marius de Zayas, "Picasso Speaks," *The Arts*, May 1923, p. 323.

133. De Kooning, in *The Museum of Modern Art Bulletin* (see n. 129 above), p. 7.

134. Pollock, letter to Alfonso Ossorio, January 1951. There is a photocopy of the letter in the collection of the Pollock-Krasner House.

135. Pollock, letter to Ossorio, June 7, 1951. There is a photocopy of the letter in the collection of the Pollock-Krasner House.

136. For an undated statement by Motherwell about the importance of Picasso's studio paintings for his work, see Philip Rylands, *Pablo Picasso: L'Atelier* (Venice: Peggy Guggenheim Collection, 1996), p. 17.

137. Gorky was using *Guernica* as his reference in *Nude* (1946) and other works during his last five years, discussed later in this chapter.

138. This fascination with advertising images and their use in art originated with Picasso and Cubism; see Robert Rosenblum, "Picasso and the Typography of Cubism," in Roland Penrose and John Golding, eds., *Picasso in Retrospect* (New York: Praeger, 1973), pp. 49–76.

139. De Kooning, in David Sylvester, "Interview with Willem de Kooning," conducted for the B.B.C. and broadcast on December 30, 1960, published in Sylvester, *Interviews with American Artists* (New Haven: Yale University Press, 2001), p. 49.

140. See Robert Rosenblum, "The Fatal Women of Picasso and De Kooning," *Artnews* 84, no. 8 (October 1985): 98–103.

141. Willem de Kooning, "The Renaissance and Order," *Trans/formation* 1, no. 2 (1951): 86.

142. Pollock, quoted in Varnedoe, "Comet" (see n. 67 above), p. 45 and p. 82 (n. 106).

143. *Number 27, 1950* was hung vertically at Parsons, probably to save space during a rushed hanging of the many works in the exhibition; see Naifeh and Smith, *An American Saga* (see n. 66 above), p. 654, and T. J. Clark, "Pollock's Smallness," in Varnedoe and Karmel, eds., *Jackson Pollock: New Approaches* (see n. 16 above), pp. 25–26.

144. Pollock, letter to Ossorio, January 1951.

145. Pollock, letter to Ossorio and Edward F. Dragon, January 1951. There is a photocopy of the letter in the collection of the Pollock-Krasner House.

146. Emily Genauer, "Art and Artists: The Whitney's Memorial Exhibition; The Arshile Gorky Tragedy," *New York Herald Tribune*, January 14, 1951, section 2, p. 2.

147. Pollock, quoted in Rubin, "Pollock as Jungian Illustrator" (see n. 62 above), p. 257.

148. Pollock, quoted in Francis Valentine O'Connor, *Jackson Pollock: The Black Pourings* (Boston: Institute of Contemporary Art, 1980), p. 20.

149. Jordan Benjamin Kantor, "Jackson Pollock's Late Paintings, 1951–53," unpublished Ph.D. dissertation, Harvard University, 2003, p. 165.

150. Jonathan Weinberg has suggested the relevance of Picasso's etching *Painter with a Model Knitting* (1927) for Pollock's dual image in *Portrait and a Dream*; see his "Pollock and Picasso" (see n. 16 above), p. 47.

151. Sam Hunter, "Jackson Pollock," in *The Museum of Modern Art Bulletin* 24, no. 2 (1956–57): 5–13, reprinted in Helen A. Harrison, ed., *Such Desperate Joy: Imagining Jackson Pollock* (New York: Thunder's Mouth Press, 2000), p. 110. Hunter's text in this issue of the *Bulletin* served as the catalogue of the Museum's exhibition *Jackson Pollock*, December 19, 1956–February 3, 1957.

152. For opposing views of Pollock's late work see Varnedoe, "Comet" (see n. 67 above), pp. 62–67, and Kantor, "Jackson's Pollock's Late Paintings" (see n. 148 above), pp. 173–79.

153. Clement Greenberg, "Picasso at Seventy-Five," reprinted in *Greenberg: Collected Essays and Criticism*, ed. O'Brian (see n. 116 above), vol. 4, pp. 26–35.

154. Greenberg added a footnote stating, "*The Kitchen* reminds me in more ways than one of the 'pictographs' Adolph Gottlieb used to do, and it is reported that Picasso was much struck by reproductions of these he saw in 1947"; ibid., p. 33. In fact, Picasso could have seen "Introduction à la peinture moderne américaine," the April 1947 exhibition at the Galerie Maeght, Paris, that included paintings by Gottlieb, as well as by Baziotes, Bearden, Browne, Holty, and Motherwell.

155. Ibid., p. 35. In an essay of 1966, "Picasso since 1945," Greenberg added that "Samuel Kootz has told me that some years back Picasso said to him, producing a used blotter, that Pollock's art was impossible because it lacked 'construction'"; *Greenberg: Collected Essays and Criticism*, ed. O'Brian (see n. 116 above), vol. 4, p. 238. If so, Picasso was probably taunting Kootz for his support of contemporary American art.

156. Alfred Barr, "Foreword," *Picasso: 75th Anniversary Exhibition* (New York: Museum of Modern Art, 1957), p. 4.

157. Barr, *Picasso: Fifty Years of His Art* (see n. 60 above), p. 250.

158. Barr, letter to Penrose, January 16, 1957, in the Museum of Modern Art Archives, AHB Papers, Box 2, Subgroup II, Series C. See FitzGerald, "Reports from the Home Fronts" (see n. 105 above), p. 121 and p. 245 (n. 40).

159. Barr, "Foreword and Acknowledgements," in *Picasso: Forty Years of His Art* (see n. 6 above), p. 6.

160. Barr, "Preface and Acknowledgements," *Picasso: 75th Anniversary Exhibition* (see n. 156 above), p. 3.

161. For an extensive discussion of Picasso's series after Delacroix's *Femmes d'Alger* and his other variations on previous art, see Susan Grace Galassi, *Picasso's Variations on the Masters: Confrontations with the Past* (New York: Harry N. Abrams, 1996), esp. pp. 127–47.

162. Picasso, quoted in Roland Penrose, *Picasso: His Life and Work* (New York: Harper and Row, 1973), p. 406.

163. See Michael FitzGerald, ed., *A Life of Collecting: Victor and Sally Ganz* (New York: Christie's, 1997).

CHAPTER FIVE

1. Picasso, in Christian Zervos, "Statement by Picasso: 1935," in Alfred H. Barr, Jr., *Picasso: Forty Years of His Art* (New York: Museum of Modern Art, 1939), p. 15. Lichtenstein's copy is in the possession of the Lichtenstein Foundation, New York.

2. Ibid., pp. 18, 10, 17, 16, respectively.

3. See Richard Brown Baker, "Interview with Roy Lichtenstein, November 15 and December 6, 1963; January 15, 1964," unpublished transcript of a tape-recorded interview conducted in Lichtenstein's studio, produced for the Archives of American Art, Smithsonian Institution, tape 1, side 2, p. 85 (copy of typescript in the Lichtenstein Foundation, New York).

4. Ibid. In fact Craven served as the general editor of *A Treasury of Art Masterpieces* (New York: Simon and Schuster, 1939), and the unsigned text on *Girl before a Mirror* is rather neutral (p. 554).

5. Edward Quinn and David Douglas Duncan in particular took many photographs of Picasso in his last decades. See Roland Penrose, *Portrait of Picasso* (New York: Museum of Modern Art, 1971), for an extensive selection of these images.

6. A number of Andy Warhol's musings about Picasso, including remarks on a desire to share Picasso's fame, appear in Warhol and Pat Hackett, *POPism: The Warhol '60s* (New York: Harper and Row, 1980). Mark Lancaster, a member of the Warhol entourage in 1964, is quoted saying to Warhol, "You'd stand there painting . . . and you'd say, 'Do you think Picasso's ever heard of us?' and then you'd send me off to see people" (p. 72). While in Toronto for the opening of an exhibition of his work (presumably in 1965), Warhol recalls, "All I could think of was that if I was still this big a nobody in Canada, then Picasso certainly hadn't heard of me. This was definitely a setback, because I'd sort of decided by then that he might have" (p. 82). After an exhibition of his work at the Sonnabend gallery, Paris, in May 1965, Warhol went to Tangier: "I was happy as we left Paris for Tangier, because I felt sure, that with all the publicity we'd just gotten in the French press, that Picasso must have heard of us at last. (One afternoon as we were sitting at a sidewalk café, little Paloma Picasso had walked by. Gerard [Malanga] recognized her immediately from seeing her picture in *Vogue*.) Picasso was the artist I admired most in all of history, because he was so prolific" (p. 114). During Truman Capote's famous Black and White Ball at New York's Plaza Hotel in November 1966, Warhol mused, "I wondered if anybody ever achieves an attitude where nothing and nobody can ever intimidate them. I thought, 'Does the president of the United States ever feel out of place? Does Liz Taylor? Does Picasso? Does the queen of England? Or do they always feel equal to anyone and anything?'" (p. 196).

7. According to Sheila Schwartz, director of the Saul Steinberg Foundation, each artist kept two of these drawings. One of Steinberg's is in the collection of the Beinecke Rare Book and Manuscript Library, Yale University; the other is in a private collection. Despite efforts by the Foundation and myself to find the two works that were in Picasso's possession, their location remains unknown.

8. Lichtenstein recalled that he thought Picasso's work was "insensitive" when he first saw it; Baker, "Interview with Roy Lichtenstein" (see n. 3 above), tape 1, side 2, p. 89.

9. Jasper Johns, quoted in Mark Stevens with Cathleen McGuigan, "Super Artist: Jasper Johns, Today's Master," *Newsweek* 90, no. 17 (October 24, 1977), quoted in Lilian Tone, "Chronology," in Kirk Varnedoe, *Jasper Johns: A Retrospective* (New York: Museum of Modern Art, 1996), p. 120.

10. Red Grooms has made a number of works about Picasso, including *Picasso Goes to Heaven* (1973). One surprising use of Picasso's work is Norman Rockwell's *Triple Self-Portrait* (1960), in which he depicted himself next to self-portraits by Dürer, Rembrandt, van Gogh, and Picasso. The reference to Picasso is unusual not only because Rockwell was generally opposed to modern art but also because the Picasso painting he chose to depict was generally called *Bust of a Woman* (1929) until the 1970s. Rockwell's decision to include it among his group of self-portraits suggests that he either read or heard about the biography of Picasso by Penrose in which this painting was first published as a self-portrait (*Picasso: His Life and Work* [New York: Harper and Row, 1958], p. 235). Apparently, Rockwell had a greater interest in Picasso's work than is generally believed.

11. Lichtenstein, in Baker, "Interview with Roy Lichtenstein" (see n. 3 above), tape 2, side 2, pp. 67–68.

12. James Lord presented his experiences with Picasso in a memoir, *Picasso and Dora* (New York: Farrar, Straus & Giroux, 1993).

13. Jack Youngerman, in "Interview: Jack Youngerman Talks with Colette Robert," *Archives of American Art Journal* 17, no. 4 (1977): 11, 12.

14. See Yve-Alain Bois, Jack Cowart, and Alfred Pacquement, *Ellsworth Kelly: The Years in France, 1948–54* (Washington, D.C.: National Gallery of Art, 1992), p. 178.

15. For example, *Poitiers* and *Woman with Arm Raised* (both 1949), reproduced in ibid., plates 8 and 14. These paintings by Ellsworth Kelly are comparable to Picasso's paintings during the mid-1940s, particularly *Femme-fleur* (Françoise Gilot), 1946.

16. The exhibition took place in July and included sixty-four works.

17. Daix 620.

18. Apparently, Kelly visited the exhibition in mid-July; see Nathalie Brunet, "Chronology, 1943–54" in Bois, Cowart, and Pacquement, *Ellsworth Kelly* (see n. 14 above), p. 182.

19. My thanks to Kelly for discussing these matters with me and allowing me to study early work in his possession. For a treatment of Kelly's responses to Picasso's art, see ibid., p. 16.

20. These include Jean Cassou, *Picasso* (Paris: Braun, 1947), and Jaime Sabartés, *Picasso* (Paris: Louis Carré, 1946).

21. Robert Desnos, *Picasso: Seize Peintures, 1939–43* (Paris: Éditions du chêne, 1943); Paul Éluard, *À Pablo Picasso* (Paris: Éditions des trois collines, 1944).

22. In 2005, Cassandra Lozano, managing director of the Lichtenstein Foundation, discovered this portfolio among the artist's books. Plate VI reproduces Picasso's *Femme dans un fauteuil* (141; Zervos XI.343), which is the basis for Lichtenstein's 1963 painting of the same title. Plate XI reproduces the Picasso on which Lichtenstein based *Femme au chapeau* (1962). Plate VI from Lichtenstein's copy of the portfolio has tape abrasion indicating that it has been attached to the wall or some other support—presumably when he used it to prepare his painting. Plate XI is missing from his copy of the portfolio; apparently he did not return it after use. Otherwise the portfolio is complete. In Lozano's view, Lichtenstein's signature on the portfolio seems to date from the 1940s.

23. Jack Cowart, executive director of the Lichtenstein Foundation, and Lozano date the drawings to around 1947.

24. Cowart brought to my attention Lichtenstein's M.F.A. thesis (1949), which consists of nine prose poems. The second includes references to several artists, including this passage about Picasso: "And of Picasso's electric expression, / And, of Braque, / Bright, with even effort, / Neither so good nor so bad as Picasso."

25. Lichtenstein, quoted in Joseph Young, "Lichtenstein: Printmaker," *Art and Artists* 10 (March 1970): 50.

26. The dark band across the center of Lichtenstein's painting is inscribed with calligraphic figures that may derive from Picasso's fluidly rendered musical notations in *Three Musicians*. Lichtenstein inscribed a cryptic form of his signature at the upper right of his painting.

27. Lichtenstein, in Baker, "Interview with Roy Lichtenstein" (see n. 3 above), tape 3, side 1, p. 3.

28. See Diane Waldman, *Roy Lichtenstein* (New York: Solomon R. Guggenheim Museum, 1993), pp. 8–9.

29. Presumably Lichtenstein based this painting on a reproduction of an unattributed portrait of James Lawrence, Esq., that appears in *Album of American History*, ed. James Truslow Adams (New York: Scribner, 1944), vol. 3, p. 134. Lichtenstein's copy is in the possession of the Lichtenstein Foundation, New York.

30. Lichtenstein, in Baker, "Interview with Roy Lichtenstein" (see n. 3 above), tape 2, side 1, p. 4.

31. Lichtenstein, in John Coplans, "An Interview with Roy Lichtenstein," *Artforum* 2, no. 4 (October 1963), reprinted in Coplans, ed., *Roy Lichtenstein* (New York: Praeger, 1972), p. 51.

32. Ibid., p. 52.

33. This page of Claes Oldenburg's sketchbook is illustrated in Barbara Rose, *Claes Oldenburg* (New York: Museum of Modern Art, 1970), p. 41.

34. My thanks to Oldenburg for discussing these matters with me; our conversation took place on July 14, 2005.

35. Lichtenstein, in Alan Solomon, "Conversation with Lichtenstein," *Fantazaria* 1, no. 2 (July–August 1966), reprinted in Coplans, ed., *Roy Lichtenstein* (see n. 31 above), p. 66.

36. Lichtenstein, in John Coplans, "Talking with Roy Lichtenstein," *Artforum* 5, no. 9 (May 1967), reprinted in ibid., p. 89.

37. Ibid., p. 90.

38. Lichtenstein, in Baker, "Interview with Roy Lichtenstein" (see n. 3 above), tape 1, side 2, p. 89.

39. Ibid.

40. Beginning in 1948, *Femme au chapeau* was in the collection of Mr. and Mrs. Alex L. Hillman, New York, but Lichtenstein is unlikely to have had access to it.

41. The reproduction of Picasso's painting in the portfolio measures 10 3/8 x 8 5/16 in.; the page measures 14 1/2 x 10 11/16 in.

42. Lichtenstein said that he generally based the titles of his variations on the text printed on the reproduction he used. See Diane Waldman, "Roy Lichtenstein Interviewed," in Waldman, *Roy Lichtenstein* (New York: Harry N. Abrams, 1971), reprinted in Coplans, ed., *Roy Lichtenstein* (see n. 31 above), p. 109.

43. Lichtenstein, in Coplans, "Talking with Roy Lichtenstein" (see n. 36 above), p. 86.

44. Lichtenstein, in Baker, "Interview with Roy Lichtenstein" (see n. 3 above), tape 1, side 2, p. 83.

45. Ibid., tape 1, side 1, p. 2.

46. Lichtenstein, in Coplans, "Talking with Roy Lichtenstein" (see n. 36 above), p. 86.

47. Some revision is apparent, particularly in the lower part of the canvas.

48. Lichtenstein, in Coplans, "Talking with Roy Lichtenstein" (see n. 36 above), p. 87.

49. See Otto Hahn, "Roy Lichtenstein," *Art International* 10, no. 6 (Summer 1966), reprinted in Coplans, ed., *Roy Lichtenstein* (see n. 31 above), p. 139, for an outline of the differences between Picasso's *Femme dans un fauteuil* and Lichtenstein's version. In terms of Lichtenstein's variations, the major innovation is the use of different colors in his dot patterns.

50. Delacroix painted two versions of the composition, in 1834 and 1849. On Picasso's variations on Delacroix's compositions, see Leo Steinberg, "The Algerian Women and Picasso at Large," *Other Criteria: Confrontations with Twentieth Century Art* (New York: Oxford University Press, 1972), pp. 125–234, and Susan Grace Galassi, *Picasso's Variations on the Masters* (New York: Harry N. Abrams, 1996), pp. 127–47.

51. Lichtenstein, in Baker, "Interview with Roy Lichtenstein" (see n. 3 above), tape 2, side 1, p. 3.

52. Ibid., tape 2, side 1, p. 2. For the opening of this exhibition, Lichtenstein made his first trip to Paris since World War II.

53. Leo Castelli held his first exhibition of Lichtenstein's work in February 1962; he began handling it in late 1961.

54. Lichtenstein's *Femme d'Alger* was in the "Popular Image Exhibition" at the Washington Gallery of Modern Art in April–June 1963, so it must have been finished by spring of that year.

55. No evidence of Victor Ganz's response to the painting is known. Ganz made no record of further purchases of Lichtenstein's work.

56. Lichtenstein, in Baker, "Interview with Roy Lichtenstein" (see n. 3 above), tape 1, side 2, pp. 88–89.

57. As Lozano noted when we examined the drawing, Lichtenstein mixed blue and yellow colored pencils to make green, rather than add a green pencil to his set.

58. Lichtenstein, in Baker, "Interview with Roy Lichtenstein" (see n. 3 above), tape 2, side 2, p. 47.

59. Ibid., p. 46.

60. Ibid. This section includes Lichtenstein's description of how he used "frisk-it" sheets to block the composition.

61. Ibid., p. 47.

62. Picasso's painting is smaller–approximately 38 1/2 x 51 1/4 inches.

63. See Baker, "Interview with Roy Lichtenstein" (see n. 3 above), tape 2, side 1, p. 29.

64. Lichtenstein, quoted in Barbaralee Diamonstein, "Caro, de Kooning, Indiana, Lichtenstein, Motherwell and Nevelson on Picasso's Influence," *Artnews* 73, no. 4 (April 1974): 46.

65. On Lichtenstein's sculptures, see Waldman, *Roy Lichtenstein* (see n. 28 above), pp. 313–43; many of these works make references to Picasso.

66. On this commission see Roland Penrose, *Picasso: His Life and Work*, 3rd ed. (Berkeley: University of California Press, 1981), pp. 442–46. Penrose served as an intermediary between Picasso and the committee. See also Werner Spies, *Picasso: The Sculptures* (Stuttgart: Hatje Cantz, 2000), pp. 328–29, 422.

67. Zervos II².773.

68. On the Apollinaire commission, see Michael FitzGerald, "Pablo Picasso's Monument to Guillaume Apollinaire: Surrealism and Monumental Sculpture in France, 1918–1959," unpublished Ph.D. dissertation, Columbia University, 1987, pp. 350–75. In 1956, one of Picasso's sculptures (*Female Head [Dora Maar]*, 1941) was finally erected in a small park next to the church of Saint Germain-des-Prés in Paris. It ended nearly forty years of effort to establish a monument to Apollinaire, although it is not the monument that Picasso proposed.

69. Penrose, *Picasso: His Life and Work* (see n. 66 above), p. 446.

70. Harry Golden, Jr., "Barber's in Lather over Picasso Fees," *Chicago Sun-Times*, November 15, 1967, p. 4.

71. Ibid.

72. My thanks to Oldenburg for discussing this project with me.

73. On Oldenburg's exhibition, held the following spring, see Richard Feigen, *Tales from the Art Crypt* (New York: Knopf, 2000), pp. 234–39, and the exhibition catalogue *"Richard J. Daley": The 20th Anniversary* (New York: Richard Feigen Gallery, 1988).

74. The copyright was registered to the Public Building Commission of Chicago. Barnet Hodes's legal opinion, dated August 26, 1968, was published by William Copley along with related documents in *The Barber's Shop* (Chicago: The Letter Edged in Black Press, 1969).

75. In later years, this *Pattern Model* deteriorated, and Oldenburg destroyed it (Oldenburg, in conversation with the author, July 2005).

76. See Oldenburg's statement in Matthew Diehl, "Picasso Was Here," *Art and Antiques* 6, no. 2 (February 1989), p. 37.

77. Ibid.

78. Oldenburg, quoted in Barbara Haskell, *Claes Oldenburg: Object into Monument* (Pasadena: Pasadena Art Museum, 1971), p. 85.

79. Oldenburg, quoted in Diehl, "Picasso Was Here" (see n. 76 above), p. 37.

80. Haskell, *Oldenburg: Object into Monument* (see n. 78 above), p. 85.

81. Oldenburg, quoted in Diehl, "Picasso Was Here" (see n. 76 above), p. 37.

82. My thanks to Oldenburg for confirming to me that he saw the exhibition (conversation with the author).

83. Robert Motherwell, quoted in "Picasso Is Dead in France at 91," *New York Times*, April 9, 1973, p. 47.

84. The portfolio, *Hommage à Picasso*, was published in six volumes by Propyläen Verlag, Berlin, and Pantheon Press, Rome, from 1973 to 1993.

85. Zervos IX.160

86. Lichtenstein, quoted in Diamonstein, "Caro, de Kooning, Indiana, Lichtenstein, Motherwell and Nevelson on Picasso's Influence" (see n. 64 above), p. 46.

87. Willem de Kooning, quoted in ibid., pp. 44–45.

88. Lichtenstein, quoted in ibid., p. 46.

89. Because of obvious similarities in title and subject, Lichtenstein's second and third versions of *Girl with Beach Ball* are often discussed in relation to Picasso's *Bather with Beach Ball* (1932, MoMA); version III, however, is more closely related to *Girl before a Mirror*.

90. For an extensive discussion of the painting's composition and imagery, see William Rubin, *Picasso in the*

Collection of the Museum of Modern Art (New York: Museum of Modern Art, 1972), p. 138.

91. Zervos VII.290.

92. See Robert Pincus-Witten's untitled text and Robert Rosenblum's "Notes on Mike Bidlo" in a pamphlet published by the Leo Castelli Gallery, New York, in conjunction with the exhibition "Mike Bidlo: Picasso's Women, 1901–1971," January 1988, and Joseph Masheck, "Bidlo's Pablo," *Art in America* 76, no. 5 (May 1988): 172–75.

93. Gert Schiff, *Picasso: The Last Years, 1963–1973* (New York: Solomon R. Guggenheim Museum, 1983), p. 11.

94. Ibid.

95. Picasso, quoted in Pierre Daix, *Picasso: Life and Art* (New York: Icon, 1993), p. 369.

96. In the mid-1980s, Condo made a series of paintings and drawings that manifests a particularly sophisticated command of Picasso's varied styles and an intellectual grasp of their aesthetic foundations that enabled Condo to surpass most of his contemporaries in appropriating and transforming Picasso's art; see *George Condo: Gemälde/Paintings 1984–87*, exh. cat. (Munich: Kunstverein München, 1987), pp. 52–53. (Munich: Kunstverein München, 1987), and such works as the painting *Edith Piaf* (1987–88) and a large drawing, *Untitled* (1987), which is in the collection of the Whitney Museum of American Art. In 1984, Jean-Michel Basquiat painted *Untitled (Pablo Picasso)*, a loose portrait of Picasso in a horizontally striped shirt like one he wears in a number of photographs taken particularly in the 1950s. Besides inscribing "PABLO PICASSO" seven times on the metal surface of the painting, Basquiat wrote across the striped shirt "PICASSO AS A FIFTEEN YEAR OLD"—an age that roughly corresponds to Basquiat's youthful image of the artist. It is reproduced in Richard Marshall, *Jean-Michel Basquiat* (Paris: Galerie Enrico Navarra, 1996), vol. 1, p. 287. On Basquiat's interest in Picasso since his teenage years, see Phoebe Hoban, *Basquiat: A Quick Killing in Art* (New York: Viking, 1998), pp. 17, 38–39, 195, 257.

97. Warhol bought Picasso's *Head of a Woman* (1965; Zervos XXV.144) from Swiss art dealer Thomas Ammann. My thanks to Doris Ammann for confirming the sale.

98. See Robert Rosenblum, "Warhol's Picassos," and Rainer Crone and Petrus Graf Schaesberg, "Variations of the 'Imago': Andy Warhol's Picasso Adaptations," both in Thaddeus Ropac, ed., *Andy Warhol: Heads (After Picasso)* (Paris: Galerie Thaddeus Ropac, 1997), pp. 11–13 and 18–23, respectively.

99. Andy Warhol, *The Philosophy of Andy Warhol (From A to B and Back Again)* (New York: Harcourt Brace Jovanovich, 1975), p. 148.

100. Lichtenstein, in an unpublished transcript of an interview with Diehl, June 1988, p. 2. The transcript is in the archives of the Lichtenstein Foundation. An edited version of the interview was published as Diehl, "Picasso Was Here" (see n. 76 above).

101. Ibid., p. 5. With Cowart's permission, I have removed the brackets from the citation of this quote in the title of this chapter.

102. Picasso's drawing is Zervos IX.85. There is a slide of it in Lichtenstein's papers at the Lichtenstein Foundation.

103. Lichtenstein, in an interview with Carter Ratcliff, "Roy Lichtenstein: Donald Duck et Picasso," *Art Press* (Paris) 140 (October 1989): 13. Lichtenstein only spoke of examining *The Studio*, although he presumably also examined the other paintings in this series that are in the Modern's collection.

104. A slide of Picasso's *Bathers with Beach Ball* (1928) is among Lichtenstein's papers preserved in the Lichtenstein Foundation.

105. The painting is reproduced on p. 73 of David Douglas Duncan, *Picasso's Picassos* (New York: Harper & Brothers, 1961). Lozano found this marker in Lichtenstein's copy of the book and realized its relevance to *Nude*.

106. Although Lichtenstein's works after *Female Nude* reverse Picasso's composition, they echo the colors of Picasso's painting.

107. For a reproduction of one of Johns's first "flagstone" paintings, *Harlem Light* (1967), see Varnedoe, *Jasper Johns: A Retrospective* (see n. 9 above), pp. 254–55. On Lichtenstein's "Abstractions" see Jack

Cowart, *Roy Lichtenstein: 1970–1980* (New York: Hudson Hills, 1981), pp. 78–82.

108. Lichtenstein included a similar Johnsian motif in *Two Paintings*, a 1984 lithograph related to *Two Paintings with Dado*. Varnedoe noted that "over the past two decades these two [Johns and Lichtenstein] have shown, aside from their mutual demonstrations of interest in Pablo Picasso, several common elements of both theme and style." And Varnedoe also suggested that some of Lichtenstein's pictures seem "to prefigure aspects of Johns's paintings of the 1980s. (Works by Johns are in turn sometimes pictured, in satirically reductive imagery, in Lichtenstein's later interior views)"; Varnedoe, "Introduction: A Sense of Life," in *Jasper Johns: A Retrospective* (see n. 9 above), pp. 106–7.

109. For Johns's account of seeing the flagstone motif, see Michael Crichton, *Jasper Johns*, rev. ed. (New York: Harry N. Abrams, 1994), pp. 52–53.

110. Johns, quoted in Ann Hindry, "Conversations with Jasper Johns," *Artstudio*, no. 12 (Spring 1989), reprinted in Kirk Varnedoe, ed., *Jasper Johns: Writings, Sketchbook Notes, Interviews* (New York: Museum of Modern Art, 1996), p. 227.

111. Johns, quoted in Stevens with McGuigan, "Super Artist: Jasper Johns, Today's Master" (see n. 9 above), p. 120.

112. Johns does not remember precisely where in New York City he saw this first Picasso painting, but believes it was in a gallery rather than a museum (Johns, in conversation with the author, August 2003). Given the limited number of exhibitions of Picasso's work in New York during the late 1940s, he may well have seen the picture at Sam Kootz's gallery on 53rd Street. If so, it would very likely have been one of the wartime or immediately postwar paintings that Kootz purchased from Picasso, as discussed in chapter 4.

113. Johns, in Billy Klüver and Julie Martin, interview with Johns, February 26, 1991, published in Varnedoe, ed., *Jasper Johns: Writings, Sketchbook Notes, Interviews* (see n. 110 above), p. 42.

114. Grace Glueck, "How Picasso's Vision Affects American Artists," *New York Times*, June 22, 1980, section D, p. 7.

115. The exhibition opened in January 1958.

116. Kirk Varnedoe, *Masterworks from the Louise Reinhardt Smith Collection* (New York: Museum of Modern Art, 1995), p. 56.

117. Varnedoe, "Introduction: A Sense of Life" (see n. 108 above), p. 24.

118. See Crichton, *Jasper Johns* (see n. 109 above), p. 42.

119. Johns, quoted in ibid.

120. On the Ganzes' purchases, see "Chronology of the Collection," in Michael FitzGerald, ed., *A Life of Collecting: Victor and Sally Ganz* (New York: Christie's, 1997), pp. 230–37.

121. The Ganzes purchased one work by Richard Hunt, in 1958, before they acquired their first Johns; ibid., p. 231.

122. Castelli, in Michael FitzGerald, "Interview with Leo Castelli," in ibid., p. 86.

123. Ibid.

124. The Ganzes had nearly stopped buying Robert Rauschenberg's work by 1969. Their collection of paintings by Frank Stella was primarily kept in a gallery in the basement of their apartment building.

125. David Sylvester, "Picasso, Johns, and Grisaille," in FitzGerald, ed., *A Life of Collecting* (see n. 120 above), p. 113.

126. On Johns's possible use of Cézanne's bather in *Diver*, see Roberta Bernstein, "Seeing a Thing Can Sometimes Trigger the Mind to Make Another Thing," in Varnedoe, *Jasper Johns: A Retrospective* (see n. 9 above), p. 42, and Christian Geelhaar, "The Painters Who Had the Right Eyes: On the Reception of Cézanne's Bathers," in Mary Louise Krumrine, *Paul Cézanne: The Bathers* (Basel: Museum of Fine Arts, 1989), p. 298.

127. See Amei Wallach, "Jasper Johns at the Top of His Form," *New York Newsday*, October 30, 1988, reprinted in Varnedoe, ed., *Jasper Johns: Writings, Sketchbook Notes, Interviews* (see n. 110 above), p. 227. Wallach states that the invitation came from the Museum of Modern Art, although Johns himself does not recall this (Johns, in conversation with the author, November 2005).

128. Johns, quoted in Wallach, "Jasper Johns at the Top of His Form" (see preceding note), p. 266.

129. This configuration was suggested to Johns by a particular vase, made in 1977 to commemorate the Silver Jubilee of Queen Elizabeth II of England, that he has often reproduced in his work. For a reproduction of that vase, see Nan Rosenthal and Ruth E. Fine, *The Drawings of Jasper Johns* (Washington, D.C.: National Gallery of Art, 1990), p. 286.

130. The "Rubin's figure" is a device named after Danish psychologist Edgar Rubin. "Such perceptual images were used to illustrate visual alternatives between figure and ground. Johns has said that the coronation [Silver Jubilee] vase was the first three-dimensional example of this optical phenomenon he had seen." Ibid.

131. Johns's 1962 parody, *Cup We All Race 4*, reproduces the name of John Peto and the word "cup" instead of the utensil. It is illustrated in Varnedoe, *Jasper Johns: A Retrospective* (see n. 9 above), p. 56, fig. 12.

132. For an overview of Johns's interest in Marcel Duchamp, see Bernstein, "Seeing a Thing" (see n. 126 above), pp. 39–46.

133. Johns remembers that the photograph was supplied by someone at the Museum of Modern Art (Johns, in conversation with the author, November 2005). Picasso used a generalized version of his own profile in *The Studio* (1929–28; Musée Picasso, Paris) and *Bust of a Woman with Self-Portrait* (1929; private collection). The latter painting is included in Norman Rockwell's *Triple Self-Portrait* (1960).

134. *Souvenir* (1964; collection of the artist) contains a photographic image of Johns with a mirror and flashlight positioned so that its beam is reflected onto John's image. It seems to be one of the first works in which Johns referred to fame.

135. Johns does not see these references as particularly significant (conversation with the author, August 2003). They include the cloth rendered in *Perilous Night* (1982; National Gallery of Art; reproduced in Varnedoe, *Jasper Johns: A Retrospective* [see n. 9 above], p. 325), which has been interpreted as a citation of Picasso's "Weeping Woman" prints (1937); see Mark Rosenthal, *Jasper Johns: Work since 1974* (Philadelphia: Philadelphia Museum of Art, 1988), p. 65.

136. Johns, quoted in Bernstein, "Seeing a Thing" (see n. 126 above), p. 49. See also p. 71 (n. 56) for other authors' speculations on the crosshatch pictures.

137. For Johns's description of seeing the car, see Crichton, *Jasper Johns* (see n. 109 above), p. 57.

138. Duncan, *Picasso's Picassos* (see n. 105 above), p. 11.

139. Johns elaborated this composition in a series of paintings, including *Untitled (M.T. Portrait)* (1986; collection Robert and Jane Meyerhoff), reproduced in Varnedoe, *Jasper Johns: A Retrospective* (see n. 9 above), p. 349. The "M.T." in the title was added at the suggestion of Jane Meyerhoff and refers to Picasso's mistress Marie-Thérèse Walter, among other things. Johns may also have been prompted to include a wristwatch in this painting by Picasso's *Seated Woman with Wrist Watch* (1932; pl. 101), which he saw in the home of the owner.

140. For Johns's references to skin in his work and use of his own features, see Varnedoe, "Introduction: A Sense of Life" (see n. 108 above), pp. 29–30.

141. *In the Studio* (1982) is generally seen as the first major work exploring these new modes; see ibid., p. 319.

142. In conversation in August 2003, Johns mentioned to me that his favorite Picasso in the Ganz collection was *Bather with Beach Ball* (1932; Museum of Modern Art), because of its extravagant form and unpredictability.

143. In recent years, Johns has made a few variations after *Straw Hat with Blue Leaves*, including an untitled drawing (2001; collection of the artist).

144. For Johns's use of this child's drawing, which he recalled seeing in a 1952 article by Bruno Bettelheim, see Bernstein, "Seeing a Thing" (see n. 126 above), p. 60.

145. Johns based his image of Duchamp's *Bride* on a free variation made by Duchamp's brother Jacques Villon as a print, of which Johns owns a copy; see ibid.

146. The entry on *Untitled* in Nan Rosenthal and Ruth E. Fine, *The Drawings of Jasper Johns* (Washington,

D.C.: National Gallery of Art, 1990), p. 308, suggests that the profiles in this watercolor seem "to bear both [Johns's] own and Picasso's profiles." For a photograph in profile in 1992, see Varnedoe, *Jasper Johns: A Retrospective* (see n. 9 above), p. 362.

147. This configuration is based on the Silver Jubilee vase.

148. My thanks to Paul Brach for discussing this matter with me. To date, no evidence has been found to authenticate the statement ascribed to Picasso. Johns's literal use of this statement is analogous to his use, in *Painted Bronze*, of de Kooning's reported remark that Castelli could sell cans of beer as works of art.

149. Johns, quoted in Wallach, "Jasper Johns at the Top of His Form" (see n. 127 above), p. 226.

150. Johns, quoted in Aimee Wallach, "Jasper Johns: On Target," *Elle*, November 1988, p. 154.

151. Picasso's *Reclining Nude* was shown in the exhibition "Picasso's Dora Maar/De Kooning's Women," at the C&M gallery, New York, April 2–May 28, 1998. Johns saw it hanging at C&M some months later, after he had finished his painting. His studies for the picture are dated "St. Martin, August 1998."

152. A related painting, which Picasso painted six days later (on May 23, 1938; *Reclining Nude* was painted on May 17), shows a similar woman surrounded by a hen, chicks, and particularly the rooster of France (*The Farmer's Wife*, Musée Picasso, Paris).

153. The paintings by Picasso and Johns are nearly the same height, although Johns's decision to delete the right side of Picasso's composition substantially alters the width of Johns's painting. The Picasso painting is 35 3/8 x 46 5/8 in.; the Johns is 34 1/2 x 28 1/2 in.

154. On the *Seasons*, see Roberta Bernstein, "Jasper Johns's The Seasons: Records of Time," in *Jasper Johns: The Seasons* (New York: Brooke Alexander Editions, 1991), pp. 9–12, and the publications about the series cited in this text and its bibliography, pp. 5–57.

155. Duncan, *Picasso's Picassos* (see n. 105 above), p. 87.

156. In a related watercolor, *Man Wearing a Mask, Woman with a Child in Her Arms* (1936; Z.VIII.278), Picasso juxtaposed a bearded man holding a mask of a Minotaur with a woman (resembling Walter) holding a baby who reaches toward the unresponsive man.

157. This configuration is generally interpreted as a reference to both Cézanne and a Japanese brush painting. See Bernstein, "Seeing a Thing" (see n. 126 above), p. 57.

158. Johns, quoted in Crichton, *Jasper Johns* (see n. 109 above), p. 68.

159. Picasso, quoted in Duncan, *Picasso's Picassos* (see n. 105 above), p. 183.

160. Although the figure is not a strict portrait of Gilot, it does show the voluptuous features that Picasso used to characterize her.

161. Johns painted a bird he had observed in a tree in his garden in St. Martin (Johns, in conversation with the author, February 2004).

162. In 1942, Picasso had painted a composition depicting "Three Ages of Man," with the middle figure holding the Minotaur's mask; see Michael FitzGerald, *Picasso: The Artist's Studio* (New Haven: Yale University Press, 2001), pp. 49–50.

163. The aquatint is *The Seasons*, printed at Universal Limited Art Editions, New York, 1990; reproduced in Varnedoe, *Jasper Johns: A Retrospective* (see n. 9 above), p. 368.

164. Johns derived this figure from Picasso's *Fall of Icarus* (1958), a large mural commissioned by UNESCO for its Paris headquarters. Johns told Bernstein that he saw the work reproduced in Arianna Stassinopoulos Huffington, *Picasso: Creator and Destroyer* (New York: Simon & Schuster, 1988); see Bernstein, "Seeing a Thing" (see n. 126 above), p. 66.

165. For an insightful discussion of a closely related version of this composition, see Varnedoe, "Introduction: A Sense of Life" (see n. 108 above), pp. 13–15.

166. The Icarus figure and elements of *The Seasons* compositions also appear in the "Mirror's Edge" paintings (1993).

167. For a discussion of the iconography of the ladder in medieval art and in Johns's work, see Victor I. Stoichita, "Three Academic Ideas," in Joan Rothfuss, *Past Things and Present: Jasper Johns since 1983* (Minneapolis: Walker Art Center, 2003), p. 44.

168. These self-portraits were highlights of the Guggenheim Museum's 1983 exhibition of Picasso's late work.

169. Johns has said, "Painting can be a conversation with oneself and, at the same time, it can be a conversation with other paintings. What one does triggers thoughts of what others have done or might do. . . . This introduces a degree of play between the possible and the necessary, which can allow one to learn from other artists' work that might seem otherwise unrelated or irrelevant"; quoted in Hindry, "Conversation with Jasper Johns" (see n. 110), p. 13.

170. For an explanation of "catenary," see Richard S. Field, "Chains of Meaning: Jasper Johns's *Bridge* Paintings," in *Jasper Johns: New Paintings and Works on Paper* (San Francisco: San Francisco Museum of Modern Art, 1999), p. 18. Field quotes a dictionary definition of "catenary": "the curve assumed by a cord of uniform density and cross section that is perfectly flexible but not capable of being stretched and that hangs freely from two fixed points." Since Johns's string can stretch, he is clearly not following the term strictly.

171. The cloth depicted in Johns's *Perilous Night*, see note 135.

172. See Field, "Chains of Meaning" (see n. 170 above), p. 31.

173. Johns, in conversation with the author, August 2003.

174. For a history of the representation of Harlequin in late-nineteenth- and early-twentieth-century art, see Theodore Reff, "Themes of Love and Death in Picasso's Early Work," in John Penrose and John Golding, eds., *Picasso in Retrospect* (New York: Praeger, 1973), pp. 11–47. Picasso's two versions of *Three Musicians* (1921) are also major Cubist depictions of Harlequin, but show him grouped with two other figures.

175. The woman is Germaine Pichot. For an analysis of the painting, see Reff, "Themes of Love and Death" (see preceding note), pp. 33–34.

176. As a Spanish citizen, Picasso was not drafted, nor did he volunteer (as did Apollinaire, an Italian national).

177. On the context of *Harlequin* (1915), see Michael FitzGerald, *Making Modernism: Picasso and the Creation of a Market for Twentieth-Century Art* (New York: Farrar, Straus and Giroux, 1995), pp. 59–62.

178. *Ventriloquist* (1983; Museum of Modern Art) and *Untitled* (1984; collection Eli and Edythe L. Broad); both are reproduced in Varnedoe, *Jasper Johns: A Retrospective* (see n. 9 above), pp. 333, 334.

179. In *Pyre 2*, Johns stenciled the letters on their sides; a circle at the left side of the composition is partially covered by the slat down the center of the painting.

180. Johns used these words to characterize the paintings, in conversation with the author, November 2005. Picasso's *Death of Harlequin* (1905–6; National Gallery of Art, Washington, D.C.), shows the costumed figure laid on a bed; I know of no evidence that Johns was aware of the painting when he painted *Pyre* and *Pyre 2*.

SELECTED CHRONOLOGY OF EXHIBITIONS, AUCTIONS, AND MAGAZINE REPRODUCTIONS, 1910–1957

JULIA MAY BODDEWYN

This chronology has served as the foundation for our investigation into how knowledge of Picasso's oeuvre developed in the United States and how American artists responded to the works by him that they saw in exhibitions and publications. It is an attempt to compile an exhaustive record of the opportunities that Americans had for seeing Picasso's work in the U.S., beginning with the first reproductions of his paintings in an American magazine in 1910 up through the Museum of Modern Art's Picasso retrospective in 1957. Included here, in addition to almost all the exhibitions that presented Picasso's works during that period, are selective instances of American magazines reproducing his works until 1926, when the French periodical *Cahiers d'art* began publication and became an oft-consulted source for reproductions of contemporary art, frequently by Picasso. Similarly, it includes important early auctions that offered works by Picasso, providing significant opportunities to view them in pre-sale exhibitions and published catalogues. By the late 1950s, his works were so frequently exhibited and reproductions of them were so broadly disseminated that Picasso's reputation was firmly established. The chronology ends then, since exhibitions and publications after that time had less impact on American audiences than those that had been seen in the U.S. during the preceding four decades.

Although this chronology is not comprehensive (it excludes prints and sculptures), I believe that the level of detail for the time span covered will make it invaluable to scholars. The chronology focuses only on the six cities that constituted the major art centers in the U.S. during this period: Chicago, Los Angeles, New York, Philadelphia, San Francisco, and Washington, D.C. An exception is the inclusion of the seminal retrospective held in 1934 at the Wadsworth Atheneum in Hartford, Connecticut.

Many of the early exhibitions were largely undocumented; for these, I have relied on modern sources or contemporaneous reviews to help identify the works exhibited. Here, titles of works that have been identified appear in brackets, along with the date, medium, dimensions, and lender when these distinguishing details were known. My references for these undocumented exhibitions appear in the notes at the end of the chronology (pp. 378–83). In addition, I have sometimes given a brief explanation about an exhibition, collector, or dealer, also in brackets. For information that came from a published catalogue or checklist issued by the gallery or museum that held a show—or when a list of works presented in that show was available instead through a museum's archives or registrar—the title, date, medium, dimensions, and lender are listed as they appeared in the original source, without brackets. Note that nearly all information in this chronology that is enclosed by brackets is from later sources, and that information

within parentheses is from the presenting institution at the time, including exhibition numbers (if given), whether a work was reproduced in an exhibition catalogue (if there was one), and details about the venues (for works in traveling exhibitions); occasionally, brackets are also used for titles—of exhibitions or of individual works—mentioned in contemporaneous third-party sources, such as reviews or listings of shows in a magazine. Where a current title of a work differs from the one originally assigned to it for an exhibition, that information is given in brackets immediately after the original title; and if more information about a work's date, medium, or lender is now known, that information is also given in brackets. Occasionally, alternative titles and dates were noted in the original source (in parentheses or separated by slant marks), and I have included these too. I have also included the reference number from the Zervos catalogue raisonné and the present location of the work, wherever possible, also in brackets. (Note that I have not added the dimensions if I give the Zervos reference number for the work, since that information is usually available in the catalogue raisonné.)

Regarding the order in which works are listed: In most of the exhibitions, the works were numbered, and that order has been maintained here; in exhibitions where the works were unnumbered and not in chronological order, I have revised the order chronologically.

Note: An asterisk (*) after a title indicates a work that is included in the present exhibition.

1910

May 1910: Gellett Burgess, "The Wild Men of Paris," *Architectural Record* 27, no. 5
> ill. p. 403: *La Femme* [current title: *The Dryad*, 1908. Z.II¹.113; Hermitage, St. Petersburg]
> ill. p. 404: *Meditation* [current title: *Seated Nude*, 1908. Z.II¹.68; Hermitage, St. Petersburg]
> ill. p. 407: *"La Femme"* [current title: *Three Women*, 1908. Z.II¹.108; Hermitage, St. Petersburg]
> ill. p. 408: *Study* [current title: *Les Demoiselles d'Avignon*, 1907. Z.II¹.18; Museum of Modern Art, New York]

1911

March 28–May 1911: 291, Little Galleries of the Photo-Secession, New York
["Exhibition of Early and Recent Drawings and Water-Colors by Pablo Picasso of Paris" / First showing of Picasso's work in the United States: forty-nine drawings and watercolors, 1905–10, plus thirty-four additional drawings available to viewers on request. Only three works in this exhibition have been identified with certainty.]
> [*Peasant Woman with a Shawl*, 1906, charcoal. Z.XXII.386; Art Institute of Chicago]
> [*Study of a Nude Woman*, 1906, gray brown ink on brown paper. Museum of Fine Arts, Boston / This drawing, one of two works sold from the exhibition, was purchased by Hamilton Easter Field.]
> [*Standing Female Nude*,* 1910, charcoal. Z.II¹.208; Metropolitan Museum of Art, New York / Purchased from the exhibition by Alfred Stieglitz, director of the 291 gallery.]

October 1911: *Camera Work* 36
> ill. p. 63: *Drawing* [current title: *Standing Female Nude*,* 1910, charcoal. Z.II¹.208; Metropolitan Museum of Art, New York]

1912

August 1912: *Camera Work* SN ["Special Number" devoted to essays by Gertrude Stein on Henri Matisse and Picasso.]
> ill. p. 31: *The Wandering Acrobats* [current title: *Acrobat Standing on a Ball*, 1905. Z.I.290; Pushkin State Museum of Fine Arts, Moscow]
> ill. p. 33: *Untitled* [current title: *Head of a Woman in a Mantilla*, 1909. Z.II¹.171; private collection, France]
> ill. p. 35: *Spanish Village* [current title: *The Reservoir at Horta de Ebro*, 1909. Z.II¹.157; Museum of Modern Art, New York]
> ill. p. 37: *Portrait, M. Kahnweiler* [1910. Z.II¹.227; Art Institute of Chicago]
> ill. p. 39: *Drawing* [current title: *Standing Female Nude*,* 1910. Z.II¹.208; Metropolitan Museum of Art, New York]

1913

February 17–March 15, 1913: 69th Infantry Regiment Armory, New York
"International Exhibition of Modern Art"; traveled to the Art Institute of Chicago, March 24–April 16, 1913
> *Nature morte No. 1*, oil / Leo Stein, Paris (no. 345 in New York; no. 288 in Chicago)
> *Nature morte, No. 2*, oil / Leo Stein, Paris (no. 346 in New York; no. 289 in Chicago)
> *Les Arbres* [current title: *Landscape (Two Trees)*], 1907 [actual date: 1908], [gouache] / Daniel-Henry Kahnweiler, Paris (no. 347 in New York; no. 290 in Chicago) [Z.II¹.54; Philadelphia Museum of Art / This work was sold at the Armory Show to Arthur B. Davies, New York.]
> *Mme. Soler*, [1903], oil / Daniel-Henry Kahnweiler, Paris (no. 348 in New York; no. 291 in Chicago) [Z.I.200; Staatsgalerie Moderner Kunst, Munich]
> *Tête d'homme*, [1912], oil / Daniel-Henry Kahnweiler, Paris (no. 349 in New York; no. 292 in Chicago)
> *La Femme au pot de moutarde*,* [1910], oil / Daniel-Henry Kahnweiler, Paris (no. 350 in New York; no. 293 in Chicago) [Z.II¹.211; Gemeentemuseum, The Hague]

Drawing [current title: *Standing Female Nude*,* [1910, charcoal] / Alfred Stieglitz, New York (no. 351 in New York; no. 287 in Chicago) [Z.II¹.208; Metropolitan Museum of Art, New York]

June 1913: *Camera Work* SN ["Special Number"]
> ill. p. 49: *Portrait–Gertrude Stein* [Z.I.352; Metropolitan Museum of Art, New York]
> ill. p. 51: *Woman with Mandolin* [Z.II¹.235; Museum of Modern Art, New York]
> ill. p. 53: *Drawing* [current title: *Standing Female Nude*.* Z.II¹.208; Metropolitan Museum of Art, New York]

December 1913: Bellevue-Stratford Hotel, Philadelphia [Title of exhibition unknown.]
> [*Landscape (Two Trees)*, 1908 / Arthur B. Davies, New York. Z.II¹.54; Philadelphia Museum of Art]

1914

Summer 1914: Washington Square Gallery, New York ["Picasso" / According to an article published in 1975, "Picasso was the subject of the first exhibition" held at Washington Square Gallery, and it "probably consisted of small drawings like those which Stieglitz displayed in 1911."]

December 9, 1914–January 11, 1915: 291, New York ["An Exhibition of Recent Drawings and Paintings by Picasso and by Braque, of Paris"]
> [*Bathers in a Forest*, 1908, watercolor, gouache, and graphite on paper. Z.II¹.105; Philadelphia Museum of Art]
> [*Head*, 1909, brush and ink on paper, 24 3/4 x 18 7/8 in. Metropolitan Museum of Art, New York]
> [*Head of a Woman*, 1909, brush and ink and charcoal on paper, 25 x 19 3/8 in. Metropolitan Museum of Art, New York]
> [*Still Life*, 1909, charcoal on paper. Z.II².683; Metropolitan Museum of Art, New York]
> [*Study* (current title: *Head of Fernande*), 1909, watercolor on tan wove paper. Z.XXVI.413; Art Institute of Chicago]
> [*Bottle and Wine Glass on a Table*,* 1912, charcoal, ink, cut and pasted newspaper, and graphite on paper. Z.II².428; Metropolitan Museum of Art, New York / Purchased from the exhibition by Alfred Stieglitz, director of the 291 gallery.]
> [*Seated Man Reading a Newspaper*, 1912, 12 1/8 x 7 3/4 in. Metropolitan Museum of Art, New York]
> [*Still Life: Cruet Set*, 1912, pen and ink on paper, 12 3/8 x 9 5/8 in. Metropolitan Museum of Art, New York]
> [*Violin*, ca. 1912, charcoal on paper, 18 1/2 x 12 3/8 in. Philadelphia Museum of Art]
> [*Violin and Guitar*, 1913, oil, cloth, charcoal, and gesso on canvas. Z.II².363; Philadelphia Museum of Art]
> [*Guitar and Wine Glass*, 1912, collage and charcoal. Z.II².423; Marion Koogler McNay Art Museum, San Antonio / This may have been one of the works included in the exhibition, according to one modern source.]

December 20, 1914–January 9, 1915: Carroll Galleries, New York
"First Exhibition of Contemporary French Art" [This exhibition included at least one work by Picasso, although no specific titles of works have been identified.]

1915

January 12–26, 1915: 291, New York
[Untitled exhibition in a small interior room at the gallery, consisting of nine works on paper by Picasso from the collection of Adolphe Basler; one work remains unidentified, and may have been a print.]
> [*Study of Harlequin*, 1905, pen and ink on lined paper, 5 5/8 x 3 5/8 in. Metropolitan Museum of Art, New York]
> [*Head*, 1909, brush and ink on paper, 24 3/4 x 18 7/8 in. Metropolitan Museum of Art, New York]
> [*Head of a Woman*, 1909, brush and ink and charcoal on paper, 25 x 19 3/8 in. Metropolitan Museum of Art, New York]
> [*Still Life*, 1909. Z.II².683; Metropolitan Museum of Art, New York]
> [*Study (Head of Fernande)*, 1909, black crayon and gouache. Z.XXVI.413; Art Institute of Chicago]
> [*Head of a Man*, 1912, charcoal on paper, 24 1/2 x 19 in. Metropolitan Museum of Art, New York]
> [*Seated Man Reading a Newspaper*, 1912, ink, 12 1/8 x 7 3/4 in. Metropolitan Museum of Art, New York]
> [*Still Life: Cruet Set*, 1912, pen and ink on paper, 12 3/8 x 9 5/8 in. Metropolitan Museum of Art, New York]

Late winter–early spring 1915: Washington Square Gallery, New York
[Title of exhibition unknown. It included four paintings and six drawings by Picasso, although no specific titles of works have been identified.]

March 1915: *291*, no. 1
> ill. n.p.: *Oil and Vinegar Caster* [current title: *Still Life: Cruet Set*, 1912, pen and ink on paper, 12 3/8 x 9 5/8 in. Metropolitan Museum of Art, New York]

March 8–April 3, 1915: Carroll Galleries, New York
"Third Exhibition of Contemporary French Art"
> *The Sad Mother* (no. 1 in exh.) [Z.I.115; Fogg Art Museum, Harvard University, Cambridge, Massachusetts]
> *Two Women* [current title: *Two Female Nudes*, 1906] (no. 2 in exh.) [Z.I.366; Museum of Modern Art, New York]
> *The Guitarrist* [sic] [current title: *The Old Guitarist*, 1903] (no. 3 in exh.) [Z.I.202; Art Institute of Chicago]
> *Woman Dressing Her Hair* [current title: *Woman Combing Her Hair*, 1906] (no. 4 in exh.) [Z.I.336; Museum of Modern Art, New York]
> *Woman at a Table* (no. 5 in exh.) [Z.I.96; Fogg Art Museum, Harvard University, Cambridge, Massachusetts]
> *Figure*, [1909] (no. 6 in exh.)
> *Still-Life* (no. 7 in exh.)

October 7–November 13, 1915: Modern Gallery, New York
["Paintings by Picabia, Braque, Picasso" / No works from this exhibition have been identified, but they are presumed to have been works previously seen in New York.]

November 1915: *291*, no. 9
> ill. n.p.: [*Violin*, ca. 1912, charcoal on paper, 18 1/2 x 12 3/8 in. Philadelphia Museum of Art / No title or other identifying information was provided with the illustration for this work.]

December 1915–January 1916: *291*, nos. 10/11
> ill. on cover: Picasso [*Glass, Pipe, Dice and Playing Card*, 1914. Z.II².830; Musée Picasso, Paris / No title or other identifying information was provided with the illustration for this work.]

December 13, 1915–January 3, 1916: Modern Gallery, New York
["Picasso Exhibition"]
> [*Nature morte*, Paris, 1913 (no. 1 in exh.) / This was probably *Bar-Table with Musical Instruments and Fruit Bowl*,* ca. 1913 (Z.II².759), now in a private collection.]
> [*Figure d'homme*, Sorgues, 1912 (no. 2 in exh.)]
> [*Jeune Fille*, Avignon, 1914 (no. 3 in exh.). Z.II².528; Musée National d'Art Moderne, Centre National d'Art et de Culture Georges Pompidou, Paris]
> [*Nature morte*, Avignon, 1914 (no. 4 in exh.)]
> [*Glass, Pipe, and Playing Card*, 1915 (no. 5 in exh.). Z.II².830; Musée Picasso, Paris]
> [*Untitled (Man with a Moustache, Buttoned Vest, and Pipe, Seated in an Armchair), (Man with a Pipe)*,* 1915 (no. 6 in exh.). Z.II².564; Art Institute of Chicago / It is probable, but not certain, that this painting is the one that appeared on the checklist as no. 6, *Nature morte*.]
> [*Nature morte*, 1915 (no. 7 in exh.)]

[*Nature morte*, 1915 (no. 8 in exh.)]
[*Nature morte*, 1915 (no. 9 in exh.)]
[*Nature morte*, 1915 (no. 10 in exh.)]
[*Nature morte*, 1915 (no. 11 in exh.)]

1916

January 1916: Albert C. Barnes, "Cubism: Requiescat in Pace," *Arts and Decoration* 6, no. 3
 ill. p. 123: *Portrait of M. Kahnweiler* / reproduced with the credit line "Permission of '291'" [Z.II¹.227; Art Institute of Chicago]
 ill. p. 124: *Head*, 1909 / reproduced with the credit line "Permission of '291'" [Z.II¹.171; private collection, France]

February 12–March 1, 1916: Modern Gallery, New York ["Exhibition of Paintings by Cézanne, van Gogh, Picasso, Picabia, Braque, Desseignes, Rivera"]
 [*Nature morte* (no. 5 in exh.)]
 [*Figure d'homme* (no. 6 in exh.)]
 [*Jeune Fille* (no. 7 in exh.)]
 [*Nature morte* (no. 8 in exh.)]

March–April 1916: Washington Square Gallery, Washington, D.C.
[Exhibition of modern European art, the title of which is unknown. Twenty works were presented, including at least one by Picasso, although no specific titles of works have been identified.]

April 1916: Marius de Zayas, "Cubism," *Arts and Decoration* 6, no. 6
 ill. p. 285: *Still Life* [*Violin and Guitar*, 1913. Z.II².363; Philadelphia Museum of Art]

April 29–June 10, 1916: Modern Gallery, New York ["Paintings by Cézanne, van Gogh, Picasso, Picabia, Rivera"]
 [*Violin and Guitar*, 1913. Z.II².363; Philadelphia Museum of Art]

May 17–June 15, 1916: McClees Galleries, Philadelphia ["Philadelphia's First Exhibition of Advanced Modern Art"]
 [*Still Life* / This piece may have been owned by John Quinn, who helped organize the exhibition. Quinn, a New York lawyer, was an active proponent of modern art in the United States who did much to further awareness of contemporary European art. He was also a leading collector who had amassed a large and important collection (one that included many works by Picasso) by the time of his premature death in 1924.]

September 11–30, 1916: Modern Gallery, New York ["Exhibition of Paintings and Sculpture"]
 [*In the Manner of Redon, Guys, and Lautrec*, drawing, medium not specified (no. 13 in exh.)]
 [*Figure of a Woman* (no. 16 in exh.) / Described as having been done "in the usual block and plane style" in a contemporaneous review]
 [*A Boy*, drawing, medium not specified (no. 17 in exh.)]

1917

April 10–May 6, 1917: Grand Central Palace, New York ["Exhibition of the Society of Independent Artists"]
 [*Portrait* (no. 78 in exh.; ill. in cat.)]
 [*Portrait* (no. 79 in exh.)]

June 9–30, 1917: Modern Gallery, New York ["Exhibition of French and American Artists (drawings)" / This exhibition included at least one work by Picasso, although no specific titles of works have been identified.]

Through December 29, 1917: Cosmopolitan Club, New York
["Modern Paintings" / This exhibition included one painting by each of the following artists: Georges Braque, Jean Crotti, André Derain, Louis Eilshemius, Man Ray, Francis Picabia, Picasso, Dorothy Rice, Diego Rivera, Joseph Stella.]

[*Still Life* / A contemporaneous review noted that this painting "introduces reinforced concrete."]

1918

March 11–30, 1918: Modern Gallery, New York ["Exhibition of Paintings by Picasso, Derain, Gris, Rivera, Burty, Ferat" / This exhibition included at least one work by Picasso, although no specific titles of works have been identified.]

April 20–May 12, 1918: Society of Independent Artists, New York
[Title of exhibition unknown.]
 [*Woman Dressing Her Hair* (no. 587 in exh.)]
 [*Still Life* (no. 588 in exh.)]

April 22–May 3, 1918: Anderson Galleries, New York "Selections from the Léonce Alexandre-Rosenberg Collection: Early Egyptian Art, primitive Chinese bronzes, Cubist paintings and sculptures, Persian Miniature paintings" [Pre-sale exhibition; the sale date was May 3, 1918.]
 Still Life, painted [in oil] on cardboard, 10 1/4 x 18 in. (lot 86 / Sold to John Quinn, New York) [Philadelphia Museum of Art]
 Still Life: beer bottle, newspaper and other objects on a table, oil painting on cardboard, glass beads and sawdust set into painting, 20 1/4 x 26 1/2 in. (lot 87 / Sold for $370)

1919

April 29–May 24, 1919: Arden Gallery, New York "The Evolution of French Art from Ingres and Delacroix to the latest Modern Manifestations" / organized by Marius de Zayas [Presumably, de Zayas provided the works that are not listed as "loaned." De Zayas, a caricaturist whose work appeared in a successful show at 291 in 1910, became one of the gallery's "scouts" in Paris. He helped arrange the 1911 exhibition at 291, and went on to open his own gallery, the Modern Gallery, in the fall of 1915.]
 Portrait, drawing [medium not specified] (no. 192 in exh.)
 The Hack, drawing [medium not specified] (no. 193 in exh.)
 Head, drawing [medium not specified] (no. 194 in exh.)
 Two Women, drawing [medium not specified] (no. 195 in exh.)
 Figure, drawing [medium not specified] (no. 196 in exh.)
 Figure of a Woman, drawing [medium not specified] (loaned; no. 197 in exh.)
 Portrait, drawing [medium not specified] (no. 198 in exh.)
 Figures, drawing [medium not specified] (loaned; no. 199 in exh.)
 Figures and Landscape, drawing [medium not specified] (loaned; no. 200 in exh.)
 Apples, drawing [medium not specified] (loaned; no. 203 in exh.)
 Trees, watercolor (loaned; no. 204 in exh.)
 Head, drawing [medium not specified] (loaned; no. 205 in exh.)
 Figures and Landscape, watercolor (loaned; no. 207 in exh.)
 The Lamp, drawing [medium not specified] (loaned; no. 210 in exh.)
 Head, drawing [medium not specified] (no. 211 in exh.)
 Still Life, drawing [medium not specified] (loaned; no. 212 in exh.)
 Figure, watercolor (no. 213 in exh.)

December 14–31, 1919: De Zayas Gallery, New York ["Drawings, Etchings, Lithographs by French Artists" / This exhibition included four works by Picasso: a still-life drawing with *papier collé*, and three other works (but it is not known if they were drawings or prints).]
 [*Still Life* / A contemporaneous review called this piece a "drawing of diagrammatic and paper pasting work, most puzzling."]

1920

April 17–May 9, 1920: Pennsylvania Academy of the Fine Arts, Philadelphia "Exhibition of Paintings and Drawings by Representative Modern Artists" / organized by Arthur B. Carles, Carroll Tyson, and William Yarrow [The show's organizers were three Philadelphia artists, all of whom studied at the Pennsylvania Academy. Before returning to Philadelphia from years living abroad, both Carles and Yarrow spent time studying and painting in Paris, where they came to know and admire the work of the European modernists.]
 Pen Portrait, (drawing) [medium not specified] / anonymous loan (no. 184 in exh.)
 Violin and Flask, [oil] / anonymous loan (no. 185 in exh.)
 Trees, [watercolor] / anonymous loan (no. 186 in exh.)
 Charcoal Portrait / anonymous loan (no. 187 in exh.)
 Abstraction [current title: *Bottle and Wine Glass on a Table*]* / Mr. Alfred Stieglitz, New York (no. 188 in exh.) [Z.II².428; Metropolitan Museum of Art, New York]
 Portrait, [oil] / anonymous loan (no. 189 in exh.)
 Still Life, [oil] / anonymous loan (no. 190 in exh.)
 Head, [watercolor] / anonymous loan (no. 191 in exh.)
 Figures, [watercolor] / anonymous loan (no. 192 in exh.)
 Lamp, (watercolor) / anonymous loan (no. 193 in exh.)
 Céret, [oil] / anonymous loan (no. 194 in exh.)
 Still Life / Mr. Alfred Stieglitz, New York (no. 195 in exh.) [Z.II².683; Metropolitan Museum of Art, New York]
 Portrait [current title: *Standing Female Nude*],* drawing [charcoal] / Mr. Alfred Stieglitz, New York (no. 196 in exh.) [Z.II¹.208; Metropolitan Museum of Art, New York]
 Portrait / Marius de Zayas, New York (no. 197 in exh.)
 Water Color / Marius de Zayas, New York (no. 199 in exh.)
 Water Color / Marius de Zayas, New York (no. 200 in exh.)
 Water Color / Marius de Zayas, New York (no. 201 in exh.)
 Still Life / Marius de Zayas, New York (no. 202 in exh.)
 Still Life / Marius de Zayas, New York (no. 203 in exh.)

August 2–September 11, 1920: Galleries of the Société Anonyme, New York
[Title of exhibition unknown. It included some works lent by Walter Arensberg and at least one work by Picasso, although no specific titles of works have been identified.]

December 15, 1920–February 1, 1921: Galleries of the Société Anonyme, New York
["Matisse, Gris, Derain, Picasso, Braque, Rivera, Gleizes, Villon" / This exhibition included several works lent by Arthur B. Davies and at least one work by Picasso, although no specific titles of works have been identified.]

1921

February 8–14, 1921: Brooklyn Museum, New York
[Untitled exhibition. First showing of a portion of the Kelekian collection (including five works by Picasso). Dikran Kelekian, a leading dealer in Near Eastern antiquities in Paris and New York, was also an important collector of modern European art. In an effort to publicize his collection with the intent of selling it, Kelekian arranged for the works to be shown at the Brooklyn Museum. After this small preview show there, nearly ninety pieces were added from the museum's collection and from other private collections to make up the exhibition that opened the following month. Of the more than 140 pieces Kelekian lent to the museum, seven were by Picasso.]
 Portrait of a Young Girl [current title: *Woman with a Cape*] / Dikran Kelekian, New York [Z.VI.542; Cleveland Museum of Art]
 Landscape [current title: *Landscape with Dead and*

Live Trees]* / Dikran Kelekian, New York
[Z.III.364; Bridgestone Museum, Tokyo]
Still Life [current title: *Abstraction, Biarritz*] / Dikran
Kelekian, New York [Z.III.162; Phillips Collection,
Washington, D.C.]
Still Life [current title: *Fruit Bowl, Wineglass, Bowl
of Fruit (Green Still Life)*] / Dikran Kelekian,
New York [Z.II².485; Museum of Modern Art,
New York)]
Still Life, watercolor [13 x 10 in.] / Dikran Kelekian,
New York

March 16–April 3, 1921: Museum of French Art, New
York
"Loan Exhibition of Works by Cézanne, Redon,
Degas, Rodin, Gauguin, Derain and others"
Trees, watercolor / anonymous loan (no. 29 in exh.)
The Lamp, watercolor / anonymous loan
(no. 30 in exh.)
Portrait, pen drawing / anonymous loan
(no. 31 in exh.)

March 24–April 10, 1921: Sculptor's Gallery, New York
"Exhibition of Contemporary French Art from the
John Quinn and other Collections"
Two Figures, 1920, oil / John Quinn, New York
(no. 85 in exh.) [Z.IV.217; Kunstsammlung
Nordrhein-Westfalen, Düsseldorf]
Harvesters, 1920, oil / John Quinn, New York (no.
86 in exh.) [Z.III.371; Museum of Modern Art,
New York]
Still Life, 1909, oil / John Quinn, New York
(no. 87 in exh.)
Interior, 1919, oil / John Quinn, New York
(no. 88 in exh.)
Harlequin [current title: *Harlequin with Violin ("Si Tu
Veux")*], 1919, oil / John Quinn, New York (no. 89
in exh.) [Z.III.160; Cleveland Museum of Art]
Musician, 1919, oil / John Quinn, New York
(no. 90 in exh.)

March 26–April 1921: Brooklyn Museum, New York
"Paintings by Modern French Masters Representing
the Post-Impressionists and Their Predecessors" [This
exhibition presented all the modern works in
Kelekian's collection (including seven works by
Picasso).]
Portrait of a Young Girl [current title: *Woman with a
Cape*] / Dikran Kelekian, New York (no. 167 in
exh.) [Z.VI.542; Cleveland Museum of Art]
Landscape [current title: *Landscape with Dead and
Live Trees*]* / Dikran Kelekian, New York (no.
168 in exh.; ill. in cat.) [Z.III.364; Bridgestone
Museum, Tokyo]
Still Life [current title: *Abstraction, Biarritz*] / Dikran
Kelekian, New York (no. 169 in exh.) [Z.III.162;
Phillips Collection, Washington, D.C.]
Still Life [current title: *Fruit Bowl, Wineglass, Bowl
of Fruit (Green Still Life)*] / Dikran Kelekian,
New York (no. 170 in exh.) [Z.II².485; Museum
of Modern Art, New York]
Still Life, [watercolor, 13 x 10 in.] / Dikran Kelekian,
New York (no. 171 in exh.)
Man Seated, drawing [medium not specified, 7 1/2 x
4 3/4 in.] / Dikran Kelekian, New York (no. 172
in exh.)
Head of a Woman, drawing [medium not specified,
7 x 4 1/2 in.] / Dikran Kelekian, New York (no.
173 in exh.)

May 1921: The Editor [Hamilton Easter Field], "The
Metropolitan French Show" *The Arts and the American
Art Student* 1, no. 5
ill. p. 21: *Woman at a Table* / credit line reads: "Lent
to the Metropolitan Museum by John Quinn"
[Z.I.96; Fogg Art Museum, Harvard University,
Cambridge, Massachusetts]

May 2–September 5, 1921: Metropolitan Museum of
Art, New York
"Loan Exhibition of Impressionist and Post-Impressionist
Paintings"
Woman with a Chignon, 1901, oil / John Quinn,
New York (no. 79 in exh.) [Z.I.96; Fogg Art
Museum, Harvard University, Cambridge,
Massachusetts]

Woman Plaiting Her Hair [current title: *Woman
Combing Her Hair*], 1906, oil / John Quinn, New
York (no. 80 in exh.) [Z.I.336; Museum of
Modern Art, New York]
Landscape [current title: *Landscape with Dead and
Live Trees*],* 1919, oil / anonymous loan (no. 81
in exh.) [Z.III.364; Bridgestone Museum, Tokyo /
The anonymous lender was Dikran Kelekian,
New York.]
Woman with a Cape, 1901, oil / anonymous loan (no.
82 in exh.) [Z.VI.542; Cleveland Museum of Art
/ The anonymous lender was Dikran Kelekian,
New York.]

June–July 1921: Louis Bouché, "Art Activities in Post
War Paris," *The Arts and the American Art Student* 1, no. 6
ill. p. 30: *Still Life* [current title: *Still Life with
Compote and Glass*,* Z.II².537; Columbus Museum
of Art, Ohio / This work was in the collection of
John Quinn at the time the article was published.]

July 1921: *The Dial* 71, no. 1
ill. before p. 1: *Woman at a Table* / reproduced with
the captions "Property of John Quinn" and "From
the Loan Exhibition of French Painting at the
Metropolitan Museum of Art" [Z.I.96; Fogg Art
Museum, Harvard University, Cambridge,
Massachusetts]

November 21–December 12, 1921: Arts Club of Chicago
"A Selected Group of American and French Paintings" /
organized by Forbes Watson [Watson was a leading
art critic in the 1920s and editor of *The Arts* between
1923 and 1931.]
Landscape [current title: *Landscape with Dead and
Live Trees*]* / Dikran Kelekian, New York (no. 29
in exh.) [Z.III.364; Bridgestone Museum, Tokyo]
Arrangement / anonymous loan (no. 30 in exh.) /
The anonymous lender of this piece was Marius
de Zayas, New York.]

November 22–December 17, 1921: Belmaison Gallery
at Wanamaker's Department Store, New York
["Exhibition of Paintings by French Cubists and Post-
Impressionists"]
[*La Dame au fauteuil* / According to a contempora-
neous review, this was a recent painting with
"Cubist lines, gold tone overall" and "slight
gradation."]

December 1921: Hamilton Easter Field, "The Kelekian
Collection," *The Arts and the American Art Student* 2,
no. 3
ill. p. 134: *Paysage* [current title: *Landscape with
Dead and Live Trees*,* Z.III.364; Bridgestone
Museum, Tokyo]
ill. p. 135: *Nature morte*, [watercolor, 13 x 10 in.]

December 1921: *The Dial* 71, no. 6
ill. after p. 698: *Arlequin*, [drawing] / reproduced
with the caption "Courtesy of the Belmaison
Gallery"
ill. after p. 698: *A Drawing* [This drawing depicts
three nude women at the seashore; it was
probably done in pencil.]

1922

January 24–30, 1922: American Art Association, New
York
"The Notable Collection of Modern French Pictures
formed by and belonging to the widely known anti-
quarian Dikran Khan Kelekian of Paris and New
York" [Pre-auction exhibition; the sale dates were
January 30–31.]
Homme assis (study), charcoal, 7 1/2 x 4 3/4 in. (lot
13; ill. in sale cat. / Sold to Ferargil Galleries)
Nature morte, watercolor, 13 x 10 in. (lot 32; ill. in
sale cat. / Sold to Charles Sheeler [as agent for
Agnes Meyer])
Petite Nature morte [current title: *Abstraction, Biarritz*],
Biarritz, 1918, 13 3/4 x 10 1/2 in. (lot 33; ill. in
sale cat. / Sold to Arthur B. Davies, New York)
[Z.III.162; Phillips Collection, Washington, D.C.]
Tête de femme, pen and ink, 7 x 4 1/2 in. (lot 39; ill.
in sale cat. / Sold to Miss S. H. Lewis)

Portrait de jeune femme [current title: *Woman with a
Cape*], 28 1/2 x 19 1/2 in. (lot 57; ill. in sale cat. /
Sold to Demotte, Inc., New York) [Z.VI.542;
Cleveland Museum of Art]
Grande Nature morte: *Le Compotier* [current title:
*Fruit Bowl, Wineglass, Bowl of Fruit (Green Still
Life)*], 1914, 23 x 31 1/4 in. (lot 75; ill. in sale
cat. / Sold to Otto Bernet [as agent for Lillie P.
Bliss]) [Z.II².485; Museum of Modern Art,
New York]
Paysage [current title: *Landscape with Dead and Live
Trees*],* 1919, oil on canvas, 19 x 25 in. (lot 141;
ill. in sale cat. / Sold to Otto Bernet [as agent for
John Quinn]) [Z.III.364; Bridgestone Museum,
Japan]

January 28–February 28, 1922: Daniel Galleries, New
York
["(Drawings by a) Group of Modern French Painters"]
[*The Imbecile*]
[*The Suicide* / This work and the one above were
referred to as "of the period before his art had
evolved beyond the pictorial" in a contempora-
neous review.]
[*Interior* / Noted in the same review as being one
of Picasso's "later abstractions."]

February 1922: Charles Henry Meltzer, "Post-Cubist
Art in Paris," *Arts and Decoration* 16, no. 4
ill. p. 275: *L'Homme à la guitare*, [1912–13. Z.II².354]

March 9–31, 1922: Belmaison Gallery at Wanamaker's
Department Store, New York
["Modern American and European Paintings" / This
exhibition included more than one "Cubist painting"
by Picasso, according to a contemporaneous review,
although no specific titles of works have been
identified.]

March 24–April 10, 1922: Sculptor's Gallery, New York
["Contemporary French Art" / According to a contem-
poraneous review, this exhibition consisted of 120
paintings, watercolors, and sculptures, including at
least one work by Picasso, identified by title. The
reviewer noted that works were lent by Quinn, Lillie
P. Bliss, and Arthur B. Davies, among others.
[*Two Female Nudes*, 1920, oil / John Quinn, New
York. Z.IV.217; Kunstsammlung Nordrhein-
Westfalen, Düsseldorf]

Through April 1922: Montross Gallery, New York
"Special Exhibition: Contemporary Art"
Portrait, oil (no. 91 in exh.)
Flowers, pastel (no. 92 in exh.)
Head, watercolor (no. 93 in exh.)

April 2–13, 1922: Colony Club, New York
"Modern Sculpture[,] Water Colors[,] and Drawings"
Harlequin (no. 143 in exh.)
Still Life (no. 144 in exh.)
Abstraction (no. 145 in exh.)
Interior (no. 146 in exh.)
Still Life (no. 147 in exh.)
Still Life, Abstraction / Marius de Zayas, New York
(no. 148 in exh.)
Head of a Girl / Marius de Zayas, New York
(no. 149 in exh.)

June 1922: *The Dial* 72, no. 6
ill. after p. 600: *Strolling Mountebanks*, [1905,
probably a pencil drawing]
ill. after p. 600: *The Cripple*, [probably a pencil
drawing]

July–August 1922: Wanamaker Gallery of Modern
Decorative Art, New York
"Summer Exhibition of Paintings, Drawings and Water
Colours by European and American Artists"
Still Life (no. 21 in exh.)
Painting (no. 22 in exh.)
Boy (no. 24 in exh.)

September 19–October 22, 1922: Art Institute of
Chicago
"Exhibition of Paintings from the Collection of the
Late Arthur Jerome Eddy"

Old Woman (no. 56 in exh.; ill. in cat.) [Z.VI.389; Philadelphia Museum of Art]

November 1922: *The Dial* 73, no. 5
ill. after p. 524: *A Drawing* [This drawing depicts a reclining nude woman at the seashore.]
ill. after p. 524: *A Drawing* [This drawing depicts a reclining nude woman at the seashore, reading a book.]

1923

January 1923: Forbes Watson, "The Barnes Foundation—Part I," *The Arts* 3, no. 1
ill. p. 23: *Young Acrobat* / reproduced with the captions "The Barnes Foundation" and "Photograph by Charles Sheeler" [Barnes Foundation, Merion, Pennsylvania]

March 1923: *The Dial* 74, no. 3
ill. after p. 272: *Woman Reading* / reproduced with the credit line "Courtesy of the Galerie Paul Rosenberg, Paris" [Z.IV.180; Musée National d'Art Moderne, Centre National d'Art et de Culture Georges Pompidou, Paris]
ill. after p. 272: *Woman and Child* / reproduced with the credit line "Courtesy of the Galerie Paul Rosenberg, Paris" [Z.IV.311; Art Institute of Chicago]

March 18–23, 1923: Anderson Galleries, New York "Paintings, Etchings, Drawings, Sculptures: The Collection of Marius de Zayas of New York City" [Pre-sale exhibition; the sale date was March 23, 1923. The "titles" listed here for the works are not actual titles, but merely descriptions provided in the catalogue.]
Acrobat and Monkey, pen and ink drawing, 8 1/2 x 5 in. (lot 41)
Abstraction, 1916, watercolor, 12 1/4 x 9 1/4 in. (lot 42)
Boy, nude, one hand on hip, pencil drawing, 7 x 4 1/4 in. (lot 43)
Seated figure in cloak and cowl, pen and ink drawing (lot 44)
Group of figures in 18th century costume, watercolor, 7 3/4 x 8 3/4 in. (lot 45)
Young man in pale yellow straw hat, evening dress, and young lady wearing feather boa, elaborate hat, seated at restaurant table, watercolor, 12 x 9 in. (lot 46)
2 drawings on one sheet, recto: Sketch of nude woman standing, pencil; verso: 2 Heads and study of hand, ink, 6 1/2 x 4 in. (lot 47)
Portrait of M.A.N. Brenet seated at desk working, crayon, 14 1/2 x 10 1/2 in. (lot 48)
Nude woman standing one hand raised to cheek, pencil drawing, 6 1/2 x 4 1/2 in. (lot 49)
Man with pipe, pen and ink sketch—leaf from notebook (lot 50)
Self-portrait, pen and ink sketch—page from notebook (lot 51)
Abstraction, on paper, 7 1/4 x 9 1/2 in. (lot 96)

March 20–April 22, 1923: Art Institute of Chicago: Arts Club Exhibitions at the Art Institute of Chicago "Original Drawings by Pablo Picasso"
A Head, 1907 (no. 1 in exh.)
A Woman, 1907, [watercolor] (no. 2 in exh.)
A Woman, 1908 [gouache] (no. 3 in exh.)
Man Sitting on a Chair, 1914, [watercolor] (no. 4 in exh.)
Man with a Pipe, 1914–18, [gouache] (no. 5 in exh.)
Girl with Guitar, 1915 (no. 6 in exh.)
Three Apples, 1917, [pencil] (no. 7 in exh.)
Harlequin, 1917, [gouache] (no. 8 in exh.)
Circus People, 1917, [pencil] (no. 9 in exh.)
Study of a Woman in an Armchair, 1918, [gouache] (no. 10 in exh.)
Study of a Woman in an Armchair, 1918, [gouache] (no. 11 in exh.)
Study of a Woman in an Armchair, 1918, [gouache] (no. 12 in exh.)
Study of a Woman in an Armchair, 1918, [gouache] (no. 13 in exh.)
La Toilette, 1918, [pencil] (no. 14 in exh.)

Dancer, 1919, [pencil] (no. 15 in exh.)
Reaper Studies, 1919, [pen] (no. 16 in exh.)
Nude Study, 1919, [pencil] (no. 17 in exh.)
Window: St. Raphael, 1919, [gouache] (no. 18 in exh.)
Window: St. Raphael, 1919, [gouache] (no. 19 in exh.)
Still-Life; Plate of Fruits, a White Pitcher and a Glass, 1919, [pencil] (no. 20 in exh.)
Woman with a Pitcher, 1919, [pencil] (no. 21 in exh.)
Still-Life; Compote Glass, Pipe and Parcel of Tobacco, 1919, [pencil] (no. 22 in exh.)
Flowers in a Vase, 1919, [pencil heightened with pink] (no. 23 in exh.)
Russian Ballet Dancer, 1919, [pencil] (no. 24 in exh.)
Six Woman Bathers, 1920, [mixed media] (no. 25 in exh.)
Three Woman Bathers, 1920, [pencil] (no. 26 in exh.)
A Centaur, 1920, [mixed media] (no. 27 in exh.)
Woman on Beach, 1920, [pencil] (no. 28 in exh.)
White Rose, 1920, [watercolor] (no. 29 in exh.)
Basket of Fruits, 1920, [watercolor] (no. 30 in exh.)
Red Flowers, 1920, [watercolor] (no. 31 in exh.)
Sport on Beach, 1920, [mixed media] (no. 32 in exh.)
Interior with Table, 1920, [gouache] (no. 33 in exh.)
Guitar and Music, 1920, [gouache] (no. 34 in exh.)
Table in a Garden, 1920, [gouache] (no. 35 in exh.)
Compote with a Pear and Grapes, 1920, [gouache] (no. 36 in exh.)
Still-Life; Study in Colors, 1920, [gouache] (no. 37 in exh.)
Man Sitting in Armchair Playing Guitar, 1920, [gouache] (no. 38 in exh.)
Girl with Racket, 1920, [pencil] (no. 39 in exh.)
Punch, 1920, [gouache] (no. 40 in exh.)
A Hand, 1920, [pencil] (no. 41 in exh.)
Nude in Armchair, 1921 [actual date: 1920, watercolor] (no. 42 in exh.)
Mornings, 1921, [pencil] (no. 43 in exh.)
Sleep, 1921 [pastel and pencil] (no. 44 in exh.)
A Woman's Head, 1921, [sanguine and charcoal] (no. 45 in exh.)
Study for the Picture "At the Fountain," 1921 (no. 46 in exh.)
Landscape, 1921 (no. 47 in exh.)
Still-Life, 1922 (no. 48 in exh.)
A Family, 1922, [pencil] (no. 49 in exh.)
Woman's Head, 1922, [red chalk] (no. 50 in exh.) [Z.XXX.380; Arts Club of Chicago]
Still-Life; Glass, Tobacco Pouch, 1922, [pastel] (no. 51 in exh.; ill. in cat.)
Three Women Bathers with One Child, [actual date: 1921, pencil] (no. 52 in exh.)
Wild Grape Leaves, [actual date: 1921, pencil] (no. 53 in exh.)

April 11–May 9, 1923: Pennsylvania Academy of Fine Arts, Philadelphia "Exhibition of Contemporary European Paintings and Sculpture" [This exhibition, presented in anticipation of the opening of Dr. Albert C. Barnes's foundation for modern art, included seventy-five works. It represented a sampling of some of the works in his collection, many of which were recent acquisitions. By 1923, Barnes owned fifteen works by Picasso, only two of which were included in this showing.]
Baby [current title: *Child Seated in a Chair*, 1901] (no. 22 in exh.) [Z.I.116; Barnes Collection, Merion, Pennsylvania]
Composition [current title: *Composition: The Peasants*, 1906] (no. 29 in exh.; ill. in cat.) [Z.I.384; Barnes Collection, Merion, Pennsylvania.]

May 1923: Whitney Studio Club, New York "Recent Paintings by Pablo Picasso and Negro Sculpture"; opened again at American Art Galleries, New York, May 21–June 9, 1923, as "The Spring Salon" / organized by Marius de Zayas and Juliana Force [There was no catalogue or checklist for this exhibition. Michael FitzGerald identified all the works listed here by examining Charles Sheeler's photographs of the exhibition and an invoice from Paul Rosenberg's Paris gallery dated March 31, 1923; he found the dates, mediums, and related information in modern sources. The exhibition included one additional small oil (a still life) that could not be identified, as well as pochoir reproductions of the gouaches published by Paul Rosenberg circa 1922. All

works except *Female Nude (J'aime Eva)* (which, while not included on the invoice, is visible in an installation photograph) were lent by Rosenberg. A leading dealer of modern art in Paris, Rosenberg became Picasso's dealer in the fall of 1918. Rosenberg's association with Georges Wildenstein, a powerful dealer of old master paintings also based in Paris, gave him access to the latter's highly respected New York gallery, where he staged exhibitions of Picasso's work. Rosenberg worked tirelessly to promote the artist in the United States, frequently lending pieces from his personal collection to exhibitions across the country. Rosenberg and Picasso's successful partnership lasted for more than two decades.]
[*Portrait of Wilhelm Uhde*, 1910, oil on canvas. Z.II¹.217; Pulitzer Foundation for the Arts, St. Louis, Missouri]
[*Bowl of Fruit (The Fruit Dish)*,* 1912, oil on canvas. Z.II¹.302; private collection]
[*Female Nude (J'aime Eva)*,* 1912–13, oil, sand, and charcoal on canvas. Z.II¹.364; Columbus Museum of Art, Ohio / Sold from the exhibition to Arthur B. Davies, New York]
[*Guitar, Clarinet and Bottle on a Pedestal Table*, 1916, oil and sand on canvas, 46 x 29 1/2 in. Private collection, United States]
[*Paquet de tabac, vase à fleurs, journal, verre, bouteille*,* 1918, oil and sand on canvas. Z.III.142; private collection]
[*Pipe and Package of Tobacco*, 1919, oil on canvas. Z.III.291]
[*Bottle of Port and Glass (Still Life [Oporto])*,* 1919, oil on canvas. Z.III.290; Dallas Museum of Art / This work was sold from the exhibition, possibly to Earl Horter of Philadelphia]
[*Still Life with Glass*, 1919, gouache. Z.II¹.572]
[*Girl with a Hoop*, June 6, 1920, gouache. Z.III.287; Kunstmuseum, Winterthur, Switzerland]
[*Young Woman with a Racquet*, July 12, 1920, gouache. Z.IV.123]
[*Guitar and Score*, 1920, gouache. Z.IV.195]
[*Guitar and Score on a Pedestal Table*, 1920, gouache. Z.IV.88]
[*Guitar and Score on a Pedestal Table*, 1920, gouache. Z.IV.93]
[*Guitar and Score on a Pedestal Table*, 1920, gouache. Z.IV.95]
[*Pedestal Table with a Guitar and Score*, 1920, gouache. Z.IV.82]
[*Piano*, 1920, gouache. Z.IV.196]
[*Pierrot and Harlequin Seated on a Café Terrace*, 1920, gouache over pencil on paper. Z.IV.64]
[*Bottle, Glass and Grapes* (current title: *Bouteille et raisins [Bottle and Grapes]*), 1922, oil on canvas, 18 1/4 x 21 1/2 in. Kunstmuseum, Winterthur, Switzerland]
[*Cup and Spoon*, 1922, oil on canvas. Z.IV.419]
[*Fish, Newspaper, and Glass*, 1922, oil on canvas. Z.IV.397]
[*Glass and Lemon*, 1922, oil on canvas. Z.IV.420]
[*Packet of Tobacco and Glass*, 1922, oil on canvas. Z.IV.426]

May 1923: "Picasso Speaks: A Statement by the Artist," *The Arts* 3, no. 5
ill. p. 314: *Mme. Picasso* [current title: *Portrait of Olga*, January 27, 1918, oil on canvas. Z.III.125; private collection]
ill. p. 315: *Portrait of the Artist* [current title: *Self-Portrait*, 1918, pencil on paper. Z.III.75; private collection]
ill. p. 316: *Peasant*
ill. p. 317: *Still Life* [current title: *Bowl of Fruit (The Fruit Dish)*,* 1912] / reproduced with the credit line "Courtesy Whitney Studio Galleries" [Z.II¹.302; private collection]
ill. p. 318: *Figures* [current title: *Two Nudes and One Draped Figure by the Sea*, 1920, pencil. Z.IV.320; Metropolitan Museum of Art, New York]
ill. p. 319: *Bull Fight* [Z.III.308]
ill. p. 320: *Painting* [current title: *Man Leaning on a Table*. Z.II².550; private collection]
ill. p. 321: *Mme. Picasso* [current title: *Olga in an Armchair*, 1917, oil on canvas. Z.III.83; Musée Picasso, Paris]
ill. p. 322: *Head*

ill. p. 323: *Painting* [current title: *Bottle of Port and Glass (Still Life [Oporto])*]* / reproduced with the credit line "Courtesy Whitney Studio Galleries" [Z.III.290; Dallas Museum of Art]

ill. p. 324: *Mother and Child* [current title: *Portrait of Madame Paul Rosenberg and Daughter*, 1918. Z.III.242; private collection, Paris]

ill. p. 325: *Harlequin* [current title: *Harlequin with Violin ("Si Tu Veux")*. Z.III.160; Cleveland Museum of Art]

ill. p. 326: *Fish Seller*

ill. p. 326: *Reclining Figures* [Z.IV.105; Metropolitan Museum of Art, New York]

ill. p. 327: *Portrait*

ill. p. 328: *Stravinsky*, 1917 [Z.IV.60; Musée Picasso, Paris]

ill. p. 329: *Portrait of Erik Satie* [Z.IV.59; Musée Picasso, Paris]

ill. p. 370: *Peasants* [Z.III.371]

September 1923: *The Dial* 75, no. 3
ill. before p. 1: *The Bullfight* [1919] / reproduced with the credit line "Courtesy of the Galerie Paul Rosenberg, Paris" [Z.III.308]

October 5–24, 1923: Wanamaker Gallery of Modern Decorative Art, New York
"Exhibition of Modern Paintings"
La Grenade (no. 17 in exh.)
Flowers (no. 18 in exh.)

November 1923: *The Dial* 75, no. 5
ill. after p. 434: *La Comtesse Etienne de Beaumont* [probably a pencil drawing] / reproduced with the credit line "Photograph: Druet"

November 1923: Andrew Dasburg, "Cubism—Its Rise and Influence," *The Arts* 4, no. 5
ill. p. 278: *Still Life* [current title: *Violon, partition et journal*, 1912, oil and sand on canvas; private collection]
ill. p. 279: *Still Life* [current title: *Bouteille et raisins (Bottle and Grapes)*, 1922. Z.IV.407; Kunstmuseum Winterthur]
ill. p. 281: *Figure*
ill. p. 283: *Still Life* [Z.IV.82]

November 17–December 8, 1923: Wildenstein Galleries, New York
"Exhibition of Recent Works by Picasso"; traveled to the Art Institute of Chicago: Arts Club Exhibitions at the Art Institute of Chicago, December 18, 1923–January 21, 1924, as "Paintings by Pablo Picasso"/ organized by Paul Rosenberg, who lent all the works
Deux Femmes nues, 1920, pastel, 19 x 24 1/2 in. (no. 1 in exh.; titled *Two Nude Women* in Chicago)
Tête de femme, 1921, pastel, 19 1/4 x 24 3/4 in. (no. 2 in exh.; titled *Head of a Woman* in Chicago)
Baigneuse, 1921, pastel, 19 3/4 x 25 5/8 in. (no. 3 in exh.; titled *Bather* in Chicago)
Baigneuse, 1922, oil on canvas, 19 3/4 x 25 1/2 in. (no. 4 in exh.; titled *Bather* in Chicago)
Maternité, 1922, oil on canvas, 32 x 39 1/2 in. (no. 5 in exh.; ill. on cover of exh. cat.; titled *Maternity* in Chicago) [Z.IV.370]
Maternité, 1922, oil on canvas, 32 x 39 1/2 in. (no. 6 in exh.; titled *Maternity* in Chicago)
Tête de femme, 1923, oil on canvas, 19 3/4 x 24 in. (no. 7 in exh.; titled *Head of a Woman* in Chicago)
Femme au turban, 1923, oil on canvas, 35 x 45 3/4 in. (no. 8 in exh.; titled *Woman with a Turban* in Chicago) [Z.V.22]
La Réponse, 1923, oil on canvas, 32 x 39 1/2 in. (no. 9 in exh.; titled *The Answer* in Chicago) [Z.V.30]
Femme au voile bleu, 1923, oil on canvas, 32 x 39 1/2 in. (no. 10 in exh.; titled *Woman with a Blue Veil* in Chicago) [Z.V.16: Los Angeles County Museum of Art]
Saltimbanque, 1923, oil on canvas, 38 1/4 x 51 in. (no. 11 in exh.; titled *Saltimbanque* in Chicago)
Les Amoureux, 1923, oil on canvas, 38 1/4 x 51 in. (no. 12 in exh.; titled *The Lovers* in Chicago) [Z.V.14; National Gallery of Art, Washington, D.C.]
Arlequin, 1923, oil on canvas, 38 1/4 x 51 in. (no. 13 in exh.; titled *Arlequin* in Chicago) [Musée

National d'Art Moderne, Centre National d'Art et de Culture Georges Pompidou, Paris]
Femme assise, 1923, oil on canvas, 32 x 39 1/2 in. (no. 14 in exh.; titled *Woman Seated* in Chicago) [Z.V.29; National Gallery of Art, Washington, D.C.]
Arlequin, 1923, oil on canvas, 38 1/4 x 51 in. (no. 15 in exh.; titled *Arlequin* in Chicago) [Z.V.23; Öffentliche Kunstsammlung Basel, Kunstmuseum]
Arlequin, 1923, oil on canvas, 38 1/4 x 51 in. (no. 16 in exh.; titled *Arlequin* in Chicago) [Z.V.17; Musée National d'Art Moderne, Centre National d'Art et de Culture Georges Pompidou, Paris]

December 1923: Waldemar George, "Painting at the Salon d'Automne," *The Arts* 4, no. 6 [All works listed here were reproduced with the credit line "Paul Rosenberg, Paris"]
ill. on cover: *Portrait of Guillaume Apollinaire Wounded*, 1916
ill. p. 330: *The Woman with the Blue Veil* [Z.V.16; Los Angeles County Museum of Art]
ill. p. 333: *Woman Seated*, 1923 [Z.V.29; National Gallery of Art, Washington, D.C.]
ill. p. 334: *Mother and Child*, 1922, drawing [medium not specified] [Z.IV.371; Baltimore Museum of Art]
ill. p. 335: *Mountebank*, 1923 [Z.V.15; National Gallery of Art, Washington, D.C.]
ill. p. 336: *The Lovers*, 1923 [Z.V.14; National Gallery of Art, Washington, D.C.]
ill. p. 337: *The Reply*, 1922 [Z.V.30]
ill. p. 338: *Harlequin*, 1923 [Z.V.37]

1924

January 26–February 14, 1924: Montross Gallery, New York
"Original Paintings, Drawings and Engravings being exhibited with the Dial Folio, Living Art" [*The Dial*, owned and edited by Scofield Thayer from 1919, became a leading publication of modern literature and art under his direction. Thayer had been building a collection of modern art, some of which appeared as illustrations in his magazine; reproductions of Picasso's work appeared in its pages more than any other artist's. The Dial Collection was started as a source of images to reproduce in the magazine, but works from other collections were also reproduced. This 1924 exhibition presented the works in his collection that had been published in December 1923 as a portfolio of reproductions entitled *Living Art*. Thayer's collection was on deposit at the Worcester Art Museum from 1926 until 1984, when it went by his bequest to the Metropolitan Museum of Art.]
Mother and Child, 1901, oil on canvas, 16 1/8 x 12 7/8 in. (no. 29 in exh.) [Z.I.107; Metropolitan Museum of Art, New York]
Horses at the Watering Place, 1905, gouache on pulp board, 14 7/8 x 22 13/16 in. (no. 30 in exh.) [Z.I.265; Metropolitan Museum of Art, New York]
Classic Head, September 1921, pastel, 25 9/16 x 19 9/16 in. (no. 31 in exh.) [Z.IV.346; Metropolitan Museum of Art, New York]
Boy, 1905, gouache on pulp board, 31 3/16 x 23 7/16 in. (no. 32 in exh.) [Z.I.276; Metropolitan Museum of Art, New York]
Two Nudes and One Draped Figure by the Sea, 1920, pencil, 19 5/16 x 25 1/8 in. (no. 34 in exh.) [Z.IV.320; Metropolitan Museum of Art, New York]
Three Nude Women by the Sea, 1920, pencil, 19 7/16 x 25 1/8 in. (no. 35 in exh.) [Z.IV.105; Metropolitan Museum of Art, New York]
Two Nude Women by the Sea, September 4, 1920, pencil, 29 9/16 x 41 in. (no. 36 in exh.) [Z.IV.181; Metropolitan Museum of Art, New York]
Heroic Head of a Woman, 1922, charcoal and red crayon, 42 1/4 x 28 1/4 in. (no. 37 in exh.) [Z.IV.306; Metropolitan Museum of Art, New York]
Peasant Women from Andorra, pen, brush and ink, 24 7/8 x 18 1/4 in. (no. 38 in exh.) [Z.I.339; Metropolitan Museum of Art, New York]

February 1924: *The Dial* 76, no. 2
ill. after p. 202: Pencil drawing [current title: *Two Nude Women by the Sea*, September 4, 1920 / reproduced with the credit line "From Living

Art." Z.IV.181; Metropolitan Museum of Art, New York]

February 13–March 6, 1924: Galleries of the Société Anonyme, New York
"Paintings by Derain, Lozowick, Malevich, Gris, Metzinger, Braque and Others" [This exhibition included at least one work by Picasso, although no specific titles of works have been identified.]

February 27–March 11, 1924: Whitney Studio Club, New York
"Paintings and Drawings by Marcel Duchamp, Pablo Picasso, Georges Braque: Selected and Arranged by Charles Sheeler"
Still-Life (no. 10 in exh.)
Portrait (no. 11 in exh.)
Still-Life (no. 12 in exh.)

April 1924: *The Dial* 76, no. 4
ill. before p. 1: *Enfant au cheval* / reproduced with the caption "Collection Mendelssohn"

April 8–10, 1924: Union League Club, New York
"Modern Pictures Representing Impressionist, Post-Impressionist, Expressionist and Cubist Painters"
La Parisienne (no. 28 in exh.) [Z.I.65]
Pierret [sic] (no. 29 in exh.) [Z.III.137; Museum of Modern Art, New York]

ca. April 12, 1924: Brooklyn Museum, New York ["Albert E. Gallatin Collection" / In 1927, Gallatin, a painter and leading collector of modern art, opened the Gallery of Living Art at New York University, the first public gallery in the United States devoted to modern art.]
[*Portrait de femme*, 1901, oil]

June 1924: *The Dial* 76, no. 6 [All three works listed here were reproduced (possibly erroneously for the second two) with the credit line "Courtesy of the Galerie Paul Rosenberg, Paris."]
ill. after p. 492: Pencil Drawing [current title: *Three Nude Women by the Sea*, 1920. Z.IV.182]
ill. after p. 492: Pencil Drawing [current title: *Two Nudes and One Draped Figure by the Sea*, 1920. Z.IV.320; Metropolitan Museum of Art, New York]
ill. after p. 492: Pencil Drawing [current title: *Three Nude Women by the Sea*, 1920. Z.IV.105; Metropolitan Museum of Art, New York]

July 1924: *The Arts* 6, no. 1
ill. p. 93: *Boy* [Z.I.276; Metropolitan Museum of Art, New York]

August 1924: *The Dial* 77, no. 2
ill. after p. 120: *Le Poéte*, painting / reproduced with the credit "Courtesy of Galerie Simon, Paris" [Z.I.97; Pushkin State Museum of Fine Arts, Moscow]
ill. after p. 120: *Le Pierrot* / reproduced with the credit "Courtesy of Galerie Flechtheim, Berlin" [Z.III.137; Museum of Modern Art, New York]
ill. after p. 120: *Baigneuses* / reproduced with the credit "Courtesy of Paul Rosenberg, Paris" [Z.III.237; Musée Picasso, Paris]
ill. after p. 120: *A Pastel* [Z.IV.280 / This work depicts three nude women at the seashore.]

December 1924: *The Dial* 77, no. 6
ill. before p. 1: *King Lear* [1905. Z.VI.798; Kunsthaus, Zurich]

1925

February 1925: *The Dial* 78, no. 2
ill. after p. 138: *A Drawing* [This drawing depicts a reclining nude woman holding a hand mirror, with a cupid seated in front of her; the medium probably is pencil.]

April 1925: Oliver S. Tonks, "The Creed of Abstract Art," *The Arts* 7, no. 4
ill. p. 215: *Drawing* [medium not specified] [current title: *Instruments de Musique et Partition devant une fenêtre ouverte*, 1919. Z.III.385]

June 1925: *The Dial* 78, no. 6
 ill. before p. 1: *Le Bain des chevaux* / reproduced with the credit line "From Living Art" [Z.I.265; Metropolitan Museum of Art, New York]

September 8–October 8, 1925: Art Institute of Chicago
"Birch-Bartlett Collection"
 [*The Old Guitarist*. Z.I.202; Art Institute of Chicago]

November 3–12, 1925: Arts Club of Chicago
"French Watercolors and Drawings Assembled by Pierre Matisse"
 Saltimbanque, drawing [medium not specified] (no. 33 in exh.)
 Still Life, drawing [medium not specified] (no. 34 in exh.)

December 1925: *The Dial* 79, no. 6
 ill. before p. 1: *Arlequin* / reproduced with the caption "The Dial Collection" [Z.I.276; Metropolitan Museum of Art, New York]

1926

January 1926: Forbes Watson, "The John Quinn Collection," *The Arts* 9, no. 1
 ill. p. 8: *Reclining Nude*, [35 3/4 x 25 3/4 in.]
 ill. p. 10: *Nude with Girl Holding Mirror* [current title: *La Toilette*, 1906. Z.I.325; Albright-Knox Art Gallery, Buffalo]
 ill. p. 17: *Woman Dressing Her Hair* [current title: *Woman Combing Her Hair*. Z.I.336; Museum of Modern Art, New York]

January 7–30, 1926: Art Center, New York
"Memorial Exhibition of Representative Works Selected from the John Quinn Collection"
 Maternity [current title: *Mother and Child*] (no. 19 in exh.) [Z.IV.311; Art Institute of Chicago]
 The Sad Mother (no. 20 in exh.) [Z.I.115; Fogg Art Museum, Harvard University, Cambridge, Massachusetts]
 Still Life [current title: *Still Life with a Bottle, Newspaper, and a Glass*, ca. 1914, oil, graphite, tempera, and cork on cardboard] (no. 48 in exh.) [Philadelphia Museum of Art]
 Woman Dressing Her Hair [current title: *Woman Combing Her Hair*], [1906] (no. 59 in exh.) [Z.I.336; Museum of Modern Art, New York]

January 26–February 15, 1926: Wildenstein Galleries, New York
"Exhibition of Tri-National Art: French, British, American" / organized by Marie Harriman [The wife of the Honorable W. Averell Harriman, Marie Harriman opened her eponymous gallery–devoted to modern art–in New York in 1930.]
 Portrait (no. 185 in exh.)
 Figure (no. 186 in exh.)
 Head of Man (no. 187 in exh.)
 Two Boys / Yvon Helft, Paris (no. 188 in exh.) [Z.I.305; National Gallery of Art, Washington, D.C.]
 Le Gueridon (no. 189 in exh.)
 Fried Eggs / Wildenstein & Co., New York (no. 190 in exh.) [Z.V.266]

February 1926: frontispiece, *The Arts* 9, no. 2
 ill. p. 60: *Figure Painting* [current title: *La Vie*] / Thannhauser Galleries, Lucerne and Munich [Z.I.179; Cleveland Museum of Art / The pages of each volume of *The Arts* were continuous, rather than starting each issue with a new page 1; that is why the frontispiece in issue no. 2 was on page 60.]

February 1926: Forbes Watson, "The John Quinn Collection. Part II," *The Arts* 9, no. 2
 ill. p. 86: *Maternité* [current title: *Mother and Child*. Z.IV.311; Art Institute of Chicago]

February 22–March 13, 1926: Ferargil Galleries, New York
"Modern French Paintings from the Collection of Arthur B. Davies" [An American painter and impor-

tant proponent of modern art in this country, Davies was a leading organizer of the 1913 Armory Show.]
 [*Flowers in Pitcher*, pastel / Sold for $300]
 [*Figures* / Sold for $350]
 [*Design*]
 [*Landscape (Two Trees)*, 1908, gouache. Z.II¹.54; Philadelphia Museum of Art]
 [*Design on Red*, oil on canvas, 13 x 16 in.]
 [*Music Arrangement*, watercolor]
 [*Coret (sic)*. The actual title is Céret. / Sold for $350]
 [*Design on Black*, watercolor]
 [*Flacon*, inscribed: "Vieux Marc," oil on canvas. Z.II¹.355]
 [*Portrait Arrangement* (current title: *Female Nude [J'aime Eva]*).* Z.II¹.364; Columbus Museum of Art]
 [*Lady Seated*, oil on canvas, 39 1/2 x 28 1/2 in.]
 [*Musical Arrangement* (current title: *Bar-Table with Musical Instruments and Fruit Bowl*),* ca. 1913. Z.II².759; private collection]
 [*Apples*, watercolor, 9 1/2 x 12 1/2 in.]

March 1926: Brummer Galleries, New York
["Exhibition of Prints, Paintings and Sculpture from the John Quinn Collection including Rousseau's Jungle"]
 [*Harlequin*. Z.I.79; Metropolitan Museum of Art, New York]
 [*Mother and Child*. Z.IV.311; Art Institute of Chicago]

March 19–April 25, 1926: Art Institute of Chicago: Arts Club Exhibitions at the Art Institute of Chicago
"A Group of Paintings by Various Modern Artists loaned by the American painter Arthur B. Davies"
 Lady Seated [oil on canvas, 39 1/2 x 28 1/2 in.] (no. 26 in exh.)

March 20–July 31, 1926: Wildenstein Galleries, New York
"Important Modern French Painters"
 Woman at Table [Z.I.96; Fogg Art Museum, Harvard University, Cambridge, Massachusetts]

May 1926: *The Dial* 80, no. 5
 ill. before p. 1: *Mother and Child* [probably an oil dated ca. 1902]

May 3–30, 1926: Art Institute of Chicago
"The Sixth International Water Color Exhibition"
 Cheminée (no. 425 in exh.)

June 1926: Forbes Watson, "A Note on the Birch-Bartlett Collection," *The Arts* 9, no. 6
 ill. p. 307: *The Old Guitarist* [Z.I.202; Art Institute of Chicago]

June 12–October 14, 1926: Brooklyn Museum, New York
"Paintings by Modern French and American Artists"
 Still Life [current title: *Fruit Bowl, Wineglass, Bowl of Fruit (Green Still Life)*] / anonymous loan [Z.II².485; Museum of Modern Art, New York / The anonymous lender was Lillie P. Bliss.]
 Arlequin [current title: *Harlequin*], [oil on canvas] / anonymous loan [Z.I.79; Metropolitan Museum of Art, New York / The loan was arranged by Cornelius J. Sullivan, lawyer for the Quinn estate.]

July 1926: Forbes Watson, "American Collections: no. III–The Adolph Lewisohn Collection," *The Arts* 10, no. 1
 ill. p. 39: *Pierrot* [Z.III.137; Museum of Modern Art, New York]

August 1926: "Paris Letter," *The Arts* 10, no. 2
 ill. p. 113: *Still Life* / Paul Rosenberg [Z.V.445]

September 1926: *The Dial* 81, no. 3
 ill. before p. 1: *A Head*, pastel. Z.IV.346; Metropolitan Museum of Art, New York]

October 1926: Helen Appleton Read, "The Exhibition Idea in Germany," *The Arts* 10, no. 4
 ill. p. 208: *Boy with a Horse* / reproduced with the caption "Shown by Galerie Flechtheim in the Dresden International" [Z.I.264; Museum of Modern Art, New York]

November 1926: "New York Exhibitions," *The Arts* 10, no. 5
 ill. p. 293: *Woman in Blue* / Mr. Adolph Lewisohn, Courtesy Wildenstein & Co.

November 19, 1926–January 9, 1927: Société Anonyme at Brooklyn Museum, New York
"An International Exhibition of Modern Art Assembled by the Société Anonyme" [Founded in 1920 by artists Katherine Dreier, Marcel Duchamp, and Man Ray, the Société Anonyme promoted modern art through exhibitions, symposia, and lectures. Dreier organized this exhibition of approximately three hundred contemporary works of art; it is considered the Société's greatest achievement.]
 Music–Abstract Painting [current title: *Bar-Table with Musical Instruments and Fruit Bowl*,* ca. 1913] (no. 212 in exh.) [Z.II².759; private collection]
 Rhum [current title: *Pipe, Glass, and Bottle of Rum*]* / Mrs. Juliana Force, New York (no. 213 in exh.) [Z.II².787; Museum of Modern Art, New York]

December 1926: William M. Milliken, "Fifty Years of French Art," *The Arts* 10, no. 6
 ill. p. 338: *Two Boys*

1927

January 15–February 5, 1927: Reinhardt Galleries, New York
"Loan Exhibition of Paintings from El Greco and Rembrandt to Cézanne and Matisse"
 Les Amoureux / Miss Mary Hoyt Wiborg, New York (no. 25 in exh.; ill. in cat.) [Z.V.14; National Gallery of Art, Washington, D.C.]

January 25–February 5, 1927: Anderson Galleries, New York
"The International Exhibition of Modern Art Assembled by the Société Anonyme"
 Music–Abstract Painting [current title: *Bar-Table with Musical Instruments and Fruit Bowl*,* ca. 1913] (no. 124 in exh.) [Z.II².759; private collection]

Fall 1927: Chester Johnson Galleries, Chicago
[Exhibition of modern French paintings and sculptures; title of exhibition unknown. It included at least one work by Picasso, although no specific titles of works have been identified.]

October 7–22, 1927: C. W. Kraushaar Galleries, New York
"Exhibition of Modern French Paintings, Water Colors and Drawings"
 Femme en blanc [current title: *Woman in White*] * / Lillie P. Bliss, New York (no. 17 in exh.; ill. in cat.) [Z.V.1; Metropolitan Museum of Art, New York]

November 5–26, 1927: Reinhardt Galleries, New York
"Exhibition of Paintings by Picasso, Matisse, Derain, Bracque [sic], Pascin, Modigliani, Dufy, Utrillo, Vlaminck, Soutine, Friesz, Laurencin, Sorine and Soudeikine"
 The Mother (no. 1 in exh.) / Wildenstein & Co., New York
 The Bal Tabarin (no. 2 in exh.; ill. in cat.)
 Portrait of the Artist's First Wife (no. 3 in exh.)
 Breton Peasants (no. 4 in exh.)

December 1927–January 1928: Wildenstein Galleries, New York
"Exhibition of Drawings by Picasso"; traveled to the Arts Club of Chicago, February 28–March 13, 1928, as "Original Drawings by Pablo Picasso" / organized by Paul Rosenberg
 Arlequin (no. 1 in exh.)
 Saltimbanque assis, sépia (no. 2 in exh.)
 Saltimbanque assis, sanguin (no. 3 in exh.)
 Joueur de flûte et mains, feuilles d'études (no. 4 in exh.)
 Joueur de flûte (no. 5 in exh.)
 Deux Femmes et joueurs de flûte, encre de Chine (no. 6 in exh.)
 Saltimbanque tenant une glace, encre de Chine (no. 7 in exh.)

Femme nue allongée et joueur de flûte (no. 8 in exh.)
Deux Femmes et joueur de flûte (no. 9 in exh.)
Trois Danseurs (no. 10 in exh.)
Deux Danseuses, encre de Chine (no. 11 in exh.)
Groupe de trois danseurs (no. 12 in exh.)
Deux Danseurs (no. 13 in exh.)
Deux Danseurs (no. 14 in exh.)
Deux Danseuses, fusain (no. 15 in exh.)
Deux Danseuses, fusain (no. 16 in exh.)
Deux Danseuses, fusain (no. 17 in exh.)
Deux Danseurs assis (no. 18 in exh.)
Deux Danseurs (no. 19 in exh.)
Deux Danseurs (no. 20 in exh.)
Femmes assises nues (no. 21 in exh.)
Deux Femmes (no. 22 in exh.)
Femme allongée sur un divan (no. 23 in exh.)
Femme retenant son peignoir (no. 24 in exh.)
Femme étendue sur un divan (no. 25 in exh.)
Femme vue de dos (no. 26 in exh.)
Femme debout (no. 27 in exh.)
Deux Femmes debout (no. 28 in exh.)
Group de cinq femmes (no. 29 in exh.)
Femme assise, encre de Chine (no. 30 in exh.)
Deux Baigneurs (no. 31 in exh.)
Baigneuses courant (no. 32 in exh.)
Jeunes baigneurs (no. 33 in exh.)
Baigneuses faisant des exercices (no. 34 in exh.)
Baigneuses faisant des exercices (no. 35 in exh.)
Baigneuses au repos (no. 36 in exh.)
Trois Baigneuses (no. 37 in exh.)
Deux Femmes debout et une femme assise (no. 38 in exh.)
Les Moissonneurs, feuilles d'études (no. 39 in exh.)
L'Embouchure de la rance (no. 40 in exh.)
Vue de St. Malo (no. 41 in exh.)
Vue de St. Servan (no. 42 in exh.)
Peintre dessinant devant le modèle (no. 43 in exh.)
Jeune peintre dessinant (no. 44 in exh.)
La Pose du modèle (no. 45 in exh.)
La Conversation (no. 46 in exh.)
La Récit (no. 47 in exh.)
Femme retirant sa chemise (no. 48 in exh.)
Femme endormie (no. 49 in exh.)
L'Entretien (no. 50 in exh.)
Groupe de deux femmes et d'un homme (no. 51 in exh.)
Femme assise, encre de Chine (no. 52 in exh.)
Deux Femmes assises sur un banc (no. 53 in exh.)
Une Femme et deux hommes agés (no. 54 in exh.)
Groupe de quatre personnages (no. 55 in exh.)
Le Repos des saltimbanques (no. 56 in exh.)
Trois Femmes dans un intérieur (no. 57 in exh.)
Fontaine à Fontainebleau (no. 58 in exh.)
Fontaine à Fontainebleau (no. 59 in exh.)
Fontaine à Fontainebleau (no. 60 in exh.)
Femme drapée debout (no. 61 in exh.)
Buste de femme, aquarelle (no. 62 in exh.)
Femme et enfant (no. 63 in exh.)
Maternité (no. 64 in exh.)
Profil de femme (no. 65 in exh.)
Tête d'ange, aquarelle (no. 66 in exh.)
Nature morte (no. 67 in exh.)
Panier de fruits, aquarelle (no. 68 in exh.)
Paysage, pastel (no. 69 in exh.)

December 3, 1927–January 31, 1928: Phillips Memorial Gallery, Washington, D.C.
"Leaders of French Art To-Day"
> *Early Morning* [current title: *The Blue Room*] (ill. in cat.) [Z.I.103; Phillips Collection, Washington, D.C.]

December 13, 1927–January 15, 1928: Gallery of Living Art, New York University
"Opening Exhibition" [Gallatin exhibited the collection of the Gallery of Living Art only a part at a time, rotating the works on a regular basis, and frequently showing his recent acquisitions. Between 1929 and 1943, he published six catalogues of the rapidly growing collection, although, with the exception of this exhibition, the catalogues were general references and did not refer to specific installations or exhibitions.]
> *Composition*, oil / Messrs. Wildenstein & Co., New York
> *Still Life* [current title: *Still Life with Bottle, Playing Cards, and a Wineglass on a Table*, 1914], oil [Z.II².516; Philadelphia Museum of Art]
> *Open Window*, watercolor [Z.III.386; Philadelphia Museum of Art]

Composition, watercolor [possibly Z.II².460; Philadelphia Museum of Art]
Guitar and Bottle, pencil [Z.II².389; Philadelphia Museum of Art]

December 17, 1927–January 23, 1928: Valentine Gallery, New York
["Exhibition of Paintings" / This exhibition included at least one work by Picasso, although no specific titles of works have been identified.]

1928

February 1928: Lord & Taylor, New York
"An Exposition of Modern French Decorative Art" / organized by Dorothy Shaver, Director of Fashion and Decoration, Lord & Taylor.
> *Femme Nue* (no. 422 in exh.)
> *Aquarelle* (no. 424 in exh.)
> *Aquarelle* (no. 425 in exh.)

February 27–March 17, 1928: Reinhardt Galleries, New York
"Loan Exhibition of Paintings from Memling, Holbein and Titian to Renoir and Picasso"
> *Still Life* / Mary Hoyt Wiborg, New York (no. 28 in exh.; ill. in cat.) [Z.V.228]

March 7–13, 1928: Renaissance Society of the University of Chicago
"Modern French Painting and Sculpture" [This exhibition included at least one work by Picasso, although no specific titles of works have been identified. It consisted of thirty-four paintings from the Chester Johnson Galleries, Chicago, that had been part of an exhibition held there in the fall of 1927.]

Opened March 28, 1928: Pennsylvania Museum of Art, Philadelphia
[Inaugural Exhibition / This exhibition celebrated the opening of the newly constructed building that housed the Pennsylvania Museum of Art, now known as the Philadelphia Museum of Art.]
> [*Nudes in a Forest, Study for "Three Women"* (current title: *Bathers in a Forest*), ca. 1908, watercolor and gouache / Samuel S. White, III, Ardmore, Pennsylvania. Z.II¹.105; Philadelphia Museum of Art]
> [*Still Life*, 1919, oil on canvas / Samuel S. White, III, Ardmore, Pennsylvania. Z.III.278]

April 1928: Lord & Taylor, New York
[Title of exhibition unknown.]
> [*Glass and Pipe*, 1919, oil on canvas Z.III.280; Art Institute of Chicago]

October 1928: Wildenstein Galleries, New York
"Loan Exhibition of Modern French Art from the Chester Dale Collection" [Dale and his wife, Maud, a painter, formed a significant collection of more than eight hundred works, primarily from the late nineteenth and early twentieth centuries.]
> *La Mère* (no. 33 in exh.) [Saint Louis Art Museum, Missouri]
> *Bateleur à la nature morte* (no. 34 in exh.) [Z.I.294; National Gallery of Art, Washington, D.C.]

October 1928–January 1929: Phillips Memorial Gallery, Washington, D.C.
"Tri-Unit Exhibition of Paintings and Sculpture: Art Is International"
> *Morning* [current title: *The Blue Room*] / Phillips Art Gallery, Washington, D.C. [Z.I.103; Phillips Collection, Washington, D.C.]

October 1–18, 1928: C. W. Kraushaar Galleries, New York
"Exhibition of Modern French Paintings, Water Colors and Drawings"
> *Mother and Child*, drawing [medium not specified] (no. 61. in exh.)

November 1928: Wildenstein Galleries, New York
"Loan Exhibition of Modern French Art from the Chester Dale Collection for the Benefit of the French Hospital of New York"

Juggler with Still Life, 1905, gouache on cardboard, 39 3/8 x 27 1/2 in. (no. 34 in exh.) [Z.I.294; National Gallery of Art, Washington, D.C.]

November 12–December 8, 1928: M. Knoedler & Co., New York
"A Century of French Painting"
> *L'Enfant à la Colombe*, ca. 1903, oil on canvas, 29 x 21 in. / Mrs. R. A. Workman, London (no. 47 in exh.) [Z.I.83; National Gallery of Art, London, on loan from a private collection]

Opened December 3, 1928: Gallery of Living Art, New York University
[Recent Acquisitions]
> [*Pipe and Violin*, 1914, oil on canvas. Z.II¹.475; Philadelphia Museum of Art]

December 17–31, 1928: De Hauke & Co., New York
"Exhibition of Water Colors and Drawings by 19th Century and Contemporary French Artists"
> *Standing Nude*, drawing [medium not specified] (no. 51 in exh.)

1929

January 4–18, 1929: Arts Club of Chicago
"Loan Exhibition of Modern Paintings: Privately Owned by Chicagoans"
> Pablo Picasso [*sic*] (no. 24 in exh.; no title given) / Mrs. John Alden Carpenter

January 7–19, 1929: Daniel Galleries, New York
[Title of exhibition unknown] / organized by the Société Anonyme [This exhibition contained twenty paintings and included at least one work by Picasso, although no specific titles of works have been identified.]

January 28–February 23, 1929: Valentine Gallery, New York
["A Group of Modern French Paintings"]
> [*Portrait* / Described in a contemporaneous review as "cubistic."]

February 22–March 8, 1929: Arts Club of Chicago
"Some Modern Paintings" / Loaned [*sic*] by Paul Rosenberg, Paris through the Courtesy of Wildenstein & Company, New York
> *Landscape*, 1924 (no. 7 in exh.)

February 23–March 16, 1929: Reinhardt Galleries, New York
"Loan Exhibition of Paintings of Women and Children by Masters from the Fifteenth to the Twentieth Centuries"
> *The Dancer* / Adolph Lewisohn, New York (no. 31 in exh.; ill. in cat.) [Z.I.65]

March 1–23, 1929: De Hauke & Co., Inc., New York
"Exhibition of Works by 19th Century and Contemporary French Artists: Watercolors and Drawings"
> *Arlequin*, pastel (no. 49 in exh.)

March 19–April 21, 1929: Art Institute of Chicago
"European Paintings from the Carnegie International Exhibition"
> *Figure (Pink)*, 1903 (no. 57 in exh.) / Leonard C. Hanna, Jr., Cleveland [Z.I.317; Cleveland Museum of Art]
> *Still Life*, 1925 / Paul Rosenberg, Paris (no. 58 in exh.)

April 16–17, 1929: American Art Association, New York
"The [Auction of the] Arthur B. Davies Art Collection"
> *Nude Study*, pen and ink drawing, 7 1/2 x 3 1/2 in. (lot 13 / Sold to Valentine Gallery, New York)
> *Hercules*, pen and ink drawing, 7 x 4 in. (lot 14 / Sold to Downtown Gallery, New York)
> *Portrait of a Lady*, pen and ink drawing, 7 x 4 1/2 in. (lot 15 / Sold to J. B. Neumann, New York)
> *Apples*, watercolor, 9 1/2 x 12 1/2 in. (lot 42 / Sold to E. L. Bernays)
> *Artist's Paraphernalia* [current title: *Abstraction, Biarritz*], 14 x 10 1/2 in. (lot 61 / Sold to

Valentine Dudensing, owner of the Valentine Gallery, New York) [Z.III.162; Phillips Collection]
Study of Two Nudes, pencil drawing on white, 25 x 18 1/2 in. (lot 86 / Sold to E. Weyhe, New York)
Portrait, crayon drawing, 25 x 19 in. (lot 87 / Sold to Demotte, Inc., New York)
La Lampe, 1912, pencil drawing, 9 1/2 x 12 1/2 in. (lot 374 / Sold to Demotte, Inc., New York)
"On Red Design," oil on canvas, 13 x 16 in. (lot 398 / Sold to Morris Hillquit)
The Flagon, inscribed: "Vieux Marc," oil on canvas, 18 x 13 in. (lot 404 / Sold to Ferargil Galleries, New York) [Z.II¹.355]
Interior of a Café with Figures, charcoal drawing, 19 x 14 1/2 in. (lot 409 / Sold to Jane Rogere)
Portrait Arrangement (Eva) [current title: *Female Nude (J'aime Eva)*],* 1912, oil on canvas, 39 1/2 x 25 1/2 in. (lot 434 / Sold to Ferdinand Howald, Columbus, Ohio) [Z.II¹.364; Columbus Museum of Art]
Portrait of a Lady Seated, oil on canvas, 39 1/2 x 28 1/2 in. (lot 435 / Sold to Paul Rosenberg, Paris)

May 20–July 1, 1929: Reinhardt Galleries, New York
"Exhibition of Modern Paintings"
The Nurses, painted about 1904 (no. 8 in exh.)

October 1929–February 1930: Phillips Memorial Gallery, Washington, D.C.
"Tri-Unit Exhibition of the Season of 1929–1930"
Early Morning [current title: *The Blue Room*] / Phillips Memorial Gallery, Washington, D.C. (no. 119 in exh.) [Z.I.103; Phillips Collection, Washington, D.C.]
Abstraction [current title: *Abstraction, Biarritz*] / Phillips Memorial Gallery, Washington, D.C. (no. 120 in exh.) [Z.III.162; Phillips Collection, Washington, D.C.]

October 1–19, 1929: De Hauke & Co., New York
"30 Years of French Painting: 1900–1930"
Soupir (no. 17 in exh.) [Z.V.12; Museum of Modern Art, New York]

October 5–28, 1929: C. W. Kraushaar Art Galleries, New York
"Exhibition of Modern French Paintings, Water Colors and Drawings"
Mother and Child (no. 47 in exh.)
Studies of Figures (no. 48 in exh.)
Horse and Rider (no. 49 in exh.)

October 12–November 9, 1929: Reinhardt Galleries, New York
"Exhibition of Drawings, Paintings and Water Colors by Picasso, Matisse, Derain, Modigliani, Braque, Dufy, Utrillo, Vlaminck, Laurencin, Henri Rousseau, Gauguin, Redon and others"
The Harlequin, painting (no. 1 in exh.; ill. in cat.)
Portrait of a Lady, painting (no. 2 in exh.)
Woman and Cats, painting (no. 3 in exh.) [Z.I.93; Art Institute of Chicago]
The Actor, [drawing or watercolor] (no. 18 in exh.)
Head of a Woman, 1903, [drawing or watercolor] (no. 19 in exh.)
Abstraction, [drawing or watercolor] (no. 20 in exh.)
Three Figures, [drawing or watercolor] (no. 21 in exh.)

Opened mid-November 1929: Gallery of Living Art, New York University
[Recent Acquisitions]
[*Self-Portrait* (current title: *Self-Portrait with Palette*), 1906, oil on canvas. Z.I.375; Philadelphia Museum of Art]
[*Bowls and Jug*, 1908, oil on canvas. Z.II¹.63; Philadelphia Museum of Art]
[*Abstract Composition*, oil / This work could possibly be *Still Life* [Z.II¹.63] or *Guitar and Glasses*, both of which were recent acquisitions and were shown in the 1929 Brummer Gallery exhibition (see next entry).]

November 30–December 13, 1929: Brummer Gallery, New York

"Contemporary Paintings: Recent Acquisitions Made by Mr. A. E. Gallatin for the NYU Gallery of Living Art"
Portrait of the Painter [current title: *Self-Portrait with Palette*], oil (no. 1 in exh.) [Z.I.375; Philadelphia Museum of Art]
Still Life, oil (no. 2 in exh.) [Z.II¹.63; Philadelphia Museum of Art]
Guitar and Glasses, oil (no. 3 in exh.) [Philadelphia Museum of Art]

December 1929: De Hauke & Co., Inc., New York
"Exhibition of Water Colors and Drawings by 19th Century and Contemporary French Artists"
La Famille d'Arlequin, pen drawing and watercolor (no. 36 in exh.)

1930

January 3–17, 1930: Arts Club of Chicago
"Loan Exhibition of Modern Drawings and Sculpture: Privately Owned by Chicagoans"
Nude Study / Mr. and Mrs. Walter S. Brewster (no. 27 in exh.) [Z.XXII.353; Art Institute of Chicago]
Woman Seated, [1924] gouache / Mrs. John Nef (no. 94 in exh.)
Reclining Nude / Mr. Martin C. Schwab (no. 110A in exh.)
Cavalier / anonymous loan through Roullier Galleries (no. 130 in exh.)

January 19–February 16, 1930: Museum of Modern Art, New York
"Painting in Paris from American Collections"
The Dancer, 1900–1901 / private collection, New York (no. 64 in exh.) [Z.I.65 / The anonymous lender was Adolph Lewisohn, New York.]
The Sweet Tooth, 1902 / Josef Stransky, New York (no. 65 in exh.; ill. in cat.) [Z.I.51; National Gallery of Art, Washington, D.C.]
Head of Peasant Woman, 1905, gouache / T. Catesby Jones, New York (no. 66 in exh.) [Z.I.319]
La Toilette, 1905 [actual date: 1906]/ Albright Art Gallery, Buffalo, New York (no. 67 in exh.; ill. in cat.) [Z.I.325; Albright-Knox Art Gallery]
Green Still Life [also known as: *Fruit Bowl, Wineglass, Bowl of Fruit*], about 1914 / private collection, New York (no. 68 in exh.) [Z.II².485; Museum of Modern Art, New York / The anonymous lender was Lillie P. Bliss.]
Abstract Still Life [current title: *Abstraction, Biarritz*], 1918 / Phillips Memorial Gallery, Washington, D.C. (no. 69 in exh.) [Z.III.162; Phillips Collection, Washington, D.C.]
Pierrot, 1918 / Adolph Lewisohn, New York (no. 70 in exh.; ill. in cat.) [Z.III.137; Museum of Modern Art, New York]
Abstraction, 1921 / The Reinhardt Galleries, New York (no. 70A in exh.)
Head of a Woman, 1923, red chalk / Chicago Arts Club (no. 71 in exh.) [Z.XXX.380; Arts Club of Chicago]
Musical Instruments, 1923 / Mrs. John Alden Carpenter, Chicago (no. 72 in exh.)
Lovers, 1923 / Mary Hoyt Wiborg, New York (no. 72A in exh.) [Z.V.14; National Gallery of Art, Washington, D.C.]
Woman in White,* about 1923 / private collection, New York (no. 73 in exh.) [Z.V.1; Metropolitan Museum of Art, New York / The anonymous lender was Lillie P. Bliss.]
Woman and Child, 1923 / private collection, New York (no. 74 in exh.) [Z.IV.455]
Still Life, about 1924 / Mary Hoyt Wiborg, New York (no. 75 in exh.) [Z.V.228]
Seated Woman, 1927 / Mary Hoyt Wiborg, New York (no. 76 in exh.; ill. in cat.) [Z.VII.77; Museum of Modern Art, New York]

January 25–February 21, 1930: Reinhardt Galleries, New York
"Retrospective Exhibition of Paintings by Picasso and Derain"
Bal Tabarin, about 1901 (no. 1 in exh.)
Portrait of a Child, about 1901 / Ralph H. Booth (no. 2 in exh.)

Femme accoudée, about 1903 / Adolph Lewisohn, New York (no. 3 in exh.; ill. in cat.) [Z.I.160; private collection]
Harlequin Family, about 1904, drawing [medium not specified] (no. 4 in exh.)
The Supper Party, 1904 / Chester H. Johnson Galleries, Chicago (no. 5 in exh.)
Le Saltimbanque, about 1905 / de Hauke & Co., New York (no. 6 in exh.)
Head, 1906, drawing [medium not specified] (no. 7 in exh.)
Nude, 1907 / private collection, New York (no. 8 in exh.) [The anonymous lender was James Johnson Sweeney.]
Abstraction, Rome, 1917 / Wildenstein & Co., New York (no. 9 in exh.)
Abstraction, 1917 / private collection, New York (no. 10 in exh.) [The anonymous lender was James Johnson Sweeney.]
Abstraction, 1919 / J. B. Neumann, New York (no. 11 in exh.)
Le Soupir, about 1923 / de Hauke & Co., New York (no. 12 in exh.) [Z.V.12; Museum of Modern Art, New York]
Harlequin, 1923 (no. 13 in exh.)
Woman in a Chair, 1924 / M. Knoedler & Co., New York (no. 14 in exh.; ill. in cat.) [Z.V.154]
Abstraction, 1924 / Wildenstein & Co., New York (no. 15 in exh.)
Abstraction–Dinard, 1928 / R. Sturgis Ingersoll, Philadelphia (no. 16 in exh.)
Abstraction–Dinard, 1928 / Wildenstein & Co., New York (no. 17 in exh.)
[Drawing–3 Figures, ca. 1923, medium not specified] (no. 18 in exh.) [This last entry was handwritten on the printed checklist of the exhibition, suggesting that this piece was a late addition to the exhibition.]

February 4–18, 1930: Renaissance Society of the University of Chicago
"Modern French Paintings" / organized by Chester Johnson Galleries, Chicago
The Acrobat's Wife [current title: *Woman with Helmet of Hair*. Z.I.233; Art Institute of Chicago / The lenders may have been Mr. and Mrs. Walter Brewster.]

February 17–March 8, 1930: Valentine Gallery, New York
"Six Major Paintings by the Modern Masters of France: Braque, Derain, Matisse, Picasso and one important work by Henri Rousseau"
La Statuaire, 1925 (no. 5 in exh.; ill. in cat.) [Z.V.451; private collection]
Nature morte, 1925 (no. 6 in exh.; ill. in cat.) [Z.V.446]

March 3–15, 1930: Junior League of New York
"An Exhibition of French Oils and American Watercolors by Contemporary Artists"
Still Life / Valentine Dudensing, New York (no. 15 in exh.)
Le Soupir / De Hauke & Co., New York (no. 16 in exh.) [Z.V.12; Museum of Modern Art, New York]

March 26–April 9, 1930: Arts Club of Chicago
"Paintings by Pablo Picasso"
Les Amoureux, 1925 [actual date: 1923] / Miss Mary Hoyt Wiborg, New York (no. 1 in exh.) [Z.V.14; National Gallery of Art, Washington, D.C.]
Still Life, about 1924 / Miss Mary Hoyt Wiborg, New York (no. 2 in exh.) [Z.V.228]
Seated Woman, 1927 / Miss Mary Hoyt Wiborg, New York (no. 3 in exh.; ill. on cover of cat.) [Z.VII.77; Museum of Modern Art, New York]
Flowers, 1903 / Chester H. Johnson Galleries, Chicago (no. 4 in exh.)
Supper Party, 1913 / Chester H. Johnson Galleries, Chicago (no. 5 in exh.)
Le Guitariste, about 1910 [actual date: 1903] / Art Institute of Chicago (no. 6 in exh.) [Z.I.202; Art Institute of Chicago]
Italienne, 1917 / Wildenstein & Company, New York (no. 7 in exh.) [Z.III.18]
Dinard, 1928 / Wildenstein & Company, New York (no. 8 in exh.)

Soupir, about 1923 / De Hauke & Company, New York (no. 9 in exh.) [Z.V.12; Museum of Modern Art, New York]

Head of Woman [current title: *Woman with Helmet of Hair*], 1921 [actual date: 1904] / Mr. and Mrs. Walter S. Brewster (no. 10 in exh.) [Z.I.233; Art Institute of Chicago]

Still Life, 1923 / Mrs. John Alden Carpenter, Chicago (no. 11 in exh.) [This may have been *Musical Instruments*, 1923.]

Abstraction, 1923 / Valentine Gallery, New York (no. 12 in exh.)

Abstraction, 1924 / Valentine Gallery, New York (no. 13 in exh.) [Z.V.243]

Harlequin, about 1923 / Reinhardt Galleries, New York (no. 14 in exh.)

Three Figures, about 1923, drawing [medium not specified] / Reinhardt Galleries, New York (no. 15 in exh.)

April 1930: De Hauke & Co., Inc., New York
"Exhibition of Cubism (Period 1910–1913)"
Nature morte, 1911 (no. 1 in exh.) [Z.II¹.224; private collection]
Nature morte, 1911 (no. 2 in exh.)
Homme et femme, 1912 (no. 3 in exh.)
Sur le piano, 1912 (no. 4 in exh.)
Femme assise (no. 5 in exh.)
Femme à la mandoline (no. 6 in exh.)
Nature morte / private collection, America (no. 7 in exh.)

April 7–21, 1930: Renaissance Society of the University of Chicago
"Exhibition of Modern European and Oriental Art"
Landscape / Mr. Thomas Gerrity (no. 25 in exh.)

April 14–October 1930: Valentine Gallery, New York ["Exhibition of Paintings by Matisse, Picasso, Derain, Dufy and Segonzac" / As indicated by its title, this exhibition included at least one work by Picasso, although no specific titles of works have been identified.]

June 15–September 1930: Museum of Modern Art, New York
"Summer Exhibition: Retrospective"
Abstract Still Life / Stephen C. Clark, New York (no. 74 in exh.) [Z.V.268]
Abstraction / Mrs. Charles H. Russell, New York (no. 75 in exh.) [Z.II¹.355]
Beggar / Joseph Stransky, New York (no. 76 in exh.) [Z.I.222; Art Institute of Chicago]
Harlequin / private collection, New York (no. 77 in exh.) [Z.I.79; Metropolitan Museum of Art, New York / The anonymous lender was Julia Quinn Anderson, the daughter of John Quinn.]
Harlequin / Samuel A. Lewisohn, New York (no. 78 in exh.)
Mother and Child / Joseph Stransky, New York (no. 79 in exh.) [Z.I.12]
Pierrot / Adolph Lewisohn, New York (no. 80 in exh.) [Z.III.137; Museum of Modern Art, New York]
Seated Woman / Mary Hoyt Wiborg, New York (no. 81 in exh.) [Z.VII.77; Museum of Modern Art, New York]
Small Abstraction / Valentine Gallery, New York (no. 82 in exh.)
Small Abstraction / Valentine Gallery, New York (no. 83 in exh.)
Woman Combing [*Her*] *Hair* / Mrs. Edward A. Jordan, New York (no. 84 in exh.) [Z.I.336; Museum of Modern Art, New York]

July–August 1930: Renaissance Society of the University of Chicago
"Modern European Paintings"
Les Amoureux / Mary Hoyt Wiborg, New York [Z.V.14; National Gallery of Art, Washington, D.C.]
Still Life / Mary Hoyt Wiborg, New York [Z.V.228]

October 1–November 1, 1930: John Becker Gallery, New York
"Drawings and Gouaches by Pablo Picasso"; traveled to the Arts Club of Chicago, November 28–December 13, 1930, as "Exhibition of Original Drawings by Pablo Picasso" [For the New York exhibition, a card was printed announcing the exhibition and indicating that all the works came from Picasso's studio. The works shown in Chicago were the same as those in New York, except one, a drawing entitled *Le Cheval*, lent by Mrs. John Alden Carpenter, a Chicago collector. The titles given below are from a typed list from the Arts Club Records, Midwest Manuscript Collection, Newberry Library, Chicago.]
Femme nue, 1920, drawing [medium not specified]
Les Baigneuses, 1920, drawing [medium not specified]
Femme couchée, 1920–21, drawing [medium not specified]
Danseuse, 1919, drawing [medium not specified]
Danseuses, 1919, drawing [medium not specified]
Le Repas, 1908, watercolor
Deux Danseurs, 1919, drawing [medium not specified]
Tête, 1907, drawing [medium not specified]
Feuilles, 1921, drawing [medium not specified]
Ex Cathedra, 1918, gouache
Ex Cathedra, 1918, gouache
Le Cheval, 1925, drawing [medium not specified] / Mrs. John Alden Carpenter, Chicago
Femmes grecques, 1922, gouache and oil
Femme au miroir, 1918, drawing [medium not specified]. Z.III.200
Deux Femmes, 1928(?), gouache
Vue du balcon de l'artiste, 1919, drawing [medium not specified]
Composition, 1919, gouache
Composition, 1919, gouache
Composition, 1922, gouache

October 4–31, 1930: Marie Harriman Gallery, New York
"Opening Exhibition"
Woman with the Loaves (no. 14 in exh.) [Z.VI.735; Philadelphia Museum of Art]
Adolescence (no. 15 in exh.)
Mother and Child (no. 16 in exh.) [Z.IV.370]
Harlequin (no. 17 in exh.)

October 5, 1930–January 25, 1931: Phillips Memorial Gallery, Washington, D.C.
"An International Group"
Still Life [current title: *Studio Corner*], watercolor (no. 70 in exh.) [Z.IV.241; Phillips Collection, Washington, D.C.]

November 10–27, 1930: Print Club of Philadelphia
"Drawings: Modern French School (Contemporary French Drawings in Black and White and Color)"
Abstraction [current title: *The Violin*], drawing [chalk on paper] / Earl Horter, Philadelphia (no. 60 in exh.) [Z.XXVIII.103; private collection]
Abstraction [current title: *Still Life with Bottle, Cup and Newspaper*], drawing [collage composed of pasted paper, charcoal and graphite on paper] / Earl Horter, Philadelphia (no. 61 in exh.) [Z.II².397; Museum Folkwang, Essen, Germany]
On the Beach, colored drawing [medium not specified] / Franklin C. Watkins, Philadelphia (no. 62 in exh.; ill. in cat.) [Z.IV.225]
Head of Woman, drawing [medium not specified] / Henry Reinhardt & Son, Inc., New York (no. 63 in exh.) [Z.I.38]
Three Figures, drawing [medium not specified] / Henry Reinhardt & Son, Inc., New York (no. 64 in exh.; ill. in cat.)
Abstraction, watercolor / Maurice Speiser, Philadelphia (no. 65 in exh.) [Z.II¹.55]
Abstraction, gouache / Bernard Davis, Philadelphia (no. 66 in exh.)

Opened December 1, 1930: Gallery of Living Art, New York University
["Recent Acquisitions"]
[*Still Life*]

1931

January 1931: Museum of French Art, New York
"Portraits of Women: Romanticism to Surrealism"
Portrait, Mme. Picasso, 1923 / Chester Dale Collection (no. 27 in exh.) [Z.V.29; National Gallery of Art, Washington, D.C.]

January 5–March 16, 1931: Rand School of Social Science, New York
["Third Exhibition in Connection with the Rand School"] / organized by the Société Anonyme [This exhibition included one drawing by Picasso, but the checklist could not be located, and no specific titles of works have been identified.]

January 5–February 7, 1931: Valentine Gallery, New York
"Abstractions of Picasso"
Nature morte, 1913 (no. 1 in exh.)
Nature morte, 1914 (no. 2 in exh.)
Femme au chapeau jaune, 1921 (no. 3 in exh.) [Z.IV.258]
Nature morte, 1922 (no. 4 in exh.)
Composition, 1922 (no. 5 in exh.) [Z.IV.422]
Nature morte à la guitare (no. 6 in exh.) [Z.V.91; Philadelphia Museum of Art]
La Portée de musique, 1923 (no. 7 in exh.)
La Pomme, 1923 (no. 8 in exh.)
La Verre, 1924 (no. 9 in exh.) [Z.V.243]
L'Intérieur, 1927 (no. 10 in exh.) [Z.V.268]
L'Harlequin, 1927 (no. 11 in exh.)
Nature morte à la guitare, 1927–29 / Mrs. W. Averell Harriman, New York (no. 12 in exh.) [Z.VII.75]
La Cabine de bain, 1928 (no. 13 in exh.)
La Plage, 1928, [oil on canvas, 13 3/4 x 9 1/2 in.] (no. 14 in exh.)
L'Allegorie, 1929 (no. 15 in exh.) [Z.VII.252; Metropolitan Museum of Art, New York]
Formes abstraites, fond jaune, 1930 (no. 16 in exh.)
Formes abstraites, fond de ciel bleu, 1930 (no. 17 in exh.) [Z.VII.300]
Abstraction en blanc et noir, fond gris, 1930 (no. 18 in exh.) [Z.VII.299]
Formes abstraites, fond gris, n.d. (no. 19 in exh.)
Formes abstraites, fond de ciel bleu, 1930 (no. 20 in exh.)
Formes abstraites, fond brun, 1930 (no. 21 in exh.) [Z.VII.121]
Formes abstraites, fond gris fonce, 1930 (no. 22 in exh.) [Z.VII.420]
Formes abstraites, fond de ciel bleu, 1930 (no. 23 in exh.) [Z.VII.304; Art Institute of Chicago]

January 26–February 9, 1931: Renaissance Society of the University of Chicago
"Annual Exhibition of Modern French Painting" / organized by Chester Johnson Galleries, Chicago
Guitare rose [1919] (no. 17 in exh.)

February 1931: Museum of French Art, New York
"Picasso–Braque–Léger"
The Tragedy, 1903 / Chester Dale (no. 2 in exh.) [Z.I.208; National Gallery of Art, Washington, D.C.]
Two Youths, 1905 / Chester Dale (no. 3 in exh.) [Z.I.305; National Gallery of Art, Washington, D.C.]
Family of Saltimbanques, 1905 / Chester Dale (no. 4 in exh.) [Z.I.285; National Gallery of Art, Washington, D.C.]
Juggler with Still Life, 1905 / Chester Dale (no. 5 in exh.) [Z.I.294; National Gallery of Art, Washington, D.C.]
Still Life, 1918 / Chester Dale (no. 6 in exh.) [Z.III.257; National Gallery of Art, Washington, D.C.]
Classical Head, 1922 / Chester Dale (no. 7 in exh.) [Z.IV.396; National Gallery of Art, Washington, D.C.]
Madame Picasso, 1923 / Chester Dale (no. 8 in exh.) [Z.V.29; National Gallery of Art, Washington, D.C.]

February 1931: Valentine Gallery, New York
[Group Show / This exhibition included at least one work by Picasso, although no specific titles of works have been identified.]

February 1931: Women's University Club, New York
[Exhibition title unknown] / organized by the Société Anonyme [This show consisted of seven paintings, including at least one by Picasso, although no specific titles of works have been identified.]

February 1931: Pennsylvania Museum of Art, Philadelphia
[Untitled exhibition, publicizing a patron's recent gift of a painting by Picasso.]
Woman with Loaves, 1906, oil on canvas, 39 3/8 x 27 1/2 in. / recent gift of Charles E. Ingersoll [Z.VI.735; Philadelphia Museum of Art]

February–June 1931: Phillips Memorial Gallery, Washington, D.C.
"French Paintings from Manet to Derain"
The Blue Room (no. 93 in exh.) [Z.I.103; Phillips Collection, Washington, D.C.]

February–June 1931: Phillips Memorial Gallery, Washington, D.C.
"The New Decorative Idioms in Painting"
Studio Corner, [1921] (no. 42 in exh.) [Z.IV.241; Phillips Collection, Washington, D.C.]
Abstraction [current title: *Abstraction Biarritz*, 1918] (no. 43 in exh.) [Z.III.162; Phillips Collection, Washington, D.C.]

Opened February 2, 1931: Gallery of Living Art, New York University
[Recent Acquisitions]
[*Still Life / The Mandolin*, 1923, oil, 32 x 39 in. Philadelphia Museum of Art]
[*Bather, Dinard / Design for a Monument*, 1928, oil on canvas, 9 1/2 x 6 1/2 in. Z.VII.209; Philadelphia Museum of Art]

February 24–March 14, 1931: M. Knoedler & Co., Chicago
"A Century of French Painting"
Femme assise dans un fauteuil (no. 21 in exh.; ill. in cat.) [Z.V.154]

March 10–April 21, 1931: Art Institute of Chicago
"European Paintings from the Carnegie International Exhibition"
Portrait of Mme. Picasso (no. 58 in exh.) [Z.V.53 / Awarded first prize, Carnegie Institute, 1930.]
The Three Graces (no. 59 in exh.)

March 15–April 4, 1931: American Art Association, Anderson Galleries, New York
"Exhibition of Important Paintings: Old and Modern Masters in the New York Art Market from the Collections of Leading New York Dealers" [This was a benefit show organized by a group of leading New York art dealers.]
Femme assise dans un fauteuil / M. Knoedler & Co., New York (no. 67 in exh.) [Z.V.154]
Femme au chapeau jaune / Valentine Gallery, New York (no. 106 in exh.) [Z.IV.258]

April–October 1931: Valentine Gallery, New York
[Group show / Among the works included in this exhibition, in addition to the gouache listed here, were small drawings by Picasso.]
[*Blue Boy*, 1905, gouache / Edward M. M. Warburg, New York. Z.I.271]

April 6–18, 1931: M. Knoedler & Co., New York
"Pictures of People 1870–1930"
Deux Harlequins, 1905, gouache, 21 x 28 in. / anonymous loan (no. 19 in exh.; ill. in cat. [Z.I.295; National Museum of Art, Osaka / The anonymous lender was Stephen C. Clark, New York.]

April 11–May 9, 1931: Demotte, Inc., New York
"Drawings from Ingres to Picasso"
Tête d'homme (no. 34 in exh.)
Groupe antique (no. 35 in exh.)
Quatre Personnages (no. 36 in exh.)
Deux Danseuses (no. 37 in exh.)
Nu (no. 38 in exh.) [Z.XXII.469]

April 15–May 2, 1931: F. Kleinberger Galleries, New York
"Exhibition of Paintings: Corot to Picasso" [This exhibition included at least one work by Picasso, although no specific titles of works have been identified.]

April 30–May 31, 1931: Art Institute of Chicago
"The Eleventh International Exhibition: Water Colors, Pastels, Drawings, Monotypes and Miniatures"
Head of a Woman (no. 218 in exh.)
Repast (no. 219 in exh.)
Russian Ballet (no. 220 in exh.)
Scene in Theatre (no. 221 in exh.)
Woman Seated (no. 222 in exh.; ill. in cat.) [Z.IV.360]

May 17–September 27, 1931: Museum of Modern Art, New York
"Memorial Exhibition: The Collection of Miss Lizzie P. Bliss" [One of the three founders of the Museum of Modern Art, Bliss built her own important collection of modern art. Her bequest of these works to the museum, less than two years after it opened, formed the core of the collection.]
Green Still Life [also known as: *Fruit Bowl, Wineglass, Bowl of Fruit*] (no. 100 in exh.) [Z.II².485; Museum of Modern Art, New York]
*Woman in White** (no. 101 in exh.) [Z.V.1; Metropolitan Museum of Art, New York]

October 23–November 6, 1931: Chester H. Johnson Galleries, Chicago
"Special Exhibition of Paintings, Drawings and Water Colors"
Paintings:
Une Rue la nuit–Barcelona, [painting] (no. 3 in exh.)
Guitare rose, [1919, painting] (no. 4 in exh.)
Drawings or watercolors:
Self-Portrait, [drawing or watercolor] (no. 1 in exh.)
Ballet Russe, [drawing or watercolor] (no. 2 in exh.)
Portrait of a Man, [drawing or watercolor] (no. 3 in exh.)
Nu debout, [drawing or watercolor] (no. 4 in exh.)
Mother and Child, [drawing or watercolor] (no. 5 in exh.)

October 26–November 24, 1931: M. Knoedler & Co., New York
"The Landscape in French Painting: XIX–XX Centuries"
La Sortie du village, ca. 1928 [actual date: 1921], pastel, 19 x 25 1/2 in. (no. 35 in exh.; ill. in cat.) [Z.IV.279]

November 14–December 5, 1931: Pierre Matisse Gallery, New York
"Pierre Matisse presents a group of paintings by Braque, Derain, Dufy, Lurçat, Matisse, Picasso, Rouault, Rousseau" [As indicated by its title, this exhibition included at least one work by Picasso, although no specific titles of works have been identified.]

November 20, 1931–January 1, 1932: Pennsylvania Museum of Art, Philadelphia
"Living Artists"
The Woman with the Loaves, 1905, oil on canvas / Pennsylvania Museum of Art, Philadelphia [Z.VI.735; Philadelphia Museum of Art]

December 1931: Demotte, Inc., New York
"Pablo R. Picasso"; traveled in part to the Arts Club of Chicago, January 4–16, 1932, as "Paintings by Pablo Picasso" / organized by Mary Hoyt Wiborg
La Course de taureaux, 1901 (no. 1 in New York)
La Jeune Fille [current title: *Woman with a Cape*], 1902 (no. 2 in New York; ill. in cat.) [Z.VI.542; Cleveland Museum of Art]
La Verre d'absinthe, 1902 (no. 3 in New York)
La Gommeuse, 1902 (no. 4 in New York)
Chagrin, 1903 (no. 5 in New York; no. 1 in Chicago)
La Chevelure, 1904 (no. 6 in New York; no. 2 in Chicago)
Les Saltimbanques au bord de la mer, 1905 (no. 7 in New York)
Jeune Fille au repos, 1906 (no. 8 in New York; no. 3 in Chicago)
Jeune Fille à la chevelure, 1906 (no. 9 in New York; no. 4 in Chicago; ill. in cat.)
Époque nègre, 1908 (no. 10 in New York; no. 5 in Chicago)
Époque d'Avignon, 1908 (no. 11 in New York; no. 6 in Chicago)

Jeune Fille en jaune, 1908 (no. 12 in New York; no. 7 in Chicago)
Jeune Femme, 1909 (no. 13 in New York; no. 8 in Chicago)
Paysage, 1909 (no. 14 in New York; no. 9 in Chicago)
Fruits et objets, 1909 (no. 15 in New York; no. 10 in Chicago)
Portrait de femme, 1909 (no. 16 in New York; no. 11 in Chicago)
Baigneuse, 1909 (no. 17 in New York; no. 12 in Chicago; ill. in cat.)
La Conversation, 1909 (no. 18 in New York; no. 13 in Chicago)
Le Compotier, 1909 (no. 19 in New York; no. 14 in Chicago)
Abstraction, 1910 (no. 20 in New York; no. 15 in Chicago; ill. in cat.) [Z.II¹.263]
Paysage du midi, 1910 (no. 21 in New York; no. 16 in Chicago)
Nature morte à la pipe et au verre, 1910 (no. 22 in New York; no. 17 in Chicago)
Abstraction, 1910 (no. 23 in New York; no. 18 in Chicago)
L'Italienne, 1917 (no. 24 in New York; ill. in cat.) [Z.III.18]
Les Amoureux, 1923 / Miss Mary Hoyt Wiborg, New York (no. 25 in New York) [Z.V.14; National Gallery of Art, Washington, D.C.]
Nature morte, 1924 / Miss Mary Hoyt Wiborg, New York (no. 26 in New York) [Z.V.228]
Portrait [current title: *Seated Woman*], 1927 / Miss Mary Hoyt Wiborg, New York (no. 27 in New York) [Z.VII.77; Museum of Modern Art, New York]
Baigneuses, 1928 (no. 28 in New York)
Abstraction, 1928 (no. 29 in New York)
Baigneuses, 1928 (no. 30 in New York)
Abstraction, 1929 (no. 31 in New York)

December 28, 1931–January 16, 1932: Valentine Gallery, New York
"Since Cézanne: A Cross Section of 17 Leading Painters of the École de Paris"
Femme assise [also known as: *Seated Woman*],* 1927 (ill. in cat.) [Z.VII.81; Art Gallery of Ontario, Toronto]
[*The Studio*,* 1927–28, oil. Z.VII.142; Museum of Modern Art, New York / *The Studio* was reproduced in the catalogue without a caption, merely with a note stating that it was available but not included in the exhibition.]

1932

January 9–29, 1932: Julien Levy Gallery, New York
["Surréalisme: Eugène Atget, Herbert Bayer, Jacques-André Boiffard, Jean Cocteau, Joseph Cornell, Salvador Dalí, Max Ernst, Charles Howard, George Platt Lynes, Man Ray, László Moholy-Nagy, Roger Parry, Pablo Picasso, Pierre Roy, Maurice Tabard, Umbo, Unknown Master, Jean Viollier" / This exhibition included two works by Picasso, although no specific titles of works have been identified.]

January 23–February 20, 1932: Reinhardt Galleries, New York
"22 Important Contemporary Paintings"
Harlequin, 1923 (no. 19 in exh.)

February 15–March 12, 1932: Brooklyn Museum, New York
"Modern Catalan Painting"
18 Sketches of Catalonian Artists, painting (no. 36 in exh.)

March 31–May 30, 1932: Art Institute of Chicago
"The Twelfth International Exhibition: Water Colors, Pastels, Drawings and Monotypes"
Portrait of a Man (no. 170 in exh.)

April 6–October 9, 1932: Art Institute of Chicago
"The Mrs. L. L. Coburn Collection: Modern Paintings and Watercolors"
On the Upper Deck, 1901, oil on canvas, 15 1/2 x 24 1/4 in. (no. 27 in exh.; ill. in cat.) [Z.XXI.168; Art Institute of Chicago]

April 16–October 1932: Valentine Gallery, New York ["Advanced School of French and American Moderns including Lurçat, Braque, de Chirico, Matisse, Picasso and others"]

[*Woman Crouching*, 1902 / Adolph Lewisohn, New York. Z.I.160; private collection]

June 7–October 30, 1932: Museum of Modern Art, New York "Summer Exhibition"

Woman, blue period [current title: *Woman Crouching*, 1902] / Adolph Lewisohn, New York [Z.I.160; private collection]

Head, ca. 1908 [Z.II¹.76; Metropolitan Museum of Art, New York]

Portrait of Braque, [1909] / Frank Crowninshield, New York [Z.II¹.177; Staatliche Museen zu Berlin, Nationalgalerie, on permanent loan from the Berggruen collection]

Green Still Life [also known as: *Fruit Bowl, Wineglass, Bowl of Fruit*], 1914 [Z.II².485; Museum of Modern Art, New York]

November 1932: M. Knoedler & Co., New York "'Flowers' by French Painters (XIX–XX Centuries)"

Roses, ca. 1900, oil on canvas, 14 1/8 x 16 5/8 in. / Baron Napoléon Gourgaud, Paris (no. 33 in exh.) [Z.I.9]

Nature morte au vase de fleurs, 1905, cardboard, 28 x 21 1/4 in. / Pablo Picasso (no. 34 in exh.)

Le Vase bleu, 1906, watercolor, 9 x 6 in. (no. 35 in exh.)

December 5, 1932–January 7, 1933: Valentine Gallery, New York "'Selection': Newest Canvases from 'The School of Paris'"

Le Corsage bleu, 1921 (no. 10 in exh.; ill. in cat.) [Z.IV.307]

La Table, 1920 / Smith College Museum of Art, Northampton, Massachusetts (no. 11 in exh.; ill. in cat.) [Z.III.437; Smith College Museum of Art]

1933

February 16–March 7, 1933: Renaissance Society at the University of Chicago "Pure Line Drawing–from the Greek to the Modern"
Head, pencil / Mrs. Robert M. Hutchins, Chicago
Cavalier, pencil / Mrs. Shreve Badger

February 21–March 15, 1933: Marie Harriman Gallery, New York "French Paintings"

La Femme à l'éventail / private collection (no. 3 in exh.) [Z.I.308; National Gallery of Art, Washington, D.C. / The anonymous lenders were Mr. and Mrs. W. Averell Harriman.]

Nature morte à la guitare [current title: *Glass, Guitar and Bottle*], papier collé (no. 4 in exh.) [Z.II².419; Museum of Modern Art, New York]

Abstraction, papier collé / private collection (no. 13 in exh.)

March 3–31, 1933: Pierre Matisse Gallery, New York "Group Exhibition: Dufy, Gromaire, Lurçat, Maillol, Masson, Matisse, Picasso, Rouault, Severini" [As indicated by its title, this exhibition of pastels, watercolors, and drawings included at least one work by Picasso, although no specific titles of works have been identified.]

March 6–April 6, 1933: Valentine Gallery, New York "Exhibition of 7 Outstanding Paintings by Picasso"

La Famille d'Arlequin, 1905, gouache [actual medium: oil], 23 x 17 in. / Samuel A. Lewisohn, New York (no. 1 in cat.) [Z.I.298; private collection]

La Coiffeuse, 1905, oil, 70 x 51 in. / Lewisohn Collection, New York (no. 2 in exh.)

Les Deux Soeurs, 1921, pastel, 42 x 29 in. / Valentine Gallery, New York (no. 3 in exh.) [Z.IV.358]

Trois Personnages sur la plage, oil on wood, 32 x 39 in. (no. 4 in exh.) [Z.IV.169]

Jeune Fille au chapeau jaune, April 16, 1921, pastel, 41 x 29 in. (no. 5 in exh.) [Z.IV.258]

Deux Nus, 1920, pastel, 24 x 18 in. / Mrs. Valentine Dudensing, New York (no. 6 in exh.)

L'Intérieure [current title: *The Studio*],* 1927–28, oil, 59 x 91 in. (no. 7 in exh.) [Z.VII.142; Museum of Modern Art, New York]

June 1–November 1, 1933: Art Institute of Chicago "A Century of Progress: Exhibition of Paintings and Sculpture lent from American Collections"

Blue Room / Phillips Memorial Gallery, Washington, D.C. (no. 399 in exh.; ill. in cat.) [Z.I.103; Phillips Collection, Washington, D.C.]

Figures (Pink) / The Harem, 1905 / Leonard C. Hanna, Jr., Cleveland (no. 400 in exh.) [Z.I.321; Cleveland Museum of Art]

Le Gourmet, 1901 / Josef Stransky, lent through the Worcester Art Museum, Worcester, Massachusetts (no. 401 in exh.) [Z.I.51; National Gallery of Art, Washington, D.C.]

The Old Guitarist / Art Institute of Chicago, Birch-Bartlett Collection (no. 402 in exh.) [Z.I.202; Art Institute of Chicago]

On the Upper Deck (The Omnibus), 1901 / Art Institute of Chicago, Mr. and Mrs. Coburn Collection (no. 403 in exh.) [Z.XXI.168; Art Institute of Chicago]

La Toilette, 1905 / Albright Art Gallery, Buffalo, New York (no. 404 in exh.) [Z.I.325; Albright-Knox Art Gallery]

Woman and Child at Fountain, 1903 / Mr. and Mrs. Potter Palmer, Chicago (no. 405 in exh.) [Z.I.80]

La Coiffure [current title: *Woman Combing Her Hair*], 1906 / Marie Harriman Gallery, New York (no. 406 in exh.) [Z.I.336; Museum of Modern Art, New York]

*Woman in White** / Museum of Modern Art (no. 407 in exh.) [Z.V.1; Metropolitan Museum of Art, New York]

Lady with a Fan, 1905 / Mr. and Mrs. W. Averell Harriman, New York (no. 408 in exh.) [Z.I.308; National Gallery of Art, Washington, D.C.]

Woman with Loaves, 1906 / Pennsylvania Museum of Art, Philadelphia (no. 409 in exh.) [Z.VI.735; Philadelphia Museum of Art]

June 2–July 15, 1933: Arts Club of Chicago "Modern Sculpture and Drawings by Sculptors"

Sepia Head / The Arts Club of Chicago (no. 103 in exh.) [Z.XXX.380; Arts Club of Chicago]

Head, [pencil] / Mrs. Robert M. Hutchins, Chicago (no. 104 in exh.)

July 10–September 30, 1933: Museum of Modern Art, New York "Summer Exhibition: Painting and Sculpture"

Absinthe Drinker [Z.I.62 / The lender was George Gershwin.]

Girl with Chignon, 1901, [29 1/2 x 20 in.] [Z.I.76; Fogg Art Museum, Harvard University, Cambridge, Massachusetts / The lenders were Dr. and Mrs. Harry Bakwin, New York.]

Woman Leaning on Table [Z.I.76; Fogg Art Museum, Harvard University, Cambridge, Massachusetts / The lenders were Dr. and Mrs. Harry Bakwin, New York.]

Blue Boy, 1905, gouache [Z.I.271 / The lender was Edward M. M. Warburg, New York.]

La Coiffure, 1905 / private collection [Z.I.313; Metropolitan Museum of Art, New York / The lender was Stephen C. Clark, New York.]

Portrait of Braque [Z.II¹.177; Staatliche Museen zu Berlin, Nationalgalerie, on permanent loan from the Berggruen Collection / The lender was Frank Crowninshield, New York.]

Cubist Composition [current title: *Head*, about 1912 / The lender was Marie Harriman Gallery, New York.]

Mother and Child [Z.IV.370 / The lenders were Mr. and Mrs. E. H. Harriman, New York.]

Guitare et compotier sur un guéridon, 1924, [oil on canvas, 51 3/4 x 31 1/2 in.]

Compote with Eggs, [ca. 1928 / The lender was Marie Harriman Gallery, New York.]

October 4–25, 1933: Museum of Modern Art, New York "Modern European Art" / organized by Stephen C. Clark [Clark, an astute collector with an inherited fortune from the Singer Sewing Machine Company, served as the first chairman of the Board of Trustees of the Museum of Modern Art between 1939 and 1946. With works selected from various private collections and the inventory of several New York dealers, this exhibition was in large part a continuation of the summer 1933 exhibition at the Museum of Modern Art (see the preceding entry).]

Woman Leaning on Table, 1901, [29 1/2 x 20 in.] / Dr. and Mrs. Harry Bakwin, New York [Z.I.76; Fogg Art Museum, Harvard University, Cambridge, Massachusetts]

Blue Boy, 1905 / Edward M. M. Warburg, New York [Z.I.271]

La Coiffure, 1905 / private collection [Z.I.313; Metropolitan Museum of Art, New York / The anonymous lender was Stephen C. Clark, New York.]

Cubist Composition [current title: *Head*], about 1912 / Marie Harriman Gallery, New York

Girl in Blue, 1921 / Valentine Gallery, New York

Abstraction, about 1926 / private collection [Z.V.268 / The anonymous lender was probably Stephen C. Clark, New York]

Fruit Dish and Eggs, about 1928 / Marie Harriman Gallery, New York

Figures on the Seashore, Dinard, 1928 / George L. K. Morris, New York [Z.VII.230]

November 2–18, 1933: Julien Levy Gallery, New York "Twenty Five Years of Russian Ballet from the Collection of Serge Lifar: Group Show"; traveled to the Arts Club of Chicago, November 28–December 23, 1933 [Note: Since a checklist for the New York exhibition could not be found, the titles and descriptions are from the Chicago checklist.]

"*Le Tricorne*," 1919 (no. 127 in exh.) [Described in the Chicago checklist as an "esquisse de décor" (sketch for the set décor).]

"*Le Pas de deux*" (no. 128 in exh.)

Danseur (no. 129 in exh.)

Tête de danseur (no. 130 in exh.)

Auto-Portrait (no. 131 in exh.)

November 4–December 6, 1933: Pennsylvania Museum of Art, Philadelphia "Loan Exhibition of Contemporary Painting and Sculpture from the Collections of Miss Anna Warren Ingersoll and Mr. and Mrs. R. Sturgis Ingersoll"

Dinard, 1928 (no. 33 in exh.)

Woman with Loaves, 1905 / Pennsylvania Museum of Art, gift of the late Charles E. Ingersoll (no. 34 in exh.) [Z.VI.735; Philadelphia Museum of Art]

November 10–25, 1933: Arts Club of Chicago "Exhibition of the George Gershwin Collection of Modern Paintings"

Absinthe Drinker (no. 33 in exh.; ill. on cover of cat.) [Z.I.62]

Man and Horse (no. 58 in exh.) [This work is a watercolor, lithograph, or drawing.]

November 16–December 8, 1933: Museum of Modern Art, New York "Gifts and Loans from the Collection of Mrs. Saidie A. May"

Head, about 1908, gouache [Z.II¹.148; Museum of Modern Art, New York]

November 25–December 31, 1933: Los Angeles County Museum "'Five Centuries of European Painting' A Collection of European Paintings: from the Early Renaissance to the Modernists"; loaned by Wildenstein & Co., New York and Paris

Harlequin, 1927, canvas, 21 1/8 x 18 1/8 in. / from Picasso's studio (no. 55 in exh.)

The Eggs, 1924, canvas, 15 x 18 in. / from Picasso's studio (no. 56 in exh.) [Z.V.266]

December 9, 1933–January 10, 1934: Pennsylvania Museum of Art, Philadelphia "The Collection of Mr. and Mrs. S. S. White III"

Still Life Abstraction (no. 34 in exh.) [Z.III.278]

Forms and Trees [current title: *Bathers in a Forest*]
(no. 92 in exh.) [Z.II¹.105; Philadelphia Museum
of Art]

"*Nudes*," ca. 1908, [watercolor and gouache] (no. 93
in exh.) [Philadelphia Museum of Art]

1934

January 12–February 2, 1934: Renaissance Society of
the University of Chicago
"Abstract Painting by Four Twentieth Century
Painters: Picasso–Gris–Braque–Léger"

Vieux Marc / Mrs. Charles H. Russell, New York
[Z.II¹.355]

Nature morte, 1914, [oil, 14 x 24 in.] / Sidney Janis,
New York

Papier collé [current title: *Still Life with a Calling
Card*, 1914] / Mrs. Charles B. Goodspeed,
Chicago [Z.II².490; private collection]

Girl with Yellow Hat / Valentine Gallery, New York
[Z.IV.258]

Still Life, 1923 / Sidney Janis, New York

Seated Woman, 1927 / Sidney Janis, New York
[Z.VII.60]

Glass and Fruit / Valentine Gallery, New York
[Z.V.68]

Abstraction / Valentine Gallery, New York

Dinard / Valentine Gallery, New York

Intérieur, watercolor / Mrs. Morris Hillquit

(No Title), watercolor / Mrs. Morris Hillquit

January 13–February 14, 1934: Pennsylvania Museum
of Art, Philadelphia
"Loan Exhibition of Contemporary Paintings from the
Collection of Mr. and Mrs. Maurice J. Speiser"

Clown, [watercolor and gouache on paper mounted
on board, 30 x 22 1/4 in.] (no. 32 in exh.)
[Z.III.44]

Tree Forms (no. 51 in exh.) [Z.II¹.55]

February 6–March 1, 1934: Wadsworth Atheneum,
Hartford, Connecticut
"Pablo Picasso"

La Mère et l'enfant, 1895, canvas, 17 3/8 x 8 3/8 in. /
Josef Stransky, New York (no. 1 in exh.) [Z.I.12]

Les Roses, 1898, canvas, 16 3/4 x 14 1/4 in. / Baron
Napoléon Gourgaud, Paris (no. 2 in exh.; ill. in
cat.) [Z.I.9]

Jeune Femme, 1901, canvas, 17 1/2 x 14 3/4 in. /
Quincy A. Shaw McKean, Boston (no. 3 in
exh.) [Z.VI.385]

Courtisane au chapeau, 1901, canvas, 26 x 20 in. /
Adolph Lewisohn, New York (no. 4 in exh.;
ill. in cat.) [Z.I.65]

Au Moulin Rouge, 1901, canvas, 27 1/2 x 21 in. /
M. Knoedler & Co., New York (no. 5 in exh.; ill.
in cat.) [Z.I.69]

Fille au chignon, 1901, canvas, 20 3/4 x 19 1/2 in. / Dr.
and Mrs. Harry Bakwin, New York (no. 6 in exh.;
ill. in cat.) [Z.I.96; Fogg Art Museum, Harvard
University, Cambridge, Massachusetts]

Fillette au chapeau, 1901 (verso of no. 6) / Dr. and
Mrs. Harry Bakwin, New York (no. 7 in exh.)
[Z.I.76]

Femme accroupie et enfant, 1901, canvas, 43 3/4 x
38 1/4 in. / Baron Fukushima, Paris (no. 8 in
exh.) [Z.I.115; Fogg Art Museum, Harvard
University, Cambridge, Massachusetts]

Rue à Barcelone, 1903, canvas, 15 1/8 x 24 1/8 in. /
Josef Stransky, New York (no. 9 in exh.) [Z.I.122]

Les Misérables, 1903, canvas, 24 x 20 in. / Jere
Abbott, Northampton, Massachusetts (no. 10 in
exh.) [Z.I.197; Smith College Museum,
Northampton, Massachusetts]

Vieux Guitariste, 1903, canvas, 47 3/4 x 32 1/2 in. /
The Art Institute, Chicago (no. 11 in exh.;
ill. in cat.) [Z.I.202; Art Institute of Chicago]

Vieille Femme, 1903, gouache, 12 3/4 x 9 1/2 in. /
A. Conger Goodyear, New York (no. 12 in exh.)

Chevaux au bain, 1905, gouache, 14 3/4 x 22 3/4 in. /
anonymous loan through Worcester Art Museum,
Worcester, Massachusetts (no. 13 in exh.) [Z.I.265;
Metropolitan Museum of Art, New York / The
source of the anonymous loan was Scofield
Thayer's Dial Collection. Thayer, editor and

owner of *The Dial* magazine, was also a collector
of modern art, some of which appeared as illus-
trations in his magazine. Thayer's collection was
on deposit at the Worcester Art Museum from
1926 until it went by his bequest to the
Metropolitan Museum of Art in 1984.]

Garçon bleu, 1905, gouache, 39 1/4 x 22 1/2 in. /
Edward M. M. Warburg, New York (no. 14 in exh.;
ill. in cat.) [Z.I.271]

La Famille d'Arlequin, 1905, canvas, 22 3/4 x 17 1/4 in.
/ Mr. and Mrs. Sam A. Lewisohn, New York (no.
15 in exh.; ill. in cat.) [Z.I.298; private collection]

La Coiffure, 1905, canvas, 31 3/4 x 25 1/2 in. / Paul
Rosenberg, Paris (no. 16 in exh.) [Z.I.309]

La Femme à l'éventail, 1905, canvas, 39 x 31 1/2 in. /
Mr. and Mrs. W. Averell Harriman, New York
(no. 17 in exh.; ill. in cat.) [Z.I.308; National
Gallery of Art, Washington, D.C.]

La Toilette, 1905 [actual date: 1906], canvas, 59 1/2 x
39 1/2 in. / Albright Art Gallery, Buffalo, New York
(no. 18 in exh.; ill. in cat.) [Z.I.325; Albright-
Knox Art Gallery]

Woman Combing Her Hair, 1905 [actual date:
1906], canvas, 49 x 35 in. / Marie Harriman
Gallery, New York (no. 19 in exh.; ill. in cat.)
[Z.I.336; Museum of Modern Art, New York]

Self-Portrait [current title: *Self-Portrait with
Palette*], 1906, canvas, 36 x 28 in. / Albert
Eugene Gallatin, New York (no. 20 in exh.; ill.
in cat.) [Z.I.375; Philadelphia Museum of Art]

Femme assise, 1909, canvas, 39 1/4 x 27 3/4 in. /
Paul Rosenberg, Paris (no. 21 in exh.; ill. in
cat.) [Z.II¹.200]

La Tube de peinture [current title: *Still Life with
Liqueur Bottle*], 1909, canvas, 31 1/2 x 25 1/4
in. / Wildenstein & Co., New York (no. 22
in exh.) [Z.II¹.173; Museum of Modern Art,
New York]

Composition, 1911, canvas, 39 1/2 x 20 3/4 in. / Marie
Harriman Gallery, New York (no. 23 in exh.)

Nature morte à la guitare [current title: *Glass, Guitar
and Bottle*], 1913, canvas, 25 1/2 x 21 in. / Marie
Harriman Gallery, New York (no. 24 in exh.; ill. in
cat.) [Z.II².419; Museum of Modern Art, New York]

Dans le jardin, 1914, canvas / Mme. Eugenia
Errazuriz, Paris (no. 25 in exh.)

Nature morte, 1914, canvas, 14 x 24 in. / Mr. and Mrs.
Sidney Janowitz [Sidney Janis], New York (no.
26 in exh.)

Vive-là, 1914, canvas, 20 x 25 in. / Mr. and Mrs.
Sidney Janowitz [Sidney Janis], New York (no.
27 in exh.; ill. in cat.) [Z.II².523; private collection]

Verre et pipe, 1914, canvas, 8 1/2 x 9 in. / George L.
K. Morris, New York (no. 28 in exh.) [Z.II².454]

La Cheminée, 1915, canvas, 51 1/4 x 38 in. /
Wildenstein & Co., New York (no. 29 in exh.)

Homme à la pipe [current title: *Untitled (Man with a
Moustache, Buttoned Vest, and Pipe, Seated in an
Armchair), (Man with a Pipe)*],* 1916 [actual date:
1915], canvas, 51 3/4 x 24 1/2 in. / Mme. Eugenia
Errazuriz, Paris (no. 30 in exh.) [Z.II².564; Art
Institute of Chicago]

L'Italienne, 1917, canvas, 59 x 39 7/8 in. / Wildenstein
& Co., New York (no. 31 in exh.; ill. in cat.)
[Z.III.18]

Paysage [current title: *Landscape with Dead and Live
Trees*],* 1919, canvas, 19 1/4 x 25 1/4 in. /Baron
Fukushima, Paris (no. 32 in exh.; ill. in cat.)
[Z.III.364; Bridgestone Museum, Tokyo]

Les Paysans, 1919, gouache, 12 1/4 x 18 7/8 in. /
Baron Fukushima, Paris (no. 33 in exh.; ill.
in cat.) [Z.III.371; Museum of Modern Art,
New York]

La Fenêtre ouverte, 1919, canvas, 82 1/2 x 46 1/2 in. /
Paul Rosenberg, Paris (no. 34 in exh.)

Nature morte devant la fenêtre, 1919, gouache,
8 1/4 x 8 1/4 in. / Paul Rosenberg, Paris
(no. 35 in exh.)

La Table, 1920, canvas, 50 x 29 1/2 in. / Smith
College Museum of Art, Northampton,
Massachusetts (no. 36 in exh.; ill. in cat.)
[Z.III.437; Smith College Museum of Art]

Guitare Cheminée, 1920, canvas, 25 1/2 x 36 1/4 in. /
Paul Rosenberg, Paris (no. 37 in exh.)

The Rape, 1920, gouache, 9 x 12 1/2 in. / Philip
Goodwin, New York (no. 38 in exh.; ill. in cat.)

[Z.IV.109; Museum of Modern Art, New York]

Légende de la source, 1921, canvas, 26 x 36 in. /
Pierre Matisse, New York (no. 39 in exh.; ill.
in cat.) [Z.IV.304]

Les Trois Masques [current title: *The Three Musicians*],
1921, canvas, 80 3/4 x 88 1/2 in. / Paul Rosenberg,
Paris (no. 40 in exh.; ill. in cat.) [Z.IV.331;
Museum of Modern Art, New York]

Femme nue, 1922, panel, 7 1/2 x 5 1/2 in. / Wadsworth
Atheneum, Hartford, Connecticut (no. 41 in exh.;
ill. in cat.) [Z.IV.382; Wadsworth Atheneum]

Mère et enfant, 1923, canvas, 6 x 8 in. / Mr. and Mrs.
James Thrall Soby, Hartford, Connecticut (no. 42
in exh.)

Maternité, 1923, canvas, 6 x 4 in. / Pablo Picasso
(no. 43 in exh.; ill. in cat.)

Jeux familiaux, 1923, canvas, 6 3/4 x 7 3/4 in. /
Pablo Picasso (no. 44 in exh.; ill. in cat.)

Femme et enfant, 1923, canvas, 51 1/2 x 38 1/4 in. /
Pierre Matisse, New York (no. 45 in exh.)
[Z.IV.455]

Course de taureaux, 1923, canvas, 8 3/4 x 10 1/2 in. /
Baron Napoléon Gourgaud, Paris (no. 46 in exh.;
ill. in cat.) [Z.V.149]

Le Soupir, 1923, canvas, 23 1/2 x 19 in. / Mr. and
Mrs. James Thrall Soby, Hartford (no. 47 in
exh.) [Z.V.12; Museum of Modern Art, New York]

Personnages sur la plage, 1923, panel, 31 7/8 x
39 3/4 in. / Wildenstein & Co., New York (no. 48
in exh.)

Composition, 1923, canvas, 24 x 18 in. / Valentine
Gallery, New York (no. 49 in exh.)

Femmes grecques, 1923–24, gouache and oil, 12 x 9 in.
/ John Becker Gallery, New York (no. 50 in exh.)

Le Biscuit, 1923, canvas, 31 3/4 x 39 1/2 in. / Paul
Rosenberg, Paris (no. 51 in exh.) [Z.V.242;
Cleveland Museum of Art]

La Tranche de melon, 1924, canvas, 38 1/4 x 51 1/4 in.
/ Paul Rosenberg, Paris (no. 52 in exh.)

Les Deux Oeufs, 1924, canvas, 15 x 18 in. /
Wildenstein & Co., New York (no. 53 in exh.)
[Z.V.266]

La Guitare aux étoiles, 1924, canvas, 38 1/4 x 51 1/4 in.
/ Paul Rosenberg, Paris (no. 54 in exh.; ill. in
cat.) [Z.V.225]

La Bouteille de vin, 1925, canvas, 38 1/4 x 51 1/4 in. /
Paul Rosenberg, Paris (no. 55 in exh.; ill. in cat.)
[Z.VI.1444]

Nature morte au filet de pêche, 1925, canvas, 39 1/2 x
31 3/4 in. / Paul Rosenberg, Paris (no. 56 in exh.;
ill. in cat.) [Z.V.459]

La Cage, 1925, canvas, 32 x 39 1/2 in. / Paul
Rosenberg, Paris (no. 57 in exh.)

Le Bras de plâtre, 1925, canvas, 38 1/4 x 51 1/4 in. /
Paul Rosenberg, Paris (no. 58 in exh.) [Z.V.444;
Metropolitan Museum of Art, New York]

Femme à la table, 1925, canvas, 51 1/4 x 38 1/4 in. /
Paul Rosenberg, Paris (no. 59 in exh.; ill. in cat.)
[Z.V.30]

La Statuaire, 1925, canvas, 51 1/2 x 38 1/2 in. /
Stephen C. Clark, New York (no. 60 in exh.;
ill. in cat.) [Z.V.451; private collection]

Seated Woman, 1927, panel, 52 x 39 in. / Mr. and Mrs.
James Thrall Soby, Hartford (no. 61 in exh.; ill. in
cat.) [Z.VII.77; Museum of Modern Art, New York]

Seated Figure, 1927, canvas, 8 1/2 x 5 in. / Mr. and
Mrs. Sidney Janowitz [Sidney Janis], New York
(no. 62 in exh.) [Z.VII.60]

L'Atelier [current title: *Painter and Model*], 1928,
canvas, 51 1/4 x 63 3/4 in. / Mr. and Mrs. Sidney
Janowitz [Sidney Janis], New York (no. 63 in
exh.) [Z.VII.143; Museum of Modern Art, New
York]

La Palette du peintre, 1927–29, canvas, 39 x 51 1/2 in.
/ Marie Harriman Gallery, New York (no. 64 in
exh.) [Z.VII.75]

Fauteuil rouge, 1928, canvas, 36 1/4 x 28 3/4 in. /
Paul Rosenberg, Paris (no. 65 in exh.)

Baigneuse, 1929, canvas, 16 1/4 x 10 1/2 in. /
Paul Rosenberg, Paris (no. 66 in exh.)

Bathers at Dinard, 1929, canvas, 7 1/2 x 12 3/4 in. /
George L. K. Morris, New York (no. 67 in exh.;
ill. in cat.) [Z.VII.230]

Composition, 1929, canvas, 28 3/4 x 23 1/2 in. /
Paul Rosenberg, Paris (no. 68 in exh.)
[Z.VII.273; Baltimore Museum of Art]

Grande nature morte, 1931, canvas, 51 1/4 x 76 1/4 in. / Paul Rosenberg, Paris (no. 69 in exh.; ill. in cat.) [Z.VII.326; St. Louis Art Museum, Missouri]

Femme devant une glace, 1932, canvas / Pablo Picasso (no. 70 in exh.) [Z.VII.379; Museum of Modern Art, New York]

Femme dans un fauteuil [current title: *The Dream*], 1932, canvas / Pablo Picasso (no. 71 in exh.) [Z.VII.364; Wynn Collection, Las Vegas]

Nature morte, 1932, canvas / Pablo Picasso (no. 72 in exh.) [Z.VII.376]

[Works listed as nos. 73–77 appear under the heading "Addenda."]

The Supper Party, 1902, panel, 23 x 31 in. / Chester Johnson Gallery, Chicago (no. 73 in exh.) [This piece erroneously appears twice in the catalogue (number 8A as well as 73).]

Portrait, 1907, canvas, 36 3/4 x 17 in. / James Johnson Sweeney, New York (no. 74 in exh.)

Baigneuse, 1921, canvas / Pablo Picasso (no. 75 in exh.)

La Toilette, 1922, canvas / Pablo Picasso (no. 76 in exh.)

Femme à la guitare, 1924, canvas / Paul Rosenberg, Paris (no. 77 in exh.)

[Works listed as nos. 78–137 appear under the heading "Drawings, Watercolors, Gouaches and Prints."]

Nude and Seated Man, pen and wash drawing / Frank C. Smith, Worcester, Massachusetts (no. 78 in exh.)

Double Portrait, pen drawing / A. Conger Goodyear, New York (no. 79 in exh.)

Le Mendiant, pastel / Josef Stransky, through the Worcester Art Museum, Worcester, Massachusetts (no. 80 in exh.) [Z.I.222; Art Institute of Chicago]

Mother and Child, 1904, pencil drawing / Paul J. Sachs, through the Fogg Art Museum, Cambridge, Massachusetts (no. 82 in exh.) [Z.I.220; Fogg Art Museum, Harvard University]

Femme et enfant, ca. 1906, crayon drawing / Pierre Matisse, New York (no. 87 in exh.)

Nude, pen drawing / Julien Levy Gallery, New York (no. 88 in exh.)

Nude Figure of Man, pencil drawing / The Art Institute, Chicago (no. 89 in exh.)

La Toilette, watercolor / Mrs. Cornelius Sullivan, New York (no. 90 in exh.) [Z.XXII.433]

Nue, ca. 1906, watercolor / Cleveland Museum of Art (no. 91 in exh.) [Z.I.317; Cleveland Museum of Art]

Paysannes d'Andorre, pen and pencil drawing / The Art Institute, Chicago (no. 92 in exh.) [Z.IV.780; Art Institute of Chicago]

Two Women, pen and brush drawing / anonymous loan, through Worcester Art Museum, Worcester, Massachusetts (no. 93 in exh.) [Z.I.339; Metropolitan Museum of Art, New York / The source of the anonymous loan was Scofield Thayer's Dial Collection, on deposit at the Worcester Art Museum from 1926 until it went by his bequest to the Metropolitan Museum of Art in 1984.]

Head of Woman, pencil drawing / Mrs. Cornelius Sullivan, New York (no. 94 in exh.)

Figures and Trees [current title: *Bathers in a Forest*], gouache / Samuel S. White, III, Ardmore, Pennsylvania (no. 95 in exh.) [Z.II¹.105; Philadelphia Museum of Art]

Reclining Nude, gouache / Samuel S. White, III, Ardmore, Pennsylvania (no. 96 in exh.)

Male Figure, [1906], charcoal drawing / anonymous loan, through the Worcester Art Museum, Worcester, Massachusetts (no. 97 in exh.) [Metropolitan Museum of Art, New York / The source of the anonymous loan was Scofield Thayer's Dial Collection, on deposit at the Worcester Art Museum from 1926 until it went by his bequest to the Metropolitan Museum of Art in 1984.]

Le Repas, ca. 1908–9, watercolor / John Becker Gallery, New York (no. 98 in exh.)

Head, gouache / Museum of Modern Art, New York (no. 99 in exh.) [Z.II¹.148; Museum of Modern Art]

Papier collé [current title: *Head*], ca. 1911–13 / Julien Levy Gallery, New York (no. 100 in exh.) [Z.II².403; Museum of Modern Art, New York]

Bathers, pencil drawing / Paul J. Sachs, through the Fogg Art Museum, Cambridge, Massachusetts (no. 101 in exh.) [Z.III.233; Fogg Art Museum]

Femme au miroir, 1918, pencil drawing / John Becker Gallery, New York (no. 102 in exh.) [Z.III.200]

Woman with Cupid, 1918, pencil drawing / John Becker Gallery, New York (no. 103 in exh.) [Z.III.199]

Ex Cathedra No. 1, ca. 1918, watercolor / John Becker Gallery, New York (no. 104 in exh.)

Ex Cathedra No. 2, 1918, watercolor / John Becker Gallery, New York (no. 105 in exh.)

Sketches from a Window, 1919, pen drawing / John Becker Gallery, New York (no. 106 in exh.)

Abstraction, gouache / Bernard Davis, Philadelphia (no. 107 in exh.)

Nu, pen drawing / T. Catesby Jones, New York (no. 108 in exh.)

Le Joueur de flûte, pen drawing / John Nicholas Brown, Providence (no. 109 in exh.)

Figure on Beach, pen drawing / Mrs. Lillian H. Haass, Grosse Point, Michigan (no. 110 in exh.)

Three Nudes, 1920, pencil drawing / anonymous loan, through the Worcester Art Museum, Worcester, Massachusetts (no. 111 in exh.) [Z.IV.105; Metropolitan Museum of Art, New York / The source of the anonymous loan was Scofield Thayer's Dial Collection, on deposit at the Worcester Art Museum from 1926 until it went by his bequest to the Metropolitan Museum of Art in 1984.]

Two Nudes, September 4, 1920, pencil drawing / anonymous loan, through the Worcester Art Museum, Worcester, Massachusetts (no. 112 in exh.) [Z.IV.181; Metropolitan Museum of Art, New York / The source of the anonymous loan was Scofield Thayer's Dial Collection, on deposit at the Worcester Art Museum from 1926 until it went by his bequest to the Metropolitan Museum of Art in 1984.]

Three Female Nudes, 1920, pencil drawing / anonymous loan, through the Worcester Art Museum, Worcester, Massachusetts (no. 113 in exh.) [Z.IV.320; Metropolitan Museum of Art, New York / The source of the anonymous loan was Scofield Thayer's Dial Collection, on deposit at the Worcester Art Museum from 1926 until it went by his bequest to the Metropolitan Museum of Art in 1984.]

Le Guéridon, 1920, watercolor / A. Conger Goodyear, New York (no. 114 in exh.)

Reclining Nude, June 23, 1920, pencil drawing / John Becker Gallery, New York (no. 115 in exh.)

Sur la plage, April 17, 1921, pastel / anonymous loan (no. 116 in exh.)

Leaves, 1921, pencil drawing / John Becker Gallery, New York (no. 117 in exh.) [Z.IV.292; private collection]

Heroic Head of a Woman, 1922, crayon drawing / anonymous loan, through the Worcester Art Museum, Worcester, Massachusetts (no. 118 in exh.) [Z.IV.306; Metropolitan Museum of Art, New York / The source of the anonymous loan was Scofield Thayer's Dial Collection, on deposit at the Worcester Art Museum from 1926 until it went by his bequest to the Metropolitan Museum of Art in 1984.]

Philosopher, pencil drawing / Paul J. Sachs, through the Fogg Art Museum, Cambridge, Massachusetts (no. 119 in exh.) [Z.III.256; Fogg Art Museum, Harvard University]

Clown, pencil drawing / Paul J. Sachs through the Fogg Art Museum, Cambridge, Massachusetts (no. 120 in exh.) [Z.III.126; Fogg Art Museum, Harvard University]

Standing Nude, pen drawing / John Nicholas Brown, Providence (no. 121 in exh.)

Quatre Femmes nues, pen drawing / Wildenstein & Co., New York (no. 122 in exh.)

Danseuses, pen drawing / Wildenstein & Co., New York (no. 123 in exh.)

Le Peintre et son modèle, pen drawing / Wildenstein & Co., New York (no. 124 in exh.)

Ballet Figure No. 1, 1923, pencil drawing / John Becker Gallery, New York (no. 125 in exh.)

Ballet Figures No. 2, 1923, pencil drawing / John Becker Gallery, New York (no. 126 in exh.)

Ballet Figures No. 3, 1923, pencil drawing / John Becker Gallery, New York (no. 127 in exh.)

Mother and Child, pencil drawing / Mr. and Mrs. Lewis B. Williams, Cleveland (no. 128 in exh.)

Nude, pencil drawing / Frank Crowninshield, New York (no. 129 in exh.) [Z.IV.377; Metropolitan Museum of Art, New York]

Mother and Child, pencil drawing / Mrs. John D. Rockefeller, Jr., New York (no. 130 in exh.)

Variations, ca. 1924, watercolor / John Becker Gallery, New York (no. 131 in exh.)

Sisley Family, 1924, pencil drawing / John Becker Gallery, New York (no. 132 in exh.)

Nude Figures, 1925, pen drawing / Mrs. John D. Rockefeller, Jr., New York (no. 133 in exh.)

Deux Danseuses, 1925, pen drawing / Wadsworth Atheneum, Hartford, Connecticut (no. 134 in exh.)

Quatre Personnages, 1926, pen drawing / Wadsworth Atheneum, Hartford, Connecticut (no. 135 in exh.)

Abstraction, pastel / T. Catesby Jones, New York (no. 136 in exh.)

Les Saltimbanques, 1926, pen drawing / M. Knoedler & Co., New York (no. 137 in exh.)

February 17–March 13, 1934: Pennsylvania Museum of Art, Philadelphia
"The Earl Horter Collection"; traveled to the Arts Club of Chicago, April 3–26, 1934, as "Modern Paintings from the Collection of Mr. Earl Horter of Philadelphia" [Horter–an artist and avid collector of modern, Native American, and African art–at one time owned one of the largest collections of Picasso's Cubist works in the United States. The works in the exhibition were organized by number in Chicago, but not in Philadelphia.]

[*Nude*, 1909 (no. 49 in Chicago, with an added descriptive within parentheses: "Negro period"). Z.II¹.176; private collection]

[*Woman with a Book*, 1909 (no. 45 in Chicago, with a different title: *Abstract Figure*). Z.II¹.150; private collection]

[*Study of Fruit*, ca. 1909, watercolor on paper, 9 5/8 x 12 3/8 in. (no. 50 in Chicago, with a slightly different title: *Fruit*)]

[*Head of a Woman*, 1909–10, watercolor and gouache on paper (no. 47 in Chicago, with no title but with the descriptive: "Water color–Negro period"). Z.XXVI.400; Art Institute of Chicago]

[*Nude Figure*, 1909–10 (no. 44 in Chicago, with a different title: *Abstraction*). Z.II¹.194; Albright-Knox Art Gallery, Buffalo, New York]

[*Portrait of a Woman*, 1910 (no. 41 in Chicago, with a different title: *Abstraction*). Z.II¹.234; Museum of Fine Arts, Boston]

[*Portrait of Daniel-Henry Kahnweiler*, 1910 (no. 53 in Chicago, with an added descriptive: "Cubist"). Z.II¹.227; Art Institute of Chicago]

[*The Rower*, 1910. Z.II¹.231; Museum of Fine Arts, Houston / It is uncertain whether this work was included in Chicago as it does not appear on the printed checklist.]

[*Girl from Arles (L'Arlésienne)*, 1912, gouache and ink on paper mounted on canvas (no. 42 in Chicago, with a slightly different title: *Arlesienne*). Z.II¹.337; Menil Collection, Houston]

[*Still Life with Bottle, Cup and Newspaper*, 1912 (no. 54 in Chicago, with a different title: *Still Life*). Z.II².397; Museum Folkwang, Essen, Germany]

[*The Violin*, 1912, drawing [chalk on paper] (no. 43 in Chicago, with a slightly different title: *Violin*). Z.XXVIII.103; private collection]

[*Bottle of Bass, Glass and Pipe*, 1914 (no. 51 in Chicago, with a different title: *Still Life*). Z.II².513]

[*Dice, Wineglass, Bottle of Bass, Ace of Clubs and Visiting Card*, 1914 (no. 52 in Chicago, with a different title: *Still Life–Dice and Glass*). Z.II².789; private collection]

[*Guitar*, 1914, drawing (no. 38 in Chicago)]

[*Heure*, 1914, oil and sand on board, 5 7/8 x 6 3/4 in. (no. 40 in Chicago, with a different title: *Still Life-Table Top*). Private collection]

[*Still Life with Bottle of Port (Oporto)* [current title: *Bottle of Port and Glass (Still Life [Oporto])*],* 1919 (no. 46 in Chicago, with a different title: *Still Life–Bottle and Glass*). Z.III.290; Dallas Museum of Art]
[*Two Women*, 1920 (no. 48 in Chicago, with a different title: *Two Figures*). Z.IV.55]

March 13–31, 1934: Durand-Ruel Galleries, New York
"Paintings by Braque, Matisse, Picasso: from the Collection of Paul Rosenberg" [No catalogue or checklist was published by the gallery for this exhibition. However, *Art News* ran a two-page review and printed a complete checklist; in addition, four of the works by Picasso were illustrated in the magazine.]
"Complete Catalogue of the Paintings by Georges Braque–Henri Matisse–Pablo Picasso from the Paul Rosenberg Collection," *Art News* 32, no. 24 (March 17, 1934), p. 5
Woman in Niche, 1933, watercolor (no. 1 in exh.)
Sculpture and Boat, 1933, watercolor (no. 2 in exh.)
Nude Woman at the Seaside, 1933, watercolor (no. 3 in exh.)
Woman Lying on Seashore, 1933, watercolor (no. 4 in exh.)
Sculpture and Nude Woman, 1933, watercolor (no. 5 in exh.)
Woman of Avignon [current title: *Young Girl*], 1914 (no. 7 in exh.; ill. p. 4) [Z.II².528; Musée National d'Art Moderne, Centre National d'Art et de Culture Georges Pompidou, Paris]
The Letter, 1923 (no. 10 in exh.) [Z.V.30]
The Coiffure, 1905 (no. 12 in exh.; ill. p. 6) [Z.I.309]
Slice of Melon, 1924 [canvas, 38 1/4 x 51 1/4 in.] (no. 15 in exh.)
Woman with Mandolin, 1925 (no. 17 in exh.; ill. p. 9 with a slightly different title: *Woman with a Mandolin*) [Z.V.442; Norton Simon Museum, Pasadena, California]
Bottle of Wine, 1926 (no. 19 in exh.) [Z.VI.1444]
Ram's Head, 1925, [oil, 32 1/8 x 39 1/2 in.] (no. 20 in exh.)
Three Masks, Fontainebleau [current title: *Three Musicians*], 1921 (no. 21 in exh; ill. p. 3 with a slightly different title: *The Three Masques*) [Z.IV.331; Museum of Modern Art, New York]
The Biscuits, 1924 (no. 22 in exh.) [Z.V.242; Cleveland Museum of Art]
Woman Sleeping, 1932 (no. 34 in exh.)
Purple Harlequin, 1923 (no. 35 in exh.)
Mother and Child, 1902, pastel (no. 36 in exh.)
Sculpture, 1933, watercolor (no. 37 in exh.)
Maternity, 1901 (no. 38 in exh.)

May–September 1934: Museum of Modern Art, New York
"The Lillie P. Bliss Collection"
Green Still Life [also known as: *Fruit Bowl, Wineglass, Bowl of Fruit*], 1914, oil on canvas, 23 1/2 x 31 1/4 in. (no. 47 in exh.; ill. in cat.) [Z.II².485; Museum of Modern Art, New York]
Woman in White,* 1923, oil on canvas, 39 3/4 x 32 in. (no. 48 in exh.) [Z.V.1; Metropolitan Museum of Art, New York]

June 1–November 1, 1934: Art Institute of Chicago
"A Century of Progress"
The Old Guitarist, 1903 / Art Institute of Chicago, Birch-Bartlett Collection (no. 358 in exh.) [Z.I.202; Art Institute of Chicago]
On the Upper Deck (The Omnibus), 1901 / Art Institute of Chicago, Coburn Collection (no. 359 in exh.) [Z.XXI.168; Art Institute of Chicago]
Woman and Child at Fountain / Potter Palmer, Chicago (no. 360 in exh.) [Z.I.80; Art Institute of Chicago]

June 8–July 8, 1934: California Palace of the Legion of Honor, San Francisco
"Exhibition of French Painting from the Fifteenth Century to the Present Day"
Old Woman, oil on canvas, 26 1/2 x 20 3/4 in. / Mr. and Mrs. Walter C. Arensberg, Hollywood (no. 217 in exh.; ill. in cat.) [Z.VI.389; Philadelphia Museum of Art]
Glass and Apples, oil on canvas, 9 x 11 in. / Valentine Gallery, New York (no. 218 in [Z.V.68]

Man with Mandolin [current title: *Man with Violin*], oil on canvas, 39 1/2 x 28 3/4 in. / Mr. and Mrs. Walter C. Arensberg, Hollywood (no. 219 in exh.) [Z.II².289; Philadelphia Museum of Art]
Head of a Woman, gouache, 23 x 17 in. / Miss Harriet Levy, San Francisco (no. 220 in exh.) [San Francisco Museum of Modern Art]
The Guitar, oil on canvas, 32 x 39 in. / Valentine Gallery, New York (no. 221 in exh.)
The Blind Man, 1903, gouache on canvas, 21 1/4 x 14 in. / Toledo Museum of Art (no. 222 in exh.) [Z.I.172; Fogg Art Museum, Harvard University, Cambridge, Massachusetts]
Woman in Pink [study for "Harem"], gouache on paper, 25 x 19 in. / Toledo Museum of Art (no. 223 in exh.) [Z.I.333]
Classical Figure (La Grecque), oil on canvas, 72 7/8 x 29 1/2 in. / M. Knoedler & Co., New York (no. 224 in exh.; ill. in cat.) [Z.V.249]
Abstraction, oil on canvas, 21 1/4 x 25 1/2 in. / Mr. Sidney Janowitz [Sidney Janis], New York (no. 225 in exh.) [Z.II².523; private collection]
Abstraction, oil on canvas, 51 1/4 x 63 3/4 in. / Mr. Sidney Janowitz [Sidney Janis], New York (no. 226 in exh.) [Z.VII.143; Museum of Modern Art, New York]
Woman Combing Her Hair, 1907 [actual date: 1906], oil on canvas, 49 x 35 in. / Marie Harriman Gallery, New York (no. 227 in exh.) [Z.I.336; Museum of Modern Art, New York]

June 20–August 20, 1934: Renaissance Society of the University of Chicago
"A Selection of Works by Twentieth Century Artists" / organized by James Johnson Sweeney [James Johnson Sweeney was curator of the Museum of Modern Art from 1935 to 1946.]
Still Life, 1927–29, oil on canvas, 51 x 38 in. / Mr. and Mrs. W. Averell Harriman, New York (no. 24 in exh.; ill. in cat.) [Z.VII.75]
Still Life [current title: *The Studio*],* 1927–28, oil on canvas, 90 1/2 x 59 in. / Valentine Gallery, New York (no. 25 in exh.; ill. in cat.) [Z.VII.142; Museum of Modern Art, New York]
"*Metamorphose*," May 13, 1929, oil on canvas, 36 3/8 x 28 7/8 in. / Paul Rosenberg, Paris (no. 26 in exh.; ill. in cat.) [Z.VII.275]
Composition, February 1, 1930, oil on canvas, 26 x 19 1/2 in. / Valentine Gallery, New York (no. 27 in exh.)

October 22–November 2, 1934: Julien Levy Gallery, New York
["Eight Modes of Painting: Survey of 20th-Century Art Movements" / This exhibition included at least one work by Picasso, although no specific titles of works have been identified.]

November 20, 1934–January 20, 1935: Museum of Modern Art, New York
"Modern Works of Art: 5th Anniversary Exhibition"
Blue Boy, 1905, gouache, 38 1/2 x 21 in. / Edward M. M. Warburg, New York (no. 123 in exh.; ill. in cat.) [Z.I.271]
Portrait of Braque, ca. 1908, oil on canvas, 23 1/4 x 19 1/4 in. / Frank Crowninshield, New York (no. 124 in exh.; ill. in cat.) [Z.II¹.177; Staatliche Museen zu Berlin, Nationalgalerie, on permanent loan from the Berggruen Collection]
Green Still Life [also known as: *Fruit Bowl, Wineglass, Bowl of Fruit*], 1914, oil on canvas, 23 1/2 x 31 1/4 in. / Museum of Modern Art, New York (no. 125 in exh.; ill. in cat.) [Z.II².485; Museum of Modern Art]
Study for Ballet Costume, gouache, 6 x 4 in. / Mrs. James B. Murphy (no. 126 in exh.)
The Rape, 1920, gouache on cardboard, 9 x 12 1/2 in. / Philip L. Goodwin, New York (no. 127 in exh.; ill. in cat.) [Z.IV.109; Museum of Modern Art, New York]
Three Musicians,* summer 1921, oil on canvas, 80 3/4 x 88 1/2 in. [actual dimensions: 80 1/2 x 74 1/8 in.] (no. 128 in exh.; ill. in cat.) [Z.IV.332; Philadelphia Museum of Art]
Woman in White,* 1923, oil on canvas, 39 3/4 x 32 in. / Museum of Modern Art, New York (no.

129 in exh.; ill. in cat.) [Z.V.1; Metropolitan Museum of Art, New York]
Figures on the Sea-Shore, 1928, oil on canvas, 7 1/2 x 12 3/4 in. / George L. K. Morris, New York (no. 130 in exh.; ill. in cat.) [Z.VII.230]
Pitcher and Fruit Dish, 1931, oil on canvas, 51 3/8 x 64 1/8 in. / Paul Rosenberg, Paris (no. 131 in exh.) [Z.VII.322; Solomon R. Guggenheim Museum, New York]
Balcony, 1933, gouache, 16 x 19 7/8 in. / Pablo Picasso (no. 132 in exh.; ill. in cat.)

December 4–31, 1934: Arts Club of Chicago
"Léonide Massine Collection of Modern Paintings"; traveled to Marie Harriman Gallery, New York, February 18–March 9, 1935, as "French Paintings: Collection of Léonide Massine"
Still Life, 1916 (no. 53 in Chicago; no. 20 in New York)
Watercolor, 1916 (no. 54 in Chicago; no. 21 in New York)
Newspaper, 1916 (no. 55 in Chicago; no. 22 in New York)
Harlequin, 1917 (no. 56 in Chicago; no. 23 in New York)
Portrait of Léonide Massine, 1917 (no. 57 in Chicago) [This work was not included in the New York show and may have been sold in Chicago.]
Pompeian Painting, 1916 (no. 58 in Chicago; no. 24 in New York)
Interior, 1915, watercolor (no. 59 in Chicago; no. 25 in New York)
The Door, 1918, watercolor [6 x 4 3/4 in.] (no. 60 in Chicago; no. 26 in New York)
Harlequin, 1918, drawing [medium not specified] (no. 61 in Chicago) [This work was sold in Chicago and therefore was not included in the New York show.]
Portraits, 1918, drawing [medium not specified] (no. 62 in Chicago; no. 27 in New York) [Z.XXIX.235]
Drawing [medium not specified] on blotting paper, 1917 (no. 63 in Chicago; no. 28 in New York)
Portrait of Léonide Massine, 1917, drawing [graphite on cream wove paper] (no. 64 in Chicago; no. 29 in New York; ill. on cover of cat.) [Art Institute of Chicago]
Pulcinella and Harlequin, drawing [medium not specified] (no. 65 in Chicago; no. 30 in New York)
Harlequin, 1918, drawing [medium not specified] (no. 66 in Chicago; no. 31 in New York)
Drawing [medium not specified] on blotting paper, 1919 (no. 67 in Chicago; no. 32 in New York)
Portrait of Léonide Massine, 1919 (no. 68 in Chicago; no. 33 in New York) [Z.III.297; Art Institute of Chicago]
Still Life, 1920, pastel (no. 69 in Chicago; no. 34 in New York)
Still Life, 1920, pastel (no. 70 in Chicago; no. 35 in New York)
Two Harlequins Lighted by a Lantern, 1920 (no. 71 in Chicago) [This piece was sold in Chicago and therefore was not included in the New York show.]
White Harlequin and Black Harlequin, 1920, watercolor (no. 72 in Chicago; no. 36 in New York)

1935
March 12–May 8, 1935: Pennsylvania Museum of Art, Philadelphia
"Les Fauves and After"
The Moulin Rouge, 1901
Woman Combing [Her] Hair, 1905 [actual date: 1906] / Marie Harriman Gallery, New York [Z.I.336; Museum of Modern Art, New York]
Woman with the Loaves, 1905 / Pennsylvania Museum of Art, Philadelphia [Z.VI.735; Philadelphia Museum of Art]
Mother and Child, 1923 [Z.IV.455]
The Two Eggs, 1924 [Z.V.266]
Classical Head, 1922
Harlequin, watercolor
Mythological Subject, crayon drawing
Seated Saltimbanques, 1926, pen drawing / Pennsylvania Museum of Art, Philadelphia

March 15–April 25, 1935: San Francisco Museum of Art
"1934–1935 Carnegie International: European Section"
 The Letter / Paul Rosenberg, Paris (no. 54 in exh.;
 ill. in cat.) [Z.V.30]
 Still Life with Guitar / Paul Rosenberg, Paris (no. 54
 in exh.)

March 26–April 6, 1935: Marie Harriman Gallery, New
York
"Exhibition Braque, Gris, La Fresnaye, Léger,
Lipschitz [*sic*], Marcoussis, Picasso"
 Woman Reclining (no. 31 in exh.)
 The Table, pastel (no. 32 in exh.)
 Package of Tobacco, pastel (no. 33 in exh.)

April 5–24, 1935: Arts Club of Chicago
"Exhibition of the Sidney Janis Collection of Modern
Paintings"
 Tête, 1912, papier collé, 16 x 11 in. (no. 2 in exh.)
 [Z.II².403; Museum of Modern Art, New York]
 Nature morte à la guitare [current title: *Glass, Guitar
 and Bottle*], 1913, oil, 25 x 21 in. (no. 3 in exh.)
 [Z.II².419; Museum of Modern Art, New York]
 Nature morte, 1914, oil, 14 x 24 in. (no. 4 in exh.)
 "*Vive la France*," 1914–15, oil, 21 1/4 x 25 1/2 in.
 (no. 5 in exh.) [Z.II².523; private collection]
 Femme assise, 1927, oil, 8 1/2 x 5 in. (no. 6 in exh.)
 [Z.VII.60]
 Le Peintre et son modèle, 1928, oil, 51 1/4 x 63 3/4 in.
 (no. 7 in exh.; ill. on cover of cat.) [Z.VII.143;
 Museum of Modern Art, New York]

June 4–September 24, 1935: Museum of Modern Art,
New York
"Summer Exhibition: Twentieth Century Paintings of
the School of Paris"
 Harlequin, 1905 / Mr. and Mrs. Samuel A. Lewisohn,
 New York [Z.I.298; private collection]
 Head, 1912, papier collé / private collection, New
 York [Z.II².403; Museum of Modern Art, New York
 / The anonymous lender was Sidney Janis.]
 Still Life with Guitar [current title: *Glass, Guitar and
 Bottle*], 1913 / private collection, New York
 [Z.II².419; Museum of Modern Art, New York /
 The anonymous lender was Sidney Janis.]
 Still Life, 1914 / private collection, New York
 [The anonymous lender was Sidney Janis.]
 "*Vive la France*," 1914–15 / private collection,
 New York [Z.II².523; private collection / The
 anonymous lender was Sidney Janis.]
 Green Still Life [also known as: *Fruit Bowl, Wineglass,
 Bowl of Fruit*], 1914 / Museum of Modern Art,
 New York [Z.II².485; Museum of Modern Art]
 Woman in White,* 1923 / Museum of Modern Art,
 New York [Z.V.1; Metropolitan Museum of Art,
 New York]
 Nude Figures, 1925, ink / Museum of Modern Art,
 New York, gift of Mrs. John D. Rockefeller, Jr.
 Seated Woman, 1927 / private collection, New York
 [Z.VII.60 / The anonymous lender was Sidney
 Janis.]
 [*The Studio*,* 1927–28, oil on canvas. Z.VII.142;
 Museum of Modern Art, New York / *The Studio*
 does not appear on the original checklist of the
 exhibition.]
 The Painter and His Model, 1928 / private collection,
 New York [Z.VII.143; Museum of Modern Art,
 New York / The anonymous lender was Sidney
 Janis.]

July–October 1935: Art Institute of Chicago
"Summer Loan Exhibition of Paintings and Sculpture"
 [*Crazy Woman with Cats*, 1901, oil on pulp board /
 Robert R. McCormick, Chicago (no. 32 in exh.)
 Z.I.93; Art Institute of Chicago]

November 1935: College Art Association, New York
"12 Paintings by 6 French Artists"; traveled to San
Francisco Museum of Art, May 15–June 29, 1936 /
from the collection of M. Paul Rosenberg
 Still Life and Tulips (no. 3 in exh.; ill. in cat.)
 [Z.VII.376; Wynn Collection, Las Vegas]
 Composition (no. 4 in exh.)

November 22, 1935–January 20, 1936: San Francisco
Museum of Art

"Original Costume and Stage Designs for the Ballet"
 Le Pas de Deux, line drawing
 Harlequin, abstract in tempera
 Black and White Harlequin, abstract in tempera
 Harlequin, pencil sketch
 [*Dancer*], pencil sketch
 [*Dancer for "La Boutique Fantasque"*], pencil sketch
 Pen and ink sketches on blotting paper

December 15, 1935–January 12, 1936: San Francisco
Museum of Art
"Abstractions by Braque and Picasso"
 Still Life / Stanley Rose Gallery (no. 20 in exh.)
 Newspaper, 1916 (no. 22 in exh.)
 Harlequin (no. 23 in exh.)
 Harlequin, 1918, watercolor / Léonide Massine
 (no. 26 in exh.)
 Still Life, 1918, watercolor (no. 27 in exh.)
 Drawing [medium not specified] on blotting paper,
 [1917] / Léonide Massine (no. 28 in exh.)
 Portrait of Léonide Massine, [1917, pencil, 26 1/4 x
 18 1/2 in.] / Léonide Massine (no. 29 in exh.)
 Dancers from the Boutique Fantasque (no. 30 in exh.)
 Drawing [medium not specified] on blotting paper
 (no. 32 in exh.)
 Portrait of Léonide Massine, [1919, pencil] (no. 33 in
 exh.) [Z.III.297; Art Institute of Chicago]
 Still Life, 1920, pastel / Mme. Bucher (no. 34 in exh.)
 Black and White Harlequin, [1920] (no. 36 in exh.)
 The Door (butcher shop), 1918, [watercolor, 6 x
 4 3/4 in.] (no. 76 in exh.)
 Portraits (Picasso & wife–Massine and Diaghilev), 1918,
 drawing [medium not specified, 7 1/2 x 10 1/2 in.]
 (no. 77 in exh.)

1936

January 1936: Valentine Gallery, New York
"Ten Important Paintings by XX Century French
Masters"
 Nu à la draperie, [1923] (no. 5 in exh.) [Mary Morsell,
 a reviewer writing in *Art News*, described this
 work as painted in a "grand, classical style."]
 Femme au tambourin (no. 6 in exh.) [The same
 reviewer called this a "cubist odalisque."]

January 6–31, 1936: Philadelphia Art Alliance,
Philadelphia
"African Art and Its Modern Derivatives"
 Figures, 1909 / Mr. and Mrs. Samuel S. White, III,
 Ardmore, Pennsylvania
 Figure / Earl Horter, Philadelphia [Z.II¹.150; private
 collection]
 Watercolor / Earl Horter, Philadelphia
 *Abstract Sand Painting of Glass Bottle, Pipe and
 Playing Cards* [current title: *Still Life with Cards,
 Glasses, and Bottle of Rum ("Vive la France")*] /
 Earl Horter, Philadelphia [Z.II².523; private
 collection]
 Abstraction of Glass and Bottle (Cubistic influence) /
 Earl Horter, Philadelphia [private collection]
 Abstract Figure [current title: *L'Arlésienne*], (Cubist
 period) drawing [medium not specified] / Earl
 Horter, Philadelphia [Z.II¹.337; Menil Collection,
 Houston]
 Abstraction of Violin, drawing [medium not specified]
 / Earl Horter, Philadelphia [Z.XXVIII.103; private
 collection]
 Figure / Earl Horter, Philadelphia
 Abstraction / Mr. and Mrs. Samuel S. White, III,
 Ardmore, Pennsylvania [Z.III.278]
 African Figures / Mr. and Mrs. Samuel S. White, III,
 Ardmore, Pennsylvania [Z.II¹.105; Philadelphia
 Museum of Art]
 Abstraction–Nude / Earl Horter, Philadelphia
 [Z.II¹.194; Albright-Knox Art Gallery, Buffalo]

January 14–February 8, 1936: Pierre Matisse Gallery,
New York
"Large Paintings: Eight Moderns"
 The Schoolgirl [*sic*], 1920 (no. 9 in exh.)
 Woman and Child, 1923 (no. 10 in exh.) [Z.IV.455]

Opened February 17, 1936: Marie Harriman Gallery,
New York
"Paul Cézanne, André Derain, Walt Kuhn, Henri

Matisse, Pablo Picasso, Auguste Renoir, Vincent van
Gogh"
 Mother and Child, [1923, oil on canvas, 51 1/2 x
 38 1/4 in.] / Marie Harriman Gallery, New York
 (no. 12 in exh.) [Z.IV.455]

March 2–April 19, 1936: Museum of Modern Art, New
York
"Cubism and Abstract Art"; traveled to San Francisco
Museum of Art, July 28–August 23, 1936 [The works
are numbered in the New York catalogue, but not in
the San Francisco catalogue.]
 *Study for "The Young Ladies of Avignon": half-length
 figure*, 1907, oil on canvas, 32 x 22 1/2 in. / Mme.
 Paul Guillaume, Paris (no. 203 in New York; ill.
 in cat.)
 Study for "The Young Ladies of Avignon," 1907,
 watercolor, 6 3/4 x 8 3/4 in. / Gallery of Living
 Art, New York University (no. 204 in New York;
 did not travel) [Z.II¹.21; Philadelphia Museum
 of Art]
 Bowls and Jug, 1907, oil on canvas, 32 x 25 1/2 in. /
 Gallery of Living Art, New York University (no.
 206 in New York; did not travel; ill. in cat.)
 [Z.II¹.63; Philadelphia Museum of Art]
 Dancer, 1907–8, oil on canvas, 59 3/8 x 39 1/2 in. /
 Mme. Paul Guillaume, Paris (no. 207 in New
 York; ill. in cat.) [Z.II¹.35; private collection,
 New York]
 Head of a Woman, 1908–9, oil on canvas, 25 1/2 x
 21 1/4 in. / Mme. Paul Guillaume, Paris (no. 208
 in New York; ill. in cat.) [Z.II¹.172; Museu de
 Arte Moderna, Rio de Janiero]
 Portrait of Braque, 1909, oil on canvas, 24 1/4 x
 19 3/4 in. / Frank Crowninshield, New York (no.
 209 in New York; ill. in cat.) [Z.II¹.177; Staatliche
 Museen zu Berlin, Nationalgalerie, on permanent
 loan from the Berggruen Collection]
 The Tube of Paint [current title: *Still Life with
 Liqueur Bottle*], 1909, oil on canvas, 31 1/2 x
 25 1/2 in. / Wildenstein & Co., New York (no. 210
 in New York; did not travel; ill. in cat.) [Z.II¹.173;
 Museum of Modern Art, New York]
 Drawing, 1913, (to explain no. 210 [*The Tube of
 Paint*]) [medium not specified] / Wildenstein &
 Co., New York (no. 211 in New York; ill. in cat.)
 Figure [current title: *Standing Female Nude*,* 1910,
 charcoal drawing, 19 x 12 1/4 in. / Alfred Stieglitz,
 New York (no. 213 in New York; did not travel;
 ill. in cat.) [Z.II¹.208; Metropolitan Museum of
 Art, New York]
 The Poet, 1911, oil on canvas, 51 1/2 x 35 in. /
 George L. K. Morris, New York (no. 214 in
 New York; ill. in cat.) [Z.II¹.285; Peggy
 Guggenheim Collection, Venice]
 Head of Young Woman, 1913, oil on canvas, 21 5/8 x
 15 in. / private collection, New York (no. 216 in
 New York; did not travel; ill. in cat.) [Z.II².396]
 Violin, ca. 1912, oil on canvas, 39 x 28 in. [oval] /
 Kröller-Muller Foundation, Wassenaar, the
 Netherlands (no. 217 in New York; ill. in cat.)
 [Z.II².374; Rijksmuseum Kröller-Muller, Otterlo]
 Head, 1912, paper collage and pencil drawing on
 paper, 16 x 11 in. / Sidney Janis, New York (no.
 218 in New York) [Z.II².403; Museum of Modern
 Art, New York]
 Still Life [current title: *Bottle and Wine Glass on a
 Table*],* 1913 [actual date: 1912], collage, charcoal,
 pencil, and ink on paper, 24 1/4 x 18 1/2 in. /
 Alfred Stieglitz, New York (no. 219 in New York;
 did not travel; ill. in cat.) [Z.II².428; Metropolitan
 Museum of Art, New York]
 Still Life with Guitar, 1913, oil and paper collage on
 canvas, 25 x 21 in. / Sidney Janis, New York (no.
 220 in New York; did not travel; ill. in cat.)
 [Z.II².419; Museum of Modern Art, New York]
 Green Still Life, 1914, oil on canvas, 23 1/2 x 31 1/4 in.
 / Museum of Modern Art, The Lillie P. Bliss
 Collection (no. 221 in New York; did not travel;
 ill. in cat.) [Z.II².485; Museum of Modern Art,
 New York]
 The Table, ca. 1919–20, oil on canvas, 50 x 29 1/2 in. /
 Smith College Museum of Art, Northampton,
 Massachusetts (no. 224 in New York; did not
 travel; ill. in cat.) [Z.III.437; Smith College
 Museum of Art]

Guitar, 1919, oil on canvas, 32 x 17 3/4 in. /
Kröller-Muller Foundation, Wassenaar, The
Netherlands (no. 225 in New York; ill. in cat.)
[Z.III.140; Rijksmuseum Kröller-Muller, Otterlo]

Still Life, 1923, oil on canvas, 38 x 51 in. / Mrs.
Patrick C. Hill, Pecos, Texas (no. 226 in New York;
did not travel; ill. in cat.)

Harlequin, 1927, oil on canvas, 37 7/8 x 26 3/4 in. /
Wildenstein & Co., New York (no. 227 in New
York)

The Painter and His Model, 1928, oil on canvas,
51 1/4 x 63 3/4 in. / Sidney Janis, New York (no.
228 in New York; did not travel; ill. in cat.)
[Z.VII.143; Museum of Modern Art, New York]

The Studio, 1928 [actual date: 1927–28], oil on
canvas, 59 x 91 in. / Museum of Modern Art, gift
of Walter P. Chrysler, Jr. (no. 229 in New York;
ill. in cat.) [Z.VII.142; Museum of Modern Art,
New York]

Woman in an Armchair, 1929, oil on canvas, 36 3/8 x
26 7/8 in. / private collection, New York (no. 230
in New York; did not travel; ill. in cat.) [Z.VII.275
/ The anonymous lender was James Johnson
Sweeney.]

Bather by the Sea, 1929, oil on canvas, 51 1/4 x
38 1/4 in. / Bignou Gallery, New York (no. 231 in
New York; did not travel; ill. in cat.) [Z.VII.252;
Metropolitan Museum of Art, New York]

Costume of manager, "Parade," Diaghileff's Russian
Ballet, 1917 (no. 372 in New York)

Setting, "Pulcinella," Diaghileff's Russian Ballet, 1920
(no. 373 in New York)

March 28–June 29, 1936: San Francisco Museum of Art
"Braque and Picasso Abstractions"
Abstraction / Putzel Gallery, Los Angeles
Still Life, oil

April 15–30, 1936: Boyer Galleries, Philadelphia
"Nineteenth and Twentieth Century French Paintings"
Dame à la violette [current title: *Woman with a Cape*],
ca. 1901, oil on canvas, 26 x 20 in. / Mrs. C.
Shillard Smith (no. 7 in exh.; ill. in cat.) [Z.VI.542;
Cleveland Museum of Art]

April 25–May 16, 1936: Valentine Gallery, New York
"Selected Examples of French Masters of the XIXth
and XXth Centuries"
La Coiffure, [1906, oil on canvas, 20 1/2 x 12 1/2 in.]
(no. 11 in exh.)
Le Mendiant (no. 12 in exh.)

October 1936: Metropolitan Museum of Art, New York
"Loan exhibition"
[*Head of a Woman from Picasso's Blue Period* /
anonymous loan. Possibly Z.VI.548, now in
the Metropolitan Museum of Art, New York.]

October 26–November 21, 1936: Valentine Gallery,
New York
"Picasso 1901–1934: Retrospective Exhibition"
Femme écrivant, 1934 (no. 1 in exh.)
Jeune Fille au miroir, March 14, 1932 (no. 2 in exh.)
[Z.VII.379; Museum of Modern Art, New York]
Corsage jaune, 1907–8 (no. 3 in exh.) [Z.II¹.43;
Pulitzer Foundation for the Arts, St. Louis,
Missouri]
Nature morte aux tulipes, 1932 (no. 4 in exh.)
[Z.VII.376; Wynn Collection, Las Vegas]
Le Chapeau rouge, 1934 (no. 5 in exh.) [Z.VIII.241;
Pulitzer Foundation for the Arts, St. Louis,
Missouri]
Femme tenant un livre, 1932 (no. 6 in exh.)
[Possibly Z.VIII.070, now in the Norton
Simon Museum of Art, Pasadena, California.]
Trois Personnages, 1933 (no. 7 in exh.)
Homme assis, 1933 (no. 8 in exh.)
Femme sur une terrasse, 1933 (no. 9 in exh.)
Sur la terrasse, 1933 (no. 10 in exh.)
Intérieur, 1933 (no. 11 in exh.)
Cabines de bain, Dinard, 1929 (no. 12 in exh.)
[Z.VII.211; Museum of Modern Art, New York]
Cabines de bain, Dinard, 1929 / Mrs. R. Dudensing,
III (no. 13 in exh.) [The lender was the wife of
Richard Dudensing (brother of Valentine,
proprietor of the Valentine Gallery).]

Arlequin au bicorne, 1917 / Dr. T. E. Hanley,
Bradford, Pennsylvania (no. 14 in exh.) [Z.III.1]
Mère et petite fille, 1903 (no. 15 in exh.) [Z.I.115;
Fogg Art Museum, Harvard University,
Cambridge, Massachusetts]
Maternité, 1921 (no. 16 in exh.)
L'Aveugle, 1903 (no. 17 in exh.) [Z.I.172; Fogg Art
Museum, Harvard University, Cambridge,
Massachusetts]
Chevelure noir, 1906 (no. 18 in exh.)
Projet pour un monument, February 19, 1930 (no. 19
in exh.) [Z.VII.420; private collection]
Tête d'enfant, 1923 (no. 20 in exh.)
Évocation, 1901 (no. 21 in exh.)
Nu à la draperie, 1921 (no. 22 in exh.)
Femme au peigne, 1906 (no. 23 in exh.)
Jeunes Femmes, 1921 (no. 24 in exh.) [Z.IV.315]
Mère et enfant, 1921 (no. 25 in exh.)
Tête, 1909 (no. 26 in exh.)
Couseuse, 1909 (no. 27 in exh.) [Z.II¹.199]
Tête, 1901 (no. 28 in exh.)
Buste d'homme, 1907–8 / Walter P. Chrysler, Jr., New
York (no. 29 in exh.) [Z.II¹.76; Metropolitan
Museum of Art, New York]
Baigneuse, 1909 (no. 30 in exh.)
Buste de femme, 1907–8 (no. 31 in exh.) [Z.I.374; Art
Institute of Chicago]
Chez Picasso [current title: *The Dressing Table*], 1912
(no. 32 in exh.) [Z.II¹.220]
Paysage–à Céret, 1911 (no. 33 in exh.) [Z.II¹.281;
Solomon R. Guggenheim Museum, New York]
Composition [current title: *Glass of Absinthe*], 1912 /
Walter P. Chrysler, Jr., New York (no. 34 in exh.)
[Z.II¹.261; Allen Memorial Art Museum, Oberlin
College, Ohio]
Paysage, 1911 (no. 35 in exh.)
Buste, 1911 (no. 36 in exh.)

Opened October 27, 1936: Museum of Living Art,
New York University [The Gallery of Living Art was
renamed Museum of Living Art with this exhibition in
the fall of 1936.]
[Recent Acquisitions / According to a Museum of
Living Art press release, five recently purchased works
by Picasso were to go on view as of October 27, 1936.
Gail Stavitsky, in her Ph.D. dissertation on the
Gallatin collection, has identified four of these works
with reasonable certainty, and a fifth more tentatively.
Two of these were lithographs, and are therefore not
included in the list below.]
[*Three Musicians,* 1921, oil, 80 1/2 x 74 1/8 in.
Z.IV.332; Philadelphia Museum of Art]
[*Composition / Still Life: Glass and Package of
Tobacco*, 1922, oil, 6 7/8 x 9 1/8 in. Z.IV.413;
Philadelphia Museum of Art]
[*The Zither*, 1926, pastel and ink on paper, 12 1/4 x
18 1/4 in. Z.VII.28; Philadelphia Museum of Art]

November 2–26, 1936: Jacques Seligmann & Co., New
York
"Picasso 'Blue' and 'Rose' Periods: 1901–1906"
Portrait of a Woman, 1901, oil, 17 1/2 x 14 1/2 in. /
Mr. and Mrs. Q. A. Shaw McKean, Boston
(no. 1 in exh.; ill. in cat.) [Z.VI.385]
The Entombment / The Dead, 1901, oil, 39 1/2 x
35 1/2 in. / Pierre Loeb, through Pierre Matisse
Gallery, New York (no. 2 in exh.; ill. in cat.)
Harlequin Propped on Elbow [current title: *Harlequin*],
1901, oil, 36 x 29 in. / anonymous loan (no. 3 in
exh.; ill. in cat.) [Z.I.79; Metropolitan Museum of
Art, New York / The anonymous lender was
either Mary Anderson, a relative of Julia Quinn
Anderson—daughter of John Quinn—or Henry P.
McIlhenny who acquired the work in 1936.]
Early Morning / The Tub / The Blue Room, 1901, oil,
20 x 24 in. / Phillips Memorial Art Gallery (no. 4
in exh.; ill. in cat.) [Z.I.103; Phillips Collection,
Washington, D.C.]
Gustave Coquoit, 1901, oil, 18 1/8 x 15 in. (no. 5 in
exh.; ill. in cat.)
Mother and Child near Fountain, 1901, oil, 16 x
12 3/4 in. / anonymous loan through the
Worcester Art Museum (no. 6 in exh.; ill. in cat.)
[Z.I.107; Metropolitan Museum of Art, New York
/ The source of the anonymous loan was Scofield
Thayer's Dial Collection, on deposit at the

Worcester Art Museum from 1926 until it went by
his bequest to the Metropolitan Museum of Art
in 1984.]
Little Girl with Hat (verso of no. 8), 1901, oil, 29 1/2 x
20 in. / Dr. Harry Bakwin, New York (no. 7 in exh.;
ill. in cat.) [Z.I.76; Fogg Art Museum, Harvard
University, Cambridge, Massachusetts]
Girl with Chignon (verso of no. 7) / Dr. Harry
Bakwin, New York (no. 8 in exh.; ill. in cat.)
[Z.I.96]
Elégie, 1901, oil, 32 x 23 in. / Mr. and Mrs. Chauncey
McCormick (no. 9 in exh.; ill. in cat.) [Z.I.105]
Dame à la Violette [current title: *Woman with a Cape*],
ca. 1901, oil, 26 x 20 in. / Mrs. C. Shillard Smith
(no. 10 in exh.; ill. in cat.) [Z.VI.542; Cleveland
Museum of Art]
Flowers / Peonies, 1901, oil, 22 3/4 x 15 1/2 in. / Mrs.
Charles B. Goodspeed, Chicago (no. 11 in exh.;
ill. in cat.) [Z.I.60; National Gallery of Art,
Washington, D.C.]
Old Woman, [1903], gouache, 12 3/4 x 9 1/2 in. / Mr.
A. Conger Goodyear, New York (no. 12 in exh.)
Woman Seated with Fichu / La Mélancolie, 1902, oil,
39 3/8 x 27 1/8 in. / anonymous loan (no. 13 in
exh.; ill. in cat.)
Woman Crouching, 1902, oil, 24 1/2 x 18 1/2 in. /
Adolph Lewisohn, New York (no. 14 in exh.; ill.
in cat.) [Z.I.160; private collection]
The Old Guitar Player, 1903, oil on canvas, 47 3/4 x
32 1/2 in. / Art Institute of Chicago, Birch-
Bartlett Collection (no. 15 in exh.; ill. in cat.)
[Z.I.202; Art Institute of Chicago]
Woman with a Helmet of Hair, 1904, gouache,
16 1/2 x 12 in. / Mr. and Mrs. Walter J. Brewster,
Chicago (no. 16 in exh.; ill. in cat.) [Z.I.233; Art
Institute of Chicago]
Woman with a Crow, 1904, oil, 25 1/2 x 19 1/2 in. /
Toledo Museum (no. 17 in exh.) [Z.I.240; Toledo
Museum of Art, Ohio]
Nude Sleeping, 1904, watercolor, 14 1/2 x 10 5/8 in. /
Mr. Jules Furthman (no. 18 in exh.)
Blue Boy, 1905, gouache, 39 3/8 x 22 1/2 in. / Mr.
Edward M. M. Warburg, New York (no. 19 in
exh.; ill. in cat.) [Z.I.271]
Boy with Collar, 1905, gouache, 33 x 23 3/4 in. /
anonymous loan through Worcester Museum (no.
20 in exh.; ill. in cat.) [Z.I.276; Metropolitan
Museum of Art, New York / The source of the
anonymous loan was Scofield Thayer's Dial
Collection, on deposit at the Worcester Art
Museum from 1926 until it went by his bequest
to the Metropolitan Museum of Art in 1984.]
Lady with Fan, 1905, oil, 39 x 31 1/2 in. / Mr. and
Mrs. W. Averell Harriman, New York (no. 21 in
exh.; ill. in cat.) [Z.I.308; National Gallery of Art,
Washington, D.C.]
*Woman Dressing with Harlequin Child / Famille
d'Arlequin*, 1905, gouache, 22 3/4 x 17 1/8 in. /
Mr. and Mrs. Samuel A. Lewisohn, New York (no.
22 in exh.; ill. in cat.) [Z.I.298; private collection]
Study for "The Jugglers" / Les Bateleurs, 1905, gouache
and pastel, 26 x 22 in. (no. 23 in exh.; ill. in cat.)
[Z.I.284]
The Acrobat's Meal, 1905, watercolor and gouache,
12 3/8 x 9 1/4 in. (no. 24 in exh.; ill. in cat.)
[Z.I.292]
Head of a Woman with Hair Falling Down Back, 1905,
gouache, 25 x 19 in. / Toledo Museum (no. 25 in
exh.; ill. in cat.) [Z.I.333]
Nude Young Woman, 1905, oil, 31 7/8 x 21 1/4 in. / Mr.
Maurice Wertheim (no. 26 in exh.) [Musée de
l'Orangerie, Paris]
Nude (Study for "Harem"), 1905, gouache, 25 1/4 x
19 1/4 in. / Cleveland Museum (no. 27 in exh.;
ill. in cat.) [Z.I.317; Cleveland Museum of Art]
The Harem, 1905, oil, 60 1/4 x 43 1/4 in. / Leonard C.
Hanna, Jr., Cleveland (no. 28 in exh.; ill. in cat.)
[Z.I.321; Cleveland Museum of Art]
La Toilette / The Toilette, 1905 [actual date: 1906], oil,
58 x 39 1/2 in. / Albright Art Gallery, Buffalo,
New York (no. 29 in exh.; ill. in cat.) [Z.I.325;
Albright-Knox Art Gallery]
The Adolescents, 1905, oil, 62 1/2 x 46 1/2 in. (no. 30 in
exh.; ill. in cat.) [Z.I.305; National Gallery of Art,
Washington, D.C.]
Woman with Loaves, 1905, oil, 39 x 27 1/2 in. /

Pennsylvania Museum of Art, Philadelphia (no. 31 in exh.; ill. in cat.) [Z.VI.735; Philadelphia Museum of Art]

La Coiffure / La Toilette, 1906, oil, 20 1/2 x 12 1/2 in. / Mr. and Mrs. James P. Warburg (no. 32 in exh.)

La Coiffure [current title: *Woman Combing Her Hair*], 1906, oil, 49 x 35 in. / Marie Harriman Gallery, New York (no. 33 in exh.; ill. in cat.) [Z.I.336; Museum of Modern Art, New York]

Woman with a Comb, 1906, gouache, 41 1/2 x 31 7/8 in. (no. 34 in exh.; ill. in cat.) [Z.I.344; Kimbell Art Museum, Fort Worth]

December 1936–January 1937: Museum of Modern Art, New York
"Fantastic Art, Dada, Surrealism"; traveled in part to San Francisco Museum of Modern Art, August 6–31, 1937

Ma Jolie, 1911–12, oil on canvas, 39 3/8 x 25 3/4 in. / Museum of Modern Art (ill. in cat.) [Z.II¹.244; Museum of Modern Art, New York]

Man with a Hat, 1913, collage, charcoal, and ink, 24 1/2 x 18 1/4 in. / Museum of Modern Art (ill. in cat.) [Z.II².398; Museum of Modern Art, New York]

Harlequin, 1918, oil on canvas, 58 x 26 1/2 in. / Joseph Pulitzer, Jr., St. Louis (ill. in cat.) [Z.III.159; Pulitzer Foundation for the Arts, St. Louis, Missouri]

Seated Woman, 1927, oil on wood, 51 1/8 x 38 1/4 in. / James Thrall Soby (ill. in cat.) [Z.VII.77; Museum of Modern Art, New York]

Metamorphosis (Bather) [current title: *Bather by the Sea*], 1929, oil on canvas, 51 1/4 x 38 1/4 in. / private collection (ill. in cat.) [Z.VII.252; Metropolitan Museum of Art, New York]

Bullfight,* 1934, oil and sand on canvas, 13 x 16 1/8 in. / Henry P. McIlhenny, Philadelphia [Z.VIII.233; Philadelphia Museum of Art]

December 9–31, 1936: Arts Club of Chicago
"Exhibition of the Joseph Winterbotham Collection"
Prisoner, pastel (no. 30 in exh.)
Man, drawing [medium not specified] (no. 62 in exh.)

1937

January 1937: Marie Harriman Gallery, New York
"French Painting"
Boy Leading a Horse, 1905 / anonymous loan (no. 11 in exh.) [Z.I.264; Museum of Modern Art, New York / The anonymous lender was William S. Paley, New York.]

Woman with a Blue Veil, 1923 (no. 12 in exh.) [Z.V.16; Los Angeles County Museum of Art]

The Acrobat, 1923 (no. 13 in exh.)

January 5–30, 1937: Pierre Matisse Gallery, New York
"Masterpieces of Modern Painting and Sculpture"
Nude, 1905 (no. 18 in exh.) [Z.I.257; Musée National d'Art Moderne, Centre National d'Art et de Culture Georges Pompidou, Paris]

Painting, 1932 (no. 19 in exh.)

January 8–31, 1937: Arts Club of Chicago
"Exhibition of the Walter P. Chrysler, Jr. Collection"
[Walter P. Chrysler, Jr., son of the founder of the automobile corporation that bears his name, began collecting art at the age of fourteen. Over more than seven decades, he amassed a diverse collection, including old master paintings, modern art, African masks, American primitives, and furniture. His unrivaled collection of works by Picasso—the most represented artist in the group—numbered eighty-nine in 1941 when the collection was on one of its numerous tours around the country and a full catalogue was published.]

Nature morte [current title: *Glass of Absinthe*], 1911–12, oil on canvas, 15 x 18 1/4 in. (no. 20 in exh.) [Z.II¹.261; Allen Memorial Art Museum, Oberlin College, Ohio]

Figure, 1907, ink wash, 11 1/2 x 7 in. (no. 21 in exh.)

Les Deux Soeurs, 1921, pastel, 41 3/8 x 29 1/2 in. (no. 22 in exh.; ill. in cat.) [Z.IV.358]

Jeune Fille au chapeau jaune, April 16, 1921, pastel on carton (no. 23 in exh.) [Z.IV.258]

Verre, pomme et couteau, 1922, oil and sand on canvas, 9 x 11 in. (no. 24 in exh.) [Z.V.68]

Verre et pomme, 1923, oil on canvas, 9 x 11 in. (no. 25 in exh.)

La Plage, 1928 (or 1929?), oil on canvas, 14 1/4 x 9 7/8 in. (no. 26 in exh.) [Z.VII.213]

Study for "Les Demoiselles d'Avignon," 1907, pastel, 8 3/4 x 6 1/2 in. (no. 27 in exh.) [Z.II.5; private collection, New York]

Seated Woman, 1927, demi-gouache on grey paper, 8 1/2 x 7 1/2 in. (no. 28 in exh.)

Composition fond vert et bleu, 1922, oil on canvas, 32 1/4 x 39 3/8 in. (no. 29 in exh.) [Z.IV.422]

Abstraction, 1921, watercolor, 8 x 10 in. (no. 30 in exh.)

Untitled (House), oil on panel, 3 3/4 x 5 1/2 in. (no. 31 in exh.)

"No title" (Street Scene), oil on panel, 3 1/2 x 5 1/2 in. (no. 32 in exh.)

Bone Forms against the Sky, [February 1], 1930, oil on wood, 26 x 19 1/2 in. (no. 33 in exh.) [Z.VII.300]

Guitar on a Table, 1921, gouache and watercolor on carton, 10 1/2 x 8 1/4 in. (no. 34 in exh.)

Fête, 1903 (1904?), watercolor, 21 3/4 x 17 in. (no. 35 in exh.) [Z.I.213]

Tête nègre [current title: *Bust of a Man*], 1907–8, oil on canvas, 24 3/4 x 17 in. (no. 36 in exh.) [Z.II¹.76; Metropolitan Museum of Art, New York]

Table de Toilette, 1910, oil on canvas, 24 x 18 1/4 in. (no. 37 in exh.) [Z.II¹.220]

February 8–27, 1937: Durand-Ruel Galleries, New York
"Modern Paintings"
Les Deux Soeurs / Walter P. Chrysler, Jr., New York (no. 6 in exh.) [Z.IV.358]

February 8–28, 1937: Philadelphia Art Alliance
"Solomon R. Guggenheim Collection of Non-Objective Paintings"
Landscape, Seret [sic], summer 1911, oil on canvas, 25 5/8 x 19 3/4 in. (no. 186 in exh.) [Z.II¹.281; Solomon R. Guggenheim Museum, New York]

Pierrot (Accordionist), summer 1911, oil on canvas, 51 1/4 x 35 1/4 in. (no. 187 in exh.) [Z.II¹.277; Solomon R. Guggenheim Museum, New York]

Carafe, Jug and Fruit Bowl, summer 1909, oil on canvas, 28 1/4 x 25 3/8 in. (no. 190 in exh.) [Z.II¹.164; Solomon R. Guggenheim Museum, New York]

February 8–27, 1937: Courvoisier Galleries, San Francisco
"French Paintings: Nineteenth and Twentieth Centuries"
Woman with Cape, oil on canvas, 28 1/2 x 19 1/2 in. (no. 12 in exh.) [Z.VI.542; Cleveland Museum of Art]

March 1–20, 1937: Valentine Gallery, New York
"XIX and XX Century French Paintings"
Nu, 1906 (no. 10 in exh.)
Tête, 1905 (no. 11 in exh.)
À la fontaine, 1921 (no. 12 in exh.)

March 18–May 16, 1937: Art Institute of Chicago
"The Sixteenth International Exhibition: Water Colors, Pastels, Drawings and Monotypes"
Boy with Cattle, gouache / Columbus Gallery of Fine Arts, Ferdinand Howald Collection (no. 113 in exh.) [Z.I.338; Columbus Museum of Art, Ohio]

Boy Standing, in Profile, gouache / anonymous loan through the courtesy of the Worcester Art Museum, Worcester, Massachusetts (no. 114 in exh.) [Z.I.276; Metropolitan Museum of Art, New York / The source of the anonymous loan was Scofield Thayer's Dial Collection, on deposit at the Worcester Art Museum from 1926 until it went by his bequest to the Metropolitan Museum of Art in 1984.]

Horses Bathing, gouache / anonymous loan through the courtesy of the Worcester Art Museum, Worcester, Massachusetts (no. 115 in exh.) [Z.I.265; Metropolitan Museum of Art, New York / The source of the anonymous loan was Scofield Thayer's Dial Collection, on deposit at the Worcester Art Museum from 1926 until it went by his bequest to the Metropolitan Museum of Art in 1984.]

Figure, ink / Mrs. Lillian Henkel Haass, Grosse Pointe Farms, Michigan (no. 116 in exh.)

Head of the Acrobat's Wife, gouache / Mr. and Mrs. Walter S. Brewster, Chicago (no. 117 in exh.) [Z.I.233; Art Institute of Chicago]

Nude (Pink), gouache / Cleveland Museum of Art (no. 118 in exh.; ill. in cat.) [Z.I.317; Cleveland Museum of Art]

Pierrot, oil on paper / Mr. G. David Thompson, Pittsburgh (no. 119 in exh.)

The Rape, gouache / Mr. Philip L. Goodwin, New York (no. 120 in exh.) [Z.IV.109; Museum of Modern Art, New York]

Seated Woman, gouache / Mr. and Mrs. John U. Nef, Chicago (no. 121 in exh.)

Still Life: Musical Instruments, gouache / Art Institute of Chicago, Robert Allerton Collection (no. 122 in exh.)

Terrace Window, gouache / Mrs. W. Averell Harriman, New York (no. 123 in exh.)

Studio Corner, gouache / Phillips Memorial Gallery, Washington, D.C. (no. 124 in exh.) [Z.IV.241; Phillips Collection, Washington, D.C.]

Tricorne [current title: *Pierrot and Harlequin*], gouache / Mrs. Charles B. Goodspeed, Chicago (no. 125 in exh.) [Z.IV.69; National Gallery of Art, Washington, D.C.]

Woman with Crow, gouache / Toledo Museum of Art (no. 126 in exh.) [Z.I.240; Toledo Museum of Art, Ohio]

Woman in Rose, [1905], gouache, [25 1/8 x 19 in.] / Toledo Museum of Art (no. 127 in exh.) [Z.I.333]

March 29–April 18, 1937: Pennsylvania Museum of Art, Philadelphia
"Exhibition of French Paintings"
Harlequin, 1901 / anonymous loan
The Mother, 1901 / anonymous loan
Portrait of Angel Fernandez de Soto, 1903 / William H. Taylor, West Chester, Pennsylvania [Z.I.201]
Woman with the Loaves, 1905 / Pennsylvania Museum of Art, Philadelphia, Gift of Charles E. Ingersoll [Z.VI.735; Philadelphia Museum of Art]

March 25–May 13, 1937: San Francisco Museum of Art
"Harriet Levy Collection"
Cocks, watercolor [Z.VI.725; San Francisco Museum of Modern Art]
Danse barbare, ink [Z.VI.812; San Francisco Museum of Modern Art]
Figure Seated, ink [Z.VI.810; San Francisco Museum of Modern Art]
Head, gouache
Street Scene in Paris, oil [Z.VI.302; San Francisco Museum of Modern Art]
Three Figures, ink [Z.VI.809; San Francisco Museum of Modern Art]

April 12–May 1, 1937: Pierre Matisse Gallery, New York
"Pastels, Watercolors, Drawings"
Le Repas des acrobates, 1905, gouache / Seligmann Galleries, New York (no. 15 in exh.) [Z.I.292]

April 12–May 1, 1937: Valentine Gallery, New York
"Drawings, Gouaches and Pastels by Picasso"
Bather, 1931 (no. 1 in exh.)
Compotier et guitare, 1924 (no. 2 in exh.)
Compotier et guitare, 1924, [gouache, watercolor, pen, and ink on carton, 4 3/4 x 6 1/4 in.] (no. 3 in exh.)
Head of Boy, 1923 (no. 4 in exh.) [Z.V.97]
Standing Nudes, 1906 (no. 5 in exh.)
Matador, 1922 (no. 6 in exh.)
Still Life on Table, 1916 (no. 7 in exh.)
Head, 1908 (no. 8 in exh.) [Z.II¹.10; Museum of Modern Art, New York]
Nude, 1921, [pencil, 7 3/4 x 10 1/2 in.] (no. 9 in exh.)
La Source, 1921, [pastel on paper, 5 1/4 x 6 1/2 in.] (no. 10 in exh.)
Harlequin, 1910 (no. 11 in exh.)
Harlequin and Nude, 1919 (no. 12 in exh.)
Nudes, 1923, [charcoal, 6 x 4 3/4 in.] (no. 13 in exh.)
Man with Pipe, 1914 (no. 14 in exh.)
Seated Guitarist, 1915 (no. 15 in exh.)

Lady with Dotted Scarf, 1915 (no. 16 in exh.)
Two Nudes, 1923, [pastel on paper, 9 3/4 x 7 1/4 in.] (no. 17 in exh.)
Seated Man, 1914 (no. 18 in exh.) [Z.II².506; Museum of Modern Art, New York]
Composition, 1914 (no. 19 in exh.)
Girl with Bouquet, 1906 (no. 20 in exh.)
Ballet Dancers, [no date given] (no. 21 in exh.)
Still-Life, 1921 (no. 22 in exh.)
Reclining Nude, 1920 (no. 23 in exh.)
Two Nudes, [February 27], 1921, [pencil, 8 3/4 x 12 1/4 in.] (no. 24 in exh.)
Cup, 1916 (no. 25 in exh.)
Lady Painting, 1933, [charcoal, 11 x 10 1/8 in.] (no. 26 in exh.)
Seated Figure and Head, 1930, [ink and pencil on paper, 11 1/8 x 10 1/8 in.] (no. 27 in exh.)
XX Century Orpheus, 1923 (no. 28 in exh.)
Man at Table, 1914, [pencil on paper, 13 x 10 in.] (no. 29 in exh.)
Nudes on Beach, 1921 (no. 30 in exh.)
Interior, 1916 (no. 31 in exh.) [Z.II².567; private collection, New York]
Italian Girl, 1920 (no. 32 in exh.)
Ballet Dancers, 1919 (no. 33 in exh.)
Man at Table, 1914 (no. 34 in exh.)
Card Player, 1914 (no. 35 in exh.)
Peasant, 1914 (no. 36 in exh.)
Fallen Gladiator, 1923 (no. 37 in exh.)
Head of Girl, 1923 (no. 38 in exh.)
Study of Hands, 1921 (no. 39 in exh.)
Head, 1926, [pastel and fusion on paper, 25 x 19 in.] (no. 40 in exh.)
Standing Nude, 1921 (no. 41 in exh.)
Study of Hand, 1921 (no. 42 in exh.) [Z.IV.239]
Three Nudes, 1920 (no. 43 in exh.)
On the Beach, 1920 (no. 44 in exh.)
Bathers, 1920 (no. 45 in exh.)
Nudes on the Beach, 1920 (no. 46 in exh.)
Orpheus, 1923 (no. 47 in exh.)
Nude on Beach, 1920 (no. 48 in exh.)
Acrobats, 1923, [ink wash on paper, 24 1/8 x 18 3/4 in.] (no. 49 in exh.)
Still-Life, 1921 (no. 50 in exh.)
Nude Reading, 1920 (no. 51 in exh.)
Lady Painting, 1933, [charcoal on paper, 11 1/8 x 10 1/8 in.] (no. 52 in exh.)

May 8–June 12, 1937: Brooklyn Museum, New York
"International Exhibition of Water Colors: Ninth Biennial"
Three Figures in Interior, watercolor (no. 145 in exh.)

May 25–June 30, 1937: San Francisco Museum of Art
"Drawings from the Permanent Collection of the Museum of Modern Art"
Dancers, pen and ink [Z.V.422; Museum of Modern Art, New York]

By October 1, 1937: Phillips Memorial Gallery, Washington, D.C.
["Picasso, 'Bull Fight,' Dufy, 'Polo,' Oils and Watercolors by Demuth, Marin, Dove, Davis, Klee and Knaths"]
[*Bull Fight* / Phillips Memorial Gallery, Washington, D.C. Z.VIII.218; Phillips Collection, Washington, D.C.]

October–November 1937: Perls Galleries, New York
"For the Young Collector, An Exhibition of Pictures, Watercolors and Drawings by Picasso, Utrillo, Raoul Dufy, Rouault and Other Modern French Painters"
Danseuse espagnole, 1900, pastel (no. 1 in exh.)
Les Danseuses du "Jardin de Paris," 1902, watercolor (no. 2 in exh.) [Z.VI.367; Metropolitan Museum of Art, New York]
Deux Têtes de femmes et une main, 1902, drawing [medium not specified] (no. 3 in exh.)
Têtes d'étude, 1902, drawing [medium not specified] (no. 4 in exh.)
Scène de bar, 1902, drawing [medium not specified] (no. 5 in exh.)
La Maternité, 1905, oil (no. 6 in exh.)
La Toilette, 1906, drawing [medium not specified] (no. 7 in exh.)
La Repasseuse, 1906, pastel (no. 8 in exh.) [Z.I.248]
Le Clown, 1905, watercolor (no. 9 in exh.)

Tête de femme, 1910, oil (no. 10 in exh.)
Pierrot avec masque, vers 1923, drawing [medium not specified] (no. 11 in exh.)

October 27–December 27, 1937: An American Place, New York
"Beginnings and Landmarks: '291' 1905–1917" [The director of An American Place, Alfred Stieglitz, owned the two Picasso drawings shown in this exhibition. He had purchased them from exhibitions he had held in 1911 and 1914–15 at his first gallery, 291.]
Drawing [current title: *Standing Female Nude*],* 1910, [charcoal] (no. 38 in exh.) [Z.II¹.208; Metropolitan Museum of Art, New York]
Drawing [current title: *Bottle and Wine Glass on a Table*],* ca. 1913 [actual date: 1912, charcoal, ink, cut and pasted newspaper, and graphite on paper] (no. 39 in exh.) [Z.II².428; Metropolitan Museum of Art, New York]

November 1937: Valentine Gallery, New York
"Picasso Retrospective: From 1901 to 1937"
Chapeau rouge, 1934 (no. 1 in exh.) [Z.VIII.241; Pulitzer Foundation for the Arts, St. Louis, Missouri]
Portrait de femme, 1932 (no. 2 in exh.)
Nature morte, 1919 (no. 3 in exh.)
Nu, 1934 (no. 4 in exh.)
Baigneuses, 1932 (no. 5 in exh.)
Masque africain, 1929 (no. 6 in exh.)
Arlequin, 1923 (no. 7 in exh.)
Verre sur la table, 1922 (no. 8 in exh.)
Chanteuse en blanc, 1901 (no. 9 in exh.)
Femme à la draperie, 1921 (no. 10 in exh.)
Danseuse, Avignon, 1910 (no. 11 in exh.) [Z.II¹.35; private collection, New York]
Tête, Avignon, 1910 (no. 12 in exh.)
À la fontaine, 1921 (no. 13 in exh.)
Deux Nus, 1923 (no. 14 in exh.)
Marchand de fleurs, 1905 (no. 15 in exh.)
Baigneuses, 1908 (no. 16 in exh.)
Dinard, 1929 (no. 17 in exh.)
Deux Fillettes, 1934 (no. 18 in exh.) [Z.VIII.192; private collection]
Femme endormie, 1935 (no. 19 in exh.) [Z.VIII.266]
Le Compotier, 1923 (no. 20 in exh.)
Le Cirque, 1933 (no. 21 in exh.)
Paysage du midi, 1937 (no. 22 in exh.)
L'Arlésienne, 1937 (no. 23 in exh.)
Portrait of a Young Man, 1906 (unnumbered) [Z.VI.781 / This work was reportedly included in the exhibition, although it was not in the catalogue checklist.]
Blue Guitar, 1927–29 (unnumbered) [Z.VII.75 / This work was reportedly included in the exhibition, although it was not in the catalogue checklist.]

November 1–20, 1937: Jacques Seligmann & Co, New York
"20 Years in the Evolution of Picasso, 1903–1923"
La Jeune Fille [current title: *Woman with a Cape*], 1903, oil on canvas, 28 1/2 x 19 3/4 in. / Leonard C. Hanna, Jr., Cleveland (no. 1 in exh.; ill. in cat.) [Z.VI.542; Cleveland Museum of Art]
Le Meneur de cheval, 1905, oil on canvas, 87 x 51 in. / William S. Paley, New York (no. 2 in exh.; ill. in cat.) [Z.I.264; Museum of Modern Art, New York]
Tête d'Arlequin, 1905, oil on canvas, 16 x 12 1/2 in. (no. 3 in exh.; ill. in cat.)
Tête de garçon, 1905, gouache on cardboard, 12 3/4 x 9 1/2 in. (no. 4 in exh.; ill. in cat.) [Z.I.303; Cleveland Museum of Art]
Les Demoiselles d'Avignon, 1907, oil on canvas, 96 x 92 in. (no. 5 in exh.; ill. in cat.) [Z.II¹.18; Museum of Modern Art, New York]
Tête nègre [current title: *Bust of a Man*], 1907–8, oil on canvas, 24 3/8 x 17 in. / Walter P. Chrysler, Jr., New York (no. 6 in exh.) [Z.II¹.170; Metropolitan Museum of Art, New York]
Femme aux poires, 1908, oil on canvas, 36 x 28 3/4 in. / Walter P. Chrysler, Jr., New York (no. 7 in exh.; ill. in cat.) [Z.II¹.170; Museum of Modern Art, New York]
Homme avec une guitare, 1912, oil on canvas, 51 x 35 in. (no. 8 in exh.; ill. in cat.)

Composition cubiste, 1912, oil on canvas, 28 3/4 x 39 1/2 in. / Mr. and Mrs. W. A. Harriman (no. 9 in exh.) [Z.II¹.224]
Composition cubiste, 1912, oil on canvas, 25 1/2 x 19 3/4 in. (no. 10 in exh.; ill. in cat.)
Ma Jolie, 1914, oil on canvas, 18 x 21 1/2 in. (no. 11 in exh.; ill. in cat.) [Z.II².527; private collection]
Arlequin, 1918, oil on canvas, 56 1/2 x 28 in. / Mr. Joseph Pulitzer, Jr., St. Louis (no. 12 in exh.) [Z.III.159; Pulitzer Foundation for the Arts, St. Louis, Missouri]
La Première Communion, 1919, oil on canvas, 13 1/4 x 9 1/2 in. (no. 13 in exh.; ill. in cat.) [Z.III.286]
Study of a Hand, pastel on paper, 8 3/8 x 12 1/2 in. / Walter P. Chrysler, Jr., New York (no. 14 in exh.; ill. in cat.) [Z.IV.239]
Nature morte, 1921, oil on canvas, 40 x 40 in. (no. 15 in exh.; ill. in cat.)
Arlequin, 1923, oil on canvas, 51 1/2 x 38 1/2 in. (no. 16 in exh.; ill. in cat.)
Femme et enfant, 1923, oil on canvas, 51 1/2 x 38 1/4 in. / Walter P. Chrysler, Jr., New York (no. 17 in exh.; ill. in cat.) [Z.IV.455]

November 15–December 15, 1937: Los Angeles Art Association
"Loan Exhibition of International Art"
Old Woman, oil on canvas, 26 1/2 x 20 3/4 in. / Mr. and Mrs. Walter C. Arensberg, Hollywood (no. 170 in exh.) [Z.VI.389; Philadelphia Museum of Art]
Woman with Blue Turban, 1923, oil on canvas, 46 x 35 in. / Wright S. Ludington, Esq., Santa Barbara (no. 171 in exh.) [Z.V.22]

December 6–31, 1937: Perls Galleries, New York
"Holiday Exhibition 'For the Young Collector': Modern French Paintings"
Pierrot, 1923, drawing [medium not specified] (no. 25 in exh.)

December 6–23, 1937: Residence of Mrs. Cornelius J. Sullivan, New York
"French Paintings, Drawings and Lithographs"
Portrait (no. 27 in exh.)
Mère et enfant, [Blue Period, pen and watercolor, 18 1/2 x 12 3/4 in.] (no. 28 in exh.)
La Toilette, [1905, watercolor, 10 x 6 1/2 in.] (no. 29 in exh.) [This is a study for *La Toilette* in the collection of the Albright-Knox Art Gallery, Buffalo.]

1938

January 3–29, 1938: Perls Galleries, New York
"Pissarro to Utrillo: 'For the Young Collector'"
Tête d'une femme, oil (no. 14 in exh.)

January 3–29, 1938: Valentine Gallery, New York
"15 Selected Paintings by French XX Century Masters"
Baigneuses, 1923 (no. 8 in exh.) [Z.IV.169]
Compotier, 1923 (no. 9 in exh.)

January 4–29, 1938: Pierre Matisse Gallery, New York
"From Matisse to Miró: Recent Paintings"
Nature morte [current title: *Plaster Head and Bowl of Fruit*], 1933 / Mr. Joseph Pulitzer, Jr., St. Louis (no. 9 in exh.) [Z.VIII.84; Fogg Art Museum, Harvard University, Cambridge, Massachusetts]
Nus à la fenêtre, 1933 (no. 10 in exh.)
L'Arlésienne, 1937 (no. 11 in exh.)

January 5–29, 1938: Marie Harriman Gallery, New York
"French Paintings from the Collection of Dikran Kelekian"
Figure, pen drawing (no. 15 in exh.)

March 1–29, 1938: Wildenstein & Co., New York
"Great Portraits from Impressionism to Modernism"
Mme. Picasso and Child, 1922, oil on canvas, 39 1/2 x 32 in. / Mrs. W. Averell Harriman, New York (no. 30 in exh.) [Z.IV.370]
Portrait of a Boy (Le Garçon Bleu), 1905, gouache, 39 1/4 x 22 1/2 in. / Edward M. M. Warburg, New York (no. 31 in exh.) [Z.I.271]

Italienne, 1917, oil on canvas, 59 x 39 7/8 in. / Wildenstein & Co., New York (no. 32 in exh.) [Z.III.18]

Georges Braque, 1909, oil on canvas, 24 1/4 x 19 3/4 in. / Mr. Frank Crowninshield, New York (no. 33 in exh.; ill. in cat.) [Z.II¹.177; Staatliche Museen zu Berlin, Nationalgalerie, on permanent loan from the Berggruen Collection]

March 29–April 24, 1938: Museum of Modern Art Gallery, Washington, D.C.
"Flowers and Fruits"
Peonies / Mrs. Charles Goodspeed, Chicago (no. 37 in exh.) [Z.I.60; National Gallery of Art, Washington, D.C.]

April 10–May 1, 1938: Phillips Memorial Gallery, Washington, D.C.
"Picasso and Marin: An Exhibition"
Early Morning [current title: *The Blue Room*], 1901 / Phillips Collection, Washington, D.C. (no. 1 in exh.) [Z.I.103; Phillips Collection, Washington, D.C.]
Street in Barcelona, 1902 / Wildenstein & Co., New York (no. 2 in exh.) [Z.I.122]
Woman with Bang, 1902 / Miss Etta Cone, Baltimore (no. 3 in exh.) [Z.I.59; Baltimore Museum of Art]
Circus Horse in Action, 1905, drawing [medium not specified] / Miss Etta Cone, Baltimore (no. 4 in exh.) [Baltimore Museum of Art]
Circus Horse, 1905, drawing [medium not specified] / Miss Etta Cone, Baltimore (no. 5 in exh.) [Baltimore Museum of Art]
Bust of a Little Boy, 1905 / Miss Etta Cone, Baltimore (no. 6 in exh.) [Baltimore Museum of Art]
Lady with Fan, 1905 / Mrs. Marie Harriman, New York (no. 7 in exh.) [Z.I.308; National Gallery of Art, Washington, D.C.]
Jester and Boy, 1905 / Stephen C. Clark, New York (no. 8 in exh.) [Z.I.295]
Sketch for Flower Vendors / Valentine Gallery, New York (no. 10 in exh.) [Z.I.311; Metropolitan Museum of Art, New York]
Group of Jugglers, 1906 / Miss Etta Cone, Baltimore (no. 11 in exh.) [Baltimore Museum of Art]
Woman with Loaves, 1906 / Pennsylvania Museum of Art, Philadelphia (no. 12 in exh.) [Z.VI.735; Philadelphia Museum of Art]
Two Nudes, 1906 / Miss Etta Cone, Baltimore (no. 13 in exh.) [Z.XXII.411; Baltimore Museum of Art]
Standing Woman, 1906, pen drawing / Miss Etta Cone, Baltimore (no. 14 in exh.) [Baltimore Museum of Art]
Woman and Child, 1906, drawing [medium not specified] / Miss Etta Cone, Baltimore (no. 15 in exh.) [Baltimore Museum of Art]
Abstraction [current title: *Abstraction, Biarritz*], 1918 / Phillips Collection, Washington, D.C. (no. 16 in exh.) [Z.III.162; Phillips Collection]
Lady with Scarf, 1923 / Marie Harriman Gallery, New York (no. 17 in exh.)
Portrait of an Acrobat, 1923 / Marie Harriman Gallery, New York (no. 18 in exh.)
Studio Corner, 1921 / Phillips Collection, Washington, D.C. (no. 19 in exh.) [Z.IV.241; Phillips Collection]
Still Life, 1919 / Valentine Gallery, New York (no. 20 in exh.)
Standing Youth, 1922 / Stephen C. Clark, New York (no. 21 in exh.)
The Eggs, 1924 / Wildenstein & Co., New York (no. 22 in exh.) [Z.V.266]
Abstraction, 1924 / Miss Mary Hoyt Wiborg, New York (no. 23 in exh.) [Z.V.228]
Ovid's Metamorphosis, 1926 / Miss Etta Cone, Baltimore (no. 24 in exh.) [Baltimore Museum of Art]
Bull Fight, 1934 / Phillips Collection, Washington, D.C. (no. 25 in exh.) [Z.VIII.218; Phillips Collection]

April 28–May 30, 1938: Art Institute of Chicago
"The Seventeenth International Exhibition: Water Colors, Pastels, Drawings and Monotypes"
Study of Figures, pen and ink (no. 129 in exh.)
Woman in White, gouache (no. 130 in exh.)

August 2–22, 1938: San Francisco Museum of Art
"The Putzel Collection of French Modern Masters"

Abstraction, 1920, gouache
Composition with Guitar, 1920, gouache [Z.IV.41]
Classical drawing [medium not specified]
Still Life, 1937, oil on panel [Possibly misdated? If this work is actually from 1927 rather than 1937, it would be Z.VII.64.]

September 12–October 22, 1938: Perls Galleries, New York
"The School of Paris: Modern French Paintings 'For the Young Collector'"
La Maternité, 1906, oil (no. 1 in exh.)
Le Secret de la mer, 1905, watercolor, [14 1/4 x 10 1/4 in.] / Walter P. Chrysler, Jr., New York (no. 2 in exh.; ill. in cat.)
Les Jongleurs, 1905, gouache (no. 3 in exh.)
Le Jardin de Paris, 1902, watercolor (no. 4 in exh.) [Z.VI.367; Metropolitan Museum of Art, New York]

November 4–25, 1938: Arts Club of Chicago
"Loan Exhibition of Modern Paintings and Drawings from Private Collections in Chicago"
Élegie, oil / private collection (no. 98 in exh.)
Rider (Cavalier), drawing [medium not specified] / Mr. Shreve Cowles Badger (no. 99 in exh.)
Woman Reclining on a Divan, 1933, oil / Mr. Edward H. Bennett (no. 100 in exh.)
Portrait of Kahnweiler, (Cubist 1911), oil / Mrs. Charles B. Goodspeed (no. 101 in exh.) [Z.II.227; Art Institute of Chicago]
Harlequin, (Cubist 1911), oil / Mrs. Charles B. Goodspeed (no. 102 in exh.)
Flowers, (Blue Period), oil / Mrs. Charles B. Goodspeed (no. 103 in exh.) [Z.I.60; National Gallery of Art, Washington, D.C.]
Tricorne [current title: *Pierrot and Harlequin*], gouache / Mrs. Charles B. Goodspeed (no. 104 in exh.) [Z.IV.69; National Gallery of Art, Washington, D.C.]
Polichinelle et Arlequin, drawing [medium not specified] / Mrs. Charles B. Goodspeed (no. 105 in exh.) [Z.III.135; Art Institute of Chicago]
Head, drawing [pencil] / Mrs. Robert M. Hutchins (no. 106 in exh.)
Picasso et un ami, watercolor / Mrs. Winfield Scott Linn (no. 107 in exh.)
Woman Playing with Cats, oil / Mrs. Robert R. McCormick (no. 108 in exh.) [Z.I.93; Art Institute of Chicago]
Nurse and Child, oil / Mrs. Potter Palmer (no. 109 in exh.) [Z.I.80]
Femme en profile, [1901], drawing [watercolor, gouache, and pen and brown ink on cream laid paper] / Mrs. Potter Palmer (no. 110 in exh.) [Art Institute of Chicago]
Two Figures, 1925, drawing [medium not specified] / Mrs. Potter Palmer (no. 111 in exh.)

November 7–26, 1938: Valentine Gallery, New York
"Picasso: Twenty-One Paintings–1908 to 1934"
Compotier, 1908 (no. 1 in exh.)
Femme au poire, 1908 / Walter P. Chrysler, Jr., New York (no. 2 in exh.) [Z.II¹.70; Museum of Modern Art, New York]
Femme au paysage / Walter P. Chrysler, Jr., New York (no. 3 in exh.) [Z.II¹.150; private collection]
L'Indépendent, 1911 (no. 4 in exh.) [Z.II¹.264; private collection]
Le Poète, 1911 / George L. K. Morris, New York (no. 5 in exh.) [Z.II¹.285; Peggy Guggenheim Collection, Venice]
Guitare, 1917 (no. 6 in exh.)
Nature morte, 1917 (no. 7 in exh.)
Nature morte, 1922 / Walter P. Chrysler, Jr., New York (no. 8 in exh.) [Z.IV.427]
Le Compotier, 1922 (no. 9 in exh.)
La Nappe rouge, 1922 (no. 10 in exh.)
Grand Nature morte, 1922 (no. 11 in exh.)
Le Jour, 1925 / private collection (no. 12 in exh.)
La Statuaire, 1925 / private collection (no. 13 in exh.) [Z.V.451; private collection / The anonymous lender was Stephen C. Clark, New York.]
Nature morte, 1927 (no. 14 in exh.)
Femme assis, 1926 / Sidney Janis, New York (no. 15 in exh.) [Z.VII.60; Museum of Modern Art, New York]

Masque, 1929 (no. 16 in exh.)
Arlequin, 1929 (no. 17 in exh.)
Sculpture nègre, 1929 (no. 18 in exh.) [Z.VII.247]
Portrait, 1930 (no. 19 in exh.)
Artiste et modèle, 1934 (no. 20 in exh.)
Odalisque, 1934 / private collection (no. 21 in exh.)

November 28–December 15, 1938: Newhouse Galleries, New York
"French Modern Art Landscapes and Other Subjects" [This exhibition included several works by Picasso, but the exhibition checklist gave no titles, and none has been identified.]

December 13, 1938–January 3, 1939: Julien Levy Gallery, New York
"Documents of Cubism"
Abstract, 1911, oil (no. 1 in exh.)
Homme avec une guitare, 1912, oil (no. 2 in exh.)
Composition, 1920, gouache (no. 3 in exh.)

1939

January 1939: Pierre Matisse Gallery, New York
"Early Paintings by French Moderns"
Nu gris, 1905 (no. 13 in exh.) [Z.I.257; Musée National d'Art Moderne, Centre National d'Art et de Culture Georges Pompidou, Paris]
Le Jeune Mendiant, 1905 (no. 14 in exh.)

January 3–27, 1939: Arts Club of Chicago
"Exhibition of Drawings by Pablo Picasso Loaned by Mr. Walter P. Chrysler, Jr., New York"
Jeune Fille, pastel (no. 1 in exh.) [Z.IV.258]
Deux soeurs, pastel (no. 2 in exh.; ill. in cat.) [Z.IV.358]
La Répasseuse, pastel (no. 3 in exh.) [Z.I.248]
Interior, watercolor (no. 4 in exh.) [Z.II².567; private collection, New York]
Guitar on Table, [1921], gouache (no. 5 in exh.)
Nude, pencil drawing (no. 6 in exh.)
(no title), pastel drawing (no. 7 in exh.)
Seated Woman, [1927], demi-gouache (no. 8 in exh.)
Abstraction, [1921], watercolor (no. 9 in exh.)
Man at Table, pencil drawing (no. 10 in exh.) [Z.II².506; Museum of Modern Art, New York]
Compotier et guitare, [1921], gouache (no. 11 in exh.) [Z.IV.240]
Seated Man, [1914], watercolor (no. 12 in exh.)
Seated Figure and Head, [1930], ink and pencil (no. 13 in exh.)
La Source, [1921], pastel (no. 14 in exh.)
Woman in Studio, [1933], charcoal (no. 15 in exh.)
Two Nudes, [1923], pastel (no. 16 in exh.)
Nudes, [1923], charcoal (no. 17 in exh.)
Head of Boy, gouache (no. 18 in exh.)
Fête, watercolor (no. 19 in exh.) [Z.I.213]
Acrobats, [1923], ink wash (no. 20 in exh.)
Study of Hand, [1921], pastel (no. 21 in exh.) [Z.IV.239]
Figure, ink wash (no. 22 in exh.)
Head, [1926], pastel (no. 23 in exh.)
Two Nudes, [February 27, 1921], pencil drawing (no. 24 in exh.)
Secret de la mer, [1904], watercolor [14 1/4 x 10 1/4 in.] (no. 25 in exh.)

January 9–28, 1939: M. Knoedler & Co., New York
"Paintings of Views of Paris"
Sur le Pont, 24 1/4 x 15 1/2 in. / Art Institute of Chicago, Mr. and Mrs. L. L. Coburn Collection (no. 46 in exh.) [Z.XXI.168; Art Institute of Chicago]

January 29–February 26, 1939: Museum of Modern Art Gallery, Washington, D.C.
"Paris Painters of Today" [The announcement card for the exhibition indicates that the show included canvases by a large group of artists, including Picasso, although no specific titles have been identified.]

January 30–February 18, 1939: Marie Harriman Gallery, New York
"Figure Paintings: Picasso"
Lady with a Fan, 1905 / Mrs. W. Averell Harriman,

New York (no. 1 in exh.) [Z.I.308; National
Gallery of Art, Washington, D.C.]

Woman Combing Her Hair, 1906 (no. 2 in exh.)
[Z.I.336; Museum of Modern Art, New York]

Negro Head [current title: *Bust of a Man*], 1907–8 /
Walter P. Chrysler, Jr., New York (no. 3 in exh.)
[Z.II[1].76; Metropolitan Museum of Art, New York]

Dancer (Grand Danseuse d'Avignon), 1907–8 / Walter
P. Chrysler, Jr., New York (no. 4 in exh.) [Z.II[1].35;
private collection, New York]

Woman with Pears, 1908 / Walter P. Chrysler, Jr.,
New York (no. 5 in exh.) [Z.II[1].170; Museum of
Modern Art, New York]

The Poet (Le Poète), August 1911 / George L. K.
Morris, New York (no. 6 in exh.) [Z.II[1].285;
Peggy Guggenheim Collection, Venice]

Two Women (Deux Femmes nues) [current title: *Two
Female Nudes*], 1920 / Walter P. Chrysler, Jr., New
York (no. 7 in exh.) [Z.IV.217; Kunstsammlung
Nordrhein-Westfalen, Düsseldorf]

Mother and Child (Mère et enfant), 1922 / Mrs. W.
Averell Harriman, New York (no. 8 in exh.)
[Z.IV.370]

Woman with Blue Veil, 1923 (no. 9 in exh.) [Z.V.16;
Los Angeles County Museum of Art]

Seated Acrobat, 1923 (no. 10 in exh.)

February 18–October 29, 1939: Palace of Fine Arts,
San Francisco
"Golden Gate International Exposition: Contemporary
Art"

Guitar and Fruit, 1927 / Museum of Modern Art,
New York (no. 37 in exh.) [Z.V.268]

Life (La Vie), 1903 / Rhode Island School of
Design (no. 38 in exh.) [Z.I.179; Cleveland
Museum of Art]

Woman with Blue Turban, 1923 / Mr. S. Wright
Ludington, Santa Barbara (no. 39 in exh.) [Z.V.22]

Woman with a Crow, 1904, gouache / Toledo
Museum (no. 40 in exh.; ill. in cat.) [Z.I.240;
Toledo Museum of Art, Ohio]

February 19–March 12, 1939: Brooklyn Museum, New
York
"French Drawings from the Collection of Paul Sachs"

Female Nude Reclining, drawing [medium not
specified] (no. 11 in exh.) [Z.V.46; Fogg Art
Museum, Harvard University, Cambridge,
Massachusetts]

Philosopher, drawing [medium not specified] (no. 12
in exh.) [Z.III.256; Fogg Art Museum, Harvard
University, Cambridge, Massachusetts]

Portrait of the Artist Fonte, [ca. 1899–1900], drawing
[charcoal and oil-based wash on cream laid paper]
(no. 13 in exh.) [Fogg Art Museum, Harvard
University, Cambridge, Massachusetts]

Clown, drawing [medium not specified] (no. 14 in
exh.) [Z.III.126; Fogg Art Museum, Harvard
University, Cambridge, Massachusetts]

Bathers, drawing [medium not specified] (no. 15 in
exh.) [Z.III.233; Fogg Art Museum, Harvard
University, Cambridge, Massachusetts]

Mother and Child, drawing [medium not specified]
(no. 16 in exh.) [Z.I.220; Fogg Art Museum,
Harvard University, Cambridge, Massachusetts]

March 23–May 14, 1939: Art Institute of Chicago
"The Eighteenth International Exhibition: Water
Colors, Pastels, Drawings and Monotypes"

Dancers, ink / Mr. Walter P. Chrysler, Jr., New York
(no. 134 in exh.)

Jardin de Paris / Mr. Walter P. Chrysler, Jr., New
York (no. 135 in exh.) [Z.VI.367; Metropolitan
Museum of Art, New York]

The Jugglers / Mrs. Potter Palmer, Chicago
(no. 136 in exh.)

Nude, ink / Mrs. Potter Palmer, Chicago
(no. 137 in exh.)

Seated Figure of a Woman in Profile, pen and ink,
watercolor / Mrs. Potter Palmer, Chicago
(no. 138 in exh.) [Art Institute of Chicago]

March 27–April 29, 1939: Käthe Perls Galleries, New
York
"Picasso before 1910"

Le Vieux Musicien, 1900, pencil drawing / Walter P.

Chrysler, Jr., New York (no. 1 in exh.)

Danseuse espagnole, 1900, pastel / Elmer Rice
(no. 2 in exh.)

Chanteuse en blanc, 1901, pastel (no. 3 in exh.)

Au Moulin Rouge, 1901, watercolor (no. 4 in exh.;
ill. in cat.) [Z.VI.351]

Au Moulin de la Galette, 1901, watercolor
(no. 5 in exh.)

Deux Têtes et une main, 1901, pastel / Charles M. Ayer
(no. 6 in exh.)

Le Couple, 1901, pencil drawing (no. 7 in exh.)

La Jeune Bijou, 1902, pastel / Mrs. Dwight F. Davis
(no. 8 in exh.)

Au Théâtre, 1902, watercolor (no. 9 in exh.; ill. in cat.)

Le Mendiant, 1903, pen and ink / Walter P. Chrysler,
Jr., New York (no. 10 in exh.)

L'Hôtel de l'Ouest, 1904, gouache (no. 11 in exh.; ill.
in cat.) [Z.I.213]

Un Enterrement, 1904, watercolor (no. 12 in exh.)
[Z.VI.330]

La Répasseuse, 1904, pastel and gouache / Walter P.
Chrysler, Jr., New York (no. 13 in exh.) [Z.I.248]

Le Secret de la mer, 1904, watercolor, [14 1/4 x
10 1/4 in.] / Walter P. Chrysler, Jr., New York
(no. 14 in exh.)

Couple et enfant (Three Figures), [1904, pen, ink,
crayon, 10 1/2 x 8 1/4 in.] / Walter P. Chrysler, Jr.,
New York (no. 15 in exh.)

Femmes au bar, 1905, oil / Walter P. Chrysler, Jr.,
New York (no. 16 in exh.; ill. in cat.) [Z.I.132;
Hiroshima Museum of Art]

Jeune Arlequin, 1905, pencil drawing / Herman
Shulman (no. 17 in exh.)

Gamin, 1905, pencil drawing / Walter P. Chrysler,
Jr., New York (no. 18 in exh.)

Clown, 1906, pencil drawing (no. 19 in exh.)

Homme assis, 1906, pencil drawing / Lee A. Ault,
New Canaan, Connecticut (no. 20 in exh.)

Tête de jeune homme, 1906, gouache / Lee A. Ault,
New Canaan, Connecticut (no. 21 in exh.)
[Z.VI.781]

Négresse, 1907, pencil drawing / Lee A. Ault, New
Canaan, Connecticut (no. 22 in exh.) [Z.XXII.462]

Nu couché, 1907, ink / Walter P. Chrysler, Jr.,
New York (no. 23 in exh.) [Z.II[1].17]

Demoiselle d'Avignon, 1907, pastel / Walter P.
Chrysler, Jr., New York (no. 24 in exh.)
[Z.II[1].5; private collection, New York]

Nu, 1907, ink wash / Walter P. Chrysler, Jr., New York
(no. 25 in exh.)

Nu, 1910, watercolor (no. 26 in exh.)

April 10–29, 1939: M. Knoedler & Co., New York
"Classics of the Nude, Loan Exhibition: Pollaiuolo to
Picasso"

The Toilette / Albright Art Gallery, Buffalo (no. 31 in
exh.) [Z.I.325; Albright-Knox Art Gallery]

April 17–May 13, 1939: Bignou Gallery, New York
"Twentieth Century French Painters and Picasso"

Roses, 1901, oil on canvas, 13 3/4 x 16 1/2 in.
(no. 13 in exh.; ill. in cat.) [Z.I.9]

Tête, 1906–7, oil on canvas, 21 1/4 x 15 3/4 in.
(no. 14 in exh.)

Le Compotier, 1908, oil on canvas, 28 3/4 x 23 3/8 in.
(no. 15 in exh.) [Z.II[1].121; Museum of Modern Art,
New York]

Femme au bouquet, 1909, oil on canvas, 22 7/8 x
19 3/4 in. (no. 16 in exh.)

Abstraction, 1930, panel, 19 1/4 x 26 in. (no. 17 in
exh.) [Cincinnati Art Museum]

Le Corsage jaune, 1937, oil on canvas, 21 5/8 x
18 1/8 in. (no. 18 in exh.)

La Lecture, 1938, oil on canvas, 27 1/8 x 21 5/8 in.
(no. 19 in exh.)

Le Chapeau vert, September 6, 1938, oil on canvas,
25 3/8 x 19 1/2 in. (no. 20 in exh.; ill. in cat.)

April 24–May 5, 1939: Valentine Gallery, New York
"XX Selected Paintings by XX Century French Moderns"

Mère et enfant, 1903 (no. 9 in exh.)

L'Indépendent, 1914 (no. 10 in exh.)

À la fontaine, 1921 (no. 11 in exh.)

L'Atelier, 1928 (no. 12 in exh.)

April 25–May 20, 1939: Wildenstein Gallery, New York
"The Sources of Modern Painting"

Les Oeufs, 1924, oil on canvas, 15 x 18 in. (no. 12 in
exh.; ill. in cat.) / Wildenstein & Co., New York
[Z.V.266]

Woman with Pears (La Femme aux poires), 1908, oil
on canvas, 36 x 28 3/4 in. / Walter P. Chrysler,
New York (no. 14 in exh.; ill. in cat.) [Z.II[1].170;
Museum of Modern Art, New York]

Harlequin, 1918, oil on canvas, 58 x 26 1/2 in. /
Joseph Pulitzer, Jr., St. Louis (no. 15 in exh.; ill.
in cat.) [Z.III.159; Pulitzer Foundation for the
Arts, St. Louis, Mo.]

Still Life, 1924, oil on canvas, 40 x 62 1/4 in. /
anonymous loan (no. 16 in exh.; ill. in cat.)
[Z.V.228]

Negro Head [current title: *Bust of a Man*], 1907–8,
oil on canvas, 24 3/4 x 17 in. / Walter P. Chrysler,
Jr., New York (no. 31 in exh.; ill. in cat.)
[Z.II[1].76; Metropolitan Museum of Art, New York]

Dancer [current title: *Nude with Raised Arms (The
Dancer of Avignon)*], 1907–8, oil on canvas, 59 x
39 1/4 in. / Walter P. Chrysler, Jr., New York (no.
33 in exh.; ill. in cat.) [Z.II[1].35; private collection,
New York]

Female Head, 1921, pastel, 25 1/4 x 19 1/4 in. /
Courtesy of the Worcester Art Museum (no. 41 in
exh.; ill. in cat.) [Z.IV.346; Metropolitan Museum
of Art, New York / The source of the loan was
Scofield Thayer's Dial Collection, on deposit at
the Worcester Art Museum from 1926 until it
went by his bequest to the Metropolitan Museum
of Art in 1984.]

May 5–June 1, 1939: Valentine Gallery, New York
"The Masterpiece *Guernica* by Pablo Picasso, together
with Drawings and Studies"; traveled to Stendahl Art
Galleries, Los Angeles, August 10–21, 1939, and to the
Arts Club of Chicago, October 2–10, 1939 [The
Valentine Gallery published an exhibition pamphlet
(also used by the Arts Club of Chicago for their exhi-
bition) that contains three illustrations, but does not
itemize the works that were on view or even specify
how many drawings and studies were exhibited. The
Stendahl Art Galleries' pamphlet notes that there were
"sixty-three related paintings and drawings" exhib-
ited, but does not list them. Because there were
approximately thirty later sketches of the "weeping
woman," which Picasso completed after he finished
Guernica, there is some confusion about the total
number of studies and related pieces for the painting
and, consequently, about which pieces were included
on this tour. The following list contains fifty-nine of
them. To provide some clarification, I have included
current titles and sketch numbers assigned to the
works by Herschel B. Chipp in his authoritative
book on the painting, *Picasso's Guernica: History,
Transformations, Meanings*. Note that the order of
these works in this entry is based on the date of the
work and the sketch numbers assigned by Chipp.]

Guernica, 1937 (ill. in cat.) [Z.IX.65; Museo Nacional
Centro de Arte Reina Sofia, Madrid]

Composition Study, May 1, 1937, pencil on blue
paper, 8 1/4 x 10 5/8 in. [Sketch 1 / Z.IX.1; Museo
Nacional Centro de Arte Reina Sofia, Madrid]

Composition Study, May 1, 1937, pencil on blue
paper, 8 1/4 x 10 5/8 in. [Sketch 2 / Z.IX.2; Museo
Nacional Centro de Arte Reina Sofia, Madrid]

Composition Study, May 1, 1937, pencil on blue
paper, 8 1/4 x 10 5/8 in. [Sketch 3 / Z.IX.3; Museo
Nacional Centro de Arte Reina Sofia, Madrid]

Composition Study [current title: *Horse*], May 1, 1937,
pencil on blue paper, 8 1/4 x 10 5/8 in. [Sketch 4
/ Z.IX.4; Museo Nacional Centro de Arte Reina
Sofia, Madrid]

Study for the Horse, May 1, 1937, pencil on blue
paper, 8 1/4 x 10 1/2 in. [Sketch 5 / Z.IX.5; Museo
Nacional Centro de Arte Reina Sofia, Madrid]

Composition Study, May 1, 1937, pencil on gesso,
21 1/8 x 25 1/2 in. [Sketch 6 / Z.IX.10; Museo
Nacional Centro de Arte Reina Sofia, Madrid]

Study for the Horse, May 1, 1937, pencil on blue
paper, 8 1/4 x 28 3/4 in. [This drawing is not
included in Chipp's book.]

Study for Horse's Head [current title: *Head of Horse*],
May 2, 1937, pencil on blue paper, 10 1/2 x 8 1/4 in.

[Sketch 7 / Z.IX.6; Museo Nacional Centro de Arte Reina Sofía, Madrid]

Study for Horse's Head [current title: *Head of Horse*], May 2, 1937, pencil on blue paper, 8 1/4 x 6 in. [Sketch 8 / Z.IX.7; Museo Nacional Centro de Arte Reina Sofía, Madrid]

Horse's Head [current title: *Head of Horse*], May 2, 1937, oil on canvas, 25 1/2 x 36 1/4 in. (ill. in cat.) [Sketch 9 / Z.IX.11; Museo Nacional Centro de Arte Reina Sofía, Madrid]

Horse and Bull, early May 1937, pencil on tan paper [ochre cardboard], 8 7/8 x 4 3/4 in. [Sketch 11 / Z.IX.9; Museo Nacional Centro de Arte Reina Sofía, Madrid]

Composition Study, May 8, 1937, pencil on white paper, 9 1/2 x 17 7/8 in. [Sketch 12 / Z.IX.13; Museo Nacional Centro de Arte Reina Sofía, Madrid]

Horse and Woman with Dead Child, May 8, 1937, pencil on white paper, 9 1/2 x 17 7/8 in. [Sketch 13 / Z.IX.12; Museo Nacional Centro de Arte Reina Sofía, Madrid]

Woman with Dead Child, May 9, 1937, ink on white paper, 9 1/2 x 17 7/8 in. [Sketch 14 / Z.IX.14; Museo Nacional Centro de Arte Reina Sofía, Madrid]

Composition Study, May 9, 1937, pencil, 9 1/2 x 17 7/8 in. [Sketch 15 / Z.IX.18; Museo Nacional Centro de Arte Reina Sofía, Madrid]

Woman with Dead Child on Ladder, May 9, 1937, pencil on white paper, 17 7/8 x 9 1/2 in. [Sketch 16 / Z.IX.16; Museo Nacional Centro de Arte Reina Sofía, Madrid]

Studies for the Horse [current title: *Horse*], May 10, 1937, pencil on white paper, 9 1/2 x 17 7/8 in. [Sketch 17 / Z.IX.17; Museo Nacional Centro de Arte Reina Sofía, Madrid]

Leg and Heads of Horses, May 10, 1937, pencil, 17 7/8 x 9 1/2 in. [Sketch 18 / Z.IX.21; Museo Nacional Centro de Arte Reina Sofía, Madrid]

Bull's Head [current title: *Head of a Man with Bull's Horns*], May 10, 1937, pencil on white paper, 17 7/8 x 9 1/2 in. [Sketch 19 / Z.IX.20; Museo Nacional Centro de Arte Reina Sofía, Madrid]

Horse, May 10, 1937, pencil and color crayon on white paper, 9 1/2 x 17 7/8 in. [Sketch 20 / Z.IX.19; Museo Nacional Centro de Arte Reina Sofía, Madrid]

Woman with Dead Child [current title: *Mother with Dead Child on Ladder*], May 10, 1937, color crayon and pencil on white paper, 17 7/8 x 9 1/2 in. [Sketch 21 / Z.IX.15; Museo Nacional Centro de Arte Reina Sofía, Madrid]

Bull [current title: *Bull with Human Head*], May 11, 1937, pencil on white paper, 9 1/2 x 17 7/8 in. [Sketch 22 / Z.IX.23; Museo Nacional Centro de Arte Reina Sofía, Madrid]

Head [current title: *Head of Woman*], May 13, 1937, pencil and color crayon on white paper, 17 7/8 x 9 1/2 in. [Sketch 23 / Z.IX.22; Museo Nacional Centro de Arte Reina Sofía, Madrid]

Hand with Broken Sword [current title: *Hand of Warrior with Broken Sword*], May 13, 1937, pencil on white paper, 9 1/2 x 17 7/8 in. [Sketch 24 / Z.IX.24; Museo Nacional Centro de Arte Reina Sofía, Madrid]

Woman with Dead Child, May 13, 1937, color crayon and pencil on white paper, 9 1/2 x 17 7/8 in. [Sketch 25 / Z.IX.25; Museo Nacional Centro de Arte Reina Sofía, Madrid]

Study for Bull's Head [current title: *Sketch of a Head of a Bull-Man*],* May 20, 1937, pencil on gray tinted paper, [9 x 11 5/16 in. Sketch 26 / Z.IX.28; Museo Nacional Centro de Arte Reina Sofía, Madrid]

Study for Bull's Head [current title: *Head of Bull-Man with Studies of Eyes*], May 20, 1937, pencil [and gouache] on gray tinted paper, 9 1/4 x 11 1/2 in. [Sketch 27 / Z.IX.29; Museo Nacional Centro de Arte Reina Sofía, Madrid]

Horse's Head [current title: *Head of Horse*], May 20, 1937, pencil and gouache on white paper, 11 1/2 x 9 1/4 in. [Sketch 28 / Z.IX.27; Museo Nacional Centro de Arte Reina Sofía, Madrid]

Head of Horse, May 20, 1937, pencil and gouache,

9 1/4 x 11 1/2 in. [Sketch 29 / Z.IX.26; Museo Nacional Centro de Arte Reina Sofía, Madrid]

Head of Woman, May 20, 1937, pencil and gouache on white paper, 11 1/2 x 9 1/4 in. [Sketch 30 / Z.IX.32; Museo Nacional Centro de Arte Reina Sofía, Madrid]

Head [current title: *Head of Weeping Woman*], May 24, 1937, pencil and gouache on white paper, 11 1/2 x 9 1/4 in. [Sketch 31 / Z.IX.31; Museo Nacional Centro de Arte Reina Sofía, Madrid]

Head [current title: *Sketch of a Head of Weeping Woman (II)*],* May 24, 1937, pencil and gouache on white paper, [11 5/16 x 9 in. Sketch 32 / Z.IX.33; Museo Nacional Centro de Arte Reina Sofía, Madrid]

Head [current title: *Head of Fallen Figure (woman?)*], May 24, 1937, pencil and gouache on white paper, 9 1/4 x 11 1/2 in. [Sketch 33 / Z.IX.30; Museo Nacional Centro de Arte Reina Sofía, Madrid]

Head [current title: *Head of Weeping Woman*, May 27, 1937, pencil on gray paper, 9 1/4 x 11 1/2 in. [Sketch 34 / Z.IX.36; Museo Nacional Centro de Arte Reina Sofía, Madrid]

Man [current title: *Falling Man*], May 27, 1937, pencil and gouache on white paper, 9 1/4 x 11 1/2 in. [Sketch 35 / Z.IX.34; Museo Nacional Centro de Arte Reina Sofía, Madrid]

Woman with Dead Child [current title: *Mother with Dead Child*], May 28, 1937, pencil, ink, and gouache on gray paper, 9 1/4 x 11 1/2 in. [Sketch 36 / Z.IX.38; Museo Nacional Centro de Arte Reina Sofía, Madrid]

Woman with Dead Child [current title: *Mother and Dead Child (IV)*],* May 28, 1937, pencil, color crayon, and oil [and hair] on white paper, [9 x 11 5/16 in. Sketch 37 / Z.IX.37; Museo Nacional Centro de Arte Reina Sofía, Madrid]

Head [current title: *Head of Weeping Woman*], May 28, 1937, pencil, color crayon, and gouache on white paper, 9 1/4 x 11 1/2 in. [Sketch 38 / Z.IX.35; Museo Nacional Centro de Arte Reina Sofía, Madrid]

Head [current title: *Head of Weeping Woman (III)*],* May 31, 1937, pencil, color crayon, and gouache on white paper, [9 x 11 5/16 in. Sketch 39 / Z.IX.39; Museo Nacional Centro de Arte Reina Sofía, Madrid]

Weeping Head [current title: *Head of Weeping Woman*], June 3, 1937, pencil and color crayon [and gouache] on white paper, 9 1/4 x 11 1/2 in. [Sketch 40 / Z.IX.40; Museo Nacional Centro de Arte Reina Sofía, Madrid]

Weeping Head [current title: *Head of Weeping Woman*], June 3, 1937, pencil and color crayon [and gouache] on white paper, 9 1/4 x 11 1/2 in. [Sketch 41 / Z.IX.44; Museo Nacional Centro de Arte Reina Sofía, Madrid]

Weeping Head [current title: *Head of Weeping Woman*], June 3, 1937, pencil and color crayon [and gouache] on white paper, 9 1/4 x 11 1/2 in. [Sketch 42 / Z.IX.41; Museo Nacional Centro de Arte Reina Sofía, Madrid]

Head and Horse's Hoofs [current title: *Head of Warrior and Horse's Hoof*], June 3, 1937, pencil and gouache on white paper, 9 1/4 x 11 1/2 in. [Sketch 43 / Z.IX.45; Museo Nacional Centro de Arte Reina Sofía, Madrid]

Head [current title: *Head of Warrior*], June 4, 1937, pencil and gouache on white paper, 9 1/4 x 11 1/2 in. [Sketch 44 / Z.IX.42; Museo Nacional Centro de Arte Reina Sofía, Madrid / According to Chipp (p. 133), this is the last dated sketch to be incorporated into the final painting.]

Head, June 4, 1937, pencil and gouache on white paper, 9 1/4 x 11 1/2 in. [Not in Chipp.]

Head, June 8, 1937, pencil and color crayon on white paper, 11 1/2 x 9 1/4 in. [Museo Nacional Centro de Arte Reina Sofía, Madrid / Not in Chipp.]

Head, June 8, 1937, pencil and color crayon on white paper, 11 1/2 x 9 1/4 in. [Museo Nacional Centro de Arte Reina Sofía, Madrid/ Not in Chipp.]

Head [current title: *Head of Weeping Woman*], June 13, 1937, pencil and color crayon [and gouache] on white paper, 11 1/2 x 9 1/4 in. [Sketch 48 / Z.IX.47; Museo Nacional Centro de Arte Reina Sofía, Madrid / Despite Chipp's note about Sketch 44

being the last dated one in the series, he called this work Sketch 48 (possibly erroneously?).]

Weeping Head, June 15, 1937, pencil and oil on canvas, 21 5/8 x 18 1/8 in.

Weeping Head, June 21, 1937, oil on canvas, 21 5/8 x 18 1/8 in.

Woman, June 22, 1937, pencil and oil on canvas, 21 5/8 x 18 1/8 in.

Weeping Head, June 22, 1937, pencil and gouache on cardboard, 4 5/8 x 3 1/2 in.

Weeping Woman, June 26, 1937, gouache and colored pencil on canvas (ill. in cat.) [This work is illustrated in the Valentine Gallery and Stendahl Galleries pamphlets; however, it was not included in the 1939–40 MoMA exhibition, and it is not included in Chipp's book.]

Weeping Head, July 4, 1937, ink on white paper, 10 x 6 3/4 in.

Weeping Head, July 6, 1937, ink on tan paper, 6 x 4 1/2 in.

Composition Study, September 26, 1937, oil on canvas, 76 3/4 x 51 1/4 in. [Museo Nacional Centro de Arte Reina Sofía, Madrid]

Head, October 12, 1937, pencil and ink on white paper, 35 3/8 x 23 in. [Museo Nacional Centro de Arte Reina Sofía, Madrid]

Head, October 13, 1937, ink and oil on canvas, 21 5/8 x 18 1/8 in. [Museo Nacional Centro de Arte Reina Sofía, Madrid]

Head, October 17, 1937, oil on canvas, 36 1/4 x 28 5/8 in. [Z.IX.77; Museo Nacional Centro de Arte Reina Sofía, Madrid]

May 8–30, 1939: Uptown Gallery, New York ["Masters of Modern French Painting" / This exhibition included several drawings by Picasso, although no specific titles of works have been identified.]

May 9–June 16, 1939: Bucholz Gallery, New York ["Contemporary European Sculpture, Paintings" / This exhibition included two works by Picasso that were described in a review as "whitecoated gouache abstractions of 1922." However, no specific titles of works have been identified.]

May 10–September 30, 1939: Museum of Modern Art, New York
"Art in Our Time: An Exhibition to Celebrate the tenth anniversary of the Museum of Modern Art and the opening of its new building"

Two Women at a Bar, 1902, [oil], 31 1/2 x 36 in. / Walter P. Chrysler, Jr., New York (no. 153 in exh.; ill. in cat.) [Z.I.132; Hiroshima Museum of Art]

Youth, 1905, gouache, 40 x 22 1/2 in. / Edward M. M. Warburg, New York (no. 154 in exh.; ill. in cat.) [Z.I.271]

Two Acrobats (Deux Saltimbanques au chien), 1905, gouache, 41 1/2 x 29 1/2 in. / Thannhauser Gallery, Paris (no. 155 in exh.; ill. in cat.) [Z.I.300; Museum of Modern Art, New York]

Youth Leading a Horse, 1905, [oil], 86 1/2 x 51 1/4 in. / William S. Paley, New York (no. 156 in exh.) [Z.I.264; Museum of Modern Art, New York]

Les Demoiselles d'Avignon, 1906–7, [oil], 96 x 92 in. / Museum of Modern Art (no. 157 in exh.; ill. in cat.) [Z.II¹.18; Museum of Modern Art, New York]

The Poet, 1911, [oil], 51 1/2 x 35 1/4 in. / George L. K. Morris, New York (no. 158 in exh.; ill. in cat.) [Z.II¹.285; Peggy Guggenheim Collection, Venice]

Harlequin, 1918, [oil], 56 x 39 1/2 in. / Paul Rosenberg, Paris (no. 159 in exh.; ill. in cat.)

Woman in White,* 1923, [oil], 39 x 31 1/2 in. / Museum of Modern Art (no. 160 in exh.; ill. in cat.) [Z.V.1; Metropolitan Museum of Art, New York]

Seated Woman [also known as *Femme Assise*],* 1927, [oil], 51 1/2 x 38 1/2 in. / Museum of Modern Art, anonymous gift (no. 161 in exh.; ill. in cat.) [Z.VII.81; Art Gallery of Ontario, Toronto]

Portrait, 1938, [oil], 28 1/2 x 24 1/4 in. / Walter P. Chrysler, Jr., New York (no. 162 in exh.; ill. in cat.) [Z.IX.157]

The Mirror [current title: *Girl Before a Mirror*], 1932, [oil], 63 3/4 x 51 1/4 in. / Museum of Modern Art, Mrs. Simon G. Guggenheim gift (no. 163 in exh.; ill. in cat.) [Z.VII.379; Museum of Modern Art, New York]

May 22–October 1, 1939: Marie Harriman Gallery, New York
"Modern French Masters: Important Paintings"
Lady with a Fan, 1905 (no. 9 in exh.) [Z.I.308; National Gallery of Art, Washington, D.C.]

June–October 1939: Pierre Matisse Gallery, New York
"Summer Exhibition by French Moderns"
L'Arlésienne, (1911) (no. 12 in exh.) [Z.II¹.356; private collection]

July 1–September 20, 1939: Los Angeles County Museum
"The Maitland Collection"
Femme sur une terrasse, August 1933, watercolor, 13 1/4 x 18 in. (no. 47 in exh.)
Nude on Beach, pastel, 18 1/2 x 24 1/2 in. (no. 49 in exh.)

October 31–November 25, 1939: Bucholz Gallery, New York
"Sculpture by Painters"
Page d'études, drawing [medium not specified] (no. 39 in exh.)
Les Pauvres, watercolor (no. 40 in exh.)
Painter and Model, drawing [medium not specified] (no. 41 in exh.)
Nudes at the Beach, drawing [medium not specified] (no. 42 in exh.)
Nudes, drawing [medium not specified] (no. 43 in exh.)

November 1939: Pierre Matisse Gallery, New York
"Modern French Painting"
Arlésienne (no. 1 in exh.)

November 13–December 2, 1939: Perls Galleries, New York
"Drawings by Picasso 'For the Young Collector'" [A printed card announcing this exhibition includes illustrations of three works by Picasso, although no specific titles have been identified.]

November 15, 1939–January 7, 1940: Museum of Modern Art, New York
"Picasso: Forty Years of his Art"; traveled to the Art Institute of Chicago, February 1–March 3, 1940; and to San Francisco Museum of Art, June 25–July 22, 1940, as "Pablo Picasso" [Because of the war, shipping works of art became difficult, if not impossible, particularly with overseas shipments. This meant that some of the works that appear in the catalogue could not be exhibited. While a few of these pieces belonged to local collections–including the Museum of Modern Art–the reason for their exclusion from the exhibition is unclear. Note: Only some of the works traveled to San Francisco; these are indicated by the phrase "shown in San Francisco"; there were also four works that were shown only in San Francisco, and not in New York or Chicago.]
Roses, 1898, oil, 14 1/4 x 16 3/4 in. / Bignou Gallery, New York (no. 1 in exh.) [Z.I.9]
The Artist's Sister, Barcelona, 1899, oil, 59 x 39 1/2 in. / Pablo Picasso (no. 2 in exh.)
Self-Portrait, Madrid, 1900, conté crayon, 13 1/2 x 6 in. / Justin K. Thannhauser, New York (no. 3 in exh.; ill. in cat.) [Z.I.45]
Heads and Figures (Scène de bar), page from a sketchbook, Paris, 1900?, conté crayon, 5 1/8 x 8 1/4 in. / Walter P. Chrysler, Jr., New York (no. 4 in exh.) [Z.VI.327]
Le Moulin de la Galette, Paris, 1900, oil on canvas, 35 1/4 x 45 3/4 in. / Justin K. Thannhauser, New York (no. 5 in exh.; ill. in cat.) [Z.I.41; Solomon R. Guggenheim Museum, New York]
Old Musician, 1900?, pencil, 17 1/8 x 11 3/8 in. / Walter P. Chrysler, Jr., New York (no. 6 in exh.)
Paris Street, Paris, 1900, oil, 18 1/2 x 26 in. / Miss Harriet Levy, Berkeley, California (no. 7 in exh.; ill. in cat.) [Z.VI.302; San Francisco Museum of Modern Art]
Two Women and a Hand, 1901?, black and color crayon, 5 1/4 x 7 1/2 in. / Perls Galleries, New York (no. 8 in exh.)
On the Upper Deck, Paris, 1901, oil, 19 1/8 x 25 1/4 in. / Art Institute of Chicago, Mr. and Mrs. L. L. Coburn

Collection (no. 9 in exh.; ill. in cat.) [Z.XXI.168; Art Institute of Chicago]
Bull Ring, Paris?, 1901, pastel, 7 1/8 x 9 1/2 in. / Justin K. Thannhauser, New York (no. 10 in exh.) [Z.VI.379; Solomon R. Guggenheim Museum, New York]
Chrysanthemums, Paris, 1901?, oil, 32 x 25 3/4 in. / Walter P. Chrysler, Jr., New York (no. 11 in exh.; ill. in cat.; shown in San Francisco) [Z.VI.647; Philadelphia Museum of Art]
Harlequin, Paris, 1901, oil, 31 1/2 x 23 3/4 in. / Mr. and Mrs. Henry Clifford, Radnor, Pennsylvania (no. 12 in exh.; ill. in cat.) [Z.I.79; Metropolitan Museum of Art, New York]
Burial, Paris, 1901?, pencil and watercolor, 16 3/4 x 19 1/2 in. / Walter P. Chrysler, Jr., New York (no. 13 in exh.; ill. in cat.) [Z.VI.330]
"Jardin Paris," design for a poster, Paris, 1901-2, watercolor, 25 1/8 x 19 1/4 in. / Walter P. Chrysler, Jr., New York (no. 14 in exh.; ill. in cat.) [Z.VI.367; Metropolitan Museum of Art, New York]
The Blue Room (Le Tub; Interior with a Bather; Early Morning), Paris, 1901, oil, 20 x 24 1/4 in. / Phillips Memorial Gallery, Washington, D.C. (no. 15 in exh.; ill. in cat.) [Z.I.103; Phillips Collection]
Woman with Folded Arms (Elégie), Paris, 1901, oil, 31 7/8 x 23 in. / Mr. and Mrs. Chauncey McCormick, Chicago (no. 16 in exh.; ill. in cat.; shown in San Francisco) [Z.I.105]
Mother and Child, Paris, 1901, oil, 44 1/4 x 38 1/2 in. / Maurice Wertheim (no. 17 in exh.; ill. in cat.) [Z.I.115; Fogg Art Museum, Harvard University, Cambridge, Massachusetts]
Two Women at a Bar, Barcelona, 1902, oil, 31 1/2 x 36 in. / Walter P. Chrysler, Jr., New York (no. 18 in exh.; ill. in cat.) [Z.I.132; Hiroshima Museum of Art]
La Vie (Couple nu et femme avec enfant), Barcelona, 1903, oil, 77 3/8 x 50 7/8 in. / Museum of the Rhode Island School of Design, Providence (no. 19 in exh.; ill. in cat.; shown in San Francisco) [Z.I.179; Cleveland Museum of Art]
The Old Guitarist, Barcelona, 1903, oil on panel, 47 3/4 x 32 1/2 in. / Art Institute of Chicago, Helen Birch-Bartlett Memorial Collection (no. 20 in exh.; ill. in cat.) [Z.I.202; Art Institute of Chicago]
Street Urchins (Les va-nu-pieds; Enfants de la rue), Barcelona, 1903, color crayon, 14 1/4 x 10 1/2 in. / Justin K. Thannhauser, New York (no. 21 in exh.)
Beggar, 1903?, ink and pencil, 12 1/4 x 4 5/8 in. / Walter P. Chrysler, Jr., New York (no. 22 in exh.; ill. in cat.)
Mother and Child, Paris, 1904, black crayon, 13 1/2 x 10 1/2 in. / Fogg Art Museum, Harvard University, Cambridge, Paul J. Sachs Collection (no. 23 in exh.; ill. in cat.) [Z.I.220; Fogg Art Museum]
Woman with a Helmet of Hair (Head of Acrobat's Wife), Paris, 1904, gouache, 16 1/2 x 12 in. / Mr. and Mrs. Walter S. Brewster, Chicago (no. 24 in exh.; ill. in cat.) [Z.I.233; Art Institute of Chicago]
Woman with a Crow, Paris, 1904, gouache and pastel, 25 1/2 x 19 1/2 in. / Toledo Museum of Art (no. 25 in exh.; ill. in cat.) [Z.I.240; Toledo Museum of Art, Ohio]
Woman Ironing, Paris, 1904, oil, 46 1/8 x 29 1/8 in. / Justin K. Thannhauser, New York (no. 27 in exh.; ill. in cat.) [Z.I.247; Solomon R. Guggenheim Museum, New York]
"Esquisse pour Hôtel de l'Ouest . . . Chambre 22," Paris, 1904, watercolor, 21 3/8 x 16 3/4 in. / Walter P. Chrysler, Jr., New York (no. 28 in exh.) [Z.I.213]
The Actor, Paris, winter 1904-5, oil, 77 1/4 x 45 1/8 in. / Rosenberg & Helft Ltd., London (no. 29 in exh.; ill. in cat.; shown in San Francisco) [Z.I.291; Metropolitan Museum of Art, New York]
Blue Boy, Paris, 1905, gouache, 40 x 22 1/2 in. / Edward M. M. Warburg, New York (no. 30 in exh.; ill. in cat.) [Z.I.271]
Two Acrobats with a Dog, Paris, 1905, gouache, 41 1/4 x 29 1/2 in. / Justin K. Thannhauser, New York (no. 31 in exh.; ill. in cat.) [Z.I.300; Museum of Modern Art, New York]
The Harlequin's Family, Paris, 1905, gouache, 23 x 17 1/4 in. / Samuel A. Lewisohn, New York (no.

47 in exh.; ill. in cat.) [Z.I.298; private collection]
Cocks, 1905?, gouache, 8 3/4 x 9 5/8 in. / Miss Harriet Levy, Berkeley, California (no. 48 in exh.; ill. in cat.) [Z.VI.725; San Francisco Museum of Modern Art]
"Danse barbare," 1905?, ink, 15 3/4 x 6 1/2 in. / Miss Harriet Levy, Berkeley, California (no. 49 in exh.) [Z.VI.812; San Francisco Museum of Modern Art]
"EX-LIBRIS: Guillaume Apollinaire," Paris, 1905, ink and watercolor, 7 1/2 x 4 3/4 in. / Walter P. Chrysler, Jr., New York (no. 50 in exh.) [Z.I.225]
La Coiffure, Paris, 1905, oil, 68 7/8 x 39 1/4 in. / Museum of Modern Art, New York (no. 51 in exh. cat.) [Z.I.313; Metropolitan Museum of Art, New York / This work appears in the exhibition catalogue, but could not be included in the exhibition due to shipping complications caused by the war.]
The Watering Place (Chevaux au bain; L'Abreuvoir), Paris, 1905, gouache, 14 7/8 x 23 in. / anonymous loan through the Worcester Art Museum (no. 52 in exh.; ill. in cat.) [Z.I.265; Metropolitan Museum of Art, New York / The source of the anonymous loan was Scofield Thayer's Dial Collection, on deposit at the Worcester Art Museum from 1926 until it went by his bequest to the Metropolitan Museum of Art in 1984.]
Youth on Horseback, Paris, 1905, charcoal, 18 3/8 x 12 in. / John W. Warrington, Cincinnati (no. 53 in exh.; ill. in cat.) [Z.VI.682]
Boy Leading a Horse (Le Meneur de cheval), Paris, 1905, oil, 86 1/2 x 51 1/4 in. / William S. Paley, New York (no. 54 in exh.; ill. in cat.; shown in San Francisco) [Z.I.264; Museum of Modern Art, New York]
Woman with a Fan (Femme au bras levé), Paris, 1905, oil, 39 1/2 x 32 in. / Mr. and Mrs. W. Averell Harriman, New York (no. 55 in exh.; ill. in cat.; shown in San Francisco) [Z.I.308; National Gallery of Art, Washington, D.C.]
Woman with Loaves, Gosol, 1905, oil, 39 x 27 1/2 in. / Philadelphia Museum of Art (no. 56 in exh.; ill. in cat.; shown in San Francisco) [Z.VI.735; Philadelphia Museum of Art]
La Toilette, Gosol, 1905 [actual date: 1906], oil, 59 1/2 x 39 1/2 in. / Buffalo Fine Arts Academy, Albright Art Gallery, Buffalo (no. 57 in exh.; ill. in cat.) [Z.I.325; Albright-Knox Art Gallery]
Fernande Olivier, Paris, 1905 or Gosol, summer 1906, oil, 39 3/8 x 31 7/8 in. / anonymous loan (no. 58 in exh.; ill. in cat.)
Standing Nude, Gosol, 1905, gouache, 25 1/4 x 19 1/4 in. / Cleveland Museum of Art, Hinman B. Hurlbut Collection (no. 61 in exh.; ill. in cat.) [Z.I.317; Cleveland Museum of Art]
Head with a Kerchief, Gosol, 1905, gouache, 24 x 18 in. / T. Catesby Jones (no. 62 in exh.; ill. in cat.) [Z.I.319; Virginia Museum of Fine Arts, Richmond]
Peasants from Andorra, Gosol, 1906, ink, 22 7/8 x 13 1/2 in. / Art Institute of Chicago, gift of Robert Allerton (no. 63 in exh.; ill. in cat.) [Z.IV.780; Art Institute of Chicago]
Figure Study, Back, 1906, charcoal, 24 1/2 x 18 1/2 in. / Walter P. Chrysler, Jr., New York (no. 64 in exh.; ill. in cat.)
Gertrude Stein, Paris, 1906, oil / Miss Gertrude Stein, Paris (no. 65 in exh.; ill. in cat.) [Z.I.352; Metropolitan Museum of Art, New York / This work appears in the exhibition catalogue, but could not be included in the exhibition due to shipping complications caused by the war.]
Self-Portrait [current title: *Self-Portrait with Palette*], Paris, 1906, oil, 36 x 28 in. / Museum of Living Art, New York University (no. 66 in exh.; ill. in cat.) [Z.I.375; Philadelphia Museum of Art]
Two Nudes, Paris, 1906, oil, 59 3/4 x 36 5/8 in. / Rosenberg & Helft, Ltd., London (no. 67 in exh.; ill. in cat.; shown in San Francisco) [Z.I.366; Museum of Modern Art, New York]
Composition study for "Les Demoiselles d'Avignon," 1907, charcoal and pastel, 18 7/8 x 25 in. / Pablo Picasso (no. 68 in exh.; ill. in cat.) [Z.II¹.19; Kunstmuseum, Basel]
Composition study for "Les Demoiselles d'Avignon,"

Paris, 1907, oil on wood, 7 3/8 x 9 3/8 in. / Pablo Picasso (no. 69 in exh.; ill. in cat.) [Z.II¹.20]

Composition study for "Les Demoiselles d'Avignon," 1907, watercolor, 6 3/4 x 8 3/4 in. / Museum of Living Art, New York University (no. 70 in exh.; ill. in cat.; shown in San Francisco) [Z.II¹.21; Philadelphia Museum of Art]

Les Demoiselles d'Avignon, Paris, 1906–7, oil, 96 x 92 in. / Museum of Modern Art, New York (no. 71 in exh.; ill. in cat.; shown in San Francisco) [Z.II¹.18; Museum of Modern Art]

Dancer (Grande danseuse d'Avignon; Danseuse nègre) [current title: *Nude with Raised Arms (The Dancer of Avignon)*], Avignon?, 1907, oil, 59 x 39 1/4 in. / Walter P. Chrysler, Jr., New York (no. 72 in exh.) [Z.II¹.35; private collection, New York]

Dancer, 1907, watercolor, 25 3/4 x 19 1/2 in. / Walter P. Chrysler, Jr., New York (no. 73 in exh.; ill. in cat.)

Standing Figure, 1907, brush and ink, 11 1/2 x 7 1/4 in. / Walter P. Chrysler, Jr., New York (no. 74 in exh.)

Head (Femme au nez en quart de Brie), 1907?, oil, 13 7/8 x 10 3/4 in. / Roland Penrose, London (no. 76 in exh.; ill. in cat.)

Woman in Yellow (Le Corsage jaune), 1907, oil, 51 1/4 x 37 7/8 in. / Mr. and Mrs. Joseph Pulitzer, Jr., St. Louis (no. 77 in exh.; ill. in cat.) [Z.II¹.43; Pulitzer Foundation for the Arts, St. Louis, Mo.]

Head (Tête nègre) [current title: *Bust of a Man*], summer 1908, oil, 24 1/2 x 17 in. / Walter P. Chrysler, Jr., New York (no. 78 in exh.; ill. in cat.) [Z.II¹.76; Metropolitan Museum of Art, New York]

Bowls and Jug, Paris, summer 1908, oil, 32 x 25 1/2 in. / Museum of Living Art, New York University (no. 79 in exh.; ill. in cat.) [Z.II¹.63; Philadelphia Museum of Art]

Landscape with Figures, Paris, autumn 1908, oil, 23 5/8 x 28 3/4 in. / Pablo Picasso (no. 80 in exh.; ill. in cat.) [Z.II¹.79; Musée Picasso, Paris]

Figures in a Landscape, autumn 1908, gouache, 18 3/4 x 23 1/8 in. / Mr. and Mrs. Samuel S. White, III, Ardmore, Pennsylvania (no. 81 in exh.; shown in San Francisco) [Z.II¹.105; Philadelphia Museum of Art]

Fruit Dish, spring 1909, oil, 28 3/4 x 23 3/8 in. / Bignou Gallery, New York (no. 82 in exh.; ill. in cat.) [Z.II¹.121; Museum of Modern Art, New York]

Woman with Pears, 1909 (sometimes dated 1908), oil, 36 x 28 3/4 in. / Walter P. Chrysler, Jr., New York (no. 84 in exh.; ill. in cat.) [Z.II¹.170; Museum of Modern Art, New York]

Head, 1909, gouache, 24 1/2 x 18 1/2 in. / Walter P. Chrysler, Jr., New York (no. 87 in exh.) [Z.II¹.140; Art Institute of Chicago]

Woman's Head, 1909, gouache, 24 x 18 in. / Museum of Modern Art, gift of Mrs. Sadie A. May (no. 88 in exh. cat.) [Z.II¹.148; Museum of Modern Art, New York / This work appears in the exhibition catalogue, but was not included in the exhibition.]

Portrait of Braque, late 1909, oil, 24 1/4 x 19 3/4 in. / Frank Crowninshield, New York (no. 89 in exh.; ill. in cat.) [Z.II¹.177; Staatliche Museen zu Berlin, Nationalgalerie, on permanent loan from the Berggruen Collection]

Woman in a Landscape, late 1909, oil, 36 1/4 x 28 1/2 in. / Walter P. Chrysler, Jr., New York (no. 90 in exh.; ill. in cat.) [Z.II¹.150; private collection]

Woman with a Mandolin, 1910, oil, 39 1/2 x 29 in. / Roland Penrose, London (no. 91 in exh.; ill. in cat.) [Z.II¹.235; Museum of Modern Art, New York]

Figure [current title: *Standing Female Nude*],* 1910, charcoal, 19 x 12 1/4 in. / Alfred Stieglitz, New York (no. 92 in exh.; ill. in cat.) [Z.II¹.208; Metropolitan Museum of Art, New York]

Standing Figure, 1910? (also dated 1911 and 1912), oil / Mrs. Meric Callery, Boulogne-sur-Seine, France (no. 94 in exh.; ill. in cat.) [Z.II¹.233; National Gallery of Art, Washington, D.C.]

Nude, Cadaqués, 1910?, oil, 38 3/4 x 30 1/2 in. / Mr. and Mrs. Walter C. Arensberg, Hollywood (no. 95 in exh.; ill. in cat.) [Z.II¹.225; Philadelphia Museum of Art]

Portrait of Kahnweiler, autumn 1910, oil, 39 1/4 x 28 1/4 in. / Mrs. Charles B. Goodspeed, Chicago (no. 96 in exh.; ill. in cat.; San Francisco) [Z.II¹.227; Art Institute of Chicago]

Pierrot (Seated Man; Accordionist), Cerét, summer 1911, oil, 51 1/4 x 35 1/8 in. / Solomon R. Guggenheim Foundation, New York (no. 97 in exh.; ill. in cat.) [Z.II¹.277; Solomon R. Guggenheim Museum, New York]

Girl and Soldier, Paris, spring 1912, oil, 47 1/2 x 33 in. / Pierre Loeb, Paris (no. 98 in exh. cat.) [This work appears in the exhibition catalogue, but could not be included in the exhibition due to shipping complications caused by the war.]

"Ma Jolie" (Woman with a Guitar), Paris, spring 1912, oil, 39 3/8 x 25 3/4 in. / Marcel Fleischmann, Zurich (no. 99 in exh.) [Z.II¹.244; Museum of Modern Art, New York]

L'Arlésienne, Sorgues, summer 1912, oil, 28 3/4 x 21 1/4 in. / Walter P. Chrysler, Jr., New York (no. 100 in exh.; ill. in cat.) [Z.II¹.356; private collection]

Still Life with Chair Caning, 1911–12, oil and pasted paper simulating chair caning on canvas, oval, 10 5/8 x 13 3/4 in. / Pablo Picasso (no. 103 in exh.; ill. in cat.; shown in San Francisco) [Z.II¹.294; Musée Picasso, Paris]

Guitar, 1912, charcoal, 24 3/8 x 18 3/8 in. / Rosenberg & Helft, Ltd., London (no. 104 in exh.; ill. in cat.)

Man with a Hat, Paris, winter 1913, pasted paper, charcoal, and ink, 24 1/2 x 18 1/4 in. / Museum of Modern Art, New York (no. 105 in exh.) [Z.II².398; Museum of Modern Art, New York / This work appears in the exhibition catalogue, but could not be included in the exhibition due to shipping complications caused by the war.]

Man with a Violin, 1913, pasted paper and charcoal, 48 5/8 x 18 1/8 in. / Roland Penrose, London (no. 106 in exh.; ill. in cat.) [Z.II².399; Metropolitan Museum of Art, New York]

Still Life [current title: *Bottle and Wine Glass on a Table*],* 1913 [actual date: 1912], pasted paper and charcoal, 24 1/4 x 18 1/2 in. / Alfred Stieglitz, New York (no. 107 in exh.; ill. in cat.) [Z.II².428; Metropolitan Museum of Art, New York]

Portrait with the Words "J'aime Eva" [current title: *Female Nude (J'aime Eva)*],* 1912, oil, 38 3/4 x 25 in. / Columbus Gallery of Fine Arts, Ferdinand Howald Collection (no. 108 in exh.; ill. in cat.) [Z.II².364; Columbus Museum of Art]

The Model, 1912 or 13, oil, 45 1/2 x 31 1/2 in. / Walter P. Chrysler, Jr., New York (no. 109 in exh.; ill. in cat.) [Z.II².361; private collection, New York]

Head, 1912–13, charcoal, 24 x 18 3/8 in. / anonymous loan (no. 110 in exh.)

Still Life with a Guitar, Paris, spring 1913, oil and pasted paper, 25 5/8 x 21 1/8 in. / Sidney Janis, New York (no. 111 in exh.; ill. in cat.) [Z.II².419; Museum of Modern Art, New York]

Still Life with Fruit, Paris, winter 1913, pasted paper and charcoal, 25 1/2 x 19 1/2 in. / Museum of Living Art, New York University (no. 112 in exh.) [Philadelphia Museum of Art]

Still Life [current title: *Violin and Guitar*], 1913?, oil / Mr. and Mrs. Walter C. Arensberg, Hollywood (no. 113 in exh.; ill. in cat.) [Z.II².363; Philadelphia Museum of Art / This work appears in the exhibition catalogue, but could not be included in the exhibition due to shipping complications caused by the war.]

Twelve Cubist Studies, 1912?–13, ink, [ranging from] ca. 5 to 7 in. high / Pierre Loeb, Paris (no. 114 in exh.; ill. in cat.) [These works appear in the exhibition catalogue, but could not be included in the exhibition due to shipping complications caused by the war.]

Still Life with a Calling Card (The Package of Cigarettes), 1914, pasted paper and crayon, 5 1/2 x 8 1/4 in. / Mrs. Charles B. Goodspeed, Chicago (no. 116 in exh.; ill. in cat.)

Head, 1914 (also dated 1913), pasted paper and charcoal, 17 1/8 x 13 1/8 in. / Roland Penrose, London (no. 117 in exh.; ill. in cat.) [Z.II².414; private collection, London]

Bird on a Branch, Céret, summer 1913, oil, 13 x 5 7/8 in. / anonymous loan (no. 118 in exh.; ill. in cat.) [Z.II².532; private collection / The anonymous lender was Paul Rosenberg.]

Green Still Life, 1914, oil, 23 1/2 x 31 1/4 in. / Museum of Modern Art, Lillie P. Bliss Collection (no. 120 in exh.) [Z.II².485; Museum of Modern Art, New York / This work appears in the exhibition catalogue, but could not be included in the exhibition due to shipping complications caused by the war.]

Still Life: "Vive la . . . ," Avignon, 1914–Paris, 1915, oil, 21 3/8 x 25 3/4 in. / Sidney Janis, New York (no. 122 in exh.; ill. in cat.) [Z.II².523; private collection]

Head, 1917, oil on panel, 9 1/4 x 7 1/4 in. / George L. K. Morris, New York (no. 124 in exh.; ill. in cat.)

Fireplace with a Guitar, 1915, oil, 51 1/4 x 37 7/8 in. / Pierre Loeb, Paris (no. 125 in exh.; ill. in cat.) [Z.II².540 / This work appears in the exhibition catalogue, but could not be included in the exhibition due to shipping complications caused by the war.]

Harlequin, 1915, oil, 71 1/4 x 41 3/8 in. / anonymous loan (no. 126 in exh.; ill. in cat.) [Z.II².555; Museum of Modern Art, New York / This work appears in the exhibition catalogue, but could not be included in the exhibition due to shipping complications caused by the war.]

The Fireplace, 1916–17, oil, 58 1/8 x 26 1/2 in. / Mr. and Mrs. Joseph Pulitzer, Jr., St. Louis (no. 127 in exh.; ill. in cat.) [Z.II².565; St. Louis Art Museum]

Guitar, 1916–17, oil, charcoal, and pinned paper, 85 x 31 in. / A. Conger Goodyear, New York (no. 128 in exh.; ill. in cat.) [Z.II².570; Museum of Modern Art, New York]

Chinese Conjurer's Costume (Le Chinois), Rome?, 1917, gouache, 10 3/4 x 7 3/8 in. / anonymous loan (no. 129 in exh.; ill. in cat.) [Z.XXIX.253]

Diaghilev and Selisburg, Rome or Florence, 1917, pencil, 24 7/8 x 18 7/8 in. / Pablo Picasso (no. 130 in exh.; ill. in cat.) [Z.III.301; Musée Picasso, Paris]

Head of Pierrot, 1917, ink, 23 1/2 x 19 in. / John W. Warrington, Cincinnati (no. 131 in exh.; ill. in cat.) [Z.III.13]

Three Ballerinas, 1917?, pencil and charcoal, 23 1/8 x 17 3/8 in. / Pablo Picasso (no. 132 in exh.; ill. in cat.)

Pierrot and Harlequin, 1918, pencil, 10 1/4 x 7 1/2 in. / Mrs. Charles B. Goodspeed, Chicago (no. 133 in exh.; ill. in cat.) [Z.III.135; Art Institute of Chicago]

Pierrot and Harlequin, 1919, gouache, 10 1/8 x 7 3/4 in. / Mrs. Charles B. Goodspeed, Chicago (no. 134 in exh.; ill. in cat.) [Z.IV.69; National Gallery of Art, Washington, D.C.]

Study for the curtain of the ballet, Le Tricorne, 2nd version, 1919, oil, 14 3/4 x 18 in. / anonymous loan (no. 135 in exh.; ill. in cat.)

Costume Design, 1919?, gouache, 6 x 4 in. / Mrs. Ray Slater Murphy (no. 136 in exh.; ill. in cat.)

Harlequin, 1919–20?, gouache, 13 x 9 1/2 in. / Miss Edith Wetmore (no. 137 in exh.)

The Theatre Box, 1921, oil, 76 1/2 x 58 3/8 in. / Rosenberg & Helft, Ltd., London (no. 138 in exh.; ill. in cat.)

Pierrot Seated, 1918, oil, 36 1/2 x 28 3/4 in. / Samuel A. Lewisohn, New York (no. 139 in exh.; ill. in cat.) [Z.III.137; Museum of Modern Art, New York]

The Violinist ("Si tu veux") [current title: *Harlequin with Violin ("Si Tu Veux")*], 1918, oil, 56 x 39 1/2 in. / anonymous loan (no. 140 in exh.; ill. in cat.; shown in San Francisco) [Z.III.160; Cleveland Museum of Art / The anonymous lender was Paul Rosenberg, New York.]

Still Life with a Pipe, 1918, oil, 8 5/8 x 10 1/2 in. / anonymous loan (no. 141 in exh.) [The anonymous lender was Paul Rosenberg.]

Bathers, 1918, pencil, 9 1/8 x 12 1/4 in. / Fogg Art Museum, Harvard University, Cambridge, Massachusetts, Paul J. Sachs Collection (no. 142 in exh.) [Z.III.233; Fogg Art Museum]

Philosopher, 1918?, pencil, 23 5/8 x 10 7/16 in. / Fogg Art Museum, Harvard University, Cambridge, Massachusetts, Paul J. Sachs Collection (no. 143 in exh.) [Z.III.256; Fogg Art Museum]

Fisherman, 1918, pencil, 13 3/4 x 10 in. / anonymous loan (no. 144 in exh.; ill. in cat.) [Z.III.250; private collection / The anonymous lender was Paul Rosenberg.]

The Window, 1919, gouache, 13 3/4 x 9 3/4 in. / anonymous loan (no. 145 in exh.; ill. in cat.)

Table before a Window, 1919, oil, 11 1/8 x 9 in. / anonymous loan (no. 146 in exh.) [Z.III.417 / The anonymous lender was Paul Rosenberg.]

The Table, 1919–20, oil, 51 x 29 5/8 in. / Smith College Museum of Art, Northampton, Massachusetts (no. 147 in exh.; ill. in cat.) [Z.III.437; Smith College Museum of Art]

Still Life on a Table, 1920, oil, 8 3/4 x 5 in. / anonymous loan (no. 148 in exh.) [The anonymous lender was Paul Rosenberg.]

Landscape, 1920, oil, 20 1/2 x 27 1/2 in. / Pablo Picasso (no. 149 in exh.)

The Rape, 1920, tempera on wood, 9 3/8 x 12 7/8 in. / Philip L. Goodwin, New York (no. 150 in exh.; ill. in cat.) [Z.IV.109; Museum of Modern Art, New York]

Centaur and Woman, September 12, 1920, ink, 7 7/8 x 10 1/2 in. / Gilbert Seldes (no. 151 in exh.; ill. in cat.)

Two Women by the Sea, September 4, 1920, pencil, 29 1/2 x 41 1/4 in. / anonymous loan, courtesy the Worcester Art Museum (no. 152 in exh.) [Z.IV.181 / The source of the anonymous loan was Scofield Thayer's Dial Collection, on deposit at the Worcester Art Museum from 1926 until it went by his bequest to the Metropolitan Museum of Art in 1984.]

Four Classic Figures, 1921, tempera on wood, 4 x 6 in. / anonymous loan (no. 153 in exh.; ill. in cat.) [The anonymous lender was Paul Rosenberg.]

Women by the Sea, April 29, 1921, pencil, 9 1/8 x 13 in. / Mrs. Charles J. Liebman (no. 154 in exh.; ill. in cat.)

Two Seated Women [current title: *Two Female Nudes*], 1920, oil, 76 3/4 x 64 1/4 in. / Walter P. Chrysler, Jr., New York (no. 155 in exh.; ill. in cat.; shown in San Francisco) [Z.IV.217; Kunstsammlung Nordrhein-Westfalen, Düsseldorf]

Landscape, 1921, pastel, 19 1/2 x 25 1/4 in. / Walter P. Chrysler, Jr., New York (no. 156 in exh.; ill. in cat.) [Z.IV.279]

Hand, January 20, 1921, pastel, 8 1/4 x 12 5/8 / Walter P. Chrysler, Jr., New York (no. 157 in exh.; ill. in cat.) [Z.IV.239]

Classic Head, 1921, pastel, 25 1/4 x 19 1/4 in. / anonymous loan, courtesy the Worcester Art Museum (no. 158 in exh.; ill. in cat.) [Z.IV.346; Metropolitan Museum of Art, New York / The source of the anonymous loan was Scofield Thayer's Dial Collection, on deposit at the Worcester Art Museum from 1926 until it went by his bequest to the Metropolitan Museum of Art in 1984.]

Bathing Woman, 1921?, oil on wood, 5 7/8 x 3 7/8 in. / James Thrall Soby (no. 159 in exh.) [Z.IV.309; Museum of Modern Art, New York]

Standing Nude, 1921?, oil, 10 5/8 x 8 3/4 in. / Mrs. Lloyd Bruce Wescott (no. 161 in exh.)

Still Life, January 8, 1921, gouache, 8 1/4 x 10 1/4 in. / Walter P. Chrysler, Jr., New York (no. 162 in exh.; ill. in cat.)

Girl in a Yellow Hat, April 16, 1921, pastel, 41 1/4 x 29 1/2 in. / Walter P. Chrysler, Jr., New York (no. 163 in exh.; ill. in cat.) [Z.IV.258]

Three Musicians (Three Masks), Fontainebleau, summer 1921, oil, 80 3/4 x 88 1/2 in. / anonymous loan (no. 164 in exh.; ill. in cat.; shown in San Francisco) [Z.IV.331; Museum of Modern Art, New York / The anonymous lender was Paul Rosenberg.]

Three Musicians,* Fontainebleau, summer 1921, oil, 80 x 74 in. / Museum of Living Art, New York University (no. 165 in exh.; ill. in cat.) [Z.IV.332; Philadelphia Museum of Art]

Guitar, 1922, oil, 32 1/8 x 45 7/8 in. / Paul Willert (no. 166 in exh.; ill. in cat.) [Z.IV.440]

The Race, 1922, tempera on wood, 12 7/8 x 16 1/4 in. / Pablo Picasso (no. 167 in exh.; ill. in cat.) [Z.IV.380; Musée Picasso, Paris]

Nude, 1922?, pencil, 16 1/4 x 11 1/4 in. / Frank

Crowninshield, New York (no. 168 in exh.) [Z.IV.377; Metropolitan Museum of Art, New York]

Standing Nude, 1922, oil on wood, 7 1/2 x 5 1/2 in. / Wadsworth Atheneum, Hartford, Connecticut (no. 169 in exh.; ill. in cat.) [Z.IV.382; Wadsworth Atheneum]

Head of a Man, 1922?, pastel, 25 5/8 x 19 3/4 in. / Mrs. Charles H. Russell, Jr. (no. 170 in exh.; ill. in cat.) [Z.V.96]

View of St. Malo, (Dinard?), 1922, ink and pencil, 11 1/8 x 16 1/8 in. / anonymous loan (no. 171 in exh.; ill. in cat.) [The anonymous lender was Paul Rosenberg.]

Studies of Nude, 1923, ink, 9 3/8 x 11 1/2 in. / anonymous loan (no. 172 in exh.; ill. in cat.) [The anonymous lender was Paul Rosenberg.]

The Pipes of Pan, 1923, ink, 9 1/4 x 12 1/8 in. / John Nicholas Brown (no. 173 in exh.; ill. in cat.)

The Sigh, 1923, oil and charcoal, 23 3/4 x 19 3/4 in. / James Thrall Soby (no. 174 in exh.; ill. in cat.) [Z.V.12; Museum of Modern Art, New York]

Head of a Young Man, 1923?, black crayon on pink paper, 23 x 17 1/8 in. / Brooklyn Museum, New York (no. 178 in exh.) [Z.V.95; Brooklyn Museum]

Woman in White,* 1923, oil, 39 x 31 1/2 in. / Museum of Modern Art, New York, Lillie P. Bliss Collection (no. 179 in exh.; ill. in cat.) [Z.V.1; Metropolitan Museum of Art, New York]

By the Sea [current title: *Three Bathers*], 1923 [actual date: June 1920], oil on wood, 32 x 39 1/2 in. / Walter P. Chrysler, Jr., New York (no. 180 in exh.; ill. in cat.) [Z.IV.169 / Picasso had erroneously dated this work 1923, visible on the painting itself.]

The Pipes of Pan, 1923, oil, 80 1/2 x 68 5/8 in. / Pablo Picasso (no. 181 in exh.; ill. in cat.) [Z.V.141; Musée Picasso, Paris]

Musical Instruments, 1923, oil, 38 x 51 in. / Mrs. Patrick C. Hill, Pecos, Texas (no. 182 in exh.; ill. in cat.)

Still Life, 1924, conté crayon with oil wash, 9 1/4 x 6 3/4 in. / Museum of Living Art, New York University (no. 183 in exh.) [Philadelphia Museum of Art]

Three Graces, 1924, oil and charcoal, 78 7/8 x 59 in. / Pablo Picasso (no. 184 in exh.; ill. in cat.)

Still Life with a Mandolin and Biscuit, May 16, 1924, oil, 38 1/4 x 51 1/4 in. / anonymous loan (no. 185 in exh.; ill. in cat.) [Z.V.185; Metropolitan Museum of Art, New York]

Still Life with Biscuits, 1924, oil and sand, 32 x 39 3/4 in. / anonymous loan (no. 186 in exh.) [Z.V.242; Cleveland Museum of Art / The anonymous lender was Paul Rosenberg.]

The Red Tablecloth (Le Tapis Rouge), December 1924, oil, 38 3/4 x 51 3/8 in. / anonymous loan (no. 187 in exh.; ill. in cat.) [Z.V.364; private collection, New York / The anonymous lender was Paul Rosenberg.]

Woman with a Mandolin (La Musicienne), 1925, oil, 51 3/8 x 38 5/8 in. / anonymous loan (no. 188 in exh.; ill. in cat.) [Z.V.442; Norton Simon Museum, Pasadena, California / The anonymous lender was Paul Rosenberg.]

The Fish Net, Juan les Pins, summer 1925, oil, 39 3/4 x 32 3/8 in. / anonymous loan (no. 189 in exh.; ill. in cat.) [Z.V.459 / The anonymous lender was Paul Rosenberg.]

The Three Dancers, 1925, oil, 84 5/8 x 56 1/4 in. / Pablo Picasso (no. 190 in exh.; ill. in cat.) [Z.V.426; Tate Gallery, London]

The Ram's Head, Juan les Pins, summer 1925, oil, 32 1/8 x 39 1/2 in. / anonymous loan (no. 191 in exh.; ill. in cat.) [Z.V.443; Norton Simon Museum, Pasadena, California]

The Studio, Juan les Pins, summer 1925, oil, 38 5/8 x 51 5/8 in. / private collection (no. 192 in exh.; ill. in cat.) [Z.V.445; Museum of Modern Art, New York / The anonymous owner was James Johnson Sweeney. This work appears in the exhibition catalogue, but could not be included in the exhibition due to shipping complications caused by the war.]

Still Life with a Bottle of Wine, 1926, oil, 38 5/8 x 51 1/4 in. / anonymous loan (no. 193 in exh.; ill.

in cat.) [Z.VI.1444 / The anonymous lender was Paul Rosenberg.]

Three Dancers Resting, 1925, ink, 13 3/4 x 9 7/8 in. / anonymous loan (no. 194 in exh.; ill. in cat.) [The anonymous lender was Paul Rosenberg.]

Four Ballet Dancers, 1925, ink, 13 1/2 x 10 in. / Museum of Modern Art, gift of Mrs. John D. Rockefeller, Jr. (no. 195 in exh.; ill. in cat.) [Z.V.422; Museum of Modern Art, New York]

Two Ballet Dancers Resting, 1925, ink, 13 5/8 x 9 7/8 in. / Wadsworth Atheneum, Hartford (no. 196 in exh.) [Wadsworth Atheneum]

Pas de deux (Two Ballet Dancers), 1925, ink, 24 1/2 x 18 7/8 in. / Mrs. Ray Slater Murphy (no. 197 in exh.)

Head, 1926, charcoal and white chalk, 25 x 19 in. / Walter P. Chrysler, Jr., New York (no. 199 in exh.; ill. in cat.)

Guitar, 1926, canvas with string, pasted paper, oil paint, and cloth fixed with two-inch nails (points out), 38 1/4 x 51 1/4 in. / Pablo Picasso (no. 200 in exh.; ill. in cat.) [Z.V.9; Musée Picasso, Paris]

Guitar, 1926, panel with string, bamboo, and cloth applied with tacks, 51 1/8 x 38 1/4 in. / Pablo Picasso (no. 201 in exh.) [This work appears in the exhibition catalogue, but could not be included in the exhibition due to shipping complications caused by the war.]

The Painter and His Model, 1926, ink, 11 1/4 x 14 3/4 in. / anonymous loan (no. 204 in exh.) [The anonymous lender was Paul Rosenberg.]

Seated Woman,* 1926–27 [actual date: 1927], oil, 51 1/2 x 38 1/2 in. / Museum of Modern Art, New York (no. 207 in exh.; ill. in cat.) [Z.VII.81; Art Gallery of Ontario, Toronto]

Woman in an Armchair, January 1927, oil, 51 3/8 x 38 1/4 in. / Pablo Picasso (no. 208 in exh.; ill. in cat.) [Z.III.79; private collection]

Seated Woman, 1927, oil on wood, 51 1/8 x 38 1/4 in. / James Thrall Soby (no. 209 in exh.; ill. in cat.) [Z.VII.77; Museum of Modern Art, New York]

Figure,* 1927, oil on plywood, 51 1/8 x 38 1/8 in. / Pablo Picasso (no. 210 in exh.; ill. in cat.) [Z.VII.137; Musée Picasso, Paris]

Seated Woman, 1927, oil, 8 1/2 x 4 3/4 in. / Sidney Janis, New York (no. 211 in exh.) [Z.VII.60]

The Studio,* 1927–28, oil, 59 x 91 in. / Museum of Modern Art, gift of Walter P. Chrysler, Jr. (no. 212 in exh.; ill. in cat.; shown in San Francisco) [Z.VII.142; Museum of Modern Art, New York]

Painting (Running Minotaur), April 1928, oil, 63 3/4 x 51 1/4 in. / Pablo Picasso (no. 213 in exh.; ill. in cat.) [Z.VII.135; Musée National d'Art Moderne, Centre National d'Art et de Culture Georges Pompidou, Paris]

The Studio, 1928, oil, 63 5/8 x 51 1/8 in. / Pablo Picasso (no. 215 in exh.; shown in San Francisco) [Z.VII.136; Peggy Guggenheim Collection, Venice]

The Painter and His Model, 1928, oil, 51 5/8 x 63 7/8 in. / Sidney Janis, New York (no. 216 in exh.; ill. in cat.) [Z.VII.143; Museum of Modern Art, New York]

Head of a Woman, 1927 or 1928, oil and sand, 21 5/8 x 21 5/8 in. / Pablo Picasso (no. 217 in exh.; ill. in cat.)

Head, 1928, oil, 21 3/4 x 13 in. / anonymous loan (no. 218 in exh.; ill. in cat.)

On the Beach, Dinard, 1928, oil, 7 1/2 x 12 3/4 in. / George L. K. Morris, New York (no. 220 in exh.; ill. in cat.) [Z.VII.230]

Beach Scene [current title: *Bathers with Beach Ball*],* Dinard, August 21, 1928, oil, 6 1/2 x 9 1/8 in. / Rosenberg & Helft, Ltd., London (no. 221 in exh.) [Z.VII.226; private collection]

Bather, 1929, oil, 16 1/4 x 10 3/4 in. / Pierre Loeb, Paris (no. 224 in exh.) [This work appears in the exhibition catalogue, but could not be included in the exhibition due to shipping complications caused by the war.]

Woman in an Armchair, 1929, oil, 36 3/8 x 28 3/4 in. / anonymous loan (no. 228 in exh.; ill. in cat.; shown in San Francisco) [Z.VII.275]

Woman in an Armchair, May 5, 1929, oil, 76 3/4 x 51 1/8 in. / Pablo Picasso (no. 229 in exh.; ill. in cat.) [Z.VII.263; Musée Picasso, Paris]

Bather, Standing, May 26, 1929, oil, 76 3/4 x
51 1/8 in. / Pablo Picasso (no. 230 in exh.;
ill. in cat.) [Z.VII.262; Musée Picasso, Paris]
Seated Bather, 1929, oil, 63 7/8 x 51 1/8 in. / Mrs.
Meric Callery, Boulogne-sur-Seine, France (no.
231 in exh.; ill. in cat.; shown in San Francisco)
[Z.VII.306; Museum of Modern Art, New York]
Acrobat, January 18, 1930, oil, 63 7/8 x 51 3/8 in. /
Pablo Picasso (no. 232 in exh.; ill. in cat.)
[Z.VII.310; Musée Picasso, Paris]
Crucifixion, February 7, 1930, oil on wood, 20 x
26 in. / Pablo Picasso (no. 233 in exh.; ill. in cat.)
[Z.VII.287; Musée Picasso, Paris]
Project for a Monument (Métamorphose), February 19,
1930, oil on wood, 26 x 19 1/8 in. / Walter P.
Chrysler, Jr., New York (no. 234 in exh.; ill. in
cat.) [Z.VII.420; private collection]
Swimming Woman, November 1929, oil, 63 7/8 x
51 1/8 in. / Pablo Picasso (no. 235 in exh.; ill. in
cat.)
By the Sea, Juan les Pins, August 22, 1930, plaster
and sand relief, 10 5/8 x 13 3/4 in. / Pablo Picasso
(no. 236 in exh.) [Musée Picasso, Paris]
Figure Throwing a Stone, March 8, 1931, oil, 51 1/4 x
76 5/8 in. / Pablo Picasso (no. 237 in exh.; ill. in
cat.)
Pitcher and Bowl of Fruit, February 22, 1931, oil,
51 1/2 x 64 in. / Rosenberg & Helft Ltd., London
(no. 238 in exh.; ill. in cat.) [Z.VII.322; Solomon
R. Guggenheim Museum, New York]
Still Life on a Table, March 11, 1931, oil, 76 3/4 x
51 1/8 in. / Pablo Picasso (no. 240 in exh.;
ill. in cat.) [Z.VII.317; Musée Picasso, Paris]
Reclining Woman, November 9, 1931, oil, 76 3/4 x
51 1/4 in. / Pablo Picasso (no. 241 in exh.)
Seated Nude, December 21, 1931, oil, 63 7/8 x
51 1/8 in. / Pablo Picasso (no. 242 in exh.)
Still Life with Tulips, March 2, 1932, oil, 51 1/4 x
38 1/4 in. / A. Bellanger, Paris (no. 243 in exh.;
shown in San Francisco) [Z.VII.376; Wynn
Collection, Las Vegas]
Nude on a Black Couch, March 9, 1932, oil, 63 3/4 x
51 1/4 in. / Mrs. Meric Callery, Boulogne-sur-
Seine, France (no. 244 in exh.; ill. in cat.; shown
in San Francisco) [Z.VII.377]
The Mirror, Paris, March 12, 1932, oil, 51 1/4 x
38 1/4 in. / Pablo Picasso (no. 245 in exh.;
ill. in cat.; shown in San Francisco) [Z.VII.378;
private collection, Monaco]
Girl before a Mirror, Paris, March 14, 1932, oil,
63 3/4 x 51 1/4 in. / Museum of Modern Art
(no. 246 in exh.; ill. in cat.; shown in San
Francisco) [Z.VII.379; Museum of Modern Art,
New York]
Figure in a Red Chair, 1932, oil, 51 1/8 x 38 1/4 in. /
Pablo Picasso (no. 247 in exh.; ill. in cat.)
Seated Woman and Bearded Head, 1932, ink and
pencil, 11 1/8 x 10 1/8 in. / Walter P. Chrysler,
New York (no. 248 in exh.)
Seated Woman, 1932, oil on wood, 29 1/4 x 20 5/8 in. /
Lee A. Ault, New Canaan, Connecticut (no. 249
in exh.; ill. in cat.; shown in San Francisco)
[Z.VII.405]
Woman Sleeping, 1932, oil, 39 3/8 x 32 in. / Justin K.
Thannhauser, New York (no. 250 in exh.; shown
in San Francisco) [Z.VII.333; Solomon R.
Guggenheim Museum, New York]
Three Women by the Sea, November 28, 1932, oil,
32 x 39 3/8 in. / Pablo Picasso (no. 254 in exh.;
ill. in cat.)
Two Women on the Beach, Paris, January 11, 1933,
oil, 28 7/8 x 36 1/4 in. / Pablo Picasso (no. 255 in
exh.; ill. in cat.)
Plaster Head and Bowl of Fruit, January 29, 1933, oil,
28 7/8 x 36 1/4 in. / Mr. and Mrs. Joseph Pulitzer,
Jr., St. Louis (no. 256 in exh.; ill. in cat.)
[Z.VIII.84; Fogg Art Museum, Harvard University,
Cambridge, Massachusetts]
Silenus, Cannes, July 14, 1933, gouache, 15 1/2 x
19 3/4 in. / A. Conger Goodyear, New York
(no. 257 in exh.)
Two Figures on the Beach, Cannes, July 28, 1933, ink,
15 3/4 x 19 5/8 in. / anonymous loan (no. 258 in
exh.)
Sculptor and His Statue, Cannes, July 20, 1933,
gouache, 15 3/8 x 19 1/2 in. / anonymous loan

(no. 260 in exh.; ill. in cat.) [The anonymous
lender was Paul Rosenberg.]
On the Beach, Cannes, July 11, 1933, watercolor and
ink, 15 5/8 x 19 3/4 in. / Dr. and Mrs. Allan Roos
(no. 261 in exh.; ill. in cat.)
Circus (Acrobats), Paris, February 6, 1933, oil, 18 1/8 x
14 7/8 in. / Pablo Picasso (no. 262 in exh.; ill. in
cat.)
Bull Fight, Boisgeloup, July 27, 1934, oil, 19 3/4 x
25 3/4 in. / Phillips Memorial Gallery, Washington,
D.C. (no. 263 in exh.; ill. in cat.) [Z.VIII.218;
Phillips Collection]
Girl Writing, 1934, oil / Peter Watson, London
(no. 264 in exh.; ill. in cat.) [Z.VIII.246;
Metropolitan Museum of Art, New York]
Two Girls Reading, March 28, 1934, oil, 31 7/8 x
25 1/2 in. / Mrs. John W. Garrett, Baltimore
(no. 265 in exh.; ill. in cat.) [Z.VIII.192; private
collection]
Interior with Figures, 1934, oil, ca. 9 x 12 in. / Mme.
Christian Zervos, Paris (no. 266 in exh.) [This
work appears in the exhibition catalogue, but
could not be included in the exhibition due to
shipping complications caused by the war.]
Bull Fight,* Boisgeloup, September 9, 1934, oil,
13 x 16 1/8 in. / Henry P. McIlhenny, Philadelphia
(no. 267 in exh.; shown in San Francisco)
[Z.VIII.233; Philadelphia Museum of Art]
Interior with a Girl Drawing, Paris, February 12, 1935,
oil, 51 1/8 x 76 5/8 in. / Mrs. Meric Callery,
Boulogne-sur-Seine, France (no. 268 in exh.; ill.
in cat.) [Z.VIII.263; Museum of Modern Art,
New York]
Sleeping Girl, February 3, 1935, oil, 18 1/8 x
21 5/8 in. / Walter P. Chrysler, Jr., New York
(no. 269 in exh.; ill. in cat.) [Z.VIII.266]
Study for "Lysistrata" illustrations, Paris, January 4,
1934, ink and wash, 9 1/2 x 13 1/4 in. / Museum
of Living Art, New York University (no. 271 in
exh.; shown in San Francisco) [Philadelphia
Museum of Art]
Pitcher and Candle, Paris, January 30, 1937, oil, 15 x
18 1/8 in. / Rosenberg & Helft Ltd., London (no.
276 in exh.; ill. in cat.)
Still Life, January 21, 1937, oil, 19 1/2 x 24 in. /
Bignou Gallery, New York (no. 277 in exh.)
[Z.VIII.329; Solomon R. Guggenheim Museum,
New York]
Negro Sculpture before a Window, April 19, 1937, oil,
27 3/4 x 23 5/8 in. / anonymous loan (no. 278 in
exh.; ill. in cat.) [This work appears in the
exhibition catalogue, but could not be included
in the exhibition due to shipping complications
caused by the war.]
Girls with a Toy Boat, February 12, 1937, oil and
charcoal, 51 1/8 x 76 3/4 in. / Mrs. Meric Callery,
Boulogne-sur-Seine, France (no. 279 in exh.; ill.
in cat.; shown in San Francisco) [Z.VIII.344;
Peggy Guggenheim Collection, Venice]
Guernica, May–early July? 1937, oil on canvas,
11 ft. 6 in. x 25 ft. 8 in. / Pablo Picasso (no.
280 in exh.; ill. in cat.) [Z.IX.65; Centro de
Arte Reina Sofia, Madrid
[The exhibition also included fifty-nine *Guernica*
studies and "postscripts" (nos. 281–340). They have
been omitted from this list, since all of these
entries, as they appeared in the catalogue for this
1939 MoMA exhibition, can be found in the list for
Valentine Gallery's *Guernica* exhibition of May
1939, above. Note that the order of these works in
that catalogue and the order given by Zervos and
Chipp are all somewhat different; the order that I
have used for the Valentine Gallery list more or less
follows the date of the work and Chipp's order by his
assigned sketch numbers. I have provided a key to
MoMA's order in the notes section for this
chronology.]
Birdcage and Playing Cards, 1937, oil, 32 x 23 3/4 in. /
Mme. Elsa Schiaparelli (no. 341 in exh.; ill. in cat.)
Portrait of a Lady, 1937, oil, 36 1/4 x 25 1/2 in. /
Pablo Picasso (no. 342 in exh.; ill. in cat.)
[Z.VIII.331; Musée Picasso, Paris]
Portrait of Nusch, August 3, 1937, pen and ink wash /
Roland Penrose, London (no. 343 in exh.; ill. in
cat.)
The End of a Monster, Paris, December 6, 1937,

pencil, 15 1/8 x 22 1/4 in. / Roland Penrose,
London (no. 344 in exh.; ill. in cat.)
Girl with a Cock, Paris, February 15, 1938, oil,
57 1/4 x 47 1/2 in. / Mrs. Meric Callery,
Boulogne-sur-Seine, France (no. 345 in exh.; ill.
in cat.) [Z.IX.109]
Cock, Paris, March 29, 1938, pastel, 30 1/2 x 22 1/4 in. /
anonymous loan (no. 346 in exh.; ill. in cat.)
Cock, Paris, March 23, 1938, charcoal, 30 1/8 x
21 3/4 in. / Pierre Loeb, Paris (no. 347 in exh.)
Cock, Paris, March 29, 1938, pastel, 30 1/4 x
22 1/8 in. / Walter P. Chrysler, Jr., New York
(no. 348 in exh.) [Z.IX.113]
Portrait, May 24, 1938, oil, 28 1/2 x 24 1/4 in. /
Walter P. Chrysler, Jr., New York (no. 349 in
exh.; ill. in cat.) [Z.IX.157]
Head of a Woman, Paris, April 27, 1938, color crayon,
30 1/8 x 21 3/4 in. / Mrs. Meric Callery,
Boulogne-sur-Seine, France (no. 350 in exh.)
Seated Woman, April 28, 1938, ink, 30 x 21 3/4 in. /
Mrs. Meric Callery, Boulogne-sur-Seine, France
(no. 351 in exh.)
Woman in an Armchair, Paris, April 29, 1938, color
crayon over ink wash, 30 1/8 x 21 3/4 in. / Mrs.
Meric Callery, Boulogne-sur-Seine, France (no.
352 in exh.; ill. in cat.) [Z.IX.132; Metropolitan
Museum of Art, New York]
Woman in an Armchair, Paris, July 4, 1938, ink and
crayon, 25 1/2 x 19 3/4 in. / Mrs. Meric Callery,
Boulogne-sur-Seine, France (no. 353 in exh.)
Three Figures, Mougins, August 10, 1938, ink and
wash, 17 5/8 x 26 3/4 in. / Mrs. Meric Callery,
Boulogne-sur-Seine, France (no. 354 in exh.)
Man with an All-day Sucker, August 20, 1938, oil,
26 7/8 x 18 in. / Walter P. Chrysler, Jr., New York
(no. 355 in exh.; ill. in cat.) [Z.IX.203;
Metropolitan Museum of Art, New York]
Girl in a Straw Hat, Mougins, August 29, 1938, oil,
25 5/8 x 19 3/4 in. / Lee A. Ault, New Canaan,
Connecticut (no. 356 in exh.)
Head of a Woman, Mougins, September 8, 1938, ink,
26 3/4 x 17 5/8 in. / Mrs. Meric Callery,
Boulogne-sur-Seine, France (no. 357 in exh.; ill.
in cat.)
Still Life of a Bull's Skull, January 15, 1939, oil /
anonymous loan (no. 358 in exh.) [This work
appears in the exhibition catalogue, but could
not be included in the exhibition due to shipping
complications caused by the war.]
Girl with Dark Hair, Paris, March 29, 1939, oil on
wood, 23 3/4 x 17 7/8 in. / Rosenberg & Helft
Ltd., London (no. 359 in exh.; ill. in cat.)
Girl with Blond Hair, Paris, March 28, 1939, oil on
wood, 23 3/4 x 17 3/4 in. / Rosenberg & Helft
Ltd., London (no. 360 in exh.; shown in San
Francisco) [Z.IX.276; Solomon R. Guggenheim
Museum, New York]
[The following works were in the San Francisco
show only:]
Corbeille aux fruits, December 9, 1927
Bowl with Fruit, Violin and Wineglass / Albert E.
Gallatin, New York [Z.II².385; Philadelphia
Museum of Art]
Guitar on a Table [Philadelphia Museum of Art]
Woman with Guitar, 1913, oil on canvas, 39 3/8 x
32 in. / Galka Scheyer, Los Angeles [Z.II².380;
Norton Simon Museum, Pasadena, California]

December 29, 1939–January 28, 1940: California
Palace of the Legion of Honor and M. H. de Young
Memorial Museum, San Francisco
"Seven Centuries of Painting: A Loan Exhibition of
Old and Modern Masters"
The Moulin Rouge, 1901, watercolor, 25 1/2 x
19 1/2 in. / Mr. Walter P. Chrysler, Jr., New York
(no. Y-190 in exh.) [Z.VI.351]
Nude in Gray, 1905, tempera on board, 40 1/4 x
29 1/4 in. / Mr. Walter P. Chrysler, Jr., New York
(no. Y-191 in exh.; ill. in cat.) [Z.I.257; Musée
National d'Art Moderne, Centre National d'Art et
de Culture Georges Pompidou, Paris]
Portrait of a Woman, 1906, canvas, 31 1/2 x 25 1/4 in. /
Mr. Walter P. Chrysler, Jr., New York (no. Y-192
in exh.) [Z.I.374; Art Institute of Chicago]
Two Cubistic Heads, 1910, canvas, 14 1/2 x 14 3/4
in. / Mr. Walter P. Chrysler, Jr., New York

(no. Y-193 in exh.) [Z.II¹.162; private collection]
A Glass of Absinthe, 1911–12, canvas, 18 1/4 x 15 in. /
Mr. Walter P. Chrysler, Jr., New York (no. Y-194
in exh.) [Z.II¹.261; Allen Memorial Art Museum,
Oberlin College, Ohio]
Interior, 1916, watercolor, 12 1/4 x 9 1/2 in. / Mr.
Walter P. Chrysler, Jr., New York (no. Y-195
in exh.) [Z.II².567; private collection, New
York]
Cubist Abstraction, 1921, canvas, 72 1/2 x 29 1/2 in. /
Mr. Walter P. Chrysler, Jr., New York (no. Y-196
in exh.)
Guitar on a Table, 1921, gouache, 8 1/4 x 10 1/2 in. /
Mr. Walter P. Chrysler, Jr., New York (no. Y-197
in exh.) [Z.IV.240]
Two Nudes, [February 27], 1921, pencil drawing,
8 5/8 x 12 1/4 in. / Mr. Walter P. Chrysler, Jr.,
New York (no. Y-198 in exh.)
Head of a Woman, 1922, oil on wood, 7 1/2 x
9 3/8 in. / Mr. Walter P. Chrysler, Jr., New York
(no. Y-199 in exh.) [Z.IV.355]
Mother and Child, 1922, canvas, 39 1/2 x 32 in. /
Marie Harriman Gallery, New York (no. L-200 in
exh.; ill. in cat.) [Z.IV.370]
Mother and Child, 1923, canvas, 51 1/2 x 38 1/4 in. /
Mr. Walter P. Chrysler, Jr., New York (no. Y-201
in exh.) [Z.IV.455]
Acrobats, 1923, ink wash, 24 1/2 x 18 3/4 in. / Mr.
Walter P. Chrysler, Jr., New York (no. Y-202 in
exh.)
Bone Forms against the Sky, 1930, oil on wood,
26 x 19 1/2 in. / Mr. Walter P. Chrysler, Jr.,
New York (no. Y-203 in exh.) [Z.VII.300]
The Sculptor, 1932, ink drawing, 12 1/2 x 12 1/2 in. /
Mr. Walter P. Chrysler, Jr., New York (no. Y-204
in exh.)
Woman Artist and Model, 1933, charcoal on paper,
11 1/8 x 10 in. / Mr. Walter P. Chrysler, Jr., New
York (no. Y-205 in exh.)
Seated Woman, 1937, gouache, 9 x 8 in. / Mr. Walter
P. Chrysler, Jr., New York (no. Y-206 in exh.)
Man at Table, 1937, pencil drawing, 13 x 10 in. / Mr.
Walter P. Chrysler, Jr., New York (no. Y-207 in
exh.)
Two Nudes, [1923], pastel, 9 3/4 x 7 1/4 in. / Mr.
Walter P. Chrysler, Jr., New York (no. Y-209 in
exh.)

1940

January 8–February 3, 1940: Valentine Gallery, New
York
"A Group of Modern French Paintings"
Compotier, 1908 (no. 19 in exh.)

January 18–February 5, 1940: San Francisco Museum
of Art
"Contemporary Art: Paintings, Watercolors and
Sculpture owned in the San Francisco Bay Region, 5th
Anniversary Exhibition"
Abstraction, 1916, watercolor, 10 7/8 x 8 1/2 in.
(no. 240 in exh.)
Abstraction, 1920, pastel, 9 3/4 x 7 1/2 in. /
Mrs. Adolph Mack, San Francisco (no. 241
in exh.; ill. in cat.)
Bathers, 1921, oil on canvas, 14 7/8 x 18 in. (no. 242
in exh.; ill. in cat.)
Circus Panels (*4 Panel Screen*), oil on canvas, 58 x
17 1/4 in. each / Mr. Templeton Crocker, San
Francisco (no. 243 in exh.)
Composition, gouache and woodcut, 8 3/8 x 10 1/2 in.
(no. 244 in exh.)
Composition, gouache and woodcut, 10 5/8 x 8 1/4 in. /
Mr. Worth Ryder, Berkeley (no. 245 in exh.)
Head of a Woman, [1905], watercolor and ink,
21 3/8 x 16 1/8 in. / Miss Harriet Levy, Berkeley
(no. 246 in exh.)
Mother and Child, oil on canvas, 35 3/8 x 25 1/8 in. /
anonymous loan (no. 247 in exh.; ill. in cat.)
[The anonymous lender was Mr. J. R.
Oppenheimer, Berkeley, California.]

January 26–March 24, 1940: Museum of Modern Art,
New York
"Modern Masters from European and American
Collections"

The Studio, 1925, oil on canvas, 38 5/8 x 51 5/8 in. /
anonymous loan (no. 22 in exh.; ill. in cat.)
[Z.V.445; Museum of Modern Art, New York /
The anonymous lender was James Johnson
Sweeney.]

March 5–30, 1940: Bucholz Gallery, New York
"Pablo Picasso: Drawings and Watercolors"
In the Café, 1901, pencil, 8 1/8 x 11 in. (no. 1 in exh.)
Ballet Scene, 1901, pencil, 8 x 11 3/4 in. (no. 2 in exh.)
Seated Woman, 1905, ink, 5 1/2 x 3 3/4 in.
(no. 3 in exh.)
Seated Woman with Cloak, 1905, ink, 6 x 3 3/4 in.
(no. 4 in exh.; ill. in cat.) [Z.VI.424]
Profile, 1905, charcoal, 6 1/2 x 4 1/4 in. /
Mr. John S. Newberry, Detroit (no. 5 in exh.)
Heads, 1905, ink, 6 1/2 x 9 1/2 in. (no. 6 in exh.)
Mother and Child, 1905, sepia, 6 1/2 x 3 3/4 in.
(no. 7 in exh.)
Les Pauvres, 1905, watercolor, 10 x 13 1/2 in. /
Marie Harriman Gallery, New York (no. 8 in exh.)
Woman and Devil, 1906, ink, 10 1/2 x 8 in.
(no. 9 in exh.) [Z.VI.804; Solomon R.
Guggenheim Museum, New York]
Girl with Bouquet, 1906, ink, 24 1/2 x 18 1/2 in.
(no. 10 in exh.)
Bust of a Man, 1907, charcoal, 24 1/2 x 18 1/2 in.
(no. 11 in exh.)
Head, 1907, watercolor, 8 3/4 x 6 3/4 in. / Mr.
John S. Newberry, Detroit (no. 12 in exh.)
[Z.II¹.10; Museum of Modern Art, New York]
The Guitar, 1913, watercolor, 13 x 8 1/4 in.
(no. 13 in exh.)
Guitar and Bottle, 1913, charcoal, 12 1/4 x 12 1/4 in.
(no. 14 in exh.)
The Glass, 1914, pencil, 15 x 19 1/4 in. (no. 15 in exh.)
Nude Woman in Armchair, 1914, pencil and
watercolor, 10 1/2 x 7 1/4 in. (no. 16 in exh.)
Woman Resting, 1919, pencil, 8 x 10 1/2 in.
(no. 17 in exh.)
Le Guéridon I, 1920, gouache, 8 x 10 in. (no. 18 in
exh.)
Le Guéridon II, 1920, gouache, 10 3/4 x 8 1/4 in.
(no. 19 in exh.; ill. in cat.)
Le Guéridon III, 1920, gouache, 7 3/4 x 8 1/2 in.
(no. 20 in exh.)
Femme en Chemise, 1920, pencil, 12 x 8 1/4 in.
(no. 21 in exh.; ill. in cat.) [Z.VI.1357]
Woman Resting at Seashore, 1920, pencil and
sepia, 9 1/4 x 16 in. (no. 22 in exh.)
Women at Seashore, 1920, pencil, 8 1/2 x 12 in.
(no. 23 in exh.)
Bathers at Seashore, 1920, ink, 10 1/4 x 16 in.
(no. 24 in exh.)
Bathers, 1920, ink, 10 3/4 x 10 1/4 in. (no. 25 in exh.)
Nude, 1920, pencil, 12 1/4 x 8 1/8 in. (no. 26 in exh.)
Young Girl, 1920, watercolor, 11 1/2 x 7 3/4 in.
(no. 27 in exh.)
Reclining Nude, 1920, pencil, 8 1/4 x 12 in.
(no. 28 in exh.)
Still Life, 1920, watercolor, 8 1/4 x 12 in.
(no. 29 in exh.)
The Table, 1920, gouache, 10 x 7 1/2 in.
(no. 30 in exh.)
Violin on the Table, 1920, watercolor, 8 1/2 x 6 3/4
in. (no. 31 in exh.)
Bowl of Fruit, 1920, gouache, 10 1/2 x 16 in.
(no. 32 in exh.)
Masqueraders, 1921, pencil and watercolor,
8 1/2 x 7 1/4 in. (no. 33 in exh.)
Guitar and Fruit Bowl, 1921, pastel and pencil,
12 1/4 x 9 3/4 in. (no. 34 in exh.)
The Table, 1921, gouache and pencil, 12 1/2 x
9 1/4 in. (no. 35 in exh.)
Pipe and Tobacco, 1921, gouache, 4 3/4 x 6 1/4 in.
(no. 36 in exh.)
Glass and Apples, 1923, oil, 9 x 11 in.
(no. 37 in exh.)
Two Personages, 1925, pastel, 6 1/2 x 6 1/2 in.
(no. 38 in exh.)
Nudes (Man and Woman), 1925, ink, 10 x 13 1/2
in. (no. 39 in exh.)
In the Wings, 1925, pencil, 9 1/4 x 15 3/4 in.
(no. 40 in exh.)
Dancers, 1925, pencil, 19 1/2 x 15 3/4 in.
(no. 41 in exh.)

Bust of a Woman, 1925, India ink, 4 x 5 1/4 in.
(no. 42 in exh.)
The Guitar, 1925, ink and wash, 5 1/2 x 4 1/4 in.
(no. 43 in exh.)
The Table, 1925, pencil, 4 1/2 x 9 1/2 in.
(no. 44 in exh.)
The Mandolin, 1925, pencil, 5 3/4 x 6 1/4 in.
(no. 45 in exh.)
The Mandolin, 1925, pencil, 4 3/4 x 6 3/4 in.
(no. 46 in exh.)
Girl's Head, 1926, charcoal, 23 1/2 x 18 1/2 in.
(no. 47 in exh.; ill. in cat.)
Bathers, 1928, oil, 7 1/2 x 12 1/2 in. (no. 48 in exh.)
The Sculptor, 1931, ink, 12 1/4 x 9 3/4 in.
(no. 49 in exh.)
The Serenade I, 1932, ink, 9 1/4 x 12 1/2 in.
(no. 50 in exh.)
The Serenade II, 1932, ink, 9 3/4 x 12 1/2 in.
(no. 51 in exh.)
Women at Seashore, 1932, ink, 9 1/2 x 13 1/4 in.
(no. 52 in exh.)
At the Seashore, 1933, ink, 15 3/4 x 19 3/4 in.
(no. 53 in exh.)
Two Bathers, 1933, watercolor, 15 1/2 x 20 in.
(no. 54 in exh.)
Swimmers, 1933, ink, 13 1/4 x 17 1/2 in.
(no. 55 in exh.)
Bathing Girl, 1933, ink and wash, 9 x 11 1/2 in.
(no. 56 in exh.)
Torso, 1933, ink, 15 1/2 x 19 3/4 in. (no. 57 in exh.)
Minotaur I, 1933, ink, 15 1/2 x 19 3/4 in.
(no. 58 in exh.)
Minotaur II, 1934, ink, 9 1/2 x 13 1/4 in.
(no. 59 in exh.)
Sleeping Nude, 1934, ink, 10 3/4 x 12 1/2 in.
(no. 60 in exh.)
Nudes, 1934, ink, 9 1/2 x 13 1/4 in. (no. 61 in exh.)
Bathers, 1934, ink, 9 1/4 x 13 1/4 in. (no. 62 in exh.)

March 5–6, 1940: Mayflower Hotel, Washington, D.C.
"Exhibition of Modern Paintings, Drawings and
Primitive African Sculpture from the Collection of
Helena Rubinstein"
Inspiration (no. 1 in exh.)
Harlequin (no. 2 in exh.) [Possibly *Harlequin*, 1913,
gouache.]
Two Figures (no. 3 in exh.)
Seated Figure (no. 4 in exh.) [Either this work or
no. 15 below might be *Seated Nude*, 1906, lavis,
12 1/4 x 18 3/4 in., Z.I.362.]
Figure of a Man (no. 5 in exh.) [This might be
Homme nu aux mains croisées, 1907, gouache,
24 1/2 x 18 1/4 in., identified in a sale catalogue
("Helena Rubinstein Collection, Part 1,"
Parke-Bernet Galleries, New York, April 20,
1966) as Z.II¹.15.]
Head of Woman (no. 6 in exh.)
Abstraction (no. 7 in exh.)
Cubist Abstraction (no. 8 in exh.)
Head of Boy (no. 9 in exh.) [This might be the work
identified in the Helena Rubinstein Collection
sale catalogue as Z.VI.892.]
Two Figures in a Café (no. 10 in exh.)
Spanish Beggar (no. 11 in exh.)
Bust of Young Girl (no. 12 in exh.)
Abstract Still Life (no. 13 in exh.) [Possibly a collage
dated 1917, or *Nature morte-verre et pomme*, 1911,
10 3/4 x 6 1/2 in., identified in the Helena
Rubinstein Collection sale catalogue as Z.VI.892.]
Head of Woman (no. 14 in exh.)
Seated Figure (no. 15 in exh.)

April 1–May 11, 1940: Valentine Gallery, New York
"Three Spaniards: Gris, Miró, Picasso"
Nature morte aux poisson, 1923, oil on canvas, 18 1/4 x
21 1/2 in. / Philip L. Goodwin, New York
[Wadsworth Atheneum, Hartford, Conn.]
La Lecture interrompue, December 11, 1932, oil on
panel, 25 5/8 x 20 in. [Z.VII.363]
Arlequin, 1935, oil on canvas, 24 1/4 x 19 3/4 in.
[Albright-Knox Art Gallery, Buffalo]
Portrait of Dora Maar, August 29, 1938, oil on canvas,
25 5/8 x 19 3/4 in. [Z.IX.211; private collection]
Portrait of Dora Maar, 1938, pastel, ink, and sand on
canvas, 19 5/8 x 23 in. [Pulitzer Foundation for
the Arts, St. Louis, Mo.]

April 2–30, 1940: Arts Club of Chicago
"Origins of Modern Art"
Two Girls Reading, [March 28], 1934, 31 7/8 x
25 1/2 in. / John W. Garrett, Baltimore (no.
18 in exh.) [Z.VIII.192; private collection]
Mother and Child, 1923, 51 1/2 x 38 1/4 in. / Walter
P. Chrysler, Jr., New York (no. 42 in exh.)
[Z.IV.455]
Abstraction in Primary Colors, February 10, 1922, oil
on canvas, 45 1/2 x 28 1/2 in. / Walter P. Chrysler,
Jr., New York (no. 53 in exh.; ill. in cat.) [Z.IV.427]
Still Life: "Vive la . . . ," 1914, oil on canvas,
21 3/8 x 25 3/4 in. / Sidney Janis, New York
(no. 66 in exh.) [Z.II².523; private collection]
Buste de Femme, 1906, oil on canvas, 31 1/2 x
25 1/4 in. / Walter P. Chrysler, Jr., New York
(no. 68 in exh.; Art Institute of Chicago)
[Z.I.374; Art Institute of Chicago]
Portrait of a Woman, summer 1909, oil on canvas,
23 7/8 x 20 3/16 in. / Art Institute of Chicago,
Winterbotham Collection (no. 70 in exh.)
[Z.II¹.167; Art Institute of Chicago]

April 7–May 1, 1940: Phillips Memorial Gallery,
Washington, D.C.
"Great Modern Drawings"
Mother and Child and 4 Studies of Her Right Hand,
1904 / Paul Sachs (no. 26 in exh.) [Z.I.220; Fogg
Art Museum, Harvard University, Cambridge,
Massachusetts]
The Philosopher/Portrait of a Man, 1919 / Fogg Art
Museum, Harvard University, Cambridge,
Massachusetts (no. 27 in exh.) [Z.III.256; Fogg
Art Museum]

April 8–May 4, 1940: Marie Harriman Gallery, New York
"Flowers: Fourteen American Fourteen French Artists"
Vase de fleurs (no. 22 in exh.)

April 25–May 26, 1940: Art Institute of Chicago
"The Nineteenth International Exhibition of Water
Colors"
The Poor (no. 110 in exh.)
Reclining Nude, pencil / Mr. Martin C. Schwab,
Chicago (no. 111 in exh.)

May 25–June 22, 1940: French Art Galleries, New York
"Women and Children in French Painting"
Mother and Child, 1922 / Marie Harriman Gallery,
New York (no. 8 in exh.; ill. in cat.) [Z.IV.370]
Tête de Femme, 1901 / M. Knoedler & Co, New York
(no. 9 in exh.) [Z.I.73; Philadelphia Museum of
Art]
Girl on Horseback, 1904 / European private collection,
lent by French Art Galleries (no. 10 in exh.)

May 25–September 29, 1940: Palace of Fine Arts, San
Francisco
"Golden Gate International Exposition"
Portrait of Mme Picasso / Bignou Gallery, New York
(no. 691 in exh.; ill. in cat.)
Seated Acrobat / Marie Harriman Galleries, New York
(no. 692 in exh.)
Back Stage at the Circus / Mr. Marcel Fleischmann,
Zurich, through Phillipp Loewenfeld, New York
(no. 693 in exh.)
Nudes / Mr. Marcel Fleischmann, Zurich, through
Phillipp Loewenfeld, New York (no. 694 in exh.)

October 21–November 9, 1940: Arden Gallery, New York
"Exhibition of Paintings and Sculpture by
Contemporary French Masters"
Portrait of Georges Braque (no. 16 in exh.) [Z.II¹.177;
Staatliche Museen zu Berlin, Nationalgalerie, on
permanent loan from the Berggruen Collection]
Dance of Herodias (no. 36 in exh.)
Three Figures (no. 41 in exh.)

December 1940–January 1941: M. H. de Young
Memorial Museum, San Francisco
"The Painting of France since the French Revolution"
Portrait of a Woman (Mlle. Suzanne B.), 1904, canvas,
24 7/8 x 21 3/8 in. / Mrs. H. Bieber, Lugano,
Switzerland (no. 149 in exh.; ill. in cat.) [Z.I.217]
The Reply, 1923, canvas, 39 3/8 x 24 in. / Paul
Rosenberg, New York (no. 150 in exh.) [Z.V.30]

December 30, 1940–January 25, 1941: Pierre Matisse
Gallery, New York
"Landmarks in Modern Art"
The Mantel, 1915, oil on canvas, 51 x 37 1/2 in.
[Metropolitan Museum of Art, New York]

1941

January 15–March 2, 1941: Los Angeles County
Museum
"Aspects of French Painting from Cézanne to Picasso"
The Actor, 1905, oil, 77 1/4 x 45 1/8 in. / Paul
Rosenberg, New York (no. 31 in exh.) [Z.I.291;
Metropolitan Museum of Art, New York]
Barcelona in Blue, ca. 1903, oil, 21 x 15 in. / Felix
Wildenstein & Co., New York (no. 32 in exh.)
[Z.I.122]
Blue and Yellow Vase, [1938, 23 3/4 x 28 3/4 in.] /
Paul Rosenberg, New York (no. 33 in exh.)
Guernica, Woman with Handkerchief, oil sketch,
21 x 17 1/2 in. / Thomas Mitchell, Hollywood
(no. 34 in exh.) [Z.IX.51; Los Angeles County
Museum of Art]
Man with Guitar, 1911, oil, 32 x 19 in. / Mme. Galka
E. Scheyer, Los Angeles (no. 34a in exh.)
Mother and Child, 1922, oil, 39 1/2 x 32 in. / Marie
Harriman Gallery, New York (no. 35 in exh.)
[Z.IV.370]
Portrait of a Woman (Mlle. Susan B.), 1904, oil,
24 7/8 x 21 3/8 in. / Mrs. H. Bieber, Lugano,
Switzerland (no. 36 in exh.) [Z.I.217]
The Reply, 1923, oil, 39 3/8 x 24 in. / Paul
Rosenberg, New York (no. 37 in exh.) [Z.V.30]
Seated Figure, 1911, oil, 38 3/8 x 30 1/2 in. /
Walter C. Arensberg, Hollywood (no. 38 in
exh.) [Z.II¹.225; Philadelphia Museum of Art]
Woman with Blue Turban, 1923, oil, 46 x 36 in. /
S. Wright Ludington, Santa Barbara (no. 39 in
exh.) [Z.V.22]
Woman with Crow, 1904, gouache on cardboard,
19 1/8 x 25 5/8 in. / Toledo Museum of Art
(no. 40 in exh.) [Z.I.240; Toledo Museum of
Art, Ohio]

February 10–March 1, 1941: Bignou Gallery, New York
"Picasso Early and Late"
Les Roses (no. 1 in exh.) [Z.I.9]
A Cheval [sic] (no. 2 in exh.)
Le Corsage blanc (no. 3 in exh.)
Femme au bouquet (no. 4 in exh.)
La Table garnie (no. 5 in exh.)
Abstraction (no. 6 in exh.)
Nature morte au citron (no. 7 in exh.)
Abstraction [current title: *Abstraction (Head),*
January 26, 1930, oil on wood panel, 24 1/2 x
18 1/4 in.] (no. 8 in exh.) [Cincinnati Art Museum]
Nature morte (no. 9 in exh.)
Le Journal (no. 10 in exh.)
Abstraction (no. 11 in exh.)
Trois Figures (no. 12 in exh.)
Le Taureau blessé (no. 13 in exh.) [Z.VIII.228;
Metropolitan Museum of Art, New York]
La Suze (no. 14 in exh.) [Z.II².422; Washington
University Gallery of Art, St. Louis, Missouri]
Ma Jolie (no. 15 in exh.)
La Musique (no. 16 in exh.)
La Liseuse endormie (no. 17 in exh.)
Dora Mare [sic] (no. 18 in exh.) [Z.VIII.320]
Hippocampe (no. 19 in exh.)
La Lecture (no. 20 in exh.)
Tête au nez en quart de brie (no. 21 in exh.)

March 29–May 11, 1941: Philadelphia Museum of Art
"The Collection of Walter P. Chrysler, Jr."
Au moulin rouge, 1901, watercolor on paper,
25 1/2 x 19 1/2 in. (no. 148 in exh.) [Z.VI.351]
La Maternité, 1901, oil on canvas, 18 1/2 x 13 in.
(no. 149 in exh.; ill. in cat.) [Z.I.108; Metropolitan
Museum of Art, New York]
Les Chrysanthèmes, 1901, oil on canvas, 32 x 25 1/2 in.
(no. 150 in exh.; ill. in cat.) [Z.VI.647;
Philadelphia Museum of Art]
Femmes au bar, 1902, oil on canvas, 31 1/2 x 36 in.
(no. 151 in exh.; ill. in cat.) [Z.I.132; Hiroshima
Museum of Art]
La Repasseuse, 1904, pastel, 14 1/2 x 20 1/4 in.

(no. 152 in exh.; ill. in cat.) [Z.I.248]
Nude in Grey, 1905, tempera on board, 40 1/2 x
29 1/2 in. (no. 153 in exh.) [Z.I.257; Musée
National d'Art Moderne, Centre National
d'Art et de Culture Georges Pompidou, Paris]
Buste de femme, 1906, oil on canvas, 31 1/2 x
25 1/4 in. (no. 156 in exh.; ill. in cat.) [Z.I.374;
Art Institute of Chicago]
Grande Danseuse d'Avignon [current title: *Nude
with Raised Arms (The Dancer at Avignon)*],
1907, oil on canvas, 59 x 39 1/2 in. (no. 157
in exh.; ill. in cat.) [Z.II¹.35; private collection,
New York]
Tête nègre [current title: *Bust of a Man*], 1907–8, oil
on canvas, 24 3/4 x 17 in. (no. 158 in exh.; ill. in
cat.) [Z.II¹.76; Metropolitan Museum of Art,
New York]
Femme aux poires, 1908, oil on canvas, 36 x
28 3/4 in. (no. 159 in exh.) [Z.II¹.170;
Museum of Modern Art, New York]
Head of a Woman, 1909, gouache and oil on
paper, 25 1/2 x 19 in. (no. 160 in exh.; ill. in cat.)
[Z.II¹.140; Art Institute of Chicago]
Woman and Landscape, 1909, oil on canvas,
36 x 28 3/4 in. (no. 161 in exh.; ill. in cat.)
[Z.II¹.150; private collection]
Nature morte au siphon [current title: *Still Life
with Liqueur Bottle*], Horta del Ebro, Spain,
1909, oil on canvas, 32 x 25 1/2 in. (no. 162
in exh.; ill. in cat.) [Z.II¹.173; Museum of
Modern Art, New York]
Tête cubiste, 1910, oil on canvas, 14 5/8 x 13 1/8 in.
(no. 164 in exh.) [Z.II¹.162; private collection /
This painting and no. 165 were formerly a single
canvas that was later cut in two; consequently,
they share one Zervos reference number.]
Deux Têtes cubistes, 1910, oil on canvas, 14 3/4 x
14 1/2 in. (no. 165 in exh.) [Z.II¹.162; private
collection]
Table de toilette, 1910, oil on canvas, 24 x 18 1/4 in.
(no. 166 in exh.; ill. in cat.) [Z.II¹.220]
L'Arlésienne, 1911, oil on canvas, 30 x 21 3/4 in.
(no. 167 in exh.) [Z.II¹.356; private collection]
Un Verre d'absinthe, 1911–12, oil on canvas, 15 x
18 1/4 in. (no. 168 in exh.) [Z.II¹.261; Allen
Memorial Art Museum, Oberlin College, Ohio]
Le Modèle, 1912, oil on canvas, 45 3/8 x 31 1/2 in.
(no. 169 in exh.; ill. in cat.) [Z.II².361; private
collection, New York]
Deux Femmes nues [current title: *Two Female Nudes*],
1920, oil on canvas, 77 x 64 in. (no. 170 in exh.)
[Z.IV.217; Kunstsammlung Nordrhein-Westfalen,
Düsseldorf]
Jeune Fille au chapeau jaune, April 16, 1921,
41 1/4 x 29 1/2 in. (no. 171 in exh.) [Z.IV.258]
Landscape, 1921, pastel, 19 x 25 1/8 in. (no. 172
in exh.; ill. in cat.) [Z.IV.279]
Cubist Abstraction, 1921, oil on canvas, 72 1/2 x
29 1/2 in. (no. 173 in exh.; ill. in cat.)
Les Deux Soeurs, 1921, pastel on carton, 41 3/8 x
29 1/2 in. (no. 174 in exh.) [Z.IV.358]
Head of a Woman, 1922, oil on wood, 9 3/8 x
7 1/2 in. (no. 175 in exh.; ill. in cat.) [Z.IV.355]
Abstraction in Primary Colors, February 10, 1922,
oil on canvas, 45 1/2 x 28 1/2 in. (no. 176 in
exh.; ill. in cat.) [Z.IV.427]
Composition fond vert et bleu, 1922, oil on canvas,
32 1/4 x 39 3/8 in. (no. 177 in exh.) [Z.IV.422]
Mother and Child, 1923, oil on canvas, 51 1/2 x
38 1/4 in. (no. 178 in exh.) [Z.IV.455]
Les Baigneuses, 1923, oil on wood, 32 x 39 1/2
in. (no. 179 in exh.; ill. in cat.) [Z.IV.169]
*The Studio,** 1927–28, oil on canvas, 59 x 90 in. /
Loaned [sic] by the Museum of Modern Art to
which this was presented by Mr. Walter P.
Chrysler, Jr. in 1935 (no. 180 in exh.; ill. in cat.)
[Z.VII.142; Museum of Modern Art, New York]
La Plage, 1928, oil on canvas, 14 1/4 x 9 7/8 in.
(no. 181 in exh.) [Z.VII.213]
Sculpture nègre, 1929, oil on canvas, 28 5/8 x
19 5/8 in. (no. 182 in exh.; ill. in cat.) [Z.VII.247]
Bone Forms Against the Sky, February 1, 1930,
oil on wood, 26 x 19 1/2 in. (no. 183 in exh.)
[Z.VII.300]
Project for a Monument, February 19, 1930, oil
on wood, 26 x 19 1/2 in. (no. 184 in exh.)

[Z.VII.420; private collection]
Jeune Fille endormie, 1935, oil on canvas, 18 x
21 1/2 in. (no. 185 in exh.; ill. in cat.) [Z.VIII.266]
Le Coq, March 29, 1938, pastel on paper, 30 1/2
x 21 1/4 in. (no. 186 in exh.; ill. in cat.) [Z.IX.113]
Homme à la soucette, Mougins, August 20, 1938,
oil and benzine on paper, 26 3/4 x 17 1/2 in.
(no. 187 in exh.; ill. in cat.) [Z.IX.203; Metropolitan
Museum of Art, New York]
Portrait, 1938, oil on canvas, 28 1/2 x 24 1/2 in.
(no. 188 in exh.; ill. in cat.) [Z.IX.157]
Scène de bar, 1900, crayon drawing, 5 x 8 in.
(no. 189 in exh.) [Z.VI.327]
Têtes d'étude I, 1900, crayon drawing, 5 x 8 in.
(no. 190 in exh.)
Têtes d'étude II, 1900, crayon drawing, 8 x 5 in.
(no. 191 in exh.)
Le Vieux Musicien, 1900, pencil drawing, 18 x
11 3/4 in. (no. 192 in exh.)
Chevaux et enfant, 1901, crayon drawing, 8 3/4 x
5 3/4 in. (no. 193 in exh.)
Jardin de Paris, 1902, watercolor, 26 x 19 in.
(no. 194 in exh.) [Z.VI.367; Metropolitan
Museum of Art, New York]
Old Beggar, 1903, ink and pencil, 12 1/2 x 5 in.
(no. 195 in exh.)
Ex Libris Guillaume Apollinaire, 1905, ink and
watercolor drawing, 7 1/2 x 4 3/4 in. (no. 196
in exh.) [Z.I.225]
Gamin, 1903-5, pencil, 7 x 4 in. (no. 197 in exh.)
Repos des moissoneurs, 1904, ink, 9 3/4 x 12 1/2
in. (no. 198 in exh.)
Solitude, 1904, aquarelle, 14 1/4 x 10 1/4 in.
(no. 199 in exh.; ill. in cat.)
Bon Homme assis, 1904, ink drawing, 11 1/2 x
8 1/2 in. (no. 200 in exh.)
Fête–Sketch for the Hôtel de l'Ouest, 1904, water-
color, 21 1/4 x 17 in. (no. 201 in exh.) [Z.I.213]
Three Figures, 1904, ink drawing, 10 1/2 x 8 1/4
in. (no. 202 in exh.)
Enterrement, 1904, watercolor, 16 3/4 x 20 in.
(no. 203 in exh.) [Z.VI.330]
Figures on Horses, 1905, pencil drawing, 11 1/4 x
17 1/2 in. (no. 205 in exh.) [Z.XXII.266]
Study for "La Toilette," 1905, watercolor, 10 x 6 1/2 in.
(no. 207 in exh.; ill. in cat.)
Peasant Woman, pen drawing, 16 x 11 1/4 in.
(no. 208 in exh.)
Nu de dos, 1906, crayon drawing, 25 x 18 1/2 in.
(no. 209 in exh.)
Nu aux bras levés, 1906, pen drawing, 15 3/4 x
10 7/8 in. (no. 210 in exh.)
Nu aux mains jointes, 1906, pencil drawing,
24 1/2 x 18 5/8 in. (no. 211 in exh.)
Demoiselle d'Avignon, 1907, pastel, 8 3/4 x 6 1/2 in.
(no. 212 in exh.) [Z.II¹.5; private collection,
New York]
Nu allongé, 1907, ink wash, 7 3/4 x 11 3/4 in.
(no. 213 in exh.; ill. in cat.)
Nu, 1907, ink wash, 7 x 11 3/4 in. (no. 214 in exh.)
Nu, étude, 1908, watercolor, 25 3/4 x 19 1/2 in.
(no. 215 in exh.) [Z.II¹.13; private collection,
New York]
Seated Man, 1914, watercolor, 13 x 9 1/4 in. (no. 216
in exh.)
Man at Table, 1914, pencil, 13 x 10 in. (no. 217 in
exh.) [Z.II².506]
Interior, 1916, watercolor, 12 1/4 x 9 1/2 in.
(no. 218 in exh.) [Z.II².567; private collection,
New York]
Head of a Woman, pencil drawing, 9 x 6 3/4 in.
(no. 219 in exh.)
Guitar on Table, 1921, gouache, 10 1/2 x 8 1/4 in.
(no. 220 in exh.)
Nude, 1921, pencil drawing, 7 1/4 x 10 3/4 in.
(no. 221 in exh.)
Abstraction, 1921, watercolor, 8 1/4 x 10 1/4 in.
(no. 222 in exh.)
La Source, 1921, pastel, 5 1/4 x 6 1/2 in. (no. 223
in exh.)
Study of a Hand, [January 20], 1921, pastel,
8 1/8 x 12 1/4 in. (no. 224 in exh.) [Z.IV.239]
Two Nudes, February 27, 1921, pencil drawing,
8 5/8 x 12 1/4 in. (no. 225 in exh.)
Two Nudes, 1923, pastel, 9 3/4 x 7 1/4 in. (no. 226
in exh.)

Two Nudes, 1923, charcoal drawing, 6 1/8 x 4 5/8 in.
(no. 227 in exh.)
Head of a Boy, 1923, gouache, 19 1/2 x 14 in.
(no. 228 in exh.; ill. in cat.)
Acrobats, 1923, ink wash, 24 1/2 x 18 3/4 in.
(no. 229 in exh.)
Compotier et guitare, 1924, gouache, 4 3/4 x 6 1/4 in.
(no. 230 in exh.) [Z.IV.240]
Head, 1926, pastel and fusion, 25 x 19 in.
(no. 231 in exh.)
Seated Woman, 1927, demi-gouache, 9 x 8 in.
(no. 232 in exh.)
Seated Figure and Head, 1930, pen and pencil
drawing, 11 1/8 x 10 1/8 in. (no. 233 in exh.)
Le Sculpteur, 1932, ink drawing, 12 1/2 x 12 1/2 in.
(no. 234 in exh.)
Woman Painter and Model, 1933, charcoal drawing,
11 1/8 x 10 1/8 in. (no. 235 in exh.)
Portrait of Dora Maar, April 19, 1938, pen drawing,
33 1/4 x 25 1/2 in. (no. 236 in exh.)

April 7–26, 1941: Bucholz Gallery, New York
"Beaudin [*sic*], Braque, Gris, Klee, Léger, Masson,
Picasso"
La Toilette, 1905, pencil, 12 x 9 1/4 in. (no. 38
in exh.)
Woman and Devil, 1906, ink, 10 1/2 x 8 in.
(no. 39 in exh.)
Reclining Nude, 1920, pencil, 8 1/2 x 12 in.
(no. 40 in exh.)
The Table, 1920, gouache, 10 x 7 1/2 in. (no. 41
in exh.)
Bowl of Fruit, 1920, watercolor, 10 1/2 x 16 in.
(no. 42 in exh.)
The Table, 1920, watercolor, 6 3/4 x 9 1/4 in.
(no. 43 in exh.)
Still Life, 1920, gouache, 8 1/4 x 12 1/2 in.
(no. 44 in exh.)
Nude, 1920, pencil, 12 1/4 x 8 1/8 in. (no. 45 in exh.)
Masqueraders, 1921, pencil and watercolor,
8 1/2 x 7 1/4 in. (no. 46 in exh.)
Pipe and Tobacco, 1921, gouache, 4 3/4 x 6 3/4 in.
(no. 47 in exh.)
Still Life, 1922, pencil, 9 3/4 x 12 3/4 in. (no. 48
in exh.)
In the Wings, 1925, pencil, 19 1/4 x 15 3/4 in.
(no. 49 in exh.)
Serenade, 1932, ink, 9 1/4 x 12 1/2 in. (no. 50 in exh.)

April 10–May 20, 1941: Art Institute of Chicago
"Masterpieces of French Art lent by the Museums and
Collectors of France"
Portrait of a Woman (Mlle. Suzanne B.), 1904, oil on
canvas, 24 3/4 x 21 1/4 in. / Justin K. Thannhauser,
New York (no. 120 in exh.) [Z.I.217]
The Reply, 1923, oil on canvas, 39 3/8 x 24 in. /
Paul Rosenberg, New York (no. 121 in exh.;
ill. in cat.) [Z.V.30]
Still Life with a Bottle of Wine, 1926, oil on canvas,
38 5/8 x 51 1/4 in. / Paul Rosenberg, New York
(no. 122 in exh.) [Z.VI.1444]

April 15–May 3, 1941: Pierre Matisse Gallery, New York
"Small Pictures by French Painters"
Nude with a Guitar (no. 13 in exh.)
Still Life (no. 14 in exh.)

May 11–June 1, 1941: Phillips Memorial Gallery,
Washington, D.C.
"Picasso: Etchings, Lithographs, Drawings"
Masqueraders, 1921, pencil and watercolors
(no. 29 in exh.)
Still Life, 1922, pencil (no. 30 in exh.)
Painter and Model (no. 31 in exh.)
Serenade, 1932, ink (no. 32 in exh.)
Reclining Nude, 1920, pencil (no. 33 in exh.)
Portrait of a Labarte (no. 34 in exh.)
Nude / [Estate of?] Arthur B. Davies (no. 35 in exh.)
In the Wings, 1925, pencil (no. 36 in exh.)

Summer 1941: M. H. de Young Memorial Museum,
San Francisco
"French Drawings and Water Colors: Supplement to
the Painting of France since the French Revolution"
The Painter and His Model, Juan les Pins, September
1926, pen and ink and wash on white paper,

11 5/8 x 15 1/8 in. / Baron Gourgaud, Paris
(no. 287 in exh.)
Head of a Woman, red chalk and charcoal on
white paper, 25 1/8 x 19 1/4 in. / Justin K.
Thannhauser, Paris (no. 288 in exh.)

July 15–September 7, 1941: Museum of Modern Art,
New York
"Masterpieces of Picasso"
Le Moulin de la Galette, Paris, 1900, oil / Justin
K. Thannhauser, Paris (ill. in cat.) [Z.I.41;
Solomon R. Guggenheim Museum, New York]
Woman Ironing, Paris, 1904, oil / Justin K.
Thannhauser, Paris [Z.I.247; Solomon
R. Guggenheim Museum, New York]
Two Acrobats with a Dog, Paris, 1905, gouache /
Justin K. Thannhauser, Paris (ill. in cat.) [Z.I.300;
Museum of Modern Art, New York]
Boy Leading a Horse, Paris, 1905, oil / Mr. William
S. Paley, New York (ill. in cat.) [Z.I.264; Museum
of Modern Art, New York]
Woman with a Mandolin, 1910, oil / Mr. Roland
Penrose, London [Z.II¹.235; Museum of Modern
Art, New York]
Man with a Violin, 1913, pasted paper and charcoal /
Mr. Roland Penrose, London [Z.II².399;
Metropolitan Museum of Art, New York]
Chinese Conjurer's Costume, Rome?, 1917, gouache /
anonymous loan [Z.XXIX.253]
Diaghilev and Selisburg, Rome or Florence, 1917,
pencil / Pablo Picasso [Z.III.301; Musée Picasso,
Paris]
Three Ballerinas, 1917?, pencil and charcoal / Pablo
Picasso
Three Musicians, Fontainebleau, summer 1921, oil /
anonymous loan [Z.IV.331; Museum of Modern
Art, New York / The anonymous lender was
Paul Rosenberg, New York.]
The Race, 1922, tempera on wood / Pablo Picasso
[Z.IV.380; Musée Picasso, Paris]
The Pipes of Pan, 1923, oil / Pablo Picasso [Z.V.141;
Musée Picasso, Paris]
The Red Tablecloth, December 1924, oil / anonymous
loan [Z.V.364; private collection, New York / The
anonymous lender was Paul Rosenberg.]
The Three Dancers, 1925, oil / Pablo Picasso [Z.V.426;
Tate Gallery, London]
The Ram's Head, Juan les Pins, summer 1925, oil /
anonymous loan [Z.V.443; Norton Simon Museum,
Pasadena, California]
Still Life with a Bottle of Wine, 1926, oil / anonymous
loan [Z.VI.1444 / The anonymous lender was
Paul Rosenberg, New York.]
Figure, 1927, oil on plywood / Pablo Picasso
The Painter and His Model, 1928, oil / Sidney Janis,
New York [Z.VII.143; Museum of Modern Art,
New York]
Seated Bather, 1929, oil / Mrs. Meric Callery, New
York [Z.VII.306; Museum of Modern Art, New
York]
Crucifixion, February 7, 1930, oil on wood / Pablo
Picasso [Z.VII.287; Musée Picasso, Paris]
Girl Reading, 1934, oil / Mr. Peter Watson, London
[Z.VIII.246; Metropolitan Museum of Art, New
York]
Girls with a Toy Boat, February 12, 1937, oil and
charcoal / Mrs. Meric Callery, New York
[Z.VIII.344; Peggy Guggenheim Collection,
Venice]
Guernica, 1937, oil / Pablo Picasso [Z.IX.65; Museo
Nacional Centro de Arte Reina Sofia, Madrid]
The End of a Monster, Paris, December 6, 1937,
pencil / Mr. Roland Penrose, London
[The exhibition also included seventeen "studies
for *Guernica*," dated between May 2 and July 4,
1937, all of which were on loan from the artist:]
Composition Study, May 2, pencil on gesso
[Sketch 10 / Z.IX.8; Museo Nacional Centro
de Arte Reina Sofia, Madrid]
Horse's Head, May 2, oil on canvas [Sketch 9 /
Z.IX.11; Museo Nacional Centro de Arte
Reina Sofia, Madrid]
Horse and Bull, early May, pencil on brown paper
[Sketch 11 / Z.IX.9; Museo Nacional Centro de
Arte Reina Sofia, Madrid]
Horse and Woman with Dead Child, May 8, pencil on

white paper [Sketch 13 / Z.IX.12; Museo Nacional Centro de Arte Reina Sofia, Madrid]
Woman with Dead Child on Ladder, May 9, pencil on white paper [Sketch 16 / Z.IX.16; Museo Nacional Centro de Arte Reina Sofia, Madrid]
Head, May 13, pencil and color crayon on paper [Sketch 23 / Z.IX.22; Museo Nacional Centro de Arte Reina Sofia, Madrid]
Study for Bull's Head [current title: *Sketch of a Head of a Bull-Man*],* May 20, pencil [Sketch 26 / Z.IX.28; Museo Nacional Centro de Arte Reina Sofia, Madrid]
Woman with Dead Child, May 28, pencil, ink, and gouache on paper [This could be either Sketch 36 or 37 / Z.IX.38 or Z.IX.37*; Museo Nacional Centro de Arte Reina Sofia, Madrid]
Head [current title: *Head of Weeping Woman (III)*],* May 31, pencil, color crayon, and gouache on paper [Sketch 39 / Z.IX.39; Museo Nacional Centro de Arte Reina Sofia, Madrid]
Weeping Head, June 3, pencil and color crayon [This could be Sketch 40, 41, or 42 / Z.IX.40, Z.IX.44 or Z.IX.41; Museo Nacional Centro de Arte Reina Sofia, Madrid]
Head and Hand, June 4, pencil and gouache on paper [Museo Centro de Arte Reina Sofia, Madrid]
Head, June 8, pencil and color crayon on paper [Z.IX.46; Museo Nacional Centro de Arte Reina Sofia, Madrid]
Head, June 8, pencil and color crayon on paper [Z.IX.48; Museo Nacional Centro de Arte Reina Sofia, Madrid]
Weeping Head, June 15, pencil and oil on canvas [Museo Centro de Arte Reina Sofia, Madrid]
Weeping Head, June 21, oil on canvas [Museo Centro de Arte Reina Sofia, Madrid]
Woman, June 22, pencil and oil on canvas [Museo Centro de Arte Reina Sofia, Madrid]
Weeping Head, July 4, ink on white paper [Z.IX.55]
[In addition, there were "two studies related to *Guernica*, (made after the completion of the picture)":]
Head, October 13, ink and oil on canvas. [21 5/8 x 18 1/9 in. Museo Nacional Centro de Arte Reina Sofia, Madrid]
Head, October 17, oil on canvas, Z.IX.77; Museo Nacional Centro de Arte Reina Sofia, Madrid]

July 17–October 5, 1941: Art Institute of Chicago
"The Twentieth International Exhibition of Water Colors"
The Abduction, pen and ink (no. 152 in exh.)
At the Seashore, pen and ink (no. 153 in exh.)
Four Personages, pen and ink (no. 154 in exh.)

October 7–November 1, 1941: Pierre Matisse Gallery, New York
"Exhibition of French Modern Paintings"
Woman from Arles (no. 15 in exh.)

October 27–November 22, 1941: Bignou Gallery, New York
"A Selection of 20th century Paris Painters"
Tête de femme, 1908 (no. 17 in exh.)

November 1–29, 1941: Perls Galleries, New York
"Four Masters: Rouault, Picasso, Utrillo and Raoul Dufy"
Intérieur à Boisgeloup, 1932, oil (no. 8 in exh.; ill. in cat.) [Z.VII.404]
La Sérénade, 1932, ink (no. 9 in exh.)
Le Minotaur, 1933, ink (no. 10 in exh.)
Étude de "Trois femmes," 1938, ink (no. 11 in exh.)
Le Collier, 1938, ink (no. 12 in exh.)
Portrait de Dora, 1938, ink (no. 13 in exh.)

November 3–December 6, 1941: Phillips Memorial Gallery, Washington, D.C.
["*The Three Musicians* (1921) by Pablo Picasso"]
The Three Musicians, 1921 / anonymous loan through Museum of Modern Art [Z.IV.331; Museum of Modern Art, New York / The anonymous lender was Paul Rosenberg, New York.]

November 24–December 31, 1941: Valentine Gallery, New York
"Program"
Tête classique (no. 17 in exh.) [Z.IV.338]

December 1–31, 1941: Perls Galleries, New York
"For the Young Collector: Holiday Show" [This exhibition included several works by Picasso, although no titles of specific works were provided on the gallery's exhibition list.]

1942

January 19–February 16, 1942: California Palace of the Legion of Honor, San Francisco
"Painters as Ballet Designers"
Theater Box, section from Scenery for Cuadro Flemenco [*sic*], 1921 / Jacques Helft, New York
Theater Box, section from Scenery for Cuadro Flemenco [*sic*], 1921 / Jacques Helft, New York

January 20–February 6, 1942: McMillen, Inc., New York
"American and French Paintings" [This exhibition was arranged by John Graham, the Russian-born painter who, after moving to New York, became part of a tight-knit group that included Arshile Gorky, Stuart Davis, and Willem de Kooning. The show, which compared the work of established European and American artists to a number of virtually unknown Americans, included works by Picasso, Henri Matisse, Georges Braque, and Amedeo Modigliani, together with Walt Kuhn, de Kooning, Davis, and Jackson Pollock, among others.]
Portrait de Dora Mare [*sic*] (no. 5 in exh.)
Femme au fauteuil, deux profils (no. 21 in exh.) [Z.VII.78; Minneapolis Institute of Arts]
Roses (no. 23 in exh.)

January 20–February 14, 1942: Pierre Matisse Gallery, New York
"Figures [*sic*] Pieces in Modern Painting"
Seated Woman / Mr. and Mrs. Lee Ault, New Canaan, Connecticut (no. 9 in exh.) [either Z.IX.211; private collection or Z.VII.405]

February 11–March 7, 1942: Paul Rosenberg & Co., New York
"Loan Exhibition of Masterpieces by Picasso (from 1918 to 1926)"
Arlequin ("Si tu veux") [current title: *Harlequin with Violin ("Si Tu Veux")*], 1918 (no. 1 in exh.) [Z.III.160; Cleveland Museum of Art / The lender was Paul Rosenberg, New York.]
La Cuisine, 1922 (no. 2 in exh.)
La Galette, 1923 (no. 3 in exh.)
Les Biscuits, 1924 (no. 4 in exh.) [Z.V.242; Cleveland Museum of Art / The lender was Paul Rosenberg, New York.]
Le Tapis rouge, 1924 (no. 5 in exh.) [Z.V.364; private collection, New York / The anonymous lender was Paul Rosenberg.]
Le Tapis rouge et palette, 1924 (no. 6 in exh.)
La Femme à la mandoline, 1925 (no. 7 in exh.) [Z.V.442; Norton Simon Museum, Pasadena, California / The lender was Paul Rosenberg, New York.]
Le Filet, 1925 (no. 8 in exh.) [Z.V.459 / The lender was Paul Rosenberg, New York.]
La Tête de bélier, 1925, [oil, 31 1/2 x 39 1/2 in.] (no. 9 in exh.) [The lender was Paul Rosenberg, New York.]
La Tête de plâtre, 1925 (no. 10 in exh.)
La Bouteille de vin, 1926 (no. 11 in exh.) [Z.VI.1444 / The lender was Paul Rosenberg, New York.]

March 25–May 3, 1942: Museum of Modern Art, New York
"Acquisitions and Extended Loans: Cubist and Abstract Art"
Painted Head, 1908 (no. 1 in exh.)
Green Still Life, 1914, oil on canvas (no. 3 in exh.) [Z.II2.485; Museum of Modern Art, New York]
The Young Ladies of Avignon [current title: *Les*

Demoiselles d'Avignon], 1906–7, oil on canvas (no. 205 in exh.) [Z.II1.18; Museum of Modern Art, New York / This was a photograph of the painting, rather than the actual work.]
Dancer [current title: *Nude with Raised Arms (The Dancer of Avignon)*], 1907–8, oil on canvas / Mme Paul Guillaume, Paris (no. 207 in exh.) [Z.II1.35; private collection, New York]
Head of a Woman, 1908–9, oil on canvas / Mme Paul Guillaume, Paris (no. 208 in exh.) [Z.II1.172; Museu de Arte Moderna, Rio de Janiero]
Portrait of Braque, 1909, oil on canvas / Frank Crowninshield, New York (no. 209 in exh.) [Z.II1.177; Staatliche Museen zu Berlin, Nationalgalerie, on permanent loan from the Berggruen Collection]
The Tube of Paint [current title: *Still Life with Liqueur Bottle*], 1909, oil on canvas / Wildenstein & Co., New York (no. 210 in exh.) [Z.II1.173; Museum of Modern Art, New York]
The Poet, 1911, oil on canvas / George L.K. Morris, New York (no. 214 in exh.) [Z.II1.285; Peggy Guggenheim Collection, Venice]
Violin, ca. 1912, oil on canvas [oval] / The Kröller-Muller Foundation, Wassenaar, The Netherlands (no. 217 in exh.) [Z.II2.374; Rijksmuseum Kröller-Muller, Otterlo]
Dog and Cock, 1921, oil on canvas, 61 x 30 1/4 in. / new acquisition, gift of Mrs. Simon Guggenheim (unnumbered in exh.) [Z.IV.335; Yale University Art Gallery, New Haven, Connecticut]

April 1–May 15, 1942: Helena Rubinstein's New Art Center, New York
"Masters of Abstract Art"
The Poet, 1911, oil / George L. K. Morris, New York (no. 61 in exh.; ill. in cat.) [Z.II1.285; Peggy Guggenheim Collection, Venice]
Harlequin, 1913, gouache / Mme. Helena Rubinstein (no. 62 in exh.)
Still Life, 1917, collage / Mme. Helena Rubinstein (no. 63 in exh.)

June 16–July 12, 1942: San Francisco Museum of Art
"Modern Paintings from Five Local Collections"
Le Journal / Mrs. Adolph Mack, San Francisco [San Francisco Museum of Modern Art]

September 1942: Paul Rosenberg & Co., New York
"19th and 20th Century French Paintings"
Femmes à la fontaine, 1921, 31 1/2 x 26 3/4 in. (no. 11 in exh.)

November 2–28, 1942: Valentine Gallery, New York
"Picasso & Miró"
Chanteuse en blanc, 1900 (no. 1 in exh.)
Nu, 1908 (no. 2 in exh.)
Compotier, 1910 (no. 3 in exh.)
Tête classique, 1921 (no. 4 in exh.; ill. in cat.) [Z.IV.338]
Deux Nus, 1923 / Collection B. B. (no. 5 in exh.) [The lender is presumed to have been Mrs. Valentine "Bibi" Dudensing, wife of the gallery's proprietor.]
Arlequin, 1927 (no. 6 in exh.)
Nature morte, 1927 (no. 7 in exh.)
Baigneuse, 1929 (no. 8 in exh.)
Portrait [current title: *Bust of a Woman with Self-Portrait*], 1929 (no. 9 in exh.; ill. in cat.) [Z.VII.248; private collection]
Cirque, 1933 (no. 10 in exh.)
Bonnet rouge, 1934 (no. 11 in exh.) [Z.VIII.241; Pulitzer Foundation for the Arts, St. Louis, Missouri]
La Liseuse, 1938 (no. 12 in exh.)

December 8, 1942–January 24, 1943: Museum of Modern Art, New York
"Twentieth Century Portraits"; a part of this exhibition traveled to the Arts Club of Chicago, May 4–31, 1943, and to the California Palace of the Legion of Honor, San Francisco, June 14–July 12, 1943.
Mme Soler, Barcelona, 1903, oil on canvas, 40 x 28 in. / Justin K. Thannhauser, New York [Z.I.200; Staatsgalerie Moderner Kunst, Munich]

Fernande, 1908, oil on canvas, 24 1/4 x 16 3/4 in. / Bignou Gallery, New York (ill. in cat.)

Georges Braque, 1909, oil on canvas, 24 1/4 x 19 3/4 in. / Frank Crowninshield, New York [Z.II¹.177; Staatliche Museen zu Berlin, Nationalgalerie, on permanent loan from the Berggruen Collection / This is the only one by Picasso among the works that were shown in Chicago and San Francisco.]

Henry Kahnweiler, 1910, oil on canvas, 39 1/2 x 28 5/8 in. / Mrs. Charles B. Goodspeed, Chicago [Z.II¹.227; Art Institute of Chicago]

Dr. Claribel Cone, 1922, pencil, 25 1/4 x 19 1/4 in. / Cone Collection, Baltimore (ill. in cat.) [Z.IV.362; Baltimore Museum of Art]

The Reply (Mme. Picasso), 1923, oil on canvas, 40 x 32 1/4 in. / Paul Rosenberg & Co., New York (ill. in cat.) [Z.V.30]

Dora Maar, 1937, oil on canvas, 21 5/8 x 18 1/8 in. / Bignou Gallery, New York (ill. in cat.) [Z.VIII.320]

1943

January 23–February 20, 1943: Valentine Gallery, New York
"11 Modern Painters Exhibit 11 Abstract Paintings" [This exhibition included at least one work by Picasso, although no titles of specific works have been identified.]

February 8–March 20, 1943: Bignou Gallery, New York
"A Selection of Paintings of the Twentieth Century"
Seated Woman (no. 13 in exh.)

March 9–April 3, 1943: Pierre Matisse Gallery, New York
"War and the Artist"
Girl with a Cock, 1938 / Mrs. Meric Callery, New York (no. 11 in exh.) [Z.IX.109; private collection]
Dreams and Lies of Franco, 1938 (no. 12 in exh.)

April 1943: Valentine Gallery, New York
"20 Modern Paintings and Sculptures by Leading American and French Artists"
Tête classique, 1921, oil on canvas, 26 x 20 in. [Z.IV.338]
Portrait [current title: *Bust of a Woman with Self-Portrait*], 1929, oil on canvas, 29 x 24 in. [Z.VII.248; private collection]

April 4–30, 1943: Phillips Memorial Gallery, Washington, D.C.
"20th Century Drawings: A Loan Exhibition"
Guitar and Bottles, 1913, charcoal (no. 18 in exh.)
View of St. Malo Taken from Dinard, 1922, pencil (no. 26 in exh.)
The Fisherman, 1918, pencil (no. 27 in exh.) [Z.III.250; private collection]
Two Nudes on the Beach, 1921, pencil (no. 30 in exh.)
Study for "Two Nudes," charcoal (no. 31 in exh.)
La Source, 1921, pencil (no. 32 in exh.; ill. in cat.)
Three Dancers Resting, 1925, ink (no. 34 in exh.; ill. in cat.)
"Pour Eugenie," 1919, pencil (no. 35 in exh.)
Minotaur, 1933, ink and wash (no. 37 in exh.)
Studies of the Nude, 1923, ink (no. 38 in exh.)
The Painter and His Model, 1926, ink (no. 40 in exh.)

April 6–May 1, 1943: Paul Rosenberg & Co., New York
"Paintings by Braque and Picasso"
La Petite Cuisine, 1922, 32 x 39 1/2 in. (no. 7 in exh.)
Femme à la mandoline, 1925, 38 x 50 in. (no. 8 in exh.) [Z.V.442; Norton Simon Museum, Pasadena, California / The lender was Paul Rosenberg, New York.]
Le Rêve, 1932, 38 x 58 in. / Mr. and Mrs. Victor Ganz, New York (no. 9 in exh.) [Z.VII.364; Wynn Collection, Las Vegas]
La Fenêtre ouverte, 1937, 29 x 35 in. (no. 10 in exh.)
Nature morte dessin bleu, 1937, 19 3/4 x 25 1/2 in. (no. 11 in exh.)
Nature morte: la carafe bleu et jaune, 1938, 23 3/4 x 28 3/4 in. (no. 12 in exh.)
Le Pot au lait, 1938, 18 x 24 in. (no. 13 in exh.)
L'Assiette jaune et rose, 1938, 23 3/4 x 28 3/4 in. (no. 14 in exh.)

April 13–May 1, 1943: Pierre Matisse Gallery, New York
"About 30 Years Ago . . ."
Figure, ca. 1912

April 28, 1943–1952: Art Institute of Chicago
"20th Century French Paintings, Chester Dale Collection" (extended loan); traveled to the National Gallery of Art, Washington, D.C., 1952–53 [The works in this exhibition were unnumbered in Chicago, but numbered in Washington, D.C.; note also that one work by Picasso was shown only in the first venue, and another was shown only in the second venue.]
Le Gourmet, 1901 (unnumbered, not shown in Washington, D.C.) [Z.I.51; National Gallery of Art, Washington, D.C.]
The Tragedy, 1903, panel, 41 1/2 x 27 1/8 in. (no. 48 in Washington, D.C.; ill. in cat.) [Z.I.208; National Gallery of Art, Washington, D.C.]
Juggler with Still Life, 1905, gouache on cardboard, 39 3/8 x 27 1/2 in. (no. 49 in Washington, D.C.; ill. in cat.) [Z.I.294; National Gallery of Art, Washington, D.C.]
Two Youths, 1905, oil on canvas, 59 5/8 x 36 7/8 in. (no. 50 in Washington, D.C.; ill. in cat.) [Z.I.305; National Gallery of Art, Washington, D.C.]
Family of Saltimbanques, 1905, oil on canvas, 83 3/4 x 90 3/8 in. (no. 51 in Washington, D.C.; ill. in cat.) [Z.I.285; National Gallery of Art, Washington, D.C.]
Still Life, 1918, oil on canvas, 38 1/4 x 51 1/4 in. (no. 52 in Washington, D.C.; ill. in cat.) [Z.III.257; National Gallery of Art, Washington, D.C.]
Classical Head, 1922, oil on canvas, 24 x 19 3/4 in. (no. 53 in Washington, D.C.; ill. in cat.) [Z.IV.396; National Gallery of Art, Washington, D.C.]
Portrait of Madame Picasso, 1923, oil on canvas, 39 7/8 x 32 1/4 in. (no. 54 in Washington, D.C.; ill. in cat.) [Z.V.29; National Gallery of Art, Washington, D.C.]
The Lovers, 1923, oil on canvas, 51 1/4 x 38 1/4 in. (no. 55 in Washington, D.C.; ill. in cat.) [Z.V.14; National Gallery of Art, Washington, D.C.]
Portrait of Dora Maar, 1941, oil on canvas, 28 3/4 x 23 5/8 in. (not shown in Chicago; no. 56 in Washington, D.C.; ill. in cat.)

May–June 1943: Bignou Gallery, New York
"Ancient Chinese and Modern European Paintings"
Portrait of Fernande, 1908, oil on canvas, 24 1/4 x 16 3/4 in. (no. 47 in exh.)
Still Life, 1913, oil on canvas, 21 1/4 x 17 3/4 in. (no. 48 in exh.)
Circus Performers, 1905, ink drawing, 6 x 12 1/4 in. (no. 49 in exh.)

May 14–August 1943: Philadelphia Museum of Art
"The Gallatin Collection" [This exhibition celebrated the gift of the Gallatin Collection to the museum. Although Gallatin did publish a catalogue of the collection in 1943, it was largely a reprint of the 1940 collection catalogue and not considered an exhibition catalogue per se. The *Philadelphia Museum Bulletin* described it as having included "over twenty paintings by Picasso." This number may have included some prints and undoubtedly included drawings, since Gallatin did not own twenty paintings by Picasso. Below are the works by Picasso (eight oils and ten works on paper) now in the museum's collection.]
Self-Portrait [current title: *Self-Portrait with Palette*], 1906, oil (ill. on cover of *PM Bulletin*) [Z.I.375; Philadelphia Museum of Art]
Study for "The Young Ladies of Avignon," 1907, watercolor [Z.II¹.21; Philadelphia Museum of Art]
Bowls and Jug, 1908, oil [Z.II¹.63; Philadelphia Museum of Art]
Violin and Fruit Bowl, 1912–13, charcoal and black crayon on paper [Z.II².390; Philadelphia Museum of Art]
The Violin, 1913, collage of charcoal, black chalk, watercolor, oil paint, newspaper, and colored papers on thin cardboard (ill. in *PM Bulletin*) [Z.II².385; Philadelphia Museum of Art]
Guitar and Bottle, 1913, charcoal and pencil on paper [Z.II².389; Philadelphia Museum of Art]
The Glass, 1914, gouache and pencil [Z.II².460; Philadelphia Museum of Art]
Pipe and Violin, 1914, oil [Z.II¹.475; Philadelphia Museum of Art]
Still Life, 1914, oil [Z.II².516; Philadelphia Museum of Art]
Open Window, 1919, gouache and watercolor [Z.III.386; Philadelphia Museum of Art]
The Three Musicians,* 1921, oil (ill. in *PM Bulletin*) [Z.IV.332; Philadelphia Museum of Art]
Composition, 1922, oil [Z.IV.413; Philadelphia Museum of Art]
The Mandolin, 1923, oil [Z.V.91; Philadelphia Museum of Art]
Mandolin on a Table, 1924, Conté crayon on paper [Z.V.215; Philadelphia Museum of Art]
Mandolin on a Table, 1924, Conté crayon on paper [Z.V.216; Philadelphia Museum of Art]
The Zither, 1926, pastel and ink on paper [Z.VII.28; Philadelphia Museum of Art]
Bather, Dinard (Design for a Monument), 1928, oil [Z.VII.209; Philadelphia Museum of Art]
Study for "Lysistrata" illustrations, January 4, 1934, ink and wash [Philadelphia Museum of Art]

May 24–June 30, 1943: Valentine Gallery, New York
"French and American Figure Paintings"
La Greque (no. 6 in exh.) [Z.IV.284]

June 15–July 31, 1943: Pierre Matisse Gallery, New York
"Modern Pictures Under Five Hundred [Dollars]"
Personage, drawing [medium not specified], 10 1/8 x 12 3/4 in.

July 26, 1943–October 1953: Museum of Modern Art, New York
"Guernica [and related studies]" (on extended loan) [When Picasso sent *Guernica* and its related works on the tour of the U.S. that began at the Valentine Gallery in May 1939, he might have been anticipating an impending outbreak of war. That autumn, after the war began, he decided to assign custody of the works to the Museum of Modern Art for its duration. The painting (and presumably some of the studies) remained on view there "almost continuously" between July 26, 1943, and October 1953. For the next five years, *Guernica* toured Europe, returning to MoMA intermittently; and in 1958, Picasso renewed his long-term loan of these works to the museum. In 1981, the painting and sixty-two related sketches were given to the Spanish state in accordance with the artist's wishes.]
Guernica, 1937, oil on canvas [Z.IX.65; Museo Nacional Centro de Arte Reina Sofia, Madrid]

August–September 1943: Paul Rosenberg & Co., New York
"French and American Paintings of the 20th Century"
The Reply, 1923 (no. 18 in exh.) [Z.V.30]
Women at the Fountain, 1920 (no. 19 in exh.)

October 5–23, 1943: Pierre Matisse Gallery, New York
"Water Colors and Drawings" [This exhibition included at least one work by Picasso, although none has been identified.]

November 30–December 1943: Pierre Matisse Gallery, New York
"Picasso Exhibition"
Young Boy, 1905, gouache (no. 1 in exh.)
Two Nudes, 1905, drawing [medium not specified] (no. 2 in exh.)
La Toilette, 1906, drawing [medium not specified] (no. 3 in exh.)
Nude with Guitar, 1908, oil on canvas (no. 4 in exh.)
Standing Figure, 1910, watercolor (no. 5 in exh.)
Nude, 1911–12, oil on canvas (no. 6 in exh.; ill. in cat.) [Z.II¹.194; Albright-Knox Art Gallery, Buffalo]
The Mantelpiece, 1915, oil on canvas (no. 7 in exh.) [Metropolitan Museum of Art, New York]
The Guitar, 1919, oil on canvas (no. 8 in exh.)
Abstraction, 1920, gouache (no. 9 in exh.)
Mother and Child, 1921, oil on canvas / private collection (no. 10 in exh.)
Head, 1921, colored drawing [medium not specified] (no. 11 in exh.)

Nude Reclining, 1932, oil on canvas (no. 12 in exh.)
Figures on a Beach, 1933, watercolor, [16 x 20 in.] (no. 13 in exh.)
The Plaster Head, 1933, gouache / Mr. Keith Warner, New York (no. 14 in exh.)
The Swallows, 1934, drawing [medium not specified] (no. 15 in exh.)
Head, 1934, drawing [medium not specified] (no. 16 in exh.)
The Minotaur, 1935, colored pencil (no. 17 in exh.)
L'Arlésienne, 1937, oil on canvas, [32 x 25 in.] / Mrs. Meric Callery, New York (no. 18 in exh.)

December 6–31, 1943: Bignou Gallery, New York
"Raoul Dufy and some of his Contemporaries"
Dora Maar (no. 12 in exh.) [Z.VIII.320]

1944

January 17–March 10, 1944: Valentine Gallery, New York
"School of Paris: Abstract Paintings"
Nu, 1908 (no. 20 in exh.)
Compotier, 1910 (no. 21 in exh.)
Monument, 1930 (no. 22 in exh.) [private collection]

January 29–March 15, 1944: Niveau Gallery, New York
"French Masters of the 20th Century (Paintings Never Shown Before)"
Danseuses au repos (no. 14 in exh.)
Deux Femmes (no. 15 in exh.)

January 31–March 11, 1944: Perls Galleries, New York
"Classics from the School of Paris"
À Boisgeloup, 1932, oil (no. 8 in exh.) [Z.VII.404]
Baigneuses, 1932, drawing [medium not specified] (no. 9 in exh.)
À la plage de Cannes, 1933, watercolor (no. 10 in exh.)
La Peintresse, 1933, drawing [medium not specified] (no. 11 in exh.)
Trois Nus, 1934, drawing [medium not specified] (no. 12 in exh.)

February–May 1944: Museum of Modern Art, New York
"Modern Drawings"; traveled to California Palace of the Legion of Honor, San Francisco, August 1–29, 1944 [Although some of the works in the exhibition were not included in San Francisco, all the works by Picasso were shown there.]
Portrait of Angel de Soto, ca. 1900, brush and watercolor, 7 1/2 x 5 1/2 in. / Justin K. Thannhauser Gallery, New York
Head of a Woman, 1904, pencil and gouache, 14 x 10 in. / Mr. and Mrs. Justin K. Thannhauser, New York (ill. in cat.) [Z.I.221; Solomon R. Guggenheim Museum, New York]
Mother and Child, 1904, crayon, 13 1/4 x 10 3/8 in. / Fogg Art Museum, Harvard University, Cambridge, Paul Sachs Collection [Z.I.220; Fogg Art Museum]
Two Nudes, 1906, crayon, 24 1/2 x 17 1/2 in. / Jacques Seligmann & Co., New York (ill. in cat.) [Z.XXII.465; Art Institute of Chicago]
Figure [current title: *Standing Female Nude*],* 1910, charcoal, 19 x 12 1/4 in. (ill. in cat.) / Alfred Stieglitz, New York [Z.II¹.208; Metropolitan Museum of Art, New York]
Diaghilev and Selisburg, 1917, pencil, 24 7/8 x 18 7/8 in. / extended loan from Picasso to Museum of Modern Art, New York [Z.III.301; Musée Picasso, Paris]
Philosopher, 1918, pencil, 13 5/8 x 10 7/16 in. / Fogg Art Museum, Harvard University, Cambridge, Paul J. Sachs Collection (ill. in cat.) [Z.III.256; Fogg Art Museum]
The Fisherman, 1918, pencil, 13 3/4 x 10 in. / private collection, New York (ill. in cat.) [Z.III.250; private collection]
Bathers, 1918, pencil, 8 3/4 x 11 7/8 in. / Fogg Art Museum, Harvard University, Cambridge, Paul Sachs Collection [Z.III.233; Fogg Art Museum]
Pierrot and Harlequin, 1918, pencil, 10 1/4 x 7 3/8 in. / Mrs. Charles B. Goodspeed, Chicago [Z.III.135; Art Institute of Chicago]
Two Men on the Beach, 1921, pencil, 19 x 23 1/2 in. / Paul Rosenberg & Co., New York
Three Sketches, 1923, pen and ink, 9 3/8 x 11 1/2 in.

private collection, New York
Four Ballet Dancers, 1925, pen and ink, 13 1/2 x 10 in. / anonymous gift to Museum of Modern Art (ill. in cat.) [Z.V.422; Museum of Modern Art, New York]
Painter and His Model, 1926, pen and ink, 11 1/4 x 14 3/4 in. / private collection, New York
Artist in Her Studio, 1933, charcoal, 11 x 10 1/8 in. / Mrs. John Wintersteen, Philadelphia
Minotaur, 1933, pen and ink wash, 18 7/8 x 24 3/4 in. / private collection, New York, Courtesy Kleemann galleries (ill. in cat.)
Two Figures on the Beach, 1933, pen and ink, 15 3/4 x 19 5/8 in. / Museum of Modern Art [Museum of Modern Art, New York]
[Seven *Guernica* studies, 1937, including three with Zervos reference numbers: Z.IX.16, Z.IX.9, Z.IX.22 / None of the seven is on the checklist. All were on extended loan from the artist to the Museum of Modern Art at the time of the exhibition.]
The End of a Monster, 1937, pencil, 15 1/8 x 22 1/4 in. / Roland Penrose, London, on extended loan to Museum of Modern Art (ill. in cat.)
Three Figures, 1938, pen and ink, 17 1/4 x 26 1/2 in. / Valentine Gallery, New York
Cock, 1938, pastel, 30 1/2 x 22 1/4 in. / Miss Helen Resor, Washington, D.C.

February 20–March 20, 1944: Phillips Memorial Art Gallery, Washington, D.C.
"Picasso: Still Life Masterpieces, 1924–1926" [All works in this exhibition were from the private collection of Paul Rosenberg, New York.]
Still Life with Biscuits, 1924, oil and sand, 32 x 39 3/4 in. (ill. in cat.) [Z.V.242; Cleveland Museum of Art]
The Red Table Cloth (Le Tapis Rouge), December 1924, oil on canvas, 38 3/4 x 51 3/8 in. (ill. in cat.) [Z.V.364; private collection, New York]
The Fish Net (Le Filet), Juan les Pins, summer 1925, oil, 39 3/4 x 32 3/8 in. (ill. in cat.) [Z.V.459]
Still Life with a Bottle of Wine, 1926, oil, 38 5/8 x 51 1/4 in. (ill. in cat.) [Z.VI.1444]

March 8–31, 1944: Durand-Ruel Galleries, New York
"Still Life: Manet to Picasso"
Compotier et Verre / private collection (no. 15 in exh.; ill. in cat.) [Z.VIII.334]

March 21–April 15, 1944: Pierre Matisse Gallery, New York
"Ivory Black in Modern Painting"
Still Life, 1921 / private collection (no. 15 in exh.)

April 10–29, 1944: Valentine Gallery, New York
"Modern Paintings: The Lee Ault Collection" [Ault began collecting art at an early age. After World War II, he founded Quadrangle Press, publishing high-quality illustrated artist's monographs, but turned to oil exploration as his principal occupation. In 1957, he bought the magazine *Art in America*, and sold it in 1970, the year he opened a contemporary art gallery.]
Blue Guitar, 1927–29, painting, 38 x 51 in. (no. 33 in exh.; ill. in cat.) [Z.VII.75]
Madame X, 1932, painting, 28 1/2 x 20 in. (no. 34 in exh.; ill. in cat.) [Z.VII.405]
Portrait of a Young Man, 1906, gouache, 15 1/4 x 10 1/2 in. (no. 35 in exh.; ill. in cat.) [Z.VI.781]
Au café, 1901, drawing [medium not specified], 8 1/4 x 10 1/2 in. (no. 36 in exh)
Wounded Toreador, 1902, colored drawing [medium not specified], 5 1/2 x 3 1/2 in. (no. 37 in exh.)
Playful Nude, 1904, drawing [medium not specified], 7 1/2 x 11 in. (no. 38 in exh.)
Portrait of Don José, 1906, drawing [medium not specified], 10 1/2 x 8 in. (no. 39 in exh.)
Femme (époque Negre), 1908, drawing [medium not specified], 25 x 18 1/4 in. (no. 40 in exh.) [Z.XXII.462]
Sussanah, 1933, drawing [medium not specified], 9 x 12 in. (no. 41 in exh.)
Minotaur, 1933, drawing [medium not specified], 15 1/2 x 19 1/2 in. (no. 42 in exh.)
Bull-Fight, Bois-le-Joup, 1935, drawing [medium not specified], 13 3/4 x 20 in. (no. 43 in exh.)

Pêcheur, 1938, drawing [medium not specified], 12 x 9 in. (no. 44 in exh.) (Metropolitan Museum of Art, New York) [Z.IX.188]
L'Homme au melon, drawing [medium not specified], 5 1/4 x 3 1/2 in. (no. 45 in exh.)

May 24–October 15, 1944: Museum of Modern Art, New York
"Art in Progress"
Woman Ironing, 1904, oil on canvas, 46 1/8 x 29 1/8 in. / Justin K. Thannhauser, New York (ill. in cat.) [Z.I.247; Solomon R. Guggenheim Museum, New York]
Woman with a Mandolin, 1910, oil on canvas, 39 1/2 x 29 in. / private collection (ill. in cat.) [Z.II.235; Museum of Modern Art, New York]
Three Musicians, 1921, oil on canvas, 80 3/4 x 88 1/2 in. / private collection–extended loan to the Museum of Modern Art (ill. in cat.) [Z.IV.331; Museum of Modern Art, New York / The anonymous lender was Paul Rosenberg, New York]
Seated Woman, 1927, oil on wood, 51 1/8 x 38 1/4 in. / private collection (ill. in cat.) [Z.VII.77; Museum of Modern Art, New York / The anonymous lender was James Thrall Soby.]
The Pipes of Pan, 1923, oil on canvas, 80 1/2 x 68 5/8 in. / Pablo Picasso [Z.V.141; Musée Picasso, Paris]
Still Life with a Cake, 1924, oil on canvas, 38 1/2 x 51 1/2 in. / Museum of Modern Art [Z.V.185; Metropolitan Museum of Art, New York]
Woman Seated before a Mirror, 1937, oil on canvas, 51 x 77 in. / Paul Rosenberg & Co., New York (ill. in cat.) [Z.VIII.340; private collection]

June 27–July 31, 1944: Pierre Matisse Gallery, New York
"Pictures Under Five Hundred [Dollars]" [This exhibition included one work by Picasso, although no specific title has been identified.]

September–October 22, 1944: Philadelphia Museum of Art
"History of an American, Alfred Stieglitz: '291' and after; Selections from the Stieglitz Collection"
Harlequin Head, ca. 1905, pen drawing (no. 88 in exh.)
Woman Ironing, ca. 1904, oil on canvas [mounted on wood] (no. 89 in exh.) [Z.XXI.263; Metropolitan Museum of Art, New York]
Woman's Head, ca. 1904, oil on canvas (no. 90 in exh.)
Still Life, 1909, charcoal drawing (no. 91 in exh.) [Z.II².683; Metropolitan Museum of Art, New York]
Man's Head, Large, 1909, brush drawing (no. 93 in exh.) [Metropolitan Museum of Art, New York]
Woman's Head, Large, 1909, brush drawing (no. 94 in exh.) [Metropolitan Museum of Art, New York]
Woman's Head, Small, 1909?, colored wash drawing (no. 95 in exh.) [Z.XXXVI.413; Art Institute of Chicago]
Composition [current title: *Seated Man Reading a Newspaper*], ca. 1912, pen drawing, [12 1/8 x 7 3/4 in.] (no. 97 in exh.) [Metropolitan Museum of Art]
Torso, ca. 1912, pen drawing (no. 98 in exh.) [Metropolitan Museum of Art, New York]
Head of Man, ca. 1912, charcoal drawing (no. 99 in exh.) [Metropolitan Museum of Art, New York]
Still Life [current title: *Bottle and Wine Glass on a Table*],* 1913 [actual date: 1912], collage and drawing (no. 100 in exh.) [Z.II².428; Metropolitan Museum of Art, New York]

November 1944: Art of This Century, New York
["Photographs of Picasso's Work" / See note in November 14–27 entry below.]

November 6–December 2, 1944: Paul Rosenberg Gallery, New York
"Exhibition of Paintings by Braque, Matisse, Picasso" [All four works in this exhibition were from the collection of Paul Rosenberg.]
Arlequin, "Si Tu Veux," 1918, 56 x 39 1/2 in. (no. 8 in exh.) [Z.III.160; Cleveland Museum of Art]

Les Bisquits [*sic*], 1924, 32 x 39 3/4 in. (no. 9 in exh.) [Z.V.242; Cleveland Museum of Art]
Tête de bélier, 1925, 31 1/2 x 39 1/2 in. (no. 10 in exh.)
Le Sculpteur et son oeuvre, 1933, 15 3/4 x 19 1/2 in. (no. 11 in exh.) [Z.VIII.120]

November 14–27, 1944: Museum of Modern Art, New York
"The War Years: Color Reproductions of Works by Picasso, Matisse and Bonnard, 1939–43" [This exhibition included a portfolio of photographs of Picasso's paintings, published by Maurice Girodias in 1943. It entered MoMA's collection in November 1944, the same month that it was exhibited. Likewise, another edition of this portfolio of Picasso photographs was shown at Art of this Century Gallery at the same time (see November 1944 entry above). However, specific titles of individual works in the portfolio have not been identified.]

December 9–31, 1944: Pierre Matisse Gallery, New York
"Homage to the 'Salon d'Automne' 1944: 'Salon de la Liberation'"
Peinture (no. 22 in exh.)

1945

January 1945: Philadelphia Museum of Art
"The Callery Collection: Picasso-Léger" [Meric (also known as Mary) Callery, a sculptor and collector, moved to Paris in 1930 and befriended Picasso soon thereafter. She amassed a large group of his works during her years there and, after returning to the U.S. in 1940, was a generous lender of these works to gallery and museum exhibitions. Note: In lieu of a catalogue for this exhibition, an illustrated checklist appeared in the *Philadelphia Museum Bulletin*.]
[Paintings:]
Baigneuse, 1908, oil, 51 x 38 1/2 in. [Z.II¹.11; Museum of Modern Art, New York]
Standing Figure, 1910 (also dated 1911 and 1912), oil, 71 x 23 1/2 in. (ill. in *PM Bulletin*) [Z.II¹.233; National Gallery of Art, Washington, D.C.]
Nature morte–rose, 1913, oil, 46 x 32 in. [Z.II².442]
Nature morte au guéridon, 1914, oil, 51 x 35 in. (ill. in *PM Bulletin*) [Z.II².533]
Nature morte–table–tache bleue, 1919, oil, 87 x 46 in.
Nature morte au papier bleu, 1921, oil, 39 1/2 x 40 in.
Nature morte verte, 1921, oil, 65 x 80 in.
Nature morte–marron, 1921, oil, 65 x 80 in.
Fontainebleau [current title: *Three Women at the Spring*], 1921, oil, 79 1/2 x 67 in. (ill. on cover of *PM Bulletin*) [Z.IV.322; Museum of Modern Art, New York]
Nature morte au tapis rouge, 1925, oil, 37 3/4 x 50 3/4 in.
Mother and Child, 1925, oil, 9 1/2 x 7 in.
Tête grise No. I, 1929, oil, 25 3/4 x 20 1/2 in.
Tête grise No. II, 1929, oil, 28 x 19 1/2 in.
Seated Bather, 1929, oil, 51 1/8 x 63 7/8 in. (ill. in *PM Bulletin*) [Z.VII.306; Museum of Modern Art, New York]
Nude on a Black Couch, March 9, 1932, oil, 63 1/4 x 50 1/2 in. (ill. in *PM Bulletin*) [Z.VII.377]
Le Rêve, 1932, oil, 38 x 58 in. [Z.VII.364; Wynn Collection, Las Vegas]
Interior with a Girl Drawing, Paris, February 12, 1935, oil, 51 1/8 x 76 5/8 in. (ill. in *PM Bulletin*) [Z.VIII.263; Museum of Modern Art, New York]
Girls with a Toy Boat, February 12, 1937, oil and charcoal, 51 1/8 x 76 3/4 in. (ill. in *PM Bulletin*) [Z.VIII.344; Peggy Guggenheim Collection, Venice]
Arlésienne, 1937, oil, 32 x 25 in.
Tête de femme, 1937, oil, 26 3/4 x 20 3/4 in.
Girl with a Cock, Paris, February 15, 1938, oil, 57 1/4 x 47 1/2 in. (ill. in *PM Bulletin*) [Z.IX.109; private collection, Switzerland]
Seated Woman in a Garden, December 10, 1938, oil, 51 x 38 in. (ill. in *PM Bulletin*) [Z.IX.232; Metropolitan Museum of Art, New York]
Tête de Femme, May 21, 1939, oil, 26 x 21 1/2 in.
[Drawings:]
Baigneuse, 1908, pencil, 19 1/2 x 12 1/2 in. [Z.II¹.110]
Lysistrata, January 11, 1934, ink, 14 x 20 in.

Head of Woman, April 27, 1938, gouache, 31 x 23 in.
Tête de femme, April 28, 1938, ink, 29 3/4 x 21 3/4 in.
Seated Woman, April 29, 1938, pastel, 30 1/4 x 22 in. [Z.IX.132; Metropolitan Museum of Art, New York]
Dinard, June 3, 1938, ink and color, 17 1/2 x 9 1/2 in.
A. *Portrait of Mary Callery*, Paris, June 9, 1938, ink, 17 1/2 x 9 1/2 in.
B. *Portrait of Mary Callery*, ink, 14 3/4 x 23 in.
Seated Woman, July 4, 1938, ink, 25 x 19 1/4 in. (ill. on back cover of *PM Bulletin*)
Cabaña, August 10, 1938, ink, 17 1/4 x 26 1/2 in.
Head of a Woman, Moujins, September 8, 1938, ink, 26 1/2 x 17 1/2 in.
Drawing for Sculpture, 1940, pencil, 25 1/2 x 19 3/4 in.

January 8–27, 1945: Bignou Gallery, New York
"Exhibition of Modern Paintings"
Still-Life (no. 13 in exh.)

January 18–February 5, 1945: San Francisco Museum of Art
"Art of Our Time: 10th Anniversary Exhibitions"
Guitar and Fruit, 1927, 51 1/2 x 38 1/2 in. (no. 37 in exh.)
Woman Seated before a Mirror, 1937, 51 x 77 in. / Paul Rosenberg, New York (no. 38 in exh.) [Z.VIII.340; private collection]

January 29–March 3, 1945: Perls Galleries, New York
"Modern French Paintings"
Femme accroupie, 1902, pen and ink, 6 x 4 1/4 in. (no. 27 in exh.)
Buste d'homme, 1907, charcoal, 24 1/2 x 18 1/2 in. (no. 27a in exh.)
Femme nue dans un fauteuil, 1914, watercolor, 10 5/8 x 7 1/4 in. (no. 27b in exh.)
Baigneuse, 1920, pencil and sepia, 9 7/8 x 16 in. (no. 28 in exh.)
Trois Femmes au puits, 1921, oil, 7 1/2 x 10 1/2 in. (no. 29 in exh.; ill. in cat.)
Deux Personnages, 1925, pastel, 7 x 7 in. (no. 30 in exh.)
Baigneuses à la plage, 1932, pen and ink, 9 3/4 x 13 1/2 in. (no. 31 in exh.)
La Sérénade, 1932, pen and ink, 9 3/4 x 12 1/2 in. (no. 32 in exh.)
L'Enlèvement, 1933, watercolor, 13 3/8 x 17 3/4 in. (no. 33 in exh.; ill. in cat.)
Cannes: Baigneuses, 1933, watercolor, 15 3/4 x 19 1/2 in. (no. 34 in exh.)
Baigneuses, 1934, pen and ink, 9 7/8 x 13 5/8 in. (no. 35 in exh.)

February 19–March 10, 1945: Valentine Gallery, New York
"20 Women by 20 Painters"
Tête classique, 1921
Portrait, 1929

February 27–March 17, 1945: Bucholz Gallery, New York
"Picasso: Exhibition of Paintings and Drawings by Pablo Picasso from a Private Collection" [All the works were on loan from the collection of Mrs. Meric Callery.]
[Paintings:]
Bather, 1908, oil on canvas, 51 x 38 1/2 in. (no. 1 in exh.) [Z.II¹.11; Museum of Modern Art, New York]
Standing Figure, 1938 [actual date: 1910], oil, 71 x 23 1/2 in. (no. 2 in exh.) [Z.II¹.233; National Gallery of Art, Washington, D.C.]
Still Life–Rose, 1913, oil on canvas, 46 x 32 in. (no. 3 in exh.)
Le Guéridon, 1914, oil on canvas, 51 x 35 in. (no. 4 in exh.)
Green Still Life, 1921, oil on canvas, 65 x 80 in. (no. 5 in exh.)
Fontainebleau [current title: *Three Women at the Spring*], 1921, oil on canvas, 79 1/2 x 67 in. (no. 6 in exh.) [Z.IV.322; Museum of Modern Art, New York]
Still Life with Red Rug, 1925, oil on canvas, 37 3/4 x 50 3/4 in. (no. 7 in exh.)
Mother and Child, 1925, oil on canvas, 9 1/2 x 7 in. (no. 8 in exh.)

Head in Gray No. II, 1929, oil on canvas, 28 x 19 1/2 in. (no. 9 in exh.)
Nude on a Black Couch, March 9, 1932, oil on canvas, 63 1/4 x 50 1/2 in. (no. 10 in exh.) [Z.VII.377]
Interior with a Girl Drawing, February 12, 1935, oil on canvas, 51 1/8 x 76 5/8 in. (no. 11 in exh.) [Z.VIII.263; Museum of Modern Art, New York]
Girls with a Toy Boat, February 12, 1937, oil and charcoal, 51 1/8 x 76 3/4 in. (no. 12 in exh.) [Z.VIII.344; Peggy Guggenheim Collection, Venice]
Head of a Woman, 1937, oil on canvas, 26 3/4 x 20 3/4 in. (no. 13 in exh.)
Girl with a Cock, February 15, 1938, oil on canvas, 57 1/4 x 47 1/2 in. (no. 14 in exh.) [Z.IX.109; private collection, Switzerland]
Head of a Woman, May 21, 1939, oil on canvas, 26 x 21 1/2 in. (no. 15 in exh.)
Woman from Arles, 1937, oil on canvas, 32 x 25 in. (no. 16 in exh.)
Seated Woman in a Garden, December 10, 1938, oil on canvas, 51 x 38 in. (no. 17 in exh.) [Z.IX.232; Metropolitan Museum of Art, New York]
[Drawings:]
Baigneuse, 1908, pencil, 19 1/2 x 12 1/2 in. (no. 18 in exh.) [Z.II¹.110]
Lysistrata, January 11, 1934, ink, 14 x 20 in. (no. 19 in exh.)
Head of Woman, April 27, 1938, gouache, 31 x 23 in. (no. 20 in exh.)
Tête de femme, April 28, 1938, ink, 29 3/4 x 21 3/4 in. (no. 21 in exh.)
Seated Woman, April 29, 1938, pastel, 30 1/4 x 22 in. (no. 22 in exh.) [Z.IX.132; Metropolitan Museum of Art, New York]
Dinard, June 3, 1938, ink and color, 17 1/2 x 9 1/2 in. (no. 23 in exh.)
Seated Woman, July 4, 1938, ink, 25 x 19 1/4 in. (no. 24 in exh.; ill. in cat.)
Cabaña, August 10, 1938, ink, 17 1/4 x 26 1/2 in. (no. 25 in exh.)
Head of a Woman, Moujins, September 8, 1938, ink, 26 1/2 x 17 1/2 in. (no. 26 in exh.)
Drawing for Sculpture, 1940, pencil, 25 1/2 x 19 3/4 in. (no. 27 in exh.)

March 1–28, 1945: Wildenstein Gallery, New York
"The Child Through Four Centuries"
Boy in Harlequin Jacquet [*sic*]/ anonymous loan through the Worcester Art Museum (no. 52 in exh.; ill. in cat.) [Z.I.276; Metropolitan Museum of Art, New York / The source of the anonymous loan was Scofield Thayer's Dial Collection, on deposit at the Worcester Art Museum from 1926 until it went by his bequest to the Metropolitan Museum of Art in 1984.]

April 2–May 5, 1945: Paul Rosenberg & Co., New York
"Exhibition of XIXth and XXth Century French Paintings by Cézanne, Corot, Courbet, Manet, Monet, Pissarro, Renoir, Braque, Matisse, Picasso"
La Fenêtre ouverte, 1937, 29 x 35 in. (no. 11 in exh.)

April 10–28, 1945: Pierre Matisse Gallery, New York
"11 Nudes by XX Century Artists"
Nu debout

May 26–October 1945: Philadelphia Museum of Art
"Picasso–Braque: Collection Lent Anonymously"; presumably, part of this exhibition traveled to the Art Institute of Chicago, July 28–September 30, 1946, for "14 Paintings by Pablo Picasso and Braque" [No catalogue exists from either venue. The anonymous lender was Paul Rosenberg.]
Le Guéridon, 1920, oil (no. 5143 in exh.)
Femme à la mandoline, 1925, oil (no. 5144 in exh.) [Z.V.442; Norton Simon Museum, Pasadena, Calif.]
Nature morte aux biscuits, 1924, oil and sand (no. 5145 in exh.) [Z.V.242; Cleveland Museum of Art]
Le Tapis rouge, 1924, oil (no. 5146 in exh.) [Z.V.364; private collection, New York]
Tête de bélier, 1925, oil, [31 1/2 x 39 1/2 in.] (no. 5147 in exh.)
Le Filet, 1925, oil (no. 5148 in exh.) [Z.V.459]

Nature morte à la bouteille de vin, 1926, oil (no. 5149 in exh.; shown in Chicago) [Z.VI.1444]
La Fenêtre ouverte, 1919, gouache (no. 5150 in exh.)
Le Tricorne, 1919, oil, [14 3/4 x 18 in.] (no. 5151 in exh.)
Quatre Nus classiques, 1921, tempera on wood (no. 5153 in exh.)
L'Oiseau sur la branche, 1913, oil (no. 5154 in exh.) [Z.II².532; private collection]
Vue de Saint Malo, 1922, ink and pencil (no. 5156 in exh.)
Le Peintre et son modèle, 1926, ink and pencil (no. 5157 in exh.)
Trois Danseurs au repos, 1925, ink and pencil, 13 3/4 x 9 7/8 in. (no. 5158 in exh.)
La Pêcheur, 1918, pencil (no. 5159 in exh.) [Z.III.250; private collection]
Le Sculpteur et son oeuvre, 1933, gouache, [15 3/8 x 19 1/2 in.] (no. 5160 in exh.)
Table devant la fenêtre, 1919, oil (no. 5161 in exh.) [Z.III.417]
Études de nus, 1923, ink, [9 3/8 x 11 1/2 in.] (no. 5162 in exh.)
Arlequin . . . "Si Tu veux" [current title: *Harlequin with Violin ("Si Tu Veux")*], 1918, oil, [56 x 39 1/2 in.] (no. 5164 in exh.) [Z.III.160; Cleveland Museum of Art]
Nature morte à la pipe, 1918, oil, [8 1/2 x 10 1/4 in.] (no. 5227 in exh.)
[There were two unnumbered works by Picasso in the exhibition:]
Woman before a Mirror, 1937, [51 x 77 in. Z.VIII.340; private collection / This work was shipped from Denver, and was exhibited for three weeks only.]
Femme à la Mandoline, Vue de Saint Malo, [1925. Z.V.442; Norton Simon Museum, Pasadena, California]

Summer 1945: Phillips Memorial Gallery, Washington, D.C.
"Summer 1945 in the Phillips Memorial Gallery"
Musical Instruments / Mrs. Patrick C. Hill, Pecos, Texas

December 11–31, 1945: Pierre Matisse Gallery, New York
"Pictures Under Five Hundred [Dollars]" [This exhibition included at least one work by Picasso, although no titles of specific works have been identified.]

1946

January 2–31, 1946: Pierre Matisse Gallery, New York
"Group Exhibition" [This exhibition included several works by Picasso, although no titles of specific works have been identified.]

Opened February 16, 1946: Art Institute of Chicago
"Drawings Old and New"
Head of a Woman, ca. 1909, black crayon and gouache on paper, 24 5/16 x 18 3/4 in. / Art Institute of Chicago (no. 41 in exh.) [Z.II¹.140; Art Institute of Chicago]
Large Standing Nude, December 25, 1923, brush with olive green wash on paper, 42 5/8 x 28 1/4 in. / Art Institute of Chicago (no. 42 in exh.)
Two Nudes, ca. 1906, pencil and estompe on paper, 24 13/16 x 18 1/2 in. / Art Institute of Chicago, Mrs. Potter Palmer gift (no. 43 in exh.) [Z.XXII.465; Art Institute of Chicago]

March 5–30, 1946: Arts Club of Chicago
"Variety in Abstraction"
Head, 1909 / Museum of Modern Art (no. 14 in exh.) [Z.II¹.148; Museum of Modern Art, New York]
Man with a Hat, 1913 / Museum of Modern Art (no. 15 in exh.; ill. in cat.) [Z.II².398; Museum of Modern Art, New York]
Harlequin / Mr. and Mrs. Charles B. Goodspeed, Chicago (no. 19 in exh.) [Possibly either *Pierrot and Harlequin*, gouache, Z.IV.69, National Gallery of Art, Washington, D.C., or *Pierrot and Harlequin*, pencil, Z.III.135, Art Institute of Chicago]
The Chimney Piece, 1915, [51 1/4 x 38 1/4 in.] / Mr. and Mrs. Samuel Marx, Chicago (no. 21 in exh.) [Metropolitan Museum of Art, New York]

March 12–30, 1946: Pierre Matisse Gallery, New York
"Paintings, Gouaches, Drawings"
Figures on a Beach, 1933, watercolor, pen, and ink, 16 x 20 in. (no. 22 in exh.)

March 14–April 4, 1946: Phillips Memorial Art Gallery, Washington, D.C.
"Objects as Subjects"; traveled to California Palace of the Legion of Honor, San Francisco, May 21–June 11, 1946
Still Life with Chair Caning, 1911–12, oil and pasted paper on canvas / Pablo Picasso [Z.II¹.294; Musée Picasso, Paris]

March 25–April 13, 1946: Valentine Gallery, New York
"School of Paris"
Léda, 1933 (no. 17 in exh.)
Deux nus, 1921 (no. 18 in exh.)

April 1–27, 1946: M. Knoedler & Co., New York
"An Exhibition of Paintings and Prints of Every Description on the Occasion of Knoedler One Hundred Years, 1846–1946"
Angel Fernandez de Soto, 1903 / private collection (no. 76 in exh.) [Z.I.201 / The anonymous lender was William H. Taylor, West Chester, Pennsylvania.]

April 1–May 4, 1946: Perls Galleries, New York
"The Perls Galleries Collection of Modern French Paintings"
Trois profils d'homme, 1901, wash, 5 1/8 x 3 1/2 in. each (no. 33 in exh.)
"La Vache," etc, 1901, wash, 5 1/8 x 3 1/2 in. each (no. 34 in exh.)
Trois allégories, 1901, pen and ink, 5 1/8 x 3 1/2 in. each (no. 35 in exh.)
Femme accroupie, 1902, pen and ink, 6 x 4 1/4 in. (no. 36 in exh.)
Étude pour "La Soupe," 1902, pencil, 9 x 11 3/4 in. (no. 37 in exh.)
Buste d'homme, 1907, charcoal, 24 1/2 x 16 1/4 in. (no. 40 in exh.)
Nus dans un paysage, 1907, pen and ink, 10 1/2 x 16 1/4 in. (no. 41 in exh.)
Baigneuse, 1920, pencil and sepia, 9 7/8 x 16 in. (no. 42 in exh.)
Nature morte au verre bleu, 1923, oil, 9 x 11 in. (no. 43 in exh.; ill. in cat.)
La Sérénade, 1932, pen and ink, 9 3/4 x 12 1/2 in. (no. 46 in exh.; ill. in cat.)
Baigneuses à la plage, 1932, pen and ink, 9 3/4 x 13 1/2 in. (no. 47 in exh.)
L'Enlèvement, 1933, watercolor, 13 3/8 x 17 3/4 in. (no. 48 in exh.)
Cannes: Baigneuses, 1933, watercolor, 15 3/4 x 19 1/2 in. (no. 49 in exh.; ill. in cat.)
Baigneuses, 1934, pen and ink, 9 7/8 x 13 5/8 in. (no. 50 in exh.)
Tête de femme, 1941, pencil, 10 5/8 x 8 3/8 in. (no. 51 in exh.)

May 1–30, 1946: Pierre Matisse Gallery, New York
"Paintings from Paris"
Nature morte à la bougie, 1944 (no. 11 in exh.; ill. in cat.) [Z.XIII.256]

July 2–September 22, 1946: Museum of Modern Art, New York
"Paintings from New York Private Collections"
The Harlequin's Family, 1905, gouache, 24 x 18 in. / Mr. and Mrs. Samuel A. Lewisohn, New York [Z.I.298; private collection]
Still Life: "Vive la . . . ," 1914–15, oil on canvas, 21 3/8 x 25 5/8 in. / Mr. Sidney Janis, New York [Z.II².523; private collection]
Seated Woman, 1927, oil on panel, 51 1/8 x 38 1/4 in. / Mr. James Thrall Soby [Z.VII.77; Museum of Modern Art, New York]
The Painter and His Model, 1928, oil on canvas, 51 5/8 x 63 7/8 in. / Mr. Sidney Janis, New York [Z.VII.143; Museum of Modern Art, New York]
Portrait of a Woman, 1939, oil on canvas, 25 1/8 x 19 1/8 in. / Mr. and Mrs. Lee Ault, New Canaan, Connecticut [Z.IX.211; private collection]

October 10–November 2, 1946: Pierre Matisse Gallery, New York
"First Showing" [This exhibition included at least one work by Picasso, although no titles of specific works have been identified.]

October 16–November 6, 1946: Jacques Seligmann & Co., Inc., New York
"1910–12: The Climactic Years in Cubism"
Le Rameur, 1910, oil on canvas, 28 3/8 x 23 3/8 in. / Mr. and Mrs. Ralph Colin, New York (no. 11 in exh.) [Z.II¹.231; Museum of Fine Arts, Houston]
La Table de Toilette, 1910, oil on canvas, 24 x 18 1/4 in. / Mr. and Mrs. Ralph Colin, New York (no. 12 in exh.) [Z.II¹.220]
Standing Figure, 1910, oil on canvas, 73 x 23 1/2 in. / private collection (no. 13 in exh.) [Z.II¹.233; National Gallery of Art, Washington, D.C. / The anonymous lender was Mrs. Meric Callery, New York.]
Figure–Cubist Study, 1911–12, oil on canvas, 30 1/4 x 39 in. / Mr. and Mrs. Pierre Matisse, New York (no. 14 in exh.) [Z.II¹.194; Albright-Knox Art Gallery, Buffalo]
Guitare, verre et bouteille de vieux marc, 1912, oil on canvas, 18 x 13 in. / Mrs. Charles H. Russell, Jr. (no. 15 in exh.) [Z.II¹.355]

November 1–27, 1946: Arts Club of Chicago
"Paintings and Drawings from the Josef von Sternberg Collection"
La Gommeuse, 1905, painting (no. 19 in exh.)

November 4–30, 1946: Perls Galleries, New York
"Modern French Paintings"
Nature morte au guéridon, 1920, gouache (no. 16 in exh.)
Jeune Femme au chapeau, 1923, pencil (no. 17 in exh.)
La Femme au fauteuil [current title: *Woman in an Armchair (Two Profiles)*], 1927, oil (no. 18 in exh.; ill. in cat.) [Z.VII.78; Minneapolis Institute of Arts]
Nature morte, 1944, oil (no. 19 in exh.)

November 12, 1946–January 12, 1947: Museum of Modern Art, New York
"'Le Tricorne' by Picasso" [According to a statement now in the Registrar Exhibition File in the archives at MoMA, this exhibition included "The Picasso Portfolio," a collection of drawings for the scenery and costumes for Diaghilev's original production of the ballet *The Three-Cornered Hat (Le Tricorne)* in 1919, which had recently been purchased by the museum's Department of Dance and Theater Design. Titles of specific works from this portfolio, however, could not be identified.]
Preliminary Sketch for the Setting, from "Le Tricorne," ca. 1919, iron gall ink on paper, 6 3/16 x 8 13/16 in. / Wadsworth Atheneum, Hartford, Connecticut [The source for this loan was the Serge Lifar Collection at the Wadsworth Atheneum.]
Theater Box, section from Scenery for "Cuadro Flamenco," 1921 / anonymous loan [The anonymous lender was Jacques Helft, of Jacques Helft & Co., New York.]
Theater Box, section from Scenery for "Cuadro Flamenco," 1921 / anonymous loan [The anonymous lender was Jacques Helft, of Jacques Helft & Co., New York.]
Four Ballet Dancers, 1925, ink on paper / Museum of Modern Art [Z.V.422; Museum of Modern Art, New York]

December 1946: Pierre Matisse Gallery, New York
"Selected Works by XX Century Artists"
La Toilette, 1905, drawing [medium not specified]
Nudes, 1906, drawing [medium not specified]

December 3–26, 1946: Arts Club of Chicago
"Landscapes: Real and Imaginary"; traveled to San Francisco Museum of Art, June 3–22, 1947.
On the Beach, 1933, watercolor and ink (no. 23 in exh.)
Landscape, 1920, oil on canvas (no. 24 in exh.)

1947

January 2–28, 1947: Bucholz Gallery, New York
"Painting and Sculpture from Europe"
Still Life, 1942, oil, 38 1/2 x 51 1/4 in. (no. 28 in exh.; ill. in cat.)
Standing Woman, 1907, pen and ink, 24 1/2 x 17 1/2 in. (no. 29 in exh.)
Women at the Sea, [July 31], 1920, pencil, 10 1/2 x 16 3/4 in. (no. 30 in exh.; ill. in cat.)

January 12–February 21, 1947: James Vigeveno Galleries, Los Angeles
"French Paintings: New Acquisitions at the James Vigeveno Galleries"
Head, 1923 (no. 12 in exh.)
Still Life with Glass, 1923 (no. 13 in exh.)

January 25–March 2, 1947: Whitney Museum of American Art, New York
"Painting in France, 1939–1946"
Seated Woman in Yellow Robe, [October 31, 1939] / Paul Rosenberg & Co., New York (no. 78 in exh.; ill. in cat.) [Berggruen Collection, Berlin]

January 27–February 15, 1947: Samuel M. Kootz Gallery, New York
"The First Post-War Showing in America of Recent Paintings by Picasso"
Jeune Fille au chapeau
Tête
Femme assise
Coq
Tête au fond
Chartreuse
Tête de femme
Femme avec tête d'agneau
Marin, 1943 (ill. in cat.) [Z.XIII.167]
Plante de tomates

February 10–March 8, 1947: Paul Rosenberg & Co., New York
"Paintings by Picasso" [The checklist for this exhibition announced that this was the first U.S. showing for the majority of these paintings.]
Fenêtre sur la rue de Penthièvre, 1920, 64 1/2 x 43 in. (no. 1 in exh.)
Nature morte aux poissons, 1922–23, 51 x 38 1/4 in. (no. 2 in exh.)
La Cage d'oiseau, 1923, 79 x 55 in. (no. 3 in exh.) [Z.V.84; private collection]
Antibes, 1924, 15 x 18 in. (no. 4 in exh.)
Le Foulard rouge, 1924, 40 x 32 in. (no. 5 in exh.)
Buste et mandoline, 1927, 23 1/2 x 29 in. (no. 6 in exh.)
Guitare et fruits sur une table, 1927, 51 x 38 1/4 in. (no. 7 in exh.)
Fleurs et fruits devant la fenêtre, 1934, 32 x 40 in. (no. 8 in exh.)
Les Poissons, 1936, 19 3/4 x 24 in. (no. 9 in exh.)
Juan-les-Pins, 1937, 15 x 18 in. (no. 10 in exh.)
La Fenêtre ouverte, 1937, 29 x 35 in. (no. 11 in exh.)
Corbeille de fleurs et pichet, 1937, 18 1/2 x 25 1/2 in. (no. 12 in exh.)

March 13–14, 1947: Residence of Stephen C. Clark, New York
"Private Collection of Stephen C. Clark"
Harlequins, [1905, gouache. Z.I.295]
Bull Fighters

March 24–April 19, 1947: Perls Galleries, New York
"The Perls Galleries Collection of Modern French Paintings"
Le Couple, 1900, pen and ink, 11 3/4 x 7 5/8 in. (no. 53 in exh.)
Trois Allégories, 1901, pen and ink, 5 1/8 x 3 1/2 in. each (no. 54 in exh.)
Femme accroupie, 1902, pen and ink, 6 x 4 1/4 in. (no. 55 in exh.)
Étude pour "La Soupe," 1902, pencil, 9 x 11 3/4 in. (no. 56 in exh.)
Nu, 1906, pastel, 25 x 18 3/4 in. (no. 57 in exh.; ill. in exh.)
Buste d'homme, 1907, charcoal, 24 1/2 x 18 1/2 in. (no. 58 in exh.)
Modèle à l'atelier, 1915, watercolor, 10 3/4 x 8 5/8 in.

(no. 59 in exh.)
Nature morte au guéridon, 1920, gouache, 10 3/4 x 8 in. (no. 60 in exh.)
Jeune femme au chapeau, 1921, pencil, 11 x 8 1/4 in. (no. 61 in exh.)
Après le bain, 1923, pen and ink, 11 1/4 x 8 3/4 in. (no. 62 in exh.)
Scène mythologique, 1923, pen and ink, 6 x 4 3/4 in. (no. 63 in exh.)
Nature morte, 1925, crayon, 10 x 13 1/2 in. (no. 64 in exh.)
La Femme au fauteuil [current title: *Woman in an Armchair (Two Profiles)*], 1927, oil, 28 3/4 x 23 5/8 in. (no. 65 in exh.) [Z.VII.78; Minneapolis Institute of Arts]
Tête de femme, 1927, oil, 21 3/4 x 13 1/4 in. (no. 66 in exh.)
Baigneuses à la plage, 1932, pen and ink, 9 3/4 x 13 1/2 in. (no. 67 in exh.)
Cannes: Baigneuses, 1933, watercolor, 15 3/4 x 19 1/2 in. (no. 68 in exh.)
Baigneuses, 1934, pen and ink, 9 7/8 x 13 5/8 in. (no. 69 in exh.)
Tête de femme, 1941, pencil, 10 5/8 x 8 3/8 in. (no. 70 in exh.)
Nu couchée, 1941, pen and ink, 8 x 10 5/8 in. (no. 71 in exh.; ill. in cat.)
Femme nue assise, 1941, gouache, 16 x 11 7/8 in. (no. 72 in exh.)
Tête de femme, 1942, gouache, 15 7/8 x 11 3/4 in. (no. 73 in exh.; ill. in cat.)
Nature morte, 1944, oil on canvas, 8 3/4 x 10 3/4 in. (no. 74 in exh.)

April–May 4, 1947: Museum of Modern Art, New York
"Large Scale Modern Paintings"
Les Demoiselles d'Avignon, 1906–7, oil on canvas, 8 ft. x 7 ft. 8 in. / Museum of Modern Art (no. 1 in exh.) [Z.II¹.18; Museum of Modern Art, New York]
Three Musicians, 1921, oil on canvas, 6 ft. 8 in. x 7 ft. 4 in. / private collection on extended loan to Museum of Modern Art (no. 7 in exh.) [Z.IV.331; Museum of Modern Art, New York / The anonymous lender was Paul Rosenberg.]
The Three Dancers, 1925, oil on canvas, 7 ft. x 4 ft. 8 in. / Museum of Modern Art, on extended loan from the artist (no. 13 in exh.) [Z.V.426; Tate Gallery, London]

April 13–May 8, 1947: James Vigeveno Galleries, Los Angeles
"French Master Drawings and Sculpture at the James Vigeveno Galleries" [This exhibition included at least one work by Picasso, although no titles of specific works have been identified.]

April 21–May 10, 1947: Paul Rosenberg & Co., New York
"Exhibition of XXth Century French Paintings"
Femme assise, robe bleue, 1939, 28 3/4 x 23 1/2 in. (no. 9 in exh.)

May–August 1947: Century Club, New York
"Drawings from the Paul J. Sachs Collection"
Mother and Child (no. 102 in exh.) [Z.I.220; Fogg Art Museum, Harvard University, Cambridge, Massachusetts]
Bathers (no. 103 in exh.) [Z.III.233; Fogg Art Museum, Harvard University, Cambridge, Massachusetts]
Philosopher (no. 104 in exh.) [Z.III.256; Fogg Art Museum, Harvard University, Cambridge, Massachusetts]
Clown, pencil drawing (no. 105 in exh.) [Z.III.126; Fogg Art Museum, Harvard University, Cambridge, Massachusetts]
Seated Man, [1914, graphite on paper, 13 x 10 in.] (no. 119 in exh.) [Fogg Art Museum, Harvard University, Cambridge, Massachusetts]

May–September 1947: Philadelphia Museum of Art
"Masterpieces of Philadelphia Private Collections"
Conversation on a Sofa, 1901 / William H. Taylor, West Chester, Pennsylvania (no. 48 in exh.) [Z.I.34]
Head of a Woman, 1901 / Mr. and Mrs. William

M. Elkins, Philadelphia (no. 49 in exh.) [Z.I.73; Philadelphia Museum of Art]
Harlequin Propped on Elbow [current title: *Harlequin*], 1901 / Mr. and Mrs. Henry Clifford, Radnor, Pennsylvania (no. 50 in exh.) [Z.I.79; Metropolitan Museum of Art, New York]
Young Man with Bouquet, 1905 / Mr. and Mrs. John Wintersteen, Philadelphia (no. 52 in exh.) [Z.I.262]
The Fan, summer 1911 / Mr. and Mrs. Henry Clifford, Radnor, Pennsylvania (no. 56 in exh.) [Z.II¹.264; private collection]
Still Life, 1919 / Mr. and Mrs. Samuel S. White, III, Ardmore, Pennsylvania (no. 71 in exh.) [Z.III.278]
Pitcher and Bowl of Fruit, 1931 / Henry P. McIlhenny, Philadelphia (no. 85 in exh.) [Z.VII.322; Solomon R. Guggenheim Museum, New York]
Bull Fight,* 1934 / Henry P. McIlhenny, Philadelphia (no. 87 in exh.) [Z.VIII.233; Philadelphia Museum of Art]
Woman Seated before a Mirror, 1937 / Mr. and Mrs. Henry Clifford, Radnor, Pennsylvania (no. 94 in exh.; ill. in cat.) [Z.VIII.340]
The Boxer, ca. 1904, gouache / Mr. and Mrs. Rodolphe M. de Schauensee (no. 163 in exh.)
Nude, Woman in Group, ca. 1909, tempera / Mr. and Mrs. Samuel S. White, III, Ardmore, Pennsylvania (no. 166 in exh.)
The White Table, 1920, gouache / Mr. and Mrs. John Wintersteen, Philadelphia (no. 172 in exh.)
Woman at the Fountain, 1921, pencil / Mr. and Mrs. Henry Clifford, Radnor, Pennsylvania (no. 175 in exh.)
In the Studio, 1933, charcoal drawing / Mr. and Mrs. John Wintersteen, Philadelphia (no. 192 in exh.)
Dance at the Seashore, August 10, 1933, pen and ink drawing / Mr. and Mrs. John Wintersteen, Philadelphia (no. 193 in exh.)

May 23–June 22, 1947: Art Institute of Chicago
"The Winterbotham Collection"
Head of a Woman, 1909, oil on canvas, 23 7/8 x 20 3/16 in. (ill. in cat.) [Z.II¹.167; Art Institute of Chicago]

May 28–June 21, 1947: Bucholz Gallery, New York
"Drawings by Contemporary Painters and Sculptors"
Woman Standing, 1907, ink, 24 1/2 x 17 1/2 in. (no. 67 in exh.)
Still Life with Fan, 1910, charcoal, 12 x 19 in. (no. 68 in exh.)
Woman, 1920, pencil, 12 x 8 1/4 in. (no. 69 in exh.)
Woman Reading before the Sea, 1920, pencil, 10 3/4 x 18 1/2 in. (no. 70 in exh.)
Sketches, ca. 1920, pencil, 12 1/2 x 8 1/2 in. (no. 71 in exh.; ill. in cat.)
Artist and Model, 1933, charcoal, 11 x 10 in. (no. 72 in exh.)
Seated Nude, 1946, wash, 26 x 17 1/2 in. (no. 73 in exh.)

June 10–August 31, 1947: Museum of Modern Art, New York
"Alfred Stieglitz Exhibition: His Collection"; traveled to Art Institute of Chicago, February 2–29, 1948 (where the works were unnumbered)
Girl Ironing, 1903, oil on canvas, 20 1/2 x 11 3/8 in. (no. 89 in exh.; not shown in Chicago) [Z.XXI.263; Metropolitan Museum of Art, New York]
Head no. 1 (Man), 1909, brush and ink on paper, 24 3/4 x 18 7/8 in. (no. 90 in exh.) [Metropolitan Museum of Art, New York]
Head no. 2 (Woman) [current title: *Head of a Woman*], 1909, brush and ink, 24 x 18 3/4 in. (no. 91 in exh.) [Metropolitan Museum of Art, New York]
Nude [current title: *Standing Female Nude*],* 1910, charcoal (no. 92 in exh.) [Z.II¹.208; Metropolitan Museum of Art, New York]
Head of a Man, ca. 1912, charcoal on paper, 23 3/8 x 17 1/2 in. (no. 93 in exh.) [Metropolitan Museum of Art, New York]
Torso [current title: *Seated Man Reading a Newspaper*], 1912, pen and ink, 11 3/4 x 7 3/8 in. (no. 94 in exh.) [Metropolitan Museum of Art, New York]
Still Life [current title: *Bottle and Wine Glass on a*

Table],* 1912–13 [actual date: 1912], pasted paper and charcoal, 24 1/4 x 18 5/8 in. (no. 95 in exh.; not shown in Chicago) [Z.II².428; Metropolitan Museum of Art, New York]

July 13–August 1947: James Vigeveno Galleries, Los Angeles
"New Acquisitions of Modern French Masters: Pissarro to Picasso" [As indicated by its title, this exhibition included at least one work by Picasso, although no titles of specific works have been identified.]

Opened ca. August 25, 1947: Samuel M. Kootz Gallery, New York
"Picasso, Paintings from the Collection of the Samuel M. Kootz Gallery" [The catalogue stated that all works came directly from Picasso's studio.]
Woman with Sheep's Skull, 1939, 25 1/2 x 31 3/4 in. (ill. in cat.)
Portrait of D.M., 1941, 25 1/2 x 36 in. (ill. in cat.)
Sailor, 1943, 31 3/4 x 51 in. (ill. in cat.) [Z.XIII.167]
Woman in Green Costume, 1943, 38 x 51 in. (ill. in cat.)
Still Life with Mirror, 1943, 39 x 32 in. (ill. in cat.)
Woman in Red, 1944, 25 1/2 x 36 in. (ill. in cat.)
Still Life with Skull, 1945, 36 1/2 x 28 1/2 in. (ill. in cat.)

October 6–25, 1947: Paul Rosenberg & Co., New York
"Vladimir Golschmann Collection" [Before this gallery exhibition in New York, the Golschmann Collection had been shown at the Cincinnati Modern Art Society several months earlier. It has not been determined how many of the works in that show were included here, but all those by Picasso are listed below.]
[*Bather*, 1908, pen and gouache on board]
[*The Balcony*, 1919, gouache, 18 x 11 1/2 in. Z.III.403]
[*The Two Lovers*, 1923, drawing, medium not specified]
[*Flowers in front of a Window*, 1934, oil, 31 1/2 x 39 in. Z.VIII.196; private collection]
[*Still Life*, 1937, oil. Z.VIII.329; Solomon R. Guggenheim Museum, New York]
[*Still Life with Blue Carafe*, 1937, oil]
[*Seated Woman*, June 13, 1938, ink drawing]
[*Still Life with Yellow and Blue Carafe*, 1938, oil]
[*Three Women on the Beach*, 1938, ink drawing, 17 1/2 x 26 in.]
[*Portrait: Blue Waist and Red Background*, 1939, oil]
[*Portrait: Red Waist and Blue Background*, 1939, oil]
[*Portrait: Woman with Purple Hat*, 1939, oil]
[*Sailor*, 1939, gouache]
[*Head*, 1940, gouache]
[*Still Life with Pigeon*, 1941, oil, 22 3/4 x 28 in.]
[*Portrait of a Young Girl*, 1944, oil]

October 15–November 8, 1947: M. Knoedler & Co., New York
"Picasso before 1907"
Street Scene, oil on canvas, 5 1/2 x 3 1/2 in. / Mr. and Mrs. Howard S. Cullman (no. 1 in exh.)
Vase of Flowers, 1898–99, oil on canvas, 15 x 18 in. / Mrs. John D. Rockefeller, New York (no. 2 in exh.)
Le Moulin de la Galette, 1900, oil on canvas, 45 3/4 x 35 1/2 in. / Mr. and Mrs. Justin K. Thannhauser, New York (no. 3 in exh.; ill. in cat.) [Z.I.41; Solomon R. Guggenheim Museum, New York]
On the Upper Deck, 1901, oil on canvas, 19 1/8 x 25 1/4 in. / Art Institute of Chicago, Coburn Collection (no. 4 in exh.; ill. in cat.) [Z.XXI.168; Art Institute of Chicago]
Harlequin Propped on Elbow [current title: *Harlequin*], 1901, oil on canvas, 23 3/4 x 31 1/2 in. / Mr. and Mrs. Henry Clifford, Radnor, Pennsylvania (no. 5 in exh.; ill. in cat.) [Z.I.79; Metropolitan Museum of Art, New York]
The Blue Room, 1901, oil on canvas, 20 x 24 1/2 in. / Phillips Memorial Gallery (no. 6 in exh.; ill. in cat.) [Z.I.103; Phillips Collection, Washington, D.C.]
Mother and Child, 1901, oil on canvas, 38 1/2 x 43 1/2 in. / Mr. and Mrs. Maurice Wertheim (no. 7 in exh.; ill. in cat.) [Z.I.115; Fogg Art

Museum, Harvard University, Cambridge, Massachusetts]
Courtesan with Jewel Collar, 1901, oil on canvas, 21 3/4 x 25 3/4 in. / Los Angeles County Museum, de Sylva Collection (no. 8 in exh.; ill. in cat.) [Z.I.42; Los Angeles County Museum of Art / This painting was excluded from the exhibition at the last minute, due to a strike.]
Drinker Propped on Elbows, 1901, oil on canvas, 16 1/2 x 21 in. / Mrs. Rose Gershwin (no. 9 in exh.; ill. in cat.) [Z.I.62]
Woman with Cape, 1901, oil on canvas, 28 1/2 x 19 1/2 in. / Leonard C. Hanna, Jr., Cleveland (no. 10 in exh.) [Z.VI.542; Cleveland Museum of Art]
Bal Tabarin, 1901, oil on canvas, 21 x 27 1/2 in. / T. E. Hanley (no. 11 in exh.) [Z.I.69]
Flowers, 1901, oil on canvas, 27 1/2 x 22 in. / Mr. and Mrs. George Lurcy (no. 12 in exh.)
La Soupe, 1902, oil on canvas, 18 1/2 x 15 in. [actual dimensions: 15 x 18 1/2 in.] / von Ripper, Paris (no. 13 in exh.) [Z.I.131; Art Gallery of Ontario, Toronto]
Courtesan with Hat, 1902, oil on canvas, 20 x 26 in. / Mr. and Mrs. Samuel A. Lewisohn, New York (no. 14 in exh.) [Z.I.65]
Angel Fernandez de Soto, 1903, oil on canvas, 21 3/4 x 27 1/2 in. / Mr. and Mrs. Donald Stralem (no. 15 in exh.; ill. in cat.) [Z.I.201]
Barcelona, 1903, oil on canvas, 21 x 15 in. / Joseph Stransky (no. 16 in exh.; ill. in cat.) [Z.I.122]
La Vie, 1903, oil on canvas, 77 3/8 x 50 7/8 in. / Cleveland Museum (no. 17 in exh.; ill. in cat.) [Z.I.179; Cleveland Museum of Art]
Woman Ironing, 1904, oil on canvas, 46 1/8 x 29 1/8 in. / Mr. and Mrs. Justin K. Thannhauser, New York (no. 18 in exh.) [Z.I.247; Solomon R. Guggenheim Museum, New York]
Boy Leading Horse, 1905, oil on canvas, 86 1/2 x 51 1/4 in. / Museum of Modern Art (no. 19 in exh.; ill. in cat.) [Z.I.264; Museum of Modern Art, New York]
Young Man with Bouquet, 1905, gouache, 21 x 25 in. / Mrs. John Wintersteen, Philadelphia (no. 20 in exh.; ill. in cat.) [Z.I.262]
Blue Boy, 1905, gouache, 39 3/8 x 22 1/2 in. / Edward M. M. Warburg, New York (no. 21 in exh.; ill. in cat.) [Z.I.271]
Saltimbanques with Dog, 1905, gouache, 29 1/2 x 41 1/2 in. / Wright Ludington, Santa Barbara (no. 22 in exh.) [Z.I.300; Museum of Modern Art, New York]
Woman with Fan, 1905, oil, 39 x 31 1/2 in. / Mr. and Mrs. W. Averell Harriman, New York (no. 23 in exh.; ill. in cat.) [Z.I.308; National Gallery of Art, Washington, D.C.]
Woman with Kerchief, 1905, gouache, 24 x 18 in. / T. Catesby Jones (no. 24 in exh.) [Z.I.319; Virginia Museum of Fine Arts, Richmond]
Standing Nude, 1905, gouache, 25 1/4 x 19 1/4 in. / Cleveland Museum, Hurlbut Collection (no. 25 in exh.) [Z.I.317; Cleveland Museum of Art]
La Toilette, 1905 [actual date: 1906], oil on canvas, 58 x 39 1/2 in. / Albright Art Gallery, Buffalo (no. 26 in exh.) [Z.I.325; Albright-Knox Art Gallery, Buffalo]
Head of a Boy, 1905, gouache, 9 1/2 x 12 3/4 in. / Leonard C. Hanna, Jr., Cleveland (no. 27 in exh.) [Z.I.303; Cleveland Museum of Art]
Head of a Boy, 1905, gouache, 11 3/4 x 15 1/4 in. / Mr. and Mrs. Lee Ault, New Canaan, Connecticut (no. 28 in exh.) [Z.VI.781]
Head of a Woman, 1905, gouache, 19 x 25 in. / Toledo Museum of Art (no. 29 in exh.; ill. in cat.) [Z.I.333]
Acrobats' Meal, 1905, gouache, 9 1/4 x 12 3/8 in. / Mrs. Frederic G. Clark (no. 30 in exh.) [Z.I.292]
Woman Dressing, 1905, gouache, 17 x 23 in. / Mr. and Mrs. Samuel A. Lewisohn, New York (no. 31 in exh.; ill. in cat.) [Z.I.298; private collection]
Woman with Loaves, 1905, oil on canvas, 39 x 27 1/2 in. / Philadelphia Museum of Art (no. 32 in exh.) [Z.VI.735; Philadelphia Museum of Art]
Gertrude Stein, 1906, oil on canvas, 39 3/8 x 32 in. / Metropolitan Museum of Art (no. 33 in exh.)

[Z.I.352; Metropolitan Museum of Art, New York]
Allan Stein, 1906, gouache, 25 x 30 in. / Mrs. Michael D. Stein (no. 34 in exh.) [Z.I.353; Baltimore Museum of Art]
Fernande Olivier, 1906, oil on canvas, 31 7/8 x 39 3/8 in. / Mr. and Mrs. A. K. Solomon (no. 35 in exh.)
Self-Portrait, approx. 27 x 21 in. / anonymous loan (unnumbered, added late to the exhibition) [Z.XXI.192; private collection]
[The following four works were listed in the catalogue as "substitutes," all unnumbered:]
Girl with Bang [current title: *Woman with Bangs*], 1902, oil on canvas, 24 x 22 in. / Miss Etta Cone, Baltimore [Z.I.59; Baltimore Museum of Art]
Leo Stein, wash drawing, 12 x 18 in. / Miss Etta Cone, Baltimore [Baltimore Museum of Art]
Harem, 1905, oil on canvas, 60 1/4 x 43 1/4 in. / Leonard C. Hanna, Jr., Cleveland [Z.I.321; Cleveland Museum of Art]
Girl with Chignon, 1901, oil on canvas, 26 x 20 in. [actual dimensions: 28 5/8 x 19 1/4 in.] / Mr. and Mrs. Maurice Wertheim [Z.I.96; Fogg Art Museum, Harvard University, Cambridge, Massachusetts]

1948

January 6–31, 1948: Bucholz Gallery, New York
"Paintings and Sculpture from Europe"
Nature morte au Boudin, 1941, oil, 36 x 25 1/2 in. (no. 24 in exh.)
Chapeau aux marguerites, 1941, oil, 24 x 19 1/2 in. (no. 25 in exh.; ill. in cat.) [Z.XI.197]

January 22–March 12, 1948: Museum of Modern Art, New York
"*Portrait of Gertrude Stein* by Picasso"
Gertrude Stein [Z.I.352; Metropolitan Museum of Art, New York]

January 26–February 14, 1948: Samuel M. Kootz Gallery, New York
"Paintings of 1947 by Picasso"
L'Hibou bleu, 1947 (no. 1 in exh.)
Femme, 1947 (no. 2 in exh.)
Le Miroire [sic], 1947 (no. 3 in exh.)
Le Verre, 1947 (no. 4 in exh.)
La Fille du concièrge, avec poupée, 1947 (no. 5 in exh.; ill. in cat.)
L'Hibou et la flêche, 1947 (no. 6 in exh.; ill. in cat.)
Les Cerises, 1947 (no. 7 in exh.)
Nature morte avec cafetière, 1947 (no. 8 in exh.) [Z.XV.45]
Les Pommes, 1947 (no. 9 in exh.)
Nature morte avec crâne, 1945 (no. 10 in exh.)
Portrait of D.M., 1944 (no. 11 in exh.)
Mère et enfant, 1943 (no. 12 in exh.)
Nature morte au miroire [sic], 1943 (no. 13 in exh.)
Femme assise, 1941 (no. 14 in exh.) [Z.XI.221]

March 1–27 and March 29–April 24, 1948: Perls Galleries, New York
"The Perls Galleries Collection of Modern French Paintings"
Le Couple, 1900, pen and ink, 11 3/4 x 7 5/8 in. (no. 71 in exh.)
Trois Allégories, 1901, pen, ink, and crayon, 5 1/8 x 3 1/2 in. each (no. 72 in exh.)
Étude pour "La Soupe," 1902, pencil, 9 x 11 3/4 in. (no. 73 in exh.)
Saltimbanque endormi, 1904, watercolor, 7 x 4 1/8 in. (no. 74 in exh.)
Mère et enfant, 1906, crayon, 11 7/8 x 9 1/4 in. (no. 75 in exh.)
Nu, 1906, pastel, 25 x 18 3/4 in. (no. 76 in exh.)
Buste d'homme, 1907, charcoal, 24 1/2 x 18 1/2 in. (no. 77 in exh.)
Modèle à l'atelier, 1915, watercolor, 10 3/4 x 8 5/8 in. (no. 78 in exh.)
Nature morte au guéridon, 1920, gouache, 10 3/4 x 8 in. (no. 79 in exh.)
Baigneuse, 1920, pencil and sepia, 9 7/8 x 16 in. (no. 80 in exh.)
Jeune Femme au chapeau, 1921, pencil, 11 x 8 1/4 in. (no. 81 in exh.)

Après le bain, 1923, pen and ink, 11 1/4 x 8 3/4 in. (no. 82 in exh.)

Scène mythologique, 1923, pen and ink, 6 x 4 3/4 in. (no. 83 in exh.)

Le Petit Déjeuner, 1924, oil, 15 1/4 x 18 1/4 in. (no. 84 in exh.; ill. in cat.) [Z.V.266]

Nature morte, 1925, crayon, 10 x 13 1/2 in. (no. 85 in exh.)

Tête de femme, 1927, oil, 21 3/4 x 13 1/4 in. (no. 86 in exh.)

Baigneuse, 1932, wash drawing, 12 3/4 x 10 3/8 in. (no. 87 in exh.)

Baigneuses à la plage, 1932, pen and ink, 9 3/4 x 13 1/2 in. (no. 88 in exh.)

Cannes: Baigneuses, 1933, watercolor, 15 3/4 x 19 1/2 in. (no. 89 in exh.)

Baigneuses, 1934, pen and ink, 9 7/8 x 13 5/8 in. (no. 90 in exh.)

Trois Nus, 1938, pen and ink, 17 x 26 3/8 in. (no. 91 in exh.)

Femme assise, 1941, oil, 36 x 28 5/8 in. (no. 92 in exh.) [Z.XI.342]

Femme nue assise, 1941, gouache, 16 x 11 7/8 in. (no. 93 in exh.)

Nature morte, 1944, oil, 8 3/4 x 10 3/4 in. (no. 94 in exh.)

March 16–April 3, 1948: Paul Rosenberg & Co., New York
"Drawings, Gouaches, Paintings from 1913 to 1947 by Picasso"

Oiseau sur une branche, 1913, 13 x 5 7/8 in. (no. 1 in exh.) [Z.II².532; private collection]

Nature morte verte [also known as: *Fruit Bowl, Wineglass, Bowl of Fruit*], 1914, 23 1/2 x 31 1/4 in. (no. 2 in exh.) / Museum of Modern Art [Z.II².485; Museum of Modern Art, New York]

Arlequin (Si tu veux) [current title: *Harlequin with Violin ("Si Tu Veux")*], 1918, 56 x 39 1/2 in. (no. 3 in exh.) [Z.III.160; Cleveland Museum of Art / The lender was Paul Rosenberg, New York.]

Pêcheur, 1918, drawing [medium not specified], 13 3/4 x 10 in. (no. 4 in exh.)

Le Tricorne, 1919, 14 3/4 x 9 3/4 in. (no. 5 in exh.)

La Fenêtre, 1919, gouache, 13 3/4 x 9 3/4 in. (no. 6 in exh.)

La Fenêtre ouverte, 1920, 64 1/2 x 43 in. (no. 7 in exh.)

Baigneuse, 1921, pastel, 29 1/2 x 24 1/2 in. (no. 8 in exh.)

Arlequin, 1922, 56 x 39 1/2 in. / Mr. and Mrs. Vladimir Horowitz (no. 9 in exh.)

Nature morte aux poissons, 1923, 51 x 38 1/4 in. (no. 10 in exh.)

Études de nu, 1923, pen and ink, 9 1/2 x 11 1/2 in. (no. 11 in exh.)

Nature morte aux biscuits, 1924, 32 x 39 3/4 in. (no. 12 in exh.) [Z.V.242; Cleveland Museum of Art / The lender was Paul Rosenberg, New York.]

Femme à la mandoline, 1925, 51 1/2 x 38 1/2 in. (no. 13 in exh.) [Z.V.442; Norton Simon Museum, Pasadena, California / The lender was Paul Rosenberg, New York.]

Le Peinture et son modèle, 1926, drawing [medium not specified], 11 x 14 1/2 in. (no. 14 in exh.)

Le Peinture et son modèle, 1926, pen and ink, 11 x 14 1/2 in. (no. 15 in exh.)

Buste et mandoline, 1927, 23 1/2 x 29 in. (no. 16 in exh.)

Composition, 1929, 29 x 23 in. (no. 17 in exh.) [Z.VII.273; Baltimore Museum of Art]

Le Sculpteur et son modèle, 1931, 7 1/2 x 9 1/2 in. (no. 18 in exh.)

Nu sur un divan noir, 1932, 63 3/4 x 51 1/4 in. / Mrs. Meric Callery, New York (no. 19 in exh.) [Z.VII.377]

Le Sculpteur et son oeuvre, 1933, gouache, 15 1/2 x 19 1/2 in. (no. 20 in exh.)

Combat de taureaux, 1934, 13 x 16 in. (no. 21 in exh.)

Femme dessinant, 1935, 51 1/8 x 76 5/8 in. / Mrs. Meric Callery, New York (no. 22 in exh.) [Z.VIII.263; Museum of Modern Art, New York]

Corbeille de fleurs et pichet, 1937, 18 1/2 x 25 1/2 in. (no. 23 in exh.)

Femme au coq, 1938, 57 1/4 x 47 1/2 in. / Mrs. Meric Callery, New York (no. 24 in exh.) [Z.IX.109]

Femme assise, robe jaune, 1939, 32 x 25 1/2 in.

(no. 25 in exh.)

Pot de tomates, 1944, 28 3/4 x 36 1/4 in. (no. 26 in exh.)

La Lampe et les cerises, 1945, 28 1/2 x 39 in. (no. 27 in exh.)

Les Volets verts, 1946, 28 3/4 x 36 1/4 in. (no. 28 in exh.)

La Table est servie, 1947, 39 1/4 x 31 1/2 in. (no. 29 in exh.)

Pipe et tabac, 1918, 10 1/8 x 13 3/4 in. (no. 30 in exh.)

La Fenêtre ouverte, 1919, 8 1/2 x 8 1/2 in. (no. 31 in exh.)

La Fenêtre ouverte, 1919, 11 x 9 in. (no. 32 in exh.)

Guéridon, 1920, 8 3/4 x 5 in. (no. 33 in exh.)

Pierrot et Arlequin, 1920, gouache, 8 1/4 x 10 1/2 in. (no. 34 in exh.)

Pierrot et Arlequin, 1920, gouache, 10 1/2 x 8 1/4 in. (no. 35 in exh.)

Pierrot et Arlequin, 1920, gouache, 10 1/2 x 8 1/4 in. (no. 36 in exh.)

Pierrot et Arlequin, 1920, gouache, 8 1/4 x 10 in. (no. 37 in exh.)

Pomme verre et citron, 1922, 8 1/2 x 10 1/2 in. (no. 38 in exh.)

Tranche de saumon, 1922, 8 3/4 x 10 1/2 in. (no. 39 in exh.)

Nature morte, 1923, 9 1/2 x 13 in. (no. 40 in exh.)

Trois danseurs, 1925, pen and ink, 13 3/4 x 9 7/8 in. (no. 41 in exh.)

Juan les Pins, 1937, 15 x 18 in. (no. 42 in exh.)

Tête de femme, 1939, 16 x 13 in. (no. 43 in exh.)

Tête de femme, 1939, 16 x 13 in. (no. 44 in exh.)

April 1–3, 1948: Residence of Stephen C. Clark, New York
[Stephen C. Clark Collection / Clark opened his magnificent home—now the Explorer's Club on East 70th Street in Manhattan—for the second year in a row to raise money for charity. For a nominal fee, one could take the elevator to the light-filled, top-floor private gallery and see "several late Picasso abstracts," among many other masterpieces, although no titles of specific works have been identified.]

May 1–September 30, 1948: Century Club, New York
"The Henry P. McIlhenny Collection"
Still Life, mural, oil, 60 x 75 in.

May 3–29, 1948: Durand-Ruel Galleries, New York
"Picasso"

Buste de femme, October 1943, 36 1/8 x 28 5/8 in. (no. 1 in exh.; ill. in cat.) [Z.XIII.140]

Portrait de femme à la broche d'or, November 4, 1941, 31 3/4 x 25 1/2 in. (no. 2 in exh.; ill. in cat.) [Z.XI.347]

Nature morte au gruyère, March 14, 1944, 23 5/8 x 36 1/8 in. (no. 3 in exh.; ill. in cat.) [Z.XIII.239]

Pot de tomates à la fenêtre, July 10, 1944, 36 1/8 x 28 5/8 in. (no. 4 in exh.; ill. in cat.) [Z.XIV.26]

Nature morte au chandelier, April 6, 1944, 25 5/8 x 36 1/8 in. (no. 5 in exh.; ill. in cat.) [Z.XIII.265]

Femme aux yeux noirs, November 17, 1941, 28 5/8 x 23 5/8 in. (no. 6 in exh.) [Z.XI.349]

Femme assise dans un fauteuil d'osier, September 24, 1943, 39 1/4 x 31 7/8 in. (no. 7 in exh.; ill. in cat.) [Z.XIII.328]

Tête de femme, May 17–July 9, 1943, 25 1/2 x 21 1/8 in. (no. 8 in exh.; ill. in cat.) [Z.XIII.69]

Femme en gris,* August 6, 1942, 39 1/4 x 31 7/8 in. (no. 9 in exh.; ill. in cat.) [Z.XIII.50; Alex Hillman Family Foundation Collection]

Femme assise dans un fauteuil, October 9, 1941, 45 1/2 x 35 in. (no. 10 in exh.; ill. in cat.) [Z.XI.333]

Buste de femme au corsage rayé, September 20, 1943, 39 1/8 x 31 3/4 in. (no. 11 in exh.; ill. in cat.) [Z.XIII.109]

Nature morte au compotier de cerises, September 17, 1943, 31 3/4 x 51 in. (no. 12 in exh.; ill. in cat.) [Z.XIII.131]

Nature morte au miroir, July 9, 1945, 31 7/8 x 45 5/8 in. (no. 13 in exh.; ill. in cat.) [Z.XIV.115]

Intérieur femme assise et nu debout, 1944, 28 5/8 x 36 1/8 in. (no. 14 in exh.) [Z.XIII.252]

Femme aux cheveux tombants, October 12, 1939, 25 1/2 x 19 5/8 in. (no. 15 in exh.) [Z.IX.354]

May 13–June 20, 1948: San Francisco Museum of Art
"Wright Ludington Collection"

Two Acrobats and a Dog [Z.I.300; Museum of Modern Art, New York]

Femme au bouquet [Z.II¹.156; private collection]

Still Life, 1916

Three Classical Figures, [1921. Z.IV.315]

Harlequin, 1923

Woman with Turban, [1923. Z.V.22]

Leda and the Swan

Woman at the Seashore

May 25–June 12, 1948: Bucholz Gallery, New York
"Drawings and Watercolors from the Collection of John S. Newberry, Jr."

Profile of a Woman, ca. 1903, charcoal, 6 3/8 x 4 1/4 in. (no. 36 in exh.)

Three Nudes, ca. 1905, pen and ink, 15 3/4 x 11 1/4 in. (no. 37 in exh.)

Study of a Sailor's Head, ca. 1907, watercolor, 8 1/2 x 6 3/4 in. (no. 38 in exh.) [Z.II¹.10; Museum of Modern Art, New York]

Man Seated at a Table, 1914, pencil, 13 x 10 in. (no. 39 in exh.; ill. in cat.) [Z.II².506; Museum of Modern Art, New York]

La Source, 1921, pencil, 19 x 21 in. (no. 40 in exh.)

July 20–September 12, 1948: Museum of Modern Art, New York
"New York Private Collections"

Still Life, 1913, oil and sand on canvas, 45 7/8 x 31 7/8 in. / Mrs. George Henry Warren

Pipe, Glass, Bottle of Rum,* 1914, collage, 15 3/8 x 20 1/2 in. [measurement by sight] / Mrs. Juliana Force, New York [Z.II².787; Museum of Modern Art, New York]

[The following seven pieces were noted as being "from a Private Collection, lent anonymously." The anonymous lender was Mrs. Meric Callery, New York.]

Seated Bather, 1929, oil on canvas, 63 7/8 x 51 1/8 in. [Z.VII.306; Museum of Modern Art, New York]

Nude on a Black Couch, March 9, 1932, oil on canvas, 63 1/4 x 51 1/4 in. [Z.VII.377]

Interior with a Girl Drawing, February 12, 1935, oil on canvas, 51 1/8 x 76 5/8 in. [Z.VIII.263; Museum of Modern Art, New York]

Girl with a Cock, February 15, 1938, oil on canvas, 57 1/4 x 47 1/2 in. [Z.IX.109; private collection, Switzerland]

Woman in an Armchair, April 29, 1938, pastel over ink, 30 1/8 x 21 3/4 in. [Z.IX.132; Metropolitan Museum of Art, New York]

Three Personages–Cabaña, August 10, 1938, ink, 17 1/4 x 26 1/2 in. [Z.IX.232]

Woman in a Garden, December 10, 1938, oil on canvas, 51 x 38 in. [Z.IX.232]

August 25–September 30, 1948: Dalzell Hatfield Galleries, Los Angeles
"Figures and Still Life"

Still Life, [oil]

La Soupe, [ca. 1902, oil on canvas, 15 x 18 1/8 in.] (ill. in cat.) [Z.I.131; Art Gallery of Ontario, Toronto]

September 14–October 17, 1948: San Francisco Museum of Art
"Picasso, Gris, Miró: The Spanish Masters of Twentieth Century Painting"

Street Scene, Paris, 1900, oil, 18 1/2 x 25 1/2 in. / Miss Harriett Levy to San Francisco Museum of Art (no. 1 in exh.; ill. in cat.) [Z.VI.302; San Francisco Museum of Modern Art]

Mother and Child, 1901, oil, 35 3/4 x 25 1/2 in. / anonymous loan to San Francisco Museum of Art (no. 2 in exh.; ill. on frontispiece of cat.) [Z.I.117]

Portrait of Gertrude Stein, 1906, oil / Metropolitan Museum of Art (no. 3 in exh.; ill. in cat.) [Z.I.352; Metropolitan Museum of Art, New York]

Woman in Yellow, 1907, oil, 51 1/4 x 37 7/8 in. / Mr. and Mrs. Joseph Pulitzer, Jr., St. Louis, Missouri (no. 4 in exh.; ill. in cat.) [Z.II¹.43; Pulitzer Foundation for the Arts]

Baigneuse, 1908, oil, 51 x 38 1/8 in. / anonymous loan (no. 5 in exh.; ill. in cat.) [Z.II¹.11; Museum of

Modern Art, New York]

"Ma Jolie," 1911–12, oil, 39 3/8 x 25 3/4 in. / Museum of Modern Art (no. 6 in exh.; ill. in cat.) [Z.II[1].244; Museum of Modern Art, New York]

Harlequin, 1918, oil, 58 x 26 1/2 in. / Mr. and Mrs. Joseph Pulitzer, Jr., St. Louis, Missouri (no. 7 in exh.; ill. in cat.) [Z.III.159; Pulitzer Foundation for the Arts]

La Fontaine [current title: *Three Women at the Spring*], 1921, oil, 81 x 66 1/2 in. / Mr. and Mrs. Allan Emil through the New Art Circle, J. B. Neumann, New York (no. 8 in exh.; ill. in cat.) [Z.IV.322; Museum of Modern Art, New York]

Bird in Cage, 1923, oil, 79 x 55 in. / Paul Rosenberg & Co., New York (no. 9 in exh.; ill. in cat.) [Z.V.84]

Still Life with Guitar and Stars, 1924, oil, 38 1/4 x 51 in. / Paul Rosenberg & Co., New York (no. 10 in exh.; ill. in cat.) [Z.V.225]

Seated Woman, 1932, oil, 28 1/2 x 20 in. / Mr. and Mrs. Lee Ault, New Canaan, Connecticut (no. 11 in exh.; ill. in cat.) [Z.VII.405]

Seated Woman with Red Bonnet, 1934, oil, 64 x 51 in. / Paul Rosenberg & Co., New York (no. 12 in exh.; ill. in cat.) [Z.VIII.238]

La Cruche fleurie, 1937, oil, 19 7/8 x 24 in. / San Francisco Museum of Art, gift of William Crocker (no. 13 in exh.; ill. in cat.) [Z.VIII.326; San Francisco Museum of Modern Art]

Still Life with Sheep's Skull, 1939, oil, 19 7/8 x 24 in. / Bucholz Gallery, New York (no. 14 in exh.; ill. in cat.) [Z.X.122; Mr. and Mrs. Marcos Micha]

Head of a Woman, 1939, oil, 25 1/2 x 19 5/8 in. / Durand-Ruel Inc., New York (no. 15 in exh.; ill. in cat.) [Z.IX.354]

Woman Seated in Armchair, 1941, oil, 45 1/2 x 35 in. / Durand-Ruel, Inc., New York (no. 16 in exh.; ill. in cat.) [Z.XI.333]

Still Life with Bull's Head, 1942, oil, 38 1/2 x 51 1/4 in. / Bucholz Gallery, New York (no. 17 in exh.; ill. in cat.)

Head of a Woman, 1943, oil, 36 1/8 x 25 5/8 in. / Durand-Ruel, Inc., New York (no. 18 in exh.; ill. in cat.) [Z.XIII.140]

Still Life with Gruyère, 1944, oil, 23 5/8 x 36 1/8 in. / Durand-Ruel, Inc., New York (no. 19 in exh.; ill. in cat.) [Z.XIII.239]

Interior with Seated Woman and Standing Nude, 1944, oil, 28 5/8 x 36 1/8 in. / Durand-Ruel, Inc., New York (no. 20 in exh.; ill. in cat.) [Z.XIII.252]

September 20–October 16, 1948: Paul Rosenberg & Co., New York
"19th and 20th Century American and French Drawings"
A Young Painter and His Model, 1926, ink on paper [Z.VII.47; San Francisco Museum of Modern Art]

October 5–30, 1948: Pierre Matisse Gallery, New York
"Twentieth Century Masters"
Still Life with a Candle, 1944, oil, 25 1/2 x 36 in. / Lee Ault, New Canaan, Connecticut (no. 10 in exh.; ill. in cat.) [Z.XIII.256]

November 15–21, 1948: California Palace of the Legion of Honor, San Francisco
"France Comes to You"
Street Scene, 1900 [Z.VI.302; San Francisco Museum of Modern Art]

November 15–December 18, 1948: Paul Rosenberg & Co., New York
"Loan Exhibition of 21 Masterpieces by 7 Great Masters"
Le Joueur de cartes (The Card Player), 1913–14, oil on canvas, 42 1/2 x 35 1/4 in. / Museum of Modern Art (no. 19 in exh.; ill. in cat.) [Z.II[2].466; Museum of Modern Art, New York]
Nature morte à la bouteille de vin (Still Life with a Bottle of Wine), 1926, oil on canvas, 38 3/4 x 51 1/4 in. / private collection, New York (no. 20 in exh.; ill. in cat.) [Z.VI.1444 / The anonymous lender was Paul Rosenberg.]
Les Volets verts (The Green Shutters), 1946, oil on canvas, 28 3/4 x 36 1/4 in. (no. 21 in exh.; ill. in cat.)

November 16, 1948–January 23, 1949: Museum of Modern Art, New York
"Timeless Aspects of Modern Art"
"Ma Jolie" (Woman and Guitar), 1911–12, oil / Museum of Modern Art (no. 3 in exh.; ill. in cat.) [Z.II[1].244; Museum of Modern Art, New York]
The Painter and His Model, 1928, oil / Sidney Janis, New York (no. 10 in exh.; ill. in cat.) [Z.VII.143; Museum of Modern Art, New York]
Horse (Study for "Guernica"), [May 2], 1937, oil / Museum of Modern Art (no. 18 in exh.; detail ill. in cat.) [Z.IX.11; Museo Nacional Centro de Arte Reina Sofia, Madrid]

1949

January 31–February 26, 1949: Perls Galleries, New York
"Picasso: 'For the Young Collector'"
Le Couple, 1900, pen and ink, 11 3/4 x 7 5/8 in. (no. 1 in exh.)
Trois Allégories, 1901, pen, ink, and crayon, 5 1/8 x 3 1/2 in. ea. (no. 2 in exh.)
Étude pour "La Soupe," 1902, pencil, 9 x 11 3/4 in. (no. 3 in exh.)
Saltimbanque endormi, 1904, watercolor, 7 x 4 1/8 in. (no. 4 in exh.)
Mère et enfant, 1906, crayon, 11 7/8 x 9 1/4 in. (no. 5 in exh.)
Nu, 1906, pastel, 25 x 18 3/4 in. (no. 6 in exh.)
Étude pour "Les Demoiselles d'Avignon": Nu, 1907, watercolor, 12 1/4 x 9 1/2 in. (no. 7 in exh.)
Étude pour "Les Demoiselles d'Avignon": Tête, 1907, watercolor, 12 1/4 x 9 1/2 in. (no. 8 in exh.)
Buste d'homme, 1907, charcoal, 24 1/2 x 18 1/2 in. (no. 9 in exh.)
La Liseuse, 1909, oil, 36 x 29 in. (no. 10 in exh.)
L'Homme au piano, 1914, pen and ink, 8 1/4 x 4 in. (no. 11 in exh.)
Modèle à l'atelier, 1915, watercolor, 10 3/4 x 8 5/8 in. (no. 12 in exh.)
Composition, 1916, watercolor, 10 7/8 x 7 3/4 in. (no. 13 in exh.)
Nature morte au guéridon, 1920, gouache, 10 3/4 x 8 in. (no. 14 in exh.)
Baigneuse, 1920, pencil and sepia, 9 7/8 x 16 in. (no. 15 in exh.)
Après le bain, 1923, pen and ink, 11 1/4 x 8 3/4 in. (no. 16 in exh.)
Scène mythologique, 1923, pen and ink, 6 x 4 3/4 in. (no. 17 in exh.)
Nature morte, 1925, crayon, 10 x 13 1/2 in. (no. 18 in exh.)
Trois Études abstraites, 1925, pencil, ca. 5 x 7 in. each (no. 19 in exh.)
La Sérénade, 1932, pen and ink, 10 x 12 3/4 in. (no. 20 in exh.)
Baigneuse, 1932, wash drawing, 12 3/4 x 10 3/8 in. (no. 21 in exh.)
Baigneuses à la plage, 1932, pen and ink, 9 3/4 x 13 1/2 in. (no. 22 in exh.)
Cannes: Baigneuses, 1933, watercolor, 15 3/4 x 19 1/2 in. (no. 23 in exh.)
Baigneuses, 1934, pen and ink, 9 7/8 x 13 5/8 in. (no. 25 in exh.)
Portrait de Dora Maar, 1938, charcoal, 30 x 22 1/4 in. (no. 26 in exh.)
Nature morte à la cruche, 1939, oil, 10 5/8 x 18 1/8 in. (no. 27 in exh.; ill. in cat.)
Femme assise, 1941, oil, 36 x 28 5/8 in. (no. 28 in exh.; ill. in cat.) [Z.XI.342]
Femme nue assise, 1941, gouache, 16 x 11 7/8 in. (no. 29 in exh.)
La Toilette, 1942, pen, ink, and wash, 16 1/4 x 11 1/4 in. (no. 30 in exh.)
L'Homme à l'agneau, 1943, pen, ink, and wash, 27 3/4 x 23 in. (no. 31 in exh.)
Nature morte, 1944, oil, 8 3/4 x 10 3/4 in. (no. 32 in exh.; ill. in cat.)

February 2–March 31, 1949: Century Association, New York
"Trends in European Painting, 1880–1930"
Still Life with Guitar, 1913, oil and pasted paper,

25 x 21 in. / Sidney Janis, New York (no. 16 in exh.; ill. in cat.) [Z.II[2].419; Museum of Modern Art, New York / This work was not exhibited, due to a lack of space.]
Vive la France, 1914–15, oil, 21 x 25 in. / Sidney Janis, New York (no. 17 in exh.; ill. in cat.) [Z.II[2].523; private collection / This work was not exhibited, due to a lack of space.]
L'Italienne, 1917, oil, 59 x 39 7/8 in. / anonymous loan (no. 22 in exh.; ill. in cat.) [Z.III.18]

February 19–March 1, 1949: New School Associates at the New School, New York
"19th and 20th Century French Paintings from the Collection of Mrs. H. Harris Jonas"
Portrait (Blue Period) (no. 9 in exh.)

February 28–March 26 and March 28–April 23, 1949: Perls Galleries, New York
"The Perls Galleries Collection of Modern French Paintings"
Le Couple, 1900, pen and ink, 11 3/4 x 7 5/8 in. (no. 72 in exh.)
Trois Allégories, 1901, pen, ink, and crayon, 5 1/8 x 3 1/2 in. ea. (no. 73 in exh.)
Mère et enfant, 1906, crayon, 11 7/8 x 9 1/4 in. (no. 74 in exh.)
Nu, 1906, pastel, 25 x 18 3/4 in. (no. 75 in exh.)
Étude pour "Les Demoiselles d'Avignon": Nu, 1907, watercolor, 12 1/4 x 9 1/2 in. (no. 76 in exh.)
Étude pour "Les Demoiselles d'Avignon": Tête, 1907, watercolor, 12 1/4 x 9 1/2 in. (no. 77 in exh.)
La Liseuse, 1909, oil, 36 x 29 in. (no. 78 in exh.)
L'Homme au piano, 1914, pen and ink, 8 1/4 x 4 in. (no. 79 in exh.)
Modèle à l'atelier, 1915, watercolor, 10 3/8 x 8 5/8 in. (no. 80 in exh.)
Composition, 1916, watercolor, 10 7/8 x 7 3/4 in. (no. 81 in exh.)
Femme au fauteuil, 1918, watercolor, 10 3/4 x 8 in. (no. 82 in exh.)
Nature morte au guéridon, 1920, gouache, 10 3/4 x 8 in. (no. 83 in exh.)
Composition, 1920, gouache, 8 1/2 x 12 1/2 in. (no. 84 in exh.)
Baigneuse, 1920, pencil and sepia, 9 7/8 x 16 in. (no. 85 in exh.)
Après le bain, 1923, pen and ink, 11 1/4 x 8 3/4 in. (no. 86 in exh.)
Scène mythologique, 1923, pen and ink, 6 x 4 3/4 in. (no. 87 in exh.)
Nature morte, 1925, crayon, 10 x 13 1/2 in. (no. 88 in exh.)
Trois Études abstraites, 1925, pencil, ca. 5 x 7 in. each (no. 89 in exh.)
La Sérénade, 1932, pen and ink, 10 x 12 3/4 in. (no. 90 in exh.)
Baigneuse, 1932, wash drawing, 12 3/4 x 10 3/8 in. (no. 91 in exh.)
Baigneuses à la plage, 1932, pen and ink, 9 3/4 x 13 1/2 in. (no. 92 in exh.)
Cannes: Baigneuses, 1933, watercolor, 15 3/4 x 19 1/2 in. (no. 93 in exh.)
Baigneuses, 1934, pen and ink, 9 7/8 x 13 5/8 in. (no. 94 in exh.)
Trois Nus, 1938, pen and ink, 17 x 26 3/8 in. (no. 95 in exh.)
Portrait de Dora Maar, 1938, charcoal, 30 x 22 1/4 in. (no. 96 in exh.)
Nature morte à la cruche, 1939, oil, 10 5/8 x 18 1/8 in. (no. 97 in exh.)
Femme assise, 1941, oil, 36 x 28 5/8 in. (no. 98 in exh.; ill. in cat.) [Z.XI.342]
Femme nue assise, 1941, gouache, 16 x 11 7/8 in. (no. 99 in exh.)
La Toilette, 1942, pen, ink, and wash, 16 1/4 x 11 1/4 in. (no. 100 in exh.)
Nature morte, 1944, oil, 8 3/4 x 10 3/4 in. (no. 101 in exh.)
La Carafe aux fleurs, 1944, oil, 18 x 13 in. (no. 102 in exh.)

March 8–April 2, 1949: Bucholz Gallery, New York
"Pablo Picasso: Recent Work"
Fawn in Sunlight, 1946, oil, 26 x 20 in. (no. 1 in exh.; ill. in cat.) [Z.XIV.240]

Trois Nus, 1938, pen and ink, 17 x 26 3/8 in. (no. 25 in exh.)

Grotto, 1946, oil, 20 x 26 in. (no. 2 in exh.; ill. in cat.) [Z.XV.14]
Flowers and Eggplant, 1946, oil, 20 x 26 in. (no. 3 in exh.; ill. in cat.) [Z.XV.15]
Coffee Pot, 1946, oil, 26 x 20 in. (no. 4 in exh.; ill. in cat.) [Z.XV.1]
Bust of a Fawn, 1946, oil, 26 x 20 in. (no. 5 in exh.)
Bust of a Fawn, 1946, oil, 26 x 20 in. (no. 6 in exh.)
Fawn (Grey Background), 1946, oil, 26 x 20 in. (no. 7 in exh.)
Still Life with Eggplant, 1946, oil, 20 x 26 in. (no. 8 in exh.)
Still Life on Tablecloth, 1946, oil, 20 x 26 in. (no. 9 in exh.; ill. in cat.)
Fruitbowl, 1946, oil, 20 x 26 in. (no. 10 in exh.)
Still Life with Eggplant, 1946, oil, 20 x 26 in. (no. 11 in exh.)
Sea Urchins, 1946, oil, 20 x 26 in. (no. 12 in exh.; ill. in cat.) [Z.XIV.251]
Vase, 1946, watercolor, 25 1/2 x 19 1/2 in. (no. 13 in exh.; ill. in cat.)
View of Minerbes I, 1946, watercolor, 12 1/2 x 19 1/2 in. (no. 14 in exh.; ill. in cat.)
View of Minerbes II, 1946, watercolor, 12 1/2 x 19 1/2 in. (no. 15 in exh.)
Bust of a Fawn, 1946, watercolor, 25 1/2 x 19 1/2 in. (no. 16 in exh.)
Games, 1946, watercolor, 19 1/2 x 25 1/2 in. (no. 17 in exh.)
Dance on the Beach, 1946, watercolor, 19 1/2 x 25 1/2 in. (no. 18 in exh.; ill. in cat.)
Dance, [August 28], 1946, crayon, 19 1/2 x 25 1/2 in. (no. 19 in exh.; ill. in cat.)
Nymphs and Fawns, 1946, watercolor, 19 1/2 x 25 1/2 in. (no. 20 in exh.; ill. in cat.)
Dance in the Hills, 1946, ink and wash, 19 1/2 x 25 1/4 in. (no. 21 in exh.)
Hommage to the Nymph, 1946, ink, 19 1/2 x 25 1/2 in. (no. 22 in exh.; ill. in cat.) [Z.XIV.226]
Games on the Beach, 1946, ink, 19 1/2 x 25 1/2 in. (no. 23 in exh.)
Head of a Fawn, 1926 [*sic*], ink, 25 1/2 x 19 1/2 in. (no. 24 in exh.) [It is likely that the date listed here as 1926 is inaccurate, and should instead be 1946.]
Fawns and Nymphs, 1946, ink, 19 1/2 x 25 1/2 in. (no. 25 in exh.)
Games and Dances, 1946, ink and wash, 19 1/2 x 25 1/2 in. (no. 26 in exh.; ill. in cat.) [Z.XIV.228]

March 20–April 15, 1949: James Vigeveno Galleries, Los Angeles
"(A French Show of) Small Paintings by Great Masters"
Deux Femmes se coiffant (no. 27 in exh.; ill. in cat.)
Still Life (no. 28 in exh.)

April 5–30, 1949: Bucholz Gallery, New York
"Cubism: Braque, Gris, Laurens, Léger, Lipchitz, Picasso"
Nude, 1907, ink and oil, 24 1/2 x 17 1/2 in. (no. 32 in exh.)
Fruitbowl, Pears and Apples, 1908, oil, 10 1/2 x 8 1/8 in. / Lee Ault, New Canaan, Connecticut (no. 33 in exh.)
Portrait of Georges Braque, 1909, oil, 24 1/4 x 19 3/4 in. / Edward A. Bragaline, New York (no. 34 in exh.; ill. in cat.) [Z.II¹.177; Staatliche Museen zu Berlin, Nationalgalerie, on permanent loan from the Berggruen Collection]
Woman with Book, 1909, oil, 36 1/4 x 28 1/2 in. (no. 35 in exh.) [Z.II¹.150; private collection]
Head of a Woman, 1909, ink and brush, 19 x 24 1/2 in. (no. 37 in exh.; ill. in cat.)
Still Life, 1909, charcoal, 18 7/8 x 24 1/4 in. (no. 38 in exh.)
Figure, 1910, oil, 30 1/4 x 39 in. / Pierre Matisse, New York (no. 39 in exh.)
Head with Pipe, 1911, oil and charcoal, 64 x 47 in. (no. 40 in exh.) [Z.II¹.280; Fogg Art Museum, Harvard University, Cambridge, Massachusetts]
Table de toilette [current title: *The Dressing Table*], 1911, oil, 61 x 46 in. / Ralph Colin, New York (no. 41 in exh.) [Z.II¹.220]
Le Pont Neuf, 1911, oil, 13 x 9 1/2 in. (no. 42 in exh.)
Man with Mandolin, 1911–12, oil, 24 x 15 in. /

private collection (no. 43 in exh.) [Z.II¹.292; private collection]
L'Homme au piano, 1912, pen and ink, 3 3/4 x 8 in. (no. 44 in exh.)
Study for a Construction, 1912, pen and ink, 6 3/4 x 4 7/8 in. / Museum of Modern Art (no. 45 in exh.) [Museum of Modern Art, New York]
Tête de femme, 1913, oil, 15 x 22 in. / private collection (no. 46 in exh.)
Still Life, 1914, oil / J. Seligmann & Co., New York (no. 47 in exh.)
Nature morte au guéridon, 1914, oil / Mrs. Meric Callery, New York (no. 48 in exh.) [Z.II².533]
Bouteille d'anis, 1915, oil, 16 1/2 x 23 in. (no. 49 in exh.) [Z.II².552; Detroit Institute of Art]
Seated Woman, 1918, gouache, 5 1/2 x 4 1/2 in. / Museum of Modern Art (no. 50 in exh.)

April 11–24, 1949: San Francisco Museum of Art
"Western Round Table Exhibition"
Girl before a Mirror / Museum of Modern Art [Z.VII.379; Museum of Modern Art, New York]
Seated Figure of a Woman / Mr. Walter C. Arensberg, Hollywood [Z.II¹.225; Philadelphia Museum of Art]

June 26–August 1949: James Vigeveno Galleries, Los Angeles
"Modern French Paintings: Renoir to Matisse" [This exhibition included at least one work by Picasso, although no titles of specific works have been identified.]

August 1949: Metropolitan Museum of Art, New York
"Loan Exhibition of French Painting"
A Woman [current title: *Woman with a Cape*] / Leonard C. Hanna, Jr., Cleveland [Z.VI.542; Cleveland Museum of Art]
Head of a Boy, 1905 / Leonard C. Hanna, Jr., Cleveland [Z.I.303; Cleveland Museum of Art]
Figures in Pink / Leonard C. Hanna, Jr., Cleveland [Z.I.321; Cleveland Museum of Art]
L'Arlésienne / Mr. and Mrs. Donald Stralem
Still Life / Mr. and Mrs. Donald Stralem

October–November 1949: Samuel M. Kootz Gallery, New York
["The Birds and the Beasts"]
[*Volaille et couteau sur une table*, March 21, 1947, oil on canvas (ill. in cat.) Z.XV.41]

October 20-December 18, 1949: Art Institute of Chicago
"Arensberg Collection" [The Arensbergs (Walter, a poet, and Louise, a pianist and singer) moved to New York in 1914, and their apartment soon became a gathering spot for the cultural avant-garde. There, they met Marcel Duchamp, who became a lifelong friend and adviser on their art collection. They built a significant collection of Cubist works as well as important holdings of works by Constantin Brancusi and Duchamp, among others. The Arensbergs moved to Hollywood in 1922 and had planned to leave their collection to a West Coast museum, but Albert Gallatin persuaded them to join him in leaving their collection to the Philadelphia Museum of Art, where the works now reside.]
Old Woman (alternative titles: *Head of Old Woman*, *The Hag*, and *Woman with Gloves*), 1901–3, oil on board, 26 1/2 x 20 1/2 in. (no. 163 in exh.) [Z.VI.389; Philadelphia Museum of Art]
Sea Shore, about 1905, pencil, 4 3/8 x 6 1/2 in. (no. 164 in exh.) [Philadelphia Museum of Art]
Female Figure, about 1905–6, ink, 6 1/2 x 4 in. (no. 165a in exh.) [Philadelphia Museum of Art]
Female Figure with Hand, about 1905–6, pencil, 6 1/2 x 4 in. (no. 165b in exh.) [Philadelphia Museum of Art]
("The above 165a and b are front and back of a single sheet.")
Head, 1906, ink, 12 1/4 x 8 7/8 in. (no. 166 in exh.) [Philadelphia Museum of Art]
Woman Seated and Woman Standing, 1906, charcoal, 24 1/4 x 18 1/2 in. (no. 167 in exh.) [Z.I.368; Philadelphia Museum of Art]
Landscape, 1907-8, gouache, 18 1/2 x 24 1/2 in.

(no. 168 in exh.) [Z.II¹.54; Philadelphia Museum of Art]
Seated Nude Woman, 1908, oil, 45 3/4 x 35 in. (no. 169 in exh.) [Z.II¹.114; Philadelphia Museum of Art]
Men (alternative titles: *Nude Man Seated* and *Three Personages*), 1908, gouache, 24 1/2 x 18 5/8 in. (no. 170 in exh.) [Z.II¹.77; Philadelphia Museum of Art]
Female Nude, 1910, oil, 38 1/2 x 30 1/4 in. (no. 172 in exh.) [Z.II¹.225; Philadelphia Museum of Art]
Violin, about 1910–12, charcoal, 18 1/2 x 12 3/8 in. (no. 173 in exh.) [Philadelphia Museum of Art]
Man with Violin, 1911–12, oil, 39 x 28 1/2 in. (no. 174 in exh.) [Z.II¹.289; Philadelphia Museum of Art]
Man with Guitar, 1912–13, oil, 51 1/4 x 35 in. (no. 175 in exh.) [Z.II¹.354; Philadelphia Museum of Art]
Violin and Guitar, 1912, collage of pencil, appliquéd plaster, oil, and material painted to simulate wood on canvas, 36 1/4 x 25 1/4 in. (oval) (no. 177 in exh.) [Z.II².363; Philadelphia Museum of Art]
Three Nudes on Shore, June 23, 1920, pencil on tan paper, 9 3/4 x 16 3/8 in. (no. 178 in exh.) [Philadelphia Museum of Art]
Still Life, April 10, 1921, pastel, 41 x 29 1/4 in. (no. 179 in exh.) [Z.IV.260; Philadelphia Museum of Art]

October 24–November 12, 1949: Paul Rosenberg & Co., New York
"Paintings by Braque, Matisse, Picasso"
Still Life with Fishes, 1923, 51 x 38 1/4 in. (no. 9 in exh.)
Bust and Mandoline [*sic*], 1927, 23 1/2 x 29 in. (no. 10 in exh.)
Fishes, 1936, 19 3/4 x 24 in. (no. 11 in exh.)
African Sculpture by the Window, 1937, 28 1/2 x 23 1/2 in. (no. 12 in exh.) [Z.VIII.360]

November 8–26, 1949: Pierre Matisse Gallery, New York
"Selections"
Figure, 1910, oil on canvas, 39 x 30 in. (no. 10 in exh.; ill. in cat.) [Z.II¹.194; Albright-Knox Art Gallery, Buffalo]

November 9–December 4, 1949: San Francisco Museum of Art
"Portraits and People"
Young Painter and His Model, 1926, pen and ink [Z.VII.47; San Francisco Museum of Modern Art / At the time of the exhibition, this work was a recent gift to the museum's collection.]

November 29–December 17, 1949: M. Knoedler Galleries, New York
"To Honor Henry McBride: An Exhibition of Paintings, Drawings and Watercolors"
Still Life, 1922, oil, 39 1/2 x 32 in. (no. 8 in exh.; ill. in cat.) [Z.XXX.286; Art Institute of Chicago]

1950
January 3–28, 1950: Perls Galleries, New York
"Mid-Century Perspective"
La Gommeuse, 1901 (no. 17 in exh.; ill. in cat.)

January 9–February 9, 1950: Louis Carré Gallery, New York
"Picasso: The Figure, November 6, 1939–May 4, 1944"
November 6, 1939 (no. 1 in exh.)
March 12, 1941 (no. 2 in exh.) [Z.XI.110]
October 24, 1941 (no. 3 in exh.) [Z.XI.344]
October 31, 1941 (no. 4 in exh.) [Z.XI.339]
November 3, 1941 (no. 5 in exh.) [Z.XI.345]
March 5, 1944 (no. 6 in exh.) [Z.XIII.235]
May 4, 1944 (no. 7 in exh.)

January 12–February 5, 1950: San Francisco Museum of Art
"Modern Masterpieces of the Bay Region, 15th Anniversary Exhibition"
Drawing [possibly: *Instruments et bol de fruits devant une fenetre*, 1915, gouache, watercolor,

wash, and charcoal on paper, 7 1/2 x 6 in.] /
Mr. and Mrs. James D. Hart
A Young Painter and His Model, 1926, ink on paper /
San Francisco Museum of Art [Z.VII.47;
San Francisco Museum of Modern Art]
Head, 1927 / Gordon Onslow-Ford, San Francisco
[Z.VII.118; Art Institute of Chicago]
La Cruche fleurie, 1937 / William W. Crocker,
San Francisco [Z.VIII.326; San Francisco
Museum of Modern Art]
Garçon assis / Mr. and Mrs. Tevis Jacobs

February 4–April 16, 1950: Philadelphia Museum of Art
"Collection of Mr. and Mrs. Samuel S. White, III"
[*Still Life: Bottle, Newspaper and Glass*, 1914, oil,
graphite, and tempera with cork on cardboard,
10 3/4 x 18 1/4 in. Philadelphia Museum of Art]
[*Still Life: Vase, Pipe and Package of Tobacco*, 1919,
oil on canvas, 25 5/8 x 21 1/4 in. Z.III.278]

**February 27–March 25, March 27–April 29, and May
1–30, 1950**: Perls Galleries, New York
"The Perls Galleries Collection of Modern French
Paintings"
Le Couple, 1900, pen and ink, 11 3/4 x 7 5/8 in.
(no. 80 in exh.)
Trois Allégories, 1901, pen, ink and crayon, 5 1/8 x
3 1/2 in. each (no. 81 in exh.)
Mère et enfant, 1906, crayon, 11 7/8 x 9 1/4 in.
(no. 82 in exh.)
Nu, 1906, pastel, 25 x 18 3/4 in. (no. 83 in exh.)
La Liseuse, 1909, oil, 36 x 29 in. (no. 84 in exh.;
ill. in cat.)
L'Homme au piano, 1914, pen and ink, 8 1/4 x 4 in.
(no. 85 in exh.)
Modèle à l'atelier, 1915, watercolor, 10 3/8 x 8 5/8 in.
(no. 86 in exh.)
Composition, 1918, watercolor, 10 7/8 x 7 3/4 in.
(no. 87 in exh.)
Composition, 1920, gouache, 8 1/2 x 12 1/2 in.
(no. 88 in exh.)
Baigneuse, 1920, pencil and sepia, 9 7/8 x 16 in.
(no. 89 in exh.)
Après le bain, 1923, pen and ink, 11 1/4 x 8 3/4 in.
(no. 90 in exh.)
Scène mythologique, 1923, pen and ink, 6 x 4 3/4 in.
(no. 91 in exh.)
Nature morte, 1925, crayon, 10 x 13 1/2 in.
(no. 92 in exh.)
Composition, 1925, pencil, 5 5/8 x 4 3/8 in.
(no. 93 in exh.)
Trois études abstraites, 1925, pencil, ca. 5 x 7 in. each
(no. 94 in exh.)
Le Pigeon blanc, 1927, oil, 10 3/4 x 13 3/4 in.
(no. 95 in exh.)
La Sérénade, 1932, pen and ink, 10 x 12 3/4 in.
(no. 96 in exh.)
Baigneuse, 1932, wash drawing, 12 3/4 x 10 3/8 in.
(no. 97 in exh.)
Baigneuses à la plage, 1932, pen and ink, 9 3/4 x
13 1/2 in. (no. 98 in exh.)
Cannes: Baigneuses, 1933, watercolor, 15 3/4 x
19 1/2 in. (no. 99 in exh.)
Baigneuses, 1934, pen and ink, 9 7/8 x 13 5/8 in.
(no. 100 in exh.)
Trois Nus, 1938, pen and ink, 17 x 26 3/8 in.
(no. 101 in exh.)
Nature morte à la cruche, 1939, oil, 10 5/8 x 18 1/8
in. (no. 102 in exh.)
Nature morte aux fruits, 1939, oil, 11 1/4 x 16 7/8
in. (no. 103 in exh.)
Femme au chapeau mauve (Dora Maar), 1939,
oil, 25 1/2 x 19 1/2 in. (no. 104 in exh.)
Femme nue assise, 1941, gouache, 16 x 11 7/8 in.
(no. 105 in exh.)
La Toilette, 1942, pen, ink, and wash, 16 1/4 x
11 1/4 in. (no. 106 in exh.)
Nature morte, 1944, oil, 8 3/4 x 10 3/4 in.
(no. 107 in exh.)
La Carafe aux fleurs, 1944, oil, 18 x 13 in.
(no. 108 in exh.)
La Cruche aux margeuites, 1944, oil, 18 x 13 in.
(no. 109 in exh.; ill. in cat.) [Z.XIV.17]

April 13–May 18, 1950: James Vigeveno Galleries, Los
Angeles

"50 Years of Modern French Paintings at the James
Vigeveno Galleries"
Stillife [*sic*], 1923 (no. 12 in exh.)

May 20–September 15, 1950: Philadelphia Museum of
Art
"Masterpieces from Philadelphia Private Collections,
Part II"
Journal, ca. 1914 / Mr. and Mrs. Samuel S.
White, III, Ardmore, Pennsylvania (no. 74 in
exh.) [Philadelphia Museum of Art]
Pitcher of Milk, 1937 / Mr. and Mrs. Frederic R.
Mann (no. 75 in exh.)

Through June 1950: Pierre Matisse Gallery, New York
"Contemporary Art: Painting and Sculpture"
Harlequin, 1927, oil (no. 15 in exh.) [Z.VII.73]

July 7–early September 1950: Metropolitan Museum
of Art, New York
"Paintings from Private Collections, Summer Loan
Exhibition"
Vase de fleurs, 1907, oil on canvas, 36 1/2 x 28 1/2 in. /
Ralph Colin, New York [Z.II¹.30; Museum of
Modern Art, New York]
Head of a Woman
Young Lady with a Hoop

July 11–September 5, 1950: Museum of Modern Art,
New York
"Three Modern Styles"
Two Cubist Heads, 1910, oil on canvas, 14 x 13 3/4
in. / Dr. Albert W. Bluem, Short Hills,
New Jersey
Still Life with a Cake, 1924, oil on canvas / Museum
of Modern Art [Z.V.185; Metropolitan Museum
of Art, New York]

August 1950: California Palace of the Legion of
Honor, San Francisco
"Vincent Price Collection" in "The Taste of Two
Collectors"
Three Graces, pen and ink, 13 3/4 x 9 7/8 in.
(no. 12 in exh.)

October 2–23, 1950: Paul Rosenberg & Co.,
New York
"Exhibition of French Drawings and Watercolors"
Landscape with Bathing Women, 1908, watercolor,
19 x 23 in. (no. 11 in exh.)
Glass and Pipe, 1914, collage, 14 x 8 in. (no. 12
in exh.)
Man with Pipe, 1915, drawing [medium not
specified], 11 x 9 in. (no. 13 in exh.)
Head of a Woman, 1922, drawing [medium not
specified], 24 x 19 in. (no. 14 in exh.)

October 15–November 16, 1950: James Vigeveno
Galleries, Los Angeles
"French Master Drawings and Early Chinese Pottery"
[This exhibition included at least one work by
Picasso, although no titles of specific works have been
identified.]

October 24–November 30, 1950: Pierre Matisse
Gallery, New York
"Selections"
Figure, 1910, 39 x 30 in. (no. 10 in exh.; ill. in cat.)
[Z.II¹.194; Albright-Knox Art Gallery, Buffalo]

November 1950: Los Angeles County Museum
"The Mr. and Mrs. George Gard de Sylva Collection
of French Impressionist and Modern Paintings and
Sculpture"
Courtesan with Jewelled Collar, 1901, oil on canvas,
25 3/4 x 25 3/4 in. (no. 11 in exh.; ill. in cat.)
[Z.I.42; Los Angeles County Museum of Art]
The Woman with the Blue Veil, 1923, oil on
canvas, 39 1/2 x 32 in. (no. 12 in exh.; ill. in
cat.)[Z.V.16; Los Angeles County Museum
of Art]

November 1950: Pierre Matisse Gallery, New York
"Selections 1950"
Harlequin, 1927, 21 1/2 x 18 in. (no. 11 in exh.;
ill. in cat.) [Z.VII.73]

November 1–December 6, 1950: San Francisco
Museum of Art
"Selected European Masters"
Untitled, April 20, 1921, oil / Gordon Onslow-Ford
[San Francisco Museum of Modern Art]
Monkey, pen and ink / anonymous loan

November 3, 1950–February 11, 1951: Philadelphia
Museum of Art
"Diamond Jubilee Exhibition"
Self-Portrait [current title: *Self-Portrait with Palette*],
1906 [Z.I.375; Philadelphia Museum of Art]

November 13–December 2, 1950: Paul Rosenberg &
Co., New York
"Exhibition of 20th Century French Paintings"
Nude–Green Leaves, 1932, 64 x 51 1/2 in. (no. 9
in exh.)
Bull, Skull and Vase, 1939, 32 x 39 in. (no. 10 in exh.)

December 20, 1950–January 10, 1951: Los Angeles
County Museum
"Twentieth-Century Master Movements: Cubism";
traveled to San Francisco Museum of Art, January
24–February 17, 1952 [This exhibition was organized
and circulated by the Museum of Modern Art, New
York.]
Landscape with Figures, 1908, oil, 23 5/8 x 28 3/4 in. /
Museum of Modern Art, New York [Musée
Picasso, Paris]
Head, 1909, gouache / Museum of Modern Art, gift
of Mrs. Sadie A. May [Z.II¹.148; Museum of
Modern Art, New York]
Woman with Mandolin, ca. 1910, oil on canvas /
Museum of Modern Art [Z.II¹.235; Museum
of Modern Art, New York]
Seated Woman, 1918, gouache / Museum of Modern
Art [Museum of Modern Art, New York]

1951

January 2–February 3, 1951: Sidney Janis Gallery, New
York
"Climax in 20th Century Art: 1913"
Nature morte à la guitare, 1913, oil and collage,
25 x 21 in. (no. 4 in exh.; ill. in cat.)
[Z.II².419; Museum of Modern Art, New York]

January 8–27, 1951: Knoedler Galleries, New York
"Exhibition of Paintings from Three Private
Collections in honor of the Philadelphia Museum of
Art Diamond Jubilee Celebration"
Femme mantille blanche [*sic*], 1901–2 / Mr. and Mrs.
Albert D. Lasker (no. 14 in exh.)
Juan les Pins, 1937 / Mr. and Mrs. Albert D. Lasker
(no. 15 in exh.) [Z.VIII.374]
Compotier, 1937 / Mr. and Mrs. Albert D. Lasker
(no. 16 in exh.) [Z.VIII.325]

February 26–March 24 and March 26–April 21, 1951:
Perls Galleries, New York
"The Perls Galleries Collection of Modern French
Paintings"
Trois Allégories, 1901, pen, ink, and crayon, 5 1/8 x
3 1/2 in. each (no. 119 in exh.)
Nu, 1906, pastel, 25 x 18 3/4 in. (no. 120 in exh.)
Le Nu au faune, 1906, watercolor, 8 1/4 x 5 3/8 in.
(no. 121 in exh.)
La Liseuse, 1909, oil, 36 x 29 in. (no. 122 in exh.)
L'Huilier, 1911, oil, 9 1/2 x 7 1/2 in. (no. 123 in exh.)
"Ma Jolie," 1913, oil, 17 7/8 x 15 7/8 in.
(no. 124 in exh.; ill. in cat.)
L'Homme au piano, 1914, pen and ink, 8 1/4 x 4 in.
(no. 125 in exh.)
Composition, 1920, gouache, 8 1/2 x 12 1/2 in.
(no. 126 in exh.)
Baigneuse, 1920, pencil and sepia, 9 7/8 x 16 in.
(no. 127 in exh.)
Composition à la cheminée, 1921, gouache, 5 1/4 x
4 1/8 in. (no. 128 in exh.)
Le Nu Arlequin, 1921, watercolor, 6 1/4 x 4 1/4 in.
(no. 129 in exh.)
Le Journal, 1922, oil, 7 1/2 x 9 3/8 in.
(no. 130 in exh.)
Verre et fruit, 1923, oil, 8 5/8 x 10 5/8 in.
(no. 131 in exh.)

Scène mythologique, 1923, pen and ink, 6 x 4 3/4 in.
(no. 132 in exh.)
Composition, 1925, pencil, 5 5/8 x 4 3/8 in.
(no. 133 in exh.)
Le Modèle classique, 1925, oil, 7 7/8 x 3 5/8 in.
(no. 134 in exh.)
Trois Études abstraites, 1925, pencil, ca. 5 x 7 in. each
(no. 135 in exh.)
Tête de femme, 1926, oil, 18 x 15 in. (no. 136 in exh.)
La Colombe blanche, 1927, oil, 10 3/4 x 13 3/4 in.
(no. 137 in exh.)
Baigneuses à la plage de Dinard, 1928, oil, 6 3/8 x
8 3/4 in. (no. 138 in exh.; ill. in cat.) [Z.VII.220]
Baigneuse, 1932, wash drawing, 12 3/4 x 10 3/8 in.
(no. 139 in exh.)
Baigneuses à la plage, 1932, pen and ink, 9 3/4 x
13 1/2 in. (no. 140 in exh.)
Cannes: Baigneuses, 1933, watercolor, 15 3/4 x
19 1/2 in. (no. 141 in exh.)
Baigneuses, 1934, pen and ink, 9 7/8 x 13 5/8 in.
(no. 142 in exh.)
Trois Nus, 1938, pen and ink, 17 x 26 3/8 in.
(no. 143 in exh.)
Nature morte à la cruche, 1939, oil, 10 5/8 x 18 1/8 in.
(no. 144 in exh.)
Nature morte aux fruits, 1939, oil, 11 1/4 x 16 7/8 in.
(no. 145 in exh.)
Femme au chapeau mauve (Dora Maar), 1939, oil,
25 1/2 x 19 1/2 in. (no. 146 in exh.)
Femme nue assise, 1941, gouache, 16 x 11 7/8 in.
(no. 147 in exh.)
La Toilette, 1942, pen, ink, and wash, 16 1/4 x
11 1/4 in. (no. 148 in exh.)
Nature morte, 1944, oil, 8 3/4 x 10 3/4 in.
(no. 149 in exh.)
La Carafe aux fleurs, 1944, oil, 18 x 13 in.
(no. 150 in exh.)
Tête d'une jeune femme, 1944, oil, 13 3/4 x 10 5/8 in.
(no. 151 in exh.)
Tête de faune, 1946, pencil, 10 1/2 x 8 1/4 in.
(no. 152 in exh.)

June 15–July 13, 1951: Arts Club of Chicago
"Paintings by Paris Masters, 1941–1951"
Figure, October 9, 1941 / Louis Carré Gallery,
New York (no. 30 in exh.) [Z.XI.333]
Figure, November 3, 1941 / Louis Carré Gallery,
New York (no. 31 in exh.) [Z.XI.345]
Portrait, 1941 / Mr. and Mrs. Samuel A. Marx,
Chicago (no. 32 in exh.) [Z.XIII.235]
Figure, March 5, 1944 / Louis Carré Gallery,
New York (no. 33 in exh.)
Woman and Cat, 1944 / Mr. and Mrs. Leigh B. Block,
Chicago (no. 34 in exh.)
Still Life with Mirror, 1945 / Louis Carré Gallery,
New York (no. 35 in exh.)
Still Life with Skull, 1945 / Mr. and Mrs. Otto L.
Spaeth, New York (no. 36 in exh.)
La Table est servie, 1947 / Paul Rosenberg & Co.,
New York (no. 37 in exh.)

June 26–September 12, 1951: Museum of Modern Art,
New York
"Selections from Five New York Private Collections"
Self-Portrait, 1901, oil on cardboard mounted on
wood, 20 1/4 x 12 1/2 in. / Mr. and Mrs. John
Hay Whitney [Z.I.113]
Absinthe Drinker, 1901, oil, 21 1/4 x 16 1/2 in. /
Mr. and Mrs. John Hay Whitney
Portrait of a Boy, 1905, oil, 39 x 31 in. / Mr. and Mrs.
John Hay Whitney [Z.I.274; private collection]
Vase of Flowers, 1907, oil, 36 1/2 x 28 1/2 in. /
Mr. and Mrs. Ralph F. Colin, New York
[Z.II¹.30; Museum of Modern Art, New York]
The Rower, 1910, oil, 28 3/8 x 23 3/8 in. / Mr. and
Mrs. Ralph F. Colin, New York [Z.II¹.231;
Museum of Fine Arts, Houston]
Red Hat, 1934, oil, 57 5/8 x 45 1/8 in. / Mr. and Mrs.
Ralph F. Colin, New York [Z.VIII.241; Pulitzer
Foundation for the Arts, St. Louis, Missouri]
Tomato Plant in a Window, 1944, oil, 36 1/4 x 29 in. /
Mr. and Mrs. John Hay Whitney [Z.XIV.22]

October 8–November 3, 1951: Paul Rosenberg & Co.,
New York
"Picasso Watercolors and Drawings (from 1914 to 1945)"

Glass and Pipe, 1914, collage, 13 1/2 x 7 1/2 in.
(no. 1 in exh.)
Man with a Pipe, 1915, pencil, 10 3/4 x 8 1/2 in.
(no. 2 in exh.)
Portrait of a Man, 1918, pencil, 14 x 10 in.
(no. 3 in exh.)
The Harvesters, 1919, pen and ink, 12 x 19 1/2 in.
(no. 4 in exh.)
Reclining Nude with Turban, 1919, pencil, 8 3/4 x
12 1/4 in. (no. 5 in exh.)
Centaur and Satyr, 1920, watercolor, 8 1/2 x 11 in.
(no. 6 in exh.)
Composition with Musical Instruments, 1920, gouache,
10 1/2 x 8 in. (no. 7 in exh.)
Composition with Musical Instruments, 1920, gouache,
10 1/2 x 8 in. (no. 8 in exh.)
View of St. Malo, 1922, pencil, 11 x 16 in.
(no. 9 in exh.)
Classical Head, 1923, charcoal, 24 x 18 1/2 in.
(no. 10 in exh.)
Studies of a Nude, 1923, pen and ink, 9 1/2 x 11 1/2 in.
(no. 11 in exh.)
Acrobats Resting, 1925, pen and ink, 13 3/4 x 10 in.
(no. 12 in exh.)
Three Acrobats, 1925, pen and ink, 13 3/4 x 10 in.
(no. 13 in exh.)
Painter and Model, 1925, pen and ink, 11 1/4 x
14 3/4 in. (no. 14 in exh.)
Bust on the Beach, 1933, ink and watercolor,
15 1/2 x 20 in. (no. 15 in exh.)
The Balcony, 1933, ink and watercolor, 15 1/2 x
19 3/4 in. (no. 16 in exh.)
Beach Scene, 1933, ink and watercolor, 15 1/2 x 19 in.
(no. 17 in exh.)
The Rape, 1933, ink and watercolor, 13 x 17 1/4 in.
(no. 18 in exh.)
Minotaur, 1934, collage, 13 x 9 1/2 in. (no. 19 in exh.)
Circus Horse, 1937, ink and watercolor, 11 1/2 x
17 in. (no. 20 in exh.)
Cup of Coffee, 1943, ink and wash, 9 3/4 x 14 1/4 in.
(no. 21 in exh.)
Tomato Plant, 1944, blue crayon, 25 1/2 x 19 3/4 in.
(no. 22 in exh.)
Young Boy, 1944, ink and wash, 19 3/4 x 11 in.
(no. 23 in exh.)
Burning Logs, 1944, ink and crayon, 19 1/2 x 23 1/2 in.
(no. 24 in exh.) [Z.XIV.59; Museum of Modern
Art, New York]

November 2–December 2, 1951: Metropolitan Museum
of Art, New York
"The Lewisohn Collection"
The Dancer, 1902, [oil on canvas], 25 3/4 x 19 1/2 in.
(no. 60 in exh.)
Pierrot, 1918, [oil on canvas], 35 x 27 5/8 in. (no. 61
in exh.; ill. in cat.) [Z.III.137; Museum of
Modern Art, New York]

November 24–December 31, 1951: Institute of
Contemporary Arts, exhibition at the Corcoran
Gallery of Art, Washington, D.C.
[Selections from the Collection of the Société
Anonyme / This exhibition included at least one work
by Picasso, although no titles of specific works have
been identified.]

December 18, 1951–January 12, 1952: Curt Valentin
Gallery, New York
"Contemporary Paintings and Sculpture"
Woman in Blue, 1949, oil, 39 1/4 x 31 3/4 in. (no. 35
in exh.) [Z.XV.127; Fogg Art Museum, Harvard
University, Cambridge, Massachusetts]
Jeannette, 1941, gouache, 15 1/2 x 10 in. (no. 36
in exh.)

1952

January 15–February 28, 1952: Louis Carré Gallery,
New York
"Picasso: Paintings 1939–45"
Girl with Purple Hat, 1939 (no. 1 in exh.)
Woman with Daisies, 1941 (no. 2 in exh.)
Woman Seated in Armchair, 1941 (no. 3
in exh.)
Girl in Blue, 1942 (no. 4 in exh.)
The Artist's Studio, 1942 (no. 5 in exh.)

Portrait of Dora Maar, 1943 (no. 6 in exh.; ill.
in cat.) [Z.XI.349]
Woman with Pink Blouse, 1944 (no. 7 in exh.)
Two Women in Interior, 1944 (no. 8 in exh.)
Head of Young Girl, 1944 (no. 9 in exh.)
Still-Life with Radishes, 1944 (no. 10 in exh.)
Still-Life with Mirror, 1945 (no. 11 in exh.)
Still-Life with Candle, 1945 (no. 12 in exh.)

February 10–March 30, 1952: Corcoran Gallery of Art,
Washington, D.C.
"Privately Owned: A Selection of Works from
Collections in the Washington Area"
Dans la loge, drawing, mixed media / anonymous
loan (no. 278 in exh.)
Still Life, oil, [12 1/8 x 18 in.] / anonymous loan
(no. 279 in exh.)
Deux Danseuses, [April 12], 1925, pencil drawing,
[19 1/2 x 15 1/2 in.] / Mr. and Mrs. Serge
Sacknoff (no. 280 in exh.)
The Mirror, [June 23, 1947], oil / Mr. William A. M.
Burden (no. 281 in exh.; ill. in cat.) [Z.XV.74;
Museum of Modern Art, New York]

February 18–March 22, 1952: Sidney Janis Gallery,
New York
"Oils by French Masters 1901–50"
(no title), 1911 (no. 16 in exh.; ill. in cat.)

February 19–March 15, 1952: Curt Valentin Gallery,
New York
"Pablo Picasso: Paintings, Sculpture, Drawings"
Bather, 1908, oil, 51 x 38 1/2 in. (no. 1 in exh.;
ill. in cat.) [Z.II¹.11; Museum of Modern Art,
New York]
Reclining Nude, 1910, oil, 8 3/4 x 17 3/4 in.
(no. 2 in exh.)
Still Life, 1920, oil, 25 1/2 x 36 in. / Mr. and Mrs.
Alex L. Hillman, New York (no. 3 in exh.)
Mother and Child, 1922, oil, 38 1/4 x 28 in. / Mr. and
Mrs. Alex L. Hillman, New York (no. 4 in exh.;
ill. in cat.) [Z.IV.289; private collection]
Still Life with Red Rug, 1925, oil, 37 3/4 x 50 3/4 in. /
anonymous loan (no. 5 in exh.)
Profile, 1927, oil, 10 x 13 3/8 in. (no. 6 in exh.)
Still Life with Guitar, 1942, oil, 40 x 32 1/2 in.
(no. 7 in exh.; ill. in cat.)
Paris, 1945, oil, 32 x 48 in. (no. 8 in exh.; ill. in cat.)
/ Mr. and Mrs. Albert D. Lasker [Z.XIV.104]
The Red Lobster, 1948, oil, 32 1/2 x 40 in. (no. 9 in
exh.; ill. in cat.) [Z.XV.96]
Woman in Blue, 1949, oil, 39 1/4 x 31 3/4 in. (no. 10
in exh.; ill. in cat.) [Z.XV.127; Fogg Art Museum,
Harvard University, Cambridge, Massachusetts]
Profile Figure, 1902, ink, 6 1/2 x 3 5/8 in.
(no. 11 in exh.)
Leo Stein, 1905, ink, 6 1/4 x 4 1/2 in. (no. 12 in exh.)
Leo Stein, 1905, ink, 7 x 4 1/2 in. (no. 13 in exh.)
Leo Stein, 1905, ink, 12 3/4 x 9 1/2 in. (no. 14 in exh.)
La Présentation dans le grand monde, 1905, ink,
9 1/2 x 12 1/2 in. (no. 15 in exh.)
Sheet of Sketches, 1905, ink, 9 1/2 x 13 in.
(no. 16 in exh.)
La Toilette, 1906, charcoal, 24 x 15 3/4 in. / Mr. and
Mrs. Alex L. Hillman, New York (no. 17 in exh.)
[Z.XXII.431; Alex Hillman Family Foundation
Collection]
Head of a Woman, 1909, wash, 24 1/2 x 19 in.
(no. 18 in exh.)
Standing Woman, 1910, ink, 12 1/4 x 8 1/2 in.
(no. 19 in exh.)
Still Life with Fan, 1910, charcoal, 12 1/8 x 18 7/8 in.
(no. 20 in exh.)
Head with Pipe, 1911, wash, 25 x 18 1/4 in.
(no. 21 in exh.; ill. in cat.) [Z.II¹.280; Fogg
Art Museum, Harvard University, Cambridge,
Massachusetts]
Still Life, 1911, ink, 12 1/2 x 13 1/4 in. (no. 22 in exh.)
Man with Mandolin, 1912, pencil, 15 x 9 in.
(no. 23 in exh.; ill. in cat.) [Z.VI.1146]
Woman in Chemise, 1915, pencil, 12 1/2 x 9 1/4 in.
(no. 24 in exh.)
Musical Instruments, 1915, watercolor, 8 1/4 x
8 3/8 in. (no. 25 in exh.) [Z.II².546]
Fruitbowl and Guitar, 1920, pencil, 10 3/4 x 8 in.
(no. 26 in exh.)

Table by a Window, 1920, pencil, 10 3/4 x 8 1/4 in. (no. 27 in exh.)
Woman with Necklace, 1920, pencil, 12 5/8 x 8 5/8 in. (no. 28 in exh.)
Woman Lying by the Sea, 1920, pencil, 10 3/4 x 16 1/2 in. (no. 29 in exh.)
St. Servan, 1922, pencil, 16 1/2 x 11 1/2 in. (no. 30 in exh.)
Mandolin, 1925, pencil, 5 3/4 x 6 1/4 in. (no. 31 in exh.)
At the Seashore, 1933, ink, 15 3/4 x 19 3/4 in. (no. 32 in exh.)
Dora Maar, 1941, gouache, 15 1/2 x 10 1/4 in. (no. 33 in exh.)
La Toilette, 1944, pencil, 19 1/2 x 14 3/4 in. (no. 34 in exh.; ill. in cat.) [Z.XIII.291; Art Institute of Chicago]
Seated Nude, 1946, watercolor, 26 x 17 1/2 in. (no. 35 in exh.; ill. in cat.)
Mother and Child, 1951, ink, 10 1/2 x 8 1/4 in. (no. 36 in exh.)
Mother and Child, 1951, ink, 10 1/2 x 8 1/4 in. (no. 37 in exh.)
Mother and Child, 1951, ink, 10 1/2 x 8 1/4 in. (no. 38 in exh.)
Mother and Child, 1951, ink, 10 1/2 x 8 1/4 in. (no. 39 in exh.)
Mother and Child, 1951, ink, 10 1/2 x 8 1/4 in. (no. 40 in exh.)

March 2–May 4, 1952: National Gallery of Art, Smithsonian Institution, Washington, D.C.
"French Paintings from the Molyneux Collection"; traveled to Museum of Modern Art, New York, June 24–September 7, 1952
Self-Portrait [Z.XXI.336; National Gallery of Art, Washington, D.C.]

March 3–April 5 and April 7–May 10, 1952: Perls Galleries
"The Perls Galleries Collection of Modern French Paintings"
Trois Allégories, 1901, pen, ink, and crayon, 5 1/8 x 3 1/8 in. each (no. 118 in exh.)
Nu, 1906, pastel, 25 x 18 3/4 in. (no. 120 in exh.)
Le Nu au faune, 1906, watercolor, 8 1/4 x 5 3/8 in. (no. 121 in exh.)
Nu (Study for "Les Demoiselles d'Avignon"), 1907, watercolor, 12 1/4 x 9 1/4 in. (no. 122 in exh.)
Pipes, tasse, cafetière, carafon, 1910–11, oil, 19 7/8 x 50 1/4 in. (no. 123 in exh.; ill. in cat.)
Composition, 1920, gouache, 8 1/2 x 12 1/2 in. (no. 124 in exh.)
Baigneuse, 1920, pencil and sepia, 9 7/8 x 16 in. (no. 125 in exh.)
La Guitare sur la table, 1920, pastel, 10 3/4 x 8 1/2 in. (no. 126 in exh.)
Nu classique, 1921, pen and ink, 7 3/4 x 10 3/4 in. (no. 127 in exh.)
Composition à la cheminée, 1921, gouache, 5 1/4 x 4 1/8 in. (no. 128 in exh.)
Le Nu Arlequin, 1921, watercolor, 6 1/4 x 4 1/4 in. (no. 129 in exh.)
Le Journal, 1922, oil, 7 1/2 x 9 3/8 in. (no. 130 in exh.)
Verre et fruit, 1923, oil, 8 5/8 x 10 5/8 in. (no. 131 in exh.)
Le Modèle classique, 1925, oil, 7 7/8 x 3 5/8 in. (no. 132 in exh.)
L'Atelier à Juan les Pins, 1925, gouache, 12 3/4 x 17 1/8 in. (no. 133 in exh.)
Trois Études abstraites, 1925, pencil, ca. 5 x 7 in. each (no. 134 in exh.)
La Colombe blanche, 1927, oil, 10 3/4 x 13 3/4 in. (no. 135 in exh.)
Baigneuses à la plage de Dinard, 1928, oil, 6 3/8 x 8 3/4 in. (no. 136 in exh.) [Z.VII.220]
Céphale et Procris, 1930, pencil, 12 7/8 x 9 3/4 in. (no. 137 in exh.)
Têtes d'homme et de femme voilée, 1930, pencil, 9 3/4 x 12 7/8 in. (no. 138 in exh.)
Baigneuses à la plage, 1932, pen and ink, 9 3/4 x 13 1/2 in. (no. 139 in exh.)
Les Trois Baigneuses, 1932, oil, 10 5/8 x 16 1/8 in. (no. 140 in exh.)
Cannes: Baigneuses, 1933, watercolor, 15 3/4 x 19 1/2 in. (no. 141 in exh.)

Scène de cirque, 1933, oil, 12 7/8 x 16 in. (no. 142 in exh.)
Baigneuses, 1934, pen and ink, 9 7/8 x 13 5/8 in. (no. 143 in exh.)
Trois Nus, 1938, pen and ink, 17 x 26 3/8 in. (no. 144 in exh.)
Nature morte à la cruche, 1939, oil, 10 5/8 x 18 1/8 in. (no. 145 in exh.)
Tête de pêcheur, 1939, pen, ink, and wash, 25 x 18 in. (no. 146 in exh.)
Femme nue dans un fauteuil, 1939, oil, 18 1/4 x 13 in. (no. 147 in exh.)
Nature morte aux fruits, 1939, oil, 18 1/4 x 13 in. (no. 148 in exh.)
Femme nue assise, 1941, gouache, 16 x 11 7/8 in. (no. 149 in exh.)
Portrait de Dora Maar, 1941, oil, 24 x 18 1/8 in. (no. 150 in exh.; ill. in cat.)
Nature morte, 1944, oil, 8 3/4 x 10 3/4 in. (no. 151 in exh.)
La Carafe aux fleurs, 1944, oil, 18 x 13 in. (no. 152 in exh.)

May 10–June 7, 1952: Fine Arts Associates, New York
"Summer Exhibition of French Paintings" [According to the exhibition announcement card, this exhibition included watercolors and drawings, some of which were by Picasso—among other artists—although no other titles of specific works have been identified.]
Landscape, 1922, pastel

June 1–30, 1952: James Vigeveno Galleries, Los Angeles
"French Master Drawings"
Woman Seated (no. 37 in exh.)
Mother and Child (no. 38 in exh.; ill. in cat.)

July 1–September 14, 1952: Metropolitan Museum of Art, New York
"The Wertheim Collection of Paintings"; traveled to the National Gallery of Art, Washington, D.C., July 1–September 13, 1953 as "The Maurice Wertheim Collection"
Woman with a Chignon / Young Girl Wearing a Large Hat, 1901, oil on canvas, 28 5/8 x 19 1/4 in. [recto and verso of the same canvas, each assigned its own number in Zervos's catalogue raisonné: Z.I.96 and Z.I.76; Fogg Art Museum, Harvard University, Cambridge, Massachusetts]
Mother and Child, 1901, oil on canvas, 44 1/4 x 38 3/8 in. [Z.I.115; Fogg Art Museum, Harvard University, Cambridge, Massachusetts]
The Blind Man, 1903, watercolor on cream wove paper mounted on canvas, 23 3/8 x 14 1/8 in. [Z.I.172; Fogg Art Museum, Harvard University, Cambridge, Massachusetts]
Mother and Daughter, 1904, crayon on cream wove paper, 14 1/2 x 11 5/8 in. [Z.I.220; Fogg Art Museum, Harvard University, Cambridge, Massachusetts]

July 7–31, 1952: Dalzell Hatfield Galleries, Los Angeles
"Modern French Masters"
Toilet of Venus (no. 14 in exh.)

September 22–October 18, 1952: Curt Valentin Gallery, New York
"Picasso: 1920–1925"
Nude, 1920, pencil, 12 1/4 x 8 1/8 in. (no. 1 in exh.)
Woman by the Sea, 1920, pencil, 10 3/4 x 16 1/2 in. (no. 2 in exh.)
Woman with Necklace, 1920, pencil, 12 1/2 x 8 1/2 in. (no. 3 in exh.)
Table before a Window, 1920, pencil, 10 3/4 x 8 in. (no. 4 in exh.)
Fruitbowl and Guitar, 1920, pencil, 10 3/4 x 8 in. (no. 5 in exh.)
The Open Book, 1920, gouache, 10 3/4 x 8 1/2 in. (no. 6 in exh.; ill. in cat.) [Z.VI.1383]
Fruitbowl, 1920, gouache, 10 3/4 x 8 1/2 in. (no. 7 in exh.; ill. in cat.) [Z.VI.1413]
Guitar and Sheet of Music, 1920, gouache, 10 3/4 x 8 1/2 in. (no. 8 in exh.; ill. in cat.) [Z.VI.1388; Pulitzer Foundation for the Arts, St. Louis, Missouri]
Bottle and Fruitbowl, 1920, gouache, 10 3/4 x 8 1/2 in. (no. 9 in exh.)

Guitar and Fruitbowl, 1920, gouache, 10 3/4 x 8 1/2 in. (no. 10 in exh.)
Round Table, 1920, gouache, 10 1/2 x 8 1/4 in. (no. 11 in exh.; ill. in cat.) [Z.VI.1384]
Guitar and Fruitbowl, 1920, gouache, 10 3/4 x 8 1/2 in. (no. 12 in exh.)
Round Table, 1920, gouache, 10 1/2 x 8 1/2 in. (no. 13 in exh.)
Women and Child by the Sea, 1920, pencil, 10 1/2 x 16 1/4 in. (no. 16 in exh.)
Hand, 1921, watercolor, 4 1/4 x 6 1/4 in. (no. 17 in exh.; ill. in cat.)
Cigarettes and Glass, 1921, oil, 7 1/2 x 11 5/8 in. (no. 18 in exh.; ill. in cat.) [Z.VI.1424]
Mother and Child, 1921, oil, 8 1/2 x 10 1/2 in. (no. 19 in exh.)
Woman Seated by the Sea, 1922, oil, 23 3/4 x 19 3/4 in. (no. 20 in exh.; ill. in cat.) [Z.IV.383; Minneapolis Institute of Art]
Bottle and Guitar, 1922, gouache, 5 1/2 x 4 1/4 in. (no. 21 in exh.)
Table before a Window, 1922, gouache, 5 3/8 x 4 1/4 in. (no. 22 in exh.) [Z.IV.432; Solomon R. Guggenheim Museum, New York]
Round Table, 1922, gouache, 6 1/2 x 4 in. (no. 23 in exh.)
Fruitbowl and Guitar, 1922, gouache, 6 1/4 x 4 1/2 in. (no. 24 in exh.)
Round Table, 1922, gouache, 6 3/8 x 4 1/8 in. (no. 25 in exh.)
Table before a Window, 1922, gouache, 4 3/4 x 6 in. (no. 26 in exh.)
Fruitbowl, Violin and Glass, 1922, gouache, 3 1/2 x 5 1/2 in. (no. 27 in exh.; ill. in cat.) [Z.XXX.427]
Guitar and Fruitbowl, 1922, gouache, 5 1/8 x 4 in. (no. 28 in exh.; ill. in cat.) [Z.XXX.421]
Table before a Window, 1922, gouache, 4 3/4 x 6 1/4 in. (no. 29 in exh.)
Guitar and Fruitbowl, 1922, gouache, 5 1/2 x 4 1/8 in. (no. 30 in exh.)
Bottle and Guitar, 1922, gouache, 4 3/4 x 6 1/4 in. (no. 31 in exh.)
Guitar, 1922, gouache, 4 1/2 x 3 in. (no. 32 in exh.; ill. in cat.) [Z.XXX.424]
St. Servan, 1922, pencil, 16 1/2 x 11 1/2 in. (no. 33 in exh.)
The Goblet, 1922, oil, 7 1/4 x 9 1/4 in. (no. 34 in exh.)
Three Women, 1923, ink and pastel, 14 1/4 x 10 1/2 in. (no. 35 in exh.)
At the Seashore, 1923, ink, 40 1/4 x 13 3/4 in. (no. 36 in exh.)
The Beach, 1923, ink, 10 1/4 x 13 3/4 in. (no. 37 in exh.; ill. in cat.) [Z.VI.1437]
Reclining Women, 1923, ink, 10 1/4 x 13 3/4 in. (no. 38 in exh.; ill. in cat.) [Z.VI.1439]
Seated Woman, 1923, ink, 10 1/4 x 13 3/4 in. (no. 39 in exh.; ill. in cat.) [Z.VI.1440]
Standing Nude, 1923, ink, 11 1/4 x 8 3/4 in. (no. 40 in exh.; ill. in cat.) [Z.VI.1430]
The Pipes of Pan, 1923, ink, 9 3/4 x 12 1/2 in. (no. 41 in exh.) [Z.VI.1441]
Three Dancers, 1925, ink, 13 3/4 x 9 3/4 in. (no. 42 in exh.)
Three Dancers, 1925, ink, 13 3/4 x 9 3/4 in. (no. 43 in exh.; ill. in cat.) [Z.VI.1451]
Four Nudes, 1925, ink, 13 3/4 x 9 3/4 in. (no. 44 in exh.; ill. in cat.) [Z.VI.1445]
Two Dancers, 1925, ink, 13 3/4 x 9 3/4 in. (no. 45 in exh.; ill. in cat.) [Z.VI.1453]

December 9–31, 1952: Pierre Matisse Gallery, New York
"Still Life and the School of Paris"
Guitar and Fruits, 1923, oil on canvas, 51 1/2 x 38 in. / Paul Rosenberg & Co., New York (no. 16 in exh.; ill. in cat.) [Z.V.268]

December 16, 1952–January 10, 1953: Curt Valentin Gallery, New York
"Drawings by Contemporary Painters and Sculptors"
Still Life, 1910, charcoal, 12 1/8 x 18 7/8 in. (no. 68 in exh.; ill. in cat.)
Standing Woman, 1910, ink, 12 1/4 x 8 1/2 in. (no. 69 in exh.)
Woman in Chemise, 1915, pencil, 12 1/2 x 9 1/4 in. (no. 70 in exh.)

Two Nudes at a Window, 1934, charcoal, 10 3/4 x
10 in. (no. 71 in exh.)
Mother and Child, 1951, ink, 10 1/2 x 8 1/4 in.
(no. 72 in exh.)

1953

January 5–February 7, 1953: Perls Galleries, New York
"Picasso: 'The Thirties'"
Céphale et Procris, 1930, pencil, 12 7/8 x 9 3/4 in.
(no. 1 in exh.)
Le Rêve, 1932, oil on canvas, 51 x 38 1/4 in. /
Mr. and Mrs. Victor Ganz, New York
(no. 2 in exh.) [Z.VII.364; Wynn Collection,
Las Vegas]
Baigneuses à la plage, 1932, pen and ink, 9 3/4 x
13 1/2 in. (no. 3 in exh.)
Les Trois Baigneuses, 1932, oil on canvas, 10 5/8 x
16 1/8 in. (no. 4 in exh.)
Les Amants (Amour et Psyché), 1932, oil on
canvas, 38 1/4 x 51 in. (no. 5 in exh.; detail
ill. in cat.)
Cannes: Baigneuses, 1933, watercolor, 15 3/4 x
19 1/2 in. (no. 6 in exh.)
Scène de plage mythologique, 1933, gouache,
13 3/8 x 17 3/4 in. (no. 7 in exh.)
Scène de cirque, 1933, oil on canvas, 12 7/8 x
16 in. (no. 8 in exh.)
Cheval et taureau, 1934, oil on canvas, 38 1/4 x
51 in. / Mr. and Mrs. Victor Ganz, New York
(no. 9 in exh.)
Baigneuses, 1934, pen and ink, 9 7/8 x 13 5/8 in.
(no. 10 in exh.)
Femme couchée, 1934, oil on canvas, 15 x 18 in.
(no. 11 in exh.)
Étude pour "Guernica": Femme pleurant, 1937, oil on
canvas, 21 1/2 x 18 in. (no. 12 in exh.) [This piece
is most likely a "postscript" to the painting,
since Picasso appears not to have made any "weeping
woman" studies in oil on canvas. Chipp states
that there were "as many as thirty later sketches
of the weeping woman made after *Guernica* was
finished."]
Trois Nus, 1938, pen and ink, 17 x 26 3/8 in.
(no. 13 in exh.)
L'Homme à la sucette, 1938, oil on canvas, 26 1/2 x
17 1/2 in. / Edward Bragaline, New York
(no. 14 in exh.) [Z.IX.203; Metropolitan Museum
of Art, New York]
Nature morte à la cruche, 1939, oil on canvas,
10 5/8 x 18 1/8 in. (no. 15 in exh.)
Nature morte aux fruits, 1939, oil on canvas,
11 1/4 x 16 7/8 in. (no. 16 in exh.)
La Femme au divan, 1939, oil on canvas, 38 1/4 x
51 in. / Mr. and Mrs. Victor Ganz, New York
(no. 17 in exh.)
Tête de pêcheur, 1939, pen and ink and wash,
25 x 18 in. (no. 18 in exh.)
Femme nue dans un fauteuil, 1939, oil on canvas,
18 1/4 x 13 in. (no. 19 in exh.)

January 5–31, 1953: Paul Rosenberg & Co., New York
"Twentieth Century French Paintings"
The Bird Cage, 1923, 79 x 55 in. (no. 11 in exh.)
[Z.V.84]
Seated Girl in Yellow Blouse, 1939, 32 x 25 1/2 in.
(no. 12 in exh.)
Lamp and Cherries, 1945, 28 1/2 x 39 in.
(no. 13 in exh.)

January 19–February 14, 1953: Sidney Janis Gallery,
New York
"French Masters 1905–1952"
(no title), 1909, 36 x 25 in. (no. 14 in exh.; ill.
in cat.) [Z.II¹.176; private collection]

January 20–February 7, 1953: Schaeffer Galleries,
New York
"Contemporary Spanish Paintings"
Two Harlequins, 1903 [actual date: 1905], pastel
[actual medium: gouache], 28 x 21 in. / Mr. and
Mrs. Stephen C. Clark, New York (no. 31 in exh.)
[Z.I.295]
Nude in Gray, oil, 40 1/2 x 29 1/4 in. / Mr. Walter P.
Chrysler, Jr., New York (no. 32 in exh.) [Z.I.257;
Musée National d'Art Moderne, Centre National

d'Art et de Culture Georges Pompidou, Paris]
Portrait of Georges Braque, 1909, oil, 24 1/4 x 20 in. /
Edward A. Bragaline, New York (no. 33 in exh.)
[Z.II¹.177]
Still Life, 1916, oil, 26 x 24 in. / Mr. Alexandre
Iolas (no. 34 in exh.)
Still Life with Fishes, 1923, oil, 51 x 38 1/4 in. / Mrs.
Albert D. Lasker (no. 35 in exh.) [Z.IV.448]
Mother and Child, 1922, oil, 38 x 27 1/2 in. /
Mr. and Mrs. A. L. Hillman, New York (no.
36 in exh.) [Z.IV.289; private collection]
Three Graces, 1923, oil, 40 x 30 1/2 in. / Mr.
Morris Gutmann (no. 37 in exh.; ill. in cat.)
Woman in Green Costume, 1943, oil, 51 1/2 x
38 1/2 in. / anonymous loan (no. 38 in exh.;
ill. in cat.) [private collection, New York]
Two Heads, 1943, oil on paper, 12 3/4 x 10 in. /
Mr. Sidney Janis, New York (no. 39 in exh.)
Mother and Child, 1922, pencil, 16 1/2 x 11 in. /
Nelson A. Rockefeller, New York (no. 41 in exh.)
[private collection]
Dancers, 1925, wash drawing, 24 x 18 in. /
Nelson A. Rockefeller, New York (no. 42 in
exh.)
Circus Rider, 1905, pen and ink drawing, 11 1/2 x
15 1/2 in. (no. 43 in exh.)

March 4–April 12, 1953: Museum of Modern Art, New
York
"Forty Paintings from the Edward G. Robinson
Collection"; traveled to the National Gallery of Art,
Washington, D.C., May 10–June 24, 1953
The Entombment, 1901?, oil on canvas, 39 3/8 x
35 1/2 in. (no. 20 in exh.) [Z.I.52]

March 9–April 11 and April 13–May 16, 1953: Perls
Galleries, New York
"The Perls Galleries Collection of Modern French
Paintings"
Trois Allégories, 1901, ink, crayon, 5 1/8 x 3 1/8
in. each (no. 129 in exh.)
Le Nu au faune, 1906, watercolor, 8 1/4 x 5 3/8
in. (no. 131 in exh.)
Nu (Study for "Les Demoiselles d'Avignon"), 1907,
watercolor, 12 1/4 x 9 1/4 in. (no. 132 in exh.)
Pipes, tasse, cafetière, carafon, 1911, oil on canvas,
19 7/8 x 50 1/4 in. (no. 133 in exh.)
Femme nue dans un fauteuil, 1914, watercolor,
10 5/8 x 7 1/4 in. (no. 134 in exh.)
Composition, 1920, gouache, 8 1/2 x 12 1/2 in.
(no. 135 in exh.)
Corbeille avec fruits, 1920, gouache, 8 1/4 x 11 7/8 in.
(no. 136 in exh.)
Baigneuse, 1920, pencil and sepia, 9 7/8 x 16 in.
(no. 137 in exh.)
Nu classique, 1921, pen and ink, 7 3/4 x 10 3/4 in.
(no. 138 in exh.)
Composition à la cheminée, 1921, gouache, 5 1/4 x
4 1/8 in. (no. 139 in exh.)
Le Journal, 1922, oil, 7 1/2 x 9 3/8 in. (no. 140 in
exh.; ill. in cat.)
Verre et fruit, 1923, oil, 8 5/8 x 10 5/8 in. (no. 141
in exh.)
Le Modèle classique, 1925, oil, 7 7/8 x 3 5/8 in.
(no. 142 in exh.)
L'Atelier à Juan-les-Pins, 1925, gouache, 12 3/4 x
17 1/8 in. (no. 143 in exh.)
Nature morte, 1925, crayon, 10 x 13 1/2 in.
(no. 144 in exh.)
Trois Études abstraites, 1925, pencil, ca. 5 x 7 in.
each (no. 145 in exh.)
La Colombe blanche, 1927, oil, 10 3/4 x 13 3/4 in.
(no. 146 in exh.)
Baigneuses à la plage de Dinard, 1928, oil, 6 3/8 x
8 3/4 in. (no. 147 in exh.) [Z.VII.220]
Têtes d'homme et de femme voilée, 1930, pencil,
9 3/4 x 12 7/8 in. (no. 148 in exh.)
Baigneuses à la plage, 1932, pen and ink, 9 3/4 x
13 1/2 in. (no. 149 in exh.)
Les Trois Baigneuses, 1932, oil, 10 5/8 x 16 1/8 in.
(no. 150 in exh.)
Les Amants (Amour et Psyché), 1932, oil, 38 1/4 x
51 in. (no. 151 in exh.)
Cannes: Baigneuses, 1933, watercolor, 15 3/4 x
19 1/2 in. (no. 152 in exh.)
Scène de cirque, 1933, oil, 12 7/8 x 16 in.

(no. 153 in exh.)
Baigneuses, 1934, pen and ink, 9 7/8 x 13 5/8 in.
(no. 154 in exh.)
Trois nus, 1938, pen and ink, 17 x 26 3/8 in.
(no. 155 in exh.)
Portrait de Dora Maar, 1938, charcoal, 30 x 22 1/4 in.
(no. 156 in exh.)
Nature morte à la cruche, 1939, oil, 10 5/8 x 18 1/8 in.
(no. 157 in exh.)
Tête de pêcheur, 1939, pen, ink, and wash, 25 x 18 in.
(no. 158 in exh.)
Femme nue dans un fauteuil, 1939, oil, 18 1/4 x 13 in.
(no. 159 in exh.)
Nature morte aux fruits, 1939, oil, 18 1/4 x 13 in.
(no. 160 in exh.)
Femme nue assise, 1941, gouache, 16 x 11 7/8 in.
(no. 161 in exh.)
Portrait de Dora Maar, 1941, oil, 24 x 18 1/8 in.
(no. 162 in exh.)
Nature morte, 1944, oil, 8 3/4 x 10 3/4 in.
(no. 163 in exh.)
La Carafe aux fleurs, 1944, oil, 18 x 13 in.
(no. 164 in exh.)

March 17–April 18, 1953: Paul Rosenberg & Co., New
York
"'Collectors' Choice': Masterpieces of French Art from
New York Private Collections"
Bowl of Fruit by Window, 1937, oil on canvas,
21 1/2 x 29 in. / Mrs. Albert D. Lasker
(no. 16 in exh.; ill. in cat.) [Z.VIII.325]
Boy with Pipe, 1905, oil on canvas, 39 x 31 in. /
Mr. and Mrs. John H. Whitney (no. 28 in exh.;
ill. in cat.) [Z.I.274]

March 29–April 30, 1953: James Vigeveno Galleries,
Los Angeles
"Early Chinese Pottery, French Master Drawings"
[This exhibition included at least one work by
Picasso, although no titles of specific works have been
identified.]

March 30–April 11, 1953: M. Knoedler & Co., New York
"Paintings and Drawings from the Smith College
Collection"
La Table, ca. 1920, oil on canvas, 50 x 29 1/2 in.
(no. 25 in exh.) [Z.III.437; Smith College
Museum of Art, Northampton, Massachusetts]

June 14–August 31, 1953: James Vigeveno Galleries,
Los Angeles
"Modern French Paintings: From Pissarro to Picasso"
[As indicated by the title, this exhibition included at
least one work by Picasso, although no titles of
specific works have been identified.]

June 16–October 21, 1953: Phillips Gallery, Washington,
D.C.
"Modern European and American Paintings from the
Collection including Cross Section of Contemporary
Trends"
Blue Room [Z.I.103; Phillips Collection, Washington,
D.C.]

October–November 1953: Residence of Mrs. H. Harris
Jonas, New York
"Collection of Mrs. H. Harris Jonas" [This exhibition
included at least one work by Picasso, although no
titles of specific works have been identified.]

November 24–December 19, 1953: Curt Valentin
Gallery, New York
"Pablo Picasso, 1950–53"
Winter Landscape, 1950, oil, 39 x 52 in. / Victor
Ganz, New York (no. 1 in exh.; ill. in cat.)
Girl Reading and Children Playing, 1951, oil,
29 1/2 x 36 3/4 in. / anonymous loan
(no. 2 in exh.; ill. in cat.)
Head of a Woman, 1952, oil, 26 x 21 3/4 in.
(no. 3 in exh.)
Head of a Woman, 1952, oil, 18 1/2 x 13 1/8 in.
(no. 4 in exh.; ill. in cat.) [Z.XV.207]
Head of a Woman, 1952, oil, 25 1/2 x 21 1/8 in.
(no. 5 in exh.; ill. in cat.) [Z.XV.213]
Head of a Woman, 1952, oil, 22 x 18 1/2 in.
(no. 6 in exh.)

Villa and Palm Tree, 1952, oil, 35 1/2 x 46 1/2 in.
(no. 7 in exh.; ill. in cat.) [Z.XV.187; Art
Institute of Chicago]
Kneeling Woman [current title: *Seated Woman*],
1953, oil, 52 x 39 in. (no. 8 in exh.; ill. in
cat.) [Z.XV.292]
Woman with Scarf, 1953, oil, 37 x 29 1/4 in. /
anonymous loan (no. 9 in exh.; ill. in cat.)
[Z.XV.240]
Woman in an Armchair, 1953, oil, 40 x 32 1/2 in.
(no. 10 in exh.; ill. in cat.) [Z.XV.239]
"Les Rougets," 1953, oil, 32 1/2 x 40 in.
(no. 11 in exh.; ill. in cat.) [Z.XV.291]
Still Life with Bowl of Cherries, 1953, oil, 32 1/2
x 40 in. (no. 12 in exh.; ill. in cat.) [Z.XV.290]
Coffee Pot and Bowl with Cherries, 1953, oil,
32 1/2 x 40 in. (no. 13 in exh.; ill. in cat.)
[Z.XV.261]
Head of a Girl, 1953, oil, 11 x 9 in. (no. 14 in exh.)
Head of a Woman, 1953, oil, 14 x 10 3/4 in.
(no. 15 in exh.; ill. in cat.) [Z.XV.257]
Head of a Woman, 1953, oil, 13 1/2 x 9 1/2 in.
(no. 16 in exh.)
Bust of a Woman, 1953, oil, 26 x 21 1/2 in.
(no. 17 in exh.; ill. in cat.)
Vallauris, 1953, oil, 8 3/4 x 13 1/4 in.
(no. 18 in exh.; ill. in cat.) [Z.XV.275]
Landscape with Pine Tree, 1953, oil, 22 x 15 1/2 in.
(no. 19 in exh.; ill. in cat.) [Z.XV.280]
The Hill, 1953, oil, 20 x 24 1/4 in. (no. 20 in exh.;
ill. in cat.) [Z.XV.281]
Gardens at Vallauris, 1953, oil, 10 3/4 x 16 1/2 in.
(no. 21 in exh.; ill. in cat.) [Z.XV.277]
"Le Grand Ciel," 1953, oil, 11 x 14 in. (no. 22 in exh.)
Houses in Vallauris, 1953, oil, 20 x 24 1/2 in.
(no. 23 in exh.) [Z.XV.284]
Pinetree and Palmtree, 1953, oil, 7 1/2 x 11 in.
(no. 24 in exh.) [Z.XV.272; Solomon R.
Guggenheim Museum, New York]
Gardens, 1953, oil, 7 1/2 x 11 in. (no. 25 in exh.)
Man Smoking Cigarette, [June 6], 1953, oil, 40 x
32 1/2 in. (no. 26 in exh.; ill. in cat.) [Z.XV.265]
Teapot and Lemon, 1953, oil, 10 3/4 x 14 in.
(no. 27 in exh.; ill. in cat.) [Z.XV.288]
Teapot and Cup, 1953, oil, 9 3/4 x 13 1/4 in.
(no. 28 in exh.; ill. in cat.) [Z.XV.287]

1954

January 4–February 6, 1954: Perls Galleries, New York
"Picasso–Braque–Gris: Cubism to 1918"
Nu (Study for "Les Demoiselles d'Avignon"), 1907, oil
wash, 12 1/4 x 9 1/4 in. (no. 1 in exh.; ill. in cat.)
Nature morte au bouquet de fleurs, 1908, oil, 15 1/8
x 18 1/4 in. / anonymous loan (no. 2 in exh.; ill.
in cat.) [Z.II¹.94]
Femme assise dans un fauteuil, 1909, oil on canvas,
32 x 25 5/8 in. / Jacques Sarlie (no. 3 in exh.; ill.
in cat.)
Portrait de Georges Braque, 1909, oil on canvas,
24 1/4 x 19 3/4 in. / Edward A. Bragaline,
New York (no. 4 in exh.) [Z.II¹.177; Staatliche
Museen zu Berlin, Nationalgalerie, on permanent
loan from the Berggruen Collection]
Pipes, tasse, cafetière, carafon, 1911, oil on canvas,
19 7/8 x 50 1/4 in. (no. 5 in exh.; ill. in cat.)
Verre, bouteille de Bass, journal, 1914, oil on canvas,
7 1/4 x 9 1/4 in. / Curt Valentin (no. 6 in exh.)
Femme nue dans un fauteuil, 1914, gouache, 10 5/8 x
7 1/4 in. (no. 7 in exh.)
Pipe, verre, bouteille de rhum, 1914, collage, 17 x
21 1/2 in. / Mr. and Mrs. John L. Senior, Jr.,
New York (no. 8 in exh.)
Bouteille d'anis del Mono, compotier, pipe, 1915, oil,
23 x 16 1/2 in. / Mr. and Mrs. John L. Senior, Jr.,
New York (no. 9 in exh.) [Z.II².553; private
collection]

February 3–21, 1954: M. Knoedler & Co., New York
["Selected Works from the Allen Memorial Art
Museum Collection, Oberlin College"]
Glass of Absinthe, 1911, oil on canvas, 15 1/8 x
18 1/4 in. (no. 68 in exh.; ill. in *OC Bulletin*)
[Z.II¹.261; Allen Memorial Art Museum, Oberlin
College, Ohio]

March 8–April 10 and April 12–May 15, 1954: Perls
Galleries, New York
"Modern French Paintings"
Trois Allégories, 1901, ink, crayon, 5 1/8 x 3 1/8 in.
each (no. 170 in exh.)
Le Nu au faune, 1906, watercolor, 8 1/4 x 5 3/8 in.
(no. 171 in exh.)
Pipes, tasse, cafetière, carafon, 1910–11, oil, 19 7/8 x
50 1/4 in. (no. 172 in exh.)
Femme nue dans un fauteuil, 1914, gouache,
10 5/8 x 7 1/4 in. (no. 173 in exh.)
Composition, 1920, gouache, 8 1/2 x 12 1/2 in.
(no. 174 in exh.)
Corbeille avec fruits, 1920, gouache, 8 1/4 x 11 7/8 in.
(no. 175 in exh.)
Baigneuse, 1920, pencil and sepia, 9 7/8 x 16 in.
(no. 176 in exh.)
Nu classique, 1920, ink, 7 3/4 x 10 3/4 in.
(no. 177 in exh.)
Composition à la cheminée, 1921, gouache, 5 1/4 x
4 1/8 in. (no. 178 in exh.)
Verre et fruit, 1923, oil on canvas, 8 5/8 x 10 5/8 in.
(no. 179 in exh.)
Le Modèle classique, 1925, oil on canvas, 7 7/8 x
3 7/8 in. (no. 180 in exh.)
L'Atelier à Juan les Pins, 1925, gouache, 12 3/4 x
17 1/8 in. (no. 181 in exh.)
Trois Études abstraites, 1925, pencil, ca. 5 x 7 in. each
(no. 182 in exh.)
La Colombe blanche, 1927, oil on canvas, 10 3/4
x 13 3/4 in. (no. 183 in exh.)
Baigneuses à la plage de Dinard, 1928, oil on canvas,
6 3/8 x 8 3/4 in. (no. 184 in exh.) [Z.VII.220]
Baigneuses à la plage, 1932, ink, 9 3/4 x 13 1/2 in.
(no. 185 in exh.)
Les Trois Baigneuses, 1932, oil on canvas, 10 5/8 x
16 1/8 in. (no. 186 in exh.)
Cannes: Baigneuses, 1933, watercolor, 15 3/4 x
19 1/4 in. (no. 187 in exh.)
Baigneuses à la plage de Cannes, 1933, watercolor,
15 7/8 x 19 7/8 in. (no. 188 in exh.)
Scène de cirque, 1933, oil on canvas, 12 7/8 x 16 in.
(no. 189 in exh.)
Baigneuses, 1934, ink, 9 7/8 x 13 5/8 in. (no. 190 in exh.)
Trois Nus, 1938, ink, 17 x 26 3/8 in. (no. 191 in exh.)
Portrait de Dora Maar, 1938, charcoal, 30 x 22 1/4 in.
(no. 192 in exh.)
Tête de pêcheur, 1939, ink and wash, 25 x 18 in.
(no. 193 in exh.)
Femme nue assise, 1941, gouache, 16 x 11 7/8 in.
(no. 194 in exh.)
Portrait de Dora Maar, 1941, oil on canvas, 24 x
18 1/8 in. (no. 195 in exh.)
Nature morte, 1944, oil on canvas, 8 3/4 x 10 3/4 in.
(no. 196 in exh.)
Le Faune au soleil, 1946, oil on canvas, 25 5/8 x
19 5/8 in. (no. 197 in exh.) [Z.XIV.240]

March 21–April 30, 1954: James Vigeveno Galleries,
Los Angeles
"XIX and XX Century Master Drawings"
Nude (no. 26 in exh.)
Seated Figure (no. 27 in exh.)

March 28–April 17, 1954: Renaissance Society of the
University of Chicago
"Contemporary Paintings, Prints and Drawings in
Memory of Elinor Castle Nef"
Seated Woman, 1924, gouache (no. 36 in exh.)
Collage, collage and etching (no. 37 in exh.)

April 1–May 18, 1954: Pierre Matisse Gallery, New York
"Aspects of Significant Form in Painting and
Sculpture" [This exhibition included at least one work
by Picasso, although no titles of specific works have
been identified.]

September 27–October 16, 1954: Paul Rosenberg &
Co., New York
"Exhibition of 20th Century French Paintings"
Beach of Dinard, 1928, 16 x 8 1/2 in. (no. 12 in exh.)
Bull Fight, 1934, 11 x 16 in. (no. 13 in exh.)
Girl from Nice, 1937, 32 x 26 in. (no. 14 in exh.)
Still Life with Blue Drawing, 1937, 20 x 26 in.
(no. 15 in exh.)
Glass and Fruit, 1937, 15 x 24 in. (no. 16 in exh.)

October 1954: Philadelphia Museum of Art
"The Louise and Walter Arensberg Collection"
Old Woman (also called *Head of Old Woman* or
Woman with Gloves), 1901, oil on cardboard,
26 3/8 x 20 1/2 in. (no. 161 in exh.; ill. in cat.)
[Z.VI.389; Philadelphia Museum of Art]
Sea Shore, ca. 1905?, pencil on paper, 4 1/8 x 6 1/2 in.
(no. 162 in exh.; ill. in cat.) [Philadelphia
Museum of Art]
Female Figure, ca. 1905–6, ink on paper, 6 1/2 x
4 1/8 in. (no. 163 in exh.; ill. in cat.)
[Philadelphia Museum of Art]
verso of 163: *Female Figure and Hand*, ca. 1905–6,
pencil on paper, 6 1/2 x 4 1/8 in. (no. 164 in exh.)
Head, 1906, ink on paper, 12 1/8 x 8 3/4 in. (no. 165
in exh.; ill. in cat.) [Philadelphia Museum of Art]
Woman Seated and Woman Standing, 1906, charcoal
on paper, 24 1/8 x 18 1/4 in. (no. 166 in exh.; ill.
in cat.) [Z.I.368; Philadelphia Museum of Art]
Landscape (also called *Trees* or *Two Trees*), winter
1907–8, gouache on paper, 19 x 25 in. (no. 167 in
exh.; ill. in cat.) [Z.II¹.54; Philadelphia Museum
of Art]
Men (also called *Three Personages*), summer 1908,
gouache on paper, 25 x 19 1/4 in. (no. 168 in
exh.; ill. in cat.) [Z.II¹.77; Philadelphia Museum
of Art]
Seated Nude Woman, 1908, oil, 45 3/4 x 35 in.
(no. 169 in exh.; ill. in cat.) [Z.II¹.114;
Philadelphia Museum of Art]
Female Nude, 1910–11, oil on canvas, 38 3/4 x 30 3/8 in.
(no. 170 in exh.; ill. in cat.) [Z.II¹.225;
Philadelphia Museum of Art]
Man with Violin, 1911, oil on canvas, 39 1/2 x
28 7/8 in. (no. 171 in exh.; ill. in cat.)
[Z.II¹.289; Philadelphia Museum of Art]
Man with Guitar, 1912, oil on canvas, 51 7/8 x 35 in.
(no. 172 in exh.; ill. in cat.) [Z.II¹.354;
Philadelphia Museum of Art]
Violin, ca. 1912, charcoal on paper, 18 1/2 x 12 3/8 in.
(no. 173 in exh.; ill. in cat.) [Philadelphia
Museum of Art]
Violin and Guitar, 1913, pasted cloth, oil, pencil, and
plaster on canvas, 36 x 25 in., oval (no. 174 in
exh.; ill. in cat.) [Z.II².363; Philadelphia Museum
of Art]
Three Nudes on Shore, 1920 [current date: June 23,
1921], pencil on tan paper, 9 3/4 x 16 1/8 in.
(no. 175 in exh.; ill. in cat.) [Philadelphia
Museum of Art]
Still Life (also called *The Table*), April 10, 1921,
pastel on cardboard, 41 3/8 x 29 1/2 in. (no. 176
in exh.; ill. in cat.) [Z.IV.260; Philadelphia
Museum of Art]

October 1–30, 1954: Arts Club of Chicago
"Twentieth Century Art Loaned by Members of the
Arts Club of Chicago"
Interior, Seated Woman and Standing Nude, 1944, oil /
Mr. Morton G. Neumann, Chicago (no. 31 in exh.)
[Z.XIII.252]
Plaster Arm, 1925, oil / Mr. and Mrs. Samuel A.
Marx, Chicago (no. 32 in exh.) [Z.V.444]
Still Life, watercolor / Mr. Harry J. Lackritz
(no. 33 in exh.)
Woman in White / Mrs. Chauncey McCormick
(no. 34 in exh.) [Z.I.105]

October 4–November 13, 1954: Perls Galleries, New York
"The William March Collection"
Femme assise, 1941, 36 x 28 5/8 in. (no. 10 in exh.; ill.
in cat.) [Z.XI.342]

October 4–November 20, 1954: Saidenberg Gallery,
New York
"Picasso: Loan Exhibition of Paintings" [This exhibi-
tion also included numerous drawings.]
Tête de femme, 1900, drawing [medium not
specified] / Mr. and Mrs. Arnold H. Maremont,
Chicago (no. 1 in exh.)
La Belle qui passe, 1904, drawing [medium not
specified] / Mr. and Mrs. Arnold H. Maremont,
Chicago (no. 2 in exh.)
La Fillette sur la boule, 1904, drawing [medium not
specified] / Mr. and Mrs. Arnold H. Maremont,
Chicago (no. 3 in exh.) [Z.VI.603]

Nu / Tête d'homme, 1905, drawings [medium not specified] / Mr. and Mrs. Arnold H. Maremont, Chicago (nos. 4A and 4B respectively in exh.)

Femme assise, 1906, drawing [medium not specified] / Mr. and Mrs. Arnold H. Maremont, Chicago (no. 5 in exh.)

Le Porcher, 1906, drawing [medium not specified] / Mr. and Mrs. Arnold H. Maremont, Chicago (no. 6 in exh.)

Femme au torso nu, 1906, drawing [medium not specified] / Mr. and Mrs. Arnold H. Maremont, Chicago (no. 7 in exh.)

Buste d'homme, 1907, drawing [medium not specified] / Mr. Richard Sisson (no. 8 in exh.)

Femme nue assise, 1908, oil / Mr. Richard Sisson (no. 9 in exh.; ill. in cat.) [Z.II¹.118]

Femme nue, 1910, watercolor, [28 3/4 x 23 1/2 in.] / Mr. Richard Sisson (no. 10 in exh.) [private collection, Houston]

Pianiste, 1916, drawing / Mr. Richard Sisson (no. 11 in exh.)

Partition, bouteille de porto, guitare, cartes à jouer, 1917, oil / Mr. Julian and Mr. Jean Aberbach (no. 12 in exh.) [Z.III.102]

Journal, verre, pacquet de tabac, 1919, oil / Mr. Julian and Mr. Jean Aberbach (no. 13 in exh.)

Nature morte devant une fenêtre, 1919, watercolor / Mr. Julian and Mr. Jean Aberbach (no. 14 in exh.)

Corbeille avec fruits, 1920, gouache / Mr. Julian and Mr. Jean Aberbach (no. 15 in exh.)

Guitare sur une table, 1920, gouache / Mr. Julian and Mr. Jean Aberbach (no. 16 in exh.; ill. in cat.) [Z.VI.1389]

Guitare et guéridon, 1920, gouache / Mr. Julian and Mr. Jean Aberbach (no. 17 in exh.)

Deux Femmes nues, 1920, gouache / Mr. Julian and Mr. Jean Aberbach (no. 18 in exh.)

Guitare et partition, 1920, gouache / Mr. Robert Saidenberg (no. 19 in exh.)

Femme assise, 1920, drawing [medium not specified] / Mr. Robert Saidenberg (no. 20 in exh.)

Trois Femmes à la fontaine, 1921, oil / Mr. Robert Saidenberg (no. 21 in exh.; ill. in cat.) [Z.VI.1421]

Trois Femmes, 1923, drawing [medium not specified] / Mr. Robert Saidenberg (no. 22 in exh.)

Mercure, étude, 1924, oil / Mr. Robert Saidenberg (no. 23 in exh.)

Antibes, 1924, oil / Mr. Robert Saidenberg (no. 24 in exh.; ill. in cat.)

Femme nue endormie, 1932, oil / Mr. Robert Saidenberg (no. 25 in exh.)

Deux Figures, 1932, drawing [medium not specified] (no. 26 in exh.)

La Sérénade, 1932, ink drawing (no. 27 in exh.)

Minotaur et femme, 1933, ink drawing (no. 28 in exh.)

L'Enlèvement, 1934, ink drawing (no. 29 in exh.)

Cruche et verre, 1937, oil (no. 30 in exh.)

Femme assise, 1938, ink drawing (no. 31 in exh.)

Femme au tub, 1939, gouache (no. 32 in exh.)

La Femme au divan, 1941, drawing [medium not specified] (no. 33 in exh.)

Deux Figures, 1942, gouache (no. 34 in exh.)

La Fenêtre, 1943, oil (no. 35 in exh.)

Faune musicien, 1947, gouache (no. 36 in exh.)

Minotaur, 1948, gouache (no. 37 in exh.)

Mère et enfant, 1951, ink drawing (no. 38 in exh.)

Le Roi du carnaval, 1952, watercolor (no. 39 in exh.)

October 19, 1954–February 6, 1955: Museum of Modern Art, New York
"Paintings from the Museum Collection: Twenty-Fifth Anniversary Exhibition"

Man's Head—Study for "Les Demoiselles d'Avignon" [current title: *Head of a Man (Study for "Les Demoiselles d'Avignon")*], 1907, watercolor, 23 3/4 x 18 1/2 in. / A. Conger Goodyear Fund [Z.VI.977; Museum of Modern Art, New York]

Les Demoiselles d'Avignon, 1907, oil on canvas, 96 x 92 in. [Z.II¹.18; Museum of Modern Art, New York]

Fruit Dish, 1908–9, oil on canvas, 29 1/4 x 24 in. [Z.II¹.121; Museum of Modern Art, New York]

Still Life with Tube of Paint [current title: *Still Life with Liqueur Bottle*], 1909, oil on canvas, 32 1/8 x

25 1/2 in. [Z.II¹.173; Museum of Modern Art, New York]

Woman in a Chair, 1909, oil on canvas, 28 3/4 x 23 5/8 in. / Gift of Mr. and Mrs. Alex L. Hillman, New York [Z.II¹.215; Museum of Modern Art, New York]

"Ma Jolie" (Woman with a Guitar), 1911–12, oil on canvas, 39 3/8 x 25 3/4 in. [Z.II¹.244; Museum of Modern Art, New York]

Man with a Hat (collage), December 1912, pasted paper, charcoal and ink, 24 1/2 x 18 5/8 in. [Z.II².398; Museum of Modern Art, New York]

Card Player, 1913–14, oil on canvas, 42 1/2 x 35 1/4 in. [Z.II².466; Museum of Modern Art, New York]

Green Still Life [also known as: *Fruit Bowl, Wineglass, Bowl of Fruit*], 1914, oil on canvas, 23 1/2 x 31 1/4 in. [Z.II².485; Museum of Modern Art, New York]

Harlequin, 1915, oil on canvas, 72 1/4 x 41 3/8 in. [Z.II².555; Museum of Modern Art, New York]

Pierrot, 1918, oil on canvas, 36 1/2 x 28 3/4 in. / Samuel A. Lewisohn Bequest [Z.III.137; Museum of Modern Art, New York]

Sleeping Peasants, 1919, gouache, 12 1/4 x 19 1/4 in. [Z.III.371; Museum of Modern Art, New York]

Three Women at the Spring, 1921, oil on canvas, 6 ft. 8 1/4 in. x 5 ft. 8 1/2 in. [Z.IV.322; Museum of Modern Art, New York]

Three Musicians, 1921, oil on canvas, 79 x 87 3/4 in. [Z.IV.331; Museum of Modern Art, New York]

Still Life with a Cake, 1924, oil on canvas, 38 1/2 x 51 1/2 in. / Museum of Modern Art [Z.V.185; Metropolitan Museum of Art, New York]

*Seated Woman,** 1926–27 [actual date: 1927], oil on canvas, 51 1/2 x 38 1/2 in. / anonymous gift [Z.VII.81; Art Gallery of Ontario, Toronto / The anonymous donor to the Museum of Modern Art was Stephen C. Clark, New York.]

*The Studio,** 1927–28, oil on canvas, 59 x 91 in. / gift of Walter P. Chrysler, Jr., New York [Z.VII.142; Museum of Modern Art, New York]

Seated Bather, 1929, oil on canvas, 64 1/4 x 51 in. [Z.VII.306; Museum of Modern Art, New York]

Night Fishing at Antibes, August 1939, oil on canvas, 6 ft. 9 in. x 11 ft. 4 in. / Mrs. Simon Guggenheim Fund [Z.IX.316; Museum of Modern Art, New York]

October 25–November 29, 1954: Sidney Janis Gallery, New York
"A First Showing of XX Century Masters"
[*Still Life*], 1939 (ill. in cat.)

1955

January 17–February 12, 1955: Paul Rosenberg & Co., New York
"Loan Exhibition of Paintings by Picasso"

Open Window in Paris, 1920, canvas, 64 1/2 x 43 in. / anonymous loan (no. 1 in exh.; ill. in cat.) [Z.IV.74]

Dog and Cock, 1921, canvas, 61 x 30 1/4 in. / Mr. Stephen C. Clark, New York (no. 2 in exh.; ill. in cat.) [Z.IV.335; Yale University Art Gallery, New Haven, Connecticut]

"Le Jour," 1921, canvas, 29 x 36 1/2 in. / Mr. and Mrs. Joseph H. Hazen (no. 3 in exh.; ill. in cat.) [Z.IV.430]

Still Life with Fishes, 1923, canvas, 51 x 38 in. / Mrs. Albert D. Lasker (no. 4 in exh.; ill. in cat.) [Z.IV.448]

Guitar with Stars, 1924, canvas, 38 1/4 x 51 in. / anonymous loan (no. 5 in exh.; ill. in cat.) [Z.IV.225]

The Red Foulard, 1924, canvas, 39 1/2 x 32 in. / Norton Gallery and School of Art, West Palm Beach, Florida (no. 6 in exh.; ill. in cat.) [Z.IV.323]

Breakfast, 1924, canvas, 15 x 18 in. / Mr. Edward A. Bragaline, New York (no. 7 in exh.; ill. in cat.) [Z.V.266]

The Plaster Arm, 1925, canvas, 38 1/2 x 51 1/2 in. / Mr. and Mrs. Samuel A. Marx, Chicago (no. 8 in exh.; ill. in cat.) [Z.V.444]

Girl in front of Mirror, 1937, canvas, 51 x 77 in. / Mr. and Mrs. Henry Clifford, Radnor,

Pennsylvania (no. 9 in exh.; ill. in cat.) [Z.VIII.340]

African Sculpture by Window, 1937, canvas, 28 1/2 x 23 1/2 in. / Mr. and Mrs. Leo Simon (no. 10 in exh.; ill. in cat.) [Z.VIII.360]

Bowl of Fruit and Pitcher, 1937, canvas, 18 x 24 in. / Mrs. Julian Bobbs (no. 11 in exh.; ill. in cat.) [Z.VIII.327]

Candle and Pitcher, 1937, canvas, 15 x 18 in. / Mr. and Mrs. Henry R. Hope, Bloomington, Indiana (no. 12 in exh.; ill. in cat.) [Z.VIII.335; Indiana University Art Museum]

Pitcher of Milk, 1938, canvas, 18 x 24 in. / Mrs. Frederic R. Mann (no. 13 in exh.; ill. in cat.)

Skull and Vase, 1939, canvas, 23 1/2 x 36 1/2 in. / Mr. and Mrs. Walter Bareiss, Greenwich, Connecticut (no. 14 in exh.; ill. in cat.) [Z.IX.238; Cleveland Museum of Art]

Tomato Plant, 1944, canvas, 36 1/2 x 29 in. / Mr. and Mrs. John H. Whitney (no. 15 in exh.; ill. in cat.) [Z.XIV.22]

January 20–February 20, 1955: Art Institute of Chicago
"Great French Paintings in memory of Chauncey McCormick"

Lady with a Fan, 39 x 31 1/2 in. / Mr. and Mrs. W. Averell Harriman, New York (no. 30 in exh.; ill. in cat.) [Z.I.308; National Gallery of Art, Washington, D.C.]

Woman Combing Her Hair, 49 x 35 in. / Mr. and Mrs. Samuel Marx, Chicago (no. 31 in exh.; ill. in cat.) [Z.I.336; Museum of Modern Art, New York]

January 25–February 19, 1955: M. Knoedler & Co., New York
"Cone Collection from the Baltimore Museum" [The first six works in the catalogue are unnumbered (without explanation); these have been reordered chronologically in the list below. The rest are numbered.]

Girl Combing Her Hair, 1905–6, pen [Baltimore Museum of Art]

Woman Returning from Market, 1906, pen (ill. in cat.) [Baltimore Museum of Art]

Head of a Young Man, ca. 1906, pen (ill. in cat.) [Baltimore Museum of Art]

Portrait of Mr. Z., 1919, pencil [Baltimore Museum of Art]

Dr. Caribel Cone, 1922, pencil (ill. in cat.) [Baltimore Museum of Art]

Three Dancers, 1925, pen [Z.V.438; Baltimore Museum of Art]

Woman with Bangs, 1902, oil on canvas, 25 5/8 x 19 1/4 in. (no. 83 in exh.) [Z.I.59; Baltimore Museum of Art]

The Coiffure, 1905, oil on canvas, 31 7/8 x 25 5/8 in. (no. 84 in exh.; ill. in cat.) [Z.VI.731; Baltimore Museum of Art]

Study for "Family of Saltimbanques," 1905, watercolor, pastel, and charcoal, 23 5/8 x 18 1/2 in. (no. 85 in exh.; ill. in cat.) [Baltimore Museum of Art]

The Monkey, 1905, watercolor and pen, 19 3/4 x 12 5/8 in. (no. 86 in exh.; ill. in cat.) [Baltimore Museum of Art]

Circus Family, 1905, watercolor and pen, 9 1/2 x 12 in. (no. 87 in exh.; ill. in cat.) [Baltimore Museum of Art]

Boy Leading a Horse, 1905, sepia brush, 19 1/4 x 6 1/8 in. (no. 89 in exh.) [Baltimore Museum of Art]

Portrait of Allan Stein, 1906, gouache, 29 1/8 x 23 1/2 in. (no. 93 in exh.) [Z.I.353; Baltimore Museum of Art]

Portrait of Leo Stein, 1906, gouache, 9 3/4 x 6 3/4 in. (no. 94 in exh.; ill. in cat.) [Z.I.250; Baltimore Museum of Art]

Two Nudes, 1906, gouache and charcoal, 25 x 19 1/8 in. (no. 95 in exh.) [Z.XXII.411; Baltimore Museum of Art]

Nude with Raised Arm, 1907, watercolor, 12 1/4 x 9 1/2 in. (no. 96 in exh.) [Z.II¹.45; Baltimore Museum of Art]

Mother and Child, 1922, oil on canvas, 39 1/2 x 31 1/2 in. (no. 97 in exh.; ill. in cat.)

[Z.IV.371; Baltimore Museum of Art]
In the Studio, 1933, watercolor and pen, 15 3/8 x
14 1/2 in. (no. 98 in exh.; ill. in cat.)
[Baltimore Museum of Art]

February 28–April 9, 1955: Sidney Janis Gallery, New
York
"Selection of French Art 1906–1954"
[*Still Life*], 1910 (ill. in cat.) [Z.II¹.190]

March 15–April 17, 1955: Museum of Modern Art, New
York
"Picasso: 12 Masterworks" [No titles of specific works
have been identified.]

April 11–May 7, 1955: Samuel M. Kootz Gallery, New
York
"A Decade of Modern Painting and Sculpture"
Woman Lying Down / Mr. and Mrs. Himan Brown
(ill. in cat.) [Z.XI.285; Metropolitan Museum of
Art, New York]

April 24–May 31, 1955: James Vigeveno Galleries, Los
Angeles
"Small Paintings and Drawings by French Masters"
Seated Figure (no. 42 in exh.)
Three Women (no. 43 in exh.)

April 29–May 14, 1955: Wildenstein & Co., New York
"Paintings from St. James' [Church] Collectors"
Pierrot / Mrs. Morton Palmer (no. 42 in exh.)

May 4–28, 1955: Wildenstein & Co., New York
"A Special Exhibition of Paintings by American and
French Modern Masters"
The Table, 1919–20, oil / Smith College Museum of
Art (no. 22 in exh.) [Z.III.437; Smith College
Museum of Art, Northampton, Massachusetts]
Dog and Cock, 1921, oil / Stephen C. Clark, New York
(no. 23 in exh.) [Z.IV.335; Yale University Art
Gallery, New Haven, Connecticut]
Femme dans un fauteuil, 1922, oil / Mr. and Mrs.
Justin K. Thannhauser, New York (no. 24 in exh.)
[Z.IV.391; Solomon R. Guggenheim Museum,
New York]

May 11–28, 1955: Pierre Matisse Gallery, New York
"Spring Exhibition: Painting and Sculpture"
The Old Musician, 1903, Conté crayon, 18 x 12 in.
(no. 15 in exh.; ill. in cat.)

May 31–September 5, 1955: Museum of Modern Art,
New York
"Paintings from Private Collections: A Twenty-Fifth
Anniversary Exhibition"
Self-Portrait, 1901, oil, 20 1/4 x 12 1/4 in. / Mr. and
Mrs. John Hay Whitney (no. 105 in exh.; ill. in cat.)
Blue Boy, 1905, gouache, 40 x 22 1/2 in. / Mr. and
Mrs. Edward M. M. Warburg, New York (no. 106
in exh.; ill. in cat.) [Z.I.271]
Boy with a Pipe, 1905, oil, 39 3/8 x 32 in. / Mr. and
Mrs. John Hay Whitney (no. 107 in exh.; ill. in
cat.) [Z.I.274]
Boy Leading a Horse, 1905, oil, 86 7/8 x 57 5/8 in. /
Mr. and Mrs. William S. Paley, New York (no.
108 in exh.; ill. in cat.) [Z.I.264; Museum of
Modern Art, New York]
Woman Combing Her Hair (La Coiffure), 1906,
oil, 49 3/4 x 35 1/2 in. / Mr. and Mrs. Samuel
Marx, Chicago (no. 109 in exh.; ill. in cat.)
[Z.I.336; Museum of Modern Art, New York]
Nudes, 1906, gouache, 24 3/4 x 19 in. / Mr. and
Mrs. Alex L. Hillman, New York (no. 110 in
exh.; ill. in cat.) [Z.I.340; Alex Hillman Family
Foundation Collection]
Two Nudes, 1906, oil, 59 3/8 x 36 5/8 in. / G. David
Thompson, Pittsburgh (no. 111 in exh.; ill.
in cat.) [Z.I.366; Museum of Modern Art,
New York]
Head, 1908, oil, 24 3/8 x 17 in. / Mr. and Mrs.
Samuel Marx, Chicago (no. 112 in exh.; ill. in
cat.) [Z.II.76; Metropolitan Museum of Art,
New York]
Woman, fall 1910, oil, 39 1/4 x 32 1/4 in. / Mrs.
Gilbert W. Chapman (no. 113 in exh.; ill. in cat.)
[Z.II¹.234; Museum of Fine Arts, Boston]

Guitar on a Mantelpiece, 1915, oil, 51 1/4 x 38 in. /
Mr. and Mrs. Samuel Marx, Chicago (no. 114 in
exh.) [Metropolitan Museum of Art,
New York]
Guitar, 1916–17, oil, charcoal, and pinned paper,
84 5/8 x 31 1/2 in. / A. Conger Goodyear, New
York (no. 115 in exh.; ill. in cat.) [Z.II².570]
Two Seated Women [current title: *Two Female Nudes*],
1920, oil, 76 3/4 x 64 1/4 in. / Walter P. Chrysler,
Jr., New York (no. 116 in exh.; ill. in cat.)
[Z.IV.217; Kunstsammlung Nordrhein-Westfalen,
Düsseldorf]
Musical Instruments, 1923, oil, 38 x 51 1/4 in. / G.
David Thompson, Pittsburgh (no. 117 in exh.; ill.
in cat.)
Seated Woman, 1927, oil, 51 1/8 x 38 1/4 in. / Mr. and
Mrs. James Thrall Soby (no. 118 in exh.; ill. in cat.)
[Z.VII.77; Museum of Modern Art, New York]
Figure by the Sea, 1929, oil, 51 x 38 in. / Mr. and Mrs.
Samuel Marx, Chicago (no. 119 in exh.; ill. in
cat.) [Metropolitan Museum of Art, New York]
Pitcher and Bowl of Fruit, 1931, oil, 51 1/2 x 64 in. /
Nelson A. Rockefeller, New York (no. 120 in exh.;
ill. in cat.) [Z.VII.322; Solomon R. Guggenheim
Museum, New York]
Girl Reading, 1934, oil, 63 3/4 x 51 in. / Mr. and Mrs.
Samuel A. Marx, Chicago (no. 121 in exh.; ill. in
cat.) [Z.VIII.246; Metropolitan Museum of Art,
New York]
First Steps, 1943, oil, 51 1/8 x 38 1/4 in. / Stephen
C. Clark, New York (no. 122 in exh.; ill. in
cat.) [Z.XIII.36; Yale University Art Gallery,
New Haven, Connecticut]
Charnel-House, summer 1945, oil, 78 5/8 x 98 1/2 in. /
Walter P. Chrysler, Jr., New York (no. 123 in
exh.; ill. in cat.) [Z.XIV.76; Museum of Modern
Art, New York]
Winter Landscape, Vallauris, 1950, oil, 40 1/2 x
49 1/2 in. / Mr. and Mrs. Victor Ganz, New York
(no. 124 in exh.; ill. in cat.)

Opened June 8, 1955: Curt Valentin Gallery, New York
"Closing Exhibition: Sculpture, Paintings and
Drawings" [This exhibition was arranged by Ralph
Colin, an important collector who was the executor of
Curt Valentin's estate.]
Man with Violin, 1913, charcoal and newspaper,
48 1/2 x 18 in. (no. 151 in exh.)
Still Life, 1919, oil, 6 1/4 x 8 3/4 in. (no. 152 in exh.)

June 17–July 10, 1955: San Francisco Museum of Art
"Art in the 20th Century"
Man with Hat, 1912–13, collage with charcoal,
24 1/2 x 18 5/8 in. / Museum of Modern Art
[Z.II².398; Museum of Modern Art, New York]
Seated Woman, 1922, 37 x 27 in. / Mr. and Mrs.
Justin K. Thannhauser, New York [Z.IV.391;
Solomon R. Guggenheim Museum, New York]
Seated Woman, 1941, 51 x 38 in. / Currier Gallery of
Art, Manchester, New Hampshire
Portrait, 1942, 26 x 22 in. / Mrs. Charlotte Mack,
San Francisco
Mother and Child, 35 3/4 x 25 1/4 in. / anonymous loan
(San Francisco Museum of Art Loan Collection)
Study: Head, watercolor, 12 x 9 3/4 in. / Mr. and
Mrs. Walter A. Haas, San Francisco [San
Francisco Museum of Modern Art]

October 3–November 4, 1955: Arts Club of Chicago
"An Exhibition of Cubism on the Occasion of the 40th
Anniversary of the Arts Club of Chicago" [This loan
exhibition was organized by Forbes Watson, who
served as editor of *The Arts* magazine in the 1920s.]
Study for "The Young Ladies of Avignon," 1907,
watercolor / Philadelphia Museum of Art, Albert
E. Gallatin Collection (no. 12 in exh.; ill. in cat.)
[Z.II¹.21; Philadelphia Museum of Art]
Woman with Pears, 1908, oil / Mr. and Mrs. Samuel
Marx, Chicago (no. 13 in exh.) [Z.II¹.170;
Museum of Modern Art, New York]
Still Life, 1908, oil (no. 14 in exh.)
Accordionist, 1911, oil / Solomon R. Guggenheim
Museum, New York (no. 15 in exh.) [Z.II¹.277;
Solomon R. Guggenheim Museum]
Bottle and Glass [current title: *Bottles and Glasses*],
1911–12, [oil on paper mounted on canvas,

25 3/8 x 19 1/2 in.] / Solomon R. Guggenheim
Museum, New York (no. 16 in exh.) [Z.II².299;
Solomon R. Guggenheim Museum]
Nude, 1909, oil / Mr. and Mrs. Morton G. Neumann,
Chicago (no. 17 in exh.; ill. in cat.) [Z.II¹.176;
private collection]
The Toreador, 1911, oil (no. 18 in exh.)
Compote, Bottle, Glass and Pipe, 1919, oil / Mr. and
Mrs. Morton G. Neumann, Chicago (no. 19 in exh.)
Head of a Woman, 1909, watercolor (no. 20 in exh.)
Woman with a Mandolin, 1910, oil (no. 21 in exh.)
Still Life, 1918, oil on wood / Mr. and Mrs. Roy
Friedman (no. 22 in exh.)
Pipes, Cups, Coffee-Pot, Carafe, 1910–11, oil /
Perls Galleries, New York (no. 23 in exh.)
Vive la France, 1914–15, oil / Mr. and Mrs.
Leigh B. Block, Chicago (no. 24 in exh.; ill. in
cat.) [Z.II².523; private collection]
Still Life: Compote with Cigarettes, 1920 / Mr. and
Mrs. Arnold H. Maremont, Chicago (no. 25 in exh.)

October 24–November 26, 1955: Sidney Janis
Gallery, New York
"New Arrivals from France: Selected Examples by
Artists from Picasso to Giacometti"
[no title], 1913, [collage] (ill. in cat.)

1956

Closed January 14, 1956: Paul Rosenberg & Co.,
New York
"Exhibition of 19th and 20th Century French Paintings"
*Bull Fight,** 1934, 13 x 16 in. (no. 15 in exh.)
[Z.VIII.233; Philadelphia Museum of Art]

January 3–February 4, 1956: Perls Galleries, New York
"The Perls Galleries Collection of Modern French
Paintings"
Les Amants, 1899, pastel, 5 3/8 x 8 3/4 in.
(no. 186 in exh.)
Pipes, tasse, cafetière, carafon, 1910–11, oil,
19 7/8 x 50 1/4 in. (no. 187 in exh.)
Poulet, verre, couteau, bouteille, 1913, collage,
18 1/4 x 22 3/4 in. (no. 188 in exh.; ill. in cat.)
[Z.II¹.430]
Femme nue dans un fauteuil, 1914, gouache,
10 5/8 x 7 1/4 in. (no. 189 in exh.)
Corbeille avec fruits, 1920, gouache, 8 1/4 x 11 7/8 in.
(no. 190 in exh.)
L'Atelier à Juan-les-Pins, 1925, gouache, 12 3/4 x
17 1/8 in. (no. 191 in exh.)
Baigneuses au ballon, 1928, oil, 6 3/8 x 8 3/4 in.
(no. 192 in exh.)
Baigneuses à la plage, 1932, ink, 9 3/4 x 13 1/2 in.
(no. 193 in exh.)
Les Trois Baigneuses, 1932, oil, 10 5/8 x 16 1/8 in.
(no. 194 in exh.)
Baigneuses, 1934, pen and ink, 9 7/8 x 13 5/8 in.
(no. 195 in exh.)
Nature morte à la cruche, 1939, oil, 10 5/8 x 18 1/8 in.
(no. 196 in exh.)
Tête de pêcheur, 1939, ink and wash, 25 x 18 in.
(no. 197 in exh.)
Portrait de femme (Mme Lambert), [April 14],
1940, oil, 28 7/8 x 23 1/4 in. (no. 198 in exh.;
ill. in cat.) [Z.X.386]
Portrait de Dora Maar, 1941, oil, 24 x 18 1/8 in.
(no. 199 in exh.)
Femme assise, 1941, oil, 36 x 28 5/8 in.
(no. 200 in exh.) [Z.XI.342]
Buste de faune, 1946, oil, 25 3/4 x 19 7/8 in.
(no. 201 in exh.)

January 3–February 4, 1956: Sidney Janis Gallery,
New York
"Cubism 1910–1912"
Compotier et tasse, 1910, oil, 15 x 21 1/2 in.
(no. 26 in exh.; ill. in cat.)
Portrait de Wilhelm Uhde, 1910, oil, 32 x 23 1/2 in. /
Mr. and Mrs. Roland Penrose, London
(no. 27 in exh.; ill. in cat.) [Z.II¹.217; Pulitzer
Foundation for the Arts, St. Louis, Missouri]
Portrait of Daniel-Henry Kahnweiler, 1910, oil,
39 3/4 x 28 3/4 in. / Art Institute of Chicago,
gift of Mrs. Gilbert Chapman (no. 28 in exh.;
ill. in cat.) [Z.II¹.227; Art Institute of Chicago]

L'Huilier, 1911, oil, 9 3/4 x 7 3/4 in. (no. 29 in exh.; ill. in cat.)

Pigeon dans son nid et oeufs, 1911, oil, 13 x 16 in. / Munson-Williams-Proctor Art Institute, Utica, New York (no. 30 in exh.; ill. in cat.)

L'Indépendent, 1911–12, oil, 23 3/4 x 19 3/4 in. / Mr. and Mrs. Henry Clifford, Radnor, Pennsylvania (no. 31 in exh.; ill. in cat.) [Z.II¹.264; private collection]

January 15–February 7, 1956: Renaissance Society at the University of Chicago
"Students as Collectors: Prints and Drawings from Callot to Picasso"
Two Dancers / lent by unnamed undergraduate student

March 12–April 7, 1956: Samuel M. Kootz Gallery, New York
"Picasso: First Showing in America–Paintings and Sculptures"
La Dame à la fleur, 1932, oil on canvas, 64 x 51 in. / Pablo Picasso (ill. in cat.) [Z.VII.381]

Nu couché, 1932, oil on canvas, 40 x 36 1/2 in. (ill. in cat.) [Z.VII.407]

Femme assise, 1938, oil on canvas, 64 x 51 in. / Pablo Picasso (ill. in cat.) [Z.IX.117]

Femme assise, 1941, oil on canvas, 29 x 24 in. (ill. in cat.) [Z.XI.221]

Tête, 1941, oil on canvas, 24 x 15 in. (ill. in cat.) [Z.XI.189]

La Dame à l'artichaut, 1942, oil on canvas, 77 x 51 in. / Pablo Picasso (ill. in cat.) [Z.XII.1; Museum Ludwig, Sammlung Ludwig, Cologne]

Tête, 1943, oil on canvas, 22 x 18 in. (ill. in cat.) [Z.XIII.144]

Nu et femme se lavant les pieds, 1944, oil on canvas, 38 x 51 in. (ill. in cat.) / Pablo Picasso [Z.XIII.273; private collection]

Femme assise, 1945, oil on canvas, 45 1/2 x 35 in. (ill. in cat.) [Z.XIV.109]

Femme assise, 1946, oil on canvas, 51 x 35 in. (ill. in cat.) / Pablo Picasso [Z.XV.13]

Femme assise, 1949, oil on canvas, 45 1/2 x 35 in. (ill. in cat.) [Z.XV.123]

April 7–May 27, 1956: Corcoran Gallery of Art, Washington, D.C.
"Visionaries and Dreamers"
Girl Having Her Hair Combed, ca. 1905, crayon on buff paper, 24 1/8 x 19 1/2 in. / Fogg Art Museum, Harvard University, Cambridge (no. 83 in exh.; ill. in cat.) [Fogg Art Museum]

April 16–May 19, 1956: Galerie Chalette, New York
"Picasso 'The Woman': Paintings, Drawings, Bronzes, Lithographs"
Head of a Woman, 1952, oil, 22 x 18 in. (no. 1 in exh.; ill. in cat.)

*Seated Woman,** 1926–27 [actual date: 1927], oil, 51 1/2 x 38 1/2 in. / Museum of Modern Art (no. 2 in exh.; ill. in cat.) [Z.VII.81; Art Gallery of Ontario, Toronto]

Seated Nude, 1922, oil, 14 1/2 x 10 1/2 in. / Mr. James Thrall Soby (no. 3 in exh.; ill. in cat.)

Head, 1907, oil, 13 7/8 x 10 3/4 in. / Mr. and Mrs. Himan Brown (no. 4 in exh.; ill. in cat.)

Head of a Woman, [March 24], 1953, oil, 18 x 15 in. (no. 5 in exh.; ill. in cat.)

Three Women, 1939, gouache, 10 1/2 x 8 1/2 in. (no. 6 in exh.; ill. in cat.)

Sleeping Woman, 1935, oil, 18 1/4 x 21 1/4 in. (no. 7 in exh.; ill. in cat.)

Seated Nude, 1906, lavis, 12 1/4 x 18 3/4 in. / Mme Helena Rubinstein (no. 8 in exh.) [Z.I.362]

Women by the Sea, 1920, pencil drawing, 9 1/8 x 13 in. / Mr. and Mrs. Albert List (no. 9 in exh.; ill. in cat.)

Woman Wearing a Hat, 1937, ink drawing, 12 3/8 x 10 in. (no. 11 in exh.; ill. in cat.)

Three Heads, [November 1], 1947, gouache and lavis, 12 3/4 x 19 1/2 in. (no. 12 in exh.; ill. in cat.)

Two Women, [May 8], 1947, ink drawing, 19 x 25 in. (no. 13 in exh.)

Head of a Woman, 1943, lavis, 25 1/4 x 19 1/2 in. (no. 14 in exh.; ill. in cat.)

Bust of a Woman, 1952, lavis, 25 1/2 x 19 1/2 in. (no. 15 in exh.; ill. in cat.)

Profile, 1942, lavis, 25 x 17 1/2 in. (no. 16 in exh.; ill. in cat.)

June 6–July 22, 1956: San Francisco Museum of Art
"Expressionism: 1900–1955"
The Mother, 1901, oil on canvas, 29 1/2 x 20 in. / City Art Museum of St. Louis (ill. in cat.) [St. Louis Art Museum, Missouri]

Grande Danseuse [current title: *Nude with Raised Arms (The Dancer of Avignon)*], 1907, oil on canvas, 59 x 39 1/4 in. / Mr. Walter P. Chrysler, Jr., New York (ill. in cat.) [Z.II¹.35; private collection, New York]

Still Life with Cherries, 1943, oil on canvas, 29 x 36 1/2 in. / Mr. and Mrs. Morton D. May, St. Louis (ill. in cat.) [Z.XIII.52]

June 12–July 11, 1956: California Palace of the Legion of Honor, San Francisco
"Paintings from the Collection of Walter P. Chrysler, Jr."; traveled to the L. A. County Museum, July 26–August 26, 1956
Femmes au bar, 1902, oil on canvas, 31 1/2 x 36 in. (no. 88 in exh.; ill. in cat.) [Z.I.132; Hiroshima Museum of Art]

Deux Femmes nues [current title: *Two Female Nudes*], 1920, oil on canvas, 77 x 64 in. (no. 96 in exh.; ill. in cat.) [Z.IV.217; Kunstsammlung Nordrhein Westfalen, Düsseldorf]

Charnel House (Le Charnier), 1945, oil on canvas, 78 5/8 x 98 1/2 in. (no. 101 in exh.; ill. in cat.) [Z.XIV.76; Museum of Modern Art, New York]

June 22–September 30, 1956: Metropolitan Museum of Art, New York
"Modern European Paintings from Private New York Collections"
Blue Boy, 1905 / Mr. and Mrs. Edward M. M. Warburg, New York [Z.I.271]

September 11–November 11, 1956: Los Angeles County Museum
"The Gladys Lloyd Robinson and Edward G. Robinson Collection"; traveled to the California Palace of the Legion of Honor, San Francisco, November 30, 1956–January 13, 1957
Entombment, ca. 1901, oil on canvas, 39 1/2 x 35 1/2 in. (no. 37 in exh.; ill. in cat.) [Z.I.52]

October 25–December 30, 1956: Brooklyn Museum, New York
"Picasso: His Prints and Drawings"
Nude Figure Facing Left, charcoal drawing (no. 10 in exh.)

Tête de jeune homme, charcoal drawing (no. 13 in exh.)

November 1–December 1, 1956: Wildenstein and Co., New York
"Nude in Painting"
La Toilette, 1906 / Albright Art Gallery, Buffalo (no. 38 in exh.) [Z.I.325; Albright-Knox Art Gallery]

1957

January 2–February 10, 1957: San Francisco Museum of Art
"Collections and Collectors"
Street Scene, Paris, oil / San Francisco Museum of Art, Harriet Lane Levy bequest, 1937 [Z.VI.302; San Francisco Museum of Modern Art]

Le Journal, ca. 1914, oil / San Francisco Museum of Art, Gift of Mrs. Charlotte Mack, 1955 [San Francisco Museum of Modern Art]

January 22–February 23, 1957: World House Galleries, New York
"The Struggle for New Form"
The Painter and His Model, 1928 / Sidney Janis, New York (no. 63 in exh.) [Z.VII.143; Museum of Modern Art, New York]

Head of Bull and Vase, 1939 / Mr. and Mrs. Walter Bareiss, Greenwich, Connecticut (no. 64 in exh.) [Z.IX.238; Cleveland Museum of Art]

Les Courses à Longchamps, 1881 [*sic*] / Mr. and Mrs. Nate B. Spingold, New York (no. 65 in exh.)

Paysage espagnole, 1905, [oil on canvas, 27 1/2 x 39 in.] / Mr. and Mrs. Nate B. Spingold, New York (no. 66 in exh.)

Le Rameur, 1911 / Mr. and Mrs. Ralph F. Colin, New York (no. 67 in exh.) [Z.II.231; Museum of Fine Arts, Houston]

Le Torrero, 1911 / Mr. and Mrs. Morton G. Neumann, Chicago (no. 68 in exh.)

February 6–March 2, 1957: Paul Rosenberg & Co., New York
"Masterpieces Recalled: A Loan Exhibition of 19th and 20th Century French Paintings"
Lady with Fan, 1905, 39 1/2 x 32 in. / Governor and Mrs. W. Averell Harriman (no. 39 in exh.; ill. in cat.) [Z.I.308; National Gallery of Art, Washington, D.C.]

Harlequin, 1915, 72 1/2 x 41 in. / Museum of Modern Art (no. 40 in exh.; ill. in cat.) [Z.II².555; Museum of Modern Art, New York]

Flowers and Fruit in front of a Window, 1934, 32 x 40 in. / Dr. Herschel Carey Walker, New York (no. 41 in exh.; ill. in cat.)

The Dove, [February 6], 1936, 18 x 21 1/2 in. / Keith Warner, New York (no. 42 in exh.; ill. in cat.)

The Tomato Plant, 1944, 36 1/2 x 29 in. / Mr. and Mrs. John H. Whitney (no. 43 in exh.; ill. in cat.) [Z.XIV.22]

March 13–April 13, 1957: Perls Galleries, New York
"Maîtres de la première génération du vingtième siècle: A group of paintings in the Collection of Peter and Elizabeth Rübel, New York"
Nature morte au bouquet de fleurs, 1908, oil on canvas, 15 x 18 1/4 in. (no. 31 in exh.; ill. in cat.) [Z.II¹.94]

Nature morte à la fenêtre, 1923, oil on canvas and paper, 8 3/4 x 10 3/4 in. (no. 32 in exh.; ill. in cat.) [Z.V.65]

Têtes, 1929, oil on canvas, 29 3/4 x 23 1/2 in. (no. 33 in exh.; ill. in cat.) [Z.VII.245]

Femme nue couchée, 1932, oil on canvas, 40 x 36 1/2 in. (no. 34 in exh.; ill. in cat.) [Z.VII.407]

Tête de femme, 1942, gouache on paper, 16 x 11 3/4 in. (no. 35 in exh.; ill. in cat.)

Tête de femme, [October 3], 1943, oil on canvas, 18 1/4 x 21 3/4 in. (no. 36 in exh.; ill. in cat.) [Z.XIII.138]

May 21–July 7, 1957: San Francisco Museum of Art
"Ayala and Sam Zacks Collection: Nineteenth and Twentieth Century Paintings and Drawings"
Woman with Necklace, 1901, oil on cardboard, 17 1/4 x 14 1/4 in. (measurement by sight) (no. 85 in exh.; ill. in cat.) [Z.VI.385]

Nude with Clasped Hands, 1905, gouache on canvas, 37 3/4 x 29 3/4 in. (no. 86 in exh.; ill. in cat.) [Art Gallery of Ontario, Toronto]

The Egyptian, 1916, oil on wood, 12 1/2 x 8 3/4 in. (no. 87 in exh.; ill. in cat.)

Two Nudes (Maternité), 1920, mixed media on paper, 24 3/4 x 19 in. (no. 88 in exh.; ill. in cat.)

Shadow on the Woman, December 29, 1953, oil on canvas, 51 1/4 x 38 1/4 in. (no. 89 in exh.) [Z.XVI.99; Art Gallery of Ontario, Toronto]

Coffee Pot, 1947, oil on canvas / Mrs. Walter A. Haas, San Francisco (supplement in exh.) [San Francisco Museum of Modern Art]

May 22–September 8, 1957: Museum of Modern Art, New York
"Picasso: 75th Anniversary Exhibition"; traveled to Art Institute of Chicago, October 29–December 8, 1957
Gypsy Girl, 1898?, oil and pastel, 18 1/2 x 24 1/4 in. / private collection (ill. in cat.)

Redemption, 1898?, watercolor and Conté crayon, 17 3/4 x 11 1/2 in. / Mr. and Mrs. Justin K. Thannhauser, New York (ill. in cat.) [Z.XXI.79; Solomon R. Guggenheim Museum, New York]

Le Moulin de la Galette, Paris, autumn 1900, oil on canvas, 35 1/4 x 45 3/4 in. / Mr. and Mrs. Justin K. Thannhauser, New York (ill. in cat.) [Z.I.41; Solomon R. Guggenheim Museum, New York]

Page of Studies (Heads and Figures), Paris, 1900, Conté crayon, 5 1/8 x 8 1/4 in. / Ivan L. Best, Seattle (ill. in cat.)

Woman in Blue, 1901?, oil on canvas, 52 5/8 x 39 3/4 in. / Museo de Arte Moderno, Madrid (ill. in cat.) [Z.XXI.211; Museo Nacional de Arte Moderno, Madrid]

Dwarf Dancer (La Nana), Paris, 1901, oil on canvas, 40 1/8 x 23 5/8 in. / Museo de Arte Moderno, Barcelona (ill. in cat.)

Self-Portrait, 1901, oil on cardboard mounted on wood, 20 1/4 x 12 1/2 in. / Ambassador and Mrs. John Hay Whitney, London (ill. in cat.) [Z.I.113]

Self-Portrait, 1901, oil on canvas, 29 x 23 1/4 in. / private collection, New York (ill. in cat.) [Z.XXI.192; private collection]

Sebastián Junyer Vidal, Barcelona, June 1903, oil on canvas, 49 3/8 x 36 in. / Sebastián Junyer Vidal, Barcelona (ill. in cat.)

Blind Man's Meal, Barcelona, 1903, oil on canvas, 37 1/2 x 37 1/4 in. / Metropolitan Museum of Art, gift of Mr. and Mrs. Ira Haupt (ill. in cat.) [Z.I.168; Metropolitan Museum of Art, New York]

Brooding Woman, Paris, 1904, watercolor, 10 5/8 x 14 1/2 in. / Museum of Modern Art, gift of Mr. and Mrs. Werner E. Josten (ill. in cat.)

Woman Ironing, Paris, 1904, oil on canvas, 46 1/8 x 29 1/8 in. / Mr. and Mrs. Justin K. Thannhauser, New York (ill. in cat.; not shown in Chicago) [Z.I.247; Solomon R. Guggenheim Museum, New York]

Meditation, Paris, 1904, watercolor, 13 3/4 x 10 1/8 in. / Mrs. Louise Smith, New York (ill. in cat.) [Z.I.235]

Woman with Crow, Paris, 1904, gouache and pastel, 25 1/2 x 19 1/2 in. / The Toledo Museum of Art, gift of Edward Drummond Libbey (ill. in cat.) [Z.I.240; Toledo Museum of Art, Ohio]

Study for "The Actor" with profiles of Fernande, Paris, winter 1904-5, pencil, 18 1/2 x 12 3/8 in. (measurement by sight) / Nelson A. Rockefeller, New York (ill. in cat.) [Z.VI.681]

Woman with Chignon (Head of the Acrobat's Wife), Paris, 1904, gouache, 16 7/8 x 12 1/4 in. / Art Institute of Chicago, bequest of Kate L. Brewster (ill. in cat.) [Z.I.233; Art Institute of Chicago]

Boy with Pipe, Paris, 1905, oil on canvas, 39 3/8 x 32 in. / Ambassador and Mrs. John Hay Whitney, London (ill. in cat.) [Z.I. 274]

Monkey, Paris, 1905, watercolor and pen, 19 3/4 x 12 5/8 in. / Baltimore Museum of Art, Cone Collection (ill. in cat.) [Baltimore Museum of Art]

Circus Family, Paris, 1905, watercolor and pen, 9 1/2 x 12 in. / Baltimore Museum of Art, Cone Collection (ill. in cat.) [Baltimore Museum of Art]

Two Acrobats with a Dog, Paris, 1905, gouache on cardboard, 41 1/2 x 29 1/2 in. / Mr. and Mrs. William A. M. Burden, New York (ill. in cat.) [Z.I.300; Museum of Modern Art, New York]

Page of Studies (Figures and Bulls), 1905, pen and ink, 12 3/4 x 9 3/4 in. / Nelson A. Rockefeller, New York (ill. in cat.)

Boy Leading a Horse, Paris, 1905, oil on canvas, 87 x 51 1/4 in. / Mr. and Mrs. William S. Paley, New York (ill. in cat.) [Z.I.264; Museum of Modern Art, New York]

Boy on a Horse (Study for "The Watering Place"), Paris, 1905, charcoal, 18 3/8 x 12 in. / Mr. and Mrs. John W. Warrington, Cincinnati (ill. in cat.) [Z.VI.682]

Landscape, Gosol, summer 1906, oil on canvas, 27 1/2 x 39 in. / Mr. and Mrs. Nate B. Spingold, New York (ill. in cat.)

The Blind Flower Vendor, 1906, ink and watercolor, 25 x 18 3/4 in. / Mr. and Mrs. S. J. Zacks, Toronto (ill. in cat.) [Z.I.311]

Peasants from Andorra, Gosol, summer 1906, ink, 22 5/8 x 13 7/8 in. / Art Institute of Chicago, gift of Robert Allerton (ill. in cat.) [Z.IV.780; Art Institute of Chicago]

Gertrude Stein, Paris, 1906, oil on canvas, 39 3/8 x 32 in. / Metropolitan Museum of Art, New York, bequest of Gertrude Stein (ill. in cat.) [Z.I.352; Metropolitan Museum of Art, New York]

Self-Portrait, Paris, autumn 1906, oil on canvas, 36 1/2 x 25 3/4 in. / Philadelphia Museum of Art,

A. E. Gallatin Collection (ill. in cat.) [Z.I.375; Philadelphia Museum of Art]

Leo Stein, Paris, 1906, gouache, 9 3/4 x 6 3/4 in. / Baltimore Museum of Art, Cone Collection (ill. in cat.) [Z.I.250; Baltimore Museum of Art]

Woman Combing Her Hair, Paris, 1906, oil on canvas, 49 3/4 x 35 1/2 in. / Florene and Samuel Marx, Chicago (ill. in cat.) [Z.I.336; Museum of Modern Art, New York]

Two Women, Paris, late 1906, charcoal, 24 3/4 x 18 1/2 in. / Mr. and Mrs. Richard S. Davis, Wayzata, Minnesota (ill. in cat.)

Woman Seated and Woman Standing, Paris, late 1906, charcoal, 24 1/8 x 18 1/4 in. / Philadelphia Museum of Art, Louise and Walter Arensberg Collection (ill. in cat.) [Philadelphia Museum of Art]

Two Nudes, Paris, late 1906, oil on canvas, 59 3/4 x 36 5/8 in. / G. David Thompson, Pittsburgh (ill. in cat.) [Z.I.366; Museum of Modern Art, New York]

Two Nudes, Paris, late 1906, pencil and estompe, 24 3/4 x 18 1/2 in. / Art Institute of Chicago, gift of Mrs. Potter Palmer (ill. in cat.) [Z.XXII.465; Art Institute of Chicago]

Harvesters, Paris, spring 1907, oil on canvas, 25 5/8 x 31 7/8 in. / Nelson A. Rockefeller, New York (ill. in cat.) [Z.II¹.2]

Jug and Bowl, Paris, 1907 (presented to Matisse 1907-8), oil on wood, 24 1/2 x 19 in. / private collection, New York (ill. in cat.)

Study for "Les Demoiselles d'Avignon," Paris, spring 1907, charcoal and pastel, 18 7/8 x 25 in. / Pablo Picasso (ill. in cat.)

Study for "Les Demoiselles d'Avignon," Paris, spring 1907, watercolor, 6 3/4 x 8 3/4 in. / Philadelphia Museum of Art, A. E. Gallatin Collection (ill. in cat.) [Z.II¹.21; Philadelphia Museum of Art]

Les Demoiselles d'Avignon, Paris, spring 1907, oil on canvas, 96 x 92 in. / Museum of Modern Art, acquired through the Lillie P. Bliss Bequest (ill. in cat.) [Z.II¹.18; Museum of Modern Art, New York]

Woman in Yellow, Paris, summer 1907, oil on canvas, 51 1/4 x 37 3/8 in. / Louise and Joseph Pulitzer, Jr., St. Louis (ill. in cat.; shown only in Chicago) [Z.II¹.43; Pulitzer Foundation for the Arts, St. Louis, Missouri]

Flowers, Paris, summer 1907, oil on canvas, 36 1/2 x 28 1/2 in. / Mr. and Mrs. Ralph F. Colin, New York (ill. in cat.) [Z.II¹.30; Museum of Modern Art, New York]

Seated Woman, Paris, early 1908, oil on canvas, 28 3/4 x 23 1/2 in. / Larry Aldrich, New York (ill. in cat.)

Woman Sleeping, Paris, spring 1908, oil on canvas, 32 x 25 1/2 in. / André Lefèvre, Paris (ill. in cat.) [Z.XXVI.303; Museum of Modern Art, New York]

Bathers in the Forest, Paris, 1908, watercolor, 19 1/8 x 23 3/4 in. / Mrs. Eleanor Rixson Cannon, New York (ill. in cat.) [Z.XXVI.291; Museum of Modern Art, New York]

Kneeling Figure (study for a figure composition), Paris, 1908, charcoal, 24 3/8 x 18 1/2 in. / Nelson A. Rockefeller, New York (ill. in cat.) [Z.II².707; Metropolitan Museum of Art, New York]

Head of a Woman, Paris, spring 1909, black crayon and gouache, 24 1/4 x 18 3/4 in. / Art Institute of Chicago, Charles L. Hutchinson Memorial, Edward E. Ayer Fund (ill. in cat.) [Z.II¹.140; Art Institute of Chicago]

Woman with Pears, Horta de San Juan, summer 1909, oil on canvas, 36 x 28 3/4 in. / Florene and Samuel Marx, Chicago (ill. in cat.) [Z.II¹.170; Museum of Modern Art, New York]

Girl with Mandolin (Fanny Tellier), Paris, early 1910, oil on canvas, 39 1/2 x 29 in. / Nelson A. Rockefeller, New York (ill. in cat.) [Z.II¹.235; Museum of Modern Art, New York]

Female Nude, Paris, spring 1910, pen and ink and watercolor, 29 1/8 x 18 3/8 in. / Mr. and Mrs. Richard S. Davis, Wayzata, Minnesota (ill. in cat.)

Nude [current title: *Standing Female Nude*],* Paris, spring 1910, charcoal, 19 1/8 x 12 1/4 in. / Metropolitan Museum of Art (ill. in cat.) [Z.II¹.208; Metropolitan Museum of Art, New York]

Wilhelm Uhde, Paris, spring 1910, oil on canvas, 30 3/4 x 22 3/4 in. / Roland Penrose, London (ill. in cat.) [Z.II¹.217; Pulitzer Foundation for the Arts, St. Louis, Missouri]

D. H. Kahnweiler, Paris, autumn 1910, oil on canvas, 39 5/8 x 28 5/8 in. / Art Institute of Chicago, gift of Mrs. Gilbert W. Chapman (ill. in cat.) [Z.II¹.227; Art Institute of Chicago]

Female Nude, Paris, late 1910, oil on canvas, 38 3/4 x 30 3/8 in. / Philadelphia Museum of Art, Louise and Walter Arensberg Collection (ill. in cat.) [Z.II¹.225; Philadelphia Museum of Art]

Man with Pipe, Céret, summer 1911, ink wash with charcoal, probably oil, 25 x 18 1/4 in. / Fogg Art Museum, Harvard University, Cambridge, Massachusetts (ill. in cat.) [Z.II¹.280; Fogg Art Museum]

"Le Torero," Céret, summer 1911, oil on canvas, 18 1/4 x 15 in. / Nelson A. Rockefeller, New York (ill. in cat.) [Museum of Modern Art, New York]

"Ma Jolie" (woman with zither or guitar), Paris, winter 1911-12, oil on canvas, 39 3/8 x 25 3/4 in. / Museum of Modern Art, acquired through the Lillie P. Bliss Bequest (ill. in cat.) [Z.II¹.244; Museum of Modern Art, New York]

Still Life with Chair Caning, Paris, winter 1911-12, oil, pasted oilcloth simulating chair caning on canvas, 10 5/8 x 13 3/4 in. (oval) / Pablo Picasso (ill. in cat.) [Z.II¹.294; Musée Picasso, Paris]

Man with Pipe, 1912, charcoal, 24 1/2 x 18 1/2 in. / Dr. and Mrs. Israel Rosen, Baltimore (ill. in cat.) [Z.VI.1144]

Bottle of "Vieux Marc," Glass, Newspaper, Céret, spring 1912, charcoal and pasted papers, 24 5/8 x 18 1/2 in. / Mme Marie Cuttoli, Paris (ill. in cat.) [Z.II¹.334; Musée National d'Art Moderne, Centre National d'Art et de Culture Georges Pompidou, Paris]

Guitar, spring 1912, charcoal and pasted papers, 24 1/2 x 18 1/2 in. (measurement by sight) / Nelson A. Rockefeller, New York (ill. in cat.) [Z.II¹.348; Museum of Modern Art, New York]

Aficionado (Bullfight Fan), Sorgues, summer 1912, oil on canvas, 53 1/4 x 32 1/2 in. / Oeffentliche Kunstsammlung, Kunstmuseum, Basel (ill. in cat.) [Z.II¹.362; Kunstmuseum, Basel]

Guitar, Sorgues, summer 1912, oil on canvas, 28 1/2 x 23 5/8 in. [oval] / Nasjonalgalleriet, Oslo (ill. in cat.) [Z.II¹.357; Nasjonalgalleriet, Oslo]

Man with Guitar, Sorgues, summer 1912–completed in Paris, spring 1913, oil on canvas, 51 7/8 x 35 in. / Philadelphia Museum of Art, Louise and Walter Arensberg Collection (ill. in cat.) [Z.II.354; Philadelphia Museum of Art]

Man with Hat, Paris, December 1912, charcoal, ink, and pasted papers, 24 1/2 x 18 5/8 in. / Museum of Modern Art, New York [Z.II².398; Museum of Modern Art, New York]

Head of a Man, Paris, winter 1912-13, charcoal, 24 1/2 x 18 5/8 in. / private collection, New York (ill. in cat.)

Man with Violin, Paris, winter 1912-13, charcoal and pasted papers, 48 5/8 x 18 1/8 in. / G. David Thompson, Pittsburgh (ill. in cat.) [Z.II².399; Metropolitan Museum of Art, New York]

Still Life (Bottle and Glass) [current title: *Bottle and Wine Glass on a Table*],* Paris, winter 1912-13, charcoal, ink, and pasted paper, 24 7/8 x 19 1/8 in. / Metropolitan Museum of Art, New York, Alfred Stieglitz Collection (ill. in cat.) [Z.II².428; Metropolitan Museum of Art, New York]

Violin and Fruit, Paris, 1913, charcoal and pasted papers, 25 1/2 x 19 1/2 in. / Philadelphia Museum of Art, A. E. Gallatin Collection (ill. in cat.) [Z.II².385; Philadelphia Museum of Art]

Violin and Guitar, Paris, early 1913, pasted cloth, oil, pencil, and plaster on canvas, 36 x 25 in. (oval) / Philadelphia Museum, Louise and Walter Arensberg Collection (ill. in cat.) [Z.II².363; Philadelphia Museum of Art]

Woman in an Armchair,* Paris, late 1913, oil on canvas, 58 1/4 x 39 in. / Mrs. Ingeborg Pudelko Eichmann, Florence (ill. in cat.) [Z.II¹.239; private collection]

Bird, late 1913, oil on canvas, 13 x 5 7/8 in. / private collection, New York (ill. in cat.)

Head, Paris, 1914?, charcoal and pasted papers on cardboard, 17 1/8 x 13 1/8 in. / Roland Penrose, London (ill. in cat.) [Z.II².414; private collection, London]

Still Life with Calling Card, Paris, 1914, pencil and pasted papers, 5 1/2 x 8 1/4 in. / Mrs. Gilbert W. Chapman, New York (ill. in cat.)

Pipe, Glass, Bottle of Rum,* Paris, 1914, pencil, gouache, and pasted papers on cardboard, 15 3/4 x 20 3/4 in. / Museum of Modern Art, gift of Mr. and Mrs. Daniel Saidenberg (ill. in cat.) [Z.II².787; Museum of Modern Art, New York]

Portrait of a Girl [current title: *Young Girl*], Avignon, 1914, oil on canvas, 51 1/4 x 38 1/8 in. / Georges A. Salles, Paris (ill. in cat.) [Z.II².528; Musée National d'Art Moderne, Centre National d'Art et de Culture Georges Pompidou, Paris]

Harlequin, Paris, late 1915, oil on canvas, 72 1/4 x 41 3/8 in. / Museum of Modern Art, acquired through the Lillie P. Bliss Bequest (ill. in cat.) [Z.II².555; Museum of Modern Art, New York]

Head of a Young Man, Paris, 1915, oil on wood, 10 x 7 1/4 in. / Fine Arts Associates, New York (ill. in cat.) [Z.VI.1281; private collection, New York]

Ambroise Vollard, Paris, August 1915, pencil, 18 3/8 x 12 1/2 in. / Metropolitan Museum of Art, Whittelsey Fund (ill. in cat.) [Z.II².922; Metropolitan Museum of Art, New York]

Man with Pipe [current title: *Untitled (Man with a Moustache, Buttoned Vest, and Pipe, Seated in an Armchair), (Man with a Pipe)*],* Paris, 1915(?), oil on canvas, 51 1/4 x 35 1/4 in. / Art Institute of Chicago, gift of Mary L. Block in memory of Albert D. Lasker (ill. in cat.) [Z.II².564; Art Institute of Chicago / This and one other work were included out of chronological order, in an Addendum at the end of the catalogue.]

Bathers, Biarritz, 1918, pencil, 9 1/8 x 12 1/4 in. / Fogg Art Museum, Harvard University, Cambridge, Massachusetts, Meta and Paul J. Sachs Collection (ill. in cat.) [Z.III.233; Fogg Art Museum]

Fisherman, Biarritz, 1918, pencil, 13 3/4 x 10 in. (measurement by sight) / private collection, New York (ill. in cat.) [Z.III.250; private collection]

Pierrot and Harlequin, Paris, 1918, pencil, 10 1/4 x 7 1/2 in. / Art Institute of Chicago, given in memory of Charles B. Goodspeed by Mrs. Gilbert W. Chapman (ill. in cat.) [Z.III.135; Art Institute of Chicago]

Diaghilev and Selisburg, 1919, pencil, 24 7/8 x 18 7/8 in. / Pablo Picasso (ill. in cat.) [Z.III.301; Musée Picasso, Paris]

Three Ballerinas, Paris, 1919, pencil and charcoal, 23 1/8 x 17 3/8 in. / Pablo Picasso (ill. in cat.)

Two Peasants (Bride and Groom), Paris, 1919, conté crayon, 23 1/2 x 18 1/4 in. / Santa Barbara Museum of Art, gift of Wright Ludington (ill. in cat.) [Z.III.431; Santa Barbara Museum of Art]

Sleeping Peasants, Paris, 1919, gouache, 12 1/4 x 19 1/4 in. / Museum of Modern Art, New York, Mrs. John D. Rockefeller, Jr. Fund (ill. in cat.) [Z.III.371; Museum of Modern Art]

Page of Sketches, 1919, pencil, 12 1/2 x 8 5/8 in. / Mrs. Culver Orswell, Pomfret Center, Connecticut (ill. in cat.) [Fogg Art Museum, Harvard University, Cambridge, Massachusetts]

Two Ballet Dancers, London, summer 1919, pencil, 12 1/4 x 9 1/4 in. / Mr. and Mrs. Victor W. Ganz, New York (ill. in cat.) [Z.III.343]

The Rape, 1920, tempera on wood, 9 3/8 x 12 7/8 in. / Philip L. Goodwin, New York (ill. in cat.) [Z.IV.109; Museum of Modern Art, New York]

Pierrot and Harlequin, Juan-les-Pins, summer 1920, gouache, 10 1/8 x 7 3/4 in. / Mrs. Gilbert W. Chapman, New York (ill. in cat.) [Z.IV.69; National Gallery of Art, Washington, D.C.]

Nessus and Dejanira, Juan-les-Pins, September 12, 1920, pencil, 8 1/4 x 10 1/4 in. / Museum of Modern Art, acquired through the Lillie P. Bliss Bequest (ill. in cat.) [Z.VI.1394; Museum of Modern Art, New York]

Nessus and Dejanira with a Satyr, Juan-les-Pins, September 12, 1920, watercolor, 8 1/2 x 11 1/4 in. / private collection, New York (ill. in cat.)

[The anonymous lender was Paul Rosenberg.]

Study of a Hand, Paris, January 20, 1921, pastel, 8 1/8 x 12 1/2 in. / Nelson A. Rockefeller, New York [Z.IV.239]

Three Musicians,* Fontainebleau, summer 1921, oil on canvas, 80 x 74 in. / Philadelphia Museum of Art, A. E. Gallatin Collection (ill. in cat.) [Z.IV.332; Philadelphia Museum of Art]

Three Musicians, Fontainebleau, summer 1921, oil on canvas, 79 3/4 x 87 3/4 in. / Museum of Modern Art, New York, Mrs. Simon Guggenheim Fund (ill. in cat.) [Z.IV.331; Museum of Modern Art]

Four Bathers, 1921, tempera on wood, 4 x 6 in. / private collection, New York (ill. in cat.)

Mother and Child, 1921, oil on canvas, 56 1/2 x 64 in. / Art Institute of Chicago (ill. in cat.) [Z.IV.311; Art Institute of Chicago]

Nude Seated on a Rock, 1921, tempera on wood, 5 7/8 x 3 7/8 in. / Mr. and Mrs. James Thrall Soby, New Canaan, Connecticut (ill. in cat.) [Z.IV.309; Museum of Modern Art, New York]

Dr. Claribel Cone, July 14, 1922, pencil, 24 3/4 x 19 1/4 in. / Baltimore Museum of Art, Cone Collection (ill. in cat.) [Z.IV.362; Baltimore Museum of Art]

St. Servan, near Dinard, 1922, pencil, 16 1/8 x 11 1/8 in. (measurement by sight) / Mr. and Mrs. Justin K. Thannhauser, New York (ill. in cat.) [Z.IV.375; Solomon R. Guggenheim Museum, New York]

Standing Nude, 1922, oil on canvas, 10 1/4 x 8 1/2 in. / private collection, New York (ill. in cat.)

Standing Nude, Dinard, 1922, oil on wood, 7 1/2 x 5 1/2 in. / Wadsworth Atheneum, Hartford (ill. in cat.) [Z.IV.382; Wadsworth Atheneum]

Actor in Green, 1922, gouache on paper, 6 3/8 x 4 1/2 in. / Stephen C. Clark, New York (ill. in cat.)

The Race, Paris, 1922, tempera on wood, 12 7/8 x 16 1/4 in. / Pablo Picasso (ill. in cat.) [Z.IV.380; Musée Picasso, Paris]

Mandolin on a Table, Paris, 1922, oil on canvas, 31 7/8 x 39 3/8 in. / Mr. and Mrs. William B. Jaffe, New York (ill. in cat.)

By the Sea [current title: *Three Bathers*], Juan-les-Pins, summer 1920 (dated by error: "1923"), oil on wood, 32 x 39 1/2 in. / G. David Thompson, Pittsburgh (ill. in cat.) [Z.IV.169]

The Pipes of Pan, 1923, oil on canvas, 80 1/2 x 68 5/8 in. / Pablo Picasso (ill. in cat.) [Z.V.141; Musée Picasso, Paris]

Paul as Harlequin, 1924, oil on canvas, 51 1/8 x 38 1/8 in. / Pablo Picasso (ill. in cat.) [Z.V.178; Musée Picasso, Paris]

Harlequin with Guitar, 1924, oil on canvas, 51 1/4 x 38 1/4 in. / Mr. and Mrs. Leigh B. Block, Chicago (ill. in cat.) [Z.V.328; National Gallery of Art, Washington, D.C.]

The Red Tablecloth, Paris, December 1924, oil on canvas, 38 3/4 x 51 3/8 in. / private collection, New York (ill. in cat.) [Z.V.364; private collection, New York / The anonymous lender was Paul Rosenberg.]

Paul as Pierrot, February 1925, oil on canvas, 51 1/8 x 38 1/8 in. / Pablo Picasso (ill. in cat.) [Z.V.374; Musée Picasso, Paris]

Ram's Head, Juan-les-Pins, summer 1925, oil on canvas, 32 1/8 x 39 1/2 in. / private collection, New York (ill. in cat.) [Z.V.443; Norton Simon Museum, Pasadena, California]

Three Dancers, 1925, oil on canvas, 84 5/8 x 56 1/4 in. / Pablo Picasso (ill. in cat.) [Z.V.426; Tate Gallery, London]

Guitar, 1926, canvas with string, pasted paper, oil paint, and cloth with two-inch nails (points out), 51 1/4 x 38 1/4 in. / Pablo Picasso (ill. in cat.) [Z.VII.9; Musée Picasso, Paris]

Head, 1927, oil and plaster on canvas, 39 1/4 x 31 3/4 in. / Art Institute of Chicago, gift of Mr. and Mrs. Samuel A. Marx (ill. in cat.) [Z.VII.118; Art Institute of Chicago]

Seated Woman, 1927, oil on wood, 51 1/8 x 38 1/4 in. / Mr. and Mrs. James Thrall Soby, New Canaan, Connecticut (ill. in cat.) [Z.VII.77; Museum of Modern Art, New York]

Figure,* 1927, oil on wood, 51 1/8 x 38 1/8 in. /

Pablo Picasso (ill. in cat.) [Z.VII.137; Musée Picasso, Paris]

Painter and Model, 1928, oil on canvas, 51 5/8 x 63 7/8 in. / Mr. and Mrs. Sidney Janis, New York (ill. in cat.) [Z.VII.143; Museum of Modern Art, New York]

Running Monster, April 1928, oil on canvas, 63 3/4 x 51 1/4 in. / Pablo Picasso (ill. in cat.)

Bather and Cabin, Dinard, August 9, 1928, oil on canvas, 8 1/2 x 6 1/4 in. / Museum of Modern Art, New York, Hillman Periodicals Fund (ill. in cat.) [Z.VII.211; Museum of Modern Art, New York]

Figure by the Sea, April 7, 1929, oil on canvas, 51 x 38 in. / Florene and Samuel Marx, Chicago (ill. in cat.) [Z.VII.252; Metropolitan Museum of Art, New York]

Woman in an Armchair, May 5, 1929, oil on canvas, 76 3/4 x 51 1/4 in. / Pablo Picasso (ill. in cat.)

Seated Bather, early 1930, oil on canvas, 64 1/4 x 51 in. / Museum of Modern Art, New York, Mrs. Simon Guggenheim Fund (ill. in cat.) [Z.VII.306; Museum of Modern Art, New York]

Crucifixion, Paris, February 7, 1930, oil on wood, 20 x 26 in. / Pablo Picasso (ill. in cat.) [Z.VII.287; Musée Picasso, Paris]

By the Sea, Juan-les-Pins, August 22, 1930, sand over cardboard plaster and canvas, 10 5/8 x 13 3/4 in. / Pablo Picasso (ill. in cat.)

Pitcher and Bowl of Fruit, Paris, February 22, 1931, oil on canvas, 51 1/2 x 63 in. / Nelson A. Rockefeller, New York (ill. in cat.) [Z.VII.322; Solomon R. Guggenheim Museum, New York]

Still Life on a Table, March 11, 1931, oil on canvas, 76 3/4 x 51 5/8 in. / Pablo Picasso (ill. in cat.) [Z.VII.317; Musée Picasso, Paris]

Nude on a Black Couch, Paris, March 9, 1932, oil on canvas, 63 3/4 x 51 1/4 in. / Mrs. Meric Callery, New York (ill. in cat.) [Z.VII.377]

Girl before a Mirror, Paris, March 14, 1932, oil on canvas, 63 3/4 x 51 1/4 in. / Museum of Modern Art, gift of Mrs. Simon Guggenheim (ill. in cat.) [Z.VII.379; Museum of Modern Art, New York]

Bather Playing Ball, Boisgeloup, August 30, 1932, oil on canvas, 57 1/2 x 45 in. / Pablo Picasso (ill. in cat.) [Z.VIII.147]

Design for Sculpture, 1932, crayon on canvas, 36 3/8 x 28 3/4 in. / G. David Thompson, Pittsburgh (ill. in cat.) [Collection Ernst Beyeler, Basel]

The Minotaur, Boisgeloup, June 24, 1933, pen and ink wash, 18 7/8 x 24 3/4 in. / Sylvester W. Labrot Jr., Hobe Sound, Florida (ill. in cat.) [Z.VIII.112; Art Institute of Chicago]

Sculptor and His Statue, Cannes, July 20, 1933, gouache and ink, 15 3/8 x 19 3/8 in. (measurement by sight) / private collection, New York (ill. in cat.) [Z.VIII.120; private collection, Switzerland]

The Balcony, Cannes, August 1, 1933, watercolor and ink, 15 3/4 x 19 7/8 in. / Mrs. Louise Smith, New York (ill. in cat.)

"Minotaure" (design for a magazine cover), 1933, pencil drawing with pasted papers, and cloth tacked on wood, 19 1/8 x 16 1/8 in. / private collection, New York (ill. in cat.)

Man Ray, Paris, January 3, 1934, pen and ink wash, 13 5/8 x 9 3/4 in. / Clifford Odets, Beverly Hills (ill. in cat.) [Z.VIII.165; Paul Kantor, Beverly Hills]

Study for illustrations to "Lysistrata," Paris, January 11, 1934, brush and ink, 14 1/4 x 19 7/8 in. / Mrs. Meric Callery, New York [Z.VIII.160]

Bullfight,* Boisgeloup, September 9, 1934, oil on canvas, 13 x 16 1/8 in. / Henry P. McIlhenney, Philadelphia (ill. in cat.) [Z.VIII.233; Philadelphia Museum of Art]

Woman with Hat, Paris, 1935, oil on canvas, 30 x 24 1/2 in. / Georges A. Salles, Paris (ill. in cat.)

Harlequin (project for a monument), Paris, March 10, 1935, oil on canvas, 24 1/4 x 20 in. / Room of Contemporary Art Collection, Albright Art Gallery, Buffalo (ill. in cat.) [Albright-Knox Art Gallery]

Reclining Nude, Paris, August 12–October 2, 1936, oil on canvas, 51 1/4 x 63 3/4 in. / private collection, Paris (ill. in cat.)

Portrait of D.M., Paris, November 19, 1936, oil on canvas, 25 1/4 x 21 1/4 in. / Mme. Marie Cuttoli, Paris (ill. in cat.)

Fruit Dish and Pitcher, Paris, January 21, 1937, oil on canvas, 20 x 24 in. / Justin K. Thannhauser, New York (ill. in cat.) [Z.VIII.329; Solomon R. Guggenheim Museum, New York / This and one other work were included out of chronological order, in an Addendum at the end of the catalogue.]

Guernica, Paris, May–early June 1937, oil on canvas, 11 ft. 5 1/2 in. x 25 ft. 5 3/4 in. / extended loan by the artist to the Museum of Modern Art, New York (ill. in cat.) [Z.IX.65; Museo Nacional Centro de Arte Reina Sofía, Madrid]
[The exhibition also included fifty-eight studies and "postscripts" for *Guernica* (listed on pages 75–78 in that catalogue, three of them reproduced). I have omitted them here.]

Weeping Woman, Paris, October 26, 1937, oil on canvas, 23 1/2 x 19 1/4 in. / Roland Penrose, London (ill. in cat.) [Z.IX.73; Tate Gallery, London]

Maia with a Sailor Doll, Paris, January 16, 1938, oil with canvas, 28 3/4 x 23 5/8 in. / Pablo Picasso (ill. in cat.)

Girl with Cock, Paris, February 15, 1938, oil on canvas, 57 1/4 x 47 1/2 in. / Mrs. Meric Callery, New York (ill. in cat.) [Z.IX.109; private collection, Switzerland]

Cock, Paris, March 29, 1938, pastel, 30 1/2 x 21 1/4 in. / Mr. and Mrs. Ralph F. Colin, New York (ill. in cat.) [Z.IX.113; private collection]

Three Women, Mougins, August 10, 1938, pen and ink wash, 17 1/2 x 26 5/8 in. / Mrs. Meric Callery, New York (ill. in cat.)

Man with Lollipop, Mougins, August 20, 1938, oil on paper on canvas, 26 7/8 x 18 in. / Edward A. Bragaline, New York (ill. in cat.) [Z.IX.203; Metropolitan Museum of Art, New York]

Still Life with Black Bull's Head, Paris, November 19, 1938, oil on canvas, 38 1/4 x 51 1/4 in. / Colonel Valdemar Ebbesen, Oslo (ill. in cat.) [Z.IX.240; Menard Art Museum, Aichi, Japan]

Still Life with Red Bull's Head, Paris, November 26, 1938, oil on canvas, 37 3/4 x 51 in. / Mr. and Mrs. William A. M. Burden, New York (ill. in cat.) [Z.IX.239; Museum of Modern Art, New York]

Still Life, Paris, February 4, 1939, oil on canvas, 13 x 18 in. / Dr. Herschel Carey Walker, New York (ill. in cat.)

Portrait of D.M., Paris, April 1, 1939, oil, 36 x 28 in. / Mlle Dora Maar, Paris (ill. in cat.) [Z.IX.282; Mrs. Lindy Bergman]

Night Fishing at Antibes, August 1939, oil on canvas, 6 ft. 9 in. x 11 ft. 4 in. / Museum of Modern Art, New York, Mrs. Simon Guggenheim Fund (ill. in cat.) [Z.IX.316; Museum of Modern Art, New York]

Jaime Sabartés, Royan, October 22, 1939, oil on canvas, 23 3/4 x 18 in. / Jaime Sabartés, Paris (ill. in cat.) [Z.IX.366]

Portrait of D.M., Royan, December 30, 1939, gouache, 18 1/8 x 15 in. / André Lefèvre, Paris (ill. in cat.)

Woman Dressing Her Hair, Royan, March 6, 1940 (as dated on stretcher, but possibly early June 1940), oil on canvas, 51 x 38 1/8 in. / Pablo Picasso (ill. in cat.) [Z.X.302; Museum of Modern Art, New York]

Still Life with Sausage, Paris, May 10, 1941, oil on canvas, 35 x 25 1/2 in. / Mr. and Mrs. Victor W. Ganz, New York (ill. in cat.) [Z.XI.112; Tony and Gail Ganz]

Serenade (L'Aubade), Paris, May 4, 1942, oil on canvas, 6 ft. 4 3/4 in. x 8 ft. 8 1/4 in. / Musée National d'Art Moderne, Paris (ill. in cat.) [Z.XII.69; Musée National d'Art Moderne, Centre National d'Art et de Culture Georges Pompidou]

Woman in Gray,* Paris, August 6, 1942, oil on canvas [actual support: panel], 39 1/4 x 31 7/8 in. / Mr. and Mrs. Alex L. Hillman, New York (ill. in cat.) [Z.XIII.50; Alex Hillman Family Foundation Collection]

Portrait of D.M., Paris, October 9, 1942, oil on canvas, 36 1/4 x 28 3/4 in. / Mlle Dora Maar, Paris (ill. in cat.) [Z.XII.154; Stephen Hahn, New York]

First Steps, Paris, May 21, 1943, oil on canvas,

51 1/4 x 38 1/4 in. / Stephen C. Clark, New York (ill. in cat.) [Z.XIII.36; Yale University Art Gallery, New Haven, Connecticut]

The Striped Bodice, Paris, September 20, 1943, oil on canvas, 40 x 32 1/2 in. / Nelson A. Rockefeller, New York (ill. in cat.) [Z.XIII.109]

Woman in Green, 1943, oil on canvas, 51 x 38 in. / private collection, New York (ill. in cat.)

Still Life with Candle, Paris, April 4, 1944, oil on canvas, 23 5/8 x 36 1/4 in. / Jacques Sarlie, New York (ill. in cat.)

Woman Washing Her Feet, Paris, May 6, 1944, pencil, 19 7/8 x 15 1/8 in. / Art Institute of Chicago, bequest of Curt Valentin (ill. in cat.) [Z.XIII.291; Art Institute of Chicago]

Woman Washing Her Feet, Paris, July 10, 1944, brush and ink, 20 x 13 1/4 in. / Museum of Modern Art, New York (ill. in cat.) [Museum of Modern Art]

Still Life, Paris, July 20, 1944, oil on canvas, 15 x 18 1/2 in. / private collection (ill. in cat.)

Tomato Plant, Paris, August 3, 1944, oil on canvas, 28 3/4 x 36 1/4 in. / Guennol Collection, New York (ill. in cat.) [Z.XIV.23]

Young Boy, Paris, August 13–15, 1944, ink and wash, 19 1/2 x 11 1/8 in. [measurement by sight] / Florene and Samuel Marx, Chicago (ill. in cat.) [Museum of Modern Art, New York]

Burning Logs, Paris, January 4, 1945, pen and ink with crayon, 19 1/2 x 23 1/2 in. / Mr. and Mrs. Walter Bareiss, Greenwich, Connecticut (ill. in cat.) [Z.XIV.59; Museum of Modern Art, New York]

Paris: Notre Dame, March 1, 1945, oil on canvas, 21 1/4 x 32 in. / Herbert and Nannette Rothschild, New York, courtesy Perls Galleries (ill. in cat.)

Seated Woman, 1946, oil on canvas, 51 x 35 in. / Mr. and Mrs. Victor W. Ganz, New York (ill. in cat.) [Z.XV.13]

Pastoral, Ménerbes, July 22, 1946, gouache on paper, 19 3/4 x 25 3/4 in. / Mr. and Mrs. Richard Deutsch, Greenwich, Connecticut (ill. in cat.; not shown in Chicago)

Nymph and Fauns, Antibes, 1946, pencil and watercolor, 19 3/4 x 25 7/8 in. / Herbert Hemphill, Jr., New York (ill. in cat.)

The Mirror, June 23, 1947, oil on canvas, 24 x 19 5/8 in. / Mr. and Mrs. William A. M. Burden, New York (ill. in cat.) [Z.XV.74]

Claude in Polish Costume, Vallauris, October 23, 1948, oil on canvas, 47 5/8 x 19 5/8 in. / Pablo Picasso (ill. in cat.) [Z.XV.101; Marina Picasso Foundation]

The Kitchen, Vallauris, November 9, 1948, oil on canvas, 68 7/8 x 98 3/8 in. / Pablo Picasso (ill. in cat.) [Z.XV.106; Museum of Modern Art, New York]

Claude and Paloma, Vallauris, January 20, 1950, oil on wood, 45 3/4 x 35 in. / Pablo Picasso (ill. in cat.)

Paloma Playing, Vallauris, February 2, 1950, oil on wood, 49 1/4 x 40 1/8 in. / Pablo Picasso (ill. in cat.)

Portrait of a Painter, after El Greco, Vallauris, February 22, 1950, oil on wood, 40 x 32 1/4 in. / Siegfried Rosengart, Lucerne (ill. in cat.) [Z.XV.165]

Winter Landscape, Vallauris, December 22, 1950, oil on wood, 40 1/2 x 49 1/2 in. / Mr. and Mrs. Victor W. Ganz, New York (ill. in cat.)

Chimneys of Vallauris, January 12, 1951, oil on canvas, 23 5/8 x 28 3/4 in. / Pablo Picasso (ill. in cat.)

Sport of Pages (or *The Knight*), Vallauris, February 24, 1951, oil on canvas, 18 1/8 x 24 in. / Pablo Picasso (ill. in cat.)

Mme H.P., Vallauris, July 30, 1952, oil on wood, 53 1/2 x 41 3/8 in. / Pablo Picasso (ill. in cat.)

Mme H.P., October 4, 1952, oil on wood, 57 1/2 x 37 3/4 in. / Pablo Picasso (ill. in cat.) [Z.XV.215]

Paloma Asleep, Vallauris, December 28, 1952, oil on wood, 44 7/8 x 57 1/2 in. / Pablo Picasso (ill. in cat.) [Z.XV.233]

The Reader, Vallauris, January 29, 1953, oil on wood, 36 1/4 x 28 5/8 in. / Art Institute of Chicago, gift of Mr. and Mrs. Arnold H. Maremont through Kate Maremont Foundation (ill. in cat.)

Chinese Commode, March 22, 1953, oil on canvas, 57 1/2 x 45 in. / Saidenberg Gallery, New York (ill. in cat.)

The Studio (Painter and Model), December 24, 1953, brush and ink, 12 5/8 x 9 1/2 in. / Mr. and Mrs. Morton G. Neumann, Chicago (ill. in cat.)

The Studio (Circus), January 10, 1954, brush and ink, 9 1/2 x 12 5/8 in. / private collection, New York (ill. in cat.)

The Studio (Visit), January 17, 1954, brush and ink, 9 1/2 x 12 5/8 in. / Nelson A. Rockefeller, New York (ill. in cat.)

The Studio (The Lady Painter), January 21, 1954, brush and ink, 9 1/2 x 12 5/8 in. / Mr. and Mrs. Daniel Saidenberg, New York (ill. in cat.)

The Studio (Models), January 21, 1954, brush and ink, 9 1/2 x 12 5/8 in. / Nelson A. Rockefeller, New York (ill. in cat.)

The Studio (King and Model), February 1, 1954, crayon, 9 1/2 x 12 5/8 in. / Mr. and Mrs. Daniel Saidenberg, New York (ill. in cat.)

Portrait of J.R. with Roses, Vallauris, June 2, 1954, oil on canvas, 39 3/8 x 31 7/8 in. / Pablo Picasso (ill. in cat.) [Z.XVI.325]

The Women of Algiers, After Delacroix (all works on canvas):

A. December 13, 1954, 23 5/8 x 28 3/4 in. / Dr. Herschel Carey Walker, New York (ill. in cat.)

B. December 13, 1954, 23 5/8 x 28 3/4 in. / Mr. and Mrs. Wilbur D. May, Reno [private collection]

C. December 28, 1954, 21 1/4 x 25 5/8 in. / Mr. and Mrs. Victor W. Ganz, New York (ill. in cat.)

D. January 1, 1955, 18 1/8 x 21 5/8 in. / Paul Rosenberg & Co., New York

E. January 16, 1955, 18 1/8 x 21 5/8 in. / Mr. and Mrs. Wilbur D. May, Reno (ill. in cat.) [Z.XVI.347; San Francisco Museum of Modern Art]

F. January 17, 1955, 21 1/4 x 25 5/8 in. / Mr. and Mrs. Daniel Saidenberg, New York (ill. in cat.)

G. January 18, 1955, 25 5/8 x 21 1/4 in. / Saidenberg Gallery, New York (ill. in cat.) [Z.XVI.349]

H. January 24, 1955, 51 1/8 x 63 3/4 in. / Mr. and Mrs. Victor W. Ganz, New York (ill. in cat.) [Z.XVI.356]

I. January 25, 1955, 38 1/8 x 51 1/8 in. / Paul Rosenberg & Co., New York [Norton Simon Museum, Pasadena, California]

J. January 26, 1955, 44 7/8 x 57 1/2 in. / Paul Rosenberg & Co., New York

K. February 6, 1955, 51 1/8 x 63 3/4 in. / Mr. and Mrs. Victor W. Ganz, New York (ill. in cat.) [Z.XVI.354]

L. February 9, 1955, 51 1/8 x 38 1/8 in. / Paul Rosenberg & Co., New York (ill. in cat.) [private collection, Washington, D.C.]

M. February 11, 1955, 51 1/4 x 76 3/4 in. / Mr. and Mrs. Victor W. Ganz, New York (ill. in cat.) [Z.XVI.357]

N. February 13, 1955, 44 7/8 x 57 1/2 in. / Paul Rosenberg & Co., New York (ill. in cat.)

O. [Final version] February 14, 1955, 44 7/8 x 57 1/2 in. / Mr. and Mrs. Victor W. Ganz, New York (ill. in cat. in color, p. 9) [Z.XVI.360; private collection]

The Studio, October 24, 1955, oil on canvas, 75 3/4 x 29 3/4 in. / Saidenberg Gallery, New York (ill. in cat.)

Seated Woman in Turkish Costume, Cannes, November 22, 1955, oil on canvas, 36 1/4 x 28 3/4 in. / private collection, New York (ill. in cat.)

Woman in Rocking Chair, Cannes, March 25, 1956, oil on canvas, 75 3/4 x 51 1/4 in. / Galerie Louise Leiris, Paris (ill. in cat.)

The Studio, Cannes, April 2, 1956, oil on canvas, 35 x 45 5/8 in. / anonymous loan (ill. in cat.)

Bullfight, Cannes, May 19, 1956, oil on canvas, 19 5/8 x 24 in. / Mr. and Mrs. Daniel Saidenberg, New York (ill. in cat.)

Jardinière with Ferns, Cannes, June 5, 1956, oil on canvas, 63 3/4 x 51 1/8 in. / Galerie Louise Leiris, Paris (ill. in cat.)

Woman by a Window, Cannes, June 11, 1956, oil on canvas, 59 x 47 1/4 in. / anonymous loan (ill. in cat.)

NOTES ON SOURCES FOR THE CHRONOLOGY

At the beginning of William Rubin's catalogue for the 1996 exhibition *Picasso and Portraiture: Representation and Transformation* at the Museum of Modern Art, a prefatory note about the titles of Picasso's works ("Notes on Titles and References," p. 11) explains the confusion surrounding this topic:

> Picasso never gave formal titles to his pictures. In exhibitions of his work arranged with his participation, the titles used, like the overwhelming majority of those he provided to the cataloguer of his oeuvre, Christian Zervos, were generic descriptions (*Seated Woman, Man Leaning on a Table*, etc.). . . . Since the 1920s, critics, biographers, museum curators, and even collectors have had a hand in inventing or reinventing titles for Picasso's pictures. Some of these have survived; many have not. It is not unusual to find half a dozen variant titles for the same well-known picture in different publications.

To assist the reader with the identification of the works listed in the Chronology, particularly those that appeared in a catalogue where they were given a generic title such as *Abstraction* or *Painting*, I have included in the listings, whenever possible, the "current title" of a work as it has been given by the institution that now owns it, or as it appears in the catalogue to MoMA's 1980 Picasso retrospective or the 1996 catalogue just cited. These current titles appear within brackets, immediately following the title as it was originally given in an exhibition list (i.e., the museum or gallery checklist, or a listing from a museum registrar, a museum archive, or a contemporaneous article about the exhibition).

Moreover, when the date given in a catalogue or checklist differs significantly from the date that is generally associated with a work (usually because of a typographical error), I have provided the "actual date" within brackets, immediately following the originally listed date. I have also done this for works where the date that was given differs from the one later assigned by the museum that acquired it, as this revised date is currently regarded as the accepted date for the work, and is also used in the captions for the figures and plates of some of the works by Picasso in the present catalogue.

In addition to the many references cited in the source notes below, the following publications were extremely useful in identifying current locations and Zervos reference numbers for particular works:

Steven A. Nash, ed., *Picasso and the War Years: 1939–1945*, exh. cat. (New York: Thames and Hudson, in association with the Fine Arts Museums of San Francisco, 1998)

William Rubin, ed., *Pablo Picasso: A Retrospective*, exh. cat. (New York: Museum of Modern Art, 1980)

William Rubin, ed., *Picasso and Portraiture: Representation and Transformation*, exh. cat. (New York: Museum of Modern Art, 1996)

Christian Zervos, *Pablo Picasso* (Paris: Cahiers d'art; New York: E. Weyhe, 1932–78), 33 vols.

For some exhibitions, I have noted that the exhibition "included at least one work by Picasso, although no specific titles of works have been identified." Where I do not name a specific source for this information, it has usually been a printed mailer card on which Picasso's name was included among the roster of artists in the show, sent by the gallery to its clientele to announce the exhibition. Occasionally, a magazine advertisement for an exhibition provided the dates and title of the show and its general contents, but, as in the gallery's mailer card, no specific titles of works were mentioned.

Provided below are the modern sources or contemporaneous reviews on which I have relied for information about works that are known to have appeared in the exhibitions listed in the preceding Chronology but for which gallery or museum checklists do not exist (or have not been found). These are keyed to the dates and venues of the exhibitions as they appear in the Chronology.
—J.M.B.

March 28–May 1911: 291, Little Galleries of the Photo-Secession, New York
Charles Brock, "Pablo Picasso, 1911: An Intellectual Cocktail," in *Modern Art and America: Alfred Stieglitz and His New York Galleries*, exh. cat. (Washington, D.C.: National Gallery of Art; Boston, New York, and London: Little Brown and Company/Bullfinch Press, 2000), pp. 117–24. Note: Alfred Stieglitz opened the Little Galleries of the Photo-Secession at 291 Fifth Avenue in 1905, which soon became known simply as 291. Although it was also referred to as the Little Galleries or the Photo-Secession Gallery, 291 is the most familiar name; it is the only name used throughout the Chronology for all references to this venue. Besides the gallery, there was a magazine called *291*, published by Stieglitz from March 1915 to February 1916, which also appears in some of the entries.

February 17–March 15, 1913: 69th Infantry Regiment Armory, New York
The dates for five of the works, and the mediums for two of them, are from Milton W. Brown, *The Story of the Armory Show* (New York: Abbeville Press, 1988), pp. 301–2.

December 1913: Bellevue-Stratford Hotel, Philadelphia
W. W. Scott, "The Artistic Vanguard in Philadelphia, 1905–1920" (Ph.D. diss., University of Delaware, 1983), pp. 178, 219 (n. 44). The one work by Picasso is listed there as *Les Arbres*, 1907.

Summer 1914: Washington Square Gallery, New York
Judith Katy Zilczer, "Chronology of Exhibitions in New York: 1908–1918," in "The Aesthetic Struggle in America, 1913–1918: Abstract Art and Theory in the Stieglitz Circle" (Ph.D. diss., University of Delaware, 1975), p. 248; and idem., "Robert J. Coady, Forgotten Spokesman for Avant-Garde Culture in America," *American Art Review* 2 (November–December 1975): 79.

December 9, 1914–January 11, 1915: 291, New York
Pepe Karmel, "Pablo Picasso and Georges Braque, 1914–1915: Skeletons of Thought," in *Modern Art and America* (see March 1911 above), pp. 185–201.

December 20, 1914–January 9, 1915: Carroll Galleries, New York
[Anon.], "Exhibitions Now On: Cubists at the Carroll Galleries," *American Art News* 13, no. 12 (December 26, 1914): 3.

January 12–26, 1915: 291, New York
Karmel, "Picasso and Braque: Skeletons of Thought"

(see December 9, 1914, above), pp. 188, 504 (n. 10), and 505 (n. 11).

Late winter–early spring 1915: Washington Square Gallery, New York
Marius de Zayas, *How, When and Why Modern Art Came to New York*, ed. Francis M. Naumann (Cambridge, Mass., and London: M.I.T. Press, 1996), p. 71; and unpublished letter between Picasso and Michael Brenner, owner of Washington Square Gallery, in the archives of the Musée Picasso, Paris. My thanks to Michael FitzGerald for alerting me to this letter.

October 7, 1915–November 13, 1915: Modern Gallery, New York
De Zayas, *How, When and Why* (see preceding entry), Appendix A: "Exhibitions at the Modern and De Zayas Galleries," p. 134.

December 13, 1915–January 3, 1916: Modern Gallery, New York
Appendix A, "Exhibitions at the Modern and De Zayas Galleries," in de Zayas, *How, When and Why*, ed. Francis M. Naumann (see late winter 1915 above), p. 135. Note that I have given the current titles for the works that were listed as nos. 5 and 6 in the exhibition; de Zayas had titled no. 5 *Nature morte dans un jardin* and no. 6 *Nature morte* (ibid., p. 135). It is probable, but not certain, that the latter was actually *Untitled (Man with a Moustache, Buttoned Vest, and Pipe, Seated in an Armchair)*, Z.II².564. It is reproduced by Naumann in *How, When and Why*, p. 30, as ill. no. 37, with the title *Man in a Bowler Hat, Seated in an Armchair*, and Naumann, in a conversation with Michael FitzGerald, told him that his analysis of the de Zayas archives convinced him that the painting was included in this exhibition (FitzGerald, e-mail to the author, April 19, 2006).

February 12–March 1, 1916: Modern Gallery, New York
De Zayas, *How, When and Why* (see late winter 1915 above), p. 138.

March–April 1916: Washington Square Gallery, Washington, D.C.
Zilczer, "Robert J. Coady, Forgotten Spokesman" (see summer 1914 above), p. 80.

April 29–June 10, 1916: Modern Gallery, New York
De Zayas, *How, When and Why* (see late winter 1915 above), p. 140.

May 17–June 15, 1916: McClees Galleries, Philadelphia
Scott, "Artistic Vanguard in Philadelphia" (see December 1913 above), pp. 193–94.

September 11–30, 1916: Modern Gallery, New York
De Zayas, *How, When and Why* (see late winter 1915 above), p. 140.
[Anon.], "At the Modern Gallery," *American Art News* 14, no. 38 (September 16, 1916): 5.

April 10–May 6, 1917: Grand Central Palace, New York
The original catalogue for this exhibition could not be located. For information about the pieces exhibited, I relied instead on the definitive book on the Society of Independent Artists: Clark S. Marlor, *The Society of Independent Artists: The Exhibition Record, 1917–1944* (Park Ridge, N.J.: Noyes Press, 1984), p. 440.

June 9–30, 1917: Modern Gallery, New York
[Anon.], "Drawings at Modern Gallery," *American Art News* 15, no. 34 (June 16, 1917): 3.

Through December 29, 1917: Cosmopolitan Club, New York
Title and date of exhibition provided by the archivist at the Cosmopolitan Club, New York, in conversation with the author, December 15, 2003. The quote about Picasso's *Still Life* is from [Anon.], "'Moderns' in a Club Show," *American Art News* 16, no. 12 (December 29, 1917): 3.

March 11–30, 1918: Modern Gallery, New York
De Zayas, *How, When and Why* (see late winter 1915 above), p. 152.

April 20–May 12, 1918: Society of Independent Artists, New York
Marlor, *Society of Independent Artists* (see April 1917 above), p. 440.

April 22–May 3, 1918: Anderson Galleries, New York
Information about the sale of *Still Life* to Quinn is from Judith Zilczer, *"The Noble Buyer": John Quinn, Patron of the Avant-Garde*, exh. cat. (Washington, D.C.: Smithsonian Institution Press, 1978), p. 130.

December 14–31, 1919: De Zayas Gallery, New York
[Anon.], "'Modern' Art at Zayas Gallery," *American Art News* 18, no. 10 (December 27, 1919): 3.

April 17–May 9, 1920: Pennsylvania Academy of the Fine Arts, Philadelphia
The contemporaneous list of works in this exhibition specified the medium for only a few watercolors; I obtained information about the mediums of several more of the works (noted in brackets in the Chronology) from Cheryl Leibold, archivist at the Pennsylvania Academy of the Fine Arts, letter to the author, August 11, 2004.

August 2–September 11, 1920: Galleries of the Société Anonyme, New York
"Exhibitions and Loans by the Société Anonyme, 1920–39," in Robert L. Herbert, Eleanor S. Apter, and Elise K. Kenney, eds., *The Société Anonyme and the Dreier Bequest at Yale University: A Catalogue Raisonné* (New Haven: Yale University Press, 1984), p. 776.

December 15, 1920–February 1, 1921: Galleries of the Société Anonyme, New York
"Exhibitions and Loans by the Société Anonyme, 1920–39" (see preceding entry), p. 776.

February 8–14, 1921: Brooklyn Museum, New York
The dates of this little-documented, preliminary exhibition of the Kelekian collection are from "French Art Exhibition," *Bulletin of the Brooklyn Institute of Arts and Sciences* 25, no. 11 (March 26, 1921): 161; the contents of the exhibition were determined from shipping lists and correspondence from Kelekian to the museum found in the archives at the Brooklyn Museum. Information about the dimensions of the watercolor *Still Life* is from the catalogue of the Kelekian collection sale in 1922 at the American Art Association, New York ("The Notable Collection of Modern French Pictures formed by and belonging to the widely known antiquarian Dikran Khan Kelekian of Paris and New York," January 24–30, 1922), lot 32.

May 2–September 5, 1921: Metropolitan Museum of Art, New York
Because the Metropolitan Museum of Art had a strict policy against dealers lending work to exhibitions, Kelekian's loans in this exhibition were required to appear in the catalogue as "anonymous loans." It is known that *Landscape* and *Woman with a Cape* were lent by Kelekian because they were in the two Brooklyn Museum exhibitions of the modern works in his collection, held February 8–14, 1921, and March 26–April 1921 (where *Woman with a Cape* was titled *Portrait of a Young Girl*), and were sold as part of his collection in the auction at the Anderson Galleries, January 30–31, 1922, lots 57 and 141.

June–July 1921: Louis Bouché, "Art Activities in Post War Paris"
Information about Quinn's ownership of this *Still Life* at that time is from Zilczer, *"The Noble Buyer"* (see April 22, 1918, above), p. 131.

November 21–December 12, 1921: Arts Club of Chicago
Information about de Zayas being the owner of *Arrangement* at that time is from a handwritten note in the copy of the exhibition catalogue in the archives of the Arts Club of Chicago, Arts Club Records, Midwest Manuscript Collection, Newberry Library, Chicago.

November 22–December 17, 1921: Belmaison Gallery at Wanamaker's Department Store, New York
The date and title of the exhibition are from [Anon.], "Wanamaker's Plans Big Modernist Show," *American Art News* 20, no. 5 (November 12, 1921): 3. The quote about the work is from [Anon.], "Modernist Art at Wanamaker's," *American Art News* 20, no. 7 (November 26, 1921): 1.

January 24–30, 1922: American Art Association, New York
The works that sold in this auction and the names of the winning bidders are from the post-sale news report, "Cézanne Leads the French Modernists," *New York Times*, February 1, 1922, p. 27. Regarding the names of the buyers of three works purchased for them by agents in this sale: for *Nature morte* (lot 32), the source is Michael FitzGerald, in chapter 2 of the present volume (p. 73); for *Green Still Life* (lot 75), the source is MoMA's "Provenance Research Project," at www.moma.org/collection/provenance; and for *Landscape with Dead and Live Trees* (lot 141), the source is Zilczer, *"The Noble Buyer"* (see April 22, 1918, above), p. 177.

January 28–February 28, 1922: Daniel Galleries, New York
[Anon.], "Current Shows in New York Galleries: Modern French Drawings," *American Art News* 20, no. 19 (February 18, 1922): 8.

March 9–31, 1922: Belmaison Gallery at Wanamaker's Department Store, New York
[Anon.], "Current Shows in New York Galleries: Modern Paintings–Arnoux Drawings," *American Art News* 20, no. 23 (March 18, 1922): 2.

March 24–April 10, 1922: Sculptor's Gallery, New York
[Anon.], "Current Shows in New York Galleries: Contemporary French Art," *American Art News* 20, no. 25 (April 1, 1922): 6.

March 20–April 22, 1923: Art Institute of Chicago: Arts Club Exhibitions at the Art Institute of Chicago
The mediums for these works, given in brackets in the Chronology, are from a typed checklist that included prices and insurance values and is part of the Arts Club Records, Midwest Manuscript Collection, Newberry Library, Chicago.

May 1923: Whitney Studio Galleries, New York
A list for the works shown at the Whitney Studio Galleries was provided by Michael FitzGerald, e-mail to the author, October 10, 2005. The fact that the exhibition continued at a different venue is from [Anon.], "The Exhibitions: The Salons of America," *The Arts* 3, no. 6 (June 1923): 427–28.

ca. April 12, 1924: Brooklyn Museum, New York
[Anon.], "Brooklyn Museum Is Lent Fine Works: Albert E. Gallatin's Collection of Modern Paintings, Pastels and Water Colors Will Be Shown," *Art News* 22, no. 27 (April 12, 1924): 3.

September 8–October 8, 1925: Art Institute of Chicago
Although no catalogue for this exhibition exists, *The Old Guitarist* was in the Birch-Bartlett collection by the fall of 1925, and I am assuming that it would have been included in the exhibition.

February 22–March 13, 1926: Ferargil Galleries, New York
Bennard B. Perlman, *The Lives, Loves and Art of Arthur B. Davies* (Albany: State University of New York Press, 1998), p. 341. *Landscape (Two Trees)*, 1908, gouache, was listed as *Trees* in this publication.

March 1926: Brummer Galleries, New York
The titles of the works are from [Anon.], "Brummer Shows New Quinn Selection," *Art News* 24, no. 23 (March 13, 1926): 3.

June 12–October 14, 1926: Brooklyn Museum, New York
No checklist for this exhibition exists; information for these works is from the archives of the Brooklyn Museum, provided by Deborah Wythe, archivist and manager of special library collections at the Brooklyn Museum, e-mail to the author, April 6, 2004.

Fall 1927: Chester Johnson Galleries, Chicago
In the announcement for the March 1928 exhibition at the Renaissance Society of the University of Chicago, "Modern French Painting and Sculpture," it was stated that the exhibition contained works that had been on view at the Chester Johnson Galleries "last fall" and included work by Picasso; the exhibition announcement is in the Renaissance Society of the University of Chicago archives, Archives of American Art, Smithsonian Institution.

December 13, 1927–January 15, 1928: Gallery of Living Art, New York University
Although a checklist for this exhibition does exist, the titles listed there are vague; therefore, to identify the Zervos reference numbers of the pieces listed, I relied on Gail Stavitsky, "The Development, Institutionalization, and Impact of the A. E. Gallatin Collection of Modern Art" (Ph.D. diss., New York University, 1990), pp. 224, 230, 237, 239.

December 17, 1927–January 23, 1928: Valentine Gallery, New York
[Anon.], "Loan Exhibitions Feature Season," *Art News* 26, no. 35 (June 2, 1928): 5.

Opened March 28, 1928: Pennsylvania Museum of Art, Philadelphia
[Anon.], "The New Museum of Art Inaugural Exhibition," *Pennsylvania Museum Bulletin* 23, no. 119 (March 1928): 3, 15, 23. This information was also confirmed by Catherine Herbert, provenance researcher at the Philadelphia Museum of Art, with research provided by Clarisse Carnell, collections registrar at the Philadelphia Museum of Art, letter to the author, March 26, 2003.

April 1928: Lord & Taylor, New York
No checklist could be located for this exhibition; information about the one piece by Picasso known to have been included is from Stephanie D'Alessandro, associate curator of modern painting and sculpture, Art Institute of Chicago, letter to the author, May 15, 2005.

Opened December 3, 1928: Gallery of Living Art, New York University
Stavitsky, "A. E. Gallatin Collection" (see December 13, 1927, above), p. 235.

January 7–19, 1929: Daniel Galleries, New York
"Exhibitions and Loans by the Société Anonyme, 1920–39," in Herbert et al., eds., *The Société Anonyme and the Dreier Bequest* (see August 1920 above), p. 778.

January 28–February 23, 1929: Valentine Gallery, New York
[Anon.], "French Paintings," *Art News* 27, no. 18 (February 2, 1929): 9.

April 16–17, 1929: American Art Association, New York
Buyer information for the works in the sale is from handwritten notes in the copy of this catalogue in the collection of the New York Public Library.

Opened mid-November 1929: Gallery of Living Art, New York University
Stavitsky, "A. E. Gallatin Collection" (see December 13, 1927, above), pp. 213, 220.

January 3–17, 1930: Arts Club of Chicago
The date and medium of *Woman Seated* (no. 94) is from the listing for this same work (but with the title *Seated Woman*) in the exhibition held March 28–April 17, 1954 at the Renaissance Society of the University of Chicago, where it was no. 36.

January 19–February 16, 1930: Museum of Modern Art, New York
Lewisohn is identified as the lender of *The Dancer* in an exhibition that took place the previous year at Reinhardt Galleries, New York, February 23–March 16, 1929, no. 31; the piece was still in the family collection more than two decades later and was included in the exhibition "The Lewisohn Collection" at the Metropolitan Museum of Art, New York, November 2–December 2, 1951, no. 60. Information about the Bliss provenance for *Green Still Life* is from MoMA's "Provenance Research Project"; see www.moma.org/collection/provenance. Information about the Bliss provenance for *Woman in White* is from Charles Sterling and Margaretta M. Salinger, *French Paintings: A Catalogue of the Metropolitan Museum of Art, XIX–XX Centuries*, vol. 3 (New York: Metropolitan Museum of Art, 1967), p. 236.

January 25–February 21, 1930: Reinhardt Galleries, New York
A copy of the *Retrospective Exhibition of Paintings by Picasso and Derain* catalogue in the collection of the Museum of Modern Art library includes hand-written notes identifying Sweeney as the owner of *Nude* (no. 8) and *Abstraction* (no. 10).

February 4–18, 1930: Renaissance Society of the University of Chicago
Mr. and Mrs. Walter Brewster lent *The Acrobat's Wife* to the exhibition held March 26–April 9, 1930, at the Arts Club of Chicago, where it was listed as *Head of Woman* (no. 10), and where they were identified as the lenders.

March 26–April 9, 1930: Arts Club of Chicago
The 1923 *Still Life* lent by Mrs. John Alden Carpenter for this exhibition (no. 11) may have been *Musical Instruments*, 1923, which she lent to the Museum of Modern Art, New York, for its exhibition "Painting in Paris from American Collections," January 19–February 16, 1930 (no. 72).

April 14–October 1930: Valentine Gallery, New York
"Exhibition Listings," *Art News* 28, no. 31 (May 3, 1930): 30.

June 15–September 1930: Museum of Modern Art, New York
Information about the Anderson provenance for *Harlequin* (no. 77) is from Sterling and Salinger, *French Paintings* (see January 19, 1930, above), p. 229.

Opened December 1, 1930: Gallery of Living Art, New York University
The work listed as *Still Life* has not been identified by Stavitsky. See her entry for this exhibition in "Chronology of the Gallery of Living Art and Museum of Living Art," in Stavitsky, "A. E. Gallatin Collection," vol. 2 (see December 13, 1927, above), n.p.

January 5–March 16, 1931: Rand School of Social Science, New York
Information about the inclusion of a drawing by Picasso in this exhibition is from "Exhibitions and Loans by the Société Anonyme, 1920–39" (see August 2, 1920, above), p. 778.

February 1931: Valentine Gallery, New York
[Anon.], "Exhibitions in New York: Modern French Painting, Valentine Gallery," *Art News* 29, no. 20 (February 14, 1931): 10.

February 1931: Women's University Club, New York
"Exhibitions and Loans by the Société Anonyme, 1920–39," in Herbert et al., eds., *The Société Anonyme and the Dreier Bequest* (see August 1920 above), p. 778.

February 1931: Pennsylvania Museum of Art, Philadelphia
[Anon.], "A Masterpiece of Modern Painting," *Pennsylvania Museum Bulletin* 26, no. 139 (February 1931): 3–5.

February–June 1931: Phillips Memorial Gallery, Washington, D.C.
The title and exhibition number of the work by Picasso in "French Paintings from Manet to Derain," one of two simultaneous exhibitions at the Phillips, is from a typed list in the Phillips Collection Archives, provided by Allison Freeman, research assistant at the Phillips Collection, accompanying her letter to the author, May 15, 2004.

Opened February 2, 1931: Gallery of Living Art, New York University
Stavitsky, "Chronology of the Gallery of Living Art and Museum of Living Art" (see December 1930 above), n.p.

April–October 1931: Valentine Gallery, New York
"Calendar of Exhibitions in New York," *Art News* 29, no. 34 (May 23, 1931): 21.

November 20, 1931–January 1, 1932: Pennsylvania Museum of Art, Philadelphia
Henri Marceau, "Living Artists," *Pennsylvania Museum Bulletin* 27, no. 145 (January 1932): 67, 73.

January 9–29, 1932: Julien Levy Gallery, New York
Lisa Jacobs, "Chronology of Exhibitions," in Ingrid Schaffner and Lisa Jacobs, eds., *Julien Levy: Portrait of an Art Gallery* (Cambridge, Mass., and London: M.I.T. Press, 1998), pp. 173–74.

February 15–March 12, 1932: Brooklyn Museum, New York
Deborah Wythe, archivist and manager of special library collections at the Brooklyn Museum of Art, e-mail to the author, April 6, 2004.

April 16–October 1932: Valentine Gallery, New York
[Anon.], "Exhibitions in New York: Selected Paintings–Valentine Gallery," *Art News* 30, no. 30 (April 23, 1932): 9.

February 21–March 15, 1933: Marie Harriman Gallery, New York
Information about the Harriman provenance of *La Femme à l'éventail* (no. 3) is from the Web site of the National Gallery of Art, Washington, D.C.; see "The Collection" at www.nga.gov/collection.

July 10–September 30, 1933: Museum of Modern Art, New York
Information about the lenders is from the registrar's office at the Museum of Modern Art, e-mail to the author, April 18, 2005.

October 4–25, 1933: Museum of Modern Art, New York
Information about the Clark provenance for *La Coiffure* is from Sterling and Salinger, *French Paintings* (see January 19, 1930, above), p. 233. Because this exhibition was organized by Clark, *Abstraction* is probably the *Abstract Still Life* that he lent for the exhibition held June 15–September 1930 at the Museum of Modern Art, New York, where it was no. 74.

November 2–18, 1933: Julien Levy Gallery, New York
I could not confirm the contents of the New York venue, but I found the exhibition listing from the Arts Club of Chicago, and I assume that the same pieces were shown at both locations; Arts Club Records, Midwest Manuscript Collection, Newberry Library, Chicago.

November 16–December 8, 1933: Museum of Modern Art, New York
Typed checklist provided by the registrar's office at the Museum of Modern Art.

December 9, 1933–January 10, 1934: Pennsylvania Museum of Art, Philadelphia
"The White Collection: December 9–January 10," *Pennsylvania Museum Bulletin* 29, no. 159 (January 1934): 33. The exhibition's contents were also confirmed by Catherine Herbert, provenance researcher at the Philadelphia Museum of Art, with research provided by Clarisse Carnell, collections registrar at the Philadelphia Museum of Art, letter to the author, March 26, 2003.

January 12–February 2, 1934: Renaissance Society of the University of Chicago
A handwritten list of the exhibition's contents was found in the records of the Renaissance Society at the University of Chicago, 1917–81, Archives of American Art, Smithsonian Institution.

January 13–February 14, 1934: Pennsylvania Museum of Art, Philadelphia
The medium and dimensions for *Clown* are from the catalogue for the sale of "Modern Art: Paintings and Sculpture Collection of Mr. and Mrs. Maurice J. Speiser" at Parke-Bernet Galleries, New York, January 26–27, 1944, lot 44.

February 17–March 13, 1934: Pennsylvania Museum of Art, Philadelphia
The contents of the Philadelphia show, for which a checklist was not published, were identified with the help of the listing published for the Chicago exhibition in conjunction with the definitive book on Horter's collection: Innis Howe Shoemaker, *Mad for Modernism: Earl Horter and His Collection*, exh. cat. (Philadelphia: Philadelphia Museum of Art, 1999), pp. 87–102.

October 22–November 2, 1934: Julien Levy Gallery, New York
Jacobs, "Chronology of Exhibitions" (see January 1932 above), pp. 176–77.

March 12–May 8, 1935: Pennsylvania Museum of Art, Philadelphia
Typed checklist provided by Catherine Herbert, provenance researcher at the Philadelphia Museum of Art, with research provided by Clarisse Carnell, collections registrar at the Philadelphia Museum of Art.

June 4–September 24, 1935: Museum of Modern Art, New York
Registrar's office at the Museum of Modern Art, e-mail to the author, April 18, 2005. *The Studio* is mentioned as having been included in this exhibition in *Collection of Walter P. Chrysler, Jr.* (Richmond, Va.: Virginia Museum of Fine Arts, 1941), p. 104.

July–October 1935: Art Institute of Chicago
No catalogue was published for this exhibition. Information about the inclusion of the one work by Picasso in this exhibition is from the Web site of the Art Institute of Chicago's "Provenance Research Project"; see www.artic.edu/aic/provenance.

December 15, 1935–January 12, 1936: San Francisco Museum of Art
Copies of shipping receipts provided to the author by Barbara Rominski, head librarian, San Francisco Museum of Modern Art.

January 1936: Valentine Gallery, New York
Mary Morsell, "French Masters of XXth Century in Valentine Show," *Art News* 34, no. 15 (January 11, 1936): 7.

February 1936: Marie Harriman Gallery, New York
Collection of Walter P. Chrysler, Jr., exh. cat. (Richmond, Va.: Virginia Museum of Fine Arts, 1941), p. 102.

March 2–April 19, 1936: Museum of Modern Art, New York
In chapter 4 of the present volume (page 169), FitzGerald mentions that twenty-nine pieces by Picasso were included in this exhibition; the entry for the same exhibition in the chronology lists only twenty-six works, because three of the works were sculptures, and I have included only paintings and drawings in the chronology.
According to the entry for *Woman in an Armchair* in a 1997 auction catalogue, Sweeney was listed as the owner of the painting beginning in 1931 and it was passed to the seller by descent (Sweeney died in 1986); catalogue for the sale of "Impressionist and Modern Paintings, Drawings and Sculpture (Part I)" at Christie's, New York, May 14, 1997, lot 44.

March 28–June 29, 1936: San Francisco Museum of Art
Copies of consignment forms provided to the author by Barbara Rominski, head librarian at the San Francisco Museum of Modern Art.

October 1936: Metropolitan Museum of Art, New York
"A Loan of Paintings," *Metropolitan Museum of Art Bulletin* 31, no. 10 (October 1936): 209.

Opened October 27, 1936: Museum of Living Art, New York University
Stavitsky, "A. E. Gallatin Collection," pp. 240, 245, 253; and for her reference to the probable inclusion of *Violin and Fruit*, 1912–13, see her "Chronology of the Gallery of Living Art and Museum of Living Art" (see December 1, 1930, above), n.p.

December 1936–January 1937: Museum of Modern Art, New York
In chapter 4 of the present volume (page 169), FitzGerald mentions that eight works by Picasso were included in this exhibition; the entry for the same exhibition in the Chronology lists only six works, because two of the works were prints, and I have included only paintings and drawings in the Chronology.

January 1937: Marie Harriman Gallery, New York
Information about the Paley provenance for *Boy Leading Horse* is from MoMA's "Provenance Research Project"; see www.moma.org/collection/provenance.

March 25–May 13, 1937: San Francisco Museum of Art
Handwritten list from the museum archives provided to the author by Barbara Rominski, head librarian at the San Francisco Museum of Modern Art.

March 29–April 18, 1937: Pennsylvania Museum of Art, Philadelphia
"Modern French Galleries Completed," *Pennsylvania Museum Bulletin* 32, no. 173 (February 1937): n.p. The contents of the exhibition were also confirmed by Catherine Herbert, provenance researcher at the Philadelphia Museum of Art, with research provided by Clarisse Carnell, collections registrar at the Philadelphia Museum of Art, letter to the author, March 26, 2003.

May 8–June 12, 1937: Brooklyn Museum, New York
Deborah Wythe, archivist and manager of special library collections at the Brooklyn Museum of Art, e-mail to the author, April 6, 2004.

May 25–June 30, 1937: San Francisco Museum of Art
Typed list from the museum archives provided to the author by Barbara Rominski, head librarian at the San Francisco Museum of Modern Art.

By October 1, 1937: Phillips Memorial Gallery, Washington, D.C.
"Exhibitions at the Phillips Collection, Appendix A" in Erika D. Passantino, ed., *The Eye of Duncan Phillips: A Collection in the Making* (Washington, D.C.: Phillips Collection, 1999), p. 661.

November 1937: Valentine Gallery, New York
According to a catalogue published by the Valentine Gallery for the April 1944 exhibition of the Lee Ault collection, *Blue Guitar* and *Portrait of a Young Man* were both included in this 1937 Picasso retrospective at the Valentine Gallery; see *Modern Paintings: The Lee Ault Collection*, exh. cat. (New York: Valentine Gallery, April 10–29, 1944), nos. 33, 34 (n.p.).

August 2–22, 1938: San Francisco Museum of Art
Copies of consignment forms provided to the author by Barbara Rominski, head librarian at the San Francisco Museum of Modern Art.

November 7–26, 1938: Valentine Gallery, New York
Information about the Clark provenance for *La Statuaire* is from the catalogue for the sale of "The Collection of Eleanore and Daniel Saidenberg" at Sotheby's, New York, November 10, 1999, lot 60.

February 19–March 12, 1939: Brooklyn Museum, New York
Titles, general medium ("drawing"), and exhibition numbers of works are from Deborah Wythe, archivist and manager of special library collections at the Brooklyn Museum of Art, e-mail to the author, April 6, 2004.

May 5–June 1, 1939: Valentine Gallery, New York
Herschel B. Chipp, *Picasso's Guernica: History, Transformations, Meanings* (Berkeley, Los Angeles, London: University of California Press, 1988), n.p. (unpaginated plates at the back of the book). The 1939–40 Picasso retrospective at the Museum of Modern Art included the painting *Guernica* along with fifty-nine related works and "postscripts" (including two prints, which are not tracked in the Chronology), all of which are listed in the catalogue for that exhibition. (When the painting and studies were presented to the Spanish state in 1981, there were sixty-two sketches that were considered part of the *Guernica* group.) Using MoMA's itemized list of these works, I have listed these works individually only for the Valentine Gallery's exhibition (the first stop on the works' U.S. tour) and, to save space, do not relist them for the museum retrospective later the same year. Discrepancies between the title assigned to a work by MoMA and Chipp's "current title" are noted; for example: *Head and Horse's Hoofs* (plural), is listed by Chipp as *Head of Warrior and Horse's Hoof.*
In addition, the four studies in the current exhibition on loan from the Museo Nacional Centro de Arte Reina Sofía (indicated with asterisks in the Chronology) have current titles that vary slightly from MoMA's. Three of the works have a Roman numeral in parentheses after the title, indicating its sequence in the series of sketches that Picasso completed on a particular date. Also, the dimensions provided by the lending institution vary slightly from Chipp's; these are indicated in brackets. Chipp gives the following titles for these works:
• Sketch 26: *Head of Bull-Man*
• Sketch 32: *Head of Weeping Woman*
• Sketch 37: *Mother with Dead Child*
• Sketch 39: *Head of Weeping Woman*

May 8–30, 1939: Uptown Gallery, New York
J.L., "New Exhibitions of the Week: Important French Painters of Today," *Art News* 37, no. 33 (May 13, 1939): 13.

May 9–June 16, 1939: Bucholz Gallery, New York
D.B., "New Exhibitions of the Week: German Expressionists & an Imposing Modern Painting Review," *Art News* 37, no. 33 (May 13, 1939): 14.

November 15, 1939–January 7, 1940: Museum of Modern Art, New York
Information about pieces listed in the catalogue but omitted from the exhibition due to wartime shipping complications came from Christel Hollevoet at MoMA, e-mail to the author, April 14, 2005. Hollevoet, who was then a provenance researcher at the museum, explained that the files do not give a clear answer to the question about

why pieces in MoMA's collection could not be included, but nonetheless her file notes indicate that these works were not exhibited.
Information about Paul Rosenberg as the anonymous lender for the following works in this exhibition is from the catalogue for the auction of the Rosenberg family's collection, "Modern Paintings and Drawings from the Paul Rosenberg Family Collection," Sotheby's, London, July 3, 1979: nos. 118, 141, 144, 145, 146, 148, 153, 171, 172, 189, 193, 194, 204, and 260. In addition to those, Rosenberg lent no. 140, *The Violinist ("Si Tu veux"),* and no. 186, *Still Life with Biscuits,* which he owned throughout the 1940s, according to Michael FitzGerald, e-mail to the author, April 13, 2006; and Rosenberg also lent no. 187, *The Red Tablecloth,* which remained in the Rosenberg family collection until the mid-1990s, according to FitzGerald, e-mail to the author, April 3, 2006. One more work, no. 188, *Woman with a Mandolin,* was also lent by Rosenberg, according to Carol Togneri, senior curator at the Norton Simon Museum, e-mail to the author, April 10, 2006.
The *Guernica* studies that were in this retrospective (not listed in this entry, but they are in the listing for the May 5–June 1, 1939, exhibition at the Valentine Gallery) are identified below by the catalogue numbers and by the corresponding sketch numbers in Chipp, *Picasso's Guernica* (see May 5–June 1, 1939, above). In a few cases in the catalogue, works sharing the same date and medium are grouped together, and since many of the pieces are not illustrated, I am unable to identify exactly which number in the catalogue referred to which specific study; I can only confirm that it was exhibited. I have preserved these groupings as they appear in the catalogue and assigned the corresponding sketch numbers for reference: MoMA nos. 281–84 = Chipp's numbered sketches 1 through 4; no. 285 = sketch 5; no. 286 = sketch 6; no. 287 (erroneously listed as 285 again) = not in Chipp; no. 288 (ill. in cat.) = sketch 9; nos. 289–90 = sketches 8 and 7 (in reversed order; these can be identified because the dimensions differ); no. 291 (ill. in cat.) = sketch 11; no. 292 = sketch 12; no. 293 (ill. in cat.) = sketch 13; no. 294 = sketch 15; no. 295 (ill. in cat.) = sketch 16; no. 296 = sketch 14; nos. 297–98 = sketches 17 and 18; no. 299 = sketch 20; no. 300 = sketch 19; no. 301 = sketch 21; no. 302 = sketch 22; no. 303 = sketch 25; no. 304 (ill. in cat.) = sketch 23; no. 305 = sketch 24; no. 306 = sketch 29; no. 307 = sketch 28; nos. 308–9 = sketches 26 and 27; no. 310 = sketch 30; nos. 311–13 = sketches 31 through 33; no. 314 = sketch 34; no. 315 = sketch 35; no. 316 = sketch 36; no. 317 = sketch 37; no. 318 = sketch 38; no. 319 = sketch 39; nos. 320–22 (no. 320 is ill. in cat.) = sketches 40 through 42; no. 323 = sketch 43; no. 324 = sketch 44, the one that Chipp considers to be the last numbered "study."
The remaining works therefore are deemed "postscripts" and are listed in the present Chronology (in the same Valentine Gallery entry as the above) in the order as they appear in the MoMA catalogue.

January 18–February 5, 1940: San Francisco Museum of Art
Information about Oppenheimer lending *Mother and Child* is from shipping forms for the exhibition provided by Barbara Rominski, head librarian at the San Francisco Museum of Modern Art.

January 26–March 24, 1940: Museum of Modern Art, New York
Registrar's office at the Museum of Modern Art, e-mail to the author, April 18, 2005.

March 5–6, 1940: Mayflower Hotel, Washington, D.C.
For further identification of some of the pieces in the collection, see "Helena Rubinstein Collection, Part 1" (New York: Parke-Bernet Galleries, April 20, 1966), lot 33, 34, 45, 50. Other works by Picasso sold in this sale from her collection are lots 27, 39, 40, 53, and lot 672a in Part 2.
N.B.: *Lavis,* the medium given for *Seated Nude,* 1906, is a French term for "wash drawing."

March 29–May 11, 1941: Philadelphia Museum of Art
A careful reader might note that the height dimensions of the two works that were cut from a single canvas, *Tête cubiste* and *Deux Têtes cubistes* (nos. 164 and 165), differ slightly. This is undoubtedly the result of an inconsistent translation of the metric dimension (37.5 cm) into inches.

July 15–September 7, 1941: Museum of Modern Art, New York
The titles, dates, and mediums of the works in this "Masterpieces of Picasso" exhibition are from a typewritten list of MoMA's exhibitions in the museum's library.
Information about Rosenberg's ownership of *Three Musicians* between 1921 and 1949, when the Museum of Modern Art purchased it from the Rosenberg family, is from MoMA's "Provenance Research Project"; see www.moma.org/collection/provenance. *The Red Tablecloth* remained in the Rosenberg family collection until the mid-1990s, according to Michael FitzGerald, e-mail to author, April 3, 2006. *Still Life with a Bottle of Wine* belonged to Rosenberg and his family between 1930 and 1979, when it was sold at auction, "Modern Paintings and Drawings from the Paul Rosenberg Family Collection," Sotheby's, London, July 3, 1979, lot 33. Thanks to Michael FitzGerald for bringing this auction to my attention.

November 3–December 6, 1941: Phillips Memorial Gallery, Washington, D.C.
For the source of information about the Rosenberg provenance for *Three Musicians*, see the preceding note.

February 11–March 7, 1942: Paul Rosenberg & Co., New York
Six of the works in this exhibition also appeared in the May 26–October 1945 exhibition held at the Philadelphia Museum of Art, "Picasso–Braque: Collection Lent Anonymously," and Paul Rosenberg has been identified as the lender of that collection (see May 26, 1945, below); in addition, the medium of *La Tête de bélier* is from the catalogue of that "Picasso–Braque" exhibition. For the seventh work lent by Rosenberg in this exhibition, *La Bouteille de vin*, see the information about *Still Life with a Bottle of Wine* in the note for July 15, 1941, above.

March 25–May 3, 1942: Museum of Modern Art, New York
Checklist in the Registrar Exhibition File in the Museum of Modern Art archives. MacKenzie Bennett, Dedalus Fellow in the Museum Archives at the Museum of Modern Art, kindly went through the file for this exhibition to verify that it was, in fact, a photograph of *Les Demoiselles d'Avignon* that was included rather than the actual painting. In an e-mail to the author, March 13, 2006, she confirmed the theory that because this painting was acquired in 1939 and had been shown on several occasions since that time, it was no longer considered a recent acquisition in 1942. Originally, this exhibition was to have included two studies for the painting that were withdrawn from the show for unspecified reasons. Ultimately, however, the photograph of the painting remained on view.

June 16–July 12, 1942: San Francisco Museum of Art
Copy of shipping receipt provided by Barbara Rominski, head librarian at the San Francisco Museum of Modern Art.

December 8, 1942–January 24, 1943: Museum of Modern Art, New York
This was a traveling exhibition arranged by the Museum of Modern Art. The contents of the exhibition when it was presented at the Arts Club of Chicago are from a checklist in the Registrar Exhibition File in MoMA's archives.

April 6–May 1, 1943: Paul Rosenberg & Co., New York
Femme à la mandoline also appeared in the May 26–October 1945 exhibition held at the Philadelphia Museum of Art, "Picasso–Braque:

Collection Lent Anonymously," and Paul Rosenberg has been identified as the lender of that collection (see May 26, 1945, below).

April 28, 1943–1952: Art Institute of Chicago
The Web site of the National Gallery of Art, Washington, D.C.; see "The Collection" at www.nga.gov/collection.

May 14–August 1943: Philadelphia Museum of Art
Henry Clifford, "The Gallatin Collection . . . Mirror of Our Time," in *Philadelphia Museum Bulletin* 38, no. 198 (May 1943): n.p.; and Gail Stavitsky, "The A. E. Gallatin Collection: An Early Adventure in Modern Art," *Bulletin of the Philadelphia Museum of Art* 89, nos. 379–80 (Winter/Spring 1994): 3–47.

July 26, 1943–October 1953: Museum of Modern Art, New York
The starting date was provided by the registrar's office at the Museum of Modern Art, e-mail to the author, April 18, 2005. Information about the works is from Chipp, *Picasso's Guernica* (see May 5–June 1, 1939, above), pp. 167–68 and 220 (nn. 39 and 40).

February 20–March 20, 1944: Phillips Memorial Gallery, Washington, D.C.
All four works in this exhibition were included in the May 26–October 1945 exhibition held at the Philadelphia Museum of Art, "Picasso–Braque: Collection Lent Anonymously," identified as the collection of Paul Rosenberg (see May 26, 1945, below). In addition, Rosenberg is the author of the short essay on Picasso in the catalogue for this 1944 exhibition.

May 24–October 15, 1944: Museum of Modern Art, New York
Information about Rosenberg's ownership of *Three Musicians* between 1921 and 1949, when the Museum of Modern Art purchased it from the Rosenberg family, is from MoMA's "Provenance Research Project"; see www.moma.org/collection/provenance. Information about Soby's ownership of *Seated Woman* between 1932 and 1961, when he presented it to the Museum of Modern Art, is also from MoMA's "Provenance Research Project."

November 1944: Art of This Century, New York
For the exhibition "The War Years," November 14–27, 1944 (see that entry in the Chronology), the Registrar Exhibition File in MoMA's archives includes the information that Art of This Century gallery also displayed an edition of this portfolio of photographs of Picasso's work.

November 6–December 2, 1944: Paul Rosenberg Gallery, New York
Arlequin, "Si Tu Veux" and *Les Bisquits* were both owned by Rosenberg throughout the 1940s, according to Michael FitzGerald, e-mail to the author, April 13, 2006.
Tête de bélier was included in the "Picasso–Braque" exhibition at the Philadelphia Museum of Art in 1945, as part of Rosenberg's collection (see May 26, 1945, below).
Le Sculpteur et son oeuvre was sold in the sale of the Rosenberg family collection at Sotheby's, London, July 3, 1979, lot 35.

November 14–27, 1944: Museum of Modern Art, New York
The title for this exhibition is given in the chronology published in Russell Lynes, *Good Old Modern: An Intimate Portrait of the Museum of Modern Art* (New York: Atheneum, 1973), p. 454. The dates are from the Registrar Exhibition File in MoMA's archives, in its listing for the exhibition.

January 1945: Philadelphia Museum of Art
Instead of a catalogue for this exhibition, the *Philadelphia Museum Bulletin* published an illustrated checklist: "The Callery Collection: Picasso–Léger," *Philadelphia Museum Bulletin* 40, no. 204 (January 1945): 35, 37, 39, plus non-paginated plates.

February 27–March 17, 1945: Bucholz Gallery, New York
When these paintings and drawings by Picasso were exhibited together with works by Léger at the Philadelphia Museum of Art in January 1945, Meric Callery was identified as the owner ("The Callery Collection: Picasso–Léger"). Almost exactly the same group of works by Picasso was shown in both exhibitions.

May 26–October 1945: Philadelphia Museum of Art
All the information about the works shown at the Philadelphia Museum for this exhibition is from Jane Joe, office of the registrar, letter to the author, July 18, 2005.
Paul Rosenberg has been identified as the lender because many of the works exhibited here remained together as part of this collection until 1979, when his heirs sold them at auction, in the sale of "Modern Paintings and Drawings from the Paul Rosenberg Family Collection," Sotheby's, London, July 3, 1979.

March 14–April 4, 1946: Phillips Memorial Art Gallery, Washington, D.C.
This was a traveling exhibition organized by the Museum of Modern Art. The date and contents are from the Registrar Exhibition File in MoMA's archives.

April 1–27, 1946: M. Knoedler & Co., New York
William H. Taylor was identified as the lender of the painting when it was exhibited March 29–April 18, 1937, at the Pennsylvania Museum of Art. This provenance was confirmed in the catalogue for the sale of "Impressionist and Modern Paintings and Sculpture from the Collection of Donald and Jean Stralem" at Sotheby's, New York, May 8, 1995, lot 14.

October 16–November 6, 1946: Jacques Seligmann & Co., Inc., New York
According to the National Gallery of Art Web site, Callery owned the painting from approximately 1939 to 1960; see "The Collection" at www.nga.gov/collection.

November 12, 1946–January 12, 1947: Museum of Modern Art, New York
Information on the exhibition and the Museum of Modern Art–owned pieces came from MoMA's registrar's office, letter to the author, April 20, 2005.

December 3–26, 1946: Arts Club of Chicago
Information about the contents of the exhibition when it was presented at the San Francisco Museum of Art was provided by Barbara Rominski, head librarian at the San Francisco Museum of Modern Art, e-mail to the author, April 14, 2004.

April–May 4, 1947: Museum of Modern Art, New York
Information about Rosenberg's ownership of *Three Musicians* between 1921 and 1949, when the Museum of Modern Art purchased it from the Rosenberg family, is from MoMA's "Provenance Research Project"; see www.moma.org/collection/provenance.

June 10–August 31, 1947: Museum of Modern Art, New York
Information about the contents of this exhibition at the Museum of Modern Art is from the checklist in the Registrar Exhibition File in MoMA's archives. Information about the contents of the exhibition when it was presented at the Art Institute of Chicago is from the collection cards in the Central Catalogue of the Metropolitan Museum of Art, New York.

October 6–25, 1947: Paul Rosenberg & Co., New York
Because a checklist for this exhibition could not be located, the contents of this exhibition were assumed to have been the same as those that appeared in the catalogue of the collection published for the "Golschmann Collection" exhibition held April 30–June 1, 1947, at the Cincinnati Modern Art Society.

January 22–March 12, 1948: Museum of Modern Art, New York

Dates of exhibition confirmed by Registrar's office, Museum of Modern Art, e-mail to the author, April 18, 2005.

March 16–April 3, 1948: Paul Rosenberg & Co., New York

For Rosenberg's ownership of nos. 3 and 12, *Arlequin ("Si Tu Veux")* and *Nature morte aux biscuits*, see the note for November 6, 1944, above. No. 13, *Woman with a Mandolin*, was also lent by Rosenberg, according to Carol Togneri, senior curator at the Norton Simon Museum, e-mail to the author, April 10, 2006.

April 1–3, 1948: Residence of Stephen C. Clark, New York

This quote is from [Anon.], "Art News of America: The Clark Collection Opens for a Charity Show," *Art News* 47, no. 1 (March 1948): 7. A second article reveals that there were "important examples of work by Picasso, among other artists"; Alonzo Lansford, "Clark Collection Shown for Charity," *Art Digest* 22, no. 12 (March 15, 1948): 9.

May 13–June 20, 1948: San Francisco Museum of Art

Copy of shipping receipt provided to the author by Barbara Rominski, head librarian at the San Francisco Museum of Modern Art.

September 20–October 16, 1948: Paul Rosenberg & Co., New York

Information about this exhibition is from the records of the San Francisco Museum of Modern Art. Since a checklist for this show could not be located, other works by Picasso may also have been included but have not been identified.

November 15–21, 1948: California Palace of the Legion of Honor, San Francisco

Information about this exhibition is from the records of the San Francisco Museum of Modern Art, which lent Picasso's *Street Scene*. Since a checklist for this show could not be located, other works by Picasso may also have been included but have not been identified.

November 15–December 18, 1948: Paul Rosenberg & Co., New York

Nature morte à la bouteille de vin belonged to Rosenberg and his family between 1930 and 1979, when his heirs sold it at auction in the sale of "Modern Paintings and Drawings from the Paul Rosenberg Family Collection," Sotheby's, London, July 3, 1979, lot 33.

February 2–March 31, 1949: Century Association, New York

A notice that two of the works were not exhibited due to lack of space is printed in the catalogue for this exhibition.

March 8–April 2, 1949: Bucholz Gallery, New York

Because this was an exhibition of recent work (as indicated by the show's title) and because all the other works in the exhibition are dated 1946, it can be assumed that the 1926 dating for *Head of a Fawn* (no. 24) was a typographical error and that the actual date of the work is 1946.

April 11–24, 1949: San Francisco Museum of Art

Copy of shipping receipt provided to the author by Barbara Rominski, head librarian at the San Francisco Museum of Modern Art.

October–November 1949: Samuel M. Kootz Gallery, New York

"The Collection of Sally and Victor Ganz" (New York: Christie's, November 10, 1997), p. 110; this exhibition is referred to in a note on that page of the sale catalogue, but no other source verifying it could be found.

November 9–December 4, 1949: San Francisco Museum of Art

Paperwork confirming this exhibition provided to the author by Barbara Rominski, head librarian at the San Francisco Museum of Modern Art.

January 12–February 5, 1950: San Francisco Museum of Art

Barbara Rominski, head librarian at the San Francisco Museum of Modern Art, e-mail to the author, March 27, 2004.

February 4–April 16, 1950: Philadelphia Museum of Art

"The Samuel S. White, 3rd, and Vera White Collection," *Philadelphia Museum of Art Bulletin* 63, nos. 296, 297 (January–March 1968 and April–June 1968): 97.

May 20–September 15, 1950: Philadelphia Museum of Art

The checklist for this exhibition appears in "Masterpieces from Philadelphia Private Collections, Part II," *Philadelphia Museum Bulletin* 65, no. 225 (Spring 1950): 97.

July 7–early September 1950: Metropolitan Museum of Art, New York

The title of the exhibition was provided to me by the department of European Paintings at Metropolitan Museum of Art, e-mail to the author, March 15, 2004.

July 11–September 5, 1950: Museum of Modern Art, New York

Checklist in the Registrar Exhibition File in MoMA's archives.

November 1–December 6, 1950: San Francisco Museum of Art

Copy of shipping receipts provided to the author by Barbara Rominski, head librarian at the San Francisco Museum of Modern Art.

November 3, 1950–February 11, 1951: Philadelphia Museum of Art

"Diamond Jubilee: 75th Anniversary, 1875–1876, 1950–1951," *Philadelphia Museum Bulletin* 65, no. 224 (Winter 1950): 86, 87.

December 20, 1950–January 10, 1951: Los Angeles County Museum

Since the L.A. County Museum had no catalogue or checklist for this show, I have relied on the checklist supplied by Barbara Rominski, head librarian at the San Francisco Museum of Modern Art, for works shown at that venue. I have not been able to confirm which of these works appeared in Los Angeles.

November 24–December 31, 1951: Institute of Contemporary Arts, exhibition at the Corcoran Gallery of Art, Washington, D.C.

Information about the inclusion of a drawing by Picasso in this exhibition is from "Exhibitions and Loans by the Société Anonyme after Its Gift to Yale in 1941," in Herbert et al., eds., *The Société Anonyme and the Dreier Bequest* (see August 1920 above), p. 782.

January 5–February 7, 1953: Perls Galleries, New York

Chipp, *Picasso's Guernica* (see May 5–June 1, 1939, above), unpaginated reproductions of the forty-five numbered sketches and p. 220 (n. 19).

February 3–21, 1954: M. Knoedler & Co., New York

The Allen Memorial Art Museum Bulletin, an Oberlin College publication, served as the catalogue for this unnamed exhibition: "The Art Department and the Museum," *Allen Memorial Art Museum Bulletin*, Oberlin College 11, no. 2 (Winter 1954): 41–43, and unpaginated plates.

October 19, 1954–February 6, 1955: Museum of Modern Art, New York

Checklist in the Registrar Exhibition File in MoMA's archives. Information about Clark being the donor of *Seated Woman* (he presented it to MoMA in December 1937, but it was subsequently sold to the Art Gallery of Ontario) is from Michael FitzGerald; see chapter 3 of the present volume (pp. 134, 139), and n. 44 of that chapter.

March 15–April 17, 1955: Museum of Modern Art, New York

There was no checklist for this exhibition, according to MoMA's registrar's office, letter to the author, April 20, 2005.

June 22–September 30, 1956: Metropolitan Museum of Art, New York

"Modern European Paintings from New York Private Collections on view in Special Summer Exhibition at Metropolitan Museum," *Metropolitan Museum of Art: News for Release* (undated, but before June 21, 1956). Courtesy of Barbara File, Archivist, Metropolitan Museum of Art.

October 25–December 30, 1956: Brooklyn Museum, New York

Deborah Wythe, archivist and manager of special library collections at the Brooklyn Museum, e-mail to the author, April 6, 2004.

January 2–February 10, 1957: San Francisco Museum of Art

Copy of typed checklist provided to the author by Barbara Rominski, head librarian at the San Francisco Museum of Art.

May 21–July 7, 1957: San Francisco Museum of Art

Information about the work added as a supplement to the exhibition is from shipping receipts provided to the author by Barbara Rominski, head librarian at the San Francisco Museum of Art.

May 22–September 8, 1957: Museum of Modern Art, New York

Paul Rosenberg was the anonymous lender of *The Red Tablecloth*, which remained in the Rosenberg family collection until the mid-1990s, according to Michael FitzGerald, e-mail to author, April 3, 2006. Rosenberg was also the anonymous lender of *Nessus and Dejanira with a Satyr*, according to the catalogue for the sale of the collection of Rosenberg's family, "Modern Paintings and Drawings from the Paul Rosenberg Family Collection," Sotheby's, London, July 3, 1979, lot 21.

EXHIBITION CHECKLIST

Unless otherwise noted, all objects are included in all three venues of the exhibition. Alternate titles appear in parentheses. All dimensions are in inches, followed by centimeters. Height precedes width precedes depth.

As of June 16, 2006

Louise Bourgeois (plate 87)
Untitled, 1940
Oil and graphite on board (double-sided)
13 1/8 x 11 7/8 in. (33.3 x 30.2 cm)
Collection of the artist, courtesy of Cheim & Read, New York

Louise Bourgeois (plate 89)
Quarantania, 1941
Wood
84 3/4 x 31 1/4 x 29 1/4 in. (215.3 x 79.4 x 74.3 cm)
Whitney Museum of American Art, New York, Gift of an anonymous donor 77.80

Louise Bourgeois (plate 88)
Untitled, 1941
Oil on canvas
31 1/2 x 47 1/2 in. (80 x 120.7 cm)
Collection of the artist, courtesy of Cheim & Read, New York

Stuart Davis (plate 30)
Garden Scene, 1921
Oil on canvas
19 1/4 x 40 in. (48.9 x 101.6 cm)
Collection of Jan T. and Marica Vilcek

Stuart Davis (plate 29)
Landscape, Gloucester, 1922
Oil on board
12 x 16 in. (30.5 x 40.6 cm)
Collection of Theodore P. Shen

Stuart Davis (plate 34)
Still Life with "Dial," 1922
Oil on canvas
49 3/4 x 31 7/8 in. (126.4 x 81 cm)
Collection of Jan T. and Marica Vilcek

Stuart Davis (plate 33)
Three Table Still Life, 1922
Oil on canvas
42 x 32 in. (106.7 x 81.3 cm)
Private collection

Stuart Davis (plate 46)
Untitled (E.A.T.), 1922
Oil on canvas
32 x 40 in. (81.3 x 101.6 cm)
Curtis Galleries, Minneapolis
San Francisco Museum of Modern Art and Walker Art Center only

Stuart Davis (plate 45)
Apples and Jug, 1923
Oil on board
21 3/8 x 17 3/4 in. (54.3 x 45.1 cm)
Museum of Fine Arts, Boston, Gift of the William H. Lane Foundation
Whitney Museum of American Art only

Stuart Davis (plate 44)
Lucky Strike, 1924
Oil on board
18 x 24 in. (45.7 x 61 cm)
Hirshhorn Museum and Sculpture Garden, Smithsonian Institution, Washington, D.C., Museum Purchase, 1974

Stuart Davis (plate 36)
Early American Landscape, 1925
Oil on canvas
19 x 22 in. (48.3 x 55.9 cm)
Whitney Museum of American Art, New York, Gift of Juliana Force 31.171

Stuart Davis (plate 35)
Super Table, 1925
Oil on canvas
48 x 34 1/8 in. (122.2 x 86.7 cm)
Terra Foundation for American Art, Chicago, Daniel J. Terra Collection, 1999.37

Stuart Davis (plate 49)
Place Pasdeloup, 1928
Oil on canvas
36 1/4 x 28 3/4 in. (92.1 x 73 cm)
Whitney Museum of American Art, New York, Gift of Gertrude Vanderbilt Whitney 31.170

Stuart Davis (plate 32)
Colonial Cubism, 1954
Oil on canvas
45 1/8 x 60 1/4 in. (114.6 x 153 cm)
Walker Art Center, Minneapolis, Gift of the T.B. Walker Foundation, 1955

Arthur G. Dove (plate 9)
Abstraction #3, ca. 1910–11
Oil on board
9 x 10 1/2 in. (22.9 x 26.7 cm)
The Newark Museum, N.J., Gift of Henry H. Ploch, 2000

Arthur G. Dove (plate 10)
Nature Symbolized No. 1 (Roofs), 1911–12
Pastel on paper
18 x 21 1/2 in. (45.7 x 54.6 cm)
Collection of Michael and Fiona Scharf
Whitney Museum of American Art only

Arthur G. Dove (plate 11)
Plant Forms, ca. 1912
Pastel on canvas
17 1/4 x 23 7/8 in. (43.8 x 60.6 cm)
Whitney Museum of American Art, New York, Purchase, with funds from Mr. and Mrs. Roy R. Neuberger 51.20
Whitney Museum of American Art only

Arshile Gorky (fig. 58)
Cubist Portrait, ca. 1928–31
Graphite on paper
30 x 22 in. (76.2 x 55.9 cm)
Private collection

Arshile Gorky (plate 62)
Harmony, ca. 1931–33
Oil on canvas
22 x 27 in. (55.9 x 68.6 cm)
Diocese of the Armenian Church of America (Eastern) on deposit at the Calouste Gulbenkian Foundation, Lisbon, Portugal

Arshile Gorky (fig. 66)
After Picasso's "Seated Woman" (Merkuhi), 1932
Ink and graphite on paper
16 x 12 in. (40.6 x 30.5 cm)
Diocese of the Armenian Church of America (Eastern) on deposit at the Calouste Gulbenkian Foundation, Lisbon, Portugal

Arshile Gorky (fig. 55)
After Picasso's Mother and Child" (Mentor I), 1932
Graphite on paper
9 5/8 x 8 1/8 in. (27.5 x 20.6 cm)
Diocese of the Armenian Church of America (Eastern) on deposit at the Calouste Gulbenkian Foundation, Lisbon, Portugal

Arshile Gorky (plate 50)
After Picasso's "Two Female Nudes" (Mentor III), ca. 1932
Graphite on paper
12 x 16 in. (30.5 x 40.6 cm)
Diocese of the Armenian Church of America (Eastern) on deposit at the Calouste Gulbenkian Foundation, Lisbon, Portugal

Arshile Gorky (plate 64)
Blue Figure in Chair, ca. 1934–35
Oil on canvas
48 x 38 in. (121.9 x 96.5 cm)
Private collection

Arshile Gorky (plate 53)
The Artist and His Mother, ca. 1926–36
Oil on canvas
60 x 50 in. (152.4 x 127 cm)
Whitney Museum of American Art, New York, Gift of Julien Levy for Maro and Natasha Gorky in memory of their father 50.17
Whitney Museum of American Art only

Arshile Gorky (plate 67)
Organization, 1933–36
Oil on canvas
49 3/4 x 60 in. (126.4 x 152.4 cm)
National Gallery of Art, Washington, Ailsa Mellon Bruce Fund 1979.13.3

Arshile Gorky (plate 69)
Composition with Head, ca. 1936–37
Oil on canvas
76 1/2 x 60 1/2 in. (194.3 x 153.7 cm)
Collection of Donald L. Bryant, Jr., Family Trust

Arshile Gorky (plate 81)
Enigmatic Combat, 1936–37
Oil on canvas
35 3/4 x 48 in. (90.8 x 121.9 cm)
San Francisco Museum of Modern Art, Gift of Jeanne Reynal

Arshile Gorky (plate 82)
Self-Portrait with Palette, 1937
Oil on canvas
55 1/4 x 23 7/8 in. (140.3 x 60.6 cm)
Private collection

Arshile Gorky (plate 122)
Nude, 1946
Oil on canvas
50 x 38 1/8 in. (127 x 96.8 cm)
Hirshhorn Museum and Sculpture Garden, Smithsonian Institution, Washington, D.C., Gift of the Joseph H. Hirshhorn Foundation, 1966

John D. Graham (plate 58)
Still Life, 1925
Oil on canvas
14 1/8 x 17 in. (35.9 x 43.2 cm)
Private collection

John D. Graham (plate 54)
Harlequin in Grey, 1928
Oil on canvas
28 5/8 x 21 1/4 in. (72.7 x 54 cm)
The Phillips Collection, Washington, D.C.

John D. Graham (plate 59)
Palermo, 1928
Oil on canvas
15 3/4 x 19 3/4 in. (40 x 50.2 cm)
The Phillips Collection, Washington, D.C.

John D. Graham (plate 55)
Portrait of Elinor Gibson, 1930
Oil on canvas
28 1/8 x 22 in. (71.4 x 55.9 cm)
The Phillips Collection, Washington, D.C.

John D. Graham (plate 60)
Blue Still Life, 1931
Oil on canvas
25 5/8 x 36 1/8 in. (65.1 x 91.8 cm)
The Phillips Collection, Washington, D.C.

John D. Graham (plate 61)
Embrace, 1932
Oil on canvas
36 x 30 in. (91.4 x 76.2 cm)
The Phillips Collection, Washington, D.C.

John D. Graham (plate 97)
Interior, 1939-40
Oil on canvas
30 x 20 in. (76.2 x 50.8 cm)
The Rose Art Museum, Brandeis University, Waltham,
Mass., Bequest of Louis Schapiro, Boston, Mass.

John D. Graham (plate 96)
Queen of Hearts, 1941
Oil on canvas
25 x 20 in. (63.5 x 50.8 cm)
Private collection

Marsden Hartley (fig. 12)
Landscape No. 10, 1911
Oil on wood panel
9 3/8 x 5 1/4 in. (23.8 x 13.3 cm)
Frederick R. Weisman Art Museum, University of
Minnesota, Minneapolis, Bequest of Hudson D. Walker
from the Ione and Hudson D. Walker Collection

Marsden Hartley (plate 7)
Landscape No. 32, 1911
Watercolor on paper
14 1/16 x 10 1/16 in. (35.7 x 25.6 cm)
Frederick R. Weisman Art Museum, University of
Minnesota, Minneapolis, Bequest of Hudson D. Walker
from the Ione and Hudson D. Walker Collection

Marsden Hartley (plate 8)
Musical Theme No. 2 (Bach Preludes et Fugues), 1912
Oil on canvas on Masonite
24 x 20 in. (61 x 50.8 cm)
Museo Thyssen-Bornemisza, Madrid
Walker Art Center only

Jasper Johns (plate 147)
Painted Bronze, 1960 (cast and painted 1964)
Painted bronze
Edition 2/2
5 1/2 x 8 x 4 1/2 in. (14 x 20.3 x 11.4 cm)
Collection of the artist
Whitney Museum of American Art only

Jasper Johns (plate 148)
Sketch for Cups 2 Picasso/Cups 4 Picasso, 1971–72
Collage, watercolor, graphite, and ink on paper
15 3/8 x 20 1/4 in. (39.1 x 51.4 cm)
Collection of the artist

Jasper Johns (plate 150)
Untitled, 1984
Pastel and graphite on paper
22 1/4 x 16 1/2 in. (56.5 x 41.9 cm)
Collection of the artist

Jasper Johns (plate 159)
Summer, 1985
Encaustic on canvas
75 x 50 in. (190.5 x 127 cm)
The Museum of Modern Art, New York, Gift of Philip
Johnson, 1998

Jasper Johns (plate 151)
After Picasso, 1986
Charcoal on paper
31 x 22 1/16 in. (78.7 x 56 cm)
Collection of the artist

Jasper Johns (plate 162)
Fall, 1986
Encaustic on canvas
75 x 50 in. (190.5 x 127 cm)
Collection of the artist

Jasper Johns (plate 163)
Study for "Fall," 1986
Watercolor on paper
17 3/8 x 21 1/4 in. (44.1 x 54 cm)
Collection of Barbaralee Diamonstein and Carl Spielvogel
Whitney Museum of American Art only

Jasper Johns (plate 152)
Untitled, 1988
Encaustic on canvas
48 x 60 in. (121.9 x 152.4 cm)
Private collection

Jasper Johns (plate 153)
Untitled, 1988
Watercolor and graphite on paper
21 3/8 x 29 3/4 in. (54.3 x 75.6 cm)
Collection of Barbaralee Diamonstein and Carl Spielvogel
Whitney Museum of American Art only

Jasper Johns (plate 155)
Untitled, 1990
Oil on canvas
75 x 50 in. (190.5 x 127 cm)
Collection of the artist

Jasper Johns (plate 154)
Untitled, 1990
Oil on canvas
31 5/8 x 41 in. (80.3 x 104.1 cm)
Collection of the artist

Jasper Johns (plate 156)
Untitled, 1991–94
Oil on canvas
60 1/4 x 40 in. (153 x 101.6 cm)
Collection of the artist

Jasper Johns (plate 164)
Untitled, 1992–94
Encaustic on canvas
78 1/2 x 118 3/8 in. (199.4 x 300.7 cm)
Collection of Eli and Edythe L. Broad
Whitney Museum of American Art and
San Francisco Museum of Modern Art only

Jasper Johns (plate 158)
After Picasso, 1998
Ink and graphite on paper
40 x 27 in. (101.6 x 68.6 cm)
Collection of the artist

Jasper Johns (plate 157)
After Picasso, 1998
Oil on canvas
34 1/2 x 28 1/2 in. (87.6 x 72.4 cm)
Collection of the artist

Jasper Johns (fig. 121)
After Picasso, 1998
Graphite on paper
22 5/8 x 15 7/16 in. (57.5 x 39.2 cm)
Collection of the artist

Jasper Johns (fig. 122)
Study After Picasso, 1998
Graphite on paper
24 1/4 x 19 1/2 in. (61.6 x 49.5 cm)
Collection of the artist

Jasper Johns (plate 166)
Untitled, 1998
Ink on paper glued to backing sheet
41 x 25 3/16 in. (104.1 x 64 cm)
Collection of the artist

Jasper Johns (plate 165)
Untitled, 1998
Ink and graphite on paper glued to backing sheet
41 x 25 in. (104.1 x 63.5 cm)
Collection of the artist

Jasper Johns (plate 167)
Pyre, 2003
Encaustic on canvas with wood slat and hinge
66 1/2 x 44 1/8 x 2 1/8 in. (168.9 x 112.1 x 5.4 cm)
Private collection
Whitney Museum of American Art and
San Francisco Museum of Modern Art only

Jasper Johns (plate 168)
Pyre 2, 2003
Oil on canvas with wood slat, string, and hinge
66 1/4 x 44 x 6 3/4 in. (168.3 x 111.8 x 17.1 cm)
Private collection
Whitney Museum of American Art and
San Francisco Museum of Modern Art only

Willem de Kooning (plate 77)
Untitled, 1937
Oil on board
4 x 7 in. (10.2 x 17.8 cm)
Private collection, courtesy Allan Stone Gallery, New York

Willem de Kooning (plate 78)
Untitled, 1937
Oil on board
9 x 13 3/4 in. (22.9 x 35 cm)
Private collection

Willem de Kooning (plate 79)
Untitled, 1939–40
Oil on mat board
8 1/2 x 12 3/4 in. (21.6 x 32.4 cm)
The Picker Art Gallery, Colgate University, Hamilton,
N.Y.

Willem de Kooning (plate 102)
Seated Woman, ca. 1940
Oil and charcoal on Masonite
54 1/16 x 36 in. (137.3 x 91.4 cm)
Philadelphia Museum of Art, The Albert M. Greenfield
and Elizabeth M. Greenfield Collection, 1974

Willem de Kooning (plate 83)
Standing Man, ca. 1942
Oil on canvas
41 x 34 in. (104.1 x 86.4 cm)
Wadsworth Atheneum Museum of Art, Hartford,
Conn., The Ella Gallup Sumner and Mary Catlin
Sumner Collection Fund

Willem de Kooning (plate 104)
Pink Angels, ca. 1945
Oil and charcoal on canvas
52 x 40 in. (132.1 x 101.6 cm)
Frederick R. Weisman Art Foundation, Los Angeles
Whitney Museum of American Art only

Willem de Kooning (plate 116)
Event in a Barn, 1947
Oil on paper and Masonite
24 x 36 in. (61 x 91.4 cm)
Private collection, courtesy Allan Stone Gallery, New York

Willem de Kooning (plate 118)
Untitled (Three Women), ca. 1948
Oil and crayon on thick white paper adhered to board
20 x 26 3/8 in. (50.8 x 67 cm)
Frances Lehman Loeb Art Center, Vassar College,
Poughkeepsie, N.Y., Gift of Mrs. Richard Deutsch
(Katherine W. Sanford, class of 1940)
Whitney Museum of American Art only

Willem de Kooning (fig. 88)
Attic Study, 1949
Oil, graphite, and enamel on paperboard mounted on
Masonite
18 7/8 x 23 7/8 in. (47.9 x 60.6 cm)
The Menil Collection, Houston
Whitney Museum of American Art only (plate 87)

Willem de Kooning (plate 105)
Abstraction, 1949–50
Oil on cardboard
14 1/2 x 18 1/2 in. (36.8 x 47 cm)
Museo Thyssen-Bornemisza, Madrid
Walker Art Center only

Willem de Kooning (plate 120)
Woman and Bicycle, 1952–53
Oil on canvas
76 1/2 x 49 in. (194.3 x 124.5 cm)
Whitney Museum of American Art, New York,
Purchase 55.35

Lee Krasner (plate 99)
Untitled, 1940
Oil on canvas
30 1/4 x 24 1/4 in. (76.8 x 61.6 cm)
Private collection, courtesy of Cheim & Read,
New York

Lee Krasner (plate 100)
Composition, 1943
Oil on canvas
30 1/8 x 24 1/4 in. (76.5 x 61.6 cm)
Smithsonian American Art Museum, Washington, D.C.
Museum Purchase made possible by Mrs. Otto L.
Spaeth, David S. Purvis, and anonymous donors and
through the Director's Discretionary Fund

Roy Lichtenstein (plate 126)
The Musician, 1948
Oil and graphite on canvas
18 x 16 1/4 in. (45.7 x 41.3 cm)
Private collection

Roy Lichtenstein (plate 127)
James Lawrence Esq., 1953
Oil on canvas
24 x 18 in. (61 x 45.7 cm)
Collection of the Marks Family

Roy Lichtenstein (plate 130)
Femme au Chapeau, 1962
Oil and Magna on canvas
68 x 56 in. (172.7 x 142.2 cm)
Collection of Martin Z. Margulies

Roy Lichtenstein (plate 131)
Femme d'Alger, 1963
Oil on canvas
80 x 68 in. (203.2 x 172.7 cm)
Collection of Eli and Edythe L. Broad
Whitney Museum of American Art and San Francisco
Museum of Modern Art only

Roy Lichtenstein (fig. 105)
Drawing for "Still Life After Picasso," 1964
Graphite and colored pencil on paper
5 1/8 x 5 7/8 in. (13 x 14.9 cm)
Private collection

Roy Lichtenstein (plate 132)
Still Life after Picasso, 1964
Magna on plexiglass
48 x 60 in. (121.9 x 152.4 cm)
Collection of Barbara Bertozzi Castelli

Roy Lichtenstein (plate 135)
Girl with Beach Ball III, 1977
Oil and Magna on canvas
80 x 66 in. (203.2 x 167.6 cm)
Collection of the Robert and Jane Meyerhoff Modern
Art Foundation, Inc., Phoenix, Md.

Roy Lichtenstein (plate 136)
Girl with Tear I, 1977
Oil and Magna on canvas
70 x 50 in. (177.8 x 127 cm)
Solomon R. Guggenheim Museum, New York, Gift of
the artist, by exchange, 1980

Roy Lichtenstein (plate 139)
Two Paintings with Dado, 1983
Oil and Magna on canvas
50 x 42 in. (127 x 106.7 cm)
Collection of Hope and Howard Stringer

Roy Lichtenstein (plate 140)
Paintings: Picasso Head, 1984
Magna and oil on canvas
64 x 70 in. (162.6 x 177.8 cm)
Private collection

Roy Lichtenstein (plate 141)
Collage for Reflections on "The Artist's Studio," 1989
Graphite, colored pencil, and collage on chromogenic
color print
5 x 7 in. (12.7 x 17.8 cm)
Private collection

Roy Lichtenstein (plate 142)
Collage for Reflections on "Painter and Model," 1990
Graphite, colored pencil, and collage on postcard
4 1/4 x 6 in. (10.8 x 15.2 cm)
Private collection

Roy Lichtenstein (plate 143)
Collage for Beach Scene with Starfish, 1995
Tape, painted and printed paper on board
39 3/16 x 79 1/8 in. (99.5 x 201 cm)
Private collection

Jan Matulka (plate 56)
Seated Nude with Eyes Closed, ca. 1921
Oil on canvas
48 x 34 in. (121.9 x 86.4 cm)
Thomas McCormick Gallery, Chicago
San Francisco Museum of Modern Art and Walker Art
Center only

Jan Matulka (plate 57)
Arrangement with Phonograph, 1929
Oil on canvas
30 x 40 in. (76.2 x 101.6 cm)
Whitney Museum of American Art, New York, Gift of
Gertrude Vanderbilt Whitney 31.298

Robert Motherwell (plate 117)
La Résistance, 1945
Collage with oil on paperboard
36 x 47 3/4 in. (91.4 x 121.3 cm)
Yale University Art Gallery, New Haven,
Gift of Fred Olsen
Walker Art Center only

Claes Oldenburg (plate 134)
*Soft Version of Maquette for a Monument Donated to the
City of Chicago by Pablo Picasso*, 1969
Canvas and rope, painted with synthetic polymer
Dimensions variable, 38 x 28 3/4 x 21 in. (96.5 x 73 x
53.3 cm) at full height
Musée National d'Art Moderne, Centre Georges
Pompidou, Paris

Pablo Picasso (plate 1)
Still Life, ca. 1908
Oil on panel
10 x 8 in. (25.4 x 20.3 cm)
Private collection

Pablo Picasso (plate 12)
Head of Fernande, 1909
Bronze
16 1/4 in. (41.3 cm) high
Private collection

Pablo Picasso (plate 5)
Standing Female Nude, 1910
Charcoal on paper
19 x 12 3/8 in. (48.3 x 31.4 cm)
The Metropolitan Museum of Art, New York, Alfred
Stieglitz Collection, 1949 (49.70.34)
Whitney Museum of American Art only

Pablo Picasso (plate 14)
Woman with Mustard Pot, 1910
Oil on canvas
28 3/4 x 23 5/8 in. (73 x 60 cm)
The Gemeentemuseum Den Haag, The Hague,
The Netherlands

Pablo Picasso (plate 40)
Bowl of Fruit (The Fruit Dish), 1912
Oil on canvas
21 5/8 x 18 1/2 in. (54.9 x 47 cm)
Private collection

Pablo Picasso (plate 19)
Bottle and Wine Glass on a Table, 1912
Charcoal, ink, cut and pasted newspaper, and graphite
on paper
24 5/8 x 18 5/8 in. (62.6 x 47.3 cm)
The Metropolitan Museum of Art, New York, Alfred
Stieglitz Collection, 1949 (49.70.33)
Whitney Museum of American Art only

Pablo Picasso (plate 39)
Female Nude (J'aime Eva), 1912–13
Oil, sand, and charcoal on canvas
29 3/4 x 26 in. (75.6 x 66 cm)
Columbus Museum of Art, Ohio, Gift of Ferdinand
Howald
Whitney Museum of American Art only

Pablo Picasso (plate 21)
Bar-Table with Musical Instruments and Fruit Bowl, ca. 1913
Oil on canvas
39 3/8 x 31 7/8 in. (100 x 81 cm)
Private collection

Pablo Picasso (plate 145)
Woman in an Armchair, 1913
Oil on canvas
59 x 39 3/16 in. (149.9 x 99.5 cm)
Private collection
Whitney Museum of American Art only

Pablo Picasso (plate 37)
Pipe, Glass, and Bottle of Rum, March 1914
Cut-and-pasted colored paper, printed paper, and
painted paper, pencil, and gouache on gessoed board
15 3/4 x 20 3/4 in. (40 x 52.7 cm)
The Museum of Modern Art, New York, Gift of Mr.
and Mrs. Daniel Saidenberg
Whitney Museum of American Art only

Pablo Picasso (plate 146)
Absinthe Glass, 1914
Painted bronze
8 1/2 x 6 1/2 in. (21.6 x 16.5 cm)
Private collection
Whitney Museum of American Art only

Pablo Picasso (plate 20)
Still Life with a Bunch of Grapes, 1914
Oil and sawdust on cardboard
10 1/2 x 9 3/4 in. (27 x 25 cm)
Staatliche Museen zu Berlin, Nationalgalerie, Museum
Berggruen

Pablo Picasso (plate 31)
Still Life with Compote and Glass, 1914–15
Oil on canvas
25 x 31 in. (63.5 x 78.7 cm)
Columbus Museum of Art, Ohio, Gift of Ferdinand
Howald

Pablo Picasso (plate 22)
Untitled (Man with a Moustache, Buttoned Vest, and Pipe, Seated in an Armchair), (Man with a Pipe), 1915
Oil on canvas
51 1/4 x 35 1/4 in. (130.2 x 89.5 cm)
The Art Institute of Chicago, Gift of Mrs. Leigh B. Block in memory of Albert D. Lasker

Pablo Picasso (plate 41)
Paquet de tabac, vase à fleurs, journal, verre, bouteille, 1918
Oil and sand on canvas
18 1/4 x 18 1/4 in. (46.4 x 46.4 cm)
Private collection

Pablo Picasso (plate 43)
Bottle of Port and Glass (Still Life [Oporto]), 1919
Oil on canvas
18 x 24 in. (45.7 x 61 cm)
Dallas Museum of Art, Museum League Purchase Fund, The Cecil and Ida Green Foundation, Edward W. and Evelyn Potter Rose, The Pollock Foundation, Mary Noel Lamont, Mr. and Mrs. Thomas O. Hicks, Howard E. Rachofsky, an anonymous donor, Mrs. Charlene Marsh in honor of Tom F. Marsh, Gayle and Paul Stoffel, Natalie H. (Schatzie) and George T. Lee, Mr. and Mrs. Jeremy L. Halbreich, Dr. and Mrs. Bryan Williams, and Mr. and Mrs. William E. Rose

Pablo Picasso (plate 27)
Landscape with Dead and Live Trees, 1919
Oil on canvas
19 1/4 x 25 3/16 in. (49 x 64 cm)
Bridgestone Museum of Art, Ishibashi Foundation, Tokyo
Whitney Museum of American Art only

Pablo Picasso (plate 52)
Bathers, 1920
Oil on canvas
21 1/4 x 31 7/8 in. (54 x 81 cm)
Acquavella Galleries, New York

Pablo Picasso (fig. 39)
Pierrot and Red Harlequin, Standing, ca. 1920
Stencil
10 13/16 x 8 3/8 in. (27.5 x 21.3 cm)
The Museum of Modern Art, New York, Lillie P. Bliss Collection, 1934

Pablo Picasso (fig. 38)
Seated Figure, ca. 1920
Stencil
12 5/16 x 8 3/16 in. (31.2 x 20.8 cm)
The Museum of Modern Art, New York, Lillie P. Bliss Collection, 1934

Pablo Picasso (fig. 40)
Still Life, ca. 1920
Stencil
10 9/16 x 8 1/8 in. (26.9 x 20.6 cm)
The Museum of Modern Art, New York, Lillie P. Bliss Collection, 1934

Pablo Picasso (fig. 36)
Still Life–Horizontal, ca. 1920
Stencil
8 3/8 x 10 5/8 in. (21.3 x 27 cm)
The Museum of Modern Art, New York, Lillie P. Bliss Collection, 1934

Pablo Picasso (fig. 37)
Two Figures, Seated, ca. 1920
Stencil
8 7/16 x 10 1/2 in. (21.4 x 26.7 cm)
The Museum of Modern Art, New York, Lillie P. Bliss Collection, 1934

Pablo Picasso (plate 65)
Three Musicians, 1921
Oil on canvas
80 1/2 x 74 1/8 in. (204.5 x 188.3 cm)
Philadelphia Museum of Art, A. E. Gallatin Collection, 1952
Whitney Museum of American Art only

Pablo Picasso (plate 47)
Woman in White, 1923
Oil on canvas
39 x 31 1/2 in. (99.1 x 80 cm)
The Metropolitan Museum of Art, New York, Rogers Fund, 1951, Acquired from The Museum of Modern Art, Lillie P. Bliss Collection (53.140.4)
Whitney Museum of American Art only

Pablo Picasso (plate 63)
Femme Assise (Seated Woman), 1927
Oil on canvas
51 x 38 in. (130.8 x 97.8 cm)
Art Gallery of Ontario, Toronto, Purchase, with assistance from the Women's Committee and anonymous contributions, 1964

Pablo Picasso (plate 103)
Figure, 1927
Oil on plywood
50 13/16 x 37 7/16 in. (129 x 96 cm)
Musée National Picasso, Paris
Whitney Museum of American Art only

Pablo Picasso (plate 66)
The Studio, 1927–28
Oil on canvas
59 x 91 in. (149.9 x 231.2 cm)
The Museum of Modern Art, New York, Gift of Walter P. Chrysler, Jr., 1935

Pablo Picasso (plate 144)
Bathers with Beach Ball, 1928
Oil on canvas
6 1/4 x 8 1/4 in. (15.9 x 21 cm)
Private collection

Pablo Picasso (not illustrated)
Figure, 1928
Iron
23 2/5 x 7 3/10 x 16 in. (59.5 x 18.5 x 40.8 cm)
Musée National Picasso, Paris

Pablo Picasso (plate 74)
Head of a Woman, 1930
Iron
39 3/8 in. (100 cm) high
Musée National Picasso, Paris
Whitney Museum of American Art only

Pablo Picasso (plate 101)
Seated Woman with Wrist Watch, August 17, 1932
Oil on canvas
51 3/16 x 38 3/16 in. (130 x 97 cm)
Collection of Emily Fisher Landau
Whitney Museum of American Art only

Pablo Picasso (plate 108)
Bullfight, 1934
Oil and sand on canvas
13 x 16 1/8 in. (33 x 41 cm)
Philadelphia Museum of Art, Gift of Henry P. McIlhenny, 1957

Pablo Picasso (plate 160)
Minotaur Moving, April 6, 1936
Oil on canvas
18 1/8 x 21 5/8 in. (46 x 55 cm)
Private collection

Pablo Picasso (plate 149)
Woman in a Straw Hat with Blue Leaves, 1936
Oil on canvas
23 13/16 x 19 11/16 in. (61 x 50 cm)
Musée National Picasso, Paris

Pablo Picasso (plate 91)
Sketch of a Head of a Bull-Man, May 20, 1937
Graphite and gouache on paper
9 x 11 5/16 in. (23 x 29 cm)
Museo Nacional Centro de Arte Reina Sofia, Madrid
San Francisco Museum of Modern Art only

Pablo Picasso (plate 85)
Sketch of a Head of Weeping Woman (II), May 24, 1937
Graphite and gouache on paper
11 5/16 x 9 in. (29 x 23 cm)
Museo Nacional Centro de Arte Reina Sofia, Madrid
San Francisco Museum of Modern Art only

Pablo Picasso (plate 84)
Mother and Dead Child (IV), May 28, 1937
Graphite, crayon, gouache, and hair on paper
9 x 11 5/16 in. (23 x 29 cm)
Museo Nacional Centro de Arte Reina Sofia, Madrid
Walker Art Center only

Pablo Picasso (plate 93)
Head of Weeping Woman (III), May 31, 1937
Graphite, crayon, and gouache on paper
9 x 11 5/16 in. (23 x 29 cm)
Museo Nacional Centro de Arte Reina Sofia, Madrid
Walker Art Center only

Pablo Picasso (plate 129)
Woman in Grey, 1942
Oil on panel
39 1/4 x 31 7/8 in. (99.7 x 81 cm)
The Alex Hillman Family Foundation, New York
Whitney Museum of American Art only

Pablo Picasso (plate 161)
The Shadow, 1953
Oil and charcoal on canvas
51 x 30 3/16 in. (129.5 x 76.6 cm)
Musée National Picasso, Paris

Pablo Picasso (plate 133)
Maquette for Richard J. Daley Center Monument, 1965
Welded steel (simulated and oxidized)
41 1/4 x 27 1/2 x 19 in. (104.8 x 69.9 x 48.3 cm)
The Art Institute of Chicago, Gift of Pablo Picasso

Jackson Pollock (plate 90)
Head, ca. 1938–41
Oil on canvas
24 x 23 3/5 in. (61 x 60 cm)
The Berardo Collection, Sintra Museum of Modern Art, Lisbon

Jackson Pollock (plate 95)
Masqued Image, ca. 1938–41
Oil on canvas
40 x 24 in. (101.6 x 61 cm)
Modern Art Museum of Fort Worth, Museum Purchase made possible by a grant from The Burnett Foundation

Jackson Pollock (plate 92)
Untitled (Orange Head), ca. 1938–41
Oil on canvas
18 1/4 x 15 1/4 in. (46.4 x 38.7 cm)
Private collection

Jackson Pollock (plate 98)
The Magic Mirror, 1941
Oil, granular filler, and glass fragment on canvas
46 x 32 in. (116.8 x 81.3 cm)
The Menil Collection, Houston
Whitney Museum of American Art only

Jackson Pollock (fig. 83)
Untitled, ca. 1939–42
India ink on paper (double-sided)
18 x 13 7/8 in. (45.72 x 35.24 cm)
Whitney Museum of American Art, New York, Purchase, with funds from the Julia B. Engel Purchase Fund and the Drawing Committee 85.19a-b
Whitney Museum of American Art only

Jackson Pollock (plate 111)
Gothic, 1944
Oil on canvas
84 5/8 x 56 in. (215 x 142.2 cm)
The Museum of Modern Art, New York, Bequest of Lee Krasner, 1984

Jackson Pollock (plate 106)
Untitled (Composition with Sgraffito II), ca. 1944
Oil on canvas
18 1/4 x 13 7/8 in. (45.7 x 35.2 cm)
Courtesy Joan T. Washburn Gallery, New York, and
The Pollock-Krasner Foundation, Inc.

Jackson Pollock (plate 112)
Troubled Queen, 1945
Oil and enamel on canvas
74 1/8 x 43 1/2 in. (188.3 x 110.5 cm)
Museum of Fine Arts, Boston, Charles H. Bayley
Picture and Painting Fund and Gift of Mrs. Albert J.
Beveridge and Juliana Cheney Edwards Collection, by
exchange

Jackson Pollock (plate 109)
The Water Bull, ca. 1946
Oil on canvas
30 1/8 x 84 7/8 in. (76.5 x 215.6 cm)
Stedelijk Museum, Amsterdam

Jackson Pollock (plate 113)
Galaxy, 1947
Aluminum paint, oil-based commercial paint, and
small gravel on canvas
44 x 34 in. (111.8 x 86.4 cm)
Joslyn Art Museum, Omaha, Nebr., Gift of Peggy
Guggenheim

Jackson Pollock (plate 114)
Number 27, 1950, 1950
Oil on canvas
49 x 106 in. (124.5 x 269.2 cm)
Whitney Museum of American Art, New York,
Purchase 53.12
Whitney Museum of American Art only

Jackson Pollock (plate 123)
Number 18, 1951, 1951
Enamel on canvas
59 1/4 x 55 7/8 in. (150.5 x 141.9 cm)
Whitney Museum of American Art, New York, Gift of
The American Contemporary Art Foundation Inc.,
Leonard A. Lauder, President 2002.258

Jackson Pollock (plate 125)
Portrait and a Dream, 1953
Oil on canvas
58 1/2 x 134 3/4 in. (148.6 x 342.3 cm)
Dallas Museum of Art, Gift of Mr. and Mrs. Algur H.
Meadows and the Meadows Foundation, Incorporated
Whitney Museum of American Art and Walker Art
Center only

Man Ray (plate 13)
Portrait of Alfred Stieglitz, 1913
Oil on canvas
10 1/2 x 8 1/2 in. (26.7 x 21.6 cm)
Beinecke Rare Book and Manuscript Library, Yale
University, New Haven
Whitney Museum of American Art only

Man Ray (plate 16)
Five Figures, 1914
Oil on canvas
36 x 32 in. (91.44 x 81.28 cm)
Whitney Museum of American Art, New York, Gift of
Katherine Kuh 56.36

Morgan Russell (fig. 6)
Study after Picasso's "Three Women," ca. 1911
Graphite on paper
11 5/8 x 9 1/8 in. (29.5 x 23.2 cm)
Montclair Art Museum, N.J., Gift of Mr. and Mrs.
Henry Reed, 1985.172.39
Whitney Museum of American Art only

Charles Sheeler (fig. 33)
*Installation view of Whitney Studio Club Exhibition "Recent
Paintings by Pablo Picasso and Negro Sculpture,"* 1923
Gelatin silver print
7 7/16 x 9 3/8 in. (18.9 x 23.8 cm)
Whitney Museum of American Art, New York, Gift of
Gertrude Vanderbilt Whitney 93.23.1
Whitney Museum of American Art only

Charles Sheeler (fig. 32)
*Installation view of Whitney Studio Club Exhibition "Recent
Paintings by Pablo Picasso and Negro Sculpture,"* 1923
Gelatin silver print
7 1/16 x 9 5/16 in. (17.9 x 23.7 cm)
Whitney Museum of American Art, New York, Gift of
Gertrude Vanderbilt Whitney 93.23.2
Whitney Museum of American Art only

Charles Sheeler (fig. 30)
*Installation view of Whitney Studio Club Exhibition "Recent
Paintings by Pablo Picasso and Negro Sculpture,"* 1923
Gelatin silver print
7 1/2 x 9 3/8 in. (19.1 x 23.8 cm)
Whitney Museum of American Art, New York, Gift of
Gertrude Vanderbilt Whitney 93.23.3
Whitney Museum of American Art only

Charles Sheeler (fig. 31)
*Installation view of Whitney Studio Club Exhibition "Recent
Paintings by Pablo Picasso and Negro Sculpture,"* 1923
Gelatin silver print
7 3/8 x 9 3/16 in. (18.7 x 23.3 cm)
Whitney Museum of American Art, New York, Gift of
Gertrude Vanderbilt Whitney 93.23.4
Whitney Museum of American Art only

Charles Sheeler (fig. 35)
*Installation view of Whitney Studio Club Exhibition "Recent
Paintings by Pablo Picasso and Negro Sculpture,"* 1923
Gelatin silver print
7 7/16 x 9 3/8 in. (18.9 x 23.8 cm)
Whitney Museum of American Art, New York, Gift of
Gertrude Vanderbilt Whitney 93.23.5
Whitney Museum of American Art only

Charles Sheeler (fig. 34)
*Installation view of Whitney Studio Club Exhibition "Recent
Paintings by Pablo Picasso and Negro Sculpture,"* 1923
Gelatin silver print
7 1/2 x 9 1/4 in. (19.1 x 23.5 cm)
Whitney Museum of American Art, New York, Gift of
Gertrude Vanderbilt Whitney 93.23.6
Whitney Museum of American Art only

David Smith (plate 72)
Untitled, March 1935
Oil on canvas
17 x 17 in. (43.2 x 43.2 cm)
Collection of Terese and Alvin S. Lane

David Smith (plate 70)
Untitled (Billiard Players), 1936
Oil on canvas
46 7/8 x 52 in. (119.1 x 132.1 cm)
Collection of Barney A. Ebsworth

David Smith (plate 71)
Interior, 1937
Welded steel with cast iron balls
15 1/2 x 26 x 6 in. (39.4 x 66 x 15.2 cm)
Weatherspoon Art Museum, University of North
Carolina at Greensboro, Museum Purchase, with
funds from anonymous donors, 1979

David Smith (plate 73)
Sculptor and Model, 1937
Welded iron painted with red oxide
28 1/2 x 18 7/8 x 16 5/8 in. (72.4 x 47.9 x 42.2 cm)
Collection of Aaron I. Fleischman
Whitney Museum of American Art only

David Smith (plate 75)
The Hero, 1951–52
Steel
73 11/16 x 25 1/2 x 11 3/4 in. (187.2 x 64.8 x 29.8 cm)
Brooklyn Museum, Dick S. Ramsay Fund 57.185

Alfred Stieglitz (plate 18)
From the Back Window, 291, 1915
Platinum print
9 7/8 x 7 15/16 in. (25.1 x 20.2 cm)
The Metropolitan Museum of Art, New York, Alfred
Stieglitz Collection, 1949 (49.55.35)
Whitney Museum of American Art only

Abraham Walkowitz (not illustrated)
Untitled, ca. 1915
Charcoal and graphite on paper
12 1/2 x 8 in. (31.75 x 20.32 cm)
Whitney Museum of American Art, New York, Gift of
Mr. and Mrs. Benjamin Weiss 79.68
Whitney Museum of American Art only

Andy Warhol (plate 137)
Head (After Picasso), 1985
Synthetic polymer on canvas
50 x 50 in. (127 x 127 cm)
Collection of David Teiger

Andy Warhol (plate 138)
Head (After Picasso), 1985
Synthetic polymer on canvas
50 x 50 in. (127 x 127 cm)
Collection of Thaddaeus Ropac

Max Weber (plate 2)
African Sculpture, 1910
Gouache on board
13 1/2 x 10 1/2 in. (34.3 x 26.7 cm)
Collection of Mr. and Mrs. Henry C. Schwob

Max Weber (plate 4)
Composition with Three Figures, 1910
Watercolor and gouache on brown paper
47 x 23 in. (119.4 x 58.4 cm)
Ackland Art Museum, The University of North
Carolina at Chapel Hill, Ackland Fund 60.4.1
Whitney Museum of American Art only

Max Weber (plate 3)
Two Figures, 1910
Oil on board
47 1/2 x 24 1/2 in. (120.7 x 62.2 cm)
Curtis Galleries, Minneapolis
San Francisco Museum of Modern Art and Walker Art
Center only

Max Weber (fig. 11)
Forest Scene, 1911
Watercolor and graphite on paper
12 1/2 x 8 in. (31.75 x 20.32 cm)
Whitney Museum of American Art, New York,
Purchase, with funds from the Felicia Meyer Marsh
Purchase Fund and an anonymous donor 81.7

Max Weber (plate 6)
Trees, 1911
Oil on canvas
28 x 22 in. (71.1 x 55.9 cm)
Collection of Michael and Fiona Scharf

Max Weber (plate 15)
Figures in a Landscape, 1912
Oil on canvas
28 x 23 in. (71.1 x 58.4 cm)
The Rose Art Museum, Brandeis University, Waltham,
Mass., Gift of Mrs. Max Weber and her children
Maynard and Joy, Great Neck, N.Y., In memory of
Max Weber

Max Weber (plate 17)
Bather, 1913
Oil on canvas
60 5/8 x 24 3/8 in. (154 x 61.9 cm)
Hirshhorn Museum and Sculpture Garden,
Smithsonian Institution, Washington, D.C., Gift of
Joseph H. Hirshhorn, 1966

Max Weber (plate 23)
Chinese Restaurant, 1915
Oil on canvas
40 x 48 in. (101.6 x 121.92 cm)
Whitney Museum of American Art, New York,
Purchase 31.382

Max Weber (plate 25)
Conversation, 1919
Oil on canvas
42 x 32 in. (106.7 x 81.3 cm)
McNay Art Museum, San Antonio, Museum Purchase

Max Weber (plate 26)
Three Figures, 1921
Oil on canvas
36 x 30 in. (91.4 x 76.2 cm)
Collection of James and Linda Ries
San Francisco Museum of Modern Art and Walker Art
Center only

Tom Wesselmann (plate 128)
Still Life #30, 1963
Oil, enamel, and synthetic polymer paint on composi-
tion board with collage of printed advertisements,
plastic flowers, refrigerator door, plastic replicas of
7-Up bottles, glazed and framed color reproduction,
and stamped metal
48 1/2 x 66 x 4 in. (123.2 x 167.6 x 10.2 cm)
The Museum of Modern Art, New York, Gift of Philip
Johnson, 1970

ACKNOWLEDGMENTS

MICHAEL FITZGERALD

In the summer of 1995, when Adam D. Weinberg, then curator of the permanent collection at the Whitney, invited me to join him in reviewing the museum's holdings to select a few dozen drawings to represent American artists' involvement with Picasso's art, I anticipated an enjoyable month's work. Not long after the exhibition closed, however, Adam returned with a far more ambitious idea—an exhibition that would not only tell this fundamental story with the finest works by American artists but also include a full complement of works by Picasso. Having secured the approval of the Whitney's director, David Ross, Adam soon left the Whitney to become director of the Addison Gallery of American Art, and Ross departed to lead the San Francisco Museum of Modern Art. With the support of Willard Holmes (then deputy director of the Whitney) and chairman Leonard A. Lauder, I began the research that would facilitate the selection of the essential objects and allow me to develop the specific comparisons between the work of Picasso and the Americans that provide the foundation of this book and exhibition. In 2002, I began the long process of convincing owners to lend paintings, sculptures, and drawings that are in many cases the premier works in their collections.

Rekindling hope that there might be a benevolent intelligence guiding everyday life, Adam returned to the Whitney as director just as we began the final and most intensive phase of preparation for the exhibition. It has been a tremendous pleasure to work with him in realizing a project that has stretched over approximately ten years. Throughout the preparations, Dana Miller, associate curator, has been my primary liaison with the Whitney. During the last three years, she has worked side by side with me on every aspect of the exhibition and has contributed significantly to each one. Without Dana's encyclopedic knowledge of the institution, her respected standing both inside and outside the museum, and her consummate skill, it would probably have been impossible for a guest curator to complete an exhibition of this scale and difficulty. During these final years, Stacey Goergen, curatorial assistant, has kept the voluminous paperwork moving smoothly and often helped resolve challenging situations with her good humor and savvy understanding of human behavior. Jennie Goldstein, curatorial assistant, has provided crucial help over the past year.

Julia May Boddewyn, too, was waylaid by this project. Our conversations in the summer of 2001 about the activities of the Valentine Gallery soon expanded to the broader question of the history of exhibitions of Picasso's work and ultimately became a five-year effort to document to the fullest extent possible the acquisition and exhibition of his work in this country. Throughout this long process of exacting research, Julia has never wavered in her dedication to uncovering little-known exhi-

bitions and identifying obscure works. Moreover, she pursued this discipline with remarkable grace, while constructing a document that has guided my own conclusions and is likely to be a standard resource for decades to come.

We are profoundly indebted to the institutions and individuals (acknowledged specifically elsewhere in this volume) who have so generously lent works to the exhibition. Many of them have parted with the treasures of their collections for upwards of a year in order that we might make the precise juxtapositions necessary for the exhibition. Among the mainstays to the exhibition, Jasper Johns deserves special recognition. He unhesitatingly agreed to lend every one of the many works we requested from his collection. Beyond this great contribution, he did me a tremendous personal favor by giving up many hours to respond with patience and consideration to the questions of someone who is still only beginning to understand his work.

A scholarly enterprise of this kind is deeply dependent on the willingness of other scholars and individuals to generously share their knowledge and join our campaign to bring greater understanding of our subject. I particularly thank Aaron Fleischman for his passion for the subject and his multi-faceted support from the beginning of this project.

Among the many who have contributed significantly to the extensive research necessary for this book and exhibition are: William Agee, Stephanie D'Alessandro, Maxwell Anderson, Susan Anderson, Karekin Arzoomanian, Michael Auping, Francis Beatty, Neal Benezra, Sarah Bergh, Roberta Bernstein, James Bibo, Flora Biddle, Louise Bourgeois, Ani Boyajian, Paul Brach, Emily Braun, Martha Briggs, Charles Brock, Donald Bryant, Lilly Burke, Sara Campbell, Clarisse Carnell, Barbara Bertozzi Castelli, Leo Castelli, Ellen Conti, Cyanne Chutkow, Susan Cooke, Jack Cowart, Eric Crosby, Sarah Crowner, Kathy Curry, Feri Daftari, Malcolm Daniel, Mary DelMonico, Joelle Dickie, Fiona Donovan, Susan Dunne, Dominique Dupuis-Labbé, John Elderfield, Michelle Elligott, Paloma Esteban, Agnes Fielding, Barbara File, Michael Findlay, Jay Fisher, Robert Fishko, Jack Flam, Laura Fleischmann, Allison Freeman, Larry Gagosian, Gregory Galligan, Tony Ganz, Gary Garrels, Michelle Gilbert, Carmen Giménez, Elizabeth Glassman, Arne Glimcher, Jane Glover, Judith Goldman, Jerry Gorovoy, Dieter von Graffenried, Paul Gray, Susan Greenberg, Ted Greenberg, Sarah Greenough, Madeleine Grynsztejn, Karen Haas, Allison Harding, Helen Harrison, Michelle Harvey, James Haug, Claire Henry, Catherine Herbert, Hayden Herrera, Megan Heuer, Joanne Heyler, Katherine Hinds, Beth Hinrichs, Taffy Holland, Christel Hollevoet, Milan Houston, Geurte Imanse, Carroll Janis, Jane Joe, Brooks Joyner, Pepe Karmel, William Katz, Lynn Kearcher, Ellsworth Kelly,

Joseph Ketner, Joseph King, Marjorie King, Dorothy Kosinski, Melvin Lader, Heather Lammers, Emily Fisher Landau, Leonard A. Lauder, Brigitte Léal, Cherly Leibold, Dorothy Lichtenstein, William Lieberman, Raimond Livasgani, Cassandra Lozano, Nanette Maciejunes, Ted Mann, Martin Margulies, Matthew Marks, Karen Marta, Karin Marti, Marilyn McCully, Andrew McDiarmid, Jane and Robert Meyerhoff, Lucy Mitchell-Innes, Charles Moffett, Bo Mompho, Steven Nash, Francis Naumann, Annegreth Nill, Sarah Norieka, Percy North, Claes Oldenburg, Nathaniel Owings, Michael Parke-Taylor, Mark Pascale, Ann Percy, Lisa Phillips, Sandra Phillips, Claude Picasso, Joachim Pissarro, Marla Prather, Emily Rauh Pulitzer, Michael Raeburn, Eliza Rathbone, Theodore Reff, Gérard Régnier, Sabine Rewald, John Richardson, Nicole Rivette, Leith Rohr, Barbara Rominski, Rona Roob, Elaine Rosenberg, Robert Rosenblum, James Rosenquist, William Rubin, Helen Rundell, Jennifer Russell, Edward Russo, Bart Ryckbosch, Lawrence Salander, Ikkan Sanada, Amy Schichtel, Dieter Scholz, Daniel Schulman, Dieter Schwarz, Sheila Schwartz, Henry Schwob, Hélène Seckel, Roger Sherman, William Siegmann, Natasha Sigmund, Jenna Siman, Patterson Sims, Anne Smith, Katie Solender, Matthew Spender, Gail Stavitsky, Laurie Stein, Peter Stevens, Miriam Stewart, Claudia Stone, Robert Storr, Charles Stuckey, Jeanne-Yvette Sudour, Diana Sudyka, Sarah Taggart, Patricia Tang, Michael Taylor, Ann Temkin, Eugene Thaw, Carolyn Thum, Danielle Tilkin, Gary Tinterow, Jennifer Tobias, Frederic Tuten, Kirk Varnedoe, Ana Vasconcelos, Sylvie Vautier, Ingo Walther, Joy Weber, Jeffrey Weiss, Edye Weissler, Leah Whittington, Matt Wiggins, Wendy Williams, Patricia Willis, Charles Wylie, Deborah Wythe, and Judith Zilczer.

We have been extremely fortunate to have Yale University Press as our partner in the preparation of this book. We owe particular thanks to Yale's Patricia Fidler, publisher, art and architecture; Kate Zanzucchi, senior production editor, art books; and John Long, photo editor and assistant production coordinator. Sue Medlicott and Nerissa Dominguez Vales at Working Dog Press have expertly produced the volume. Rachael de W. Wixom, head of publications and new media at the Whitney, oversaw the production of the book with calm determination; and Makiko Ushiba Katoh, manager, graphic design, has created a design that presents a vast amount of information in a visually engaging form. David Frankel edited the text of the book with consummate grace and insight. Stephen Robert Frankel brought rigorous clarity to the voluminous chronology and significantly improved every element of the book. Thanks are also due to Anita Duquette, manager of rights and reproductions; Vickie Leung, production manager; Jennifer MacNair, associate editor; and Jerry Thompson, who skillfully photographed many of the works.

At the Whitney, every department has contributed enormously to this exhibition. Donna De Salvo, chief curator and associate director for programs; Barbara Haskell, curator; and David Kiehl, curator of prints, generously offered their great talents in service of the exhibition. Carol Mancusi-Ungaro, associate director for conservation and research, and Claire Gerhard, associate conservator, lent their expertise with the many conservation concerns. Evelyn Hankins, former assistant curator, prepared the initial loan requests. Several interns have helped over the course of the last six years: Amanda Bowker, Kim Conaty, Mia Khimm, Marika Knowles, Susanne Scharff, and Emily Schuchardt.

In the Exhibitions and Collections Management department, Christy Putnam, associate director for collections and exhibitions management, deserves special thanks, as do Beverly Parsons, senior registrar, and Carolyn Padwa, manager of touring exhibitions, who coordinated the complex registration arrangements. Nicholas Holmes, legal officer/exhibitions and collections coordinator; Barbi Spieler, senior registrar; Kelly Loftus, paper preparator; and Suzanne Quigley, former head registrar, also contributed to the project. We owe a debt of gratitude to Mark Steigelman, manager of design and construction, for the installation that is being planned as I write, and to Joshua Rosenblatt, head preparator, and his crew, for the installation itself.

Thanks are also due to Carol Rusk, the Irma and Benjamin Weiss Librarian; Jan Rothschild, associate director for communications and marketing; Stephen Soba, communications officer; Meghan Bullock, communications coordinator; Randy Alexander, director of major gifts; Adrienne Edwards, former director of foundations and government relations; Nathan Davis, former foundations and government relations assistant; Amy Roth, director of corporate partnerships; Bette Rice, former director of corporate partnerships; Raina Lampkins-Fielder, associate director and Helena Rubenstein Chair for Education; Frank Smigiel, manager of adult programs; Kathryn Potts, head of museum interpretation; and Jane Royal, manager of school, youth, and family programs.

Trinity College's decision to award a Faculty Research Grant to me in 2001 and a Three-Year Expense Grant in 2001–3 provided crucial support at an early stage of the project.

My heartfelt thanks to May Castleberry, whose twenty-year involvement with the Whitney introduced me to this wonderful, striving institution, and to our son, James, whose birth in 1998 caused him to grow up with this project. May his devotion to the long haul of gardening result in many books. On second thought, maybe not.

INDEX

Note to the reader: Pages on which illustrations appear are indicated by *italics*. Galleries are alphabetized under the surname of the owner (Paul Rosenberg & Co.) or organization (Galleries of the Société Anonyme) where applicable. Exhibition titles from the Chronology have been abridged and are listed under venues in chronological order.

COPYRIGHT AND PHOTOGRAPHY CREDITS